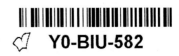

Y0-BIU-582

Long Island
Country Houses and
Their Architects,
1860–1940

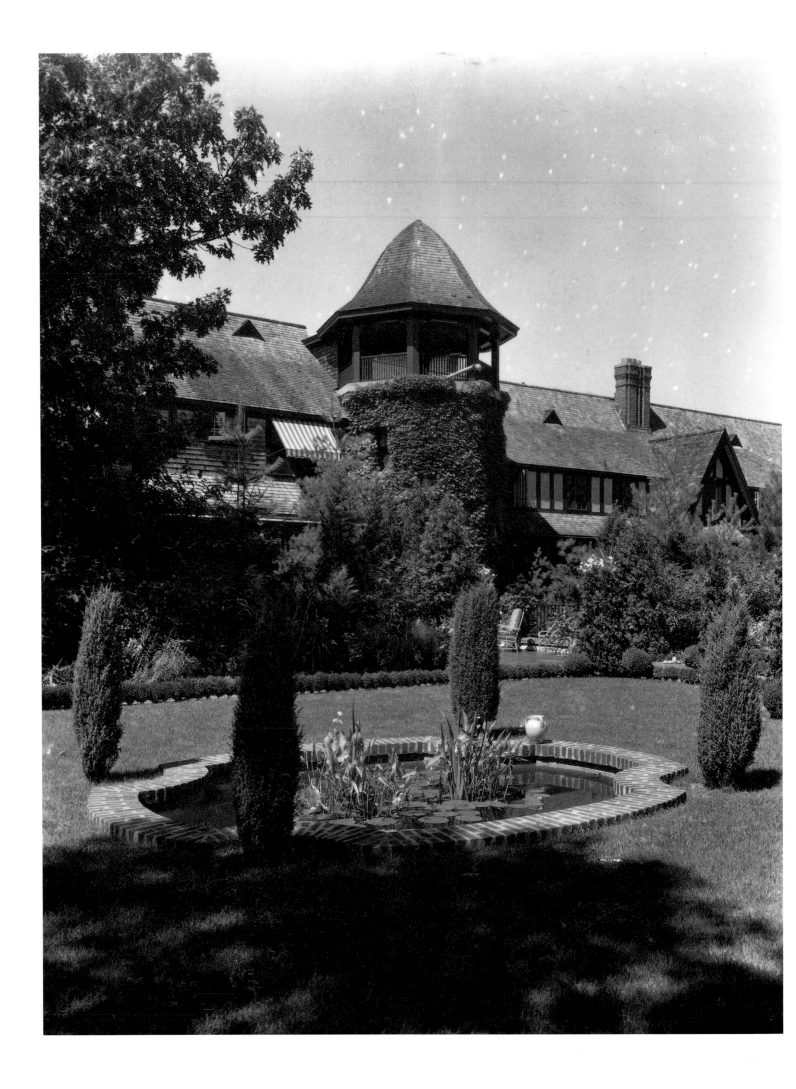

Long Island Country Houses and Their Architects, 1860–1940

EDITED BY

ROBERT B. MACKAY, ANTHONY K. BAKER,
AND CAROL A. TRAYNOR

FOREWORD BY BRENDAN GILL

THE BRYANT LIBRARY
2 PAPER MILL ROAD
ROSLYN, N.Y. 11576-2193

SOCIETY FOR THE PRESERVATION OF LONG ISLAND ANTIQUITIES
IN ASSOCIATION WITH
W. W. NORTON & COMPANY · NEW YORK AND LONDON

Copyright © 1997
by the Society for the Preservation of Long Island Antiquities
All rights reserved.
Printed in Hong Kong by Palace Press, Ltd.
First Edition
Designed and typeset in Adobe Garamond by Katy Homans
with Deborah Zeidenberg, Kara VanWorden, and Philip Kovacevich

Library of Congress Cataloging-in-Publication Data
Long Island country houses and their architects. 1860–1940 / edited
by Robert B. MacKay, Anthony Baker, and Carol A. Traynor :
foreword by Brendan Gill.
 p. cm.
 Includes bibliographical references and index.
 ISBN 0-393-03856-4
 1. Country homes—New York (State)—Long Island.
2. Architecture, Modern—19th century—New York (State)—Long
Island. 3. Architecture, Modern—20th century—New York
(State)—Long Island. I. MacKay, Robert B. II. Baker, Anthony K.
III. Traynor, Carol A.
 NA7561.L665 1997
 728.8'09747'2109034—dc20 96-30375
 CIP

W. W. Norton & Company, Inc., 500 Fifth Avenue,
New York, N.Y. 10110
http://www.wwnorton.com

W. W. Norton & Company Ltd., 10 Coptic Street,
London WC1A 1PU

1 2 3 4 5 6 7 8 9 0

Table of Contents

Thanks

Many individuals have contributed to the success of this project, but it clearly would not have been possible without the assistance of my co-collaborator Anthony K. Baker, who served as photo editor for this publication, spent thousands of hours in the research efforts, and has truly earned the title of the great country-house sleuth having literally pursued elusive estates by land, water, and air, often resorting to "fly overs" of places we were attempting to document.

Replacing Valerie Neil Hassin, an early facilitator of this project, Carol Traynor has for over a decade been the great archivist of this project, overseeing an archive that now can probably be measured not only by the yard but by the rod. She has also been involved in every aspect of this project, including research, writing, editing, and production. Trained as an archaeologist she has brought the attention to detail of her field to the marshaling of the information herein.

Fannia Weingartner, our late Pittsburgh based editor, treaded where others dared not in taking on an assignment some of her colleagues found too great in magnitude. Her editorial skills transformed many disparate writing styles into a more cohesive series of contributions, while her humor, zeal, and sage advice have been invaluable to this effort.

Katy Homans, the designer, also faced a herculean task in laying out this publication and has succeeded beyond all expectations.

Joan K. Davidson both inspired and supported this undertaking, and we are grateful for her assistance. We are also indebted to the late Alan Burnham, an early and enthusiastic collaborator, whose stylistic identification codes are found in the appendices.

Jim Mairs, our editor at W. W. Norton, has been steadfast in his support and eternally patient, encouraging us to include all the pertinent material on Long Island country houses. Also patient have been our 55 authors who include not only scholars long associated with the firms profiled on the following pages, such as Richard Guy Wilson, Pauline Metcalf, and Keith Morgan, but also contributors who were willing to take on the task of writing about the work of the lesser known practitioners. In this regard we salute Michael Adams, Ellen Fletcher, Peter Kaufman, Joy Kestenbaum, Wendy Joy Darby, Christopher Miele, Joel Snodgrass, Zachary Studenroth, Carol Traynor, and James A. Ward.

We would also like to thank Adolf Palzek, who was Librarian of the Avery Architecture Library at Columbia University for facilitating our research at that institution, and Hope Alswang, Zachery Studenorth, Frank Matero, Anne Van Ingen, and other former Columbia students who helped scour the pages of periodicals for references. Special thanks are also due in this regard to Richard Winche of the Nassau County Museum Reference Library, Wally Broege of the Suffolk County Historical Society, and to the archivists of the Museum of the City of New York and the Frederick Law Olmsted National Historic Site, Brookline, Massachusetts.

Our thanks also to Betty Kuss of the W. K. Vanderbilt Historical Society who has done so much to preserve the history of the Southside Sportsmen's Club and the neighboring estates of its members. The late Roger Gerry, president of the Roslyn Landmark Society, and Richard Gachot, Historian of the Village of Old Westbury, were equally generous in providing facts and resources they had spent many years compiling. Fred Hicks and Henry Lewis provided a treasure house of data in giving us access to the archives of the Hicks and Lewis & Valentine Nurseries, respectively. Long Island's town and city historians also provided valuable information and particular thanks are due to Dorothy H. McGee of Oyster Bay, the late Rufus Langhans of Huntington, Dan Russell of Glen Cove, Carl Starace of Islip, and Daniel Overton of Brookhaven. The Society's computer programmers, Robin Mancuso and Cynthia Druckman, have helped process the sea of paperwork this project has generated and designed the computer program to facilitate access to the material. Barbara Van Liew, editor of the Society's Preservation Notes periodical and a walking dictionary on Long Island's built environment, has solved many mysteries for us in the course of this project, and unswerving in their support has been the Society's Board of Trustees under five presidents, Huyler C. Held, Patricia P. Sands, George Hossfeld, Rodney B. Berens, and Alexander J. Smith.

Funding for this study has been made possible by the George F. Baker Foundation, whose support has largely been responsible for its publication, the J. M. Kaplan Foundation, Inc., and the New York State Council on the Arts.

Robert B. MacKay

Preface

The inspiration for *Long Island Country Houses and Their Architects* was actually an earlier study initiated by Joan Davidson while she was director of the New York State Council on the Arts in 1975. Concerned that large estates in New York State were increasingly threatened by destruction or unsympathetic alteration, she recognized that these properties were not simply anachronistic class symbols of aristocratic life styles but rather cultural and environmental resources that were worthy of preservation and of real benefit to future generations. She proposed that the Council help identify mechanisms for saving such properties. The resulting study, published in 1978, was undertaken by William C. Shopsin, AIA, and edited by Grania Bolton Marcus under the auspices of the Society for the Preservation of Long Island Antiquities (SPLIA); it presented case studies on how country houses could be adaptively re-used for a wide range of new purposes. After going through three editions during the course of the study, it became apparent to us that it was necessary not only to identify the mechanisms by which these estates could be saved but to document the extent of the phenomenon in the region that SPLIA is chartered to serve, Long Island.

In the following years SPLIA conducted a survey of both written records and physical remains of the country-house movement on Long Island. From their appearance in the 1860s while the Civil War was still raging to the conclusion of the phenomenon with the end of the Second World War, every architectural magazine and dozens of architecturally related magazines were screened for information on Long Island country houses, public and private collections were consulted, previous writings surveyed, and attempts made in many instances to locate descendants of the original owners who might have photographic images or information about various country houses. This archive was complemented by SPLIA's involvement in conducting large portions of the New York State Inventory of Historic Resources for Nassau and Suffolk Counties during the 1970s and 1980s which led to the discovery in the field of dozens of houses for which there was no written documentation. All of the research and information, including original owners and subsequent owners, architects, landscape architects, dates, locations, and other defining criteria, has been painstakingly rendered into a computer program, perhaps one of the first used in an architectural history project.

Robert B. MacKay

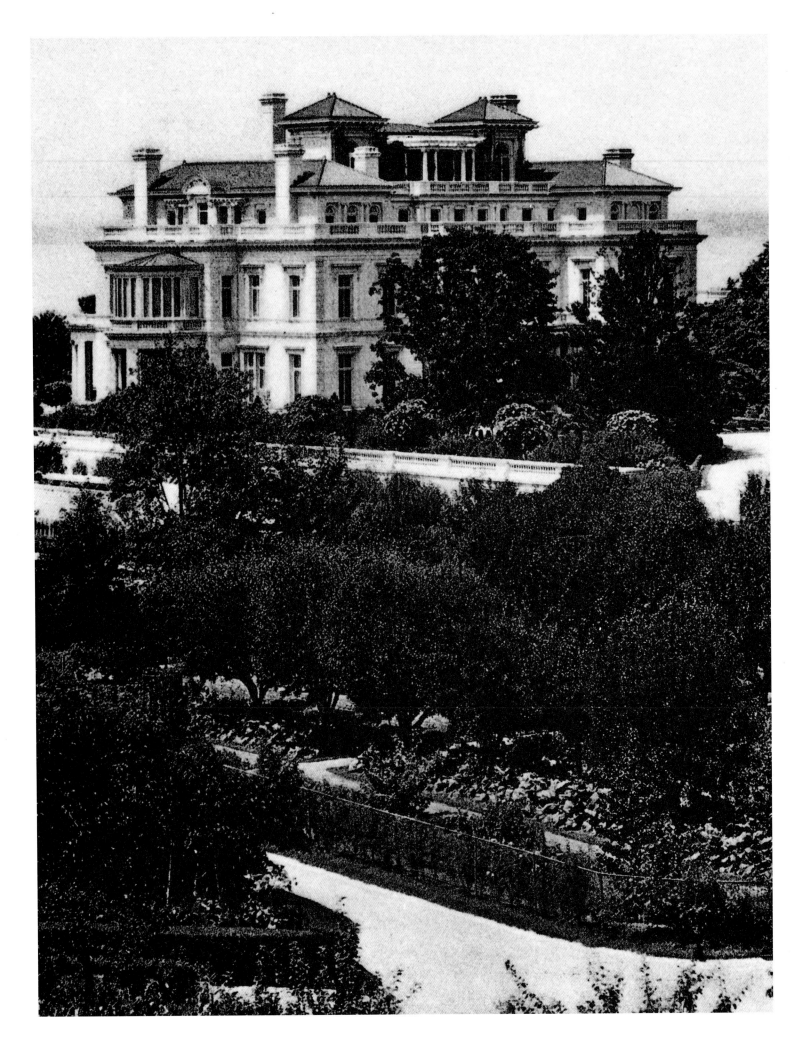

Foreword

The inhabitants of New York City have always been celebrated for two closely related aspects of their character: the fierce and unrelenting eagerness with which they devote themselves to making money and the gentler but no less unrelenting eagerness with which they seek to show it off. Like the ambitious Venetian ship-owners and merchants of a much earlier day (for Venice, like New York, was founded as a trading port and achieved fame by getting and spending on a colossal scale), New Yorkers have been quick to see that the simple act of building is the surest means of announcing that one has made good. A man who puts up a bigger house than his neighbor—or buys a bigger apartment, or drives a costlier car—is a better man than his neighbor: the set of values that most of us live by is, I fear, as simple and un-discriminating as that.

If in Venice in the 15th and 16th centuries fanciful palaces leaped up in gaudy rivalry out of the shimmering waters of the lagoon, so in the 19th and 20th centuries fanciful palaces leaped up along the rocky spine of Manhattan, first on Broadway and later on Fifth Avenue. The purpose of these palaces was less to ensure that their owners were comfortable than to en-sure that they were conspicuous. "Look!" the limestone and marble housefronts asserted, on behalf of their often tongue-tied possessors. "Can you not see that we have arrived? Arrived so vehemently and with such a lust to be one of you that there is no use in your pretending not to see us? Surely you will come to the parties that we intend to invite you to and surely you will not fail to invite us to your parties in return?"

In some such raw and innocent fashion each generation of "new" money has jostled its way into the company of "old" money. Once upon a time, the Astors were at the bottom of the social ladder, looking up at the de Peysters and Stuyvesants; but a couple of generations of judicious money-making and marriage-making brought them to the top. Soon enough, the crude but numerous and immensely wealthy Vanderbilts were gaining access to the ball-rooms of the Astors, not least by dint of build-ing bigger ballrooms for themselves. Today, the Vanderbilts pass for aristocrats, as do the Whitneys and Rockefellers, though a friend of mine in New York remembers that as a little boy he was allowed to play with Morgans and Minturns and Lockwoods but not with Rocke-fellers. The family had but recently arrived from Cleveland (on the wrong side of the Ap-palachians), they had the misfortune to be Bap-tists instead of Episcopalians or Presbyterians, and it was whispered that the family fortune had been acquired with a ruthlessness excep-tional even by the low standards of the day.

A not altogether unpleasant aspect of one's struggle rung by rung up the social ladder is that the competition is so difficult to outwit. For example, by the last quarter of the 19th cen-tury a grand house in town was by no means sufficient to appease the critical eyes of fellow-climbers; a truly ambitious member of society was expected to have a country place on Long Island as well, to say nothing of a seaside cot-tage in Newport, a camp in the Adirondacks, a house for the few weeks of racing at Saratoga, and a winter hideaway in the South. One sees how absurd it is to speak of the idle rich, when the fact is that by tradition they are constantly, tirelessly on the go from one seasonal dwelling place to the next, in a never-ending hurly-burly of sailing, polo, golf, tennis, and shooting. The idle rich are, in fact, the busy rich, and only the fittest of them can hope to survive into old age. Contrary to what is commonly thought, cente-narians abound in the proletariat and are almost unheard of in society; I am prepared to believe that this is a consequence of something more than a mere disparity in numbers.

Though Newport is probably the most famous gathering place of our American rich, it is Long Island that possesses by far the great-est and most interesting assortment of houses designed for the very rich, the rich, and the so-called "well-fixed." From just beyond the bor-oughs of Brooklyn and Queens, which mark the easternmost boundaries of New York City, to where the moors of Montauk pitch headlong in a scatteration of glacial boulders into the foam-ing Atlantic, the entire island amounts to a trea-

"Pembroke," Captain J. R. Delamar Residence, Glen Cove, designed by C. P. H. Gilbert, 1916–18 (AMAR, 1919)

"Beacon Towers," Mrs. O. H. P. Belmont Residence, Sands Point, designed by Hunt & Hunt, c. 1917 (VIEW, c. 1930)

"Oheka," Otto Kahn Residence, Cold Spring Harbor, designed by Delano & Aldrich, 1915–17 (The man and woman in the photograph are thought to be Mr. & Mrs. Kahn. HUNT, n.d.)

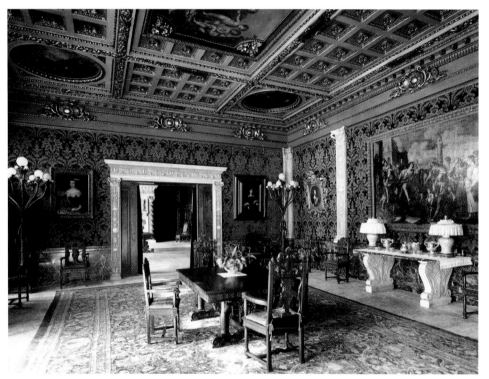

Dining Room, W. L. Stow Residence, Roslyn, designed by John Russell Pope, 1900–03 (WURT, n.d.)

have been the chief patrons of architecture. (Someone may fussily cavil that there have been rulers who were noted patrons of architecture and were not rich; but in respect to monarchs, dictators, and other public figures, let us assume what is so obviously the case: power equals money every bit as readily as money equals power.) How could the rich have failed to become the chief patrons of architecture, given that all architecture, public and private, is dependent upon the harsh, inescapable problem of its cost? Even the pharaohs had treasurers, who must have shaken their heads over the expense of putting up the Pyramids—at once acts of personal vanity and acts necessary to the religious observances of the state. Bleak as the Pyramids may appear to us from the outside, the quarters within those houses of death bespeak a cozy domesticity: one is reminded that throughout history it has often happened that the tomb has been furnished as if it were a home. Bleak or cozy, the Pyramids embody the architecture of opulence, justified (as opulence so often is) by religion, as one sees in St. Peter's in Rome, St. Paul's in London, and St. Bartholomew's in New York. A similar opulence is justified by kingship, since the lower orders are constantly in need of some outward and visible sign of the divine right of their masters to rule over them—a right emphasized, for a man occupying a hovel, by the sheer unattainableness of Versailles, Schönbrunn, or the Hermitage.

Opulence is expensive, and in the 18th century many superior young men of good birth and substantial purse ruined themselves in the course of building homes better than they could afford. There are *palazzi* in Venice left unfinished since the 18th century, when family fortunes ran out; there are pleasant country seats in the English countryside that three generations of a family spent their lives paying for. It was often the case that a young milord would be encouraged in his *folie de bâtir* by some golden-tongued architect hovering in the background. As soon as there was such a profession as architecture in America, professionally seductive architects sprang into being, and the process of seduction has continued unabated to the present day. What a spellbinder Richard Morris Hunt was! So, of course, were Charles McKim and Stanford White and, prince of eloquent rascals, Frank Lloyd Wright. (I cannot resist noting among contemporary spellbinders the presence of Philip Johnson, I. M. Pei, and Kevin Roche. Birds flutter helplessly down out of trees when they speak.)

Those great mansions that hug the bluffs and bays of the so-called "Gold Coast" of Long Island—how many of them are twice or three

sure-house of domestic architecture in a score of styles, representative of the changes in American building tastes that have taken place over a period of 150 odd years. One "reads" Long Island as if it were an encyclopedia—one whose only defect is its lack of an index. For Long Island, small as it appears to be on a map, as a terrain to be explored it is as vast as a continent. One could devote a lifetime to the task, knowing that, at the end of a lifetime, certain areas would have to be marked "terra incognita," to which one might feel inclined to add a warning much honored by our ancestors, "Here be dragons."

Because the rich must build in order to be seen to be rich, from time immemorial they

Cottages on the Dunes, East
Hampton (FULL, n.d.)

times the size that the owners had intended
them to be? For the rich, and especially the
new rich, tend to be ignorant with respect to
the understanding of blueprints; they are con-
tent with pretty renderings of a house as they
will one day see it, nestled among trees that
often serve to conceal a low-roofed wing that
fulfills the architect's aesthetic needs but has lit-
tle to do with the practical requirements of his
clients. On being asked to reduce the size of a
country house, architects (Edwin Lutyens
among them) have been known to reduce the
scale upon which the floor plans have been
drawn. Once in a while, though rarely, the op-
posite situation has arisen; I remember William
Adams Delano telling me how the Otto Kahns,
having bought in the 1910s a large tract of land
on the North Shore, insisted on his designing a
house for them of a quite unnecessary vastness.
Delano sought to outwit them by designing the
house in as simple a French style as he dared,
with a few exceedingly high windows interrupt-
ing the length of the facade. "From a distance,"
Delano recalled, "one might have mistaken it
for a chateau of quite reasonable size." Mrs.
John Barry Ryan, a daughter of the Otto Kahns,
commenting on her parents' Long Island house
(72 rooms and 25 baths) and on their town
house on Fifth Avenue (65 rooms), "I can't *think*
why my mother wished to build such big hous-
es; it must have been something in the air in
those days."

I had better take care not to exaggerate the
number of French châteaus, English castles,
and Italian villas that have come to crown the
tiny eminences of Long Island over the past
century and a quarter. They are superlative feats
of ego and have been, in their time, occasions
for superlative feats of artisanship as well—
masons, roofers, carpenters, blacksmiths,

blowers of glass, and a score of other species of
craftsmen have labored as their ancestors labored
at Nonesuch and Blois and Caserta, and it is our
good fortune that so much of their handiwork
remains—but high and mighty buildings of this
sort are exceptional to the point of eccentricity.
They are more likely to amuse us than to in-
struct us; their histories so often lack the rich
gilding of romance called for by their towery
silhouettes against the sky that we manufacture
gossip about them having little or no relation-
ship to the facts. Gossip, it turns out, is some-
times as hard to live up to as to live down.

Speaking for myself, when it comes to a
big house I am instantly credulous; I will be-
lieve anything about its owner as long as it is
outrageous. The truth of the matter is that I
have a soft spot in my heart for any house that
has over 100 rooms. In proof of which I may
just mention that 50 years ago I was spending
a weekend with a college friend whose family
lived in Old Westbury. We arrived at his place
late on Friday evening, and even as we were
going to bed I was sufficiently impressed with
the grandeur of my surroundings. I said some-
thing to this effect the next morning; my friend
looked bewildered. "But this is the gatehouse!"
he said, and—sure enough—after breakfast we
drove up a long avenue planted on either side
with shapely lindens to arrive at an immense
brick and half-timbered Tudor pile, set in the
midst of green lawns that, more closely exam-
ined, proved to be a private golf course. Little
by little, I learned not to gape.

More characteristic of Long Island architec-
ture than its castles are its cottages; but one has-
tens to point out that "cottage" on Long Island,
as in Newport, North East Harbor, and other

"Box Hill," Stanford White Residence, St. James, designed by McKim, Mead & White, 1884–1906 (FERR, 1903)

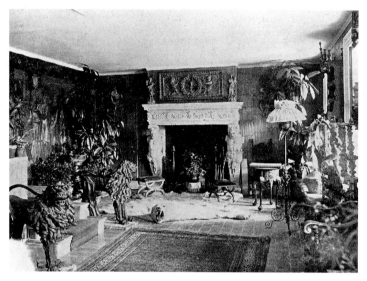

Entrance Hall, "Box Hill," Stanford White Residence, St. James, designed by McKim, Mead & White, 1884–1906 (FERR, 1903)

heard and one could gauge the lightning's distance and imagine the fearful damage it had caused. On the ground floor, room opened into room with no more barrier between them than, say, a set of portieres fashioned out of opalescent seashells; upstairs, half a dozen bedrooms and a bathroom or two opened off a corridor that took its time winding back into the servants' quarters. In the attic, under the high gables, the heat would be suffocating; steamer trunks were piled there, along with warped tennis rackets, Japanese lanterns, and costumes from a ball.

These cottages were to be found both on the North Shore, facing Long Island Sound, and on the South Shore, looking out over the illimitable Atlantic. At first by rail and then by automobile, the rich and the "well-fixed" made their way farther and farther eastward, from Oyster Bay to Shelter Island, from Quogue to Amagansett. When, in the late 1870s, McKim, Mead & White designed in the oak and pine scrub of Montauk a cluster of brown shingle houses as a hunting and fishing camp for some wealthy New Yorkers, the railroad ran only as far as Bridgehampton; from there Stanford White would set out by horse and buggy to oversee the project. At the time, the highway was a pair of dimpled, shifting tracks in the dunes; White, the most impatient of men, must have groaned at the pace he was condemned to follow. Later, he would remodel an old farmhouse for himself and his family, in the village of St. James, looking out over the Sound. He called the place "Box Hill" and it was—and is—an extraordinary house, giving evidence at every turn of White's voracious aesthetic appetite. There was almost nothing in the way of decorative plunder, prized out of the Old World and shipped across the sea to the new, that White wasn't ready to insert somewhere in the grand tangle of his estate. What were all these souvenirs of the European past—limestone sarcophagi, garlanded lead and clay tubs, Dutch tiles, paneled mahogany doors, intricately carved marble mantelpieces—doing in and around a farmhouse on Long Island? Only this, that they measured up to some singular standard of acquisition that White himself defined by the simple expletive, "Bully!" White's partner, McKim, said of the house that it suffered the ineradicable taint of its origins; in spite of everything that White had done to conceal the fact, it was still at heart an awkward makeshift—but for as long as White was alive and filling it with his joyous energy, nobody appeared to notice how odd it was.

Later still, White designed, for a golf club that he belonged to in the windy Shinnecock

summer resorts, is an affectionate diminutive and has little to do with the size of a dwelling. The cottages that I am thinking of contain anywhere from 10 to 30 rooms; in a few cases, they are 18th-century farmhouses, not so much "restored" (though their owners may claim to have done this) as made comfortable through expansion and modernization. But in most cases they will have been built in that extended period between the 1870s and the turn of the century, when the so-called Shingle Style was at the height of its popularity. They are high-gabled and many-chimneyed, with broad porches that often come close to doubling the area of the house. One was intended to live all summer long in the shadowy depths of those cave-like porches, lounging about on wicker sofas and chairs or swinging back and forth in a canvas hammock hung on chains from a matchwood ceiling (the matchwood's varnish slowly silvering in the salt air). Enchanting to watch, from the safety of that shelter, a storm darkly careening across the sky, to see the sudden flash of light and begin counting "One . . . and a two . . . and a three . . ." until the thunderclap was

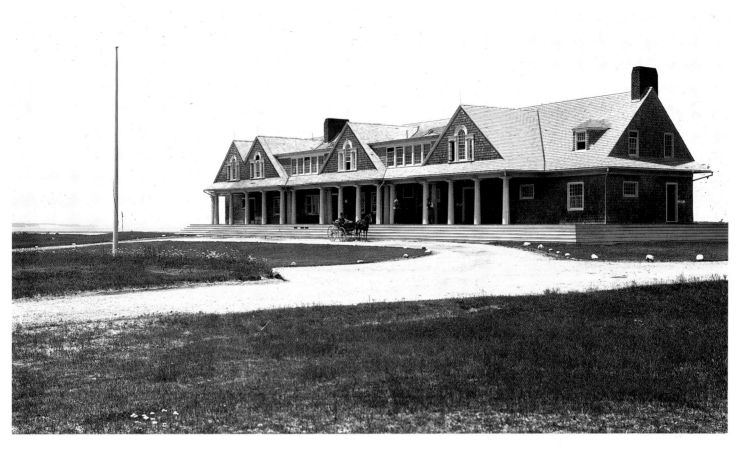

Shinnecock Hills Golf Club, Southampton, designed by McKim, Mead & White, 1891–92, 1895 (FULL, n.d.)

hills, what was said to be the first building expressly intended to serve as a clubhouse for golfers—surely the least important superlative attached to White's name. It was also in Shinnecock that White designed a summer cottage for his friend William Merritt Chase; both the interior and the exterior of the house, the poppy-filled fields around it, and the blue skies above it are familiar to us from many Chase paintings. Mercifully for us, house, fields, and sky are much the same today as they were 100 years ago, when Chase stood at his easel in the bright summer air, painting them.

Artists and writers have always been drawn to eastern Long Island; for 100 years, the environs of East Hampton have been peopled by the most prosperous among them. In the past, they had a tendency to dress like respectable businessmen on holiday; today, they disguise themselves as down-at-heel drifters, congenitally unemployable. Despite their disguises, they are almost certainly far richer than their predecessors and they have proven to be generous patrons of the profession of architecture, which, as we have seen, is always quick to accommodate the desire of the affluent to make their affluence visible. New categories of occupations have come into existence in recent times—movie directors, movie producers, rock stars, rock star managers, and the like—and they, too, are gnawed by a need that only architecture can wholly satisfy. A year or so ago, a movie director of unprecedented fame and

wealth bought property in East Hampton for the purpose of building a house there. He and his architect thought it would be wise to gain an advantageous view of the sea by erecting an artificial dune upon which to set his house. In Hollywood, after all, if one is in want of a mountain, one builds a mountain. However, the movie director's new neighbors in East Hampton thought that nature had already been sufficiently tampered with in that locality and the artificial dune was reluctantly abandoned.

Nowadays, architects are supposed to design houses out of the exquisite murk of their unconscious minds, slightly modified, for better or worse, by the resources of contemporary technology. In an earlier time, architects were expected to comply with their clients' wishes, however peculiar, without feeling that their own intellectual and artistic integrity had been placed in jeopardy. Tucked away in bosky dells throughout Long Island and, in some cases, perched naked atop its most conspicuous knolls are 19th-century houses in a dozen or more exotic styles. William Welles Bosworth, a well-known architect at the turn of the century, would be delighted to offer you the sketch of a house à la Japonaise in the morning and, if that didn't altogether please you, a Swiss chalet in the afternoon. If it was necessary to build a

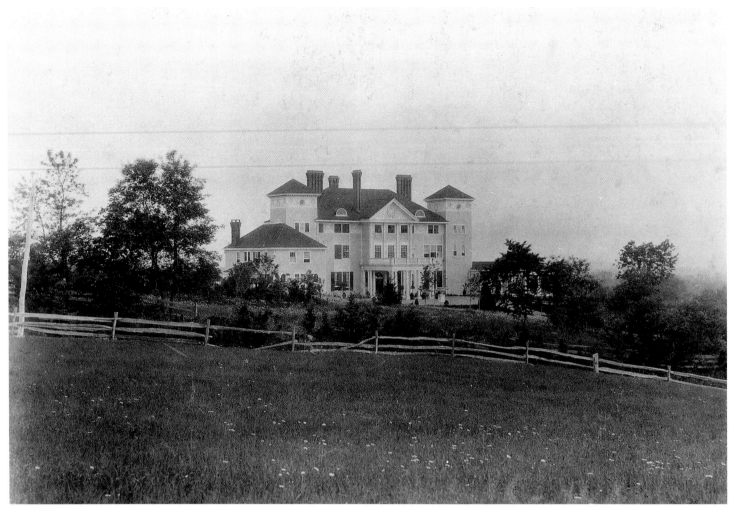

J. F. D. Lanier Residence,
Westbury, designed by James
Brown Lord, 1891 (Courtesy
of Ulysses G. Dietz, n.d.)

water tower on your estate, you could certainly
do worse than have the tower designed in the
form of an Italian campanile, clad in russet
shingles. What was the point of going to all
the bother and expense of travel if one couldn't
produce at home an optical reminiscence of
that bother and expense—a Palladian villa not
on the Brenta but on Mecox Bay?

It was, of course, the case in those days, as
it is today (and was no doubt with the designer
of the first ziggurat in Nineveh), that the rela-
tionship between client and architect is both
symbiotic and adversarial. Each takes care to
blame the other when something goes wrong
in the design and building of a structure, and
each takes credit when things happen to go well.
Nevertheless, it is a fact that architects through-
out history have used clients as an excuse for
what fellow architects and architectural critics
have discerned as blunders in their handiwork.
Because a client is rarely present and therefore
rarely in a position to protest that he had noth-
ing to do with the decisions that led to the

blunders, the architect damns the absent client,
shrugs, and proceeds to call attention to some
particular felicity in the plan that is his alone.

The traditional subterfuge loses its applica-
bility when an architect yields to the temptation
of becoming his own client. After a lifetime of
studying architects, I have reached the conclu-
sion that the temptation, dangerous as it is,
nearly always proves irresistible to them. Only
the lack of enough money with which to build
stands between them and the probable folly of
showing off their professional cleverness. Poor
devils, they are stripped of every conventional
defense against unbridled ego. Rhetorically,
they ask, "If I am not fit to design the perfect
house for the person I know myself to be, who
is?" Undertaking to design "Monticello" and
"Poplar Forest," Jefferson may have asked him-
self the same question and so may have Wright
in undertaking to design his Taliesins East and
West; in their cases, the results have amply
justified their recklessness, and it is only fair
to say that many architects practicing on Long
Island have designed houses for themselves
that reveal them, not at their worst (as I would
have feared and predicted), but in most cases
at their best.

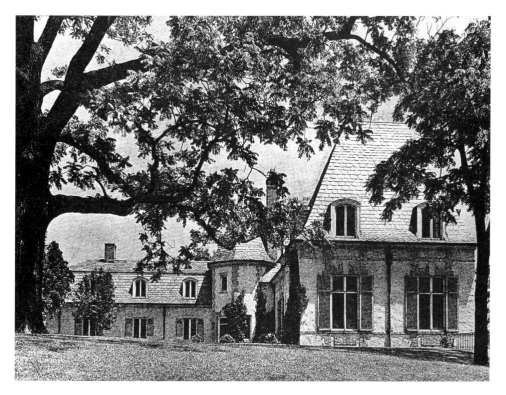

"Goodwin Place," Philip O.
Goodwin Residence,
Woodbury, designed by
Goodwin, Bullard &
Woolsey, 1917 (COUN, 1920)

Stanford White's gorgeous, higgledy-piggledy "Box Hill" has already been mentioned; among the other self-designed architects' houses to be encountered in the course of this book are those of Grosvenor Atterbury, William Adams Delano, Philip Goodwin, Allston Flagg, Thomas Hastings, Harrie T. Lindeberg, Goodhue Livingstone, C. L. W. Eidlitz, Charles Rich, and Addison Mizner. All of these houses are still standing, except for the Goodwin place, and are well worth seeking out, even by stealth in the instances where cautious owners make stealth imperative. Atterbury's house has been defiled by repeated remodelings; its name could now be "Sore Thumb," but one sees what he was after and what has been taken away. Delano's house is characteristically modest, while Goodwin's is a snobbish miniature château, coolly superior to its louche American neighbors. Flagg's sprawling, modified Georgian house is made unnecessarily harsh by its boulder-like stone cladding and heavy slate roofs; in contrast, Lindeberg's house, also of stone, is of an ancient-seeming, tawny-and-ocher softness. (Lindeberg built houses very like his own for brand-new millionaires from coast to coast; how grateful they must have been to him for bestowing upon them and their ramshackle families what Henry James called "the tone of time"!) As for Thomas Hastings's house, which he called "Bagatelle," I am at a loss to understand the disparity between the correctness of so much of its detailing (I assume that Hastings, like White, incorporated a number of antique fragments of

buildings into the fabric of his house) and the coarseness of its fenestration and overall proportions. The house is a Franco-American mélange, flung together by the man who uttered the well-known (and intrinsically meaningless) aphorism, "Style is the problem solved."

It strikes me that even the most casual peruser of the pages that follow cannot fail to be astonished by the richness of the architectural heritage of Long Island. Having experienced this astonishment myself, I confess to feeling a slight twinge of guilt over the impertinent teasing of the rich that characterizes the opening paragraphs of this preface. I should not begrudge the rich their indispensability to the cause of architecture, nor should I neglect to mention the hospitality that they have dispensed to all of us, scholars and mock-scholars alike, in the course of our attempts to identify and preserve the most highly valued remnants of our brick-and-mortar past. If it is costly to build houses that measure up to a high standard, it is still costlier to maintain them in a fashion that will secure their being handed down to no telling how many future generations. Nor is it only mansions I have in mind. Whenever I visit East Hampton, I am fortunate enough to be put up in a snug little 17th-century cottage—a true cottage—that was once a clock shop on the village green. A few years ago, it was threatened with demolition; in the nick of time, a wise woman, not without means, plucked it up and set it down in a pine grove on the edge of the dunes. From its casement windows, I look out over the Atlantic toward Portugal; behind me a fire crackles and snaps on the hearth and I am happy to share its warmth with the ghosts of all those long-dead Dominy clockmakers. This little house and all the houses of whatever size and degree of grandeur that lie in the low hills and secret valleys and sandy reaches of this greeny fluke of land are but a single incomparable benefaction. We do well to cherish it and to promise, not grimly but with joy, as with the picking up and carrying of the most precious of burdens, never to let it go.

Brendan Gill

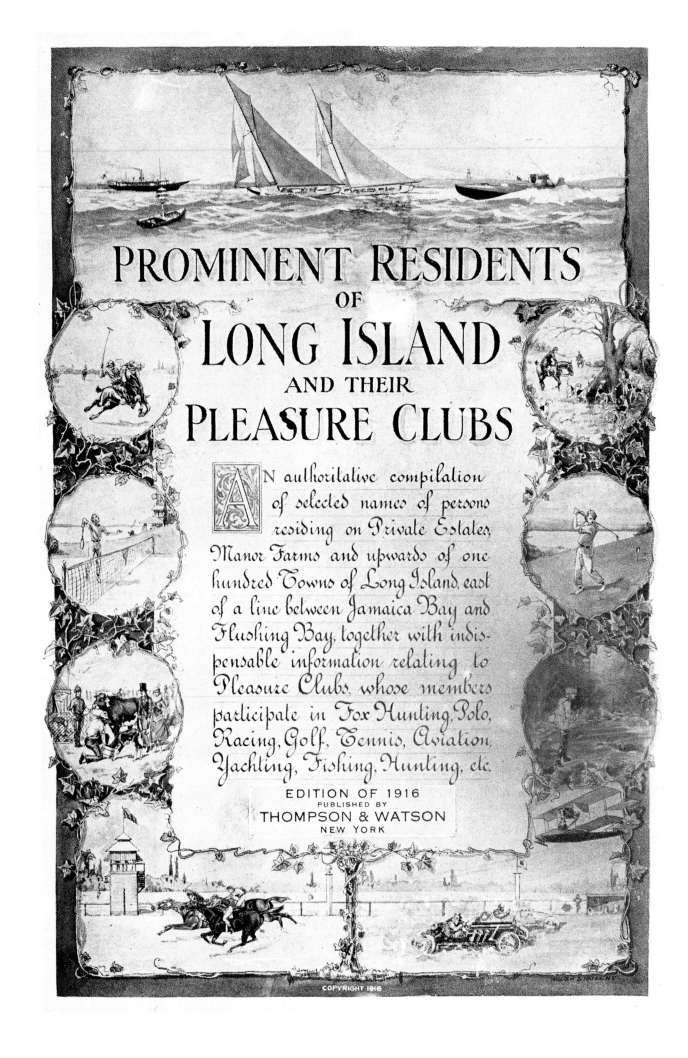

PROMINENT RESIDENTS
OF
LONG ISLAND
AND THEIR
PLEASURE CLUBS

AN authoritative compilation of selected names of persons residing on Private Estates, Manor Farms and upwards of one hundred Towns of Long Island, east of a line between Jamaica Bay and Flushing Bay, together with indispensable information relating to Pleasure Clubs, whose members participate in Fox Hunting, Polo, Racing, Golf, Tennis, Aviation, Yachting, Fishing, Hunting, etc.

EDITION OF 1916
PUBLISHED BY
THOMPSON & WATSON
NEW YORK

COPYRIGHT 1916

Introduction

The arrival of the SS *Berengaria* in New York Harbor on August 29, 1924, signaled the beginning of a celebration unequaled even in the excessive annals of the nation's leading playground. "Here He Is Girls—The Most Eligible Bachelor Yet Uncaught," heralded a New York tabloid as His Royal Highness Edward, Prince of Wales, stepped aboard the yacht *Black Watch* which would carry him on the last leg of his journey to Long Island's North Shore. The *raison d'être* for the Prince's visit was the international polo matches of 1924 between Great Britain and the United States, the first since World War I, and Long Island was prepared for the occasion. The James A. Burdens had turned over "Woodside," their Syosset estate, to the Prince whose whirlwind of social activities over the next fortnight on what F. Scott Fitzgerald would describe as that "slender riotous island" made a deep impression on the future Edward VIII. "Compared to the creature comforts Americans took for granted, the luxury I was accustomed to in Europe seemed almost primitive," he noted in his memoirs. "My American hosts spared no expense in demonstrating the splendor of a modern industrial republic." For this member of the royal family America was a country "in which nothing was impossible" and, he reported, "Long Island did nothing to disabuse me of this conception."[1]

Indeed, Long Island could not have dissuaded the Prince from this view, so great and apparent was the concentration of wealth. Of the 50 captains of finance and industry profiled by B. C. Forbes in his 1917 bestseller *Men Who Are Making America*, 21 either resided on Long Island for part of the year or had children who maintained country houses east of the city line. Twenty years later, Ferdinand Lundberg's Depression-era *America's 60 Families* charted an even greater concentration. Fourteen of the nation's 25 richest families could be linked to Long Island. The names of these captains of industry and finance read like a chronicle of American economic history: J. P. Morgan, William K. Vanderbilt, William Randolph Hearst, Russell Sage, Vincent Astor, Pierre Lorillard, F. W. Woolworth, Otto Kahn, Walter P. Chrysler, Harry Payne Whitney,

W. R. Grace, Marshall Field, Alfred I. and Henry F. du Pont, Marjorie Meriwether Post and her husband Edward I. Hutton, Louis Comfort Tiffany, the sons of Andrew Carnegie's partners, Henry Phipps and Henry Clay Frick, and sons of Henry Ford, Thomas A. Edison, Charles Pratt, Meyer Guggenheim, and Jay Gould all resided on Long Island.

Between the Civil War and World War II, more than 975 estates were created from the city limits east to Montauk. "Country homes, with their mile long driveways are continuous for a hundred miles," reported the *New York Herald* in 1902; "Long Island is rapidly being divided up into estates of immense acreage . . . beyond all precedent of American country life."[2] It was the "density of the millionaire population" that astonished the *Herald*. "Nowhere else, certainly in America, possibly the world, are to be found so many great landed estates in any similar area." The *Brooklyn Daily Eagle* commented that Long Island had been "touched by magic, a new version of the Sleeping Princess," and the accolades were to continue for decades.[3] As late as 1946, *Life* called the region "the most socially desirable residential area in the United States," and *Holiday* reported two years later that "while time is making some changes" it was clear that the "estates of Long Island's North Shore are close to an American ultimate in elegance, exclusiveness and display."[4]

What made this phenomenon all the more remarkable was that as late as the 1870s and 1880s Long Island had been relatively unknown as a watering spot, unmentioned in the guidebooks that extolled the merits of such nationally known resorts as the Jersey Shore, Newport, and the Adirondacks. "Dreary sandy wastes" was its popular image as we learn from Theodore Roosevelt's friend Joseph Choate.[5] Tile Club artists thought of visiting its eastern extremities because "nobody goes there," and, as late as the 1890s, the architect Robert Gibson lamented that "so few people know the North Shore."[6]

This introduction examines the reasons behind the rise of the Long Island estate phenomenon, which reached its zenith in the decades before World War I and whose origins can be traced to the third quarter of the 19th century. Also to be explored is the impact of the estate phenomenon on Long Island's way of life and economy, the estate planning process, and some of the statistical results of the Society for the Preservation of Long Island Antiquities' computer-assisted survey of Long Island country houses built between 1860 and 1940 that appears in the Appendix.

Frontispiece, *Prominent Residents of Long Island and Their Pleasure Clubs* (SPLI, 1916)

His Royal Highness, Edward, Prince of Wales, at the Piping Rock Club, 1924 (Courtesy of the Piping Rock Club)

Vacationers arriving by steamboat and rail connection to "Laurelton Hall," Cold Spring Harbor (Long Island Railroad brochure, 1898, SPLI)

Via Long Island Railroad to Syosset Station or Boat direct.

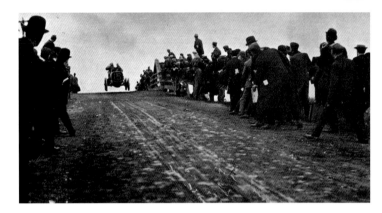

Automobile races on the Long Island Motor Parkway near Hauppauge, c. 1910 (SPLI, c. 1910)

Why Long Island?

To late 20th-century developers of projects such as Mexico's Cancun resort, planning has become a computer science in which key factors such as location, climate, transportation links, the availability of labor, and proximity to urban areas can easily be quantified. Long Island met all of the criteria favorably, as did many other 19th-century watering places, but its development as the national resort was due to a series of overwhelming additional advantages. These included ease of access to the nation's social, economic, and media capital, the development of recreational pursuits for the leisure class, and a collateral movement that proceeded apace, namely, the founding of clubs around these sporting interests.

Although Long Island had been a seasonal retreat since the 17th century when such early New York notables as Governor Thomas Dongan and Mathias Nicoll established estates in what is now Nassau County (also the site of one of the nation's first resort hotels, the Marine Pavilion [1833–1864] at Far Rockaway, frequented by such luminaries as Henry Longfellow and Washington Irving), it was the beginning of the construction of the Long Island Railroad (LIRR) in 1834 that presaged the first advantage.[7] Originally conceived as a direct route from New York to Boston via steamers from Greenport to Stonington, Connecticut, and then to Boston by rail, the railroad was forced to focus on its hinterlands when a competing line marshaled the technology to bridge Connecticut's rivers a decade later.

The decision of the LIRR to build stations and spurs sparked the summer colony movement. While steamships serviced many Long Island towns, the vessels were seasonal at best and had trouble running on schedule. The surviving papers of the Swan family, among the earliest summer colonists at Oyster Bay, indicate that the railroad was the preferred means of travel, with steamers being used primarily to transport freight. So rapid was the speed of railroad travel that, according to notes made by Caleb Swan in 1855, the trip from the depot nearest Oyster Bay to his lower Manhattan residence took only about 30 minutes longer than today's commute, although Swan crossed the East River by boat and then traveled downtown on a horse-drawn omnibus.[8] With each extension of the railway another section of Long Island developed as a resort. For example, the construction of a spur from Hicksville to Syosset in 1854 greatly facilitated the establishment of a summer colony at Oyster Bay by members of Manhattan's Union League Club, while Glen Cove's popularity with a coterie of Brooklyn's elite burgeoned after a line reached that town in 1867. The extension of the South Side Railroad to Patchogue in 1869, the completion of the Port Washington line in 1898 and its electrification 15 years later, and the completion in 1910 of the East River tunnels providing direct service to Manhattan's Pennsylvania Station were other milestones in the litany of progressive rail improvements.

Long Island's transportation advantages continued to build in the early years of the automobile age with the completion of the East River bridges. The Queensboro or 59th Street Bridge (1909) was particularly important because it dramatically shortened the trip from midtown Manhattan to the North Shore via Route 25 or 25A. For those heading to the south and east it also connected easily to William K. Vanderbilt, Jr.'s new Long Island Motor Parkway, the first limited-access highway. Commissioned in 1906, the parkway counted many Long Island estate owners among its stockholders. Writing in *Harper's Weekly* in 1907, A. R. Pardington, the parkway's chief engineer, foresaw that the completion of the Queensboro Bridge would allow executives to commute by automobile a generation before Robert Moses's parkway system and more reliable automobiles would make this a reality for thousands of New Yorkers:

Think of the time it will save the busy man of affairs, who likes to crowd into each day a bit of relaxation. He will leave downtown at Three o'clock in the afternoon, take the subway to a garage within striking distance of the new Blackwells Island-East River Bridge. In twenty minutes a 60-horse-power car will have him at the western terminus of the motor parkway. Here a card of admission passes him through the gates,

Commuting by Motor Yacht
(COUN, 1922)

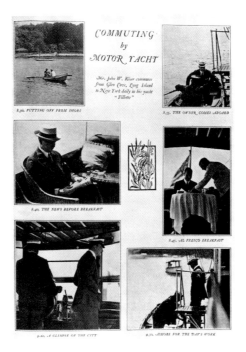

these commuting yachts achieved speeds of between 30 and 50 knots by the 1920s, whisking their city-bound owners to Wall Street in an hour's time from estates 30 miles distant. Due to the compactness and reliability of the new engines, economies were achieved in boat length and crew size, which brought this method of commuting within the reach of most estate owners, many of whom apparently considered it a prerequisite of country life. The surviving building records for Wilton Lloyd-Smith's Lloyd Neck estate, designed by Bertram G. Goodhue, are interspersed with invoices for *Argo,* his 60-foot commuter, which was being constructed simultaneously.[11]

This mode of commuting reached its peak in popularity between the World Wars, becoming the preferred way to get to work for such captains of finance as Walter P. Chrysler, J. P. Morgan, George F. Baker, Jr., Nelson Doubleday, Otto Kahn, Marshall Field, and the Pratt brothers. Toward the end of this period some of the more adventurous, including Tommy Hitchcock, the polo legend, turned to seaplanes, winging their way to Wall Street under and over the great East River bridges along the business-boat route.

Collectively, these travel advantages to Manhattan by rail, road, and water, coupled with the comparative nearness of most of Long Island's estate country vis-a-vis such long-established watering places as the Jersey Shore and Hudson River Valley (not to mention the distant resorts of Newport and Bar Harbor), made Long Island the ideal choice of Pardington's "man of affairs." Here was a place where one could experience country life without losing contact with developments in the city and office. The South Shore summer colony historian, Mosette Broderick, has compared the LIRR's importance to those communities with that of an umbilical cord.[12] Unlike Newport, which was a place to be seen (an extension of its resort hotel origins which, Ada Louise Huxtable reminds us, were stage sets for the ritual of "flirtation, promenade, and social gamesmanship"), Long Island was always more a place to be experienced than to be seen. Nor was Long Island ever to offer the retreat from realities that Fisher Island provided the very rich between the World Wars, nor to become a gathering place for intellectual and artistic enclaves akin to Edith Wharton's Lenox, despite the presence of figures like William Cullen Bryant, William Merritt Chase, and Bret Harte. Complementing its convenient

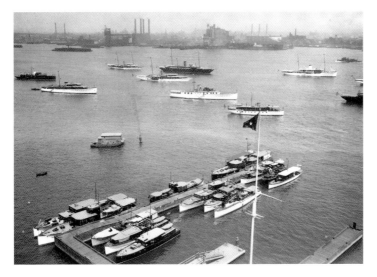

The New York Yacht Club's East River landing at 26th Street, jammed with "business boats," c. 1929 (Rosenfeld Collection, Mystic Seaport Museum, Inc.)

speed limits are left behind, the great white way is before him and with throttle open he can go, go, go and keep going fifty, sixty, or ninety miles an hour until Riverhead or Southampton is reached.[9]

For those who found the wicker-seated private club cars of the LIRR too slow and long-distance travel by "motor" uncomfortable or unreliable, Long Island's protected waterways facilitated the ultimate method of accessing one's country estate—commuting by yacht. The *New York Herald* reported in 1902 that "an enormous fleet of private yachts" regularly plied the waters of Long Island Sound to "carry owners at racing speed twice a day from their great estates to the wharf on Manhattan Island nearest their offices."[10] The seasonal phenomenon in which conventional steam yachts were first employed soon gave birth to a whole class of yachts known as "commuters" or "business boats." Given a boost by the development of the high-powered combustion engine for World War I aircraft,

Field day at the Piping Rock
Club, 1912 (SPLI, 1916)

access to Manhattan, Long Island also possessed an ample and varied topography perfectly suited for well-heeled America's new experiment in country living. Carefully chronicled from 1901 to 1942 by the magazine *Country Life* (published on Long Island by Doubleday's Country Life Press) and influenced by English pastimes, the movement stemmed from the development of American recreational pursuits and the associated creation of a new form of sodality—the founding of recreational clubs.

In some ways, Long Island had always been a focus of sporting activity. In 1665 Governor Richard Nicolls laid out on the Hempstead Plain what is generally considered to have been the country's first formal racecourse and presented a trophy to the winner of a race for the purpose of "encouraging the bettering of the breed of horses," thus establishing the region as a center for thoroughbred racing.[13] Long Island tracks were to gain their preeminence in this sport, however, in the early decades of the 19th century. Milestones in the establishment of that hegemony were the opening of the Union Course just west of Jamaica in 1821, the first "skinned" or "naked soil" racetrack in America; the great North-South match races before the Civil War; and the opening of the Sheepshead Bay Course in 1890, Aqueduct in 1894, and in 1905 Belmont Park, home of the American derby, the Belmont Stakes. By the 1920s the last-mentioned tracks held every American course record from seven furlongs through two miles, not to mention purse records.

Other sporting pastimes for which the region had been famous from virtually the onset of European settlement were angling and fowling. It was not insignificant that the 1664 deed by which Tobaccus sold land to the Setauket settlers granted "the liberty for fishing, fowling and hunting."[14] Positioned astride the Atlantic flyway, Long Island teemed with both wild and water fowl while boasting some fine trout streams. The first series of sporting lithographs in America—Currier & Ives, drawn by artist

Frances F. "Fanny" Palmer—depicted Long Island hunting scenes, and, not surprisingly, the region's first ornithological guide, J. P. Giraud's *Birds of Long Island* (1844), was written with the sportsman rather than the naturalist in mind. Giraud's intent was to place "within the reach of gunners, the means of becoming more thoroughly acquainted with the birds frequenting Long Island," for he felt "no portion of our country, of the same extent, is richer in resources for the student of Natural History, or more inviting to the sportsman than this garden of the middle districts."[15]

Among the important persons to discover the garden in the early decades of the 19th century was Daniel Webster, whose catch of a record trout at the Mill Pond on Carmans River in 1827 is depicted in the Currier & Ives 1854 print titled *Catching A Trout 'We Hab You Now, Sar.'* Webster subsequently secured fishing rights along a portion of the river both for his use and for that of a group of friends, including future president Martin Van Buren, railroad pioneers John and Edmund Stevens, diarist Philip Hone, and Walter Bowne. This group is considered to have been the forerunner of the Suffolk Club organized in New York City on April 6, 1858, by August Belmont (1816–1890) in concert with Watt Sherman, W. Butler Duncan, and others. The Suffolk Club acquired a 1,500-acre preserve along the river and built a three-story clubhouse in which each of the 15 members had rooms. The Suffolk Club can lay claim to being the region's first formally organized sporting club with grounds, facilities, and a nonresident membership.[16] What happened next—the natural extension of the creation of sporting clubs—would quickly become a Long Island phenomenon. Perhaps seeking better accommodations than the club offered, and certainly realizing he would be able to facilitate his interests both in field and stream *and* turf and field, Belmont in 1864 acquired 1,100 acres in nearby North Babylon to start "The Nursery," a stud farm, and build a 24-room mansard-roofed country house designed by Detlef Lienau which a sporting paper described as "so lofty that we should think the Fire Island Lighthouse and the sea might be seen from the top of it on a clear day."[17] The construction of country houses on Long Island based entirely on sporting rather than agricultural or ancestral *raison d'être* had begun. (The exceptions to this rule almost can be counted on one hand and included a few rusticators, like panorama artist John Banvard, who constructed "Glenada," a castellated mansion at Cold Spring Harbor in 1853, and William Cullen Bryant, who had discovered Roslyn Harbor as early as 1845.)

The death in 1861 of Liff Snedecor, proprietor of a popular Oakdale hunting lodge, led to the creation of the South Shore's second sporting club of consequence, incorporated in 1866. Membership in the South Side Sportsmen's Club soon became the impetus for the estate development of the South Shore from Babylon to Quogue. So profound was its influence that even maps of this area in the 1990s show that virtually all of the surviving open space is comprised of the former estates of South Side members, including those of the Singer sewing machine magnate Frederick Bourne (now La Salle Military Academy), William K. Vanderbilt (now Dowling College), Bayard Cutting (now Bayard Cutting Arboretum), Henry B. Hyde (now Southward Ho Country Club), Harry Peters ("Windholme" now demolished), and August Belmont (now Belmont State Park), while the club itself is now the Connetquot State Park.

Spurred on by another nascent recreational interest, "Corinthian" or amateur yachting, which was then coming into vogue in England, estate development proceeded apace on Long Island's North Shore. Here the retreat of the last ice age had carved deep harbors out of the glacial moraine, offering some of the finest protected anchorages on the Eastern seaboard. In short, ideal conditions were present for the nurturing of the new sport, many of whose adherents were collegians and young men who considered it a "matter of personal pride to scrape, paint, rig, and sail their own boats, the races being local and informal."[18]

This activity stood in marked contrast to the professional stake races and yacht club regattas of the time in which owners considered it below their dignity to assume command of their own vessels. In Hempstead Harbor the first amateur yachtsmen were part of William Cullen Bryant's circle, including his son-in-law, Parke Godwin, and Thomas Clapham, heir to a British fortune. The latter's granite villa, "Stonehouse," completed in 1868 to designs by Central Park architect Jacob Wrey Mould, was the first country house on a grand scale in this area of the North Shore. Clapham, who was to become a noted designer and builder of small yachts, and the Roslyn contingent competed in races at Oyster Bay (the next harbor to the east) which had become a center of amateur sailing activity in the 1860s. The sons of a number of wealthy New York families who "hired" houses for the season at that quiet watering spot, the ancestral home of the influential Townsend, Weeks, and Underhill families, avidly participated in the informal sailing contests. In 1872 they organized the Seawanhaka Corinthian Yacht Club (roughly translated, Long Island Amateur Yacht Club), which hosted the nation's first open amateur regatta and became a leading force in the development of amateur sailing. However, ashore, the new club's most discernible impact was on the area's real estate values. Seawanhaka's decision to build a clubhouse on Centre Island in Oyster Bay in 1892 encouraged nine of its members to build mansions there by 1912. In the general vicinity of Oyster Bay, over 30 members had built houses by 1932 following their election to the club. While it is impossible now to determine the exact motivation of each mansion builder, it is evident that this yacht club and others that soon followed, such as the Manhasset Bay Yacht Club (1891), the Huntington Yacht Club (1911), and the Penataquit-Corinthian Yacht Club at Bay Shore, had a similar impact on their environs, as dozens of affluent urbanites began to see the advantages that Long Island's protected waterways held for the new pastime of amateur sailing.

And if Long Island beckoned to the sportsman and yachtsman, the equestrian was not far behind, soon re-establishing the 18th-century pastime of fox hunting in the region. H. S. Page, the well-traveled sportsman, noted that Nassau County's terrain was "better suited to drag than fox hunting, on account of the size of

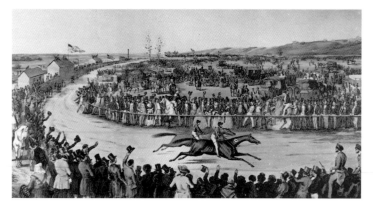

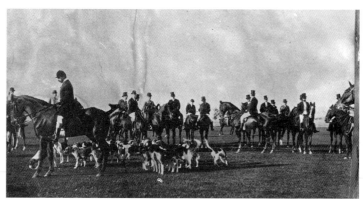

"Petonya and Fashion at the Union Race Course, 1845." Nathaniel Currier lithograph (SPLI)

Preparing for a hunt at the Meadow Brook Club, c. 1890 (Courtesy of the Meadow Brook Club)

"A Wagonette Break, driven by John Townsend over the Shinnecock Hills." Lynwood Palmer, 1892 (The Museums at Stony Brook, gift of Lida Fleitman Bloodgood in memory of John R. Townsend, 1957)

"The Meadow Brook Hunt, January 21, 1933." (From an original painting in the collections of Mrs. Richard Babcock)

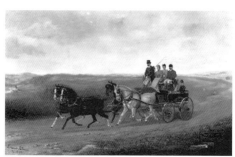

the coverts and the sandy condition of the soil —grand for going but at times bad for scent." Yet he felt it justly deserved to be termed "the Leicestershire of America."[19] Meeting at the Garden City Hotel in 1877, the Queen's County Hounds are thought to have been the first organized pack of drag hounds in the United States, while the Rockaway Hunt Club (1878) can lay claim to being America's oldest such organization in continuous operation, edging out the Meadow Brook Club by three years. So many disputes over hunting boundaries occurred between Rockaway and Meadow Brook that in 1893 an agreement was reached dividing present-day Nassau County on a line between Rocky Point Beach and Mineola.

The competition between the rival clubs continued into the new sport of polo, introduced into the United States in 1867 and in full swing on Long Island in the early 1880s. Meadow Brook, aptly dubbed the "Heart of American Polo,"[20] was to boast eight fields (each larger than seven football fields) by the early decades of the new century, including the International Field where 40,000 spectators crowded into the sky-blue grandstands for matches against the British and Argentines.

Of the 21 Americans to play against Great Britain in the dozen international matches held between 1886 and 1939, all but a few were Long Islanders who, by the outset of World War II, were playing on some 28 fields. Coaching, the

steeplechase (a course for which Rockaway had laid out as early as 1882), gymkhanas (an equine field day), hunt meets, and, of course, horse shows, including such nationally prominent fixtures as the North Shore and Piping Rock shows, rounded out Long Island's equestrian events. However, for those who preferred the less strenuous pursuit of trail riding, the Country Lanes Committee maintained a vast network of carefully marked trails, lanes, fields, and unpaved roads stretching almost the length of Nassau County from Hempstead Harbor east to Cold Spring Harbor and accessed by "Westbury Gates," which could be opened from the saddle by levers. Long Island was simply "a paradise for equestrians," as *Country Life in America* remarked in 1913.[21] "Everyone rode, hunted, or played polo and fairly lived out of doors," Rockaway's ten-goal polo ace and steeplechase champion Foxhall Keene was to recall in his memoirs: "Sunday morning you would see thirty or forty men riding over the countryside larking over fences and having a wonderful time."[22] "The beauty and fashion were all collected there," H. S. Page wrote, "the hardest riding men, the top polo players, the first flight gentlemen jockeys."[23] Even the meeting of trains became an equine event. "The display of blooded horses and elaborate turn-outs" at the new depot in Glen Cove impressed a *Brooklyn Daily Eagle* reporter, who wrote, "It has become the correct thing for the cottagers to drive to the station and meet the members of their families

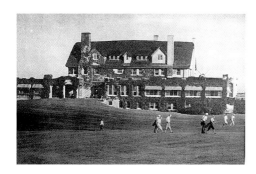

National Golf Links of America, Southampton (SPLI, n.d.)

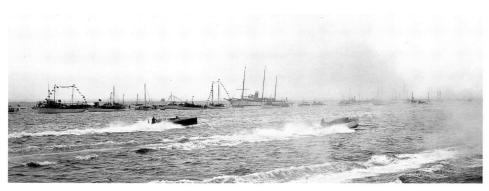

Start of the International Motorboat Races (Rosenfeld Collection, Mystic Seaport Museum, Inc.)

Robert Graves's "garage-hotel" in Mineola, c. 1905 (VANB, n.d.)

or expected guests, and it is not unusual to see a party of eight drive to meet one new arrival."[24] For the well-heeled whose conception of country life was synonymous with owning horses, central Nassau County and, particularly, Westbury and its environs had become the retreat. By 1910 as many as 16 of the people listed on Meadow Brook's polo roster at the turn of the century had built country houses in the vicinity.

Golf, introduced to America in 1888 at Yonkers, found its model for emulation when Southampton's Shinnecock Hills Golf Club (1891–92) became the first professionally designed course in America to be built in conjunction with a clubhouse. By the early 1890s the sport was played at Rockaway, Seawanhaka Corinthian Yacht Club, and Meadow Brook, site of the first USGA Women's Amateur Championship in 1895. The new clubs formed around this pastime, including the Oakland at Bayside (1896), the Nassau Country Club at Glen Cove (1899), the Garden City Golf Club (1899), and the National Golf Links at Southampton (1907), site of the first Walker Cup in 1922, were to have a major role in the development of their environs as resorts.

Tennis, first played in this country at Staten Island in 1874, was quite popular on Long Island by the late 1870s, with nets a common

sight on estate lawns. From the day in 1914 that the West Side Tennis Club's grass courts were hauled by horse-drawn carts from their former site near Van Cortlandt Park in the Bronx to Forest Hills, Long Island could lay claim to being the American capital of that sport as well. The U.S. Open matches were first held on the transplanted courts in 1915 and the first great tennis arena, the 13,000-seat Forest Hills Stadium, was completed in 1923.

The list of games the sporting gentry engaged in ran the gamut from pursuing imported European hares with foot hounds (Locust Valley's Buckram Beagles) to bicycle polo (an attempt to play the game with automobiles proved short lived). Even aviation was regarded as a gentrified pursuit: the New York Aeronautic Society had facilities in Mineola as early as 1909, while the Long Island Aviation Country Club, with a clubhouse and field at Hicksville, flourished between the World Wars.

By the close of the first decade of the 20th century, Long Island was the cradle of many of the nation's nascent recreational pursuits, a great national playground where grand prix sporting events often took place concurrently. For instance, those here for "the season" in 1910 and 1911 might have seen polo's "Big Four" (Harry Payne Whitney, Devereux Milburn, Sr., and the Waterbury brothers) take on the British for the Westchester Cup; witnessed aerial acrobatics and a new world altitude record (9,714 feet) at the first International Air Show at Belmont Race Track (August Belmont, Jr., was an early patron of aviation); thrilled to *Dixie IV*'s successful defense of the British International Trophy (Harmsworth Trophy) in front of the fashionable Beaux Arts Casino on Huntington Bay, in which August Heckscher's speedboat edged out the Duke of Westminster's entry at speeds in excess of 40 mph; heard some of the world's greatest drivers tune up their engines at Robert Graves's novel garage-hotel in Mineola before putting their "motors" to the test in the Vanderbilt Cup Races; watched Sweep, from the Turf and Field Club, as she swept the Belmont Stakes; observed the spectacle as the New York Yacht Club's *Squadron* set sail with the America's Cup defense candidates from its station on Hempstead Harbor; or viewed one of the myriad club-sponsored horse shows, hunt meets, dog shows, or other sporting events.

"Club life," *Harper's* was to observe as early as the 1880s, had become "an interesting feature of the region" that was having "an important influence in developing its prosperity."[25] The 1916 edition of the directory *Prominent Residents of Long Island and Their Pleasure Clubs* listed 71

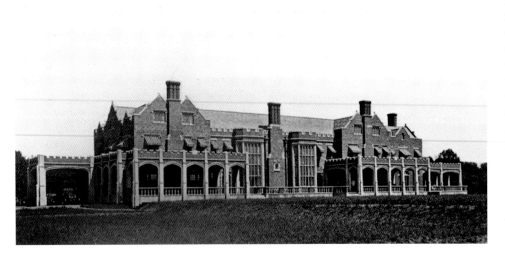

Nassau County Clubhouse,
Woodruff Leeming, 1910
(SPLI, 1916)

clubs east of a line between Jamaica and Flushing Bay "whose members participate in Fox Hunting, Polo, Racing, Golf, Tennis, Aviation, Yachting, Fishing, Hunting, etc."[26] Moreover, every time a club would throw open its grounds for a challenge cup, race, or show, the Brooklyn and New York press were there to herald the success of the event, positive coverage being assured by the presence of their publishers among the membership and participants.[27]

The publicity accelerated interest in Long Island's playgrounds, and estate development intensified as speculators saw an opportunity for profit. By the eve of the First World War, L'Ecluse, Washburn & Co., the Manhattan realtors, were advertising as "club specialists" who were "particularly well informed" about estates in the neighborhood of a list of well-known clubs.[28] Dozens began to speculate in estate country real estate, including a few country-house owners like Paul D. Cravath, the principal of the Manhattan law firm that still bears his name. Described in his firm's history as "an extrovert with unbounded determination and self-confidence," Cravath became a major booster of the North Shore and Locust Valley in particular, helping to create not only the clubs, but the entire infrastructure needed to support the country-life experience. Cravath's hand is seen in almost every detail of Locust Valley life just after the turn of the century. He led a successful petition drive to create the local fire district in 1909, a critical development in the sporting gentry's fire insurance picture; advanced recreation by managing the region's largest horse show; and served as the catalyst in the founding of the Country Lanes Committee in 1912, which preserved and maintained hundreds of miles of equestrian trails across the North Shore. Cravath also furthered the incorporated village movement that gave the estate owners both zoning and police powers, the essential instruments for neighborhood

preservation, and was a factor in the development of two clubs: the Piping Rock Club in 1911 and The Creek in 1923. Of the Piping Rock Club, *Country Life* quipped, "the sort of thing George Washington would have built if he had the money."[29] Cravath established The Creek on the grounds of his first estate after his house had twice burned, reportedly after a dispute with the contractor. No doubt, Cravath was also instrumental in introducing his clients to both Long Island and club life; among those to whom the Cravath Syndicate sold property was the insurance magnate W. R. Coe.

With the passage of time, and particularly after the inflationary period that followed World War I, the growth of recreational clubs began to slow down. A 1919 scheme hatched by Reginald C. Vanderbilt to create "a completely equipped country club of the most comprehensive sort"[30] in Lloyd Harbor, mixing links with riding, polo, bathing, and tennis facilities, never reached fruition despite publicity and a distinguished board of governors which included C. K. G. Billings, E. D. Morgan, Harry Payne Whitney, and William R. Coe. Lloyd Harbor was 37 miles from Manhattan's 59th Street Bridge by the route taken in 1919 and a dozen miles east of the greatest concentration of links. Desirable locations for clubs within easy reach of the city were fast disappearing. Nor did club projects fare any better where real estate speculation was the primary motivation. A 1925 plan to establish a country club on the Centre Island estate of the late Colgate Hoyt in which "Founders, a representative group of Men"[31] were sought for a subscription of $1,000 to form a holding company that would delegate the task of forming a membership to a committee, failed. W. Emelen Roosevelt, a prospective founder, writing to club organizer and Oyster Bay realtor, Mrs. Percy S. Weeks, in May of that year declined an invitation to join noting that he was already "a member of two golf clubs" and "if I had another club, I would not play any more golf, but it would cost me more per game." "From another point of view," Roosevelt concluded, "I do not care at the present time to go into a real estate speculation on the property."[32]

Long Island had reached its saturation point for new clubs by World War I, for only a handful, like Locust Valley's Creek Club and the Deepdale Golf and Country Club, succeeded after this point in time.[33]

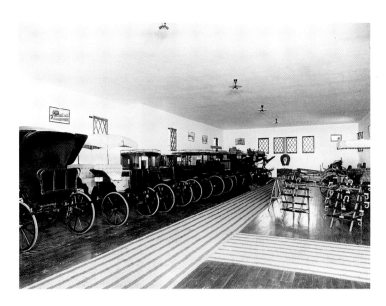

Garage, "Northwood," the Mortimer Schiff estate, Oyster Bay (Courtesy of John M. Schiff, Pach Bros. photograph, n.d.)

Estate Planning: "One Half for the Pudding, The Other for the Sauce"

"No side of the life of New York," the *Brooklyn Daily Eagle*'s Cromwell Childe wrote in 1902 *is more interesting than the splendid way men of wealth and fashion have thrown themselves into making country places. One year a bare hillside, a field, a rugged shore front; then rumors of its purchase from the farmers who have owned it for generations go about; suddenly a sale is recorded at the country seat, and the next year a transformation has been wrought. Where but a few months before there was undeveloped country now a summer house stands, all but complete.*[34]

As miraculous as it may have seemed, the development of an estate was a complex process involving dozens of professionals. Attorneys, surveyors, architects (house, landscape, farm group, recreational), landscapers, interior decorators, a variety of engineers (sewage, structural, and electrical), and a host of contractors ranging from well drillers to organ installers were usually involved before the edifice was finished. Of central importance was the principal house architect, who, in addition to designing the dwelling, might assume the responsibility for other roles as well, such as the landscape design and interior decoration. Thomas Hastings, of the distinguished New York architectural firm Carrère & Hastings, advised his clients that "the best results" in finding a proper site for a country house could only be obtained by "consulting your architect before buying." Only in this way could one be assured of success, because the importance of the "character of the grade; the character of the trees; and the way they are placed on the grounds; the view of the surrounding country, and other conditions the layman may not realize, have a great deal to do with the final architectural results."[35] Walter Manning, the Massachusetts landscape architect, advised one Long Island client to "stop and live and think and study your house and house grounds problems," spending some time in a chauffeur's cottage before launching into construction prematurely.[36] Trowbridge and Ackerman went so far as to spend a summer residing at George D. Pratt's "Killenworth" before designing Pratt's new house to solve a "problem peculiar to the Glen Cove site and applicable to no other" (a decision that helped them win *Country Life in America*'s 1914 competition for the best country house in America).[37] The extent to which site concerns could predominate is certainly evidenced at "Ormston," the Aldred estate for which more than 200 Olmsted Brothers' plans survive, more than for Boston's Franklin Park.

Site acquisition was in itself a problem, as the client's attorneys faced the difficult task of assembling enough parcels to form an estate of adequate size. Usually this involved the acquisition of contiguous farms in two or three separate transactions, but it took William S. Barstow four closings to form his Kings Point property, while Payne Whitney required five before assembling his Manhasset estate and William K. Vanderbilt, Jr., was at it six or seven times at Lake Success. Unquestionably, the most remarkable feat of assembly in Long Island's country-house annals took place in 1910, when New York attorney W. D. Guthrie and utility magnate John E. Aldred acquired 400 acres on the North Shore to establish their adjoining estates. The parcel included an entire hamlet consisting of more than 60 structures which the partners demolished. Aldred was to recall for a *World Telegram* reporter in later years that "Mr. Guthrie and I destroyed the village of Lattingtown to get the view we wanted."[38]

Following acquisition of the property, architect Thomas Hastings advised dividing whatever amount his clients intended to spend in two equal parts, half going for the house and the rest for the outbuildings, or as he termed it "one half for the pudding, the other for the sauce." It was "the sauce" that first had to be prepared to ensure an orderly progression. Certain support buildings, such as the gate house (often multiple) and stable/garage, were absolute requisites, not to mention quarters for the superintendent, and for utilitarian facilities ranging from pumping stations to water towers. In the optional category came the farm group, power plant, winter cottage for off-season weekends, greenhouse complex (which might supplement a conservatory—Louis Comfort Tiffany's "Laurelton Hall" had 15 greenhouses which supplied fresh thematic floral arrangements for the house each week),[39] and casino or indoor sports facilities that might contain a pool, bowling alley, and a variety of racquet courts.

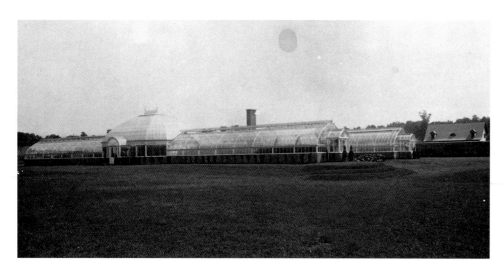

Conservatory, "Deepdale,"
the William K. Vanderbilt,
Jr., estate, Lake Success, 1905
(VANB)

Barn, Pratt Complex, Glen
Cove (Courtesy of Lawrence
and Anne Van Ingen)

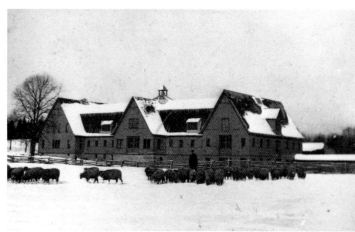

Administration Building,
Pratt Oval, Glen Cove
(Courtesy of Lawrence and
Anne Van Ingen)

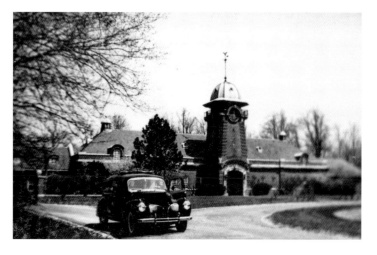

Boathouses, docks, guest cottages, servant cottages (there were 21 on Marshall Field's place), outdoor pools, kennels, indoor riding rings, polo stables, and golf courses were other ingredients for "the sauce." A dozen or more of these ancillary structures were not uncommon and in many cases the number was much larger. George C. Taylor's Moriches estate boasted 30 such buildings and included a bicycle house with storage and repair facilities overseen by an English velocipede instructor. That the

mundane in outbuildings could be made picturesque is attested to by William C. Whitney's 187-foot eight-story McKim, Mead & White–designed water tower in Old Westbury, the most prominent feature on the estate, and Marshall Field's imposing polo stables designed by John Russell Pope.

Support structures of this scale, however, presented design problems without parallel in the history of American domestic architecture. Hence, a few country-house architects began to specialize in the more complex types of estate ancillaries. J. W. O'Connor became the leading architect of indoor tennis courts, while Alfred Hopkins established a thriving practice in farm group design and is credited with at least a dozen such complexes on Long Island. The well-developed farm group brought together the country gentleman's herd of prize cattle, milking cows, sheep, pigs, poultry, racehorses (work, show, and driving horses would usually be stabled elsewhere), wagons, and trucks, in an integrated complex which often included adjoining housing facilities for the farmhands. As Hopkins wrote to a prospective client in 1924, while he didn't expect laymen to read his book on the subject, *Modern Farm Buildings*, estate owners could be assured that the Hopkins office considered "practical requirements very carefully," and "ventilation, sanitation and the dairy in particular."[40] While the average farm group may have provided cream for the owner's table, it was never designed to be income producing or even self-sustaining. In many instances farm groups were essentially breeding clinics where country gentlemen with a fondness for the genteel pastime of raising prize livestock or poultry could pursue their hobby. Marshall Field could lecture for hours on the bloodlines of his prize cows and maintained as many as 500 Guernseys at his Lloyd Neck estate, while at Sands Point, Howard Gould let his passion for peafowl, turkeys, and "the showier breeds of chickens" have full play. A reporter for the *New York Tribune* visiting "Castle Gould" in 1902 found his henneries, duckhouse, and pheasant, peacock, turkey, and other fancy fowl runs and nurseries "among the most extensive and best arranged to be found in the United States."[41]

Perhaps the most remarkable estate building erected in this country at the turn of the century was for William C. Whitney's Old Westbury estate. The 800-foot-long racing stable with an adjoining one-mile track contained 83 box stalls each measuring 20 by 25 feet, and a second story devoted to the grooms' dining room, gym, dormitory, and library! If the *Tribune* reporter was impressed by Gould's henneries, he was simply amazed by Whitney's racing stable:
Although a hundred persons occupy the place when the horses are there, a regiment of soldiers could be

added without crowding. The metal bedsteads, with their white coverings and pillow cases, arranged in long rows in the immense rooms, remind one of a ward in a hospital. On the same floor in the central wing is the kitchen, an immense room with every modern convenience on a scale large enough for a hotel. An icebox as large as the kitchen adjoins it. A Chinese cook presides over this department and keeps everything so scrupulously inviting that visitors seeing the place feel a strong desire to lunch there.[42]

The Whitney stable, however, could not match the dimensions of the Pratt Oval, the service center for "Dosoris Park," the Pratt family's estate colony at Glen Cove. Built between 1904 and 1906 on the site of an earlier wooden structure, the handsome brick, limestone, and terra-cotta edifice represented the entire infrastructure for a family compound which by the 1930s had grown to 21 residences and 61 ancillary structures. The Oval's support functions included that of stable, farm group, garage, and housing for grooms, coachmen, and chauffeurs. The central structure or "administration building" contained the estate offices and switchboard from which upwards of 400 "Dosoris Park" employees were directed. Adjacent to the Oval to the north were the workshops for plumbing, carpentry, and the blacksmith's forge. The Pratt Oval stands apart in the Long Island country-house experience—housing the services that would have been found in an entire manorial village in the English countryside.

It was these differences in organization, conveniences, and, above all, in the vocational and recreational nonessentials that so surprised foreign observers. As the Prince of Wales had noted on seeing Clarence H. Mackay's "Harbor Hill," the "paintings, tapestries, old china and armor would have been commonplace enough in a British country house; what was surprising was to find on the same property a squash-rackets court, a gymnasium, an indoor swimming pool, and a Turkish bath."[43]

The Impact of the Estates: Agrarian Displacement and a New Economic Order

The country-house phenomenon was as disruptive to Long Island as had been European settlement or the more recently manifested post-World War II influx of suburbanites. In some cases the very landscape was altered. Otto Kahn, the investment banker, was so late in discovering the North Shore that he did not build his 100-room chateau designed by Delano &

Aldrich until 1915, after most of the prime estate sites had already been taken. He was not to be discouraged, however, and relied on earth-moving equipment to build up a huge hill on his Cold Spring Harbor property which would offer the commanding prospect he desired for his residence. Further north, the development at the turn of the century of Walter Jennings's and Louis Comfort Tiffany's estates on opposite sides of Cold Spring Harbor led to the removal of two of the North Shore's largest resort hotels, the Glenada and Laurelton, while Clarence Mackay's purchase of the 368-foot-high Harbor Hill at Roslyn led to the closing of Taber's Observatory, a popular attraction and picnicking site. Unquestionably, the most disruptive undertaking of the sort was the already mentioned destruction of the village of Lattingtown by Messrs. Guthrie and Aldred to achieve the views they desired.

The reaction of native Long Islanders to the onslaught of the rich seems to have ranged from anger and resistance to bewilderment. "We, the undersigned farmers of the South side of Long Island, do hereby notify and forbid the so-called Rockaway Hunting Club from crossing our land with horses and dogs," the farmers of Oceanside notified the club's governors in 1895. "We are determined to put a stop to this nuisance which has been going on the past eight years."[44] Yet Isaac Hicks, the Quaker nurseryman from Westbury, seemed resigned to the changing scene in a letter written in 1900 to Friends in Pennsylvania:
Yes the world around here moves rapidly. The great wealthy ones continually come and a large number of small ones come too. But our Friends— where are they—¾ gone. The last purchase is the great Harbor Hill Clarence Mackay estate and a farm and 300 acres of woodland besides and they are working all the time. We, my brother Samuel and I, had 16 acres of woodland there and we sold $441.00 pr. acre. Worth perhaps $75. pr. acre old time.[45]

Who were these "wealthy ones" who would pay more for land than its agricultural worth? What would happen to the North Shore's Quaker communities which had cultivated this land for over two centuries? Evidence indicates substantial displacement in agrarian acres, with only the most resourceful of families holding on to their property. Isaac's son Henry accomplished this feat by turning a nursery business based on supplying fruit trees to local farmers into a concern that moved large specimen trees and did landscaping for estates. A 1903 *New York Herald* article documented the displacement process by recording the establishment dates of the five family farms that Payne Whitney acquired to form "Greentree":[46]

FARM	IN FAMILY SINCE
Charles T. Mitchell	*1728*
George W. Ketchum	*1767*
A. L. Brinkerhoff	*1725*
Louisa Skidmore	*1800*
Schenck	*1690*

As the farm land went so went the shore front that had always been accessible to town folk for recreation and clamming. In Oyster Bay in 1910, the baymen, feeling the effects of estate encroachment, reasserted their right to access to the clamming beaches at Centre Island by circling the island in a wagon and cutting through all the new docks that blocked their way. Henceforth, Centre Island docks were to incorporate an unusual feature, hinged sections which could be raised when the baymen appeared.[47]

The *Long Islander,* based in Huntington, railed against this undemocratic estate encroachment in 1906, warning its readers that their town's beaches were "slowly but surely being appropriated by due process of law by those owning the adjacent upland, to the exclusion of the general public."[48] William J. Matheson, the new owner of "Fort Hill" on Lloyd Neck, the paper commented, was "the latest member of the millionaire contingent" to ask the Commissioners of the Land Office of the State of New York for an underwater land grant. The approximately 13 acres Matheson requested were for his "beneficial enjoyment," for he planned to erect thereon "docks, boat-houses, bathing houses, jetties, bulkheads and other structures." The paper predicted that Matheson and other local estate owners who were making similar applications would face strong opposition because their actions had given "the common people nerve enough to get ready to demand their own."[49]

The citizens of the town of North Hempstead barely saved "their own" in one of the most publicized town vs. estate-owner battles of the era. William K. Vanderbilt, Jr., wanted Lake Success, its four approaches and water rights, after having secretly purchased the 640 surrounding acres in 1902. On this land stood dozens of buildings and the Lake Success Hotel, which he intended to raze to make way for a huge Hunt & Hunt-designed castle. Vanderbilt's attorneys offered the town $30,000 for the lake and forced a special election over the issue in which pro and contra slates of trustees contended, arousing feelings the *New York Herald* reported were "more bitter than those engendered by a Presidential campaign."[50] The proposition went down to defeat (although the *Herald* found that a $100,000 offer might have made the difference) in one of the few instances where even the most grandiose aspirations of an estate owner were not fully realized. Even the local merchants had misgivings about the estate boom. Huntington's *Long Islander* noted in 1904 that so many farms had been sold in its environs that the town was ceasing to be a farm center as evidenced by the fact that now only one sailing packet carrying farm produce ran to New York for a few months each year whereas formerly three vessels had made the trip year round. The paper contended that the 80 miles of shore front from Cold Spring Harbor to Northport could be covered "with handsome houses built on villa plots." Why, there was room for "thousands of them" and Main Street's post-agricultural prosperity depended on attracting commuters and summer people. "When farms have been cut up and sold in plots as in the case of Selleck, Conklin, Atwater, Fleet and other estates on East Neck, now covered with scores of beautiful places, the change had been a beneficial one," the paper opined, "but where large tracts of hundreds of acres are monopolized for the enjoyment of a single owner, the change is one to be regretted." Where Main Street could only sell one lawn mower, how many might have been sold if only "the wealthy man" would be content with five or ten acres rather than buying up farms for "the purpose of carrying out large and extensive schemes of improvement."[51]

In time, the estates did win a large measure of acceptance from Long Islanders as the issues of displacement, the appropriation of the public domain, and Main Street's expectations of profitability began to dissipate in the face of new economic opportunities. Vanderbilt had said it would be so in 1902. Why should the voters of North Hempstead worry if his acquisition of Lake Success prevented a handful of people from making a living by cutting ice? Didn't they realize how many people would be employed in his castle? A staff numbering in the teens was required to run even a modest country house, and the 23 servants' rooms at the Cruger-Pierce-Williams mansion in Bayville was not considered an unusual number in service. A particular interest such as Marshall Field's penchant for Guernsey cattle required additional help. The Chicago department store heir is said to have had a grounds crew of 85 in the heyday of "Caumsett," while the seasonal force at "Planting Fields" is thought to have reached several hundred.[52] Of course, nothing exceeded the 400 employees required to run "Dosoris Park," the Pratt family's Glen Cove compound. The Pratts provided much of the available employment in Glen Cove for three or four decades. It was not

Minnie Steed, a cook in the kitchen of the Mackay estate, with an assistant, 1909 (Courtesy of Bryant Library, Local History Collection, Roslyn)

Planting large trees at the Herbert L. Pratt estate, Glen Cove, by Hicks Nurseries, c. 1905 (HICK)

long before the local business community also felt the trickle-down effect. Roy K. Davis, the liveryman, could not believe his good fortune in 1923 when he landed the contract from the Whitney Company, principal contractors for the construction of "Caumsett," to transport between 400 and 500 employees out to Lloyd Neck and back daily! The *Long Islander* reported on February 9 of that year that Davis "already had one Reo bus accommodating 20 people in service, and within the next three weeks expects to have more of these vehicles, which are the latest and best made."[53] New York City–based subcontractors soon found they had so much estate work on Long Island that branch offices and local employees were required. James McCullagh, Inc., the plumbing and heating firm, established its North Shore office in Hicksville and could report by the spring of 1925 that they had installed heating systems in five mansions and one country club in the last two years.[54] Lewis & Valentine, the famous landscape concern, with offices at 47 West 34th Street in Manhattan, boasted four nurseries and branch offices on Long Island at this time and was doing such a business that its boxwood expert regretted to inform Mrs. Lloyd-Smith in September 1924 that the last train-load of Old English boxwood for the season had arrived at Glen Head and orders should

be placed promptly before the ten freight cars were emptied.[55]

New industries were also appearing on Long Island, largely to meet the needs of the new estates. The Nassau Light and Power Company, which provided service to dozens of North Shore communities from its modern plant at Glenwood Landing and comprised a major segment of what was to become LILCO, actually had its origin in E. D. Morgan's desire to obtain electricity for his Wheatley Hills estate in the 1890s. The hand of the summer community is also seen in the spread of the telephone, the region's first service having been established by the Glen Cove Central Exchange as early as 1884, and in the founding of the first hospitals. The Nassau Hospital (now Winthrop University Hospital) in Mineola, Long Island's first voluntary, nonprofit hospital east of the city line, moved in 1900 from temporary quarters to its first permanent facilities. Located next to the railroad tracks for the convenience of patients arriving by train from eastern Long Island, the complex was designed by no less a practitioner than Richard Morris Hunt, architect of the Vanderbilts' cottages at Newport and Oakdale. Nassau's first wards were named for its major patrons, the Vanderbilts, Harpers, and Belmonts. Estate owners were also involved in the development of community hospitals. Yet, no one family did more to establish advanced health care on Long Island than the Whitneys, who were instrumental in the later expansion of Nassau Hospital and the growth of North Shore University Hospital at Manhasset.

In the political arena the estate owners also made positive contributions, both through their own The North Shore Improvement Association (incorporated) and the Nassau County Association, a good-government group formed in 1913 to assist town and county officials "in helping and caring" for public charges and to see that the administration of public affairs "was conducted on efficient and economic lines regardless of any political creed or prejudice."[56] It was the Nassau County Association that took the lead in promoting county charter reform, the major political issue in Nassau County for a quarter century. Estate owners also represented Long Island in Congress, such as Perry Belmont, F. Truber Davison, and Ruth Pratt McLean in 1900, as a kind of civic association of the country-house set which sought to control sand mining, eradicate mosquitoes, and deal with other "nuisances," while others served on county boards, as was the case for such Locust Valley attorneys as William D. Guthrie

1910 International Air Show, Belmont Park (SPLI)

and John W. Davis, the 1924 Democratic presidential nominee.

Long Island's first art museums, the Heckscher at Huntington and the Parrish at Southampton, were the gifts of prominent summer residents. The hand of the estate owners was even seen in the development of Long Island's primary industry of the 20th century—aviation. When flying was still thought to be something of a daredevil's sport with few practical applications, these individuals invested in aeronautics. Nelson Doubleday's popular magazine, *Country Life in America,* which chronicled the leisure activities of the rich, gave monthly coverage to the exciting new pastime of flying. August Belmont, a director of Orville and Wilbur Wright's airplane company, was behind the first international air show at Belmont Park in 1910. Its top prize of $10,000 had been put up by another Long Island millionaire, Thomas Fortune Ryan of Manhasset.

In the final analysis, the coming of the estates brought opportunities for economic and social progress to a region that had been a backwater since the opening of the Erie Canal had ended its role as Manhattan's breadbasket. The barrier island, the agrarian outpost which had been passed over by the industrial revolution for lack of falling water to power mill turbines, was suddenly the most desirable residence in the United States, with the capital, connections, and infrastructure of social services, utilities, and employment opportunities that had seemed unattainable just a generation earlier.

Country-House Statistics: Quantifying the Phenomenon

Even as this encyclopedia of country-house architecture is being sent to press after more than a decade of research, hitherto unknown examples are appearing at the rate of several per month. The extent of the phenomenon will never be precisely known, but they number in excess of 1,000. Part of the ambiguity, as Richard Guy Wilson suggests, is in the very definition of a country house, "generic to a whole cast of buildings which might include, in descriptive terms, country seat, villa, place, estate, plantation, manor, lodge, resort, suburban ranch, cottage, a house in the country, tract mansions, and possibly the farm house."[57] In plan, style, and appointments, the differences were even more profound. Long Island after the onset of the 20th century was at once Colonial Virginia with dozens of "Mount Vernon" and "Westover" lookalikes, Shropshire and Cotswold exhibiting a compendium of English country-house styles, Bavaria, Normandy, and, to Louis Comfort Tiffany, a vision on the Moroccan coast replete with minarets and palm trees. Yet whether one's notion of country life and rural ideals was "a colossal affair by any standard," as had been Jay Gatsby's "factual imitation of some Hotel de Ville in Normandy,"[58] or the Quaker farmhouse that had been enlarged to form a family compound as was the case with William Russell Grace's place in Great Neck, the country-house phenomenon on Long Island was very discernible. The new residences were built on fields, woodlots, and shorelands beyond the limits of the existing villages and market towns, breaking a residential pattern that had existed for centuries. They were also designed by architects at a time when, within the region, only churches, public buildings, and a few country seats had been professionally designed. Finally, they were to be occupied seasonally (fall and spring being preferred) and owned by individuals with no previous connection to Long Island, with but a handful of exceptions in each instance. Falling within these parameters were 975 houses built between the outset of the Civil War, when Long Island was "discovered" thanks to new transportation links (and perhaps helped by new urban insecurities brought to focus by the Civil War draft riots and continuing warm-weather epidemics), and World War II when, after slowing to a crawl during the Depression, the construction of country houses ceased. Two hundred and nine architects or firms were to design houses on Long Island during the period and, while the great majority of the practitioners had offices in New York, the national flavor of the Long Island country-house movement can be seen in the commissions here of Guy Lowell from Boston, Wilson Eyre, John T. Windrim, and Horace Trumbauer from Philadelphia, David Adler of Chicago, and George Crawley and Sir Alfred Bossom from London.

J. P. Morgan Estate, Glen Cove, demolished in 1980 (SPLI)

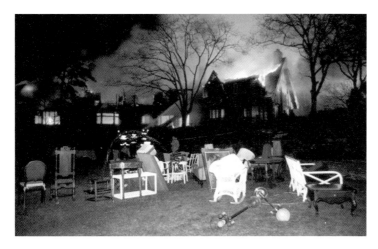

Frank Melville Estate, "Sunwood," Stony Brook, destroyed by fire in 1986 (Lenny Kostas photograph)

Economics was the great determinant of the phenomenon, with prosperity the catalyst. Hence, it is not surprising to find that mansion starts slowly increase through the period, with 8 in the 1860s, 15 in the 1870s, 37 in the 1880s, and 131 in the 1890s. It was the unparalleled industrial expansion between 1900 and the end of World War I in 1918 that caused 400, or 41 percent, of the houses to be built. Factors previously mentioned, such as the inflation induced by World War I, the advent of federal income and property taxes, along with the inevitable escalation in the cost of property and labor as Long Island matured as a resort, were among the factors that helped slow construction in the 1910s and 1920s, a period in which the average country house became decidedly smaller and new arrivals intent on acquiring significant acreage, such as Otto Kahn and Marshall Field, were forced to the eastern fringe of estate areas. During the Depression, a much smaller number of new houses were built, with a total of only 80 for the entire decade after 1930. All construction terminated with the onset of World War II, when a number of the houses, including Louis Comfort Tiffany's "Laurelton Hall" and Daniel Guggenheim's "Hempstead House," were used by the military, while others housed children fleeing the terror of the European war theater (Henry Phipps's "Old Westbury Gardens" and Howard Phipps's "Bonnie Blink"). The war also marked the end of *Country Life in America,* the Doubleday periodical that had been the chief chronicler of the phenomenon.

The postwar period brought about the destruction of many of the country houses. Caught between the development pressure of the G.I. Bill era and a new generation of owners who saw their family houses as expensive burdens, Long Island's mansions had become an endangered species. They were never dynastic seats or the powerhouses of a ruling class, as Mark Girouard has described the English country houses of centuries ago when the ownership of land and the income derived from it equated with real power. Rather, they were closer to the "great mammoths of domestic architecture," as Clive Aslet has termed the country houses built in Britain between 1890 and 1939, which had "grazed in a savannah of cheap labor and cheap fuel" and were inherently "ill-equipped for survival."[59] However, by happenstance rather than planning, a surprising number of Long Island mansions were able to find adaptive reuse in the postwar era as schools, golf clubs, nursing homes, and religious retreats. Hence, in the late 1980s, 574 or 58.4 percent of the houses in our survey survived; 424 were still in residential use, while 84 had found adaptive reuses. Within the last-mentioned category, 31 were now fulfilling new roles on school or college campuses, while religious use was the second most common adaptation (20), followed by roles as museums/arboretums (12) and golf clubs (10). The rate of loss has also slowed in recent decades to one or two per year, with fire now an equal partner in destruction to neglect or development. Problems still continue; the public sector seems to be particularly inept in the handling of such maintenance-intensive cultural properties as large country houses, and the incorporated villages in which 65 percent of the surviving mansions are situated continue in their restrictive zoning practices which preclude such creative adaptive reuse possibilities as corporate offices or condominiums. Yet, with each passing year, there seems to be more interest in the country houses, thanks to a growing volume of exhibitions, catalogues, decorator showcases, books, tours, and films. The serendipitous survival of so many estates has provided postwar Long Island with a great wealth of significant domestic architecture and formal landscape design. The estates also comprise a significant percentage of its remaining open space, not to mention its recreational and educational facilities, parks, and arboretums. Today, the surviving country houses and their estate settings remain important contributors to the region's identity, quality of life, and, hence, to its economic vitality; in short, they are resources that continue to make Long Island a desirable place in which to live.

Robert B. MacKay

Long Island Country Houses and Their Architects, 1860–1940

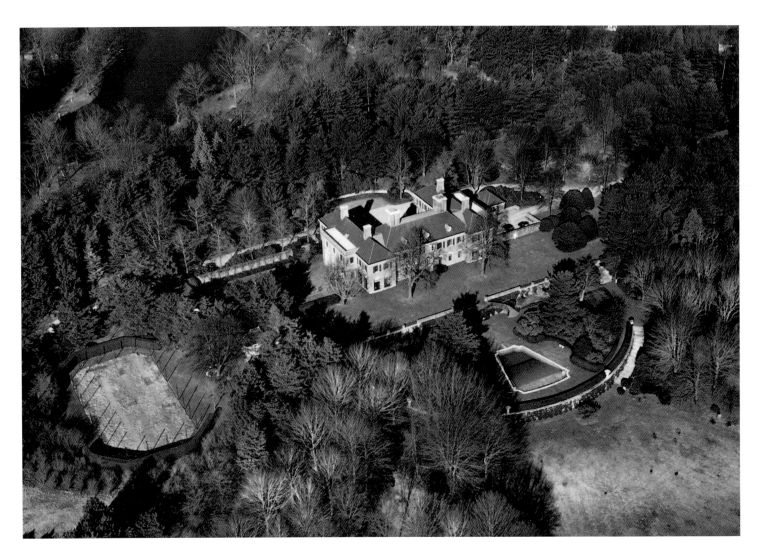

Adams & Prentice: Howard Phipps, Sr., Residence, Old Westbury, 1935 (Courtesy of Howard Phipps, Jr.)

■

Adams & Prentice, 1929–1942
Lewis Greenleaf Adams, 1897–1977
Thurlow Merrill Prentice, 1898–1985

Lewis Greenleaf Adams was born in Lenox, Massachusetts, received his B.A. from Yale University in 1920 (after naval service in World War I), and attended the Ecole des Beaux-Arts, Paris, from 1923 to 1926. Before and after going to Paris, he worked as a draftsman for the architectural firm of Delano & Aldrich. Thurlow Merrill Prentice was born in Hartford, Connecticut, earned his B.S. degree from Yale in 1921 and his B. Arch. from Columbia University in 1924. He attended the Ecole des Beaux-Arts from 1925 to 1928. In Paris, both Adams and Prentice studied in Victor Laloux's atelier. In 1929, they formed a partnership in New York City that lasted until 1941 or 1942. After World War II, they followed separate careers in the firms of Adams & Woodbridge, New York, and Ebbets, Frid & Prentice, Hartford, respectively.

On Long Island, the firm of Adams & Prentice was responsible for the Howard Phipps, Sr., summer house, built in 1935 at Old Westbury (extant). Colonial Revival in style, the house is symmetrical, with two-story, red-brick walls supporting gently pitched roofs surmounted by broad chimneys. However, the U-shaped plan, entrance court, long garden-front, terrace, and axial view into the distance evoke the composition of a French château of the 17th or 18th century. Thus, though the house seems to be part of the Anglo-American Georgian-Colonial tradition, its underlying idea is French.

Richard Chafee

■

Adams & Warren, 1900–1914
William Adams, 1871–1956
Charles Peck Warren, 1868–1918

William Adams, at one time in partnership with Charles Peck Warren (a professor of architecture at Columbia University), was a popular designer of handsome, commodious, year-round houses on Long Island. Adams was admired for the way

Adams & Warren: Front
Facade, Mrs. S. P. Sampson
Residence, Lawrence, c. 1900
(INDO, 1906)

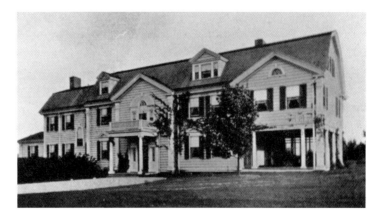

William Adams: Rear
Facade, Howard S. Kniffen
Residence, Cedarhurst, 1911
(HEWI, n.d.)

William Adams: Floor Plan,
Howard S. Kniffen
Residence, Cedarhurst, 1911
(ARRC, 1918)

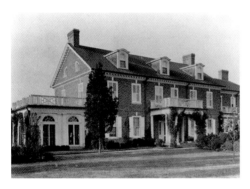

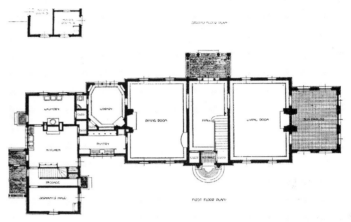

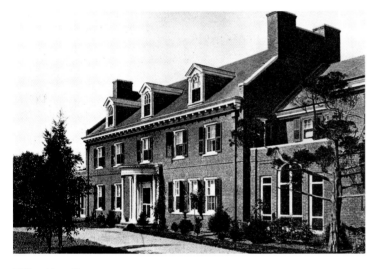

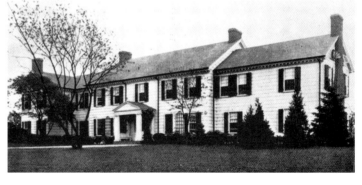

William Adams: Front
Facade, Norton Perkins
Residence, Lawrence, 1914
(ARRC, 1918)

William Adams: Front
Facade, Arthur N. Peck
Residence, Woodmere, 1910
(HOUS, 1912)

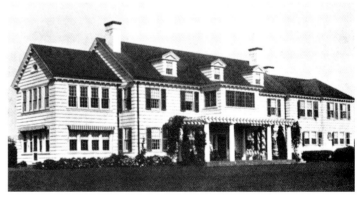

William Adams: Rear
Facade, Edmund S. Twining
Residence, Southampton,
1910 (ARRC, 1918)

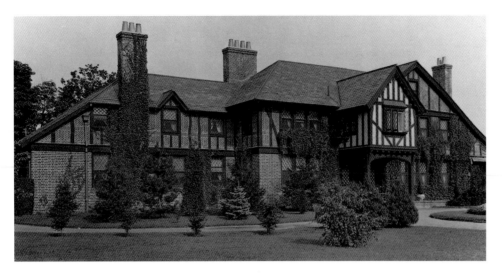

William Adams: Front Facade, J. Edward Meyer Residence, Great Neck, 1909 (HEWI, n.d.)

William Adams: Garden Facade, Frederick L. Richards Residence, Great Neck, 1910 (ARRC, 1918)

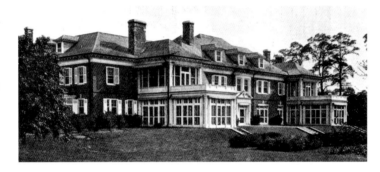

his plans capitalized on their sites, for the straightforward arrangement and good proportion of his rooms, and for the appropriateness of his designs to the Long Island landscape. Nearly all the houses he built in the area are long, low Georgian or Federal Revival designs reminiscent of old Long Island farmhouses.

Houses by Adams have many features in common. In each, the main public rooms (entry hall, living room, dining room, and den or library) occupy the ground floor of the main block, with sun rooms in one wing and kitchen and service rooms in another wing on the opposite side of the main block. With the exception of the Sampson house, all the firm's work is extant.

Many Adams houses stand on the South Shore. The earliest, designed by Adams &

David Adler: Front Facade and Entrance Court, Mrs. Diego Suarez Residence, Syosset, 1931 (SPLI, n.d.)

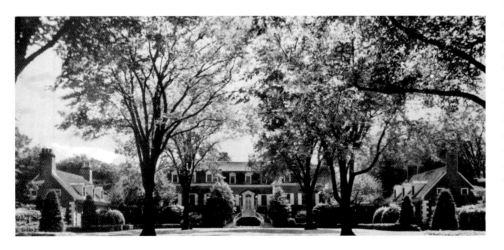

Warren for Mrs. S. P. Sampson, was built in Lawrence in 1900. It is a two-story, gambrel-roofed, Federal Revival shingle house, with a broad, pedimented entrance bay centering the main block. The rest of the houses described here were designed by William Adams alone.

The brick-faced Howard S. Kniffen house (1911) and the brick Norton Perkins (1914) house, also in Lawrence, have similar floor plans and Georgian Revival detailing. The John F. Scott house in Hewlett is much like them, while stockbroker Arthur N. Peck's house (1910) in Woodmere is shingled, but otherwise recognizable as from the same hand as the others.

The Edmund S. Twining house in Southampton (1910) is another long, low, three-wing house with Georgian detail, including 12-over-12 windows, balustraded entry porch, and modillioned cornice.

Two houses in Great Neck and Kings Point differ somewhat from the typical Adams designs. The picturesque half-timber and brick Jacobean dwelling built for J. Edward Meyer (1909), with its asymmetrical sweeping roofs and clustered chimneys, is stylistically unexpected. It looks nothing like a Dutch-type farmhouse. But the floor plan is typical Adams: the apparent irregularity conceals the traditional center hall and main-block rooms, covered porch, and opposing service wing. The tall, hipped-roof Georgian Revival Frederick L. Richards house (1910) is the largest and most elaborate of the Adams houses, although it, too, follows the same plan as the others, allowing for more generous proportions and a few more rooms.

Ellen Fletcher

David Adler, 1882–1942

David Adler, "the house architect for the Chicago establishment," was a product of Princeton University and the Ecole des Beaux-Arts, Paris. The Milwaukee native's only Long Island commission was appropriately enough for Mrs. Evelyn Field (later Mrs. Diego Suarez), the former wife of Chicago department-store heir Marshall Field III. Inspired by the restoration of Williamsburg, "Easton," Mrs. Suarez's Syosset Georgian country house, was built in 1931 to resemble a Tidewater Virginia mansion. Palladian in plan, the brick main block, raised on a high basement, boasted a mansard roof with gable-roofed flanking wings, one of which served as the winter cottage. Although the central section was demolished in the 1950s, the wings survive.

Robert B. MacKay

Harrie T. Lindeberg,
1891–1959 (COUN, 1927)

■

Albro & Lindeberg, 1906–1914
Lewis Colt Albro, 1876–1924
Harrie T. Lindeberg, 1880–1959

In the late 1950s, when John E. Burchard and
I [Alfred Bush Brown] were writing *The Arch-
itecture of America, A Social and Cultural History*
(Boston, Atlantic-Little, Brown, 1961), we
featured Harrie T. Lindeberg to represent the
residential taste of the American architect and
client in the period 1913 to 1933. From our bias
of favoring modern expression of urban themes,
Lindeberg seemed to dramatize cultural alle-
giances in retreat from the opportunities and
problems of the period between World War I
and the Great Depression. Those 20 years,
following a period of municipal reform, the
Armory Show, and the completion of the Wool-
worth Building, encouraged architects like
Hugh Ferriss to imagine tall, cubistic forms and
ribbon highways for tomorrow's metropolis.
Others, like Clarence Stein and Henry Wright,
organized cul-de-sac grouped houses, and still
others—notably Louis Sullivan, who died in
1924, and Frank Lloyd Wright, though tem-
porarily in eclipse—proposed a distinctly
American architecture. They protested the
American client's enthrallment by romantic
rural scene makers like Lindeberg, who deftly
provided what he called "the manor house on
its broad acres."[1]

*Of all the chameleon designers [we wrote] Harrie
T. Lindeberg was the most popular and versatile.
At Lake Minnetonka, Minnesota, he provided an
Elizabethan house for John S. Pillsbury; Duncan
Harris's house at South Norwalk, Connecticut, was
rustic rural; H. L. Batterman at Locust Valley,
Long Island, wanted Roman Doric, while a slate-
roofed Tudor housed Eugene du Pont at Greenville,
Delaware; the dwelling for Nelson Doubleday at
Oyster Bay, Long Island, was red-tiled Spanish
Colonial, and Clyde Carr had a half-timbered
dovecote at Lake Forest, Illinois. No two designs
were alike, and though he tended to favor pic-
turesque thatched-shingled roofs, Lindeberg was
accurately praised for his "freedom from formula."
He even put many of these [elements] together in
the new Houston suburb of River Oaks.*[2]

Our parade of Lindeberg's work as a gallery
of dexterous stylistic whimsies exposes our
thinking in the late 1950s. Then, many issues
divided the proponents of modern architecture
from the reigning Harrie T. Lindeberg, Wilson
Eyre, Frank Forster, and Addison Mizner, who
recently had built suburban villas in regional
adaptations of English, French, Spanish, or
Italian precedent. It was difficult to strip away
the regionalists' preoccupation with style and
to recognize that Mellor, Meigs, and Howe in

Philadelphia or Coolidge, Shepley, Bulfinch,
and Abbott in Boston built well and composed
admirably.

As the modern German, Dutch, and French
architects gained editorial champions in the new
American journal *Architectural Forum,* and the
rejuvenated *Architectural Record,* and after the
Museum of Modern Art in New York promoted
the unfortunately named "International Style,"
Lindeberg and other fashionable American ar-
chitects were forced into debate, recorded in
Arts and Decoration, Country Life, and *American
Architect and Building News.* Should American
architects aspire to a machine aesthetic as an
expression of America's industry and its finan-
cial corporations, or, as Lindeberg believed,
should they stress continuity with heritage—
in his mind, the English precedent of the Vic-
torian Arts and Crafts movement? "I heartily
disapprove of the so-called modern movement,"
Lindeberg said in 1933. "Good taste, after all, is
the essence of restraint."[3]

He planted his feet against cubistic forms,
exposed metal structure, calibrated joints, and
mirror polish, favoring instead aged patina with
ashlar facture and grained miter of wood join-
ery. Handcrafted ornament and natural textures
and colors were not to be ruined by machines.
He had an anti-urban bias in favor of pastoral
settings, and his sense of scale and grandeur
was baronial. In this, he had his own morality,
recalling Viollet-le-Duc's love of revealed struc-
ture, which justified his fidelity to materials in
beautiful brick arches, ledge-rock walls, and
exposed mortice-and-tenon oak joinery. There
could be lapses: Lindeberg worried about his
red-cedar shingles steamed to fit thatch-derived
roof forms, and his insistence upon local mate-
rials was never so doctrinaire as to reject import-
ed English paneling and Holland brick. Nor
was his traditionalism so messianic as to ally
him with Ruskin's equating of Gothic art with
a good society, as Lindeberg's contemporary
Ralph Adams Cram still preached at Princeton
University's Chapel and Bryn Athyn's Cathedral
around 1930. Instead, Lindeberg's heroes were
secular artist-builders. He preferred Cram's part-
ner, Bertram Goodhue, and allied himself with
Goodhue and those architects who said they
were developing an American architecture in
regional interpretations of English and conti-
nental practice. The regionalists made charm-
ing compositions of mansions with cottages,
stables, gazebos, fountains, and dovecotes,
punctuated by playful rooflines and chimneys.

Harrie Thomas Lindeberg was born in
Bergen Point, New York, on April 10, 1880,
the son of Theodore and Eleanor (Osterlon)
Lindeberg. His father had immigrated from

Albro & Lindeberg: Garden
Facade, "Little Burlees,"
Edward T. Cockcroft
Residence, East Hampton,
1905 (COUN, 1911)

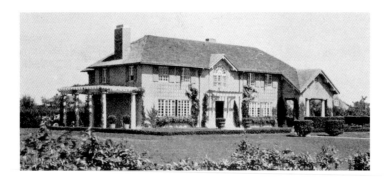

Albro & Lindeberg: Garden
Facade, Frederick K.
Hollister Residence, East
Hampton, 1910 (Courtesy of
Harvey Weber)

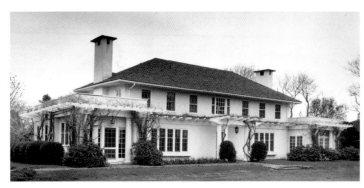

Sweden in 1870 and settled in Bergen Point, where he worked as a shipbuilder. After receiving his preliminary education at public and private schools, Lindeberg, like his future partner Lewis Albro, studied architecture for six years in the office of McKim, Mead & White.

Lewis Colt Albro, Lindeberg's partner from 1906 to 1914, was born in Pittsfield, Massachusetts. He had an early interest in architecture and, at 18, studied for a year at the Metropolitan Art School. Around 1896, he entered the office of McKim, Mead & White, first as a student draftsman and later as a full draftsman and designer. Albro remained with the firm for nine years and was closely associated with the design for the Columbia University and Carnegie libraries in New York.

During their eight-year partnership, Albro & Lindeberg collaborated on at least eight country houses on Long Island. According to a 1912 article in *Architecture,* Lindeberg took charge of the design and drafting room, while Albro devoted his time to the construction and business aspects of the work. After the partnership dissolved in 1914, Albro practiced independently until his death in 1924. Lindeberg continued to practice until his death in 1959, maintaining an office in New York City until 1958 and thereafter working from his residence in Locust Valley, Long Island.[4]

Albro & Lindeberg's commissions were enviable. The sites were often large tracts of deciduous-wooded, rolling land, with high hills affording views of ponds and long, winding approaches that could be lined with azaleas and rhododendrons. The clients were often rich owner-managers of corporations who, accustomed to delegating, gave Lindeberg large scope to guide the total commission, including the siting and the design for the landscape, the house and its outbuildings, the interiors, and the furnishings. Stanford White had taught Lindeberg to take total command, including the decoration of each room. And craftsmen were ready to execute Lindeberg's imaginative designs in wrought iron, glass, brick, limestone, and tile. His stair balustrades, peacocks for entrance piers, fanlights, and window grilles were wrought in iron by Yellin, Zimmerman, and Bach in their West Philadelphia atelier. In a day when architects worked with craftsmen on the site, allowing their skill in bricklaying or woodcarving to decide the displayed form, the charm imputed to Lindeberg's work came as much from craftsmen's detail as from the architect's outline.

Edward T. Cockcroft Residence, "Little Burlees," East Hampton, 1905 (Extant)

Frederick K. Hollister Residence, East Hampton, 1910 (Extant)

John E. Erdman Residence, "Coxwould," East Hampton, 1912 (Extant)

Clarence F. Alcott Residence, East Hampton, 1915 (Extant)

Within view of each other off Lily Pond Lane in East Hampton, four houses designed by Lindeberg between 1905 and 1915 reveal a remarkable evolution in his command of plan and silhouette. The beginnings were domestic and simple. The Edward T. Cockcroft house of 1905, like the 1910 house for Frederick K. Hollister, physician and lecturer at New York Medical College, consists essentially of a single parallelepiped, a symmetrical arrangement of fenestration, a central entrance directly into the living room, broad hipped roofs over large planes of plain walls, and a few irrelevant Doric columns. Moving toward molded, connected spaces in the interior and asymmetric balances in mass and fenestration, Lindeberg began to suggest his talent in the house of 1912 he designed for another physician, John E. Erdman. It appears to have been envisioned as a vast hipped roof, nearly married to the earth at the entrance porch, lifted to allow casement windows to swing out beneath eyebrow dormers, and pierced by a row of attic windows bracketed by two tall chimneys.

Then, in 1915, at the Clarence F. Alcott House, Lindeberg declared a single mass, sheltered by low, sloping, flared eaves. Beneath these, three central bays on the garden side are

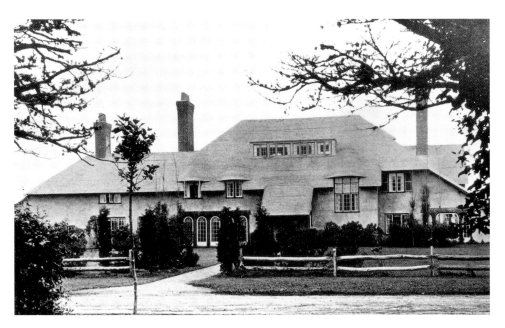

Albro & Lindeberg: Front Facade, "Coxwould," John E. Erdman Residence, East Hampton, 1912 (ARTR, 1915)

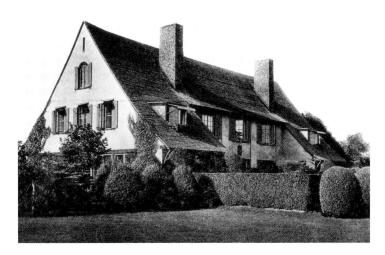

Albro & Lindeberg: Garden Facade, Clarence F. Alcott Residence, East Hampton, 1915 (COUN, 1925)

Such reduction to axioms nearly proved Lindeberg's undoing. Fascinated with simple, well-proportioned, harmonious outlines, Lindeberg became famous for his roofs. "The principal feature of the country house," he wrote, "is the roof, sheltering . . . the whole building."[7] In 1909, *The Brickbuilder* published Lindeberg's essay, "Thatched Roof Effect with Shingles," illustrating it with Lindeberg's sketches for James A. Stillman's house at Pocantico Hills and several gate lodges, farm buildings, and stables he had designed in Westchester County. Lindeberg described a method he developed from earlier suggestions by Charles McKim and Henry Van Buren Magonigle for bending cedar shingles to cover curved surfaces. Carried on furring attached to the rafters, the shingles rounded each valley, wrapped each ridge, and flowed in long irregular waves down to the rolled, thick eaves. The "Lindeberg roof" threatened to haunt him: He reported that a lady from St. Louis wrote, "How much will you charge a foot to design such a roof?"[8] One admiring critic in 1912 praised Lindeberg's first house for Carleton Macy with this description: "Greek Doric columns were set into a symmetrical facade and crowned with a thatch-like shingle roof. . . ."[9] Had Lindeberg not evolved his art in the Erdman and Alcott houses, he would be remembered, if at all, for what C. Matlack Price in 1915 called "ingenious and pleasing handling of roofs."[10]

Arthur W. Rossiter Residence, "Cedarcroft," Glen Cove, 1906 (Extant)

Carleton Macy Residence, "Wonder Why," Hewlett, 1908

V. Everett Macy Residence, Hewlett, c. 1910

Russell S. Carter Residence, Hewlett, 1910

Henry L. Batterman Residence, "Beaverbrook Farm," Mill Neck, 1914

Lindeberg's early work is distinguished more for grandeur and comfort than for architectural quality. The 1906 house for investment broker Arthur W. Rossiter on Ridge Road, Glen Cove, is generous and comfortable, and the house for Carleton Macy, industrialist and engineer, at Hewlett (1908) is a needlessly confused jumble of scales and geometry, with numerous rooms blanketed by a shingled roof. Nothing inspiring can be found in the mechanical composition of two bays on either side of the vaulted entrance at the V. Everett Macy house at Hewlett or in the Russell S. Carter house of 1910 (also at Hewlett), which is stately and grand, with a hipped roof and chimneys bracketing an arched

recessed between wings, while the entrance porch offers an eccentric introduction to the staircase and living room. Here, Lindeberg realized his ideal: a "spirit of domesticity," "interior convenience," "structural integrity and honesty of expression; right proportion and simplicity of outline."[5] Today, all four houses survive as private residences.

The Erdman and the Alcott houses at East Hampton won national recognition for Albro & Lindeberg. By 1916, Lindeberg's talent was generally recognized. His formal alliances lay in the English tradition of Richard Norman Shaw (1831–1912), the early work of Edwin Lutyens, and, most closely, the domestic designs of Charles Francis Annesley Voysey (1857–1941), whose houses and cottages of 1890 to 1900 display plans and massings resembling Lindeberg's. In 1912, Lindeberg published some of the principles guiding his residential designs: *One dimension should dominate; . . . rhythmic spacing of the windows . . . effect of light and shadow; . . . unbroken surfaces; . . . the small house should . . . give the effect of being low . . . ; a peculiar charm is often attained by rambling single-story wings.*[6]

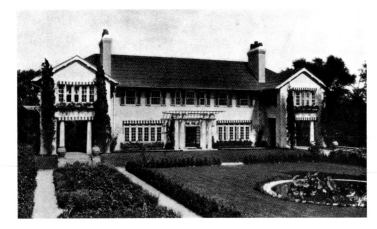

Albro & Lindeberg: Garden Facade, "Cedarcroft," Arthur W. Rossiter Residence, Glen Cove, 1906 (ARTR, 1912)

Albro & Lindeberg: Floor Plan, "Cedarcroft," Arthur W. Rossiter Residence, Glen Cove, 1906 (ARTR, 1912)

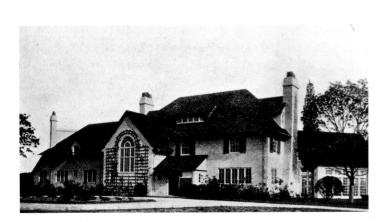

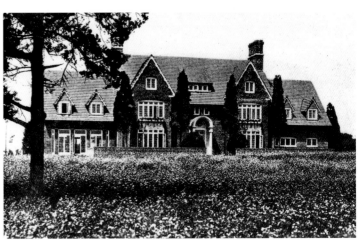

Albro & Lindeberg: Front Facade, "Wonder Why," Carleton Macy Residence, Hewlett, 1908 (ARTR, 1912)

Albro & Lindeberg: Rear Facade, V. Everett Macy Residence, Hewlett, c. 1910 (ARTR, 1912)

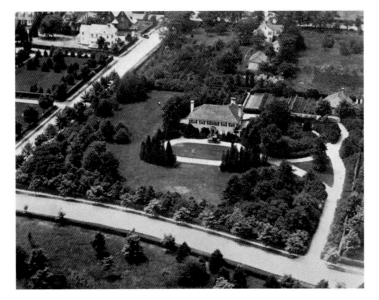

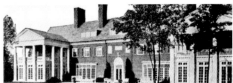

Albro & Lindeberg: Russell S. Carter Residence, Hewlett, 1910 (VIEW, c. 1930)

Albro & Lindeberg: Garden Facade, "Beaverbrook Farm," Henry L. Batterman Residence, Mill Neck, 1914 (HOUS, 1920)

entrance. Perhaps the epitome in grandiose decorating of mass by classical orders was the residence for merchant and real-estate developer Henry L. Batterman on Frost Mill Road, Mill Neck (1914), for which only outbuildings survive. Its Palladian portico was praised in *Arts and Decoration,* 1925, for carrying on the Georgian tradition of "Homewood" in Baltimore. Even C. Matlack Price, one of Lindeberg's more serious supportive critics, commented in 1915 that Albro & Lindeberg "borrowed with remarkable skill and admirable frankness from the great storehouse of precedent. . . ."[11]

Nelson Doubleday House, "Barberrys," Mill Neck, 1916 (Extant)

Lindeberg's consummately fine orchestration is epitomized in the house he designed at Mill Neck in 1916 for Nelson Doubleday, the publisher and son of F. N. Doubleday. Through vistas over gardens and woodlands designed by the Olmsted Brothers, the terrace and house offered views of Oyster Bay. Rising from the lawns and terraces, the beautifully sited house consists of a

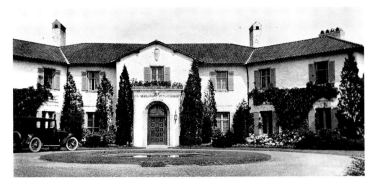

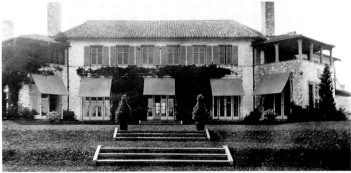

Harrie T. Lindeberg: Front Facade, "Barberrys," Nelson Doubleday Residence, Mill Neck, 1916 (FLON, 1922)

Harrie T. Lindeberg: Garden Facade, "Barberrys," Nelson Doubleday Residence, Mill Neck, 1916 (FLON, 1922)

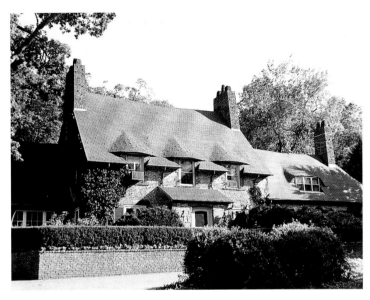

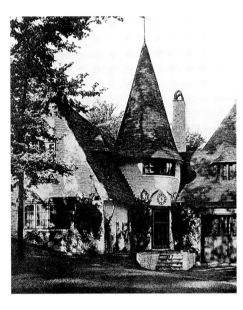

Harrie T. Lindeberg: Front Facade, "Goose Point," Irving Brokaw Residence, Mill Neck, 1914 (INVE, 1978)

Harrie T. Lindeberg: Garage, "Goose Point," Irving Brokaw Residence, Mill Neck, 1914 (LINB, 1940)

main block standing between pairs of V-shaped wings, with semicircular bays on the garden facade. The refinements of proportion, both on the exterior and interior, are brought to perfection at the entrance, where the prevailing theme of pier and arch is stated wonderfully in the soffited entrance and iron grille. Seeing that virtuoso performance in dignified scale and exquisite proportions, one senses that Lindeberg's talent did not really need the red-tiled Spanish or Italian Renaissance idiom he drew upon.

Rather, Lindeberg had begun about 1914 to strike more elemental chords than Doubleday's stylistic trills suggest. Still well under the age of 40, Lindeberg began to grasp large masses, subdue detail, compose geometry as a series of vertical accents arranged along a meandering horizontal axis, gain scale from functional structural members, apertures, chimneys, and bays, and achieve character through the native textures of wood, stucco, brick, and stone. The two previously cited examples of 1912 and 1915 at East Hampton (the Erdman and Alcott houses) caution us to expect Lindeberg to remain constrained within the mode of Cotswold cottages. Like Henry Hobson Richardson before 1880, and Frank Lloyd Wright before 1908, when he designed the Robie House in Chicago, Lindeberg was gaining his distinctive grasp of composition within historical styles.

Irving Brokaw Residence, "Goose Point," Mill Neck, 1914 (Extant)

In fact, Lindeberg's individuality defies discovery in a Chipping Campden or Morton-on-the-Marsh of any Cotswold precedent for his Irving Brokaw house of 1914 at Mill Neck. Sited on the side of a hill overlooking a pond, "Goose Point," as it is still called by its current owner, responded to the special tastes of Brokaw, a national figure-skating champion. He invited friends to skating parties on the ponds and built dormitories above the garages for their weekend sojourns, arranging these around a courtyard where a brick conical turret admits entry diagonally through the corner cylinder. The cottage itself rides the hillside, poking eyebrows through gently curved roofs and capping brick chimneys with terra-cotta pots, until at the eastern terrace a sunlit stucco wing exposes joined timbers arched around a window affording views of the ponds that join Shu Swamp and Beaver Lake. Three houses of 1920 in Locust Valley show similar compositions of simple elements.

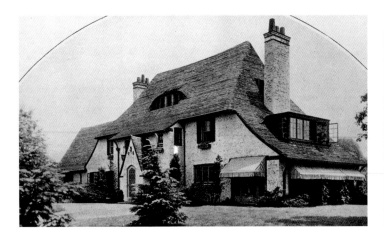

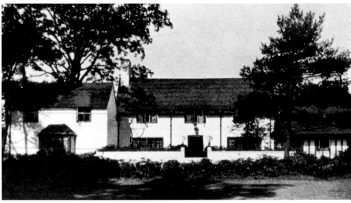

Harrie T. Lindeberg: Front Facade, "Little Waddingfield," James B. Taylor, Jr., Residence, Glen Cove, 1920 (COUN, 1922)

Harrie T. Lindeberg: Bertrand L. Taylor Residence, Locust Valley, c. 1920 (LINB, 1940)

Harrie T. Lindeberg: Richard E. Dwight Residence, Locust Valley, c. 1920 (HOUS, 1921)

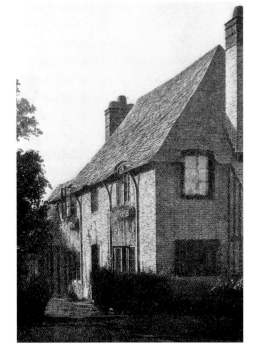

James B. Taylor, Jr., Residence, "Little Waddingfield," Glen Cove, 1920 (Extant)

Bertrand L. Taylor Residence, Locust Valley, c. 1920 (Extant)

Richard E. Dwight Residence, Locust Valley, c. 1920 (Extant)

For business executive and noted aviator James B. Taylor, Jr., Lindeberg achieved a direct expression in brick with a roof that swings out over a loggia; for Bertrand L. Taylor, on Chicken Valley Road, a composition of large planes of stucco wall sheltered by a dark roof and sharply punctured by fenestration; and for lawyer Richard E. Dwight, on the same road, an almost vernacular reduction of residential elements to doors, roofs, and chimneys, unbroken wall surfaces, and dominant roof. All three estates have remained as private residences.

Horace O. Havemeyer, Jr., Residence, "Olympic Point," Islip, 1918

Was it the taste of clients that lured Lindeberg away from Brokaw's elemental charm, or was Lindeberg, once independent from Albro, truly the chameleon designer, ready, even intent, to display his repertory of styles? The Horace Havemeyer, Jr., house in Islip of 1918, for the son of the founder of the American Sugar Refining Company, does not admit an answer in either alternative. Here was a harmonious wedding of client's taste and Lindeberg's talent. Few architects then or now could have composed a more successful series of vertical accents within a long, horizontal range, profusely studded with Renaissance English gables, windows, and chimneys.

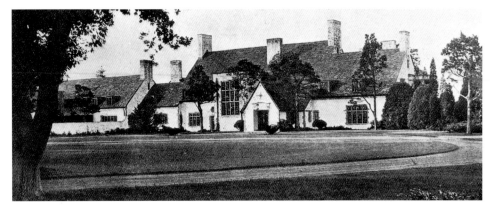

Harrie T. Lindeberg: Entrance Drive and Front Facade, "Olympic Point," Horace O. Havemeyer, Jr., Residence, Islip, 1918 (ARRC, 1924)

Harrie T. Lindeberg: Entrance Facade, "Laurel Acres," Frederick L. Lutz Residence, Oyster Bay, 1920 (LINB, 1940)

Harrie T. Lindeberg: Entrance Front, "White Acre," W. N. Dykman Residence, Glen Cove, 1920 (COUN, 1925)

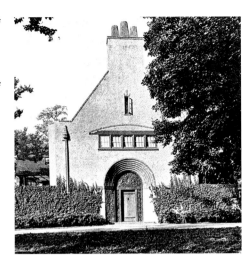

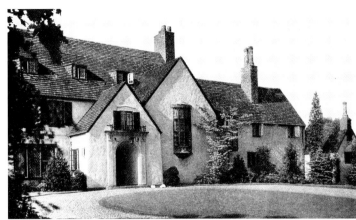

Harrie T. Lindeberg: George Bourne Residence, Mill Neck, 1920 (HOUS, 1921)

Harrie T. Lindeberg: Jackson E. Reynolds Residence, Lattingtown, 1919 (ARRC, 1924)

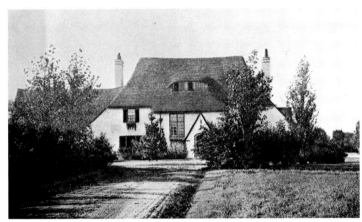

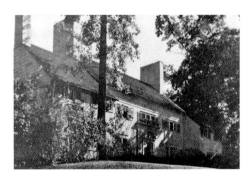

Frederick L. Lutz Residence, "Laurel Acres," Oyster Bay, 1920 (Extant)

W. N. Dykman Residence, "White Acre," Glen Cove, 1920 (Extant)

George Bourne Residence, Mill Neck, 1920 (Extant)

Jackson E. Reynolds Residence, Lattingtown, 1919 (Extant)

Henry C. Martin Residence, Glen Cove, 1924 (Extant)

Taken singly, each of Lindeberg's elevations is a masterly composition, best appreciated in the elegant entrance facade of the 1920 Oyster Bay house of Frederick L. Lutz, a prominent metallurgist and engineer. Here an archivolted door, a range of windows beneath a relieving arch, and a vertical window in the chimney face are harmoniously aligned within the flat stucco wall that sharply outlines the building's roofline and summit. Exhibiting greater exuberance, Lindeberg's house for W. N. Dykman in Glen Cove is an asymmetrical balance of gabled bays, and his George Bourne house at Mill Neck, also of 1920, composes gabled wings, tall chimneys, and large and small windows around a juxtaposed, steeply roofed porch and vertical staircase windows in a remarkable act of asymmetrical balance. Alongside those compositions, Lindeberg's clapboarded Georgian house for Jackson

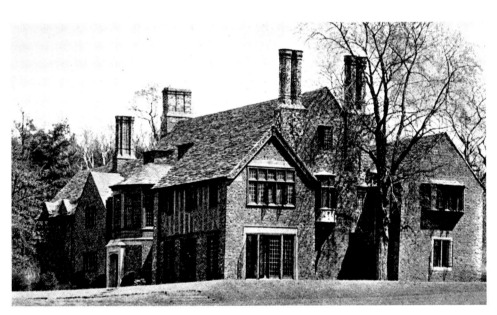

Harrie T. Lindeberg: Henry C. Martin Residence, Glen Cove, 1924 (HOUS, 1924)

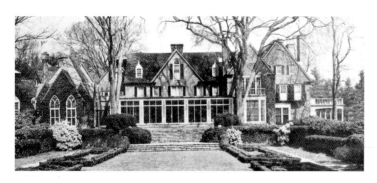

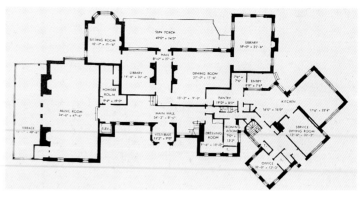

Harrie T. Lindeberg: Garden
Facade, "Underhill Farm,"
Myron C. Taylor Residence,
Lattingtown, alterations,
c. 1922 (SPLI, n.d.)

Harrie T. Lindeberg: Floor
Plan, "Underhill Farm,"
Myron C. Taylor Residence,
Lattingtown, alterations,
c. 1922 (SPLI, n.d.)

Harrie T. Lindeberg: J. J.
Levison Residence, Glen
Head, 1924 (ARRC, 1933)

Harrie T. Lindeberg: Harrie
T. Lindeberg Residence,
Matinecock, 1926 (ARRC,
1933)

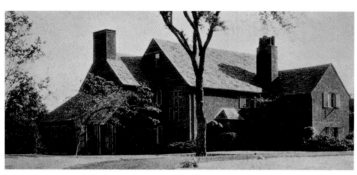

Harrie T. Lindeberg:
Entrance Detail,
"Eckington," George Gales
Residence, Lattingtown,
1927 (ARRC, 1933)

Myron C. Taylor Residence, "Underhill Farm," Lattingtown, c. 1922 (Extant)

For the chairman of U.S. Steel, Myron C. Taylor, who became America's envoy to the Vatican, Lindeberg remodeled a pre–Civil War house at Lattingtown and incorporated it within wings containing ten master bedrooms, two libraries, a 47-foot-long solarium, and a music room measuring 24.5 by 47.6 feet, all overlooking a 6-acre lake and 65 acres of meadow and woodland composed to the designs of Vitale & Geiffert with Annette Hoyt Flanders. Whether it was a trail leading to a waterfall or a hall with Gothic windows, linenfold paneling, or a Renaissance fireplace topped by a broken scroll, each vista announced what a contemporary journalist called "baronial living." Since 1955, the residence has served as the offices of the Protestant Episcopal Diocese on Long Island.

In addition to his work on the Myron Taylor house, Lindeberg was involved in altering two other Long Island residences, the Wilbur Ball house in Lattingtown (1928) and the C. O. Iselin house in Brookville (1941).[12]

J. J. Levison Residence, Glen Head, 1924 (Extant)

Harrie T. Lindeberg Residence, Matinecock, 1926 (Extant)

George Gales Residence, "Eckington," Lattingtown, 1927 (Extant)

One wonders why Lindeberg so readily abandoned his own successful compositions in more modest commissions. His 1924 house at Glen Head for J. J. Levison, the landscape architect, returned to the themes of strong masses, asymmetrical balance, long unbroken walls, and clear junctures of clean volumes. His own house of 1926 near the Piping Rock Club in Matinecock deftly composes a stone facade that is half wall and half hipped roof, with windows symmetrically placed at long intervals, all introduced by low ranges of gabled side wings. "In an era of change," C. Matlack Price wrote when Lindeberg's house was published in *Country Life in America* in 1936, "tradition takes on a

E. Reynolds in Lattingtown (until recently the rectory for St. John's) seems constrained and dull, while the rambling English Tudor house Lindeberg provided in 1924 for Henry C. Martin in North Country Colony, Glen Cove, compiles carved verge boards, brick nogging in half-timber frames, myriad slate roofs, limestone doorways, an oriel, and clustered chimney flues with Samuel Yellin's grille work and Abram Poole's arboreal mural in the dining room.

Harrie T. Lindeberg: Garden Facade, Dale Parker Residence, Sands Point, 1929 (ARRC, 1933)

Harrie T. Lindeberg: Entrance and Front Facade, "Three Brooks," Charles T. Church Residence, Mill Neck, 1930 (COUN, 1933)

special importance," and he spoke of "cultural nostalgia."[13]

That is a minor part of what we admire in Lindeberg's house today, and we are rewarded again in his 1927 residence for George Gales, president of the Liggett Drug Co., in Lattingtown's Overlook Road. Here again is a total presence, perhaps Lindeberg's finest composition. Situated downward from its entering driveway, it invites a diagonal glimpse of its massing, so that the perspective shifts from looking upon roofs to peering up at them. The approach closes at the entry, a deep, welcoming half-timbered vestibule. From there one moves forward to a flow of rooms and out to the noble trees beyond the garden terrace; pausing at a massive limestone fireplace; noting the plaster decoration in the dining room and the carved and paneled library; feeling the masonry walls, 13 inches thick throughout the house; and admiring the bricklayer's art in curved brick and marvelous bonds.

Dale Parker Residence, Sands Point, 1929 (Extant)

Charles T. Church Residence, "Three Brooks," Mill Neck, 1930 (Extant)

Later there were large houses, like the Dale Parker house of 1929 in Sands Point and the Charles T. Church house of 1930 in Mill Neck, designed for the head of the Arm & Hammer

Baking Soda Co. These houses also enjoyed the craftsman's touch, but their sites, symmetrical balance, and academic arrangement of hipped roof over entrance and bays and studied, dry window compositions never approached the magic of the Gales's house.

It is sad to see Lindeberg ending his career in a correct, academic formula, far less the grand designer his earlier work promised. While his shingle-thatched roof had not trapped him, his axiomatic formulas had. Russell J. Whitehead was right to remark in 1924 on Lindeberg's "surprise element," and to say, "It is as if we were watching a conjuror."[14] For when one sees the Alcott, Brokaw, and Gales houses on Long Island or the Ledyard house in Stockbridge, Massachusetts, one is astonished by Lindeberg's virtuosity in wedding landscape and building; and when one sees the Doubleday and Lutz houses, one thinks that never were elevations more angelically scaled and proportioned.

If we were asked to choose a single image on Long Island as a memorial to Lindeberg, we would choose the Lutz's entrance facade. In suburban Dayton, Lake Forest, Morristown, and Houston, Lindeberg is still remembered for his distinctive imagery. He thought of himself as forward looking, "blossoming out into a mature personal art on new lines," as he said about Goodhue in 1933, "modern if you will." Among modernists, he admired Saarinen and Ostberg: "They know form and color, and how to use materials."[15] But unlike Goodhue, Ostberg, and Saarinen, Lindeberg set himself to serve a society that was to be shattered by the Great Depression. When, in the mid-1930s, he attempted a design in mass-produced, welded, cellular steel construction, with all ornament eliminated—"even the cornice"[16]—the result was a flaccid, puerile memory of French academic villas. The spatial and proportional freedoms made possible by the new technology eluded him, and there were fewer clients between 1935 and 1950 for a baronial mansion on its broad acres. Sadder still, in 1985, not a mile from Lindeberg's own house, new houses being built along Piping Rock Road showed that a faint memory of Lindeberg's legacy, the domestic mixture of porte cochere, pavilion, turret, dovecote, conical roof, and oriel still signified domestic bliss, as though Benjamin A. Thompson at the modern Burke house on Centre Island had not shown a graceful alternative.

Alfred Bush Brown with Thomas R. Hauck

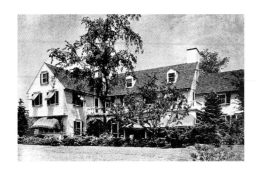

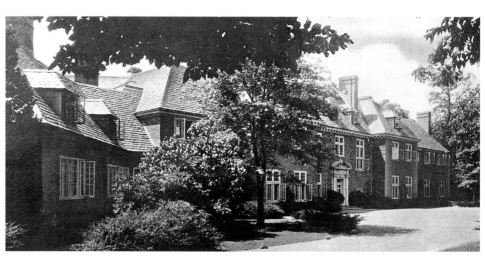

William T. Aldrich: Rear Facade, George Mixter Residence, Manhasset, c. 1930 (HOUS, 1932)

William T. Aldrich: Entrance Detail, "Broadhollow," Winthrop Aldrich Residence, Brookville, 1926 (SPLI, 1949)

William T. Aldrich, 1880–1966

A graduate of the Massachusetts Institute of Technology and the Ecole des Beaux-Arts, Paris, William Truman Aldrich began his career in the offices of Carrère & Hastings in 1909. As the son of a famous United States senator, the brother of the chairman of the Chase Manhattan Bank and later Ambassador to the Court of St. James, and the brother-in-law of John D. Rockefeller, Aldrich possessed connections that soon helped him establish a thriving practice in country-house design. Numbered among his commissions were country seats in Massachusetts for Henry Cabot Lodge at Beverly and for T.

Jefferson Coolidge at Brookline, as well as a number of academic buildings and museums, including the Rhode Island School of Design. His c. 1930 Georgian residence for George Mixter at Manhasset, Long Island, is indicative of his preference for New England domestic architecture, incorporating such 17th-century features as overhangs at the gable ends. Aldrich may also have been responsible for his brother Winthrop's large Georgian mansion of 1926 in Brookville. Both men shared common interests and in the early 1930s served as commodores of the Eastern Yacht Club at Marblehead, Massachusetts, and the New York Yacht Club, respectively. Aldrich was often mentioned in the press when, as a member of the Fine Arts Commission, he joined colleagues in an unsuccessful attempt to stop President Truman from building a porch within the south portico of the White House.

Robert B. MacKay

Augustus N. Allen, 1868–1958

Augustus N. Allen, a graduate of the Columbia University School of Architecture, maintained an office in New York City from 1900 until his retirement in 1933. His diverse Long Island work includes a commission for a country house, a major estate service building, and the Russell Sage Library in Sag Harbor.

In 1902, Allen was given the commission to lay out the site for Howard Gould's Sands Point estate, "Castlegould," and eventually designed the stable building. The Goulds initially set out to model their main house on Ireland's Kilkenny Castle as interpreted by architect Abner J. Haydel. Haydel's published plans (*Architecture*, 1904) show a remarkable similarity to the Irish castle. While these plans were rejected—the

Augustus N. Allen: Stables, "Castlegould," Howard Gould Estate, Sands Point, 1902 (NYAR, 1907)

Augustus N. Allen: Stables, Floor Plan, "Castlegould," Howard Gould Estate, Sands Point, 1902 (NYAR, 1907)

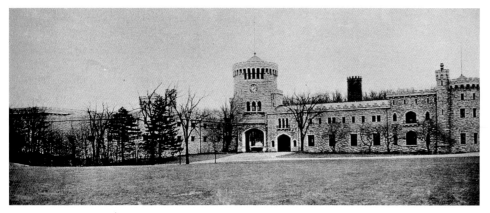

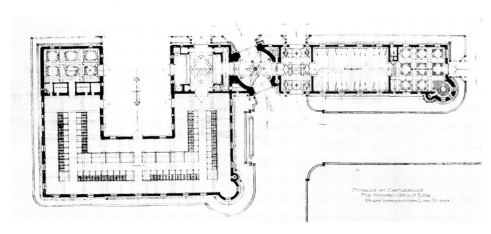

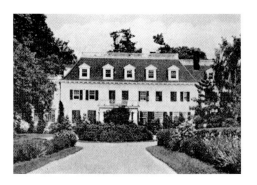

Augustus N. Allen: Front
Facade, "The Lindens,"
Julius Fleischmann
Residence, Sands Point, c.
1910 *(Port Recalled,* 1967)

clients opting for a quieter, more formal Tudor style for the main house—the Goulds realized their desire for a romantic castellated structure in their stables, one of the largest estate service buildings on Long Island. As at Kilkenny, the design followed the favored medieval plan of drum-shaped towers placed at each corner of an irregular rectangle, as well as incorporating the castle's distinctive crenellated parapets and mock machicolation. However, in keeping with formal Beaux-Arts composition, Allen's tower is placed on axis, giving access to the complex which includes the U-shaped stables on one side and the rectangular carriage area on the other. The stables and the main house, designed by Hunt & Hunt in 1909, were sold to Daniel Guggenheim in 1917. In 1971 both were deeded to the Nassau County Museum.

Allen's only known country-house commission was the 25-room Georgian Revival residence he designed for Julius Fleischmann of the Fleischmann yeast family. Built in c. 1910 in Sands Point, "The Lindens" is extant today.

<div style="text-align: right">Carol A. Traynor</div>

■

Grosvenor Atterbury, 1869–1956

Grosvenor Atterbury differs from most of the other architects included here in that he was, to some degree, a product of Long Island. His father, Charles Larned Atterbury, was a successful New York corporation lawyer who had a summer house at Shinnecock Hills near Southampton, where the younger Atterbury experienced firsthand the natural beauties of land, sea, and sky both by living with them and by studying them for three years (1890–93) in the summer painting classes given in the area by William Merritt Chase. He also became familiar with much of the island through his family's social and business connections, so that it was natural for his career to begin there. It was as a creator of country houses that Atterbury made his name, and the buildings discussed here were the major contributors to that reputation.

After his graduation from Yale University in 1891, Atterbury embarked on a six-month trip to Europe and Egypt that solidified his resolve to become an architect. He subsequently enrolled as a special student in construction at the Columbia College School of Architecture for the year 1892–93 and, at the same time, became familiar with office procedures by working for McKim, Mead & White. Stanford White, a friend of the family, also had a house on the Island. The year 1894–95 Atterbury spent in Paris at the Ecole des Beaux-Arts, Atelier Blondel, after which he returned to New York City to begin his career.

The success of his Long Island houses, especially the residence for Robert W. de Forest, brought Atterbury his greatest opportunity. In 1909, the Russell Sage Foundation, of which de Forest was president, decided to finance the construction of a model town at Forest Hills Gardens, Queens, destined to become the most famous of American garden suburbs. The street layout and the landscaping were handled by Frederick Law Olmsted, Jr. Atterbury was responsible for the main group of buildings around, and including, the railroad station, several series of row houses, and many other large and small domestic designs. Especially noteworthy were his massing of various units to create dramatic effects, his beautifully textured surfaces, and his overall consistency of style. This consistency was extended to all buildings in the development, since Atterbury's approval was required for all designs, no matter who the architect. At Forest Hills Gardens, the Sage Foundation also gave Atterbury the chance to demonstrate his theories and research into the development of standardized low-cost housing construction by building a plant for the casting of large prefabricated concrete sections with which whole buildings were erected. These were some of the earliest successful examples of such structures, partly due to Atterbury's effort to make them look like houses rather than boxes. He was involved in other housing schemes as well, especially in Worcester, Massachusetts (1915–16), and in Erwin, Tennessee (1916). Indeed, Atterbury never stopped trying to perfect his prefabrication systems, but Forest Hills Gardens remained his greatest achievement.

Other major projects, such as the First Phipps Model Tenement (1907), the Russell Sage Foundation Building (1915), the American Wing of The Metropolitan Museum of Art (1924–25) —all in New York City—numerous buildings for Bloomingdale Hospital in White Plains, New York, and other hospitals, and the Medical Library at Yale University, attest to the wide-ranging nature of Atterbury's career. Although he eventually built houses from New England to South Carolina and Arizona, it was as a town planner with a special concern for housing the poor and for hospitals that he wished to be known. Architects with such interests rarely become famous.

Befitting his social position and upbringing, Atterbury belonged to many organizations and clubs. He was a fellow of the American Institute of Architects, an academician of the National Academy of Design, president (1915–17) of the

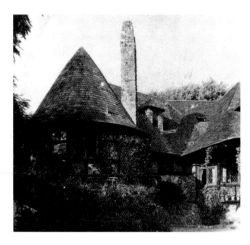

Grosvenor Atterbury: Detail View, "The Lodge," Grosvenor Atterbury Residence, Southampton, alterations, c. 1900–25 (ARTS, 1926)

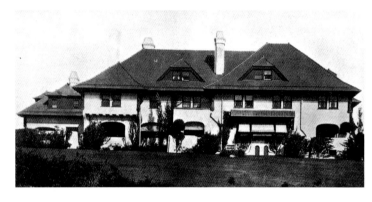

Grosvenor Atterbury: Rear Facade, Arthur B. Clafin Residence, Southampton, 1896–98 (AABN, 1908)

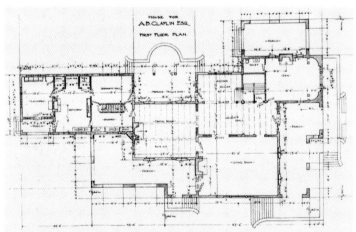

Grosvenor Atterbury: First Floor Plan, Arthur B. Clafin Residence, Southampton, 1896–98 (AABN, 1908)

Grosvenor Atterbury Residence, "The Lodge," Southampton, alterations c. 1900–25 (Partially Extant)

Atterbury's approach to architecture, as well as one of the best examples of the successful aspects of his style, can be seen in his own house at Shinnecock Hills. Initially erected by his father in the 1880s, the house continued to expand in stages into the early years of the 20th century. It was located on rolling and fairly barren hillsides and was carefully designed to follow those contours. While this relates the house very well to its natural setting, it does result in a rather rambling composition made up of a series of almost unrelated parts.

Unity was achieved by Atterbury's approach to the component materials, which were all natural and either taken from, or related to, the local site. The weathered cedar and pine were native woods and the stone was the gray stone of the boulders at the lower end of Long Island. Most important, and probably used here for the first time in domestic construction, was the over-burnt "lammie" brick. Atterbury recognized the great possibilities inherent in the color and texture of this brick, which was a waste product of local kilns. Atterbury's use of this material became something of a signature in his other buildings. An article in *Arts & Decoration,* March 1912, refers to Atterbury as one of the most original and "modern" of architects simply because of his treatment of every house with careful respect for the site and for the materials inherent to that site.

The vigorous and highly textured handling of the surfaces was another Atterbury trademark. This was evident on the exterior of his house with its half-timbered walls and multi-patterned brickwork resting on rough stone masonry. Even on the inside the wood framework was made of untrimmed trees with merely the bark removed and the interstices filled with rough-cast plaster. Similarly, the roof line, always an important point for Atterbury, was formed of a number of different shapes with an amazing variety of dormers projecting, at times, from the most startling positions. Add to this the plantings, whose welcome spots of color further softened the lines of the building, and the result was a house, which while large—the living-dining room area was 60 feet long—seemed intimate in scale and charming in effect in the juxtaposition of its many parts.

Arthur B. Clafin Residence, Southampton, 1896–98 (Extant)

Atterbury's first major commission on Long Island was in Shinnecock Hills for Arthur B. Clafin, a wealthy textile manufacturer. Here the hill site, unlike the rolling Atterbury tract with

Architectural League of New York, a founder and director of the National Housing Association, and a member of many councils and committees. His work combined stylistic conservatism with advanced technological thinking in a unique way.

The following is a presentation of his major Long Island houses. Worth mentioning as well are two public structures in Southampton: the Arcade and Memorial Hall of the Parrish Art Museum (1898) and the Southampton Club (1899).

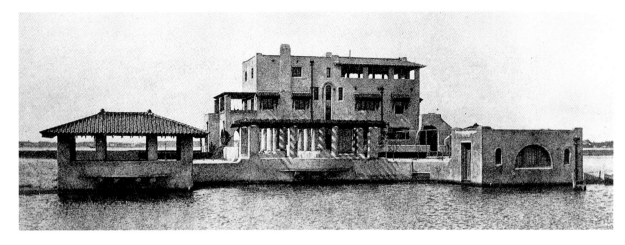

Grosvenor Atterbury: "Modern Venice," H. O. Havemeyer Residence, Islip, 1897–98 (EMBU, 1909)

Grosvenor Atterbury: View of Residences at Bayberry Point, Islip (FULL, 1900)

its small hillocks and hollows, was much broader and almost plantless. The site also contained a windmill at its highest point adjacent to which Claflin proposed to have his home built. Atterbury's solution was a large, rectangular, two-storied structure rising proudly above the surrounding countryside, capped with a hipped roof whose lines stepped up from the windmill and emphatically repeated the brow of the hill.

Because of the exposed nature of the house, great attention was given to the problem of ventilation. The many porches, subsumed within the wall, provided not only the necessary movement of air and protection from the elements, but also allowed a smoother flow from interior to exterior space, while keeping the masses from scattering into smaller fragments. The second-story windows, with their diamond-paned upper sashes for shade and single-paned lower sashes for view, were simply grouped in such a manner as to reinforce the horizontality of the roof line. Other forms, the low arches and the dormers with their jerkin-headed roofs, were typical of Atterbury's work. Here again the materials—the relatively unusual stucco and the tile roof—related to the site, in that the only visible building source was the earth itself.

Henry O. Havemeyer Residence, Islip, 1897–98 (Extant)

Atterbury's next major commission, in fact not one house but ten, was done for Henry O. Havemeyer, founder of the American Sugar

Refining Company, at Bayberry Point in Islip. Havemeyer's concept was to build a summer colony for which, at great expense, he built up the point, dug a canal down the center, and asked Atterbury to design a series of interrelated houses—in essence, a suburb for the wealthy. Following suggestions from Louis Comfort Tiffany, a family friend, Atterbury produced the series of so-called "Moorish" designs. With their spare and dramatic geometric configurations, flat roofs, and simple wall surfaces with equally simple rectangular and round-headed openings, these houses tend to look very modern indeed and clearly relate to the starkness and flatness of the site. Again, the porches are integral to the masses rather than being additions to the exterior. In plan, Atterbury ingeniously created ten houses from four different designs by varied siting and reversed placement of the main structures and their outbuildings. Here, however, he went one step further than the Claflin residence and actually created stucco wall surface from the local sand. Vivid color was supplied by the red and green tiles of the roofs. There was no plan for grass or large trees since these were not native to a sandbar.

This project, more than any other except Forest Hills Gardens, received great attention in the architectural periodicals of the time due to its unusual program and to Atterbury's ability to handle a multitude of picturesque forms. Unfortunately, the houses did not do as well in attracting buyers as Havemeyer had hoped, and many of the community amenities, such as an accompanying tower, were never built. Furthermore, subsequent owners, upset by the uncompromising forms, added pitched roofs and shutters and much more greenery to give their houses a more "normal" look.

Robert W. de Forest Residence, "Wawapek Farm," Cold Spring Harbor, 1898–1900 (Extant)

Corporate lawyer and philanthropist Robert W. de Forest, a good friend of Havemeyer, a relation by marriage to Tiffany, and a colleague of

Grosvenor Atterbury: Facade and Courtyard, "Wawapek Farm," Robert W. de Forest Residence, Cold Spring Harbor, 1898–1900 (HEWI, n.d.)

Grosvenor Atterbury: Garden Facade, "The Creeks," Albert Herter Residence, East Hampton, 1898–99 (HEWI, n.d.)

Grosvenor Atterbury: Front Facade, "Eagle's Beak," Dr. Walter B. James Residence, Cold Spring Harbor, 1899 (VANO, n.d.)

Grosvenor Atterbury: Stables, "Eagle's Beak," Walter B. James Residence, Cold Spring Harbor (VANO, n.d.)

the elder Atterbury, asked the younger Atterbury to design his summer house in Cold Spring Harbor in 1898. Mrs. de Forest wanted the house to have the qualities of both a Long Island summer home and an Adirondack hunting lodge. Atterbury's answer was to create a structure whose first floor and stair tower were of stone quarried in the Adirondacks and barged down the Hudson, and whose major interior space included a large boulder fireplace. The upper portions of the house are closer to Long Island Shingle Style houses of the 1890s. Here, for the first time, Atterbury created a residence of highly textured surfaces in both stone and shingles, including double-thickness tiers of

the latter on the roofs. The entrance beautifully combines the two, tying them together with a two-storied columned porch, again subsumed into the mass of the house and surmounting the whole with a Palladian window.

The building, halfway up a steep hillside, marked Atterbury's first effort to come to grips with the more dramatic positions of North Shore sites. The entrance courtyard acts as a closed nucleus from which the house expands as it opens up to the view. The plan, as following a curve in the hillside, creates a series of fascinating interrelationships of wings at various angles to one another.

Albert Herter Residence, "The Creeks," East Hampton, 1898–99 (Extant)

A further development of the de Forest plan can be seen in the Albert Herter house at East Hampton. Here the angled wings and the flowing interior spaces are far more regularized, creating a plan that looks much neater and yet retains a series of sometimes extraordinary shapes, like the octagonal living and dining rooms. In fact, a greater simplicity seems to be the keynote of the entire complex. On the exterior, the entrance side of the house obviously forms three sides of a hexagon; its smooth featureless stucco surfaces and dormerless roof create a gentle, almost Japanese feeling. Even more than in the Claflin house, one notices the regularity and order of the diamond-paned upper windows. The subdued quality is more than balanced by an unexpected, new feeling for color, in that the stucco wall is pink, the wood trim a blue-green, the under-eaves Pompeian crimson and the roof cast copper tile aged to a mottled green.

Herter was himself an artist and had laid out the gardens with close connections to the exteriors. For the hexagonal entrance court he

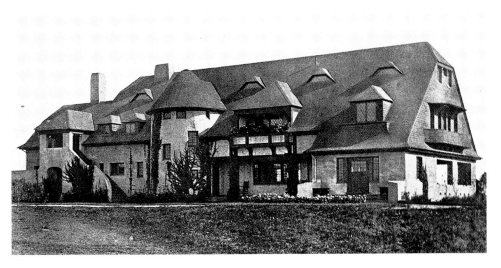

Grosvenor Atterbury: Front
Facade, Dr. C. C. Rice
Residence, East Hampton,
c. 1900 (AABN, 1908)

Grosvenor Atterbury: View
of House and Stables, Dr.
C. C. Rice Residence, East
Hampton, c. 1900 (HEWI,
n.d.)

Grosvenor Atterbury:
"Elyria," Dr. Albert H. Ely
Residence, Southampton,
c. 1900 (ARLN, 1907)

houses but appeared to be floating and unrelated to the forms below. The windows also seemed too small and almost scattered across the wall surface. The projecting wings, at right angles to the main mass, gave the house a fortresslike, formal quality that Atterbury normally avoided. In fact, throughout his career, he was relatively uncomfortable with really huge structures. That this was not due to a lack of enthusiasm for the project as a whole can be seen in the much more elegantly handled, and still existing, stable block. The house itself was demolished.

Dr. C. C. Rice Residence, East Hampton, c. 1900

A number of commissions came to Atterbury around 1900, of which the most publicized was the Dr. C. C. Rice house on the dunes at East Hampton. It was often cited as an example of how to relate a building successfully to the surrounding landscape. The quite large, rectangular mass, including subsumed porches, was effectively broken up by a whole series of typical Atterbury shapes: the low, round stair tower, as used in the de Forest house; dormers; and the outside staircase to the left. Also helpful is the carrying of the roof line down to the top of the first floor, giving the house a more intimate scale and relating it to the smooth shapes of the dunes. In this context, the jerkin-headed dormers and roof ends could be seen as ripples on a large wave.

Dr. Albert H. Ely Residence, "Elyria," Southampton, c. 1900 (Reworked)

Essentially a recombination of forms from earlier designs, the Dr. Albert H. Ely residence in Southampton suggests either that Atterbury may have been overworked or that he had been picked as architect with specific models in mind. The design for this house is a rectangular reconfiguration of the Herter house, combining such elements as plain, stucco walls and simple roof lines with the window pattern of the Clafin house. This house has been much tampered with.

Robert Waller Residence, "Vyne Croft," Southampton, c. 1900 (Extant)

Of more interest is the Robert Waller house, also in Southampton, since it is the first example on Long Island of Atterbury as a designer of Colonial Revival houses. Few of his early buildings may be defined by any easy stylistic

planned the "Garden of the Sun," entirely in yellows and salmon pink, and on the opposite side, overlooking Agawam Pond, he placed a terrace called the "Garden of the Moon," whose colors were white and blue, matching the ceramic tiles in the center fountain and those set into the walls of the house.

Dr. Walter B. James Residence, "Eagle's Beak," Cold Spring Harbor, 1899

For Dr. Walter Belknap James's residence in Cold Spring Harbor, Atterbury struggled unsuccessfully to articulate an enormous mass with his usual small-scaled elements. The dormers in the roofs had the same shape as in the earlier

is connected to the second story of the house proper by unclassical strips of hanging diagonal wall. Above is a series of four dormers, the right one being totally different in shape and scale from the others. Between these two areas are wide, projecting eaves whose beams appear to be a grossly overfed modillioned cornice. The result is a house more Mannerist than classical and more exciting than dull.

Walter G. Oakman Residence, "Oakdene," Roslyn, c. 1900

Atterbury's approach to the Waller house is seen in a more extreme statement in the house of Walter G. Oakman, a financier and chairman of the board of the Guaranty Trust Company. At "Oakdene," the overscaled entrance portico, strongly articulated at the angles by an arrangement of two columns with a corner pier, contrasts spectacularly with the crowded, small-scale elements on the walls at either side. The ground-floor triple windows are startlingly surmounted by paired second-story windows whose pediments overlap the architrave, creating the same kind of architectural excitement within a classical vocabulary that Atterbury achieved in other contexts with his dormers and stair towers.

Harmonious with exterior complexities on the house were the commodious and lavish interior spaces, carefully arranged to display furniture and architectural fragments—columns, ceilings, woodwork, etc.—collected by Mrs. Oakman, a daughter of Roscoe Conkling. That money was no object could also be seen on the site as a whole, where more than 60 varieties of evergreens were planted, some nearly full grown, to establish an instant feeling of permanence on what had been a barren promontory. The house no longer exists.

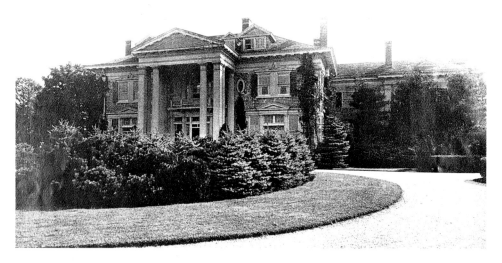

Grosvenor Atterbury: Front Facade, "Vyne Croft," Robert Waller Residence, Southampton, c. 1900 (PREV, n.d.)

Grosvenor Atterbury: Entrance Drive and Front Facade, "Oakdene," Walter G. Oakman Residence, Roslyn, c. 1900, (PREV, n.d.)

appellation, and none of them is a specifically "correct" rendering of a particular style. Atterbury's eclecticism was of the most unfettered kind, allowing individually recognizable details and patterns to be used but always in unorthodox and imaginative combinations with each other and with the whole. Contemporary writers had the greatest difficulty identifying his buildings, often desperately grasping at the inappropriate—for example, calling the Herter house "Italian"—and finally falling back on "modern" for want of a more familiar term. Here there are unexceptional elements like simple massing, shuttered windows, and gigantic pilasters, but Atterbury used them in a context that defies all the classical rules of composition. The entranceway, while itself symmetrical, is placed asymmetrically within the facade. It is flanked by bays of markedly different size and configuration, especially the bay on the left, with its incomplete Palladian window. And it

Lucien Oudin Residence, Water Mill, c. 1905

Not exactly a mansion but representative of several houses built by Atterbury along the South Shore in the first decade of the 20th century is the Lucien Oudin house at Water Mill. Here, Atterbury was able to show both a feeling for stark simplicity, in the very clean overall outline, and his ability to create architectural interest within that simplicity by the play of the individual parts, especially that between different balconies and the bay windows behind them. His concern for texture is expressed in the almost fantastically surfaced brick columns and chimneys, contrasting with the plain, shingle surfaces. The same juxtaposition of contrasts is also evident in the interiors, with their highly textured fireplaces of brick and stone and the smooth surfaces of their exposed studs and

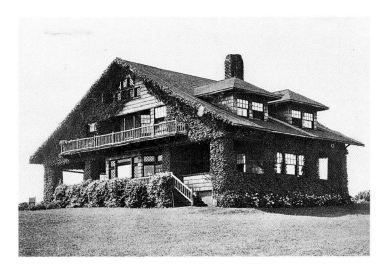

Grosvenor Atterbury: Lucien
Oudin Residence, Water
Mill, c. 1905 (AABN, 1908)

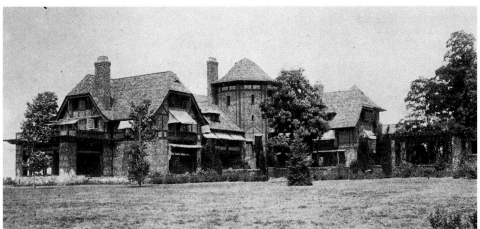

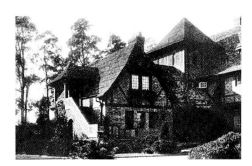

Grosvenor Atterbury: James
Byrne Residence, Oyster Bay,
1906 (EMBU, 1909)

Grosvenor Atterbury: Facade
Detail, James Byrne
Residence, Oyster Bay, 1906
(ARLG, 1908)

beams. The subsumed porches give a feeling of openness and allow the interior rooms more exposure for light and air. The house is sited overlooking Water Mill Pond and successfully meets the architect's requirements of relating easily and naturally with its setting.

The decade from 1896 to 1906 was the most fruitful for Atterbury in terms of commissions for large mansions. After 1906, he had become extremely involved with the development and construction of Forest Hills Gardens, giving him little time for other projects. Nevertheless, he built several major residential structures, whose very infrequency seems to have granted the architect more freedom to develop his ideas and to refine his details.

James Byrne Residence, Oyster Bay, 1906

This large and rambling structure for lawyer James Byrne was only built after an exhaustive investigation of the site and its potential. Atterbury's intent was to create a house at one with the landscape and that seemed added onto in various ways at various times. To this end, the wings of the L-shaped plan became more and more complex as they moved further away from the anchoring octagonal stair tower. The diverse shapes of the roofs, dormers, chimneys, and

exterior staircases all added to the picturesque quality of the whole. As at Forest Hills Gardens, the architectural forms were Atterbury's own mixture of French, English, and German. Unusual for the time was the construction of the exterior walls with real half-timber, not just veneer. Atterbury considered the relationship of rough wood, textured brick, and multicolored slates to be one of his most successful efforts. It is especially unfortunate, then, that the house was destroyed by fire in 1918. Walker & Gillette's "Coe Hall" was later built on its foundations.

H. G. Trevor Residence, "Meadowmere," Southampton, c. 1910

Very striking, but almost overwhelming, is Atterbury's use of texture in the H. G. Trevor house in Southampton. Here, the surface of the emphatically three-dimensional and varicolored brick simply takes over, making the smooth roof appear almost as an afterthought. The unusual arrangement, shapes, and proportions of the porte cochere and stair tower, with their connecting wall fragment, gives a Mannerist quality to the building (emphasized today by absence

Grosvenor Atterbury:
Entrance Courtyard,
"Meadowmere,"
H. G. Trevor Residence,
Southampton, c. 1910
(BRIC, 1913)

Grosvenor Atterbury: Floor
Plans, "Meadowmere,"
H. G. Trevor Residence,
Southampton, c. 1910
(BRIC, 1913)

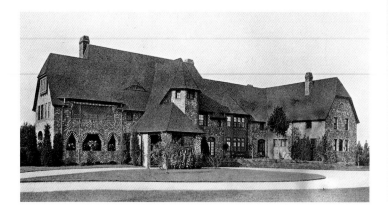

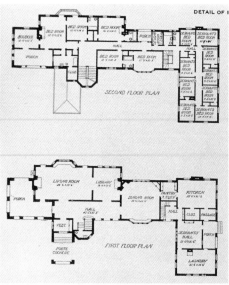

Grosvenor Atterbury:
Charles A. Peabody, Jr.,
Residence, Cold Spring
Harbor, 1910–12 (BRIC, 1913)

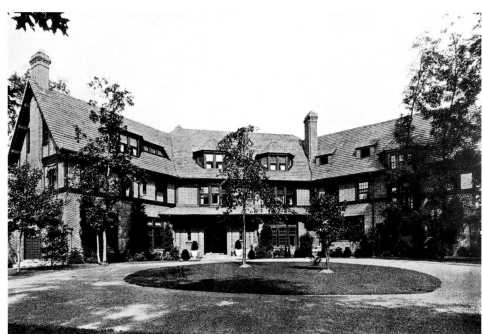

of the servants' wing, demolished after World War II). The interiors counteract this excitement for, by this time, Atterbury's plans are mostly a series of boxes, lacking the interconnectedness of his earlier designs.

Charles A. Peabody, Jr., Residence, Cold Spring Harbor, 1910–12

Atterbury's compartmentalization of plan continued even into houses with angled wings, such as the Cold Spring Harbor house for Charles Peabody, president of the Mutual Life Insurance Company. Superficially similar to the Herter house, the interior spaces remained separate from each other. The exterior of the house, however, was a superb mixture of formal and informal elements, often in striking juxtaposition. The symmetrical placement of the entrance facade between two wings was countered by the division of its central unit into two, rather than

three, parts, with the door situated at the left. Picturesque, asymmetrical elements abound, such as the dormer at the upper left made of two entirely different shapes. But the most magnificent elements of the Peabody house are the brickwork, with its harmonious blend of different patterns and textures, and the specially designed tile roof. The house is no longer extant.

Rufus L. Patterson Residence, "Lenoir," Southampton, 1915 (Extant)

William H. Woodin Residence, "Dune House," East Hampton, 1916 (Extant)

Other houses of the period—such as the Rufus L. Patterson house, an elaborate remodeling of an existing house of the 1880s, for this wealthy

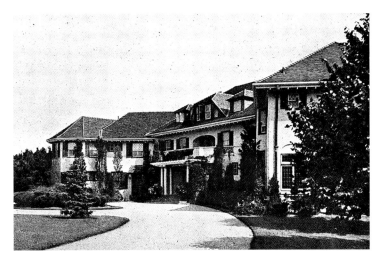

Grosvenor Atterbury: Facade and Entrance Courtyard, "Lenoir," Rufus L. Patterson Residence, Southampton, 1915 (ARRC, 1918)

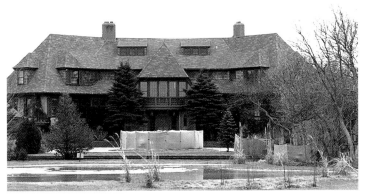

Grosvenor Atterbury: Front Facade, "Dune House," William H. Woodin Residence, East Hampton, 1916 (INVE, 1979)

Grosvenor Atterbury: Gardener's Cottage, "Dune House," William H. Woodin Residence, East Hampton, 1916 (INVE, 1979)

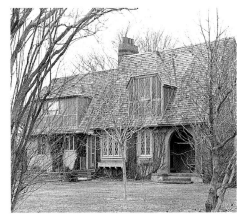

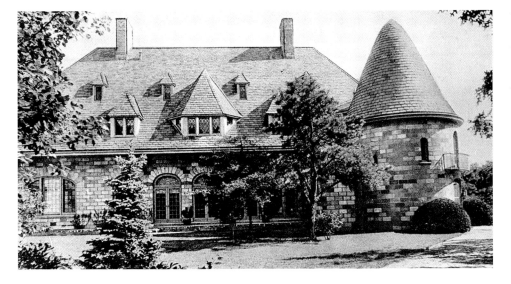

Grosvenor Atterbury: "Wereholme," Harold H. Weeks Residence, Islip, 1917 (Courtesy of Charles Webster)

manufacturer; and the house for William H. Woodin, president of the American Car & Foundry Company and one-time Secretary of the Treasury—take early forms and recombine them. The remodeling of the Patterson house, which reminds one of the James house in Cold Spring Harbor, is much less successful than that of the main facade of the Woodin house, where the roof breaks and dormers are related in a new and almost streamlined manner. Exactly what Atterbury was trying to do can be seen in the Woodin gardener's cottage, where the main dormer, a typical Atterbury form, was greatly enlarged and its detail flattened out so that the total effect is very striking. One of Atterbury's strong points was his ability to consistently transform recognizable motifs into a totally new expression. Both the Patterson and the Woodin houses remain private residences.

Harold H. Weeks Residence, "Wereholme," Islip, 1917 (Extant)

The last of Atterbury's major Long Island houses is the residence of Harold H. Weeks in Islip, part French château (the towers and conical roofs) and part more obviously Atterbury (shaped dormers). There is a tendency in the architect's later buildings for styles to become more recognizable. But texture is still of the greatest importance. So too is color, the roof here being a mottled green and purple and the wall a series of colored blocks made not from stone but from concrete finished with a colored aggregate. The latter derives from his work at Forest Hills Gardens, where Atterbury developed a method of building using prefabricated concrete panels with a similar surface. The Weeks house is a fascinating attempt to use this new technique in a more traditional vein, thus combining the two major directions of his career at the time.

Donald Dwyer

Babb & Cook, 1877–1884

Babb, Cook & Willard, 1884–c. 1904

Babb, Cook & Welch, 1904–1916

Babb, Cook & Willard (later Welch) were New York City architects. In the early 1900s, however, the firm designed four country houses on Long Island. George Fletcher Babb, the senior partner, was born in New York in 1836. His father, William George Babb, born in London in 1794, had come to the United States as a two-year-old. In 1815 the elder Babb married Anna Earle, with whom he had 12 children.

Young Babb already began to draw plans for houses in his childhood and was quickly recognized by his family as gifted in music, painting, and literature. In the mid-1850s, Babb entered the New York City office of the English-born architect T. R. Jackson. When Babb arrived, the Jackson office was working on the design for the first headquarters for the *New York Times* on Park Row. At the same time the firm took on a young graduate of the Free Academy (later City College), Peter Bonnett Wight (1838–1925), a member of the small band of American artists drawn to the teachings of John Ruskin. Babb and Wight developed a close friendship, which led to the former's assisting Wight with drafting and furniture design for the no-longer-extant Brooklyn Mercantile Library (1865–69). Projects like this in which he served as a draftsman and interiors specialist, formed the key to Babb's career.[1]

In 1859 Babb entered into a partnership with a rather obscure architect, Nathaniel G. Foster (1833–1907) at 167 Broadway. Due to the virtual cessation of construction during the Civil War years, this new partnership generated little business, a situation that probably led to its termination in 1865. Needing work, Babb accepted a drafting position in the office of architect Russell Sturgis (1836–1909), soon to become an author and critic. During this time, Sturgis was building Farnam Hall at Yale University (1868–70) and was about to begin work on the Battell Chapel (1874–76). He employed Babb's decorative skills for the interior.

Although a taciturn man, Babb was considered a good teacher of the principles and aesthetics of architecture, and in the mid-1860s he was asked to become a founding member of the department of architecture at the Massachusetts Institute of Technology.[2] An exceedingly modest man, Babb declined the offer, remaining content to teach from the practical confines of Sturgis's New York City office. There he had a profound effect on the young William R. Mead and Charles Follen McKim.[3] The young Stanford White, who may have known Babb from the Sturgis days, also held Babb in high esteem.[4]

In the 1870s and 1880s, Babb had a desk at 57 Broadway, where Richardson, and later McKim and Mead, had taken office space. In the company of McKim, Babb must have met Walter Cook, who became his partner. Babb's close ties with McKim, Mead & White continued until 1893, when a dispute over the Cullum Memorial at West Point led to a cooling of the relationship between his firm and theirs.

Walter Cook was born in 1846 in New York City. Cook's father, Edward, was an Englishman who had come to the United States in 1815 and had established himself as a merchant in New York. There, he met and married Catherine Ireland, daughter of real-estate speculator George Ireland. Catherine Cook inherited her father's property and was a property owner on a moderate scale in the city. Young Walter Cook was sent to private school in New York and then to Yale, transferring to Harvard University in his sophomore year and graduating in 1869. At Harvard, Cook was known for his humanistic values and literary taste. However, he exhibited no artistic inclination and seemed to be headed toward a career in law. Yet, in the summer of 1869, Cook decided to become an architect. Perhaps he was interested in redeveloping his mother's properties, or perhaps he was influenced by his cousin Prescott Hall Butler, whose closest friend was Charles F. McKim.

Cook began his architectural studies in Germany at the Royal Polytechnic in Munich in 1869, and then went to Paris to the Ecole des Beaux-Arts, which McKim had just left. In Paris Cook joined the atelier of Emile Vaudremer (1829–1914), an important training ground for American architects. In the studio at the same time as Cook were Louis H. Sullivan (1856–1924) and William Rotch Ware (1848–1917). Cook seems to have remained in Paris until 1877 or so, marrying Marie Elizabeth Hugot there in 1876. The couple came to the United States when Cook formed a partnership with Babb.

Babb had a well-established reputation in New York and Cook had enough capital and the assurance of jobs to allow his advancement to partner without the customary prior training in an established architect's office. Babb & Cook shared the space in McKim's rooms at 57 Broadway with McKim and Mead, who were later joined by a third partner, William B. Bigelow (d. 1917).

Babb & Cook quickly received work from the latter's mother, including the design of a loft building at 173–175 Duane Street (1879–80)

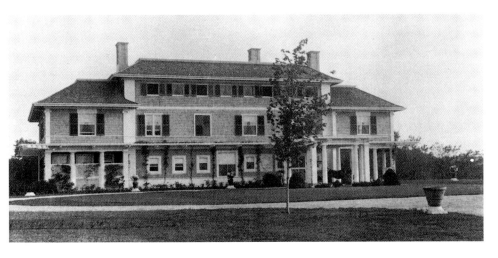

Babb, Cook & Willard:
Front Facade, "Poplar Hill,"
Frederic B. Pratt Residence,
Glen Cove, 1898 (Courtesy
of Mrs. Richardson Pratt)

and the remodeling of some existing buildings. They also designed a slender brick office building at 55 Broadway with large iron-framed windows in 1880. Babb & Cook's early work was modest in scale and expense, varying from the well-organized arcade treatment of the Duane Street building to the slightly busy building at 55 Broadway. The work the firm did in New York could be characterized as ground breaking in the post cast-iron genre of commercial buildings. A third partner was added in 1884, Daniel Wheelock Willard.

Willard was born in 1849 in Brookline, Massachusetts. Trained as a mechanical engineer, he graduated from the Massachusetts Institute of Technology in 1870. His engineering skills added a new component to the firm's offerings, enabling it to take on a series of larger and more challenging commercial buildings. This included the Hanan Building (1884–85), office buildings for the New York Life Insurance Co. in New York, St. Paul, Minnesota, and Montreal, and the DeVinne Press building (1885–86). The latter is one of the most successful commercial structures of the period; its spare ornament and fine proportions have made the building a national landmark.[5]

In the 1880s, Babb, Cook & Willard's domestic mode consisted mainly of shingled wood-frame houses, characterized by prominent gables in the manner of Richard Norman Shaw, the 19th-century British architect, a style quite similar to that of McKim, Mead & White's modest houses. In fact, it is difficult to separate the work of the two firms during the first half of the decade, since they were still closely intertwined. Babb worked on two interior projects for McKim, Mead & White: the C. T. Barney house and the Villard house. But in the mid-1880s, academicism became the dominant aesthetic at McKim, Mead & White. Babb's taste, however, remained fixed in the mid-century, and the two firms drifted apart. By the late 1890s Babb's professional and social standing had declined.[6] He was no longer in the avant-garde of architecture and, having resisted

McKim and White's efforts to make him a clubman, he was not well-connected socially. Walter Cook had become the major partner both in attracting new clients and in the firm's design work.

In the late 1890s and early 1900s, Babb, Cook & Willard began to design residences for some of the new millionaires in the New York metropolitan area. Cook designed the houses and Babb the interiors. The attorney Paul D. Cravath commissioned a house at 107 East 39th Street in 1896 (demolished), and Frederic B. Pratt commissioned one at 229 Clinton Avenue in Brooklyn. Both clients would shortly ask for houses on Long Island. The firm's most important urban residential commission of this period was the mansion for Andrew Carnegie at Fifth Avenue and 91st Street (1899–1901).[7] It appears that at this point Willard was no longer associated with the firm; he turns up in Redlands, California, in 1904, submitting an entry to a competition for a customs house in San Francisco.

Frederic B. Pratt Residence, "Poplar Hill," Glen Cove, 1898

The house for Frederic B. Pratt was the firm's first commission on Long Island. The Pratt family began to build a series of wooden summer houses in an area of Glen Cove named Dosoris. Family members tended to live in close proximity and often commissioned the same architect for their city and country homes. This was true of Frederic B. Pratt, one of six sons of Charles and Mary Pratt. The father was involved with J. D. Rockefeller in organizing the Standard Oil Company and founded the Pratt Institute. Frederic served on the board of trustees of the Institute throughout his adult life.

Commissioned about the same time as the Brooklyn house, the Glen Cove house was more modest. It was dramatically sited on a hill, with its rear section terraced down the grade, and gave the appearance of being absorbed into an orchard. The main section of the house was on level ground and consisted of a three-story central rectangle flanked by two-story symmetrical wings. The house was shingled, orderly, and unpretentious. Its design was so simple that only wooden porches, which banded the wings, an entry door, and a porte cochere enlivened the design. The structure appeared more vernacular than many other country houses of this date. "Poplar Hill" was demolished in the 1920s, when Frederic Pratt asked Charles A. Platt to build him a grand Georgian-inspired house in Glen Cove.

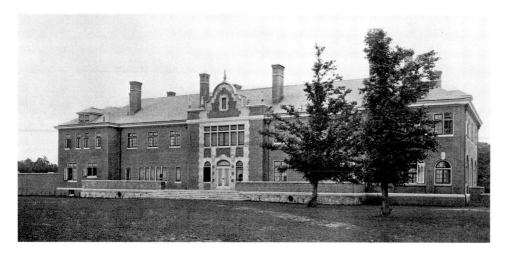

Babb, Cook & Willard: Rear Facade, "Dunstable," Winslow S. Pierce Residence, Bayville, 1903 (ARTR, 1903)

Babb, Cook & Willard: Entrance Front, "Dunstable," Winslow S. Pierce Residence, Bayville, 1903 (ARTR, 1903)

Babb, Cook & Willard: Hall, "Dunstable," Winslow S. Pierce Residence, Bayville, 1903 (ARTR, 1903)

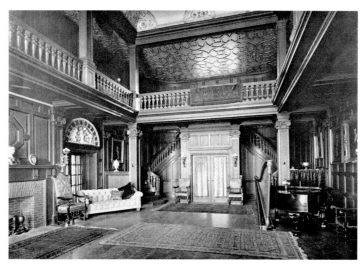

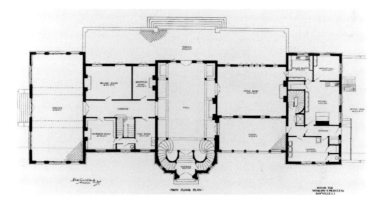

Babb, Cook & Willard: First Floor Plan, "Dunstable," Winslow S. Pierce Residence, Bayville, 1903 (ARTR, 1903)

Winslow S. Pierce Residence, "Dunstable," Bayville, 1903

In 1903 Babb, Cook & Willard designed their first important house on Long Island at Bayville for Winslow Shelby Pierce (1857–1938), a corporate attorney. Pierce commissioned this house a year after forming the law firm of Pierce & Greer, which specialized in railroad law. Bayville, a North Shore town some 40 miles from the city, had no social cachet as a resort, although Stephen Van Rensselaer Cruger, a New York City real-estate speculator, had built a summer house there as early as the 1870s. Indeed, Pierce really

established the village of Bayville, where he lived until his death in 1938.

The Pierce house, a long rectangular block with wings that projected forward, lacked any particular style. Only the projecting central entrance bay had a clearly recognizable historical precedent. The central bay on both the main entrance and garden side consisted of a half-circular Dutch gable of the type found in England in the early 17th century.[8]

The main entrance consisted of a two-story brick bay with stone trim, the door flanked by paired fluted pilasters. The second floor had a three-light, stone mullioned window bounded by two unfluted pilasters. Above this rose the pediment, marked by a blank square of white stone in its center. The virtual absence of decorative sculptural ornament contributed to an austere appearance.

The main hall of the house consisted of a two-story space that recalled the stair hall of the Carnegie residence. The motif of the hexagonal Tudor panel above the mantelpiece had been used by Babb in the triple drawing room of the Villard house of 1883–86. The Villard woodwork was, however, elaborately inlaid, while the Pierce mantel was of strictly plain woodwork. The interiors, probably by Babb, were created for year-round living, since this was Pierce's primary residence. The choice of rather remote Bayville as the location for a year-round home was somewhat unusual for the time, but President Theodore Roosevelt had already set a precedent by converting his summer home in nearby Cove Neck into a year-round residence.

The Pierce family remained in the house at least through the 1920s. When Harrison Williams bought the house around 1927, he called upon Delano & Aldrich to alter the original design to the more fashionable Georgian style of the day.

Babb, Cook & Welch: Front Facade, "Welwyn," Harold I. Pratt Residence, Glen Cove, 1904–16 (Pratt Family Album)

Babb, Cook & Welch: Rear Facade, "Welwyn," Harold I. Pratt Residence, Glen Cove, 1904–16 (Pratt Family Album)

Babb, Cook & Welch: Front Facade, "Veraton (I)," Paul D. Cravath Residence, Lattingtown, 1905 (ARTR, 1908)

Babb, Cook & Welch: "Veraton (I)," Paul D. Cravath Residence, Lattingtown, 1905 (ARTR, 1908)

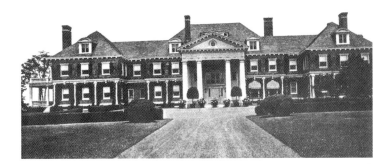

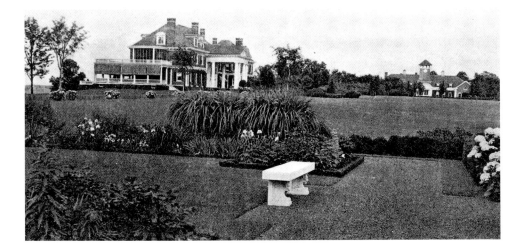

Harold I. Pratt Residence, "Welwyn," Glen Cove, 1904–16

In the late 1910s, Babb, Cook & Welch built a house in the Dosoris area of Bayville for Harold Irving Pratt, brother of Frederic. Harold, the youngest child in the family, devoted his career to managing the family funds.

In design, "Welwyn" was quite similar to the firm's other work on Long Island. Like the house designed for Frederic, the Harold Pratt house was a long rectangle with porches at either end, and the entrance was asymmetrically placed. Four bays of shuttered windows separated by oriel windows provide the main interest in the design. The shingled mansard roof was interrupted by four projecting dormers that continued the lines of the window bays of the lower floors. At the center of the mansard, a small, narrow Colonial gabled window broke the curve of the roof, resembling the jeweled tip of a tiara. On the garden side of the house, projecting corner wings and extensive window areas offered fine views of the formal gardens planted by James L. Greenleaf and the Olmsted brothers. As with the other Long Island works of Babb, Cook & Welch, the house did not reflect the style of the day and was transformed by Delano & Aldrich into a more acceptable Georgian-style house around 1920.

Paul D. Cravath Residence, "Veraton (I)," Lattingtown, 1905

The last home designed by Babb, Cook & Welch on Long Island was for Paul Drennan Cravath at Lattingtown, not far from the Pratt family compound. This English-style estate was the best work by the firm on Long Island. The son of a Congregational minister in Ohio, Cravath founded the law firm that still bears his name. He served as a delegate to the Republican Convention of 1898, which nominated Theodore Roosevelt for governor of New York State. Perhaps Cravath wished to live near Roosevelt, for he bought a fine hilltop in Lattingtown and built a house at its crest.

The Cravath house follows a design for grand English country estates on Long Island that was conventional at the time. However, the house was built of unpainted shingles instead of the more expensive brick, and burned in 1908. Cravath's estate had a fine allée and excellent views, which may have been created at the expense of the local village, making Mr. Cravath a less than popular neighbor. Cravath would eventually build two more houses on this site.

By the time the Long Island houses were being finished, Babb, Cook & Welch were receiving virtually no commissions. Only a few branch buildings for the New York Public Library system kept the firm in business in the years before World War I. Around 1912 Babb, now in his late 70s, moved to the house of his brother, the Rev. Thomas E. Babb, in Holden, Massachusetts. He died penniless in 1915. Walter Cook fell ill about the same time and died in 1916. The firm's most important work was done in the early years. Much of the later work, especially private houses, exhibits minimal inventiveness, perhaps reflecting a desire for unobtrusive architecture for their country houses on the part of the clients.

Mosette Glaser Broderick

Donn Barber: Garden and
Estate Outbuildings,
"Boscobel," Horatio S.
Shonnard Residence, Oyster
Bay, c. 1920 (ARLG, 1922)

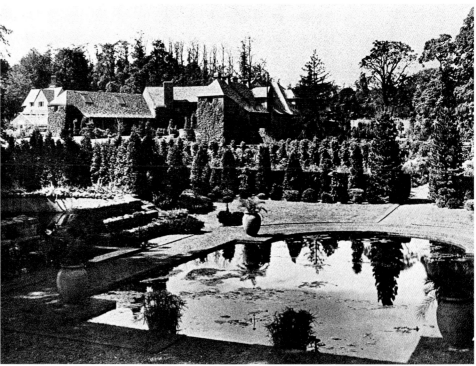

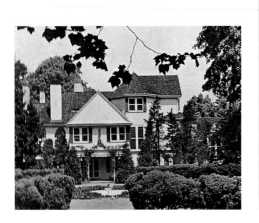

Donn Barber: Front Facade,
"Boscobel," Horatio S.
Shonnard Residence, Oyster
Bay, alterations, c. 1920
(Courtesy of Mrs. Albert L.
Kay)

Donn Barber, 1871–1925

One of New York City's most respected archi-
tects at the beginning of the 20th century, Donn
Barber graduated from Yale University in 1893
and entered the firm of Carrère & Hastings.
Encouraged by Carrère, Barber took a special
course in architecture at Columbia University
and late in 1894 enrolled at the Ecole des Beaux-
Arts in Paris. As a member of the Architec-
tural League of New York and of the Society of
Beaux-Arts Architects, Barber was instrumental
in developing the atelier concept in the United
States, forming the Atelier Donn Barber in New
York. Barber received his only Long Island com-
mission shortly before his death at 54. "Bosco-
bel," at Oyster Bay, was originally built for
Francis T. Underhill around 1885. Over a period
beginning in 1920, Barber remodeled the house
for Horatio S. Shonnard. The original shingled
Queen Anne house was enlarged in a Colonial
Revival style. Barber also created a complex
formal garden and designed several outbuild-
ings, including a garage, stables, and a boat-
house. Departing from the simplicity of the
house, these structures were designed in a free
Tudor Revival style that relied greatly on the
sensitive juxtaposition of different materials.

Michael Adams

Barney & Chapman, c. 1900–1908
John Stewart Barney, 1869–1925
Henry Otis Chapman, 1862–1929

The Long Island work of John Stewart Barney
and Henry Otis Chapman consists of four
country-house commissions dated between
1900 and 1908. In addition, Chapman execu-
ted three designs between 1912 and 1917, and
Barney executed one around 1920, after their
partnership had been discontinued. While styl-
istically diverse, the later projects reveal both
the restrained classicism of Chapman and the
medieval revivalism of Barney, styles that the
architects had blended successfully in their
earlier commissions. Indeed, two of their col-
laborations count among Long Island's largest
Tudor house designs and reflect a preference
for the style that may be seen in their contem-
porary commercial and ecclesiastical work.

John Stewart Barney was born and educated
in New York City. He graduated from Colum-
bia College in 1890,[1] completing his training at
the Ecole des Beaux-Arts in Paris. On his return
to the United States, he opened an office in New
York, concentrating primarily on the design of
churches, hotels, and commercial structures.
The monumentality of such works as the Hotel
Navarre at 7th Avenue and 39th Street (1899),
the Church of the Holy Trinity at East 88th
Street (1899), and the Emmet Building at 95
Madison Avenue (1912) undoubtedly influenced
the scale of his designs for Long Island country

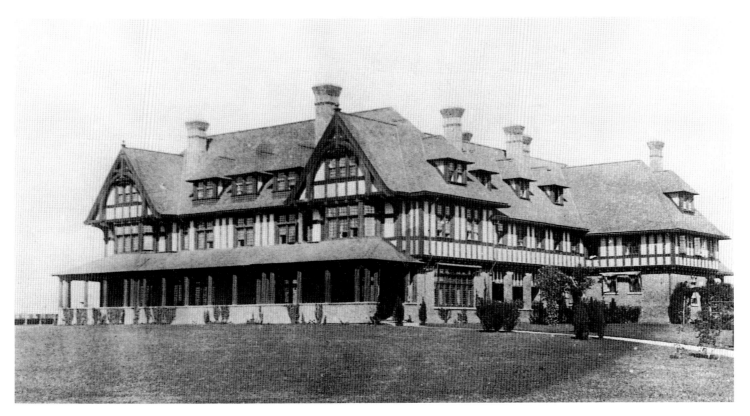

Barney & Chapman: Dr. Peter B. Wyckoff Residence, Southampton, c. 1900 (VANO, n.d.)

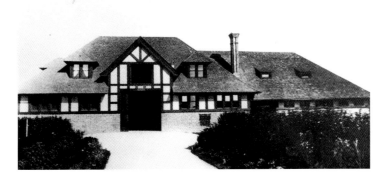

Barney & Chapman: Stables, Dr. Peter B. Wyckoff Residence, Southampton, c. 1900 (VANO, n.d.)

houses. He is also credited with the Hart Memorial Library (1897) in Troy, New York, which is the earliest documented work of Barney and Chapman's short-lived collaboration. Barney is said to have abandoned architecture for painting in 1915; he died in 1925.

His partner, Henry Otis Chapman, spent a year of study and travel in Europe prior to commencing his architectural practice in New York City.[2] Born at Otisville, New York, Chapman graduated from Cornell University in 1890. As with Barney, his most noted work was on churches and commercial structures. These include the Rutgers Presbyterian Church, the Broadway Tabernacle, the Union Sulphur Building at Rector and West streets, and the U.S. Mortgage & Trust Co. building at 73rd Street and Broadway, all in New York City. Chapman died in 1929.

Three of Barney & Chapman's four joint projects on Long Island were illustrated by Montgomery Schuyler in the *Architectural Record* (Vol. XVI, September 1904), while the fourth appeared in *Architecture* (Vol. 17, January 1908) and may postdate the others by a few years. All four are monumental works that display a range of styles characteristic of the eclecticism of the period. The Wyckoff residence in Southampton, for example, employs the vocabulary of an English medieval manor house, while the Porter residence in Lawrence, in brick with stone detailing, draws upon a contemporary tradition of ecclesiastical design. The Colonial Revival style of the Maxwell residence in Glen Cove, however, is unrelated to the other commissions. Chapman later used this style in the Provost residence in East Norwich, which he designed without Barney's collaboration around 1912.

Dr. Peter B. Wyckoff Residence, Southampton, c. 1900

The massive residence of Dr. Peter B. Wyckoff fronted on the ocean and on Lake Agawam in Southampton. It was constructed around 1900 by the firm of J. E. Van Orden; its plantings were supplied by the Hicks Nursery in Jericho. In its design, the architects combined elements

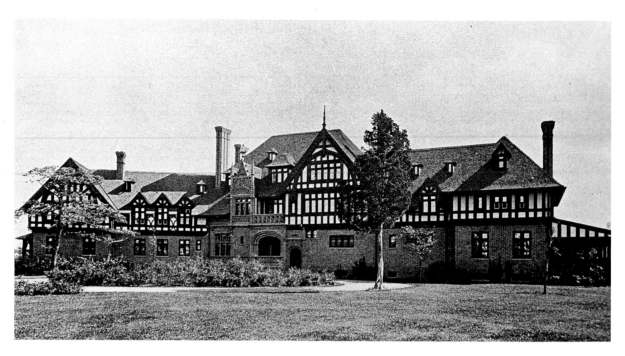

Barney & Chapman: Front Facade, "Lauderdale," Henry H. Porter Residence, Lawrence, c. 1900 (BRIC, 1902)

of English medieval construction such as multi-paned casement windows, an upper story of stucco and half-timber, eight clustered brick chimneys, and an attic story with dominating facade gables. The monumentality of the L-shaped plan and secondary service wing departed from tradition, however. In size, the Wyckoff residence ranks among Barney & Chapman's largest commissions, comparing favorably to some of the more ambitious designs of other architects of the same period. The house was remodeled in 1928 by Mrs. James P. Donohue, the owner from 1920 to 1937. At the time the property consisted of 16 acres of land with 610 feet of ocean frontage. The main house was then supplemented with greenhouses, two garages, and a gardener's cottage. The house was demolished in 1938.

Henry H. Porter Residence, "Lauderdale," Lawrence, c. 1900 (Extant)

A contemporary commission, and one which bears many resemblances to the Wyckoff house, is the c. 1900 Henry H. Porter residence on Ocean Avenue in Lawrence.[3] Like the Southampton house, the Porter house combines a principal story of brick with second-story stucco and half-timber work, as well as numerous facade gables and dormer windows. Unlike the Wyckoff design, however, the Porter project featured an asymmetrical juxtaposition of stone carving at the front entry, which gave the house an English Tudor appearance. The complexity of the roof resulted from the massing of the principal block and service wing, as well as the numerous dormers, gables, and chimneys that punctuate the facades at irregular intervals.

The client, Henry H. Porter (1865–1947), was a public utility official whose engineering background (Columbia School of Mines) prepared him for a career as the director of numerous transportation, mercantile, and power companies. Like Chapman, Porter was a member of the Rockaway Hunt Club in Lawrence; his residence, in fact, was built in the Rockaway Hunt section of the village, which had been laid out by the Lawrence family as a park-like development in 1873–74.

Henry Otis Chapman Residence, Woodmere, c. 1900

Chapman designed and built his own house in nearby Woodmere in collaboration with Barney. Although reduced in scale, it employed the familiar brick, stucco, and half-timber vocabulary. The house was not of mansion size, but in its use of dominant facade gables, clustered brick chimneys, and bold half-timber on the second story, it achieved a monumentality not dissimilar from that of the two architects' larger projects.

E. L. Maxwell Residence, "Maxwell Hall," Glen Cove, c. 1900

Barney & Chapman's last documented joint venture departed from their previously cited projects in its use of shingles as well as in its classical style, massing, and overall design. Built on Lattingtown Road in Glen Cove for E. L. Maxwell, the frame house is symmetrically

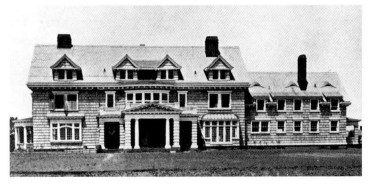

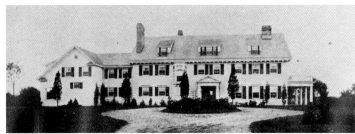

Barney & Chapman: "Maxwell Hall," E. L. Maxwell Residence, Glen Cove, c. 1900 (ARTR, 1908)

Henry Otis Chapman: Front Facade, "Woodstock Manor," Cornelius Provost Residence, East Norwich, c. 1912 (LEVA, 1916)

Henry Otis Chapman: Front Facade, "Blythewood," George Smith Residence, Muttontown, 1913 (Richard Cheek, 1981)

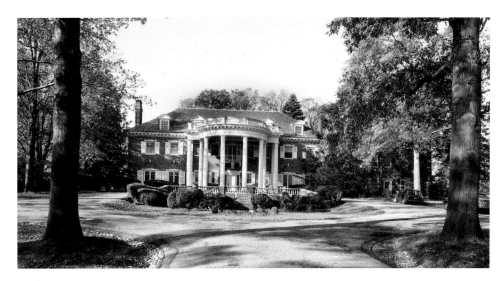

designed around a temple-front entrance. Dentils, flared eaves, and louvered shutters are further suggestions of the architects' familiarity with Colonial Revival design. The residence bears no resemblance to the architects' contemporary Long Island commissions, but displays their ability to combine certain innovations of the Shingle Style such as the eyebrow windows and subsumed porch to enliven an otherwise straightforward example of the Colonial Revival style. The use of Doric columns and balustrades on the ground story anticipates the style of Chapman's Chrysler commission at Kings Point (c. 1916).

Cornelius Provost Residence, "Woodstock Manor," East Norwich, c. 1912 (Extant)

After the Maxwell residence, Chapman designed at least three country homes without the assistance of Barney. The earliest of the three was built in East Norwich around 1912 for Cornelius Provost. Here Chapman employed the same Colonial Revival elements as in the design for the Maxwell house, although the latter achieved greater variety in massing. The asymmetrically placed bay window, indicative of the main staircase adjacent to the front door, is reminiscent of the architect's earlier use of Tudor design elements.

George Smith Residence, "Blythewood," Muttontown, 1913 (Extant)

One year later, Chapman designed a brick Georgian Revival house for George Smith in Muttontown. Smith named the estate "Blythewood" and resided there until 1923, when it was sold to Alfred C. Bedford, chairman of the board of Standard Oil Company. The two-story center block of the house is flanked by two large wings, and the whole is rendered in brick and roofed with slate. The hipped roof, pedimented dormers, and arched reveals above the first-story windows are all drawn from English design precedents. The monumental, two-story bowed portico enlivens an otherwise restrained facade.

Henri Bendel Residence, "Forker House," Kings Point, c. 1916–17 (Extant)

The landscape architect for "Blythewood" was Charles W. Leavitt, who also provided designs for Chapman's Bendel residence in Kings Point. Henri Bendel (1867–1936), who founded the noted specialty store that bears his name, sold the estate to Walter P. Chrysler (1875–1940), the car manufacturer, in 1923. The Bendel house is

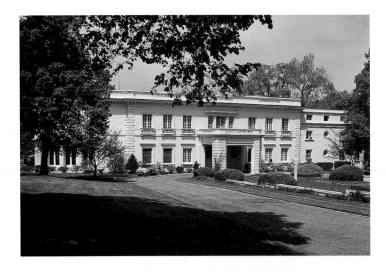

Henry Otis Chapman: Front
Facade, "Forker House,"
Henri Bendel Residence,
Kings Point, c. 1916–17
(Bob Zucker, 1976)

Henry Otis Chapman: Floor
Plans, "Forker House,"
Henri Bendel Residence,
Kings Point, c. 1916–17
(SPLI, n.d.)

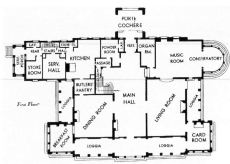

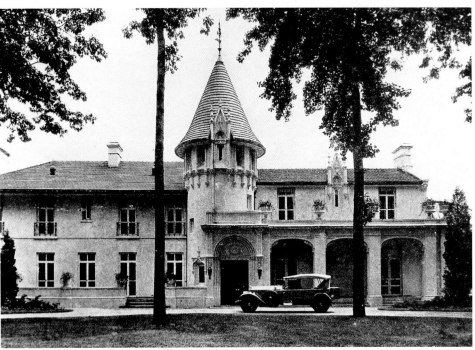

J. Stewart Barney: Front
Facade, "Dorwood," Victor
Emanuel Residence,
Manhasset, c. 1920–25
(SPUR, 1927)

doors leads to an axial main hall, which opens to the second story. Unlike Chapman's earlier Tudor and Colonial Revival designs, the Bendel commission incorporated not only an interior plan but also exterior detailing that reflect the formality of the Beaux-Arts style.

Victor Emanuel Residence, "Dorwood," Manhasset, c. 1920–25 (Extant)

Also finished in stucco, but bearing little resemblance to Chapman's Renaissance-inspired design for Bendel, is Barney's only Long Island residence that can be documented after the dissolution of his affiliation with Chapman.[4] Built in Manhasset in the early 1920s for corporate executive Victor Emanuel (1898–1960), the house was named "Dorwood" after Dorothy Elizabeth Woodruff, whom Emanuel married in 1920. The structure has been described as a French château, although Barney's conical entry tower, pinnacled squint windows, and open loggia express the architect's free use of various European design elements and a background in diverse medieval styles. In fact, the house's tile roof and stuccoed facades are reminiscent of the quasi-Spanish William K. Vanderbilt house, "Eagle's Nest" (c. 1910–33) in Centerport, Huntington, Long Island, designed by Warren & Wetmore with additions by Ronald H. Pearce. "Dorwood" was advertised for sale in 1929 and was later acquired by its present owner, Our Lady of Grace Convent.

Zachary Studenroth

Chapman's last known commission on Long Island and is unique among the architect's projects in its use of French Renaissance design elements. Once known as "Forker House," the estate was acquired by the federal government in 1938 and renamed "Wiley Hall." It now serves as an administration center for the United States Merchant Academy, which was established on the estate in 1943.

The Bendel residence is of reinforced concrete and stucco construction. The simplicity of its blocklike form is relieved by balustrades at the second-story windows, a porte cochere, and the roof. The main facade incorporates casement windows, which are dominated by a tripartite window above the entry. The facade facing the water employs a long, arcaded loggia with round-headed windows flanking a Palladian doorway. Each of the two principal

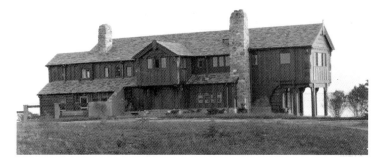

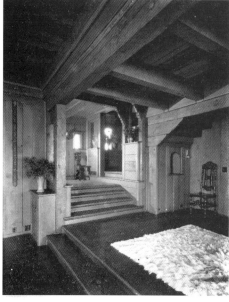

Thorbjorn Bassoe: Front
Facade, "Gissa Bu,"
Lamotte T. Cohu Residence,
Southampton, c. 1930
(HEWI, 1930)

Thorbjorn Bassoe: Interior,
"Gissa Bu,"
Lamotte T. Cohu Residence,
Southampton, c. 1930
(HEWI, 1930)

Dwight James Baum: Front
Facade, "Wildflower,"
Arthur Hammerstein
Residence, Whitestone,
c. 1925 (HELB, 1927)

Thorbjorn Bassoe, practiced 1930s

Thorbjorn Bassoe's only Long Island house
commission appears to have come from a fellow
Scandinavian, Lamotte T. Cohu. Although little
is known of Bassoe, Cohu was a corporate exec-
utive and director in the 1930s of several airlines,
including American Airways (now American
Airlines). "Gissa Bu" was built around 1930 at
Southampton of redwood, brick, and stone in
the Scandinavian style. Both the exterior detail
and the exposed wood ceilings and walls of the
interior were noteworthy for their excellent
craftsmanship, a Scandinavian tradition.

Carol A. Traynor

Dwight James Baum, 1886–1939

Dwight James Baum designed several Long
Island country houses during the 1920s in his
favorite mode, the Tudor Revival style. A 1909
graduate of Syracuse University, Baum spent
the first several years of his career perfecting his
drafting skills with three New York City archi-
tectural firms. As a result, he developed a strong
sense of plan and an understanding of spatial
relationship and scale. His ability to consistently
resolve conflicting requirements earned him
admiration and honors. C. Matlack Price, in his
1927 monograph, *The Work of Dwight James
Baum,* wrote, "With houses of moderate size the
architect is constantly called upon to achieve the
greatest possible effect with the greatest econo-
my of means." A good measure of Baum's suc-
cess lay in his application of this principle to
even his most ambitious projects.

Of Dutch ancestry, Baum was born in Little
Falls, New York, in 1886. Baum was steeped in
the traditions and lore of the New Netherlands,
so it is not surprising that his early houses were
unpretentious renditions of gambrel-roofed
Hudson Valley farmhouses.

In 1912 Baum married Katherine Crouse,
and two years later opened his own architectural
office. In 1916 the couple built "Sunnybank," a
clapboarded Colonial Revival house in River-
dale-on-Hudson, near his Tudor-style architec-
tural studio. By placing the service wing on a
90-degree angle to the rear of the house, Baum
reduced the apparent size of the structure by
half. This was one of several devices he would
employ again to achieve a human scale in
large residential commissions. Much admired,
"Sunnybank" led to a score of commissions,
at first primarily in Riverdale.

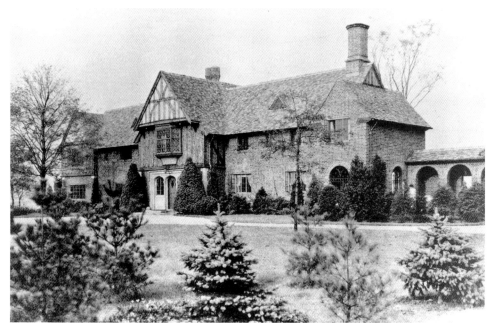

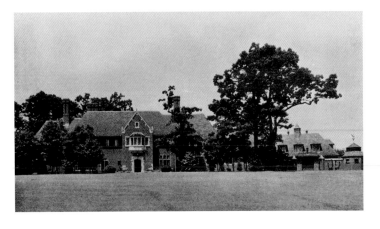 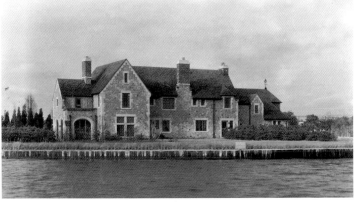

Dwight James Baum: Front
Facade, John F. Murray
Residence, Old Westbury,
c. 1930 (HOWE, 1933)

Dwight James Baum: Rear
Facade, "O'Co'nee,"
Timothy J. Shea Residence,
Bayshore, c. 1930 (GOTT,
n.d.)

Among Baum's many public and commercial
buildings were a hospital, a hotel, a courthouse
at Sarasota, university buildings at Syracuse, and
a country club and inn at Riverdale. Neverthe-
less, neither these nor the West Side Y.M.C.A.
Building in New York City brought him fame.
His reputation would rest on domestic work,
which, in tune with the times, was increasingly
influenced by the English Arts and Crafts
movement.

Beginning in 1916, Baum designed several
modest suburban houses on Long Island, and
around 1925 he received his first commission
for a country house there (at the time he was
completing a Venetian palace in Sarasota,
Florida, for John Ringling). Arthur Hammer-
stein, uncle of composer Oscar Hammerstein
II, was an irrepressible entrepreneur with an
abiding interest in show business. His Broad-
way successes included *Firefly* and *Rose-Marie.*
Another hit, *Wildflower,* provided the name
for his seaside estate. Erected at Whitestone
Landing, the house was a present for the third
of Hammerstein's four wives. "Wildflower"
consisted of two separate structures connected
by an arcaded passageway. The right-hand unit,
topped by a great jerkin-headed, dormered roof,
contained garages, workshops, and servants'
rooms. With little in the way of applied orna-
ment, the buildings relied upon contrast in tex-
ture, pattern, and color for decorative effect.
Large expanses of "tapestry" brick set in a
Flemish bond possibly were meant to evoke
Hammerstein's start as a bricklayer.

Baum's next effort, much in the same mode,
was the summer residence of John F. Murray at
Old Westbury. His third Long Island commis-
sion, for Timothy J. Shea, a Brooklyn lawyer,
however, was unornamented, except for stone
trim which stood in marked contrast to the
sandstone walls. The Murray residence was
perhaps more Norman than Tudor in style,
displaying varied fenestration and massing,
but again relying on color and texture.

Michael Adams

■

Beers & Farley, 1919–1949
William Harmon Beers, 1881–1949
Frank C. Farley

Born in Greensburg, Indiana, William Harmon
Beers studied engineering in Göttingen and
Dresden, Germany, for two years before com-
pleting his training at the Columbia School
of Mines in 1903. He went on to study painting
and architecture at the Ecole des Beaux-Arts
in Paris, returning to New York in 1909. There
he worked in the office of William Welles Bos-
worth as a draftsman until 1912, when he started
his own practice. In 1919 he formed a partner-
ship with Frank C. Farley, an adept businessman
who ran the office, leaving Beers to concentrate
on design.

Beers & Farley maintained a prolific practice,
specializing in domestic design. Like his contem-
poraries, Beers developed a distinctive style based
on general elements of the Colonial Revival style,
characterized by a simple pitched or hipped roof,
tall chimneys, dormers, and a symmetrical dis-
position of masses about a central, circulating
entry hall and stairway. Whitewashed brick,
stucco, and white clapboard replaced the more
picturesque materials favored in the early domes-
tic work of Charles Follen McKim, as the 19th-
century preference for pictorial values yielded to
a simplified classicism that stressed strong con-
trasts of light and shade. Contemporary archi-
tectural writers welcomed this development of
what they saw as a thoroughly modern American
domestic style, free of historical pretense and
perfectly suited to suburban living.[1]

John P. Kane Residence, Matinecock, c. 1920

This Colonial Revival house of whitewashed
brick has a symmetrical main facade arranged
around a two-story temple-front portico with
Corinthian columns. Two pairs of tall chimneys
mark the division between the main living block
and the side wings, softening the transition in

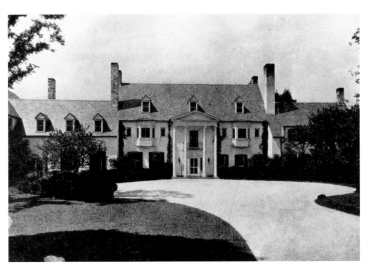

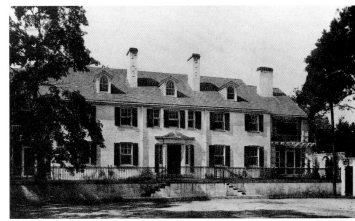

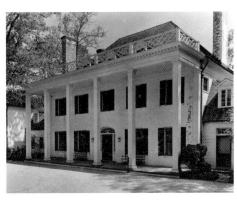

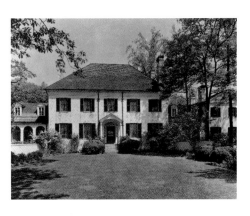

Beers & Farley: Front Facade and Entrance Court, John P. Kane Residence, Matinecock, c. 1920 (SPUR, 1932)

Beers & Farley: Front Facade, "Overfields," George deForest Lord Residence, Syosset, 1927 (HEWI, 1937)

Beers & Farley: Garden (Rear) Facade, George deForest Lord Residence, Woodmere, 1924 (HOWE, 1933)

Beers & Farley: Garden (Rear) Facade, "Overfields," George deForest Lord Residence, Syosset, 1927 (HEWI, 1937)

roof heights. Although the wings enhance the overall symmetry of the composition, a large dormer in the east wing and a simple gabled projection in the west wing lessen the strict formality of the design. (The west wing contained the servants' quarters and kitchen facilities.) With the exception of the carved capitals on the central portico, the detailing is generally restrained.

George deForest Lord Residence, Woodmere, 1924

While there is some confusion about the original ownership of this house,[2] there is no reason to doubt its attribution to Beers, as it seems perfectly in keeping with other examples of his work, particularly the Kane residence. George deForest Lord would have lived there before 1927, when he commissioned Beers to design a house in Syosset (see below).

In the Woodmere house Beers introduced a feature that he would repeat in later work on Long Island, namely, prominent drainpipes. On the garden facade, these became playful references to columns, while clearly marking the interior division of the entry hall and second-story landing, which, in houses of this kind, form a central circulating core.

George deForest Lord Residence, "Overfields," Syosset, 1927 (Extant)

The owner of "Overfields" was born in Lawrence, Long Island. Lord (1891–1930) was educated at Yale and received his law degree from Columbia University, going on to practice in the Manhattan firm of Lord, Day, and Lord. He commissioned Beers, a close friend and relative, to design the brick Syosset house.[3] Beers used a version of a pavilion plan to organize the various domestic functions: The main public areas and master bedrooms were located in the main block; the service wing, off to one side, is connected to the main house by a single-storied passageway, recalling late 18th-century Greek Revival structures. It is balanced on the other side by an informal entry way.

The main facade, Georgian Revival in style, is adorned with a colossal porch but, in keeping with Beers's classically inspired approach, the detailing is restrained. All the moldings have been simplified, and plain impost blocks have been used in place of carved capitals. The garden facade is more French in style. The gardens were designed by Ellen Shipman and, like the rest of the house, have been superbly maintained by Mr. Lord's grandchildren.

Beers & Farley: Garden
Facade,"Cottsleigh,"
Franklin B. Lord Residence,
Syosset, 1927 (HEWI, 1930)

Algernon S. Bell: Entrance
Front, R.P.R. Nielson
Residence, Westbury, c. 1910
(WURTS, n.d.)

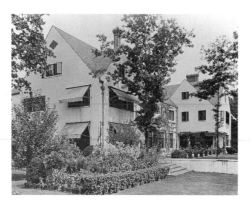

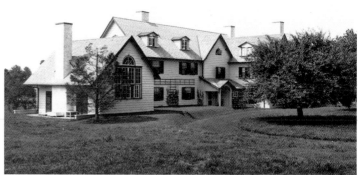

Franklin B. Lord Residence, "Cottsleigh," Syosset, 1927

Beers also served as architect for Franklin B. Lord, brother and law partner of George. Unlike the residences described above, "Cottsleigh" drew on the principles of 19th-century English Arts and Crafts architecture. The asymmetrical massing, smooth stuccoed surface, and hand-beaten tin gutters and leaders, as well as the use of decorative brickwork for the roof venting recall the turn-of-the-century work of Baillie Scott, Sir Edwin Lutyens, and Charles Rennie Mackintosh. In keeping with the tradition of late 19th-century English picturesque, the garden, designed by Ellen Shipman, was set to serve as a natural exterior to the house.

Christopher E. Miele

Algernon S. Bell, d. 1936

Practicing in New York City from 1887 through the late 1910s, Algernon S. Bell was associated with Robert C. Walsh during the early part of his career. His commissions include a residence for F. L. Stetson in Ringwood, New Jersey (1899–1901), and a country house on Long Island for R. P. R. Nielson (c. 1910). Located in Westbury, the Nielson residence is an eclectic rendition of a Long Island farmhouse, using shingles, small-paned sash windows and louvered shutters, simple gabled roofs, and attached wings. This residence is extant.

Carol A. Traynor

John P. Benson: William F.
Ashley Residence, Shoreham,
c. 1910 (TOWN, 1912)

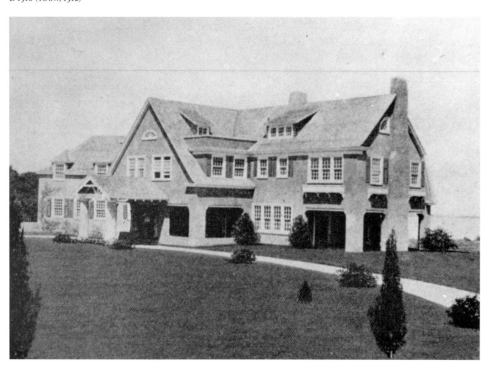

John P. Benson, 1865–1947

Information on John P. Benson is limited, but he is known to have shared a private practice with various partners in the 1890s and early 1900s, among them Ernest Flagg. During this time he designed the Medical College at Syracuse and the Bank of Syracuse. His only known architectural commission on Long Island was the William F. Ashley residence in Shoreham. Despite the incongruous use of stucco for the exterior, this Colonial Revival house, built c. 1910, incorporates many early period elements: dormers with shed roofs set in the gable-ended steeply pitched roof as well as in the cross gable; upper-story windows set directly under the strongly projecting eaves; and windows with 9-over-9 or 12-over-12 lights. Other somewhat Georgian-style features include the semicircular window set in the apex of the cross gable and the quarter-circle windows flanking the chimney.

In 1923 Benson left the architectural profession to devote himself exclusively to painting, and went on to execute some murals for the American Museum of Natural History.

Wendy Joy Darby

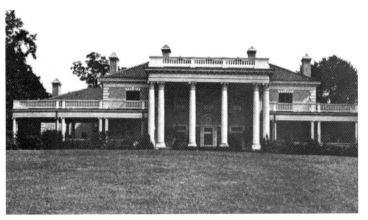

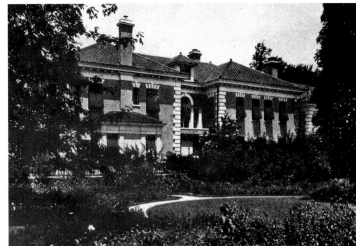

Charles I. Berg: Garden Facade, "Moorelands," John Chandler Moore Residence, Oyster Bay, c. 1915 (ARTR, 1918)

Charles I. Berg: Front Facade, "Moorelands," John Chandler Moore Residence, Oyster Bay, c. 1915 (ARTR, 1918)

■

Charles I. Berg, 1856–1926

Born in Philadelphia, Charles I. Berg was among a host of talented American architects who emerged from the Ecole des Beaux-Arts in Paris. One of his earliest works, designed while he was a member of the firm of Cady, Berg and See, was the Metropolitan Opera House (opened in 1883), followed shortly by the first of the American Museum of Natural History buildings. "Moorelands," the Oyster Bay country house designed around 1915 for John Chandler Moore, chairman of Tiffany & Company, is an Italian Renaissance villa. The garden facade consists of two low verandas supported by paired Ionic pillars flanking a colossal Corinthian portico. Double balusters, barrel tiles, quoins, and a Venetian window enhance this distinctly Italianate design.

Michael Adams

■

Wesley Sherwood Bessell, 1883–1967

A graduate of Columbia University, New York, Wesley Sherwood Bessell was responsible for a number of large projects, including the Mount Vernon Seminary for Girls in Washington, D.C., and Cunard Hall at Wagner College on Staten Island. Of his residential commissions, the only known Long Island example is

Wesley S. Bessell: Entrance Detail, "Hemlock Hollow," Leroy Latham Residence, Plandome, 1927 (PREV, n.d.)

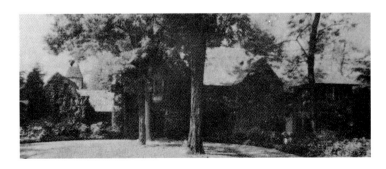

"Hemlock Hollow," the Plandome home of Leroy Latham, a Long Island City businessman. Built in 1927 and still standing, the Tudor Revival house, which stands on a hill overlooking a brook and tree-framed pond, boasts hand-cut stone, shingle roofing, and mullioned casement windows. Exposed oak beams, recycled from old Long Island barns, were used in some of the interiors. The grounds included an enclosed formal perennial garden, a terraced flower garden, and a rock garden.

Wendy Joy Darby

■

Boring & Tilton, 1890–1929
William A. Boring, 1859–1937
Edward L. Tilton, 1861–1933

William A. Boring studied architecture at the University of Illinois and Columbia University before going on to the Ecole des Beaux-Arts in Paris. After working briefly in the offices of McKim, Mead & White, he formed a partnership with Edward L. Tilton that lasted from 1890 to 1929. In 1915 Boring joined the faculty of Columbia's School of Architecture as a design associate. He eventually became Dean of the school. His future partner, Edward Tilton, also had trained in the offices of McKim, Mead & White and had studied at the Ecole des Beaux-Arts, returning to New York in 1890 when he and Boring became partners. They were awarded the 1900 Paris Exposition Gold Medal for their design of the U.S. Immigration Station on Ellis Island. Shortly thereafter, the firm was commissioned by William John Matheson to remodel his recently acquired 315-acre "Fort Hill" estate at Lloyd Harbor (one of the relatively few private commissions the firm undertook). Brooklyn-born Matheson was a successful chemist and business leader who played a key role in the de-

Boring & Tilton: "Fort
Hill," W. J. Matheson
Residence, Lloyd Harbor,
1900 (Courtesy of Mrs. Jean
Preston)

Boring & Tilton: Facade
View, "Fort Hill," W. J.
Matheson Residence, Lloyd
Harbor, 1900 (Courtesy of
Mrs. Jean Preston)

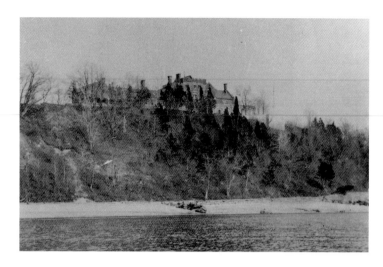

Boring & Tilton: Hall, "Fort
Hill," W. J. Matheson
Residence, Lloyd Harbor,
1900 (SPLI, 1987)

J. Clinton Mackenzie: Gate
Lodge, "Fort Hill," W. J.
Matheson Residence, Lloyd
Harbor, 1910 (Courtesy of
Lloyd Hatcher)

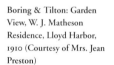
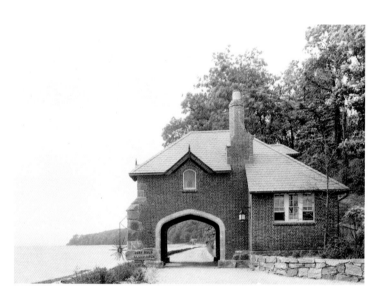

Boring & Tilton: Garden
View, W. J. Matheson
Residence, Lloyd Harbor,
1910 (Courtesy of Mrs. Jean
Preston)

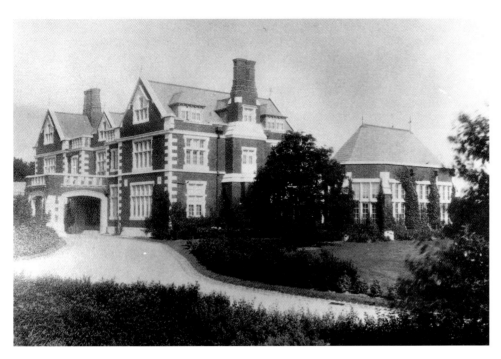

Alfred C. Bossom: Entrance Court, Henry D. Whiton Residence, Hewlett, 1914 (Courtesy of Lawrence Country Day School)

Alfred C. Bossom: "Avondale Farms," Joseph Harriman Residence, Brookville, 1918 (PREV, n.d.)

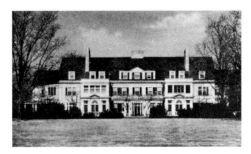

kennels, and storage shed added by Matheson in 1910, and probably also designed the concrete farm group, pump house, and cottage. At about the same time, Matheson, in collaboration with Mackenzie, designed a series of formal gardens. The symmetrical, terraced plan incorporates brick paths and open, wood pergolas, as well as a fountain with a bronze fish designed earlier by Augustus Saint-Gaudens. The main house, which has remained intact and unaltered since its 1900 remodeling, is in private ownership.

Wendy Joy Darby

Sir Alfred C. Bossom, 1881–1965

London-born Alfred Bossom studied at the Royal Academy of Arts Architectural School. He came to America in 1904 as an associate of George A. Crawley, the principal designer of the John S. Phipps estate at Old Westbury. After the completion of "Westbury House," Bossom remained in New York, undertaking a variety of major commercial and industrial commissions. These included planning two factory towns, which instilled a lifelong concern for workers' housing. Toward the close of World War I, he designed a housing development for Bayles Shipyard, Inc., in Port Jefferson, undertaken by the Emergency Fleet Corporation for the U.S. Shipping Board.[1]

On Long Island, Bossom independently designed two country houses. In 1914, commissioned by industrialist Henry Devereux Whiton, he created a robust rendition of an early Stuart manor house in Hewlett. This house, which has been the Lawrence Country Day School since 1920, vividly contrasted dark russet brickwork with a proliferation of quoins and other buff-colored stone trim. The trim outlined openings and emphasized the demarcation of floors and bays. Bossom's felicitous attention to the service portions of the Hoppin & Koen house that he remodeled in 1918 for banker Joseph Harriman in Brookville led *Architectural Record* writer John Taylor Boyd, Jr., to comment: "It is rarely that one sees a house with such a complete, even sumptuous, service wing. The only step left to take would be to allot the main part of the house to the servants."[2] At the Harriman residence, Bossom not only substantially enlarged the Colonial Revival structure, but also introduced a Tudor Revival drawing room complete with quarter-sawn oak wainscotting and a molded plaster ceiling. Today only a gardener's cottage remains from the once extensive estate.

Michael Adams

velopment of the synthetic dye industry in the United States as president and chairman of the board of the National Aniline & Chemical Co., later the Allied Chemical & Dye Corporation.

"Fort Hill" took its name from the nearby remains of Fort Franklin, built by the British in 1778. The original country house on the site, placed at the edge of a high, steep cliff overlooking Cold Spring Harbor, had been built in 1879 to the designs of Charles Follen McKim of McKim, Mead & Bigelow as a summer home for Mrs. Anne C. Alden of New York City. The Shingle Style "cottage," with its horizontal massing punctuated by two polygonal towers, was transformed by Boring & Tilton in 1900 into a Tudor Revival mansion, a massive three-story brick and limestone structure with an asymmetrical, sprawling plan. Only the conical towers of the original house can be seen beneath the masonry Tudor Revival alterations. A glazed conservatory and two-story east wing connected to the main house above an elaborate porte cochere were added to the plan. Interior detailing included oak linenfold paneling in the entry hall and central stairwell and, in the dining room, frescoed murals of historic Cold Spring Harbor executed by Griffith Baily Coale in 1931.

J. Clinton Mackenzie was the architect for the estate's gate lodge, poured-concrete garage,

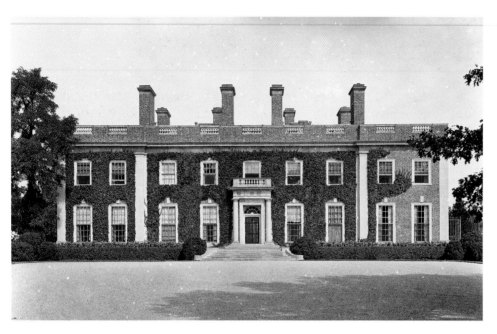

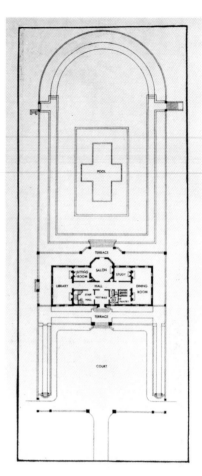

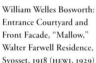

William Welles Bosworth:
Entrance Courtyard and
Front Facade, "Mallow,"
Walter Farwell Residence,
Syosset, 1918 (HEWI, 1929)

William Welles Bosworth:
First Floor Plan, "Mallow,"
Walter Farwell Residence,
Syosset, 1918 (PREV, n.d.)

William Welles Bosworth, 1869–1966

William Welles Bosworth graduated in architecture from M.I.T. in 1889, and subsequently worked for three prominent firms (Shepley, Rutan & Coolidge; Frederick Law Olmsted; and Ware & Van Brunt) before opening his own office. After practicing briefly, he returned to Europe—he had made a grand tour with William R. Ware several years earlier—where he studied with Sir Lawrence Alma-Tadema in London and, later, at the Ecole des Beaux-Arts, Paris. When he returned to the United States in 1900, Bosworth worked briefly for Carrère & Hastings before re-establishing his own practice. He worked for the Rockefellers, designing the gardens for the family estate in Pocantico Hills, New York (1908–10), and John D. Rockefeller's New York City mansion (1914). With the financial backing of the Rockefellers, he restored the châteaux and gardens of Versailles and Fontainebleau. He also directed the restoration of Rheims Cathedral. For this work, the French government awarded him the rank of Commander of the Legion of Honor. The M.I.T. campus in Cambridge, Massachusetts (1913), and the first American Telephone and Telegraph Headquarters in New York City are also among his best-known works.

Walter Farwell Residence, "Mallow," Syosset, 1918 (Extant)

Walter Farwell was director of a London-based real-estate firm with large holdings in Texas. Originally from a prominent Chicago family, Farwell first traveled east to study at Yale University. In 1918 he returned to the East Coast with his wife, a political correspondent for the *Chicago Tribune,* and built this brick Georgian Revival house. The composition is dominated by a heavy brick balustrade at the cornice level. Colossal pilasters to either side of the Doric entrance portico mark internal divisions. The dining room was in the west portion of the house, the library in the east. A polygonal, two-story bay on the south elevation contains an octagonal salon on axis with the main entry hall. The garden, like the house, is arranged symmetrically, terminating in a large hemicycle that corresponds to the salon bay in the south elevation.

Cornelius N. Bliss, Jr., Residence, "Oak Hill," Wheatley Hills, c. 1916 (Partly Extant)

Cornelius N. Bliss, Jr., was born in New York City and educated at Harvard University. His father was Secretary of the Interior under

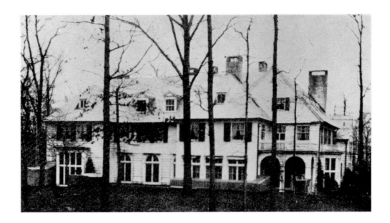

William Welles Bosworth:
Rear Facade, "Oak Hill,"
Cornelius N. Bliss, Jr.,
Residence, Wheatley Hills,
c. 1916 (HOWE, 1933)

William Welles Bosworth:
Front Facade, "Old Trees,"
William Welles Bosworth
Residence, Matinecock, 1921
(SPLI, 1978)

William Welles Bosworth:
Entrance Court and Front
Facade, Charles A. Stone
Residence, Matinecock,
1927 (SPLI, 1979)

President McKinley and served as treasurer of the Republican National Committee when Theodore Roosevelt first ran for president. Bliss entered his father's business, a dry-goods whole-sale firm, in 1898 and eventually became chairman. Throughout much of his life, he was a director of the Metropolitan Opera Association. "Oak Hill" was a sprawling shingled structure. While the house clearly draws on vernacular sources, there are also references to the French country château, which became increasingly popular in the 1920s. The round-arched porch and the high-hipped roof can be found in many of the best examples of this type. The clap-boarding, however, adds an informal, domestic touch to the residence.

William Welles Bosworth Residence, Matinecock, 1921 (Extant)

Charles A. Stone Residence, Matinecock, 1927

The Bosworth house was built around an earlier farmhouse (c. 1859), completely obscuring the original structure. The most impressive feature of this "remodeling" is the monolithic effect achieved by the smoothly finished exterior (stucco over brick construction) on which the restrained detailing is outlined. The slender molding separating the second from the third stories becomes a simple Tuscan capital when it meets the pilasters on either side of the main

entry. Relief carvings of caryatids adorn the pilasters in the attic story. The garden facade features a Palladian window. The composition and individual elements of the house, seemingly inspired by Tuscan or Venetian villas, anticipate a streamlined neoclassicism that took the form of a stripped-down modernism during the 1920s and 1930s. The house remains a private residence.

Bosworth also designed a house in 1927 for his next-door neighbor, the noted engineer Charles A. Stone. Built of whitewashed brick, the two-and-a-half-story, hip-roofed house was remodeled in the 1950s.

Christopher E. Miele

William Lawrence Bottomley, 1883–1951

Hewitt & Bottomley, 1912–1919

Bottomley, Wagner & White, 1928–1932

William Lawrence Bottomley was born in New York City, the son of John and Amelia Steers Bottomley. His father had migrated to the United States from Ireland to represent the interests of an uncle, William Thomson, Lord Kelvin, the physicist renowned for his work in thermodynamics and electricity. William

Hewitt & Bottomley:
Edward E. Bartlett, Jr.,
Residence, Amagansett,
c. 1915 (ARRC, 1915)

Bottomley received a degree in architecture from Columbia University in 1906. Awarded the McKim Fellowship in Architecture, he spent the winter of 1907–8 at the American Academy in Rome and the following one at the Ecole des Beaux-Arts in Paris.[1] On his return to the United States, he married Harriet Townsend, whose father owned property on Long Island. Bottomley later did extensive remodeling for his father-in-law and brother-in-law.[2]

Bottomley's practice soon prospered. He was a principal in the firm of Hewitt & Bottomley from 1912 to 1919, and thereafter was associated variously with L. F. Peck, Edward C. Dean, J. L. Mills, and A. P. Hess. In 1928 he founded the firm of Bottomley, Wagner & White, which lasted until 1932. The offices for this firm, as well as most of his other associations, were in New York City.

From his own statements it is clear that Bottomley was an architect of wide vision, as well as something of a perfectionist, admitting that "often, I regret to say, I am extremely disagreeable if I do not like what is going on."[3] He believed that if a building "can be invested with style . . . that intangible quality, that stamp which gives it life and individuality [it] will be both sound and original."[4] Life, individuality, soundness, and originality can be seen in almost all his work. Bottomley also insisted on beautiful interiors, for he believed that "when you have a well-designed series of rooms, in harmony and in scale with the rest of the house, things fit into their places in an extraordinary way."[5] Likewise, he kept a firm hand on landscape design.

Although Bottomley is known primarily as a residential architect, his buildings, including schools, a city hall, an immigration station, apartment houses, a florist's shop, a church, a restaurant with dancing pavilion, some hotels, and even a tomb can be found along the eastern seaboard from Florida to Maine and as far west as Texas. His style was eclectic, showing manifold influences: Gothic, Louis XV, Georgian, Federal, Tudor Revival, Mediterranean, and Art Deco, among others, including Long Island Shingle Style.

In New York City, the firm of Bottomley, Wagner & White's most significant commission was the "River House" (1932), still highly esteemed for its originality of plan and detailing. On Long Island, Bottomley's residences clearly demonstrate his versatility, knowledge, and mastery of form. A 1947 article in *House and Garden* featuring his garden in Old Brookville indicates that these powers, applied to landscape, showed no diminution with age.[6] At the time of his death in 1951, one commentator praised him as a true architect who realized that "functionalism—that much abused term—was, ipso facto, a necessity of structure, [but] he nonetheless never forgot that beauty was essential in plan and design."[7]

Edward E. Bartlett, Jr., Residence, Amagansett, c. 1915 (Extant)

The firm of Hewitt and Bottomley is credited with the design for this house for Bartlett, a prominent broker and partner of Merrill, Lynch, Pierce, Fenner, and Beane until his retirement in 1940.[8] The house and landscaping were published in architectural magazines soon after completion.

These early views show a large stucco house surrounded by a planned, but not yet mature, landscaping scheme. Steep roofs, tall chimneys, and simple detailing give this residence the air of a small French château. The interiors are less elaborate than others designed by this firm but the drawing room, with its delicately molded paneling, high ceiling, and inset mirrors is, if less sturdy, more refined.

J. Randolph Robinson Residence, Brookville, 1927–28 (Extant)

This house was constructed of brick, an appropriate choice given that Robinson was the New York representative of the Pittsburgh brick manufacturing firm of Hardison, Walker, and Company. By this time Bottomley had acquired a considerable reputation for his use of brick and color. He described the house as follows: *Laid in Flemish bond the bricks are a deep, soft-toned red, resembling the old handmade bricks of the colonies. Smoke colored bricks are interspersed for variety. The roof is of rough slate, blue-black in color. . . . The shutters and woodwork of the doorway are oyster white while the window sashes are clear white.*[9]

William L. Bottomley:
Garden Facade, J. Randolph
Robinson Residence,
Brookville, 1927–28 (COUN,
1934)

Bottomley, Wagner & White:
Entrance Court and Front
Facade, "Green Court,"
Norman DeR. Whitehouse
Residence, Brookville, 1928
(SPLI, 1979)

Bottomley, Wagner & White:
Garden Facade, Lewis V.
Luckenbach Residence, Glen
Cove, c. 1928–30 (COUN,
1937)

Bottomley used a Palladian five-part plan with the living room, in one dependency terminated by a fireplace at one end and a Palladian loggia at the other. The opposite dependency contains a four-car garage and service quarters. The elliptically shaped entrance hall is the only untouched portion of the interior, which has been adapted for use as the Long Island University Administration Center. Although renovations have obscured "the original garden elevation," as has been pointed out:

One can see Bottomley's attention to historical detail in the broken-segmental pediment and fanlight over the entrance door and in the fine detailed circular windows that appear both on the second floor above the entry and on the first floor in the connecting links to each of the side wings.[10]

Norman DeR. Whitehouse Residence, "Green Court," Brookville, 1928 (Extant)

This house, designed by Bottomley soon after he formed the firm of Bottomley, Wagner & White, incorporated the elements of an existing structure to develop a new creation. Reusing "soft, old, rosy brick from New Haven, Connecticut, that has almost an overcast of violet," the architect "practically rebuilt" the facade, removed wings, and added a new cornice and roof. The house remains a splendid example of an imaginative collaboration between architect and client. While Bottomley gave much credit to Mrs. Whitehouse, one commentator wrote:
Whoever is primarily responsible, the effect obtained is that of a comely, orderly residence which has been intelligently subjected to esthetic discipline in the matter of garden arrangements, and exterior and interior ornament. . . .[11]

Lewis V. Luckenbach Residence, Glen Cove, c. 1928–30 (Extant)

The owner of this large house on Crescent Beach Road in Glen Cove was the grandson of the founder of the Luckenbach Steamship Co. Although made of brick, the residence marks a departure from Bottomley's Georgian Revival designs, since here he was inspired by French Norman houses down to the sturdy, circular stair tower which he tucked into one corner. The style also required steep roofs and segmental arched windows with wooden casements. An earlier house on the site was demolished. The three-and-a-half-story building with its immense roofs, tall chimneys, and bell-cupola high above the entrance door is massive enough to be imposing, but sufficiently articulated to be picturesque. A formal, cobblestone forecourt overshadows the natural informality of the site. The house was built of
Holland brick, a very soft pinkish gray, the color of an old wall, with cornices of brick patterns, and ornamental cast lead gutters. The stone trim and balustrades are a rich creamy travertine, while the shutters are gray-green to harmonize with the willows. The roof is French shingle tile, a sepia with a reddish tone, carrying the same soft pearly warmth of the rest of the house into a darker tone.[12]

Bottomley, Wagner & White: Entrance Court and Front Facade, George E. Fahys Residence, Matinecock, c. 1928 (SPLI, 1979)

Bottomley, Wagner & White: Rear Facade, George E. Fahys Residence, Matinecock, c. 1928 (SPLI, 1979)

George Ernest Fahys Residence, Matinecock, c. 1928 (Extant)

Bottomley's client was a manufacturer described as having a "cultivated taste for art and a critical appreciation of music." The Mediterranean-style residence Bottomley designed for Fahys was appropriately responsive to his client's refined taste. L-shaped in plan, the two-story house on Piping Rock Road in Matinecock is approached across a walled forecourt. The front entrance has a rusticated, Italianate cast-stone surround set into stucco walls. The shutters are pecky cypress and the low-pitched, hipped roofs are covered with tiles that also cap the decorative chimneys. There is a cupola as well, pierced with round-headed windows. This attention to detail extended to the interior, the main floor, which has terrazzo floors. The house remains in private hands.

Bottomley designed other houses in the Mediterranean style in Florida, Maine, Pennsylvania, and Virginia.

Graham Bethune Grosvenor Residence, "Graymar," Westbury, c. 1930 (Extant)

An engineer and inventor, Graham Grosvenor had a distinguished career with the Otis Elevator Corporation, and subsequently with Fairchild Aviation Corporation and Pan American Airways.[13] The house Bottomley designed for this client consists of a two-story, five-bay central mass flanked by one-story wings. Dressed stone was used for the corner quoins and left slightly irregular for the intervening spaces.

Projecting forward a few inches from the main mass, the center bay is crowned with a pediment pierced by a bull's-eye window, giving emphasis to the entrance. The hipped roof is punctuated with two chimneys, one at each end.

Despite the Georgian Revival character of the house, including such details as a string course at the second-story window level, it has casement rather than double-hung windows. The total effect exemplifies the boldness with which Bottomley adapted a style, suiting his creation to his client but retaining the freedom to explore the flexibility of his chosen visual solution. "Graymar" is still in private hands.

James Mulford Townsend, Jr., Residence, "Brookshot," St. James, 1931 (Extant)

Bottomley executed another Georgian Revival residence for his brother-in-law, James Townsend, who had decided to build in St. James, where his wife had been raised. Like the Grosvenor house, "Brookshot" has a central mass flanked by wings, but the main portion of the building is only three bays wide and two-and-a-half stories high. The wings are also three bays wide, but only one-and-a-half stories high. The hipped roofs, steeper than those of the Grosvenor house, give the structure considerable verticality, allowing it to dominate its site on a sharp rise above the harbor. The living and dining rooms afford views of the water through French doors opening onto terraces.

The architectural impact of the entrance side of this brick house depended almost entirely on its quoins, cornice, and the rich enframement of the central door, which is crowned by a broken, segmental pediment supported by brackets at either side of the door, enclosing not only the door but the leaded fanlight above it. Though not huge, the house included ample service

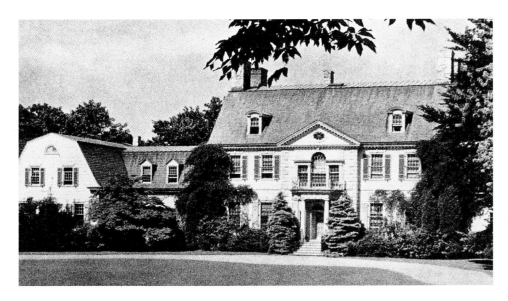

Bottomley, Wagner & White:
Entrance and Front Facade,
"Lynrose," Mrs. Herbert
Shipman Residence, Roslyn,
1931 (PREV, n.d.)

William L. Bottomley:
Entrance Court and Front
Facade, "Pelican Farm,"
J. Cornelius Rathborne
Residence, Old Westbury,
c. 1937 (COUN, 1940)

The interior is rather more elaborate than one would expect from the comparatively simple exterior. The huge living room (41 ½ by 29 feet) and dining room (39 ½ by 19 ½ feet) each have intricate mantels and overmantels, while the library is fully paneled. The service areas encompassed what today would seem an army of servants and included a caretaker's apartment, ten servants' rooms, three servants' baths, and a servants' sitting room.

J. Cornelius Rathborne Residence, "Pelican Farm," Old Westbury, c. 1937

"Pelican Farm" was the last of Bottomley's Long Island houses. Designed for Mr. and Mrs. J. Cornelius Rathborne, Southerners who were fond of horses (he especially, for he had played polo internationally), the building is a remarkable, almost playful, Georgian Revival composition of pavilions, large in reality, but made to look small by overscaling its openings. The horizontal lines of the brick-walled entrance court reflected the house's flat landscape setting. It also had a five-part plan, but all three major pavilions were only one-and-a-half stories high, while the connectors were a little lower. The massive entrance surround was tall, topped by a segmental pediment sheltering an urn. Silhouetted against the brick of the house, the pediment over the central bay was triangular, a form that was echoed in small, semicircular dormers centered on the hipped-roofed dependencies.

The interiors, executed by the McMillan Studios, reflected the Rathbornes' interest in the sporting life. The dining room, for example, had murals after 19th-century prints of big-game hunting in India, while "between the living room and dining room [was] a generous space . . . the floor of which [was] covered with splendid lion skins and with those of other big game animals which have fallen to the marksmanship of the Rathbornes."[15] The house is no longer standing.

William B. O'Neal

■

F. Nelson Breed, b. 1890

Franklin Nelson Breed, a graduate of Trinity College, Hartford, Connecticut, completed his architectural training at M.I.T. in 1913. Breed then joined the architectural firm of Putnam and Cox in Boston, where he remained until 1917. From 1920 to 1922, he worked for the New York City firm of Peabody, Wilson & Brown. In 1922 Breed established his own architectural firm in Hartford. While the majority of Breed's

areas. Situated on four-and-a-half acres, the four-bedroom house was served by three maids' bedrooms, a maids' dining room, kitchen, and pantry. In addition, there were a five-room gardeners' cottage, a three-car garage, a small stable, and a boathouse with two dressing rooms.

Mrs. Herbert Shipman Residence, "Lynrose," Roslyn, 1931

One of the more unusual houses that Bottomley designed on Long Island was "Lynrose," built for Mrs. Herbert Shipman in 1931 on Glenwood Road in Roslyn overlooking Hempstead Harbor. Constructed of steel-reinforced concrete and hollow tile covered with asbestos shingles, the house aesthetically fits into the Long Island shingle tradition, while being fireproof.

This large, ten-bedroom house has a five-part plan. The central mass, two-and-a-half stories high, has a gambrel roof, corner quoins, and an axial bay that is pulled slightly forward. This feature, which is repeated on both facades, has a Palladian window above the first-floor entrances. The connectors, one-and-a-half stories high, are also gambrel-roofed, as are the dependencies at either end. Bottomley's usual care with color is seen in the whitewashed shingles and the trim, which is a slightly warmer oyster white.[14]

F. Nelson Breed: "Holmdene," J. Herbert Ballantine Residence, Kings Point, 1929 (HOUS, 1929)

F. Nelson Breed: Kingsland Macy Residence, Islip, 1929 (HOUS, 1929)

commissions were located in Connecticut, he designed a house for Douglas Burden in Bedford, New York, as well as two Long Island country houses. "Holmdene" was built in 1929 for J. Herbert Ballantine, president of the Neptune Motor Company, at Kings Point, Great Neck. In 1929 Breed also designed a residence in Islip for stockbroker and political figure Kingsland Macy. Breed's Long Island commissions, although located on opposite shores, show a marked similarity in design. Built of stucco in a modified Georgian Revival style, both have facades dominated by gable ends, six-over-six sash windows with shutters, and columned porticoes surmounted by decorative wrought-iron railings. While the Ballantine house is no longer standing, the Kingsland Macy house remains a private residence.

Carol A. Traynor

Herbert R. Brewster, d. 1937

If any style was indigenous to late 19th-century Long Island, it was the low, rambling mode that evolved out of the Queen Anne and Shingle styles. Three representatives of this hybrid type were the Long Island houses designed by Herbert R. Brewster. The earliest was built in 1900 at Glen Cove for lawyer Henry Louis Batterman. After selling his family's Brooklyn department store, H. Batterman, Inc., in 1909, Batterman turned his energies to developing residential real estate on Long Island and to breeding Guernsey cattle.

For Batterman, Brewster designed an unadorned shingle-clad dwelling with a gambrel roof and a long veranda on squat pillars; it was the simplest sort of Colonial Revival house.

In 1905 cement magnate John Rogers Maxwell created a family compound in Glen Cove, erecting a residence for his son Howard adjoining his own earlier stucco residence. Here again, simplicity was the keynote. The house was demolished in 1950.

In 1912 Brewster designed the Herbert Smith estate, "Oliver's Point," a most faithful rendition of the Shingle Style. The plan of "Oliver's Point" promoted a sense of openness by using sliding doors to allow the dining room, hall, and living rooms to flow together. In the late 1930s Walker & Gillette eliminated the great sun-catching bays and otherwise reduced the size of the Smith house. Brewster moved to Pasadena, California, in 1923. There he continued to design resort houses until his death in 1937.

Michael Adams

Herbert R. Brewster: Garden Facade, Henry Louis Batterman Residence, Glen Cove, c. 1900 (ARBJ, 1917)

Herbert R. Brewster: Front Facade, Howard Maxwell Residence, Glen Cove, 1905 (ARBJ, 1917)

Herbert R. Brewster: Front Facade, "Oliver's Point," Herbert Smith Residence, Centre Island, 1912 (ARBJ, 1917)

Herbert R. Brewster: Floor Plan, "Oliver's Point," Herbert Smith Residence, Centre Island, 1912 (ARBJ, 1917)

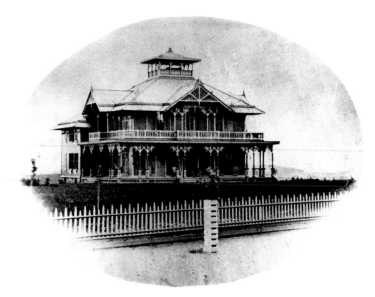

Briggs & Corman: Front Facade, Dr. James S. Satterthwaite Residence, Southampton, 1874 (*East Hampton Star*, n.d.)

Although no definite attribution for this commission exists, the latter firm did design a New York City townhouse for Thompson in 1893.

Carol A. Traynor

Briggs & Corman, practiced 1870s

Although its present Colonial Revival appearance reflects the extensive remodeling carried out in 1894–95, the summer villa built in Southampton in 1874 by the New Jersey architectural firm of Briggs & Corman was originally designed in the then-popular Stick Style. The Satterthwaite villa exhibited the style's expressive use of wooden elements, including exposed framing and highly decorative porch braces. The remodeling, undertaken 20 years later for Charles Thompson, the subsequent owner, was carried out by George Eldridge, a local builder, who supposedly followed plans drawn up by the architectural firm of McKim, Mead & White.

Brite & Bacon, 1896–1903
James Brite, d. 1942
Henry Bacon, 1866–1924

Prior to the formation of their partnership, James Brite and Henry Bacon both apprenticed at the prestigious firm of McKim, Mead & White, where they presumably met.[1] Originally from the South, Brite was awarded the Archi-tectural League of New York's gold medal in 1888.[2] He concentrated on residential work, his best-known effort being the Herbert L. Pratt house on Long Island. Although he is known to have worked at least until 1924,[3] he is best known for his accomplishments during his partnership with Bacon and the years up to World War I.

In contrast, Bacon designed primarily civic, institutional, and commercial buildings, as well as a great many pedestals and architectural settings for statues. His crowning achievement was his design of the setting for the Lincoln Memorial in Washington, on the steps of which President Warren G. Harding presented him with the American Institute of Architect's gold medal just months before he died.[4] A local example of such work is the Lafayette Monument

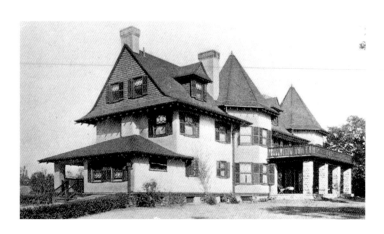

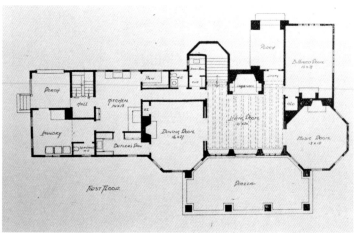

Brite & Bacon: "Deephaven," W. de Forest Wright Residence, Sands Point, c. 1900 (AMHO, 1906)

Brite & Bacon: Floor Plan, "Deephaven," W. de Forest Wright Residence, Sands Point, c. 1900 (AMHO, 1906)

Brite & Bacon: William H. Arnold Residence, Great Neck, c. 1900 (VANO, n.d.)

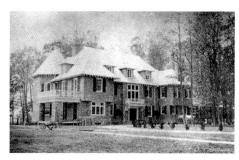

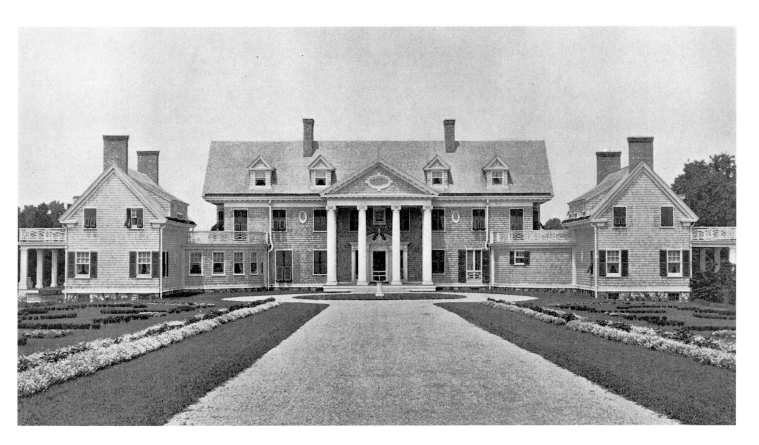

Brite & Bacon: Entrance
Court and Front Facade,
"The Braes," Herbert L.
Pratt Residence, Glen Cove,
c. 1902 (ARTR, 1902)

in Brooklyn's Prospect Park, unveiled in 1917
and executed in collaboration with Daniel
Chester French,[5] with whom Bacon produced
some 50 monuments (including the Lincoln
Memorial). Bacon also worked with many
of the other prominent sculptors of his day.
The majority of his work exhibits a classical
influence, particularly from Greek sources,
which gives it a distinctive austerity.[6] Two of
the early commissions received by the Brite &
Bacon firm were the Jersey City Public Library
(1899),[7] won in competition, and "Laurel Hill,"
an imposing porticoed Georgian Revival man-
sion (1897) in Columbia, South Carolina, which
is no longer standing.[8] The firm also designed
three substantial houses on Long Island around
1900, none of which is extant. How each of
these clients chose the firm is unknown. All
three houses were built in different towns for
different families.

W. de Forest Wright Residence, "Deephaven," Sands Point, c. 1900

William H. Arnold Residence, Great Neck, c. 1900

Both of these houses were Norman in feeling,
and while the former was of stone and stucco[9]
and the latter shingle-clad, they shared the use
of symmetrical, projecting bays within an over-
all asymmetrical plan, as well as large faceted
turrets, substantial porches, and projecting,
bracketed eaves.

Herbert L. Pratt Residence, "The Braes," Glen Cove, c. 1902

Herbert Lee Pratt, former president and chair-
man of the board of the Standard Oil Company
of New York, was one of eight children of kero-
sene magnate Charles Pratt, who became a
founder of the Standard Oil Company and
started Pratt Institute. Herbert, like all but one
of Pratt's children, chose to build his country
houses within the confines of the family enclave
established by his father in the part of Glen Cove
known as "Dosoris," where everyone shared the
stable, garage, beach, and dairy facilities.[10]

In contrast to the Wright and Arnold resi-
dences, the firm's Pratt house, the most preten-
tious of the three Long Island commissions, was
symmetrical in plan and exhibited considerable
Georgian Revival detailing. After this commis-
sion, the partnership having dissolved, Brite
went on alone to design both a Brooklyn house
(1903) for Pratt and a larger masonry replace-
ment for the Glen Cove house (1912) on the
same site.[11]

The most salient feature of the initial Glen
Cove house was its C-shaped plan. Its gable-
topped, nine-bay-long central block was flanked
by southerly projecting wings, the sections
closest to the main block being convex-shaped,
flat-roofed, and one story high. These sections
culminated in one-and-a-half-story gable-

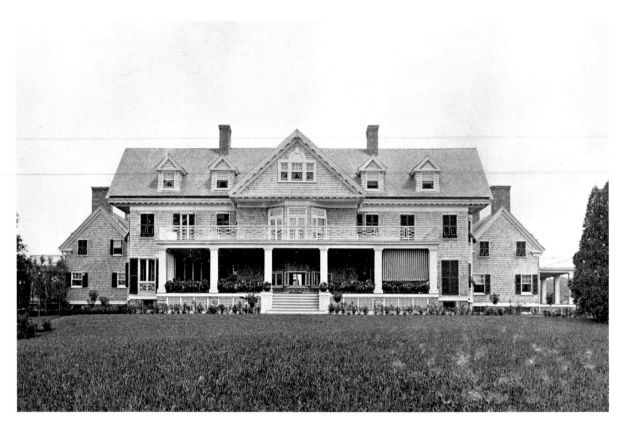

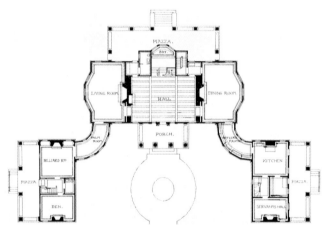

Brite & Bacon: Garden Facade, "The Braes," Herbert L. Pratt Residence, Glen Cove, c. 1902 (ARTR, 1902)

Brite & Bacon: First Floor Plan, "The Braes," Herbert L. Pratt Residence, Glen Cove, c. 1902 (ARTR, 1902)

roofed end sections. A handsome, pedimented Ionic portico graced the center of its southern entrance facade, while a balustraded porch extended the full northern facade of the house, punctuated by a central bay topped by a long, triangular pediment on axis with that on the front.

Whether the house was designed by one of the partners individually or in collaboration is not known, but two different renderings were published together in 1900 labeled "Proposed . . ." and "Executed . . . ," both signed by "H. Bacon, del."[12]

The house Brite designed for Herbert L. Pratt in the Clinton Hill section of Brooklyn was likewise Georgian Revival in style, but was of masonry construction. Similar to much

of the masonry work he and the firm had designed, the house was composed of red brick trimmed with limestone. Other examples of his and the firm's work in brick and limestone include their townhouse for Mrs. E. K. Hudson in Manhattan (1898), the E. C. Scranton Memorial Library in Madison, Connecticut (1899), and Brite's large country residence for George Crocker, in Mahwah, New Jersey (1904–07).[13]

Herbert L. Pratt Residence, "The Braes," Glen Cove, 1912–14 (Extant)

The second, much larger country house that Brite designed for Herbert L. Pratt replaced the home built in 1902. Also called "The Braes," this Jacobean-style limestone and brick structure is much more imposing than its predecessor. It is a substantial masonry mansion, rather than a pretentious summer cottage. The firm's townhouse for Mrs. Hudson and Brite's mansion for George Crocker were earlier domestic essays in the Jacobean manner. The latter, in particular, seemingly provided much of the inspiration for "The Braes," while certainly the British mansion "Bramshill" in Hants (1605–12) served as one of the original sources for both houses. Characteristically, "The Braes" house has an H-plan, tall decorative chimneys, and a mix of Tudor- and Renaissance-derived ornament both inside and out. On the exterior, for example, a Renaissance-style strapwork balustrade encircles the roof, and tall, Tudor-inspired leaded casement windows are used throughout. On the

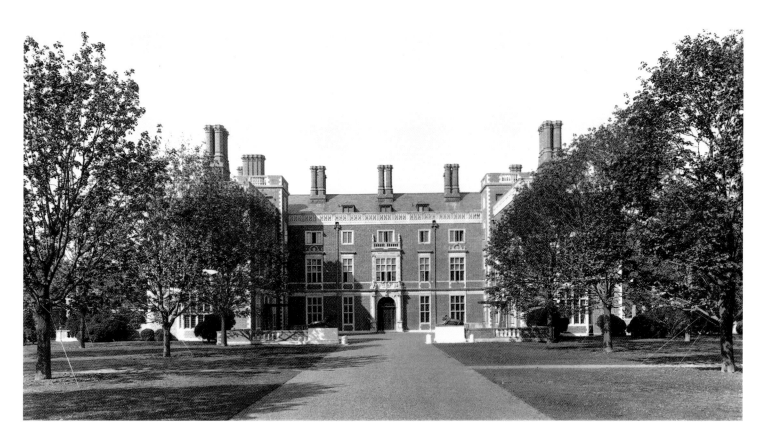

James Brite: Front Facade, "The Braes," Herbert L. Pratt Residence, Glen Cove, 1912–14 (WURT, n.d.)

James Brite: Hall Detail, "The Braes," Herbert L. Pratt Residence, Glen Cove, 1912–14 (WURT, n.d.)

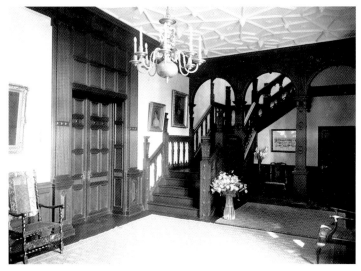

James Brite: First Floor and Garden Plan, "The Braes," Herbert L. Pratt Residence, Glen Cove, 1912–14 (ARTR, 1914)

interior, most of the ceiling plasterwork takes its inspiration from both Renaissance and Tudor sources, while dark, Tudor-inspired wainscoting lines most of the walls (originally, a heavily carved, dark, stained wooden mantle from an English banqueting room was installed in the library).[14] The single exception was the drawing room, which was completely Georgian in style.[15]

The landscape design was executed by James L. Greenleaf in collaboration with Brite.[16] As executed, two long pergolas, one terminated by a tea room and the other by a playroom, flanked the house, while a formal rose garden was located along its western facade. The most striking feature of the overall scheme, however, was the treatment of the land between the house and Long Island Sound, consisting of three dramatically composed and richly land-

scaped terraces descending toward the shore, with a formal water garden in the central tier.[17] Soon after Pratt's death in 1945, Webb Institute for Naval Architecture became the owner and occupant of "The Braes." The Institute had been founded in 1899 by William H. Webb, a successful shipbuilder, who believed that the advent of iron shipbuilding necessitated a formal course of study.[18]

Erin Drake Gray

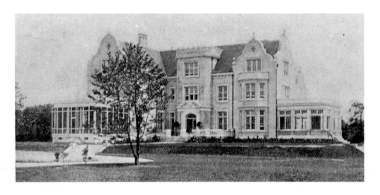

Buchman & Fox: "Roselle Manor," Isaac D. Levy Residence, Cedarhurst, c. 1900 (RUTH, 1909)

The firm's only known Long Island work was "Roselle Manor," the estate of Isaac D. Levy at Cedarhurst, completed in the early 1900s. No longer extant, the sedate mansion incorporated curved gables, mullioned windows, and other motifs of English Renaissance manor houses, and included an attached conservatory planned with the assistance of Lord & Burnham, the prominent horticultural architects. Levy was the president of Oppenheim Collins & Co., another New York–based retail establishment for which Buchman & Fox designed several buildings.

Joy Kestenbaum

■

Buchman & Fox, 1900–1919
Albert C. Buchman, 1859–1936
Mortimer J. Fox, 1874–1948

Buchman & Fox earned their reputation as the original architects for such distinguished New York City department stores as Bloomingdales, Saks Fifth Avenue, Bonwit Teller & Co., and L. P. Hollander & Co. The partners also designed many apartment hotels and private dwellings in New York City. Albert C. Buchman, a graduate of Cornell University, had an impressive 53-year career with his successful partners, including Herman J. Schwarzmann, Gustav Deisler, Mortimer J. Fox, and Eli Jacques Kahn, making a specialty of commercial buildings. Fox received his education at the College of the City of New York and Columbia University School of Mines. Combining a talent for business and art, he retired from the firm in 1917 to pursue first banking and then landscape painting.

The partnership of Buchman & Fox received several noteworthy commissions for country houses, including a residence in Deal, New Jersey, for Henry Morgenthau, Sr., real estate developer, diplomat, and Fox's father-in-law.

■

Katherine Budd, 1860–1951

After beginning her career as a painter, Katherine Cotheal Budd became one of a handful of women to successfully practice architecture during the first quarter of this century. In the 1890s Budd studied portrait and landscape painting with William Merritt Chase, both in New York City and at his art colony at Shinnecock Hills, near Southampton, where she maintained a summer residence. She attended Columbia University's School of Architecture as a special student and later studied in the same Paris atelier as her West Coast contemporary, Julia Morgan. Budd practiced in New York City for roughly 30 years. In 1916 she became one of the first female members of the local chapter of the American Institute of Architects and in 1924 was elected to national membership. She specialized in all forms of domestic architecture, designing homes, hotels, clubs, and community houses, espousing, in her design and writing, household management, kitchen efficiency, and economical building construction. One of her major clients was the Y.M.C.A., which commissioned many "Hostess Houses" to serve as temporary lodgings for women who were visiting friends and relatives in the armed forces during World War I. Recognized for her drafting skills, she worked for other architects and exhibited at the Chicago Architectural Club and the Architectural League of New York and was a member of several New York women's groups, including the Women's Art Club (now the National Association of Women Artists) and the Women's Municipal League.

Howland Residence, Southampton, 1896

Budd's earliest known work was the summer cottage for the Howland sisters, Georgina and Abby Roberta, Budd's friends and fellow students at Chase's summer school at Shinnecock Hills. Situated near the summer house that

Katherine Budd: Howland Residence, Southampton, 1896 (COUN, 1903)

Katherine Budd: Floor Plans, Howland Residence, Southampton, 1896 (COUN, 1903)

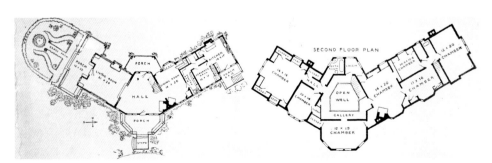

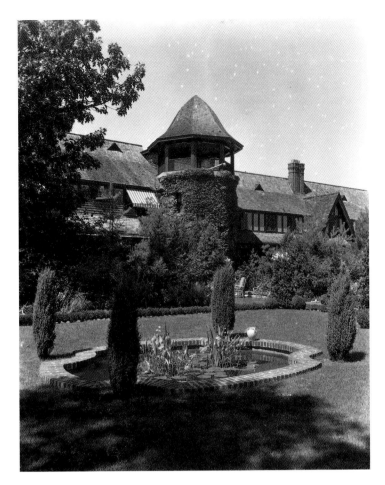

Katherine Budd:
"Sunwood," Frank Melville,
Jr., Residence, Old Field,
1919 (HEWI, 1932)

Stanford White built for Chase, the Howland cottage was sited to provide expansive views of the grassy dunes and nearby ocean and bay. Planned as two wings opening out from a large, two-story, central entrance hall, this charming 12-room shingled "bungalow," as it was called, hugs the top of a hill, protected from the ocean winds. The dominant feature, the shingled roof with its low, flared eaves, covers the several porches and is pierced only by the chimneys and second-floor dormers. Soundly constructed in 1896 for the modest sum of $2,700, the Howland cottage is well cared for by its present owner, the photographer Francesco Scavullo.

Frank Melville, Jr., Residence, "Sunwood," Old Field, 1919

Budd's other known Long Island commission was demolished in 1986 after a devastating fire. Overlooking Smithtown Bay in Old Field along the North Shore, "Sunwood" was built in 1919 for Frank Melville, Jr., president of the Melville Shoe Corporation. Mrs. Melville, an amateur landscape gardener who personally laid out and supervised the planting of "Sunwood's" gardens and later organized and headed the local garden club, is said to have selected the architect after admiring the way in which a house Budd designed on the South Shore (most likely the

Howland house) seemed to fit into the natural topography. The Melvilles commissioned a 40-room mansion, which was similar in plan, although constructed on a larger scale with a more complex multi-textured exterior that combined brick, stone, stucco, and half-timbering, as well as natural shingling. This Tudor Revival house epitomized Budd's personal style, which was a subdued and unpretentious synthesis of diverse Anglo-American domestic revival modes. In 1959 Ward Melville, son of the original owners, donated the family estate to the State University of New York at Stony Brook, which still owns the property.

Joy Kestenbaum

Roger H. Bullard, 1884–1935
Goodwin, Bullard & Woolsey, 1916–1920

Roger H. Bullard's career as a designer of Long Island summer houses, mansions, country homes, and golf clubs for members of New York's monied elite began as the United States entered World War I and ended in the early 1930s, when the Great Depression reduced the financial circumstances of many wealthy Americans.[1] Among Bullard's clients were three of John Pierpont Morgan's grandchildren, including Junius Spencer Morgan, for whom Bullard designed "Apple Trees," a large Tudor-style house, as well as the palatial "Salutations" on Dosoris Island, Junius Morgan's principal residence in his later years. "Rynwood," the estate of Sir Samuel A. Salvage, founder of the American rayon industry, is probably the most famous of Bullard's Long Island projects, earning the architect an Honorable Mention in the 44th Annual Exhibition of the Architectural League of New York.[2] "Rynwood's" gardens, the work of Ellen Shipman, were considered exemplary and have been frequently published.

Bullard's career as an architect was cut short by his premature death from pneumonia in 1935. Still, a substantial and varied body of work remains and attests to his talent, knowledge, and energy. In addition to his Long Island projects, Bullard was commissioned to design private homes and country clubs in Connecticut and New Jersey. He designed a post office building in Floral Park, New York, a high school in Manhasset (with the firm of Tooker and Marsh), the chapel at the Kent School in Connecticut, and various commercial buildings, including a Barney's Market in Flushing, New York, and an office building in Hartford, Connecticut (with Philip Goodwin). He also collaborated with Goodwin and Kenneth Franzheim on the apartment building at 400 East 57th Street in New

Roger H. Bullard, 1884–1935
(Courtesy of Henry S.
Bullard)

York City, being largely responsible for the design of the exterior.

Bullard was born in Flushing, New York, and attended public schools in that area. In 1903 he entered the School of Architecture at Columbia University, graduating in 1907. As a student he was a member of St. Anthony's Fraternity, to which many socially prominent young men belonged. Pierpont, Morgan, and Low are among the surnames that appear on the fraternity's roster during the period when Bullard was a member. Three of his fraternity brothers later became his clients, as did a number of their friends and relatives.[3]

It is hard to say what specific influence Bullard's Columbia education had on his development as an architect. He undoubtedly studied drafting with William A. Delano who, in partnership with Chester H. Aldrich, designed Long Island homes for many prominent New Yorkers. And it was probably at this time that Bullard became acquainted with the Tudor-style English architecture that would provide inspiration for much of his work. In England, this style already had been revived and used for country homes early in the 19th century. By mid-century, it was employed by the extremely influential architect Richard Norman Shaw, whose houses, with their tall chimneys, steeply peaked roofs, and flat, continuous facades seem to have served as prototypes for Bullard's work. By the 1880s Shaw's Queen Anne-style architecture had achieved great popularity in the United States, both because of its resemblance to American Colonial architecture and because of its inherently unpretentious quality.[4] In turn-of-the-century England, Shaw's influence can be seen in the vernacularizing architecture produced by members of the Arts and Crafts movement—the so-called "Free-style architecture." Although this term is rarely used to describe American architecture, it applies to the work of the many early 20th-century architects like Bullard, who found inspiration in, and adopted motifs from, traditional building types. After his graduation from Columbia, Bullard worked for two years as "Architect Auxiliar" in Cuba, assisting in the design of various official buildings, including courthouses, custom houses, and schools.

Upon his return to New York City in 1910, Bullard became engaged to Annie Adams Sturges, whom he married two years later. Working in Grosvenor Atterbury's office, he participated in the well-known urban development project of Forest Hills Gardens. One can only guess to what degree the Tudor and Elizabethan motifs so prevalent in these buildings reflect Bullard's input. Certainly, he must have felt an affinity for this project, in which many of the forms that became his trademark play a major role.

In 1916 Bullard joined Philip Goodwin (1885–1958) and Heathcot Woolsey to form the firm of Goodwin, Bullard & Woolsey.[5]

Philip L. Goodwin Residence, "Goodwin Place," Woodbury, 1917

By 1917 the firm was involved in three building projects on Long Island, one of which was for partner Philip Goodwin. It is unlikely that Bullard had much to do with the design for this residence, since it bears no relationship stylistically to his later work. Its sources are French, rather than English or American, and it is far more specifically referential historically than any of Bullard's other projects, being modeled on the Château des Grotteaux near Blois.[6]

Junius Spencer Morgan Residence, "Apple Trees," Matinecock, 1917 (Extant)

Paul G. Pennoyer Residence, "Round Bush," Matinecock, 1917 (Extant)

The other residences constructed in 1917 were for two of John Pierpont Morgan's grandchildren, Junius Spencer Morgan and his wife Louise Converse, and Junius's sister Frances, Mrs. P. G. Pennoyer. The young couples were close in age to the members of the firm, and Junius Morgan and his sister were, in fact, second cousins of Philip Goodwin.[7]

About the time the Morgans and Pennoyers commissioned their homes, the United States entered World War I. Goodwin and Woolsey, who were both bachelors, joined the army, but Bullard, who had three children, was not allowed to enlist. Consequently, he assumed the leading role in the design of the two residences.[8]

Junius Morgan's home "Apple Trees" and Frances Pennoyer's domicile "Round Bush," with their myriad gables, chimney stacks, and dormers, speak of an informal, family-oriented approach to life. Traditional, durable materials were used in the construction of these houses: the weight-bearing walls are stucco and brick, the roofs slate. The use of brick trim and Tudor half-timbering is also expressive of rural domesticity.

Despite their simplicity, neither "Apple Trees" nor "Round Bush" seems plain. Bullard's sensitivity to composition ensured an attractive exterior arrangement of volumes. "Round Bush" is laid out in a simple line, while the plan of "Apple Trees" is a more sprawling U-shape. Bullard's ability to subtly manipulate form further reveals itself in both residences in the slightly flaring roofs and the extra height of the chimneys, which are decorated with pilasters and corbeled caps.

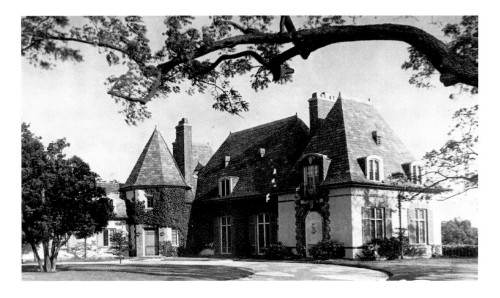

Goodwin, Bullard &
Woolsey: Entrance Facade,
"Goodwin Place," Philip L.
Goodwin Residence,
Woodbury, 1917 (SPLI,
c. 1930)

Goodwin, Bullard &
Woolsey: "Apple Trees,"
Junius S. Morgan Residence,
Matinecock, 1917 (SPLI, 1979)

Goodwin, Bullard &
Woolsey: "Round Bush,"
Paul G. Pennoyer Residence,
Matinecock, 1917 (ARLG,
1923)

Roger H. Bullard: Oakland
Golf Club, Bayside, c. 1920
(SPUR, 1924)

Oakland Golf Club, Bayside, c. 1920 (Extant)

Early in 1920, Bullard left the firm to practice as
an independent architect.[9] His first major Long
Island commission was the clubhouse for the
all-male Oakland Golf Club in Bayside. (Today
the clubhouse and surrounding grounds are part
of Queensboro Community College.) Organ-
ized in 1896, this was the second-oldest golf club
in the East, a wealthy institution to which many
New York City officials belonged. The original
club had had a nine-hole golf course, but by
the time Bullard designed its second clubhouse
(the first having been destroyed by fire in 1915),
it had been expanded to an 18-hole course.

The clubhouse is an L-shaped structure, one
wing serving primarily as a locker room for
mem-bers, the other containing the kitchen and
staff rooms. Two dining rooms were located at
the exterior angle of the L. The larger of these
spaces, to which a lounge was attached, projects
along a 45-degree axis from the corner of the
building and terminates in a faceted semicircle.
This ar-rangement not only improved the light-
ing and ventilation of the room but also allowed
better views of the golf course.

The exterior of the clubhouse is Colonial.
The building is predominantly fieldstone,
with shingled gable ends and a tiled roof. The
entire exterior was whitewashed. Although
two-storied, the building was designed to
appear low and sprawling, to give an appear-
ance of domesticity. In the words of the archi-
tect, "The long, low roof-lines are accentuated
to carry out the character of a dwelling."[10]

The interior is similarly rustic. The wall plas-
ter is applied unevenly, and the ceiling beams
(made of pine stained and rubbed down to look
old) were exposed in many of the rooms. Fire-
places in the lounges and dining areas added
to the cozy, rustic character of the interior.

Roger H. Bullard: The Maidstone Club, East Hampton, 1923 (ARFO, 1925)

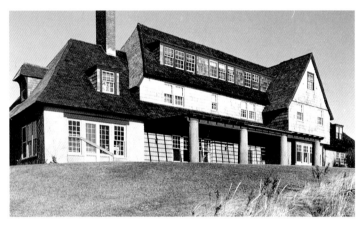

Roger H. Bullard: Rear Facade, Paul Salembier Residence, East Hampton, 1924 (SPLI, 1980)

Extraneous details are few. Two iron weather vanes (a whale on the service wing and the Maidstone lion on the main stair tower), a bit of half-timbering, and an occasional frieze beneath the roof are all that offer relief to a building that was characterized as "somewhat stiff and abstract. . . ."[12] Bullard seems to have intended that the structural elements of the building—the beams supporting the overhanging roofs or porches and the colored frames of the bay windows—provide the principal embellishments for this structure.

The interior styling of the Maidstone clubhouse was similar to that of the Oakland Golf Club. The use of exposed beams, fireplaces, and occasional wood paneling helped create a pleasantly domestic ambience. The most important room at the Maidstone was the "Great Hall," which measured 80 by 40 feet. This room had blue wainscotting, a lofty trussed ceiling, two-storied bay windows, and a fireplace at one end. It served as a reception area as well as being used for weekly dances.

The furnishings of the Maidstone clubhouse carried out the domestic theme. Upholstered furniture was covered in chintz; occasional chairs and tables were colonial in styling; and carpets of oriental design created patches of color on the polished wood floors. As Bullard notes, the effect of the whole was "in accord with sunlight, blue ocean, white sand, and green fairways."[13]

Concurrently with his work on the Maidstone project, Bullard was commissioned to design two private homes facing the ocean along the same set of dunes at East Hampton.

Maidstone Club, East Hampton, 1923 (Extant)

Shortly after designing the Oakland clubhouse, Bullard was commissioned to draw up plans for a third clubhouse for the Maidstone Club (the first and second, both designed by Isaac Henry Green, having burned in 1901 and 1922, respectively).

Like many of the summer colony residences located on the dunes, the Maidstone clubhouse shows the influence of French and English vernacular architecture. The exterior was more than an exercise in style: it was also planned to complement the landscape. As Bullard described it:

The skyline of the building conforms to the undulation of the dunes, the wings at either end rising gradually to the main ridge, the general character and roof lines suggesting the farm houses of Normandy. The walls are of stucco, of about the same color as the dunes, with dark weathered shingle roofs and stained timbers. The casement sash, flower boxes and doorways are painted bluish green, and the awnings which are orange help to give the gay atmosphere which is carried on inside as well. . . .[11]

Paul Salembier Residence, East Hampton, 1924 (Extant)

Like the Maidstone clubhouse, this stucco house in the Tudor style was very simple in design. In 1927 Salembier, a New York dealer in raw silks, had the house remodeled by Grosvenor Atterbury, whose firm specialized in houses with picturesque detailing and relatively colorful exteriors. It is likely that the exterior trellises and columns that support the overhanging eaves were added at this time.[14]

Ellery S. James Residence, "Heather Dune," East Hampton, 1926 (Extant)

Unlike the Salembier house, this residence designed by Bullard for a Morgan banking partner remains largely in its original condition. In 1929 it was published in detail in a ten-page lay-

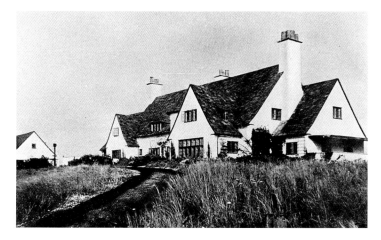

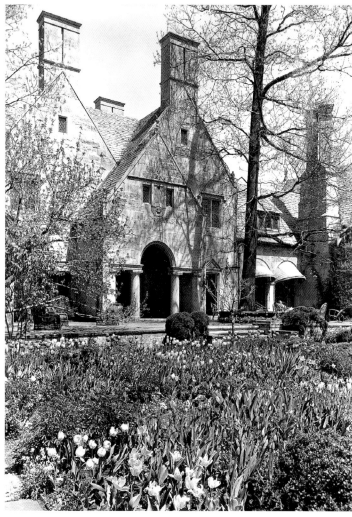

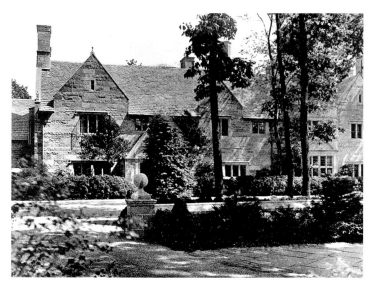

Roger H. Bullard: "Heather Dune," Ellery S. James Residence, East Hampton, 1926 (ARTS, 1929)

Roger H. Bullard: Front Facade, "Rynwood," Samuel A. Salvage Residence, Glen Head, 1928 (ARTS, 1929)

Roger H. Bullard: Rear Facade, "Rynwood," Samuel A. Salvage Residence, Glen Head, 1928 (HEWI, 1934)

out in *The American Architect,* which included ground plans, architect's drawings, and interior and exterior views.[15] Built in a modified Tudor style, with exterior stucco walls, the house has a steeply peaked slate roof. The turret with the conical roof suggests that here, as at Maidstone, Bullard was influenced by the Norman vernacular. Inside, the characteristic exposed timbers appear in the ceilings of the hall and living room, while fireplaces are a dominant feature of both the living and dining rooms. Bullard added an interesting feature by setting the living room crosswise to the main axis of the house, with bays at both ends opening to views over the ocean to the south, and inland across the dunes to the north.

Sir Samuel A. Salvage Residence, "Rynwood," Glen Head, 1928 (Extant)

This is one of Bullard's most impressive Long Island designs. Henry Bullard, the architect's son, related how it was conceived. One day, the English-born neighbor and friend of Bullard in Flushing asked the architect what it would cost to have a decent home built. Unaware that Salvage had made a fortune, Bullard quoted

what he considered to be an exorbitant figure—$350,000. To his surprise, Salvage asked that plans and sketches for the house be ready when he and his wife returned from a trip to Europe.

The plans for the Tudor Cotswold-style mansion were presented to the Salvages upon their return and, subsequently, a model was made and contractors' bids sent for. A second surprise occurred when the lowest bid came in at slightly under $1,000,000, but when Salvage recovered from the shock, he decided to go ahead and build his mansion. Construction on the estate was completed in 1928.

The main house is an imposing, multigabled structure built of limestone. The interior volumes, strung together in a serial manner, suggest that the size of the family and staff grew through the years, making additions to the house necessary.

The garden walls and many outbuildings, which include a tea house, a laundry, a gatehouse, a garage, and greenhouses, are also constructed of cut limestone. All of the windows are leaded; in the main house, the window frames, in Tudor style, are carved from stone. Applied decoration is minimal. A simple

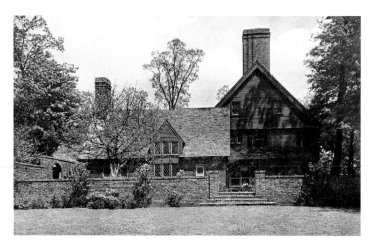

Roger H. Bullard: Rear
Facade, "Sunninghill,"
Martin Richmond
Residence, Glen Head,
c. 1928 (ARAT, 1929)

Roger H. Bullard: Design
Rendering, William Everdell,
Jr., Residence, Manhasset,
c. 1928 (ARTS, 1929)

Roger H. Bullard: Entrance
Detail, E. J. Dimock
Residence, Manhasset,
c. 1928 (SPLI, n.d.)

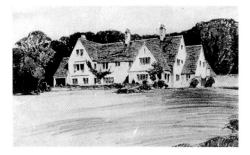

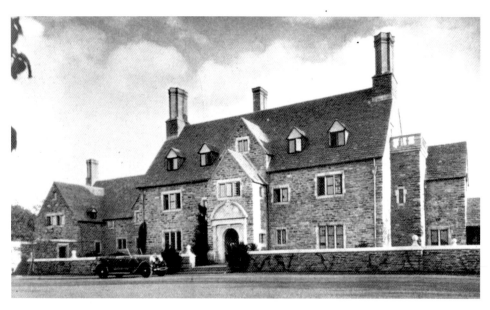

Roger H. Bullard: Front
Facade, Henry Upham
Harris Residence, Brookville,
c. 1929 (AMAR, 1932)

of an angel-head is set behind the gable above the entranceway on the rear facade. On this side of the house, strapwork trim embellishes one of the bay windows, above which is set a pair of perpendicular-style lancets.

Bullard's son describes the living room as having oak-paneled walls and a richly ornamented plaster ceiling. A library, complete with cathedral ceiling, was structurally almost separate from the house. He also recalls that "Rynwood" was often the site of great festivities.[16]

Martin Richmond Residence, "Sunninghill," Glen Head, c. 1928 (Extant)

For Mrs. Salvage's brother Martin Richmond, Bullard designed a much less elaborate residence adjacent to "Rynwood." Simple materials—clapboard for the house and brick for the garden walls and chimneys—rather than the magisterial limestone found throughout "Rynwood" were employed for the construction of "Sunninghill." Nevertheless, this house is in a similar 17th-century style, with a steeply peaked roof and leaded-glass windows. Shutters on the upstairs windows at the back of the house suggest that this design had American as well as English sources.

William Everdell, Jr., E. J. Dimock, Roger H. Bullard Residences, Manhasset, c. 1928 (Extant)

At the time that Bullard was designing for the Salvages and Richmonds, he decided to build a home for himself and his family on Long Island. With three other friends, Bullard purchased land from the Louis Sherry estate in Manhasset, and by 1928 four homes had been constructed there. The houses are stylistically varied: the William Everdell, Jr., home is Tudor in style and compact in its massing, while the E. J. Dimock residence (Mrs. Dimock was Bullard's first cousin) is sprawling and predominantly Colonial in style.

Henry Upham Harris Residence, Brookville, c. 1929 (Extant)

Built in 1930 for a one-time J. P. Morgan partner, this house could be considered a smaller version of "Rynwood." Here, too, the main house, walls, and surrounding structures are made of limestone. But Bullard was never one to repeat himself exactly, and the central block of the main house has a Renaissance cast to it.

converse molding delineates the gables and window bays, and a spherical finial occasionally appears above the quoins or gables. The chimneys, constructed of limestone blocks identical to the ones used on the exterior, are also simply adorned. Realizing that a monolithic form would be too heavy for the building visually, Bullard split the chimneys midway into two units, reuniting them with a simple, rectangular molding.

The entrances are set within their own gables. The door of the main entrance, set flush with the wall, is surrounded by a simple rectilinear molding and an oversized, broken, segmental pediment above. The pediment motif is repeated over one of the bay windows. A relief

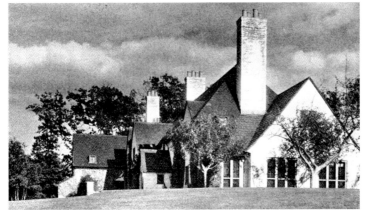

Roger H. Bullard: Henry E. Coe, Jr., Residence, Syosset, c. 1930 (ARFO, 1931)

Roger H. Bullard: Floor Plan, Henry E. Coe, Jr., Residence, Syosset, c. 1930 (ARFO, 1931)

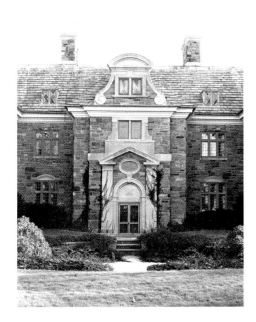

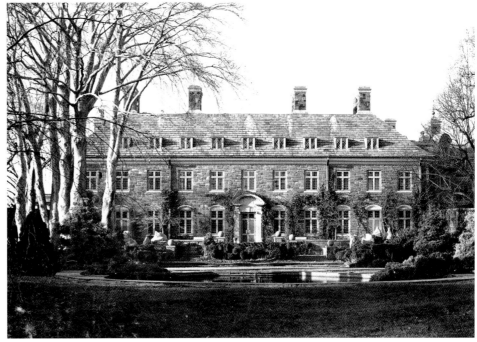

Roger H. Bullard: Entrance Front, "Salutations," Junius S. Morgan Residence, Glen Cove, 1930 (SPLI, 1980)

Roger H. Bullard: Rear Facade, "Salutations," Junius S. Morgan Residence, Glen Cove, 1930 (SPLI, 1980)

Henry E. Coe, Jr., Residence, Syosset, c. 1930 (Extant)

A house for Coe, an independent stockbroker who at one time was associated with the Morgan bank, also was completed by around 1930. Although this residence is in the Tudor style, it is charmingly spare in design. The exterior is whitewashed and the roof slate with a bell-cast flare.

Junius Spencer Morgan Residence, "Salutations," Glen Cove, 1930 (Extant)

The last of the grand Long Island residences to be designed by Bullard was "Salutations," the country home of Junius Spencer Morgan on Dosoris Island near Glen Cove. Built of stone, "Salutations" was in the style of an English manor house. The 20-acre estate was embell-

ished with formal and informal gardens. John Pierpont Morgan, Jr., father of Junius and Frances, had built his country estate on the adjoining East Island in 1913.

Despite Bullard's large number of impressive country houses on Long Island, the achievement that brought his work to the attention of the public at large was his entry for the 1933 "America's Little House" competition sponsored by Better Homes in America, Inc. His design was awarded the gold medal, and the following year, a newly established Better Homes Committee for New York City decided to build the house he had designed at 39th Street and Park Avenue.[17]

Colonial in style, the house had white clapboard siding and gray shutters and roof shingles. Many of the elements characteristic of Bullard's

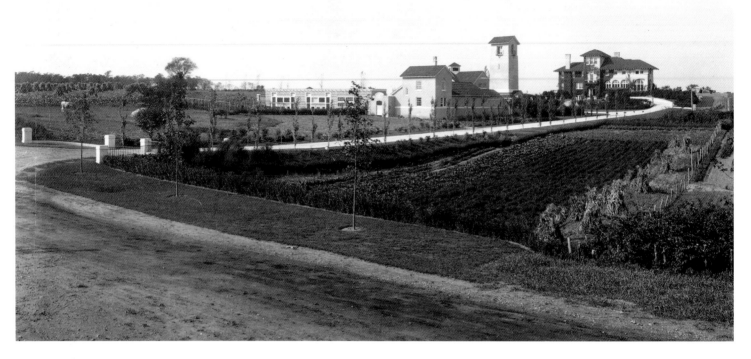

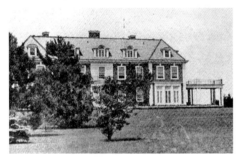

James L. Burley: View of
Estate from Entrance Gate,
Edward D. Cahoon
Residence, Southold, 1900
(WURT, n.d.)

James L. Burley: "Eastward,"
Alfred H. Cosden Residence,
Southold, c. 1900
(TOWN, 1920)

residential commissions appeared in this design: a fireplace in the living room and bay windows in both the dining and living rooms. But "America's Little House" was more than a building: it was a statement of Bullard's philosophy that "Every American family should have a house with a front yard, no matter how small."[18]

Anna Lee Spiro

James L. Burley, 1873–1942

Born in Ohio and educated at the University of West Virginia and Lehigh University, James L. Burley practiced architecture in New York and was active in town planning in Queens, Kings, and Nassau counties. His most notable works included the James W. Packard Laboratory, Administration Building, and Sports Building at Lehigh University; the General Hospital in Norwalk, Connecticut; and the U.S. Defense Housing Project in Fairfield, Connecticut. In 1900 Edward D. Cahoon, president of the United Drug Company, commissioned Burley to design a summer residence in Southold. The Cahoon house represented an early example of the Mediterranean villa style on Long Island. Turning to a more formal Georgian mode, Burley designed a nearby country house for Alfred H. Cosden, c. 1900. Based on a house in Surrey, England, "Eastward" was constructed of red tapestry brick trimmed with white marble. Both the Cahoon and Cosden houses are no longer extant, although several outbuildings remain for each estate.

Joel Snodgrass

Butler & Corse, practiced 1920s–1930s

Henry Corse, d. 1949

Little is known about either architect. According to the obituary in the *New York Times,* Henry Corse lived for several years in Manhattan practicing architecture in the firm of Butler & Corse during the 1920s and 1930s. At the time of his death he was a resident of Saugerties, New York. Information about his architectural training and later business activities has yet to come to light. But it is known that in addition to several houses on Long Island, including one for financier Edwin Gould, Corse built many houses in Hobe Sound, Florida.

Henry Corse: Front Facade,
Francis L. Steeken
Residence, Old Field,
c. 1920 (HOUG, 1923)

Butler & Corse: Garden
Facade, "Cherridore," H. C.
Taylor Residence, Cold
Spring Harbor, c. 1923
(ARRC, 1926)

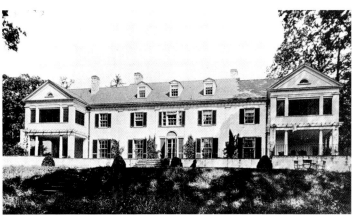

Butler & Corse: Front
Facade and Entrance Court,
"Highwood," Edwin Gould
Residence, Oyster Bay Cove,
1931 (COUN, 1935)

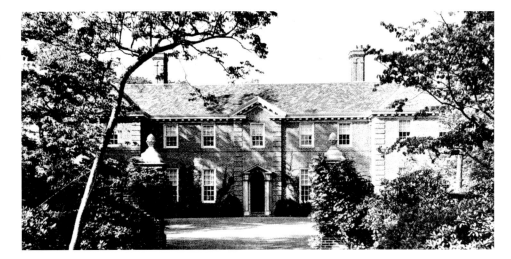

Francis L. Steeken Residence, Old Field, c. 1920 (Extant)

This stone house has a shallow, hipped roof of Spanish tile. Although the entry facade is austere, it is quite powerful. Heavily rusticated stone voussoirs around the main entrance, coupled with wrought-iron grates over the ground-floor windows, impart a defensive quality to the facade. While the house anticipates later developments in the Spanish Colonial Revival, the almost expressionistic distortion of the facade's proportions gives this residence a noteworthy aspect. The grounds along the side are enclosed by a high, smooth stone wall. Access to the heavily wooded site is through a plain gate in the classical vein. The unrelenting forcefulness of the entry facade is relieved by the picturesque massing on the side elevation. The extensive glazing on the side wing's second-story living room has a well-known and clear precedent in the Isabel Roberts House in River Forest, Illinois (1908), designed by Frank Lloyd Wright. The house survives today as the Maryville Convent.

H. C. Taylor Residence, "Cherridore," Cold Spring Harbor, c. 1923 (Extant)

This whitewashed brick Colonial Revival house, built for the daughter and son-in-law of Walter Jennings, has square Doric pilasters surmounted by an ornately carved architrave. Both the garden and main facades are arranged symmetrically about an interior hall that extends the width of the house. The garden entry is set within a simplified Palladian window. The wings flanking the main block recall late 18th-century Greek Revival houses. On the ground floor they open to the garden terrace on three sides. Attached pergolas offer refuge from the summer heat. Above are screened-in rooms that may have served as sleeping porches in milder weather.

Edwin Gould Residence, "Highwood," Oyster Bay Cove, 1931 (Extant)

Edwin Gould (1866–1933) was the son of railroad tycoon Jay Gould. Although his father discouraged him from entering the business world, Edwin quickly demonstrated acumen in that area. Within a year of receiving his B.A. from Columbia College he had made his first million by consolidating his Continental Match Company with the Diamond Match Company.

Henry Corse: Entrance Facade, "Hillandale," Mrs. Bradley Watson Dickerson Residence, Mill Neck, 1936–37 (SPLI, 1978, Robert Zucker photo)

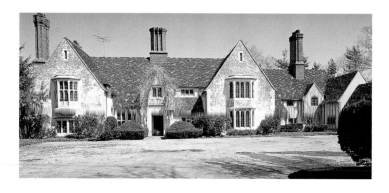

Henry Corse: Main Living Hall, "Hillandale," Mrs. Bradley Watson Dickerson Residence, Mill Neck, 1936–37 (SPLI, 1978, Robert Zucker photo)

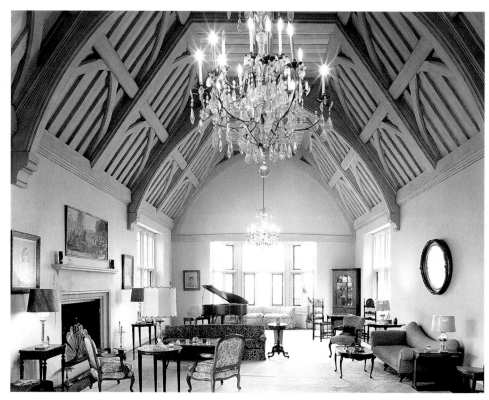

Later, he became executive vice-president of Bowling Green Trust—his father's trading firm—which eventually merged with the Equitable Trust Company. He was a resident of Manhattan for most of his life and built "Highwood" just two years before his death.

While this residence in general adheres to English country-house design, the main facade evokes French models as well. Two slightly projecting brick pavilions, each articulated with brick quoining, form a small forecourt, which is extended and enclosed by a low brick wall. The resulting space is formal, even ceremonial. The focus of the garden facade is a shallow Palladian pavilion which, in its simplicity and thinly proportioned details, recalls the late 18th-century work of Robert Adam. The side bays and chimneys are Jacobean. The landscaping, designed by Innocenti & Webel, is based on late 18th-century English models, as well. The interior fittings are extremely rich and finely crafted. Corse also designed the outbuildings, including a seven-bedroom servants' house. The house remains a private estate.

Mrs. Bradley Watson Dickerson Residence, "Hillandale," Mill Neck, 1936–37 (Extant)

The Dickerson estate was separated from the extensive Beekman estate in 1889 when the Long Island Railroad was extended to Oyster Bay. Nearby are houses by several important architects, including Delano & Aldrich, Lamb & Rich, and McKim, Mead & Bigelow. The Dickerson residence is a monumentalized Cotswold cottage in brick with stone trim. Half-timbering is used in the service wings. Corse used a variety of contrasting materials rather than applied decoration to ornament the house. This is in keeping with the principles of 19th-century English design reformers who insisted that ornament should arise naturally from the method of construction. There is a spectacular hammerbeam roof in the main living hall. The dining hall and grounds served as sets for several scenes in the 1979 movie *Hair*. The house survives unaltered in one of the most dramatic locations on Long Island.

Christopher E. Miele

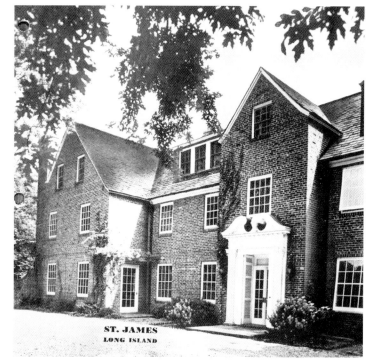

Lawrence Butler: Terrace Side of Residence, Francis C. Huntington Residence, St. James, 1908 (SPLI, n.d.)

Lawrence Butler: Front Facade, "Tulip Knoll," Mrs. Alice T. McLean Residence, St. James, 1910, 1920 (SPLI, n.d.)

■

Lawrence S. Butler, 1876–1954
Ford, Butler & Oliver, practiced 1910S–1920S

A prominent member of Long Island society, Lawrence Butler was a descendant of Richard "Bull" Smith, the founder of Smithtown. He lived in St. James, where he was known for the musical and other entertainments he gave at his estate.

Butler was responsible for designing two Long Island country houses, both in St. James, as well as several smaller houses and remodelings in the same area. In 1908 he designed an 18-room stucco house in the Georgian style for his sister Susan, wife of lawyer Francis C. Huntington, on Moriches Road. The couple had been given the land by the Butler family. In 1920 Butler remodeled a house for Alice T. McLean in honor of a forthcoming visit from the Prince of Wales. The brick house, in the early Georgian Revival style, replaced the original clapboard house Butler had designed in 1910 for the same site.

Ellen Fletcher

■

J. E. R. Carpenter, 1867–1932

Born in Columbia, Tennessee, J. E. R. Carpenter studied architecture at M.I.T. and at the Ecole des Beaux-Arts in Paris. After practicing in Virginia, where he designed a number of banks and office buildings, Carpenter moved East in 1910, and established a successful practice in New York City. He became noted in the field of large, luxury apartment-house design, for which he won American Institute of Architects Gold Medal awards in 1916 and 1926. Carpenter designed a country residence for his own use in Sands Point in 1931. The following year, before he could occupy the house, he died of a heart attack in his Madison Avenue office. The brick, seven-bay Georgian house, extremely austere in its lack of exterior detail, survives as a private residence.

Carol A. Traynor

J. E. R. Carpenter: Front Facade, J. E. R. Carpenter Residence, Sands Point, 1931 (*Newsday*, 1973)

John M. Carrère, 1858–1911

Thomas Hastings, 1860–1929

Carrère & Hastings, 1885–1911
John Merven Carrère, 1858–1911
Thomas Hastings, 1860–1929

The partnership of John Merven Carrère and Thomas Hastings lasted for 25 years and garnered an impressive array of commissions for country estates, public buildings, commercial structures, and city-planning schemes. After Carrère's death in 1911, Hastings reminisced about the beginning of their association:

[I]t was . . . in the year 1885 that we resolved to enter into a partnership agreement. There was no written agreement until the year 1900, but we did agree that in case any work were to come our way we would share alike in the profits under the firm name Carrère & Hastings, he being two or three years my senior. We sent out the usual engraved announcements and waited for months, continuing our relation with McKim, Mead & White until one day I was sent for by Mr. Flagler, who told me that he contemplated building a large hotel in St. Augustine.[1]

Henry M. Flagler, who had made a fortune with the Standard Oil Company, was a friend and parishioner of Hastings's father, a highly regarded Presbyterian minister in New York.[2] At this stage, Flagler was intent upon developing Florida into a winter vacation land. Initially, he engaged Carrère & Hastings to make simply "a picture" of a hotel for local builders to follow. Not surprisingly, disagreements soon arose over the builders' interpretation of the drawing, and Hastings eventually convinced Flagler that the architects should supervise the construction. For three years, Carrère and Hastings worked exclusively on this great hotel, the Ponce de Leon, in St. Augustine, with Carrère making over 100 trips to Florida for the project. The immediate success of the Ponce de Leon, which was built of concrete in a Spanish style, catapulted Carrère and Hastings into an elevated position in their profession at a young age. Flagler soon commissioned more buildings in Florida, thereby launching the firm's practice financially and establishing the pattern for each partner's responsibility.

Born in 1860, Hastings initiated his design training in the architectural-design department of Herter Brothers, one of the leading decorating and furniture-making firms in New York City. In 1880 he left New York for Paris to study at the Ecole des Beaux-Arts. Following his graduation four years later, Hastings entered the New York office of McKim, Mead & White, where Carrère too was employed as a draftsman.

Carrère had also studied at the Ecole des Beaux-Arts, but in a different atelier. Hastings later recalled only one casual conversation the two had had in Paris, when Carrère solicited Hastings's aid in defining "water table," a term frequently mentioned in the building program for a competition for a model tenement in New York. Until this encounter, Hastings had assumed from appearance and speech that Carrère was French. In fact, Carrère had a cosmopolitan background. He was born in Rio de Janeiro in 1858, where his father, a descendant of early French émigrés to Baltimore, was engaged in the coffee trade. At 14 Carrère was sent to Europe, to study in Switzerland and, eventually, France. He left Paris in 1882, and the following year entered the office of McKim, Mead & White. There, Carrère and Hastings were assigned to the same job, a large house in Baltimore. Some years later, Hastings recalled that this project was "what brought us together."[3]

With the success of the Florida buildings, two other commissions for large hotels soon followed—the Laurel-in-the-Pines Hotel at Lakewood, New Jersey, and the Hotel Jefferson in Richmond, Virginia. After that, Hastings said, "work seemed to continually follow."[4] During the first ten years, the firm designed over 100 other projects, including the Mail and Express Building, the Life Building, the Edison Building, and the West End Chapel, all in New York; the Central Congregational Church in Providence, Rhode Island; the Paterson, New Jersey, City Hall; and residences for Dr. Christian Herter and H. T. Sloan in New York and for Mrs. R. H. Townsend in Washington, D.C. Prominent businessmen engaged the firm to design country estates being developed around New York: E. C. Benedict commissioned a house in Greenwich, Connecticut; Daniel Guggenheim, a residence in Elberon, New Jersey; and Salem Wales and his son-in-law, Elihu Root, summer houses in Southampton. In 1892 the firm's competition design for the Cathedral of St. John the Divine in New York brought the firm more public attention.[5]

Five years later Carrère & Hastings won another competition for a building that is often considered their best work and was reportedly Carrère's favorite—the New York Public Library. Two other large, complex commissions solidified the firm's preeminent position—the New Theatre (later the Century) in New York, which was the first fan-shaped theater in America, and the House and Senate Office Buildings in Washington, D.C., which required "artistry combined with the greatest possible efficiency."[6]

After 1900, the firm concentrated on governmental and institutional building. Commissions included the Portland, Maine, City Hall; the Richmond Borough Hall and the nearby St. George Ferry Terminal on Staten Island;

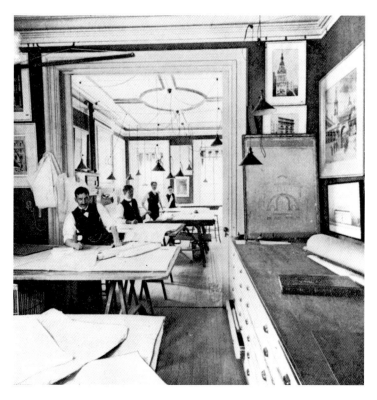

Office of Carrère &
Hastings, Second Floor
Drafting Room (ARRC, 1900)

approaches to the Manhattan and Brooklyn
bridges; the Carnegie Institution in Washington, D.C.; Carnegie branch libraries in New
York; buildings for Cornell and Yale universities; and the McKinley Monument in Buffalo.
The firm designed banks in Cleveland, Toronto,
Montreal, and Paterson, and the Blair Building
in New York, which was later acclaimed as
marking "a step in the development of logical
design for tall buildings."[7]

At the same time, the firm's reputation for
domestic buildings flourished. Its design for
the Murry Guggenheim House in New Jersey
won a gold medal from the American Institute
of Architects. Other prominent Americans who
commissioned houses from Carrère & Hastings
included Frank Goodyear, William Rockefeller,
E. H. Harriman, Alfred I. du Pont, and Henry
Flagler. On Long Island specifically, the firm did
work for Walter Jennings, William K. Vanderbilt,
Jr., Herman B. Duryea, Robert S. Lovett, James
A. Blair, Jr., and William P. Thompson.

In the early years of the century, each partner acquired a country place and remodeled an
old farmhouse on the site, Carrère near White
Plains and Hastings at Port Washington on
Long Island. In 1908 Hastings designed a small-scale estate in Westbury for himself and his
wife, Helen Ripley Benedict, an accomplished
horsewoman.

Even before the partnership was established,
Hastings had been much impressed with Carrère's "executive and practical ability."[8] Hastings
took on the primary role of designer, while
Carrère dealt with the organization of the office,
the clients, and the contractors. Later in the
partnership, Carrère developed an increasing

interest in city planning and worked on projects
for Grand Rapids, Hartford, and Cleveland,
where he served on a commission with Daniel
Burnham. In 1901 Carrère served as chief architect for the Pan American Exposition in Buffalo.

Bernard Maybeck, who worked for Carrère &
Hastings after completing his Paris training, described the day-to-day operations of the office:
*Hastings made the preliminary drawings and explained the scheme. These drawings were given to
the draughtsmen to draw up, putting the practical
work on paper. Then Hastings or Maybeck "studied" proportions, etc. The drawings were corrected
accordingly and turned over to the main office for
engineering, electrical, and plumbing drawings.
Then the whole thing went to Carrère. . . .*[9]

In addition to managing a busy practice,
both Carrère and Hastings were active in the
American Institute of Architects and in the
Society of Beaux-Arts Architects. Hastings was
an original member of the Federal Commission
of Fine Arts, president of the Architectural
League of New York, and a Chevalier of the
Legion of Honor, a French award.

Carrère was committed to the cause of architectural education. A trustee of the American
Academy in Rome, he revised the curriculum
for American schools of architecture. Carrère
took special interest in young colleagues who
wished to study in Paris. He gave them extra
work so that they could save for the trip, and
once they were in Paris he employed them on
various projects to help support them.[10] He
contributed to a series of magazine articles on
the choice of careers, referring to architecture
as "an ideal profession."[11]

In February 1911 Carrère was fatally injured
when a cab in which he was riding collided with
a streetcar. In an unusual salute, Carrère's body
lay in state at the New York Public Library.
Hastings wrote: "I can not help feeling that the
entire profession shares my loss—the loss of a
friend more even than the loss of a fellow architect, and that I feel the loss of my companion
even more than the loss of my partner."[12]

Hastings carried on the practice without a
partner, but retained the original name of the
firm. Prestigious residential commissions continued to flow to the office. In New York,
Henry Clay Frick requested a design for a Fifth
Avenue residence that was intended to serve
as a public art museum in the future. Alfred I.
du Pont, for whom Hastings had designed a
house in Wilmington, Delaware, engaged the
firm to design a house on Long Island. In the
last four years of his life, Hastings designed
two houses for members of the Pratt family at
Glen Cove.

Large-scale projects of this period included
the Tower of Jewels for the 1915 Panama–Pacific

International exhibition in San Francisco, city improvements for Baltimore, and a plan for an industrial town in Duluth, Minnesota, commissioned by U.S. Steel. In New York, Hastings designed the Richmond County Courthouse and the Liggett, Standard Oil, and Macmillan buildings; won the competition for the Pulitzer fountain at the Plaza entrance to Central Park; and served as consulting architect for the Cunard Building and the Ritz Tower. Other projects from the period after Carrère's death include banking houses in Bangor, Maine, and in Niagara Falls and stations for the Union Pacific Railroad in Idaho and Nebraska. He also designed Devonshire House, a palatial apartment building in London.

In 1922 King George V presented Hastings with the Gold Medal of the Royal Institute of British Architects, a rare honor for an American. In an interview at that time, Hastings was described as:

An extremely active and energetic man for his age—which is sixty-two—or, one might add, for any age. His quick motions and eager speech, together with a bright complexion and strongly marked, mobile features, indicate a man with the best of his life still before him. One feels at home with him immediately, because of his responsiveness and lack of all assumption.[13]

His last completed work was the reconstruction of the U.S. Senate Chamber. At the time of his death, he was at work on a scheme for the Triborough Bridge in New York. Hastings died of appendicitis in 1929.

The firm Carrère & Hastings was one of the leading proponents of Beaux-Arts architecture in America. In a 1923 magazine article entitled "Simplicity of Form Is Beauty's Blood-Brother," Hastings summarized the application of his Beaux-Arts training:

In the first year of my architectural career I was accused by my fellow countrymen of attaching too much importance to the artistic study of the floor plan; it was constantly asserted that I was trying to inculcate the Beaux Arts methods of education into our American architectural practice, my critics not realizing that those methods of study in plan have been adhered to at all times since the beginning of architecture. They little appreciate that if the floor plan, determining two of the three dimensions in space, is well studied, beautiful in proportions, with a proper distribution of piers, thickness of walls, logically disposed with good circulation, there will be no structural difficulties, and that this principle has obtained ever since the dawn of architectural history. The plan itself lends itself to thinking in three dimensions. When the plan looks well it builds well, constructs well, so that we find we need very little of the analytical mathematics to assist us, excepting as a mere matter of verification.[14]

Hasting's concern with the fundamentals of the building program occurs as well in his treatises on architectural styles. His firm is cited frequently as purveyors of the French Renaissance style, but Hastings believed the connection with the Renaissance to be much more than stylistic. He warned architects against the slavish copying of historical styles, especially the medieval, whose revival he considered "cold, lifeless and uninteresting."[15] "To be modern," he wrote, "should be the common aim of all living architects. . . .The question should not be, what is modern Renaissance architecture? but, rather, how shall we be modern Renaissance architects?"[16] Hastings believed that like the Renaissance architect, the modern architect should use "all that he could find in classic and Renaissance precedents" and then modify them to meet present-day conditions.[17]

In planning estates, Hastings considered the architect's task to include the design of both the house and the landscaping. Indeed, he believed that the landscape should be the architect's starting point. In 1912 Hastings advised the readers of *Country Life in America:*
In selecting a site for a country house, the best results should obtain by consulting your architect before buying. Some sites are suggestive and others are forbidding. The character of the grade; the character of the trees; and the way they are placed on the grounds; the view of the surrounding country, and other conditions the layman may not realize, have a great deal to do with the final architectural results. There are things which should, at the outset, greatly influence the architect's conception, and when the house is designed for the site it should, in turn, have the greatest influence upon the design and general treatment of the grounds. Only so can harmony and good composition obtain.[18]

Salem H. Wales Residence (Alterations), "Ox Pasture," Southampton, c. 1880s

Elihu Root Residence, Southampton, c. 1896 (Extant)

By 1912 Carrère & Hastings had had 20 years of experience in planning and building country houses. On Long Island, the firm's residential work had begun modestly during the late 1880s with the remodeling of a Shingle Style house into a Colonial Revival structure for Samuel H. Wales, an early promoter of Southampton. Around 1896 Carrère & Hastings designed a substantial country house there as well for Elihu Root, a prominent attorney who was married to Wales's daughter. The massiveness of the main block of Root's shingled house is relieved by projecting porches, wings placed at oblique

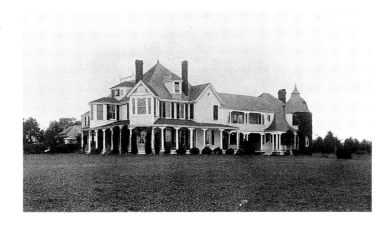

Carrère & Hastings: Rear
Facade, "Ox Pasture," Salem
H. Wales Residence,
Southampton, c. 1880s
(PELL, 1903)

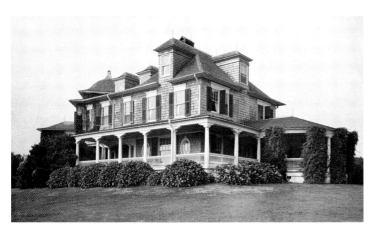

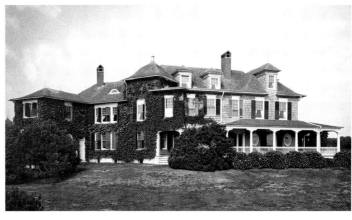

Carrère & Hastings: Elihu
Root Residence,
Southampton, c. 1896
(Courtesy of Ulysses G.
Dietz)

Carrère & Hastings: Front
Facade, Elihu Root
Residence, Southampton,
c. 1896 (Courtesy of Ulysses
G. Dietz)

angles, numerous windows, and intersecting roof planes, punctuated with a variety of dormers. Root went on to become a nationally and internationally prominent figure, first as Secretary of War, later as Secretary of State, and in 1912 as winner of the Nobel Peace Prize.

Walter Jennings Residence, "Burrwood," Cold Spring Harbor, 1898–1900

"Burrwood," built for the oil magnate Walter Jennings and his family, sat on a bluff overlooking Cold Spring Harbor. As in later houses, the long view is not apparent from the entrance court; rather it is screened by foliage and the imposing facade of the house itself. An old photograph in a Jennings family album is labeled "an English house used as a Suggestion for our house."[19] While there are certain similarities in the hipped roofs, the detailing of the red-brick masonry, and the projecting wings flanking a central entry, Carrère & Hastings created a much more dynamic composition.

White marble trim surrounds the major windows on the second story and frames the doorway as well. A range of tall chimney stacks adds emphasis to the commodious roof over the main block of the house. The dramatic approach to the house is heightened by the elliptical drive that frames a sunken garden, creating the sense of an outdoor room. On the water side of the house, the transition to the outdoors

occurs in stages; a broad terrace with a porch at each end steps down to a narrow strip of lawn and a steep, wooded hillside. To the south, along the crest of the bluff, is a walk that is ornamented with a pergola and a fountain and terminates in a space enclosed by columns. The grounds were landscaped by the Olmsted Brothers between 1916 and 1938.

The entrance on the garden front of the house opens into a low-ceilinged vestibule that leads up a few steps to a spacious hall from which the harbor can be viewed. The *Brooklyn Daily Eagle* described the interior in the summer of 1899:

The first floor, with fourteen foot ceilings, is to be finished in the most valuable hard woods. It contains, besides vestibule and entrance hall, a billiard room and a playroom, each 20 by 20; a drawing room, 22 by 22; a breakfast room, 17 by 18; dining room, 22 by 44; library, 20 by 40, with necessary butler's and servants' pantries. The second floor contains nine chambers with dressing rooms, baths, nursery, etc. On the third floor are nine bedrooms, store rooms, trunk rooms and servants' bath.[20]

Fine materials were used throughout "Burrwood." Over the years the family made only a few changes to the original scheme. Oculus dormers were added high up on the roof, a Palladian window was inserted into an existing opening over the entrance, and more elaborate mantels were installed.

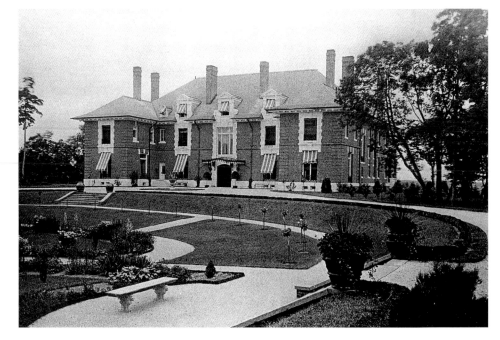

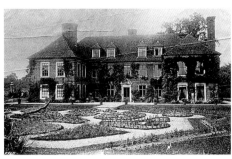

Jennings Family Album, "Photograph of an English house used as a Suggestion for our house" (Courtesy of Jennings Family; photo by Paul Basirico, Setauket)

Carrère & Hastings: Front Facade, "Burrwood," Walter Jennings Residence, Cold Spring Harbor, 1898–1900 (AABN, 1900)

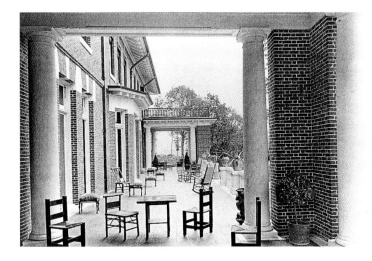

Carrère & Hastings: Rear (West) Facade, "Burrwood," Walter Jennings Residence, Cold Spring Harbor, 1898–1900 (AABN, 1900)

Walter Jennings, a director and secretary of the Standard Oil Company and president of the National Fuel Gas Company, died in 1933. After his wife's death the house passed to their son, Oliver Burr Jennings, who sold the property to the Industrial Home for the Blind, which occupied it from 1952 to 1985. The house was demolished in 1994.

Herman B. Duryea Residence, "Knole," Old Westbury, 1903 (Extant)

The firm's next major Long Island commission came from Hastings's friend, Herman B. Duryea, a prominent owner of racehorses. In the woodlands at Old Westbury, Carrère & Hastings planned a widely publicized estate that still retains the ambience and elegance of an early 20th-century enclave.

The entrance to the estate passes a modestly scaled, well-proportioned frame gatehouse and

stable, which was remodeled from an earlier farmhouse. A writer in *Town and Country* remarked that these "buildings do not prepare one for the house itself, yet they are so far removed from it that there is no sense of a lack of harmony."[21] The road rises and winds through the woods, the house then appears suddenly at the top of the hill. The remarkable entrance facade is austere and massive, rising two stories above a rusticated basement.

One enters through a small double doorway, barely recessed into the facade, and passes into a small vestibule a few steps below a small transverse hall. Leading up from this hall is a pair of curving stone stairways. At the top of the stairway is a two-story, oval rotunda, a startling contrast with the modest, dimly lighted sequence of entry spaces. The rotunda is the center of the house, aesthetically and functionally; all rooms radiate from it. Barr Ferree, an eminent early 20th-century writer on American houses, called this space:

[A] brilliant conception carried out in a brilliant way . . . the great merit of this hall is its complete privacy and its splendid effect, and the monumental character, which is completely surprising. No one knows, on entering the house, what one is to see . . . one is certainly not prepared for the very great charm of this very surprising hall.[22]

On the west front, two wings, one containing the living room and the other the dining room, extend into the garden; each wing terminates in a loggia originally used as a garden room. *Town and Country* called the loggias "an inspiration":

The great arched entrances are trellised with green lattice, the floor is concrete overlaid with rich rugs, the rooms are spacious and lofty and the vines and blooms that climb the lattice billow into the

Carrère & Hastings: Front
Facade, "Knole," Herman B.
Duryea Residence, Old
Westbury, 1903 (FERR, 1904)

Carrère & Hastings: Floor
Plans, "Knole," Herman B.
Duryea Residence, Old
Westbury, 1903 (Bob Zucker
photo, 1978)

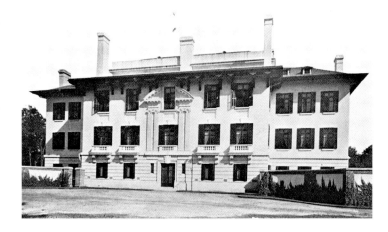

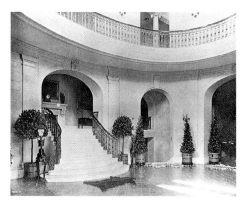

Carrère & Hastings: The
Hall, "Knole," Herman B.
Duryea Residence, Old
Westbury, 1903 (FERR, 1904)

Carrère & Hastings: Garden
Facade, "Knole," Herman B.
Duryea Residence, Old
Westbury, 1903 (FERR, 1904)

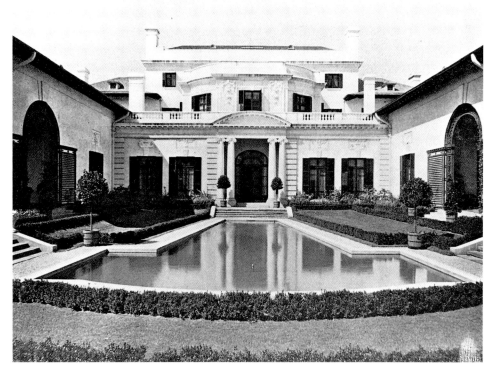

Carrère & Hastings: West
Facade, "Knole," Herman B.
Duryea Residence, Old
Westbury, 1903 (SPLI, 1979)

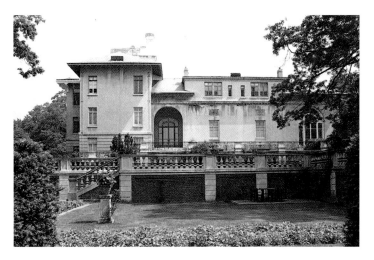

Carrère & Hastings: Garden
Facade, "Deepdale,"
William K. Vanderbilt, Jr.,
Residence, Great Neck, 1903
(ARRC, 1910)

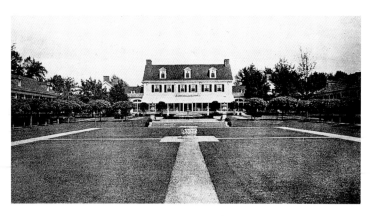

*interior riotously. Plants and shrubs in huge
Italian jars furnish the decoration and complete
the charm of the willow lounging chairs and tea-
tables and smoking tables.*[23]

The wings form a court with a reflecting
pool. The west end of the pool intersects a very
long, narrow north-south vista carved from the
woods. Terraced gardens step down from the
north side of the house.

Ferree wrote admiringly, "Every single fea-
ture, the decorated walls, the delightful end
porches, the novel trellises, the water garden in
the center, the blooming plants and vines, all
help in creating an ensemble of very great charm
and interest."[24] The Duryea residence illustrates
well the integration of landscape and structure
for which the firm was renowned. According
to Hastings, landscaping should "surround and
support the building, serving both as frame and
as pedestal."[25] Hastings called the Duryea resi-
dence his dream house.

Faced with growing anti-gambling sentiment
in America, Duryea shipped his stable of race-
horses to France and sold the house in 1910. The
new owners, Bradley Martin and Helen Phipps
Martin, were well known in New York, London,
and Scotland for their lavish entertaining. They
made a few changes, adding a library and a ten-
nis court. A family member still holds title to
the property.

William K. Vanderbilt, Jr., Residence, "Deepdale," Great Neck, 1903

The estate of William K. Vanderbilt, Jr., over-
looking Lake Success at Great Neck, was simi-
larly celebrated in American magazines for
the studied relationships between house and
grounds. Of this house Carrère remarked,
"When we come to understand that a house
should be merely one feature in a landscape
theme, we will make fewer architectural blun-
ders."[26] Ferree commented:
*In the development of most of the Long Island es-
tates the first step has been the erection of a splen-
did mansion; the second has been the arrangement
of the grounds and the cultivation of the land.*

*Mr. Vanderbilt has, in a sense, reversed this system,
and has directed his attention in the first place
more particularly to his land, giving the house
problem a somewhat secondary consideration.
Instead of beginning with a great house, such as
might naturally have been expected with a proper-
ty of this size, he built a house of comparatively
modest size in 1902, and enlarged it in 1903 and
1904, giving his chief attention to the development
of his land.*[27]

The architects' challenge here was to re-
model a farmhouse, and they carried out this
task with vigor. The architects used long, curved
arcades to connect the main building, which
housed the principal living spaces, with the
wings, which ranged 70 feet in length and con-
tained the guest rooms. *The Spur* reported that
"the entire structure takes on a nearly semi-
circular shape, thus forming a court that is quite
removed from conventional lines."[28] Another
striking feature of the house was the remodeled,
138- foot-long entrance facade, which was treated
as an arcaded porch that could be enclosed in
glass and converted into a winter garden. The
garden theme was enhanced by completely
covering the interior wall surfaces with lattice
and furnishing the area with plants and wicker
furniture.

Thomas Hastings Residence, "Bagatelle," Old Westbury, 1910 (Extant)

It was in Westbury, an area well known to
Hastings from his work on the Duryea house,
that he purchased a 15-acre tract and began to
build his own country house in 1908. Describ-
ing the project, he wrote:
*It is like an old Italian farmhouse, if such a thing
exists. We did not want too much architecture;
wanted to keep the house very simple . . . so that
I can do things during the years to come. Wanted
to be able to grow vines; have no repairs—house
all masonry and no woodwork exposed outdoors
except the window sashes. That was the program.*[29]

Two years later, while Hastings was on one of
his frequent trips to Europe, the house burned.
In keeping with his beliefs that "every house
ought to burn down after one had lived in it"
and that a house was "like a suit of clothes and
should be tried on and then altered to fit,"[30]
Hastings set to work. The walls were torn down,
but the house was rebuilt with only a few alter-
ations: two porches were added, and the loggia
decorations changed, but the plan was preserved.

The short, narrow drive climbs a small hill
and passes the working side of the stable and
the carriage house. The house sits at the north
end of a courtyard, which is framed on the west
by the service wing, on the east by a row of
trees, and along the south, in rather surprising

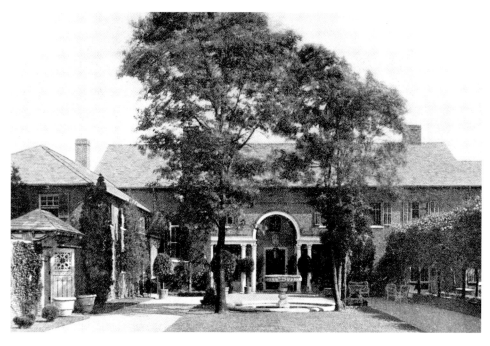

Carrère & Hastings: Front Courtyard, "Bagatelle," Thomas Hastings Residence, Old Westbury, 1910 (PATT, 1924)

Carrère & Hastings: Garage and Stable Group, "Bagatelle," Thomas Hastings Residence, Old Westbury, c. 1910 (PATT, 1924)

Carrère & Hastings: Staircase, "Bagatelle," Thomas Hastings Residence, Old Westbury, 1910 (SPLI, 1977)

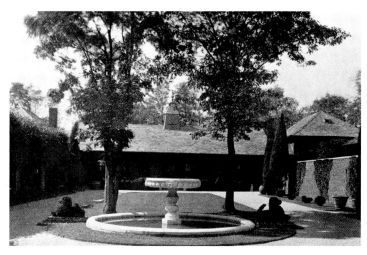

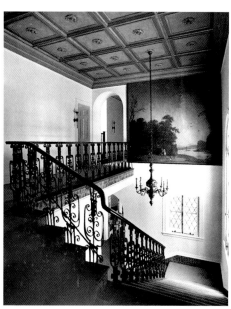

proximity to the house, by the stable. "The idea," Hastings wrote, "was that we were living on Long Island where the principal interest of the residents is horses and everything that has to do with horses."[31] From the front door, the Hastingses could see their horses peering over the doors of their box stalls. The axis of the courtyard extended through the entrance hall of the house, across the terrace, and then north through a natural opening in the trees. While charming and picturesque, the layout of the ensemble was highly rationalized.

The main block of the house is generally symmetrical in plan, with a porch at each end and the living room and dining room flanking a hallway and overlooking the terrace. Shortly after the rebuilding, *American Country Homes of Today* reported on the interior:

Within, it is full of color. The wall of the hall is blue. It is by means of a red-tile staircase that we climb to the upper story. The balustrading is of wrought-iron, taken from a fragment of old work which Mr. Hastings fortunately found in Europe.

The ceiling is an old Italian painter's work of considerable merit, and very beautiful and low in tone. The dining-room is an English example of wall panelling of the eighteenth century. The painting of the ceiling is of a religious significance of the same period. The library, the largest room in the house, is a portion of the original building, which survived the fire. It was rebuilt in part. The owner is fond, among other things, of maps, charts, plans and surveys. Above the books are lockers, an ingenious contrivance whereby the maps may be hauled down or rolled up, as you will, out of sight but forever within reach.[32]

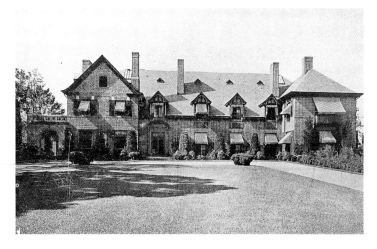

Carrère & Hastings:
Entrance Courtyard,
"Ontare," James A. Blair, Jr.,
Residence, Oyster Bay,
c. 1910 (TOWN, 1910)

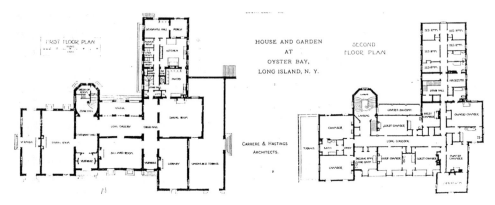

Carrère & Hastings: Floor
Plans, "Ontare," James A.
Blair, Jr., Residence, Oyster
Bay, c. 1910 (BRIC, 1910)

Carrère & Hastings:
"Woodfield," Robert S.
Lovett Residence,
Lattingtown, c. 1910 (BRIC,
1913)

James A. Blair, Jr., Residence, "Ontare," Oyster Bay, c. 1910

During the years when Hastings was at work on his own house, the firm was busy with three other Long Island estates, all of which have been demolished. The first, completed by 1910 on a hill overlooking Oyster Bay, was for James A. Blair, Jr., a bachelor businessman. The architects created an uncharacteristically irregular plan in order to provide numerous wall surfaces to show off elaborate patterns in tapestry brick. An extensive terrace and spacious veranda with a fireplace promoted the enjoyment of the out-of- doors. The veranda overlooked a large formal garden and stable, a composition that *Town and Country* called "a triumph of landscape gardening . . . where art assists nature."[33]

Robert S. Lovett Residence, "Woodfield," Lattingtown, c. 1910

A more restrained and formal design was executed for the family of Robert S. Lovett, a Texas attorney who was then president of the Union Pacific and Southern Pacific railways. Located in Lattingtown, this brick-front house had an L-shaped plan that formed an entrance court. Some unusual features included a hall on the first floor that extended 55 feet across the garden front, a similarly sized "sitting hall" on the second floor, and an enclosed outdoor living room/breakfast porch overlooking the gardens.

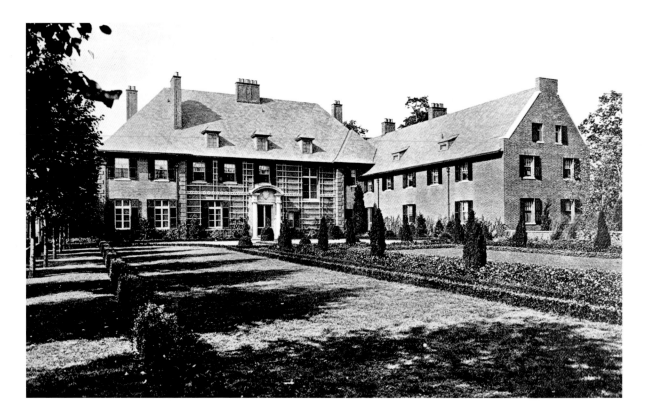

Carrère & Hastings: "Longfields," William P. Thompson Residence, Westbury, c. 1910 (VIEW, c. 1930)

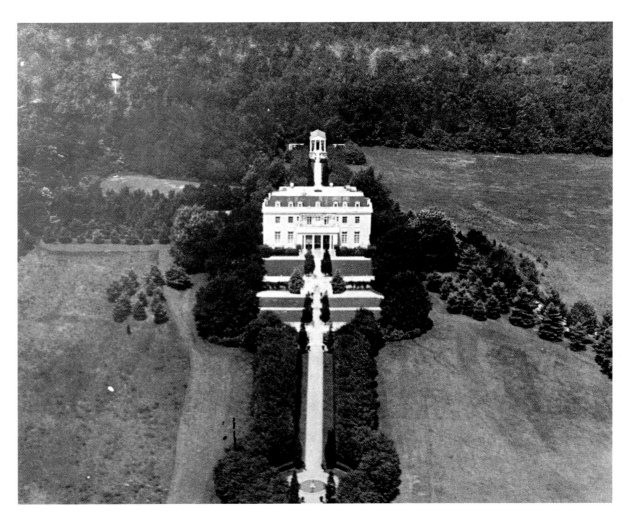

Carrère & Hastings: Front (South) Facade, "Longfields," William P. Thompson Residence, Westbury, c. 1910 (SPLI, n.d.)

William P. Thompson Residence, "Longfields," Westbury, c. 1910

The third of these houses was built for William P. Thompson on a rise overlooking the Westbury woods. Markedly different from the Blair and Lovett houses, the Thompson house was a massive, rectangular block with a mansard roof and a shallow entrance porch at the top of a broad flight of stairs. It sat midway along a vista that extended hundreds of yards from each facade, creating an unusually long north-south axis on the property. A terrace, partly covered and partly open, extended the full width of the garden facade, the first of several descending levels. Overall, this design lacked the sophistication and easy transition between house and landscape that characterized the previous work of Carrère & Hastings.

Alfred I. du Pont Residence, "White Eagle," Wheatley Hills, 1916–17 (Extant)

Begun just before World War I and located near Roslyn on a slightly undulating plot, the du Pont house sits some distance south of the road, separated from it by a meadow and a pond. The two garden facades are visible from the entrance road, which near the house is closely framed by high brick walls and clipped trees. The red-brick house is at the end of a curved courtyard, its entrance framed by pairs of Corinthian columns that support a two-story portico.

The house was designed in 1916–17 for Alfred I. du Pont, former head of E. I. du Pont and Company. By 1923 it had been acquired by Frederick and Amy Phipps Guest. In 1968 it was purchased by the New York Institute of Technology for use as a conference center and in 1991 was purchased by Canon USA, Inc. Each owner made substantial alterations. The Guests transformed the entry hall, which originally provided direct access and a view to the garden and fields beyond, by installing a marble stairway brought from their New York City residence. The circulation pattern was changed when the stair hall,

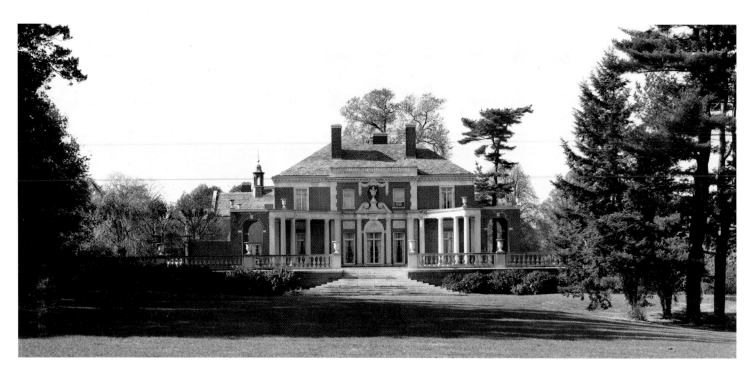

Carrère & Hastings: Garden Facade, "White Eagle," Alfred I. du Pont Residence, Wheatley Hills, 1916–17 (SPLI, Richard Cheek photo, 1981)

Carrère & Hastings: Elevation Details of Main Entrance, "White Eagle," Alfred I. du Pont Residence, Wheatley Hills, 1916–17 (AMAR, 1917)

Carrère & Hastings: Rear Facade, "White Eagle," Alfred I. du Pont Residence, Wheatley Hills, 1916–17 (ARTS, 1923)

to the left of the entry, was converted to a sitting room.[34] The Institute turned the kitchen into a dining room and added a large glassed-in dining room.

Many important aspects of the landscape survive. The loggia off the ballroom and the terraces demonstrate Hastings's ability to create a facile transition from indoor to outdoor spaces. Hastings explained his views on the relationship of a house to its setting as follows:

Having considered the plans of buildings, we might speak briefly of the plan of the immediate surroundings. We have a very characteristic name for this portion of the composition. We call it the "sauce of the architecture." It is this portion of the design which unites or marries the building with its natural surroundings or the landscape. Most of the same principles of composition obtain in the planning of this portion of the work as in the planning of the building itself. The architect should always have control of the design or plan of the immediate surroundings of his building.[35]

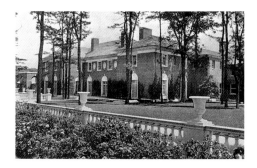

Edith Pratt McLane Residence, "Homewood," Glen Cove, c. 1924 (Extant)

The last country-house commissions that Hastings undertook on Long Island reflected the changes of postwar life, which required smaller houses staffed by fewer servants. In the mid-1920s, he planned two houses at Glen Cove for daughters of Herbert L. Pratt, who was a friend of Hastings. For Edith Pratt McLane, Hastings designed a red-brick house, known from an early date as "Homewood" and said to have been "inspired by its famous namesake in Baltimore."[36] However, Hastings characteristically refrained from copying an earlier design literally. While the McLane house is smaller in scale than the architect's prewar houses, he repeated two themes: he placed the primary living rooms at the garden side of the house, and he used flanking wings to enclose an outdoor space. The facade of the McLane house is dominated by an imposing portico; the end blocks were later raised to a full two stories.

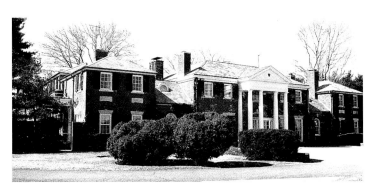

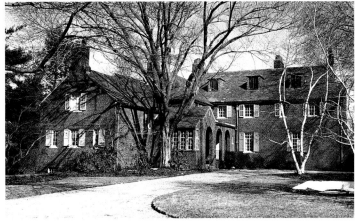

Carrère & Hastings: Front
Facade and Entrance,
"Homewood," Edith Pratt
McLane Residence, Glen
Cove, c. 1924 (SPLI, n.d.)

Carrère & Hastings:
Entrance Drive,
"Preference," Harriet Pratt
Van Ingen Residence, Glen
Cove, c. 1924 (SPLI, n.d.)

Carrère & Hastings:
"Highpool," W. Deering
Howe Residence, Brookville,
1926–27 (AVER, n.d.)

Carrère & Hastings:
"Highpool," W. Deering
Howe Residence, Brookville,
1926–27 (AVER, n.d.)

Harriet Pratt Van Ingen Residence, "Preference," Glen Cove, c. 1924 (Extant)

For Harriet Pratt Van Ingen, second daughter
of Herbert L. Pratt, Hastings designed a house
perched on the top of a hill, with fine views of
Long Island Sound. Once again Hastings calcu-
lated the approach to hold some surprise; the
entrance courtyard and facade are not visible
until one is at the crest of the hill. He experi-
mented here with an arcaded entrance porch
tucked along the side of the service wing. Con-
structed of red brick and featuring small-paned
windows, the Van Ingen house is unpretentious
in design. One enters into a modest stair hall;
the living room, to the right, overlooks the
sound. Interior alterations were carried out in
1935 and more recently.

W. Deering Howe Residence, "Highpool," Brookville, 1926–27 (Extant)

The stucco house built for W. Deering Howe
near Brookville was one of Hastings's last resi-
dential commissions. The one-story main fa-
cade is complemented by multistory wings and
steeply pitched slate roofs. A separate six-stall
garage also survives. In 1959 the property was
purchased by the Lutheran High School As-
sociation. When enrollment quickly exceeded
the classroom space available in the house, the
school erected new buildings around the house
that make it difficult to envision the original
scheme. The interiors of the service wing have
been little altered.

Despite the unfortunate destruction of sev-
eral Long Island estates designed by Carrère &
Hastings, many of the remaining ones are of
exceptional quality; the Duryea and Hastings
houses, for example, quickly spring to mind.
These, taken together with the Root, du Pont,
and Pratt houses, demonstrate the full range of
the firm's significant contribution to country-
house architecture on Long Island.

Diana S. Waite

Walter B. Chambers, 1866–1945

A native of Brooklyn and a brother of novelist
Robert Chambers, Walter Boughton Chambers
began his architectural training at Yale Univer-
sity. After studying in Munich and at the Ecole
des Beaux-Arts in Paris, he worked in New York
City for Ernest Flagg, becoming Flagg's junior
partner in 1895. In 1906 Chambers opened his
own office and became well known for his
apartment-house designs.

The Brookville country house Walter
Chambers planned for the newly wed Brewster
Jennings in 1924 was seemingly small and un-
pretentious. Jennings, educated at St. Paul's

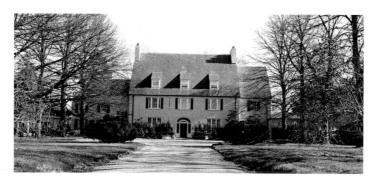

Walter B. Chambers:
Entrance Drive and Front
Facade, "Windward,"
Brewster Jennings
Residence, Brookville, 1924
(INVE, 1979)

and Yale, went to work for the Standard Oil Company in New York in 1920, and was instrumental in transforming it into the Mobil Oil Corporation. Jennings's house, "Windward," an unusual Federal-style, whitewashed brick house, is characterized by receding wings that diminish in scale and steep roofs relieved by shed dormers. A narrow window introduced at the second story seems to mock the fastidiously aligned, three-level main facade. The recessed bay windows of the first and second story and the semi-elliptical arched entry with a continuous border of sidelights and outer fanlight, add an elegant refinement.

Michael Adams

Clinton & Russell, Wells, Holton & George, 1894–c. 1930

This firm continued the practice of Clinton & Russell, created in 1894 by the partnership of Charles William Clinton (1838–1910)[1] and William Hamilton Russell (1856–1907).[2] A New Yorker, Clinton attended public school and then proceeded directly to the office of Richard Upjohn, an important church architect. Russell, a fellow New Yorker, graduated from Columbia College and went to work with his great-uncle, ecclesiastical architect James Renwick. Thus the partners joined forces, having served their apprenticeship with two of the chief exponents of the Gothic Revival style in America.

Clinton & Russell are best known for their pioneering contributions to Manhattan skyscrapers. Contemporary critic Herbert Croly pointed out in 1903 that the firm's office buildings were as different from the earlier 19th-century four- and five-story brick commercial buildings as the great country houses were from the rustic retreats built before 1880.[3] However, the firm also designed other building types for its affluent clients, its repertoire including armories, apartment buildings, row houses, and even country mansions. Before the partners' deaths, the firm had designed at least two Long Island houses, a simple classical dwelling in

Oyster Bay, and a French Renaissance villa in Islip. The owners of these houses were not named in Russell Sturgis's 1897 catalogue of the firm's work.[4]

The firm continued to use its founders' names long after their deaths, and by 1923 was known as Clinton & Russell, Wells, Holton & George. Colonel James Hollis Wells, who became the senior partner of the reorganized firm, was born in England in 1864 and emigrated to the United States as a boy. After graduating from Lehigh University in 1885 with a degree in civil engineering, he taught for a year, then secured a job in New York City as an inspector of pavements. After working as an engineer for a contracting firm and then as clerk of the works for Cornelius Vanderbilt, he became a draftsman for Clinton & Russell. Soon he took charge of the planning and construction of the firm's large commercial buildings. A member of the New York National Guard, he commanded the 71st Regiment in Cuba during the Spanish-American War in 1898. As much a contractor and engineer as an architect, Wells served as New Jersey Bridge and Tunnel Commissioner under an appointment from Governor Woodrow Wilson in 1913, and as consulting engineer for the U.S. Treasury Department from 1914 to 1918. He died at home in Jersey City in September 1926.[5]

Alfred J. S. Holton and Thomas J. George, born in Brooklyn and Rome, respectively, both began their careers as draftsmen for Clinton & Russell and stayed with the firm for the rest of their working lives.

The country houses designed by the firm are stylistically conservative but structurally modern buildings that show a fluency in historical architectural styles. Personal recollections attest that the firm gave clients what they wanted—traditional-looking buildings built to high standards of comfort and efficiency.

Mrs. Lillian Sefton Dodge Residence, "Sefton Manor," Mill Neck, 1923 (Extant)

Wells designed the firm's most ambitious Long Island house, "Sefton Manor," for Lillian Sefton Thomas Dodge, president of Harriet Hubbard Ayer Co. (Founded in 1907 by Mrs. Dodge's first husband, Vincent B. Thomas, the firm became one of the world's largest cosmetics concerns under her direction and was acquired by Lever Brothers, Inc., after Mrs. Dodge retired in 1947.)

Mrs. Dodge purchased the building site, including the burnt remains of an older house, from Harvey Murdock of Oyster Bay in 1922[6] and the following year commissioned the firm,

Clinton & Russell: Front Facade and Entrance Court, "Sefton Manor," Mrs. Lillian Sefton Dodge Residence, Mill Neck, 1923 (SPLI, 1979)

Clinton & Russell: Rear Facade, "Sefton Manor," Mrs. Lillian Sefton Dodge Residence, Mill Neck, 1923 (SPLI, 1979)

Clinton & Russell: First Floor Plan, "Sefton Manor," Mrs. Lillian Sefton Dodge Residence, Mill Neck, 1923 (SPLI, n.d.)

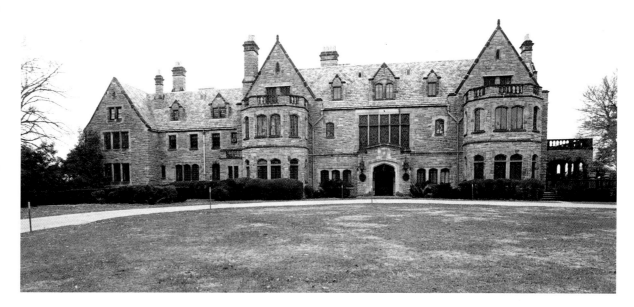

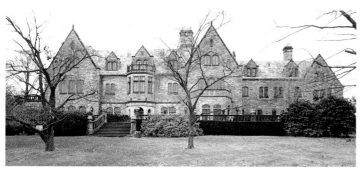

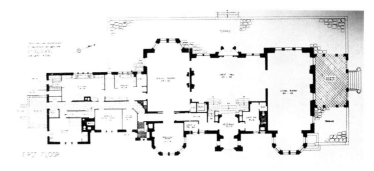

Clinton & Russell: Rear Facade, "Creekside," Harry K. Knapp, Jr., Residence, East Islip, c. 1930 (HOWE, 1933)

represented by Wells, to design her house.[7] According to her daughter's recollections, Mrs. Dodge's English heritage and personal inclination may have influenced her choice of an English-born architect and of the Tudor Revival style for her house.

Nothing about the house is stylistically or structurally innovative; it is, in fact, remarkably similar in overall appearance to the Tudor mansion built by Clinton & Russell before 1897 for D. Willis James in Madison, New Jersey.[8]

"Sefton Manor" is a two-story house with a dormer-windowed third floor under the slate roof and a full basement. Light-brown Westchester granite trimmed with limestone sheaths the steel-frame construction. Inspired by English Gothic country houses of the late 16th century, "Sefton Manor" has a symmetrical main block, with a service wing to the south. The design is rich in stylistic references: the entry porch on the east facade was adapted from Great Chatfield Manor, Wiltshire; the west facade from St. Catherine's Court, Somersetshire.

As one enters the house, a low, small vestibule opens to the oak-paneled Great Hall. Leaded- and stained-glass windows executed by Charles Connick of Boston include a series of five depicting scenes from Shakespearean plays selected by Mrs. Dodge's daughter. Some of the trim was adapted from English prototypes known through architectural publications, including the Great Hall's molded plaster ceiling from Burton Agnes in Yorkshire and the dining room's stone mantel from Tattershall Castle in Lincolnshire.

The gardens were designed by landscape architect Charles W. Leavitt, and a group of Tudor-inspired farm buildings, greenhouses, and a potting shed, added in 1929, were the work of an unidentified architect.

Harry K. Knapp, Jr., Residence, "Creekside," East Islip, c. 1930

Clinton and Russell's final identifiable Long Island house, "Creekside," was built around 1930 for Harry K. Knapp in East Islip. The firm's principals by that time were Alfred J. S. Holton and Thomas J. George.

Ellen Fletcher

Ogden Codman, Jr., 1863–1951 (SPNE, n.d.)

Ogden Codman, Jr., 1863–1951

This architect is known for his collaboration with the distinguished novelist Edith Wharton as coauthor of *The Decoration of Houses*, published in 1897. Born in Boston to a distinguished New England family, Ogden Codman, Jr., spent much of his life in France, living there from 1872 to 1882, and again from 1920 to the end of his life. Codman began his professional career in 1891, opening an office in Boston, followed shortly by a branch in Newport and a permanent location in New York. Both as an architect and as a decorator, he became known for his classical interiors adapted from 18th-century French, English, and American houses, particularly ones built on a smaller, human scale.

During the next three decades his office carried out approximately 120 residential commissions, including the design and remodeling of 31 houses, primarily for well-to-do, old-guard families of the northeast United States. Despite minimal formal training in architecture—one year at M.I.T., followed by several years with local architectural firms, including Andrews & Jacques of Boston—Codman's grammatical interpretations of historical styles show a greater command of the classical vocabulary than do those of many of his contemporaries. An important factor in his education was his study of 18th-century buildings in the Boston area. Guided by his uncle, architect John Hubbard Sturgis, he made measured drawings of many of them. An associate and consultant to many members of the cultural elite of his day, Codman was influential as an interpreter of the traditional style of interior decoration popularized by Elsie de Wolfe and graduates of the Parsons School of Design.

Codman was responsible for the complete design and decoration of two residences on Long Island, although several other decorating commissions are mentioned in his accounts and correspondence.[1] The first was built for Lloyd Stevens Bryce in c. 1901, at Roslyn, and the second, "Haut Bois," in 1916 for Walter Effingham Maynard in Jericho. A comparison of the two commissions reveals the way Codman adapted the vocabulary and forms of 18th-century architecture to create a house in the English or French style, or, as in the case of the Bryce house, a composite of English Georgian and American Colonial Revival detailing. It is also evident that, by the end of his career, he relied less on details, preferring to use the simplest stylistic elements to evoke the historical precedent, as in the case of the Maynard house. Despite stylistic differences in the exterior treatment, the form and plan in both commissions is the same as in all of Codman's country houses—a center block with hipped roof and projecting wings on both sides. The specific use and function of the main rooms depended on the size and siting of the particular house.

Lloyd Stevens Bryce Residence, "Bryce House," Roslyn, c. 1901 (Extant)

In Codman's correspondence of the late 1890s and early 1900s, there is no particular explanation for the Bryce commission, but the two men may well have met as members of the relatively small Newport-New York social circle. Codman mentioned that 1900 was his busiest and most successful year to date, with commissions for houses in Newport and Providence, Rhode Island; Lenox, Massachusetts; and Long Island. At the same time he was supervising the alterations to his own house in Lincoln, Massachusetts.[2] He also designed and decorated a New York townhouse for Lloyd Bryce at 1025 Fifth Avenue several years later.

For Bryce, Codman designed a country estate befitting Bryce's position as a gentleman, congressman, diplomat, and author. The house was based on an early Georgian prototype with Palladian overtones, with two one-story pavilions linked by curved arcades. Combined with brick walls and cement quoins, the pavilions gave the house a distinctly American air, reminiscent of some 18th-century residences in Virginia and the Philadelphia area. Despite its crowded details and cramped fenestration, a critic of the day noted that "the house charms and satisfies by the directness of its design, the simplicity of its detail, and the dignity of its proportions."[3] The arched windows on the garden facade were a feature Codman frequently used in his country houses, and later for "La Leopolda," his own house, built in the south of France in 1929.

The original interior schemes illustrate many features that would have been prescribed in *The Decoration of Houses*, published shortly before the Bryce house was built. Rebelling against the clutter and heavy-handed excesses of many Victorian interiors, Codman and Wharton believed that the treatment of the interior should be based on good proportions, balancing of door and window spacing, and simple, unconfused lines. In the drawing room of the Bryce house, the walls of paneled wood were painted a pearl gray with white trim; the curtains and furniture were covered in a rich red damask; and the furniture, finished in white or gold, was a mixture of antique and reproduction pieces. The marble mantel, crystal chandelier, and fine "objects" were all typical of Codman's interior decoration schemes. The library, paneled in walnut, was appointed with a mixture

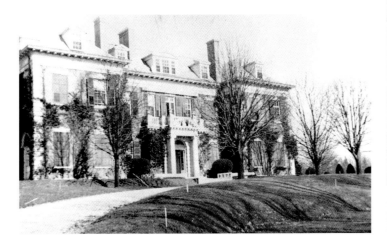

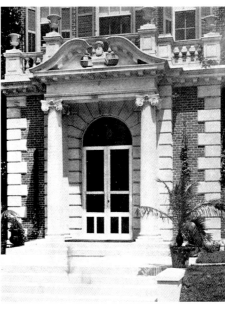

Ogden Codman, Jr.: Front Facade, "Bryce House," Lloyd Bryce Residence, Roslyn, c. 1901 (Roslyn Landmark Society, c. 1900)

Ogden Codman, Jr.: Detail, Main Doorway, "Bryce House," Lloyd Bryce Residence, Roslyn, c. 1901 (FERR, 1904)

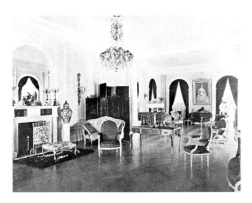

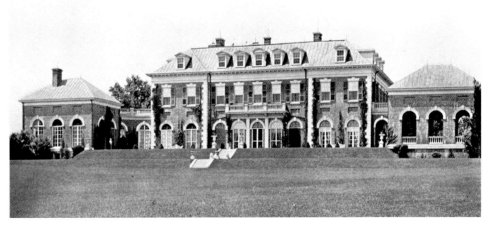

Ogden Codman, Jr.: The Drawing Room, "Bryce House," Lloyd Bryce Residence, Roslyn, c. 1901 (FERR, 1904)

Ogden Codman, Jr.: Garden Facade, "Bryce House," Lloyd Bryce Residence, Roslyn, c. 1901 (FERR, 1904)

Ogden Codman, Jr.: Front Facade with Altered Main Doorway by Sir Charles Carrick Allom, 1919, "Bryce House," Lloyd Bryce Residence, Roslyn, c. 1901 (SPLI, 1979)

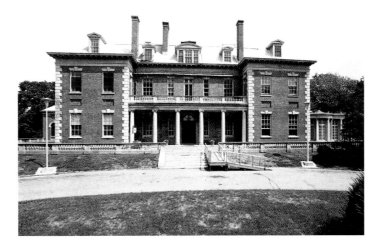

of English and French furniture and detailing, a treatment found in many Codman designs.

After Bryce's death in 1917, the estate was sold to Childs Frick, the son of Henry Clay Frick, and given the name of "Clayton." To make exterior and interior alterations, Frick employed Sir Charles Carrick Allom (1865–1947) of White, Allom (an important English decorating firm), responsible for the interiors of the Frick mansion in New York City. He

engaged Marian C. Coffin to replant the garden. On the exterior, Allom replaced Codman's original handsome entrance portico, accentuated by a broken pediment, with an open loggia connecting the projections on either side of the central block. The interior plan of the house was changed substantially, confusing the original arrangement of rooms. Among the changes were

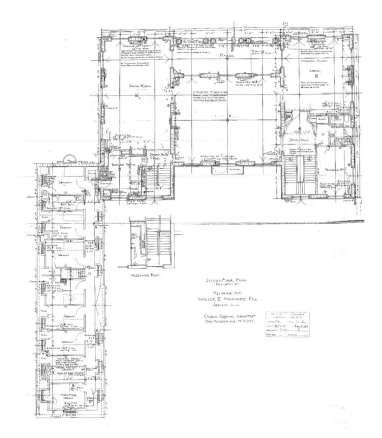

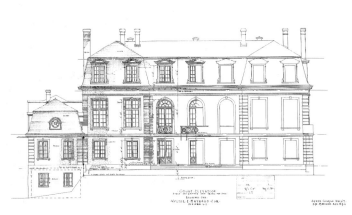

Ogden Codman, Jr.: Court Elevation, "Haut Bois," Walter E. Maynard Residence, Jericho, 1916 (SPNE, n.d.)

Ogden Codman, Jr.: Second Floor Plan, "Haut Bois," Walter E. Maynard Residence, Jericho, 1916 (SPNE, n.d.)

the replacement of the circular entrance hall by a more conventional rectangular space; the addition of a service wing and breakfast room to the south; and alterations to the dimensions of the library and drawing room, including the doorway and window openings. Virtually all the interior details and moldings were altered in some way. As a result, the house no longer reflects Codman's concept. Once part of the William Cullen Bryant estate, the Bryce/Frick house is situated on the summit of a hill overlooking Hempstead Harbor. Although some of the landscaping remains, the original planting of the formal terrace adjacent to the garden facade has been completely grassed over, the fountain and reflecting pool removed, and flower beds edged with boxwood. The property is now owned and administered by the Nassau County Office of Cultural Development. Architects Henry O. Milliken and Newton P. Bevin designed a teak trellis for the property in 1930, one of the most important examples of garden architecture to survive in America.

Walter Effingham Maynard Residence, "Haut Bois," Jericho, 1916 (Extant)

The last of Codman's country houses, and probably his finest in the French classical mode, "Haut Bois" was the result of a close collaboration between the architect and his client on all aspects of the exterior and interior design. The Maynard and Codman families had known one another for many years, and were passionate

Francophiles (Maynard was made a Chevalier of the French Legion of Honor), as well as mutual friends of Edith Wharton. Surviving correspondence between Maynard and Codman indicates how insistent Maynard was that every aspect and detail of the exterior be consistent stylistically with the overall concept of the house— that of an early 18th-century manor house or hunting lodge. He queried Codman about the design of the ironwork for the "grille" and for the balcony over the front door, noting, in a letter of November 6, 1916, "I cannot help feeling that the house is earlier in style than Louis XVI, and that we ought not to use iron work of that style." To achieve the proper historical reference, Codman relied chiefly on the accuracy of proportion, fenestration, roof line, and, finally, the contrast of brick trim and quoining against the plaster wall. Codman graded the site so that the main rooms, when approached from the courtyard entrance, are located on the second floor, but on the garden side, they open onto a terrace. This plan, not original to Codman, was used in French 18th-century buildings such as Jacques-Ange Gabriel's Petit Trianon at Versailles. By employing this classical device, Codman was also able to design the entrance vestibule as a "grotto" of sorts, with walls in rough-cast plaster and niches for statuary.

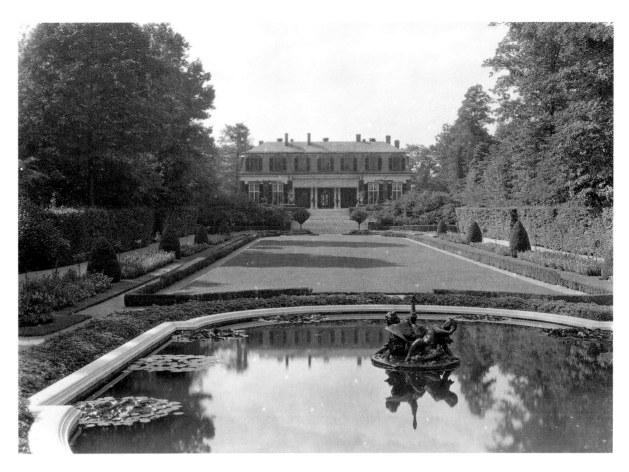

Ogden Codman, Jr.: Garden Facade, "Haut Bois," Walter E. Maynard Residence, Jericho, 1916 (HEWI, 1930)

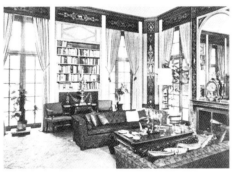

Ogden Codman, Jr.: The Library, "Haut Bois," Walter E. Maynard Residence, Jericho, 1916 (SPLI, n.d.)

Although used in Italian houses as an extension of the outdoors, this approach was almost unique in America. (Edith Wharton employed a similar device at "The Mount," her house in Lenox, Massachusetts, which was originally conceived by Codman but carried out by Francis L.V. Hoppin.)

The plan for the Maynard house, like the one for the Bryce house, is a modified H, with a service wing extending to one side to form a courtyard. A considerable debate developed between architect and client as to how to provide sufficient light and air for the functional demands of this service area without disturbing the overall aesthetic concept of the total scheme. A trellis placed along the wall to obscure additional windows provided the solution.

The interior of the house fulfills the requirements set forth in *The Decoration of Houses.* As in other Codman houses, the fixtures, hardware, and mantels were imported from France. The gold and black Directoire boiserie in the library

came from a French château. The French antique furnishings acquired by the Maynards during many buying trips reflected the concurrence of taste between the architect and client. When Edith Wharton made her last visit to America in 1923 to receive a doctorate of letters from Yale University, she stayed at "Haut Bois," and was enchanted to find that her friends had created a truly French atmosphere on this side of the Atlantic.

In keeping with the French style throughout the house, the garden was designed by the noted French landscape architect and planner Jacques Gréber. He maintained the harmony between house and garden by means of a simple axial vista, which led from the steps of the house past borders of clipped boxwood and flower beds and terminated with a pool and fountain. Gréber worked on several other gardens on Long Island, notably at "Harbor Hill," the Clarence Mackay estate, the Edgar Luckenbach estate at Sands Point, and the Phipps estate in Old Westbury.

Walter Maynard died in 1925, enjoying "Haut Bois" for only eight years. After the death of his widow, the house was sold to opera star Patrice Munsell and subsequently to its present owners. The house remains structurally unaltered, although paint now obscures the exterior detailing and a swimming pool has replaced the reflecting pool and fountain in the garden.

Pauline C. Metcalf

Marian C. Coffin, 1876–1957

Between 1890 and 1930, landscape design in the United States changed considerably, in both style and professional practice. The picturesque style of landscape gardening that had been so dominant during the 19th century gave way to an interest in formal design, inspired by French and Italian gardens. Though the plant-collecting mania remained strong, botanical display once again became subservient to design. Similarly, the taste for exotic plants was balanced by a new interest in native species more suited to their climate.

With this attitudinal change came a shift of professional energy from the public to the private sphere and a new understanding of landscape architecture as a legitimate design profession. During this period, too, a large number of women entered the profession, exerting their collective influence on the development of American landscape design. One of the most important of these pioneers was Marian Cruger Coffin, who was responsible for several major commissions on Long island.

In the lakefront community of Geneva, New York, where Coffin spent most of her childhood among wealthy relatives, she met many prominent families and developed a life-long friendship with Henry F. du Pont. These friendships would stand her in good stead in her professional life.

Having decided to be a "landscape gardener,"[1] Coffin enrolled at M.I.T. as a special student in 1901, graduating in 1904, one of only four women among 500 students.[2] Since most landscape architects still refused to hire women, she opened her own office in two small rooms in New York City.[3]

The times were favorable for such an undertaking, for the wealthy had developed a taste for "a country place," and the services of architects and landscape designers were much in demand. Coffin's social contacts gave her access to many prospective clients and an abundance of personal recommendations.

In the years following World War I, requests for residential work poured into her office;[4] she executed the majority of her commissions between 1918 and 1930. Most of the gardens she created were located in New York City's fashionable suburbs of Westchester and Long Island, and in the country-house communities of Connecticut and New Jersey. This extensive residential work established her reputation as one of the most notable landscape architects on the East Coast. Although she continued to work until the end of her life, her career never again achieved such heights. As a result, the Long Island gardens provide an excellent example of the work Coffin carried out at the peak of her career.

Coffin's Long Island commissions were principally in two locations: in the Hamptons on the easternmost part of the south fork, and on the North Shore between Oyster Bay and Roslyn. Although it is difficult to generalize about the style of these commissions, certain design qualities remain constant throughout Coffin's work.

Among such persistent elements is a certain formality or classicism. Even Coffin's most naturalistic gardens are orderly and readily understandable. Constant, as well, was her display of a painter's sensibility, her subtle color modulations and contrasts. Yet, without a doubt, the two surest indications of her hand was her "attention to the grand scheme" and an unflinching "sense of appropriateness." The former quality represents a commitment to the overall design and to the third dimension, considerations often lacking in the work of her contemporaries. Coffin's only book, *Trees and Shrubs for Landscape Effects,* addresses these issues.[5]

Coffin was not afraid to take her inspiration from the site, the "genus loci," even if that demanded a rather unconventional solution. In *Trees and Shrubs,* she distinguished five types of houses: English Cottage; Derivative ("of distinct European, French, Italian or Spanish design"); Colonial or Georgian; Suburban; and Rural. She then presented the important elements of landscape design and discussed their appropriate application to each of the five house types. Her Long Island commissions demonstrate some of these distinctions.[6]

Charles H. Sabin Estate, "Bayberryland," Southampton, Landscape Design, 1919

Of the Hampton commissions, Coffin's most refined design was for the Sabin estate, whose house had been designed by Cross & Cross in the English Cottage mode, evoking the work of C. F. A. Voysey and the English Arts and Crafts movement. In keeping with what she termed the "picturesque porches, gables, and other irregularities"[7] of this type of architecture, Coffin created a landscape scheme that incorporated several small gardens, each different in mood, style, and function, yet axially related to some part of the house and integrated with one another through a careful circulation system. The center of the design is the great lawn. To the east is an Italianate terraced garden, a tour de force of formal design and naturalistic planting in the style of Gertrude Jekyll. These are separated by a "wild" garden with overgrown

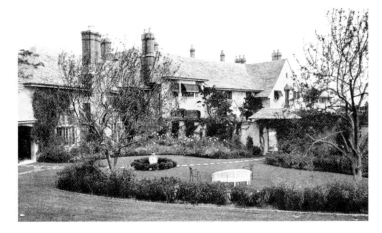

Marian C. Coffin: Sundial Garden, "Bayberryland," Charles H. Sabin Estate, Southampton, 1919 (PATT, 1924)

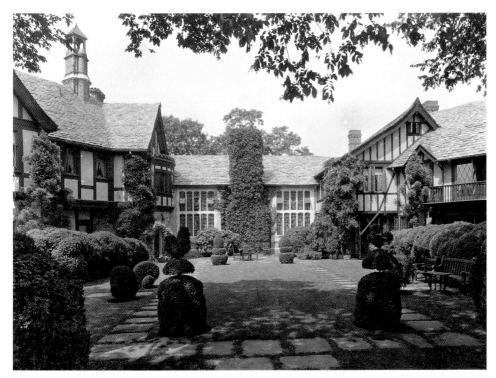

Marian C. Coffin: Boxwood Allée, "Hillwood," Edward F. Hutton Estate, Wheatley Hills, 1921 (HEWI, 1924)

estate of her childhood friend Henry F. du Pont,[8] Coffin reportedly had her client buy a farm in New York, all of whose topsoil was trucked to Long Island to transform a salty site.[9] Her plan also called for the creation of a large sand dune, a sea wall, and plantings appropriate for dunes, including sea grasses and black pines.

Edward F. Hutton and Marjorie Meriwether Post Estate, "Hillwood," Wheatley Hills, Landscape Design, 1921

The estate designed in western Long Island for New York stockbroker Edward F. Hutton by Hart & Shape is an excellent example of what Coffin termed "Derivative," being in the Tudor style popular for American country estates. It is a rambling, half-timbered structure, deliberately asymmetrical, with picturesque gables and leaded casements. As she recommends in *Trees and Shrubs,* Coffin's garden scheme was in keeping with the "lines of the building" and "in the character of its derivative style."[10] The elaborate plan evoked English Manorial precedents and echoed the scale and grandeur of the house. Typically, Coffin created a number of discrete, yet interrelated garden units. Principal elements included the double allée of boxwood and magnolia backed by a cedar hedge, creating a distinctive, dignified effect that set the tone for the entire landscape scheme, including the covered brick rose arbor that oriented the garden in an east-west direction and defined its southern limit. Though delicate in its planting, the massive piers and sturdy arches of this construction provided an appropriately architectural counterbalance to the substantial manor house which defined the northern limit of the garden. Given Coffin's sensitivity to the dictates of place and to the importance of sculptural form, a topiary garden was added at the south end of the house, this form of planting having come to be considered particularly appropriate for American country houses in the Tudor style.[11]

borders of tritoma and low, gray foliage plants that line a path to the sea. Other principal gardens are the formal rose garden to the south and the more picturesque sundial garden to the east. The whole is brilliantly integrated through subtly placed paths and openings.

Albert B. Boardman Estate, "Windswept," Southampton, c. 1930

W. W. Benjamin Estate, East Hampton

Henry F. du Pont Estate, Southampton

Other commissions of note in the Hamptons included Coffin's design for the estate of New York lawyer Albert B. Boardman (c. 1930). This was a rather informal garden for a rambling house of brick and half-timber. For the W. W. Benjamin residence Coffin developed a much more architectural garden that derived definition from rigidly edged pools, carefully shaped hedges, and well-placed sculptures. For the

Childs Frick Estate, "Clayton," Roslyn, Landscape Design, c. 1919

One of Coffin's principal commissions in western Long Island was for prestigious client Childs Frick. The son of Pittsburgh steel magnate and notable art collector Henry Clay Frick, Coffin's client was a paleontologist and a philanthropist in his own right. In 1917 he acquired the Roslyn residence built for Lloyd Bryce around 1901 by Ogden Codman, Jr. The new owner hired the English architect Sir Charles Carrick Allom to

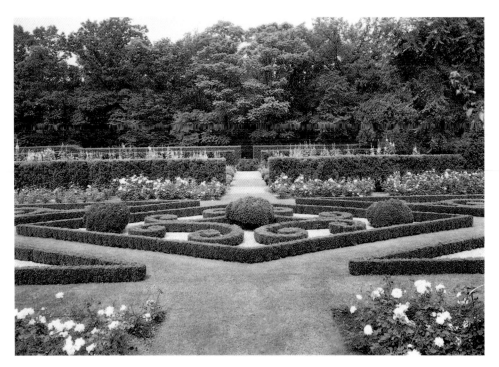

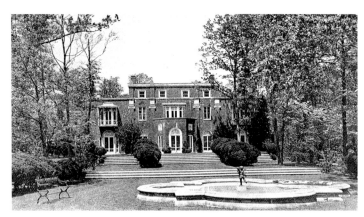

Marian C. Coffin: Rose and Boxwood Garden, "Clayton," Childs Frick Estate, Roslyn, c. 1919 (GOTT, 1931)

Marian C. Coffin: "Goose Point," Irving Brokaw Estate, Mill Neck, c. 1930 (ARAT, 1931)

area decoratively paved in various colored flagstones—interrupted the walkway as it crossed the carriage road. Appropriately, a strong sense of procession pervades the design.

Marshall Field III Estate, "Winter Cottage," Lloyd Harbor

Harry Benkard Estate, Oyster Bay, Landscape Design, c. 1919

While engaged on the Hutton and Frick estates, Coffin also worked on several neighboring commissions. For the Lloyd Harbor estate of publishing magnate Marshall Field III, she designed a planting scheme for the fieldstone hideaway known as "Winter Cottage," one of several cottages on Field's large estate. The design is basically simple, a circular area of lawn enclosed by hedges and focused by a centrally placed statue of Pan.

For the Oyster Bay estate of Mr. and Mrs. Harry Benkard, she developed a similarly simple, yet elegant solution in the form of a three-tiered terrace garden that permitted changing experiences and moods within the confines of a rather small site. As ever, the relationship to the reserved Colonial architecture was critically maintained.

Irving Brokaw Estate, "Goose Point," Mill Neck, Landscape Design, c. 1930

Perhaps Coffin's last work on Long Island was for the socially prominent New Yorker and former national figure-skating champion Irving Brokaw. For the grounds of his Georgian Revival house, Coffin created a rather architectural garden defined by hedges and allées, clearly delineated pools, subtle changes in level, and strategically placed sculpture.

With the onslaught of the Great Depression, estate building on a large scale declined. Thereafter, Coffin focused on smaller suburban gardens or public projects like botanical gardens and college campuses. The Long Island commissions therefore assume particular importance, providing an excellent measure of Coffin's work at the peak of her career. They embody the design principles that, from 1918 to 1930, inspired the creation of more than 50 estate gardens, and established her reputation as an important figure in the history of American landscape design.

Jeanne Marie Teutonico

alter the house and retained Coffin soon thereafter to develop a comprehensive landscape plan.

Commenting on the commission for what was essentially a Georgian Revival residence, Marian Coffin noted that this type of building "simply cries out for restraint in treatment,"[12] and created a formal French parterre garden for the Fricks. Grand in scale but appropriately lacking in exuberance, it consisted of four discrete parterres, separated by boxwood and yew hedging, organized about a central axis that terminated on the north in a magnificent teak trellis, designed in 1930 by the architects Henry O. Milliken and Newton P. Bevin. Each parterre was meant to contain a different type of planting, with the beds organized into elaborate geometrical patterns of clipped boxwood laid in gravel, a clear reference to the 17th-century gardens of French royalty. A picturesque brick walkway lined with several varieties of flowering trees and shrubs connected the garden to the house. An astragal garden—basically a circular

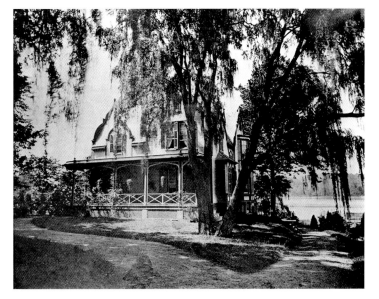

Frederick S. Copley:
"Clifton," Anna Eliza Cairs
Residence, Roslyn Harbor,
1863 (ROSL, C. 1890)

■

Frederick S. Copley, practiced 1860s

An artist, architect, and protégé of the poet
William Cullen Bryant, Frederick S. Copley
designed one of the earliest country houses on
Long Island. A floor plan and description of the
house appeared in 1865 in *Woodward's Country
Homes* and in *The Horticulturalist,* originally
published by Andrew Jackson Downing, the
well-known landscape architect. In 1863 Anna
Eliza Cairs, a neighbor of Bryant's in Roslyn,
commissioned Copley to design a residence
which she intended as a future home for one
of her grandchildren. Situated on the west bank
of Roslyn Harbor, "Clifton" is a two-and-a-
half-story house with unusual Flemish gable
ends and Gothic Revival detailing. The steeply
pitched, slate-roofed house was originally flush-
boarded and painted to look like stone. An
elaborate porch and windows are capped with
Tudor arches. From 1876 until 1917 the house was
occupied by Mrs. Cairs's grandchild Blanche
Willis and her husband, William Helmsby Em-
ory. Two of the subsequent owners have made
alterations to "Clifton," which is being sympa-
thetically restored by its current owners.

Carol A. Traynor

*Portrait of George A.
Crawley* (1919), by Sir
Oswald Birley (British,
1880–1952) (Collections of
Old Westbury Gardens,
Herbert Spiselman photo)

■

George Abraham Crawley, 1864–1926

Old Westbury Gardens (formerly "Westbury
House") is the single remaining work in Amer-
ica by this London designer and connoisseur.
How George Abraham Crawley obtained the
commission and what he did with it form an
intriguing subchapter in the larger story of
Anglo-American cultural relations at the be-
ginning of the 20th century.

When steel magnate Henry Phipps retired
in 1901, he began to direct his attention both
to a greater involvement in philanthropies and
to the construction of a residence in Manhattan.
That same year his son John Shaffer "Jay" Phipps
(1874–1958) purchased at Westbury over 175 rol-
ling acres of land that until that time had been
composed of a number of self-sufficient Quaker
homesteads, complete with farmhouses.[1]

It had been the custom of the Phipps family
to lease homes in Great Britain for part of each
year, and it was during one of those visits that
Jay met Margarita "Dita" Celia Grace (1876–
1957), one of Edwardian society's "Three Graces,"
whose father was the co-founder of the Grace
shipping line. Their marriage took place in
November 1903.

In 1903 George Crawley was among the
house guests at Beaufort Castle, Henry Phipps's
rented home in Scotland. Phipps had brought
with him Trowbridge & Livingstone's plans for
his white-marble mansion under construction
at 1063 Fifth Avenue, several blocks south of the
home of his friend and former partner Andrew
Carnegie. The client and his architects disagreed
as to how the house should be finished. Crawley
reportedly "threw himself heart and soul into
all of the details" of the plans under discussion
and so impressed his host that Henry Phipps
invited him to come and inspect the new town-
house.[2] Crawley accepted, and shortly thereafter
was commissioned to complete the work. When
Crawley returned to England, he revised the
plans and assembled a team of craftsmen and
decorators to assist him in the project. Chief
among his associates were the decorative painter
A. Duncan Carse, the sculptor Francis Derwent
Wood, the antique metals dealer Starkie Gard-
ner, and fledgling architect Alfred C. Bossom.

Recently married, and living in England, Jay
Phipps functioned as his father's agent. He devel-
oped an affectionate respect for Crawley and sug-
gested that the latter design a country home on
the family's Westbury property. While a Quaker
farmhouse might function quite adequately as
bachelor quarters, it was deemed unsuitable for
the new English bride and the family to follow.

The initial design of "Westbury House," a
manor in the style of Charles II, began to take
form in late 1904.[3] Since Crawley had received
no formal architectural training, outside tech-
nical expertise was required to translate his
ideas into scale drawings and workable plans.
The choice fell on Grosvenor Atterbury (1869–
1956), a registered American architect trained
in Paris. Then at the threshold of what would
become a distinguished career, Atterbury al-
ready had several Long Island homes to his
credit and his acquaintance with the Phipps
family was established.[4]

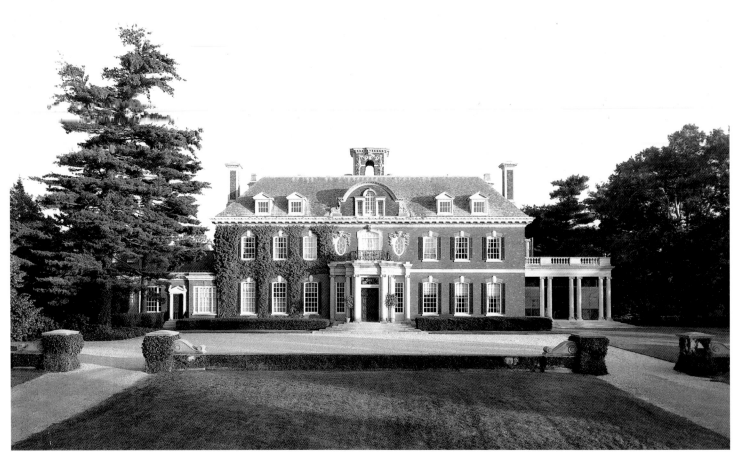

George A. Crawley, in collaboration with Grosvenor Atterbury: North (Front) Facade, "Westbury House," John S. Phipps Residence, Westbury, 1905–07 (Old Westbury Gardens, Richard Cheek photo, 1981)

George A. Crawley, in collaboration with Grosvenor Atterbury: Floor Plans, "Westbury House," John S. Phipps Residence, Westbury, 1905–07 (Old Westbury Gardens)

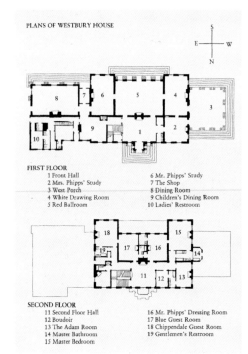

PLANS OF WESTBURY HOUSE

FIRST FLOOR
1 Front Hall
2 Mrs. Phipps' Study
3 West Porch
4 White Drawing Room
5 Red Ballroom
6 Mr. Phipps' Study
7 The Shop
8 Dining Room
9 Children's Dining Room
10 Ladies' Restroom

SECOND FLOOR
11 Second Floor Hall
12 Boudoir
13 The Adam Room
14 Master Bathroom
15 Master Bedroom
16 Mr. Phipps' Dressing Room
17 Blue Guest Room
18 Chippendale Guest Room
19 Gentlemen's Restroom

At least at the outset, the relationship between Crawley and Atterbury was conflicted, since Crawley was compelled to rely upon a French-trained architect with experience not wholly attuned to the idiosyncratic nature of what he proposed.[5] However, through the intercession of Jay Phipps, a clear division of responsibility was eventually achieved. Simply stated, the plan, elevation, and decorative details are Crawley's and all technical matters were resolved by Atterbury.[6] Once this fundamental decision was made, work progressed smoothly. Atterbury was to be rewarded for his cooperation and contribution with additional commissions from the Phipps family.[7]

Construction on "Westbury House" began in July 1905, and by year's end, the exterior walls and three-quarters of the roof were completed. The walls were built of handmade Virginia clay bricks laid in a "double diamond" diaper pattern. At Crawley's insistence, honey-toned limestone was imported from Rutland, in the English Midlands, to be used for the roof tiles.

In 1906, the doorway on the north and most of the interior, with the exception of the front hall, were finished. Above the door is inscribed "PAX. INTROENTIBUS. SALUS. EXEUNTIBUS" or "Peace on those who enter / Godspeed to those who depart."[8] The family, now including three children (joined eventually by a fourth), moved into the house in March 1907, but it was not

George A. Crawley, in col-
laboration with Grosvenor
Atterbury: Second Floor
Hall, "Westbury House,"
John S. Phipps Residence,
Westbury, 1905–07 (Old
Westbury Gardens, Richard
Cheek photo, 1980)

George A. Crawley: Garden
Looking North, "Westbury
House," John S. Phipps
Residence, Westbury,
1905–07 (Old Westbury
Gardens, Richard Cheek
photo, 1980)

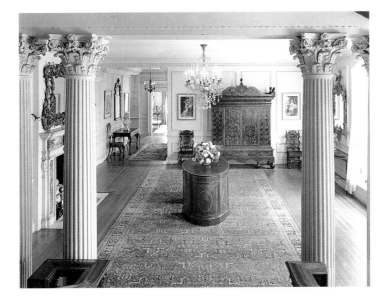

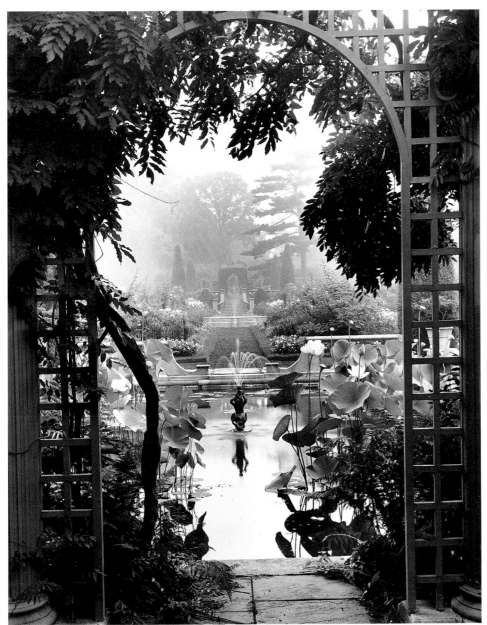

until 1910 that the Derwent Wood carvings for the hall were finally installed. Crawley's associates—Carse, Derwent Wood, Gardner, and others—all played active roles in the "Westbury House" interiors.

Crawley was also involved in landscaping the property, including the construction of a polo field (1905),[9] tennis courts (1906), and a rose garden (1907). A walled garden, complete with latticework and corner pavilions, was constructed in 1907.

In 1909, shortly after the family moved in, an adjoining kitchen and servants' wing was added, designed by Philadelphia architect Horace Trumbauer. He returned a decade later to make extensive alterations within "Westbury House."[10] Later still, he directed the expansion of the red drawing room into a ballroom.

In 1915, a combination playroom and classroom was added to the southeast corner of the house behind an exterior faced in limestone. This room achieved its final form in 1927, after the boiserie and fittings from the Crawley-designed dining room of Henry Phipps's Manhattan townhouse were reconstituted in this space to create a new dining room for "Westbury House."[11]

Although Crawley continued to remain in favor with his American clients, Jay Phipps did not hesitate to seek the expertise of others. Crawley's 1918 proposal for a swimming pool, for example, was discarded in favor of one by Boston architect Paul R. Smith and, although Crawley prepared additions to "Casa Bendita," the family's oceanfront villa in Palm Beach, it was Addison Mizner who had received the initial commission for the house. Crawley's last work in America was to expand the one-bay west porch at "Westbury House" into three bays, glazing it with hydraulic windows and creating what all agree is one of the most pleasant rooms in the house. He did not live to see the area beyond the west porch developed.[12] The steps leading down to the west pond and the formal boxwood garden on the far shore were executed after Crawley's death by White/Allom & Co. in 1928.

Mr. and Mrs. Phipps enjoyed "Westbury House" for over half a century. At their death, their children arranged to have the property converted to public use; in 1958 over 70 acres of land, rechristened "Old Westbury Gardens," became one of Long Island's most popular attractions—a place of natural beauty and a monument to a way of life shared by a very few for a very short period of time.[13]

Jethro Meriwether Hurt III

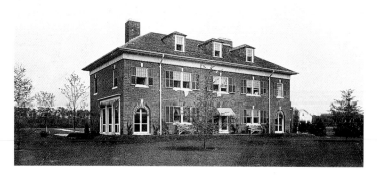

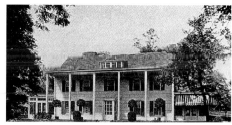

Cross & Cross: Rear Facade,
"Crickholly," H. B. Hollins,
Jr., Residence, Islip, c. 1907
(VAND, n.d.)

Cross & Cross: Front
Entrance before Alterations,
F. S. von Stade Residence,
Westbury, c. 1914 (ARTR,
1915)

Cross & Cross: Front
Facade, Mrs. Herbert M.
Harriman Residence,
Jericho, 1915 (SPLI, n.d.)

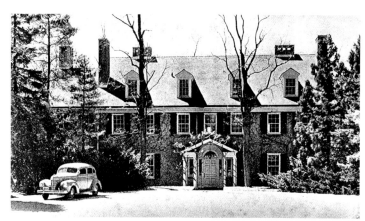

Cross & Cross, 1907–1940
John Walter Cross, 1878–1951
Eliot B. Cross, 1884–1949

Self-assuredly elegant, the work of brothers John
Walter Cross and Eliot B. Cross, and their stand-
ing as members of "Old New York Society," made
for an especially fashionable practice. Born at the
family summer residence in Orange, New Jersey,
the brothers grew up at 6 Washington Square
North, in New York City.[1] Following prepara-
tory school, John attended Yale University, Class
of 1900, and Eliot Harvard University, Class of
1906. Deciding to become an architect, Eliot
left his postgraduate engineering course to study
abroad, where John was already enrolled at the
Ecole des Beaux-Arts in Paris. After they re-
turned from Europe in 1907, the Cross brothers
formed the partnership of Cross & Cross. While
John Cross was more often involved in design,
Eliot established real estate interests, including
the development firm of Webb & Knapp in
1922. This sideline brought a certain amount
of work to Cross & Cross, when, for example,
Eliot headed the syndicate that developed
Beekman Place. Most of their jobs, however,
came via the brothers' extensive social network.
John had married the popular debutante Lily
Lee Page in 1909.[2] Thirteen years after her death
in 1920, he married Katherine Hoyt Mather, the

widow of a Cleveland millionaire. Eliot married
Martha McCook of Tuxedo Park in 1921.

The Cross brothers and their families were
popular. They belonged to select clubs, and the
greatest accomplishments of their firm—the
design of structures no less discreet than stylish
—reflected the primary concerns of their elite
clientele. From the Georgian Revival-style Links
Club (1917) to an apartment house in the same
mode at 1 Sutton Place designed in 1926 in asso-
ciation with Rosario Candela, their work con-
veyed a sense of dignity. In spite of a crown of
stylized radio waves, their Art Deco RCA Tower
(1931, now the General Electric Building) so
complements Bertram Goodhue's St. Bartholo-
mew's Church behind it, that the office building
almost functions like an enormous campanile.
In the Citibank-Farmers' Trust Building (1931),
the firm combined Art Deco and Greek Revival
elements, a mode repeated in its final work, the
Tiffany & Company Building (1941).

"Crickholly," the firm's first Long Island
country house, was built at Islip for Harry B.
Hollins, Jr., a partner in the investment firm
of H. N. Whitney, Goadby & Co. This modest
c. 1907 Georgian Revival brick house was not a
particularly successful design. Of more interest
was the firm's 1914 shingled residence, built on
an L-shaped plan, for noted sportsman and
polo player F. Skiddy von Stade, Sr., in the Mt.
Vernon mode. Less than a year later, the firm
produced another variation on a Colonial theme
at Jericho for Mrs. Herbert M. Harriman.

A rambling Colonial Revival house, designed
for Mr. and Mrs. Edward Moore at Old West-
bury, was completed around 1920. For recreation,
industrialist Moore raised horses in Lexington,
Kentucky, and cattle in Wyoming. Like the
Cross brothers, he was a member of the fashion-
able Links Club and the Racquet and Tennis
Club. His Westbury residence was a version of
the shingled farmhouses that populated Long
Island in the Colonial period.

Colonial architecture particularly appealed to
the Cross firm's client, Henry Francis du Pont,

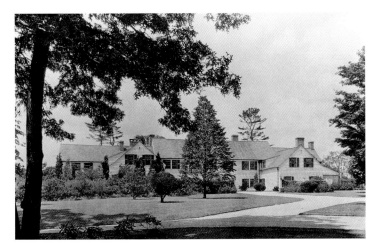

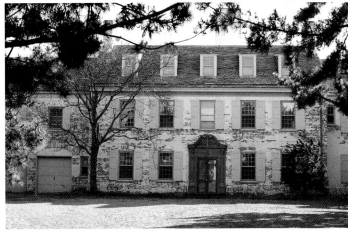

Cross & Cross: Entrance Drive and Front Facade, Edward S. Moore Residence, Old Westbury, c. 1920 (HEWI, n.d.)

Cross & Cross: Front Facade, "Chestertown House," Henry F. du Pont Residence, Southampton, 1925 (SPLI, n.d.)

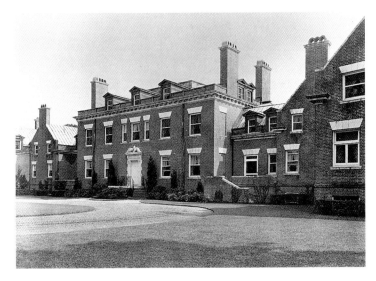

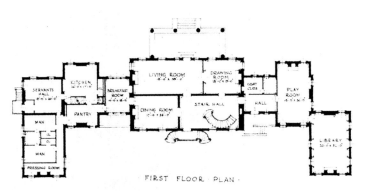

Cross & Cross: Front Facade, Eliot Cross Residence, Westbury, c. 1927 (HEWI, n.d.)

Cross & Cross: First Floor Plans, Eliot Cross Residence, Westbury, c. 1927 (PREV, n.d.)

the nation's preeminent collector of early American decorative arts. Famous for collecting actual period rooms, he transformed his father's Gilded Age Delaware château, Winterthur, into a museum to house his extraordinary collection. In 1925, desiring a retreat by the sea, du Pont commissioned Cross & Cross to build "Chestertown House" on the Ocean Road at Southampton. With 50 rooms, plus 20 additional rooms in a two-and-a-half-story garage and service building across the street, "Chestertown House" was the firm's largest Long Island

commission. Here, Cross & Cross's use of Colonial detailing became more academic. For their antiquarian client, the Cross brothers employed such 18th-century features as paneled shutters, shed dormers, 12-over-12 sash windows, and a Connecticut Valley–inspired doorway. The extent of this sizable structure is cleverly concealed on the north (public) facade, while the pleasing scale and whitewashed brick facade made "Chestertown" one of the firm's most successful country houses. The estate was extensively landscaped by Marian C. Coffin.

For the Cross brothers and their clients, a country house for use on weekends and in the summer was an essential element of a well-ordered existence. For many years, the Crosses gathered at their parents' New Jersey summer place. In 1925 Eliot Cross acquired the H. P. Bingham estate at Westbury. Originally built for Perry Tiffany in 1891, this substantial brick Georgian Revival house, designed by Gage & Wallace, was strictly symmetrical; a huge Ionic portico graced the garden front, while distinctive marble window cornices further enhanced the design. Dependencies included both a gate lodge and a U-shaped stable and garage structure. The latter building, with stalls for 30 horses and space for five cars, was altered by Cross, who added a portico that echoed the house. Inspired by Tidewater mansions such as "Westover" and "Carter's Grove," the existing house was raised on a high basement. In contrast to the wings, the center portion was two-and-a-half stories. Cross added two additional flanking wings to form a U-shaped configuration. He also replaced the porte cochere with a graceful double flight of steps and a broken pedimented door. On the interior, the most prominent alteration was the creation of a large two-story hall with a freestanding spiral staircase. When the remodeling was finished, Eliot Cross's summer house had a dozen fireplaces and as many servants' rooms.

Like the firm's Georgian and Colonial Revival buildings, the three manor houses Cross &

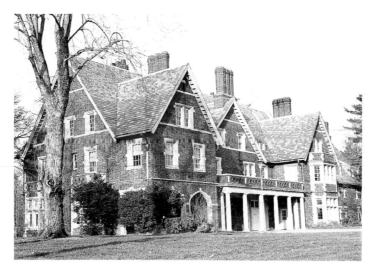

Cross & Cross: Front Facade
and Entrance Drive,
"Woodbury House," J.
Watson Webb Residence,
Syosset, c. 1915 (Nassau
County Planning
Department, 1970)

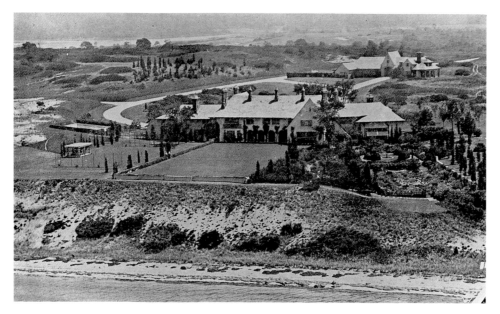

Cross & Cross: Garden Side
with Garage Complex in
Background, "Bayberryland,"
Charles H. Sabin Residence,
Southampton, 1919 (ELWO,
1924)

Cross & Cross: Front
Facade and Entrance
Courtyard, "Bayberryland,"
Charles H. Sabin Residence,
Southampton, 1919 (HEWI,
n.d.)

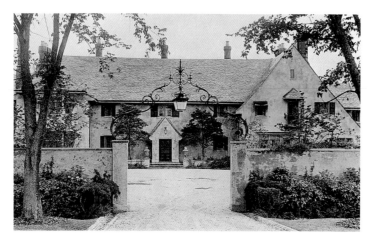

Cross & Cross: Rendering
of Entrance Front,
"Rivington House," Percy
R. Pyne II Residence,
Roslyn, c. 1927 (COUN,
1927)

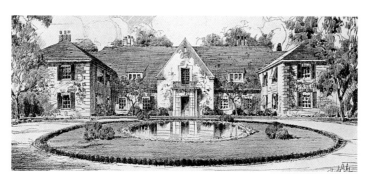

Cross built on Long Island, though derivative, never replicated period styles. Only the first of these, built at Syosset in 1915 for Eliot's business associate, the celebrated polo player J. Watson Webb, could be called Tudor Revival. Yet, English manor houses were the inspiration for all three of them. Of this group, "Bayberryland," built in 1919 for Charles H. Sabin, chairman of the Guaranty Trust Company of New York, was the most successful and widely published.[3] Set in the Shinnecock Hills, the estate was laid out by Marian C. Coffin. The ample garage and service group acted as a gate lodge through which one drove to reach the house. From a large, walled forecourt on the entrance front, one faces a long, low-gabled facade of gray-green stucco. Occasional stone trim, as in the quoined entrance, fanciful twisted brick chimney stacks with pots, and shutters add notes of color. Purposely constructed with sags, the great stone roof of inch-thick slate tile provides further variety. As in several other Cross & Cross houses, the hall at "Bayberryland" is reached through an entrance below the stair landing, from which two staircases descend. Seemingly meant to convey the evolution of the house, the majority of the rooms were crisply detailed with Georgian ornament, creating a harmonious environment for the Sabins's superlative collection of antiques.

For its last residential commission on Long Island, Cross & Cross had a client well-suited to appreciate the exactitude of the firm's design. Percy R. Pyne II grew up on Park Avenue in a house designed by McKim, Mead & White. "Rivington House," his residence at Roslyn, modeled on a late-Stuart manor house, was landscaped by Beatrix Farrand and James L. Greenleaf. The scale of the house is deceptive, with a one-and-a-half-story central section imparting an intimate scale to the whole. However, the house contains 30 large rooms replete with 15 marble mantels. The E-shaped plan, with a transverse gabled entrance in stone, was flanked by two-story, hipped-roof wings constructed of Flemish-bond brickwork and quoins. Because of the low lines of the central part of the house, the hall, planned for use as a ballroom, takes one by surprise. As at the Sabin house, one enters below the broad landing of the staircase.

Michael Adams

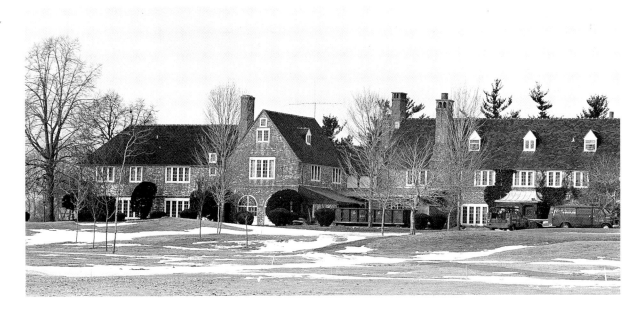

Robert Crowie: Rear
Facade, "Appledore," Henry
P. Davison, Jr., Residence,
Brookville, c. 1926 (SPLI,
1983)

Robert Crowie, practiced 1920s

No biographical information has come to light
about the architect of "Appledore" in Brookville
(not to be confused with the residence of the
same name designed by Archibald M. Brown
for Hiram Dewing in Locust Valley in 1928).
Henry P. Davison, Jr., a banker and vice presi-
dent of Morgan Guarantee Trust Co., commis-
sioned Robert Crowie to build this large and
rambling Tudor-style house. The estate on
which it stands was sold to the Mill River Club
in 1964, and it now serves as a country club.

Carol A. Traynor

George B. de Gersdorff, b. 1866

Educated at Harvard University and the Ecole
des Beaux-Arts in Paris, George B. de Gersdorff
worked in the offices of McKim, Mead &
White for eight years before going into private
practice. De Gersdorff established a national
reputation for designing America's first concrete
stadium for his alma mater Harvard in 1903.
His only known Long Island commission,
"Sunken Orchard," was built around 1914 at
Oyster Bay for Fay Ingalls, a lawyer who had
founded the firm of Holter, Ingalls & Guthrie
in 1912. This Georgian-style brick house was
curiously truncated, consisting of a main mass
with an off-center large projecting bay and one
flanking wing. The landscaping was done by
the firm of Innocenti & Webel. The house was
later extensively remodeled: the central section
was enlarged and a balancing bay and west wing
added. The fenestration was also altered at this
time. The attribution for these alterations is
unclear, although it is likely that de Gersdorff
was involved, as he is still listed as the architect
in the 1928 book *Country Homes* (published by
Eliot C. Brown & Co.). Around that time
minor alterations were made by architect James
W. O'Connor for subsequent owners, Mr. and
Mrs. Charles McCann. O'Connor also designed
a large playhouse, pool, and indoor tennis court
for the estate, now owned independently of the
house. Today the house survives as a private res-
idence, although the west wing was removed in
the 1960s. The sunken orchard, for which the
estate was named, also survives.

Wendy Joy Darby

George B. de Gersdorff:
Front Facade, "Sunken
Orchard," Fay Ingalls
Residence, Oyster Bay, 1914
(GOTT, 1936)

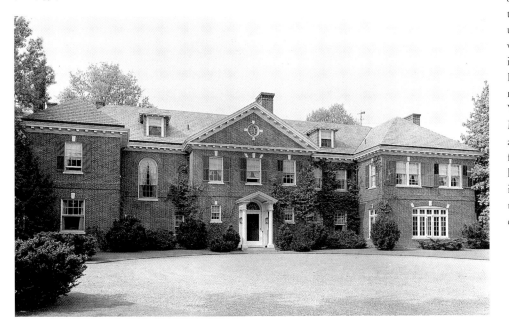

d'Hauteville & Cooper:
Entrance Court,
"Greentree,"
William Payne Whitney
Residence, Manhasset, 1903
(TOWN, 1917)

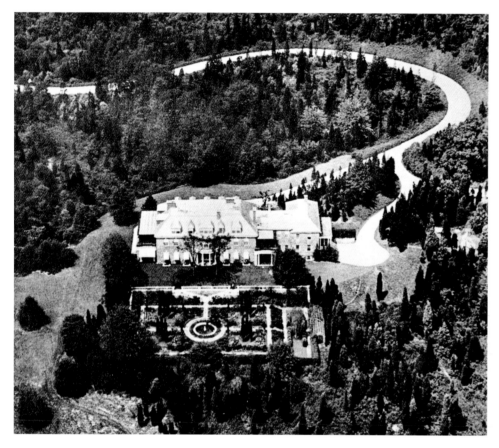

d'Hauteville & Cooper:
"East Woods," Henry
Rogers Winthrop Residence,
Woodbury, c. 1910 (COUN,
1923)

d'Hauteville & Cooper, practiced c. 1903–1916

The peak of country-house construction on Long Island between 1900 and America's entry into World War I was characterized by the sudden emergence of a number of small, talented architectural firms that would disappear just as rapidly with the onset of hostilities and the virtual cessation of building activity. d'Hauteville & Cooper was such a firm, and while nothing is known of P. G. d'Hauteville, a notion of James E. Cooper's early career can be gleaned from his 1920 membership application to the American Institute of Architects. Born in Rockville,

Maryland, Cooper was first employed as a draftsman when he was 16 in the Baltimore office of Baldwin and Pennington, while studying architecture at the Maryland Institute. Soon finding "the possibilities exhausted," he moved to New York. As a draftsman for Warren and Wetmore he worked on that firm's New York Yacht Club and Belmont Hotel commissions, while augmenting his training in the Manhattan ateliers of Masqueray and Hornbostel. Although he qualified for the Paris Prize competition, Cooper was not able to compete, since he had begun to practice on his own. Later, he entered into partnership with d'Hauteville. In addition to its Long Island work, the firm of d'Hauteville & Cooper designed residences for Henry and Fitzhugh Whitehouse, Munson Morris, and Joseph Laroque, the last in Bernardsville, New Jersey.

During the war, Cooper worked for the Bureau of Standards, then spent a brief stint in Scranton, Pennsylvania, before moving to Washington, D.C., in 1921. There he designed residences, bakeries, and stores. However, he appears never to have regained the status he enjoyed in his prewar career.

The Long Island country houses d'Hauteville & Cooper designed for William Payne Whitney and Henry Rogers Winthrop show considerable talent. The L-shaped Dutch Colonial house for William Payne Whitney in Manhasset, built in 1903, was an unpretentious shingle and fieldstone retreat with an inventive floor plan and fenestration. "Greentree" enclosed and opened on a garden, designed by Boston architect Guy Lowell, in which the gradual transition from interior to exterior was governed by covered piazzas and pergolas. Later the home of John Hay Whitney, the house survives in a somewhat altered state.

Only an aerial view survives of "East Woods," the hipped-roof, Georgian-style house that the firm designed for investment banker and society leader Henry Rogers Winthrop in 1910. The house appears to have been built of brick and, once again, the landscaping was the work of Guy Lowell. This may well explain why Lowell was asked to landscape the Piping Rock Club in 1911, since Henry Winthrop was the club's first president. Collaterally, the Winthrop commission may have come to d'Hauteville & Cooper as a result of their work for the Whitehouse brothers, since Henry Winthrop was a senior partner of Winthrop, Whitehouse & Company.

Robert B. MacKay

William A. Delano,
1874–1960 (COUN, 1927)

Delano & Aldrich, 1903–1940
William Adams Delano, 1874–1960
Chester Holmes Aldrich, 1871–1940

In November 1928, in recognition of the 25th anniversary of one of America's leading architectural firms, *Time* magazine evoked the setting of Delano & Aldrich's best-known work: *Stretched eastward from Manhattan in the shape of a candle flame lies Long Island. Here in a country made for pleasure, live socially minded persons who dart to their diversions along concealed and crooked trails, inserted through the woods or strewn upon the shore. Their houses, lying between hills or built above bright beaches, are walled with forests and reticent behind curling drives. Who builds them and makes them beautiful?*[1]

Two years later, in a rare cover story devoted to an individual architect, *Time* wrote about William Adams Delano: "He paints watercolors for diversion, jots down architectural sketches during his morning train ride from his home in the D. & A.-dotted Long Island countryside." The article also characterized the firm's work: "D. & A. designs are never spectacular. Praised by other architects for their finesse, their nicety in detail, their discreet erudition, they may be truly said to constitute an architectural aristocracy."[2] Confirming this judgment was an article by A. Lawrence Kocher in the *Architectural Record:* "Mr. William A. Delano more than any other American architect has set the style for country residences on Long Island."[3]

From the vantage point of over a half-century later, the assessment of these writers appears remarkably correct. Delano & Aldrich's country houses, and specifically the firm's Long Island designs, remain some of the most interesting and talented work of the 1910s and 1920s. The work of Delano & Aldrich ranks with the earlier work of McKim, Mead & White or Alexander Jackson Davis, as the best of its time. From about 1910, Delano & Aldrich was *the* quality country-house architectural firm in the United States, and while the focus of its work was on Long Island, it also designed country houses for more distant venues like Cleveland, Lake Forest, Charlottesville, and Santa Barbara, as well as for many other sites throughout the Northeast. The firm's clients were a virtual roll call of American wealth and society: Astor, Burden, Havemeyer, Kahn, Lindbergh, Pratt, Rockefeller, Straight, Vanderbilt, Whitney, and many more. Indeed, its eminence in the country-house field was so great, that even during the Depression when many of the firm's competitors failed or changed direction to pursue commercial and public work, Delano & Aldrich continued to design country houses for clients on Long Island, including the Flinsch house at Lloyd Harbor (1937).

All architectural works, including the Long Island houses of Delano & Aldrich, are a product of their location and the time and circumstance in which they were designed and built, as well as of their owners' desires. The Long Island residences by Delano & Aldrich were designed for a particular style of life, and they contributed to the fostering of that life. At the same time, these country houses had another dimension; many critics and architects of the period saw them as particularly American and exemplars of the modern. The two-man architectural partnership of Delano & Aldrich set the standard for the period.

Over time William Adams Delano has emerged as the firm's dominant personality. He was born on January 21, 1874, in the parsonage of New York's Madison Square Presbyterian Church. His maternal grandfather, Dr. William Adams, soon to become head of Union Theological Seminary, was pastor of the church. Delano explained later in life: "I'm of pure New England ancestry—parson, shipbuilders and shipowners, schoolmasters, bankers, and so forth. . . . The night of my birth was very, very cold." His father, a partner in the Brown Brothers investment banking concern, took over that firm's Philadelphia branch and commissioned a large house in Bryn Mawr. Delano recalled, "Our architect was Theophilus P. Chandler, and I admired the way he gave orders to the masons when he rode over to supervise the construction. That's what I want to do, I thought. I was twelve." After attending Lawrenceville Preparatory School, Delano entered Yale as a member of the class of 1895. There he took some courses in painting and drawing from John F. Weir, "a charming gentleman," and was elected to Scroll and Key.[4] Delano studied architecture at

Delano & Aldrich: Garden Facade, "Target Rock Farm," Olga Flinsch Residence, Lloyd Harbor, 1937 (SPLI, c. 1950)

Columbia University, graduating in 1899, and then worked off and on for Carrère & Hastings where he met his future partner Chester Holmes Aldrich.

Delano recounted how Thomas Hastings, whose father was also a clergyman and a past president of Union Theological Seminary, convinced Delano's "very reluctant Presbyterian family to send me to the Ecole des Beaux-Arts for one year," although they feared "Paris was the road to Hell."[5] He entered the atelier of Victor Laloux, becoming one of 132 Americans to study with that popular teacher. Laloux was the school's most successful teacher—16 of his students won the Prix de Rome, the highest award a student could gain at the Ecole.[6] Delano stayed abroad nearly five years, graduating in 1902.[7] After traveling in Europe, he returned to New York and in September 1903 formed a partnership with Chester Aldrich that would last until the latter's death in 1940. In 1907 Delano married Louisa Potter, the daughter of the prominent Victorian architect Edward Tuckerman Potter. They had one son. The Delanos owned a house in the East 30s in the city, and a country house in Syosset, Long Island.

Delano's public career was extraordinary by any standards. He taught architecture at Columbia from 1903 to 1910, supervising the drafting room. He joined the American Institute of Architects (AIA) in 1907 and in 1912 became a fellow. In 1923 he was made a Chevalier of the French Legion of Honor and in the 1930s, after designing the American Chancellery in Paris, he was elected a Corresponding Member of the Académie des Beaux-Arts of the Institut de France, a very high honor to be conferred on a foreigner. From 1924 to 1928 Delano served on the Commission of Fine Arts, the oversight committee for the architecture and planning of Washington, D.C. In 1927 Secretary of the Treasury Andrew Mellon invited him to join the advisory group for the planning and designing of the Federal Triangle in Washington, D.C. Delano & Aldrich's responsibility became the Post Office Building (1931–35), a great Doric hemicycle structure. Like Charles McKim before him, Delano became the unofficial architect of the White House, doing remodeling under Coolidge and, from 1949 to 1951, directing the restoration under President Truman and adding the famous second-story porch. "I loved Truman," Delano claimed. "He knew exactly what he wanted."[8]

Delano served on the planning board of the 1939 New York World's Fair, and his firm was responsible for the original La Guardia Airport (demolished) and the Marine Air Terminal, both built in 1940. He served as president of the American Society for Beaux-Arts Architects from 1927 to 1929 and president of the New York Chapter of the AIA from 1928 to 1930. In 1939, after he had designed the Divinity School at Yale University (1932), his alma mater presented him with an honorary Master of Arts degree. In 1940 he received the Gold Medal of the National Institute of Arts and Letters. Finally, in 1953, he received the highest honor in American architecture, the AIA Gold Medal. He died in 1960.

Chester Holmes Aldrich appears to have been more reticent than his partner Delano, and hence less is known about his private life. Aldrich was born into a prominent Rhode Island family in Providence on June 4, 1871. He studied architecture at Columbia College, graduating in 1893, and then worked for nearly two years for Carrère & Hastings. He entered the Ecole des Beaux-Arts in 1895 and worked in the atelier of Honoré Daumet (with whom Charles McKim had studied) and Pierre Léon Esquie. After receiving his *diplôme* in 1900, Aldrich traveled before returning to the United States. He worked for Carrère & Hastings until 1903, when he and Delano set up their practice. Between 1903 and 1910, Aldrich served as Thomas Hastings's assistant in a "downtown" atelier run by the School of Architecture at Columbia. He joined the AIA in 1907, becoming a fellow in 1916.

A lifelong bachelor, Aldrich nevertheless was very active in social and civic affairs, serving on the boards of a great many charitable organizations. During World War I he was the director general of civil affairs of the American Red Cross Mission in Italy, looking after refugee families of soldiers, establishing workshops, and helping in hospitals. His efforts were recognized by the award of the Order of St. Maurice and Lazarus, the Order of the Crown of Italy, and the medal of honor of the Italian Red Cross. In a more professional vein, he belonged to and served on the committees of the various architectural organizations and was, for a time, chairman of the board of trustees of the Beaux-Arts Institute of Design. He received an honorary Doctor of Letters degree from Columbia University in 1929. Aldrich was also known as a painter and had several exhibits of his work. His greatest passion was Italy, and he spent many vacations studying Italian gardens and architecture. In 1935 he was appointed director of the American Academy in Rome, which had been founded by Charles McKim. Aldrich died in Rome in 1940.[9]

The firm of Delano & Aldrich was successful from the outset. In 1904, a year after its founding, the firm was asked to design the Walters Art Gallery in Baltimore, a commission

Delano & Aldrich: Charles
S. Payson Residence,
Manhasset, 1924 (HOWE,
1933)

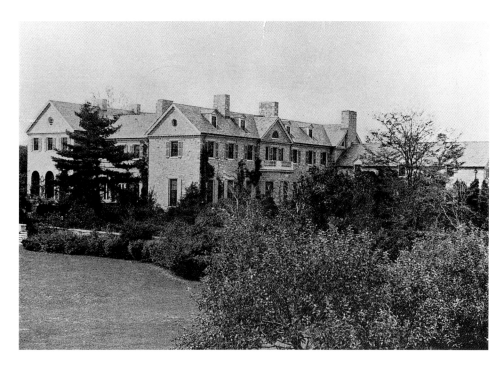

of unprecedented size for such a young practice. Delano later explained that the commission was the result of his having met Henry Walters, a leading American collector, in Venice during the summer of 1903. Walters knew his own mind, and although he thought "McKim [to be] the greatest architect in the country," he considered McKim "too damn stubborn." The consequence was that he told the young architects, "I'm going to give you boys the chance to build the Walters Art Gallery, if you do what I tell you to do." However, after the building was completed in 1910, Delano remembered Walters telling him, "I think you're a damn sight more stubborn than McKim."[10]

A measure of Delano & Aldrich's success is the number of commissions the firm received. Although a complete tally is uncertain, in 1935 the partners circulated a list that contained 243 individual commissions, of which 111 were for country houses, and including 32 located on Long Island.[11] This number is for individual commissions, and included alterations and subsequent remodelings. In the case of country houses, the listing could include—in addition to the main house—gardens, stables, farm buildings, gate lodges, and other appendant structures. Delano & Aldrich also designed public buildings, churches, and commercial structures, including air stations for Pan American Airways in Miami, and on Midway, Wake, and Guam islands. By the standards of the inter-war years when it was at its peak, Delano & Aldrich was not a large firm—*Time*, in commenting on the practice in 1930, referred to a complement of 67 employees. The partners kept the office small on purpose so that they could control the design projects personally.[12] In 1928 it was estimated that they designed about 30 buildings a year.[13]

The individual attention given to clients, and the personalities and backgrounds of the partners were important factors in securing commissions for the firm, especially on Long Island. Both Delano and Aldrich were cultivated and gregarious gentlemen, with what were considered "good" backgrounds and proper educational credentials. Both were members of many New York City clubs and—after McKim, Mead & White—were responsible for the design of more New York City club buildings than any other architectural firm, including the Knickerbocker (1914), the Colony (1924), and the Union (1932), as well as several others. They designed buildings not only for Yale and for Smith College, but also for Lawrenceville and St. Bernard's preparatory schools. *Time* noted in 1930: "Socialite daughters are educated amidst D. & A. architecture at Miss Chapin's and Miss Nightingale's schools in Manhattan."[14] Delano and Aldrich belonged to the social elite of New York City and, by extension, of the entire East Coast—they were the society architects of the period between 1910 and 1940.

In many ways the firm was the successor of McKim, Mead & White in country-house design. Neither Delano nor Aldrich ever worked for that venerable firm, but they knew its partners well, and Delano recalled going to McKim for advice on a design problem.[15] From about 1880 to 1906 McKim, Mead & White was the leading design firm for resort/country houses in the United States; however, after the death of White in 1906 and McKim's virtual retirement (he died in 1909), the firm pursued urban commissions almost exclusively.[16] Charles Adams Pratt in New England, Hoppin & Koen in the

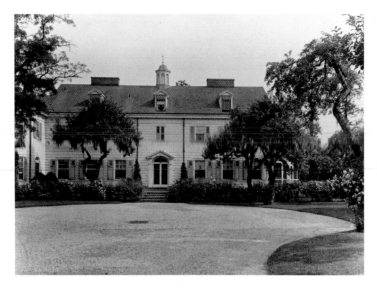

Delano & Aldrich: Front Facade and Entrance Court, "Muttontown Meadow," Egerton L. Winthrop, Jr., Residence, Syosset, 1903–04 (HEWI, n.d.)

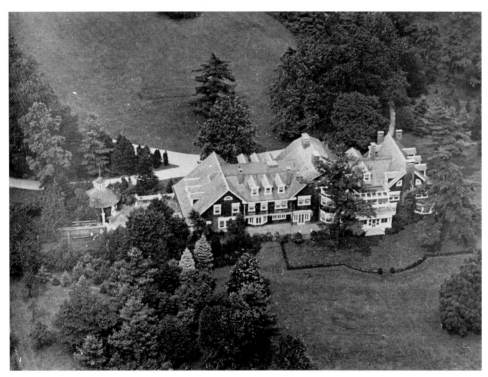

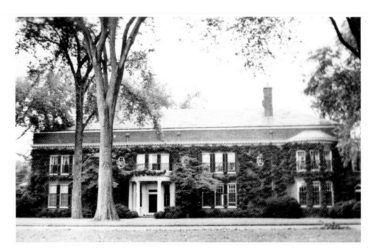

Delano & Aldrich: "Applegreen," Willard D. Straight Residence, Old Westbury, alterations, 1912–13 (NASS, n.d.)

Delano & Aldrich: "Welwyn," Harold I. Pratt Residence, Glen Cove, alterations, mid-1910s (Courtesy of Lawrence Van Ingen)

Berkshires, Carrère & Hastings around New York, and Horace Trumbauer in Philadelphia became the leading architects of country houses in those areas. On Long Island, and especially on the North Shore, McKim, Mead & White had enjoyed what was, in effect, a monopoly in the design of large estates.

Delano & Aldrich entered the scene in 1903–04 with the Egerton L. Winthrop, Jr., house in Syosset, which in its Southern and Federal form and details recalls several McKim houses: the James L. Breese in Southampton, and the Devereux Emmett and Stanford White residences in St. James. Appropriately, Delano & Aldrich sheeted their Winthrop house in white-stained shingles, much as McKim, Mead & White had done on its Long Island commissions. With the Otto Kahn commission (see below) at Cold Spring Harbor (1915–17), Delano & Aldrich came to the fore, since that commission fully equaled McKim, Mead & White's most luxurious Long Island design, the Clarence Mackay estate, "Harbor Hill" at Roslyn, in both cost and style. From then on Delano & Aldrich never looked back. As with McKim, Mead & White, the firm of Delano & Aldrich was responsible for both the Long Island country and the city houses of many of their clients. For the Willard Straights, the partners designed alterations and stables for the family's residence at Old Westbury (1912–13), a house at Fifth Avenue and 94th Street in New York (1914), and a classroom building at Cornell University. For Harold Pratt, the son of one of the scions of the Standard Oil fortune, Delano & Aldrich made major alterations and additions to a house and estate at Glen Cove in the mid-1910s, and built a large, limestone, English-style palace at Park Avenue and 68th Street (1920).

In some cases, Delano & Aldrich actually inherited McKim, Mead & White commissions, such as the Roslyn studio for Gertrude Vanderbilt Whitney, wife of Harry Payne Whitney and founder of the Whitney Museum of American Art in New York City. McKim, Mead & White had done major remodeling for William C. Whitney, father of Harry Payne Whitney, in New York City and designed an extensive country estate at Old Westbury. For the young, newly married couple, McKim, Mead & White designed a palatial Fifth Avenue townhouse in 1902. After the elder Whitney's death in 1904, Harry Payne and Gertrude Vanderbilt Whitney inherited the Old Westbury estate and in 1913 commissioned Delano & Aldrich to design a sculpture studio for Gertrude (see below). Delano explained: "Mrs. Harry Payne Whitney asked me to build a studio in the woods at Westbury, where she could get away from Harry's polo-playing friends. She

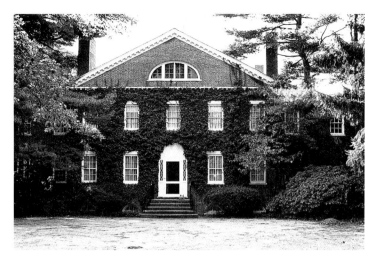

Delano & Aldrich: Front Facade, "Hark Away," Mrs. Richard F. Babcock Residence, Woodbury, 1923 (Courtesy of Mrs. Richard F. Babcock)

put me in full charge, with no mention of cost. An architect's dream!"[17]

Attribution of specific designs to one or the other of the two partners in the firm can never be completely certain. Delano recalled that when the office was established, "We tossed to see whose name should come first. Aldrich designed the jobs he brought in, and I designed the jobs I brought in. It was a wonderfully happy partnership."[18] However, similar to the attribution of everything done by the McKim, Mead & White firm to "Stanny" White, "Billy" Delano, the more public personality, frequently receives sole credit for all designs, especially by later owners of the property. But there is evidence of Aldrich's hand. In fact, one of the major characteristics of the firm's work—the way its country houses fit into the landscape and their relation to the garden—may be most due to Aldrich, reflecting his lifelong passion for and study of Italian villas and their gardens. However, in the case of the Long Island commissions, Delano may have played the more prominent part simply because he lived there.

Certainly, as in most architectural offices, one or the other partner assumed the primary responsibility for different projects, but since both had been trained in design methodology and the ideals of collaboration at the Ecole des Beaux-Arts, they interacted and served as critics of each other's work. As designing partners they were responsible for meeting and securing clients, and for deciding on the style, parti, and general layout of the house and estate. It is likely that as time went on and they built up an office staff to which they could delegate responsibility, many of the details and probably a portion of the designing was attended to by assistants. Of these only a few are known: Herbert Godwin, Carl F. Grieshaber, George F. Licht, James Stewardson, and H. S. Waterbury. All rose to the position of associate in the firm.[19] From the evidence, and as might be expected,

neither Delano nor Aldrich ever did working drawings and, indeed, left the checking of these to assistants.[20]

Delano & Aldrich used a wide variety of stylistic idioms: Georgian for the Mrs. Richard Babcock house at Woodbury (1923) and the Edwin A. Fish house, Matinecock (1920); French Renaissance for the Benjamin Moore house at Syosset (1924) and the Roderick Tower house at Brookville (1924); American Colonial for the Egerton L. Winthrop, Jr., residence at Syosset (1903–04); Italian Renaissance for the Gertrude Vanderbilt Whitney studio at Roslyn (1913); French 18th-century classical for the Bertram G. Work house (see below) at Mill Neck (1916); a stripped classical idiom for others such as the Chalmers Wood in Syosset (1927; see below); and many more. Some critics responded to this wide-ranging eclecticism and the Parisian training of the partners by coining the term "Beaux-Arts Eclectic" to describe the work of Delano & Aldrich and that of architects with similar propensities during these years. However, "Beaux-Arts Eclectic" is more a description of a methodology, of how the architects chose and designed, than a stylistic definition.

One feature that does make the firm's work stand apart is the general avoidance of any of the picturesque, medievally based styles, though the partners did use aspects of the Old English and Norman idioms. As the critic Royal Cortissoz pointed out in a 1924 essay on the firm, Delano & Aldrich rejected "picturesqueness" as a feature; the firm's facades seldom departed "from an unbroken line," nor did the designs seek to enliven the skyline with dormers, tall chimney stacks, and variegated roofs. Generally, ornament and detail are subdued to the main mass—and are "so trifling as to be negligible." Cortissoz summed up: "What is important here, and elsewhere, is the definition of the house in pure line and mass, the linear idiom manifesting itself in peculiarly personal accents."[21]

Cortissoz's observations on Delano & Aldrich's anti-picturesqueness need to be qualified, for in a 1929 interview in Arts & Decoration Chester Aldrich stated: "I am not adverse to the picturesque." "From my point of view," he explained, "the picturesque is something which happens of itself." In this interview, "The Classic Spirit In Our Country Homes," Aldrich showed a preference for restful, non-agitated forms, deploring artificial, waving ridge lines and pock-marked stucco. "Proportion and form," he claimed, "the spacing and disposition of solids are the fundamentals of architecture."

While there is a definite bias toward classical styles, Delano & Aldrich were not single-track eclectics, as can be seen in the houses designed for Bronson Winthrop (1910; see below) in Syosset, and Vincent Astor (1922; see below)

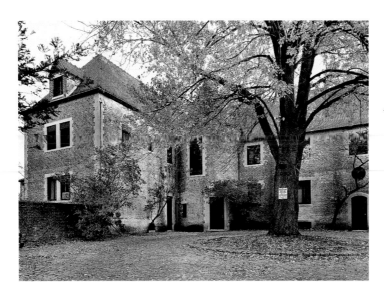

Delano & Aldrich: Front
Facade and Entrance Court,
Roderick Tower Residence,
Brookville, 1924 (SPLI,
Richard Cheek photo, 1981)

in Port Washington, among others. Both
Delano and Aldrich were influenced by the
English Arts and Crafts movement, and these
houses with their restful roofs and stucco, re-
flecting the work of the English Arts and Crafts
architects Charles F. A. Voysey, Edwin Lutyens,
and Baillie Scott, are testimony of the catholic
nature of the American firm's stylistic choices.
At the same time, the highly controlled, inven-
tive plans of the Winthrop and Astor houses
have little to do with the English style.[22]

For the earlier generation of architects like
McKim, Mead & White or Carrère & Hastings,
replication of archaeologically correct details
and, in some cases, entire forms was the keystone
of their methodology, which can be termed sci-
entific eclecticism.[23] In contrast, both Delano
and Aldrich tended to view historical styles and
ornament far more abstractly, tending to main-
tain a single-track and sober eclecticism. They
never mixed styles or details, but they never were
completely true to the originals: they would wil-
lingly pare down, simplify, and reduce the origi-
nal models. This simplification emerged as the
firm's architecture evolved. But even at its most
sizable and richest, as in the Otto Kahn house,
the entire mass and ornament were simplified
in comparison to the earlier McKim, Mead &
White design for the Clarence Mackay house.
The keynote of Delano & Aldrich's use of style
was restraint; the designs are not loud and pom-
pous, but delicate and almost spare or, as Cor-
tissoz said about the Bertram Work house, "This
is an austere design."[24]

Stylistic definitions irritated the partners,
who, to some degree, saw themselves as modern.
As Delano explained in 1927:
*Unfortunately, every owner wants to have a name
for the style in which his house is built. I find this
both difficult and annoying. I wish people would
accept the present method of construction for what
it is and be satisfied to call the result "Modern."
A modern style has as much right to exist as a*

*Renaissance or Colonial. It does not necessarily
mean anything cubistic or impressionist. Like all
other good styles it takes sound traditions wherever
they can be found and adapts them to present day
conditions. It is such a deadening thing to have to
follow a particular style slavishly. To do so is copy-
ing and nothing more. Yet most people want to
call their houses Georgian or Norman or Palla-
dian, and are not satisfied with accepting a good
house, well arranged, without a fancy name.*[25]

As Delano's statement implies, the external
style is but one portion of the total country-
house design; more important is the plan and
the relationship of the building to the site be-
cause, as he said, "The exterior is necessarily
determined by the plan."[26] In plan, many of
Delano & Aldrich's Long Island country houses
show tight organization, with emphasis on the
bilateral symmetry of the outer facade. Houses
are composed around a central entrance, whose
axis continues through the house to the garden
or terrace on the other side. The outer symme-
try frequently is subverted on the interior by a
functional room arrangement; and often a wing
was appended, as in the Victor Morawetz house
(1915; see below). Strictly speaking, Delano &
Aldrich did not create strong cross axes; instead,
they allowed rooms to open off freely from the
central axis, sometimes aligned, other times ar-
ranged according to function. This characteris-
tic might be singled out as peculiar to Delano &
Aldrich, for, as Cortissoz noted in his introduc-
tion to *Portraits of Ten Country Houses Designed
by Delano and Aldrich,* "There is no flatly sym-
metrical framing of the rooms anywhere, and
in one or two instances the disposition of the
space seems emphatically free and flexible."[27]

Not all the Long Island works of Delano
& Aldrich were symmetrical. In the Frederic
Watriss house at Greenvale (1920), one approach-
es a one-and-a-half-story entrance pavilion, be-
yond which one sees a rambling assemblage of
forms. The axis runs down one side of the house,
embracing a large entrance vestibule and a long,
70-foot corridor, from one side of which one
looks out to the gardens and the stable yard. At
the end is the living room and, off to the right,
another linear passage that becomes an open ar-
cade. At Delano's own house at Syosset (1915),
visitors were not brought in through the front,
but through the side, directly into the stair hall.
The living and dining rooms also opened off
the stair hall, allowing visitors to avoid com-
pletely passing through any corridors on the
ground floor. These eccentricities of arrange-
ment, coupled with strange twists even in the
more conventional axial houses—as exemplified

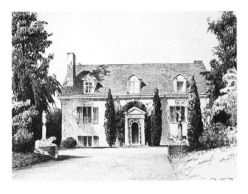

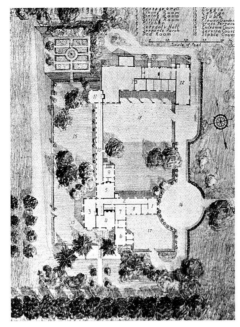

Delano & Aldrich: Drawing of Open Arcade, Frederic Watriss Residence, Greenvale, 1920 (COUN, 1924)

Delano & Aldrich: Site Plan, Frederic Watriss Residence, Greenvale, 1920 (COUN, 1924)

Delano & Aldrich: Front Facade, "Huntover," Lloyd P. Griscom Residence, East Norwich, 1920 (PHDA, 1922)

in the consciously slight asymmetry in the entrance facade of the Lloyd Griscom house (1920) at East Norwich—stemmed from the site planning of the houses. They arc also manifestations of what Delano undoubtedly would have claimed was their modernity.

Delano & Aldrich's planning—the relationship of the house to its approach, gardens, terraces, and auxiliary structures—must be considered the firm's outstanding accomplishment. Although Delano and Aldrich did use landscape architects, especially the Olmsted Brothers and Ferruccio Vitale, it is obvious that the siting and general relationship of parts were determined by the designing partner. The landscape architect worked with him, certainly made suggestions, and developed a planting scheme, but either Delano or Aldrich was ultimately responsible. In 1927 Delano explained how he approached the problem:

My explanation as to how I go to work must of necessity be indefinite, for each case demands different handling. But in general this is what I try to do. I avoid thinking of the new job until I have seen the site and examined it carefully. Contour maps, no matter how crammed with data, are misleading. You must see a place in all its aspects before you can have an adequate idea of its possibilities. A glimpse of a vista here or a tree there or even the roll of the ground may give you the inspiration you are always hoping for. I try in general to avoid hilltops unless it happens that there is a wide plateau, and I try to have my house face as nearly as possible to the south, for in this part of the world the winds blow from the southwest nine days out of ten in the summer. A southerly exposure affords not only sunlight but coolness. I try to keep the service part of the house as much out of sight as possible. If I can I put the entrance door on the

north side, and by the same token the staircase, for these elements do not require sunlight as the living room and bedrooms do. Very often, unfortunately, this arrangement is not possible, and then I come as near it as I can. I generally work on a small pad, which I carry in my pocket until I find the solution which pleases me. Then it is drawn out at one-sixteenth scale and I talk this over with the client, trying to explain as clearly as possible why each room has been placed where it is.[28]

Not until the plan was "fairly well determined upon," Delano continued, did he "undertake the exterior." He noted that, "In building country houses it seems to me that the surroundings of the house are as much a part of the picture as the house itself. I have always insisted upon doing the gardens immediately adjoining the residence." [29]

As indicated by the *Time* article in general, all of the houses were secluded structures, not easily observable from the entrance. If possible the house was placed on a rise rather than a hilltop so that it had some view. The approach, usually through a dense grove of trees, would finally bring the visitor to the house, either dead on axis, or along the front. Neither partner seems to have had a decided preference on the approach, except that the entire house was never seen at once —it would gradually open and expand, although the front was always clearly defined. While the entrance axis generally ran through the house, the formal gardens were never on that axis, but were placed off to one side. This gave the house a broad outlook over terraces across a spreading lawn and fields, thereby increasing the sense of domination, with no firm boundaries as limits. The formal garden off to the side then became a more private and intimate place.

This play with scale and distance is easily seen in the Bronson Winthrop house, Syosset (1910; see below), where the terrace in front of the living room gives onto a broad lawn, and then an alley of poplars channels the vision off into the distance. Placed on a diagonal in a depression and sheltered by a hedge is the swimming pool. To the west, a broad lawn stretches, a vast space carefully and simply defined by a hcdgc of clippcd maplcs, and beyond that is the tennis court. Thus the architects managed to place the house in such a way as to create a sense of control of large space and at the same time to achieve definition and limits.

In these extraordinary plans in which the house is part of the landscape, the heritage of both Italy and England is evident. Although Delano & Aldrich's work is not specifically

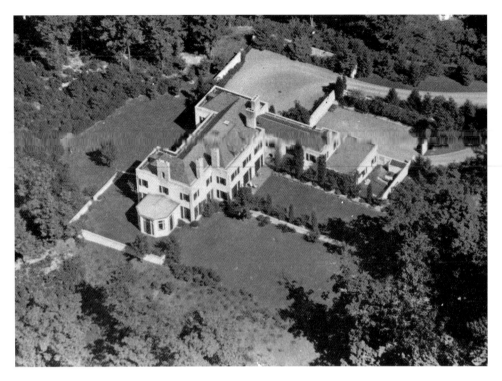

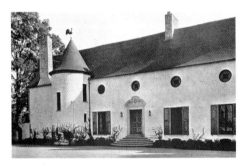

Delano & Aldrich: "White
Eagle," Beverly Duer
Residence, Syosset, 1929
(SPLI, n.d.)

Delano & Aldrich: Front
Facade, "Chelsea,"
Benjamin Moore Residence,
Syosset, 1924 (HOWE, 1933)

Italianate in style, it gleans from the partners'
experience of Italy, where houses are intimately
related to their gardens. The English influence
is mainly that of Edwin Lutyens and his collab-
orator Gertrude Jekyll. The work of Lutyens
and Jekyll was reproduced in many publications
and Delano & Aldrich adapted it to suit their
own purposes.[30] Their designs have more struc-
ture and spatial relationships than that of the
English team, but in the end they are American
equivalents of Lutyens's and Jekyll's creations.

While some critics, like Lewis Mumford, cas-
tigated Delano and Aldrich and their contempo-
raries for being merely imitators, it is evident
that many others considered their work distinct-
ly modern and American.[31] The 1930 *Time* article
claimed that Delano & Aldrich practiced "the
modern adaption of old forms."[32] Certainly the
partners were never modernists in the sense of
adhering to the International Style. Indeed, in
the 1930s Delano became an outspoken oppo-
nent of what he considered sterile design.[33] Un-
derlying the partners' design vocabulary was an
essentially geometric order that emerged as a
series of austere forms, which could be aligned
in either a symmetrical balance, as in the Beverly
Duer house (1929), or asymmetrically, as in the
Benjamin Moore house (1924), both located in
Syosset. In all cases some sort of period style
might be applied, but the overall impression is
of elegantly studied and composed forms. The
firm's work is best characterized as representing
a conservative modernism, which developed a
new and simplified architectural language based
on tradition.

Delano & Aldrich's peculiarly American
identification comes from both critics and
rivals, like William Lawrence Bottomley, who

in 1923 wrote a long review of the firm's work,
stating that its historical and eclectic details
were "typical of the best traditions of American
art," and represented distinguished contribu-
tions to "our national style."[34] A. Lawrence
Kocher, one of the most perceptive critics of the
day, wrote several long articles for the *Architec-
tural Record* in which he claimed that American
architects were developing a particular national
style for the country house. He noted the tre-
mendous rise in the number of contracts for
country houses in the post–World War I years,
and commented that while the designs to some
degree derived from English, French, Italian,
and Colonial roots, they were ultimately dis-
tinctly American. Describing this approach,
Kocher wrote, "It takes European affinities,
native elements and ingenious original features
and is often able to mingle them with a superb
independence, free from the 'archaeological
taint.'"[35] As an example he cited Delano &
Aldrich's residence for Vincent Astor in Port
Washington (1922) as:

[F]ree from stilted reminiscence. Possibly its roofs
and the walls, with their whitewashed effects, are
early American, and its window patterns are dis-
tinctly English. But the real fascination of such
houses as this springs from their frank originality
and their restrained simplicity.[36]

However, the American qualities of such
houses went far beyond style and details, extend-
ing to the entire setting and social nature of the
houses. Although modeled to some degree upon
the English country house—hence the particu-
lar fascination with Lutyens—the Long Island
country houses of Delano & Aldrich were, nev-
ertheless, distinctly different. While some inspi-
ration was drawn from European and English
manor houses, the American counterparts were
minuscule in comparison. Sometimes a work-
ing farm was included in the composition—as
on Otto Kahn's estate—but it was simply for
show, and generally this feature was excluded.
As a matter of fact, farms were displaced by the
country estates. By 1927 it was estimated that
country estates, country clubs, golf courses, and
polo fields occupied nearly half as much ground
as all the farms of Long Island, accounting for
more than 116,000 acres.[37] As one critic claimed,
the Long Island country places designed by
Delano & Aldrich and their contemporaries
were part of a large spacious suburb or "rural
park."[38] Houses were located on large plots of 15
to 80 acres, not as in England and Europe be-
cause of family title or ties to the land, or for
purposes of gaining a livelihood from the soil,
but because of the scenery and proximity to lei-
sure activities and New York City, which could
be reached quickly by train or motor car. It was

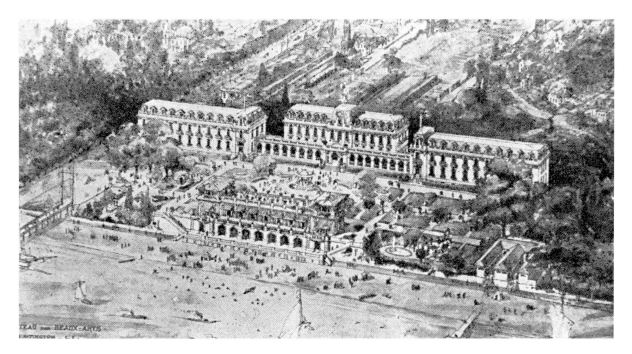

Delano & Aldrich and Maurice Prevot: Rendering of Proposed Design, Château des Beaux-Arts, Huntington, 1905–07 (SPLI, 1907)

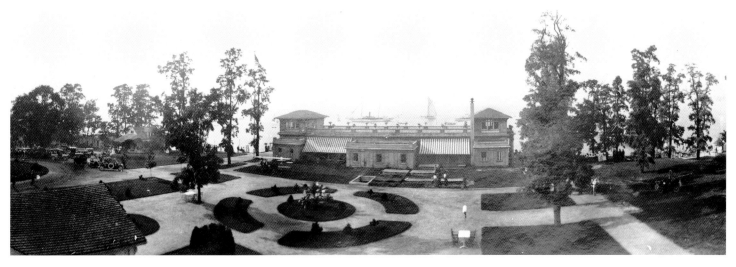

Delano & Aldrich: As Built, Beaux-Arts Casino, Huntington, 1905–07 (HUNT, n.d.)

a "near-to-nature" way of living devoted to sophisticated sports and pleasures: golf, hunting, riding, the beach, yachts, tennis, parties, and relaxation.

A striking confirmation of the American character of the larger setting of Delano & Aldrich's Long Island work can be found in the memoirs of Edward, Prince of Wales (later Duke of Windsor), who stayed in the James Burden residence at Syosset (see below) in the summer of 1924. He noted, "My American hosts spared no expense in demonstrating the splendor of a modern industrial republic." He continued, "America meant to me a country in which nothing was impossible. And the scale of hospitality purveyed on Long Island did nothing to disabuse me of this conception." Describing the Burden house, he wrote:
All around were fine homes with well-kept lawns and swimming pools. Compared to the creature comforts Americans took for granted, the luxury to which I was accustomed in Europe seemed almost

primitive. Seen from Syosset, my American prospects were most agreeable; and the proximity of New York offered assurance that the hours not occupied with polo could be spent satisfying my curiosity about the varied activities of that great city.[39]

A more detailed examination of selected Delano & Aldrich Long Island country houses will reveal both the American attributes and the unique qualities that place them among the best works of their day.

Château des Beaux-Arts, Huntington, 1905–07

Delano & Aldrich's Château des Beaux-Arts was in the tradition first set by the Newport Casino (1879–81) designed by McKim, Mead & White, and emulated in resort architecture in many other places. The design for the Château (or Casino) des Beaux-Arts in Huntington served as ample confirmation of the leisure-time, pleasure-seeking nature of life on Long Island's North Shore. Located on 400 acres, the Château des Beaux-Arts was to be situated

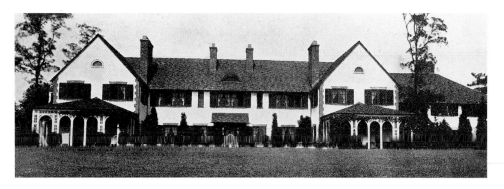

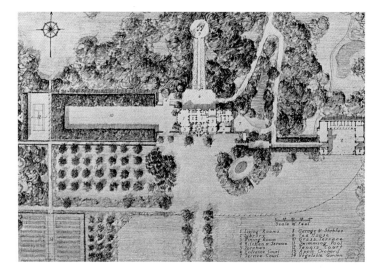

Delano & Aldrich: Site Plan,
Bronson Winthrop
Residence, Syosset, 1910
(PHDA, 1922)

right at the water's edge and to comprise a
large restaurant and entertainment facilities,
with a hotel and grounds to the rear. To be
included were a dock for yachts, bathing facili-
ties, polo grounds, tennis courts, "a field for all
sports," formal gardens, and villas. The owners,
Bustanoby Brothers, New York restaurateurs,
intended to keep it open all year round—then
considered an unusual feature. A garage was ap-
pended to accommodate 50 automobiles, and a
66-foot-wide road was to "connect directly with
the new 'automobile speedway,' which is now in
the course of construction."[40] The entire com-
plex was to be constructed out of reinforced
concrete, covered with stucco, with all orna-
mental work to be executed in concrete.

According to Delano & Aldrich's publicity,
the design, done in association with Maurice
Prevot, a French colleague, was to be "treated
somewhat in the manner of certain French
establishments, such as the Pre-Catalan in the
Bois de Boulogne."[41] The name "Beaux-Arts,"
while referring to the Bustanoby Brothers'
Café des Beaux-Arts in New York, was certainly
appropriate, for the entire project strongly re-
calls student projects at the Ecole, in the layout
of strong axes and cross axes, the particulariza-
tion of each volume of building and room, the
enfilades, and especially the lighthearted and
festive air. While in Paris, both Delano and

Aldrich had been exposed to two great casino
competition entries, the one Louis-Hippolyte
Boileau's design of 1897 and the other Paul
Bigot's winning entry for the 1900 Prix de
Rome.[42]

In the end, only a portion of the Château
des Beaux-Arts complex was ever built—the
casino and one wing of the hotel. An older
wooden lodge that stood on the property was
also used to accommodate guests. The resort
succeeded for only a couple of years and then
fell on hard times and a succession of owners.
In the 1950s it was completely destroyed.

Bronson Winthrop Residence, Syosset, 1910 (Extant)

Bronson Winthrop (1863–1944) was a descen-
dant of old New York and New England fami-
lies. He was educated at Trinity College, Cam-
bridge, in England, and Columbia University
Law School. A leading member of a well-known
Wall Street law firm, Winthrop was a cultivated
man who knew what he wanted in houses.

Delano & Aldrich designed two houses for
Winthrop. The first, a large wooden shingled
structure at Syosset (1903–04) recalled McKim,
Mead & White's Long Island work. This house
passed to Bronson's brother Egerton L. Win-
throp, Jr., in 1911, when the firm built a second
house on adjoining property.

This new Bronson Winthrop house was con-
structed of block and stuccoed in the English
Arts and Crafts manner. A masterly composi-
tion, it features a long, calm roof line and twin
pavilions framing the main body. Stylistically in
the so-called "Free Style," it owes a great deal to
Charles F. A. Voysey's cottages with their power-
ful all-encompassing roofs. Although it is nearly
devoid of ornament, brick quoins and window
heads add minor accents. In spite of the outer
symmetry, the plan is actually asymmetrical and
recalls Aldrich's observation, "In cases where the
practical requirements of the house dictated an
unsymmetrical treatment, this was obtained
without sacrificing the essentials of order and
balance."[43] A small entrance vestibule gives on
a living room that opens directly on the terrace
and an allée of trees in the distance. A large
living room, occupying one entire end of the
house, has its own grass terrace that measures
400 feet in length.

Mrs. Harry Payne Whitney, "The Studio," Roslyn, 1913 (Extant)

Gertrude Vanderbilt Whitney (1875–1942)
commissioned this studio both as a retreat for
herself and as an entertainment pavilion for

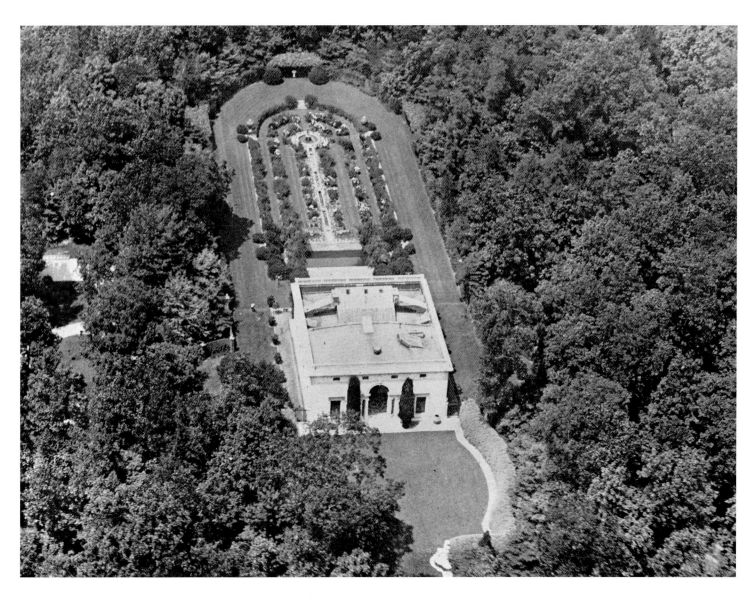

friends. A well-known sculptor with a number of major public commissions to her credit, she was also a patron of the arts and hosted a salon in New York City. She demonstrated her devotion to art by founding the Whitney Museum of American Art.

According to Delano, the designing partner in charge, Mrs. Whitney gave him the commission indicating that cost was no object.[44] His solution recalls Italian garden casinos—the building is a solid cubic mass punctured by an elegant Palladian entrance, carefully placed windows, and a rich frieze derived from Jacopo Sansovino's Library of Saint Mark in Venice.[45] The severe classicism of the building extends to the landscape. The axis of the site is directly north and south, with the front treated as a formal entrance court—though grass was used instead of pavement—and the rear developed as a more intimate garden with a swimming pool and sunken parterre. This site plan, with few exceptions to the axis and no diagonals, is the most severely formal of all of Delano's designs.

William A. Delano Residence, "Muttontown Corners," Syosset, 1914–15 (Extant)

Feeling secure with a number of large commissions in the office, especially the Otto Kahn estate, Delano purchased a relatively small piece of land in Syosset around 1914 and designed a small country retreat for himself and his family. His interest in an informal, yet highly organized site and house is obvious. The site plan is an object lesson in arranging a variety of spaces and incidents on an intimate scale, yet giving the overall setting an air of great expanse. In fact the entire composition, as a purely formal object, easily could be compared to cubistic paintings of the period, or to Frank Lloyd Wright's site plan for Taliesin East. Delano's house clearly shows his interest in modern design.

The building itself is composed of a juxta-position of volumes that create the feel of the Arts and Crafts style. Emphasis on windows and doors provides the basic order. Exterior details are reduced to a minimum, with historical detailing avoided except for the bricks projecting around the openings that suggest quoins.

Delano & Aldrich: Site Plan, "Muttontown Corners," William A. Delano Residence, Syosset, 1914–15 (PHDA, 1922)

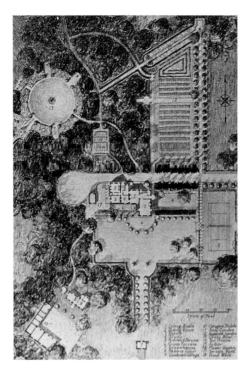

Delano & Aldrich: "Muttontown Corners," William A. Delano Residence, Syosset, 1914–15 (COUN, 1918)

The structure is covered in stucco and has a shingled roof.

The plan of the house itself has already been referred to, though it should be noted that each of the main ground-floor rooms has a southern exposure and opens onto the terrace. A wide terrace off the living room has an allée of trees centering on a greenhouse, to the east of which is a gardener's cottage forming one side of the service court for automobiles and box stalls. The grounds include a grass bowl sporting a sundial, a rose garden, a cutting garden, and a tennis court, all admirably integrated into a cohesive whole.

Otto H. Kahn Residence, "Oheka," Cold Spring Harbor, 1915–17 (Extant)

The Otto H. Kahn house, "Oheka," is the largest private house Delano & Aldrich ever designed. Both the size—an estimated 62,000 square feet comprising approximately 72 rooms and 25 baths—and the picturesque style are atypical of the firm. Indeed, the general air of ostentatious bombast and preening indicates that Otto Kahn dominated the design, and that the architects were in a sense realizing his fantasies. The partners were probably somewhat embarrassed by the entire affair.

Otto Kahn (1867–1934) was a financial manipulator who gained control of corporations' assets through what he called "reorganization."[46] He was also known for his love of the arts. A great art collector, he headed the board of the Metropolitan Opera and supported young and aspiring artists. Born in Germany, he first immigrated to England, where he developed an admiration for the style of life of the country

gentlemen. After becoming wealthy in the United States he temporarily took up residence in England again, but eventually returned to America to build his ideal of an English country estate on Long Island.

Kahn's 500-acre estate at Cold Spring Harbor was one of the largest on the island. Olmsted Brothers were the landscape architects and Lewis Valentine carried out their plans, though as noted, the firm of Delano & Aldrich was much involved in the siting and gardens.

Kahn wanted "Oheka" to outshine other lavish estates nearby, especially Clarence Mackay's "Harbor Hill" in Roslyn. Mackay supposedly occupied the highest point on Long Island, and so for two years Kahn had men, horses, and equipment toil to create an artificial mound on which his house could sit. He reportedly had three firms draw up plans for the house, from which he selected the one that suited him best. Delano & Aldrich must have known of his rivalry with Mackay because the firm's winning design is clearly molded on the latter's McKim, Mead & White French-styled château. Both have similar H-plans, tall peaked roofs, and carefully dressed stone. Similar, as well, are the French-styled gardens stretching down the hillside from the side of the house. However, there are also major differences. While the Delano & Aldrich design derives from Loire Valley châteaus of the French Renaissance, Stanford White based his design on Mansart's Maison Lafayette and later 17th-century models.

Delano & Aldrich greatly simplified and restrained the ornamental detailing, so that

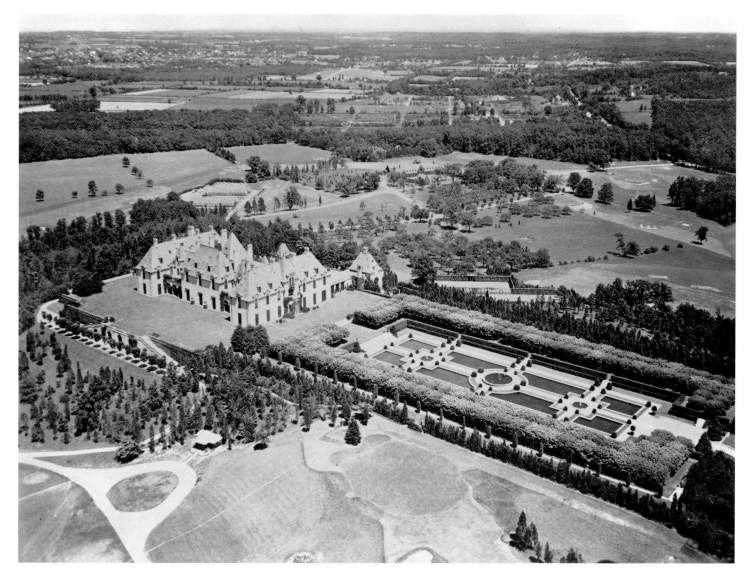

Delano & Aldrich:
"Oheka," Otto H. Kahn
Residence, Cold Spring
Harbor, 1915–17 (HEWI,
n.d.)

Delano & Aldrich: Floor
Plans, "Oheka," Otto H.
Kahn Residence, Cold
Spring Harbor, 1915–17
(SPLI, C. 1940)

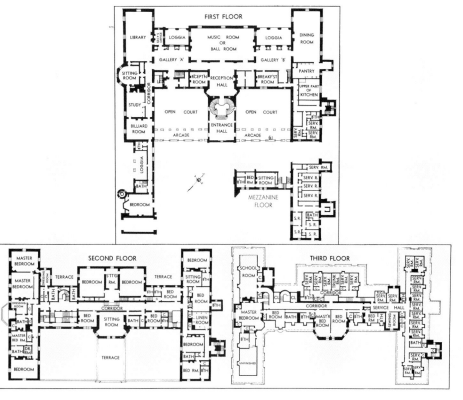

Delano & Aldrich: Early Construction Photograph, "Oheka," Otto H. Kahn Residence, Cold Spring Harbor, 1915–17 (HUNT, n.d.)

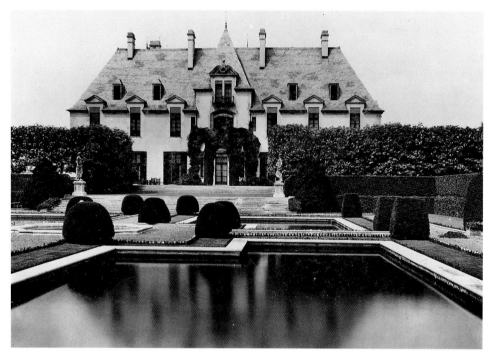

Delano & Aldrich: Garden Facade, "Oheka," Otto H. Kahn Residence, Cold Spring Harbor, 1915–17 (HEWI, n.d.)

Delano & Aldrich: Entrance Hall and Grand Staircase, "Oheka," Otto H. Kahn Residence, Cold Spring Harbor, 1915–17 (PREV, c. 1940)

Delano & Aldrich: Stables, "Oheka," Otto H. Kahn Residence, Cold Spring Harbor, 1915–17 (PREV, 1924)

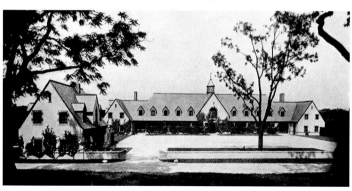

the building is almost austere in its lack of applied ornament. The approach to the house is through gate houses—a series of long, straight drives through woods from which the house can be seen at a distance crowning the top of a small rise. Closer, the visitor passes the garden wall with the house continuing to rise up. The immediate approach is through an entrance archway and then the entire facade spreads out in front of one at an oblique angle. One then turns and enters the house on axis—though the curving steps of the entrance hall move one slightly off axis, thereby increasing the length of the approach and also subtly hinting at the enfilade that runs cross-axially through the house. Beyond the very impressive enfilade is the major space, a large, 70-by-30-foot ballroom. At the time there were great views from the ballroom and the surrounding terraces across fields to Long Island Sound. The interior was impressively decorated and paneled and contained portions of Kahn's art collection.

Bertram G. Work Residence, "Oak Knoll," Mill Neck, 1916 (Extant)

Delano described his first contact with Bertram Work, then president of the B. F. Goodrich Company as follows:

One day my telephone rang and a voice said, "I'm Mr. B. G. Work, of Akron, Ohio; you've never heard of me. I've bought a piece of land at Oyster Bay, Long Island. May I see you? You're the only architect in New York who hasn't asked to build my house." . . . He said he wanted a small but perfect house. "And I want to build it out of income —not a cent of capital," he added. He must have had a huge income, for the house, garage, and gardens cost nearly a million dollars by the time they were finished.[47]

Known as "Oak Knoll," the residence occupied a very complicated site on a hilltop overlooking Oyster Bay. Delano solved the difficulties it posed by placing a skillfully designed classical courtyard off the road, with handsome paving and niches enriched with sculpture and wrought iron. From this court, the visitor winds up the hill via a curving road to a second paved court with a fountain on one side and the front facade of the house at the other. The facade is a formal composition in stucco and stone, with a circular portico set into a niche. The entrance is approached via a pair of semicircular stairs bordered by an exquisite wrought-iron railing. The design of the ironwork by Samuel Yellin of Philadelphia is based upon the innate function of wrought iron following both the rods and flat, hammered surfaces of the material. The motifs in the ironwork, as well as in the cornices and throughout

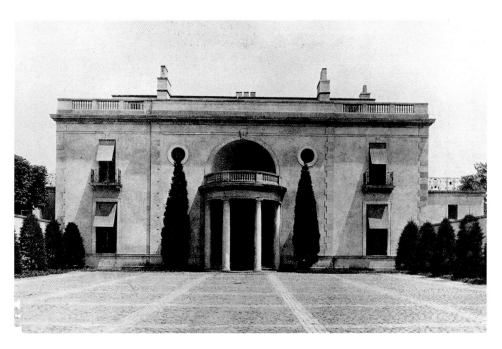

Delano & Aldrich: Front Facade and Entrance Forecourt, "Oak Knoll," Bertram G. Work Residence, Mill Neck, 1916 (COUN, 1918)

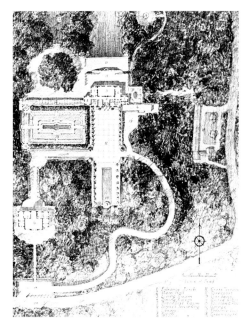

Delano & Aldrich: Site Plan, "Oak Knoll," Bertram G. Work Residence, Mill Neck, 1916 (PHDA, 1922)

Union and Knickerbocker clubs in New York. On either side of the entry are powder rooms for men and women. Directly on axis with the entry hall is the drawing room, which is beautifully paneled with a very simple shell motif in the cornice. To the left is the library, also paneled, and adjoining the loggia; to the right is the dining room adjoining a breakfast room. The fireplaces all have handsome marble mantels. The upper floor is devoted to bedrooms. With its site, superb garden, and handsome architecture, the Work house is without question one of the great 20th-century estates in North America.

James A. Burden Residence, "Woodside," Syosset, 1916–18 (Extant)

The Burden house, generally cited as one of the finest designs of Delano & Aldrich, won the Medal of Honor at the 1920 Architectural League Exhibition in New York. Royal Cortissoz wrote, "Delano and Aldrich have done nothing more exquisitely studied than this house, in which dignity and a gracious, endearing friendliness are suavely combined."[48]

James Abercrombie Burden (1871–1932) inherited from his father the presidency of the Burden Iron Works of Troy, New York. He attended Harvard College and one year of Harvard Law School. In 1895 he married Florence Adele Sloane. The estate at Syosset encompassed about 130 acres: 20 of these surrounded the house and included formal and informal gardens; the remaining acreage was devoted to a farm and wood lot. Delano & Aldrich began work in 1916, designing the entire complex of house, garage, stables, and farm group. In 1926 the firm added the gate house and made some alterations to the main house. The initial gardens were by Delano & Aldrich, though the Olmsted Brothers made some alterations between 1922 and 1926. Delano was apparently the main designer.

The Burden house is an admirable example of the simplicity and restraint that characterizes the best work of Delano & Aldrich. Stylistically the house is Georgian, its broad facade and extended wings perhaps reflecting the influence of the Southern-styled Georgian Revival houses of McKim, Mead & White.

Except for the suggestion of brick quoins, much of the rich feeling of the Burden house's exterior is due to the elegant brickwork in Flemish bond. A handsome wrought-iron stair leads to an entrance door with a fanlight. The lateral Palladian wings, which emphasize the symmetry of the house, are connected to

the interior of the house, are related to the sea—shells, turtles, and flying fish.

As was usual with Delano's houses, the gardens were also his design. Beyond the second court, surrounded by an arbor of trees and out of sight of the water, is a great, square formal garden with a central gazebo. The back of the house overlooks the bay, and from a broad terrace one can look down the steep hillside toward the distant water.

"Oak Knoll's" interior plan lent itself very well both to the informality of a country house and to the formality of the owner's way of life. One enters through a small vestibule that opens into a wide cross hall, beautifully paved with gray and white marble squares. All of the rooms open into this corridor, including the stair hall, which is finished with a wrought-iron railing and rusticated walls resembling those of the

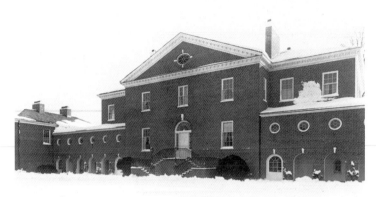

Delano & Aldrich: Front Facade, "Woodside," James A. Burden Residence, Syosset, 1916–18 (HEWI, n.d.)

overlooking a meadow on one side of the tennis court. On the other side is a formal garden with a pool and pergolas, with its central orientation toward the garage and laundry. Delano's penchant for arranging asymmetrical gardens here reaches its height, for there is also a serpentine wall off the formal garden surrounded by shrubs and trees. The house is entered through a circular hall that opens onto a long cross hall. At one end is the drawing room and at the other end the dining room, with a morning room and library located between the two.

The design of the gate house, added to the estate in 1926, is based on gate houses for Devonshire House, Piccadilly, London, designed in 1735 by William Kent. Surviving drawings by Delano's craftsman Herbert Godwin adopted the proportions of Kent's recently demolished gate houses to the Long Island countryside.[49] In 1929 Delano & Aldrich also designed a tomb for the Burden family plot in Troy, New York.

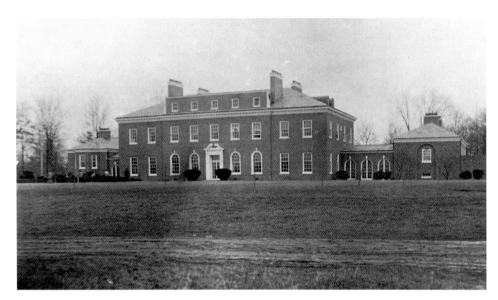

Victor Morawetz Residence, Woodbury, 1915 (Extant)

Victor Morawetz (1859–1938) was a wealthy New York City lawyer known for his astute dealings with railroads and corporations. After his death his estate was purchased by Mrs. Ailsa Mellon Bruce, who subsequently gave it to the Town of Oyster Bay.

The house, evidently designed by Delano, is a stunning example of his simplified 20th-century classicism. Austere in aspect, the house has plain stucco walls beneath a simplified parapet and cornice. The entrance is relieved only by a plain Greek Doric tabernacle and a broad terrace enriched with the simplest wrought iron.

On one side of the forecourt is a two-story service wing that is balanced on the other by a single-story wall, pierced at the center by an entrance framed with a broken pediment and Doric pilasters that open into the formal garden. The entrance to the forecourt is bounded by a simple wrought-iron fence that creates an enclosed court.

The L-shaped plan contains a central hall with a fireplace on axis with the entrance—a familiar arrangement of the architect. On one side is the living room, on the other a den, stair hall, and dining room. In the wing are servants' quarters and kitchens. The interior of the house is treated with the same restraint and simplicity of detail as the exterior.

In front of the south face of the house Delano created a broad grassy terrace with an oval pool to balance the circular pool in the forecourt. The sunken garden to the east is completely enclosed and has a pool at its center.

Delano & Aldrich: South (Rear) Facade, "Woodside," James A. Burden Residence, Syosset, 1916–18 (HICK, n.d.)

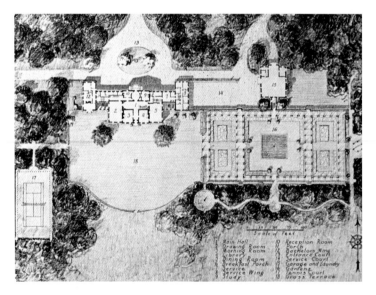

Delano & Aldrich: Site Plan, "Woodside," James A. Burden Residence, Syosset, 1916–18 (PHDA, 1922)

the main building by a first-floor arcade with arched openings and bulls-eye windows above. The wing designated as the bachelor's quarters balances the service wing, but bays, arcades, and walls relieve the symmetry.

Delano's ability to combine elegance with access to the delights of country living is very apparent in the Burden house. The beautiful garden is entered through a broad terrace of grass

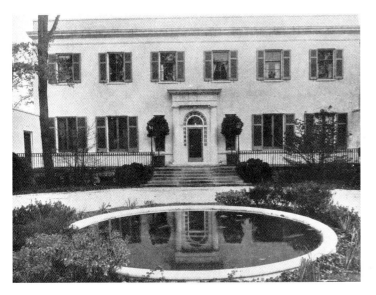

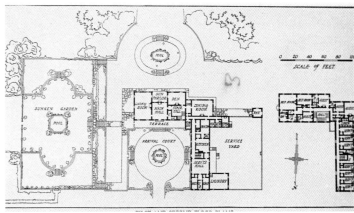

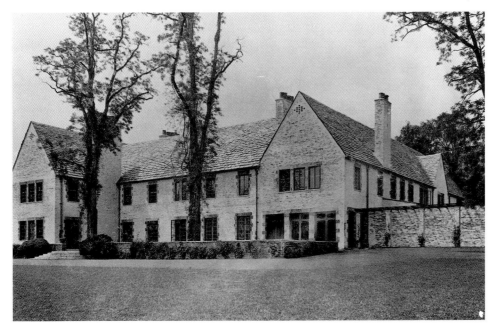

Delano & Aldrich: Front
Facade and Entrance Court,
Victor Morawetz Residence,
Woodbury, 1915 (ARTR, 1918)

Delano & Aldrich: Site and
Floor Plans, Victor
Morawetz Residence,
Woodbury, 1915 (ARFO,
1918)

Delano & Aldrich: Garden
Facade, Vincent Astor
Residence, Port Washing-
ton, 1922 (HEWI, n.d.)

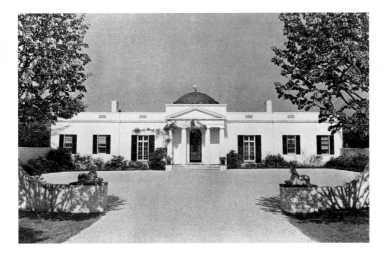

Delano & Aldrich: Front
Facade, "Little Ipswich,"
Chalmers Wood Residence,
Syosset, 1927 (HOWE, 1933)

Vincent Astor Residence, Port Washington, 1922 (Extant)

Designed for a member of the prominent New York family, the Vincent Astor house is more picturesque than is usual for Delano & Aldrich. The house is built of brick painted a flat white and trimmed with seam-faced granite, reflecting once again the attraction of the English Arts and Crafts movement. The roof of heavy Vermont slate was purposely aged; broken and chipped slates were used, and an early photograph even shows slate chips lying on the roof. While the great commanding roof recalls Voysey, the chimneys, pavilions, and overall character are more reminiscent of such Lutyens works as Marshcourt, Hampshire (1901–04). The house was designed around a venerable maple tree, which became the main focus of the terrace.

Chalmers Wood Residence, "Little Ipswich," Syosset, 1927 (Extant)

The Wood house, built toward the end of the 1920s, indicates the growing interest in simplified and modern classical architecture. Delano and Aldrich were among the leaders both in America and internationally in creating this clean, stripped idiom. In fact, the Wood house relates equally well to the Scandinavian and German classicism of the period. Although detail is restrained and minimal, the basic classical forms dominate.

The central block contains the doorway and a Greek Doric portico. It is covered with a low dome, and a parapet hides the roof. The wings at each end of the house, containing the bedroom and service areas, have traditional doublehung sashes. The house is entered through a large gravel court guarded by a pair of sphinxes. Five French doors mark the garden facade. Although the house looks small, the wings add to its size.

Richard Guy Wilson

Bradley Delehanty: Garden Facade, Renard/Erbe Residence, Lattingtown, alterations, c. 1927 (HEWI, 1927)

Bradley Delehanty: Front Facade, Frank Finlayson Residence, Locust Valley, alterations, c. 1936 (DELE, 1939)

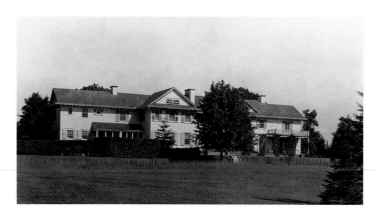

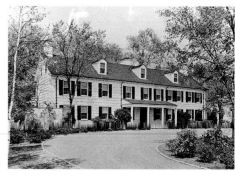

■

Bradley Delehanty, 1888–1965

John Washington Bradley Delehanty, one of Long Island's most prolific estate architects, was well-loved by his clients. He died at the age of 77[1] after a career that spanned over half a century, leaving unbuilt an interfaith chapel for C. W. Post College in Greenvale. He is credited with 56 houses, a bank, and a cemetery lodge on Long Island, as well as commissions in the South, Maine, Wyoming, and the British West Indies.

Unlike many of his colleagues, Delehanty preferred to maintain a small professional staff and was assisted at times by only one draftsman in his New York City office at 2 Park Avenue. He was a member of the Piping Rock, Knickerbocker, and other social clubs, and maintained a steady clientele even during the post-Depression era, when he undertook a number of notable alteration projects in addition to the new designs that distinguished his career.

Dissuaded from a career in painting while at Cornell University (from which he graduated in 1910), Delehanty later received architectural training at the Ecole des Beaux-Arts in Paris. A devotee of the steeplechase, he maintained a country house in Oyster Bay, where he frequently entertained both friends and clients. His townhouse at 444 East 57th Street in New York City was convenient to his practice, and his refurbished 18th-century farmhouse on Long Island provided a relaxed setting for social contacts that often led to commissions. In fact, all but three of his mansion-scaled designs were located near his Long Island house, within the incorporated villages of Nassau County's exclusive North Shore.

Delehanty's work may be divided broadly into two categories: new designs, and alterations or additions to older structures. His new country-house commissions naturally display a greater diversity of style than his alterations, although an adherence to traditional forms and classic proportions remained fundamental throughout his career. Brick, either painted or stuccoed, was his preferred building material for new work, whereas wood, either shingled or clapboarded, typified his alterations and additions to older dwellings. In this regard, Delehanty followed the precedent of other country-house architects who chose the more monumental forms of masonry construction over the traditional and indigenous wood-frame construction. His regard for older houses is nevertheless apparent in his alterations, as well as in several of his early commissions, which appear to be replicas of historic prototypes. In these instances, wood construction was chosen as a more sympathetic and appropriate material. Examples of alteration projects in wood include the Ira Richards residence (c. 1927), the Renard/Erbe residence (c. 1927), and the Anderson/Shea residence (c. 1930), all located in Lattingtown, and the Frank Finlayson residence (c. 1936) in Locust Valley.

Col. F. W. M. Cutcheon Residence, Matinecock, c. 1920 (Extant)

Philip A. S. Franklin Residence, Matinecock, c. 1926 (Extant)

Clarence E. Groesbeck Residence, Matinecock, c. 1918 (Extant)

Among Delehanty's earliest new designs are those for Col. Franklin W. M. Cutcheon (1864–1936), a lawyer, and for Philip A. S. Franklin (1871–1939), president of International Mercantile Marine Co. Cutcheon and Franklin were two of the investors in the Underhill Development Corporation, which acquired and subdivided Delehanty's nine-acre Underhill farm in Matinecock.[2] The architect had purchased the property in 1917 and participated in this development in the 1920s.

The Cutcheon residence is of wood frame and combines Greek Revival and vernacular farmhouse forms to create a picturesque, architectural pastiche of historical modes. The

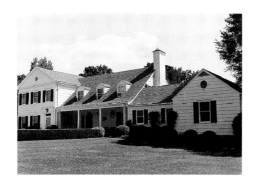

Bradley Delehanty: Front Facade, Col. Franklin W. M. Cutcheon Residence, Matinecock, c. 1920 (SPLI, 1978)

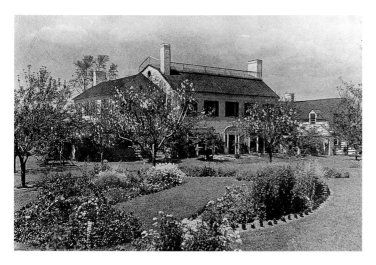

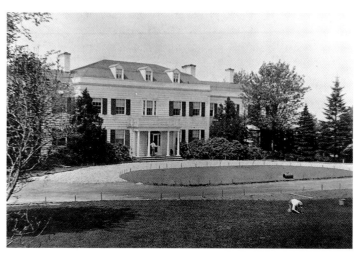

Bradley Delehanty: Rear Facade, "Hayfields House," P. A. S. Franklin Residence, Matinecock, c. 1926 (DELE, 1934)

Bradley Delehanty: Entrance and Front, Clarence E. Groesbeck Residence, Matinecock, c. 1918 (FLON, 1930)

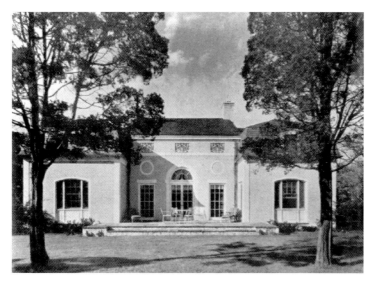

Bradley Delehanty: Rear (South) Facade, "East View," Warren S. Crane, Jr., Residence, Cedarhurst, c. 1932 (DELE, 1939)

architect's use of clapboard and faithful re-creation of historic prototypes reveal the design as an early work. The Franklin residence, also of wood, relies on an American prototype as well, but is a more ambitious work reminiscent of Long Island's larger, high-style manor houses of the mid- to late 18th century. The gambrel roof in particular has been identified as indigenous to Colonial Long Island architecture, although no specific reference may be drawn between Delehanty's design and any of the numerous surviving historic structures that display the form. His nearby commission in Matinecock for Clarence E. Groesbeck, a utilities executive, also followed this conservative historic tradition.

Built c. 1918, the house sported an unusual hipped gambrel roof and a one-story entrance porch supported by four Doric columns. The grounds were landscaped by the Olmsted Brothers.

Warren S. Crane, Jr., Residence, Cedarhurst, c. 1932 (Extant)

With regard to Delehanty's Colonial Revival work, one is tempted to speculate that he knew of "Rock Hall," the c. 1767 Josiah Martin house in Lawrence, which became the Town of Hempstead Museum in the 1950s. Delehanty designed a compact brick residence nearby on Polo Avenue for Warren S. Crane, Jr., c. 1932. The Crane commission was a late addition to the so-called Rockaway Hunt section of Lawrence, which had been laid out by the Lawrence family in the 1870s. Numerous houses had been built in this exclusive community on large lots within a parklike setting, and Warren S. Crane, Sr.,[3] commissioned the architect to design a house as a wedding present for his son. Drawing from diverse architectural styles, Delehanty created a summer house in a scale reminiscent of an English Regency "casino." Overscaled first-story windows and mansard roofs above the symmetrical wings contribute to the overall charm of the house, which was recognized as the "Bride and Groom House of the Year" in 1933.[4]

Bradley Delehanty: Front
Facade, "Still House," Paul
D. Cravath Residence,
Locust Valley, c. 1920 (DELE,
1934)

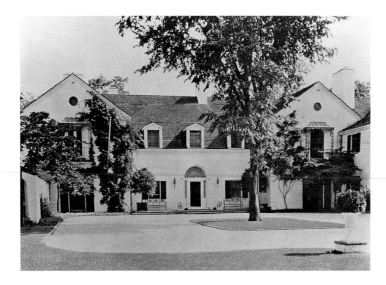

Paul D. Cravath Residence, "Still House," Locust Valley, c. 1920 (Extant)

Delehanty's preference for brick over wood
construction was well established by the early
1930s. The Paul D. Cravath residence (c. 1920)
in Locust Valley was one of his first large, brick
country houses; like his other early work, how-
ever, it drew heavily upon traditional American
architectural forms. Paul D. Cravath (1861–
1940), senior partner of the famous Manhattan
law firm of Cravath, de Gersdorff, Swaine &
Wood, had lost two other country houses to
fire, and understandably preferred fireproof
brick construction.[5] Known as "Still House,"
the large masonry residence was originally

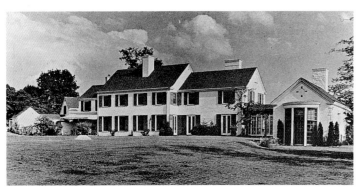

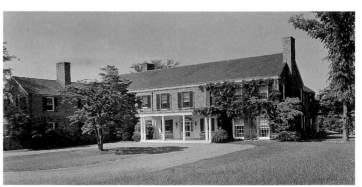

Bradley Delehanty: Rear
Facade, George W. Hepburn
Residence, Lattingtown,
c. 1927 (DELA, 1934)

Bradley Delehanty: "Long
Field," Frederick T. Hepburn
Residence, Lattingtown,
c. 1929 (GOTT, n.d.)

Bradley Delehanty: "Willow
Bank," F. Gordon Brown
Residence and Stable, Glen
Head, c. 1930 (DELA, 1934)

Bradley Delehanty: Front
Facade, "Monday House,"
Dr. Walter Damrosch
Residence, Brookville,
c. 1930 (GOTT, n.d.)

Bradley Delehanty: Entrance
and Front Facade, "Punkin
Hill," Eugene M. Geddes
Residence, Matinecock,
c. 1934 (DELA, 1934)

Bradley Delehanty: Front
Facade, Julien A. Ripley
Residence, Brookville,
c. 1934 (DELA, 1934)

Bradley Delehanty: Sam H. Harris Residence, Kings Point, c. 1920 (HEWI, 1922)

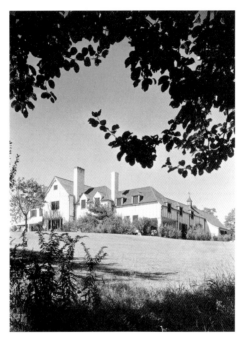

Bradley Delehanty: Robert B. Law Residence, Syosset, c. 1930 (GOTT, 1931)

whitewashed and the roof tiled. The interior plan is arranged around a wide center hall with a semicircular staircase, and employs other Colonial Revival details such as paneled doors, denticulated cornices, and built-in bookcases. Wrought-iron balconies on the exterior reflect a Southern influence, as does the massing of the house as a whole, which subordinates the large service wing to the main rectangular block.

Other, similar country houses followed the Cravath commission and emulated its formula; these include the George W. Hepburn residence (c. 1927) and the Frederick T. Hepburn residence (c. 1929) in Lattingtown, the F. Gordon Brown residence (c. 1930) in Glen Head, the Dr. Walter Damrosch residence (c. 1930) in Brookville, the Eugene M. Geddes residence (c. 1934) in Matinecock, and the Julien A. Ripley residence (c. 1934) in Brookville.

Sam H. Harris Residence, Kings Point, c. 1920 (Extant)

While working within the Colonial Revival tradition, Delehanty nevertheless found opportunities for greater diversity and experimentation. A notable and early example is the Sam H. Harris residence in Kings Point. Stuccoed and roofed with Spanish tile, the house incorporates two massive boxes connected by an arcaded entry. The low-hipped roof projects boldly beyond the walls and is supported on exposed wood elements. The window and door openings are simply articulated with unmolded surrounds. Although the residence belongs to a class of country houses inspired by Mediterranean prototypes that are well represented by the contemporary work of Long Island's country-house architects, it is the only example of the style created by Delehanty. Its choice may in fact be attributed to the client, Sam H. Harris (1872–1941), who was a theatrical manager in New York City.

Robert B. Law Residence, Syosset, c. 1930 (Extant)

Delehanty's Robert B. Law residence (c. 1930) in Syosset is equally exceptional in terms of architectural style. Advertised as "a charming, rambling Home of attractive Norman design,"[6] it was the architect's only excursion into half-timber construction. The house is L-shaped in plan and sited on a slight rise of ground. The brickwork between the exposed timbers is laid in a variety of patterns, and the leaded casement windows display a similar variety of treatments. The entrance hall and dining and living rooms occupy the largest and highest end of the house, while the kitchen and service rooms are grouped into smaller blocks that have been recessed in stages from the main section. The whole conforms to the gradual slope of the site and succeeds where a traditional and symmetrical composition might have failed.

George R. Dyer, Jr., Residence, Brookville, Alterations, c. 1939 (Extant)

Another example of Delehanty's range is his alteration scheme for the George Dyer residence (c. 1939) in Brookville. The original house was a long, rambling English-style "cottage" of 1920s vintage, with its second story, covered with clapboards, overhanging the first, and each window shuttered and fitted with window boxes to heighten its rural, romantic appeal. Delehanty's revision of the structure is as dramatic as it is radical. The walls were raised to two full stories and the exterior stuccoed. The sash windows were exchanged for casements and all exterior

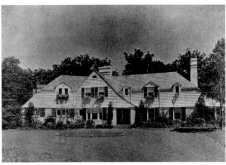

Bradley Delehanty: Entrance Elevations before Alterations, George R. Dyer, Jr., Residence, Brookville, c. 1920s (DELE, 1939)

Bradley Delehanty: Entrance Elevations after Alterations, George R. Dyer, Jr., Residence, Brookville, c. 1939 (DELE, 1939)

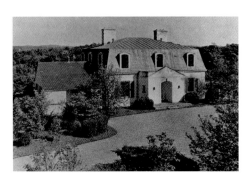

Bradley Delehanty: Front Facade, Robert Hattersley Residence, Glen Head, c. 1929 (DELE, 1939)

Robert Hattersley Residence, Glen Head, c. 1929 (Extant)

For the most part Delehanty created country houses patterned after American Colonial and English Georgian or Regency prototypes. In this regard he conformed to a popular trend of the period from 1920 to 1940. His occasional use of French details, as in the Robert Hattersley residence (c. 1929) in Glen Head, which employs a mansard roof above a single-story block, appears less frequently than comparable American or English features. With its overscaled entrance porch of brick and the combination of standing metal seam and slate roof, the Hattersley house is in some respects experimental. The effect of imbuing a relatively compact structure with the scale and importance of a larger country house is not unsuccessful, but Delehanty had more experience in handling the traditional varieties of country-house designs, which drew on American or English sources.

William J. Ryan House, St. James, c. 1930 (Extant)

The William J. Ryan residence (c. 1930) in St. James is a case in point. The Ryan house is of brick and balances a five-bay, two-story center block with side dependencies that terminate in smaller, perpendicular two-story wings. Palladian windows centered above the front and back doors confirm the internal arrangement as a center-hall type. The front door is protected by a columnar porch which carries a pediment echoed by the roofline above it. There are three roof types in all: hipped, gambrel, and gable. The hipped roof of the main block and gable roof on each wing follow historic precedent, whereas the gambrel roof of each hyphen appears to be a Delehanty innovation. Although the house is constructed of whitewashed brick and not stuccoed, its overall form, proportion, and detail recall the late 18th-century English Regency tradition of John Soane[7] as emulated in America by such architects as Charles Bulfinch.[8]

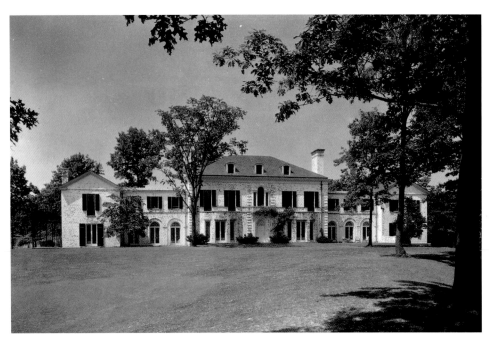

Bradley Delehanty: Rear Facade, "Yarrow," William J. Ryan Residence, St. James, c. 1930 (GOTT, 1932)

ornamentation removed. A curving balcony and rail were added above the front entry, and the house was extended at each end. A circular music room was constructed as an adjacent pavilion and connected by a glazed hyphen to the main house. The result was Delehanty's only International Style country house, and one of very few examples of that style on Long Island.

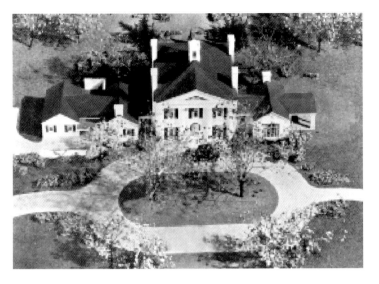

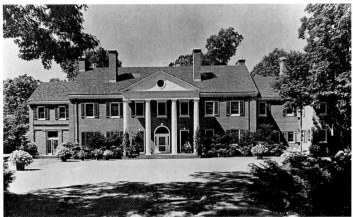

Bradley Delehanty: Entrance View, "Pidgeon Hill," William N. Davey Residence, West Hills, c. 1939 (DELE, 1939)

Bradley Delehanty: Front Facade, "Hearthstone," Hunt T. Dickinson Residence, Brookville, c. 1939 (DELE, 1939)

Bradley Delehanty: Front Facade, Kenneth Sheldon Residence, Glen Head, alterations, c. 1939 (DELE, 1939)

Bradley Delehanty: Main Entrance Detail, "Carston Hill," Edgar Marston Residence, Syosset, c. 1939 (DELE, 1939)

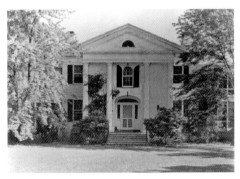

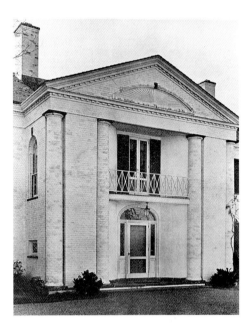

The Ryan commission is unusual for Delehanty only in its location in Smithtown, being one of two substantial country houses he designed for sites east of the Nassau County border. Delehanty's avocation as a steeplechaser and fox-hunter may have brought him into Ryan's circle. William J. Ryan, owner and publisher of *Literary Digest,* maintained a polo field at his St. James estate and shared similar interests with Delehanty. Although business reverses in 1936 may have prevented the completion of the brick stables, Ryan resided in the house until his death in 1966, when the property was acquired by the Nissequogue Golf Club, Inc.

William N. Davey Residence, "Pidgeon Hill," West Hills, c. 1939 (Extant)

Hunt T. Dickinson Residence, "Hearthstone," Brookville, c. 1939 (Extant)

Two other country houses comparable in scale to the Ryan residence are the c. 1939 William N. Davey residence in West Hills, Huntington, and the Hunt T. Dickinson residence in Brookville. The Davey house, "Pidgeon Hill," is an ambitious composition that incorporates a central, two-story block with flanking wings of one story. Four Doric columns support a colossal pediment above the main entry. Although

Delehanty drew upon Greek Revival designs for inspiration, the result is innovative in its juxtaposition of structural masses and roof lines.

The Dickinson house, "Hearthstone," in Brookville also employs a four-column portico supporting a pediment at the attic level, but is restrained in the massing of its large rectangular center block and recessed two-story wings. Such details as a denticulated cornice and the round-headed principal doorway are hallmarks of the architect's Colonial Revival work. Delehanty incorporated similar details within the pedimented facade of the Kenneth Sheldon residence, which he altered c. 1939 in Glen Head.

Edgar Marston Residence, "Carston Hill," Syosset, c. 1939 (Extant)

Smaller in scale, but equivalent in design, is the four-column entry of the Edgar Marston residence (c. 1939) in Syosset. Named "Carston Hill" for the client's wife, Florence Carr Marston, the house is of brick. The main block

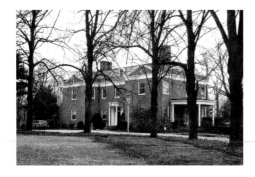
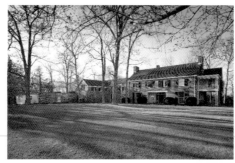

Bradley Delehanty: Front Facade, Daniel P. Woolley Residence, Lattingtown, c. 1925 (SPLI, 1978)

Bradley Delehanty: Rear Facade, John K. Colgate Residence, Oyster Bay, c. 1939 (SPLI, 1981, Michael Mathers photo)

Bradley Delehanty: George Ide/Thomas Dickson Residence, Lattingtown, alterations, c. 1929 (SPLI, 1978)

Bradley Delehanty: Front Facade, Carroll B. Alker Residence, Brookville, c. 1930 (GOTT, 1934)

Bradley Delehanty: Rendering of Front Facade, Miss Alida Livingston Residence, Brookville, c. 1939 (DELE, 1939)

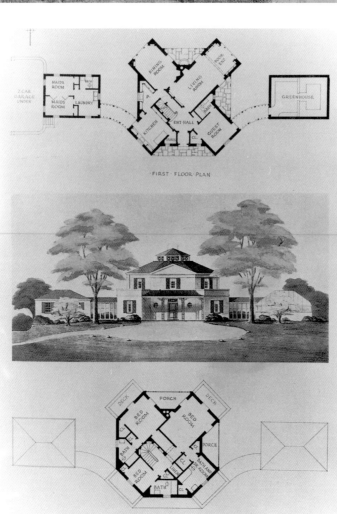

is two stories in height beneath a gable roof, and five bays wide, although the center three bays are collapsed on the back facade and concealed behind a monumental portico on the front. The engaged Doric columns of the portico are of brick and the center entry is slightly recessed beneath a second-story balcony. Round-headed windows punctuate the narrow projecting walls of the portico's second story. The overall effect of the house is of a compact villa in the English Regency country-house tradition. Other commissions of comparable scale and design include the earlier Daniel P. Woolley residence (c. 1925) in Lattingtown, the John K. Colgate residence (c. 1939) in Oyster Bay, and the remodeled Thomas Dickson residence (1929) originally designed for George Ide by James Gamble Rogers in Lattingtown.

Carroll B. Alker Residence, Brookville, c. 1930 (Extant)

Among Delehanty's larger country-house commissions, two others deserve mention as departures from his traditional work. The earlier of the two, for stockbroker and yachtsman Carroll B. Alker, is a blend of French Renaissance and Georgian Revival modes, employing a steeply pitched, hipped roof unlike the architect's customary gable, gambrel, or flatter hipped-roof forms. Two conical towers flank the front entry and complement the roof design. The windows, which also break with the Anglo-American architectural tradition, are of the casement type with segmental arch heads resembling those of Delehanty's mansard-roofed Hattersley house in nearby Glen Head.

Miss Alida Livingston Residence, Brookville, c. 1939 (Extant)

Perhaps the most innovative of Delehanty's designs is the Alida Livingston residence (c. 1939) in Brookville. Its octagonal form had precedence in both late 18th- and 19th-century experimental work, and local examples such as a hotel in Oyster Bay and houses in Huntington and Northport may be cited as possibly having

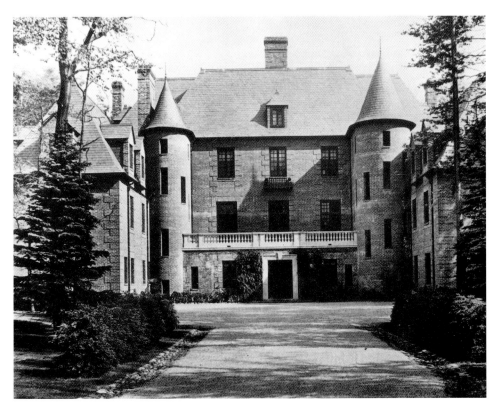

J. Henri de Sibour: Entrance Court and Front Facade, "Gloan House," Dewees W. Dilworth Residence, Roslyn, c. 1930 (NASS, n.d.)

design, Delehanty worked within the Colonial Revival vocabulary but tailored each commission to suit the individual client. He is remembered as a man of impeccable taste and an architect with an unfailing sense of scale and line; yet his clients found him to be unusually attentive to their needs. In fact, Delehanty kept the tradition of country-house design alive for several decades after many of his contemporaries had ceased practice. With his death in 1965, the heyday of estate development on Long Island had certainly come to a close.

Zachary Studenroth

influenced Delehanty or his client.[9] The Livingston house expands on the form, however, by adding two small service wings which are connected to the core by glazed, semicircular hyphens. The house also combines traditional Colonial features like sash windows and shutters, a belvedere, and a pediment above the front entry that incorporates a one-story iron veranda reminiscent of other Delehanty designs. The octagonal form and its resulting plan are virtually unique among the surviving examples of Long Island country-house design.[10]

It may be said, in summary, that Delehanty had the ability to translate his clients' requirements for good design and "livability" into successful country houses of architectural distinction. Whether embarked on the alteration of an existing structure or on an entirely new

J. Henri de Sibour, 1873–1938

Parisian-born Viscount Jules Henri de Sibour received his architectural training at the Ecole des Beaux-Arts, but spent most of his professional life in Washington, D.C. Brought to the United States at an early age by his American mother, he was educated at St. Pauls and Yale, where he starred on the gridiron. After practicing in New York as a partner of Bruce Price, de Sibour moved to Washington in 1901, where he designed Keith's Theatre and the Chevy Chase Country Club, as well as the French and Canadian embassies. His only Long Island country-house commission, "Gloan House," was built c. 1930 in Roslyn for Dewees Wood Dilworth, a Wall Street executive and member of the New York Stock Exchange. The U-shaped French château with its distinctive stair towers, renamed "Les Deux Tours" by subsequent owner Lorraine Manville, is no longer extant.

Robert B. MacKay

Frederic Diaper, 1810–1906

Born in England, Frederic Diaper was trained in the office of Robert Smirke, designer of the British Museum in London. After arriving in New York in the 1830s, Diaper established a significant architectural practice, becoming known for his commercial and residential buildings in the Greek and Renaissance Revival styles. His earliest works reveal his English training and the importation of a more restrained version of the Greek Revival style. This is demonstrated in one of his rare surviving works, "Beverwyck Manor," built between 1839 and 1842 near Albany for William Paterson Van Rensselaer, son of the last patroon of the

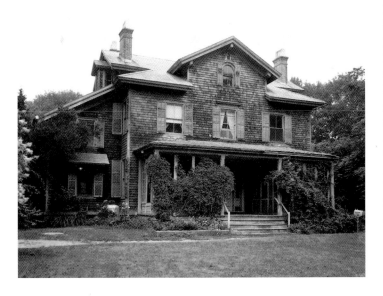

Frederic Diaper: Front Facade, "The Cedars," Selah B. Strong, Jr., Residence, Setauket, 1879 (SPLI, 1977, Bill Seeberger photo)

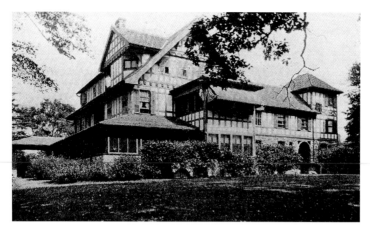

Albert F. D'Oench: Facade, "Sunset Hill," Alfred F. D'Oench Residence, Manhasset, 1905 (COUH, 1925)

manorial seat of Rensselaerwyck. Later country houses in the Second Empire style include the Park-McCullough house, 1864–65, still standing in North Bennington, Vermont (designed while in partnership with Henry Dudley, another English-born architect), and the Darius Ogden Mills house, 1870, in Millbrae, California (no longer extant). The Mills's house was designed when Diaper was practicing in San Francisco with the New York architect Alexander Saeltzer.

In 1844–45 Diaper was the natural choice as architect for "St. George's Manor," the country seat of Judge Selah B. Strong in Setauket, since a few years earlier he had married into the Strong family. (His wife's cousin Judge Strong was also cousin to the well-known lawyer and diarist George Templeton Strong.) The 23-room mansion replaced an earlier manor house and still stands overlooking Conscience Bay. A restrained Greek Revival design, it is clapboarded with pedimented gables on each of its four sides.

Thirty-five years later, in 1879, Diaper designed the country residence of Selah B. Strong, Jr., for a site on Strong's Neck near "St. George's Manor." Like his father, Selah B. Strong, Jr., had studied at Yale, practiced law, and preferred the country life of his ancestral home. An eclectic Victorian building of unpainted shingles, "The Cedars" resembles in plan and in certain

elements of its elevation the earlier Strong residence designed by Diaper, and suggests a conscious effort to refer to this building. For many years, Kate Wheeler Strong, noted local historian and daughter of Selah B. Strong, Jr., resided at "The Cedars."

Joy Kestenbaum

Albert F. D'Oench, 1852–1918

The son of German immigrants of Flemish origin, Albert Frederick D'Oench was born in St. Louis, Missouri. In 1873, after studying architecture at the Polytechnic Institute of Brooklyn, he traveled to Germany to continue his studies at the Royal Polytechnic Institute in Stuttgart. Before returning to the United States, D'Oench toured England and the Continent. Back in New York, D'Oench was employed in the office of Leopold Eidlitz, Richard Morris Hunt, and Edward Raht. In 1881 he was appointed Superintendent of Buildings for the City of New York.

D'Oench resigned this post in 1889 to form a partnership with Bernhard Simon, which was greatly patronized by the city's German community. In 1901, highly successful in his career, D'Oench married the daughter of Mayor William Grace, to whom he owed his earlier appointment as New York's building superintendent. Four years after his marriage to Alice Grace, D'Oench designed and built "Sunset Hill," a country house in Manhasset. The freely conceived Tudor Revival house (demolished in 1937) stressed the picturesque, featuring a first story of random ashlar fieldstone that contrasted with the half-timbering of the upper story and colored pantiles on the roof. D'Oench retired to "Sunset Hill" in 1916.

Michael Adams

William F. Dominick: Garden Facade, "Thorneham," Landon K. Thorne Residence, Bay Shore, 1928 (HOWE, 1933)

William F. Dominick, 1870–1945

William Francis Dominick maintained an office in New York City but is mostly remembered for the design of buildings in the Greenwich, Connecticut, area. Of his works there, the most notable are Christ Church and alterations to the home of Mrs. Archer F. Brown, for which he received the American Institute of Architects' Award of Merit in Small House Design. Born and educated in Greenwich, Dominick attended Yale and studied architecture at Columbia

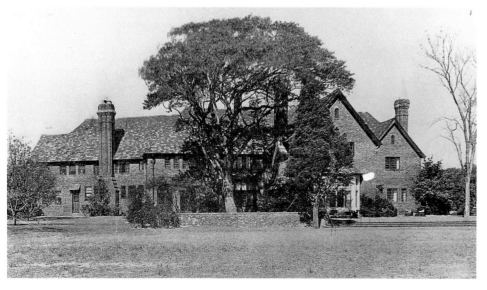

C.L.W. Eidlitz: "Overlea,"
C.L.W. Eidlitz Residence,
East Hampton, 1896–97
(SPLI, 1980)

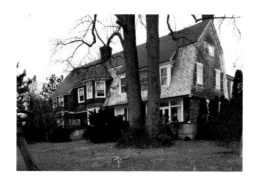

*Mr. Eidlitz, one of our Summer residents, had
quite an experience while bathing on Tuesday
morning. He was caught in a "Sea Poose" and was
unable to get to shore but being a good swimmer
he took the matter coolly, and after having been
carried by the current along the beach . . . , he
managed to work out of it and swam ashore.[2]*

C.L.W. Eidlitz: Front
Facade, Mrs. Schuyler
Quackenbush Residence,
East Hampton, 1899
(Woody Simes photo, 1976)

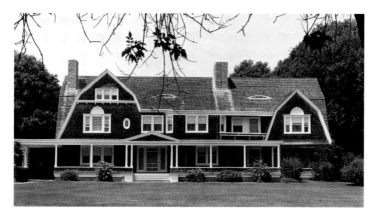

C. L. W. Eidlitz Residence, "Overlea," East Hampton, 1896–97 (Extant)

Eidlitz built his own cottage, "Overlea," on
Ocean Avenue, a gambrel-roof, shingled struc-
ture. This popular and fashionable resort style
reflected the local architectural aesthetic, evi-
dent here in the shed dormers and the steep
angle of the gambrel. Two years later Eidlitz
enlarged his cottage, which was further altered
in later years.

Mrs. Schuyler Quackenbush Residence, East Hampton, 1899 (Extant)

The *East Hampton Star,* May 31, 1899, reported
that, "G. A. Eldredge has summer residences
for S. Quackenbush, Theron Strong and E. C.
Potter about completed."[3] Harriet Quacken-
bush's house was built next door in 1899, on a
wide expanse of lawn, surrounded by a rose-
covered post-and-rail fence. Still extant and un-
altered, it is a magnificent example of the late
Shingle Style with Colonial Revival detailing.
A sophisticated asymmetrical design, the roof
first appears as a gambrel. A closer examination
reveals that the central portion containing the
swept-eyelid dormers is a plain gable section,
with gambrel cross-gables at each end and side
walls outlined by large gambrel shapes. Each
gambrel gable contains a Palladian window with
a sash of 24 lights over one. The arched top of
the window is paneled in a sunburst fashion
with a keystone at the top. The adjacent oval
window is another typical Colonial Revival
detail. A long, roofed porch across the whole
facade shelters the wide entry door, with its
Adamesque leaded sidelights.

The entry area of the porch has paired, round
Tuscan columns supporting a pediment. This
changes as the porch slides under the second
story of the smaller gambrel gable, where the
supports are shingle-covered. Above this, on the
second floor, is a romantic loggia with a bracket-
ed porch railing. This bracketed horizontal line
is repeated on the other gable, in an overhang
below the triple attic windows. A sure hand and
eye carefully balanced these details. All in all,
the house is a lively, yet restrained, essay on the
Shingle Style. While Eidlitz's own house has
been much altered, his sister's house remains a
vision of the picturesque aesthetic of the late
19th century.

Sherrill Foster

College and in Europe before opening an office
in New York. Apparently, his only work on
Long Island was a residential commission for
Landon Ketchum Thorne, president of the in-
vestment firm of Bonbright & Co. Like the
architect he selected, Thorne was born in Con-
necticut and was a graduate of Yale. "Thorne-
ham," built in 1928 and located in Bay Shore,
was a sprawling Tudor Revival estate with for-
mal gardens designed by Umberto Innocenti.

Joel Snodgrass

■

C. L. W. Eidlitz, 1853–1921

The New York City architect Cyrus Lazelle
Warner Eidlitz, son of the well-known archi-
tect Leopold Eidlitz, was well educated in
architecture. He is known for the Buffalo
Public Library, the Dearborn Railroad Station
in Chicago (both 1881), the original New York
Times building (1904), and the still-extant
building designed for the New York City Bar
Association (1896). In East Hampton, Long
Island, he designed two cottages, one for him-
self in 1896, and one for his sister Harriet (Mrs.
Schuyler Quackenbush) in 1899.[1] Both families
had rented summer cottages there for several
years before they built their own and had en-
joyed the pleasures of the country and the
excitement of ocean bathing.

Cyrus Eidlitz was 38 years old when he was
caught in a sea-poose (an underwater whirlpool
current) off the bathing beach in East Hamp-
ton. the *East Hampton Star,* August 28, 1891,
reported:

Thomas H. Ellett: "CaVa,"
Carroll B. Alker Residence,
Brookville, 1924 (SPLI, 1978)

Thomas H. Ellett: Estate
Outbuildings, Donald H.
Cowl Residence, Sands
Point, 1924 (TOWN, 1925)

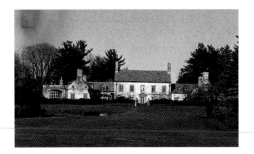

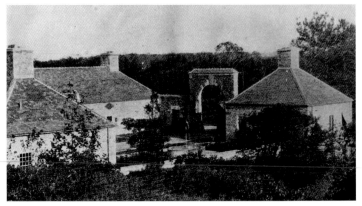

Thomas H. Ellett: Garden
Facade, "Mañana," E.
Mortimer Barnes Residence,
Glen Head, 1914 (SPLI, 1936)

Thomas H. Ellett: Garden
Facade, "Brookwood,"
Henry M. Minton
Residence, Manhasset, 1929
(HOUS, 1930)

Thomas H. Ellett: Front
Facade, "Braestead" Mrs.
Helen Peters Residence,
Brookville, 1929 (SPLI, 1978)

Thomas H. Ellett, 1880–1951

Thirteen projects on Long Island, most of them
on the North Shore, are known to have been
designed by Thomas Harlan Ellett. His build-
ings look comfortable in their country settings,
their textures and configurations being more
rustic than formal. Some show French and
Norman influence in their shape and detail.

Born in Iowa, Ellett graduated with a degree
in architecture from the University of Pennsyl-
vania in 1906. On a traveling fellowship, he
studied in Europe, primarily at the American
Academy in Rome, until 1909. Returning home,
Ellett spent several years in the office of McKim,
Mead & White. Except for service as a captain
in the 302nd Engineers in World War I, Ellett

practiced architecture on his own in New York
City from 1915 through 1941. Two of Ellett's de-
signs won awards from the Architectural League
of New York: the J. Seward Johnson house in
New Brunswick, New Jersey, won the silver
medal in 1928; and the Cosmopolitan Club on
66th Street in Manhattan won the gold medal
in 1933.

In 1924 Ellett designed "Ca Va," a house with
garage and other estate buildings, for broker and
yachtsman Carroll B. Alker on Cedar Swamp
Road in Brookville. The two-and-a-half-story
main block resembles a large, brick farmhouse,
with a simple, pedimented center entry and end
chimneys. Casement windows give the house a
European aspect, and the structure is connected
by hyphens to smaller, gable-roofed wings set
perpendicular to the main block. Iron gates in a
brick wall open from the road onto elaborately
landscaped grounds that include greenhouses, a
garage, and a service court.

Also in 1924, Ellett designed for the Port
Washington estate of Donald H. Cowl at
Barker's Point, on Sands Point, a self-contained
court of service buildings which included a gar-
age, guest house, and caretaker's cottage, as well
as a pair of arches and a wall that followed the
curve of the drive. This complex, nestled into
a low hillside, framed a view of Long Island
Sound. The richly textured walls and buildings
were laid up in plain brick, whitewashed brick,
fieldstone, and rock-faced brick, with some

Aymar Embury: Entrance
Facade, Wallace Chauncey
Residence, East Hampton,
1936 (ARTS, 1939)

Aymar Embury: Front
Facade, G. A. Schieren
Residence, Great Neck,
c. 1915 (ARTR, 1918)

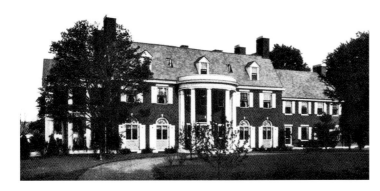

Aymar Embury: Floor Plans,
G. A. Schieren Residence,
Great Neck, c. 1915 (ARTR,
1918)

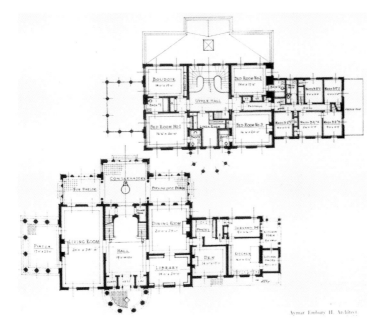

mer home for Barnes, who also had a residence on East 53rd Street in New York.

In 1929 Ellett designed "Brookwood" for Henry M. Minton and his wife, Helen Church Minton, in Manhasset. In form, the main block was a symmetrical, center-entry structure with end chimneys, similar to the Alker house in Brookville. Pargeted masonry walls gave the Minton house a rustic appearance, but the most distinctive architectural feature was the series of tall French windows on the second floor. The windows broke the eave line, terminating in Norman-inspired, sunburst-pedimented dormers. These windows gave the house an unusual picturesque character, unlike that of Ellett's other Long Island designs. The house is no longer extant.

"Braestead" on Cedar Swamp Road in Brookville was built in 1929 for Helen Peters. The most formal of Ellett's Long Island country houses, it is a brick-walled, hipped-roof Georgian Revival structure.

Ellen Fletcher

Aymar Embury, 1880–1966

One of the foremost Beaux-Arts architects of his day, Embury was one of the few American architects elected to the National Institute of Arts and Letters. His commissions included hundreds of country houses and over 70 major bridges, most notably the Triborough, Bronx-Whitestone, Henry Hudson, and Jamaica Bay bridges in the New York City area. Many of his commissions were restorations or additions to existing buildings in the Colonial Revival style, in which he was an acknowledged authority. His books advanced his reputation in this area: *The Dutch Colonial House* (1913), *Early American Churches* (1914), and *Country Houses* (1914), among others. He attended Princeton University, where he earned a Civil Engineering degree in 1900 and an M.S. the following year. He was a member of the Players and Maidstone clubs.

On Long Island, Embury can be credited with five bona-fide estates, two public buildings (East Hampton's Guild Hall and Public Library), the playhouse of Hofstra University, and a score of smaller residential commissions, including seven in Garden City alone. His Long Island residential commissions are variants of the Colonial Revival style and embrace innumerable references: Georgian, for the Wallace Chauncey house in East Hampton (1936); Federal, for the G. A. Schieren house in Great Neck (c. 1915); Dutch Colonial for one of the earliest Embury-

surfaces pargetted or heavily spattered with stucco. Casement windows and a volute-framed dormer gave a Norman character to the assemblage.

Stockbroker E. Mortimer Barnes was already living in an old farmhouse Ellett had remodeled for him on Cedar Swamp Road when he commissioned the architect to design "Mañana," a two-story, mansard-roofed residence with tower in a walled garden, as well as a garage and stables. The 35-acre estate and the formal walled garden adjacent to the house were laid out by Annette Hoyt Flanders, the plant materials being supplied by Lewis & Valentine nurseries in Oyster Bay. The Glen Head estate was a sum-

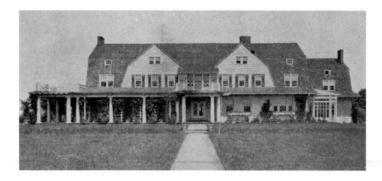

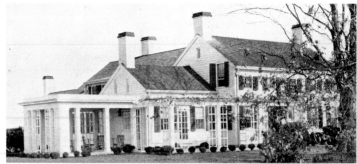

Aymar Embury: Rear Facade, Ralph Peters Residence, Garden City, c. 1904 (HOUG, 1913)

Aymar Embury: Rear Facade, Marshall Fry Residence, Southampton, c. 1911 (HOUS, 1912)

Aymar Embury: Front Facade, George Roberts Residence, East Hampton, 1930–31 (ARTS, 1932)

designed houses on Long Island, the 1904 Ralph Peters residence in Garden City for the former president of the Long Island Railroad; and vernacular prototypes such as the Marshall Fry house at Southampton (c. 1911) and the George Roberts house at East Hampton (1930–31).

Peter Kaufman

■

Harold Perry Erskine, 1879–1951

Almost devoid of exterior decoration, "White Lodge," the summer residence of G. W. White, was built in 1915 at Mill Neck and was the only Long Island commission of architect Harold Perry Erskine. Born in Wisconsin in 1879, Erskine was a graduate of Columbia University and the Ecole des Beaux-Arts, receiving training in sculpting as well as in architecture. As a

Harold Perry Erskine: Front Facade, "White Lodge," G. W. White Residence, Mill Neck, 1915 (INVE, 1979)

partner in the firm of Erskine & Blagden, he was associated with the construction of Lord & Taylor's department store on Fifth Avenue in New York City. "White Lodge," an L-shaped Federal Revival brick structure, faced south, its entry situated under a hipped-roof porch supported by Tuscan pillars. Palladian windows with French doors directed light into the solarium, which was oriented toward the southwest. The house survives today in unaltered condition.

Michael Adams

■

Ewing & Chappell, 1904–1917
Charles Ewing, 1872–1954
George Shephard Chappell, 1877–1946

A native of Washington, D.C., Charles Ewing attended Georgetown University for two years before becoming a special student in architecture at M.I.T. He went on to study in Paris from 1899 to 1901 at the atelier of Marcel Lambert and the Ecole des Beaux-Arts. On his return to the United States he worked in the office of Carrère & Hastings until 1904.

George Shephard Chappell was born in New London, Connecticut. After graduating from Yale University, he also studied in Paris from 1899 to 1902 in the atelier of Victor Laloux and at the Ecole des Beaux-Arts. In America again, he worked for two years in the firm of Lord & Hewlett.

Ewing and Chappell formed their partnership in New York in 1904 and practiced together until 1917, on and off for years employing the young Rockwell Kent as a draftsman. After that date they maintained separate practices, Ewing until around 1929 and Chappell until around 1937. Chappell also wrote humorous books and serious journalism: he was from 1926 to 1931 the first architectural critic of *The New Yorker*.

Ewing & Chappell designed the Richard E. Forrest residence in Cedarhurst, Long Island,

Ewing & Chappell: Rear (Terrace) Facade, Richard E. Forrest Residence, Cedarhurst, c. 1905 (ARLG, 1908)

Ewing & Chappell: S. B. Lord Residence, Cedarhurst, c. 1910 (ARRC, 1910)

praised.[1] By 1900 his architecture displayed a unique synthesis. Emphasizing informality, he continued the picturesque use of space and volumes characteristic of the Shingle Style which he had helped to create during the 1880s. This led to buildings planned with concern for intricate horizontal flow and quiet complexity, in contrast to the more formal Beaux-Arts approach then popular in New York City and much of the rest of the country. His extension of space, both within the house and between the house and the outdoors, was inventive and, if at times axial, displayed breaks of level and volume that often created ambiguous small units within the whole.

These effects were achieved with a simplification of forms that owed its source, in part, to Eyre's increasing commitment to the vernacular architecture of the Philadelphia region. He used ornament—often related to the Arts and Crafts and Art Nouveau movements—sparingly, highlighting relatively plain surfaces and shapes and emphasizing the natural beauty of carefully selected and crafted materials. The results achieve that combination of timelessness and tradition that he admired so much in the vernacular architecture of England and America. By the time he received his Long Island commissions, he had begun to include specific historic elements in his new architectural compositions, using them as a counterpoint as well as a form of associative continuity.

Between 1900 and 1915, Eyre had a sufficient volume of work in the New York area to maintain a local branch office in the city, using it to supervise construction and facilitate communication with his clients.[2] There is evidence of seven country-house commissions on Long Island, only three of which were executed; one remains extant.[3] While Eyre's country-house commissions on Long Island represent but a small segment of his designs, they include several important works created at the height of his powers. His Long Island involvement reflects not only the high esteem in which his work was held early in this century, but may indicate how wide-ranging were the architectural possibilities Long Islanders were willing to consider.

around 1905. In his 1919 Yale class record, Chappell referred to this commission as "my first job of any importance." In appearance it was Shingle Style, almost a bungalow. The S. B. Lord residence (c. 1910), also in Cedarhurst, could be called Colonial Revival. It resembles an early 19th-century farmhouse with several additions. Neither house survives.

Richard Chafee

Wilson Eyre, 1858–1944 (University of Pennsylvania)

Wilson Eyre, 1858–1944

The Long Island work of Philadelphia architect Wilson Eyre dates from the first decades of this century when he was at the height of his career as a leading house designer. Born in Florence, Italy, where his father, a foreign service officer, was stationed, Eyre was schooled in Europe, Canada, and Rhode Island. In 1877, after a year in the architectural program at M.I.T., he joined the office of James Peacock Sims in Philadelphia. Following a brief partnership with William Jackson, a colleague in Sims's office, Eyre entered into a partnership with John Gilbert McIlvaine (1880–1939) that lasted until McIlvaine's death. Eyre remained the primary designer in the firm.

The architectural press considered Eyre a major talent in the development of what contemporaries viewed as a uniquely American style; his residential designs, especially of country houses, became widely known and

Miss Lucille Alger Residence, Great Neck, 1902 and 1910

In 1902 Eyre designed a house (now demolished) for Miss Lucille Alger and a Miss Fuller in Great Neck. Set on a plot of ten acres, the house had gardens that extended to Mill Pond near the shore of Little Neck Bay. It was unpretentious and uninsistently asymmetrical within

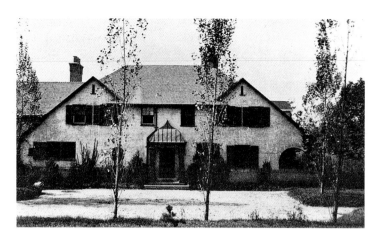

Wilson Eyre: Front Facade, Miss Lucille Alger Residence, Great Neck, 1902, alterations, 1910 (HOUS, 1906)

Wilson Eyre: Rear Facade, Miss Lucille Alger Residence, Great Neck, 1902, alterations, 1910 (HOUS, 1906)

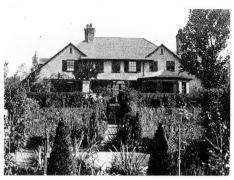

Wilson Eyre: First and Second Floor Plan, Miss Lucille Alger Residence, Great Neck, 1902, alterations, 1910 (Courtesy of Edward Teitelman, n.d.)

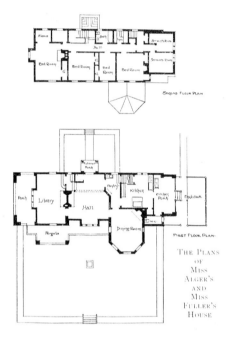

a generally symmetrical outline. Ornament was limited to an ogee-shaped copper hood over the front door, subtly varied window shapes, careful articulations of mass, and a limited color scheme. The foundation of dark, rough brick was laid with large mortar joints and carried to the first-floor windowsills; the remaining walls were rough-cast stucco, probably painted yellow-cream. The roof was of red-to-dark-brown pantiles taken from an old English building. Natural chestnut, adzed and left to weather, was extensively employed. Sashes were painted cream, while gray-green was chosen for the shutters. The surrounding grounds and gardens were developed in an informal English manner.

Inside, varied levels and the use of screening gave a sense of separation between the entrance and the stairway and living hall, while not impeding the continuity of the space as a whole. On entering through the front door, one looked

ahead into the open garden, while to the right, beyond the stair, could be seen a somewhat lower library, closed and cozy with books and fireplace. The garden was, in fact, directly off the living hall, through a door onto a porch and pergola. The dining room adjoined the kitchen and pantry to the left of the entrance hall. Visually anchored by a corner fireplace, it provided a sweeping view of the garden through windows along half its circumference. The plan of the upstairs rooms provided interior privacy with exterior vistas and good ventilation.

The house was enlarged by Eyre in 1910 for Miss Grace, an artist and the daughter of William Russell Alger and Louise Grace. William Grace was mayor of New York in the 1880s, and the family was prominent in the Great Neck area.[4] Balancing wings were set on either side of the older building, creating a somewhat awkward and rambling composition. Major changes included a new library on the first floor (with its large fireplace in an alcove built out beyond its walls), enlarged service areas, and a sleeping porch introduced into the upper front corner.

Theodore E. Conklin Residence, "Meadowcroft Farm," Quogue, 1900 (Extant)

"Meadowcroft Farm," the home Eyre designed for New York businessman and yachtsman Theodore E. Conklin, is situated at the head of an inlet in rural Quogue. Its stucco facade wraps gently around the entrance drive, and its rear facade opens to a broad view and breezes with a long, first-floor veranda, pergola, and partly screened-in bedroom floor.[5] The front is made complexly with simple means. A large bay, half of which consists of windows, is placed midway along the facade under the unifying red-tile roof. The simple arched opening to the right of the bay penetrates the house, forming the entrance. A lower kitchen wing with a high chimney situated at the left end of the house maintains an ambiguous visual relationship with the rest of the ensemble. Rhythmically placed

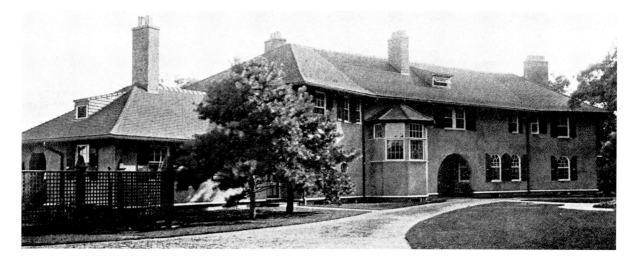

Wilson Eyre: Entrance
Front, "Meadowcroft
Farm," Theodore E.
Conklin Residence,
Quogue, 1900 (AABN, 1908)

Wilson Eyre: First and
Second Floor Plan,
"Meadowcroft Farm,"
Theodore E. Conklin
Residence, Quogue, 1900
(AABN, 1908)

Wilson Eyre: Stairway
Interior, "Meadowcroft
Farm," Theodore E.
Conklin Residence, Quogue,
1900 (Edward Teitelman,
n.d.)

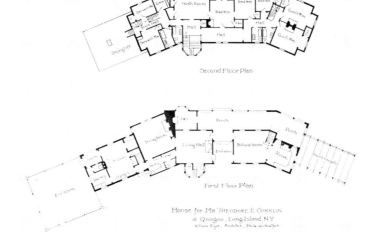

Roland R. Conklin Residence, "Rosemary Farm," Lloyd Harbor, Huntington, 1907

Eyre's commission for Roland Ray Conklin
(1907), "Rosemary Farm," reveals Eyre's special
ability to bring to a large house the same indi-
viduality and artful comfort as to his smaller
homes. The client, no direct relation of Theo-
dore Conklin, was raised in the Midwest but
came from an old Huntington family that first
settled on Long Island in 1641. He moved to
Huntington after amassing a fortune as a capi-
talist and financier widely involved in land and
utility development, including the early stages
of Baltimore's Roland Park. His cultivated taste
must have drawn him toward Eyre, who had
received several commissions in Roland Park.

The Roland Conklins moved to the site
about 1902, when Eyre remodeled an 18th-
century farmhouse for them near the road to
Lloyd Harbor. This served as their home while
the estate's main house, stables, gardens, and
working agricultural buildings were being
designed and constructed.[6] The client's attach-
ment to this picturesque and simple place they
called "Little Rosemary" was reflected in a
stained-glass window Eyre designed for Roland
Conklin's bedroom. This showed the old house
nestled under the hill with the legend "Rose-
mary—for remembrance."

"Rosemary Farm," a large, rambling, red-
brick and shingle-tile house, was set on a rise
of rolling land on 159 acres.

window openings are often flanked by green
shutters and, with the chimneys and the contin-
uous wood drip-molding over the brick founda-
tion, provide both order and variety. The result
is a composition that is experienced both as a
balanced whole and as a progressive set of ele-
ments, pivoted either on the bay or the kitchen
wing. It is a subtle, rich but restrained creation,
exquisite in proportion and detail, comfortable
but without pretention.

Equally simple but studied, the interior is
divided by the entrance passage which reaches
through to the porch. On the right, two dark
rooms designed for billiards and smoking con-
nect to guest bedrooms above. The stairway here
feels narrow and closed; it is inside the house,
constricted and framed by heavy oak posts and
beams. The parlor, dining room, and kitchen
are to the left, paneled in lighter woods and with
smaller-scaled details. A sense of complex open-
ness is created, its focus the main stair which
rises in the bay in a bright, window-walled
space experienced as jutting into the outdoors.

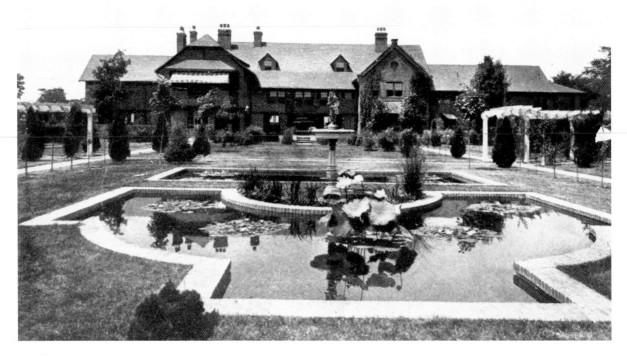

Wilson Eyre: Garden Facade, "Rosemary Farm," Roland R. Conklin Residence, Lloyd Harbor, 1907 (ARYB, 1912)

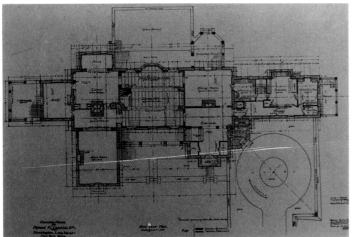

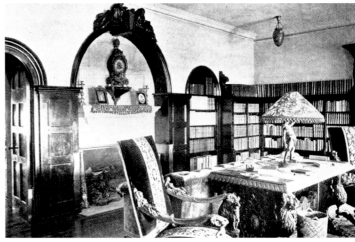

Wilson Eyre: First Floor Plan, "Rosemary Farm," Roland R. Conklin Residence, Lloyd Harbor, 1907 (AVER, n.d.)

Wilson Eyre: Library, "Rosemary Farm," Roland R. Conklin Residence, Lloyd Harbor, 1907 (ARRC, 1910)

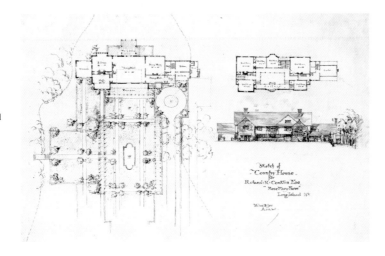

Wilson Eyre: Earlier Sketch and Plan by Architect, "Rosemary Farm," Roland R. Conklin Residence, Lloyd Harbor, 1903 (University of Pennsylvania, n.d.)

Sited amid gardens and farm fields, more on the land than along the water, it nevertheless takes advantage of the coastal view and breezes. Since Eyre was also responsible for the site plan, gardens, stables, and farm structures, the ensemble was coherent within a largely informal ordering of the land. Not only are the details of the interiors by Eyre, but the initial scheme for furnishing by the Conklins owes much to the architect's advice, mixing antiques and other furniture chosen to make an unpretentious home rather than following a particular style.[7]

The main volume of the house lies under a long helm roof, broken into three levels and complicated by four asymmetrical wings, as well as by small bays and overhangs. The composition, while essentially asymmetrical, is visually balanced and axial, perhaps most regular in the section directly fronting the formal garden. The house was described by a contemporary as ". . . mellow with soft bricks and huge, adzed oak timbers. Numerous sleeping porches cling

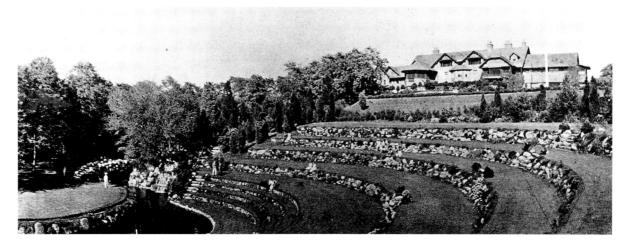

Olmsted Brothers, Landscape Design: Open Air Theater, "Rosemary Farm," Roland R. Conklin Residence, Lloyd Harbor, 1912–13 (FLON, 1912)

to its sides without destroying the vigorous simplicity of its line. . . ."[8] Exterior colors range from reds to browns and grays, with gray-green for the shutters.

The entrance is inconspicuous, set at an angle under a simple shed roof. The wide and easy stairway to the second floor is contained in a broad, oak-beamed entrance hall flanked by carved female figures of Eyre's design on the newels. Carved in the brackets where the posts meet the beams are an obedient bear bearing a shield and women holding scrolls and harvesting wheat. This hall is a semipublic-semiprivate space that leads to the second floor and also opens onto the garden, dining room, and living hall.

The living hall is the central feature of the house—extending across it from the formal garden to the grass terrace. Two heavy, braced beams bridge its length from a large brick fireplace alcove to an 18th-century Portuguese organ cased in a cabinet of Eyre's design. On entrance, the section of the hall to the left rises to the second floor and is surrounded by a solid gallery parapet punctured here and there with Eyre carvings. This space is complex, facilitating circulation on both the first and second floors. The second floor is lit by a row of windows along the outer walls. This second-floor passage is set out beyond the first-floor walls. Paneling and beams are oak, stained a shade of dark greenish brown, with the plastered upper section painted cream. Within the dark and light contrasts of the room, an old, polychromed-metal liturgical chandelier sheds a string of yellow light above, while a bright view of the garden flashes surprisingly through a large single pane of glass framed in the paneling between French doors, creating a sudden shift of space and light intensity.

In the dining room, two twisted, polychromed, Venetian columns covered with fruit and vines and a low balustrade separate the more formal area from the hexagonal breakfast porch. The dining-room chairs were converted

French medieval church choir stalls and seating was at a round table.

The library formed a dark reserve, its woodwork Cuban mahogany. Heavy, carved figures recline against a thick keystone, burdening the thin wood arch bridging the fireplace alcove. Mr. Conklin's private study, also in mahogany, adjoined, with a screened veranda beyond it. The large music room, painted in light colors to expand the sense of space under a broad, arched ceiling, was designed to also serve as a private theater, reflecting the owners' interests. A conservatory, usually crowded with flowers, completed the first floor.

Upstairs, the bedrooms were expansive, extended with balconies and sleeping porches. Mr. Conklin's bedroom opened into the roof vault and was ornamented with English fragments, while Mrs. Conklin slept in a room that was one of Eyre's rare essays into French forms. A daughter, Rosemary, had a separate but nearby wing, including quarters for a governess. The face of her tiled bedroom fireplace features a freely asymmetrical scene of Dutch children. Rooms for a son, another daughter, and guests were also provided, as were quarters for servants. A long hallway on the third floor doubled as a bowling alley.

An earlier scheme survives, showing a smaller and less developed structure but with the same basic scheme and orientation to the garden and site as the final house.[9] The configuration of the hall and gallery is also similar. The overall exterior massing is more compact, its forms recalling a farmhouse under a dominant helm roof.

By 1915, when the Conklins doubled the size of the property, they also created a large amphitheater on the hill under the south terrace from plans by the Olmsted Brothers.[10] Featuring fieldstone embankments, a moat with swans, a stage and artificial waterfall, it was a local attraction in the early days of World War I when it was used for the gala Rosemary National Red Cross Pageant. It fell into disuse and was abandoned after Mr. Conklin moved in 1924, five years after his wife's death. In 1930 the Diocese

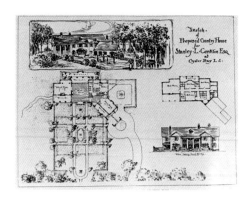

Wilson Eyre: Sketch of Proposed Residence of Stanley L. Conklin, Lloyd Harbor, 1903 (AVER, n.d.)

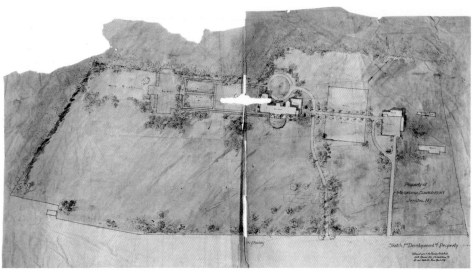

Wilson Eyre: Sketch of Proposed Residence of George E. Kent, Jericho, 1906 (University of Pennsylvania, n.d.)

Wilson Eyre: Sketch of Proposed Residence of Roswell Eldridge, Great Neck, after 1912 (University of Pennsylvania, n.d.)

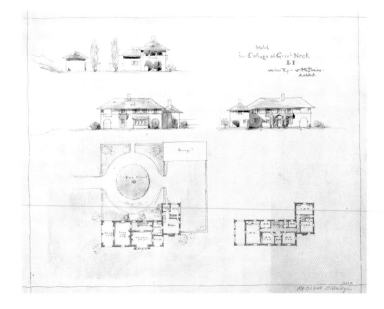

Wilson Eyre: Sketch of Proposed Residence of William Wadsworth, Belle Terre, Port Jefferson, 1912 (Courtesy of Edward Teitelman, n.d.)

of Rockville Center purchased the property and built the Seminary of the Immaculate Conception there. "Rosemary Farm" served as a conference center until it was destroyed by fire in 1992.

In 1903, while the Roland Conklins were living at "Little Rosemary," Eyre designed a house that was never executed for Roland's brother, Stanley L. Conklin. To have been situated on a high point near the Lloyd Harbor end of the Conklin property, the project was smaller and somewhat more formal in conception than "Rosemary Farm," apparently intended as a seashore house rather than a year-round home.[11] The facade above the water opened with porches, its symmetry broken by a wing angled back on one side in contrast to the irregular garden side. There, the scale was large on the left, with a two-story-high portico; on the right the low-angled wing came down to an entrance of domestic proportions under a porte cochere. Inside, a large, open hall and pleasant ordering of rooms and spaces provided broad, semi-open space for both stately entertaining and leisurely summer living. Eyre used formal axial elements here in a more obvious manner than usual, but manipulated them with no binding formality. The entrance progression, for example, would have led one through an oddly shaped, transitional space, to bring one off-axis unexpectedly into the broad axial hall and its straight-on view of the water.

Several other Eyre design projects on Long Island apparently also failed to materialize. A 1906 site plan for the development of property at Jericho for attorney George Edward Kent shows an irregular house on line with stable and gardens.[12] An existing house close to the road is indicated for removal. The Kent house, as built, did not reflect Eyre's hand or this plan and is now demolished.

Dating after 1912, an apparently unrealized sketch plan and sketch for a cottage for Roswell Eldridge at Great Neck is typical of Eyre's designs for small houses in the early 1900s.[13] A basic set of rectangular forms under strong roof overhangs creates a group of sheltered spaces interlocking simply but with asymmetrical informality. Exterior ornament is minimal, with only the doorways highlighted. The interior spaces are functional and pleasant, retaining close connections with enclosed verandas and the outside.

A sketch for a house for hosiery executive and yachtsman William Mitchell Wadsworth, at Belle Terre, Port Jefferson, dated 1912, shows a handsome, gambreled, stucco form stretching along the water.[14] Apparently never developed further than this sketch, it represents yet another variation of Eyre's adaptation of indigenous forms to create artistic and comfortable houses.

Edward Teitelman and Betsy Fahlman

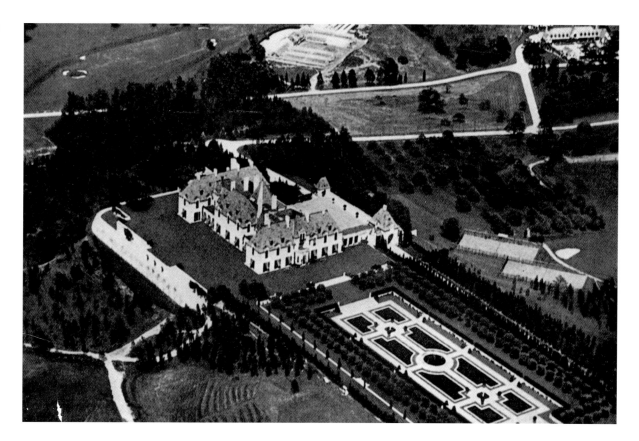

Beatrix Farrand, Landscape
Design: "Oheka," Otto H.
Kahn Estate, Cold Spring
Harbor, 1919–28 (PATT,
1924)

Beatrix Farrand, 1872–1959

The only woman among the eleven founding
members of the American Society of Landscape
Architects, Beatrix Jones Farrand designed more
than 200 landscapes of high quality, including
college campuses, institutional grounds, and
private gardens.

Farrand had valuable models for indepen-
dence and professionalism in her mother and
aunt. After her divorce, Farrand's mother sup-
ported the family by working as a literary agent
for her sister-in-law, Edith Wharton. (Wharton
and her work *Italian Villas and Their Gardens*
would have a critical influence on Farrand's
landscape designs.)

Farrand received no formal training, but
spent two years under the tutelage of Charles
Sprague Sargent at Harvard University's Arnold
Arboretum. She then went abroad to visit the
gardens of Europe. In 1895 she established her
professional practice in New York City. By the
1920s, she had built up a large and important
clientele and was able to choose among com-
missions.

Farrand sought to synthesize what were
presented as opposing landscape aesthetics: the
classical (newly revived with the architecture
of McKim, Mead & White and the Italian villas
and gardens of Charles Platt) and the romantic
(the picturesque and Arts and Crafts landscapes

associated with the architecture of bungalows,
Queen Anne, and Shingle Style buildings, as
well as with the Olmsted parks).

Probably Farrand's most important work
was for the campuses of Princeton University,
Yale University, the University of Chicago, and
the California Institute of Technology. Of her
extant commissions, Dumbarton Oaks in Wash-
ington, D.C., best illustrates the quality of her
design. But it is Farrand's extensive body of
work on Long Island that reveals the nature
of her lifelong experimentation to achieve the
synthesis of classical and romantic landscapes.

Farrand's gardens on Long Island were
designed from 1900 to 1932. All the designs
resemble one another and are, in some respects,
different from her work elsewhere; each is
organized as a series of formal geometric spaces
with differentiated plantings that stand in
contrast to a naturalistic ground plane. (The
aerial photo of the Kahn estate garden gives
some idea of this very geometric piece set into
the landscape.) The similarity of design may
have something to do with the sites, but more
likely it reflects a certain clientele with a shared
aesthetic taste in gardens.

Superficially, these gardens resemble adapta-
tions of the classical gardens of Italian villas,
translated into an American vocabulary. How-
ever, close examination reveals that their success
derives from the creation of a series of small,
well-defined garden spaces juxtaposed with
free-flowing, naturalistic massings of native
plant material that surround and envelop them.
The four most interesting gardens of the Long
Island group—those of Edward Whitney,

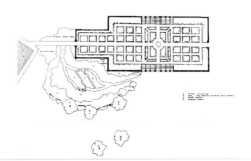

Beatrix Farrand, Landscape
Design: Planting Plan,
Edward F. Whitney Estate,
Oyster Bay, 1906–14 (FAND,
Folder 1019, #32)

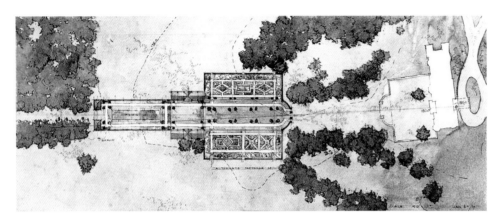

Beatrix Farrand, Landscape
Design: Plan of Garden,
"Appledore," Willard
Straight Estate, Old
Westbury, 1914–32 (FAND,
Folder 1003, #114)

Harrison Williams, Willard Straight, and Mrs. Otto Kahn—share this as their main trait. Many of the others seem to be mainly planting plans rather than garden designs. This is an important distinction; the famous English landscape designer Gertrude Jekyll produced mainly planting plans while the garden layout was often done by architect Edwin Lutyens. Farrand produced her best work in garden design, that is, the definition of outdoor spaces. Though her planting plans were highly detailed and often very beautiful, Farrand was at her best in the definition of space.

Edward F. Whitney Estate, Oyster Bay, Landscape Design, 1906–14

There is no better example of this aspect of Farrand's work than the garden she designed for Edward F. Whitney's Oyster Bay estate. It consists of a sharply defined geometric parterre set into a larger, naturalistic landscape. The garden is designed along a central axis that runs to the house; the house itself is not aligned with this axis, but set askew to it. As the first section of the garden's axis emerges from the house, it travels through an informal, asymmetrical landscape that intersects the axis with a winding secondary path. This splits into grassy walks among beds planted with groupings of dogwood, forsythia, lilac, and a few taller trees. After this frolic with nature, the walk along the axis arrives at the very formally organized parterre garden. Here space is defined by surrounding walls and organized by geometrically shaped planting beds. This interplay between the two aesthetics—

formal and informal—is the design's very essence, and represents a major synthesis in Farrand's work.

Although Farrand did not write much about her designs, one of her few articles from this early period—"The Garden as Picture" published in *Scribners'* in 1906—is fundamental to understanding her work, and especially to appreciating the synthesis achieved in the Whitney garden. In this article she questioned the most basic premise of the romantic school: that landscape design should imitate nature. Farrand argued that there is no such thing as a "natural" landscape or garden: "It is the change of scale from nature's scale that makes the composition artificial. A real garden is just as artificial as a painting." Thus, all one can do is choose a few of nature's effects and, as she put it, "tune them up." This meant exaggerating chosen effects and placing them in a strong framework. This creates a boundary that resembles a picture frame more than anything found in nature. Farrand considered the boundaries of the landscape composition essential; thus, in the Whitney garden, she set naturalistic parts of the designed landscape against an obvious boundary.

Willard Straight Estate, Old Westbury, Landscape Design, 1914–32

Farrand's next work, the Willard Straight garden, adopted much the same approach, though it was less of a synthesis. As in the Whitney garden, the walled formal garden sat within an informal landscape. But the informal romantic aesthetic merely constituted background; it neither interrupted nor interacted with the formal landscape. The garden's axis was skewed, but only slightly. The grassy path to the formal garden was surrounded by informal groupings of trees. The original aspect of this design is its incorporation of an American accoutrement, the swimming pool, into a formal layout. The formal composition ended in two small pool houses. Then the axis again turned to grass; its edges became irregular, flanked with masses of trees. The double path through the formal part of the garden, however, was awkward and unresolved. Compositionally, it left viewers ambivalent about a double entrance to the informal part of the garden. The house was designed by Delano & Aldrich.

Harrison Williams Estate, Bayville, Landscape Design, 1928–29

In the Harrison Williams garden, we find a series of formal landscape pieces set one by another without hierarchy, each displaying a different landscape treatment: an octagonal rock garden, a willow court, a Cedar-of-Lebanon garden, a long arbor, and a lily-pond garden. The most

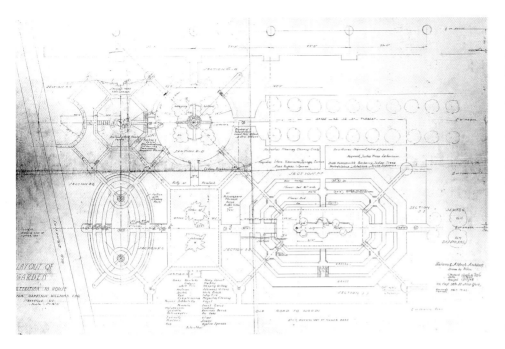

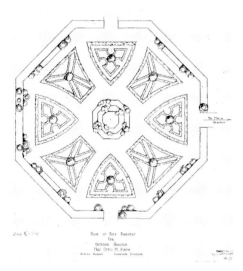

significant aspect of this design is the setting of the components side by side, in no particular order, connected by angled walks. With this technique, Farrand created a series of garden rooms that coexist with, but do not depend upon, one another.

Otto H. Kahn Estate, "Oheka," Cold Spring Harbor, Landscape Design, 1919–28

The Kahn garden shows extensive lists of special plantings, as in the Octagon and the Tulip gardens. Some valuable details about the design process emerge from notes left by Margaret Bailie, Farrand's principal assistant, who later opened her own office. These notes are in the form of memos listing the tasks to be accomplished in the garden after Farrand's site visit, and the preparations for her next visit. The plan of the octagon garden has numbered sections and with it a list of plants to be placed in each section by week. Such memos for private jobs rarely survive, but one such memo, dated January 23, 1925, indicates that scale dummies (often in cardboard) of such elements as benches, fountains, and sculptures were used in a study of the garden on site before the pieces were actually built:
Have dummies of the columns and entablature at the rose garden and rose garden entrance made before the week of February 9th. Also have dummies of the two stone statues made before the week of February 9th.
Have a couple of castings made from the forms for the base of the fruit baskets by the week of February 16th.
Get some saturated solution of permanganate of potash for staining the Octagon walls. Have this ready for the week of February 16th. (VF 918/9.)

Another memo indicates that Farrand actually did some of the planting on her site visits:
If you have an opportunity, have pockets of loam put in against the wall in the Octagon garden, as Mrs. Farrand plans to plant a number of vines. Also, add loam mixed with bone meal on the Octagon garden walks, in order to make them mossy. (VF 918/9.)

Some clues about the appearance of the Kahn garden can be garnered from these notes on the color scheme for the Octagon garden:
Plants to be potted for the Octagon Garden, to be placed on and against the wall:
Approximately, 12 to 18 Rosemary
24 Lemon Verbena
36 Fuschia (If possible, try to have these old, interesting looking plants.)
48 Lavender.
Try and get some yellow jasmine and white honeysuckle, interesting looking plants, to be planted by the benches in the Octagon Garden.
A massing of the tall and low blue Lobelias will be wanted for the entrance to the rose garden (where the Lavender usually is), also some Alteranthera. (VF 918/9, 10.)

One list of tulips has, noted alongside the botanical names, the color and hue of each, which also tells us about the particular color picture Farrand had in mind.

TULIPS, EARLY SINGLE

50 Calypso	Primrose yellow
50 Chrysolora	Golden yellow
50 Fred Moore	Apricot orange
50 Golden Queen	Rich yellow
50 Mon Tresor	Yellow
50 Prince de Ligny	Ruffled yellow
50 Rising Sun	Golden yellow
50 Yellow Prince	Apricot yellow
50 Cottage Boy	Yellow and orange
50 Diana	Pure white
100 Keiser Kroon	Red with yellow edge
50 King of the Yellows	Golden yellow
50 Max Havelaar	Orange
50 Orange Brilliant	Orange red
50 Prince of Austria	Orange vermillion

(VF 918/1.)

For this garden, too, we have some loose sketches she made for topiary pieces, as well as a plan for the garden's box borders.

Unfortunately, most of these gardens have been either changed drastically or lost altogether. According to a letter from Michael Straight to Eleanor M. Peck, of January 16, 1980, the Straight estate was sold off into "half acre lots" by a local developer. However, Great Neck Green does seem to have kept a Farrand rose garden.

The task that remains is to identify work that still can be rescued. It is hoped that one of Farrand's Long Island designs may be preserved as a permanent part of American landscape history.

Diana Balmori

Beatrix Farrand, Landscape Design: Layout of Garden, Harrison Williams Estate, Bayville, 1928–29 (FAND, Folder 1022, #3)

Beatrix Farrand, Landscape Design: Plan of Box Borders for Octagon Garden, "Oheka," Otto H. Kahn Estate, Cold Spring Harbor, 1919–28 (FAND, Folder 91, #102)

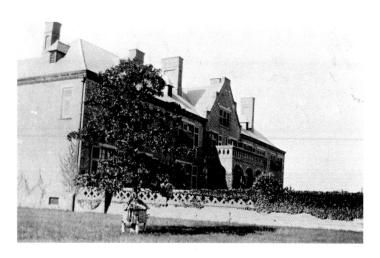

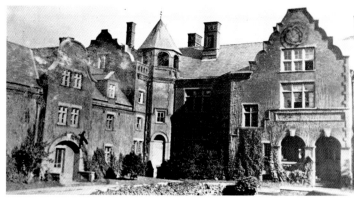

H. Edwards Ficken: South Facade, "Pepperidge Hall," Christopher R. Robert II Residence, Oakdale, 1890–96 (Queensborough Public Library, Long Island Division)

H. Edwards Ficken: Inner Courtyard Facade, "Pepperidge Hall," Christopher R. Robert II Residence, Oakdale, 1890–96 (VAND, n.d.)

H. Edwards Ficken: First Floor Plan Drawn by Sverre B. Withammer, "Pepperidge Hall," Christopher R. Robert II Residence, Oakdale, 1890–96 (VAND, n.d.)

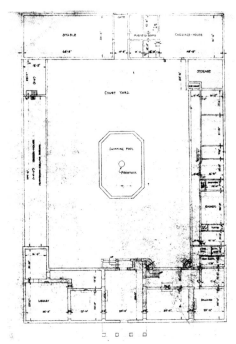

H. Edwards Ficken, d. 1929

Completed in 1896, "Pepperidge Hall," built for Christopher Rhinelander Robert II, was H. Edwards Ficken's only Long Island country-house commission. Born in London and educated in Europe, Ficken came to America in 1869. He opened an office in New York City and for a time was in partnership with Boston architect Charles Dexter Gambrill. In addition to several New York City buildings, Ficken was the supervising architect and engineer for Woodlawn Cemetery (1913) and the architect for the Sigma Delta Chi Building at Yale University.

Ficken's client, Christopher R. Robert II, came from a family tracing its lineage back to William the Conqueror. The first family member to come to America was Daniel Robert, a fleeing Huguenot who founded New Rochelle, New York. In the mid-18th century, another Daniel Robert expanded the family fortune in West Indies trading, and this fortune, invested in real estate, generated sufficient income to enable Christopher R. Robert II to plan a grand estate in the English tradition on Long Island.

Following the death of his first wife, Robert had traveled abroad, accumulating a large collection of furniture, art objects, and even architectural elements. After remarriage to a well-to-do widow with three children he acquired about 1,000 acres in Oakdale, Long Island. Here he and fellow country-house owners W. K. Vanderbilt and W. B. Cutting planned estates that provided an unbroken game preserve adjoining their club, the South Side Sportsmen's Club, and coexisted in a polite, if not always friendly, rivalry. Adopting as an ideal the life of the landed English gentry, they supplemented the expenses of the Emmanuel Episcopal Church, the local school, and road improvements bordering their property.

Robert first occupied a lodge on the property designed by Ficken in the Queen Anne style and built in 1882. When this building burned seven years later, Robert engaged Ficken to plan a proper house. The result was a massive structure that utilized an unusual rectangular plan incorporating stables, a carriage house, and other estate buildings into the house complex. A 109-foot glass conservatory spanned the west side of the rectangle. A large inner courtyard dominated the plan, centered around a 30-by-50-foot pool and fountain. Jacobean elements like the stepped gables vied with mullioned bay windows, stair turrets, and innumerable chimneys. Unfortunately, Robert did not have an opportunity to fully enjoy his creation. In an intricate and puzzling real estate transaction with developer W. K. Ashton, he traded his Oakdale estate and four Manhattan properties for the 41–44 Wall Street complex in 1896. Shortly thereafter, Robert committed suicide. Over the years a host of owners, including Ashton, attempted to develop the land and adapt the house for commercial use, including as a hotel, without much success. Several motion pictures were filmed there, notably *My Lady's Slipper* in 1915. After a long period of neglect and vandalism, "Pepperidge Hall" was demolished in 1940.

Michael Adams

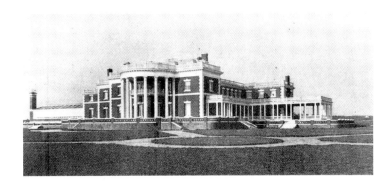

Ernest Flagg: View from the North, "Indian Neck Hall," Frederick G. Bourne Residence, Oakdale, 1897–1900 (Museum of the City of New York, 1900)

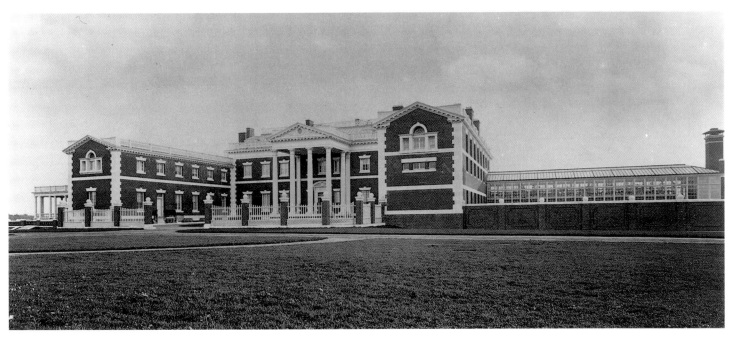

Ernest Flagg: View from the South, "Indian Neck Hall," Frederick G. Bourne Residence, Oakdale, 1897–1900 (Arthur T. Sutcliffe Papers, Avery Library, Columbia University)

Ernest Flagg, 1857–1947 (*King's Notable New Yorkers*, 1899)

Ernest Flagg, 1857–1947

At the turn of the century, the Frederick G. Bourne estate "Indian Neck Hall" in Oakdale (1897–1900, 1907–08; now the La Salle Military Academy), designed by the Beaux-Arts architect Ernest Flagg, was considered to be the largest estate on Long Island.[1] Architect of the Singer Manufacturing Company and celebrated for his Singer Tower (1896–98, 1906–08; now demolished) and Singer Loft Building (1902–04), both in New York City, Flagg designed this classically formal house early in his career as one of two he planned for Bourne, president of Singer Manufacturing Company. In contrast to this year-round house, Flagg's design for Bourne's summer residence in the Thousand Islands, "The Towers" (1903–05), employed the picturesque use of granite and sandstone which complemented the natural terrain of its Dark Island site.

A New York architect trained at the Ecole des Beaux-Arts in Paris, Flagg executed work representing the broadest range of Beaux-Arts theory and practice in America. He was a rugged individualist who was largely excluded from the pro-fessional establishment, even though his peers acknowledged him as one of America's most talented architects. Best known for his design of the U.S. Naval Academy at Annapolis (1896–1908); the Corcoran Gallery of Art in Washington, D.C., and St. Luke's Hospital in New York (both 1892–97); the Scribner Building on Fifth Avenue, New York (1912–13); and other important institutional structures, Flagg was an especially ardent promoter of urban reform. This led him in two directions. His Singer skyscraper established a new height record and set a precedent for New York City zoning restrictions. But Flagg was also widely regarded as the "father of the modern model tenement" in America. He helped to reverse a long history of indifference among noted architects toward tenement-house design in New York.[2]

Advancing the principles and aesthetics of French academic classicism in America, Flagg's Colonial design for "Indian Neck Hall" may seem anomalous. Yet the Bourne house is a curious hybrid of Federal Revival and what he termed the "modern French Renaissance" style, which characterizes the exterior and the interior,

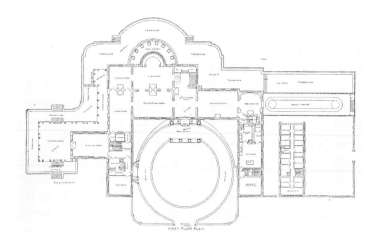

Ernest Flagg: Plan, "Indian Neck Hall," Frederick G. Bourne Residence, Oakdale, 1897 (ARRC, 1902)

respectively. The house is a striking departure from most of its Long Island neighbors, but Flagg believed that the revival of Colonial forms would advance the 19th-century search for a national style as a logical evolution from historical precedents.[3]

The monumental exterior of "Indian Neck Hall" is characterized by red brick punctuated with white marble trim. Two formal facades, each dominated by a different portico, recall Benjamin Latrobe's model for the White House. The northeast elevation contains a pedimented portico, its steep side wings terminating in walls with Palladian windows. Like many of its turn-of-the-century Newport counterparts, the main front of the Bourne house faced the sea. Flagg employed a curved, colonnaded portico on the southwest garden elevation which commanded sweeping views of the Great South Bay. A wooden veranda meandered around the east side of the garden facade so that its porches provided both sun and shade, as in antebellum plantation houses.

By 1900 the house was the centerpiece of a vast estate comprising nearly 1,000 acres. Along with many of its neighbors, including William K. Vanderbilt's "Idle Hour" (1899) at Oakdale by Richard Howland Hunt and William Bayard Cutting's "Westbrook" (1886) at Great River by Charles C. Haight, "Indian Neck Hall" set new standards for the formal country house. The estate provided numerous dependencies and so-called "hygienic improvements" that characterized both the aesthetic and the progressive elements of Flagg's approach to design

and planning. These included a stable, boathouse, electrical and refrigerator plants, a white marble-trimmed bridge, a trout pond, and a three-mile canal system with drainage and irrigation systems for the grounds. A tree-lined allée, 1,700 feet long, announced the entrance to the Bourne estate, while a deep waterway made the boathouse accessible to the sailing vessels of Bourne's neighbors and of his fellow New York City Yacht Club members.[4]

After a fire destroyed the stable in 1909, Flagg designed an imaginative automobile garage complete with a motorized turnstile.[5] While the estate lands served Bourne's outdoor recreational interests, an 80-foot-long greenhouse, a library, billiard room, bowling alley, swimming "tank," and Turkish bath served Bourne's indoor pursuits. Although renovations continued until Bourne's death in 1919, Flagg was responsible only for those of 1907–08 when he expanded the northwest wing for servants' quarters and substituted a music-room addition for the veranda.

In his design for the Bourne house, Flagg employed a broad range of 18th-century concepts. If the red-brick exterior boldly proclaimed the Colonial Revival character of the house, the interiors, with their parquet floors, marble fireplaces, and unusual staircase—white with red treads—employed a light palette and 18th-century French ornament associated with the period of Louis XV, whose revival was in vogue during the late 19th century in France. Moreover, the plan included an ingenious split axis, borrowed from 18th-century French hotel planning.[6] Flagg's design for "Indian Neck Hall" skillfully combined American Federal forms and the revival of "Modern French Renaissance" interiors and planning, thereby helping to promote a style of architecture that American Beaux-Arts architects of the 1890s perceived to be at once national and "modern."

Mardges Bacon

Montague Flagg, 1883–1924

Like his older brother, the noted Beaux-Arts architect Ernest Flagg, Montague Flagg received his education at M.I.T. and went on to study at the Ecole des Beaux-Arts in Paris. His notable commissions included the Bankers Trust Company Building and the Thomas Cook Building, both in New York City. Flagg designed a country residence for his own use in Brookville in 1914. Constructed primarily of fieldstone, this large, rambling, two-and-a-half-story, gabled-roof, residence remains relatively unaltered today.

Carol A. Traynor

Montague Flagg: Entrance Drive and Front Facade, Montague Flagg Residence, Brookville, 1914 (SPLI, 1979)

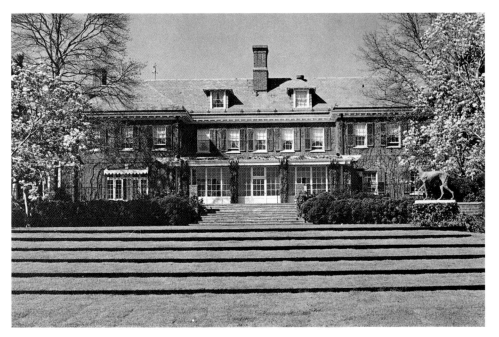

Annette Hoyt Flanders, Landscape Design: Garden Facade with Turf Panels, "Sunken Orchard," Charles McCann Estate, Oyster Bay, 1932 (PREV, n.d.)

Annette Hoyt Flanders, Landscape Design: Formal Gardens, Charles McCann Estate, Oyster Bay, 1932 (PREV, n.d.)

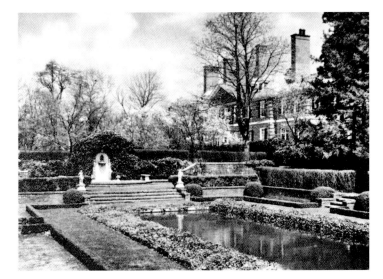

Annette Hoyt Flanders, Landscape Design: Formal Garden, "Ballyshear," Charles B. MacDonald Estate, Southampton (PREV, n.d.)

Annette Hoyt Flanders, 1887–1946

A native of Milwaukee, Wisconsin, Annette Hoyt Flanders was one of the foremost American landscape architects of the early decades of the 20th century. She enjoyed a long and varied career, designing landscapes in the United States and abroad. Her influence extended beyond her own lifetime, not only through her designs, but in the role she played as mentor and advocate for the many young landscape architects she trained and hired to work in her firm.

As a young landscape architect, Flanders became an associate in the offices of Vitale, Brinkerhoff and Geiffert and served as head designer and supervisor of planting for several years before opening her own office in New York City in 1922. In a field dominated by men, Flanders employed and encouraged many young female landscape architects. Among them were Helen Swift Jones, who became an associate in

the Flanders office, Iris Ashwell, Alice Bauhan, Helen Bullard, Mary Elizabeth Sprout, and Nelva Weber. Flanders became a member of the American Society of Landscape Architects in 1923 and was elected a Fellow in 1942.

Flanders was a prolific and versatile designer, whose public work included the "Classic Modern Garden" at New York's 1939 World's Fair, historic restoration projects in Virginia, and recreational grounds and sites for industrial plants. Private projects dominated her work, however, and these included estate gardens from New York to Honolulu, as well as city terrace and penthouse gardens, and gardens for brownstones.

Flanders wrote many articles for popular magazines like *House & Garden, House Beautiful,* and *Country Life in America,* and various garden books. She lectured to audiences at the Milwaukee Art Institute as well as to horticultural and botanical groups, schools, and clubs. She consistently stressed that in good landscape architecture the plan must suit both the site and the function that the garden was to serve.

Flanders was recognized as one of the most accomplished designers of the time, and her office handled numerous commissions. While the Kellogg Patten Gardens in Milwaukee and the estate of Phillip Armour in Lake Bluff, Illinois, were among her largest commissions, much of her best work was done on Long Island.

In 1932 Flanders won the Gold Medal of the Architectural League for the French Gardens on the McCann estate at Oyster Bay, New York. This "style garden," as it was called, incorporated parterres, turf panels, ironwork embellishments, sophisticated use of evergreen materials, and other elements of classic French landscape design. The 192-acre property was organized around an elegant plan for residential, recreational, farm, and utility areas. With its formal gardens, paved courtyards, flower-cutting gardens, ponds, swimming pool, terraces, lawns, orchards, vegetable gardens, groves of woodland, and agricultural fields, this commission afforded Flanders the opportunity to exhibit her talent in combining formal and informal elements within a cohesive design.

In her design for the Charles B. MacDonald residence, "Ballyshear," Flanders created a formal plan inspired by English gardens while

Annette Hoyt Flanders,
Landscape Design:
"Lilypond," William R.
Simonds Estate (formerly
Russell Residence),
Southampton (HEWI, 1930)

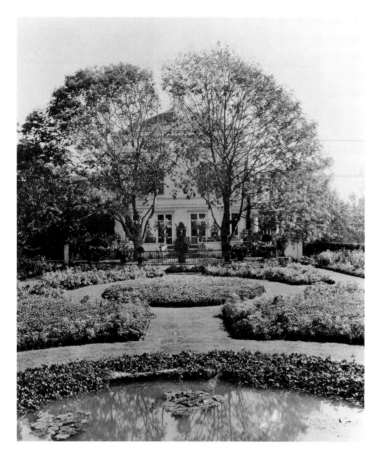

Flanders had many foreign commissions throughout her career. Reflecting the prevailing fashion in residential landscape architecture of the time, many of her American commissions were "style gardens," with French, English, or other European design vocabularies dominating. Interestingly, however, she downplayed this aspect of her work, preferring to characterize her designs as decidedly American in their accommodation to the site and sensitivity to the functional requirements of the garden.

Leslie Rose Close

Frank J. Forster, 1886–1948

Working both independently and in association with several architects, Frank Joseph Forster specialized in the field of domestic architecture and received a number of awards for excellence in house design, including the 1929 award of the Architectural Club of New York. Born in New York City, Forster was educated at Cooper Union School and completed his professional training abroad. He also wrote a number of books on architecture, including *Provincial Architecture of Northern France* (1931).

Forster criticized the use of 19th-century styles in architecture and was a great admirer of the French tradition and of the noted American advocate of Gothic architecture, Bertram G. Goodhue. These preferences were reflected in Forster's Long Island work. His first recorded commission, under his firm's name of Caretto & Forster, was the stucco and half-timbered residence for John R. Hoyt in Great Neck from around 1920. Working independently in 1928, Forster designed a vernacular rendition of a French farmhouse for Raymond F. Kilthau, also in Great Neck, utilizing a whitewashed rough-

expressing the informality and outdoor life of the summer colony of Southampton. A one-half-mile-long drive planted with trees and surrounded by lawns suggests a park-like English landscape, while furnishings on the terraces surrounding the house were rustic and informal, as were brick paths and plantings incorporating local favorites like blue hydrangeas and rambling roses. Flanders wrote that she was especially pleased with the easy manner with which one area of the landscape flowed into another and hoped that the overall effect was of "old age and intimacy."

Other major Long Island commissions included the Vincent Astor estate in Port Washington; the gardens of Benson Flagg in Brookville; the E. Mortimer Barnes residence in Glen Head; and the gardens of the William R. Simonds (formerly Russell) house in Southampton.

Caretto & Forster: Entrance
Front, John R. Hoyt
Residence, Great Neck,
c. 1920 (ARRC, 1921)

Frank J. Forster: Courtyard
Facade, Raymond F. Kilthau
Residence, Great Neck, 1928
(ARRC, 1928)

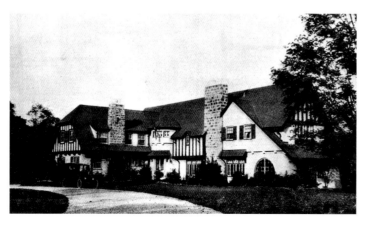

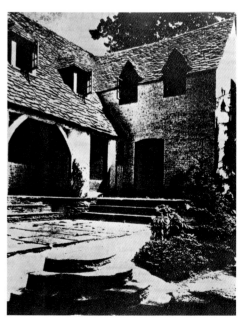

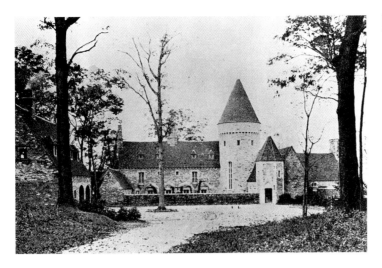

Forster & Gallimore:
Entrance Facade, "East Fair,"
Sherman M. Fairchild
Residence, Lloyd Harbor,
1930 (HOWE, 1933)

Mortimer Foster, practiced
1900–1910S

Listed as a "sanitary expert" in early architectural directories, Mortimer Foster worked in the office of McKim, Mead & White from 1899 to 1901, although he appears to have had an office in Queens as early as 1894. His one Long Island commission, "Belcaro," was built around 1910 for Frank N. Hoffstot, president of the Pressed Steel Car Co. from 1903 to 1933. Designed in the Italian Renaissance Revival style and situated on 50 acres at the head of Sands Point, the white-stucco, red-tile-roofed residence had grounds attractively landscaped with a large formal garden and pool.

Carol A. Traynor

faced brick facade and low, sweeping slate roofs in tones of green and purple. Forster's most formal composition (under the name of Forster & Gallimore) in the early French Renaissance Style was realized in "East Fair," the 1930 Lloyd Harbor residence for inventor and manufacturer Sherman Mills Fairchild, founder of the Fairchild Aerial Camera Corp. and later Fairchild Aviation Corp. Employing his preferred elements of rough-faced brick and steeply pitched slate roofs, Forster also incorporated towers crowned by conical roofs, tapestry brickwork, and, among other types, oriel window treatments.

Carol A. Traynor

Frank Freeman, 1861–1949

Born in Hamilton, Ontario, Frank Freeman studied architecture in the United States and by 1887 had established his own practice. He became one of Brooklyn's most accomplished architects, noted for his Romanesque Revival buildings, including the Brooklyn Democratic Club and the old Brooklyn Fire Headquarters (1891–92). According to family records, Freeman was the architect for the 1919 alterations

Mortimer Foster: "Belcaro,"
Frank N. Hoffstot Residence,
Sands Point, c. 1910 (VIEW,
c. 1930)

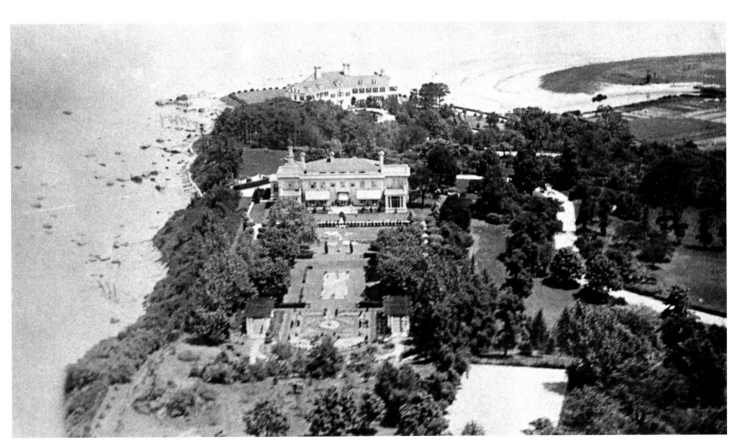

Frank Freeman: Front
Facade and Port Cochere,
"Red Gables," Dr. Edward
L. Keyes Residence, Water
Mill, c. 1895 (PELL, 1903)

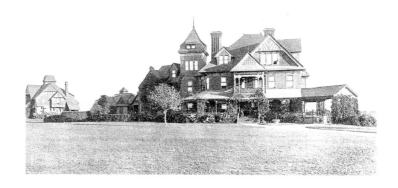

Frank Freeman: Rear Facade,
"Villa Maria," Edward P.
Morse Residence, Water
Mill, alterations, 1919
(Courtesy of Mrs. Clarence
Renshaw, n.d.)

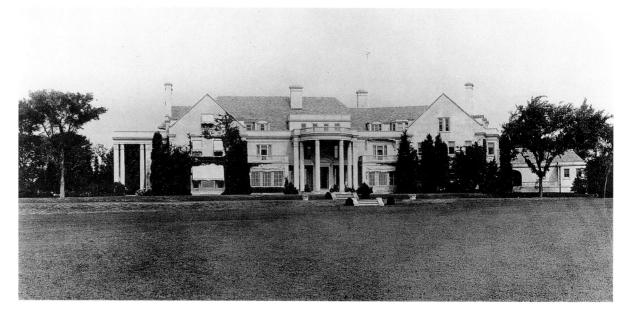

to "Villa Maria," the Water Mill residence of Brooklyn shipbuilder Edward Phinley Morse, founder of the Morse Dry Dock and Repair Co., later to become the United Shipyards.

In 1909 Morse had purchased "Red Gables," the Water Mill house and property of Dr. Edward L. Keyes, and it remains unclear whether Freeman was the architect for the original c. 1895 Queen Anne style house as well. If so, it would have been at a time when Freeman was designing his most impressive works in Brooklyn, and the Keyes's country residence certainly shows the hand of a confident and accomplished architect. With an arresting asymmetrical facade and complex roof lines breaking out into a profusion of gables and dormers, the house included a large gabled porte cochere. In 1919 (according to Morse's granddaughter) Freeman remodeled the house, doubling its size by adding a large living wing to the west end and a colossal semicircular portico, which led to its present eclectic appearance. Today "Villa Maria" is used as a convent home for retired nuns of the Dominican Order.

Carol A. Traynor

Freeman & Hasselman, practiced 1900s

George A. Freeman, 1859–1934

Francis G. Hasselman

Educated at M.I.T., George A. Freeman practiced extensively in Connecticut, New York, and, later, Florida. Among his Long Island works is "Rosemary Hall," the residence and stables at Old Westbury built around 1902 in association with Francis G. Hasselman for Foxhall P. Keene, famous polo player and sportsman. The Georgian Revival stuccoed mansion has a two-story-high, Corinthian-columned portico marking the entrance to the central great hall. A corresponding central pedimented bay is located at the rear elevation. Semicircular dormers pierce the hipped roof; small circular windows are used on the garden facade. The symmetrical disposition of rooms on either side of the central hall and the way in which these major rooms connect through wide sliding doors and lead out onto flanking piazzas and terraces is indicative of the prevailing Beaux-Arts idiom, with its emphasis

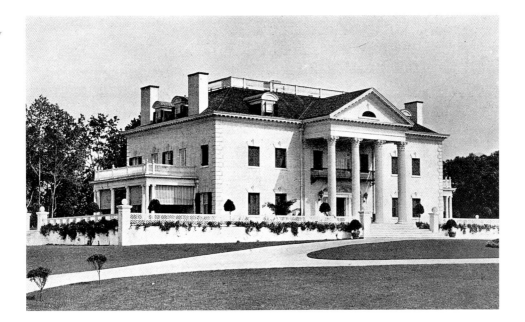

Freeman & Hasselman:
Entrance Front, "Rosemary
Hall," Foxhall P. Keene
Residence, Old Westbury,
c. 1902 (ARTR, 1902)

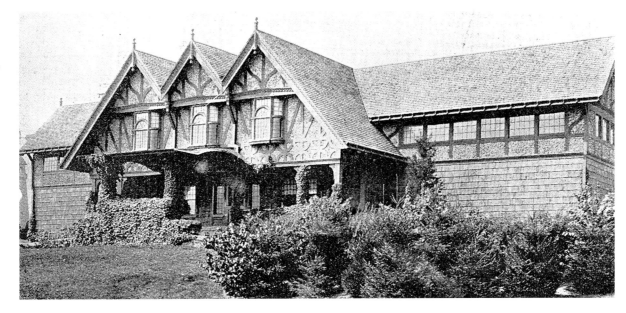

Freeman & Hasselman:
Gymnasium, William C.
Whitney Estate, Old
Westbury, 1898–99 (*New
York Tribune*, Sept. 14, 1902)

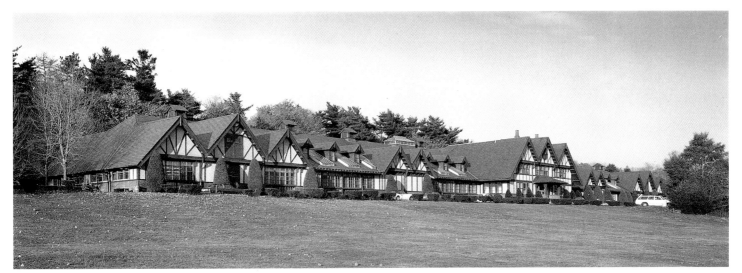

Freeman & Hasselman:
Stables, William C. Whitney
Estate, Old Westbury,
1898–99 (SPLI, Richard
Cheek photo, 1981)

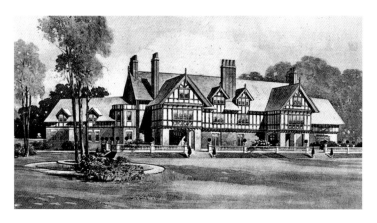

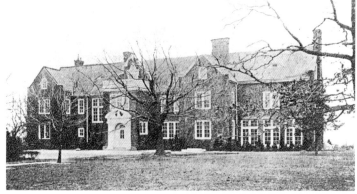

Freeman & Hasselman:
Design Proposal, William H.
Erhart Residence,
Cedarhurst, 1906 (ARTR,
1906)

Freeman & Hasselman:
Front Facade, William H.
Erhart Residence,
Cedarhurst, 1906 (SPLI, n.d.)

on hierarchies of axes and cross-axes linking both internal spaces and interior with exterior spaces. As an example, the library and billiard room opened onto a piazza from which a series of terraces descended to a formal garden designed by Charles W. Leavitt.

In 1898–99 Freeman designed the gymnasium and stables for the William C. Whitney estate at Westbury, both of which survive and, like the Keene estate, are today part of the New York Institute of Technology campus. Both the linear-plan stable complex and the "hunting lodge" gymnasium were built in the Tudor Style, with rubblestone base walls and small pebbles set in the stuccoed interstices of the half-timber designs. The buildings, particularly the stables, generated some publicity when they were erected. A *New York Tribune* article of September 14, 1902, reported, "The enormous stables, one of the largest, if not the largest, in the United States . . . are 80 feet long and 65 feet wide, with an extension 50 by 90 feet in the rear at the centre." The stable building included 83 box stalls, offices for the head stableman and veterinarian, exercising quarters, sleeping and dining rooms, a library, and other conveniences for the stablemen.

In 1906 a design rendering by Freeman & Hasselman appeared in *Architecture* magazine. The design was for a house for William H. Erhart, chairman of the board of Charles Pfizer & Co. The brick and half-timbered Tudor-style design had a steeply pitched roof with cross gables and clustered chimneys. Although the Erhart house, built in Cedarhurst, resembled the design in its roof line and crossed gables, it featured more Jacobean elements, such as the curved gable surmounting the entrance bay. While it seems likely, there is no direct documentation that Freeman & Hasselman were the architects for this house, which is no longer extant.

Wendy Joy Darby

William E. Frenaye, Jr., 1901–1960
Howard & Frenaye, practiced 1930s

A graduate of Cornell University, William E. Frenaye practiced in a partnership known as Howard & Frenaye. Later in his career he accepted a post as vice president of Eastern States Electrical Contractors. The residence he designed for Francis T. Nichols at Brookville around 1930 is French Manorial in style. Rough-faced brick, half-timbering, and high pitched roofs mark the exterior. Other distinctive features include a projecting central pavilion, paneled chimneys, and a conical tower.

Carol A. Traynor

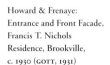

Howard & Frenaye:
Entrance and Front Facade,
Francis T. Nichols
Residence, Brookville,
c. 1930 (GOTT, 1931)

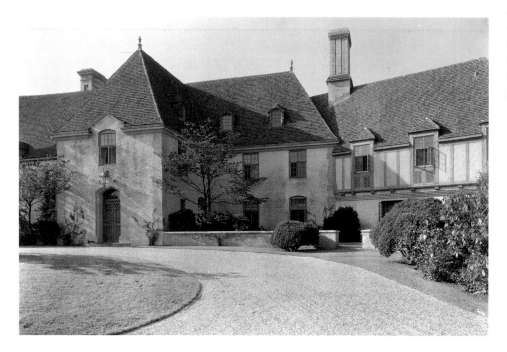

Fuller & Dick: Rear Facade, "Allen Winden," William K. Dick Residence, Islip, 1931 (HOWE, 1933)

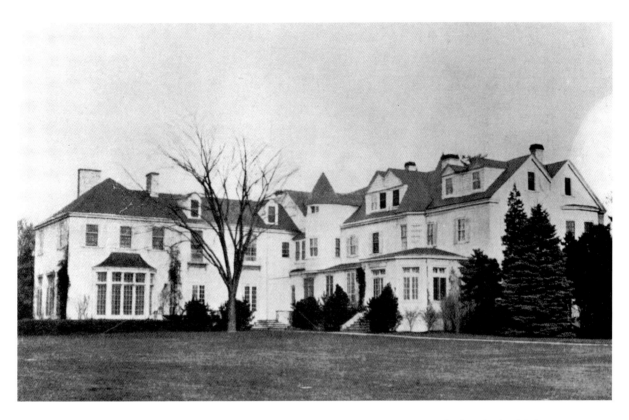

Fuller & Dick: Entrance Court, Adolph G. Dick Residence, Islip, 1931 (COUN, 1934)

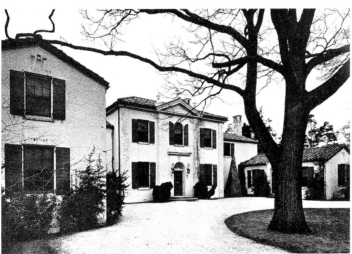

Fuller & Dick, 1931–1935
Adolph G. Dick, c. 1883–c. 1948
Charles F. Fuller, 1897–1960

The firm of Fuller & Dick occupied an office at 485 Madison Avenue, New York. Both architects worked independently before and after their partnership. Charles F. Fuller, a graduate of Columbia's School of Architecture (1923), studied in France and Italy and began practicing in 1925. Adolph G. Dick's father, John Henry Dick, had immigrated from Hanover, Germany, to Brooklyn in 1845, and quickly assumed a position of power and influence in the world of finance. Adolph's brother, William K. Dick, became involved in the family's business interests: finance, real estate, paper production, and sugar refining. Dick's two sisters married members of the Macy and Havemeyer families. With such excellent connections the success of the Fuller & Dick practice was assured.

The impetus for the remodeling of "Allen Winden," the c. 1890 Dick estate in Islip, perhaps the partner's most inspired work, most likely came from Adolph's mother, Julia Theodore Dick. In 1931 Julia gave "Allen Winden" (German for "all winds") to William in order to accommodate his growing family. In 1916 he had married Madeleine Force Astor, who had survived the *Titanic* disaster with her unborn infant in 1912. His brother added a new wing to the sprawling Queen Anne residence, incorporating superbly detailed cabinet windows and chimneys. Julia and Adolph moved into a new mansion of his design located on the same property. Modified Neo-Georgian in style, the house had terra-cotta roof tiles, buff-painted brick walls, and chocolate-toned shutters, creating an exterior counterpart to the imaginative chromatic scheme within. Both houses were demolished in the 1960s. After the termination of the partnership in 1935, Fuller produced fine Colonial Revival residences like the R. K. White house of 1936 in Mill Neck, a commission undoubtedly received through his wife, Jane Sage White.

James A. Ward

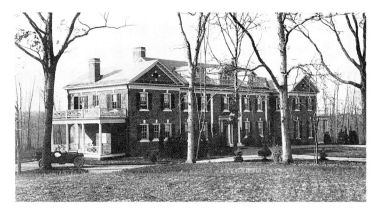

Foster, Gade & Graham:
Front Facade, Effingham
Lawrence Residence, Cold
Spring Harbor, 1909–11
(Courtesy of Kim Johnson,
c. 1915)

Gade's architectural work included the
Memorial Art Gallery in Rochester, New York,
and several residential commissions for friends,
mostly in Westchester and New York City.
On Long Island, the firm of Foster, Gade &
Graham designed a country residence at Cold
Spring Harbor for Effingham Lawrence. Built
between 1909 and 1911, the house, which is ex-
tant, is a formal brick Georgian structure with
a recessed rectangular main block flanked by
two projecting gabled wings. While the house
is still standing, it has been remodeled several
times. In 1934 a third floor was added by archi-
tect Henry R. Sedgwick; in 1951 one wing was
removed by the firm of Wyeth & King. In ad-
dition to the Lawrence house, Foster, Gade &
Graham designed a small Shingle Style house
in Cedarhurst around 1904 for George W.
Wickersham, former U.S. attorney general.
This house is no longer standing.

Carol A. Traynor

John A. Gade, 1875–1955
Foster, Gade & Graham, 1900–1914

Born in Cambridge, Massachusetts, John A.
Gade was something of a latter-day Renaissance
man. He graduated from Harvard University in
1896, but in his 60s received a master's degree
and doctorate from Columbia University. In
addition to a relatively brief architectural career
which lasted from around 1900 to World War I,
he had subsequent careers as a naval attaché,
diplomat, author of several books on history,
and member of the banking firm of White,
Weld & Co. Little is known about his partners
in the firm of Foster, Gade & Graham.

Gage & Wallace, practiced
1890s–1900s

Samuel Edson Gage, d. 1943
William J. Wallace

A graduate of Columbia University's architec-
tural program, Samuel Edson Gage maintained
an office in Queens. His designs included several
bank buildings for the Corn Exchange Bank,
some office buildings, and residences. For a
number of years he was in partnership with
William J. Wallace.

In 1906 Gage & Wallace designed a Colonial
Revival country house for Annie Arnold, widow
of William Arnold of the Arnold Constable
store. The house, which is extant, is sited spec-
tacularly on the Great South Bay in Islip. Its
extensive property includes a dock, gardens
landscaped by Prentice Sanger, and stables. The
broad V-plan of the house itself contains three
distinct pavilions connected by smaller wings,
a program typical of Colonial America. How-
ever, the shingle rendering was atypical of Anglo-
Palladian structures, even those constructed
of wood. The temple portico facing the bay is
detailed handsomely with a composite, Ionic
peristyle. The house has been converted into
condominiums.

Gage & Wallace's 1891–94 residence for Perry
Tiffany in Westbury, Long Island, has a similar
composition. However, although it conforms
to a conservative axial plan, it displays more in-
novative motifs than the Arnold house, such as
the cornices interrupted by gable-and-dormer
windows. The 18th-century norm is also com-
promised by the dependencies, which are as
prominent as the main block of the house.
The house was later remodeled and enlarged
by Eliot Cross of Cross & Cross.

James Ward

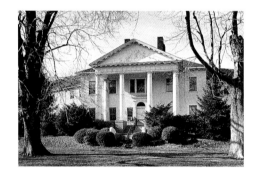

Gage & Wallace: Front
Facade, Mrs. William
Arnold Residence, Islip, c.
1906 (SPLI, Harvey Weber
photo, 1985)

Gage & Wallace: Front
Facade, Perry Tiffany
Residence, Westbury,
1891–94 (ARTR, 1901)

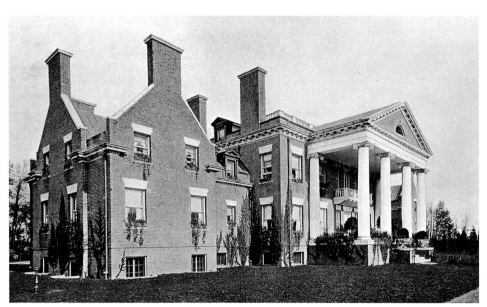

Robert W. Gibson,
1854–1927 (Courtesy of Mrs.
Joseph C. Wilberding)

Robert W. Gibson, 1854–1927

Born outside of London, in Aveley, Essex, in 1854, and trained at the Royal Academy of Art, Robert W. Gibson immigrated to the United States in 1882. At the age of 28 he was chosen over H. H. Richardson, then at the height of his career, to serve as architect of the huge All Saints Cathedral in Albany. He went on to establish a successful architectural practice, working independently first in Albany and after 1888 in New York City.

Churches—usually substantial, Gothic, and Episcopalian—were Gibson's most frequent early commissions. He also designed a number of private houses in the Shingle Style in Albany and Glens Falls in the 1880s, as well as one for E. H. Harriman in Wave Crest Park at Far Rockaway, Long Island, in 1885. In New York City he designed the Sailor's Snug Harbor Church and Music Hall on Staten Island (1893), a series of bank buildings, including the New York Clearing House (1896), and the Bronx Botanical Museum (1898).

A New York City resident, Gibson summered at Oyster Bay, where he pursued his passion for sailing canoes.[1] He was also a yachtsman, a member of the Seawanhaka Corinthian Yacht Club, and designer of the club's Centre Island station. Gibson participated in local races and, in 1898, was chosen to represent the Seawanhaka Yacht Club Race Committee at the international races in Canada.

Gibson's Long Island commissions were for sailing associates like Seawanhaka member George A. Thayer, whose shingled Colonial Revival house in Port Washington closely resembled the yacht club. In 1899, a married man and father of four, Gibson built his own summer house on the Cove Neck, Oyster Bay, site that he had coveted since he saw it during some boating explorations ten years earlier. He called the house "North Point." Each summer Gibson added a new wing, until the once-simple place had become a 30-room mansion. "It is surprising how, when mature years have taken the zest

out of many amusements, there is still enjoyment of almost youthful intensity in seeing your own house grow," Gibson wrote in 1902 at the age of 48.[2] Sadly, the house had grown in reverse proportion to its owner's means. His preoccupation with it may have compensated for, or even contributed to, the slackening of his career.

During this critical period in his career, Gibson's sailing contacts brought him welcome commissions. Morton F. Plant, railroad and real-estate scion, and owner of some of the sleekest racing yachts of the day, hired him in 1904 to design his Fifth Avenue townhouse in New York. This fine Renaissance structure on the corner of 52nd Street has housed the jewelry store Cartier since 1917. Pleased with his New York house, in 1905 Plant asked Gibson to design the 500-room Griswold Hotel in New London, Connecticut. With acres of pillars, parapets, and piazzas, the Griswold resembled a Seawanhaka yacht club on a monstrous scale.

In time, however, family problems including the death of a son, his wife's breakdowns, and his declining practice led Gibson to admit in 1907 that "our establishment began to look very large." He described 1909 as "a dreary, long torturing year—when even work was stopped and idleness made life more miserable and straitened means closed up the way to even accustomed luxury. . . ." At this time, he reluctantly let "North Point" to tenants and retreated to a more manageable farmhouse on the Jericho Turnpike in Woodbury, which he named "Aveley Farm." The following year he wrote from there, "I do not feel able to do any more than wait and this is the place to wait in." One last architectural commission from another Seawanhaka friend, George Bullock, pulled Gibson out of premature retirement in 1913.

In August 1927 Robert Gibson died at Aveley Farm, the home he named after his Essex birthplace.

The handful of Robert Gibson's Long Island works are hardly representative of the breadth of this man's career. Gibson was essentially a New York City architect whose sophisticated Beaux-Arts banks, schools, commercial buildings, and decorative Gothic churches were constructed throughout the Northeast from upstate New York to Scranton, Pennsylvania, and Washington, D.C. Gibson also contributed significantly to architectural circles in New York City as president of the Architectural League and as a director of the New York City chapter of the American Institute of Architects. It was Long Island's North Shore with its "clean, crisp salt bays and sounds" where he found peace and solitude from his professional life.

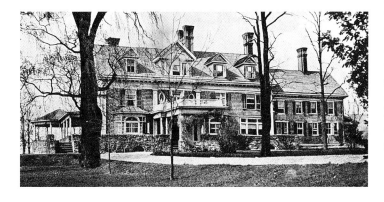

Robert W. Gibson: Front
Facade, "Robinhurst,"
George A. Thayer
Residence, Port Washington,
1898 (SPLI, n.d.)

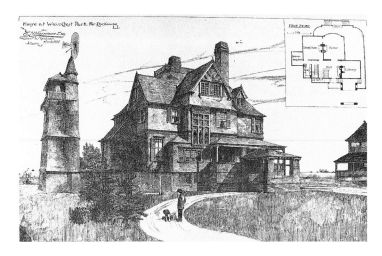

Robert W. Gibson: Sketch of Front Facade and First Floor Plan, E. H. Harriman Residence, Wave Crest Park, Far Rockaway, 1885 (AABN, 1886)

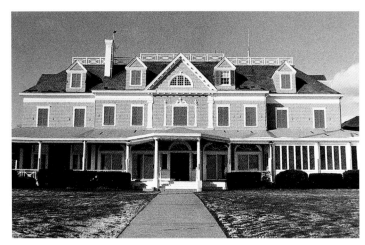

Robert W. Gibson: Front Facade, Seawanhaka Corinthian Yacht Club, Centre Island, 1891 (SPLI, 1980)

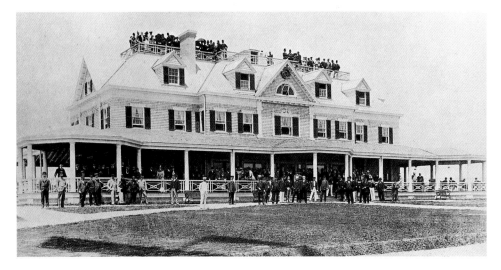

Robert W. Gibson: Seawanhaka Corinthian Yacht Club, Centre Island, Oyster Bay, 1891 (Courtesy of Seawanhaka Corinthian Yacht Club))

E. H. Harriman Residence, Wave Crest Park, Far Rockaway, 1885

This relatively modest seaside summer cottage with its accompanying water tower was published in *American Architect and Building News* in 1886.[3] The design is similar to Gibson's Craig House in Albany, built the previous year, and is characterized by half-timbered gables, varied fenestration, and banded brick chimneys. However, the design for the Harriman house was executed in shingles rather than stone and was encircled by a veranda which provided seaside

vistas. The roof line combined gables of different dimensions, culminating in a hip and parapet, a colonial feature Gibson favored. The interior plan was simple and compartmentalized. The fireplaces in all the principal rooms were probably the sole source of heat for this summer cottage.

Seawanhaka Corinthian Yacht Club, Centre Island, Oyster Bay, 1891 (Extant)

Gibson's Long Island associations really began in the mid-summer of 1889 when, in the company of another bachelor friend, he explored the Oyster Bay area seeking a suitable site for a yacht club. The friends made two landings—one at Centre Island and the other at Cove Neck. A year later Gibson designed the Seawanhaka Corinthian Yacht Club for the Centre Island site. The club history describes Gibson as "an Englishman for some years a resident of Albany, a rising young architect, and one of the leading canoe sailors, a member of the Mohican Canoe Club of Albany."[4] Transferring his business to New York, his close association with canoeists in the club soon brought him in as a member. Gibson's transition from the Shingle Style to the Colonial Revival mode is evident in this exceptionally handsome design. Colonial details and symmetry dominate the composition. The shingled exterior is decorated with pilasters, a wide entablature, a fanlight in the central gable, and, below it, a window framed with a broken scroll and ornamental urns. The hip roof, punctuated by dormers, terminates in a vast parapet. The balustrade of the parapet matches that of the ground-floor veranda facing Oyster Bay. This veranda billows forth into three semi-octagonal projections in the center and at both ends.

Robert W. Gibson Residence, "North Point," Cove Neck, Oyster Bay, 1899–1903

Begun as "a simple house" in 1899, "North Point" grew apace with its architect-owner's imagination until it had blossomed into a substantial, shingle-clad Colonial Revival mansion. Fortunately, the architect's diary chronicles the seven years of transition in which the house was altered with every building season. The pedimented front door placed asymmetrically on the south facade was soon overshadowed by a huge, two-story central portico "of a Virginian type." The original portion of the house, which had a gable roof, soon sprouted dormers as the attic

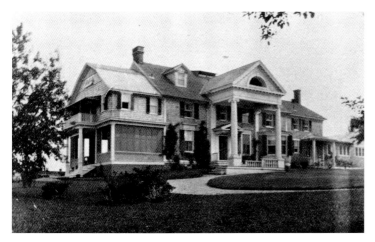

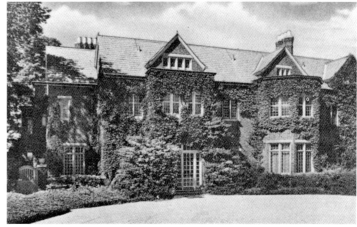

Robert W. Gibson: Front Facade with Portico and Dormer Additions, "North Point," Robert W. Gibson Residence, Cove Neck, 1902–03 (Courtesy of Mrs. Joseph C. Wilberding)

Robert W. Gibson: Front Facade, George Bullock Residence, Centre Island, Oyster Bay, 1914 (PREV, c. 1940)

rooms were finished off. The substantial west wing, completed in 1903, sported a gambrel roof. In the same year central heating was installed and a grand terrace added on the north side of the house overlooking Oyster Bay. Gibson laid out formal gardens off the west veranda and planted an avenue of maples and poplars leading from the garden to the beach.

George Bullock Residence, Centre Island, Oyster Bay, 1914

The Bullock house, one of Gibson's last commissions, represented a return to his British roots. The elaborate L-shaped brick house, Elizabethan in style, showed Gibson's interest in the work of the English architect, Edwin Lutyens. Two wings of the house pivoted around a low stair tower with a bell-shaped cap. The L surrounded a small formal garden with a reflecting pond fed by a waterfall cascading down a hillside. The gardens and tower lent interest to this otherwise awkward exterior. In addition to the main house, Gibson designed stables, farm buildings, a boathouse, and docks for Bullock.

Cornelia B. Gilder

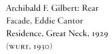

Archibald F. Gilbert, 1875–1953

Born in Bainbridge, New York, Archibald F. Gilbert began his career in the office of the well-known architectural firm of D. H. Burnham & Co., Chicago. In 1916 he opened his own office in New York City, and later formed a partnership, A. F. Gilbert & Son, with his son Daniel C. C. Gilbert. He continued to work until his death in 1953. Only one Long Island residential commission can be attributed to Gilbert during his 40-year career. In 1929, he designed a country residence in Great Neck for radio and motion-picture star Eddie Cantor. Great Neck was a natural choice for Cantor, since the area was fast becoming a summer enclave for literary and artistic celebrities, including F. Scott Fitzgerald, George M. Cohan, and Ring Lardner. Gilbert's design was a multigabled, asymmetrical brick and half-timbered Tudor manse with the fenestration boldly outlined in either stone or wood. The house was demolished in the 1950s.

Carol A. Traynor

Archibald F. Gilbert: Rear Facade, Eddie Cantor Residence, Great Neck, 1929 (WURT, 1930)

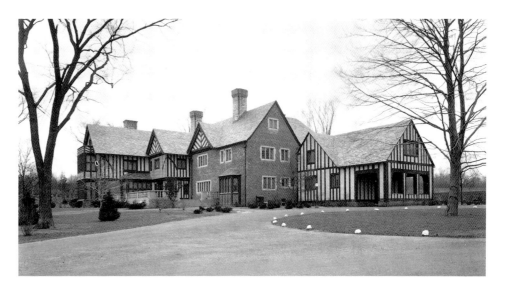

Bradford Lee Gilbert: Rear
Facade, William H. Baldwin
Residence, Lattingtown,
c. 1900 (FULL, n.d.)

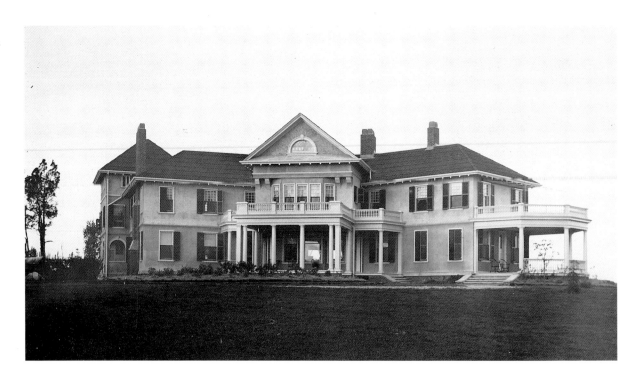

Bradford Lee Gilbert, 1853–1911

Born in Watertown, New York, Bradford Lee
Gilbert received his architectural training in the
New York office of J. Cleveland Cady. Gilbert
was an inventor as well as an architect, and is
credited with the design of the first steel-frame
skeleton for the Tower Building in New York.
After his appointment in 1876 as official archi-
tect to the New York, Lake Erie and Western
Railroad, he opened an independent office in
New York, specializing in railroad structures
and public buildings. His notable works includ-
ed the New York Riding Club and alterations to
Grand Central Station. He was a member of the
American Institute of Architects, the National
Sculpture Society, the Architectural League,
and the National Arts Club.

Gilbert's first commission on Long Island,
awarded in 1886, was to design alterations for
the South Side Sportsmen's Club in Oakdale.
These included the addition to the original
1820s tavern of a dining room, rod room, super-
intendent's quarters, and several bedrooms. His
only recorded residential commission on Long
Island was the stucco Colonial Revival house in
Lattingtown for William H. Baldwin, president
of the Long Island Railroad, around 1900. The
house was demolished in 1937.

Joel Snodgrass

C. P. H. Gilbert, 1860–1952

Glen Cove's North Country Colony is a cool
and shady green retreat, a place of tall trees and
overgrown gardens, penetrated by narrow roads.
From these quiet lanes, the presence of houses is
implied by discreet suggestions rather than obvi-
ous views: a shingled corner glimpsed through
a break in a fence, a gatepost with a nameboard,
a driveway staked "private." And here and there
is a hint of something unexpectedly magnificent:
a white-marble Roman arch at an angle to the
road or a monumental portico framed by an
opening in an apparently artless gatehouse. Age
and nature have softened the edges of a neigbor-
hood which, in its creation, reshaped a portion of
Long Island's North Shore to reflect dreams once
attainable by America's very wealthy.

Nearly a century old, North Country Col-
ony was established in 1893 as a syndicated real-
estate development featuring protected sites for
very ambitious country houses. It offered prop-
erty owners the assurance that their district
would keep its character of exclusive affluence
by establishing a system of restrictive covenants
that imposed architectural design control, and
minimum costs for residential construction.[1]

The earliest group of North Country resi-
dents built their houses between 1896 and 1900.
Syndicate president Harvey Murdock, a real-
estate developer with wealth, taste, and style, was
one of the first to build, and was quickly joined
by a dozen neighbors, almost every one of whom
was a successful lawyer, businessman, or banker
with a townhouse in Manhattan or Brooklyn.

C. P. H. Gilbert: Entrance
Facade, C. N. Hoagland/G.
P. Tangeman Residence,
Glen Cove, 1896–1900
(WURT, n.d.)

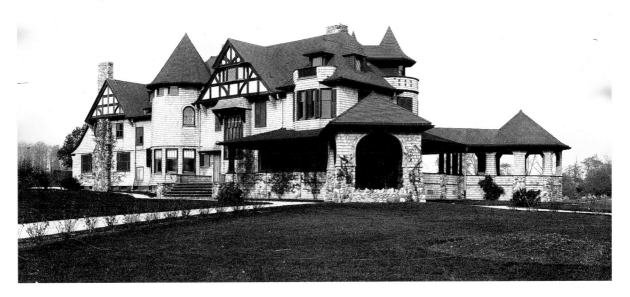

C. P. H. Gilbert: Design
Rendering, C. N. Hoagland,
Farm Buildings, Glen Cove,
1896–1900 (ARLG, 1896)

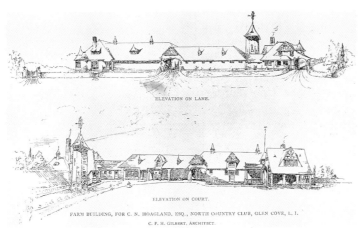

In C. P. H. Gilbert, the North Country proprietors found an ideal expert and adviser to guide them in the creation of houses that were comfortable, conservative, but technologically sophisticated and opulent. Born in New York City, Gilbert studied architecture at Columbia College and the Ecole des Beaux-Arts in Paris. After a period of building in mining towns in the West, he returned to New York around 1880 to begin a productive career designing millionaires' houses.

In Brooklyn's Park Slope neighborhood, just at the beginning of its development as a fashionable residential suburb, Gilbert's houses on Carroll Street set a standard of architectural quality for the area. This was reinforced in the 1890s with the creation by Gilbert and developer Harvey Murdock of the block-long Montgomery Place. Gilbert's first published commission was a Park Slope townhouse for Harvey Murdock, in 1889,[2] which was followed quickly by several more Park Slope houses (two

of them for North Country owners John H. Hanan and J. Adams), a Brooklyn Heights apartment house, and a hotel on Staten Island.

Gilbert's first known work in the North Country Colony was the house and farm complex apparently begun in 1896 for C. N. Hoagland, and perhaps completed for Dr. G. P. Tangeman.[3] Fashionably educated, widely traveled, capable of translating the forms and details of historical architectural styles into fully resolved domestic designs, Gilbert enjoyed the advantage of easy access to potential clients both because his office was located on lower Broadway, the City's financial district, and because he was a member of the Metropolitan and Racquet clubs, frequented by the wealthy and socially prominent. In addition to his membership in professional organizations—the New York Architectural League and the American Institute of Architects—Gilbert, by virtue of his ancestry, belonged to such organizations as the Sons of the Revolution, the Society of Colonial Wars, the New England Society, and the Society of the War of 1812. This gave him authority in the view of people who believed in the importance of tradition and stability. Although sometimes confused with him, Gilbert was not related to the prominent architect Cass Gilbert.

By 1900 Gilbert had completed at least seven major Long Island houses, five of them in the North Country Colony and another on an adjacent property. That first group of houses defined Gilbert's system of design. The houses themselves represent a variety of styles: Shingle, Colonial Revival, French Neoclassical, Gothic, Flemish, Tudor, and Mediterranean Villa.

Following the Beaux-Arts tradition, Gilbert developed a master site plan for each commission, and integrated structure and style in his

C. P. H. Gilbert: Entrance and Front Facade, L. J. Busby Residence, Glen Cove, 1896–1901 (ARTR, 1901)

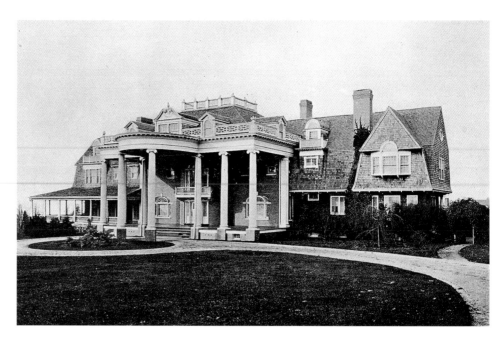

design of the house and its setting, which often included landscaping, terraces and gardens, and both functional and ornamental outbuildings. Gilbert was neither a visionary, an innovator, nor an opinionated stylist. His work was diverse but never incoherent. He knew what his colleagues were doing, he understood what his clients wanted, and he was fluent in every stylistic vocabulary current during his working period (c. 1890–1920). If his later buildings, such as the F. W. Woolworth house, completed in 1917, were academic to the extreme, his earlier work was often eclectic and energetic, full of life and promise.

C. N. Hoagland/G. P. Tangeman Residence and Farm Buildings, Glen Cove, 1896–1900 (Extant)

The secret of the relative success of Gilbert's buildings lies in the possibilities opened by the styles themselves. A strong eclectic tradition in the late 1880s and 1890s allowed designers to merge styles boldly: in the Hoagland/Tangeman house, Gilbert used Shingle Style forms to create a rambling house that hugs the ground while featuring half-timbered gables, a multifaceted tower, candle-snuffer dormers, and other exuberances, including a semi-detached gazebo and a porte cochere extended at an angle from a corner. The richness of texture and detail, and the picturesque profile of peaks, points, and conical caps are held in check by the building's horizontality and the groundward slide of angled, shingled roof planes. The house recalls the interpretations of medieval manors in the work of the English architect Richard Norman Shaw, a reference reinforced by the long, heavy-roofed sweep of farm buildings designed to screen

the house from the road while creating a courtyard for it. Although it is uncertain whether the farm buildings designed by Gilbert were actually built, the house itself survives today in a slightly altered state.

Leonard J. Busby, Residence and Stables, Glen Cove, 1896–1901 (Extant)

Approximately half a mile north of the Hoagland/Tangeman complex, on the same road, Gilbert designed a Colonial Revival house and stable for Leonard J. Busby, a Brooklyn manufacturer.[4] The stylistic vocabulary is completely different from that of the Tangeman house, but the use of forms, space, and detail suggests the same designer. A Shingle Style outbuilding screens the house from Crescent Beach Road, while the driveway entry, under a swept eave, frames a view of the house. The main block, of yellow brick beneath a tall, balustrade-crowned hipped roof, is dominated by a monumental Ionic portico which, breaking forward in a semi-circle, spans the drive to form a porte cochere. East and west wings, under deep, crossed-gambrel roofs, flank the central block and relieve its symmetry. For this Colonial Revival house, Gilbert borrowed details from various regions and periods that in the late 19th century were regarded as "Colonial." The great gambrel-roofed wings are Shingle Style and acknowledge the style's debt to early American forms. The hipped-roof square symmetry of the central block refers to mid-18th-century American translations of English Georgian forms, as do the collection of elaborate broken-scroll and segmental-headed dormers. The segmental-headed, three-part windows flanking the elaborate two-story entry arrangement come from late Georgian England by way of 1820s Boston.

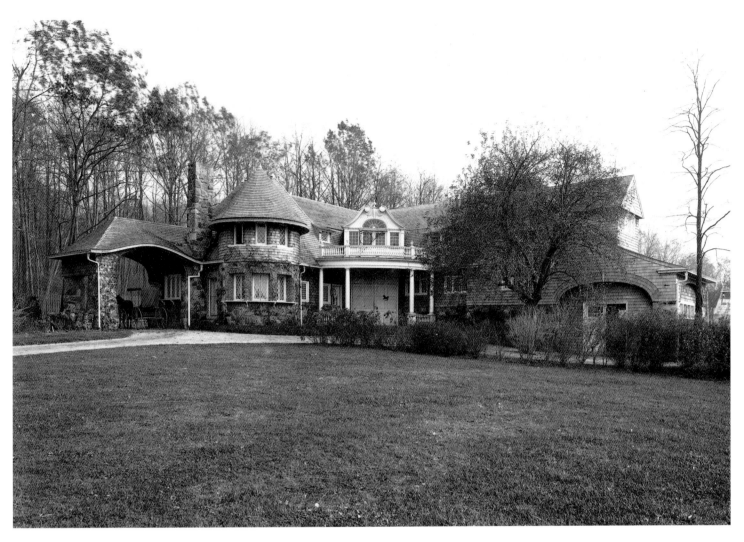

C. P. H. Gilbert: Stables,
L. J. Busby Residence,
Glen Cove, 1896–1901
(WURT, n.d.)

C. P. H. Gilbert: First Floor
Plans, L. J. Busby
Residence, Glen Cove,
1896–1901 (SAAB, 1901)

The monumental Ionic portico/porte cochere is pure inspiration, although its order and forms had been used in less elaborate designs in the Federal period.

The Shingle Style stable designed for Busby is closer in feeling to the design of the Hoagland/Tangeman house of the same period than it is to the Busby main house. An elaborate frontispiece, with balustraded porch surmounted by a major dormer with a broken-scroll pediment, is assertively thrust into an otherwise restrained structure with a deep, shingled gambrel roof broken by a conical-capped tower. House and stable face each other across a lawn enclosed by an elliptical drive, the intimacy of the court

relieving the monumentality of the house. The house and stable have survived in an unaltered state and today are used as the buildings of North Country Day School.

George E. Fahys Residence, "Hillaire," Glen Cove, c. 1900

Parker D. Handy Residence, "Groendak," Glen Cove, c. 1900

In two more houses, Gilbert developed designs based on the materials and horizontal emphasis of the Shingle Style. George E. Fahys, a civil engineer and watch-case manufacturer, and Parker D. Handy, a banker and manufacturer, were both original landowners in the North Country Colony development, and apparently commissioned Gilbert to design their houses simultaneously, as both were published in the periodical *Architecture* in January 1901.[5] Each house has its main roof broken by a major gable, slightly off-center, flanked by dormers. The similarity of the Fahys and the Handy houses ends where stylistic detail begins: the Fahys house features Gothic gables, while the

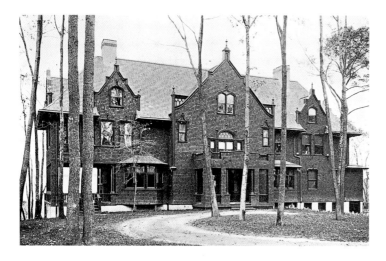

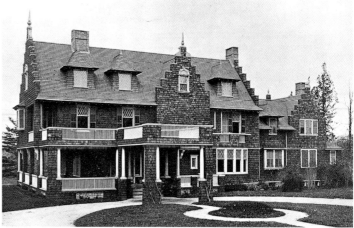

C. P. H. Gilbert: Front Facade, "Hillaire," George E. Fahys Residence, Glen Cove, c. 1900 (ARTR, 1901)

C. P. H. Gilbert: Front Facade, "Groendak," Parker D. Handy Residence, Glen Cove, c. 1900 (ARTR, 1901)

C. P. H. Gilbert: Garden Facade, Robert A. Shaw Residence, Glen Cove, c. 1900 (REAL, 1910)

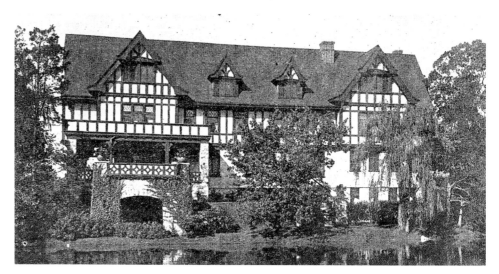

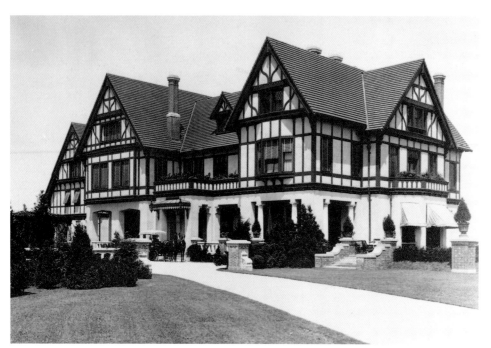

C. P. H. Gilbert: Entrance and Front Facade, "Northwood," Mortimer Schiff Residence, Oyster Bay, c. 1905, additions, c. 1911 (Courtesy of John M. Schiff)

Handy house is Flemish in detail, with Gilbert's favorite candle-snuffer dormers. Although the outbuildings for both estates survive, the main houses have been demolished.

Robert A. Shaw Residence, Glen Cove, c. 1900

Mortimer Schiff Residence, "Northwood," Oyster Bay, c. 1905, Alterations, c. 1911

In two similar Tudor Style houses, Gilbert demonstrated his ability to design buildings considered more "correct" in their time than the Elizabethan-derived scheme he devised for the Hoagland/Tangeman house. The house built for lawyer Robert Anderson Shaw in the North Country Colony was completed by 1902.[6] The one built for banker Mortimer Schiff (son of the railroad financier Jacob Henry Schiff), in Oyster Bay, was finished by 1906,[7] and enlarged, almost certainly by Gilbert, around 1911.[8] Both houses were asymmetrical compositions, their black-and-white, half-timbered walls rising over masonry bases to steep pitched roofs broken by numerous gables and dormers. Featuring a generous use of texture and detail, the houses had

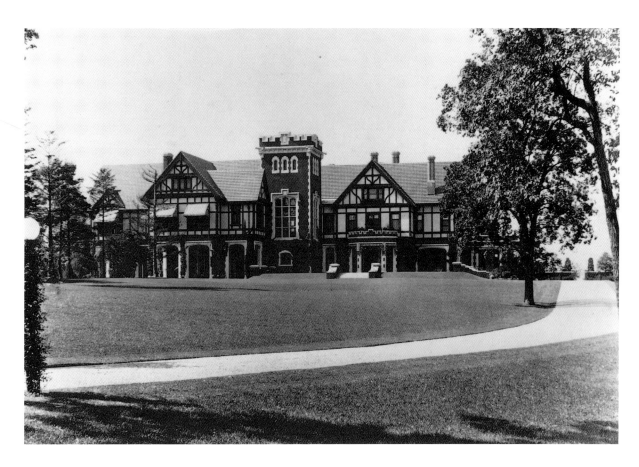

C. P. H. Gilbert: Rear
Facade, "Northwood,"
Mortimer Schiff Residence,
Oyster Bay, c. 1905, addi-
tions, 1911 (Courtesy of
John M. Schiff)

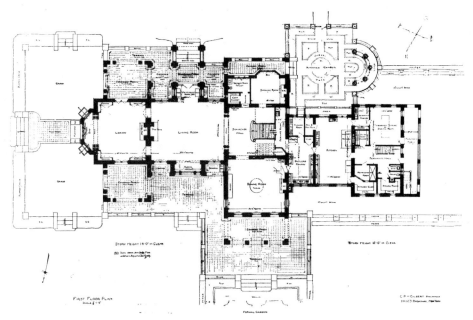

C. P. H. Gilbert: First Floor
Plan, "Northwood,"
Mortimer Schiff Residence,
Oyster Bay, 1905, additions,
1911 (ARTC, 1910)

bands of diamond-paned windows, bracketed
balconies and oriels, multilevel porches and ter-
races, and chimneys treated as clusters of flues.
In its enlargement, the Schiff house gained a
crenelated brick tower, a proliferation of half-
timbered gables and dormers, and more porches
within the masonry base of the house, all of
which created a structure more irregular and
picturesque than the original.

Photographs of the Schiff interiors show a
house in which vistas open onto one another
through arched screens, the whole anchored
by a freestanding chimneypiece flanked by
wide passages. The rooms are distinguished by
dark-colored, wood-paneled walls and ornate
plaster ceilings. The ornamental detail owes
much to the early English Renaissance period
of Henry VIII. A less historical note was struck
by the indoor swimming pool set beneath a
coved, stained-glass skylight and protected from

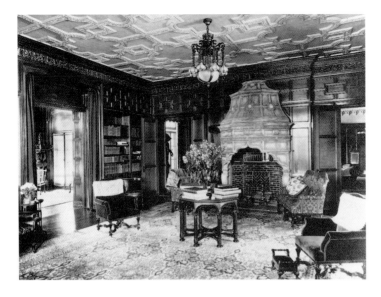

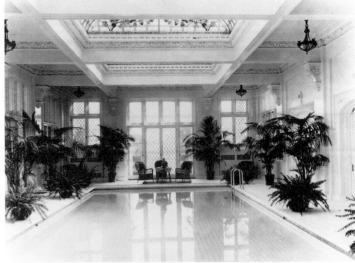

C. P. H. Gilbert: Interior Detail, "Northwood," Mortimer Schiff Residence, Oyster Bay, 1905, additions, 1911 (Courtesy of John M. Schiff)

C. P. H. Gilbert: Indoor Swimming Pool, "Northwood," Mortimer Schiff Residence, Oyster Bay, 1905, additions, 1911 (Courtesy of John M. Schiff)

C. P. H. Gilbert: Front (South) Facade, Alexander C. Humphreys Residence, Glen Cove, 1899–1902 (ARTR, 1901)

the outdoors by diamond-paned casement windows and French doors. While everything in the house was comfortable and up-to-date, it was all overlaid by architectural trim that spoke of a noble English past.

Neither the Shaw nor the Schiff residences survive, but a gate and gate lodge from the Shaw estate remain standing.

Alexander C. Humphreys Residence and Stables, Glen Cove, 1899–1902

A thoroughly literate architect at home in an eclectic era, Gilbert was as comfortable with Mediterranean as with English sources. By 1900 he had already worked in the Spanish Mission mode—a California response to the East Coast revival of English-based "Colonial" styles. (The California Building at the 1893 World's Columbian Exposition in Chicago was the first well-known building in the style, but not until around 1920 did the style become popular.)

Gilbert was just back from service in the Spanish American War when he began to design

a North Country Colony house for mechanical engineer and educator Alexander Crombie Humphreys. Humphreys assembled his land early in 1899, and the house was reported in *Architecture* in June 1900.[9]

One of the first Mediterranean villa-style residences in the New York area, the Humphreys house balanced Spanish and Renaissance details to create a formal, symmetrical villa. The walls were of rough-cast stucco over brick, and the red-tiled roof featured pyramidal gables at each end, with heavily trimmed segmental-headed dormers over the end pavilions and pyramid-capped dormers flanking the baroque scrolled pediment at the center of the main facade. The Mediterranean style, in keeping with the temperate climate in which it developed, used loggias and balconies, terraces and porches, much as did summer houses in the Northeast region of the United States. Gilbert created transitional indoor-outdoor spaces in all of his Long Island

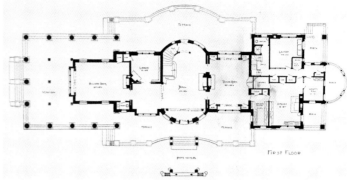

C. P. H. Gilbert: Stables, Alexander C. Humphreys Residence, Glen Cove, 1899–1902 (ATLA, 1907)

C. P. H. Gilbert: First Floor Plan, Alexander C. Humphreys Residence, Glen Cove, 1899–1902 (ATLA, 1907)

C. P. H. Gilbert: Front Facade, E. J. Rickert Residence, Great Neck, c. 1908 (TOWN, 1911)

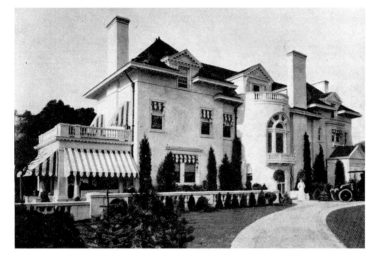

C. P. H. Gilbert: Rear Facade, "Shadowland," Dr. J. C. Ayer Residence, Glen Cove, 1910 (ARRC, 1914)

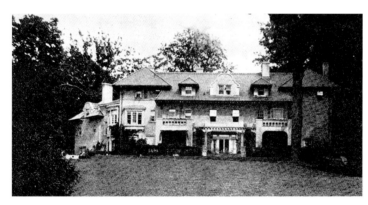

C. P. H. Gilbert: First Floor Plan, "Shadowland," Dr. J. C. Ayer Residence, Glen Cove, 1910 (ARRC, 1914)

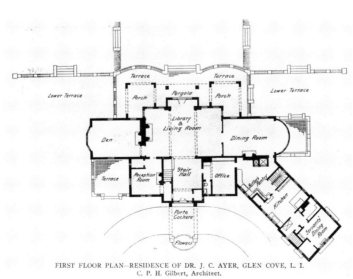

FIRST FLOOR PLAN—RESIDENCE OF DR. J. C. AYER, GLEN COVE, L. I.
C. P. H. Gilbert, Architect.

houses, but never more liberally than in the Humphreys residence. Within the formal volume of the house, these outdoor rooms, some sheltered and some open to the sun, let the sun and breeze into the house in a dozen places.

E. J. Rickert Residence, Great Neck, c. 1908

The E. J. Rickert house in the Kensington development of Great Neck was designed in an eclectic style, although it was Spanish in its pyramid-gabled tile roof and stuccoed walls. Completed by 1908, it was photographed for Frederick Ruther's *Long Island Today,* published in 1909.[10] Photographs of some interiors accompanied the exterior views and floor plan.

In the Rickert and Humphreys houses, Gilbert achieved the "stunning effect" that the contemporary critic Herbert Croly thought the villa-building architects sought above all else.[11] The size and splendor of these houses embellished with columns and balustrades and surrounded by formal terraces, was calculated to stupefy. Croly justified the public curiosity such houses aroused as "perfectly legitimate, because the buildings are, from an architectural and a social point of view, novel and significant." They were a genuine phenomenon, as different from earlier kinds of houses as the new skyscrapers were from old-fashioned four- and five-story brick commercial buildings. Neither the Humphreys nor the Rickert house survives today.

Dr. J. C. Ayer Residence, "Shadowland," Glen Cove, 1910

Gilbert's house for Dr. J. C. Ayer, facing Hempstead Harbor near Red Spring Point, east of the North Country Colony, was completed by 1910.[12] Named "Shadowland," this was a simpler and more straightforward Mediterranean-style design than the Humphreys house. Like the former residence, it had a tiled roof with pyramidal end gables and rough-cast stucco walls.

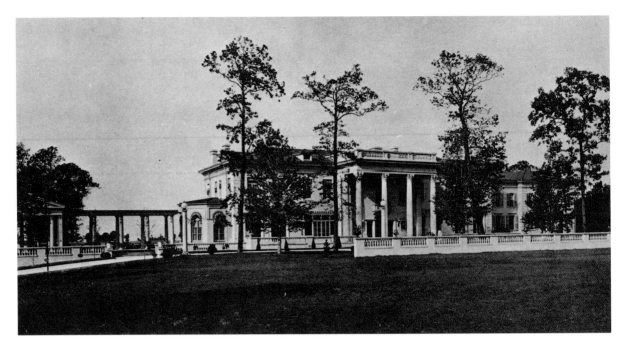

C. P. H. Gilbert: Front
Facade, "Meudon," William
D. Guthrie Residence,
Lattingtown, 1900 (ARTR,
1902)

C. P. H. Gilbert: Rear
(Garden) Facade, "Meudon,"
William D. Guthrie
Residence, Lattingtown,
1900 (ARRC, 1902)

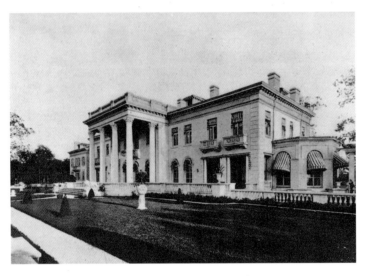

C. P. H. Gilbert: View of
Garden and Boathouse,
"Meudon," William D.
Guthrie Residence,
Lattingtown, c. 1900 (HICK,
1912)

Central bays on both land and water fronts were
crowned by baroque curved pediments. The
interiors were designed by William Chester
Chase, a Boston architect trained at M.I.T., who
planned the house for summer living on a grand
scale. A porte cochere, facing the land side of the
building, opened into a stair hall, a reception
room, and an office. Dominating the ground
floor on the side facing the water was the great
living hall and library, an immense, high room
with smooth, pale walls articulated by Ionic pi-
lasters. The west wall opened onto two porches
and a pergola, outdoor living spaces giving ready
access to the series of terraces and lawns that ex-
tended seaward from the west front of the house.

William D. Guthrie Residence, "Meudon," Lattingtown, c. 1900

Gilbert's most sumptuous and stunning houses
were designed in the Renaissance Revival style,
with neither cost nor effort spared to create a
superlative expression of taste and wealth.

Completed in 1900, lawyer William
Dameron Guthrie's 300-acre estate "Meudon"
was the first of this elaborate group.[12] However,
"to get the view we wanted," Guthrie and John
A. Aldred (see Bertram Grosvenor Goodhue),
a prospective neighbor, bought the 60 buildings
comprising the village of Lattingtown and de-
molished them.[14] In their place Gilbert laid out
Guthrie's villa and gardens, stables and farm
buildings, dairy, servants' quarters, kennel, and
beach house. The estate generated its own elec-
tric power with a 30-horsepower coal-fired gas
engine, supplied with fuel by deliveries to a
private coal dock on Long Island Sound.

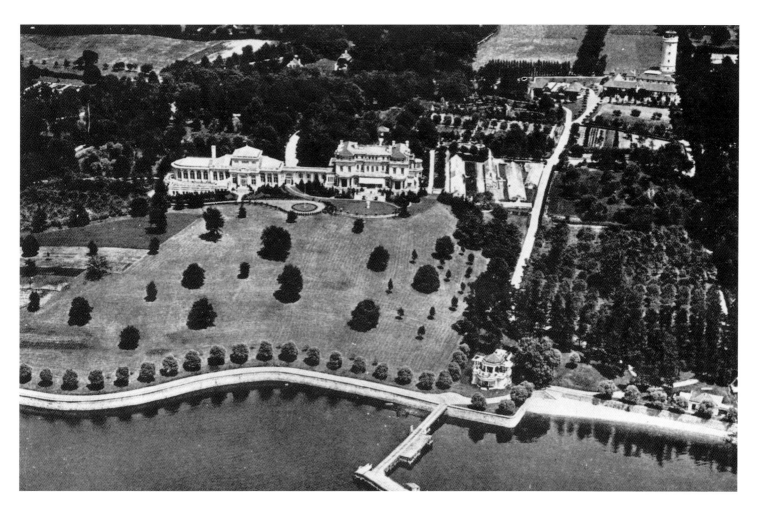

C. P. H. Gilbert:
"Pembroke," Joseph R.
DeLamar Residence, Glen
Cove, 1916–18 (COUN, 1920)

The main house, demolished around 1955, was a splendid reserved composition, the two-story, rectangular main block symmetrical under a low-hipped roof and centered around a monumental portico of the composite order carrying a full entablature crowned by a balustrade. At some point between 1902 and 1906, the east wing of the house was expanded, replacing an octagonal one-story bay and an adjacent pergola. The set-back service wing extended from the main block, continuing its roof shape and echoing its rusticated corner pilasters. Beyond the house to the north, the garden descended in stepped terraces to a horseshoe-shaped lawn, its grassy slopes and squares contained by ornamental plantings, pavements, and sculptural decorations. It had been designed by Brinley & Holbrook and the Olmsted Brothers.

Joseph Raphael DeLamar Residence, "Pembroke," Glen Cove, 1916–18

The house Gilbert designed for Joseph DeLamar is his virtuoso performance. Born in Holland in 1843, DeLamar was a mining engineer and western mine owner who was later associated with various financial interests. Possessed of a great fortune, DeLamar was 69 years old when work began on his residence at Glen Cove, facing Hempstead Harbor just

north of J. C. Ayer's "Shadowland," and west of the North Country Colony.

In 1905 DeLamar had moved into a town-house on Madison Avenue in New York City that Gilbert had designed for him, described by the *Architectural Record* as being "as French a thing as one could find, but . . . handled with extreme skill."[15] On Long Island, given his client's resources and spatial preferences, Gilbert abandoned restraint and, according to critic Herbert Croly, achieved an effect that architects dreamed of. "Pembroke," even in its world of modern palaces, stood out as stunning, and remained so even in desuetude until it was torn down in 1968.

French Neoclassical in style, "Pembroke" was, in fact, typical of American mansions of the time, complete down to the last garden ornament. It was in every way extravagant, hinting at a glittering life that flourished behind its brilliant facade.

Like its Renaissance models, "Pembroke" had a "street" and a "garden" facade, its public face more restrained than its private one. Behind an elaborately stepped and terraced sequence of formal parterres, studded with statuary and a fountain pool, the white facade of the main

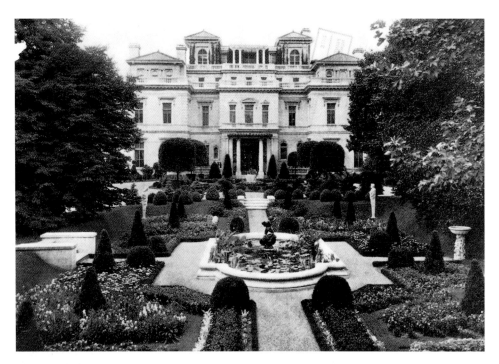

C. P. H. Gilbert: "Pembroke," Joseph R. DeLamar Residence, Glen Cove, 1916–18 (AMAR, 1919)

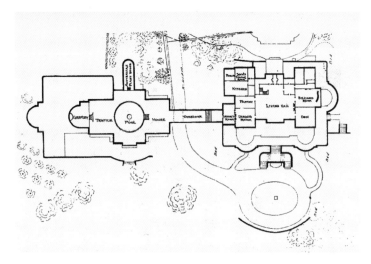

C. P. H. Gilbert: Floor Plan, "Pembroke," Joseph R. DeLamar Residence, Glen Cove, 1916–18 (AMAR, 1919)

block rose three floors to a balustrade-screened classical attic, crowned by a little pavilion repeating the three-part rhythm of the house itself. The main entry squeezed arrivals through a narrow vestibule to emerge into the high-ceilinged vastness of the westward-looking hall, the major living space in the house. Dining room, billiard room, and den opened from the hall, which in turn opened onto a terrace from which a lawn sloped down gently toward Long Island Sound and a private bathing casino and boat landing.

Connected to the main block by a corridor, the Tropical House was cruciform in plan, focusing on a mosaic-tiled swimming pool from whose center rose a delicate metal pavilion with a domed glass roof. A metal footbridge connected the pavilion with the walks outside the pool. From a grotto at the north end, water cascaded into a stream running through the building. In the Plant House, built around the north end of the Tropical House, exotic fruits grew. The basement housed a motion picture theater, squash court, and shooting range, in addition to the complex mechanical and heating equipment required by the plant houses.

DeLamar died in 1918. A subsequent owner of "Pembroke" was Marcus Loew (1870–1927), the movie theater owner and film producer. After passing to Loew's son, Arthur M. Loew, who owned it for four decades, the house was demolished in 1968.[16]

F. W. Woolworth Residence, "Winfield Hall," Glen Cove, 1916–20 (Extant)

Gilbert's last, and probably best-known, commission on Long Island was the mansion he designed for dime-store magnate Frank W. Woolworth—the most ambitious of the whole group.

Woolworth purchased the Glen Cove mansion and grounds of Alexander Humphreys in June 1914[17] and in so doing acquired the house that Gilbert had built there between 1899 and 1902. It is probably no coincidence that Woolworth's New York townhouse, a French Neoclassical building on Fifth Avenue between 79th and 80th Streets, in what was known as "the Billionaire District of New York," had been built to Gilbert's design by 1901.[18]

The original Glen Cove house, which Woolworth called "Winfield Hall" after his own middle name, burned on November 10, 1916. The ruins were barely cleared away before Gilbert was commissioned to design a new and grander house on the site of the previous one. The new house, probably habitable by 1917,[19] is the most formal of compositions. Its long entrance is oriented to the south so that its intensely symmetrical white cast-stone and marble front is illuminated through the daylight hours: the effect as first seen from the shady drive looking into the elliptical forecourt is dazzling. The smooth surfaces of the south facade are defined by an entrance bay with extended porte cochere and, on each end, broad pavilions that break slightly forward. Shallow pilasters rise from base to bracketed cornice, and the lower floors are crowned by a balustrade and capped by a set-back attic story with a flat roof. Window openings are punched at regular intervals in the white stone front, surrounded, on the ground floor, by simple architraves, and on the upper floors enriched only with sills. The triple window opening onto the balcony atop the porte cochere has a simple bracketed lintel.

Overlooking carefully graded and planted vistas, a grassy, balustraded terrace borders the south front west of the porte cochere, extending

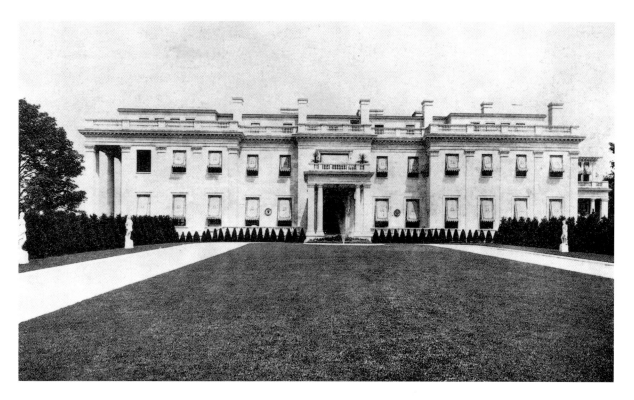

C. P. H. Gilbert: Front Facade, "Winfield Hall," F. W. Woolworth Residence, Glen Cove, 1916–20 (ARRC, 1920)

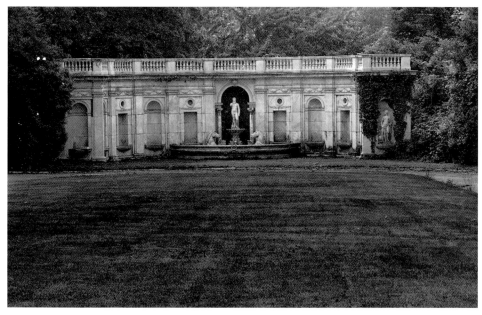

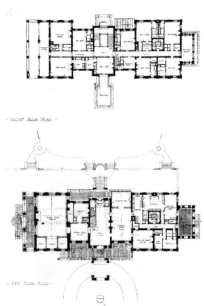

C. P. H. Gilbert: Belvedere, "Winfield Hall," F. W. Woolworth Residence, Glen Cove, 1916–20 (SPLI, Joseph Adams photo, 1980)

C. P. H. Gilbert: Floor Plan, "Winfield Hall," F. W. Woolworth Residence, Glen Cove, 1916–20 (ARRC, 1920)

along the west and north sides. A two-story portico with monumental piers and columns screens the west side of the house and looks harborward across an alley of trees and a graded landscape that becomes increasingly informal as it slopes away from the house. The long north side of the house is the garden front. Hardly less formal than the entrance, it faces a tight composition of parterres of pebbled paths, with a tea house at the extremity and a domed *tempietto* at each side.

"Winfield Hall's" interiors were designed by Helwig Schier of the Fifth Avenue decorating firm of Theo Hofstatter & Co.[20] Woolworth himself is said to have participated in planning

the decoration (in fact, to have persisted doggedly in influencing it). His growing interest in the broad range of fashionable historical styles (reaching back to his association with Cass Gilbert, architect for the Woolworth skyscraper in Manhattan, completed in 1913), may explain the unusual eclecticism that marks the interiors of "Winfield Hall." In plan, the living rooms on the ground floor are formally arranged on each side of the marble hall that runs from the entrance front to garden door. To the west are two small rooms, a foyer hall that may have functioned as a reception room, and a wood-paneled library. Occupying the entire west pavilion, the music room is the most important space in the house. In this room, the main console of a tremendous Aeolian organ is concealed by a

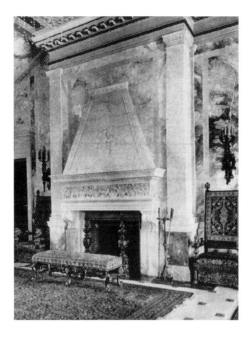

C. P. H. Gilbert: Fireplace Detail, "Winfield Hall," F. W. Woolworth Residence, Glen Cove, 1916–20 (ARRC, 1920)

delicate pierced screen. The organ could also be played from a smaller, semi-automatic console in the room itself. The music room's concealed illumination was installed by a stage-lighting company. Throughout the room, an effect of great richness is achieved through an abundance of small overall patterns, varied textures, and deep wood tones enlivened by warm colors and gilt trim. To the east of the hall is the dining room, conservatory-breakfast room, billiard room, and kitchen and service complex housed within the east pavilion.

The bedrooms with adjoining baths on the second floor were treated with close attention to detail, and offer a catalogue of architectural style. During the decade in which this house was built, enthusiastic collectors organized the spoils of their European travels according to regional or historical themes, creating domestic equivalents of the great museums' period rooms. F. W. Woolworth's bedroom is in the Empire style, and his adjacent bath is paneled in gold-veined Siena marble and boasts a solid stone sink with gilt fixtures. Other rooms are styled "Elizabethan," "French Gothic," "Chinese," "Louis XIV" (and XV and XVI), "Marie Antoinette," and "Sheraton." The interior

designer recollected that "those bedrooms and bathrooms were the most elaborate our company has ever done."[21]

Beyond the formal garden and graded terraces of "Winfield Hall," screened by planted trees from the house, is a garage built to accommodate 18 automobiles and a pair of greenhouses.

Writing in the *Architectural Record* for March 1920, following the owner's death, only four years after "Winfield Hall" had been designed, Herbert Croly noted that its significance was enhanced because it belonged to "a type of domestic architecture which is destined to disappear," as even the wealthiest of men could no longer afford, and in fact would no longer want to have, "big grandiose formal residence[s] of this kind."[22]

The Woolworth house is the only surviving example of C. P. H. Gilbert's work in the grand mode. Although it has not been a private residence for more than 30 years, it is in good condition, breathtaking in its pristine white stone handled with classical restraint. Yet there is something a little disquieting about this great white villa set among the gentle hills of northern Glen Cove. This house and the gardens that belong to it claim their site and dominate it, but they have never become part of it. They were not at peace with the landscape in the beginning, and they are no more so today. After Woolworth's death, the house remained in the family, passing to his widow in 1919, and then to their daughters from 1924 to 1929. It was subsequently owned by Richard S. Reynolds of Reynolds Aluminum from 1929 to 1964. In 1964 the estate was adapted for use as a school and later as a corporate headquarters, which it remains today.

Ellen Fletcher

John I. Glover, practiced 1854–1890s

Brooklyn architect John I. Glover, in practice from 1854, at various times worked in association with John Mumford, H. C. Carrell, and his son J. Graham Glover. The latter would go on to design the Clarendon Hotel in Brooklyn and the Empire Hotel in New York. Around 1890 Glover designed a residence for himself in Baldwin, Long Island. The two-story structure was Colonial Revival in style, with a Beaux-Arts-inspired paired-column portico extending across the front facade. At the second level a decorative swag cornice was surmounted by a balustrade, with a Palladian-inspired porte cochere located at the rear of the residence. The house was demolished in the 1950s.

Carol A. Traynor

John I. Glover: Design Rendering, John I. Glover Residence, Baldwin, c. 1890 (AABN, 1894)

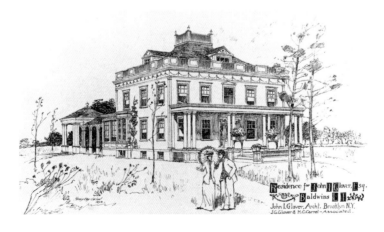

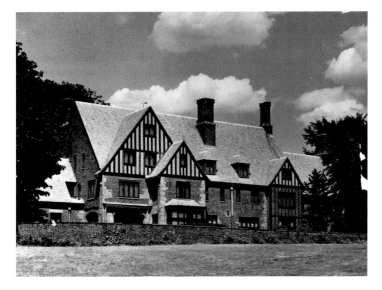

Frederick A. Godley: Jesse Ricks Residence, Plandome, 1927 (Courtesy of Mrs. Jane Ricks King)

Frederick A. Godley, 1886–1951

Educated at Yale, M.I.T., and the Ecole des Beaux-Arts, Frederick A. Godley began his career in the Boston office of architect Guy Lowell and was a partner of Raymond M. Hood in New York between 1924 and 1929. During this period, the firm designed Radio City Music Hall and the McGraw-Hill and American Radiator buildings. Godley's only recorded Long Island country-house commission, a Tudor half-timbered design for Union Carbide president Jesse Ricks, executed independently of the firm, was completed in 1927. The handsome stone structure was demolished in 1964 and the property subdivided after Ricks's heirs were unable to find a buyer for the estate.

Robert B. MacKay

William H. Gompert: "Many Gables," Mrs. Eugene S. Kienle Residence, Kings Point, 1921 (SPLI, n.d.)

William H. Gompert, 1875–1946

A native of New York City, William H. Gompert was a graduate of both Brooklyn's Pratt Institute, 1892, and the Institute of Arts and Sciences. He spent a major part of his architectural career as an architect for the Board of Education, designing more than 170 grade schools and high schools. A prolific practitioner, he also designed numerous residences, banks, and churches, and served as consulting architect for the New York County Court House. His Kings Point residence for Mrs. Eugene S. Kienle, wife of the founder and president of Kienle & Co. (a Brooklyn concern engaged in the printing business), was designed in 1921 and remains extant. Beautifully sited on Manhasset Bay with grounds landscaped by the local firm of Lewis & Valentine, the small estate included a wide sloping lawn leading down to the beach with a pier, bathhouses, and large stone boathouse. Somewhat eclectic in design, the two-and-a-half-story brick residence was named "Many Gables."

Carol A. Traynor

Bertram G. Goodhue, 1869–1924

Whether working alone or with associates, Bertram Grosvenor Goodhue displayed broad-ranging tastes both in the architectural styles from which he drew and in the types of commisions in which he participated. Among the completed works executed by Goodhue himself or in association with others, are churches, libraries, private houses, additions to a military academy, buildings for an exposition, a town plan, a naval air station, academies of arts and sciences, and a state capital. Some of the styles imitated in these works, in part or in whole, are Ionic Greek (the Gillespie House, Montecito, California, 1902); English Gothic (Chapel of the U.S. Military Academy, West Point, New York, 1903–10); Hispanic (Panama-California Exposition Buildings, San Diego, California, 1911–15); and Romanesque-Byzantine (St. Bartholomew's Church, New York City, 1914–18), all from Goodhue's early or middle period.

In general, however, the buildings of Goodhue's mature phase were relatively free of influences from the past. The most noteworthy example of this period is the Nebraska State Capital at Lincoln (1920–32). While Near Eastern, Greek, Roman, Medieval, Native American, and other motifs are evident in

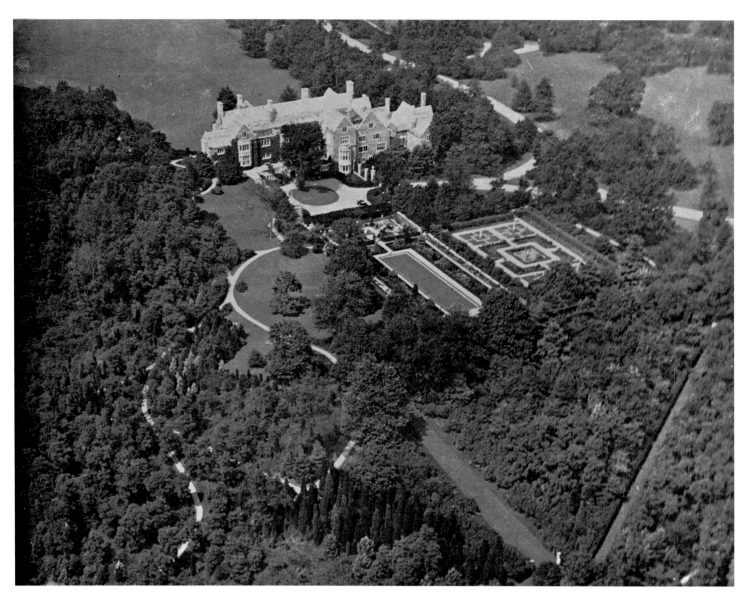

Bertram G. Goodhue: South
Facade and Formal Gardens,
"Ormston," John E. Aldred
Residence, Lattingtown,
1913–18 (ELWO, 1924)

details throughout this structure, the simplicity
and symmetry of its overall design evince a re-
freshingly modern, monumental classicism.

Goodhue was not without influence. With
his Hispanic Exposition buildings, he set in mo-
tion the Spanish Colonial Revival in California
in the 1920s; and with the bold, planar-surfaced,
400-foot-tall tower of the Nebraska Capital, he
shaped the thoughts and forms of the leading
designers of skyscrapers of that decade.

Of the some 14 completed private houses
conceived in part or in full by Goodhue, two
are situated on Long Island: the Aldred resi-
dence "Ormston," located on a 119-acre site
near Locust Valley (1913–18), and the Lloyd-
Smith residence, located on a five-acre site near
Lloyd Harbor (c. 1924–26).[1] Both are enormous,
well-appointed mansions situated within lush,
wooded surroundings, and both evoke the 16th-
century English Tudor idiom. Their silhouettes,
created by numerous gables and chimneys, ex-
hibit a picturesque jaggedness, and their inter-

nal spaces consist of a series of box-like volumes
rather varied in height, width, and length. But
each departs from Tudor tradition in ground
plan. While the plan of the typical 16th-century
English mansion usually favored symmetry, of-
ten assuming an E-shaped configuration, the
plans of these two houses display a seemingly
haphazard asymmetry.

Both the Aldred and Lloyd-Smith houses
were either being designed or constructed
during the very years in which Goodhue was
creating his most classical public architecture.
Perhaps it is because these domestic buildings
were siphoning from Goodhue's imagination
the last of his colorful romantic ideas that the
streamlined and symmetrical style exemplified
in his classical buildings was able to emerge.

John E. Aldred Residence, "Ormston," Lattingtown, 1913–18 (Extant)

John E. Aldred (d. 1945), a public-utilities
magnate and hydroelectric pioneer, was a self-
made man. At age 15, without technical train-

Bertram G. Goodhue: Front Entrance, "Ormston," John E. Aldred Residence, Lattingtown, 1913–18 (SPLI, 1977)

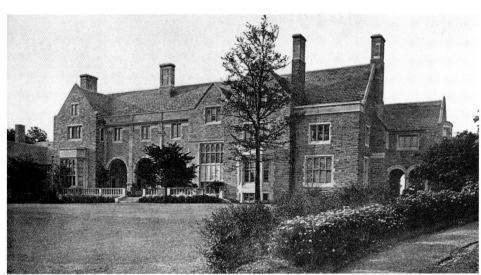

Bertram G. Goodhue: Rear Facade, "Ormston," John E. Aldred Residence, Lattingtown, 1913–18 (WHIT, 1925)

Bertram G. Goodhue: Floor Plans, "Ormston," John E. Aldred Residence, Lattingtown, 1913–18 (PREV, n.d.)

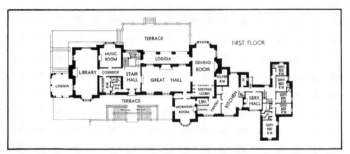

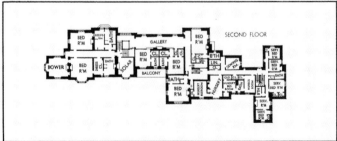

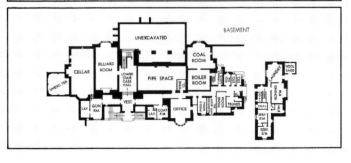

ing, Aldred began work in a cotton mill in his hometown, Lawrence, Massachusetts. Later, as a young man, he left his post as head of a small bank to travel to Quebec in order to harness the energy of the Shawinigan Falls.[2] From that point on began his dramatic ascent to a position of wealth and power. By 1931 Aldred was either a corporate executive or president of no fewer than 37 public utility companies, and by 1940 he had accumulated an estimated fortune of $80 million.[3] He invested much of his money in "Ormston" and its grounds. Some he used to endow a technical institute for the education of boys who worked in mills.[4]

In the early 1940s, Aldred lost his fortune and his estate. By then the Federal Power Act had terminated his interlocking utilities directorates, and income and property taxes had risen dramatically. But most damaging of all was the loss of his $50 million investment in Italy's incipient hydroelectric industry following that country's entry into World War II. Nevertheless, his spirit was not broken. In 1942, he said, "They can take away my money and my possessions, but they cannot take away my memories. . . . My life has been romantic, adventurous. I've had much more fun than the Morgans and the Pratts, because I am the first generation . . . [and they are] the second. . . . There's no thrill in being rich. The fun lies in making the fortune."[5] And he certainly had fun building his country residence. With William D. Guthrie, a lawyer and prospective neighbor, Aldred purchased half the village of Lattingtown and together they razed its 60 houses to create their adjacent estates (see C. P. H. Gilbert). As Aldred later recalled, "Mr. Guthrie and I destroyed the village of Lattingtown to get the view we wanted."[6]

A person of discriminating tastes, Aldred selected the most talented men to be found to landscape the grounds and design his house. Thus, the Olmsted Brothers planned the formal and informal gardens, and Goodhue, specifically asked by his client to reproduce as nearly as possible a house of the late Tudor-Elizabethan-Jacobean period, fashioned the mansion in his "Anglomaniac manner."[7] For the house and gardens, Aldred personally made numerous purchases in the course of 30 trips to England. They included a marble seat, some wrought-iron gates, and walnut paneling from Sherwood Forest in Nottinghamshire. Among the exotic shrubs and trees that were also imported was the first Cedar of Lebanon to be planted on Long Island.[8]

"Ormston" is constructed of dark gray, irregularly coursed fieldstone that is accented around the windows, doors, and along the roof lines with light, limestone trim. In keeping with the asymmetry of the plan, the front entrance, which faces south, is not in the center of the house but at a point one-third of the way down

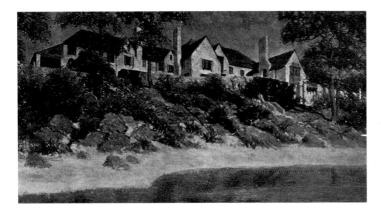

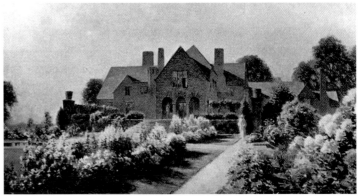

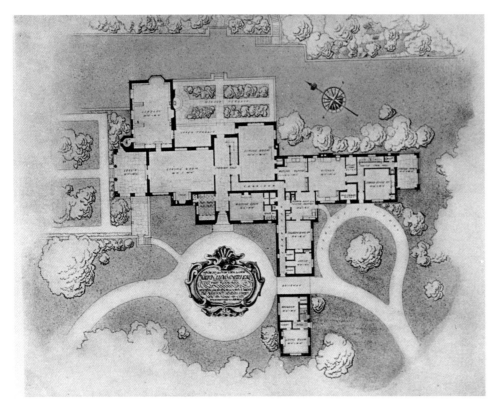

Bertram G. Goodhue: Design Rendering of Rear Facade, Wilton Lloyd-Smith Residence, Lloyd Harbor, c. 1924–26 (WHIT, 1925)

Bertram G. Goodhue: Floor Plan, Wilton Lloyd-Smith Residence, Lloyd Harbor, c. 1924–26 (WHIT, 1925)

Bertram G. Goodhue: Design Rendering of Loggia and Gardens, Wilton Lloyd-Smith Residence, Lloyd Harbor, c. 1924–26 (ARLG, 1924)

from its western end. The entrance is two-tiered: below, a Tudor-arched service entry projects forward from the primary plane of the south face; above, a round-arched main entry recedes within it. The latter is reached from both left and right by a pair of dog-leg staircases with balustraded rails.

The south face is filled with randomly scattered windows of various types and sizes, including oriels. Its western end is further enlivened by a small loggia, open on three sides. Above the loggia is an enclosed room creating a solid form superimposed above a void that creates this part of the building. The eastern half of the south face consists of two gabled masses that protrude boldly beyond its primary plane in a staggered fashion, making it truly multiplanar.

The back of the house is similar to the front because of its variegated fenestration and staggered wall planes. But unlike the front, this side is marked at midpoint by a large, three-bayed loggia with semicircular arches, giving access to the lawns. Above the loggia is an enclosed gallery, which continues the theme of solid over void.

The interior of "Ormston" is maze-like, with an off-center, spatial fulcrum located in the massive, great staircase to which the vertically paired main entries lead. On the first floor, to the right of the stairs, lies the great hall, which is one-and-a-half stories high. Like most of the formal rooms on this floor, the great hall has ceilings of ornamental plasterwork, walls of walnut paneling, and flagstone floors.

Perhaps the original spirit of "Ormston" is best captured in a letter written by Goodhue to an English architect in 1917:

It's certainly big—almost as big as one of your big English country houses and even more English than they; but there isn't a place to rest your eye upon quietly, every surface is bedeviled with ornamental low relief plaster or solid English oak panelling, carved to the utmost, or fancy electric fixtures, or historic examples and "museum" pieces in the way of furniture.[9]

Today "Ormston" and its several outbuildings serve the Ukrainian Order of St. Basil the Great as a monastery. Apart from the conversion of the outbuildings into residences for a retreat house, and the conversion of the mansion's library into a chapel, few alterations have been made.[10] Thus, an example of Goodhue's domestic architecture survives nearly intact for us to appreciate today.

Wilton Lloyd-Smith Residence, Lloyd Harbor, c. 1924–26 (Extant)

A corporate lawyer, Lloyd-Smith (1894–1940) was a descendant of an English forebear who was living in Weymouth, Massachusetts, by 1639. He received the finest of educations first at Princeton and then at Harvard Law School. He was president, vice president, or trustee of

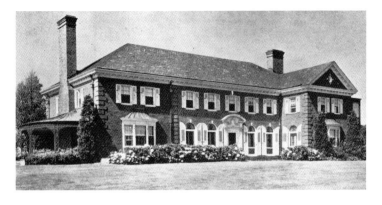

Goodwillie & Moran: Mrs. Norma T. Johnson Residence, Water Mill, c. 1925 (ARRC, 1932)

several important companies, and a member of many of the best clubs in New York, including the Knickerbocker Club. An avid hunter, he gave the American Museum of Natural History several moose for a display case in the Hall of North American Mammals.[11]

Construction of the Lloyd-Smith house was not begun until after Goodhue had died, so that it is not clear how much of the architect's personal stamp remained on its design. Moreover, since two wings were later demolished and replaced by a garage and a sunroom it is even more difficult to measure the house against Goodhue's standards.

The Lloyd-Smith house is situated on a cliff overlooking Cold Spring Harbor. It is constructed of brick accented with half-timbered trim, both unusually humble materials as far as Goodhue's oeuvre is concerned. The original plan was even more irregular than that of "Ormston," for the main body of the house had wings projecting in three different directions. However, components are composed in a more orderly manner than those of the Aldred house. Nevertheless, the Lloyd-Smith residence subtly recalls the Aldred house with an oriel here or a Tudor arch there. But, the most striking formal echo is to be found in the triple-bayed loggia with rounded arches which opens onto the lawns at the side, instead of at the rear, of the Lloyd-Smith house. Though it is no longer owned by the family that built it, the house is still in private hands.

Mary D. Edwards

Goodwillie & Moran, practiced 1910s and 1920s

Frank Goodwillie, 1866–1929

William E. Moran

Working separately and jointly in the 1910s and 1920s, Goodwillie and Moran are credited with the design of many industrial plants, business offices, and fine residences in the New York-

New Jersey area. Among their most notable works were the Wheatena Mills at Rahway, New Jersey; the Horton Ice Cream Plant and the Manice and Remsen buildings in New York City; and the Globe Indemnity Insurance building in Newark, New Jersey. Born and educated in New York City, Frank Goodwillie studied architecture at M.I.T. and began his career in the New York office of Delmos & Cordes. He served as a New York State service examiner for architects, draftsmen, and building superintendents. He also assisted in revising the building code of New York City and in preparing the architectural code of the American Institute of Architects. He was a member of the Architectural League and the American Institute of Architects. Other than his association with Goodwillie, very little is known about William E. Moran. Their work on Long Island includes the Southampton Memorial and the residence of Mrs. Norma T. Johnson, a Georgian-style brick country house built in Water Mill c. 1925.

Joel Snodgrass

Isaac Henry Green, 1858–1937

Eastern Long Island's foremost native architect of the Beaux-Arts era,[1] Isaac Henry Green was born in Riverhead, the son of Henrietta Vail and Samuel Willett Green, a lumberyard owner. Since he was named for his uncle and namesake Isaac Henry Green (1827–1907) of Sayville, the designation "Jr." was often added (and in keeping with a variant of the family name, an "e" also was often incorrectly added to his surname). Among America's oldest families, the Greens traced their ancestry back to the Great Puritan Migration to New England in the 1630s. Their Long Island roots lay in Sayville on the Great South Bay and in Riverhead, the seat of Suffolk County. Thus, in his ethnicity and ancestry, Green was highly representative of the architectural profession in the Beaux-Arts era, which was markedly New England in character.

Green moved to Sayville with his family at the age of nine and spent all his life there, worshipping at St. Anne's Episcopal Church, fathering a family, and establishing a thriving architectural practice. Members of the larger Green family enjoyed the status of patroons in the community through their ownership of most of the land in Sayville and West Sayville, going back to the Colonial period. Sayville's Green's Creek and Greene Avenue perpetuate the family name in two of the town's most prominent features. In 1896 Green settled his family on a small estate, "Brookside," located on Brook Street about one mile north of the

Isaac Henry Green, 1858–1937 (Courtesy of Suffolk County Office of Cultural Affairs)

town center. This Tudor Revival house, enclosing a small pond and ornamental plants, remained the family homestead throughout his life. Little is known of his personal life, other than that he married Emma L. Hibbard who bore him two daughters, Henrietta G. Snedecor of Bayport, and Beatrice G. Rogers of Westhampton Beach, and survived him. References to Green's social and civic life appeared regularly in the "Talk of the Town" section of the *Suffolk County News.* On November 30, 1900, for example, that newspaper reported a "progressive euchre party at Brookside [as] one of the most charming social functions of the season." More importantly, Green served on the Sayville School Board, the Sayville Hook and Ladder Company, and, from 1899 to 1923, as president of the Oystermen's Bank of Long Island, Sayville's own bank, later renamed the Key Bank of Long Island.

Green's involvement with Sayville institutions undoubtedly contributed to his architectural practice. His family's donation of land to the church certainly brought ecclesiastical commissions his way. However, at the heart of Green's practice were commissions from a discriminating band of upper-middle-class clients who could afford an architect for their principal residence. These commissions included a few large estates; a score of public, religious, and commercial buildings; and a greater number of smaller residences or estate outbuildings. Although his practice was centered on the Sayville area, his buildings can be found as far away as Seal Harbor, Maine.

There are no formal records of Green's education, training, or professional practice. He was probably educated locally, acquiring his architectural training by apprenticeship, since there are no records of his attendance at the American architectural schools in the 1870s and the early 1880s, and it is unlikely that he attended the Ecole des Beaux-Arts in Paris.[2] Family tradition has long maintained that Green apprenticed at the east end of Long Island, which may account for his early commissions in the Hamptons, but the identity of any architectural mentor he might have had remains a mystery. His obituaries noted his retirement from active architectural practice in 1922, at the age of 64.

Green's country-house commissions represent the cream of his residential design. His most important contribution to the architecture of Long Island was his pioneering use of the Dutch Colonial Revival style in residential architecture, beginning in the Hamptons in the 1880s, and his application of its motifs to the popular Shingle Style.

The Dutch Colonial style features gambrel roofs cascading down onto graceful Dutch eaves, called "sweeps," carried on stout columns and sheltering deep porches completely subsumed under second stories. Often combined with the contemporaneous and better known Queen Anne, Craftsman, and Bungalow styles, the Dutch Colonial Revival broadcast a firm sense of domesticity rooted in a secure sense of place sanctioned by attention to craftsmanship. The style was also uniquely suited to seaside living on the South Shore of Long Island—its flared eaves and deep porches providing the appropriately shaded places where one could sit on warm evenings. The style was propagated as a modern recollection of New York's Dutch Colonial architecture in Aymar Embury's classic textbook of Beaux-Arts revivalist design, *The Dutch Colonial House.* In the hands of Green, however, the style also bore a significant social relationship to the community of Sayville, specifically West Sayville, which, starting in the third quarter of the 19th century, became home for hundreds of Dutch emigrants who developed the oyster-fishing industry of the Great South Bay.[3]

Green's Munroe Residence on Ocean Avenue in East Hampton (1888) announced with clarity and conviction his synthesis of Dutch Colonial Revival and Shingle styles. Its all-embracing gambrel roof as trim as a ship's hull, its characteristic Dutch "sweeps" at the eaves, its generous subsumed porches, and its specially designed porch piers gracefully flared at the capitals illustrated the hallmarks of that synthesis, marrying the rambling spirit of the vernacular Shingle Style to the more formal motifs of the Colonial Revival.

A small group of Green's designs dating from the 1890s in East Hampton set a cultivated Colonial Revival tone for that community. In his first and second Maidstone Clubs of 1892 and 1902, respectively, and his Maidstone Inn of 1899–1901, Green stretched the canvas of his house commissions onto a larger framework. His first Maidstone Club huddled under a tent-like Victorian roof, its small dormers staring out determinedly from a sea of shingles. His second, much larger, Maidstone Club incorporated a full second story within the roofscape. His Maidstone Inn featured a huge roof structured by gambrel gables meeting the ground in sedate pedimented porches. This stunning, simple, enveloping type of roof was to dominate most of Green's larger residential commissions of this period. In East Hampton these included "Pudding Hill" for Dr. Everett Herrick (1887–88); a house for William E. Wheelock (1891–92); "Greycroft" for banker Lorenzo G. Woodhouse (1893–94); and the John D. Skidmore house (1894). In Sayville, they included the W. T. Hayward house (1893); the 1902 house for Frank Jones, president of the Jewel Tea Co.; and the Arthur K. Bourne house (1902). With

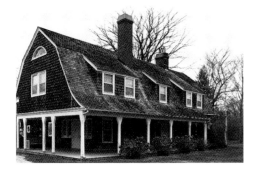

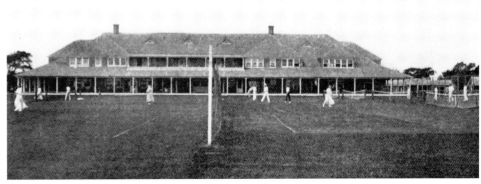

Isaac Henry Green: Front Facade, George Munroe Residence, East Hampton, c. 1888 (Harvey Weber photo, 1979)

Isaac Henry Green: Second Maidstone Club, East Hampton, 1902 (RUTH, 1909)

Isaac Henry Green: Entrance Front, "Pudding Hill," Dr. Everett Herrick Residence, East Hampton, 1887–88 (EHFL, n.d.)

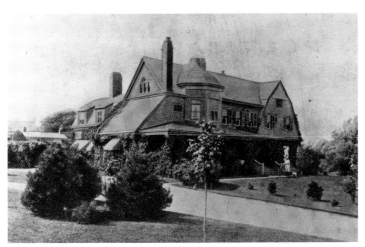

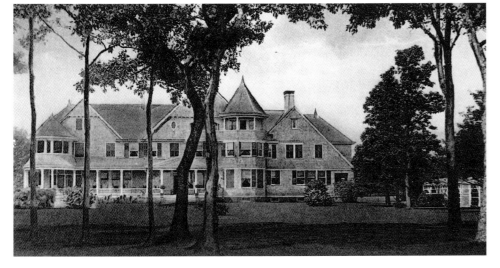

Isaac Henry Green: Front Facade, Frank S. Jones Residence, Sayville, 1902 (VAND, n.d.)

the boat-building traditions so prevalent in Suffolk County in the 19th century.

Around 1890 Green began to cultivate the more formal Federal vein of the Colonial Revival style, a sign of his sensitivity to the latest East Coast fashions set by the big New York architectural firms. "Mapleton," Green's 1890 house in Islip for Charles A. Schieren, wealthy Brooklyn manufacturer and mayor of that city in the 1890s, offers the earliest evidence of this style in Green's oeuvre in its symmetrical disposition, hipped roof, pedimented porches, Palladian window, and balustraded widow's walk. Here the mass of the roof, hallmark of Green's Shingle Style homes, gives way before the sheer frontal austerity of the Federalist style, although the house does broaden out into generous porches. This house was demolished in the 1970s.

The 1891–92 residence "Meadowcroft" for John E. Roosevelt, cousin of President Theodore Roosevelt, now owned by Suffolk County, offers a more fully developed example of the style. It consists of an eight-room addition to two adjoining 19th-century farmhouses. Additional commissions closely related in style include the 1897 house for William A. Wheelock, president of the Citizens National Bank in New York, in East Hampton; the Sayville house of 1902 for Eversley Child, the Bon Ami King; the c. 1905 house in St. James for Mrs. James W. Phyfe, wife of a New York City merchant; and "Enfin," the house for Bradish Johnson in Islip (c. 1909). "Liberty Hall," the Bayport house for Mrs. E. J. Stoppani, is perhaps the boldest example of Green's work in the related Neoclassical style. The central dormer pediment is particularly notable on this house, enclosing a sunburst motif within the outlines of a broken swan's neck. The original two-story semicircular portico on this house has been removed. Few Long Island estates carried such extroverted ornament.

For millionaire members of the South Side Sportsmen's Club in Oakdale, Green designed his most characteristic Beaux-Arts buildings in

the exception of the Jones house, which was destroyed by fire in 1959, these houses are all extant today.

Green's houses, some containing dozens of rooms, do not seem sited so much as moored in the landscape. Their simple, huge roofs stir comparison with that celebrated triangular gable that sheltered the Low House (1887) in Newport by McKim, Mead & White.[4] Green simply bent the gable down to the ground, not only connecting it more directly to the land, but indirectly, as a gambrel to that Dutch tradition of wholesomeness which flourished so strongly in Sayville. Like great arks, these houses evoke

Isaac Henry Green: East
Elevation, "Mapleton,"
Charles A. Schieren
Residence, Islip, 1890
(Courtesy of Mrs. Frederic
Atwood)

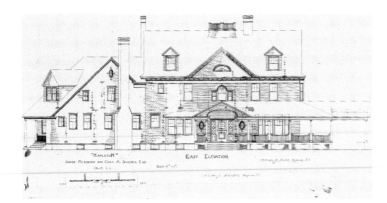

Isaac Henry Green: First
Floor Plan, "Mapleton,"
Charles A. Schieren
Residence, Islip, 1890
(Courtesy of Mrs. Frederic
Atwood)

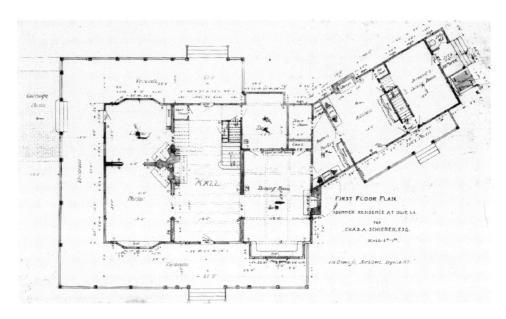

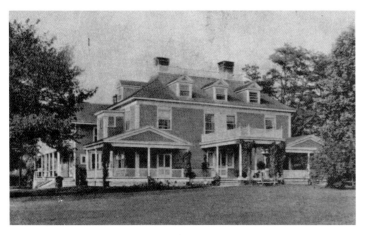

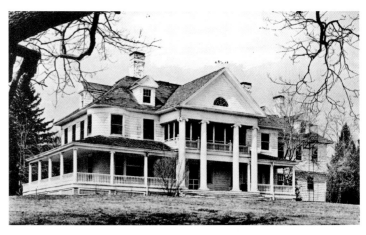

Isaac Henry Green:
"Meadowcroft," John E.
Roosevelt Residence,
Sayville, 1891–92 (VAND,
n.d.)

Isaac Henry Green: Rear
Facade, Mrs. James W. Phyfe
Residence, St. James, c. 1905
(PREV, n.d.)

Isaac Henry Green: "Liberty
Hall," Mrs. E. J. Stoppani
Residence, Bayport, 1897–98
(SPLI, West Collection, n.d.)

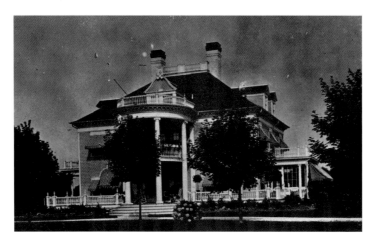

Isaac Henry Green: Front
Facade, "Meadow Edge,"
Florence and Anson Hard
Residence, West Sayville,
c. 1905 (Courtesy of the
Sayville Historical Society)

Isaac Henry Green: Gate
Lodge, William K.
Vanderbilt Residence,
Oakdale, 1898 (FULL, n.d.)

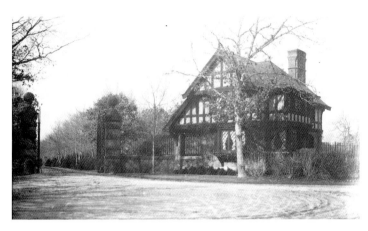

proportion, and apt siting. Well-proportioned porch columns and flared porch post capitals are emblems of the quality for which Green strove in the buildings he designed for his community—indications of real panache in a glade of builders' architecture.

Peter Kaufman

James L. Greenleaf, 1857–1933

Greenleaf's career sheds light on the early development and gradual definition of landscape architecture as a profession and a discipline in the United States.

Like many early practitioners of landscape architecture, James Leal Greenleaf was educated in another discipline—in his case, civil engineering. After graduating from the Columbia School of Mines in 1880, he almost immediately became an engineering instructor there and later adjunct professor of civil engineering, serving in this capacity until 1894. Not until the late 1890s did Greenleaf turn to landscape architecture, making a second career out of an avocation. In the ensuing quarter century he designed gardens on many large estates in the fashionable suburban areas of New York City, including Westchester County, on Long Island, and in New Jersey and Connecticut.

His Long Island commissions clearly demonstrate the design philosophy that predominated in schools of architecture and engineering during the late 19th and early 20th centuries, as well as the way in which the practice of landscape architecture functioned in its early years.

Greenleaf's first Long Island commission was the Mortimer Schiff estate known as "Northwood" in Oyster Bay. Designed around 1905 by architect C. P. H. Gilbert, the house is a rambling Tudor Revival composition with the requisite gables, chimneys, and half-timbering. Neither the house nor the original garden survives, but photographs show Greenleaf's garden design to have been a fairly straightforward Beaux-Arts statement, characterized by a strong central axis, rigid symmetry, and focusing architectural elements. Planting was clearly subservient to spatial organization.

The three most important commissions of Greenleaf's Long Island career, however, were all executed about a decade later for a single family: the Pratts of Glen Cove. During the estate era, when most design work was secured through personal contacts, such multiple commissions were quite common. In the years between 1912 and 1914, Greenleaf designed gardens for the

revivalist and free styles. The Florence Bourne Hard estate (c. 1905) in West Sayville appears to have been his only large country-house commission. Its stuccoed surface covers standard Colonial Revival forms disposed in a picturesque V shape that embraced the summer view. A model of adaptive reuse, the estate now houses the clubhouse of the West Sayville Country Golf Course, the headquarters of the County Parks Department, and, in the carriage house, the Suffolk County Marine Museum. Green also designed some outbuildings for neighboring estates, such as the Tudor Revival gate lodge for the William K. Vanderbilt estate in Oakdale and the pumping station and huge boathouse for the Frederick Bourne estate. Green's design for the annex to the South Side Sportsmen's Club was in a transitional Shingle-Colonial style.

Finally, Green designed more than a score of residential, commercial, and religious buildings in Sayville, creating much of the Beaux-Arts texture of this community in the first third of the 20th century. His religious buildings include St. Anne's Episcopal Church (1889) and the Methodist Episcopal Church (1893). His commercial buildings include the Suffolk County News building (c. 1906), the Sayville Opera House (1900), and the original home of the Oystermen's Bay Bank (c. 1899). A number of smaller houses are attributed to him on Elm, Colton, and Candee Avenues in Sayville, and many more were probably designed by him though documentation is scarce. Green's buildings distinguish Sayville's all-American townscape in their careful detailing, sure composition, solid

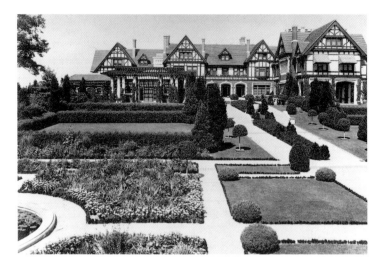

James L. Greenleaf,
Landscape Design:
"Northwood," Mortimer
Schiff Estate, Oyster Bay,
c. 1911 (Courtesy of John M.
Schiff)

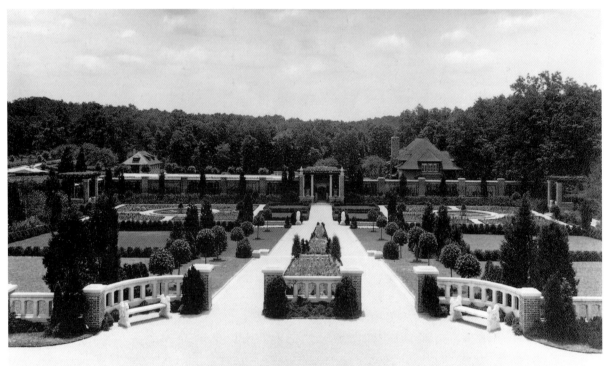

James L. Greenleaf,
Landscape Design:
"Northwood," Mortimer
Schiff Estate, Oyster Bay,
c. 1911 (Courtesy of John M.
Schiff)

country residences of Herbert Lee Pratt, George Dupont Pratt, and Harold Irving Pratt.[1]

Herbert Pratt named his estate "The Braes," a Scottish term for a hillside leading down to water.[2] The house, which sits at the top of this sloping landscape, was designed by James Brite. Best described as Jacobean in stylistic intent, it is a rigidly symmetrical H-shape with a central entrance and a long main hall. For his landscape plan, Greenleaf took his cue both from the rigid symmetry of the plan and from the sloping site. Three descending rectangular terraces connected by double staircases ease the transition from the house to Long Island Sound below. The dimensions of the terraces are defined by the symmetrical wings of the house and the demands of the site; the central axis is simply a continuation of the axis established by the main entrance. As in the case of the Schiff estate, the planting is subservient to geometry and spatial

organization. The first and the third terraces are predominantly large stretches of lawn; the second features four reflecting pools organized around a central fountain. Architectural elements such as the pergola at the level of the first terrace and the transitional stairs reinforce the well-bounded geometrical scheme.

The nearby estate of George Dupont Pratt, Herbert's older brother, is in many ways Greenleaf's best design. The house, called "Killenworth" and designed by the firm of Trowbridge & Ackerman, is also based on English precedents but of the somewhat earlier date usually referred to as Elizabethan or Early Renaissance. With its picturesque gables and buff-colored granite exterior, it is more the genial English manor house

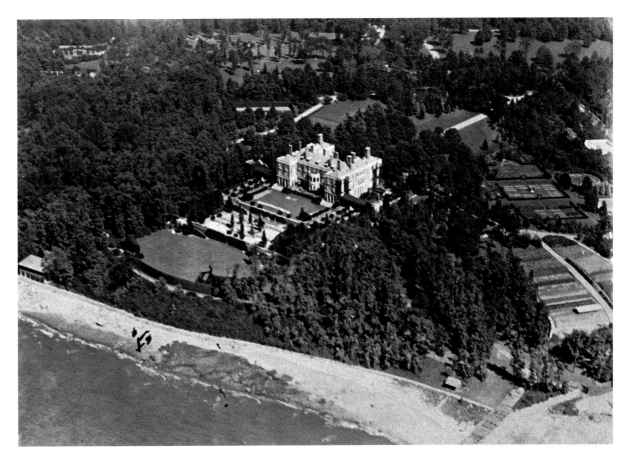

James L. Greenleaf, Landscape Design: Garden Facade and Formal Gardens, "The Braes," Herbert L. Pratt Estate, Glen Cove, c. 1912 (VIEW, c. 1930)

James L. Greenleaf, Landscape Design: View of Garden and Pergola, "The Braes," Herbert L. Pratt Estate, Glen Cove, c. 1911 (LEVA, 1916)

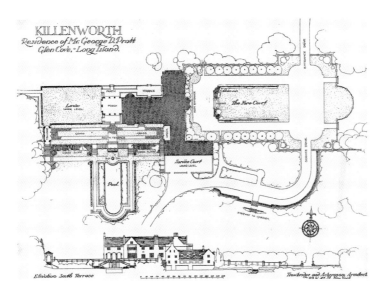

James L. Greenleaf, Landscape Design: Landscape Plan, "Killenworth," George D. Pratt Estate, Glen Cove (PREV, c. 1950)

than the ostentatiously formal country residence. While at "The Braes" Greenleaf's landscape plan is based on clear axial relationships and the exigencies of the site, the symmetry at "Killenworth" is less rigid and there is greater spatial diversity. Thus, the whole composition is far more interesting and animated.

The plan can be understood as two principal rectilinear areas located to either side of the main architectural block. East of the entrance front is an elaborate, predominantly rectangular forecourt that emphasizes the entrance axis and gives the house a proper ceremonial approach. The spatial limits of this area are defined by a low wall terminating in a semicircle and by symmetrically placed trees.

The second principal garden area, west and south of the house, has a dominant axis perpendicular to that of the forecourt. Though resembling other Greenleaf concepts based on a series of descending terraces, this design is composed of far more varied and human spaces that bear a more integral relationship to the house. The uppermost level is occupied by a lawn, accessible from the west end of the porch and by the south terrace, a long rectangular area connecting a loggia with the tea house. Descending along the major north-south axis, this terrace leads to a lower grassed area with a central sundial, and finally to the pool below. The pool reinforces

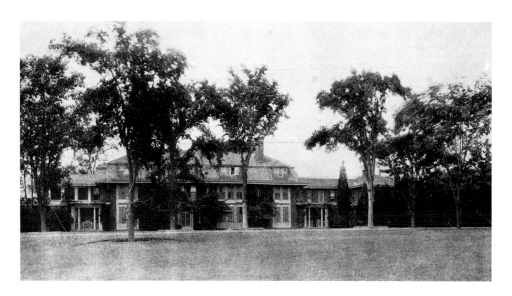

James L. Greenleaf,
Landscape Design:
"Welwyn," Harold I. Pratt
Estate, Glen Cove, c. 1914
(LEVA, 1916)

the major axis of the design and, like the forecourt, terminates in a semicircle. The two principal garden areas are subtly connected by the service drive, which has an independent entrance to the gardens on the south. As at "The Braes," Greenleaf here shows himself a student of Beaux-Arts planning principles, but at "Killenworth" he is able to create clear axial relationships and spatial progression without resorting to a coldly rigid geometry.

Greenleaf's third commission for the Pratt family was the estate of Harold Irving Pratt, known as "Welwyn." Vaguely recalling Colonial precedents, the house was originally designed by Babb, Cook & Willard (c. 1904) with landscaping by the Olmsted Brothers. Some ten years later (roughly contemporary with the building of "The Braes" and "Killenworth"), Harold Pratt

Howard Greenley:
"Portledge," Charles A.
Coffin Residence, Locust
Valley, c. 1910 (ARTR, 1912)

Howard Greenley:
"Birchwood," Anson W.
Burchard Residence,
Lattingtown, 1906 (SPLI,
n.d.)

commissioned the firm of Delano & Aldrich to alter the house. Greenleaf's contribution seems to date from this late remodeling. Though the full extent of his alterations to the original Olmsted landscape plan are not known, he is credited with bringing many of the large elm trees to the property, a practice that had become quite popular during the estate era.[3] Again, Greenleaf seems to have been more involved in general spatial planning than in developing elaborate planting schemes.

Greenleaf executed two other landscape designs for Long Island estates. Nearly contemporary with his work at "Welwyn" is his scheme for "Fairleigh," the Georgian Revival residence of George S. Brewster in Brookville by Trowbridge & Livingston. Several years later, he was called upon by Percy R. Pyne II, a wealthy banker, to design the grounds for "Rivington House," his estate in Roslyn designed by Cross & Cross. Here, Greenleaf worked with Beatrix Farrand, one of the first women to enter the field of landscape architecture in the United States. From the standpoint of both design and influence, however, Greenleaf's most important Long Island commissions were the Pratt estates, for which he was awarded the Medal of Honor for Landscape Architecture by the Architectural League of New York in 1921.

Though he continued to practice as a landscape architect, Greenleaf did little estate work after 1920. In 1918 he had been appointed a member of the National Commission of Fine Arts by President Woodrow Wilson. In that capacity and, later, as president of that Commission, he supervised the landscaping of the cemeteries of the American war dead in France and consulted on the landscaping of the National Parks. He also worked with Henry Bacon on the landscape design for the Lincoln Memorial in Washington, D.C. In his last years Greenleaf continued to contribute to the field as a fellow of the American Society of Landscape Architects and as a juror for the American Academy in Rome. When he died in 1933, he was hailed as a "pioneer in the practice of landscape architecture."[4] His Long Island commissions are evidence of his contribution to a developing discipline.

Jeanne Marie Teutonico

Howard Greenley, 1874–1963

Educated at Trinity College, Hartford, Connecticut, and the Ecole des Beaux-Arts in Paris, Howard Greenley entered private practice in 1902. Among his numerous domestic commissions were the Long Island residences (both still extant) of Charles A. Coffin, president of

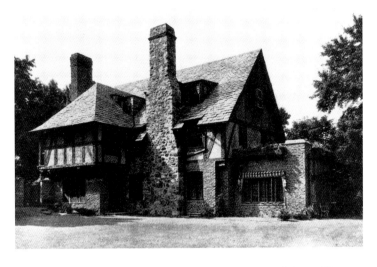

Julius Gregory: Thomas O'Hara Residence, Kings Point, early 1920s (ARTS, 1929)

Julius Gregory, 1875–1955

Known mainly for his domestic architecture, Julius Gregory also designed several churches, including the Church of All Nations in New York City. In addition to his New York practice, he served as architectural consultant for both *House and Garden* and *House Beautiful.* In the early 1920s he was commissioned by Thomas O'Hara to design the main residence at his Kings Point estate. The stuccoed and half-timbered Tudor Revival house, with its imposing fieldstone chimneys, is asymmetrical in plan. Two separate units are joined by a diagonally set hallway and conservatory; one unit contains the entry stair hall, library, and living room, while the other unit contains the dining room, adjacent kitchen, and servants' quarters. The house remains a private residence.

Wendy Joy Darby

General Electric Company, and Anson W. Burchard, who served on that company's board of directors. Greenley's c. 1910 design for "Portledge," Coffin's Locust Valley residence, was eclectic. Cross gables in the steep red-tiled roof, and bays set with casement windows, gave a Tudoresque air to the house. However, the play of solids and voids occasioned by the many bays and porches was handled in a classical vein, with screens of paired columns supporting balustraded second-story balconies. Greenley also designed the large greenhouse set close by the house, its roof line echoing the pitch of the main house roof. "Birchwood," the 1906 Burchard residence at Lattingtown, is Colonial Revival in style, its exterior sheathed in overlapping clapboard. Various Federal motifs were employed, among them a projecting elliptical garden-facade porch. There are also several Palladian-style windows. Rooms give off from either side of the central hall, which leads out onto the elliptical porch. This central axis was originally extended by a porte cochere, which was removed when the house was remodeled in the mid-1920s by architect William L. Bottomley. It was replaced by an entrance porch with columns carrying a segmental hood. The servants' wing was also removed at this time.

Wendy Joy Darby

John A. Gurd, 1870–1924

Educated at M.I.T. and the Ecole des Beaux-Arts in Paris, John Alexander Gurd designed an Italian Renaissance Revival residence in Huntington sometime before 1919. His client, who owned considerable acreage of shorefront property there, was Milton L'Ecluse, senior member of the Manhattan realty firm of L'Ecluse, Washburn & Co. The residence was a large, two-story stucco building with a tiled roof. A distinctive feature was provided by numerous French doors that opened onto open-air terraces and covered loggias. The house was demolished in the 1960s.

Carol A. Traynor

Charles C. Haight, 1841–1917

Born in New York City, Charles Coolidge Haight graduated from Columbia College in 1861, studied law for a few months, and then enlisted in the Union Army. While serving, he met the architect Emlen T. Littell and came home to study in Littell's office. He received his first major commission in 1874, a building for the School of Mines (later the Architectural School) at Columbia College. Other buildings for Columbia followed, as well as church, hospital, and residential commissions, and by the mid-1880s Haight was well established as a designer of institutional buildings, most of which were in the Gothic style.

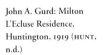

John A. Gurd: Milton L'Ecluse Residence, Huntington, 1919 (HUNT, n.d.)

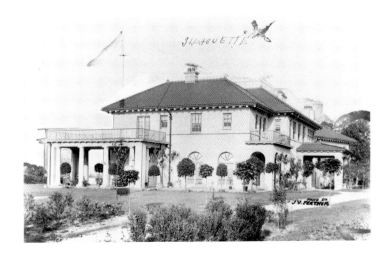

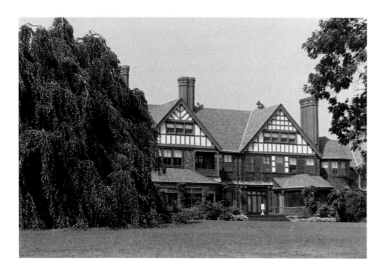

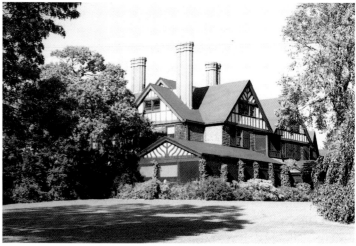

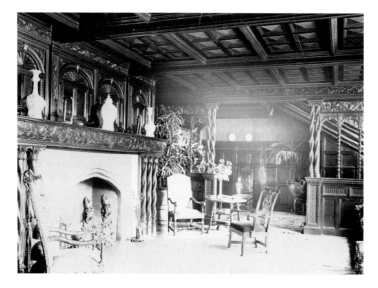

Charles C. Haight: "Westbrook," William B. Cutting Residence, Great River, 1886 (Courtesy of Long Island State Park Region)

Charles C. Haight: "Westbrook," William B. Cutting Residence, Great River, 1886 (HICK, n.d.)

Charles C. Haight: Hall, "Westbrook," William B. Cutting Residence, Great River, 1886 (Courtesy of Mr. Shuttleworth)

William Bayard Cutting, a lawyer and railroad man, was also a Columbia alumnus, and in 1880 became a trustee of that school. In 1884 Cutting purchased George L. Lorillard's former property in Oakdale, on which he established an estate that he named "Westbrook." Two years later he commissioned Charles Haight to build a house at "Westbrook," siting it by the Connetquot River. The big, brick, shingle-and-stucco house in the Queen Anne style sprawls comfortably on its site, its angled wings bound by timbered gables and gathered under a broad shingled roof. Picturesque protrusions jut out from every plane—cross gables and oriels, eye-

lid dormers, and thimble turrets—while tall clustered chimneys of molded brick pin the exuberant mass to the ground.

Inside, fireplaces were used to define space—the massive fireplace in the main hall, for example, serving to separate it from the library and drawing room. In the main hall, one of the more elaborate rooms in the house, Haight deftly incorporated paneling and hand-carved woodwork purchased in England by the Cuttings. Of special note are two magnificent stained-glass windows with medieval motifs designed by Louis Comfort Tiffany.

The house sits amid grounds laid out by Frederick Law Olmsted in the English naturalistic style made popular by the design of Central Park. Many early estate buildings survive, including the gate house (1884) and barn complex and carriage house by Haight. A cluster of dairy-farm buildings attributed to Stanford White erected in 1895 to replace an earlier octagonal stable from the Lorillard period were recently demolished. Administered by the Long Island State Park Region, the main house and much of the estate grounds are open to the public as the Bayard Cutting Arboretum.

Ellen Fletcher

Henry J. Hardenbergh, 1847–1918

Although he is highly renowned for his spectacular apartment houses and hotels, including the Dakota Apartment House (1884), Waldorf Hotel (1892), and Plaza Hotel (1906) in New York; the Raleigh and new Willard hotels in Washington, D.C. (1898); and the Copley Plaza Hotel in Boston (1912), Henry Janeway Hardenbergh also designed a country house on Long Island.

Built in 1881, 11 years into his practice, the Queen Anne house he designed for F. Thurber in Babylon, Long Island, exhibited Hardenbergh's

Henry J. Hardenbergh: F. Thurber Residence, Babylon, 1881 (ARRC, 1897)

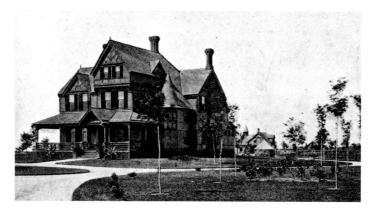

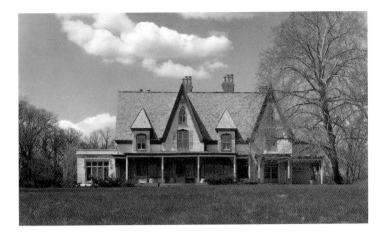

Henry G. Harrison: "The Cliffs," James W. Beekman Residence, Oyster Bay, 1863–65 (SPLI, Bob Zucker photo, 1978)

On Long Island, Harrison designed "The Cliffs" (1863–65), Beekman's summer house in Oyster Bay. The design of the Gothic Revival mansion, carriage house, caretaker's cottage, and 37-acre site clearly reflect Harrison's design aesthetic, as well as the landscape theories of Alexander Jackson Downing (1815–52) with whom Beekman had worked in the early 1850s on the establishment of Central Park. "The Cliffs" was one of the first great estates to be built on Long Island.

Anne H. Van Ingen

preference for the tightly composed, picturesque designs that would characterize his later work. The half-timbered gables and dormers, paneled brick chimneys, and articulated porch columns and railings also foreshadowed the rich detail of his great hotel commissions. The house is no longer extant.

Robert B. MacKay

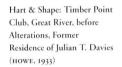

Henry G. Harrison, 1813–1895

An Englishman by birth and training, Henry Harrison started a practice in New York City in 1853. Although he was competent in several styles, his architectural background, founded on the theories of A. W. N. Pugin and the English Ecclesiologists, made him most fluent in the Gothic Revival style. He soon became a favorite architect of the Episcopal Church and built several well-designed parish churches in the New York City area. His finest ecclesiastical work, the Cathedral of the Incarnation in Garden City (1877–83), is a superb Perpendicular Gothic structure. For another important client, James W. Beekman, a prominent Manhattan philanthropist, civic leader, and legislator, Harrison built several blocks of row houses, the Beekman Hill Methodist Church (1860–62), and the North Pavilion of Women's Hospital (1862–69), all in New York City.

Hart & Shape, 1920s
Charles Mansfield Hart, 1887–1968
Robert Louis Shape, 1872–1941

Architect Charles Hart and engineer Robert Shape shared a practice on Park Avenue in New York City during the short, halcyon period between the end of World War I and the Great Depression. But it was a period that provided Long Island with noteworthy country houses. A 1930 catalogue, which proved to be a photographic epitaph for the firm, shows the range of Hart & Shape's capabilities, as well as work done by Shape's previous firm—Shape, Bready and Peterkin—which he left during World War I to work in government-assisted shipbuilding on the West Coast. Shape, Bready and Peterkin designed cooperative apartment buildings, New York City's first automobile garage, and the Candler Building on West 42nd Street. Twenty-five stories of glistening terra cotta, the Candler has stood intact over Times Square squalor since 1913 and will surely prove pivotal in that area's revival.

Shape attended Cornell University, captained America's first rowing team at England's Henley Regatta in 1895, and served in the Spanish-American War of 1898. In 1903 he developed his acumen as a construction superintendent during the erection of the New York Stock Exchange, designed by George B. Post.

Hart & Shape: Timber Point Club, Great River, before Alterations, Former Residence of Julian T. Davies (HOWE, 1933)

Hart & Shape: Timber Point Club, Great River, after Alterations, 1928 (TOWN, 1926)

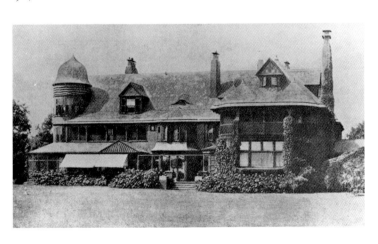

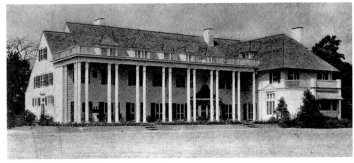

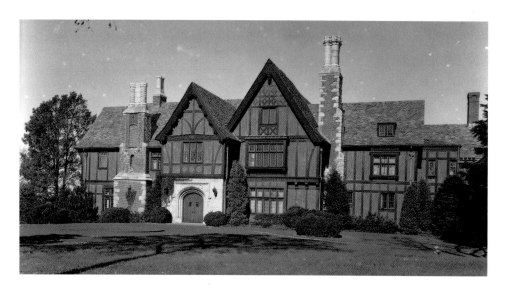

Hart, a graduate of the Pratt Institute, was inventive, almost playful, in his massings and assemblages of forms and spaces. His vitality, in concert with Shape's pragmatism, contributed to the permanence of the firm's works—Shape gave form to the delight that was at the heart of Hart's designs. The firm is remembered for the diversity of its output and its ability to adapt and blend styles. At his death in 1941, Shape was senior architect in the federal government's Resettlement Administration and senior engineer in the Works Progress Administration. Hart, who lived until 1968, was at work on projects like the Rutgers Houses on the Lower East Side in 1961 when in his 70s.

Hart & Shape: Front Facade, "The Chimneys," Mrs. C. Porter Wilson Residence, Mill Neck, 1928 (HEWI, 1930)

Hart & Shape: Living Room, "The Chimneys," Mrs. C. Porter Wilson Residence, Mill Neck, 1928 (SPLI, c. 1950)

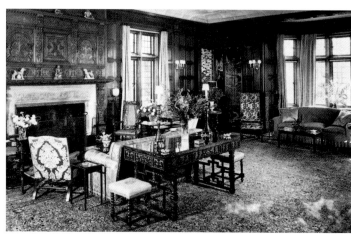

Timber Point Clubhouse, Great River, Alterations, 1928 (Extant)

On Long Island, the combined skills of Hart and Shape can be seen in the conversion of the Julian T. Davies residence at Timber Point in 1928. Here, a large, dark, shingle house of screened piazzas, thimble turrets, and eyelid dormers was transformed into a white, clapboard golf clubhouse of Adamesque porticos, open porches, and vistas, showing the firm's ability to transcend convention and adapt existing designs imaginatively. Although not as successful visually as Guy Lowell's Piping Rock Clubhouse, or the fine series of small hotels Hart & Shape designed, the impact of the transformation is evidence of the partners' strong design sense.

All of Hart & Shape's estate houses, as well as the large residences the firm designed in Bayshore, Garden City, Glen Cove, and Great Neck, share interesting contrasts between the interior and the exterior. The designs reveal a flair for using a finely detailed Adamesque motif in great expanses like stair halls, parlors, dining rooms, bedrooms, and baths, though often subtly concealed in such details as half-timbered shelves.

Mrs. C. Porter Wilson Residence, "The Chimneys," Mill Neck, 1928 (Extant)

Edward F. Hutton (Marjorie M. Post) Residence, "Hillwood," Brookville, 1921–29 (Extant)

At first glance, the textbook-perfect Tudor exterior of Mrs. C. Porter Wilson's country house in Mill Neck, with its carved half-timbers nogged (filled) with herringbone brick, forms a striking contrast with the rambling half-timber and stucco "Hillwood," designed for Edward F. Hutton and his wife Marjorie M. Post (and now part of Long Island University's C. W. Post campus

Hart & Shape: Entrance Front, "Hillwood," Edward F. Hutton Residence, Brookville, 1921–29 (HOWE, 1933)

Hart & Shape: Rear Facade, "Hillwood," Edward F. Hutton Residence, Brookville, 1921–29 (HEWI, 1924)

Hill & Stout: Entrance Drive and Front Facade, "Villa Mille Fiori," Albert B. Boardman Residence, Southampton, 1910 (ARRC, 1916)

complex). Yet the interiors of both of these residences share several characteristics: neat late-Georgian detailing on a generous scale, and baronial paneled libraries and great halls.

The picturesque elements of both the Wilson and the Hutton residences exemplified the firm's attachment to that style. Upswept slate gable ends, elaborately carved timbers, crenellated crests on bay windows, and fancy terra-cotta chimney pots are manifestations of Hart & Shape's version of "stockbroker Tudor."

The Hart & Shape designs for the outbuildings on these estates, however, are in a later clapboard style. At first glance these structures look indigenous, being similar in material to many old Long Island houses, but the profusion of Dutch curved gables, gambrels, and dentilated cornices gives them a tidier appearance than that presented by the local vernacular buildings. This style also served well for the smaller-scale homes the firm designed for Alfred Mudge at Northport; Richard Remsen at Garden City; Otto Young at Great Neck; and for Hart himself, at Pelham Manor.

Thomas R. Hauck

Hill & Stout

The architectural firm of Hill & Stout designed a large, imposing country residence in 1910 for lawyer Albert Barnes Boardman in Southampton. Called "Villa Mille Fiori" and based on the 16th-century "Villa Medici" in Rome, the Italian Renaissance-style residence was charac-

terized by its richly ornamental wall surfaces, which included bas-relief sculpture and statuary in arched niches. The tiled-roofed structure was surmounted by a third-story, balustraded terrace flanked by open-arched towers. On the garden side, a monumental Ionic portico faced a terrace from which the formal gardens extended. In 1923, when Boardman had another residence built in Southampton by Polhemus & Coffin, the estate was sold to a partner in Boardman's law firm, Morgan O'Brien. Ten years later the elaborate residence was demolished; only the gate house survives today.

Carol A. Traynor

Frederick R. Hirsh, 1865–1933

According to a biographical note that appeared in *Architectural Forum* at the time of his death, Frederick Hirsh was born in Syracuse, New York, received his early architectural training in Chicago, and was practicing as an architect in Mount Vernon, New York, at the time of his death. Although the note went on to say that he was employed by the firms of McKim, Mead & White and Carrère & Hastings before establishing his own practice, the employee roster of McKim, Mead & White does not mention him.

Hirsh is represented on Long Island by two residential designs in totally different idioms

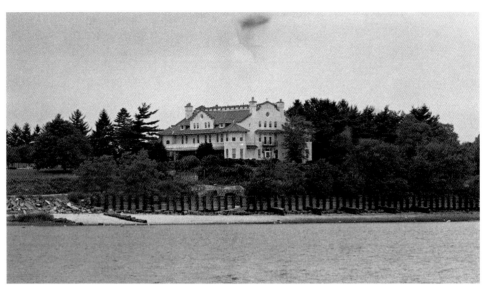

Frederick R. Hirsh: Proposed Sketch for Residence for Mr. Thatcher, Centre Island, 1899 (NYHS, 1899)

Frederick R. Hirsh: Samuel T. Shaw Residence, Centre Island, 1906 (SPLI, Joseph Adams photo, 1977)

commissioned by two different owners of the same site on Centre Island. In 1899 he prepared a sketch for a Queen Anne Shingle Style residence for a Mr. Thatcher, though it is uncertain whether it was ever built. The subsequent owner of the site, Samuel T. Shaw, a noted art patron and hotel owner, later commissioned him to design a country residence in 1906. Sited on top of a bluff overlooking the water, Hirsh's design is an impressive early example of the Spanish Colonial style on Long Island. Built on a massive stone and brick foundation, the house is rectangular in plan, with octagonal turrets at each corner. The stuccoed walls, round-arched windows, and red-tile roof carry on the Spanish motif. The house survives today as a private residence.

Carol A. Traynor

Hiss & Weekes, 1899–1933
Philip Hiss, 1857–1940
H. Hobart Weekes, 1867–1950

Based in New York City and active from 1899 to 1933, the architectural firm of Hiss & Weekes designed in several styles but worked mainly in the Beaux-Arts classical tradition, partly because founding partner Philip Hiss had pursued independent architectural studies in Paris in the late 1890s. Born in Baltimore, he received his early education in that city. He first studied architecture under private tutors and later completed his training in Paris.

Ten years younger than his associate, H. Hobart Weekes was born in New York City. He had undertaken study tours of architecture and sculpture in England, France, Italy, and Greece before coming to work as a draftsman and designer for McKim, Mead & White, which

served as a training school for young architects. Weekes remained with the firm from 1886 until 1899, when he formed his partnership with Hiss.

In partnership, Hiss and Weekes designed apartment houses, banks, churches, and other institutional buildings, as well as large private homes, including the residences of Henry Rea in Sewickley, Pennsylvania; Percy Rockefeller in Greenwich, Connecticut; and Hartley Dodge and Henry McAlpin at Bernardsville, New Jersey. The firm was especially noted for its New York City work, including the imposing Gotham Hotel on Fifth Avenue, completed in 1905. Conceived as an Italian palazzo, it retains a fashionable elegance to this day. Another Manhattan commission in the Renaissance Revival style, the Belnord Apartments, built in 1908 on New York's Upper West Side, borrowed from the planning principles of 16th-century Italian palaces. The design for these apartments included an interior garden court.

Elsewhere, the firm was involved in designs for housing projects in Bridgeport, Connecticut, and at Yale University in New Haven, designing one of the few examples of Beaux-Arts–inspired classicism for that campus. Completed in 1902 in the Neo-French Classic style, Byers Hall was modeled directly on the Petit Trianon at Versailles (1762–64) by Ange Jacques Gabriel; today it forms a part of Silliman College. The Elizabeth Arden Building in Chicago was also designed by Hiss & Weekes, as was the Church of Bethesda-by-the-Sea in Palm Beach, a joint project with Cram and Ferguson in 1928.

Charles I. Hudson Residence, "Knollwood," East Norwich, 1906–20

"Knollwood," one of the firm's most beautiful country-house commissions, was built between 1906 and 1920 for Charles I. Hudson, a New

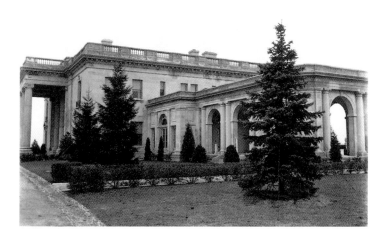

Hiss & Weekes: View from the North with Main Entrance Portico, "Knollwood," Charles I. Hudson Residence, East Norwich, 1906–20 (HICK, n.d.)

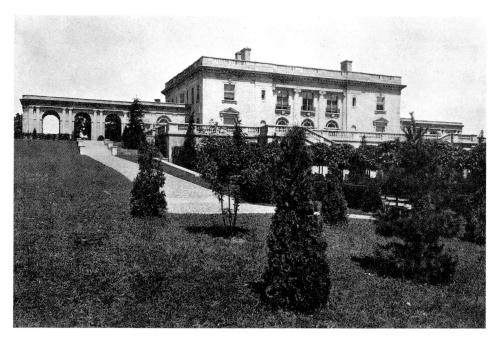

Hiss & Weekes: Garden Facade, "Knollwood," Charles I. Hudson Residence, East Norwich, 1906–20 (ARTR, 1911)

Hiss & Weekes: Interior, "Knollwood," Charles I. Hudson Residence, East Norwich, 1906–20 (SPUR, 1922)

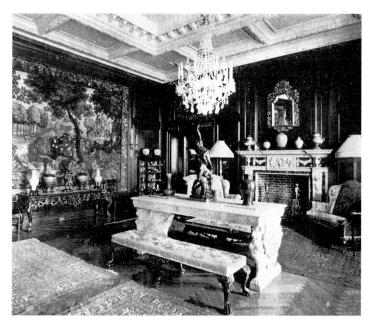

York City stockbroker, at East Norwich on Long Island's North Shore. The house was palatially scaled and elegantly faced with smooth-dressed Indiana limestone, with design details borrowed from a variety of sources, including palaces and country estates by Palladio and Vignola built for Italian princes, and royal residences erected in France during the 17th and 18th centuries.

Viewed from the north, the most striking feature of "Knollwood" was its colossal entrance portico, balustraded across the top like the main block of the house and supported by four giant Ionic columns. In most other respects, the north and south elevations were similar. At the ends of the two-and-a-half-story main block of the house were single-story wings containing Palladian-style motifs such as arched French doors flanked by lower rectangular openings. Each of the wings, in turn, opened onto a deep loggia. Viewed from the south, the house appeared to rest on a high basement, extending forward beneath the wide terrace at the back which overlooked the formal gardens. The terrace was reached from the gardens by grand staircases. Inside, the house contained 30 rooms with paneling imported from England and marble fireplaces brought from Italy, as well as coffered Renaissance-style ceilings, much in evidence in the first-floor reception rooms.

The formal gardens to the south of the house incorporated historical European precedents as well, especially in their grand scale and pronounced axiality. The landscape architect was Ferrucio Vitale. Not unlike the great country houses of the British Isles and the villas of Northern Italy, the 150-acre estate devoted a large part of its land to commercial farming and pasturing. A stuccoed combination stable and garage building included space for 12 cars and apartments for chauffeurs, grooms, and gardeners. A poultry building and a hog house were also located on the estate, as well as an additional stable that housed farm horses, wagons, and implements. Accommodations included a boarding house for farm laborers, a cottage for the farm superintendent, and an additional cottage for agricultural workers. The presence in this farming complex of a large dairy barn for 140 head of cattle was not surprising in view of the fact that Charles Hudson took a lifelong interest in the breeding of fine Jersey cattle. A white-shingled guest cottage on the estate, designed in the Colonial Revival style, came with its own garage and stables.

After the death of Charles Hudson in 1921, "Knollwood" passed to a succession of owners, including Mrs. Charles H. Senff, C. S. MacVeigh, and, quite briefly in the early 1950s, King Gustav S. Zog of Albania; the house was demolished in the 1960s.

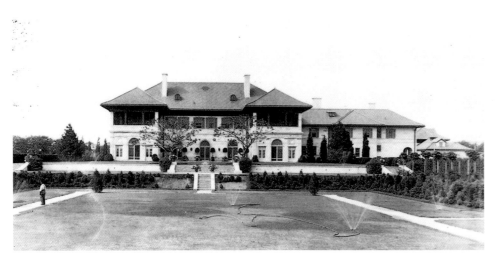

Hiss & Weekes: Rear (Garden) Facade, "Red Maples," Mrs. Alfred M. Hoyt Residence, Southampton, c. 1900 (HICK, 1912)

Hiss & Weekes: Floor Plan, "Red Maples," Mrs. Alfred M. Hoyt Residence, Southampton, c. 1900 (ARTR, 1917)

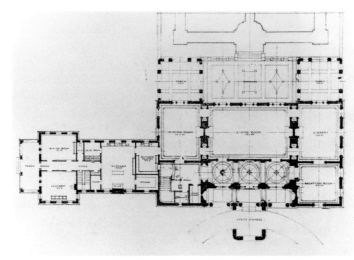

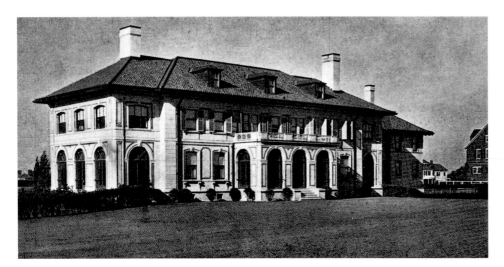

Hiss & Weekes: Mrs. Frederick Baker Residence, Southampton, c. 1915 (ARRC, 1916)

Mrs. Alfred M. Hoyt Residence, "Red Maples," Southampton, c. 1900

Smaller country-house commissions executed on Long Island by the Hiss & Weekes firm included two estates built in Southampton on the eastern end of the island. "Red Maples" had a breezy, almost Mediterranean, air to it. Stuccoed, it had a tiled roof with deep overhangs. The H-shaped plan included a pair of second-story screened sleeping porches on the southward side (later enclosed). On the

ground floor several French doors led to the outside. The south front of the house faced onto extensive sunken gardens designed by Ferrucio Vitale; on the north front, an ivy-covered loggia connected the projecting wings. The house is no longer extant.

Mrs. Frederick Baker Residence, Southampton, c. 1915

Designed in the sedate style of the French classical revival, the Baker house was smaller and more compact than "Red Maples." A long, two-and-a-half-story house, it was stuccoed and had a tiled roof. The ends of the house, with French doors on the first floor, were slightly recessed. A single-story entrance loggia with tripartite arches graced the north front of the house. The house and its loggia were destroyed by fire around 1950.

Elizabeth L. Watson

■

F. Burrall Hoffman, 1882–1980

Born in New Orleans, F. Burrall Hoffman, like many aspiring architects from other parts of the country, went east for his professional training. He graduated from Harvard University in 1903 and received further architectural training at the Ecole des Beaux-Arts, Paris, from 1903 to 1907. After returning to the United States, he maintained contact with Europe, practicing architecture in the United States and France through the New York-based firm he opened in 1910. His best-known work is the "Villa Vizcaya," built for John Deering in Miami (1912),[1] and sold to Dade County in 1952 for use as an art museum. In addition to residences and apartment houses, Hoffman designed sets for Henry Miller's Theater and the Little Theater in New York City. In the 1960s he collaborated with Schmidt & Embury in renovating the residential section of New York's Gracie Mansion.

C. H. Lee Residence, "Westlawn," Southampton, c. 1900

Hoffman designed this shingled residence soon after entering Harvard. Its high quality demonstrates that he had probably received informal, or at least some practical, experience in architecture before then. While the overall composition is little more than a simple gabled farmhouse, Hoffman's skill is apparent in the detailing. Finely carved wood moldings which mark the

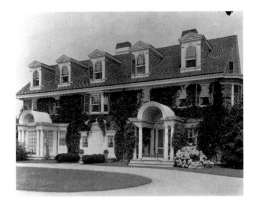

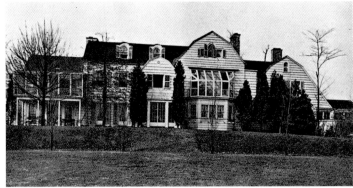

F. Burrall Hoffman: Front Facade and Entrance Court, "Westlawn," C. H. Lee Residence, Southampton, c. 1900 (HEWI, n.d.)

F. Burrall Hoffman: Rear Facade, Charles C. Rumsey Residence, Wheatley Hills, c. 1910 (ARRC, 1917)

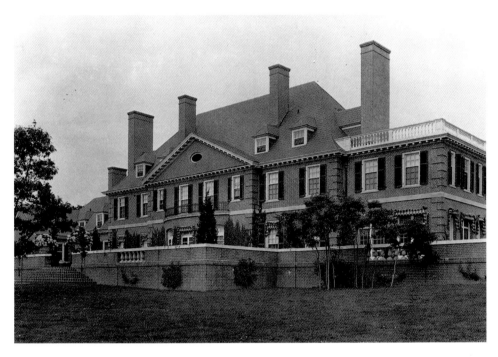

F. Burrall Hoffman: Rear (Garden) Facade, "Ballyshear," Charles B. MacDonald Residence, Southampton, 1913 (HEWI, n.d.)

of the main entrance, marked by a long, low, gambrel roof and deep eave. The dining room, second-story sleeping porch, and southwest terraces and porches were added by the architect over the next 20 years. One interesting feature, which also appears later in his residence for Charles B. MacDonald (see below), is the separation of the family parlor from the main house. The interior is a mix of Georgian and Colonial Revival details. The garden, designed by Morris & Rotch, is terraced and rather informal. Still a private residence, the house was remodeled later in the 1930s by Peabody, Wilson & Brown.

Charles B. MacDonald Residence, "Ballyshear," Southampton, 1913

Built for a golf-course designer, "Ballyshear" is in the Georgian Revival mode, with references to 16th-century French château design. The latter note is especially apparent in the north facade, which is capped by a Francis I roof. The main entry porch, elliptical stair-light above, and balustraded two-story pavilion to the east (containing the family parlor and master bedroom) refer to the Colonial Revival. The suite of rooms marked by the vestigial forecourt on the north facade projects from the garden facade and is capped by a shallow pediment. Hoffman was by no means a slave to his sources. The proportions of the whole composition are stretched and flattened. The slightly curved dining-room bay on the garden facade intensifies the attenuated proportions. The material is brick, even at the corner quoins, where one would expect to find stone. The latter material is used for the continuous strip molding which marks the division between first and second stories. The west wing has a less formal character, in keeping with its function as the service wing. The formal gardens to the east and terracing on the south are the work of landscape architect Rose Standish Nichols.

first floor jut out to become the frieze on an elegant Colonial Revival porch supported by Tuscan columns. The two-story, rounded bay to the east plays off nicely against the curved hoods of the porches. These details are grafted onto what appears to be a simple vernacular structure. This additive quality is, however, very deliberate and demonstrates Hoffman's familiarity with the domestic work of Charles F. McKim.

Charles Cary Rumsey Residence, Wheatley Hills, 1910

Charles Cary Rumsey (1879–1922), a sculptor, graduated from Harvard the year before Hoffman and completed his artistic training at the Ecole des Beaux-Arts between 1902 and 1906. The shingled house Hoffman designed for him is asymmetrically disposed around several gambrel roofs, creating a picturesque effect that evokes the character of local farmhouses which, over several generations, often grew into a cluster of buildings. One example of this romantic approach to design in the Rumsey house is the placement of the servants' wing to the south

F. Burrall Hoffman:
Playhouse for Lorenzo
Woodhouse, East Hampton,
1916 (ARLG, 1921)

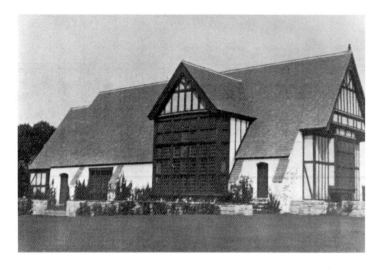

Post Office and Town Hall, Southampton, 1910 (Extant)

This multipurpose building harmonizes very well with the simple character of the village's Main Street. It is an unpretentious, three-story, brick building to which Hoffman grafted classical elements. The two-story, colossal Tuscan portico is topped by an almost residential-looking balustrade. The gable, which runs parallel to Main Street, becomes a pediment broken by a large arch. The overall composition is mannered and reminiscent of C. R. Cockerell's Bank of England Building in Liverpool.

Christopher E. Miele

Lorenzo E. Woodhouse Playhouse, East Hampton, 1916 (Extant)

Lorenzo Woodhouse hired Hoffman to design this structure for his daughter. It is said that the dancers Isadora Duncan and Ruth St. Denis both performed here. For inspiration for this project Hoffman turned to English and northern French vernacular designs. The two-story "transept" wing is half-timbered, while the main body of the building is brick. The most prominent feature of the playhouse is the steeply pitched roof, which is divided into two parts. The larger "nave" contains an auditorium. The smaller square ended "chancel" contains a stage. On the interior, Hoffman juxtaposed the half-timbering with open wood trusses reminiscent of those commonly used in rural suburban American churches. This "sacred" theme is present in the detailing as well. There are several small trefoil windows, and the dramatic two-story window contains pieces of stained glass. The ecclesiastical nature of the whole is apparent if one compares its vigorous massing with Hoffman's St. Brigid's Roman Catholic Church in Westbury of the same date.[2]

Hood & Fouilhoux, 1920s–1930s
Raymond M. Hood, 1881–1934
Jacques André Fouilhoux, 1879–1945

Working separately and jointly at various times in the 1920s and 1930s, Raymond Hood and Jacques Fouilhoux designed many of the early modern masterpieces of American architecture. In New York City, their work included the Daily News Building (c. 1930), the McGraw-Hill Building (1931), American Radiator Building (1924), and Rockefeller Center (1930–33).

The Joseph W. Brooks residence at Sands Point, built sometime after 1927, was apparently their only Long Island commission. It exemplified the hallmarks of their style, which was modern in the reticence of its massing and decoration but traditional and academic in its emphasis on bearing-wall construction and on a conventional stylistic vocabulary which extended to dentilled string courses and brick quoining.

Fouilhoux was born and educated in Paris but emigrated to the United States shortly after the turn of the century and established his first practice in Portland, Oregon, before moving to New York City. After the death of Hood, he became a partner of Wallace K. Harrison. Hood, a graduate of M.I.T., worked for Henry Hornbostel, an important Pittsburgh architect, before establishing his own practice in New York City in 1914. His start as a major designer of American skyscrapers came when John Mead Howells engaged him as an associate to develop an entry for the Chicago Tribune Tower competition of 1922–23. The Howells-Hood design won and opened the door to further significant commissions.

Peter Kaufman

Hood & Fouilhoux: Joseph
W. Brooks Residence, Sands
Point, c. 1927 (GOTT, 1934)

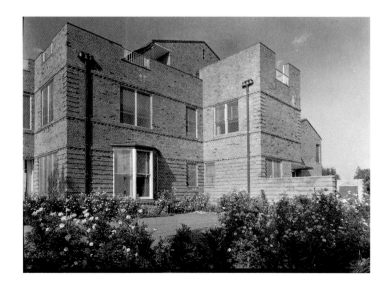

Alfred Hopkins, 1870–1941

Alfred Hopkins is best remembered as the lead-
ing architect of the nation's correctional facilities
between the two World Wars. He is credited
with popularizing the French "telephone pole"
penitentiary plan in America, designing such
massive facilities as New York State's institution
at Wallkill and the federal penitentiaries at Terre
Haute, Indiana, and Lewisburg, Pennsylvania.
At the height of his career in 1935 he headed
President Franklin D. Roosevelt's delegation to
the International Prison Conference at Berlin.
What led Hopkins from his early specialization
in estate farm groups to concentration on penal
architecture? Possibly the knowledge that a
strong practice could be built around building
types; probably a fascination with the way in
which architecture could shape behavior; and
certainly the realization that given the post-
World War I slump in estate construction, penal
architecture provided an interesting alternative.

For this meticulous scientific practitioner
who played four instruments, composed quar-
tets, and was an authority on bookbinding, ar-
chitectural life began with an interest in design-
ing the perfect sanitary environment for cows.
Born in Saratoga Springs, New York, on March
14, 1870, Hopkins received his architectural
education at the Ecole des Beaux-Arts in Paris.
By 1902, the year in which his essay on "Farm
Barns" appeared in the *Architectural Review,*
he had already established a reputation in farm
group design, having been commissioned to
build complexes for F. W. Vanderbilt in Hyde
Park, New York, and Messrs. Otto H. Kahn and
Henry Wertheim at Morristown, New Jersey.

Hopkins was associated with Edward
Burnett, a farm building "expert" before World
War I, and with Lester S. LaPiere in the 1920s.
At the time of his death, Alfred Hopkins &
Associates had offices at 415 Lexington Avenue
in New York. Hopkins is known to have de-
signed residences, office buildings, banks, and
a variety of other structures. He also wrote a
series of books about the architecture of build-
ing types. However, from the Long Island per-
spective, he is remembered for designing an
astounding 15 farm groups in Nassau and
Suffolk counties alone between 1905 and 1924,
and publishing in the process the definitive
treatise on the subject, *Modern Farm Buildings,*
which had gone into three editions by 1920.
Corresponding with prospective client Wilton
Lloyd-Smith, a Lloyd Harbor estate owner in
1924, Hopkins summarized his approach to
farm group design in a few sentences:
*I do not expect you to read my book, but I think
if you will glance through it, you will see that we*

*go into the practical requirements very carefully,
ventilation, sanitation and the dairy in particular.
In short, I can give you, I think, just the help that
you want and I believe my book will assure you
on this point.*[1]

Indeed, Hopkins's magnum opus on farm
group design included "practical requirements"
for everything from chicken houses and bull
pens to manure pits and root cellars. He provid-
ed for details ranging from sheep-feeding racks
to hardware for dairy barn doors. Spatially, his
low-slung farm groups were always composed
around several courtyards or paddocks, allowing
for the separation of cows and horses and for the
ingenious integration of barnyard and stable
functions. Yet, no two parts were alike, the arch-
itect having given up early on "the idea of form-
ulating a plan . . . along generally accepted lines
of architectural symmetry."[2] Open-sided sheds
to house farm vehicles, separate facilities for the
storage of hay and feed, and multifunctional
towers characterized the Hopkins farm groups.
The tall, picturesque towers used as windmills,
water tanks, silage bins, and even toolrooms
were the hallmarks of the architect's style.

Hopkins urged his clients not to hide their
farm groups in out-of-the-way corners of their
estates. The groups were capable of a variety of
architectural expression, he explained, noting
that "with these buildings in effective combina-
tion and appropriately placed among the fields,
the picture of the farm can be made so pleasing
and the idea of going back to nature as the source
of all sustenance so ingratiating that it would be
possible to build up an effective philosophy on
the principle that the architecture of the home
should be made to resemble the architecture of
the farm, rather than the other way about."[3]

Nevertheless, Hopkins must have continually
found himself in a subservient role to the coun-
try-house architects to whom, in many cases,
he owed his commission. Indeed, his very suc-
cess as a farm group architect may have been
hinged on his willingness to cooperate. In his
letter to Wilton Lloyd-Smith, Hopkins noted
that he had worked with Bertram Goodhue
before and would of course "be very pleased
to submit my designs to Mr. Goodhue's office
so there will be no possibility of conflict on
that score."[4] Indeed, the number of architects
Hopkins worked with on Long Island, includ-
ing Trowbridge and Livingston, John Russell
Pope, Horace Trumbauer, Charles A. Platt, and
C. P. H. Gilbert, is indicative of his ability to
key his work to that of others.

When Hopkins had a free hand he favored
placing his groups on hilltops where the roofs

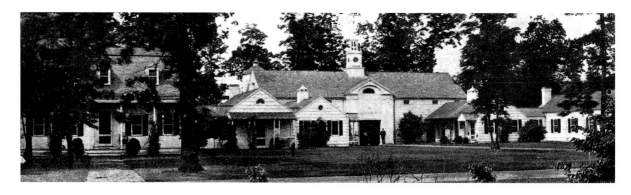

Alfred Hopkins: Cow Barn
and Farmers' Cottages,
"Fairleigh," George Brewster
Residence, Brookville,
c. 1915 (COUN, 1924)

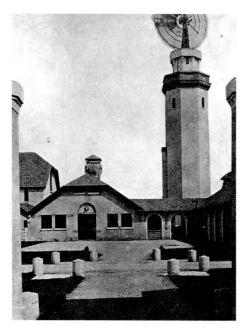

Alfred Hopkins: Water
Tower and Farm Complex
Courtyard, "Indian Neck
Hall," Frederick G. Bourne
Estate, Oakdale, c. 1900
(VAND, n.d.)

and towers could be "thrown into prominence against the background of the sky."[5] He preferred local building materials, particularly stone ("no one has ever found anything more interesting")[6] and cypress shingles, if available; but on quarryless Long Island, stucco and weatherboarding were often employed. Stylistically, Hopkins was a versatile practitioner in an age of historicizing modes. He worked easily in Tudor, Spanish, Georgian, Federal, and other styles. However, his particular preference was for the vernacular stone farm buildings of the English countryside, hence his affinity for jerkin-head roofs and dovecotes. While motoring through Surrey and Devonshire on his honeymoon, Hopkins had grasped "the possibility of combining the brightness of the wooden wall with the texture of the stone wall" and formed a lifelong preference for this combination.[7]

Hopkins became the unquestioned dean of farm group architecture, establishing a virtual hegemony in this specialty on Long Island in the years before World War I. His groups were usually more interesting than the country houses on the same estates. Of course, to this Ecole des Beaux-Arts–educated architect, this was self-evident. As he noted in 1920, the various types

of buildings needed for a farm group were "capable of such an infinite variety of groupings, that the requirements of the farm would seem to offer more scope to the architect than do the problems of the house."[8]

George Brewster, Brookville; Howard Brokaw, Brookville; Adolph Mollenhauer, Bay Shore; Conde R. Thorn, Massapequa; A. W. Burchard, Locust Valley; C. V. Brokaw, Glen Cove; Glenn Stewart, Locust Valley; Farm Groups, c. 1900–1915

Hopkins's smaller farm groups on Long Island (all built between 1900 and 1915) appear to have been shingled, and designed in the Federal/Georgian Revival style, with but a single exception. Their juxtaposed gables and rambling appearance belie the carefully integrated functions that each building or wing housed. George Brewster's farm group pictured here is typical of this effective correlation. At the left was the farmer's cottage, followed by the dairy (first gable end), cow barn (second gable), stable and wagon room (topped by the cupola), and the groom's quarters (remaining gables).

Frederick G. Bourne, Oakdale, c. 1900 (Extant)

One of the most spectacular adjuncts to any Long Island estate was the remarkable farm group commissioned for "Indian Neck Hall," the Oakdale retreat of Singer sewing machine magnate Frederick G. Bourne. The stucco-covered complex was one of Hopkins's most extensive commissions. The water tower, capped by a windmill, supplied the needs of the entire estate.

Louis Comfort Tiffany, Laurel Hollow, c. 1905

This was an early Hopkins commission in which the young architect obviously took his cues from his famous client, who was involved

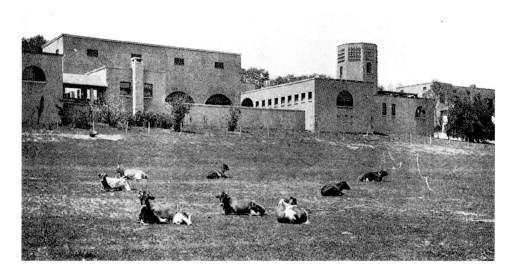

with the design of all structures built on his estate. The huge Moorish complex, which Hopkins thought suffered from a lack of peripheral planting, was linked by an elevated bridge to a dormitory complex for the superintendent and hired hands. As at the Davis group, the tower served as a toolroom at the ground-floor level, but housed a water tank above with accommodations for a host of pigeons. Portions of this complex still survive on Laurelton Beach Road, near the Laurel Hollow Village Hall.

Alfred Hopkins: General View of Farm Buildings, "Laurelton Hall," L. C. Tiffany Residence, Laurel Hollow, c. 1905 (MOFB, 1920)

Alfred Hopkins: Plan of Farm Buildings, "Laurelton Hall," L. C. Tiffany Estate, Laurel Hollow, c. 1905 (MOFB, 1920)

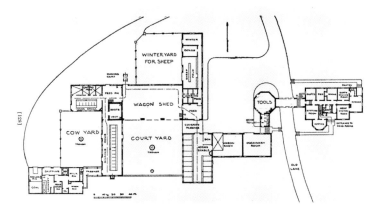

Samuel Twyford Peters, Islip, c. 1910 (Extant)

At "Windholme Farm," built for coal king Samuel T. Peters, Hopkins went so far in his imitation of the English vernacular as to employ a trompe l'oeil wave effect in the shingled roof simulating thatch, and then had some nearby hayricks and outbuildings covered in genuine thatch. The broad overhanging eaves, extensive use of brick in several old bonds, and the artificially weathered cypress doors and trim made the farm group one of the architect's most picturesque compositions. Published in *Country Life in America* in 1912, the Peters group was hailed for its pleasing "appearance, permanent construction, convenient arrangement and sanitary provisions." It was converted into housing in the 1950s by Mrs. Harry T. Peters, Samuel's daughter-in-law.

Mortimer Schiff, Oyster Bay, c. 1910 (Extant)

The Tudor farm group for Mortimer Schiff at Oyster Bay conformed in style with the investment banker's C. P. H. Gilbert-designed mansion. The period views by a professional

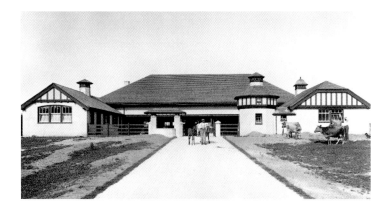

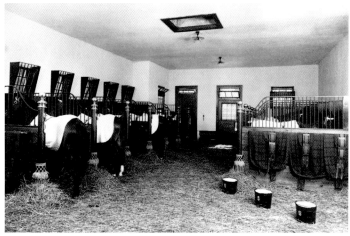

Alfred Hopkins: Farm Buildings, "Windholme," Samuel T. Peters Estate, Islip, c. 1910 (COUN, 1912)

Alfred Hopkins: Stable Complex, "Northwood," Mortimer Schiff Estate, Oyster Bay, c. 1910 (Courtesy of John M. Schiff)

Alfred Hopkins: Stable Complex Interior, "Northwood," Mortimer Schiff Estate, Oyster Bay, c. 1910 (Courtesy of John M. Schiff)

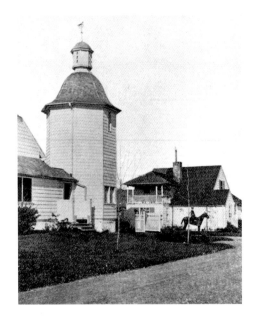

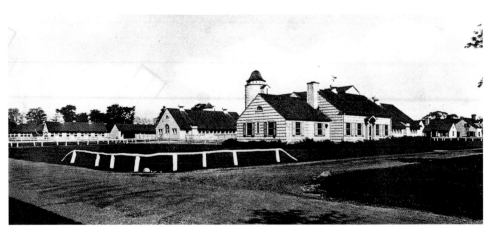

Alfred Hopkins: View of the Tower, Joseph E. Davis Residence, Upper Brookville, c. 1915 (MOFB, 1920)

Alfred Hopkins: Farm Buildings, "Caumsett," Marshall Field III Estate, Lloyd Harbor, 1925 (COUN, 1927)

photographer give some indication of the neat and sanitary farm environment Hopkins espoused. Nothing annoyed the architect more than the knowledge that his farm groups were being managed in a slovenly manner with disregard for "scientific hygiene." The Schiff group survives relatively unaltered.

Joseph E. Davis, Upper Brookville, c. 1915

One of the best-sited Hopkins farm groups was constructed c. 1915 for Joseph E. Davis, Upper Brookville's first mayor. The Davis group was a summation of the architect's favorite design solutions. Located on a hilltop, it was a shingled version of an English farm group, replete with jerkin-head roofs and a dovecote-topped tower that was visible for miles around. Its floor plan also exhibited a Hopkins characteristic, a hay barn placed between the cow yard and paddock. The author, a childhood equestrian, knew this complex well, having put foot to stirrup here many times under the guidance of the late polo player Barney Balding, who operated a riding academy here in the late 1950s. The complex was razed c. 1980 and the tower moved to a nearby estate.

Marshall Field III, Lloyd Harbor, 1925 (Extant)

In terms of both time and character, Hopkins's last commission on Long Island was markedly different from his earlier work there. His client, a member of the Chicago department-store family, and a prominent newspaper publisher and philanthropist in his own right, asked the architect to design a shingle-clad cow barn complex to house his prize herd of golden Guernseys. The complex was largely abandoned after Field's death in 1956 but survives.

Robert B. MacKay

Hoppin & Koen, 1894–1904
Hoppin, Koen & Huntington, 1904–1923
Francis L. V. Hoppin, 1867–1941
Terrence A. Koen, 1858–1923

Of the many alumni of the McKim, Mead & White office to establish their own practice, Hoppin & Koen were among the most talented, designing impressive public buildings and stylish town and country houses. Francis Hoppin had been a leading draftsman at the fabled firm and early in his career had been chosen by Edith Wharton to replace Ogden Codman as architect for her Berkshire retreat "The Mount." On Long Island the stylistic diversity of Hoppin & Koen's seven commissions was indicative of their ability to design handsome and cleverly conceived country seats in virtually any mode. A decade after forming their partnership, the two architects were joined by Robert Palmer Huntington.

Born in Providence, Rhode Island, Hoppin attended the Trinity Military Institute, served in the Spanish-American War, and intended to make the army his career until he discovered architecture, which he studied at M.I.T. and the Ecole des Beaux-Arts in Paris, before joining the office of McKim, Mead & White.

It is thought that the socially adept "Colonel Hoppin" generated most of the firm's business. A leading figure in the Newport summer colony, Hoppin's Manhattan clubs were the Union and River and he spent a good deal of time on Long Island, where he was a member of Locust Valley's Piping Rock Club.

The New York City Police Headquarters (1905–09), evoking the style of a French *hôtel de ville,* the Albany County Courthouse (1921),

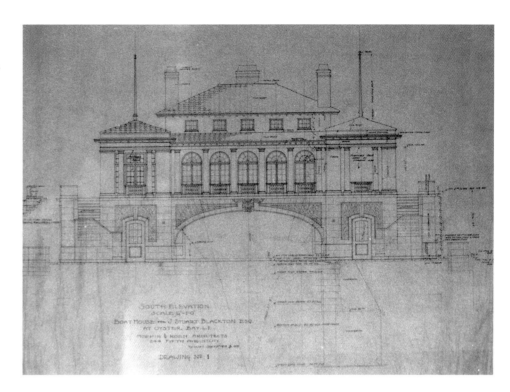

Hoppin & Koen: South
Elevation of Boathouse,
"Harbourwood," J. Stewart
Blackton Estate, Oyster Bay,
1912 (AVER, n.d.)

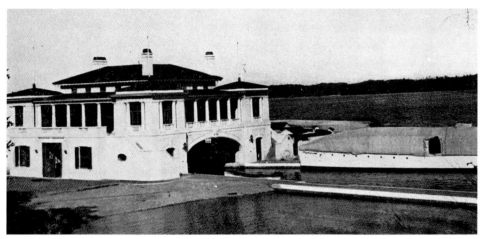

Hoppin & Koen: Boathouse,
"Harbourwood," J. Stewart
Blackton Estate, Oyster Bay,
1912 (COUN, 1928)

with high walls. The correct use of color, gradu-
ated plant materials, and "an absence of clutter"
("pergolas, for example, are very much over-
done and overused") were also seen as key com-
ponents of formal garden design. Above all he
cautioned patience: "no house is built in a day."
Hoppin's attention to detail and his Beaux-Arts
penchant for complex axial plans are evident in
the firm's Long Island country-house commis-
sions, which all date from the period 1910–18.

J. Stewart Blackton Estate Outbuildings, Oyster Bay, 1912

In 1912, the firm designed ancillary estate struc-
tures—including a cottage, farm group, and
boathouse—for this client, an early motion-
picture mogul associated with the Vitagraph
Company of America and an internationally
known speedboat racer. The main residence,
"Harbourwood," was to have been built in 1914,
but the outbreak of World War I in Europe dis-
rupted the motion-picture industry (Germany
was an important market for Vitagraph) and
prompted a broke Blackton to forsake Oyster
Bay for California in 1918. The handsome farm
group arranged around a courtyard in the
Federal Revival style survives, but the boathouse
slowly fell into ruin, and the last vestiges were
demolished in 1983 (locally it became known as
Leeds Boathouse after its second owner, William
B. Leeds). One of the most remarkable sports
buildings of the Long Island estate era, it housed
Blackton's Harmsworth Trophy racers, while

and the award-winning Roslyn War Memorial
were among the firm's major public commis-
sions. The firm also designed townhouses for
James P. Lanier and Harris Fannestock in
Manhattan, and country houses for Newbold
Morris in Lenox, Massachusetts, Charles W.
Cooper in Tuxedo Park, and Andrew Zabriskie
in Tarrytown, New York.

Hoppin's approach to country-house design,
detailed in a 1903 interview with Barr Ferree
in *Scientific American Building Monthly*, was
"to retain the interest of the client in the opera-
tion." While the interior was "more distinctly
personal to the owner," Hoppin believed strong-
ly that the exterior should be left to the archi-
tect. However, the design of both must proceed
from "a specific scheme . . . decided upon at the
outset" encompassing both house and garden.
It was an "architectural garden" that Hoppin
preferred, "laid out on axial lines," facing south

Hoppin & Koen: Entrance Court and Front Facade, "Wolver Hollow," C. Oliver Iselin Residence, Brookville, c. 1914 (SPLI, 1978)

Hoppin & Koen: Front Facade, "Bois Joli," Philip W. Livermore Residence, Brookville, c. 1910 (REAL, 1910)

the upper stories comprised a ballroom, three guest rooms, and quarters for the owner's yacht crew. Constructed in reinforced concrete with tile roofs, the Renaissance Revival boathouse is reminiscent of McKim, Mead & White's Casino at Narragansett Pier in Rhode Island. The south elevation of the Rhode Island landmark, with its open gallery above a massive arch, must have been well known to Hoppin and, in its requirements, the Blackton boathouse more closely resembled a casino than the average American boathouse.

C. Oliver Iselin Residence, "Wolver Hollow," Brookville, c. 1914

Philip W. Livermore Residence, "Bois Joli," Brookville, c. 1910

William F. Sheehan Residence, "The Height," Roslyn, 1916 (Extant)

In Brookville the firm designed two shingled residences in the Federal style for financier and America's Cup defender C. O. Iselin and for P. W. Livermore, and remodeled an existing house for lawyer William F. Sheehan in 1916, that were fairly modest by Long Island standards. This was not the case, however, with Hoppin & Koen's other North Shore commissions.

Sterling Postley Residence, "Framewood," Oyster Bay, c. 1918 (Extant)

The Tudor mansion the firm designed for this Wall Street stockbroker was surrounded by private links and described as embodying "every requisite demanded by a connoisseur of fine living." Published in both *Architecture* (April 1918) and *Country Life in America* (October 1925), the L-shaped "Framewood" was replete with half-timbered transverse gables, castellated masonry walls, and a tower that functioned as a stairwell connecting the servants' hall to the main block. The well-appointed interior included a masonry stair hall, paneled halls, galleries, reception rooms, a fruitwood-sheathed study, and a Louis XVI lady's dressing room imported from France. Presumably, the architects were also responsible for the landscape design, for which Hicks Nurseries supplied plant materials. The house survives today as a private residence.

Ormond G. Smith Residence, "Shoremond," Centre Island, c. 1910

The huge mansion on Centre Island, designed for dime novel publisher Ormond G. Smith, was basically in the Federal mode but Baroque in exuberance. Later sold to John H. Willys of automotive fame, it was demolished after just three decades. With its full attic story, colonnaded portico facing the forecourt, and semi-cylindrical portico overlooking Long Island Sound, "Shoremond" possessed all the qualities of monumentality a captain of industry could desire.

George Rose Residence, "Bennett Cottage," Westbury, 1910

A rare exercise on the Long Island landscape in English Neoclassicism, the sculptural quality of "Shoremond" gave way here in the Rose residence to reticent ornament that scarcely protruded from the plane of the wall. In contrast to the Centre Island house, as well, was the center block, which receded behind a colonnade, while the projecting wings dominated the facade. This grand house also had a short existence.

Robert B. MacKay

Hoppin & Koen: Rear
Facade before Landscaping,
"Framewood," Sterling
Postley Residence, Oyster
Bay, c. 1918 (HICK, n.d.)

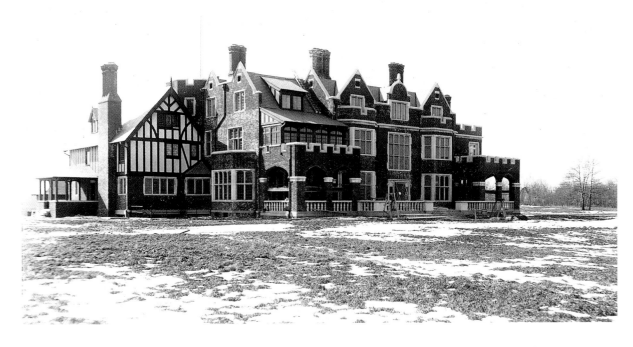

Hoppin & Koen: Front
Facade and Entrance Gate
before Landscaping,
"Framewood," Sterling
Postley Residence, Oyster
Bay, c. 1918 (HICK, n.d.)

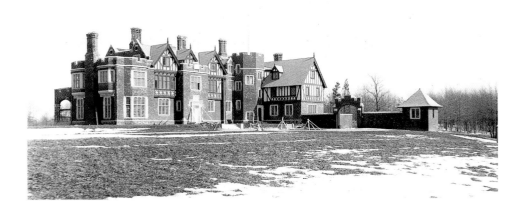

Hoppin & Koen: Floor
Plans, "Framewood,"
Sterling Postley Residence,
Oyster Bay, c. 1918 (ARTR,
1918)

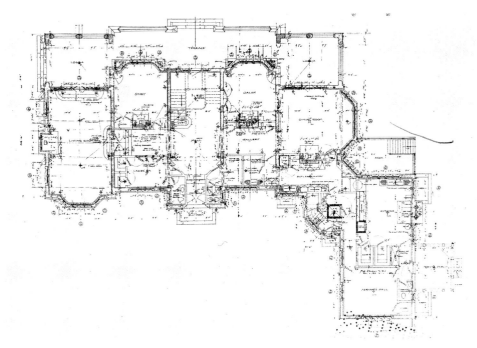

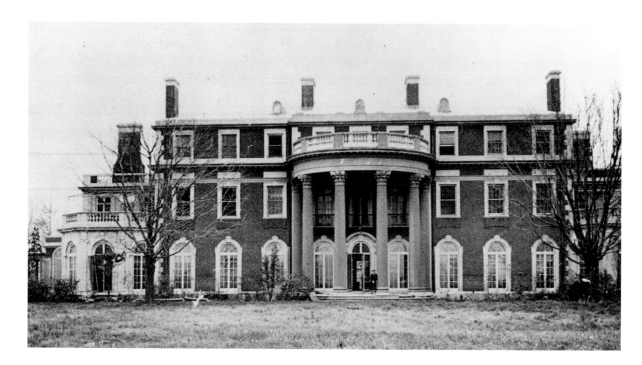

Hoppin & Koen: Rear
Facade, "Shoremond,"
Ormond G. Smith
Residence, Centre Island,
c. 1910 (Courtesy of Mr.
Thurston Smith)

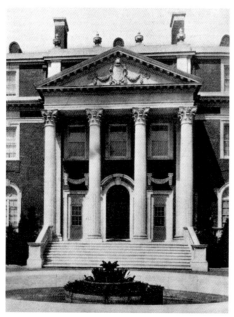

Hoppin & Koen: Detail of
Front Facade, "Shoremond,"
Ormond G. Smith
Residence, Centre Island,
c. 1910 (ARRC, 1916)

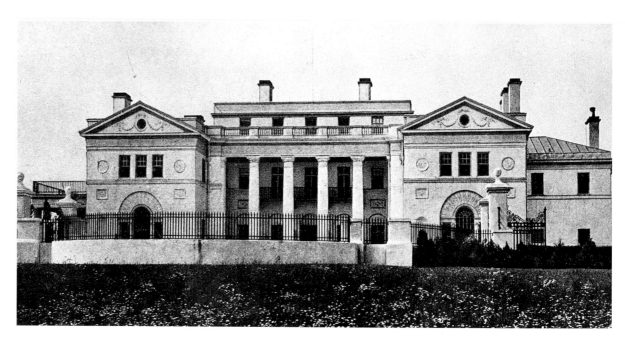

Hoppin & Koen: "Bennett
Cottage," George Rose
Residence, Westbury, 1910
(ARYB, 1912)

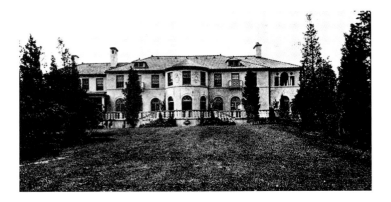

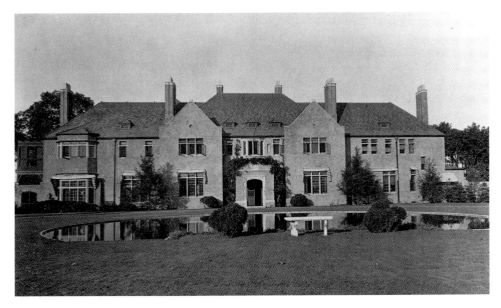

Howells & Stokes: Rear Facade, "The Cedars," H. B. Hess Residence, Huntington, c. 1914 (ARRC, 1919)

John Mead Howells: Front Facade, "Panfield," Albert Milbank Residence, Huntington, 1915 (HEWI, n.d.)

Howells & Stokes, 1897–c. 1917
John Mead Howells, 1868–1959
Isaac Newton Phelps Stokes, 1867–1944

Typical of the intricate interrelationship of professional and social life during the early 20th century was the friendship and fashionable practice of John Mead Howells and Isaac Newton Phelps Stokes. The son of a New York banker and philanthropist, Stokes had originally intended to follow his father into banking. Entering Harvard for this purpose with the Class of 1891, he met New Englander Howells, son of the novelist William Dean Howells. Giving up the idea of banking, Stokes upon graduation entered the School of Architecture at Columbia College and then joined Howells in Paris to study at the Ecole des Beaux-Arts from 1896 to 1897.

Soon after their return to New York, the young architects formed a partnership that lasted 20 years. In 1913 the firm created a sensation with the completion of the Byzantine St. Paul's Episcopal Chapel at Columbia, and, in 1923, Howells, together with Raymond Hood, won the famous Chicago Tribune Tower competition. Both partners were renowned for distinguished scholarship. Howells, an authority on early American architecture, wrote *Charles Bulfinch* (1908) and *Lost Examples of Colonial Architecture* (1931), among other books. Stokes's great enthusiasms were low-cost housing and New York history. The latter led him to edit the six volumes of *The Iconography of Manhattan Island* between 1915 and 1926. Stokes appears in the background of John Singer Sargent's superlative portrait of Mrs. Stokes, where he replaced a nervous dog.

For their several school, university, and public building designs, Howells & Stokes generally adapted the Colonial Revival or Georgian Revival modes. The Long Island houses they planned were both in Huntington. The H. B. Hess residence (c. 1914), "The Cedars," was a villa in the Italian Renaissance mode, with a sleeping porch in the guise of a Palladian loggia. It was destroyed by fire in the 1950s. "Panfield," a Tudor Revival residence with an extensive garden designed by Lewis & Valentine, was built in 1915 for Albert Milbank, a member of the law firm of Milbank, Tweed, Hope and Hadley. Howells alone is credited with "Panfield," whose most appealing feature is an unusual circular reflecting pool at the center of the forecourt.

Michael Adams

Hunt & Hunt, 1901–1924
Richard Morris Hunt, 1827–1895
Richard Howland Hunt, 1862–1931
Joseph Howland Hunt, 1870–1924

Richard Morris Hunt and his two sons, Richard Howland Hunt and Joseph Howland Hunt, who succeeded him in his practice, were responsible for several large country houses on Long Island.[1] As the first American to have studied architecture at the Ecole des Beaux-Arts in Paris, the school that formed most of the leading American architects of the next two generations, Richard Morris Hunt came to be known as the "dean" of the profession in the United States; for scores of younger men, he was like a kind uncle. His buildings were admired during his lifetime, but since then they have been overshadowed by later architecture. Looked at anew, however, his work on Long Island—and much of it elsewhere— merits respect for its intrinsic quality.[2] Richard Howland Hunt worked for his father in the later years of the senior man's activity and ran the office for five years thereafter, until he took his

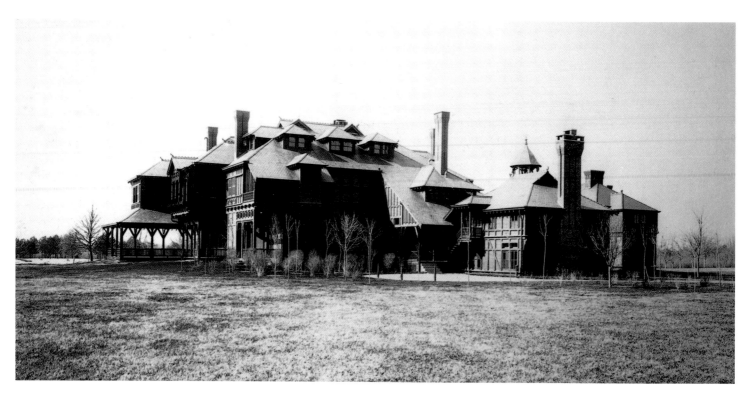

Richard Morris Hunt:
"Idle Hour," William K.
Vanderbilt Residence,
Oakdale, 1878–79 (AIA
Foundation, Washington,
D.C., c. 1880)

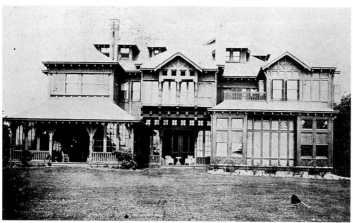

Richard Morris Hunt:
"Idle Hour," William K.
Vanderbilt Residence,
Oakdale, 1878–79 (VANB,
Album 1199, 1892)

brother Joseph as partner in 1901. The two practiced together almost two and a half decades. Though they never quite went beyond being Richard Morris Hunt's sons, their work deserves to be better known than it is.

Richard Morris Hunt was in Paris, studying architecture, from 1845 to 1854, but he had not crossed the Atlantic for that purpose. Several years earlier his widowed mother had taken her five children to Europe to live, and there the young Richard discovered his interest in architecture and was directed to the Ecole des Beaux-Arts and the atelier of Hector-Martin Lefuel (1810–80). The young American became more than a student when, in 1854, Lefuel was put in charge of the addition to the Louvre, and Hunt joined the team working on that project. He could have stayed in France and made a career for himself there, but instead the following year he chose to return to America, where he soon established himself in New York City. The prosperity that lasted for decades after the

Civil War brought him plenty of commissions for all sorts of buildings—commercial, cultural, religious, and, most of all, residential. Over the years, as the size of American fortunes increased, so did the size of his houses. In 1876 Hunt received a commission for a Long Island mansion for the Vanderbilts—the first of many he would design for various members of that family.

William Kissam Vanderbilt Residence, "Idle Hour," Oakdale, 1878–79

In 1876 William Kissam Vanderbilt (1849–1920), grandson of the Commodore, and his socially ambitious wife, Alva (1853–1933),[3] bought some 900 acres fronting Great South Bay and extending inland, along the east bank of the Connetquot River, to the Montauk Highway. Across the highway just up the river was the South Side Sportsmen's Club, formed ten years earlier to preserve an old inn and hundreds of acres of forest and meadow that had been attracting wealthy New York gentlemen for hunting and fishing since the 1820s.[4] In the mid-1860s, members of the club began to buy nearby farms on Great South Bay and to build country houses there. Thus the Vanderbilts chose for their country estate a place with a rugged, informal spirit, yet situated near the property of such wealthy and socially prominent men as George L. Lorillard, whose estate was located just across the Connetquot.

The large, wood house Richard Morris Hunt designed for William and Alva Vanderbilt embodied this spirit of roughing it in the country.

Richard Morris Hunt: St.
Mark's Church, Islip,
1879–80 (SPLI, n.d.)

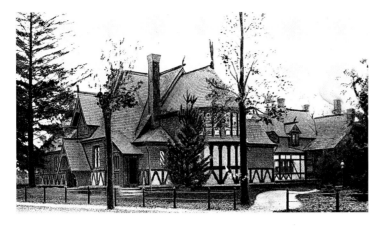

"Idle Hour" was erected in 1878–79 in a flat meadow a few feet above the water near the mouth of the slow-moving river; it was enlarged in 1883 and again in 1887–89. What we know of the house's appearance comes almost entirely from a few photos, since the first "Idle Hour" burned in 1899 and no plans seem to have survived. It looked like an enormous rustic camp. The house was rambling, with numerous projections and recessions. Porches extended outward at ground level, and dormer windows reached out through the gently pitched roofs. Some walls were half-timbered, others were clapboarded. Tall, medieval-style chimneys gave vertical accent to what was otherwise a largely horizontal composition. This picturesque house was akin to a group of smaller summer "cottages" that Hunt had designed in Newport, Rhode Island, from the 1860s on. The first of these, and the only one that remains, is the J. N. A. Griswold house (now the Newport Art Association) of 1861–63, the initial sketches for which Hunt made while revisiting France.

In creating the Griswold house and the somewhat similar ones that were to follow it, Hunt was participating in a new European revival, inspired by vernacular styles of wood architecture such as medieval half-timbered dwellings and Swiss chalets. This revival led to the construction of numerous romantic villas, some of which are still to be seen near Paris and along the Normandy coast.[5]

"Idle Hour" was by far the largest of these picturesque Hunt cottages. A newspaper article of 1880 described the house as "gayly painted" and noted that inside there was "stained glass . . . at the landing of the broad staircase" and "carved oak ceilings." There was "oaken wainscoting of the broad hall and parlors . . . so arranged that they can all be thrown together on festive occasions."[6] Possibly these surfaces looked somewhat like Hunt's interiors at "Château-sur-Mer," the Newport house that he redid in the 1870s.[7]

But it does not do "Idle Hour" justice simply to relate it to Hunt's earlier work. The house was extraordinary, with a character of its own. The photographs suggest a composition of somewhat similar units of enclosure, each broad and relatively low, and all of them organized in a way that seems additive, informal, even haphazard, but at the same time cohesive, extending outward from a generating center. And the whole thing looked as insubstantial as kindling wood. The earlier Newport chalets by Hunt appeared Gothic in their verticality; "Idle Hour," in its horizontality and breadth, was more American. Had it not burned, Richard Morris Hunt's architecture surely would be regarded differently today.

St. Mark's Church and Rectory, Islip, 1879–80 (Extant)

A suggestion of the appearance of the first "Idle Hour" can be seen in a little house Hunt designed soon afterwards—the rectory of St. Mark's Church, Islip. The rectory and the church were constructed in 1879–80, with William K. Vanderbilt as the primary donor.[8] Both buildings stand today, although the church was rebuilt after a serious fire in the late 1980s. The house, small as it is, has a kinship to "Idle Hour" in the materials (though shingles instead of clapboards), in a similar apparently random massing of units covered with shallowly pitched roofs, and in a similar breadth. St. Mark's Church is in harmony with the rectory in color and materials. The church, however, has another source, most evident in the ornamentation: Norwegian medieval church architecture, specifically wood "stave" churches. Hunt visited Norway in 1867, when he was in Europe as a member of the American Committee of Fine Arts for the Paris Exposition.[9] He made sketches of Norwegian wood vernacular architecture, such as stave churches and more modest buildings, for he saw the timber architecture of Scandinavia as a prototype for the United States. Details of St. Mark's such as the carved projections at the peak of the gables show their Scandinavian source. Yet Hunt's skill was such that the church as a whole, the rectory beside it, and the now-gone "Idle Hour" only a few miles away all seem appropriate to the American soil.

Elizabeth Coles Residence, "Rolling Stone," Glen Cove, 1887

Mention should be made, in passing, of Hunt's other work on Long Island. For Mrs. Elizabeth Coles he designed "Rolling Stone," which was built in Glen Cove in 1887. Percy Chubb bought the house about 1898, and commissioned Beatrix

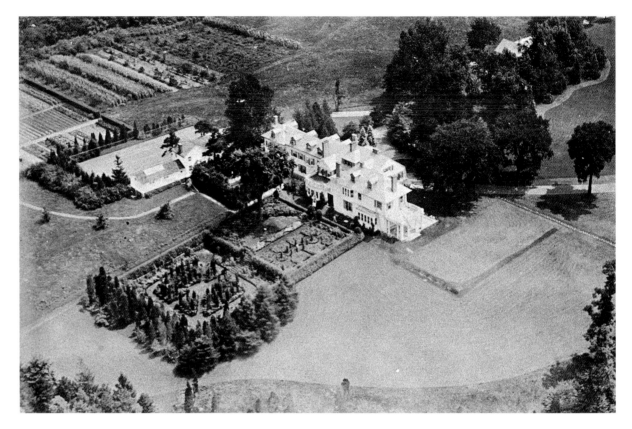

Richard Morris Hunt:
House and Gardens,
"Rolling Stone," Mrs.
Elizabeth Coles Residence,
Glen Cove, c. 1887 (AVER,
c. 1930)

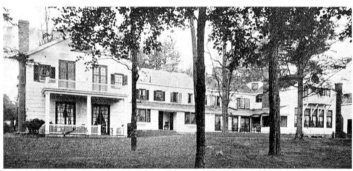

Richard Morris Hunt: Rear
Facade, "Broad Hollow
Farm," Thomas Hitchcock
Residence, Westbury,
c. 1892–93 (RUTH, 1909)

Farrand to lay out the garden in 1900. The building was demolished around 1948. An aerial photograph from about 1930 shows a rambling, two-story, white house, with a third story lit by dormer windows; the style appears to have been Colonial Revival.

Thomas Hitchcock Residence, "Broad Hollow Farm," Westbury, 1892–93 (Extant)

Hunt remodeled this residence, at the core of which is a 17th-century house around which later additions were made. As completed by Hunt, it is Colonial Revival, white, and rambling. The two-story walls were surfaced with shingles.

Richard Morris Hunt died in 1895.

Richard Howland Hunt, the oldest child of Richard Morris and Catherine Howland Hunt, was born in Paris, where his parents had gone shortly after their marriage in April 1861, and where they stayed until October 1862. Young Hunt studied architecture first at M.I.T., from

1880 to 1882, and then at the Ecole des Beaux-Arts, from 1885 to 1887.[10] He was in the atelier of Honoré Daumet (1826–1911), a contemporary of his father's at the Ecole des Beaux-Arts. Daumet had won the Grand Prix de Rome in 1855, and by the 1880s his atelier had acquired the prestige of having trained other winners of the Grand Prix.

When Hunt returned to New York in 1887, he at once began to play an important part in his father's office. With the death of Hunt senior in August 1895, Richard became the principal of the firm, and its work carried his name until January 1, 1901, when he formed a partnership with his brother Joseph. Among Richard Howland Hunt's major works are the great entrance hall at the Metropolitan Museum of Art, New York, for which his father had made the initial sketches in 1894. The son developed his father's idea and saw the building to its completion in 1902. Other buildings that are entirely by Richard Howland Hunt are Quintard and Hoffman Halls at the University of the South, Kissam Hall at Vanderbilt University, and several very large houses.[11]

O. H. P. Belmont Residence, "Brookholt," Hempstead, 1897

In 1895 Alva Vanderbilt divorced William K. Vanderbilt, and the next year she married O. H. P. Belmont (1858–1908).[12] Although she left "Idle Hour," she continued to inhabit and

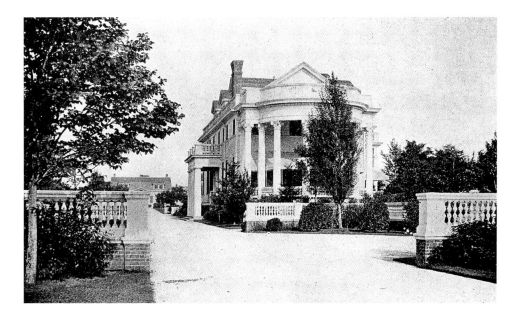

Richard Howland Hunt:
Front Entrance,
"Brookholt," O. H. P.
Belmont Residence,
Hempstead, 1897 (TOWN,
1903)

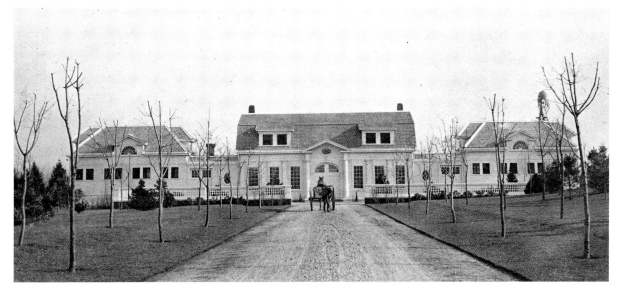

Richard Howland Hunt:
Stable/Barn Complex,
"Brookholt," O. H. P.
Belmont Residence,
Hempstead, 1897 (VANB,
Album 1237, 1901)

bring into being Hunt houses. Shortly after "Idle Hour" had been completed, Alva and William Vanderbilt commissioned Richard Morris Hunt to design a mansion in New York, and in 1878–83 on Fifth Avenue was built what looked like a Loire Valley château. It set a new standard of splendor in the city, and Alva used it to lift herself and the other Vanderbilts into the top "400" of Society. Once there, Alva evidently found the masculine rusticity of the South Shore of Long Island not the place for her ambition; during the summer of 1883, when "Idle Hour" was only four years old, a Long Island newspaper reported that Mr. and Mrs. William K. Vanderbilt were "occupying a cottage in Newport."[13] In 1888, as a birthday present from her husband, Alva had Hunt design a Newport mansion as grand as the one on Fifth Avenue: "Marble House," completed in 1892, looks like a cross between the Petit Trianon at Versailles and the White House in Washington. Three years later Alva divorced William. She kept "Marble House" but ceased

summering in it. When she married O. H. P. Belmont, she moved down Bellevue Avenue, Newport, to his house, "Belcourt," yet another château by Richard Morris Hunt. In 1897 Alva and O. H. P. Belmont engaged Richard Howland Hunt to design a house for them on Long Island. "Brookholt" has something of the spirit of the 18th-century country house—whether French classic or English Palladian—translated into white, painted wood.

William K. Vanderbilt Residence, "Idle Hour (II)," Oakdale, 1899–1900 (Extant)

In 1899 "Idle Hour" was destroyed by fire. William Vanderbilt decided almost immediately to rebuild on the same site and engaged Richard Howland Hunt as his architect. The second "Idle Hour" was completed in 1900, with an addition in 1902–04 by Warren & Wetmore. In contrast

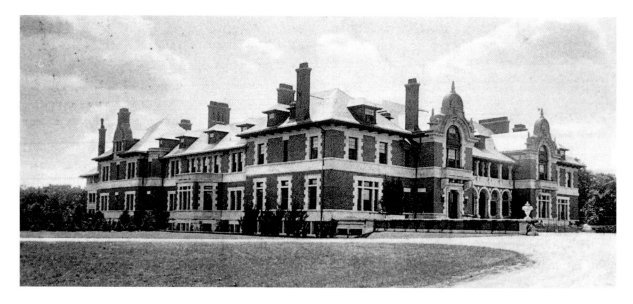

Richard Howland Hunt: "Idle Hour (II)," William K. Vanderbilt Residence, Oakdale, 1899 (VAND, c. 1907)

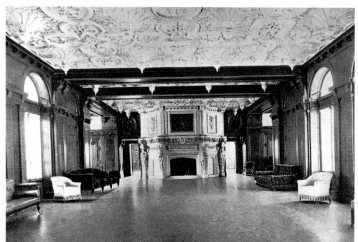

Richard Howland Hunt: Living Hall, "Idle Hour (II)," William K. Vanderbilt Residence, Oakdale, 1899 (VAND, n.d.)

Richard Howland Hunt: Staircase Detail, "Idle Hour (II)," William K. Vanderbilt Residence, Oakdale, 1899 (VAND, n.d.)

to its predecessor, "Idle Hour (II)" looks weighty, broad, and low. It is a fireproof building with brick walls and overscaled limestone trim. A limestone belt course between the two stories creates a thick horizontal extending around the house, and the shallow, hipped roofs further emphasize this horizontality. As a contrast there are recessions and projections in the wall-plane that indicate the main interior spaces of the ground floor [the treatment of "Idle Hour (I)" indicated the spaces of both stories], and, in further contrast to the horizontality, are slender chimneys rising from the roofs, and, most conspicuous, pavilions that project well forward from the walls and rise high to carry elaborate Dutch step-gables ornamented with such baroque flourishes as obelisks. Perhaps Hunt featured Dutch gables because of the Vanderbilt family's lineage. The interiors are palatial. The grand living hall has a ceiling that could almost be late Gothic pendant vaulting in England, and an enormous, freestanding fireplace that might have been found in Renaissance France. The woodwork

of the staircase and a screen in the smoking room suggests Renaissance palaces north of the Alps; one of the salons is said to have been removed from a French 18th-century building.[14] These interiors allude directly to European architecture. If "Idle Hour (I)" was an attempt to establish an American architecture, "Idle Hour (II)" embodies the wish of turn-of-the-century American millionaires to relate their lives to those of European aristocracy.

Joseph Howland Hunt, who became his brother Richard's partner on January 1, 1901, was the third of Richard Morris Hunt's five children. Born in New York City, he graduated from Harvard College in 1892 and for the next two years studied architecture at Columbia College, while working in his father's office. From 1894 until 1900 he was in Paris in the atelier Daumet and from 1895 onwards at the Ecole des Beaux-Arts. He also traveled widely throughout Europe and as far as Russia, Romania, and Turkey. His partnership with his brother endured until

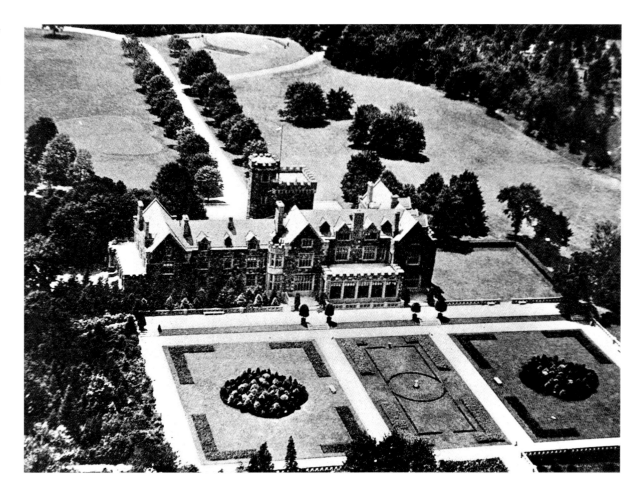

Hunt & Hunt: Rear Facade and Formal Gardens, "Castlegould," Howard Gould Residence, Sands Point, 1909–11 (ARTS, 1922)

Hunt & Hunt: Entrance Front, "Castlegould," Howard Gould Residence, Sands Point, 1909–11 (North Shore Science Museum pamphlet)

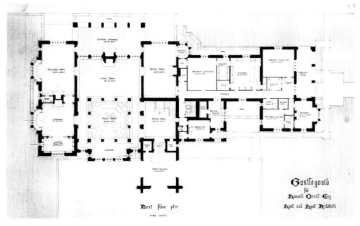

Hunt & Hunt: First Floor Plan, "Castlegould," Howard Gould Residence, Sands Point, 1909–11 (The AIA Foundation, Washington, D.C.)

Joseph's death. Among the firm's buildings that were his particular concern are, in New York City, the 69th Regiment Armory, Lexington Avenue between 25th and 26th Streets; the Fisk building, Broadway and 57th Street; Williams Hall and the Alumnae Building at Vassar College; a number of large houses; and buildings for the Tata Iron & Steel Co. at Jamshedpur, India, where he spent eight months.[15]

Howard Gould Residence, "Castlegould," Sands Point, 1909–11 (Extant)

Howard Gould (1871–1959), son of the financial and railroad magnate Jay Gould, was doubly motivated to build a castle. The woman he married in 1898 wished to have a residence that

would remind her, it is said, of Kilkenny Castle in Ireland, and he himself had lived as a boy in "Lyndhurst," A. J. Davis's Gothic pile overlooking the Hudson at Tarrytown, New York. The Goulds in 1901 hired the architect Abner J. Haydel (1868–1931) to design their Gothic house but rejected his proposal.[16] In 1907 Gould and his wife separated, yet he evidently remained convinced that his house should be in the medieval style, and in 1909 he turned to Hunt & Hunt. Richard Howland Hunt was in charge of the project.[17]

A visitor's first view of "Castlegould" is across a broad meadow, beyond a line of trees. Above the roofs and trees rises a massive tower, square

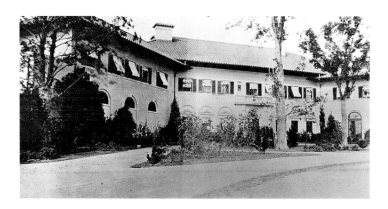

Hunt & Hunt: Front Facade, "La Selva," Henry Sanderson Residence, Brookville, c. 1915–16 (FLON, 1917)

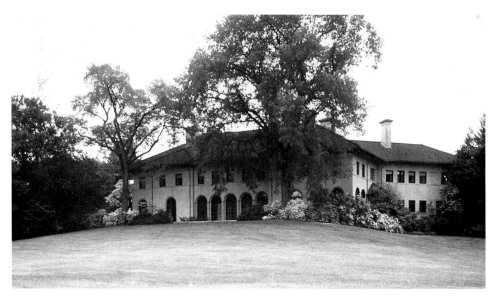

Hunt & Hunt: Rear Facade, "La Selva," Henry Sanderson Residence, Brookville, c. 1915–16 (Richard Chafee photo, 1987)

in plan, its wall crenellated like the keep of a castle. Higher yet is a slimmer tower, also crenellated. Seen up close, the building looks like a granite fortress with additions made later in a more peaceful age; from the shore of Long Island Sound, just beyond a terrace, the house looks more in the style of Elizabethan residential architecture (and almost like early 20th-century academic Gothic architecture). And yet these two main references—military and residential—are close enough so that the overall impression the exterior of the house makes is the coherent one of a *château-fort.*

Inside, there is a surprise. The plan of the major rooms on the ground floor consists of a series of axes and cross-axes—what one would expect from an architect trained at the Ecole des Beaux-Arts—but the effect is of space hollowed out of the massive building and of space within space. Extending from the approach-side to the sea-side is the main interior volume, the "living room" (as it is called on the plan). Within it, towards one end, is a "palm room," a smaller space defined by a screen of piers inside the major space of the living room. Towards the sea, the end wall of the living room consists of a pair of glass double doors on both sides of a baronial fireplace, and beyond the glass is a "covered

terrace," a space that is inside and yet more exterior than the living room proper. The relation of these main spaces in "Castlegould" is unexpected and luxurious.[18]

Henry Sanderson Residence, "La Selva," Brookville, 1915–16 (Extant)

Sanderson, who made money in electric lighting and trolley lines, and also as a broker and banker, engaged Hunt & Hunt as architects for his house on Long Island.[19] The design is said to have been by Joseph Hunt.[20] A two-story Mediterranean villa, which contemporaries saw as Italian,[21] "La Selva" has pebble-dash walls and tiled roofs, with window surrounds and doorways in the style of the Italian Renaissance. The house has what has come to be called a butterfly plan. The approach is along a gently winding road, through a pine forest—"La Selva" means forest or wood—along the edge of a meadow or two, at a slight downward incline. The road swings towards the center of the broad house, the side wings of which extend forward. Entering the front door, one passes through a vestibule and across a generous hallway beyond which, on axis, is a loggia. Beyond that is the surprise: straight ahead is a meadow that tilts downward towards a wall of trees. This meadow

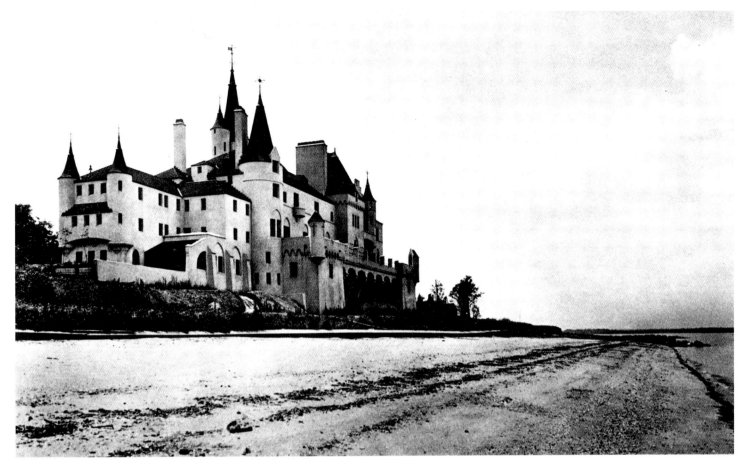

Hunt & Hunt: Rear (Water) Facade, "Beacon Towers," Mrs. O.H.P. Belmont Residence, Sands Point, 1917–18 (VANB, Album 1197, n.d.)

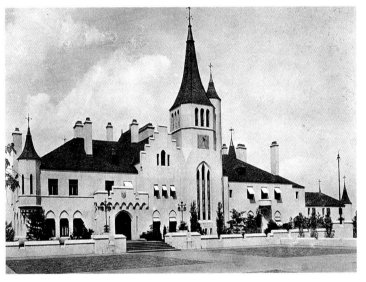

Hunt & Hunt: Front Facade, "Beacon Towers," Mrs. O.H.P. Belmont Residence, Sands Point, 1917–18 (VANB, Album 1197, n.d.)

is a broad ridge, on each side of which the land falls away steeply to the forest edge below. The gentle approach to "La Selva" gives no hint of such a dramatic landscape.

Mrs. O. H. P. Belmont Residence, "Beacon Towers," Sands Point, c. 1917–18

The last of the large Hunt & Hunt houses on Long Island was yet another residence for Alva Smith Vanderbilt Belmont, who was widowed in 1908. In the late 1910s she had Richard Howland Hunt design "Beacon Towers," a

Gothic fantasy.[22] The house looked weightless, like a painting, or a backdrop in a theater. Playful, it seemed inspired not so much by actual buildings—although it did owe something to the late medieval palace of the Alcázar in Seville—as by medieval illuminated manuscripts such as the *Très Riches Heures du Duc de Berry*. The walls were surfaced in an off-white stucco that was dreamily smooth; against the skyline rose astonishing towers and pinnacles. Expected details like window surrounds were absent, intensifying an impression of unreality. One is reminded, curiously enough, of buildings of the 1920s that are also smooth-surfaced, white, and apparently insubstantial—for example, the early work of Le Corbusier, Walter Gropius, and other members of the Modern Movement. Those architects rationalized their apparently floating buildings as appropriate to new structural materials in a new age. "Beacon Towers" did not pretend to be rational; it existed as if in a world of make-believe. The estate was sold in 1927 to the famous publisher William Randolph Hearst (1863–1951), who already owned a fantastic castle in California, the architect Julia Morgan's "San Simeon." Hearst sold "Beacon Towers" in 1942, and a year or so later it was demolished.

Forty years separate the first "Idle Hour" of 1878 and "Beacon Towers" of around 1918,

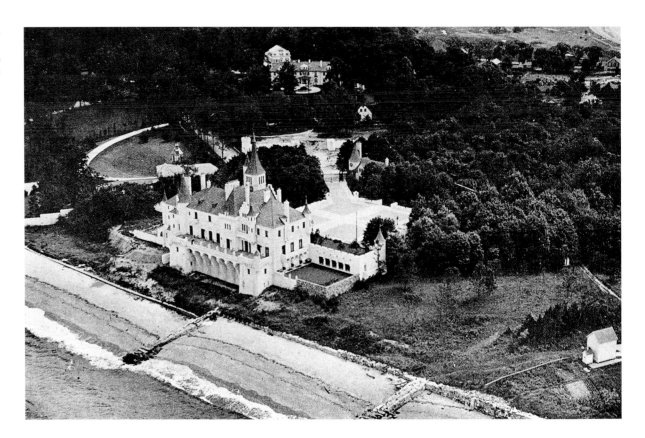

Hunt & Hunt: Aerial View, "Beacon Towers," Mrs. O.H.P. Belmont Residence, Sands Point, 1917–18 (PATT, 1924)

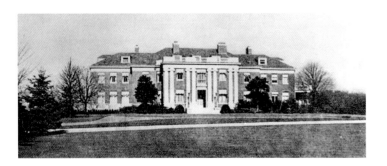

Hunt & Hunt: Front Facade, S. L. Schoonmacker Residence, Locust Valley, 1918 (ARLG, 1918)

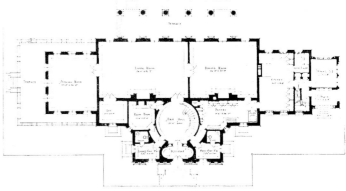

Hunt & Hunt: Floor Plan, S. L. Schoonmacker Residence, Locust Valley, 1918 (ARLG, 1918)

Richard Morris Hunt's first Long Island house, and Hunt & Hunt's last house on the island. "Idle Hour" proposes what might be an American architecture; "Beacon Towers" is a fantasy of Europe in the time of the Crusades. Both were for that singular client, Alva Smith Vanderbilt Belmont. The houses she commissioned give us glimpses of her aspirations, and all the Hunt buildings on Long Island reveal the diverse talents of the three architects.

Richard Chafee

Hunt & Kline, practiced 1920s–1930s

Edwin Kline, 1890–1956

Albert Hunt

Edwin Kline, architectural partner of F. Albert Hunt, specialized in Long Island residential architecture. He lived in Great Neck himself, and was a consultant for developments in Freeport Acres; Sutton Park, Lawrence; University Gardens, Great Neck; and Great Neck Estates, Plandome. He also designed town and village halls in North Hempstead, Lake Success, and Manor Haven.

Hunt & Kline designed "Sunny Knoll" in Kings Point for Oscar Hammerstein II around 1929. At the time, Hammerstein was married to Dorothy Blanchard. A Tudor Revival-style house, "Sunny Knoll" was a picturesque compo-

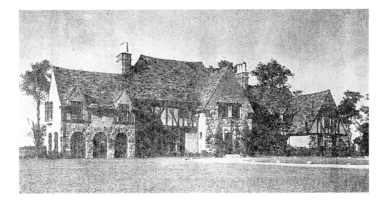

Hunt & Kline: Front facade, "Sunny Knoll," Oscar Hammerstein II Residence, Kings Point, c. 1929 (ARTS, 1929)

sition with steep roofs, projecting gables, and a richly textured exterior that combined random-ashlar fieldstone with half-timber work and rough clapboards.

The architects were much concerned with creating a sense of age, as is evident from an article Edwin Kline published about the house in *Arts & Decoration*, February 1929:

The house is built of a pleasing blend of local beach stones, hewn chestnut half-timber and rather rough cast stucco. The stone work is especially interesting and colorful as the stones were carefully selected for their color range. A suggestion of the same tones warms the stucco surfaces, produced by spraying a special paint in several colors over the natural cement stucco. The timbers are treated with a dark neutral stain which gives the impression of well-seasoned, weather-beaten woodwork and adds to the sense of age, which has withstood the onslaught of time and has profited by it. The roof is of variegated tile.

A writer of lyrics and librettos, Hammerstein collaborated with Jerome Kern and Richard Rodgers on various outstanding musicals. With the latter he produced *Oklahoma* (1943), *South Pacific* (1949), and *The King and I* (1951).

Ellen Fletcher

Innocenti & Webel: Landscape Design, "Highwood," Edwin Gould Residence, Oyster Bay, c. 1935 (GOTT, 1934)

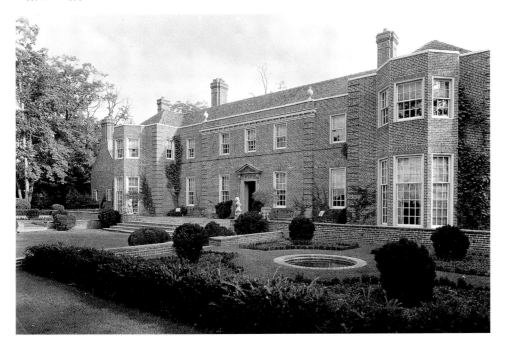

Innocenti & Webel, 1931 to present
Umberto Innocenti, 1895–1968
Richard K. Webel, 1900–1992

Born in Florence, Italy, Umberto Innocenti came to America in 1925 on a landscape scholarship from the University of Florence. Employed by Ferruccio Vitale until 1931, he then formed a partnership with Richard K. Webel. Innocenti's home in Roslyn, New York, became a horticultural showpiece where he pioneered the use of espaliered evergreens. He used annuals only in pots—so that they could be changed frequently—but made abundant use of evergreens and advocated the use of native plant materials whenever possible.[1]

Richard K. Webel was born in Frankenthal, Germany. From 1920 to 1939 he was a faculty member of the Harvard School of Design. He spent three of those years, 1926–29, at the American Academy in Rome. His design philosophy had a classical bent, stressing the use of architectural elements to define space. He saw each commission as representing its own site-specific problem which, once understood, called for the simplest solution.[2]

Edwin Gould Residence, "Highwood," Oyster Bay, Landscape Design, c. 1935

One of the firm's first commissions was the Edwin Gould estate at Oyster Bay, whose Georgian-style brick house was designed by architect Henry Corse (1931). The garden facade terrace was paved with flagstones laid in earth with plantings in the joints. Steps led down to a central stretch of lawn bordered by low brick walls which joined up to become a semicircular seating alcove. Two identical evergreen gardens flanked the lawn bordering the house. Paths divided them into quadrants, each with an evergreen-filled box-bordered bed. Each garden centered on a circular pool. The brick walls defining the walk and gardens carried both the architectural quality and the coloration of the house into the surrounding area which was screened round by woodlands.

Frank Finlayson Residence, Locust Valley, Landscape Design, c. 1937

Innocenti & Webel's design plan for the Frank Finlayson residence at Locust Valley had to be sympathetic to an existing stand of large English elms. An old farmhouse had been moved onto the site, its orientation reversed and alterations made using material from other Long Island

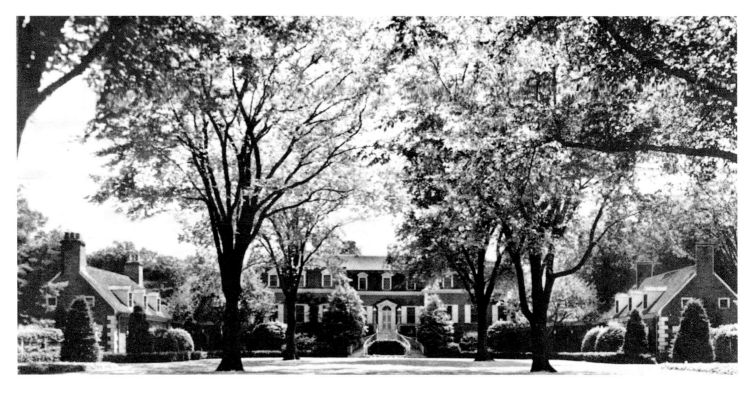

Innocenti & Webel:
Landscape Design,
"Easton," Mrs. Diego
Suarez Estate, Syosset,
c. 1936 (PREV, n.d.)

farmhouses. The architect, Bradley Delehanty, set the farmhouse among the elms with two of the trees framing a doorway. Flagstone terraces, one giving onto an enclosed garden, were set to the south and west of the house. The plantings on the rest of the grounds, most of which had had to be drained, consisted mainly of shade trees set in rolling lawns. A curved, graveled driveway completed the "English" effect.

Mrs. Diego Suarez Residence, "Easton," Syosset, Landscape Design, c. 1936

Trees were also Innocenti & Webel's main planting element for the Syosset residence of Mrs. Diego Suarez, designed by architect David Adler (c. 1933). The house was set on a very hilly site. A dip in the land to the front of the house was filled in to create a large lawn forecourt upon which were planted parallel lines of elms. The rear porticoed facade led down onto a lawn planted with specimen trees on both sides of the portico. Elms, apples, hollies, and shadblows were also planted on the estate.

Charles McCann Residence, "Sunken Orchard," Oyster Bay, Landscape Design, c. 1936

The Georgian-style brick residence of Charles McCann, designed in 1916 for an earlier owner by George de Gersdorff, was set around with shade trees, evergreens, and flowering shrubs. The northern entry-face courtyard was enlivened with dogwood, rhododendron, azalea, laurel, and white birch. The southern facade was bordered by a long, grassed terrace that joined onto landscaped lawns, with meadows stretching out beyond them. A formal feature was a turf walk, bounded on one side by a high, clipped-cedar hedge and on the other by a row of slender columns. Below the level of the walk lay an enclosed evergreen garden surrounded by magnolias.

Another formal feature was an elaborate French-style garden, designed by Annette Hoyt Flanders, which won the Architectural League of New York's Gold Medal for Landscape Design in 1932.

Other Long Island commissions by Innocenti & Webel included "Sunninghill," Martin Richmond's residence at Glen Head, with a small enclosed garden planted by Ellen Shipman; Eugene M. Geddes's residence at Locust Valley; and the Woodbury estate of Mrs. Richard Babcock, with its specimen trees, including large red maples.

Wendy Joy Darby

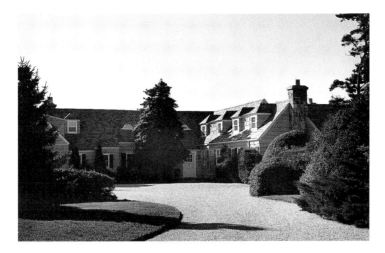

Chauncey Ives: Entrance Court, Warren Curtis Residence, Southampton, c. 1914 (INVE, 1979)

Chauncey Ives, practiced c. 1910s

A man of many talents, Chauncey Ives was a ceramicist, a gunsmith, and an architect. A longtime Southampton resident, he lived for a time in the Art Village there. Ives served as architect for the Warren Curtis residence in Southampton (c. 1914), as well as for a number of smaller homes in the area. The Curtis residence is a rambling Colonial Revival, gable-roofed, shingle house.

Carol A. Traynor

Allen W. Jackson, practiced c. 1900–1910s

Allen W. Jackson: West Elevation, "The Monastery," Dr. Farquahar Ferguson Residence, Huntington, 1908 (Family Album, courtesy of Robert King)

Allen W. Jackson: Grand Hall, "The Monastery," Dr. Farquahar Ferguson Residence, Huntington, 1908 (HUNT, n.d.)

Allen W. Jackson: Detail Showing Courtyard and Cloister, "The Monastery," Dr. Farquahar Ferguson Residence, Huntington, 1908 (Family Album, courtesy of Robert King)

An architect who practiced in Boston, Allen Jackson was commissioned to design a residence on the estate of Dr. Farquahar Ferguson, a New York City pathologist, and his wife Julia, daughter of H. Ogden Armour, founder of the Armour Meat Company. The estate overlooked Huntington Harbor, and the residence Jackson designed between 1908 and 1911 was named "The Monastery." A 50-room Italian Renaissance-style structure of concrete and stucco, it was centered around an inner courtyard and cloister and featured a great hall with skylights. A great many of the construction materials had been salvaged from European buildings, including the roof tiles, marble columns, and stone flooring. The estate was demolished in the 1970s.

Carol A. Traynor

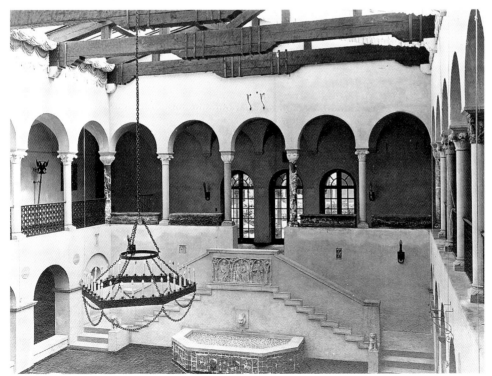

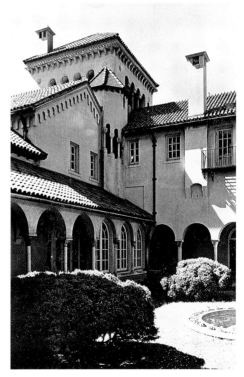

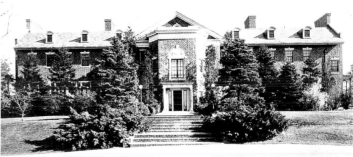

J. Sarsfield Kennedy: Foster Crampton Residence, Westhampton, c. 1909 (REAL, 1909)

Kern & Lippert: "Bayberry Hill," William Kennedy Residence, Syosset, c. 1922 (PREV, n.d.)

J. Sarsfield Kennedy, practiced c. 1909–1925

Little is known of the career of J. Sarsfield Kennedy, except that he maintained an architectural practice in Brooklyn, New York, between 1909 and 1925. His country residence in Westhampton for Foster Crampton was built before 1909, when it appeared in the *Real Estate Record and Guide*. The distinctive features of the Mediterranean villa-style residence were its fieldstone foundation and porte cochere.

Carol A. Traynor

Kern & Lippert, practiced 1920s–1930s

The architectural firm of Kern & Lippert designed the c. 1922 "Bayberry Hill" residence for William Kennedy in Syosset (still extant). Impressive in its simplicity and balance, this Georgian-style house was set in grounds beautifully landscaped by the Hicks Nurseries. "Bayberry Hill" is the second house built on this site for Kennedy, the first having been destroyed by fire in 1921, although some outbuildings in the Shingle Style probably date from the original building phases.

Carol A. Traynor

Kimball & Husted, 1934–1959
Richard A. Kimball, b. 1899
Ellery Husted, 1901–1967

Born in Ohio, Richard Kimball was educated at Yale and began his career first as a draftsman in the offices of Thomas H. Ellett and later in the James Gamble Rogers office. His future partner, New York native Ellery Husted, who also received his education at Yale, started in the office of James Gamble Rogers. The principal works of the Kimball and Husted partnership included the President's house at Yale (1938) and the Memorial Assembly Hall for St. Paul's School in Concord, New Hampshire. On Long Island, the firm designed a Federal-style brick residence for Alexander M. White, Jr., the son of the founder of the banking firm of White, Weld & Co. The two-story, T-shaped structure (c. 1935) was based on prototypes in the James River area of Virginia. In the same year, the firm also designed the gate lodge and farm buildings for the Edith Pratt McLane estate in Glen Cove. The architects continued to receive commissions on Long Island into the 1940s, designing houses for, among others, Henry E. Coe and Thomas S. Lamont in Oyster Bay.

Carol A. Traynor

Kimball & Husted: A. M. White, Jr., Residence, Oyster Bay, c. 1935 (ARRC, 1938)

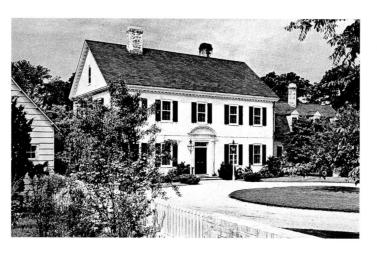

R. Barfoot King, practiced 1920s

After amassing a fortune in the synthetics industry, Pennsylvania-born Rufus Scott purchased a 19th-century Quaker farm in Lattingtown. The house had already been modified in 1923, before Scott acquired it, but he commissioned architect King to proceed with even more radical changes. King tripled the size of the building, transforming a modest farmhouse into an elegant Colonial Revival manse known as "Scottage." He provi-

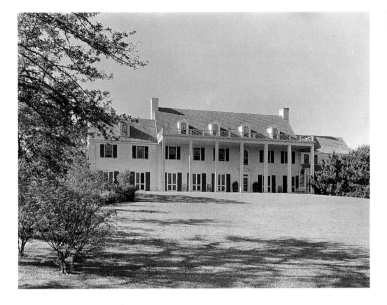

R. Barfoot King: Rear Facade, "Scottage," Rufus Scott Residence, Lattingtown, c. 1929 (GOTT, 1934)

ded a restrained interpretation of Mount Vernon—shingled, with shuttered sash in alignment, and dormers above.

On the interior, the residence was tastefully decorated by Louise Tiffany Taylor, a descendant of Louis C. Tiffany, while the extensive grounds were designed by landscape architect Noel Chamberlain in 1929. In addition to the main house, the estate contained an octagonal pavilion in the Classical style, built as a card room by Scott, as well as a guest house adjoining a sunken parterred garden. This expression of Anglo-American, country-house life remains in an excellent state of preservation.

Michael Adams

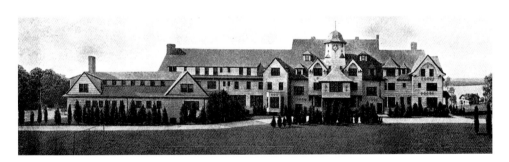

Kirby, Petit & Green: Belle Terre Clubhouse, Port Jefferson, c. 1906 (COUN, 1908)

Kirby, Petit & Green: Front Facade and Entrance Court, "Kanonsioni," Robert B. Dodson Residence, West Islip, c. 1905 (AABN, 1906)

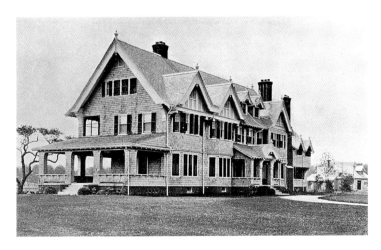

Kirby, Petit & Green, c. 1904–1909
Kirby & Petit, 1909–1915
Henry P. Kirby, 1853–1915

Stylistic variety characterized the work of Henry P. Kirby and his partners John Petit and James Green. Contemporary critics considered their Biological Laboratory for the Carnegie Institute in Cold Spring Harbor, New York (1904), "Italian Renaissance";[1] their office building for the Bush Terminal Company in Manhattan (1904–05), "Jacobean";[2] their New York townhouse for Mrs. H. P. Gilbert (c. 1908), "Gothic";[3] and their Hearst Building in San Francisco (1907–09), "Mission Style."[4] Their best-known design in the East, the Country Life Press Building in Garden City (1910), was in the manner of a Tudor palace. And the style for their country houses tended to be either Colonial Georgian, or Shingle Style with a French accent.

Facts concerning the three partners are extremely scanty; indeed only about Kirby do we know anything at all. He was born in Seneca County, New York, in 1853, the son of a local architect. Although he received no formal higher education in the United States, Kirby must have learned a great deal from his architect-father, for in the early 1880s he was accepted to the Ecole des Beaux-Arts in Paris, where he completed "an advanced course of study."[5] In 1882 he traveled through Normandy sketching half-timbered houses and Renaissance châteaus. (Some of the drawings from this trip would later appear in his 1892 book, *Architectural Compositions*.)[6] Upon his return to the United States, he became a draftsman in the New York office of George Browne Post, an extremely successful architect recognized today for his contributions to the development of the skyscraper.[7] Kirby remained Post's draftsman for 20 years (1883–1903), during which time he presumably contributed to the design of such buildings as the châteauesque Cornelius Vanderbilt House on 57th Street (1882–85) and the Greco-Roman New York Stock Exchange (1901–04). Around 1903 Kirby was promoted to head designer in Post's office, but the following year he decided to form his own practice with partners John Petit and James Green.[8] After Green left the firm around 1909, Kirby and Petit carried on until Kirby's death in 1915.

Within the first two years of their practice, Kirby, Petit & Green designed several buildings on Long Island, including the Carnegie Institute laboratory mentioned above, the Belle Terre Clubhouse at Port Jefferson (c. 1906),[9]

Kirby, Petit & Green: Front
Facade, F. N. Doubleday
Residence, Mill Neck,
c. 1904 (AABN, 1906)

Kirby, Petit & Green: Rear
Facade, F. N. Doubleday
Residence, Mill Neck,
c. 1904 (AABN, 1906)

and two shingled houses: one for Robert
Dodson in West Islip and another for Frank
Doubleday in Mill Neck.

Robert B. Dodson Residence, "Kanonsioni," West Islip, c. 1905

No drawings were ever published for this house
for Robert Dodson (1849-1938), a banker and
stockbroker, but old photographs suggest its
plan was organized along a single long axis.
In fact, the name for the Dodson House,
"Kanonsioni," was taken from an Indian word
meaning "long house." In 1928 "Kanonsioni"
was described as having "eighteen large, light,
well arranged rooms . . . four baths . . . [and]
seven open fireplaces."[10] Its 13 acres included
a gardener's cottage, a stable, a garage, some
winding nature trails, and a formal garden with
pergolas. Aside from a stone foundation and
some half-timbering in the gables, the house
was completely sheathed in shingles. The dorm-

ers and gables have deep overhanging hoods
in a French style; since similar hoods can be
found in architectural sketches Kirby executed
in Normandy in the 1880s, it is not unreason-
able to assume that in this case he was the chief
designer.

Frank Nelson Doubleday Residence, Mill Neck, c. 1904

At the time he commissioned his house, Frank
Doubleday (1862–1934) was president of Double-
day, Page and Company, one of the premier
publishing houses in America. Soon after the ar-
chitectural firm of Kirby, Petit & Green was
formed, Doubleday hired John Petit to design
a country house for himself and his wife, the au-
thor and naturalist Neltje De Graff (1865–1918).[11]

Petit's design was based on a combination
of motifs drawn from a variety of 18th- and
19th-century American houses. The cupola, and
the relationship of the main chimneys to the
cupola, for example, were inspired by George
Washington's Mount Vernon. So were the
dormers and roof-line balustrade.[12] The main
doorways with their side lights and elliptical
fanlight were drawn from Federalist models
(c. 1810), while the huge two-story porch in
back—supported with massive Ionic columns
of four volutes each—smacks of the southern
Greek Revival (c. 1850). The front entrance
porch originally had just two columns, but
between 1906 and 1912 it was replaced by a
wider porch with two pairs of columns—again
inspired by early 19th-century examples.[13] The
Y-shaped plan, however, as well as the one-story

Kirby, Petit & Green:
"Effendi Hill," Second F. N.
Doubleday Residence, Mill
Neck, 1914–16 (Courtesy of
Mrs. MacLeoud, n.d.)

porches supported by Tuscan columns, were derived not from any Georgian or Greek Revival precedents, but from such houses as McKim, Mead & White's 1886 residence for John Cowdin in Far Rockaway.

Frank Nelson Doubleday Residence, "Effendi Hill," Mill Neck, 1914–16 (Partially Extant)

In 1910, five years after he had completed the shingled Doubleday house, the satisfied publisher asked Petit to design a printing plant in Garden City for *Country Life* magazine, a publication owned by Doubleday, Page and Company. Within a couple of months Petit and Kirby had produced hundreds of drawings for the huge Tudor-style structure; and, thanks to heroic construction efforts, operations were begun in the new Country Life Press Building just six months after the first sketch.[14] Doubleday's business must have prospered quickly, for in 1914 he decided to build himself a grander house. His shingle house, less than a decade old, was razed and Petit was hired to replace it with a brick residence of generous size.

Like the first Doubleday house, the second is Colonial Georgian in style, based loosely on 18th-century plantation houses in the Tidewater region of Virginia. The main block of the house can be interpreted as an elongated version of "Westover" (c. 1730) without the hipped roof.

Besides the two-and-a-half-story brick facade, both houses share a flight of steps leading to an entrance topped with a swan's neck pediment. The gables and chimneys at either end of the Doubleday house could have been taken from the famous Reynolds-Morris house in Philadelphia (1786); the same is true for the distinctive keystone motifs over each of the windows. Since drawings of the Doubleday house were never published, there is no way of knowing whether Petit tried to follow an 18th-century plan.[15]

Both Doubleday houses were beautifully sited on a wooded hill overlooking Oyster Bay. A large formal garden was set to one side, consisting of square parterres arranged in a grid with a fountain in the middle. Adjacent to the main block of the house was a service wing containing a three-car garage. The name of the second Doubleday residence, "Effendi Hill," was Rudyard Kipling's nickname for Doubleday, a tongue-in-cheek reference to the publisher's initials, "F. N. D."

In the 1950s the house was seriously altered. The two top stories of the main block were removed and the garage was converted into a separate residence.

Gavin Townsend

Christopher Grant La Farge,
1862–1938 (BRIC, 1915)

Christopher Grant La Farge, 1862–1938

In the course of his lengthy career, Christopher Grant La Farge was associated with several partnerships: with George Louis Heins (1886–1907); with Benjamin Wistar Morris (1910–15); and, after several years of practicing alone, with the firm La Farge, Warren & Clark, and its successor firm, La Farge, Clark & Creighton. Finally, his son Christopher practiced with him in the firm of La Farge & Son. Although he is better known for his work on public and ecclesiastical buildings throughout the state of New York than for his domestic work on Long Island, La Farge was, in fact, involved in the design of at least three important residences on the Island: the J. P. Morgan, Jr., house in Glen Cove (demolished 1980); the John Hay Whitney Boathouse in Manhasset; and an addition to Theodore Roosevelt's "Sagamore Hill" in Oyster Bay.

The son of the well-known stained-glass artist John La Farge, the young La Farge was trained at M.I.T., and in the offices of H. H. Richardson, before he formed his own partnership with George Louis Heins. He had met the latter while both were students at M.I.T. In their successful partnership, La Farge designed while Heins took care of the business end of affairs.

Two years after the firm was established, it vaulted to success by winning the competition for the design of the Cathedral of St. John the Divine in New York City. Subsequent to this triumph, the firm received numerous ecclesiastical and institutional commissions, including the designs for all of the subway stations for the Rapid Transit Commission in New York and major churches throughout the United States.

Theodore Roosevelt Residence, "Sagamore Hill," Oyster Bay, 1905

La Farge received his first Long Island commission from his friend, Theodore Roosevelt, after the latter's election to a second term as President of the United States. It was to design an addition to "Sagamore Hill," Roosevelt's summer home at Oyster Bay. The 1905 addition designed by the architects was a large, cove-ceiling space that functioned both as a state reception room and as the family's gathering place. It was sufficiently large to allow several people to pursue various activities separately, without disturbing the others in the room. Built entirely of American and Philippine woods, the room is a monochromatic red-brown. The primary architectural feature is an enlarged Ionic order that encircles the room, framing windows, doors, and fireplaces. To one side, the architects placed a small reading alcove. The coved ceiling and all the wall space were paneled in classical motifs. Roosevelt called it "the most attractive feature of my house by all odds."

J. Pierpont Morgan, Jr., Residence, "Matinecock Point," Glen Cove, c. 1913

La Farge's next commission on Long Island came while he was in partnership with Benjamin Wistar Morris. Built for J. Pierpont Morgan, Jr., the son of the great financier, "Matinecock Point," c. 1913, was much grander and more formal than La Farge's previous Long Island commission. The 257-acre estate, located off Glen Cove, contained 41 rooms, 13 bathrooms, and ample service quarters. Generally H-shaped in plan, the main house was designed in a very restrained early-Georgian mode, a popular style for country houses built at this time. The main doorway is graced by a broken segmental-arched pediment supported by

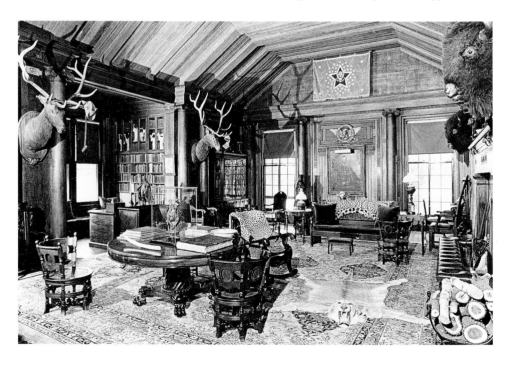

Christopher Grant La Farge: Addition to Residence, "Sagamore Hill," Theodore Roosevelt Residence, Oyster Bay, 1905 (Sagamore Hill, National Historic Site)

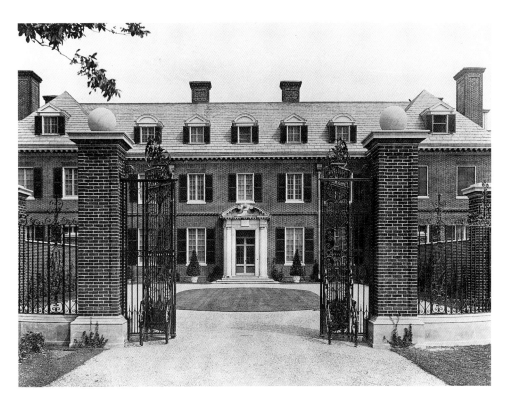

Christopher Grant La Farge: Entrance Courtyard, "Matinecock Point," J. P. Morgan, Jr., Residence, Glen Cove, 1913 (HEWI, n.d.)

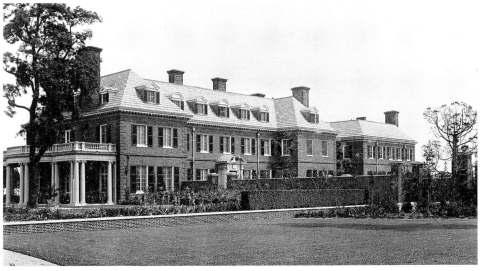

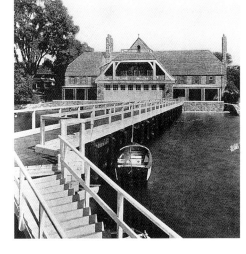

Christopher Grant La Farge: Front Facade, "Matinecock Point," J. P. Morgan, Jr., Residence, Glen Cove, 1913 (HEWI, n.d.)

Christopher Grant La Farge: John Hay Whitney Boathouse, Manhasset, 1929 (SPUR, 1929)

engaged Ionic columns. The rigid planarity of the house's wall is broken at the second story by a narrow string course, while the vast hipped roof is enlivened by dormers with alternating triangular and segmental pediments. In keeping with the Georgian flavor of the main house, all of the outbuildings are designed in a Colonial Revival mode. The simplicity of the main structure is, in this case, overplayed, with the result that the design is somewhat flaccid.

John Hay Whitney Boathouse, Manhasset, 1929

Designed in a less formal, Arts and Crafts mode, the John Hay Whitney boathouse (1929) in Manhasset is much more successful. Jerkin-head roofs, British Columbian red-cedar shingles, and golden-brown random ashlar wall treatments give the building a human scale, belying the fact

that the central boat bay was meant to accommodate an amphibious airplane with 40-foot-long wings. Above this space was built a clubroom with broad verandas that afford views of the Sound. All beams were exposed and corner-beaded in nautical rope moldings. Flanking the clubroom were bedrooms, while a living room and service rooms were placed on the ground floor. Despite its size, this scheme maintains a coherence that is rarely found in large-scale houses. The interior finishes were elaborate modern schemes that somehow managed to co-exist peacefully with the more Arts and Crafts-inspired interior.

Steven Bedford

Lamb & Rich: Front
Entrance, "Sunset Hall,"
S. P. Hinckley Residence,
Lawrence, 1883 (ARCS, 1886)

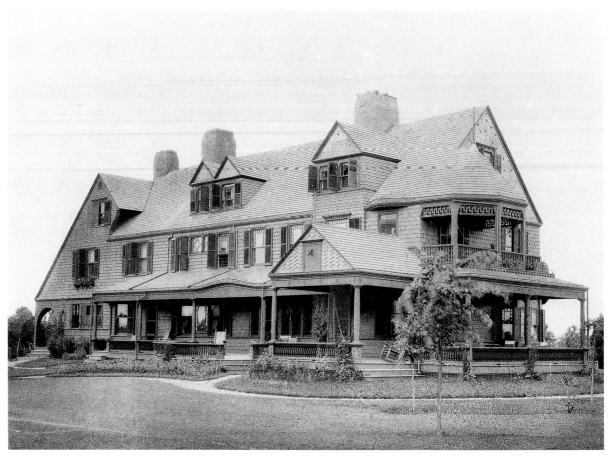

Lamb & Rich, 1881–c. 1899

Hugo Lamb, 1849–1903

Charles Alonzo Rich, 1855–1943

During most of the partnership of Lamb & Rich,[1] their offices were located at 265 Broadway in New York, not more than three blocks from the offices of McKim, Mead & White. Although they designed such structures as the Mount Morris Bank (1883), the Harlem Club (1889), and the Washington Heights Baptist Church (1899), the partners were primarily concerned with residential works, both urban and suburban, and with buildings for educational institutions.

In their own day, Lamb & Rich were well known for their Romanesque apartment houses, which often sported red and green sandstone trim, patterned brickwork, and intricate terracotta ornamentation. Sometimes filling entire blocks of Manhattan's Upper West Side, these colorful apartments provided an attractive alternative to the typical New York brownstone.[2] The firm also pioneered the development of low-cost, fire-resistant apartment houses for the middle class; their Astral apartment building in Brooklyn (1886), intended to house "the widow, shop-girl, clerk or tradesman," was a model of the properly plumbed and ventilated apartment house, containing state-of-the-art fire walls and fire escapes.[3]

The architects first gained their reputation as builders of schools and colleges in 1887, when they were commissioned to design the main building for the Pratt Institute in New York City. Three years later they designed the Berkeley School in Manhattan (now the Mechanics Institute), Milbank Hall at Barnard College, and the Butterfield Museum at Dartmouth College. Many more college buildings were to follow, particularly for Dartmouth, Rich's alma mater.[4]

Despite their many apartment houses and educational buildings, however, Lamb & Rich are best known today for their early country houses, thanks to Vincent Scully's *The Shingle Style* (1955). Scully found these architects to be innovative practitioners of the "mature" Shingle Style; their work reveals "an unrestrained love of materials, texture, and color." To describe some of their earliest houses (1882–83), Scully used words like "barbarous power," "picturesque energy," "coarse," "bold," "blatant," and "free." At the same time, he praised them for planning houses with "a sense of unified space," where rooms flow together along uncomplicated axes. As Scully suggested, the bold use of materials and the easy flow of interior space were qualities that contributed to the development of modern architecture.[5]

Most of their first country houses were built in Short Hills and in the Oranges of New Jersey (Rich himself lived in Short Hills; Lamb in East Orange). But in 1883 they started receiving commissions on Long Island, first from a real estate

Lamb & Rich: Interior Sketches, "Sunset Hall," S. P. Hinckley Residence, Lawrence, 1883 (AABN, 1884)

Lamb & Rich: "Elm Hall," S. P. Hinckley Residence, Lawrence, 1883–88 (ARBW, 1888)

Lamb & Rich: "Meadow Bank," S. P. Hinckley Residence, Lawrence, 1883–88 (ARBW, 1888)

a graduate of M.I.T., and remained a senior partner of the firm, which eventually became Rich, Mathesius & Koyl, until his retirement in 1933. He died ten years later at his home in Charlottesville, Virginia.[9]

Samuel Parker Hinckley Residence, "Sunset Hall," Lawrence, 1883

During 1882, the *American Architect and Building News* illustrated several of Lamb & Rich's houses in New Jersey.[10] Some of these designs may have favorably impressed Samuel Hinckley, a real estate speculator in Rockaway, Long Island: in 1883 he commissioned the young firm to design his own residence and four others that could be rented during the summer. Hinckley's own house, "Sunset Hall," was completed that year; the others, named "Briar Hall," "Sunnyside," "Elm Hall," and "Meadow Bank," were finished by 1888.[11] Although altered, all five houses remain standing along Ocean Avenue in Lawrence.

"Sunset Hall" was the firm's first house on Long Island. Unlike Lamb & Rich's earlier New Jersey houses, which had tall chimneys, steep gables, and asymmetrical facades, the Hinckley house is relatively compact, low to the ground, and formal in appearance. Its three chimneys barely rise above the apex of the roof, while the roof itself is long and low, interrupted by two dormers that serve to balance the large gable on the service end. This unusual gable, together with the overall massing of the house, suggests the influence of the Alexander Cochrane House, Beverly, Massachusetts (1880–81), designed by Rich's old employer, William Ralph Emerson, and published in *The American Architect,* June 25, 1881.[12]

Effort was spent to make the Hinckley house look older than it was. The shingles of the second story were stained "an old gold," while the clapboards of the first story were colored "an Indian red." This color scheme, first used two years earlier on Rich's own house, was thought to produce "the appearance of age."[13] The roof shingles were left unstained so that they would quickly turn weather-beaten gray.

The plan of the house is remarkable for its simplicity. It is essentially a rectangle, 130 feet long and 30 feet wide. Like most of the better Shingle Style houses of the 1880s, the main entrance leads to a large living hall—complete with built-in couch, massive fireplace (six-and-a-half feet wide), and primary staircase. The dining room is reached from the hall by a seven-foot-wide opening, almost giving the two rooms the appearance of being a single space. At the opposite side of the hall is the parlor, which, like the hall, extends the width of the house. These large rooms flow easily into one another along the one axis.

speculator, then from such notables as Theodore Roosevelt and Charles Pratt. Long Island eventually became home to some of Lamb & Rich's most significant works, where picturesque exteriors and spacious interiors combined to produce some fine Shingle Style, Colonial, and Tudor Revival houses.

Of the partners themselves little is known. Hugo Lamb was born in Scotland in 1849. He joined with Rich in 1881, moved his home from New York City to East Orange in about 1883, and died of typhoid fever on April 3, 1903, leaving a wife, three sons, and five daughters.[6] Where he received his education is unknown; and what his role was in the firm of Lamb and Rich is a matter of conjecture, though it is certain that he was not the chief designer. He probably handled the office's business dealings, leaving the drafting to his younger partner.

Charles Rich was born in Beverly, Massachusetts, in 1855 to the Rev. A. B. Rich. He graduated from the Chandler Scientific School at Dartmouth College in 1875, and then worked as a draftsman for William Ralph Emerson, a Boston architect known for his superb Shingle Style houses.[7] In 1879 Rich departed for a three-year tour of Europe, later publishing some of his travel sketches.[8]

By 1881 Rich returned to the United States and formed a partnership with Hugo Lamb which endured until the latter's death in 1903. Rich was then joined by Frederick Mathesius,

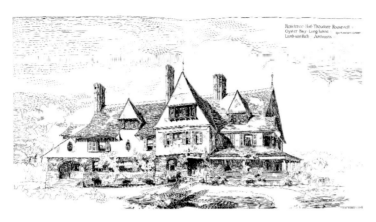

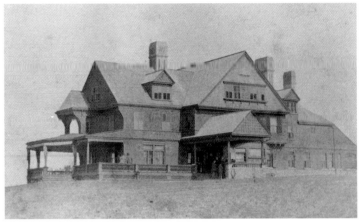

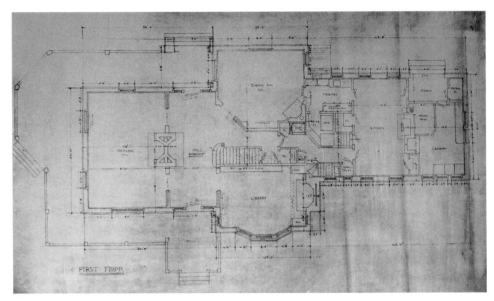

Lamb & Rich: Proposed Perspective, Later Changed, "Sagamore Hill," Theodore Roosevelt Residence, Oyster Bay (AABN, 1893)

Lamb & Rich: Front Facade, "Sagamore Hill," Theodore Roosevelt Residence, Oyster Bay, 1884–86 (Sagamore Hill, National Historic Site, n.d.)

Lamb & Rich: First Floor Plan, "Sagamore Hill," Theodore Roosevelt Residence, Oyster Bay (Sagamore Hill, National Historic Site, n.d.)

The interior was furnished "in the style of the old colonial":[14] exposed-beam ceilings, "Dutch" doors, "old colonial" mantels, and imitation 18th-century furniture.[15] Such detailing was expanded in Hinckley's rental houses to the point where Colonial imagery governed even the exteriors; "Elm Hall," for instance, had a nearly symmetrical facade, dominated by a two-story columned porch, and topped with a pediment and Palladian window.

Theodore Roosevelt Residence, "Sagamore Hill," Oyster Bay, 1884–86 (Extant)

With his first child due, Theodore Roosevelt (1858–1919), decided to build a country house in Oyster Bay, his ancestral summer home.[16] Roosevelt was then a young member of the New York State Legislature; he would become the 26th President of the United States in 1901. Lamb & Rich were asked to prepare plans in early 1884. Tragically, however, before the plans were approved, Roosevelt's wife died from childbirth complications on February 14. His mother died the same day. Despite this double loss, Roosevelt was eager for his infant daughter to have a home, and approved Rich's drawings

in March. The contractual cost totaled $16,975. Construction took two years, during which time Roosevelt spent many months in North Dakota collecting the game heads that would later decorate his house. In December 1886, Roosevelt remarried, and in the following spring he, Alice Carow (his new wife), his sister Anna, and his daughter Alice took up residence in the new house. Originally dubbed "Leeholm" in honor of Roosevelt's first wife, Alice Lee, the house was later named "Sagamore Hill," after an old Indian chief who had lived around Oyster Bay.[17]

Aside from his insistence on generous verandas from which he could view the sunset, Roosevelt left the design of the exterior to Rich,[18] who decided that his client required a picturesque residence, shingled, and with prominent gables to command a hilltop site—in short, the type of house he had designed several times before in New Jersey. As a published perspective drawing reveals,[19] the house was first planned with extremely high-pitched gables and tall chimneys; as built, however, these elements were considerably flattened, making the house appear far less medieval than originally intended.

Lamb & Rich: Front Facade
Perspective, "Old Rider
Farm," Charles A. Rich
Residence, Bellport, 1889
(AABN, 1889)

One medievalism that Rich did maintain
was a variety of exterior textures. The first story
is sheathed in stone and brick. Immediately
above is a course of shingles, laid in a wave-like
pattern. Above that is a second course of shin-
gles laid like clapboards but occasionally inter-
rupted with diamond-shaped patches. In the
main gables the shingles are divided into three
rows, a fish-scale course dividing two clapboard-
like courses. Half-timbering adorns the gables of
the dormers, while terra-cotta floral medallions
accent some of the larger first-floor windows.
The color scheme is typical of Lamb & Rich—
red on the first story, and yellow, or "old gold,"
above. Trim is a deep green. Over the west en-
trance, carved in the wood lintel, is the motto
from the Roosevelt family crest, *Qui plantavit
curabit*—"He who has planted will preserve."

In anticipation of a large family (he eventual-
ly had six children), Roosevelt approved plans
for a house of 23 rooms. He had his own ideas
for the interior: he once wrote, "I wished . . .
a library with a shallow bay window looking
south, the parlor . . . occupying all the western
end of the lower floor [and] big fireplaces."[20]
All the major rooms of the main floor were
arranged around a biaxial entrance hall, which
was paneled in dark woods and dominated by
a huge fireplace opposite the stairs. Because
"Sagamore Hill" was to be a year-round resi-
dence, provisions were made for winter habita-
tion: eight fireplaces and two hot-air furnaces
in the basement saw to that. The frame of the
house, too, was made exceptionally strong,
resting on foundations nearly two feet thick.

Roosevelt lived at "Sagamore Hill" from
the time of its completion until his death in
1919. During his presidency (1901–09) the house
served as a summer White House, calling for
the addition of a formal reception room on the
north side in 1905.[21] Otherwise, the house stands
as built, preserved by the National Park Service.

Incidentally, Rich and his wife became good
friends of the Roosevelts and visited the White
House frequently during the President's years
there.[22]

Charles A. Rich Residence, "Old Rider Farm," Bellport, 1889 (Extant)

While designing the Hinckley and Roosevelt
houses, Rich clearly acquired a taste for Long
Island. In the late 1880s he purchased a farm
in Bellport and converted it into his summer
retreat. There were several existing buildings
on the farm, including a gambrel-roofed house
of undetermined date and a 20-year-old barn
whose "very timbers were redolent with the
odor of hay and straw." Through the center
of the house Rich inserted a second gambrel,
giving him more space on the upper floor. He
then moved the barn so that it was adjacent
to the house and created a studio for himself.
This union of barn and house into a studio was,
as Rich admitted, inspired by the "Summer
Headquarters" of the celebrated artist, William
Morris Hunt. Known as "The Hulk," and locat-
ed in Magnolia, Massachusetts, Hunt's studio
was designed in 1877 by Emerson while Rich
was still in his city office.[23]

Inside his barn/studio, Rich removed one
of the two haylofts and turned the remaining
one into a gallery, supporting it with two antique
columns he had found at a secondhand lumber-
yard. He also put in a brick fireplace of a capa-
city "that allowed logs the size of a man to be
rolled into it." Large mullioned windows were
installed in the barn door openings, while the
doors themselves were left in place to serve as
giant shutters. White paint was applied to all
the interior woodwork, including the exposed
ceiling beams. And, in a manner recalling farm-
houses Rich had seen in Normandy, a veranda
was attached to the second floor of the house
facing a rear court.[24] All in all it was a masterful
conversion, producing a rustic composition with
Dutch, French, and American Colonial notes.

The house has been considerably altered.

Charles Millard Pratt Residence, "Seamoor," Glen Cove, 1890

Charles Pratt, Sr., the kerosene king and founder
of Standard Oil, was one of Lamb & Rich's big-
gest patrons. It was he who contracted the archi-
tects to design the Astral Apartments, previously
mentioned, as well as the main building of the
Pratt Institute. "Seamoor" was built for his son,
Charles Millard (1855–1935), and was among the
first of 21 estates eventually built on "Dosoris,"
a 1,100-acre plot owned by the Pratt family in
Glen Cove.[25]

In some ways "Seamoor" was a variation of
the Hinckley house. It also was two-and-a-half
stories high, shingled, with three low chimneys,
and a series of double-hung windows with shut-
ters. Unlike the Hinckley house, though, the

Lamb & Rich: Front Facade,
"Seamoor," Charles M.
Pratt Residence, Glen Cove,
1890 (Courtesy of Mrs.
Richardson Pratt)

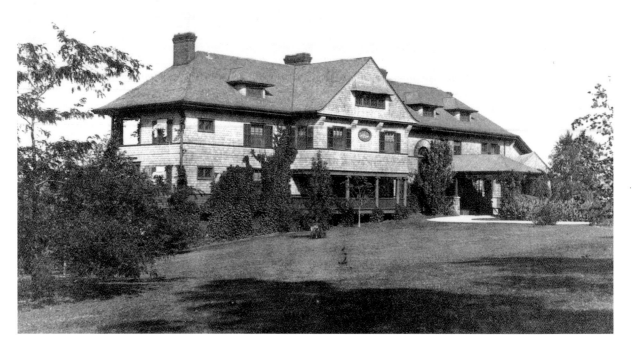

dominant gable on the Pratt house was set to-ward the center of the facade, eliminating the need for large, counter-balancing dormers. Another difference was that most of "Seamoor's" porches and verandas were incorporated into the main mass of the house, not extended out from the walls, as in the earlier work. Also un-like the Hinckley house, the Pratt house made exclusive use of shingles for exterior sheathing, providing no variation in surface texture. This new emphasis on consolidating the masses of the house and unifying the exterior with a skin of shingles was in line with similar efforts by such progressive architects as H. H. Richard-son and McKim, Mead & White.

The house is no longer standing.

Frank Lusk Babbott Residence, Glen Cove, 1890

Frank Lusk Babbott (1854–1933) was known to several circles: he was director of the Chelsea Jute Mills, a trustee of two Brooklyn banks, president of the Brooklyn Institute of Arts and Sciences, and author of *Classic English Odes* (1902). He was also known to the Pratt family, having attended Amherst with Charles Millard Pratt. He married Lydia Pratt, Charles's sister, in 1886.[26] In 1890 Babbott hired Lamb & Rich to design a summer house on "Dosoris," next to the one the architects were currently designing for his brother-in-law. He knew his architects well: three years earlier the firm had designed a fine Romanesque townhouse for him in Brook-lyn.[27] In contrast to the Shingle Style Pratt house, the Babbott residence was Georgian in

character, completely clapboarded, with a sym-metrical facade and Colonial detailing through-out. Although by no means the first Colonial Revival house in this country, it was certainly among the first to reach a high level of refined formality.

Unfortunately, the house was altered beyond recognition in the early 1950s.

Charles Benner Residence, Setauket, c. 1892 (Extant)

The Benner house is essentially a Shingle Style house with strong Colonial details. The first story is clapboarded, the second covered with darkly stained shingles. The dominant feature of the front elevation consists of a Colonial en-trancc porch, with a Palladian window above—a combination often used by Lamb & Rich. Unlike any of their other houses, though, the plan of the Benner house is bowed, an idea possibly borrowed from such buildings as the John Cowdin house, in Far Rockaway, by McKim, Mead & White.

Talbot J. Taylor Residence, "Talbot House," Cedarhurst (begun c. 1895)

Talbot Jones Taylor (1866–1938), a Wall Street stockbroker, commissioned Lamb & Rich to design "Talbot House" shortly after his marriage in 1892. Presentation drawings were published in June 1895.[28] Built of brick and half-timber, and having an informal sprawling plan, the

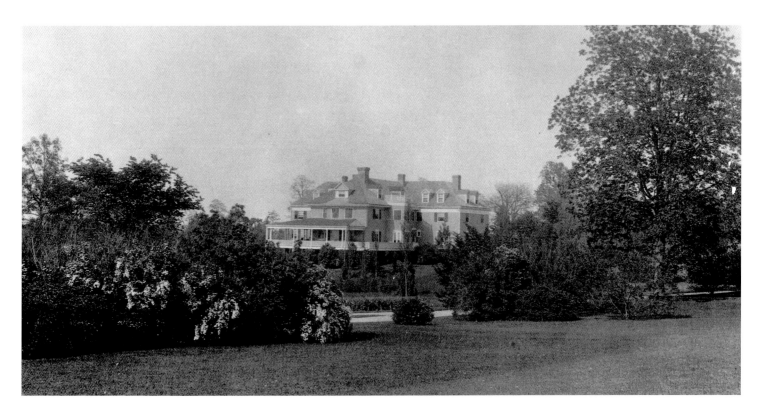

Lamb & Rich: Frank Lusk
Babbott Residence, Glen
Cove, 1890 (Courtesy of
Mrs. Richardson Pratt)

Lamb & Rich: Front Facade
Perspective, Charles Benner
Residence, Setauket, c. 1892
(AABN, 1893)

Lamb & Rich: Entrance
Court and Front Facade,
"Talbot House," Talbot J.
Taylor Residence,
Cedarhurst, c. 1895 (FERR,
1904)

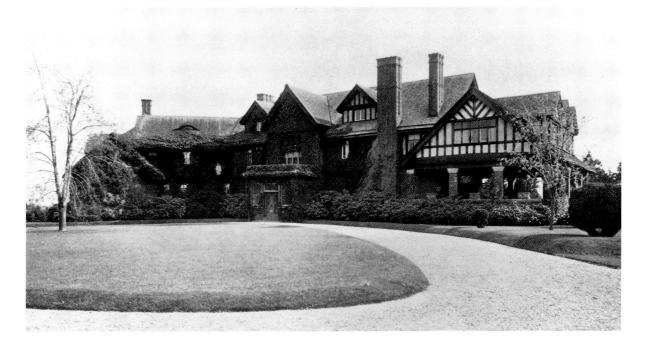

Lamb & Rich: Living Hall, "Talbot House," Talbot J. Taylor Residence, Cedarhurst, c. 1895 (FERR, 1904)

Drawing Room, Broughton Castle, Oxfordshire, England, c. 1599 (from *The Mansions of England in the Olden Time,* by Joseph Nash, 1970)

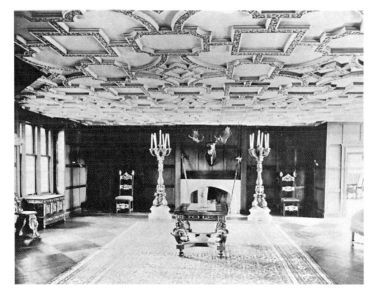

Lamb & Rich: Entrance Court and Front Facade, S. A. Jennings Residence, Glen Cove, c. 1902 (WURT, n.d.)

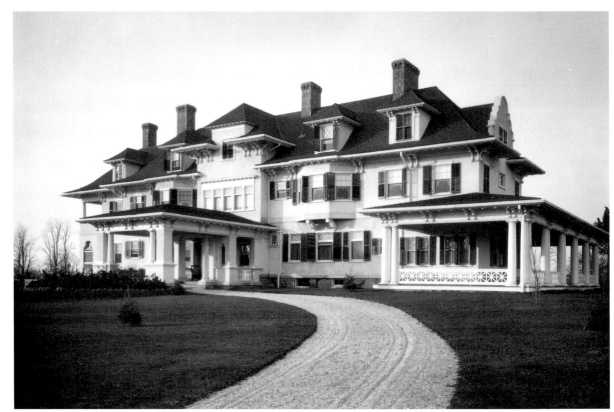

Lamb & Rich: Living Room, S. A. Jennings House, Glen Cove Residence, c. 1902 (WURT, n.d.)

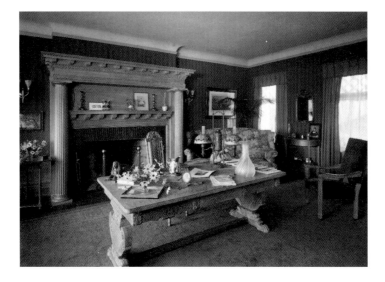

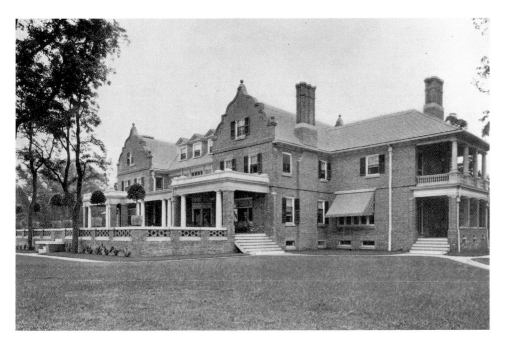

S. A. Jennings Residence, Glen Cove, c. 1902 (Extant)

When built, this house was described as "Spanish" in style.[32] Italianate brackets support all the eaves, while touches of the newly popular Mission Revival appear in the side gable and under the entrance porch. To give the building a generally Mediterranean appearance, the exterior remains uniformly plastered in white. The chimneys, windows, and columns, however, are of Colonial inspiration, and the diamond-paned sash is decidedly un-Mediterranean. The result is an eclectic but imposing mass, owned now by the local B.P.O.E.

Charles O. Gates Residence, "Peacock Point," Locust Valley, 1902

Charles Gates (1852–1906) was the millionaire president of the Royal Baking Powder Company. In 1902 he decided to build a $75,000 summer house on Peacock Point.[33] His choice of Rich as architect probably came to him by way of George Tangeman, son-in-law of the founder of the Royal Baking Powder Company and owner of a townhouse in Brooklyn designed for him by Lamb & Rich in 1891.[34]

As it was erected, the Gates house was hailed as "a palatial English manor house of the Elizabethan style of architecture."[35] Actually, with its ogee-shaped gables, it turned out to be more Jacobean than anything else, a style first made popular by the Henry W. Poor house in Tuxedo Park designed by T. Henry Randall (c. 1898).[36] Other features, though, are hardly evocative of Old English manors; the dormers, for instance, are Colonial in style and look as if they could have been lifted from the Babbott house. The symmetrically disposed plan appears as if inspired by a Beaux-Arts villa: visitors entered through a formal, tiled loggia onto the entrance podium of a huge central hall. Opposite the entrance was a large bay window and two mirror-image staircases to the second floor. To the left and right were living and dining rooms of equal dimensions, opening onto the hall through large pocket doors. Here again, circulation was designed to flow easily along one major axis.

Gates enjoyed his house for four years, until his death in 1906. Eight years later the house was destroyed.

Gavin Townsend

Lamb & Rich: Rear (North) Facade, "Peacock Point," Charles O. Gates Residence, Locust Valley, 1902 (ARTR, 1903)

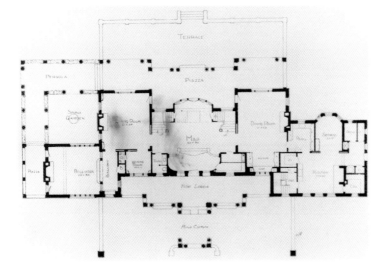

Lamb & Rich: First Floor Plan, "Peacock Point," Charles O. Gates Residence, Locust Valley, 1902 (ARTR, 1903)

Taylor house was Lamb & Rich's finest Tudor Revival project. In 1904 it was featured in Barr Ferree's *American Estates and Gardens.*[29] As with most authentic Tudor structures, "Talbot House" was not built all at once. The original structure, constructed in the mid-1890s, had a Y-shaped plan, with a semicircular veranda terminating the long end. In about 1902 this veranda was replaced with a large gabled wing, the entrance porch was enclosed, and another wing was added to the rear. Ferree noted that these additions formed a "thoroughly harmonized composition" with the older parts of the house.[30] The best room in the house was the living hall, paneled all in oak and covered with a parged ceiling whose design was probably derived from a similar ceiling in Broughton Castle, Oxfordshire (c. 1599).[31]

"Talbot House" was destroyed about 1914, leaving only a stable that was later converted into a residence.

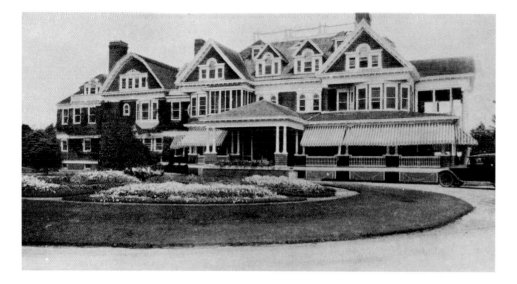

William A. Lambert: Front
Facade, "Beaurivage," John
W. Masury Residence,
Center Moriches, 1900
(Moriches Bay Historical
Society, n.d.)

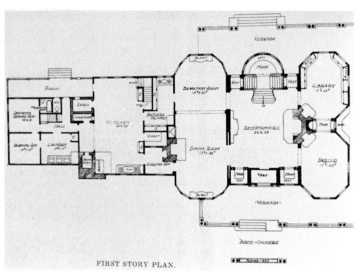

FIRST STORY PLAN.

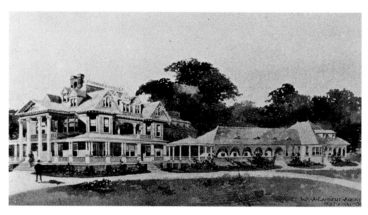

William A. Lambert: First
Floor Plan, "Beaurivage,"
John W. Masury Residence,
Center Moriches, 1900
(ARBD, 1900)

William A. Lambert: Rear
Facade Rendering Showing
Ballroom Wing,
"Beaurivage," John W.
Masury Residence, Center
Moriches, 1900 (ARBD,
1900)

William A. Lambert, practiced 1900s

New York City architect William Augustus
Lambert's only known Long Island country-
house commission was "Beaurivage," built in
1900 at Center Moriches for John W. Masury,
head of the Brooklyn paint manufacturing firm
of Masury & Son. The main house, now demol-
ished, was flanked by an adjoining bowling alley
and galleried ballroom. Designed with an exu-
berant hand, the shingled main residence pre-
sented a multiplicity of windows: a Palladian
motif set in the pediments of the cross gables,
a triple stack of dormers—Palladian, simple
pedimented, and eyelid—and oriels and bows.
A unifying deep cornice extending around the
house was reinforced by an enveloping veranda.
On one elevation the veranda extended to form
a porte cochere; on another it was pierced by
a two-story-high portico with a balcony at the
second story. The ballroom wing of the Masury
estate survives and is on the National Register
of Historic Places.

Wendy Joy Darby

J. Custis Lawrence, 1867–1944

J. Curtis Lawrence was born at First House,
Montauk, where his parents were keepers.
First House (1798) and two similar structures
were built as shelters for the herdsmen who
tended the thousands of head of cattle, sheep,
and horses pastured on Montauk's abundant
grasslands. Lawrence's father, a former whaler,
combined cattle-tending with life-saving at the
Napeague Life Saving Station. Following in his
father's footsteps, Lawrence went to sea at the
age of 14.[1] However, ten years later he changed
occupations, working as a carpenter for East
Hampton builder George A. Eldredge (1854–
1924) before moving to Connecticut to master
the trade of stair building.[2] Lawrence returned
to East Hampton, where his architectural train-
ing appears to have taken place in the Eldredge
office. This sort of catch-as-catch-can training
was not unusual in the latter half of the 19th
century, since academic architectural training
was only in its infancy.[3] As the builder's drafts-
man, Lawrence began to identify himself as
"architect" on the plans of houses built by

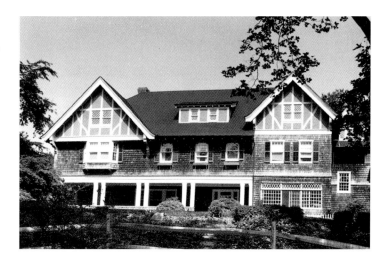

J. Custis Lawrence: Front Facade, "Onadune," Mrs. S. Fisher Johnson Residence, East Hampton, 1903–04 (Harvey A. Weber photo, 1980)

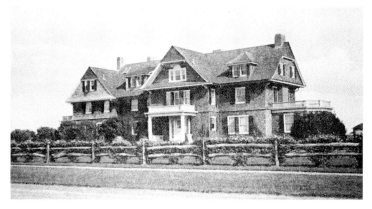

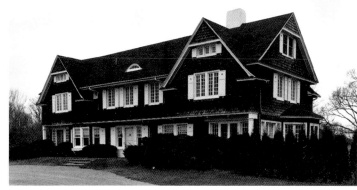

J. Custis Lawrence: Front Facade, John T. Baker Residence, East Hampton, 1907 (Photo courtesy of Sherrill Foster)

J. Custis Lawrence: Front Facade, Arthur Van Brunt Residence, East Hampton, c. 1915 (Robert J. Hefner photo)

J. Custis Lawrence: Front Facade, Benjamin Franklin Evans Residence, East Hampton, c. 1913 (INVE, 1978)

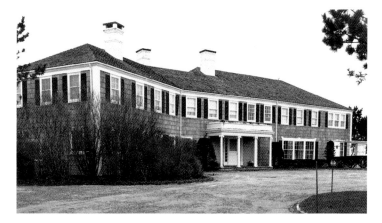

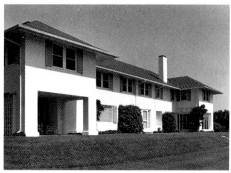

J. Custis Lawrence: Front Facade, Dr. James D. Voorhees Residence, East Hampton, 1913 (Harvey Weber photo, 1980)

J. Custis Lawrence: Front Facade, Ring Lardner Residence, East Hampton, 1927 (The White Book, privately printed, n.d.)

J. Custis Lawrence: Grantland Rice Residence, East Hampton, 1927 (The White Book, privately printed, n.d.)

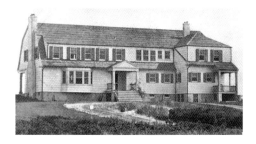

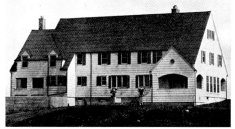

Eldredge. He was fortunate in being assigned to serve as supervising architect for many of the houses designed by New York architects and built by Eldredge. Around 1904–07 Lawrence was working as a draftsman for Thomas E. Babcock. By 1913 he had moved to the office of builder Edward M. Gay; about 1920 he registered as an architect, following passage of the New York State licensing legislation which included a grandfather clause to provide for practicing architects without formal training.[4]

A competent craftsman, Lawrence's designs were unpretentious and, not surprisingly, often reminiscent of houses built by Eldredge's firm.

His design sources were the buildings around him. His clients were people who wanted simple, easily constructed, and inexpensive residences, and Lawrence often designed two or three houses for the same client who wanted to rent them out during the summer. Lawrence's contribution to East Hampton was to expand on the unpretentious architecture of the summer colony begun in the 1880s and 1890s by I. H. Green and J. G. Thorp.

One of Lawrence's earliest commissions was "Onadune," the fourth East Hampton house for Mrs. S. Fisher Johnson, wife of the Wall Street broker, on the inner dune off Georgica Road. Mrs. Johnson had had J. Greenleaf Thorp design her three other houses, all in the gambrel-roof Shingle Style so popular in East Hampton. The facade of the Lawrence-designed house, with half-timbering in the large cross gables, almost replicates the Eldredge-built Paxton house designed by Thorp two years earlier. The facade is flat and the half-timbering design is simpler, much like Thorp's own house of 1893 (also built by Eldredge), while the subsumed porch was reminiscent of Thorp's Hackstaff house.

Lawrence's inventiveness is best seen in two houses of 1907, both built by Thomas E. Babcock. The Baker house on Lily Pond Lane is very elaborate, with heavy oversailing gables accentuated by pents and supported by brackets, hipped dormers, and a projecting cross gable of two stories with heavy, wide overhang and pent. The entry is a reduced version of the Colonial Revival one-story balustraded porch used by Thorp on his second F. G. Potter house of 1905. There is a pseudo-Venetian window in the gable over the entrance, undoubtedly a stock element. It is the mix of these details that betrays the untrained designer. For attorney Arthur H. Van Brunt's house on Ocean Avenue, Lawrence again incorporated aspects of Thorp's Hackstaff house of 1899. An important house by Lawrence was the one he designed for Benjamin Franklin Evans, founder and president of Evans, Conger and Breyer, Inc. Built in 1913 by Smith and Davis, it is laid out in the popular butterfly plan used by the Arts and Crafts architects in England and by McKim, Mead & White in their country house for the Misses Appleton at Lenox, Massachusetts (1883–85).[5] The entry is at the angle formed by the two wings of the house. A shallow hip roof overhangs rows of six-by-six sash, while shutters and a Neoclassical porch complete the design.

Lawrence designed a number of other houses in East Hampton. His 1913 house for Dr. James D. Voorhees on Dunemere Lane appears to be a copy of the 1910 Albro & Lindeberg house for Dr. Hollister. A rectangular stucco house with shallow hip roof and wide overhangs, the Voorhees's house overlooks the links of the Maidstone Club. Lawrence also designed the Shingle Style, gambrel-roof house on West End Lane for Ring Lardner, the famous short-story writer, in 1927, as well as the house next door for Lardner's friend, the sportswriter Grantland Rice. Both houses were damaged in the 1931 hurricane and moved back from the dunes.

<div align="right">Sherrill Foster</div>

Charles W. Leavitt, Jr., 1871–1928

Educated at the Gunnery in Washington, Connecticut, and the Cheltenham Academy in Pennsylvania, Charles Wellford Leavitt began his engineering career in 1891; by 1897 he had opened his own New York office specializing in civil and landscape engineering and city planning. He designed many country estates and homes in the New York area, and also as far afield as Pasadena, California, and Duluth, Minnesota. His civil engineering commissions were equally diverse, both in geographic distribution and in type, including the Federal parks in Cuba and the Washington Crossing Park on the Delaware; the town planning of West Palm Beach, Florida, and Garden City, Long Island; campus designs for the universities of Georgia and South Carolina; as well as roadway and railway systems, country clubs, and numerous racetracks.[1]

His garden schemes ranged from vast formal Italianate affairs (Loretto, Pennsylvania) to intimate wildflower enclosures (Red Bank, New Jersey). One of his earliest Long Island commissions was at the Foxhall Keene estate at Old Westbury. The house, designed by the architects George A. Freeman and Francis G. Hasselman, was flanked by piazzas, one of which gave onto a garden designed by Leavitt. It was perhaps through Keene, an avid equestrian and race-horse owner, that Leavitt later received a number of racetrack commissions.

Leavitt also worked on the Henri Bendel estate at Kings Point (c. 1917) after it was taken over by Walter Chrysler in 1923. The work of architect Henry Otis Chapman, the house was a standard Beaux-Arts processional design, functioning around a strong central axis. This extended from an eastern approach drive and gave out onto western vistas over Long Island Sound.

Leavitt's design plan reinforced both the local topography and the axial thrust of the house. The drive was bordered by elaborate flower gardens, while from the western loggia a series of

Charles W. Leavitt, Jr.: Landscape Design, Formal Garden, Foxhall Keene Estate, Old Westbury (FERR, 1904)

Charles W. Leavitt, Jr.: Landscape Design, Walter P. Chrysler Estate, King's Point (ARLG, 1929)

Charles W. Leavitt, Jr.: Landscape Design, Formal Gardens, Lillian Sefton Dodge Estate, Mill Neck (PREV, 1947)

broad terraces led down to the water's edge.[2] The uppermost terrace was the most formal, with urns and antique jars flanking the geometrically patterned central pathway; the lower terracing was grassed, as was a secondary series of terracing. An elaborate sea wall (sections of which supported pergolas), a boathouse, and a jetty completed the waterside development.

In the mid-1920s Leavitt was commissioned to design the principal formal gardens at "Sefton Manor," the Lillian Sefton Dodge Estate at Mill Neck. In keeping with the extravagant 34-room Tudor-Gothic residence designed c. 1923 by the architectural firm of Clinton & Russell, Leavitt's complex of formal gardens was approached through bronze gates designed by Brant of Paris. The gardens were set out in the form of a sundial. Each part, radiating out from a Venetian fountain, was edged in ilex. Three stone temples and various pools were dispersed among these gardens.

At "Blythewood," the estate of George C. Smith at Muttontown, large trees were transplanted onto the estate, as was the practice at the time; while at Isaac Cozzen's estate, "Maple Knoll" in Lattingtown, dense foundation plantings, vines, and screens of trees provided additional privacy for the house. Leavitt's other Long Island commissions included the estates of Anson W. Hard at West Sayville; Carlton Macy at Hewlett; and "Creekside," the home of Harry K. Knapp at East Islip.

Leavitt's successful career was cut short by his untimely death from pneumonia in 1928.

Wendy Joy Darby

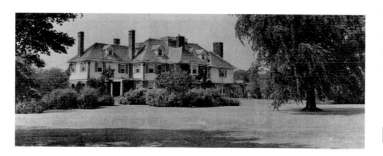

Thomas L. Leeming: Rear Facade, "Winnecomac," Abram Skidmore Post Residence, Quogue, 1908–09 (SPLI, n.d.)

Today the structure has been re-adapted as a Catholic retreat house. Leicht's only other recorded commission was the Lakewood Casino in 1899.

Carol A. Traynor

■

Thomas L. Leeming, practiced 1910s

According to family records, Thomas L. Leeming was the architect for Abram Skidmore Post's Quogue country residence, "Winnecomac." A large, hip-roofed, Neo-Georgian residence, it was built between 1908 and 1909. No biographical information has been uncovered about Thomas L. Leeming. Brooklyn architect Woodruff Leeming (1870–1919) appears in a number of directories as having designed a country residence on Long Island (location not given), as well as designing the first Nassau Country Club, a large, shingled, gambrel-roofed building built in 1899, destroyed by fire in 1909, and replaced in 1910 by the present Tudor clubhouse. It is not clear whether these two architects were related.

Carol A. Traynor

■

Adolph F. Leicht, practiced 1900s

Adolph F. Leicht, a New York City architect, was in partnership with various architects, including George H. Anderson, S. F. Austin, and Wesley J. Havell. Nothing is known about his education. In 1905 Frank Colton Haven commissioned Leicht to design his country residence in Sag Harbor. Haven, head of a San Francisco realty syndicate, was a native of Sag Harbor and returned with his family every year to summer there. Leicht's sprawling Queen Anne-style frame residence featured a dramatically overscaled porte cochere, four octagonal turrets, and spacious verandas encircling the water side.

J. J. Levison, 1873–1961

Relatively unknown in the field of estate landscape design, John Jacob Levison was one of the small group of crusading conservationists who organized the United States Forest Service in 1905 under the aegis of President Theodore Roosevelt. Born in Riga, Latvia, Levison came to this country at the age of eight, graduated from City College in 1902, and went on to receive a master's degree in forestry from Yale in 1905. On leaving the Forest Service in 1907 he became chief forester for New York City and Brooklyn Parks for ten years and was associated with such city park and garden project's as the Cloisters, the Pierpont Morgan Library garden, and the Metropolitan Museum of Art gardens. Levison lectured at Yale's Forestry School and the New School for Social Research and in 1942 conducted a course at Yale in the use of landscape design to camouflage and protect plants and industrial complexes during wartime. In 1955 Levison was honored by the Forest Service for his work "which helped lay the foundation of American forestry."

A noted aboriculturist, Levison operated a nursery business located near his Sea Cliff home, designed by architect Harrie T. Lindeberg. His private landscape practice, beginning in 1917 and continuing until his death, remains to be fully documented. While the degree of his involvement is not known, Levison was associated with a number of the North Shore's large estate gardens, including those of Walter P. Chrysler, at Kings Point; Otto Kahn at Cold Spring Harbor; Marshall Field at Lloyd Harbor; Francis Bailey at Lattingtown; Nathan S. Jonas at Great Neck; and A. J. Milbank at Lloyd Harbor.

Carol A. Traynor

Adolph F. Leicht: Front Facade, Frank C. Haven Residence, Sag Harbor, 1905 (COUN, 1921)

J. J. Levison: Landscape Design, A. J. Milbank Residence, Lloyd Harbor (PREV, n.d.)

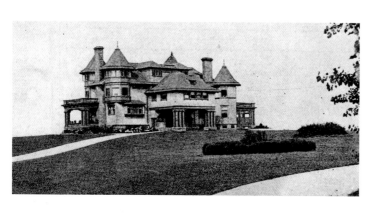

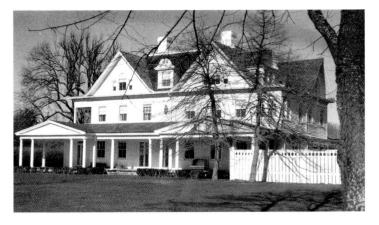

James H. L'Hommedieu:
Edward Bell Residence,
Southampton, c. 1896 (INVE,
1980)

Detlef Lienau, 1818–1887

German-born Detlef Lienau was educated in the province of Holstein, attended the Royal Architectural College in Munich, and pursued additional training in Paris under Henri Labrouste. He came to America in 1848 and established his own office and studio the following year, attracting a clientele of wealthy New Yorkers. August P. Belmont, the banker and financier, commissioned Lienau to design his residence on the 1,100-acre estate he bought in Babylon as a breeding farm for thoroughbred horses (many of which were to become internationally famous). The Belmont estate included a huge training stable, carriage houses, and kennels, among other numerous outbuildings.

Belmont's two-and-a-half-story, 24-room mansard-roofed main house, including an attached wing, was constructed in 1868. While unpretentious, it incorporated an influential and respected artist's sophisticated design elements. Lienau was the first New York City architect to experiment in the French mansard style, which was to become popular later in the century; his Hart M. Schiff house (1850) was the first example of the French Second Empire style seen in New York City. Belmont's house and estate buildings are no longer extant, but the site is now Belmont State Park (acquired in 1926) and enough of the planting remains so that one can get a sense of the original layout.

Carol A. Traynor

James H. L'Hommedieu, b. 1833

Although primarily known as a builder/contractor, James Harvey L'Hommedieu designed at least one country house on Long Island. Born at Smithtown in 1833, where he learned the trade of carpenter/builder from his uncle David C. L'Hommedieu, James Harvey had by 1857 started an extensive business in contracting and building. He attracted the attention of A. T. Stewart, the developer of Garden City, who engaged him in 1869 as the builder of the Garden City Cathedral, as well as other buildings in Garden City. Although he had little formal education, L'Hommedieu's grasp of architectural scale and proportion is evident in the Southampton country house he designed for Edward Bell, which appeared in *Scientific American, Building Edition* in 1896. This large, two-and-a-half-story Colonial Revival house characterized by its transverse end gables punctuated by Palladian windows flanking a broken-scroll pedimental dormer is reminiscent of McKim, Mead & White's 1889 Samuel L. Parrish house, also located in Southampton, and is still standing today.

Carol A. Traynor

Detlef Lienau: Front Facade,
August P. Belmont
Residence, Babylon, 1868
(*Long Island Forum*, May
1941)

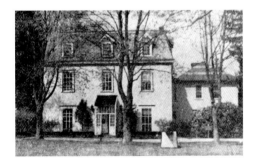

Detlef Lienau: Stables,
August P. Belmont
Residence, Babylon (BABY,
1894)

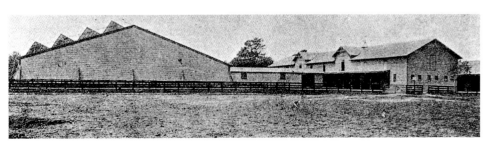

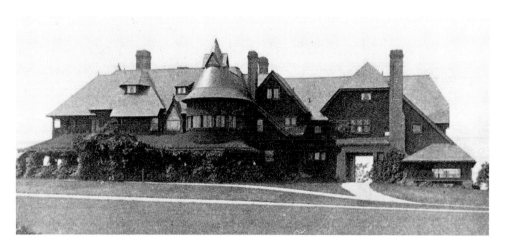

Edward D. Lindsey: Front
Facade, James H. Aldrich
Residence, Sag Harbor, 1880
(In the Land of the Sunrise
Trail: Sag Harbor, 1707–
1927, Sag Harbor, N.Y.:
Village Trustees, privately
printed, n.d.)

Edward D. Lindsey, 1841–1916

In 1886, after renting for several years, James Herman Aldrich commissioned architect and educator Edward D. Lindsey to design a summer residence for him at Sag Harbor. Lindsey, who maintained an office in New York City beginning in 1880, was a professor at Princeton's College of Applied Design. For Aldrich he designed a large Queen Anne-style shingled house with multigabled roofs and tall chimneys. In 1917 Mary G. Aldrich donated the estate, which included the main house, stable, tea house, and chapel, to the Episcopal Church. The estate now houses a parochial school administered by an order of Episcopal nuns.

Carol A. Traynor

Little & Browne, 1895–1939
Arthur Little, 1852–1925
Herbert W. C. Browne, 1860–1946

Born in 1852 in Boston, Arthur Little practiced architecture there until his death (after Little's death the firm continued to operate under the same name until 1939). Boston's rich architectural heritage deeply affected the future architect. Walter Knight Sturgis's perceptive article

on Little[1] suggests that the environment of that city and its surroundings fostered in the young man a sense of the grace and dignity of Colonial and Neoclassical buildings which he later attempted to emulate in his own designs.

Little's training at M.I.T. from 1871 to 1876 helped to crystallize the aesthetic inclinations of his youth. That institution's School of Architecture had been organized in 1868 by the progressive educator William Robert Ware. Concurrently with the University of Illinois and Cornell University, it offered the first formalized course of study for architects in the United States. Little was therefore among the earliest practitioners to be trained under the new American system of architectural education. In 1876 he was listed as taking classes in a special two-year program offered specifically to those students who were unable to enter the full four-year course. As with many two-year students, Little's training included employment in an architectural firm. He eventually became a draftsman for Peabody and Stearns, remaining with them until he opened his own practice in 1879. As was common for young professionals of his time, he supplemented his American education with a period of travel and study abroad, probably in the late 1870s. He then practiced alone in Boston from 1879 to 1889, when he entered into a partnership with Herbert W. C. Browne.

Little's first public statement was not a building, but a book of pen-and-ink sketches produced during a summer of traveling along the coast of Massachusetts, New Hampshire, and Maine. Entitled *Early New England Interiors* and published in late 1877, the book had two objectives: to preserve "the relics of a style fast disappearing," and to revive the American Colonial style, which Little saw as "everywhere marked with peculiar dignity, simplicity, and refinement."[2] With this in mind, he received his first commission from George Dudley Howe, for whom he designed "Cliffs" in Manchester, Massachusetts (c. 1878–79). This shingle house, like his book, served as a major influence on the fledgling Colonial Revival movement.

Little & Browne: Front
Facade, Horatio Adams
Residence, Glen Cove,
c. 1895 (INVE, 1979)

Little & Browne: Front
Facade, "Shadowlane,"
Charles E. Proctor
Residence, Great Neck,
c. 1914 (ARRC, 1914)

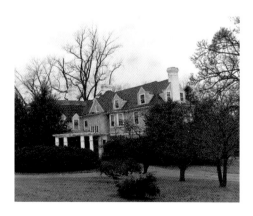

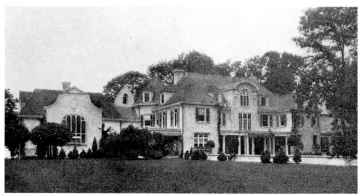

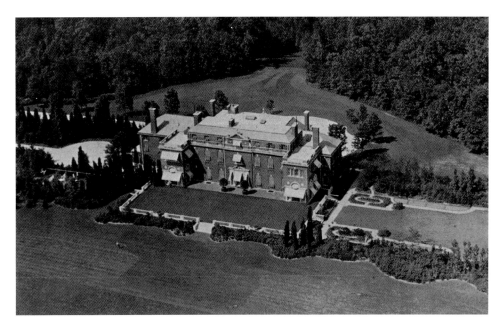

Little & Browne: Aerial View Showing Garden Facade, F. C. B. Page Residence, Brookville, c. 1917–20 (AVER, n.d.)

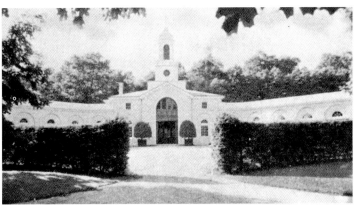

Little & Browne: Stable-Garage, F. C. B. Page Residence, Brookville, c. 1917–20 (PREV, n.d.)

Horatio Adams Residence, Glen Cove, c. 1895 (Extant)

Little & Browne's Long Island work did not begin until some 15 or 20 years after these major efforts; and only the first of these, the Horatio Adams house, retains some of the Shingle Style characteristics of Little's much earlier Manchester house. As we shall see, the academic eclecticism of the firm's later Long Island commissions was closely related to the work of McKim, Mead & White, and the resulting designs were not as innovative as Little's book of drawings or his first Shingle Style houses.

Approached from the east, the welcoming arms of the L-shaped Horatio Adams house draws the visitor in through the porte cochere set in the angle of the L. The roof lines are varied and enlivened by gabled dormers and medieval brick chimney stacks. Diamond-shaped panes in the upper sash of windows echo this medieval theme. While the Horatio Adams house contains some Colonial-style details—the diamond-paned sash, the hip and gambrel roofs—it is certainly not a replica of a Colonial building. Rather, Little, as a lover of the picturesque, freely evoked past associations. While retaining classical details, he never-

theless chose a romantic asymmetry which implied haphazard expansion of his building over time. The overall effect is one of comfort, ease, and hospitality.

Charles E. Proctor Residence, "Shadowlane," Great Neck, c. 1914

Little & Browne's second Long Island commission was for a much more ambitious residence in Great Neck, "Shadowlane." No longer extant, this stucco house was the most eclectic of this eclectic architect's Long Island designs. Medieval and classical elements were allowed to intermingle freely, even clash, throughout the fabric of the building. The facade featured a one-story classical colonnade, above which rose a three-story central pavilion crowned by an almost Baroque, segmental-arched roof. Some of the windows on this pavilion and on the symmetrically placed end bays were medieval, while others were simple and classical. A large wing extending from the main block featured an even more medieval, round-arched traceried window below a classical garland. The varied and complex roof line of the building included a polygonal tower which formed the junction of the main block with the wing; a bell-cote with a round-arched opening adorned the wing adjacent to the tower.

Frank C. B. Page Residence, Brookville, c. 1917–20

Little & Browne's design for Frank C. Bauman Page, executive vice president of the Brooklyn-based E. W. Bliss Co., manufacturers of heavy machinery and World War I munitions, was quite different from the rambling informality of either the Adams or Proctor houses. The house is generally Neoclassical Revival, but here, too, as with many of Little's buildings, the architect's

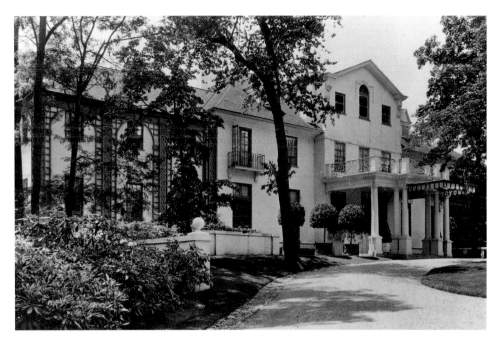

Little & Browne:
Alterations, "Morse Lodge,"
Tyler Morse Residence,
Westbury, c. 1909–10 (HEWI,
n.d.)

eclectic taste supplied details from a variety of sources. Broadly based on English Georgian homes of the late 18th century, the Page house presents a symmetrical facade with a balustrade screening a short third story. The interior is equally formal and ornate, and even more eclectic, with some of the details carried out in a finely scaled Adamesque style, while others are of a more Wren-Baroque character.

The estate as designed by Little & Browne included several outbuildings. Particularly interesting is the stuccoed stable with its hexagonal cupola over the round-arched central doorway. Its long wings extend on open angles to identical, small, gambrel-roofed cottages. Little & Browne, assisted by A. Chandler Manning, planned the extensive landscaping of the estate.

In addition to these three houses the firm was responsible for alterations to two other Long Island residences: "Morse Lodge" in Westbury and "Suffolk House" on Boney Lane in Smithtown. The date of the original building in Westbury is unknown, but the 1909–10 alterations were conceived by Little for the new owner, Tyler Morse. A large porch with smooth columns set on tall, square bases marks the entrance of the imposing, classically detailed building. The round-arch trellises which frame the simply cut windows of the wings add interest and soften the facade.

"Suffolk House" was originally built around 1860 for William J. Matheson; it was subsequently owned by Alexander A. Stewart, a director and stockholder in the Barnum & Bailey Circus. In 1912 extensive alterations and removal of the building from an exposed point of land on the Long Island Sound to its present, more protected, location were undertaken by the then owner James W. Lane and his architect Arthur Little. An old family friend, Little had already

designed two New York City houses for Lane's father-in-law, E. W. Bliss. Lane was connected with his father's important cotton merchandising firm, J. H. Lane and Co., of New York, as well as with his father-in-law's firm, the E. W. Bliss Co., mentioned in connection with the Page house above. Renovations to "Suffolk House" included stuccoing the original shingle exterior and enclosing all the outside porches. The art nouveau interiors were carried out by the designer Elsie de Wolff.

Little & Browne's Long Island work is varied and of uneven merit. Like the entire body of the firm's design elsewhere, however, it is generally picturesque, generous in form, and above all adaptable to gracious living. In these qualities lies its continuing appeal.

Gwen W. Steege

Little & O'Connor, practiced 1900s
Willard P. Little
Michael J. O'Connor, 1860–1936

This firm designed three palatial residences in Great Neck around 1900, none of which survive today.

"Martin Hall," James E. Martin's elaborate Federal Revival mansion, overlooked Little Neck Bay, its entrance front centered by a two-story Ionic-columned porte cochere; its water side featuring a monumental, semicircular Ionic portico and an arcaded ground floor. Inside, a two-story hall with beamed ceiling and double curving stair was densely trimmed with urn-capped balustrades and other ornate Federal Revival detail. The original estate, landscaped by the Olmsted Brothers, included formal gardens and a stable.

For William Gould Brokaw, son of the founder of a leading New York men's clothing store and brother of James Martin's wife, Little & O'Connor built a residence named "Nirvana." This was an astonishing Spanish-style stucco house with a pedimented, Palladian portico centering its curve-and-step-gabled facade. The Brokaw estate was renowned for its lavish Italian gardens, its theater, and its polo field and race track, where annual steeplechases were held. In ruins by 1930, "Nirvana" burned down in 1932.

"Sunshine," a large Spanish-style house, was built for Mr. and Mrs. Harry S. Gilbert. With its light-colored stucco walls, pantiled roofs, and a plethora of porches, balconies, and verandas, "Sunshine" was obviously designed to make the most of Long Island Sound views and summer breezes.

Ellen Fletcher

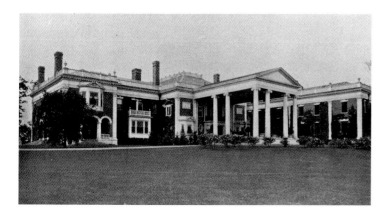

Little & O'Connor: Front
Facade, "Martin Hall,"
James E. Martin Residence,
Great Neck, c. 1900 (FERR,
1904)

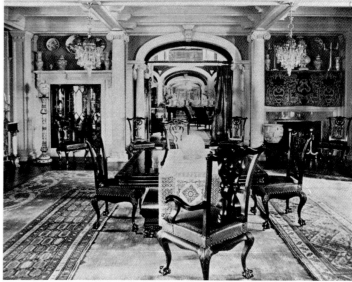

Little & O'Connor: Dining
Room, "Martin Hall,"
James E. Martin Residence,
Great Neck, c. 1900 (FERR,
1904)

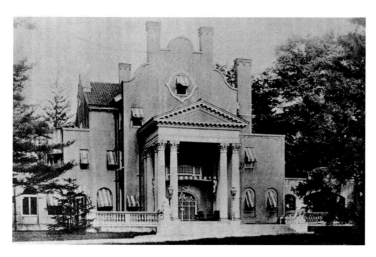

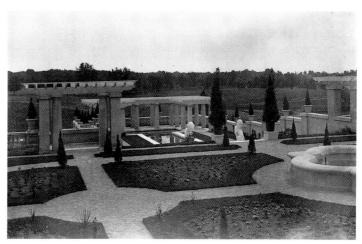

Little & O'Connor:
"Nirvana," William Gould
Brokaw Residence, Great
Neck, c. 1900 (GREA, 1975)

Little & O'Connor: Italian
Gardens, "Nirvana,"
William Gould Brokaw
Residence, Great Neck,
c. 1900 (SPLI, Gelwick
Collection, c. 1900)

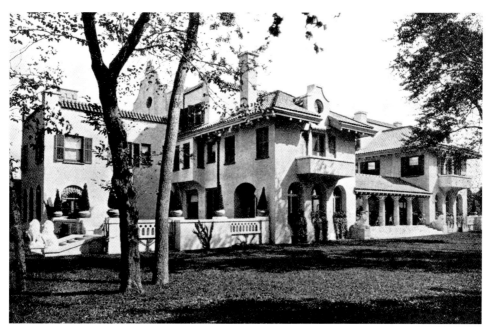

Little & O'Connor: Rear
Facade, "Sunshine," H. S.
Gilbert Residence, Great
Neck, c. 1900 (AMHO, 1911)

Grover Loening: Entrance
Court and Front Facade,
"Margrove," Grover
Loening Residence, Mill
Neck, 1930 (HOWE, 1933)

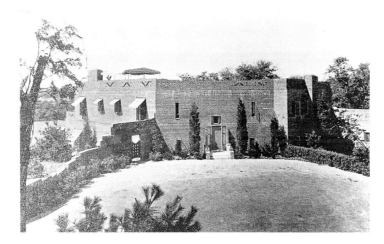

Lord & Hewlett, 1895–1922
Austin Willard Lord, 1860–1922
James Monroe Hewlett, 1868–1941

The partners met while working in the office
of McKim, Mead & White, and in 1895 they
formed a partnership, which also included
Washington Hull until his death in 1908.
Austin Lord was born in Minnesota, and
James Hewlett was of an old Long Island
family. Before their partnership, both had
first studied at top universities (Lord at M.I.T.
and Hewlett at Columbia), gained experience
in the offices of leading architects, and then
attended the Ecole des Beaux-Arts in Paris.
Both were also to direct the American Acad-
emy in Rome—Lord as its first director from
1894 to 1896, and Hewlett almost three
decades later, from 1932 to 1935.

Lord & Hewlett's Long Island work com-
prised three structures located in the village of
Lawrence. The most significant of these was the
second Rockaway Hunting Clubhouse. Estab-
lished as a polo and hunt club at Bayswater, Far
Rockaway, in 1878, the club was encouraged to
move to Lawrence in 1884. After the first club-
house there, designed by Bruce Price, burned in
1893, it was immediately replaced with designs
by Lord & Hewlett, who also planned additions
made ten years later. Stylistically, the building
resembled contemporary seaside hotels. The ini-
tial two-and-a-half-story building was enlarged
by an addition of almost equal length. Encir-
cling much of the clubhouse was a low piazza
with Tuscan pillars. The golf links, first laid out
in 1891, were redesigned in 1916–18 by Devereux
Emmett, and golf continues to flourish at the
club today.

The architects' next commission, for manu-
facturer and Rockaway Hunting Club member
Marshall C. Lefferts, combined the Shingle
Style with Colonial Revival-inspired Neoclas-
sical ornamentation, with mullioned windows
flanking the entrance surmounted by a continu-
ation of the portico's frieze. "Hedgewood," built
c. 1900, was demolished in the 1940s.

In 1927 James M. Hewlett, by then known
as a muralist as well as an architect, built a resi-
dence for himself at Lawrence. Its most striking
feature was a colossal portico with four Doric
columns.

Michael Adams

Grover Loening

In 1930 Grover Loening, the noted aeronautical
engineer and airplane designer who maintained
an office in New York City, designed his own
country residence in Mill Neck. Said to be
completed by airplane mechanics from his
own factory, "Margrove" was built in the new
International Style, characterized by strong
cubic shape, horizontality, and flat wall
surfaces, in this case of brick with a Native
American motif woven into the parapet design.
The interiors featured frescoes and balcony
railings rendered in an abstract seagull design
expressive of flight and constructed of aeronau-
tical steel alloy. Loening sold the house in 1953
and it remains in excellent condition today.

Carol A. Traynor

Lord & Hewlett: Rockaway
Hunting Club, Before 1903
Enlargement, Lawrence,
1893 (Courtesy of Mr.
Shuttleworth, n.d.)

Lord & Hewlett: Front
Facade, "Hedgewood,"
Marshall C. Lefferts
Residence, Lawrence,
c. 1900 (AABN, 1905)

James M. Hewlett: James
M. Hewlett Residence,
Lawrence, 1927 (INVE, 1978)

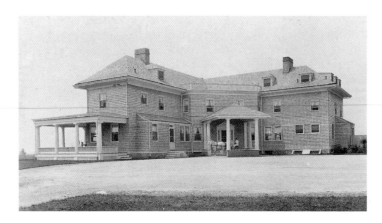

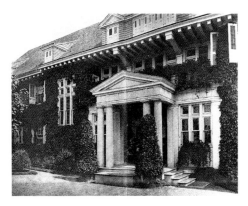

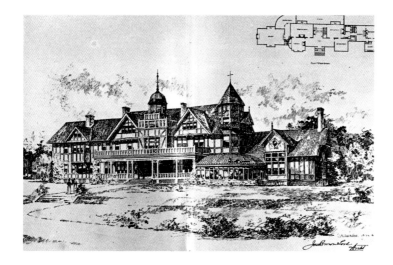

James Brown Lord: Design Rendering, "Roslyn Hall," Stanley Mortimer Residence, Roslyn (AABN, 1893)

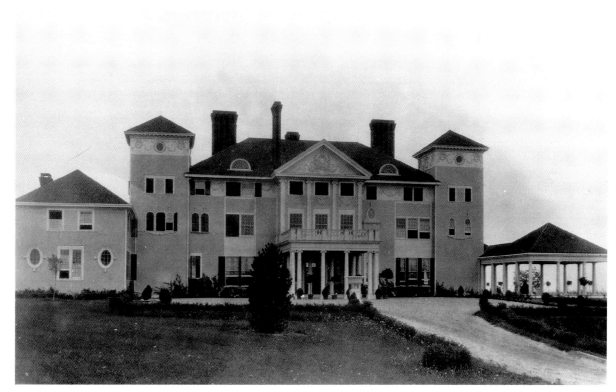

James Brown Lord: Front Facade and Entrance Court, James F. D. Lanier Residence, Westbury, 1891 (Courtesy Mrs. Karl B. Smith)

James Brown Lord, 1859–1902

Brief obituaries in the New York newspapers and reunion publications of the Princeton class of 1879 indicate that James Lord was born and grew up in a family enclave on 37th Street near Park Avenue. He married Mary Townsend Nicoll while in college, which he left before graduation to work for his uncle, the successful New York architect William A. Potter. Three years of this apprenticeship served as the only professional training Lord received.

In 1882 Lord, aged 23, started his own practice. As architect to the younger generation of the founding Lorillard family, he soon became a resident member of the exclusive Tuxedo Park Club. After a short but brilliant career, he died in 1902.

The families of both Lord's parents included several exceptionally successful professional men. For them and their friends, Lord designed row houses in Manhattan, country houses in Bar Harbor, Tuxedo Park, and Long Island, as well as buildings for the institutions on whose boards of trustees these distinguished patrons served. Among the latter were New York's Babies Hospital and the Appellate Court Building on Madison Avenue at 25th Street. A number of Lord's public buildings have survived. Most of his houses have been destroyed.

Lord's earliest buildings were in the Queen Anne style, but he always had a keen eye for what other fashionable professionals were doing. By the 1890s he was a full-blown eclectic, designing confidently in several historic styles. All three of Lord's known Long Island mansions have been destroyed, but surviving illustrations give a fair idea of the stylistic range exhibited by his big houses.

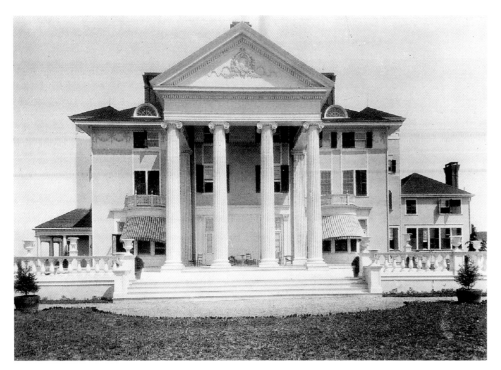

delicate wreaths and swags—McIntire mantle-piece decoration grossly misplaced. Before its dramatic remodeling by a later owner, this was perhaps Lord's most interesting building.

John Drew was among the most distinguished actors of his day, and was avuncular head of the legendary Barrymore theatrical family. In 1900 Lord designed for him a "cottage" in East Hampton. The long central rectangle was crowned by a hipped roof with extraordinarily broad eaves. Could the architect have studied Frank Lloyd Wright's Winslow House? If so, the simplicity of that model was here repeatedly compromised by porches, by a double-gabled pavilion in the center, and by a busy roof. Over all the major windows were delicate swags which in the central gables formed elaborate compositions. The relief was so low as to imply that the wall itself had little substance.

An eclectic architect often has to express a contemporary idea in a dead language. Lord was a man of talent, but because his ambition was to please the establishment, his ideas were wholly conventional. Since, in contrast to such contemporaries as Cass Gilbert, John Carrère, Thomas Hastings, and Charles Adam Platt, he visited Europe only briefly, if at all, Lord never learned to use idiomatically any of the traditional architectural languages he so highly favored.

John Coolidge

Guy Lowell, 1870–1927

Born in Boston, Guy Lowell was a member of the distinguished New England family. After early education in private schools, Lowell entered Harvard, graduating in 1892. He studied architecture at M.I.T., receiving his degree in 1894, and then at the Ecole des Beaux-Arts in Paris, earning his diploma there in 1899. While in Paris he also worked in the office of the landscape architect Édouard-François Andre.

Returning to Boston, Lowell opened his own architectural practice, began to lecture on landscape architecture at M.I.T. (an association which lasted until 1913), and compiled material for his first book, *American Gardens* (Boston: Bates & Guild, 1902). Early in his career he was appointed advisory architect to the Metropolitan Parks Commission of Boston, and in 1902 designed a series of Fenway entrances based on French Beaux-Arts precedents.

Among his important early commissions was institutional work gained through family connections. At Harvard, with which his family had a long association, he designed a new lecture hall (1902) and Emerson Memorial Hall (1903); later he designed the president's house for his cousin A. Lawrence Lowell. A 20-year

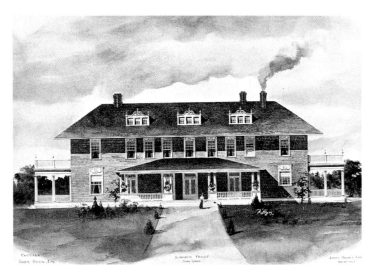

James Brown Lord: James F. D. Lanier Residence, Old Westbury, 1891 (Courtesy of Mrs. Karl B. Smith)

James Brown Lord: Garden Front, John Drew Residence, East Hampton, 1900 (ARTR, 1900)

In 1891 Lord designed for Stanley Mortimer in Roslyn a 60-room English manor house. Although all the exterior walls were consistently half-timbered, the house as a whole epitomizes the restlessness and love of variety characteristic of the Queen Anne style. Inside, Lord designed a spacious hall, a chapel with stained glass, and, repeatedly in the dark rooms, the richly carved wood paneling he favored.

James Franklin Doughty Lanier was a class behind Lord at Princeton and spent his working life in the New York private bank his grandfather had founded. For Lanier, in 1891, Lord produced an unusual classic house in Westbury, a symmetrical composition of smooth-walled blocks and towers. An out-of-scale Ionic portico was attached to one front; otherwise, the orders play a minor role. Especially characteristic of Lord's work were large white fields at the roof line, against which were arranged circular windows surrounded by

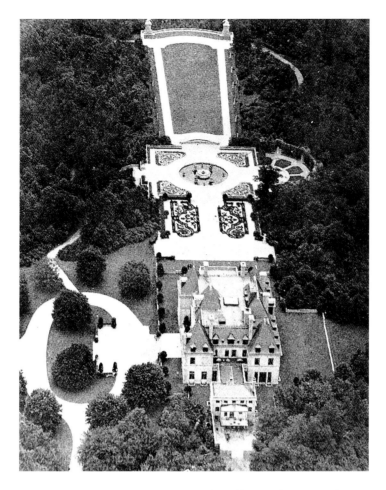

Guy Lowell: Landscape
Design, Aerial View of
House and Formal Gardens,
"Harbor Hill," Clarence H.
Mackay Residence, Roslyn,
1902 (TOWN, 1923)

association with Phillips Academy in Andover, Massachusetts, began in 1903 with his design for the Museum of Archaeology. George H. Edgell has called Lowell "the leading spirit of the architectural expression of Phillips Academy" where he designed 25 buildings.[1] Other academic work included the Carrie Memorial Tower (1903) at Brown University, a dormitory and refectory (1903) for Simmons College, Boston, and buildings for the Massachusetts State Normal School.

Lowell remains best known today for two major institutional works, the Boston Museum of Fine Arts and the New York County Courthouse. Lowell was appointed architect for the museum in 1906, and his handsome Beaux-Arts-inspired design was built between 1907 and 1915. He won the New York County Courthouse commission in competition in 1912; it was completed in 1927. Originally designed with a circular plan, the design was modified to a hexagonal form, graced by a monumental temple-front entrance portico.

While pursuing institutional work, Lowell also developed an active practice in the design of suburban and country houses. By 1906, when a major article on his work was published,[2] Lowell had designed at least nine such houses in a variety of styles that reflected both his academic training and his use of American Colonial and English precedents.

Landscape design was a continuing concern for him during this period, and several of his gardens were featured in the 1906 article. It was as a landscape architect that Lowell first made his mark on Long Island. His tenure on Long Island spanned some 20 years—a major portion of his career—and encompassed residential and landscape work, both major facets of his oeuvre. With the exception of one Sag Harbor commission, Lowell's work was centered on a relatively small area along the North Shore of Nassau County between Manhasset and Oyster Bay. The majority of his commissions are located in the vicinity of Oyster Bay and appear to be an outgrowth of his work for the Piping Rock Club. Ranging from relatively modest houses to grand estates, Lowell's work displays his predilection for the forms of American Colonial architecture.

Clarence Mackay, "Harbor Hill," Roslyn, Landscape Design, 1902

The firm of McKim, Mead & White brought Lowell his first Long Island commission in 1902 to design the landscaping of Clarence Mackay's Roslyn estate, "Harbor Hill" (no longer extant). Lowell had featured several of the firm's gardens in *American Gardens,* but landscaping was not a specialty. Clarence Hungerford Mackay (1874–1938), the creator of International Telephone and Telegraph, philanthropist, and society leader, and his new wife Katherine began work on their Stanford White-designed château in 1899. Consequently the house was under construction when Lowell was brought in. He was, nonetheless, responsible for the location of the auxiliary buildings, the design of the approaches and the connecting roads, the plantings, and the garden.

The design of the grounds around the house was of a formal nature "so that a proper transition can be made between the definite lines of architecture and the sinuous incoherence of nature."[3] The topography of the land aided this scheme. Lowell's work was praised for seeking "simplicity and propriety of effect; and in seeking for these simple effects [using] only the simplest means," as well as for supplying to American landscape architects "a model of consistency and economy, both of purpose and of means, in the treatment of a large estate which is needed and may well be edifying."[4]

William Payne Whitney, "Greentree," Manhasset, Landscape Design, 1905

William Payne Whitney (1872–1930), financier and sportsman, gave Lowell his next Long Island commission in 1905. Whitney's relatively modest Colonial-style country house in

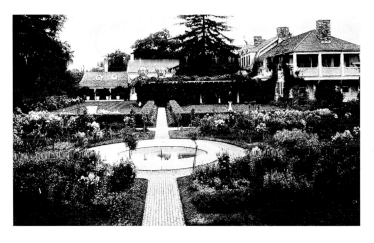

Guy Lowell: Landscape Design, View of House and Garden, "Greentree," William Payne Whitney Residence, Manhasset, 1905 (COUN, 1914)

Guy Lowell: Rear Facade, Julian A. Ripley Residence, Brookville, c. 1910 (NASS, Korten Collection, c. 1910)

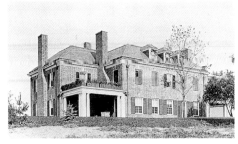

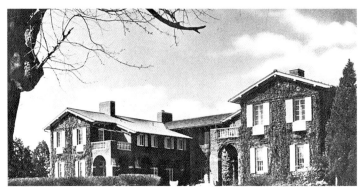

Guy Lowell: Entrance Front, "West Banks," Reginald Barclay Residence, Sag Harbor, 1910–12 (PREV, n.d.)

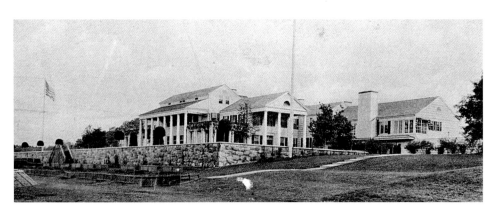

Guy Lowell: Piping Rock Clubhouse, Locust Valley, 1911 (VAND, c. 1915)

Manhasset was designed by P. G. d'Hauteville and J. E. Cooper. L-shaped in plan, the house partially enclosed Lowell's garden (no longer extant), which featured a pergola, an axial path leading to a circular fountain, hedges defining quadrants of lawn, and masses of flowering plants. Almost ten years after its creation, it was described as "a very intimate little garden that has found itself."[5]

Julian A. Ripley Residence, Brookville, c. 1910 (Extant)

Lowell appears to have received his first residential commission for Long Island around 1909 or 1910.[6] Julien A. Ripley asked him to design a house in Brookville of relatively modest size and proportions. In its form and details it looks to the precedents of American Georgian architecture, with its Flemish-bond brickwork, keystones in the flat window arches, hipped roofs

with dormers, and tall brick chimneys. Columned porches are tucked in front of the wings of the house.

Reginald Barclay Residence, "West Banks," Sag Harbor, 1910–12 (Extant)

In 1910–12 Lowell designed and built "West Banks" for Reginald Barclay (d. 1925), a New York socialite and yachtsman.[7] Barclay's yachting interests seem to have dictated the Sag Harbor location. The 97-acre estate incorporates a large house on a cliff above the shore, a garage, barn and stable, vegetable gardens, and oak woodlands. The main residence is U-shaped in plan, with a long wing extending to the north. Although faced in brick, the form and details of the house, with its arcaded porches and tiled gabled roofs, recall an Italian villa. The arms of the U encompass a garden entrance court on the east side of the house, while the southern arm opens onto a columned terrace structure. The interior details of the house suggest 18th-century English country-house prototypes, particularly the treatment of the reception hall. Set away from the main house is a group of simple, low, shingled farm buildings with steep gabled roofs. Surviving records do not indicate whether Lowell designed the landscape features, but the incorporation of relatively formal gardens around the house and the retention of the extensive woodland suggest precedents from the Mackay estate.

Piping Rock Clubhouse, Locust Valley, 1911 (Extant)

The clubhouse of the Piping Rock Club (1911), located in Locust Valley, was the first of a series of commissions linked by geography. Here Lowell sought to evoke America's Colonial heritage in a cluster of shingled and porticoed forms—"the sort of thing that George Washington would have built if he had had the money," quipped *Country Life*.[8]

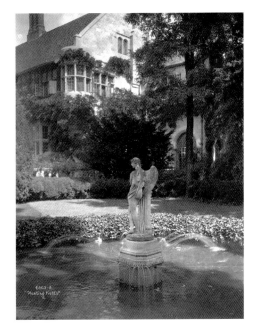

Guy Lowell and A. Roland Sargent: Landscape Design, Garden View, William R. Coe Residence, Oyster Bay, 1913–18 (DEBE, 1956)

Guy Lowell: "Farnsworth," C. K. G. Billings Residence, Matinecock, 1914 (Courtesy of Mrs. Jane Ricks King)

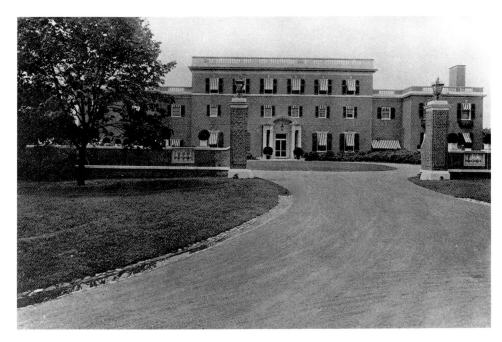

Lowell devised a plan around an internal courtyard which incorporates the requisite lounging rooms, club rooms, dining rooms, and service facilities. The majority of rooms open onto the hall encircling the courtyard, as well as onto a series of porches and verandas encompassing the exterior of the building. Thus the building was placed into, and linked with, the landscape.

William Robertson Coe, "Planting Fields," Oyster Bay, 1913–18 (Extant)

In 1913 William Robertson Coe (1869–1955), a successful insurance executive and a member of the Piping Rock Club, commissioned Lowell to do the landscaping for his estate "Planting Fields," in Oyster Bay. Lowell carried out this work in conjunction with his brother-in-law, A. Roland Sargent (d. 1918), who by that time had joined Lowell's firm as the chief landscape partner.[9] The Coes, who had purchased the site with an existing house, wished to landscape and otherwise improve the property. Lowell enlarged an existing greenhouse, remodeled the garden house, and designed the superintendent's house. In addition, he and Sargent planned a series of formal landscape elements. In March 1918, the house burned to the ground; its replacement, completed in 1921, was inserted into the existing landscape.[10] The landscaping of other portions of the estate was carried out by James Frederick Dawson of Olmsted Brothers, but Lowell's and Sargent's work appears to survive largely intact.

C. K. G. Billings Residence, "Farnsworth," Matinecock, 1914

In 1914 Lowell was given the opportunity to completely design the buildings and grounds of an estate (only small portions survive) for

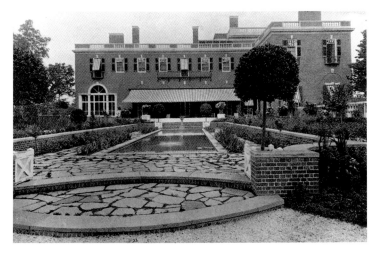

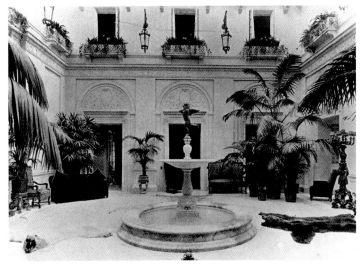

Guy Lowell and A. Roland Sargent: Rear Facade and Formal Garden, "Farnsworth," C. K. G. Billings Residence, Matinecock, 1914 (Courtesy of Mrs. Jane Ricks King)

Guy Lowell: Marble Patio and Organ Room, "Farnsworth," C. K. G. Billings Residence, Matinecock, 1914 (Courtesy of Mrs. Jane Ricks King)

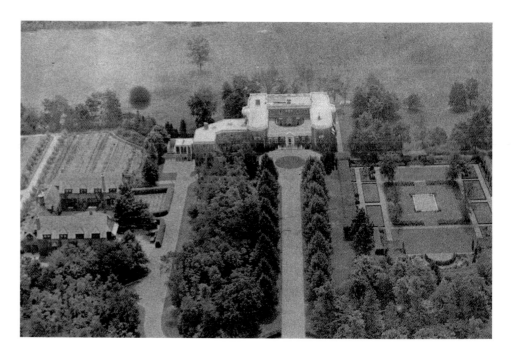

Guy Lowell: Aerial View of Gardens and Entrance Court, "Veraton (III)," Paul D. Cravath Residence, Locust Valley, 1914 (AVER, c. 1930)

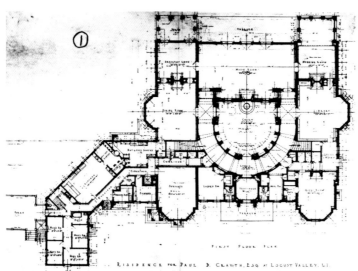

Guy Lowell: First Floor Plan, "Veraton (III)," Paul D. Cravath Residence, Locust Valley, 1914 (PREV, n.d.)

RESIDENCE FOR PAUL D. CRAVATH, ESQ AT LOCUST VALLEY, L.I.

The design was almost severe, yet refined, with carefully laid brick facing accented by stone details. A balustrated brick wall with tall gate-posts enclosed the entrance court. The west side opened onto a terrace, partially enclosed by the projecting trophy-room wing, and extended into a formal garden. Lavish effects were reserved for the interior. The house was planned around a double-height covered patio which served as an organ room. In its details and rich marble surfaces, this space recalled the atrium of an Italian palazzo. Equally lavish was the oval-shaped loggia which functioned as a music room. Its rich Adamesque decoration took its cue from 18th-century English country houses. The house was renowned for its Aeolian organs. The brick outbuildings (still surviving), located to the southwest of the main house, are much simpler in design, yet harmonious.

Cornelius Kingsley Garrison Billings (1891–1937), capitalist, president of the Peoples Gas Light and Coke Co. of Chicago, chairman of the board of Union Carbide, and avid horseman. "Farnsworth"[11] in Matinecock, Oyster Bay, was close to both the Piping Rock Club and "Planting Fields." In 1905 Lowell had designed a stable for Billings at his Fort Tryon estate in New York City. The 65-acre Long Island estate contained the main house, a superintendent's house, seven smaller houses for servants, a garage, greenhouse, powerhouse, and stable with 20 box stalls. The grounds were laid out from A. Roland Sargent's plans, presumably under Lowell's overall direction.

The main house, a major essay in Neo-Georgian architecture, was three stories high and almost square in plan, with two wings extending from the entrance facade, one housing the kitchen and the other the trophy room.

Paul D. Cravath Residence, "Veraton (III)," Locust Valley, 1914 (Extant, but altered)

Although within a different township, Locust Valley, the estate of Paul Drennan Cravath (1861–1940) is very close to that of C. K. G. Billings; it is adjacent to the Piping Rock Club. Built about 1914, this is only one of four Long Island houses constructed for Paul Cravath, a prominent lawyer and partner in the firm of Cravath, de Gersdorff, Swaine & Wood. It survives in an altered state. Here Lowell again used the Neo-Georgian style he favored for so many of these estates. Faced with red brick, it had contrasting stone detail and was crowned by a balustraded parapet. Far more remarkable than the detail was the plan and massing of the structure. The main block of the house, while symmetrically organized, incorporated several

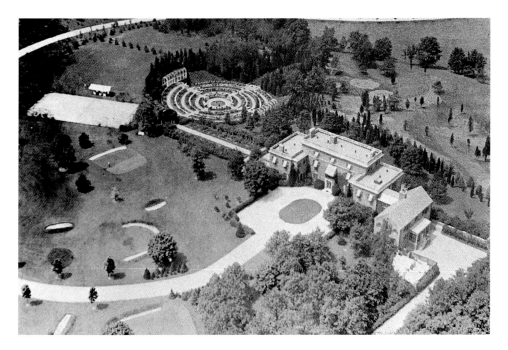

Guy Lowell and A. Roland Sargent: Aerial View of Entrance Court and Formal Garden, "Farlands," Guernsey Curran Residence, Oyster Bay, c. 1918 (AVER, c. 1930)

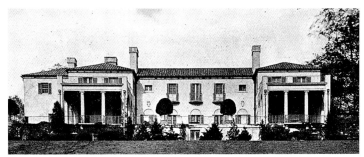

Guy Lowell: Rear Facade, Arthur V. Davis Residence, Mill Neck, 1922 (COUN, 1928)

decidedly nonrectilinear features, including apsidal wings flanking the entrance facade, projecting bays on the side elevations, and an internal semicircular loggia enclosing an open court. This type of court, previously used in the Piping Rock Clubhouse and the Billings house, here took on its most unusual form. The loggia and court opened onto a large music room which in turn opened onto a covered terrace at the rear facade of the house. The music room undoubtedly reflected Cravath's interests as president of the Metropolitan Opera Association. Extending at an angle from the main block of the house was the servants' wing. Set fairly close to the house but beyond the servants' wing was a large U-shaped garage and stable structure. Both Lowell's firm and Olmsted Brothers worked on the landscaping. Among the notable landscape features were an allée of trees leading to the entrance of the house and a large formal garden that balanced the placement of the garage and stable.

Guernsey Curran Residence, "Farlands," Oyster Bay, c. 1918

Lowell's design for Guernsey Curran's estate, "Farlands,", would seem to date from about 1918.[12] The 90-acre estate featured the main

house, a recreation building, and an extensive group of farm buildings and a gatehouse, both well removed from the main house. Only these outbuildings survive. For the design of the main house Lowell again turned to the Georgian prototypes that he used for the commissions of so many of his Long Island clients. The house was faced with brick and set off with contrasting stone details, including a small, columned, entrance portico and a balustrade at the roof line. The main block of the house was three stories, set off by two projecting wings containing the living room and dining room. Placed asymmetrically off the dining room wing was another wing with kitchen and servants' quarters, distinguished by its steep gabled roof. Contrasting with this was a one-story, flat-roofed enclosed porch opening off the living room wing. Close to the main house was the low-lying recreation house. This structure contained a swimming pool, tennis court, music room, and drawing room. The landscaping of the estate, by A. Roland Sargent of Lowell's firm, featured a formal circular terraced garden with central pond, north of the main house.[13]

Arthur V. Davis Residence, Mill Neck, 1922 (Extant)

Lowell's final Long Island commission was for Arthur Vining Davis (1867–1962), chairman of the Aluminum Co. of America, and a director of the Mellon National Bank. Rather than looking to early American prototypes, Lowell here chose the inspiration of the Italian Renaissance villa. Faced in cream-colored stucco, the house features a low-hipped, red-tile roof, arched window openings, and arcaded and columned porticos, set in projecting wings on the entrance facade and extending across the rear overlooking the waters of Oyster Bay. As in the Reginald Barclay house of some 12 years earlier, Lowell chose to place Georgian-inspired interior spaces into an Italian villa design. The house, set on a raised terrace, is surrounded by gardens. This too contrasts with Lowell's earlier designs in which a formal garden is set apart from, yet carefully related to, the house. The landscape design here is credited to Ferruccio Vitale.[14]

Lowell's Long Island work remains a respectable, yet lesser-known, part of his career. In his use of stylistic prototypes he was following the fashions of the period, yet his handling of space and forms indicates a keen architectural sensibility which appears to have met the needs and purposes of his clients. His landscape work was an important adjunct. Unfortunately, as large estates have fallen prey to declining fortunes and changing lifestyles, few of his executed designs survive to allow for full appreciation of Lowell's talents.

Marjorie Pearson

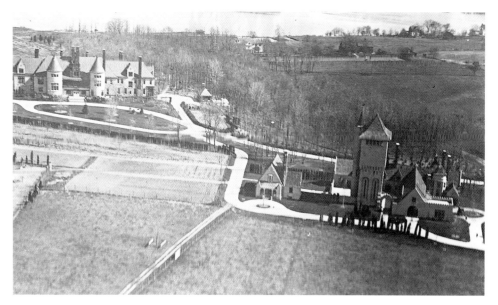

Clarence S. Luce: "West Neck Farms," George McKesson Brown Residence, Lloyd Harbor, 1911–15 (HUNT, n.d.)

Clarence S. Luce, 1852–1924

Born in Newport, Rhode Island, Clarence Sumner Luce practiced in Boston before moving to New York in 1885. He is known for his Queen Anne and Shingle Style domestic commissions, as well as for his exposition pieces like the Massachusetts State Building at the Philadelphia Centennial (1876). George McKesson Brown, of the McKesson Chemical Company of Connecticut, retained Luce to design "Coindre Hall" at Lloyd Harbor. Built between 1911 and 1915, the chateau-style residence shows a symmetrical disposition of conically roofed towers, high brick chimneys, and steep masonry roof gables. The service buildings, comprising a stable group and a boathouse, repeat the motifs of elongated brick chimneys and towers, with the stable group dominated by a 100-foot-high corbelled square water tower, and the boathouse incorporating an octagonal tower. The Brown residence was purchased in 1973 by the Suffolk County Department of Parks and renamed "Coindre Hall."

Wendy Joy Darby

J. Clinton Mackenzie, 1872–1940

Nothing is known about J. Clinton Mackenzie's education and training, but he can be best described as an eclectic Beaux-Arts architect. Mackenzie worked on projects throughout the United States, including the planning of Kingsport, Tennessee, one of the country's first model industrial suburbs. He is also known to have been an avid yachtsman, officiating at the America's Cup Race of 1934 as a member of the New York Yacht Club's race committee. He maintained an office at 116 Broad Street in New York City.

Four commissions can be attributed to Mackenzie on Long Island. His own residence at Centre Island, Oyster Bay, constructed soon after 1900, is an exuberant Mediterranean-Mission-Style design, featuring paired, gabled pavilions front and back with scrolled pediments and a Spanish tiled roof. It was illustrated in five contemporary publications, including *Architectural Review* and *House Beautiful,* sometimes as a concrete country house, although it was actually constructed out of brick and tile with a stucco finish. Although altered, the house survives as a private residence.

Also located on Centre Island, the Henry A. Rusch residence, from around 1908, with its curved plan, owes something to the famous Appleton House in Lenox, Massachusetts (1883–84), and "Wave Crest," the John Cheever house in Far Rockaway (1885), both by McKim, Mead & White. Like these pioneering works in an inventive, progressive manner, the Rusch residence hugs the ground under a closely hipped roof, while bending its form around the driveway and minimizing surface ornamentation. With its casement-styled windows, shed-roofed dormers, and bare stuccoed walls, it resembles the work of Charles F. A. Voysey, the creative British architect of the period. In 1920 Mackenzie designed "The Point," the B. H. Inness Brown residence in Plandome Manor, in a large-scaled Colonial Revival manner.

Mackenzie was also a prolific designer of estate outbuildings for various clients on Long Island between 1900 and 1920. Around 1910 he executed the garden, garage, and gate lodge in the popular Tudor Revival style for the William Matheson residence at Lloyd Harbor, Huntington. His commissions included, as well, an elaborate brick farm complex for "Burrwood," the Walter Jennings estate in Cold Spring Harbor, and barns for Robert W. de Forest at Cold Spring Harbor (c. 1900) and for James A. Blair at Oyster Bay (1915).

Peter Kaufman

J. Clinton Mackenzie: Front Facade, J. Clinton Mackenzie Residence, Centre Island, c. 1900 (EMBU, 1909)

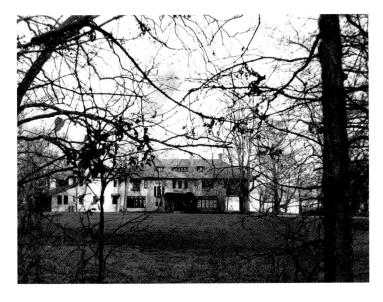

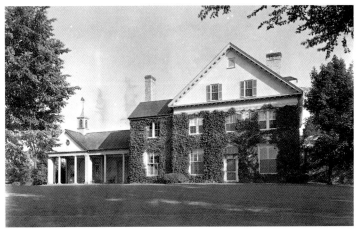

J. Clinton Mackenzie: Front Facade, "June Acres," Henry A. Rusch Residence, Centre Island, c. 1908 (INVE, 1918)

J. Clinton Mackenzie: Rear (Garden) Facade, "The Point," B. H. Inness Brown Residence, Plandome Manor, 1920 (GOTT, 1935)

J. Clinton Mackenzie: Landscape Design, Formal Gardens, "Fort Hill," W. J. Matheson Residence, Lloyd Harbor, c. 1910 (ARLG, 1910)

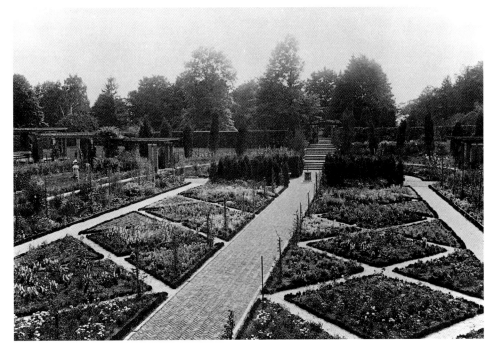

J. Clinton Mackenzie: Farm Complex, Walter Jennings Estate, Cold Spring Harbor (WURT, n.d.)

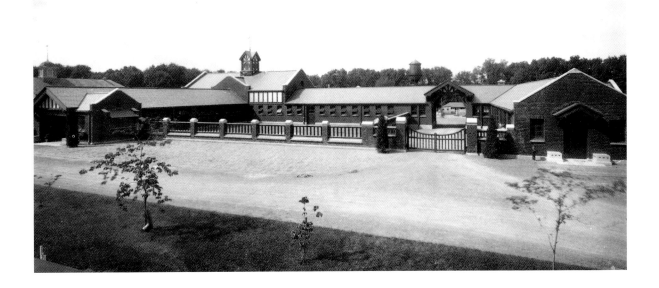

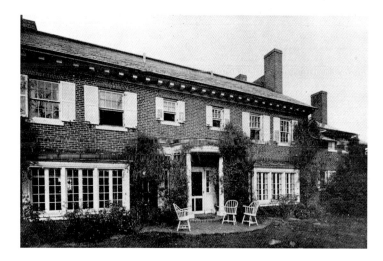

Alexander Mackintosh: "Underhill House," John Slade Residence, Oyster Bay, c. 1918 (ARLG, 1924)

Alexander Mackintosh, 1861–1945

A native of London, England, Alexander Mackintosh was educated and worked in Scotland before joining the London office of Sir Ashton Webb. Arriving in America in 1896, he joined the New York architectural firm of Francis H. Kimball. In 1901 Mackintosh established his own practice, working on both commercial projects and country estates. His major Long Island work was "Underhill House" at Oyster Bay, commissioned by John Slade. Built around 1918, the brick house incorporated Federal-style features, notably a protruding semicircular entrance portico with complete Classical order, and Palladian-style windows set within recessed arches. The ellipsoid form of the portico was echoed by its small brick patio, flanked in turn by a scalloped flower bed which fronted the house.

Wendy Joy Darby

H. van Buren Magonigle: Garden Facade, "Villa Carola," Isaac Guggenheim Residence, Sands Point, 1916 (PATT, 1924)

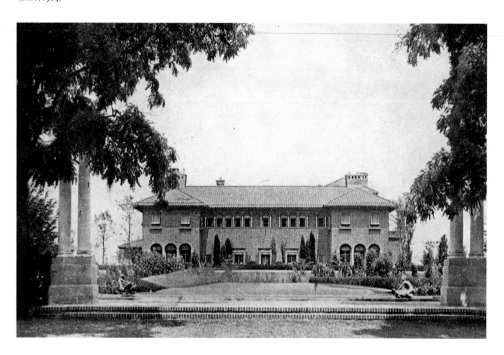

H. van Buren Magonigle, 1867–1935

A successful self-taught architect of the City Beautiful era, Magonigle mastered a wide variety of styles. He became well known in the New York City area during his lifetime not only for his architectural commissions, many of which he decorated himself, but also for his numerous writings on architecture. "Villa Carola," the house he designed in Sands Point for Isaac Guggenheim (1916) displays his skill in adapting an Italian villa style to the needs of a 20th-century country house. The most frequently illustrated portion of the building is the garden facade. A careful study of balanced wings and restrained fenestration with minimal decoration, it nevertheless avoids a sense of severity. Magonigle was also the architect for the private golf clubhouse built on this estate in 1920. Some two years later, following Isaac's death, the estate became the country house of his brother, Solomon R. Guggenheim, founder of New York City's Guggenheim Museum. Today, IBM Corporation has re-adapted "Villa Carola" to serve as its Management Training Center.

Peter Kaufman

Howard Major, 1883–1974

Like his Palm Beach competitor Addison Mizner, Howard Major made his start on Long Island during the high period of country-house construction, just before and after World War I. By the time he moved to Florida in 1925, Major had designed several country houses, and received commissions for seven alterations, all in Glen Cove or nearby Lattingtown. For the most part, his Long Island work was in the Georgian Revival mode but was accented with features from the forgotten Greek Revival style, for which he became the leading exponent.

Educated at Brooklyn's Adelphi Academy and Pratt Institute, Major received his professional training at the atelier of Henry Hornbostel of the Society of Beaux-Arts Architects, before joining the office of Charles A. Rich in 1904. By the time he left Rich's employ a decade later, he had risen to the position of head draftsman and had begun to establish the social connections which were to facilitate his long career in domestic architecture. A handsome and polished figure, Major joined Manhattan's prestigious Metropolitan Club and Squadron A. At the time of his death he was a member of Palm Beach's exclusive Bath and Tennis Club and the Indian Harbor Yacht Club of Greenwich, Connecticut.

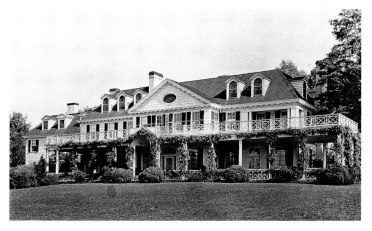

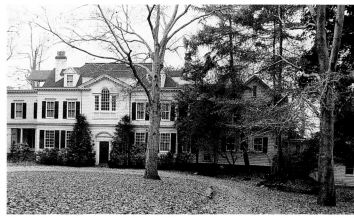

Howard Major: Alterations, "Oakleigh," James H. Ottley Residence, Glen Cove, c. 1915 (Courtesy of Mrs. Crisp)

Howard Major: Alterations, Front Facade, William Hester Residence, Glen Cove, c. 1915 (INVE, 1979)

Howard Major: Alterations, Samuel D. Brewster Residence, Glen Cove, c. 1915 (HEWI, 1929)

Howard Major: Alterations, William Beard Residence, Glen Cove, c. 1918 (ARRC, 1918)

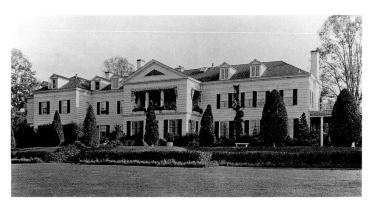

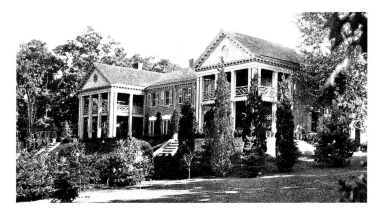

Among Major's better-known commissions were the Porcupine Club at Nassau in the Bahamas and the Port Royal Development plan and the Church of the Trinity-by-the-Sea in Naples, Florida. At Nassau, Hobe Sound, and Palm Beach, Major designed residences for well-heeled clients, including Arthur Vining Davis, Howard Whitney, John Hertz, Charles Merrill, and Edward Lynch. Despite his successful practice, Major was not entirely at ease with the Palm Beach architectural scene. In his biography of Mizner, Donald W. Curl notes that while Major designed Spanish houses after his arrival, he became "the earliest critic" of the style that Mizner had popularized for the resort. Major published his views in his landmark study, *The Domestic Architecture of the Early American Republic: The Greek Revival,* published by Lippincott the year after he arrived in Florida:

Florida is the present day frontier, the melting pot of the Union, the cosmopolitan state. Instead of the travesty upon Latin architecture which prevails throughout its area, there should be a thoroughly American style to appropriately house its inhabitants. The houses of the Hellenic phase throughout the Gulf states, with their shaded, two-storied verandas . . . fulfill every requisite of climate, convenience and nationalism.

Latin travesty, however, was the rage in Palm Beach in 1926 and Major's views could not have helped his practice, especially when coupled with what his son recalls was an unwillingness to "bend to what he considered frivolous requests of potential clients." In time other styles were accepted, and Major's first wife, Catherine Clark (d. 1958), helped provide "the tact and at times compromise" needed to win and hold clients. Also remembered as an architectural critic, Major was a frequent contributor to the *Architectural Forum, Country Life, House and Garden,* and *Vogue.*

His Long Island work commenced in 1915, the year in which he remodeled three late-19th-century Glen Cove country houses. For publishers James H. Ottley (*McCall's Magazine*) and William Hester (*Brooklyn Daily Eagle*), Major transformed rambling Shingle Style houses into balanced Georgian Revival compositions.

What Major was responsible for at dry goods merchant Samuel D. Brewster's house, which had originally been owned by real estate entrepreneur Harvey Murdock, is not known; however, his hand is evident in the classical portico and sleeping-porch pavilion. It seems that, influenced by the Pratt brothers who were putting their vast Standard Oil wealth to use, all the residents of Glen Cove's summer colony were determined to give a facelift to their country houses during this period, so that Major received one commission after another. A house Major had rebuilt in brick for William Beard in a modified Georgian style was published in 1918 in the *Architectural Record.*

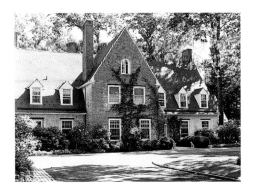

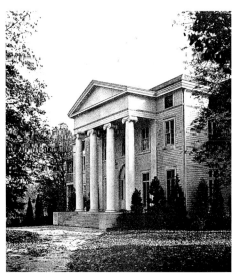

Howard Major: Front
Facade, Norman Toerge
Residence, Matinecock,
c. 1920 (INVE, 1979)

Howard Major: Alterations,
E. L. Eldridge Residence,
Glen Cove, c. 1920 (COUN,
1922)

The 1920s brought several more alteration projects for Herbert Dean and Howard Carhart (both in Lattingtown), not to mention commissions for new houses for Mrs. Howard Whitney (demolished, appearance unknown), and Norman Toerge. The house Major designed for Toerge, an eclectic, vaguely Colonial essay in brick, appeared in the *Architectural Forum* and *Arts & Decoration.* However, Major's most interesting work of the decade, particularly with regard to later developments, was the alteration around 1920 of E. L. Eldridge's sizeable 1850 Italianate mansion. Here Major seems to have had a free hand in removing the brackets, overhanging cornices, bay windows, and other period features, while adding a massive Ionic portico, so that as *Country Life in America* was able to report in 1922, "a stately house of the Greek Revival period was evolved."

Robert B. MacKay

Mann & MacNeille, 1902–1931
Horace B. Mann, 1868–1937
Perry R. MacNeille, 1872–1931

Horace Mann and Perry MacNeille practiced architecture together in New York City for almost three decades. They are represented on Long Island by a country house built for Nathan S. Jonas in Great Neck in 1927, now demolished. Mann described it as a "rambling French-English house," drawing attention to its irregular silhouette and high-hipped roof. He noted that although he "made no real effort to keep the English feeling, . . . there it is," the stable dignity of the house "superior to roof lines and other mere architectural details." The texture of the hollow "clinker" brick walls, the irregular massing of main block and wings, and the variegated gray slate of the roof conveyed visual richness to this modestly ornamented house.

Ellen Fletcher

Matthews & Short, practiced 1920s–1930s

Cincinnati-born architects Stanley Matthews and Charles W. Short (1884–1954) conducted a thriving practice for two decades, with offices both in their home town and in New York City. Short studied in London, at one point under Ralph Adams Cram, and married a granddaughter of noted British inventor Robert Whitehead. His ties to England remained strong and he returned there to practice after World War II. Before the war, Short served as architectural adviser to the Public Works Administration in Washington, D.C.

Around 1930 the firm designed a country house for Orson D. Munn, grandson of the publisher of *Scientific American Magazine,* in Southampton. The stucco house in the French Manorial style has a projecting central pavilion highlighted by a decorative ormolu frieze above the second story. The interesting use of colors and textures includes the gray wood-shingled hip roof and brown cement stone quoins.

Carol A. Traynor

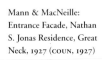

Mann & MacNeille:
Entrance Facade, Nathan
S. Jonas Residence, Great
Neck, 1927 (COUN, 1927)

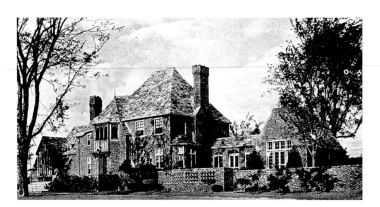

Matthews & Short: Front
Facade, "Arches," Orson
D. Munn Residence,
Southampton, c. 1930
(ARTS, 1932)

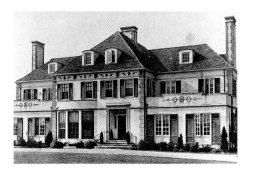

Charles Follen McKim,
1847–1909 (*King's Notable
New Yorkers*, 1899)

William Rutherford Mead,
1846–1928 (*King's Notable
New Yorkers*, 1899)

Stanford White, 1853–1906
(*King's Notable New Yorkers*,
1899)

McKim, Mead & White, 1879–1920
McKim, Mead & Bigelow, 1877–1879
Charles Follen McKim, 1847–1909
William Rutherford Mead, 1846–1928
Stanford White, 1853–1906

The impact of McKim, Mead & White on the architecture of Long Island was profound, long-lasting, and personal. The leading turn-of-the-century architectural practice in the United States, with over 1,000 designs to its credit, the firm produced some of its best and most innovative work for Long Island.[1] They were among the first architects to design houses for the new resort areas along both the north and the south coasts as they developed in the 1870s and 1880s. In the 1890s McKim, Mead & White led the transition from resort to country estate living, turning the central portion of Long Island into a "rural park."[2] In a sense the firm dominated Long Island architecture, establishing the fad for shingle-covered "modern Colonial" resort houses so successfully that today practically anything with shingles is attributed to them. The firm also introduced more accurate Colonial

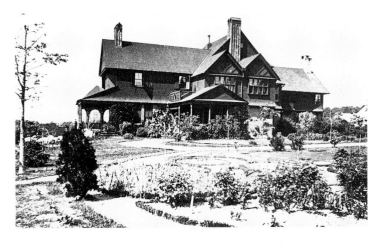

McKim, Mead & White:
Walter Tuckerman House,
Oyster Bay, 1882 (Courtesy
of Roxanne Grant Lapidus
and Gordon Grant)

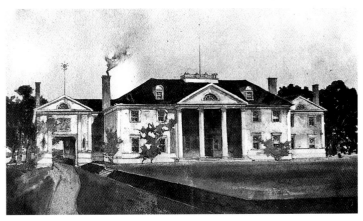

McKim, Mead & White:
Artist's Rendering, Robert
Winthrop Residence,
Westbury, 1897–1902
(AVER, n.d.)

detailing and, finally, set the pace with large mansions such as Clarence Mackay's "Harbor Hill." In addition, McKim, Mead & White designed several of the leading entertainment centers on Long Island, including the Garden City Hotel, the Babylon Casino, and the first golf clubhouse in the United States for the Shinnecock Hills Golf Club.

Personally, Long Island meant a great deal to the three partners, since its proximity to New York City made it easily reachable for a quick break. The three partners visited many Long Island locations, and as frequently happens became friends with their clients—for few things are more personal than designing a house—and returned as guests. One of Charles McKim's "first efforts in Architecture" was the Prescott Hall Butler house at St. James.[3] A few years later, Cornelia Butler's youngest sister, Bessie Smith, married Stanford White. Stanford and Bessie White purchased a nearby farmhouse and undertook a long campaign of additions and modifications. Over the years White, with the help of McKim and Mead, used the house for architectural experiments, and here, on summer weekends, the three partners frequently gathered. In time the firm designed or built additions for two more neighboring houses in St. James, the Wetherill and Emmet houses, as well as many outbuildings and stables. In the fall of 1909 a very sick McKim returned to St. James to a small house on the White property, where he died.

A note on the extent and documentation of McKim, Mead & White's work on Long Island is necessary. At present approximately 40 individual commissions (which include stables and later remodelings) can be attributed with some certainty to the firm. These range from a house and coachman's cottage for Walter C. Tuckerman at Oyster Bay (1882, demolished) to a remodeling for Edward Winslow at Great Neck (1887–89, extant) and a large Colonial Revival house and stable for Robert Dudley Winthrop at Westbury (1897–1902, demolished). The firm even designed a broadcasting tower at Wardenclyffe, Shoreham (1902), and worked on portions of the 1850s Gothic Revival church of St. James at Smithtown in 1895. Some of the commissions, like the work for Edward S. Mead at Southampton (1886, extant), must have been very minor, perhaps a remodeling, since the firm was paid only $100 for its efforts. Frances K. Pendleton paid the firm $25 in 1887 for some sort of plan. Many of the houses have disappeared with little trace, like the ones built for Charles R. Henderson (1886–87) and John F. Pupke (1892), both in Southampton, and for Charles L. Atterbury in Shinnecock (1888). Most houses had some

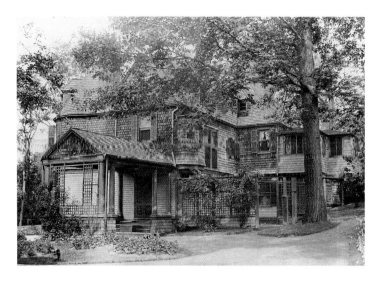

McKim, Mead & White: "Gracewood," James K. Gracie Residence, Oyster Bay, 1884 (Courtesy of Julian K. Roosevelt)

sort of stable, which frequently has been demolished or greatly altered. And some houses have been altered almost beyond recognition, such as those designed for Mrs. A. C. Alden at Lloyd's Harbor (1879), Robert Colgate at Quoque (1885), and James K. Gracie at Oyster Bay (1884). For all of the houses mentioned in this essay documentation exists either as an entry in the *McKim, Mead & White Bill Books,* or in letters and drawings.

There are many buildings on Long Island that have been attributed to McKim, Mead & White or to Stanford White personally. Certainly White, and probably McKim and Mead, made informal suggestions and perhaps even drew a rough sketch for a friend when asked to do so. But the partners were in the architecture business to make money and all work was supposed to go through the office. Even Stanford White's sisters and brothers-in-law were billed for office time spent on their houses in St. James. It is questionable whether buildings for which the partners merely offered verbal suggestions or made a rough sketch should be attributed to either the firm of McKim, Mead & White or one of the architects personally.

The firm of McKim, Mead & White was composed of three very different personalities. These differences, combined with the design talent of Charles McKim and Stanford White, to some degree help to explain the success of the firm. William Mead's talent was as an administrator; he served as office manager and his calming influence, he explained, kept his partners from "making damn fools of themselves."[4]

Charles Follen McKim was clearly the senior partner of the firm, whose name appeared first not for alphabetical reasons, but because he was the firm's leading theoretician and the style setter. McKim was born in 1847 in rural Pennsylvania, the son of an abolitionist father and a

Quaker mother,[5] both of whom were active in the intellectual circles of the day; his father helped found the reformist magazine *The Nation* in 1865. McKim spent 1866–67 at Harvard studying engineering and there he made some friends who would later become his clients, including Prescott Hall Butler. A growing interest in architecture led him to spend the summer of 1867 in the office of Russell Sturgis, after which he left for Europe. There he studied at the Ecole des Beaux-Arts and traveled. In 1870 he returned to the United States and entered the New York office of H. H. Richardson, where he worked on the Brattle Street Church and the competition drawings for Trinity Church in Boston, as well as on several other projects. In 1872 McKim began to strike out on his own, though he continued to do some work for Richardson, with whom he maintained close contact. In 1877 McKim entered into a formal partnership with William Mead with whom he had been informally associated for a number of years, and William Bigelow, his brother-in-law. McKim had married Annie Bigelow in 1874, but in 1879 they were divorced and Stanford White, an old friend of both McKim and Mead, took Bigelow's place in the firm. While he was extremely successful from a professional and financial standpoint, McKim's personal life was unhappy. In 1885 he married Julia Appleton, a member of a wealthy Boston family, who died 18 months later. For the remainder of his life McKim immersed himself in professional and public activities, serving as president of the American Institute of Architects and as a member of the McMillan Commission for Washington, D.C., and founding the American School of Architecture (later the American Academy) in Rome. Always a social individual, he was a member of numerous New York clubs—for many of which he and his firm designed the buildings—where he met prospective clients. He could count among his personal friends prominent socialites like the Vanderbilts, and powerful political figures like President Theodore Roosevelt, for whom McKim remodeled the White House. He also made suggestions for "Sagamore Hill," Roosevelt's home on Long Island.[6]

William Rutherford Mead was born in 1846 in Brattleboro, Vermont. His father was a lawyer and his mother came from the radically inclined Noyes family, founders of the Utopian Oneida community. He attended Amherst College and then apprenticed with an engineer, subsequently spending two years in the office of Russell Sturgis. In 1871 Mead traveled in Europe and briefly attended classes at the Academia delle Belle Arti in Florence. Although he was a member of several New York clubs, Mead did not emulate his partners as a social

McKim, Mead & White:
Roland G. Mitchell
Residence, Wading River,
1905–07 (Courtesy of
Wading River Historical
Society)

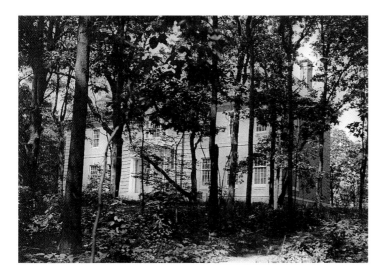

and professional leader. In 1884 he married Hungarian Olga Kilenyi in Budapest. He died in 1928 while on a visit to Rome.

Stanford White was born in New York City in 1853 and grew up on family farms nearby. His father, Richard Grant White, was a well-known, though impoverished, literary critic and certainly inspired Stanford's later craving for fame and money. An early talent for sketching and watercolors led Stanford to consider studying painting, but John La Farge, a family friend, dissuaded him with tales about the poverty-stricken lives of artists. Consequently, White entered the office of H. H. Richardson in 1870, studying and working with Richardson on a variety of projects and developing his talent as an interior designer and presentation renderer. In 1878 he made the obligatory European pilgrimage, returning in 1879 to join McKim and Mead in partnership.

In New York City White quickly became a leading man about town, known for both his appearance—tall, bright red hair, and loud clothing—and his energy and love of the high life. His marriage in 1884 did not diminish his activities; he was known as a consummate party-goer, and frequently contributed the decorations. Describing his partner's appearance at the 1892 Princeton-Yale football game, Charles McKim noted "White wore an enormous buttonhole bouquet of blue violets and perhaps the brightest blue necktie ever seen, a blue handkerchief, blue trousers—and probably a blue shirt—and the air of a Wilbur Bacon. He might have been mistaken for the Yale mascot."[7]

As the years went by, White's activities grew ever more frantic; he had to be seen at every party and opening night, and he had to know every new chorus girl in town. By 1906 he was in serious financial trouble; a large warehouse of European antiquities and *objets d'art* he had imported to sell to clients burned, leaving him deeply in debt. His murder on June 25, 1906, by Harry K. Thaw on the roof garden of Madison

Square Garden, which White had designed in 1889, was the culmination of long-standing strain. White had been attentive to Thaw's new wife, chorus girl Evelyn Nesbit, before their marriage, and she taunted her husband with accounts of White's prior attentions. Thaw's violent revenge provoked an avalanche of "Yellow Press" scandal mongering, and an unending series of books and movies, which ensured White a lasting notoriety.[8]

In addition to the three main partners, numerous other individuals employed by the office of McKim, Mead & White contributed to the firm's designs. William Bigelow, as a partner from 1877 to 1879, was involved in several commissions, including Mrs. A. C. Alden's residence at Lloyd Harbor. Bigelow had attended the Ecole des Beaux-Arts between 1873 and 1876 and possessed considerable skills as a renderer. Surviving evidence, however, suggests that although he did drawings and oversaw construction, Bigelow contributed little to the actual design process.[9] Other important figures would include Joseph Morrill Wells, an acid-tongued draftsman who entered the firm in 1879, and was evidently offered a partnership before he died of consumption in 1890. Much has been made by historians of Wells's contribution to the firm's style shift to Renaissance classicism, but while he was undoubtedly important, there is evidence that all the partners concurred and participated in this development.[10]

Sidney V. Stratton was associated with McKim, Mead & Bigelow and later McKim, Mead & White from 1877 through the mid-1880s. His name appears on the letterhead just below those of the partners. While his exact position is unclear, he appears to have worked both for the firm and on his own commissions, since bills and receipts for designs like the ones for the Quogue Episcopal Church at Quogue and the James K. Gracie residence at Oyster Bay, both from 1884, appear in the firm's bill books with the notation "Ck favor of S. V. Stratton." Also listed are charges to Stratton for rented office space.[11] Stratton had attended the Ecole des Beaux-Arts with McKim and had worked in the office of Richard Morris Hunt before forming a loose association with McKim, Mead & Bigelow beginning in 1877. Both the Gracie house, originally shingle-covered, and the Quogue Church, also shingled, could be easily mistaken for the work of McKim, Mead & White.

A similar relationship prevailed with George Fletcher Babb and his partners Thomas Cook and David Willard, as well as with John Carrère and Thomas Hastings. Babb had actually taught both McKim and Mead in the 1860s when they

worked in the office of Russell Sturgis. He joined McKim, Mead & White in 1880 and, in some press accounts, is given credit for the interior decoration of the rooms in the Henry G. Villard and Charles T. Barney residences in New York City.[12] In late 1882 Babb, in conjunction with Cook and Willard, also members of the office, rented space from McKim, Mead & White and set up their own practice. Their early work in the wooden resort cottage idiom bears a strong relation to that of McKim, Mead & White.[13] Similarly, both John Carrère and Thomas Hastings, who had entered the McKim, Mead & White office after returning from the Ecole in 1883, rented space from the firm two years later before moving out on their own. And there were others: Edward Palmer York and Philip Sawyer met in the McKim, Mead & White office and formed their own firm, as did Francis L. V. Hoppin and Terrence A. Koen, who worked there in the 1880s and 1890s before setting up their own office.

McKim, Mead & White gained such a powerful reputation that a complete list of other architects—important for both the New York area and elsewhere—who passed time in their office would be very long. While attendance at the Ecole des Beaux-Arts stood one in good stead, at a time when university education in architecture was just beginning in the United States, there was a great need for opportunities to acquire practical experience. McKim, Mead & White was the preeminent firm in the United States where this could be done. Among the firm's alumni were Cass Gilbert, Henry Bacon, Harrie T. Lindeberg, Edward Tilton, William Boring, A. Page Brown, and many more. The office records for the period 1877 to 1914 list 573 employees.[14]

In addition to the above luminaries there were architects who stayed on with McKim, Mead & White and became important in their own right. Shortly before White's murder in 1906, the partnership had been expanded to include William Mitchell Kendall, who had joined the firm in 1882; Bert L. Fenner, who had entered in 1891; and William Symmes Richardson, who had arrived in 1895. Each of these men had been assistants to the major partners on several commissions and had made substantial contributions. Kendall, in particular, was known as McKim's right-hand man.

To delineate the exact role of this large office staff, numbering over 100 in the early 1890s and again in the 1900s, is difficult, if not impossible. In some instances initials on drawings or surviving correspondence indicate the participation of an office man on the job, as in the case of the James L. Breese house and architect Harrie T. Lindeberg. In such situations, staff members would take the partners' initial sketches and work them up into designs, develop details, write specifications, and oversee the actual construction process. Henry Van Buren Magonigle, an office man from the late 1880s, remembered White's design process: "He would tear into your alcove, perhaps push you off your stool with his body while he reached for a pencil and tracing paper and in five minutes make a dozen sketches of some arrangement of detail or plan, slam his hand down on one of them—or perhaps two or three of them, if they were close together—say 'Do that,' and tear off again. You had to guess what and which he meant."[15]

Important factors in achieving the excellence for which the firm's buildings were known were the builders, material suppliers, and the craftsmen on whom McKim, Mead & White came to depend. For builders for their wooden country houses they generally preferred Mead and Taft, Taylor and Elmslie, P. E. Reid, or Nathan Baker; for their larger buildings they chose Norcross Brothers. However, it is important to keep in mind that the role of general contractor had not yet been established, so that in general, the architects themselves oversaw coordination of the work of the builder, the interior decorator, the stained glass artist, and the heating contractor. The problems encountered in achieving such coordination, especially on buildings such as the Garden City Hotel or the Clarence Mackay residence, could be formidable. As White wrote to a heating contractor:

I have the misfortune to have too much to do and I cannot attend to every detail of my work as I should wish to do. Sometimes when a new man has charge of work, things are omitted or slip in which they should not; but how you could have made a proposition for a house like Mr. Barney's without suggesting and including an estimate for thermostats, I cannot understand.[16]

While the firm maintained offices in other cities for brief periods, the main office remained in New York. In the course of the partnership, McKim, Mead & White moved four times, following the progress of commerce as it moved up Manhattan Island. The earliest office at 57 Broadway was in an old cast-iron building largely inhabited by other architects and artists. This office was not at all glamorous, consisting of a large drafting room with three little cubicles for offices. According to one draftsman, "as there was but one room for the chair in each cubicle, I attributed a large part of the firm's unique success to the fact that they (the members of the firm) were always in the drafting room."[17] From these rather primitive beginnings the firm moved in 1891 to 1 West 20th Street to the old Herter Mansion, where it occupied the entire top floor. A plan of this office reveals the increased prosperity of the firm, showing a large and small reception room, specialized spaces

not only for bookkeeping but also for drawing storage and contractors, as well as large offices for the partners.[18] The plan provided for 44 positions for draftsmen, but other space could be rented as called for by additional workloads. In 1894 the firm moved to even plusher quarters in the Mohawk Building at 160 Fifth Avenue, and in 1909 to 101 Park Avenue, to the new Architect's Office Building. Descriptions of this last office mentioned fine rugs, specimens of antique furniture in the reception room, and even a black "manservant" to greet the clients.[19]

This change in McKim, Mead & White's office quarters is telling, for it also indicates the evolution of the firm's architecture as the chief designing partners became more isolated from the drafting room—both as a result of physical removal and because of an increasing workload. The consequence of the greater latitude and initiative given to the draftsmen in working out designs meant, not so much a diminution of the final project, but the creation of an "office style." The amount of time each partner could actually give to a project decreased except where he had an overriding personal interest in a particular project. Attention to the smaller projects, such as wooden resort houses, diminished and plans for many of the houses like the Robb (1889) and Parrish (1889) residences in Southampton all followed a formula. The large houses, like the ones designed for Mackay, Morgan, and Whitney, however, obviously received great amounts of personal attention from the partners.

The achievements of the firm were manifold. Stylistically, McKim, Mead & White transformed American architecture, endowing it with an image recognized as unique worldwide. Equally important was the range of the firm's work: Its architects were responsible for a great many designs, from entire university campuses and large office buildings to small wooden resort cottages and mammoth country mansions. Some buildings, such as the Boston Public Library (1887–95), probably the firm's best-known public work, gave great impetus to the claim that America was no longer merely a follower but a leader in creating a great civilization. McKim, Mead & White also helped create the settings for great public and civic rituals, such as the World's Columbian Exposition in Chicago and the Mall in Washington, D.C., and fostered the notion of an "American Renaissance."[20] As with many American architects from the turn-of-the-century period, two goals and accomplishments can be discerned in the firm's work: a search for an architectural order, and

a search for an appropriate image for Americans. In pursuing both of these goals, the partners were reacting against the High Victorian architecture with which they had grown up and begun their professional careers. They disliked the unselective and unscholarly eclecticism of the High Victorians and, while they would always remain eclectic in their work, they attempted to provide a *raison d'être* for their selection of styles. They also reacted against the predominantly picturesque vertical organization of most building design in the High Victorian period and introduced a new feeling of mass, consolidation, and central focus. These achievements did not all occur at one time, but rather developed over the long period of the partners' careers.

Initially, most of their work and their early reputation came from the design of wooden country houses for the resorts along the New Jersey Shore, in Newport, and on Long Island. Their selection as architects for the Newport Casino (1879–81) by the principal sponsor, James Gordon Bennett, Jr., indicates their early prominence. This design and simultaneous, if not earlier, work that they—or at least McKim—carried out on Long Island has been popularly labeled by Vincent Scully, Jr., as "Shingle Style" in recognition of the wooden shingles that cover much of the exterior surfaces.[21] In the late 1870s, however, such buildings would have been identified as either "Queen Anne" or "modernized Colonial." They were attempts by McKim and his partners to create evocative images based on the American past.[22] In designs such as the Butler house at St. James (1879) and the Alden residence at Lloyd Harbor (1879), McKim and his partners drew upon the English Queen Anne style; the American wooden vernacular tradition of the 17th through the 19th centuries of shingles, wood frame, and broad roofs; the American Colonial past—or at least identified at the time as "Colonial" details—as well as some European forms. For instance, the large stair tower in the Alden house may have been inspired by the towers of the châteaus of Chambord and Blois, with which McKim became familiar on a sketching trip in rural France in the summer of 1878, but also it may owe a debt to early New England windmills.

The Alden and Butler houses also illustrate two different methods of composition that McKim, as the main designing partner, used in the late 1870s. The Alden house is a more restless composition in which a variety of forms and shapes compete for interest, and while the predominance of several large triangular forms used as gables and the long horizontal stretches of roof tend to unite the composition, variety remains the keynote. Very different is the Butler

house, which, while far smaller and less expensive, is dominated by one large gable that gathers all the activities beneath it. In fact, the dominant tendency in McKim, Mead & White's work was toward the geometrical control displayed in the Butler house and the rejection of the picturesque.

Throughout the late 1880s and 1890s the work of McKim, Mead & White was marked by an increased use of recognizable historical motifs, and the consolidation and integration of the buildings' forms. On Long Island the use of exterior shingle cladding continued; however, the overall form and details, as in the houses for William Merritt Chase at Shinnecock (1891–92) and James L. Breese at Southampton (1898–1907) were very obviously drawn from Dutch Colonial motifs and Mount Vernon, respectively.

The use of precedent drawn from the Southern Colonial style became important in some houses, leading a writer for *House and Garden* in 1903 to exclaim, with reference to the Emmet house at St. James (1895), "The country gentleman's outdoor life, his hospitality, freedom and simplicity of social habits could not very well have been expressed more naturally than they were in such Southern country houses, as, for instance, Mount Verrnon."[23] On the other hand, the firm could also choose a New England Federal precedent for some houses, as in those designed for A. C. Canfield at Roslyn (1902–03, demolished) and the house for Roland G. Mitchell at Wading River. The Canfield house was more strictly New England. The Mitchell house evoked New England in its brickwork and trim, but the two-story garden portico recalled the south elevation of the White House in Washington, D.C.

The E. D. Morgan house at Wheatley Hills (1890–91) is directly related to Colonial Long Island farmhouses, though vastly enlarged. This evolution of the firm's eclecticism toward a greater fidelity to the original sources reached its apogee with Mackay's "Harbor Hill" (1899–1905), where Katherine Mackay specifically directed White to use the 17th-century Maisons-Laffite by François Mansart as the basis for his design. A similar evolution is also apparent in the firm's nonresidential Long Island work between the Babylon Casino (1888, demolished) and the Garden City Hotel (1895; 1905, demolished). With its tall roof and corner turrets, the casino was primarily a picturesque affair. The Garden City Hotel used red brick, white trim, and Georgian detailing, and its tower evoked Independence Hall in Philadelphia. This later stage of McKim, Mead & White's eclecticism can be called "scientific"—in contrast to the earlier, more synthetic eclecticism—because of its greater fidelity to original forms and details.[24]

While the trend to greater historical accuracy seems to be the main line of McKim, Mead & White's development, one house on Long Island stands apart: the William C. Whitney mansion at Westbury (1900–02). Surviving photographs indicate that Whitney was offered several variations by McKim, Mead & White, including designs in the Châteauesque and Jacobean styles.[25] The house that was finally constructed, however, followed no one particular style. While the interiors had the typical period flavor, the exterior, with its great steep roofs that seemed to come almost to the ground and its long, linear form, was highly individual. Undoubtedly, the architects believed that the design owed something to English sources, and it may well be that one can discern the influence of English Arts & Crafts and Philip Webb, and possibly Edwin Landseer Lutyens in this building. This remarkable design—much overlooked by historians—is testimony to the continuing creativity of the firm's architects.

While the development of McKim, Mead & White's architecture can be traced through forms and details, also apparent is another evolution, one of lifestyle and the way in which buildings were used, especially with reference to Long Island. Most, if not all, of the wooden Long Island houses of the 1870s and 1880s designed by McKim and his partners were intended exclusively for summer residence. At Montauk the firm designed cottages and a clubhouse for a group of New York businessmen and their families, to be occupied only during the summer. Since the houses lacked adequate heating, winter occupation was hazardous. A similar intention was apparent for most of the houses built at Southampton, Shinnecock, Far Rockaway, and St. James. All of these houses, like the J. Hampton Robb house in Southampton (1885, extant), were directly related to summertime activities such as swimming and boating, and their shaggily weathered shingles proclaimed a definite rustic and primitive spirit.

In the 1890s a new, more luxurious tone crept into the architecture of Long Island. The strenuous summer activities remained, but to these were added more refined and sophisticated sports. As golf and polo made an appearance, rusticity was replaced by a "picnic spirit." Grounds became more formal, and garden structures, exedras and pavilions, built in the classic style, abounded. These served both for relaxation and as settings for pageants in which young women and men dressed up in costume—frequently approximating Roman and Greek garb—to act out plays. Stanford White especially loved to create such pageants at "Box Hill" and would, his son remembered:

"dress up the more beautiful members of our house parties in Greek costumes and fillets."[26] Not uncommon were elaborate gardens and rows of orange trees in tubs that stood outside in the summer, and were sheltered in an orangery during the winter.

The shift in intentions was aptly summed up by Wilhelm Miller writing in *Country Life in America* about the James L. Breese house as follows: "A foreigner who wishes to see the fashionable life of America should board the four o-clock train from New York to Southampton any week during Summer." To Miller, Southampton best represented the attempt to create an "American style of architecture"; the houses were painted white and appeared as if they "grew right out of the soil." While he criticized houses located on a "small, treeless plain by the seashore" for their lack of harmony and organic feeling, he wrote approvingly of examples like the estate of James L. Breese, describing it as "a house and garden perfectly married." For Miller it was the "Colonial" style "which should be called 'Georgian,' because we got it from England during the reign of the Georges," the shingles, and the luxuriant garden with its long central walk and pergola on three sides made the Breese estate an example to be emulated.[27] Here, amid flowers and herms and a fountain by Janet Scudder, the rituals of summer could be acted out.

Accompanying the shift toward more luxury and refinement came an increase in the scale of houses, as in E. D. Morgan's "Wheatley" at Wheatley Hills. In addition to the large three-story house, the complex came to include stables for polo and hunting, as well as transportation; a chapel; a swimming pool; and extensive farm buildings. Morgan and his wife used the estate, as it now came to be called, throughout the year, retiring there whenever the hectic social life of New York became too tiring. In the surrounding neighborhood McKim, Mead & White designed similar estates for William C. Whitney and Clarence Mackay.

The estate Clarence and Katherine Mackay created at Roslyn was the firm's most expensive Long Island commission. The main house, designed and erected between 1899 and 1902, was the first large masonry country house on Long Island and set a new standard for others to follow. Soon thereafter, one had to have a masonry house to be up-to-date, and many wooden houses—like the old Alden house the firm had designed in 1879—were encased in brick and substantially altered in 1903. The Mackay estate was large, over 600 acres, including a model farm, many outbuildings, a formal garden, and a park. In Roslyn, the Mackays endowed Trinity Episcopal Church and Parish House (1904–07) which McKim, Mead & White designed. To commentators at the time it was obvious what

both McKim, Mead & White and their clients were attempting to do—create the American equivalent of an English country house; as the Roslyn newspaper noted about "Harbor Hill," it seemed "to have flowered out of rural England and nearby soil."[28] Herbert Croly, one of the most astute critics of the time, writing about "Harbor Hill" in the *Architectural Record* noted: *The owners of such estates take more leisure now than they once did, they spend more time in the country and more money. . . . They are becoming . . . country gentlemen, though in a different sense from an English gentleman. They do not derive their substance from the soil, and their estates are laid out solely for their own pleasure. The farm is accessory to the house. The house has no function, except the important one from a certain point of view of contributing to the pleasure of the owner.*[29]

Among Morgan, Whitney, Mackay, and other nearby owners reigned a great spirit both of competition and cooperation. Each claimed that he had the highest spot on Long Island, and Whitney went so far as to have Stanford White design a 150-foot watertower to press his claim. Mackay responded by adding a flagpole to the roof of his house. Each attempted to out-do the other in adding acreage to his estate and building complete domains. Cooperatively, they conspired to keep local taxes low, and to prevent the great masses of New York City and its suburbs from using Nassau County for recreational purposes. They also cooperated on local utilities. When Morgan began building in the area, no electricity or natural gas was available. Oil was used at first but then, as Morgan noted in his autobiography, he investigated electric lighting. Having "found it to be too expensive," he investigated electric power and together with the owners of some neighboring estates (most of which had been designed by McKim, Mead & White), specifically Mackay, Whitney, and Winthrop, he set up an electric power company which the group later sold to Long Island Lighting Company.[30]

The intention of the estate owners who built in the area was twofold: to build self-contained pleasure domains, and at the same time create estates for their families along the lines of English country houses. Polo fields, golf courses, and hunt clubs in the Roslyn-Westbury area were established. The extensive landscaping carried out on the estates gave the entire area the aspect of a large park. The attention to historical fittings and styles provided the estates with instant lineages, implying roots for generations as yet unborn. The latter goal was not achieved; the estates barely lasted the lifetime of their owners before being cut up for housing developments, more country clubs, and turnpikes.[31]

McKim, Mead & Bigelow: "Bytharbor," Prescott Hall Butler Residence, St. James, c. 1879 (SPLI, 1978)

McKim, Mead & Bigelow: "Fort Hill," Mrs. A. C. Alden Residence, Lloyd Harbor, 1879–80 (AABN, 1879)

But, in their time, they were objects of wonder, not only to Americans but to foreign visitors, as well. Edward, Duke of Wales, later Edward VII, and after his abdication Duke of Windsor, visited the Old Westbury-Roslyn area in 1924 to attend the International Polo Matches held at the Meadow Brook Club. Although he stayed in a house designed by Delano & Aldrich, he visited "Harbor Hill." He described the house as:

A copy of a French chateau, it stood on top of a wooded rise overlooking Long Island Sound. I spent the day going through the place, marveling at all it contained. The art treasures alone would have sufficed the needs of an ordinary museum, and I particularly remembered the vast hall lined with figures in armor that had been obtained from various old European collections. Now paintings, tapestries, old china, and armor would have been commonplace enough in a British country house; what was surprising was to find on the same property a squash-rackets court, a gymnasium, an indoor swimming pool, and a Turkish bath.

It was only as I prepared to leave that I noticed in the entrance hall an object strangely different from all the rest: a small statue of what appeared to be a workman with a pick in his hand.

"What is that?" I asked Mr. Mackay.

"A replica of a statue of my father I have erected on the campus of the University of Nevada at Reno," he answered proudly. I admired Mr. Mackay for that.[32]

Prescott Hall Butler Residence, "Bytharbor," St. James, 1879 (Extant)

This was one of the first houses by Charles McKim on Long Island. The exact date is uncertain, and although McKim's biographer claims it to be 1872, it should be 1879.[33] Prescott Hall Butler (1848–1901), as previously noted, knew McKim at Harvard, and his wife's sister married Stanford White. McKim and Butler lived next door to each other on 13th Street in New York from 1874 to 1876, and McKim designed furniture for Butler's flat. Butler subsequently moved in 1876 to a house he purchased on 34th Street which McKim remodeled. For Prescott Hall's father, Charles E. Butler, McKim designed St. Paul's Episcopal Church, Lenox, Massachusetts (1883–85). In 1895–97, Prescott constructed a townhouse on Park Avenue after designs by the firm. Butler was a member of the New York law firm of Evarts, Choate and Beaman. McKim, Mead & White also designed a house for Joseph Choate in Stockbridge, Massachusetts (1884–1887), and did some remodeling for Charles Beaman in New York and some work on cottages at Far Rockaway. The work at Far Rockaway does not survive.

McKim's original design for the Butler house has been altered. As shown in an early rendering, the service wing was only a single story in height and somewhat shorter. Later the firm raised and lengthened this wing and designed other structures for the property, including stables and a squash court. The main portion of the house consisted of a large gable under which McKim subsumed most of the features except for chimneys and dormers. The first floor was of clapboards, with shingles used above. Certain features, such as the slight overhang at the third-floor level and the Dutch door, all indicate an attempt to relate to the American past. The plan has been greatly altered over the years but evidently was bisected by a straight-through hall containing a fireplace. The sitting room was extraordinary, with the large fireplace serving as the spatial divider. In contrast, and indicating the early date of the Butler house, the staircase is small and cramped. The interior trim that does remain is in the Eastlake style.

Mrs. Anne Coleman Alden Residence, "Fort Hill," Lloyd Harbor, 1879 (Extant, but altered)

The Alden house was a product of the short-lived McKim, Mead & Bigelow office. Charles McKim was undoubtedly the chief designer as he was a close friend of Mrs. Alden's daughter and son-in-law, Dr. Richard Derby. The Derbys were for many years McKim's New York City landlords and probably secured the commission for the young firm. About 1882 the house passed

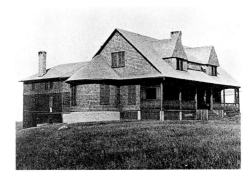
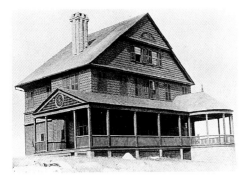
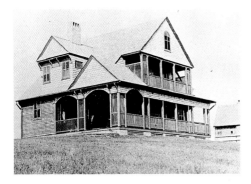

McKim, Mead & White:
Montauk Point Association
Clubhouse, 1882–83
(Courtesy of Alastair
Gordon, c. 1890s)

McKim, Mead & White:
Montauk Point Association,
Henry G. de Forest
Residence, 1882–83
(Courtesy of Alastair
Gordon, c. 1890s)

McKim, Mead & White:
Montauk Point Association,
William L. Andrews
Residence, 1882–83
(Courtesy of Alastair
Gordon, c. 1890s)

to the Derbys and then, c. 1900, to William John Matheson. In 1903 Matheson hired William Boring and Edward Tilton, former members of the McKim, Mead & White office, to remodel the house into the present Tudor-style mansion.[34]

McKim's initial design was sited on top of the remains of a British fort from the Revolutionary War era. Long and linear, the house conformed to the site. The large hall controlled the interior space and movement. Piazzas opened from most major rooms. Conceived of as a series of interlocking volumes, the different horizontal levels were integrated vertically by the stair tower. The large simple forms of the roofs and gables contrasted with the deep voids of the piazzas and windows. Detailing was freely handled with elongated Palladian windows, turned porch spindles, and exposed timbers in the gables. A remarkable design, the Alden house demonstrated young McKim's ability to create an evocative image.[35]

Montauk Point Association Residences and Clubhouse, Montauk, 1882–83

In the summer of 1881, eight New York businessmen—Dr. Cornelius R. Agnew, William L. Andrews, Arthur W. Benson, Henry G. de Forest, Alfred M. Hoyt, Alexander E. Orr, Dr. F. N. Otis, and Henry Sanger—set up an association to build cottages and a clubhouse at Montauk Point. The land had originally belonged to Arthur Benson, and Henry de Forest acted as treasurer of the group. The site, a long bluff overlooking the ocean, is sandy and covered with scrub brush. Frederick Law Olmsted prepared a site plan with the eight houses and a hall to serve as a clubhouse overlooking the ocean along the bluff. McKim, Mead & White were engaged to design seven of the cottages (excepting the one for Dr. Otis) and the clubhouse.[36] The commissions entered the McKim, Mead & White office in the summer of 1882 and all work was completed by the summer of 1883. The builders were Mead & Taft.

The clubhouse, a simple, shingle-covered structure with a hall and dining room on the first floor and guest rooms upstairs, burned many years ago. The intention was that all the families

should take their meals in common in the clubhouse. The food was to be prepared by cooks and served by butlers hired by the association.

Of the seven cottages designed by the firm, all were variations on the theme of the large central gable designed by McKim for the Prescott Hall Butler house (all but the Sanger house survive). They range from simple cottages with a few rooms, like the Benson and Andrews houses, to more elaborate cottages, like the Sanger, Orr, and Hoyt houses. In the Benson and Andrews houses the hall served as the central living space, since a separate sitting room was not provided. The de Forest house was typical of the medium-sized cottages. It was dominated by a large sweeping gable punctured by a chimney and a dormer, while a piazza across the front culminating in a rounded bay created a dark void of space. A straightforward plan has a central hall dividing the house and the major living apartments pushed forward toward the ocean. The combination of soft-gray, weathered shingles and soft-red trim gave the house a rustic air even when it was new.

Stanford White Residence, "Box Hill," St. James, 1884–1906 (Extant)

On February 7, 1884, Stanford White married Bessie Springs Smith, the youngest daughter of Judge J. Lawrence Smith of Smithtown, and shortly thereafter purchased a house and land from Samuel Carman in neighboring St. James. The house was a small wooden structure. Sporting a series of gables, turned porch posts, Italianate brackets, and lots of gingerbread, the house lacked any clearly defined style. In later years White expressed regret that he did not tear the old house down and start over again. As his son, Lawrence Grant White, also an architect, wrote:
Everything about it was wrong; it was in the wrong place; the entrance was on the wrong side; the ceiling was too low, and it was badly planned and badly built.[37]

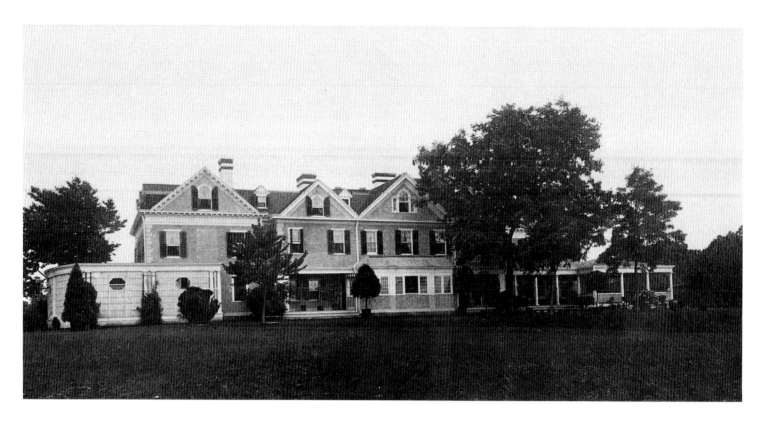

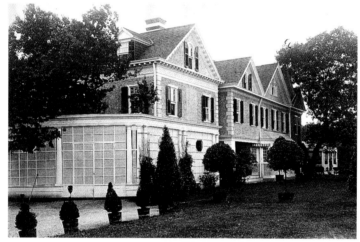

McKim, Mead & White: Alterations, "Box Hill," Stanford White Residence, St. James, 1884–1906 (SPLI, c. 1900)

McKim, Mead & White: Alterations, "Box Hill," Stanford White Residence, St. James, 1884–1906 (SPLI, c. 1900)

McKim, Mead & White: Entrance Hall, Alterations, "Box Hill," Stanford White Residence, St. James, 1884–1906 (SPLI, c. 1900)

Reputedly, Charles McKim claimed that the house "poisoned its surroundings."[38] While dates can be assigned to the building campaigns of 1886, 1892, and 1902, it is evident from letters and sketches that White constantly toyed with ideas for transforming the house, and continued to make alterations to the interior. The frequent appearance of William R. Mead and Charles F. McKim's names in the guest book, as well as the accounts by McKim's biographer, indicate that although White assumed primary responsibility, both Mead and McKim contributed to the undertaking.[39] The result, in the words of one critic, was a "mass of illogically successive rambling rooms, but in the total effect the master's charm has inevitably penetrated."[40]

The house as it stood around the time of White's death in 1906 consisted of a long rambling structure, the successive additions all organized by large gables, three on the south elevation, and six and one-half to the north. The use of gables as the primary organizing element went back to the firm's earlier work and also offered an interesting parallel to contemporary English work by Phillip Webb at Standen, Sussex.[41] The exterior wall surfaces, a gray stucco with pebble dash, also helped to unify the structure, as did the porch or piazza running along the entrance on the south, around the west end, and partly across the north elevation. The exterior trim was "Colonial" in inspiration, though very freely handled.

White experimented with numerous ideas for the house, among them using two-story-high Corinthian columns he purchased from a demolished church in Connecticut, arranging

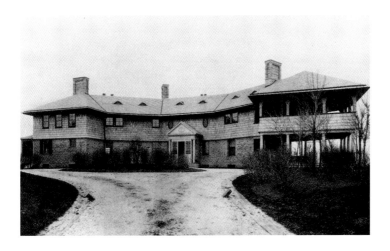

McKim, Mead & White: Front Facade and Entrance Court, "The Barracks," John H. Cheever (Mrs. John Cowdin) Residence, Far Rockaway, 1885–86 (ARCS, 1979 [1886])

McKim, Mead & White: First-Floor Plan, "The Barracks," John H. Cheever (Mrs. John Cowdin) Residence, Far Rockaway, 1885–86 (ARCS, 1979 [1886])

McKim, Mead & White: Babylon–Argyle Casino, Babylon, 1888 (Courtesy of Carl Starace)

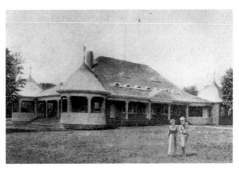

to float them across the Sound. A drawing for this scheme, which would have monumentalized the house, has the word "Superseded" written across it. It is claimed that Bessie White disapproved of the scheme, and the columns came to rest as an entranceway on the drive.[42]

The interior shows White's free treatment of precedent, as in the entrance hall in which the staircase is covered in green tile and lacks a bannister. Split-bamboo covers the other walls and four 16th-century Italian gilded columns occupy the center of the room. The problems raised by the various additions and White's attempt to create large entertainment areas are evident in several structural steel I-beams that were used throughout the ground floor to support upper-floor loads. The dining room, which faces to the north, has one wall of glass, another covered in blue-and-white delft tiles, and two other walls covered in fabric-sheathed cardboard on which were mounted Majolica plates.

Both the house and grounds became a repository for various *objets-d'art* that White collected. These included marble paving from A. T. Stewart's New York City house; carved wooden front doors originally intended for the Pierpont Morgan Library in New York but never used; and herms in the garden resembling the ones used at the James L. Breese place in Southampton.

Adjacent to the house White planned a formal garden and planted a row of trees. In the summer he brought out potted orange trees to line the entrance drive. An old cottage near the

entrance became the caretaker's residence, and he added a group of stables, an orangery, and a watertower to create an entrance court. The house remains in family hands.

John H. Cheever/Mrs. John Cowdin Residence, "The Barracks," Far Rockaway, 1885–86

John Cheever, a prominent New York businessman with interests in the New York Belt and Packing Company, gave this house as a wedding present to his daughter Gertrude and son-in-law John Elliot Cowdin, of Elliot C. Cowdin & Co., New York silk importers. The commission must have entered the McKim, Mead & White office in early 1885, and the house was completed by February 10, 1886, at a cost of $16,993.80, plus the architects' five-percent commission.[43] No longer extant, this house was located on a bluff with spectacular views overlooking the Rockaway inlet in an area known as Wave Crest. The firm had used the diagonal plan earlier for the Julia Appleton house in Lenox, Massachusetts (1883–84). The first-floor walls were brick, the second-floor walls straight-cut shingles, with the fenestration pushed to the outer surface. Ornament was minimal, consisting of an Ionic-columned Colonial-style portico and Adamesque oval windows. George William Shelton in his book *Artistic Country-Seats* (1886–87) was especially impressed with the hall and the large windows opening all the way to the floor opposite the entrance.[44] The Cowdin house, with its large projecting piazza and dining room overlooking the sea, possibly influenced several later houses, including Purcell & Elmslie's Bradley Bungalow at Woods Hole, Massachusetts.

Babylon–Argyle Casino, Babylon, New York, 1888

The Casino for the Argyle Hotel at Babylon was commissioned by the Long Island Improvement Company under the direction of Austin

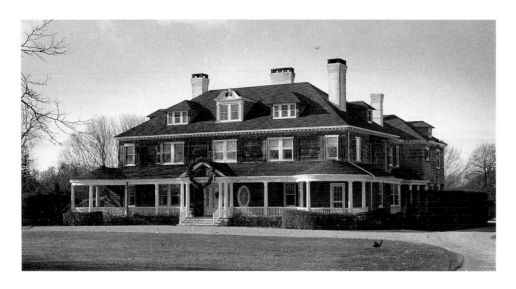

The large porch that nearly encircled the structure was originally filled in with spindle screens. A Colonial pediment crowned the entrance. A brochure issued by the hotel in 1902 described the Casino as follows:

Amusements at the Argyle are usually given in the ballroom of the Casino, which is detached from the Hotel. It is a beautiful building, one of the handsomest and most spacious of any resort. It contains a theater with stage and dressing rooms; also regulation bowling alleys, a buffet, billiard and pool tables. A first-class orchestra is engaged for the season.[48]

McKim, Mead & White: Front Facade, "White Fence," Samuel L. Parrish Residence, Southampton, 1889 (INVE, 1978)

McKim, Mead & White: South Facade, William Merritt Chase Residence, Shinnecock, 1890–92 (Courtesy of Southampton Historical Society)

Samuel Longstreth Parrish Residence, "White Fence," Southampton, 1889 (Extant)

This is one of the firm's stock house designs, produced in a number of variations in the mid- and late 1880s. In general, all the houses had a centrally placed entrance and through hall. Severely frontal and formal, these houses could be covered in shingles, clapboard, or built of bricks. The design featured such Colonial-derived details as a dentiled cornice, broken pediment, central dormer, and porch or piazza columns.

Parrish possibly knew McKim from Harvard, where they overlapped in 1866–67. He became a prominent New York lawyer and art collector, and after his retirement devoted his energies to the establishment of the Parrish Art Museum in Southampton. He also served on the board of the Shinnecock Country Club.

Corbin, who was also the president of the Long Island Railroad. The Long Island Improvement Company helped open up Long Island to the summer tourist and resort trade. Built in 1882 by the Brooklyn firm of William Field & Sons, the Argyle Hotel was set in a large landscaped park. In 1883 Bruce Price and G. A. Freeman designed ten small cottages for the hotel grounds.

In the meantime, McKim, Mead & White earned a reputation for designing casinos in Newport (1879–81); on Narragansett Pier in Rhode Island (1883–86); in Short Hills, New Jersey (1879–80); and in Stockbridge, Massachusetts (1887).[45] In February 1888, the firm received a commission to design a casino for the Argyle Hotel. The design was completed by mid-April, and the building constructed by mid-August of that year. It burned down in 1954.[46] According to George William Sheldon, the principal chronicler of the new American resort communities, McKim, Mead & White were the originators of "the country clubhouse."[47]

The Babylon-Argyle Casino is one of McKim, Mead & White's less successful designs: the relation between the corner towers and the high roof is awkward, and the entire structure gave the impression of unresolved and hurried design.

William Merritt Chase Residence and Studio, Shinnecock, 1890–92 (Extant)

In the late 1880s and early 1890s, the Shinnecock area developed a reputation as a summer artists' colony. The attraction was both the support of other summer residents who were patrons of the arts and the romantic associations of the place. An 1893 article claimed that the "beauties" of the Shinnecock Hills, a series of sand mounds once wooded but now covered with grass and brush, recalled "the Scotch heather that lends so much color to the Highland hillsides."[49] The close relationship all three of the McKim, Mead & White partners enjoyed with the New York art world paid off with several commissions in the area. Two of the summer houses, one for F. K. Pendleton and the other for Charles L. Atterbury, both New York lawyers and important art patrons, have disappeared.[50] In 1890 William Merritt Chase, the prominent painter and teacher, was lured to Shinnecock to give art lessons sponsored by two wealthy summer resort ladies with an amateur interest in the arts; Mrs. William Hoyt and Mrs. Henry Porter. They

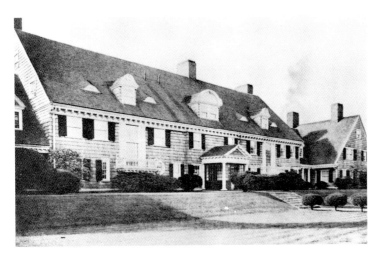

McKim, Mead & White: Front (North) Facade, "Wheatley," Edwin D. Morgan III Residence, Wheatley Hills, 1890–1900 (MCKI, 1977)

Edwin Denison Morgan III Residence, "Wheatley," Wheatley Hills, 1890–91, 1895–1900

Shortly after Morgan had commissioned Charles McKim to design "Beacon Rock" (1888–90), a summer house in Newport, Rhode Island, he and his wife started a family. This seems to have prompted Morgan to make grander plans, for he began to acquire extensive acreage near Westbury, Long Island. In time his holdings there amounted to 666 acres. Morgan was the grandson of Edwin Denison Morgan I (1811–85), a wealthy businessman, a former New York governor and senator, and a founder of the Republican Party. Born in 1854, the younger Morgan had been christened Alfred Waterman Morgan, but following the death of his father Dr. Edwin Denison Morgan II in 1879, he changed his name to Edwin Denison Morgan III at the express wish of his grandfather. Much of the younger Morgan's life can be interpreted as dedicated to living out his grandfather's wishes to create a family dynasty.[53]

The land Morgan purchased near Westbury was composed of several farms and a 300-foot-high hill, known locally as "Wheatley Hill," which had been used for years as a mariner's landmark. He called his estate "Wheatley," but to his dismay that name was soon adopted by an adjacent village, as well as by all types of local businesses, including the Wheatley Stables and the Wheatley Kennels. The dominant feature of the hill was a pair of old cherry trees standing alone at its crown some 60 yards apart. In 1890 Morgan asked McKim to make some designs for a residence on this site. The architect's initial scheme included a large house with stables and estate buildings surrounding a courtyard. This scheme was carried out with many variations over the next ten years.

First to be completed was the main house, a structure nearly 100 feet in length, later stretched to nearly 200 feet by the addition of two wings. The building was dominated by a huge, spreading roof that enclosed three full stories. Designed with major entrances on two sides, the house lay along the crest of the hill—to take advantage of views unsurpassed for Long Island. The basic form of the house was, as a critic at the time commented, an adaptation of "the Long Island farmhouse indigenous to the soil."[54] Onto this vernacular form McKim applied more academic Colonial and Georgian details. Critic Russell Sturgis, writing the first comprehensive review of McKim, Mead & White's work in 1895, identified the Morgan house as Old Colonial and in contrast to much of the firm's other current work, which he condemned, he found this design highly praiseworthy. In fact, he thought that with this house

gave Chase some land and asked him to set up a summer art school in order to teach painting in the open air (plein air). Chase apparently asked Stanford White to design a summer studio-house and White evidently did some sketches. Whether these were ever transferred into working drawings by the firm is unclear, for a commission from Chase does not appear in the McKim, Mead & White bill books. However, there is some evidence that Chase's house was designed by White and a photograph of a rendering of the house appears in the firm's files.[51] Local tradition claims that the "studio" building, a log cabin structure for indoor teaching, was also designed by White. However, both the unusual style and lack of documentary proof throw doubt on this attribution.

Chase's house was sensitively sited on a bluff overlooking Peconic Bay, with tremendous vistas that unfortunately have been obscured by tall brush. The house was described in an 1893 *Harper's* article as a "frame and shingle structure in what is called the Colonial style."[52] The dominant form of the house is the roof, a huge Dutch gambrel roof that spreads outward and encompasses the long porch across the front. This roof form had earlier been used by McKim, Mead & White in another artist's summer house, the Samuel Coleman house in Newport (1882–83). The studio wing has north-facing windows. The principal interior space is a two-story hall paneled in pine and dominated by a boulder fireplace. Old photographs and paintings by Chase show the hall filled with antique furniture, bric-a-brac, paintings, and the normal furnishings of an artist's studio of the time. From his Shinnecock house and studio, Chase would teach some 100 students two days a week every summer. He also painted a great number of canvases of both the house and the surrounding landscape.

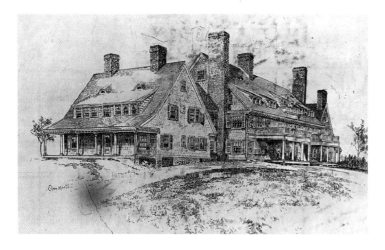

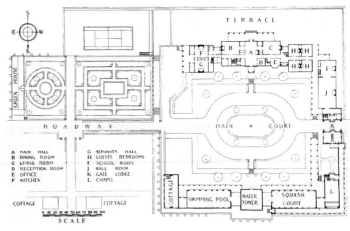

A - MAIN HALL G - SERVANTS HALL
B - DINING ROOM H - GUESTS BEDROOMS
C - LIVING ROOM I - SCHOOL ROOM
D - RECEPTION ROOM J - BALL ROOM
E - OFFICE K - GATE LODGE
F - KITCHEN L - CHAPEL

SCALE

McKim, Mead & White:
Drawing of South Facade,
"Wheatley," Edwin D.
Morgan III Residence,
Wheatley Hills, 1890–1900
(AVER)

McKim, Mead & White:
Plot Plan, "Wheatley,"
Edwin D. Morgan III
Residence, Wheatley Hills,
1890–1900 (PREV, n.d.)

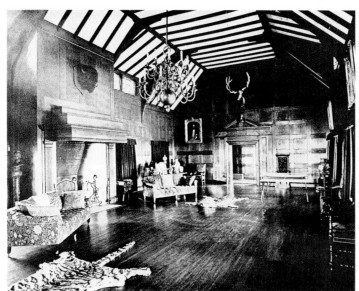

McKim, Mead & White:
Music Room, "Wheatley,"
Edwin D. Morgan III
Residence, Wheatley Hills,
1890–1900 (ARRV, 1907)

McKim, Mead & White had surpassed its original Colonial-style models.[55] A symmetrical building with the main house closed off by the end-gabled wings, "Wheatley" conveyed an impression of spread and breadth evocative of earlier Shingle Style work. As the shingles weathered and more buildings were added to the compound, the entire composition took on the air of a group of older farmhouses that had grown up over many years.

On the interior the house was arranged in an early American style, or "old farmhouse manner," a transverse hall split the house, with the kitchen and services located in one wing, and the guests housed in the other.[56] Proportionally, the rooms seemed low, especially with the exposed summer beam and floor-joist-beam. Plate rails, dark paneling, and a walk-in fireplace added character to the rooms. Heating proved to be a problem, for the family planned "to have only open fires in the houses," but, as Morgan discovered, "when we moved in, the large hall, dining-room and living-room fireplaces drew such drafts through the house that it seemed impossible to keep it warm." McKim was called down and put in front of the library fire; "First, he put his hand up to his head more or less to keep down the locks of hair that were lifted by the breeze, and then he began putting his hand out at the back of the chair, and finally he got up and said, 'Terrific draft here. This must be stopped.'"[57] The problem was solved by installing furnaces for hot air and steam heat.

The main house was completed in 1891 and, beginning in 1895, the remainder of the compound was built. First came a school-ballroom wing, added as the Morgan's first child turned six. This was quickly followed by a gate lodge, a chapel, a playroom, a water tower, a squash court, a reservoir (planned as a swimming pool but not used for that since the water proved too cold), and servants' quarters.[58] The stables for Morgan's large string of hunting, polo, tandem driving, and riding horses were located in a separate compound adjacent to the hilltop. Elsewhere farm cottages and related buildings were added to the estate. Each of the structures in the complex was designed as an individual unit; the water tower was capped by a bulbous roof with dormers and a monitor, while the gate lodge was crowned with a cupola with windows strongly reminiscent of a lighthouse, undoubtedly a tongue-in-cheek reference to the hill's function as a mariner's landmark.

Landscaping of the nearly barren hilltop proved to be a major project. In his memoirs, Morgan attributes some of his zeal in this undertaking to his childhood experiences in Europe, where he admired formal gardens. But he also recounts the influence of McKim, who during the initial building at "Wheatley" remarked, "I deplore the absence of trees here."[59] Morgan was "not a patient man," his granddaughter remembered. "He wanted what he wanted when he wanted it; and he had no intention of waiting for young trees to grow."[60] His solution was to convince a local nurseryman to transplant some fully mature trees to the hilltop. This proved to be so successful that the entire compound was soon planted and Mr. Hicks, the nurseryman, went on to a successful career providing the same service to the other estates nearby. The remainder of the hilltop was extensively terraced and landscaped, a fountain

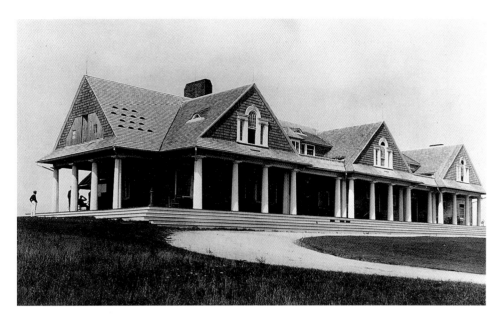

and pool placed in the center of the main court, and several arbors placed next to the buildings. An extensive formal boxwood and flower garden with greenhouses was located adjacent to the compound. A lawn tennis court was also built on the hilltop. The design of these gardens was the work of Morgan and his wife and, as he perhaps rightfully claimed, it was "almost . . . the work of a lifetime."[61]

"Wheatley" was the consummate sportsman's world. Located on a hilltop with views to the north, the Sound, the south (the Atlantic), and the surrounding countryside, "drags," with Morgan as the huntmaster, would gather in front of the pergolas before releasing the hounds. A short distance to the north was Hempstead Bay, where Morgan's yacht could tie up, while polo and racing were available within a few miles of the house. And the estate itself provided any number of recreational facilities: swimming, squash, tennis, and riding. Impressive, and intended as the family estate, the house still maintained elements of a farm-like ease that was seldom captured in other attempts to create physical symbols of lineage. Morgan's estate was the first of the country places to be built in the area, but within a few years it would be joined by the country homes of the Mackays, the Whitneys, the Canfields, the Stows, the Duryeas, the Keenes, the Bryces, and the Vanderbilts. McKim, Mead & White did not build them all, but with "Wheatley" they set a standard for other architects and their patrons to emulate. "Wheatley" itself was demolished in the 1950s.

Shinnecock Hills Clubhouse, Shinnecock Hills, 1891–92, 1895 (Extant)

The Golf Club at Shinnecock Hills is the first clubhouse designed specifically for the sport of golf in the United States, while the course is the first golf course in the United States to be laid out by a professional. In the summer of 1891 Samuel Parrish, the art-collecting patron of McKim, Mead & White, brought Willie Dunn, a leading Scottish golfer, to the Southampton area to locate a site and lay out a course. They settled on the Shinnecock Hills area, and in August a group of 17 summer residents formed an association. It included several former or prospective clients of McKim, Mead & White in addition to Parrish, namely, Edward S. Mead, Charles T. Barney, Charles L. Atterbury, and J. Hampton Robb. The group purchased 80 acres from the Long Island Improvement Company and engaged Stanford White to design a small clubhouse for $6,500.00.[62]

Sited on top of a dune, the clubhouse afforded panoramic views of the hills and the ocean from its piazza and second-floor sitting rooms. Simple and unpretentious, the clubhouse is a development of the firm's smaller casino designs, like those at Babylon and Short Hills. At the same time it also refers to the local vernacular of rectilinear and cubical forms and gray weathered surfaces. When it was built, the clubhouse was sheathed in shingles, but these were later converted to white clapboard. Originally, the clubhouse was unpretentious, its long roof pierced by two cross gables and the facade embellished with Doric porch columns and Palladian windows. In 1895 the firm was engaged to lengthen the structure, and added two more cross gables. Significantly, the addition did not duplicate the original in formal organization but varied the spacing of the cross gables, creating an impression of growth over time and adaptation to different usages. The interior was simple, composed of sitting rooms, a grill and dining area, and locker rooms. The trim was standard stock and reinforced the building's simple rustic air.

McKim, Mead & White:
Garden City Hotel, Garden
City, 1893–1901 (SPLI, n.d.)

Garden City Hotel, Garden City, 1893–95; 1899–1901

Garden City had been developed in the 1870s by New York department store magnate Alexander T. Stewart as a model suburb for working people. Laid out on a gridiron plan with broad tree-lined streets and single-family detached houses, Garden City was described with a promoters' hyperbole as a "model community, a little republic . . . a veritable Eden."[63] Stewart died in 1876 and his wife continued the development of Garden City until her death in 1886. The Stewarts were childless and, consequently, a court battle broke out over the division of their considerable estate, including Garden City. One of Mrs. Stewart's closest relatives was Sarah N. Smith of Smithtown, whose daughters were married to Stanford White, Prescott Hall Butler, and Devereux Emmet. Butler, who had successfully prosecuted the suit on behalf of the Smith family, was also a half nephew of Mrs. Stewart. In 1890 a settlement was reached and the heirs participated in the division of the estate valued at an estimated 12 million dollars. Garden City was to continue as a private corporation and by 1893 a board of directors had been set up with Stanford White, Maxwell E. Butler (Prescott's brother), and Devereux Emmet as members.

Almost immediately in 1893 plans were announced to improve Garden City and, in the process, transform its appearance, dominated by the bulbous High Victorian style of most of its buildings. Henceforth Garden City would reflect the new age of elegant architecture, represented by the work of McKim, Mead & White. The firm did draw up some plans for model homes, but the severe economic depression of the mid-1890s prevented their construction.[64] Possibly Stanford White also had a hand in the enlargement of the local casino, though there is no firm documentation on this matter.

McKim, Mead & White's most important work in this area was the enlargement and rebuilding of the Garden City Hotel (1893–95). Located at the center of town in the middle of a 30-acre park, the existing hotel was a four-story, 25-room mansarded structure designed by James Kellum and built during 1871–74. Utilizing the old hotel as the central portion of the new structure, White added parallel wings to create a U-shaped building containing 100 guest rooms, ten private bathrooms, and the usual public spaces of billiard, reading, smoking, and dining rooms. Piazzas across the front and rear could be enclosed during the winter. Furnishings included drawings by Charles Dana Gibson. Stylistically, the building was Georgian; red brick and white trim with a gambrel roof, a small cupola, and a pedimented entrance conferred status on the central landmark of Garden City.

In September 1899 the hotel was severely damaged by fire; White directed the rebuilding. The new hotel was far larger, with five stories and added wings, making the overall configuration a four-armed E. The public areas became grander with the addition of a Roman marble swimming pool and showers with needle baths. The central block and entrance required more emphasis and White designed a tower adapted from the Independence Hall in Philadelphia.[65]

McKim, Mead & White: "Head of the Harbor," Mrs. Joseph B. Wetherill Residence, St. James, 1893–95 (SPLI, 1978)

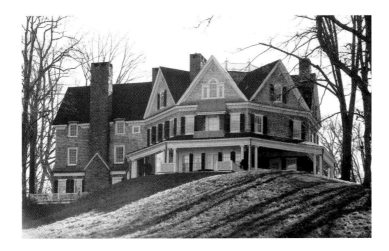

McKim, Mead & White: Alterations, "Sherrewogue," Devereux Emmet Residence, St. James, 1895 (Courtesy of Thomas McMillen)

Mrs. Joseph B. Wetherill Residence, "Head of the Harbor," St. James, 1893–95 (Extant)

Local and family tradition holds that Stanford White and his sister-in-law, Kate Smith Wetherill, had a jocular and somewhat teasing—though very aboveboard—relationship. When he was asked to design a summer house for the Wetherills on property bought from the Whites, Stanford said, "I am going to design her the ugliest house you ever saw!"[68] Whether this is apocryphal is unknown, but the house does in fact have an ungainly appearance. It also relates back to White's own "Box Hill" and its expansion with a string of gables. Perhaps stung by Kate Wetherill's jokes about his series of gables, White decided to show another way to use gables. As well as relating back to White's own house, the Wetherill design is an amalgamation of the earlier, freer resort style, with the new interest in formality. Covered in shingles, the basic form of the house is an octagon articulated on six faces by gables. A one-story piazza surrounds the house at ground-floor level. The major feature on the interior is an octagonal central hall with balconies and a skylight. Attached to the central mass is a service wing, originally one story in height, but later raised. While the interior has a spatial drama all its own, it is ultimately confining and disorienting. Only at the ground floor, where the major sitting-room doors open wide onto the hall, is there a sense of orientation.

Nearby, shingle-covered stables were also erected from plans prepared by the firm. While the work was done through the firm, the Wetherills were billed for costs only.[69]

Devereux Emmet Residence, "Sherrewogue," St. James, Alterations, 1895 (Extant)

This house, designed for Stanford White's brother-in-law, is located close to the other McKim, Mead & White houses in St. James. The Emmet house nestles into the landscape and, while it can hardly be called organic, it appears to belong there. Located near the shoreline, the house traces its ancestry back to Adam Smith and the original portion of it may date from the 1680s. This was substantially enlarged in the 18th and 19th centuries, making the central portion into a five-bay, central-hall plan with a lower service wing toward the land side. In 1895 Stanford White designed a new wing for the bay side, containing a large sitting room on the ground floor and a master bedroom and piazza on the second floor. This wing, dominated on the exterior by a large two-story portico, was obviously intended to balance the service wing on the other side.

This more specific reference indicates the growing "scientific" eclecticism in the firm's work, as well as the attempt to transcend local tradition by identification with more national emblems. At the same time there was a certain lightheartedness in White's adaptation; the tower is not an exact copy, being far more vertical than the rather ill-proportioned tower in Philadelphia. In 1911 the hotel was again enlarged and refurbished by the architectural firm of Ford, Butler and Oliver—Lawrence S. Butler also being an heir of the Stewart family. The hotel was demolished in the early 1970s.[66]

From its reopening in April 1895 until well into the 1920s, the Garden City Hotel was a social center for Long Island and New York society. Vanderbilts, Morgans, Astors, Cushings, and other socially prominent families maintained apartments in the hotel. Guests and owners of nearby estates at Westbury and Roslyn would drop over at night when things were slow at home. During the summer months many New Yorkers, like Charles McKim, took permanent apartments in the hotel to escape the city heat for the night and participate in the life of affluent suburbia.[67]

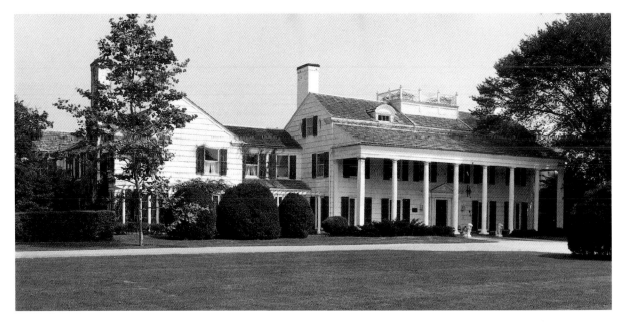

McKim, Mead & White:
Entrance and Front Facade,
"The Orchard," James L.
Breese Residence,
Southampton, 1898–1907
(SPLI, 1977)

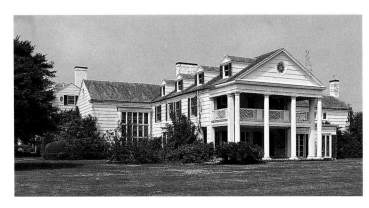

McKim, Mead & White:
Rear Facade, "The
Orchard," James L. Breese
Residence, Southampton,
1898–1907 (SPLI, 1977)

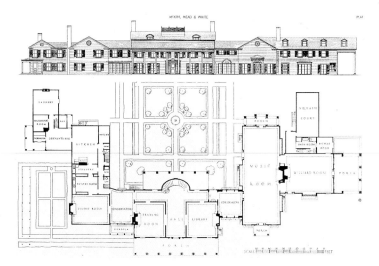

McKim, Mead & White:
Floor Plan, "The Orchard,"
James L. Breese Residence,
Southampton, 1897–1907
(MCKI, 1915)

Stylistically, White's wing was only partially
continuous with the original Smith house, since
the style he chose was Southern Colonial rather
than Long Island Colonial. A writer for *House
and Garden* in 1903 noted the connection be-
tween the lifestyle of country gentlemen of the
18th century and those of the latter part of the
19th century.

*The admirable war between how one lives and
what one lives in, is what McKim, Mead & White
have appreciated in our early Colonial country*

*houses, and copied in many of their modern ones
. . . Mount Vernon and similar examples must
have been wide open before the designers, when
they remodeled Mr. Devereux Emmet . . . what an
open armed hospitality is expressed in the porch of
Mount Vernon! How easily the stranger on the
lawn finds access to the welcome on the porch!
Like in Mr. Emmet's house.*[70]

The writer's enthusiasm is incorrect, since
the porch is not the main entrance and is acces-
sible only to those who have penetrated the gar-
den or the house, and certainly not to strangers.

Set at a diagonal from the house along a low
shrub-bordered path was a small formal garden
that continued the geometries of the house into
the landscape. White undoubtedly laid out the
garden and also the entrance drive and designed
the Colonial-style gateposts at the entrance.
Devereux Emmet was an amateur horticulturist
and took a great interest in selecting the plant
materials. Contrasting with the right-angled
geometries of the house and garden were a series
of curving paths and a small pond inhabited by
ducks and geese.

James L. Breese Residence, "The Orchard," Southampton, 1898–1907 (Extant)

McKim, Mead & White frequently used the
Southern plantation house as inspiration for
their larger country and resort houses, like the
Breese residence in Southampton. Apparently
for McKim, Mead & White, as well as for their
clients, the Southern image, as with the Mount
Vernon portico applied to the Breese house,
represented one of the few truly American
country-house idioms and conveyed a message
about the type of life they aspired to: genteel,
leisurely, and patrician.

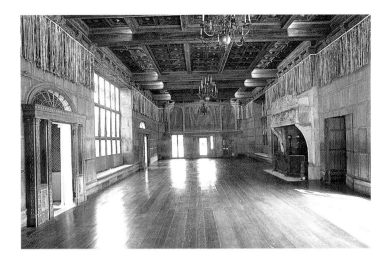

McKim, Mead & White:
Music Room, "The
Orchard," James L. Breese
Residence, Southampton,
1898–1907 (SPLI, 1977)

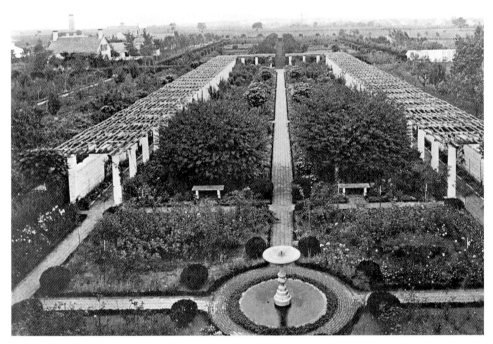

McKim, Mead & White:
Garden, "The Orchard,"
James L. Breese Residence,
Southampton, 1898–1907
(FERR, 1904)

grounds and emphatic axiality of the garden may owe something to McKim; however, White is responsible for many of the garden details. He commissioned a garden fountain from Janet Scudder, and in his own garden at St. James used herms very similar to the ones at "The Orchard."[72] Also assisting on the design were two office men, Frederick J. Adams and Harrie T. Lindeberg.[73]

On the interior, the partners retained the original features of the older portion of the house. New fireplaces and the staircase added an air of refinement and elegance not originally present. The major focus of the extensions, the music room, measured 70 feet by 28 feet, and was 18 feet high. Covered in a linenfold paneling, the music room originally contained a collection of European antiques supplied by Stanford White.

The formal garden was defined by brick herringbone-pattern walks and a Doric pergola. Broken into different sections, including a rose garden and different types of flower beds, the garden in full bloom presented an extraordinary sight on the windswept, flat Southampton landscape. A writer for *House and Garden* expressed the view that Southampton was "more fitting for endless rows of vanishing cabbages than the retreats and hidden shady nooks and walks of the ideal pleasure garden." Regarding the Breese estate the writer commented:

One might not have been surprised to have suddenly looked in upon it through some old Virginia hedge, but upon the wind-swept Long Island shore, its impression becomes doubly vivid . . . everything is green and white: an American country house with almost tropically luxuriant vegetation all around it.[74]

Today, the Breese estate has been readapted for use as condominiums.

Clarence Mackay Residence, "Harbor Hill," Roslyn, 1899–1902, 1903, 1904–05

In April 1900, as the enormous cost for the Mackay estate began to become evident, Stanford White wrote his patron:

You must acknowledge, that in the end, you will get a pretty fine chateau on the hill, and, with the exception of Biltmore, I do not think there will be an estate equal to it in the country.[75]

The estate that had no equal was a particular product of the cultural insecurity that beset so many of McKim, Mead & White's clients. Clarence (Claire) Hungerford Mackay was born in 1874 in San Francisco, the son of Louise Hungerford and John William Mackay. John Mackay had made a tremendous fortune in the

In the Breese house, the slender box posts of Mount Vernon are translated into thin Doric columns. This Southern image is somewhat altered when one views the rear, or northern elevation, and the interior staircase, for they appear to be more reminiscent of New England Federal architecture. Embedded within this play of geographical references is the actual core of the house, a Long Island farmhouse dating from the 18th century that was moved to the site. The exterior covering—hand-split cypress shingles, wide and deep (a 14-inch square of each is left exposed) and painted white—makes reference to this Long Island Colonial origin.

James L. Breese, a New York financier, was a close friend of both McKim and White and, along with both partners, Breese played a role in the design. Apparently McKim controlled the exterior, added the portico, and began the service-wing extensions of the house, incorporating some outbuildings.[71] White worked on the interiors, especially a remodeling of the music room or studio in 1906–07. The overall order of the

François Mansart: Maisons-Laffite, 1642–64. (Reproduced from *Palais, Châteaux, Hôtels et Maisons de France de XVe au XVIIIe Siècles* by Claude Sauvageot, 1867)

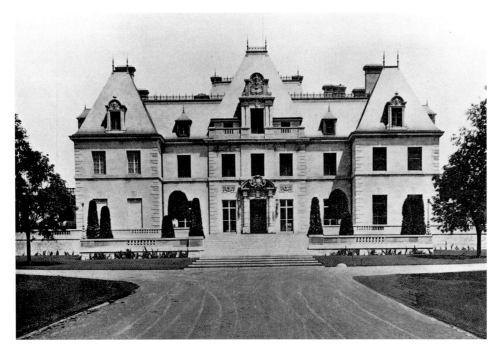

McKim, Mead & White: "Harbor Hill," Clarence H. Mackay Residence, Roslyn, 1899–1905 (FERR, 1904)

Comstock Load and came East with his family in 1876, intending to break into New York society. Instead the family was snubbed as nouveau riche and Catholic, and Louise fled to Europe where she raised her son. In 1884 John Mackay co-founded with James Gordon Bennett, Jr., the Post Telegraph–Cable Company and the Commercial Cable Company. In 1894 Clarence was sent back to New York backed by his father's fortune and his mother's desire to see him make a mark in the society that had rejected her earlier. On May 17, 1898, Clarence married Katherine Alexander Duer, a daughter of a socially prominent, but impoverished, old Knickerbocker family. Katherine was known for her beauty, tyrannous temper, and extravagant tastes. Taller than her husband, she dominated him and the house they built at Roslyn.[76]

Initially, John Mackay had given the young couple 150 acres of land at Roslyn and had promised to build them a summer cottage but, after the house they were renting burned, he increased his gift to 648 acres and a larger house. The site was one of the highest on Long Island, with a superb view.

To Katherine Mackay can be given credit for some of the initial design of the house. In late July 1899 she wrote Stanford White and asked him to "express me as soon as you get this, some books about and drawings of Louis XIV Châteaux. Their severe style preferred. Also of halls Henri II (French)." At this time she also enclosed a rough plan for her proposed house.[77] A few days later she again wrote White with very extensive descriptions of the internal layout she wanted:

The plan where the sides project is what I meant. I have made notes on it to give you points. I do mean a very severe house. The style of the full front view of the Maisons-Laffite comes nearest to what I mean. And, even that has the windows too ornate to suite [sic] us.[78]

From the letters it is apparent that Katherine had definite ideas about her new house and to a large degree Stanford White followed them. Stylistically, the choice of French 17th-century precedent was unusual for McKim, Mead & White, though earlier they had used Loire Valley and baronial idioms. The Maisons-Laffite, also known as the Château de Maisons-sur-Seine, had been designed by François Mansart in 1642 and served as the chief source for "Harbor Hill," though the general form could be found in a number of other French châteaux. Individual details for "Harbor Hill" were also derived from books such as Claude Sauvageot's *Palais, Châteaux, Hôtels, et Maisons de France de XVe au XVIIIe Siècles* (1867), a copy of which Clarence Mackay requested from White in 1903, after the house had been completed.[79] In Sauvageot there is a rendering of the Hôtel de Vogue at Dijon which has the same general composition of a central block and end pavilions, though it is asymmetrical and more ornate. The entrance to the Ancien Hôtel de Montescot at Chartres, which also appears in Sauvageot, served as the model for the doorway at "Harbor Hill."

The house as completed followed these prototypes, though in the process it became a typical McKim, Mead & White design. Severe, as Katherine had ordered, all ornament was confined to the doorway and dormer window pediments. Elsewhere, subtlety reigned: a belt course, deep entablature, and balustrades over the entrance salient and the service and piazza wings gave the house breadth, while quoins imparted emphasis and continuity to the high roofs. The particulated appearance of the building, its being able to be "read" from the exterior, and its stripped-down quality would have appeased even McKim. Indiana blue limestone was used for the exterior wall covering; the

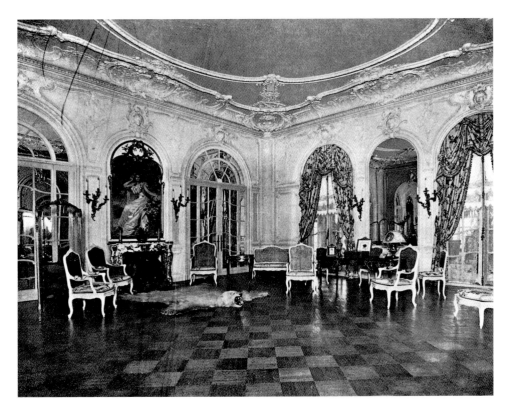

McKim, Mead & White: Drawing Room, "Harbor Hill," Clarence H. Mackay Residence, Roslyn, 1899–1905 (FERR, 1904)

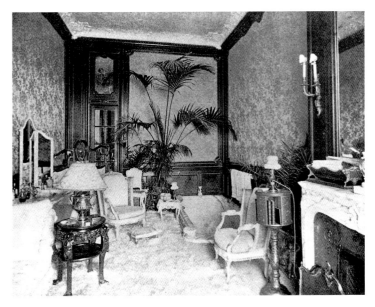

McKim, Mead & White: Mrs. Mackay's Bathroom, "Harbor Hill," Clarence H. Mackay Residence, Roslyn, 1899–1905 (FERR, 1904)

structural system was load-bearing walls, with Guastavino vaults supporting horizontal steel I-beam sections. W. A. and F. E. Conover were the builders.

In designing the interior, White only partially followed Katherine's orders. In plan, "Harbor Hill" owes little to Mansart; its source is to be found in English 16th- and early 17th-century mansions. Four corner pavilions accommodated the staircase and other spaces surrounded the double-height main hall. Appended to the main block was a service wing as well as a conservatory and piazza. White designed most of the interior fittings and A. H. Davenport, Allard et Fils, and William Baumgarten did the installation. The main hall was screened at the ends by Ionic columns and the columns, pilasters, walls, and

ceiling were in gray oak. Medieval banners, antique armor, and four choir stalls gave emphasis to the large antique fireplace imported from a French château. Barr Ferree visited "Harbor Hill" shortly after its completion and noted that "all the chimney pieces on the main floor are old ones, the spoils of European palaces. . . . The one in the hall is by far the largest of the collection, and is so huge that the wood of a single tree can be burned within it." Ferree, an astute critic, went on to describe the remainder of the house, including the stair hall done in oak with Henry II-styled balustrades, newel posts, and boiseries, and hung with tapestries and "a great bronze lamp—a late Renaissance masterpiece finding final resting place in this newest of American great houses."[80] The remainder of the ground floor was equally splendid and also lavishly furnished: a Botticelli, a Verrocchio, a Raphael, and paintings by other Renaissance masters hung in the Stone room, a great gray cold room decorated in the 16th-century Italian style. On the second floor White followed Katherine's dictums to some degree: he gave her an anteroom but not a room as large as her bath for her dresses. Her bathtub was carved from a single piece of marble. Clarence was accorded his portion of space, and the butler was also given quarters on the second floor, but the remainder of the floor was taken up with guest rooms. Quarters for the house servants were provided on the third floor, which also contained ten additional guest rooms and the nursery.

Most of the furnishings and art were picked or approved by White. For this purpose, he made his usual European expeditions, on one of which, beginning in February 1903, he visited Florence, Naples, Palermo, Malta, Marseilles, Cordova, Seville, Lisbon, Opporto, Burgos, Bordeaux, Paris, Turin, Vienna, Munich, Dresden, Berlin, Amsterdam, Paris, and London, searching for armor, tapestries, chairs, paintings, carpets, and other items. These objects were then either bought by White and later re-sold to the Mackays, or listed as offers for their consideration.[81] Other dealers tried to get into the act; Charles Platt suggested a collection of armor costing $400,000, while Tiffany's offered a silk rug being held in Russia costing between $12,000 and $15,000.

Inevitably, tensions arose over the costs. Clarence had money, and following his father's death in 1902, he inherited silver mines and telegraph companies worth approximately $500,000,000. Nevertheless, he still felt pressed. While his income could certainly support the price of the house—$781,483, plus architects' commissions of $54,953 as completed in 1902— there were additional costs to be added for much of the art, for many of the outbuildings

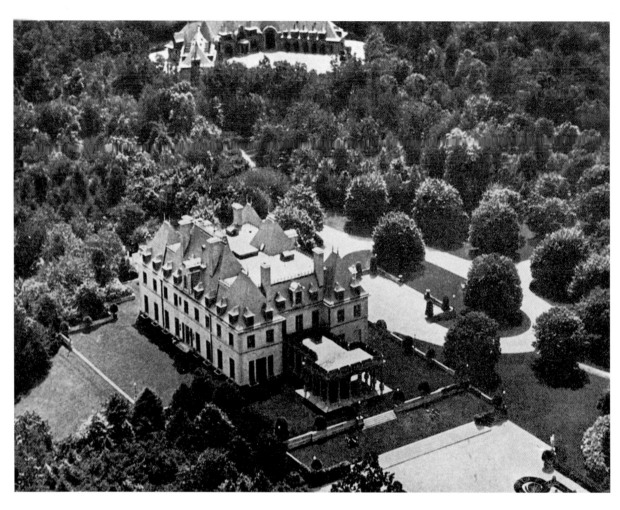

McKim, Mead & White: "Harbor Hill," Clarence H. Mackay Residence, Roslyn, 1899–1905 (PATT, 1924)

and landscaping done by others than McKim, Mead & White, and finally, $30,000 for a major remodeling of the library, hall, and bedrooms by White in 1904–05. Clarence's problem was in holding back Katherine. At one point he wrote to White: "Don't suggest any statues or any additions, as I don't want another thing at all. . . ." and later "What an appetite a new house has! Oh, for $250,000 to spend here!"[82] To a suggested purchase by White, Clarence reacted: "I will tell you right here that I would not think of paying such an absurd price as 100,000 franc for any mantel piece, unless I had the income of a Carnegie or a Rockefeller.[83] In response to White' suggestion for the purchase of a moosehead, Clarence replied, "You seem to forget the main point, viz: the price."[84] The major problems arose over the "extras," items not originally considered, such as the balustrades and terraces surrounding the house. In persuading Clarence to accept them, White wrote that he was "perfectly willing to make an agreement with you that the cost of this extra terrace wall will be more than covered (when all your contracts are let) by the saving I will have made on the final estimate on the cost of the house."[85] This was a pipedream; costs and tempers mounted as the following letter from Clarence to White reveals: *I also accept the Johnson estimate of $2790, for regulating the temperature in the house. I do hope that this is the last of these fancy tricks of yours.*

There is always something turning up, which adds extra and extra to the cost.[86]

White's audacity knew no bounds; in 1904 during the remodeling of the library he wrote that he had received new estimates that were "in certain ways very satisfactory. That is, *without changing* the room *to any great extent.* I have cut down the estimate from $40,000 to $25,995 *for the room complete in every respect,* with the exception of the movable portieres and curtains, the movable candelabra, and the fireplace fixtures."[87] Still Clarence clearly felt admiration for White. In a letter transmitting a check, he wrote: "I hope you will pay your bills with it and not blow it on suppers, etc.," adding, "to say nothing of flower pots."[88]

The house was but one part of the extensive estate that Clarence and Katherine planned. At some point well after the site of the main house had been chosen, Guy Lowell was called in to design the grounds. While Lowell later would gain a substantial reputation as an architect, at this time he was principally known as a landscape designer. In his book *American Gardens* (1902), he explained his views as follows: *Our gardens need not, when adapted to this country, follow any recognized style. In the first place we are not yet hampered by national traditions and may take only as much of any one style as happens*

McKim, Mead & White:
Plot Plan, "Harbor Hill,"
Clarence H. Mackay
Residence, Roslyn,
1899–1905 (BYRO, n.d.)

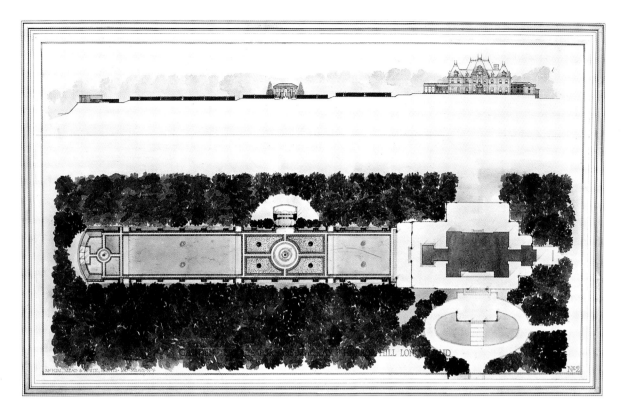

McKim, Mead & White:
Gate Lodge, "Harbor Hill,"
Clarence H. Mackay
Residence, Roslyn,
1899–1905 (ARRC, 1904)

*to please us; secondly, American vegetation is very
different from that of other countries. In spite of
the fact that the same flowers sometimes grow in
the American garden as in those abroad, they seem
to grow differently,—less formally, perhaps,—and
we, as a nation, prefer a freedom which to the
English or the French gardener would almost seem
like untidiness.*[89]

The total estate of over 600 acres was divided
into formal gardens and terraces surrounding
the house proper, and a farm area of about 70
acres, with the remainder of the grounds being
treated as a park. Entrance to the estate was
through a gate house designed in a Chateau-
esque style by Stanford White and located at
a bend in the Roslyn Road. Lowell tried to
change its location but Katherine Mackay sided
with White.

Sited on top of the hill overlooking Hemp-
stead Harbor, the house was the formal center
of the estate, with all roads radiating outward
from it. The house was approached from the
south along an easily curving road that wound
up the hillside. Existing groves of trees were
avoided, but at great expense, and it was report-
ed that the road cost Clarence approximately
$150,000. Herbert Croly writing in the *Archi-
tectural Record* claimed:
*This avenue is a case absolutely of making over the
land in order to suit the conveniences of the resi-
dents of the house.*[90]

As the visitor neared the hilltop, the road
straightened out, so that the house was ap-
proached on axis. Confronted by a wide terrace,
the visitor was forced to walk the last 50 feet.
To the west of the house a large formal garden
opened off the conservatory and piazza and
spilled down the hill for about 200 yards. The
requisite parterres, fountains, and statues were
placed about, and at the bottom were posi-
tioned two, 40-foot-tall statues, copies of Louis
XIV's horse tamers.[91]

As with most estates of this scale, some
attempt was made at farming. A carriage house
and stables were built near the hilltop, but the
remainder of the estate and farm buildings were
located along the northern portion of the estate,
well out of olfactory and auditory range of the
main house. These buildings were not in any
formal order, but placed picturesquely. Several
were original with the estate, including the
superintendent's house, a Colonial house which
the Mackays had occupied during construction
of the main house. The remainder were de-
signed by Warren & Wetmore in a variety of

McKim, Mead & White:
Trinity Church, Roslyn,
1904–07 (MCKI, 1977)

McKim, Mead & White:
Trinity Church, Roslyn,
1904–07 (MCKI, 1977)

styles, such as the exuberant Châteauesque stables and the Stick Style dog kennels. Other buildings included a squash court and indoor swimming pool, a main barn, a stable for polo ponies, greenhouses, a chicken farm, and a dairy. The rationale for choosing Warren & Wetmore for the outbuildings is unclear, but perhaps Clarence—in attempting to save some money—decided on less expensive architects for the less important buildings.

For the remainder of the estate the intention was, as Croly summed up, "to make a park—not a French park, after the model of Fountainbleau, but a park which shall keep its native American character." Lowell, the landscape architect, strove for a "simplicity and propriety of effect," and somewhat tempered the "original wildness."[92] Native trees and underbrush were kept, although there was some clearing and replanting. Lowell insisted upon native plants and trees for both the park and the formal gardens. Winding through the park were ten miles of bridle paths, just wide enough for a carriage. Barr Ferree reported:

In an instant the spirited black horses were whizzing us through the cool woods, down steep inclines, then up again to higher grades. There was barely room for the carriage to pass between the trees, and the grades were so steep I wondered the carriage brakes held. It was a veritable "scenic railway," with all the excitement of the ups and downs, but with real scenery, wild and beautiful. It was without suggestion of house, save it was Mrs. Mackay's rustic cottage, deep in the woods, but placed just where the look across the country is finest.[93]

And, so, deep in the woods Katherine had her hideaway constructed, her "le Hamleau." Near the time of "Harbor Hill's" completion the local newspaper commented that it seemed "to have flowered out of rural England and nearby soil."[94]

"Harbor Hill" became more than just a weekend house for Clarence and Katherine Mackay, drawing them into playing lord and lady of Roslyn. They immersed themselves in local politics, made gifts to the village, and even commissioned a church. Clarence was a Catholic, and Katherine an Episcopalian, and both remained true to their denominations after their marriage. In 1905 Katherine offered to construct for the local Episcopal church a new building and parish house as a memorial to her parents. She acted as the building committee on the project, accepting or rejecting White's designs with comments such as "I do not like the exterior: it is not only high and ugly but it is unfriendly."[95] A tyrant, she had the rector fired when he questioned her plans, and forced a contractor out of business when she refused to pay for changes she had ordered.

As completed, Trinity Episcopal Church, Roslyn, was a variation on mid-13th-century English parish churches. A rather unprepossessing work, its most notable features are the Harvard bricks, laid up with only headers exposed, and its wooden hammerbeam roofs. The round arches contrast with the elongated proportions of the building and give it a certain awkward air. The interior has some fine glass, especially a memorial window for the Mackay's Long Island neighbor, W. C. Whitney, created by Louis Comfort Tiffany. The parish house attached to the church is a straightforward brick structure containing spaces for classes, assemblies, a library, kitchen, and a gym.

Also for the Mackays, McKim, Mead & White designed a hunting lodge in North Carolina (1903–05), and the Mackay Mining Engineering Buildings at the University of Nevada in Reno. White was at least nominally

McKim, Mead & White: "The Manse," William C. Whitney Residence, Westbury, 1900–10 (TOWN, 1901)

McKim, Mead & White: Living Room, "The Manse," William C. Whitney Residence, Westbury, 1900–10 (DESM, 1903)

involved in both of these projects, but the basic work was carried out by office men: Frederick Adams for the hunting lodge and William Symmes Richardson for the Reno building.

The Mackays' attempt to become the lord and lady of Roslyn came to naught; their marriage, perhaps inherently unstable, came apart in 1913. Katherine divorced Clarence for a new suitor, but that relationship also failed, and at the end of her life in 1930 she embraced Roman Catholicism. Clarence paid for her funeral at St. Vincent Ferrer Church in Manhattan. He subsequently remarried, but the Great Depression severely depleted his fortune, and he sold his companies to International Telephone and Telegraph and Western Union. The art objects were sold to various museums in 1933 and he moved into the former superintendent's house, which he and Katherine had first occupied when the big house was being built. He died in 1938 and the main house was demolished in 1947. Today a housing development is located on the property. The gate lodge and a few of the farm buildings survive.

William C. Whitney Residence, "The Manse," Westbury, 1900–02, 1906–10

On his death in 1904, it was reported that Whitney had at least ten residences. One of these was a large townhouse on Fifth Avenue in Manhattan, which McKim, Mead & White,

with Stanford White as the partner-in-charge, had remodeled for him between 1899 and 1902 at a cost of nearly $1,000,000. The firm had remodeled yet another townhouse for him in 1889–1890 at a cost of $50,000. In addition, McKim, Mead & White had designed his large country mansion at Westbury at a cost in excess of $800,000.

William Collins Whitney (1841–1904) was a noted politician in the Democratic machine in New York City, Secretary of the Navy under President Cleveland, and a powerful businessman with major interests in New York City street railways. He married twice, very well, and was a constant presence in New York, Washington, and international society. He was also a considerable sportsman with a passion for horse racing. He owned a horse farm near Lexington, Kentucky, and had major stables on his Westbury estate; one of his horses won the English Derby in 1901.[96] After his death the Westbury estate passed to his son Harry Payne Whitney and his wife Gertrude Vanderbilt Whitney, who subsequently commissioned Delano & Aldrich to build a small studio for her.

While several historically styled designs were offered to Whitney by the firm, the house that was finally constructed was, as noted earlier, one of the most unusual designs from this period of the firm's life. White probably had a hand in the design—it certainly resembles neither McKim's nor Mead's work—but its character is so unusual as to suggest that someone else on the office staff may have played a major role.[97] At the same time, with its steep gabled roofs, high chimneys, and exposed-timber porch, the house was probably regarded as falling within the bounds of the English medieval style. Certainly the various and extensive outbuildings were more correctly English Tudor or Elizabethan in style. But the main house is, in a sense, closer to the English Arts and Crafts style and recalls other parallels such as Stanford White's "Box Hill" and Phillip Webb's "Standen." In particular, the work of Edwin Landseer Lutyens at "Munstead Wood" (1896) and "The Orchards" (1899), published in the English *Country Life* magazine, may have played an influential role in the design of the Whitney house at Westbury.[98] Built of buff-colored Roman brick, the house had a long horizontal spread which was balanced by steeply pitched gable roofs that from a distance appeared to drop nearly to the ground. The porches or piazzas were articulated by their own horizontal roofs. Exterior trim was minimal, consisting of some molding in the fascia of the gables and a little structural brick and limestone worked into the walls and molded chimney stacks. The interior, for which only a

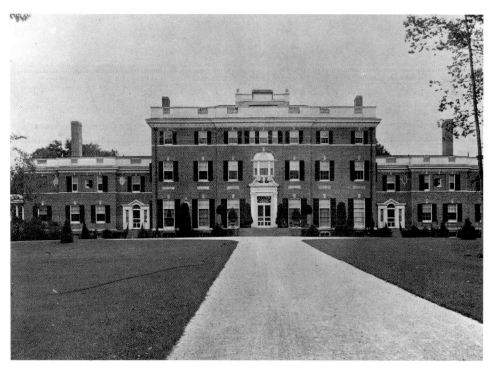

McKim, Mead & White:
Entrance Front,
"Cassleigh," A. Cass
Canfield Residence, Roslyn,
1902–03 (FERR, 1904)

few photographs survive, reveals a succession of period room decor filled with antiques and reproductions. Sadly, this extraordinary house was demolished in 1942.

A. Cass Canfield Residence, "Cassleigh," Roslyn, 1902–03

The Canfield house is one of Charles McKim's late Georgian Revival designs and shows his attempt to assimilate a variety of sources into a single composition. Both the plan with its dependent wings and the large scale recall Southern plantations. The style, however, is more reminiscent of the North, with its red-brick planar front and swelling garden bay at the rear recalling Federalist architecture like the Gore Palace in Waltham, Massachusetts. Exactly contemporary with the Canfield design, McKim was working on the Thomas Jefferson Coolidge residence in Magnolia, Massachusetts, which betrays a similar mixed parentage.[99]

Initially, McKim projected the cost of the Canfield house at $75,000, excluding furnishings. Upon completion, Canfield paid the firm a five-percent commission on $82,514 for the house, and a total of $14,000 for the stable and outbuildings. The interior furnishings cost $22,416, on which the firm received a ten-percent commission.[100] Olmsted Brothers did the grounds in 1904–06. Canfield died in 1908 and his wife remarried and lived in the house until 1915. It was demolished around 1940.

The Canfield house provides a revealing comparison with White's work: McKim's design is more rigid and sober, with symmetry and strict axial planning dominating his scheme. Typically, the appropriateness of the proportions was important; Barr Ferree writing in 1904 commented:

So much skill has been displayed in disposition of the parts forming this front, the masses of the building are so well composed, the proportions so good, the spacing of the windows so clever, and ornamental features so admirably handled, that it is, as a whole, a front of quite penetrating attractiveness.[101]

There is a stateliness, a sought-after majesty in McKim's work, that is foreign to the free-spirited conceptions of White.

Dominated by a cross axis of a central hall and corridor, the wing to the right was given over to guest rooms; the left wing was occupied by service and the children's rooms; and the main public apartments—the library, the drawing room, and the dining room—were strung across the south front. Interior furnishings were a mixture of antiques and reproductions. The hall contained an old tapestry, light standards that imitated regal insignias, and a bust of a Roman emperor. The other major rooms were done in period styles, Georgian oak for the library, French walnut in the living room, and Adamesque colors in the dining room. The entire house was designed to give an air of historical continuity. This is most apparent in the descriptions of its setting; Ferree described the view from the rear terrace as follows:

The ground dips suddenly here, with a great green field beyond, and then, as far as eye can see, stretch the undulating farmlands of the adjacent countryside, with the Hempstead plains in the distance.

It is "an entrancing outlook upon a smiling landscape of gentle woods, green fields, and thriving farms."[102] In this pastoral setting, the Canfield house appeared to dominate its landscape as if it were an English country house, though in reality it existed far apart from the local scene. The actual house and its style had nothing to do historically with the area and both the Canfields were outlanders from the Midwest. The house was manufactured for them and they owned no local farms. All their money came from mercantile endeavors.

Richard Guy Wilson

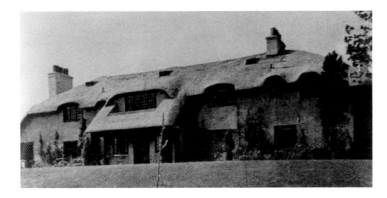

Mrs. John E. McLeran: Rear Facade, "Thatch Cottage," Charles E. Pettinos Residence, Centre Island, c. 1920 (ARTS, 1927)

Mrs. John E. McLeran, practiced c. 1920s

While no information has been discovered about the architectural career of Mrs. John E. McLeran, she is credited with designing one of the more unique country residences on Long Island, as well as a small cottage on another estate. For Charles E. Pettinos, known as "the Graphite King" because of his worldwide interest in the mineral, she created a charming rendition of a French Normandy cottage on Centre Island in Oyster Bay. The stucco house, constructed around 1920, has as its dominant feature a broad and sweeping roof of straw-colored cement, combed with a steel brush to give it a thatch-like texture. Belying its simple antecedents, the house was large and spacious. It was completely remodeled by a subsequent owner in the 1940s. A few years later, McLeran designed a guest house in Mill Neck for Irving Cox. Although it is built of brick, its deep, thatch-like roof is also its dominant feature.

Carol A. Traynor

Edward P. Mellon, 1875–1952

A member of the distinguished Mellon banking family, and nephew of U.S. Secretary of State Andrew W. Mellon, the architect Edward Mellon was known, among other commissions, for his design of the tomb for President Warren G. Harding in Marion, Ohio; participation in the design of Children's Hospital, Falk Clinic, and Presbyterian Hospital, as well as commercial buildings, in Pittsburgh, Pennsylvania; and the Presbyterian Church in East Orange, New Jersey. He served as a trustee of the American Academy in Rome. Mellon's residential projects on Long Island, "Villa Maria" and "Mylestone," were both built on Southampton's Meadow Lane, which runs east to west along a precariously narrow finger of barrier dunes lying between the Atlantic Ocean to the south and Shinnecock Bay to the north.

The sea-reflected light at Southampton can, on a given summer afternoon, almost fool one into thinking that one is by the Mediterranean Sea. Everything about Mellon's own summer home, "Villa Maria," built around 1918, was intended to evoke the romance of an old Tuscan villa. Pink-tinted stucco walls and terra-cotta tiles make perfect reflectors for the special sea light. The architect imported the decorative ironwork from Italy and recycled the marble floors inside the house from old buildings. A garage and chauffeur's cottage on the opposite side of Meadow Lane match the main house in style and material.

Like "Villa Maria," which lies just down the road, the Duncan S. Ellsworth house, "Mylestone," built around 1923, is set on the dunes of Southampton with views both north and south over the ocean and Shinnecock Bay. But, unlike Mellon's Tuscan fantasy, the Ellsworth house was executed in a more northern "cottage" tradition. While the entrance side of this five-bay house presents a fairly imposing wall of stucco and glass (altered, unfortunately, in a recent modernization), the ocean side of the house snuggles sympathetically into the gentle lines of the dunes. Two massive chimneys bracket the ends of the house's hip roof and three attic dormers project from both the north and the south sides of the roof. A large, covered porch accented by ornamental latticework opens out to the ocean vistas to the south. A four-car garage and chauffeur's cottage are attached to the main house by an arched bridge.

Alastair Gordon

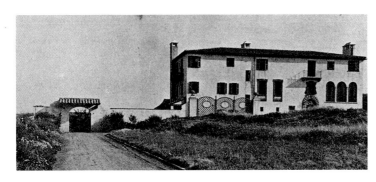

Edward P. Mellon: Front Facade, "Villa Maria," Edward P. Mellon Residence, Southampton, c. 1918 (ARTR, 1919)

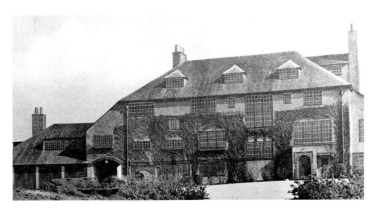

Edward P. Mellon: Front Facade, "Mylestone," Duncan S. Ellsworth Residence, Southampton, c. 1923 (PREV, n.d.)

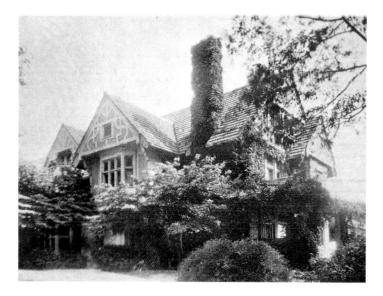

William H. Miller, died c. 1921

Based in Ithaca, New York, William Miller was associated with Samuel H. Hillger between 1892 and 1897, designing both the Boardman Law School and the Romanesque library on the campus of Cornell University. Between 1903 and 1905 he was commissioned by Timothy S. Williams, president of the Brooklyn-Manhattan Transit Company, to design his country residence in Lloyd Harbor. Situated on a site facing Cold Spring Harbor, the main house is an interesting masonry and half-timbered composition, featuring decorative cusp-work detailing on its numerous gables. Walnut and mahogany paneled walls and ceilings grace the interior. The house and garage are extant.

Carol A. Traynor

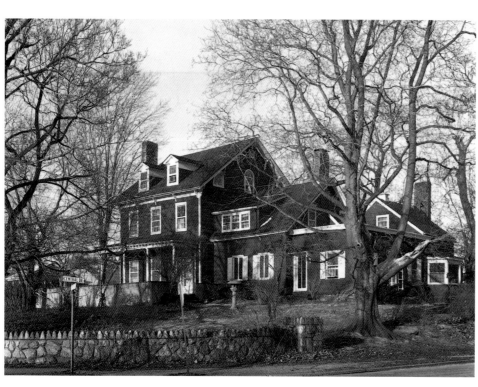

Addison Mizner, 1872–1933

Trained in the San Francisco office of Willis Polk, a leading California architect, Addison Mizner combined his apprenticeship there with further schooling in Spain and extensive travel in Europe and Asia. He gained his reputation as one of America's great society architects by his work in Palm Beach, Florida, in the 1920s, but he laid the foundation for that achievement by designing country houses on Long Island during the preceding decade. Many of the projects he executed before he moved to Florida in 1918 can be identified by plans left in his Florida office, newspaper articles, and references in his mother's correspondence.

Mizner arrived in New York in 1904 with the goal of opening an office that would specialize in country houses for the wealthy and socially prominent. Sponsoring his entry into the fashionable world of East Coast society were two California friends: Tessie Fair and her sister Birdie. Tessie had become Mrs. Hermann Oelrichs, one of America's great society hostesses, while Birdie had married William K. Vanderbilt, Jr. Mrs. Oelrichs also introduced Mizner to Stanford White, the architect of "Rosecliff," her marble palace in Newport. In his autobiography Mizner noted that his first work in New York came from commissions "too unimportant" to go through the McKim, Mead & White offices.

Addison Mizner Residence, Port Washington, 1907 (Extant)

The architect's first work on Long Island was the remodeling of an historic homestead in Port Washington to serve as his own residence. He found the old house during a spring weekend in the country in 1907. The original house, dating from 1673, had served as headquarters for Hessian troops during the Revolution. Oliver Baxter, a shipbuilder, added the main section with its "beautifully proportioned neo-classical rooms" in 1795.

In 1917 the *Architectural Record* detailed Mizner's remodeling. Sensitive to the historical character of the house, he made few changes to its exterior. Wishing to take advantage of the spectacular site overlooking Manhasset Bay, the architect moved the main entrance to the rear of the house. On the bay side he then added an 18-foot-wide private terrace surrounded by a low stone wall. While he left the roof and columns of the original front porch intact, he removed the wooden floor and railings, merging porch and terrace into one space.

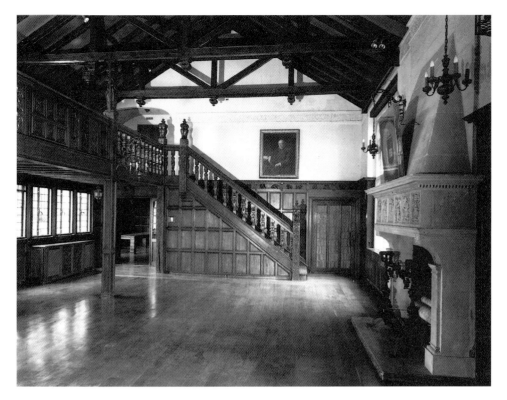

William A. Prime Residence, "Warburton Hall," Wheatley Hills, 1911 (Extant, altered) (Now C. W. Post College of Long Island University)

Mizner's first major Long Island commission was a "Spanish type of residence" for William Prime, a well-to-do marine underwriter and sportsman, who owned an estate of more than 100 acres east of Wheatley Road on the south side of Northern Boulevard. The house occupied the crest of a hill commanding distant views to the west. Only plans for the first floor remained in Mizner's collection in Palm Beach. They show a moderately large country house centered on a huge 40-by-27-foot, two-story living hall. A gallery ran the full length of the hall on the second floor and large windows on both the east and west walls flooded the room with light.

In 1921 Edward F. Hutton and Marjorie Merriweather Post, having purchased the Prime estate, asked Charles M. Hart to begin the remodeling of the house that would produce "Hillwood," the Huttons' great Tudor mansion. Hart retained Mizner's basic plan, adding only a new bedroom and service wings. The old dining room became the new entrance hall and the old kitchen the new dining room. Later the firm of Hart & Shape added another service wing (destroying Mizner's servants' quarters), as well as a wing for the children and another for a library and sun room. Throughout all the remodeling, Mizner's living hall, now called the Great Hall, remained at the heart of the house.

Addison Mizner: Reception Hall, "Warburton Hall," William A. Prime Residence, Wheatley Hills, 1911 (Courtesy of Craig Kuhner, 1982)

Addison Mizner: Facade Detail, John A. Parker Residence, Sands Point, 1912 (PREV, n.d.)

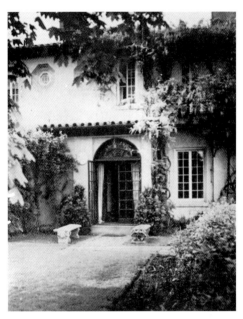

Miscellaneous Long Island Projects

Mizner's 1910 commissions on Long Island included gardens for comedian Raymond Hitchcock on Sunset Road, Kings Point, and a Norman-style tennis house for Ralph Thomas (now a guest house) on Middle Neck Road, Sands Point.

In 1911 Mizner designed a garden and amphitheater for William Bourke Cockran at "The Cedars," Hempstead Harbor and Shore Roads, Port Washington (demolished); a Japanese-style residence for Sarah Cowen Monson on Upper Drive, Huntington (demolished); and possibly a tea or beach house for Mrs. O. H. P. Belmont (the former Mrs. William K. Vanderbilt, Sr.) in Sands Point in 1915.

John Alley Parker Residence, Sands Point, 1912 (Extant)

John Parker purchased 30 acres on Sands Point Road in February 1912 and asked Mizner to plan "a handsome villa . . . after the Spanish style of architecture." Although Mizner designed a huge U-shaped house surrounding a 90-by-75 foot interior court which spread beyond its small hilltop site, Parker built only the south wing, the foundations for the proposed 50-foot-long living room, and the retaining walls for the courtyard. The hillside location of the completed wing allowed Mizner to place the kitchen and servants' rooms on a level below the courtyard. The first floor contained a reception hall, a 29-by-24-foot dining room with a stair hall, a butler's pantry, and a small porch projecting into the courtyard which Mizner labeled "temporary" on the plans. An owner's suite of bedroom, den, bath, and lavatory, and three additional bedrooms and a bath on the second floor completed the wing.

Addison Mizner: Front Facade, I. Townsend Burden, Jr., Residence, Greenvale, 1916 (Courtesy of Craig Kuhner)

Addison Mizner and Armand J. Tibbetts: Landscape Design, Garden Facade, "Solana," Stephen H. Brown Residence, Matinecock, 1917 (PREV, n.d.)

Addison Mizner: Floor Plans, "Solana," Stephen H. Brown Residence, Matinecock, 1917 (PREV, n.d.)

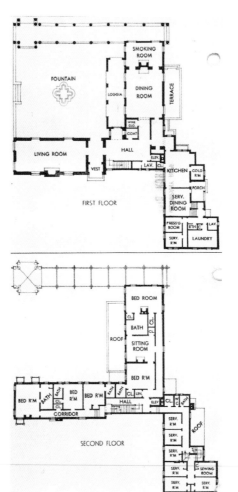

Mizner's original design called for a Spanish Colonial house with an ornate entry, wrought-iron balconies, and asymmetrical massing of the long, low living room section and the two-story south wing. When a later owner added a large porch off the reception hall (which had now become the dining room) with a sleeping porch above, little of the Spanish Colonial character of the house remained.

I. Townsend Burden, Jr., Residence, Greenvale, 1916 (Extant) (Now the New York Institute of Technology)

For the president of the Burden Iron Company, attorney I. Townsend Burden, Jr. (grandson of

Henry Burden, founder of a steel company in Troy, New York), Mizner completed a large country house, incorporating an old stable and carriage house into his plan at the request of his client. He placed the main section of the house across a courtyard from the old stable. A connecting wing of service and servants' rooms created a large U-shaped plan. The enclosure became the formal entrance court. This courtyard, the stucco walls, tiled roof, and elaborate door surrounds gave the mansion a decided Spanish air. The main section of the house contained a brick-floored entry hall, a large living room, an open porch, and a guest suite on the ground floor, and an owner's suite and five other bedrooms on the second floor.

Stephen H. Brown Residence, "Solana," Matinecock, 1917 (Extant)

In 1907 Stephen Brown, a governor of the New York Stock Exchange, quarreled with the architect of his large New York City Tudor-style townhouse on East 70th Street. Mizner, recommended by a California friend, received the job to finish the building and to do "all the interiors." Ten years later Brown decided to build a Spanish-style country house on his 15-acre estate adjoining the Piping Rock Club in Locust Valley and called upon Mizner for the design.

The last of Mizner's Long Island commissions, the Brown house marked a transition between his northern designs and his Florida work. The architect centered his plan on a three-story tower from which three wings radiated in a pinwheel. The 40-foot-long living room, dining room, smoking room, and loggia formed an L around a private courtyard, while the hall and service wing formed a second L sheltering the entry court. In this free and rambling plan Mizner departed from the tighter massing found in so many of his earlier houses. Opening the house onto a secluded patio was a device often used in Palm Beach, as was the strongly articulated roof line. The interior stone walls, beamed and paneled ceilings, tiled floors, vaulted stair halls, and particularly the loggia, also became part of Mizner's later design vocabulary.

Donald W. Curl

Benjamin W. Morris: Mrs.
Fremont C. Peck Residence,
Brookville, c. 1929 (ARAT,
1930)

Montrose W. Morris, c. 1861–1916

Montrose W. Morris was among the most tal-
ented architects active in the city of Brooklyn
during the final decades of the 19th century.
Although born in Hempstead, Long Island,
Morris was raised in Brooklyn. In 1883 he
opened an architectural office that sought
clients from among Brooklyn's large, affluent
middle-class community. Success came after
he completed his own flamboyant residence in
1885, bringing the architect a great deal of pub-
licity and a number of important clients.

Although his office was located in Manhat-
tan, Morris worked almost exclusively in
Brooklyn, or for Brooklyn clients building else-
where. His major works were designed primarily
in the Romanesque Revival style or with a com-
bination of Romanesque and Renaissance in-
spired details. He designed houses for several of
Brooklyn's wealthiest industrialists as well as
some of Brooklyn's first luxury apartment build-
ings, including The Alhambra (1890). Among
his finest Brooklyn residences are two row hous-
es designed in 1889 and 1890 for Joseph Fahys in
the Clinton Hill neighborhood. These houses,
on opposite corners of DeKalb Avenue and
Waverly Avenue, illustrate Morris's love of richly
contrasting textures and quirky design details.

Joseph Fahys was also the first to commis-
sion Morris to design a Long Island country
house. A watch case manufacturer who moved
from Brooklyn to Sag Harbor, in 1889 Fahys
had Morris design a large, multigabled, frame
house. In 1892, Fahys's son-in-law, Henry F.
Cook, commissioned a second Sag Harbor
house. This rambling residence was among the
architect's finest freestanding buildings. The
success of this house—with its contrasting tex-
tures of rough stone base and shingled upper
stories; its complex fenestration; its fusion of a
variety of bold architectural forms, including
several gambrel-roofed gables, towers with ogi-
val roofs, and projecting and recessed porches;
and its complex play of planes (particularly the
recessed second-floor loggia which was one of

Benjamin W. Morris, 1870–1944

Educated at Columbia University and the Ecole
des Beaux-Arts, Benjamin Morris worked in the
offices of Carrère & Hastings, assisting in pre-
paring their prize-winning plans for the New
York Public Library. In his later private practice
he designed many public and commercial build-
ings in Hartford, Connecticut, and New York
City. He also designed parts of the Princeton
University campus and served as Advisory
Architect to its School of Architecture in the
early 1920s. Mrs. Fremont C. Peck commis-
sioned Morris to design a residence for her in
Brookville, which was built in 1929. The house,
built of rough-set brick, is in the style of an L-
shaped French chateau; a cylindrical tower rises
at the juncture of the arms forming the L. The
main entrance doorway and tower windows
were trimmed with imported French limestone.
The house's steeply pitched roofs and the
tower's conical roof are set with shingle tiles,
graduating in color from dark gray-green at the
eaves to orange at the ridge. The house survives
in a relatively unaltered state.

Wendy Joy Darby

Montrose W. Morris: Front
Facade, "Andelmans,"
Joseph Fahys Residence,
Sag Harbor, 1889 (Gibb-
Hester Family Album)

Montrose W. Morris:
"Clench-Warton," H. F.
Cook Residence, Sag
Harbor, 1892 (Gibb-Hester
Family Album)

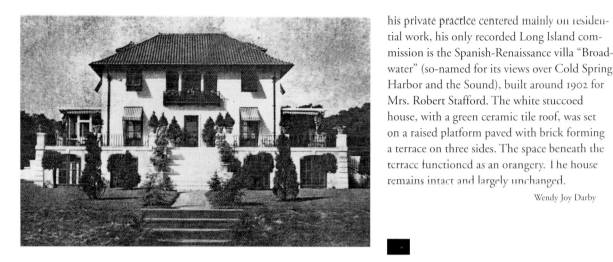

Lionel Moses: Garden Facade, "Broadwater," Mrs. Robert Stafford Residence, Lloyd Harbor, c. 1902 *(Concrete and Stucco Houses* by Oswald C. Hering, 1922)

his private practice centered mainly on residential work, his only recorded Long Island commission is the Spanish-Renaissance villa "Broadwater" (so-named for its views over Cold Spring Harbor and the Sound), built around 1902 for Mrs. Robert Stafford. The white stuccoed house, with a green ceramic tile roof, was set on a raised platform paved with brick forming a terrace on three sides. The space beneath the terrace functioned as an orangery. The house remains intact and largely unchanged.

Wendy Joy Darby

Morris's favorite architectural devices)—reflects the sophistication of the architect's work.

In 1894 Morris constructed a summer home for his own use in the North Country Colony of Glen Cove. The design of the Morris residence, with its stone base and shingled upper stories, gambrel-roofed gables, and towers, relates, on a smaller scale, to that of the Cook residence. Also in Glen Cove, Morris designed the handsome shingled stables for the E. R. Ladew estate (1898).

Andrew S. Dolkert

Lionel Moses, 1870–1931

A member of the firm of McKim, Mead & White for 44 years, Lionel Moses was particularly associated with Stanford White in the design of the New York Players' Club and several buildings at Columbia University. Although

Jacob Wrey Mould, 1825–1886

A founding member of the American Institute of Architects, this English-born architect was one of the earliest and most inventive practitioners of the polychromatic High Victorian style in America. Jacob Mould worked in the London office of Owen Jones, a master of ornamental design, and assisted with several of the latter's commissions. Among them was the decoration of the celebrated Crystal Palace (1851), for which Joseph Paxton served as architect.

In 1852 Mould arrived in New York, where he was best known for his first American commission, his Unitarian Church of All Souls, and the numerous structures and furnishings he designed, first as assistant to and then as associate of Calvert Vaux, and from 1870 to 1871 as architect-in-chief to the Department of Public Parks. In 1874 Mould accompanied the American engineer Henry Meiggs to Lima, Peru, to help lay out a large public park. Five years later, he returned to New York, where he resumed his service to the Parks Department.

Mould's two Long Island commissions, among the earliest of the large country seats built along the banks of the North Shore, both overlooked Hempstead Bay. Fortunate to find clients who had no qualms about the amount of money they spent, Mould was able to indulge his love for color, ornamental detail, and costly materials in these houses, designed at the height of his career soon after the close of the Civil War.

Thomas W. Kennard Residence, "Glen Chalet" (renamed "Elsinore"), Glen Cove, late 1860s

Located near the landing for the steamboat providing year-round access to New York City, this spacious, picturesque wooden country house was designed in a richly ornamented Swiss chalet style. It featured irregularly placed towers, gables, balconies and verandas, all fancifully carved and gilded.

Jacob Wrey Mould: "Glen Chalet," Thomas W. Kennard Residence, Glen Cove, c. 1865 (British Architectural Library, Royal Institute of British Architects)

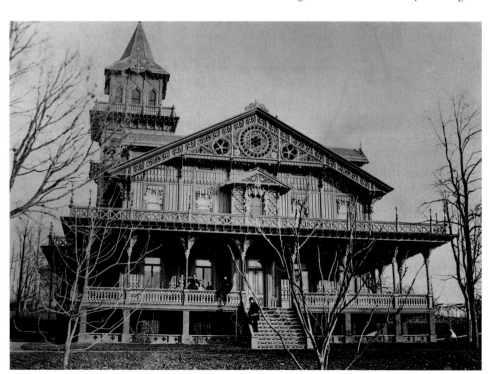

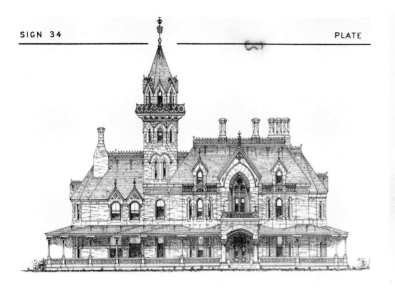

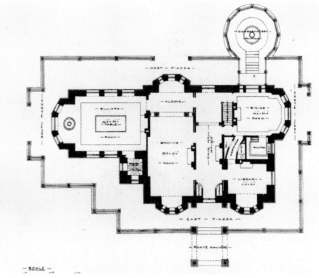

Jacob Wrey Mould: East Elevation, "The Stonehouse," Thomas Clapham Residence, Roslyn Harbor, 1868 *(Wooden and Brick Buildings* by Amos J. Bicknell, 1875)

Jacob Wrey Mould: Floor Plan, "The Stonehouse," Thomas Clapham Residence, Roslyn Harbor, 1868 *(Wooden and Brick Buildings* by Amos J. Bicknell, 1875)

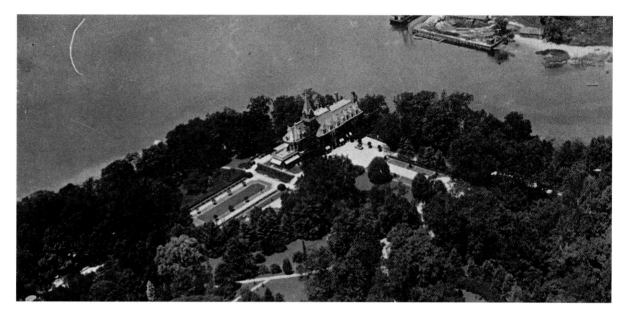

Jacob Wrey Mould: Aerial View, "The Stonehouse," Thomas Clapham Residence, Roslyn Harbor, 1868 (AVER, C. 1930)

Kennard, who commissioned other projects from Mould, was an English railroad engineer who had come to the United States to build the Atlantic and Great Western Railroad for its European stockholders. After reputed financial difficulties, Kennard returned to England and his Glen Cove estate passed to Samuel Latham Mitchell Barlow, a successful New York lawyer who had amassed a fortune as the counsel to both the Atlantic and Great Western Railroad and the Erie Railway. Tended by its various residents, the grounds were improved with gardens and greenhouses. In 1926, they were incorporated into a private park created as a memorial to Mrs. J. P. Morgan, Jr.

Thomas Clapham Residence, "The Stonehouse" (renamed "Claraben Court" and "Wenlo-on-the-Bay"), Roslyn Harbor, 1868

A native New Yorker, Thomas Clapham, a yachtsman and yacht designer, and his wife Georgia commissioned Mould to design their

granite and stone villa on Long Island. The original design called for a High Gothic prospect tower, an encircling piazza, and elaborate ornamentation on the exterior and in the interior of the house. Colored-encaustic Minton tiles, like the ones Mould had used in designing the lower level of the Central Park Terrace in New York City, were employed for the exterior friezes and flooring of the piazza and several rooms in "The Stone-house." Ironwork ornamented the columns of the veranda, the roof cresting, and the numerous balcony railings. On the principal floor the library, drawing room, and dining room opened off the main entrance hall, and a large billiard room formed an extension to the south.

After it was purchased in 1906 by the department store owner Benjamin Stern, the renamed "Claraben Court" was transformed from a High Victorian Gothic castle into a turn-of-the-century version of a French classical château. The interiors were redecorated and fitted with original 18th-century French paneling. On the outside oeils-de-boeuf and curved pediments

Kenneth M. Murchinson: Entrance Front, William J. Tully Residence, Mill Neck, 1916 (ARFO, 1916)

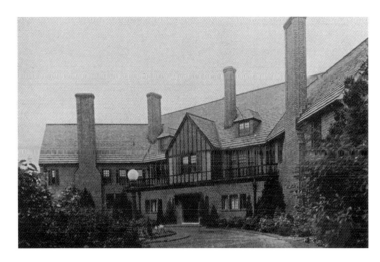

house at Mill Neck for the lawyer William J. Tully. Designed in 1916 in the Tudor Revival style, the two-and-a-half-story, gable-roof, brick mansion replaced an earlier house on the site built for F. N. Doubleday destroyed by fire in 1914.

Joel Snodgrass

Francis A. Nelson, 1878–1950

Educated at Columbia University and the Ecole des Beaux-Arts, Francis Nelson began his career in the partnership of Nelson & Van Wagener. John B. Niven, at one time the mayor of Mill Neck, and founder of the firm of Touche, Niven & Co., commissioned Nelson to design his Oyster Bay residence. Built between 1923 and 1928, "Rhuna Craig" is a one-and-a-half-story brick house in the Tudor Revival style.

An irregularly massed structure, it has a steeply pitched, rough-cut slate roof, punctuated by numerous dormers. Tudoresque features include casement windows with leaded lights and some half-timbered elevations. The service buildings were designed in the same style and, like the house, survive in a relatively unaltered state.

Wendy Joy Darby

replaced the pointed gables of the building, and formal gardens and an entrance court were added to the original park-like setting. "Wenlo-on-the-Bay," the latest name given this residence, was rebuilt in the 1960s after it had suffered extensive fire damage and was stripped of much of its ornament. This property is included in the Roslyn Harbor Village Multiple Resource Area nomination for the National Register of Historic Places.

Joy Kestenbaum

Kenneth M. Murchison, 1872–1938

Born and educated in New York, Kenneth Murchison attended Columbia College and was a student of architecture at the Ecole des Beaux-Arts. He is credited with the design of a number of noteworthy public and commercial buildings, as well as railroad terminals. Although for most of his career he practiced independently, he was associated for a time with Raymond Hood and Jacques André Fouilhoux, under the name of Murchison, Hood, Godley and Fouilhoux. Among his notable works are the Union Railroad Station in Baltimore; the First National Bank Building in Hoboken; and the Marine Hospital on Staten Island. Murchison's only Long Island commission was a country

Frank Eaton Newman, practiced 1910s–1920s

With its thatch-like wood shingled roof, multi-gabled facade incorporating jerkin-headed dormers, and door framed with stone quoining, "Nid de Papillon" in East Hampton is an eclectic rendition of a Cotswold cottage. It was built in 1918 for publisher Robert Appleton, head of the Robert Appleton Publishing Co., who owned the house into the 1940s. It is still extant.

Carol A. Traynor

Francis A. Nelson: "Rhuna Craig," John B. Niven Residence, Oyster Bay, 1923–28 (Courtesy of William S. Niven)

Frank Eaton Newman: Front Facade, "Nid de Papillon," Robert Appleton Residence, East Hampton, 1918 (PATT, 1924)

Minerva Nichols: Front Facade, J. W. T. Nichols Residence, Oyster Bay, 1903 (Courtesy of Orin Finkle)

![black square]

Minerva Nichols, practiced early 1900s

"The Kettles" was built for J. W. T. Nichols by his cousin, Minerva Nichols, a graduate of Pratt Institute, and was her only known commission on Long Island. Situated on Cooper's Bluff in Oyster Bay, the 1903 stucco residence has an irregular plan, and a three-story Dutch gabled entrance bay projecting from the main facade. The house is extant.

Carol A. Traynor

![black square]

Noel & Miller, 1930–1948
Auguste Louis Noel, 1884–1964
George Macculloch Miller, 1887–1972

A Beaux-Arts-trained architect and former draftsman for Carrère & Hastings, Auguste Noel practiced architecture with artist George Macculloch Miller until the latter's retirement in 1948. Noel continued to practice until his own death. Among their commissions was the original building for the Whitney Museum of American Art (1930) on Eighth Street, and the museum's second quarters (1954) on West 54th Street. This work may have come through Miller, a trustee of the museum and husband of the former Mrs. Flora Whitney Tower.

In 1928 the firm designed a rustic Tudor-style weekend cottage of whitewashed brick in Matinecock for Mr. and Mrs. William Greer. After a year, the Greers had "Flower de Hundred" redesigned as a full-time residence, creating a picturesque cluster of gables and terraced gardens nestled into its terraced woodland setting. The result is an asymmetrical, multilevel structure with integral porches and terraces, a basement-level dining room, and a high, timbered-and-beamed living room created from the original cottage garage.

The residence of realtor David Chester Noyes on Saw Mill Road in Huntington also dates from 1928. His wife, Eva, was a daughter of Pierre Mali, the Belgian consul-general to the United States; later her sister Gertrude Moffatt would also become a client of the firm. For the Noyes family the architects designed a house with tall, slate-covered hipped roofs, a conical-shaped turret, quoined corners, and semi-elliptical, capped dormers, which gave it a provincial French appearance.

In 1929 and 1930 the firm designed two Georgian-style houses on Long Island. The first was commissioned by Frank Miller Gould (grandson of financier Jay Gould and his wife Sara Miller), who was presumably related to George Macculloch Miller. The result, "Cedar Knolls," a stucco house located in the hamlet of Cold Spring Harbor, is a two-and-a-half-story symmetrical composition. The center entry features a dramatic front door with a bold, broken-scroll pediment. The site slopes down to the water overlooking Long Island Sound.

The firm's second Georgian-style house designed the next year was built for banker and publisher Barklie McKee Henry near Wheatley Road in Old Westbury. A symmetrical, white-washed-brick building, it had a five-bay, center-entry main block, with lateral wings flanking a shallow terrace at the rear. The two-story

Noel & Miller: Rear Facade, "Flower de Hundred," William Greer Residence, Matinecock, 1928 (INVE, 1979)

Noel & Miller: Entrance and Front Facade, D. Chester Noyes Residence, Huntington, 1928 (INVE, 1979)

Noel & Miller: Front Facade, "Cedar Knolls," Frank M. Gould Residence, Cold Spring Harbor, 1929 (COUN, 1929)

Noel & Miller: Front Facade, Barklie McKee Henry Residence, Old Westbury, 1930 (INVE, n.d.)

Noel & Miller: Douglas M. Moffat Residence, Huntington, 1931 (INVE, 1979)

Auguste Noel: W. S. Crane Residence, Lawrence, c. 1924 (HEWI, 1927)

Auguste Noel: Louis Milhau Residence, Glen Head, Alterations, c. 1920 (COUN, 1924)

entrance hall featured a domed ceiling and great curving staircase. A nine-car garage, service court, and formal garden were also located on the 12-acre grounds. This is the only one of the firm's commissions on Long Island that has not survived, having been demolished in 1975.

In 1931 Noel & Miller designed a mansard-roofed house on Woodbury Road in Huntington for lawyer Douglas M. Moffat and his wife Gertrude, near the home of her sister Eva Noyes. Although the Moffat residence was similar in spirit to the Noyes house, a balustraded parapet and exterior valances on the second-floor windows gave it a more fanciful appearance.

Prior to his partnership with Miller, Noel, working independently, had designed at least one residence on Long Island. For client William S. Crane he designed a stucco Georgian-style house in Lawrence c. 1924. Four years earlier he had carried out alterations on an older house in Glen Head for Louis Milhau.

Ellen Fletcher

James W. O'Connor, 1876–1952

Unified by a nonimposing, humanistic scale
and handsome simplicity, the work of James
W. O'Connor reflects a rare personalism in early
20th-century American architecture. A tasteful
revival of the Colonial idiom, using 18th-centu-
ry Georgian models, best represents his style.
However, as with his contemporaries, O'Con-
nor's work also reflected Tudor, Gothic, French
Manorial, and Italianate themes. Although he
designed homes, offices, churches, and schools
up and down the East Coast, he was best known
for his estate work on Long Island. Although at
this time the social elite did not readily accept
Irishmen in their circles, O'Connor (playfully
referred to as "Father O'Connor" by his friends
and associates) achieved considerable success
through the quality of his work: an understated
style, careful attention to detail, and an eye for
elegant proportions.

Born in New York City to a large Irish
Catholic family, O'Connor graduated from
Columbia University with a B.S. in Architec-
ture in 1898, and went on to study at the Ecole
des Beaux-Arts in Paris.[1] Not knowing much
French, he misunderstood the instructions and
erased a blackboard drawing before the examin-
er had reviewed it and therefore failed the exam.
Determined to enter the Ecole, he returned to
New York City where he supported himself as a
dishwasher and enrolled in a six-month course
in French. A year later he passed the test for
the Ecole and received one of the highest marks
ever given in design. It was at the Ecole that
O'Connor, working in the atelier of Redon, be-
gan to consolidate his design ideas into a *parti*
or scheme that would be the unifying theme in
his diverse body of work. His classmates, mean-
while, had nicknamed him "Koh-I-Noor" (after
a brand of drawing pencil, because that is how
they pronounced his name).

In 1902 O'Connor graduated from the
Ecole and returned to New York City. His first
job was as head draftsman with McKim, Mead
& White. The following year he established his
own firm.[2]

O'Connor's early independent success was
helped by his boyhood friendship with the sons
of W. R. Grace and his marriage to Dorothy
Ladew Williams.[3] Both the Grace and Ladew
families became his clients. The Grace family,
also Irish Catholic, was involved in widespread
domestic and international business ventures,[4]
while the Ladews had made their fortune in
tanning in upstate New York.[5]

O'Connor was known for his generosity and
charm, and was well liked in this social circle.
Professionally, he was persistent in establishing
and maintaining the contacts that ensured a
steady flow of private commissions, joining the
Racquet and Tennis Club in New York City and
the Piping Rock Club on Long Island. Person-
ally, he was most comfortable with his more
bohemian Beaux-Arts friends, becoming a
trustee of the Society of Beaux-Arts Architects
and a member of the Architectural League of
New York.[6]

O'Connor employed more than 30 drafts-
men at his office at 162 East 37th Street, as a
steady stream of commissions brought him
work until well into the 1930s. Of all his clients,
however, it was the Grace family with its need
for both commercial and residential buildings
that kept him busiest.

Pioneers in developing Long Island's North
Shore into the affluent area it is today, the Grace
family purchased tracts of farmland, some of
which they developed into large country estates.
O'Connor became the family's architect, design-
ing the estates and outbuildings that suited the
lifestyle of its members.

In addition to designing residential work
for the Grace family, O'Connor served as archi-
tect for several office buildings for the W. R.
Grace Company. In a 1975 article by Ada Louise
Huxtable, "What's Best for Business Can Rav-
age Cities," she mentions, "a fine Renaissance
style structure at Pearl and Water Streets, at
Hanover Square" that was torn down by the W.
R. Grace Company "for the inevitable parking
lot."[7] Built in 1912, the seven-story, limestone-
fronted Grace Steamship Line Building, at 7
Hanover Square, was one of two Manhattan
offices designed by O'Connor.[8] Built in 1919 for
the Atlantic and Pacific Company, Hanover
Square was also owned by Grace Lines Inc.
Directly across the street on the northwest cor-
ner of Water Street, the building was Colonial
in feeling, presenting an elegant contrast to the
earlier building. It was demolished in 1969.[9]

Another commercial effort for the Graces
was the Thomaston Building at Great Neck
Plaza on Long Island. Named after Mrs. Grace's
birthplace in Maine, this Georgian Revival-style
building was erected in 1925 to house the Grace
Realty Corporation and has been cited for land-
mark designation.

Flooded by private commissions until the
early 1930s (a 1932 catalog is devoted entirely to
indoor tennis court design[10]), from the mid-
1920s on O'Connor worked in association with
James Delany, who was instrumental in gaining
public commissions for the firm in New York
City. The firm's Colonial Revival chapel, dormi-
tory, and laboratory for Manhattan College, and
the Gothic churches of St. Nicholas of Tolentine

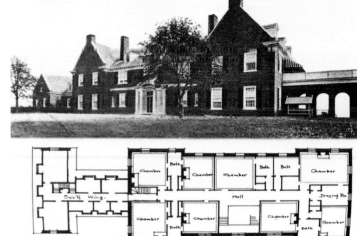

James W. O'Connor: Alterations, Entrance Facade, Mrs. W. R. Grace Residence, Kings Point, c. 1909 (TOWN, 1924)

James W. O'Connor: Front Facade, "Tullaroan," Joseph P. Grace Residence, North Hills, c. 1910 (AMAR, 1913)

and St. Anthony of Padua, both in the Bronx, also reflect the classical tradition that O'Connor assimilated from the Beaux-Arts.

By the late 1930s, however, the firm's business had dropped drastically. With the coming of the Great Depression, the era of estate building was over. Like many of his contemporaries, O'Connor struggled to keep his firm in operation. A new generation of architects, inspired by Walter Gropius and the Bauhaus, would soon take the lead designing in the International Style. Although O'Connor was open to new styles, by the 1940s he would often lament that architecture, at least as he knew it, was dead. Two later projects, the Morrisania Housing project in the Bronx[11] and a Chronic Care Facility intended for Welfare Island,[12] left O'Connor discouraged.

Mrs. William R. Grace, Kings Point, Alterations to "Mott Manor," later "Gracefield," c. 1909 (Extant)

O'Connor's first work on Long Island seems to have been done for Mrs. W. R. Grace, widow of a former mayor of New York. It consisted of alterations to an older farmhouse overlooking Cow Bay at Kings Point, known as "Mott Manor," built by an unknown architect c. 1890. O'Connor renovated the interior and added a two-story addition, virtually forming a new right wing, and transforming it into an estate known as "Gracefield." He did much to preserve the Colonial feel of the original house. The exterior's hand-split shingles were painstakingly matched on the addition, and the interior rooms, though modernized, retained their detail. The library, the main room of the addition and the largest room in the house, was filled with light by windows installed on all four sides and featured built-in bookcases and mahogany wainscoting. With its addition, "Gracefield" became one of the most important houses on the North Shore.[13] Although the

house still stands, its clapboard shingles have been bricked over by more recent owners.

Joseph P. Grace Residence, "Tullaroan," North Hills, c. 1910 (Extant)

This estate, built for J. P. Grace, lists O'Connor as sole architect for the original design and is a fine example of his early residential work. Built on the Paget farm of 198 acres in North Hills, it was ". . . a type of country house reflective of the tendency of those who are planning country homes to erect structures which in the ordinary sense are ample enough to comfortably house several families."[14] Fashioned after an old English manor house with the addition of fine Colonial detail, the facade of the H-plan residence is dominated by the huge gable ends and segmental arch entry which lend themselves handsomely to the predominantly symmetrical Georgian theme. Still standing, the estate now functions as the Deepdale Golf Club.

William Russell Grace, Jr., Residence, "The Crossroads," Westbury, c. 1919 (Extant)

This estate, with its main household and accompanying buildings—erected for William Russell Grace, Jr., in Westbury—is indicative of the type of work for which O'Connor became best known on Long Island. In addition to stables for W. R. Grace, Jr., a passionate polo player and breeder of polo ponies, O'Connor built a tennis house for "Crossroads."

By the early 1920s, O'Connor had established a reputation for designing singular indoor tennis courts. He built courts for the Piping Rock Club, as well as for a host of private clients on Long Island and elsewhere on the East Coast.[15] With the tennis court sunk below ground level, his structures had a pleasing one-story look and their proportions worked well with those of the other estate buildings. Unlike other courts, which resembled industrial struc-

James W. O'Connor: "The Crossroads," William R. Grace, Jr., Residence, Westbury, c. 1919 (ARAT, 1926)

James W. O'Connor: Indoor Tennis Court, "The Crossroads," William R. Grace, Jr., Residence, Westbury, c. 1919 (*Indoor Tennis Courts*, 1932)

James W. O'Connor: Entrance Facade, L. H. Sherman Residence, North Hills, 1918 (HOUS, 1921)

James W. O'Connor: Floor Plans, L. H. Sherman Residence, North Hills, 1918 (PREV, n.d.)

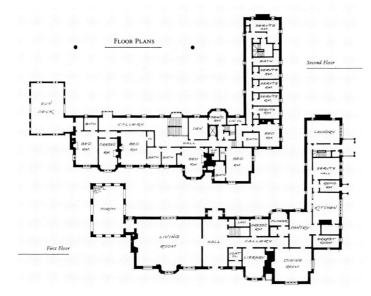

FLOOR PLANS

Second Floor

First Floor

tures, these buildings were decorated with fine classical detail on the exterior and housed lavishly furnished lounges and living rooms. Indoor swimming pools were often included and decorated with painted murals by such popular artists as Charles Baskerville. Covered with a textured nonglare glass, new at the time, they let in natural light without impairing the vision of the players.

Together with its outbuildings, "The Crossroads" reflects the range of motifs O'Connor employed. The main building represents a departure from O'Connor's prevalent use of the Georgian theme. With an accentuated, Greek-Revival-like entry porch, an Italianate stucco exterior, shutters, and other Colonial details, this expansive residence is a handsome and cohesive melange of styles. Through an ingenious use of courtyards, the interesting spatial arrangement of the design gives a sense of intimate scale to the large, sprawling complex.

L. H. Sherman Residence, North Hills, 1918 (Extant)

O'Connor designed numerous estates for other clients on Long Island. The Sherman residence, built in 1918, represents a significant departure from his recurring Colonial theme. A wealthy lawyer with vision, Sherman commissioned O'Connor to design a Tudor mansion. Comprised of 22 rooms, a courtyard of farm buildings, greenhouses, a man-made pond, and lavishly landscaped gardens, this estate displays the same architectural integrity that characterizes O'Connor's other residential work. Grand, but nonimposing in scale, it invites entry. Interior details, a frieze with scenes from Grimm's fairy tales, floor-to-ceiling oak paneling, and a

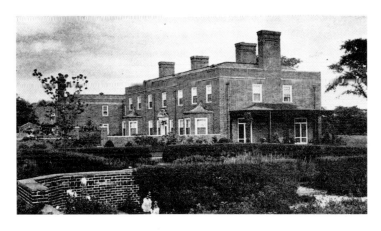

James W. O'Connor: Front Facade and Entrance Court, "Midland Farm," John F. Bermingham Residence, East Norwich, 1923 (ARRC, 1926)

James W. O'Connor: Rear Facade, "Midland Farm," John F. Bermingham Residence, East Norwich, 1923 (ARRC, 1926)

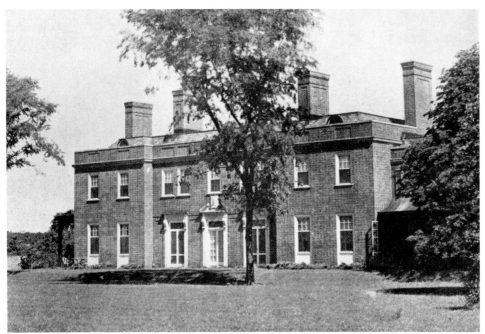

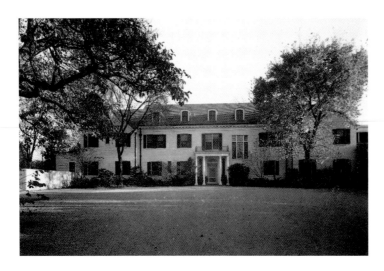

James W. O'Connor: Front Facade, "Cherryhill," George Fahys Residence, Locust Valley, c. 1910 (HEWI, n.d.)

flower room convey the personal nature of the architect-owner relationship. Sold by Sherman at the onset of the Depression to Frederick Lunning, the house is now the main building of the Buckley Country Day School.

John F. Bermingham Residence, "Midland Farm," East Norwich, 1923 (Extant)

President of a coal company and at one time mayor of Muttontown, John Bermingham commissioned O'Connor to design an estate, "Midland Farm," which best sums up over a decade of the architect's work on Long Island. O'Connor recalled:

Although I had carte blanche in the choice of design, there was no doubt in my mind as to the style of the house best suited to the site. Houses of French and Spanish type may look well in certain localities of our country, but for this Long Island landscape, to my mind at least, Georgian architecture is entirely suitable and appropriate.[16]

O'Connor adopted the plans of the Georgian vicarage of Hampton Lucy,[17] Warwickshire, England, to the needs of his American client, siting "Midland Farm" on a large tract of level ground surrounded by gardens landscaped by the Olmsted Brothers. Although the estate is especially large, the refined Georgian detail, symmetrical brick front, flat roof, and square forecourt enclosed by brick walls, give the residence a dignified appearance.

George E. Fahys Residence, "Cherryhill," Locust Valley, c. 1910

Built in Locust Valley for Fahys, a businessman, "Cherryhill" included a stable and a combination pool and tennis court building. The main house, with a brick exterior, was again clearly Georgian Revival. Other estates of this kind included the Charles H. Thieriot residence, "Cedar Hill" (1919), built in Oyster Bay; "Gray House Farm" (1924), built for Geraldyn L. Redmond, and the Sidney Z. Mitchell residence (1924–26), both in Brookville; and the A. C. Bostwick residence (c. 1930) in Old Westbury. Landscaped by the Olmsted Brothers, the Fred H. Haggerson residence (c. 1920) in Port Washington, and the S. A. Mitchell residence, "Marney" (1924–26), in Brookville, are both French Manorial in style. O'Connor also designed a number of smaller Colonial shingle-clad residences. The John N. Stearns house (c. 1939) in Brookville, modeled after an old Long Island farmhouse, is a good example.

In addition, O'Connor designed estate outbuildings throughout Long Island. The tennis court, pool, and playhouse complex he originally

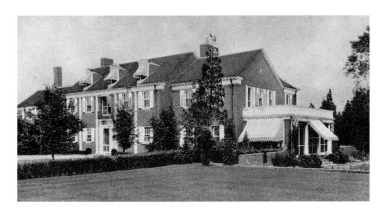

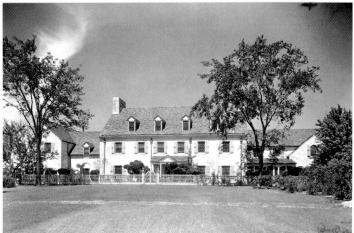

James W. O'Connor: Front Facade, "Cedar Hill," Charles H. Thieriot Residence, Oyster Bay, 1919 (Courtesy of Ms. Dickie Thieriot)

James W. O'Connor: "Gray House Farm," Geraldyn L. Redmond Residence, Brookville, 1924 (AVER, n.d.)

James W. O'Connor: Front Facade and Entrance Court, Sidney Z. Mitchell Residence, Brookville, 1924–26 (Courtesy of John Trevor and Anthony K. Baker)

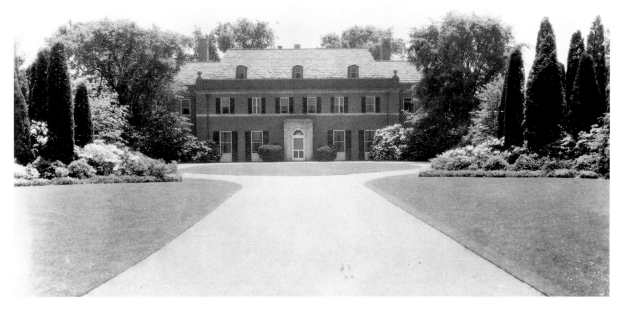

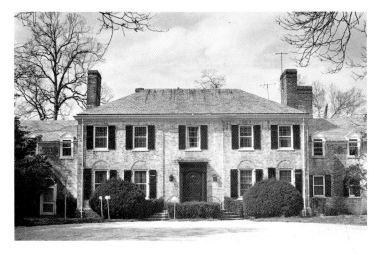

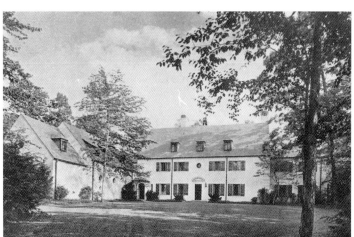

James W. O'Connor: Front Facade, A. C. Bostwick Residence, Old Westbury, c. 1930 (SPLI, Harvey Weber photo, 1980)

James W. O'Connor: Front Facade, F. H. Haggerson Residence, Port Washington, c. 1920 (OCOR, 1922)

James W. O'Connor: Front Facade, "Marney," Sidney A. Mitchell Residence, Brookville, 1924–26 (INVE, 1978)

James W. O'Connor: John N. Stearns, Jr., Residence, Brookville, c. 1939 (COUN, 1939)

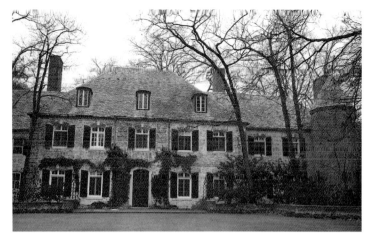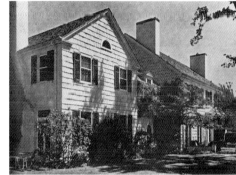

James W. O'Connor: Tennis Court and Playhouse Complex, "Sunken Orchard," Charles E. F. McCann Residence, Oyster Bay, c. 1928 (PREV, n.d.)

James W. O'Connor: Playhouse, Interior View, "Sunken Orchard," Charles E. F. McCann Residence, Oyster Bay, c. 1928 (PREV, n.d.)

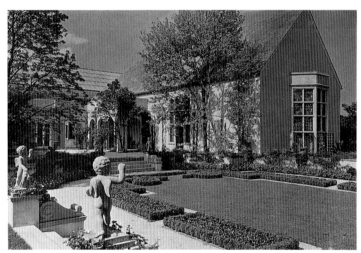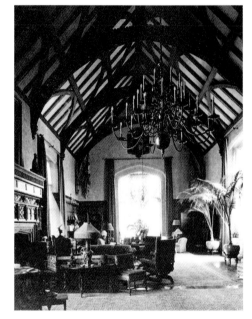

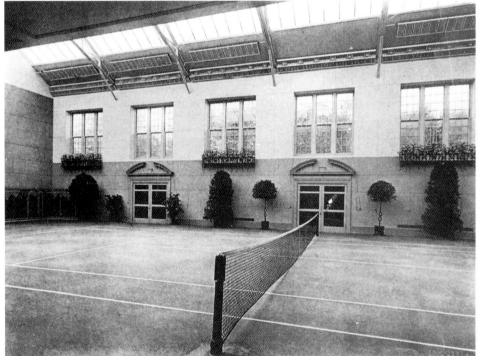

built for the Charles E. F. McCann estate "Sunken Orchard" (c. 1928) in Oyster Bay was one of his most lavish efforts. Still standing, though no longer part of the original estate, the playhouse has been converted to a chapel and has become the home of the Society of St. Pious the Tenth. Tennis buildings for Ralph Pulitzer in Manhasset, Mrs. J. W. Webb in Syosset, and Mrs. George Sloane in Locust Valley, and a stable group for Julius Fleischman in Port Washington, further reflect O'Connor's work during the 1920s. His nonresidential work on Long Island included the Split Rock School, Syosset; St. Boniface Church, Sea Cliff; the Church of St. William the Abbot, Seaford; and the Garden Apartments, located in Great Neck.

Freya Carlbom

James W. O'Connor: Covered Tennis Court, Interior View, "Sunken Orchard," Charles E. F. McCann Residence, Oyster Bay, c. 1928 (*Indoor Tennis Courts*, 1932)

James Frederick Dawson
(left) and Percival Gallagher
(right) in consultation with
Frederick Law Olmsted, Jr.
(FLON)

Olmsted & Vaux, 1858–1872

F. L. Olmsted, Landscape Architect, 1873–1883

F. L. and J. C. Olmsted, 1884–1888

F. L. Olmsted and Co., 1889–1893

Olmsted, Olmsted and Eliot, 1893–1897

F. L. and J. C. Olmsted, 1897–1898

Olmsted Brothers, 1898–1960

Frederick Law Olmsted, Sr., 1822–1903

Calvert Vaux, 1824–1895

John Charles Olmsted, 1852–1920

Frederick Law Olmsted, Jr., 1870–1957

Although Frederick Law Olmsted, Sr., and his successors are justly renowned for their parks and park systems across the country, residential design was always a major part of their practice, accounting for more than one-third of the firm's total output. Massachusetts has the greatest number of the Olmsted firm's residential commissions, but New York follows with about 350 projects, of which close to 100 were on Long Island.[1] Even more significant than the number of Long Island commissions is their quality. The size of most of the estates permitted broad scenic effects and the use of a full repertoire of compositional elements—long, winding approach roads, lawns, woodland, shrub gardens, formal gardens, and farm groups—not possible on more restricted suburban sites, important and interesting as these often are. Another striking aspect of the Olmsted firm's work on Long Island is the close cooperation between the landscape architects and Hicks Nurseries, a local company that faithfully executed many of the firm's designs. Another Long Island firm, Lewis & Valentine, also frequently collaborated with the Olmsteds. While such associations with regional nurseries may have occurred elsewhere in the country, none has yet been documented.

The work of the Olmsted firm on Long Island spans more than 65 years, but most of their commissions date from about 1905–25. Although there were few new projects after the Depression of 1929, many clients continued to retain the firm for ongoing consulting and additions to their estates. The principals during these years, with emphasis on the designers most closely associated with the Long Island jobs, are as follows.

During their early years, the founders of the firm in 1858, Frederick Law Olmsted, Sr., and Calvert Vaux, were responsible for such outstanding projects as Central Park, New York City (1858); Prospect Park, Brooklyn (1866); the park systems of Buffalo, New York (begun 1868), and Chicago (begun 1871); and the community of Riverside, Illinois (1869). Although Olmsted and Vaux also designed residential projects, they did none on Long Island.[2]

Between 1872 and 1875, Olmsted had no partner but entered into an informal association with Jacob Weidenmann (1829–93). The James H. Hyde estate in Bay Shore (c. 1873) appears to have been designed by the latter. After his graduation from Yale's Sheffield Scientific School in 1875, Olmsted's stepson, John Charles Olmsted, entered the firm and, in 1884, became a full partner. Some of the firm's most important public and private work dates from the years when John Charles was associated with Olmsted, Sr., until the latter retired in 1895. These include the Boston park system (1878–95); several collaborations with Henry Hobson Richardson in the early 1880s (including libraries, railroad stations, park structures, public buildings, and private residences); a collaboration with Richardson's successor firm, Shepley, Rutan and Coolidge, on Stanford University in Palo Alto, California (begun 1886); and the Chicago World's Fair (1890–93). Of the Long Island commissions, only the Bayard Cutting estate, "Westbrook," in Great River was designed during this period. In addition, the firm gave advice on the siting of cottages at the Montauk Summer Colony (1881–92), all of which were designed by McKim, Mead & White. There is no evidence that John Charles Olmsted was connected with "Westbrook" or with Montauk, but he was the chief designer of an important Long Island subdivision, Shinnecock Hills, in Southampton (1906–07). Two of the most talented of Olmsted's apprentices, Charles Eliot (1859–97) and Henry Sargent Codman (1864–93), became partners in the Olmsted firm in the late 1880s and early 1890s. Both had promising careers cut short by early deaths. Again, there is no record that either Eliot or Codman were involved in any of the Long Island residential commissions.[3]

Frederick Law Olmsted, Jr., entered his father's firm in 1895. His accomplishments as landscape architect, city planner, and educator were of national importance. In 1900 he established the first professional program of landscape architecture at Harvard University, and in 1901 he was a member of the McMillan Commission for the replanning of Washington, D.C. In his later years, his chief interest was the conservation of natural scenery.[4] On Long

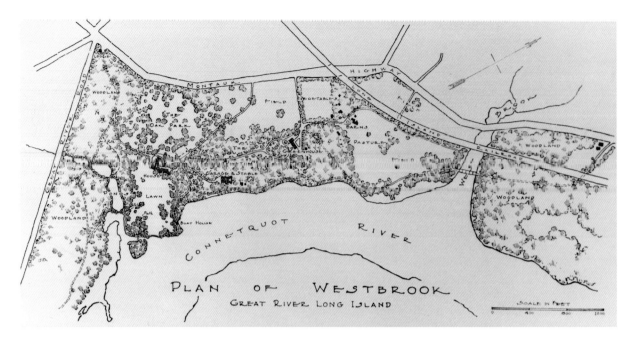

Olmsted Brothers: Landscape Design, "Westbrook," William B. Cutting Estate, Great River, 1887–94 (LAND, 1937)

Island, he served as landscape architect in charge for the amphitheater at the Roland Ray Conklin estate, "Rosemary Farm," in Huntington, and for the Henry W. de Forest estate, "Nethermuir," in Cold Spring Harbor.

In the early decades of the 20th century, the Olmsted firm was at its peak in numbers of partners, employees, and commissions, with many landscape architects of great talent and national reputation as partners or chief designers. The most important of these as far as the Long Island residential commissions were concerned were Edward Clark Whiting (1881–1962), Percival Gallagher (1874–1934), and James Frederick Dawson (1874–1941). Whiting had studied at the newly founded landscape design program at Harvard before entering the Olmsted firm. He worked on a wide variety of projects, including parks, subdivisions, and campuses, and was one of the landscape architects in charge for the John E. Aldred estate "Ormston," in Lattingtown, and the Walter Jennings estate, "Burrwood" in Cold Spring Harbor.[5] Percival Gallagher, who joined the Olmsted firm in 1894, was a direct link with both Frederick Law Olmsted, Sr., and Charles Eliot. He served as one of the chief designers for several city and county parks (those for Essex, Union, and Passaic counties in New Jersey), educational institutions (Phillips Academy, Andover, Massachusetts; Bryn Mawr, Haverford, and Vassar colleges, among others), and private country places and estates.[6] On Long Island, he was landscape architect in charge for the George F. Baker and J. E. Aldred estates in Lattingtown, the Walter Jennings estate in Cold Spring Harbor, and the H. H. Rogers, Jr., estate in Southampton.

James Frederick Dawson was the son of Jackson Dawson, superintendent of the Arnold Arboretum in Boston. He studied at the Bussey Institution of Harvard University and entered the Olmsted firm in 1896. With John Charles Olmsted, he was in charge of many of the firm's major commissions on the West Coast. Among the projects credited to him "either as a sole or principal designer or as a greatly influential collaborator" are the Seattle and Spokane park systems, the Alaska–Yukon–Pacific Exposition in Seattle, the Panama-California Exposition in San Diego, the Highlands subdivision near Seattle, and Palos Verdes Estates near Los Angeles. In the East, he was associated with the Louisville, Kentucky, park system and Fort Tryon Park in New York City.[7] For Long Island commissions, he was probably the most important member of the firm, since he was in charge of at least five major projects: the Roland Ray Conklin estate, "Rosemary Farm," in Huntington (with F. L. Olmsted, Jr.); the Henry Sanderson estate "La Selva," in Oyster Bay; the Walter Jennings estate in Cold Spring Harbor; the William R. Coe estate, "Planting Fields," in Oyster Bay; and the Sydney Z. Mitchell estate in Brookville.

With one or two exceptions, the domestic commissions, even of Frederick Law Olmsted, Sr., have been little studied. In contrast to his voluminous reports for park commissions, Olmsted wrote only two articles on residential design, and few of the estate designs with which he was personally involved were published by others.[8] Those dating from the 1880s have much in common with the park designs of the same period: they are distinguished by informal plans, winding drives and walks, and the use of predominantly native plant materials. Whenever possible, F. L. Olmsted, Sr., selected the site of the house along with the architect and client.

James Frederick Dawson
(left) and Percival Gallagher
(right) in consultation with
Frederick Law Olmsted, Jr.
(FLON)

Olmsted & Vaux, 1858–1872

F. L. Olmsted, Landscape Architect, 1873–1883

F. L. and J. C. Olmsted, 1884–1888

F. L. Olmsted and Co., 1889–1893

Olmsted, Olmsted and Eliot, 1893–1897

F. L. and J. C. Olmsted, 1897–1898

Olmsted Brothers, 1898–1960

Frederick Law Olmsted, Sr., 1822–1903

Calvert Vaux, 1824–1895

John Charles Olmsted, 1852–1920

Frederick Law Olmsted, Jr., 1870–1957

Although Frederick Law Olmsted, Sr., and his successors are justly renowned for their parks and park systems across the country, residential design was always a major part of their practice, accounting for more than one-third of the firm's total output. Massachusetts has the greatest number of the Olmsted firm's residential commissions, but New York follows with about 350 projects, of which close to 100 were on Long Island.[1] Even more significant than the number of Long Island commissions is their quality. The size of most of the estates permitted broad scenic effects and the use of a full repertoire of compositional elements—long, winding approach roads, lawns, woodland, shrub gardens, formal gardens, and farm groups—not possible on more restricted suburban sites, important and interesting as these often are. Another striking aspect of the Olmsted firm's work on Long Island is the close cooperation between the landscape architects and Hicks Nurseries, a local company that faithfully executed many of the firm's designs. Another Long Island firm, Lewis & Valentine, also frequently collaborated with the Olmsteds. While such associations with regional nurseries may have occurred elsewhere in the country, none has yet been documented.

The work of the Olmsted firm on Long Island spans more than 65 years, but most of their commissions date from about 1905–25. Although there were few new projects after the Depression of 1929, many clients continued to retain the firm for ongoing consulting and additions to their estates. The principals during these years, with emphasis on the designers most closely associated with the Long Island jobs, are as follows.

During their early years, the founders of the firm in 1858, Frederick Law Olmsted, Sr., and Calvert Vaux, were responsible for such outstanding projects as Central Park, New York City (1858); Prospect Park, Brooklyn (1866); the park systems of Buffalo, New York (begun 1868), and Chicago (begun 1871); and the community of Riverside, Illinois (1869). Although Olmsted and Vaux also designed residential projects, they did none on Long Island.[2]

Between 1872 and 1875, Olmsted had no partner but entered into an informal association with Jacob Weidenmann (1829–93). The James H. Hyde estate in Bay Shore (c. 1873) appears to have been designed by the latter. After his graduation from Yale's Sheffield Scientific School in 1875, Olmsted's stepson, John Charles Olmsted, entered the firm and, in 1884, became a full partner. Some of the firm's most important public and private work dates from the years when John Charles was associated with Olmsted, Sr., until the latter retired in 1895. These include the Boston park system (1878–95); several collaborations with Henry Hobson Richardson in the early 1880s (including libraries, railroad stations, park structures, public buildings, and private residences); a collaboration with Richardson's successor firm, Shepley, Rutan and Coolidge, on Stanford University in Palo Alto, California (begun 1886); and the Chicago World's Fair (1890–93). Of the Long Island commissions, only the Bayard Cutting estate, "Westbrook," in Great River was designed during this period. In addition, the firm gave advice on the siting of cottages at the Montauk Summer Colony (1881–92), all of which were designed by McKim, Mead & White. There is no evidence that John Charles Olmsted was connected with "Westbrook" or with Montauk, but he was the chief designer of an important Long Island subdivision, Shinnecock Hills, in Southampton (1906–07). Two of the most talented of Olmsted's apprentices, Charles Eliot (1859–97) and Henry Sargent Codman (1864–93), became partners in the Olmsted firm in the late 1880s and early 1890s. Both had promising careers cut short by early deaths. Again, there is no record that either Eliot or Codman were involved in any of the Long Island residential commissions.[3]

Frederick Law Olmsted, Jr., entered his father's firm in 1895. His accomplishments as landscape architect, city planner, and educator were of national importance. In 1900 he established the first professional program of landscape architecture at Harvard University, and in 1901 he was a member of the McMillan Commission for the replanning of Washington, D.C. In his later years, his chief interest was the conservation of natural scenery.[4] On Long

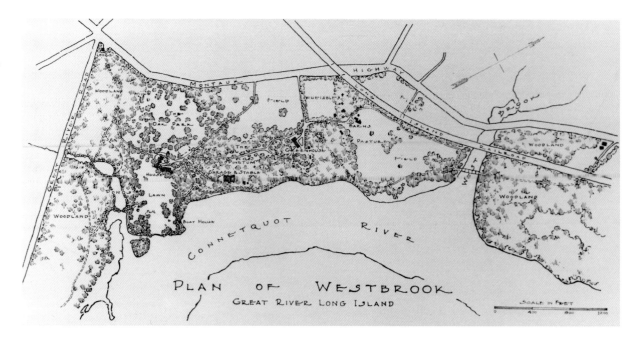

PLAN OF WESTBROOK
GREAT RIVER LONG ISLAND

Island, he served as landscape architect in charge for the amphitheater at the Roland Ray Conklin estate, "Rosemary Farm," in Huntington, and for the Henry W. de Forest estate, "Nethermuir," in Cold Spring Harbor.

In the early decades of the 20th century, the Olmsted firm was at its peak in numbers of partners, employees, and commissions, with many landscape architects of great talent and national reputation as partners or chief designers. The most important of these as far as the Long Island residential commissions were concerned were Edward Clark Whiting (1881–1962), Percival Gallagher (1874–1934), and James Frederick Dawson (1874–1941). Whiting had studied at the newly founded landscape design program at Harvard before entering the Olmsted firm. He worked on a wide variety of projects, including parks, subdivisions, and campuses, and was one of the landscape architects in charge for the John E. Aldred estate "Ormston," in Lattingtown, and the Walter Jennings estate, "Burrwood" in Cold Spring Harbor.[5] Percival Gallagher, who joined the Olmsted firm in 1894, was a direct link with both Frederick Law Olmsted, Sr., and Charles Eliot. He served as one of the chief designers for several city and county parks (those for Essex, Union, and Passaic counties in New Jersey), educational institutions (Phillips Academy, Andover, Massachusetts; Bryn Mawr, Haverford, and Vassar colleges, among others), and private country places and estates.[6] On Long Island, he was landscape architect in charge for the George F. Baker and J. E. Aldred estates in Lattingtown, the Walter Jennings estate in Cold Spring Harbor, and the H. H. Rogers, Jr., estate in Southampton.

James Frederick Dawson was the son of Jackson Dawson, superintendent of the Arnold Arboretum in Boston. He studied at the Bussey Institution of Harvard University and entered the Olmsted firm in 1896. With John Charles Olmsted, he was in charge of many of the firm's major commissions on the West Coast. Among the projects credited to him "either as a sole or principal designer or as a greatly influential collaborator" are the Seattle and Spokane park systems, the Alaska–Yukon–Pacific Exposition in Seattle, the Panama-California Exposition in San Diego, the Highlands subdivision near Seattle, and Palos Verdes Estates near Los Angeles. In the East, he was associated with the Louisville, Kentucky, park system and Fort Tryon Park in New York City.[7] For Long Island commissions, he was probably the most important member of the firm, since he was in charge of at least five major projects: the Roland Ray Conklin estate, "Rosemary Farm," in Huntington (with F. L. Olmsted, Jr.); the Henry Sanderson estate "La Selva," in Oyster Bay; the Walter Jennings estate in Cold Spring Harbor; the William R. Coe estate, "Planting Fields," in Oyster Bay; and the Sydney Z. Mitchell estate in Brookville.

With one or two exceptions, the domestic commissions, even of Frederick Law Olmsted, Sr., have been little studied. In contrast to his voluminous reports for park commissions, Olmsted wrote only two articles on residential design, and few of the estate designs with which he was personally involved were published by others.[8] Those dating from the 1880s have much in common with the park designs of the same period: they are distinguished by informal plans, winding drives and walks, and the use of predominantly native plant materials. Whenever possible, F. L. Olmsted, Sr., selected the site of the house along with the architect and client.

Olmsted Brothers: House, Lawn and Surrounding Woods, "Westbrook," William B. Cutting Estate, Great River (LAND, 1937, Fairchild Aerial Survey photo)

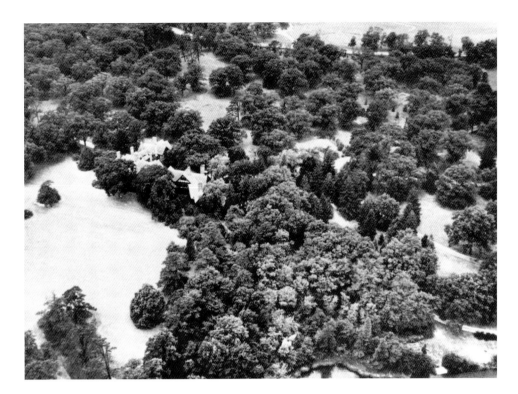

The renaissance of formal landscape design, which paralleled the revival of archaeologically correct classical styles in architecture, emerged toward the end of Olmsted's career. Although this style was not entirely congenial to him, he designed the first and probably the greatest private estate in this idiom: the George W. Vanderbilt estate, "Biltmore," in Asheville, North Carolina, begun in 1888. The entire acreage of "Biltmore" was 125,000 acres, but the approximately 165 acres of landscaped gardens, which included a formal ramped allée in the style of Le Nôtre, an Italian garden, and a bowling green, were designed to be subordinate to stunning views of the surrounding mountains, woodland, and river.[9]

After the turn of the century, formal gardens became a standard feature of all residential designs, including those by the Olmsted firm, but, as at "Biltmore," views of natural scenery were still emphasized.[10] The J. E. Aldred and Marshall Field III estates, discussed in detail below, are particularly good examples. No inclusive survey of the work of Olmsted Brothers has yet been done, let alone a study of their residential designs. However, the body of their estate work on Long Island is impressive in quality and quantity. What follows is a brief survey of ten of the most outstanding examples.

William Bayard Cutting Estate, "Westbrook," Great River, 1887–94. Olmsted firm job number 1047. Planting by Hicks Nurseries (Extant)

Of the scores of residential commissions by the Olmsted firm on Long Island, the Cutting estate is the only one dating from the career of Frederick Law Olmsted, Sr., and it bears many similarities to the great parks and private estates associated with him. However, we do not know with any certainty whether Olmsted was personally involved in this project or whether one of his talented partners took primary responsibility.

Cutting's attention was first drawn to the property when he came to Long Island to fish as a member of the nearby South Side Sportmen's Club. He acquired it in 1884 and built the house, designed by Charles Haight, in 1885.[11] Initially, Cutting purchased 931 acres, 200 of which were deeded to the State of New York in 1937. The Cutting Arboretum has since expanded to more than 600 acres. Much of the frontage of the landscaped and wooded 200-acre parcel lay directly on the Connetquot River or on West Brook.

In their plan, the Olmsted firm took full advantage of both the riverside views and the potential of the site for producing magnificent specimen and forest trees. The grounds are entered near a lodge at the corner of Great River Road and the Montauk Highway. From this point the approach road winds toward the house, with dense woodland on one side and a more open oak park on the other. Fifty years after construction, the native rhododendrons,

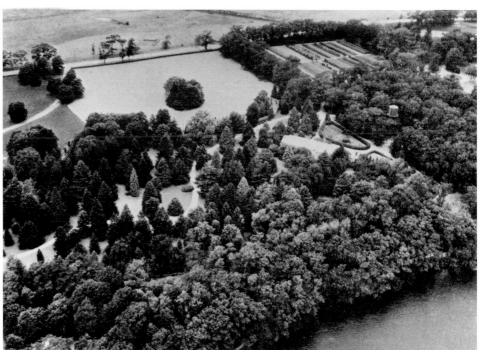

Olmsted Brothers: Pinetum, "Westbrook," William B. Cutting Estate, Great River (Davey Tree Expert Co. photo, 1937)

Olmsted Brothers: Pinetum, Conservatory, and Vegetable Garden, "Westbrook." William B. Cutting Estate, Great River (LAND, 1937, Fairchild Aerial Survey photo)

holly, and leucothoe along the drive had "matured to unbelievable proportions" and the oak park reminded visitors of the deer park at Knole in Kent, England. The house was positioned to offer a sweeping view of the Connetquot River across a broad lawn. Since Cutting was intensely concerned to preserve and develop the natural forest growth and existing topography of the site, there were no formal gardens at "Westbrook," and very few flowers. Instead, native oaks, pines, and tupelos were maintained, and the wetlands—marshes, springs, streams, and ponds— were carefully protected.[12]

In their approach to plant materials and design, Cutting and the elder Olmsted were kindred spirits. Both preferred a naturalistic effect using predominantly trees and shrubs native to the area intermingled with a few hardy exotic species that would not look noticeably out of place.[13] Along the river, a road was put in "now tunneling through arches of mixed oak and pine walled with clethra, now opening beneath a great tupelo to embrace a marshland vista." In the early 1880s, Cutting had visited the H. H. Hunnewell estate in Wellesley, Massachusetts, and admired the hardy rhododendrons there. He achieved a similar effect by massing rhododendrons in large blocks of color around the ponds on his property. The only part of "Westbrook" where foreign species predominated was the small but choice pinetum. Here, Cutting established conifers from all over the world, some imported from England. Several Chinese specimens introduced by E. H. Wilson

were given to Cutting by Professor Charles Sprague Sargent, director of the Arnold Arboretum, when they were only six inches high. In 1937 many were larger and healthier than those of the same species at the Arnold Arboretum.[14] In addition to the scenic and wooded areas, "Westbrook" was equipped with barns, greenhouses, pastures, and vegetable gardens.

Now the Bayard Cutting Arboretum, "Westbrook" is carefully maintained with the original design and many of the first plantings still evident.

Henry W. de Forest Estate, "Nethermuir," Cold Spring Harbor, 1906–27. Olmsted firm job number 3175. Landscape Architect in Charge, Frederick Law Olmsted, Jr. Planting by Hicks Nurseries (Demolished)

Henry Wheeler de Forest (1855–1938), a New York lawyer and financier, founded the de Forest Brothers law firm in 1893. Like his brother and partner Robert Weeks de Forest, who was an important writer on housing issues, Henry devoted much time to philanthropic activities, serving on the boards of several New York City hospitals and medical schools. He was also interested in wildlife preservation and helped establish the Sage and Rockefeller bird sanctuaries on the Louisiana Gulf Coast, as well as a guardianship organization to prevent the extinction of Canadian salmon. His sister Julia, who lived in a house next to Henry and near Robert in Cold Spring Harbor, wrote a history of art in 1881. Plans for her grounds are included in the same job number as those for Henry. In

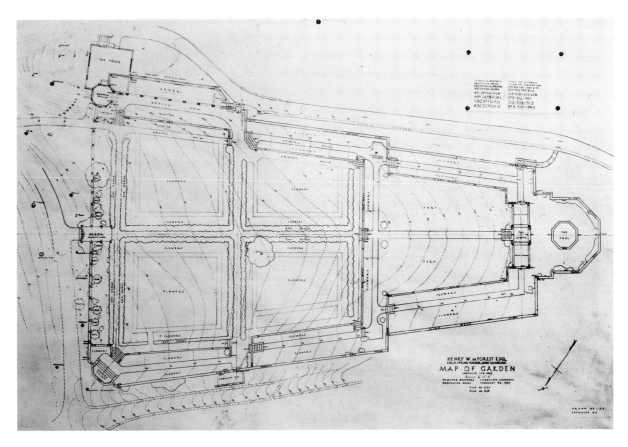

Olmsted Brothers: "Nether-muir," Henry W. de Forest Estate, Cold Spring Harbor, 1906–27 (FLON)

Olmsted Brothers: Garden and Summer House, "Nethermuir," Henry W. de Forest Estate, Cold Spring Harbor, 1906–27 (FLON, c. 1921)

addition, the Olmsted firm designed at least four projects on Long Island for Robert W. de Forest, most of which seem to have been subdivision plans. But there was an earlier connection: their father, Henry G. de Forest, had been a member of the Montauk Association in 1881.[15]

The house at "Nethermuir" was an existing structure remodeled in 1900. A few years later, Henry W. de Forest commissioned Olmsted Brothers to relandscape his grounds, beginning an association that would last more than 20 years. The most important feature of "Nethermuir" was a large formal garden at the rear of Henry's house near the stable group. The basic outlines of this garden and its four flower beds,

incompletely planted, already existed in 1906. As redesigned by the Olmsted firm, the garden consisted of the four flower beds, planted primarily with annuals, and two additional beds of turf, arranged in diminishing perspective and culminating in an octagonal pool set in an apse-like enclosure. Gravel paths surrounded each of the large flower beds, and narrower flower beds and box hedges defined the outside borders. At the wide end of the garden were arbors and, at one corner, an open summer house. The various levels of the garden were connected by steps, and retaining walls with rock garden plants were an important element in the design. In its subtle configuration of spaces and its richness of planting, the "Nethermuir" flower garden resembles slightly later work by the firm, particularly the rose garden at "Ormston." Frederick Law Olmsted, Jr., took a great personal interest in this garden, making field notes on the grounds at intervals between 1907 and 1921 and, in 1930, submitting a photograph of the garden to the National Academy of Design as an example of his work. So closely was F. L. Olmsted, Jr., identified with the "Nethermuir" garden that a photograph of it appeared in his obituary.[16]

In addition to the garden, the firm designed an extensive shrub planting around the lawn next to Henry's house and completely redesigned the grounds of Julia's house. They also laid out new roads and sited and planted outbuildings for both.

Olmsted Brothers.
Amphitheatre, "Rosemary
Farm," Roland R. Conklin
Estate, Lloyd Harbor,
1912–13 (FLON)

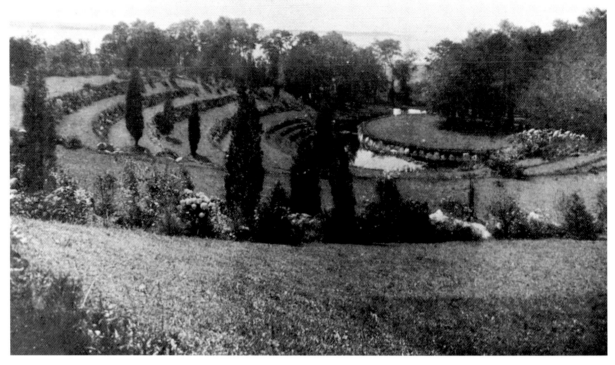

Olmsted Brothers:
Presentation Sketch of
Amphitheatre, Drawing on
Tissue, Conklin Estate,
October 1912 by Jackson
(FLON)

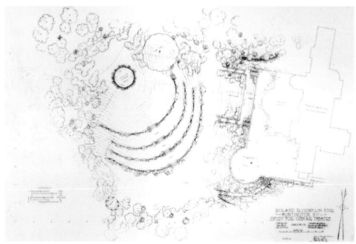

a series of semicircular terraces held in place by fieldstone retaining walls, which were covered with rock-garden plants. In place of an orchestra pit, the stage was separated from the seating by a moat complete with swans. The Olmsted firm prepared six different schemes for the amphitheater, culminating in the presentation plan, which appears to have been followed in construction. In addition to the amphitheater itself, the firm designed shrub plantings between the theater and the house.

Outdoor amphitheaters were to become increasingly popular in the first decades of the 20th century—two that come to mind are the Vassar College Outdoor Amphitheater (1915, Loring Underwood) and the Public Library Theater in Camden, Maine (1930–32, Fletcher Steele)—but the theater at "Rosemary Farm" was both relatively early and unusual in that it was designed for a private client.[18] It had a brief life as a working stage, being used primarily for Red Cross benefits during World War I. After the Conklins moved away in 1924, it was abandoned and eventually disappeared beneath rampant vegetation. In 1987 the site was cleared and the amphitheater found to be intact and usable. The property is now owned by the Diocese of Brooklyn.

Roland Ray Conklin Estate, "Rosemary Farm," Lloyd Harbor, Huntington, Amphitheater, 1912–13. Olmsted firm job number 5526. Landscape Architects in Charge, F. L. Olmsted, Jr., and James Frederick Dawson

Wilson Eyre, architect of the Conklin house, was also responsible for the formal gardens and the rest of the landscaping done when the house was built in 1907–08. However, when the Conklins decided to add an outdoor amphitheater to their grounds in 1912, they turned to Olmsted Brothers.[17]

Located on a naturally sloping site close to the main house, the amphitheater consisted of

Olmsted Brothers: General Map of Estate, February 1922, "Ormston," John E. Aldred Estate, Lattingtown, 1912–37 (FLON)

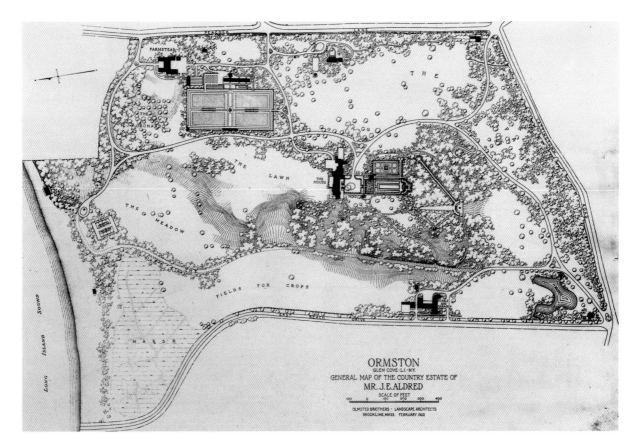

Olmsted Brothers: Estate from the Southwest Showing Formal Gardens and Allées, John E. Aldred Estate, Lattingtown, c. 1924 (ELWO, 1924)

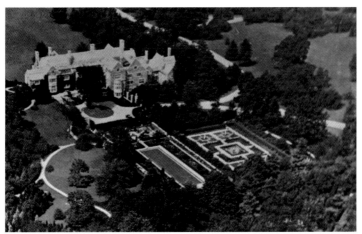

John E. Aldred Estate, "Ormston," Lattingtown, 1912–37. Olmsted firm job number 5578. Landscape Architects in Charge, Percival Gallagher and Edward Clark Whiting. Construction and/or Planting by Lewis & Valentine (Extant)

In contrast to many of their Long Island commissions, where architects, engineers, resident superintendents, and other landscape firms often had a hand in laying out the grounds, the Aldred estate was designed by Olmsted Brothers from start to finish, and the evolution of the design was overseen by them for 25 years. More than 730 drawings were prepared for every corner of the estate, including the boundary roads. The result is an exceptionally coherent and precisely articulated plan. Each walk and drive, each garden and vista was carefully orchestrated into a comprehensive whole. Since the chief feature of the 100-acre site was the view northward from the house, designed by Bertram Grosvenor Goodhue, toward Long Island Sound, all other elements of the plan were pushed to the south and east. There are two entrances to the estate, one at each corner of Lattingtown Road. The drives from these meet to form an approach road, which meanders through a sequence of open and wooded spaces in the park and terminates at the forecourt.

Rarely does one find the forecourt and gardens on the same side of a house. The designers chose this generally undesirable arrangement to avoid interfering with the all-important northerly view. They then made a virtue of necessity by a masterful manipulation of levels and spaces. In the words of Edward Clark Whiting, who completed the project after Gallagher's death:

By depressing the court and entering the house one story below the main floor, it was possible to secure an obvious and quite satisfying visual relation between the living rooms and terraces of the house and gardens proper; . . . The forecourt and formal gardens are essentially outdoor apartments belonging to the house, organically related to it, and each, like the different rooms in the house, to be planned and furnished for a special purpose. Practically independent of the surrounding landscape, they could be planned with little reference to distant

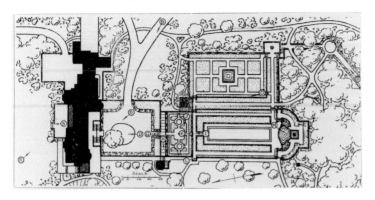

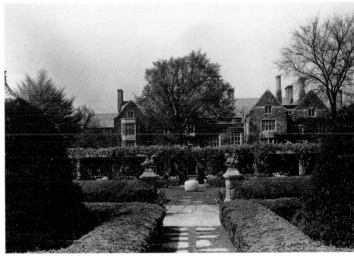

Olmsted Brothers: Plan of Gardens, Paths and Drives Near the House, John E. Aldred Estate, Lattingtown, 1912–37 (LAND, 1938)

Olmsted Brothers: Elizabethan Flower Garden, John E. Aldred Estate, Lattingtown, 1912–37 (FLON, Samuel H. Gottscho photo, c. 1930)

Olmsted Brothers: Perennial Garden, John E. Aldred Estate, Lattingtown, 1912–37 (FLON, Frances B. Johnson photo, c. 1930)

Olmsted Brothers: Rose Garden, Rock Wall and Thatched Summer House from Hornbeam Allée, John E. Aldred Estate, Lattingtown, 1912–37 (FLON, Frances B. Johnson photo, c. 1930)

Olmsted Brothers: Privet Allée and Temple, John E. Aldred Estate, Lattingtown, 1912–37 (FLON, Samuel H. Gottscho photo, c. 1930)

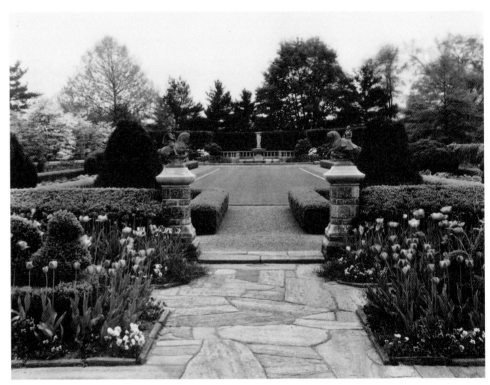

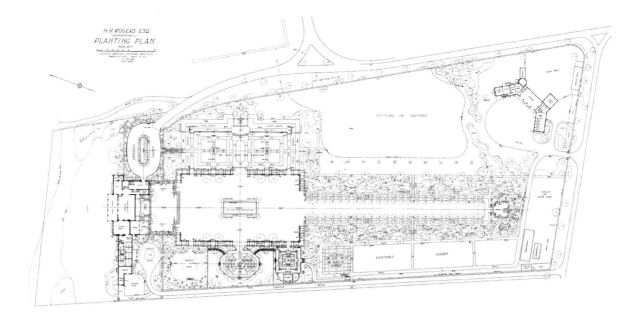

Olmsted Brothers: Planting Plan, Drawing dated March 13, 1915, by Keeling, "Black Point," Henry H. Rogers, Jr., Estate, Southampton, 1914–15 (FLON)

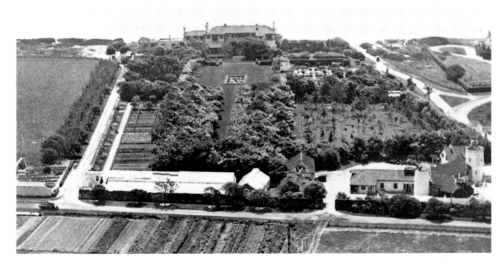

Olmsted Brothers: Aerial View, "Black Point," Henry H. Rogers, Jr., Estate, Southampton, 1914–15 (FLON, c. 1925)

views or other natural features. . . . A strong axis was therefore carried from the house through the court and two of the gardens. . . .[19]

The relationship between the forecourt, gardens, and house may be seen in the aerial photograph and the plan shown.

There are three formal gardens. Entering from the forecourt, the visitor sees first the Elizabethan garden, "small in scale and choice in detail," and its garden pavilion, built of the same stone as the main house. Next is the perennial garden, its central feature a turf bowling green. At the end of the common axis of these two gardens is a fountain and pool. The rose garden is at a slightly lower level to the east but is carefully related to the other spaces by an allée of bleached hornbeams that continues the southern cross-axis of the perennial garden. From the hornbeam allée is a vista north of a dogwood-shaded walk, a dry wall with rock-garden plants, and a thatched garden house.[20]

To the south and southeast of the gardens are groves of American beech and other native trees intersected by three allées, all focusing on an

old English sundial. From east to west, these are the privet allée, the lilac allée, and the cedar allée. The delicate classical temple and dappled light of the privet allée give it a special magic.

Beyond the formally landscaped grounds there is also much of interest: the lawn, meadow, tennis courts, and beach, numerous outbuildings, and a walled vegetable garden. Along the western side of the property is a tree-shaded bridle path called the "Greenway." Not shown on the plan but included among the drawings are other intriguing features, such as a shrub garden, a "court" golf course, and an exercise track.

"Ormston" has belonged to the Order of St. Basil for approximately 20 years and is in beautiful condition. Nearly everything described by Whiting may be seen today.[21]

Henry Huddleston Rogers, Jr., Estate, "Black Point," Southampton, 1914–15. Olmsted firm job number 6042. Landscape Architect in Charge, Percival Gallagher. Construction and/or Planting by Lewis & Valentine.

"Black Point" presented a considerable design and horticultural challenge. Sitting atop windswept dunes, the house, designed by Walker & Gillette, faced south toward the sea, its forecourt and main entrance on one side, the service entrance on the other. Landscaping was concentrated on the protected northern side, where, on a site of limited extent, the Olmsted firm planned a series of gardens of remarkable variety and interest. A consistent design philosophy was evident in both house and grounds; together the architects and landscape architects created a seamless environment of interior and exterior spaces.[22]

Olmsted Brothers: Turf Court and Long Allée, "Black Point," Henry H. Rogers, Jr., Estate, Southampton, 1914–15 (FLON, Samuel H. Gottscho photo, c. 1930)

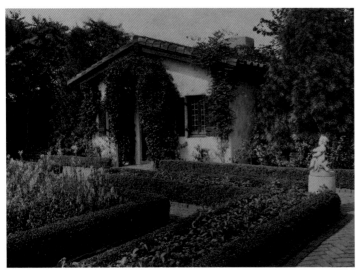

Olmsted Brothers: Children's Garden and Playhouse, "Black Point," Henry H. Rogers, Jr., Estate, Southampton, 1914–15 (FLON, Mattie E. Hewitt photo, c. 1924)

Olmsted Brothers: View from the Flower Garden across the Long Allée to the Rose Garden, "Black Point," Henry H. Rogers, Jr., Estate, Southampton, 1914–15 (FLON, Samuel H. Gottscho photo, c. 1930)

Exigencies of site dictated that the grounds be treated as a series of outdoor rooms. The landscape solution, striking in concept and scrupulously worked out in every detail, was realized in only one year. The final planting plan shows the layout of the grounds, which may also be seen in an aerial photograph of the late 1920s. (Appendix A reproduces the plant list that accompanied the plan.) To keep out the wind, a problem even on the landward side, the entire property was surrounded by a high stucco wall, while additional walls marked off the inner gardens. Further protection was provided by dense boundary plantations. Greenhouses, barns, and a windmill were placed at the northern edge, with vegetable gardens, a cutting garden, and an orchard nearby.

The gardens proper were arranged in a cruciform pattern, with a sweeping vista or allée extending from the house terraces down the long axis. Traversing this was an almost square turf court surrounded by pergolas with a lily pond in the center. Delicately scaled flower gardens were ranged along the western side of the turf court. On the other side, beginning at the house, were a croquet lawn and a rose garden backed by cedars. Next, the Rogers children had their own enclosed garden with playhouse. Some of the gardens were accented by benches, sculpture, urns, sundials, gazing globes, and columns. All use a common vocabulary of herringbone-patterned brick walks and flower beds edged with clipped box. Frequently, one garden could be glimpsed from another across the long vista through gates of varying sizes and shapes. For adults and children alike, "Black Point" must have been an enchanted world.

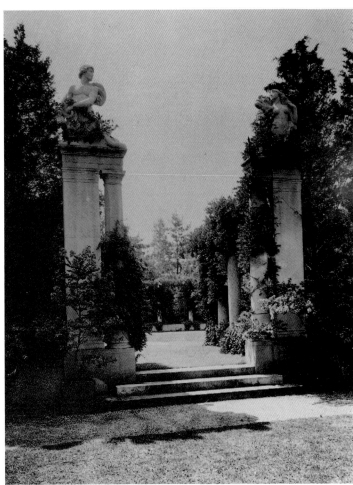

Olmsted Brothers: Selmer Larsen's Model of Proposed Garden Showing the Formal Garden, *Tapis Vert* and Cirque, "La Selva," Henry Sanderson Estate, Oyster Bay, 1915–37 (FLON, H. D. Perkins photo, July 21, 1916)

Olmsted Brothers: View into Cirque from *Tapis Vert,* "La Selva," Henry Sanderson Estate, Oyster Bay, 1915–37 (FLON, n.d.)

Henry Sanderson Estate, "La Selva," Oyster Bay, 1915–37. Olmsted firm job number 6218. Landscape Architect in Charge, James Frederick Dawson. Construction and/or Planting by Lewis & Valentine (Extant)

Like the Aldred estate, "La Selva" was designed in its entirety by the Olmsted firm.[23] The site is about 25 acres and is located on Planting Fields Road across from the Coe estate. The grounds are entered from the south and immediately to the left is a range of garages. To the right is a large, walled, vegetable garden with an intricate iron gate and espaliered fruit trees. The house, designed by Hunt & Hunt, is approached by a broad circular forecourt.

By far the most distinctive feature of the Sanderson estate is the series of elegant formal gardens on the south side of the house. Directly on axis with the living room loggia are a small, walled garden and a turf panel or *tapis vert,* framed by cedars and terminated by a pair of piers topped by statuary. Beyond this imposing entrance is the *cirque,* a large round space with a central pool surrounded by a pergola supporting wisteria vines. At the far end is a backdrop of cedars. Apart from the wisteria, there do not seem to have been any flowers in these three gardens. The original color scheme must have been a muted one, consisting of light gray or white paving, columns, and sculpture, set off against subtle gradations of green in a variety of textures: smooth clipped grass, feathery wisteria foliage, the deeper green of ivy, and, more somber still, the cedars. For the brief period when wisteria is in flower, pale-purple blossoms wreathed the *cirque.*

Lively color was probably concentrated in the formal flower garden that continues the cross-axis of the small garden next to the house. On the sloping ground beyond the balustrade enclosing the flower garden are the informal gardens: the rhododendron walk and *erica* (heather) garden and below these an open glade. On the far side of the house is a wide lawn.

In 1928 Frederick S. Wheeler bought "La Selva" from Sanderson, and, in the same year, the Olmsted firm designed a large oval swimming pool for him. The property was acquired by the St. Francis Center in the 1960s. Except for the elimination of the heather garden and some changes in planting (primarily the substitution of pines for cedars around the *cirque,* resulting in deep shade), the grounds remain fairly intact. This may well be due to the extraordinary tenure of Alex Sherrifs, who was superintendent for Sanderson from the beginning of 1915, continued with Wheeler, and then stayed with the Franciscans as superintendent and later as resident until he died in the mid-1980s at an advanced age.

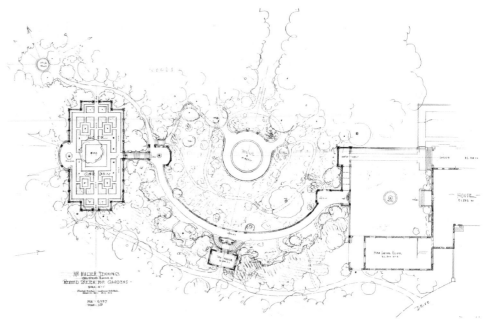

Olmsted Brothers: Looking Down Across the Ravine and Sunken Pool from the Circulating Walk, "Burrwood," Walter Jennings Estate, Cold Spring Harbor, 1916–38 (FLON, Amemya photo, n.d.)

Olmsted Brothers: Revised Sketch for Gardens Drawn by Edward Clark Whiting, August 1919, "Burrwood," Walter Jennings Estate, Cold Spring Harbor, 1916–38 (FLON)

Walter Jennings Estate, "Burrwood," Cold Spring Harbor, 1916–38. Olmsted firm job number 6287. Landscape Architects in Charge, James Frederick Dawson, Edward Clark Whiting, and Percival Gallagher. Planting by Hicks Nurseries (Demolished)

The Walter Jennings house, "Burrwood," was built in 1898–99 from designs by Carrère & Hastings, who were also responsible for laying out the grounds. Initially, the estate was about 250 acres, later expanded to more than 1,000, and included a model farm, stables, and other features of a complete country place, as well as dense natural woods. To command the best view of Cold Spring Harbor, the house was sited overlooking the water on the west with a terrace on the same side. Immediately below the terrace and on both sides, the ground dropped off precipitously. Since there was reasonably level land only to the east (entrance side) of the house, the first formal gardens were located there. The house was approached by a private road lined with poplars that led to a semicircular sunken garden with planted terraces and a fountain.[24]

Sixteen years later, Olmsted Brothers were called in to extend the landscaped grounds. They did not alter Carrère & Hastings' work but concentrated their efforts entirely on the south side of the house, producing one of their most unusual Long Island gardens. There was no room for another formal garden in the immediate vicinity of the house, so the new rose garden was perched on a bluff somewhat higher than the house and separated from it by a deep gorge. Within the gorge, the firm designed a ravine garden with a circular pool reached by steps and paths and planted with predominantly native trees and shrubs. Formal elements—a tea house with curving steps, a fountain, and a balustrade—were used at the upper levels to provide continuity with the house terrace on one side and the rose garden on the other. Below the tea house, a system of circulating paths led to the pool, which was surrounded by a stone wall ornamented by a single bench; beyond lay a view of the harbor. Numerous studies and a model were required to create this deceptively "natural" landscape.[25]

From 1952 to 1985, when the property was occupied by the Industrial Home for the Blind, the gardens were used in a way that would undoubtedly have pleased the designers: handrails and additional seats show that residents were encouraged to explore the grounds fully. Today the status of the gardens is unknown, as the house was demolished in 1993.

William R. Coe Estate, "Planting Fields," Oyster Bay, 1918–29. Olmsted firm job number 6645. Landscape Architect in Charge, James Frederick Dawson. Construction and/or Planting by Lewis & Valentine (Extant)

"Planting Fields" has a complex history and a cast of many architects and landscape designers, but the role played by Olmsted Brothers was the definitive one. In 1913 William R. Coe and his wife, the former Mai Rogers, bought the Byrne property with its house designed by Grosvenor Atterbury and existing drives and gardens. By the purchase of additional parcels of land, they brought the estate to 409 acres, of which about 132 were eventually landscaped. In 1914 Guy Lowell designed a greenhouse for the Coes, and improvements to the grounds were planned by Andrew Robeson Sargent, a landscape architect

Olmsted Brothers: Entrance to South Terrace, "Planting Fields," William S. Coe Estate, Oyster Bay, 1918–29 (FLON, Frances B. Johnston photo, c. 1928)

Olmsted Brothers: View in Flower Gardens, "Planting Fields," William S. Coe Estate, Oyster Bay, 1918–29 (FLON, Frances B. Johnston

Olmsted Brothers: Map Showing Four Stages of Landscape Design, "Planting Fields," William S. Coe Estate, Oyster Bay, 1918–29 (Planting Fields Arboretum, William Barash drawing)

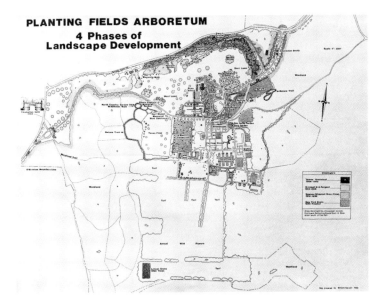

associated with Lowell. Sargent was Lowell's brother-in-law and the son of Charles Sprague Sargent; he was also the cousin of Henry Sargent Codman. At "Planting Fields," Robeson Sargent was responsible for laying out the Beech Avenue (East Drive), Linden Lanes, and the Blue Pool (Italian Garden). In 1915 two enormous copper beech trees were moved here from the estate of Coe's father-in-law, Henry Huddleston Rogers, located in Fairhaven, Massachusetts, probably under Sargent's supervision. (Only one beech survived the trip and may still be seen to the north of the house.)[26]

In 1918 the house burned and the Coes commissioned a Tudor-style country house from Walker & Gillette. Since the fire coincided with Robeson Sargent's sudden death, they also sought landscape advice from Olmsted Brothers. (Mrs. Coe's brother, Henry Huddleston Rogers, Jr., had just used both firms for his Southampton estate.) For the next 11 years, the firm completed the work begun by Sargent and brought the grounds of "Planting Fields" to their present state of unity and cohesion. The more than 300 drawings prepared by the firm include plans for the terraces and all parts of the grounds immediately adjacent to the new house, as well as studies for new drives and revisions of drives, the siting of the Carshalton Gates, flower gardens, a heather garden, rhododendron plantings, and a general plan. Of the spaces near the house, one of the loveliest is the vista and pool south of the house, begun during the Byrnes' ownership but redesigned by Olmsted Brothers. Plans were also made for more mundane features of the estate, such as chicken and duck houses and root cellars. Traditionally, the Olmsted firm is credited with choosing the splendid trees and shaping the spaces of the east and west lawns.[27]

Coe was an avid collector of hybrid camellias, an interest that stemmed from an 1915 meeting with Glomer Waterer of John Waterer and Sons, England. Although Lowell and Sargent initiated plans for the Camellia House, Olmsted Brothers designed its interior planting layout, as well as preparing numerous design, mechanical, and planting studies for later extensions of the structure.[28]

In regard to one important landscape feature at "Planting Fields"—the Blue Pool or Italian Garden—the precise role of the Olmsted firm is problematical. This delightful formal garden was begun by Robeson Sargent. The site of the Blue Pool had been used as a tennis court by the Byrnes, and a small structure designed by Atterbury as a shelter for players, now at the end of the long axis of the pool, was turned into a tea house for Mrs. Coe. Guy Lowell's remodelings consisted of raising the structure and providing a working fireplace with chimneys. The interior was painted by Everett Shinn." Sargent

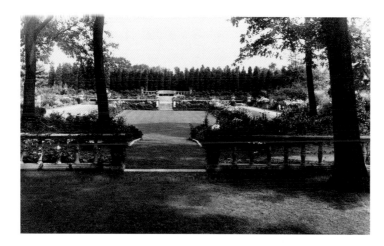

Olmsted Brothers: Sunken Garden, Sidney Z. Mitchell Estate, Brookville, 1921–39 (FLON, Amemya photo, 1926)

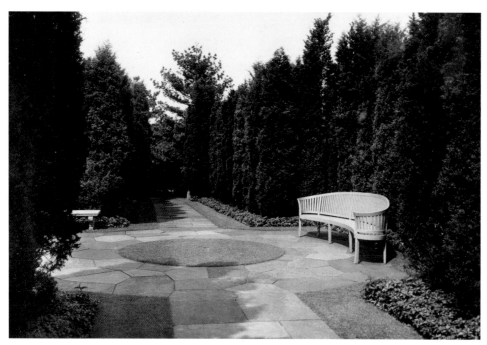

Olmsted Brothers: View Showing Garden Settee and Cedar Vista, Sidney Z. Mitchell Estate, Brookville, 1921–39 (FLON, Amemya photo, 1926)

this site, however, was the sunken garden. Located at a slight distance from the house, which was designed by James W. O'Conner, this formal garden consisted of a large rectangular turf panel from which steps led up to a terrace. On three sides, the terrace was framed by pergolas, and, on the fourth, a single curved settee was placed in front of a balustrade. This side was further emphasized by a backdrop of cedars. Occupants of the settee had the choice of surveying the garden or looking to either side down a majestic cedar vista. Conceived in an understated classical manner and immaculately executed in every detail, the Mitchell garden was a paradigm of early-20th-century residential design. A contemporary publication described it as follows:

Throughout, the architectural features of the garden, with consummate skill, have been kept subordinate to the planting, yet definitely essential to the ensemble . . . [the] sunken garden, whose central sweep of unbroken greensward, with the sentinel cedars in the background, gives an effect of spaciousness that is restful in the extreme.[30]

Marshall Field III Estate, "Caumsett," Lloyd Harbor, 1924–27. Olmsted firm job number 7359. Landscape Architect in Charge, Percival Gallagher. Planting by Hicks Nurseries (Extant)

Conceived from the beginning on a baronial scale, "Caumsett" contained more than 2,000 acres and was said to be the largest estate on Long Island. When complete, it included a dairy farm, stables, numerous cottages, athletic facilities for every sport but golf, an extensive road system, a power plant, and a dock for Field's yacht, as well as the main house and surrounding grounds. In addition, much of the land remained as open pasture for horses and livestock and as woods cut through by shooting rides. Field bought the property in 1921. Construction began the following year and continued through 1926. The workforce was several hundred strong and required an organizational chart headed by a business office and divided between design and engineering, each with its own field office. Categories of work covered excavation and grading, landscaping, building construction, electricity, water, drainage, gardening and fine-grading, and roads and drives. The firm of John Russell Pope, architect of the house and many of the outbuildings, directed all these activities.[31]

For such a large estate, the plan was remarkably simple. Its organizing principle is a sequence of four open spaces that cut diagonally across the property from southwest to northeast, paralleling the main drives. Generally speaking,

was probably unable to complete the redesign of the garden, since the Olmsted firm prepared extensive planting plans and later published the garden as its own work.[29]

The present-day visitor to "Planting Fields" senses no discontinuity in the grounds. So successfully did Olmsted Brothers integrate their landscaping with earlier designs that the estate seems the product of a single comprehensive plan. Additions made after the property became an arboretum in 1949 have been sited on the periphery and do not interfere with the sweeping lawns, specimen trees, naturalistic shrub planting, and formal gardens of the Coe era.

Sydney Z. Mitchell Estate, Brookville, 1921–39. Olmsted firm job number 6939. Landscape Architect in Charge, James Frederick Dawson. Planting by Hicks Nurseries (Demolished)

For the grounds of the S. Z. Mitchell house, Olmsted Brothers prepared a full range of plans: for grading, roads, informal shrub plantings, a cutting garden, and site plans for a greenhouse, farm group, etc. The all-important feature of

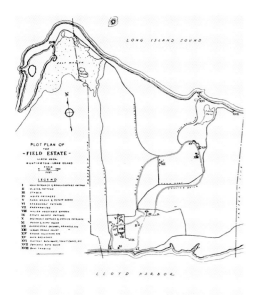

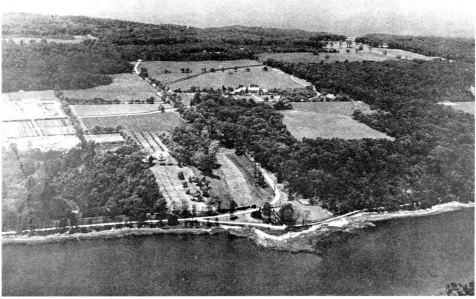

Olmsted Brothers: Plot Plan, "Caumsett," Marshall Field III Estate, Lloyd Harbor, 1924–27 (AMAR, 1928)

Olmsted Brothers: Aerial View Looking Northeast, "Caumsett," Marshall Field III Estate, Lloyd Harbor, 1924–27 (COUN, 1927)

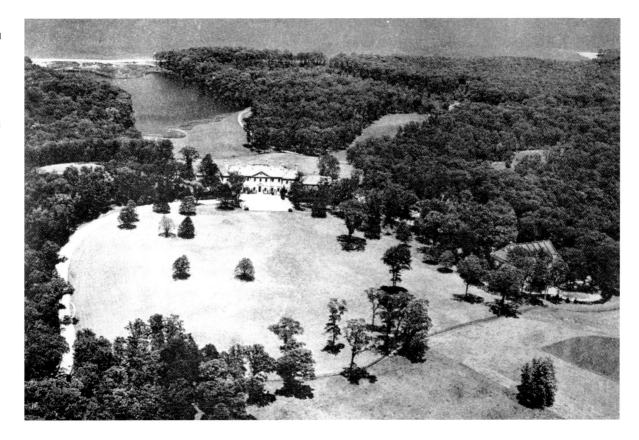

Olmsted Brothers: Aerial View Looking Northeast Across the South Lawn, Long Island Sound in Distance, "Caumsett," Marshall Field III Estate, Lloyd Harbor, 1924–27 (COUN, 1927)

these spaces decrease in size but increase in importance as one approaches and then passes the house. From the entrance lodge, the first space—farm group, greenhouses, workers' cottages, etc.—appears to the left of the approach road, which then swings northward with the stable and its fields on the right forming the second space. Next come (third and fourth) a crescent-shaped swath of lawn leading to the house, and a sloping lawn beyond it to the north.

Since "Caumsett" is comparable in size to the largest urban parks in the country, it is hardly surprising that its landscaping is more park-like than residential. The areas around the house are conceived in terms of broad passages of scenery and vistas, and the intimate spaces and small-scale detail so typical of the 1920s are seen only in the formal gardens to the west of the house. However, there are parallels with the estates or residential "parks" of 18th-century England. The greensward south of the house, dotted with large specimen trees, has an ample sweep reminiscent of the landscapes of Capability Brown, which Field undoubtedly knew from his youth in England. For most of the length of the approach road, the house is hidden by shrubbery and clumps of trees. At the

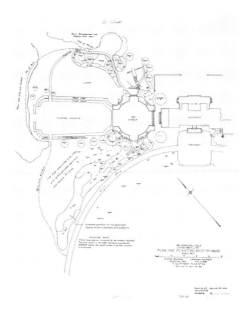

Olmsted Brothers: Plan for Planting West of the House, Showing Box Garden, Flower Garden, House, Forecourt and Main Drive, "Caumsett," Marshall Field III Estate, Lloyd Harbor, 1924–27 (FLON, 1926)

last curve of the road, these thin out to the right, and the house comes into view across the lawn. Dense rhododendron plantings remain on the left-hand side of the road along with widely spaced specimen trees on the right. The climax of the whole composition is the landscape on the north side of the house. Here, a turf terrace surrounded by a balustrade frames a panorama of sloping lawn, encircling woods, and, at the foot of the slope, a freshwater pond, its waters an even deeper blue than the Sound just beyond.[32]

The precise role of the Olmsted firm in this design may be inferred from drawings and correspondence. Of the 28 drawings, the majority are planting plans. The brilliant siting of the house, its vistas to the north and south, and the entire system of roads seem to have been designed by Pope with associated architects Warren & Wetmore. The Olmsted firm was brought in when site construction was well along and designed the formal box garden, perennial garden, and rock garden west of the house, and the surroundings of the indoor tennis court building, designed by Warren & Wetmore, which no longer stands. Olmsted Brothers also coordinated the planting for the entire estate, or at least the part of it near the house. Hicks Nurseries did the planting, which involved moving fully grown trees by barge. In the files at the Frederick Law Olmstead National Historic Site are several plant lists for "Caumsett," one an estimate for $75,000 worth of plant materials—mostly trees, but including box bushes valued at $28,000. (See Appendix B.) The formal gardens were restrained and unfussy for the era, apparently following Field's preference. Another drawing for the box garden shows an elaborate central parterre with a pattern of concentric circles, which seems not to have been carried out. Field also disliked foundation planting and is said to have instructed

his chief gardener, George H. Gillies, "Please, no little Christmas trees on each side of the door."[33]

In 1966 the Field estate was acquired by New York State and became Caumsett State Park. The house is leased by Queens College for its Center for Environmental Teaching and Research. Today, only the outlines of the formal gardens remain, and the rock garden is overgrown. However, the bold vision of Field and his designers is still apparent in the many surviving specimen trees, the lush rhododendron plantings, and the magnificently framed views.

These ten estates, five of them extant, are outstanding among the Olmsted firm's work on Long Island, but they are by no means unique. "Vikings Cove," the George F. Baker estate, next to "Ormston" in Lattingtown, remains in excellent condition, and the impressive avenue of trees leading into the Creek Club nearby still delights the eye. Others, such as the Otto Kahn estate in Cold Spring Harbor, survive in part and are being restored. Besides the Henry W. de Forest, Rogers, and Mitchell estates described above, there have been other sad losses. But whether they may be visited today or can be enjoyed only in old photographs, the nearly 100 estates by the Olmsted firm on Long Island comprise a rare legacy that is hardly paralleled in any other part of the country.

Cynthia Zaitzevsky

■

Palmer & Hornbostel, 1899–1917
Henry Hornbostel, 1867–1961
George Carnegie Palmer, 1862–1934

Born in Brooklyn, Henry Hornbostel graduated at the head of his class from the School of Mines at Columbia College in 1891. Following a brief internship in the offices of Palmer and Wood, he left for Paris to study in the atelier Ginain at the Ecole des Beaux-Arts, where he became famous for his brilliant drawing skills. While still a student at the Ecole, Hornbostel worked for Girault and Blavette on their plans for the World Exposition of 1900 to be held in Paris. In 1897 he returned to New York, where he worked as a delineator for several major firms and as a teacher at Columbia College.

His ability to extrapolate the components of building programs and render them in a bold and forceful style brought Hornbostel considerable success in open competitions. In 1899, in

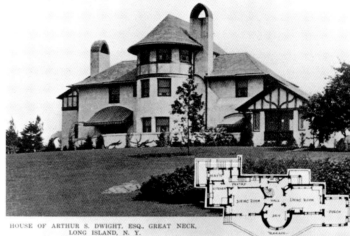

HOUSE OF ARTHUR S. DWIGHT, ESQ, GREAT NECK, LONG ISLAND, N. Y.

Palmer & Hornbostel: Design Rendering, "Driftwood Manor," J. G. Robin Residence, Riverhead, 1906–08 (ARLG, 1906)

Palmer & Hornbostel: Rear Facade, Arthur S. Dwight Residence, Kings Point, 1915 (ARTR, 1916)

Chester A. Patterson: Front Facade, "Twin Lindens," Walter Wyckoff Residence, Kings Point, c. 1920 (ARAT, 1924)

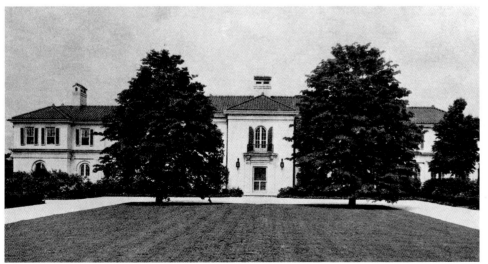

association with Howells and Stokes, he won second prize in the Hearst Competition for the University of California. In 1904, while associated with William Palmer, he won the competition for the Carnegie Institute of Technology in Pittsburgh, and while there to supervise construction, founded the School of Architecture at the Institute (now Carnegie Mellon University). Until World War I, the firm of Palmer and Hornbostel flourished. Besides designing city halls, universities, the East River crossings in New York City, including the Manhattan side of the Brooklyn Bridge (1903), the Williamsburg Bridge (1905), the Queensboro Bridge (1905), and the Hill Gate (1917), and public buildings throughout the country, the firm built two large residences on Long Island.

The first, "Driftwood Manor" (1906–08, demolished 1980), was built for the Wall Street investor J. G. Robin. Set on a slight rise overlooking the water at Riverhead, the concrete-walled, Mediterranean-style house was laid out in a linear manner, stretching across a ridge. The plan was typically academic: at the center of the house was an elliptically shaped living room, entered off-axis from an oval-shaped vestibule. The north side of the living room led onto a terrace that overlooked the water. This terrace was

flanked east and west by porches that shaded the dining room and study, respectively. Bedrooms occupied the upper floors, while service quarters trailed off to the east.

In 1915 Palmer and Hornbostel designed for mining industrialist Arthur S. Dwight a more picturesque, vaguely late-Medieval mode house in Kings Point. This style was very much in vogue during the years just before America's involvement in World War I. Its stucco exterior shares a relative lack of decoration with the Robin estate, but the squarish massing is, curiously, much more fanciful, with a three-story turret and arch-capped chimneys. In the plan, a polygonal central entry hall provides access to the stairs, living room, and dining room that flank the central circular den. Again, the upper floors are devoted to private quarters. The garage and servants' cottage were also designed in a sympathetic picturesque mode.

Following service in France during the war, Hornbostel returned to practice in 1919, and focused his work on major public commissions, including Emory University (1920) and President Harding's Memorial Tomb (1924).

Steven Bedford

Chester A. Patterson, practiced 1920s–1930s

Little is known about architect Chester A. Patterson, who designed at least four large houses on the North Shore, from Kings Point to Matinecock, between 1920 and 1930; all four are extant today.

"Twin Lindens" on West Shore Road in Kings Point was built for financial publisher Walter Wyckoff around 1920. It is a tile-roofed, stucco-and-tile Mediterranean-style villa set on a grassy terrace amid formal gardens laid out by Clarence Fowler.

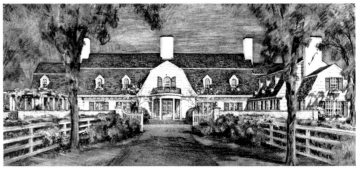

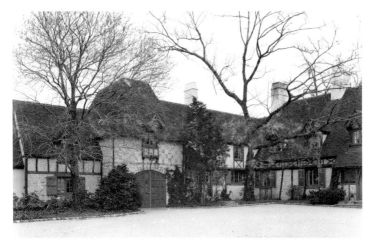

Chester A. Patterson: Front Facade, H. L. Batterman Residence, Matinecock, c. 1927 (INVE, 1978)

Chester A. Patterson: Design Rendering, Mrs. Prescott Slade Residence, 1929, Mill Neck (COUN, 1929)

Chester A. Patterson: Front Facade Detail, "The Pebbles," W. Rossiter Betts Residence, Syosset, c. 1930 (HEWI, n.d.)

In Matinecock, the architect built a low, rambling, 25-room Federal Revival mansion in 1927 for the daughter of Brooklyn department-store owner Henry Lewis Batterman. The symmetrical main block is of brick in Flemish bond, featuring a pedimented story-and-a-half entrance pavilion extending well beyond the plane of the house. A two-story portico extends between two pedimented end pavilions on the garden facade; the lateral wings are shingled. Mr. Batterman's daughter never lived in her house, which remained unoccupied into the 1950s.

Mrs. Prescott Slade's long, shingled, Dutch Colonial house (1929) nestles cozily under its deep, gambrel roof with swept eaves in the style of Long Island's late-18th-century houses—but it is far larger and more elaborate than its prototypes. Massive chimneys set at intervals within the great L-shaped house in Mill Neck seem to anchor it to the ground.

"The Pebbles," built in 1930, was W. Rossiter Betts's Norman Revival house in Syosset. Its deep, tiled roof, broken by big dormer windows with overhanging gables, is broad-pitched, with hipped-roof corner pavilions. As at Mrs. Slade's house, great chimneys pin the rambling structure to its site.

Ellen Fletcher

Peabody, Wilson & Brown, 1911–1935
Julian L. Peabody, 1881–1935
Albert E. Wilson, 1879–1955
Archibald M. Brown, 1881–1956

On a bitter cold winter's night in January 1935, the Ward liner *Mohawk,* bound for the Caribbean and Central America, was severely damaged in a collision with a freighter about eight and a half miles southeast of Sea Girt off the New Jersey coast. Within 40 minutes the ship had foundered in 30 fathoms of water. Among the 33 persons dead and 13 missing were architect Julian L. Peabody and his wife Celestin Hitchcock Peabody, who had been on their way to a holiday in Guatemala.

In the wake of the tragedy, the architectural firm of Peabody, Wilson & Brown was disbanded in deference to Peabody, who had been the senior partner. Thus ended an association of 24 years that had contributed mansions to Long Island's estate areas, large country houses in the Long Island farmhouse style, and some restored and enlarged historic 18th-century landmarks.

Julian Peabody was born in New York City, graduated from Groton in 1899, and from Harvard in 1903. After four subsequent years of studying architecture at the Ecole des Beaux-Arts in Paris, he returned to New York, where he was associated with several architects, including Grosvenor Atterbury, before establishing his own firm. Peabody's wife, Celestin E. Hitchcock, whom he married in 1913, was an accomplished horsewoman and a prominent figure in the wealthy and socially prominent riding set on Long Island. Her brother was Thomas Hitchcock, Jr., the famous ten-goal

Julian Peabody, 1881–1935
(SPLI, n.d.)

Archibald M. Brown,
1881–1956 (SPLI, n.d.)

polo player, and her sister was Mrs. J. Averell Clark of Westbury, whose country house was designed by Peabody around 1920.

Peabody's first executed work, Town Hall (1911) at Huntington, Long Island, was won in competition, with Albert Wilson as associate, shortly before the formation of the firm of Peabody, Wilson & Brown. When Peabody died he was at the height of his career and had just completed drawings for his friend James Normal Hall in Tahiti. He was a member of the American Institute of Architects and the Architectural League of New York, and was on the editorial committee of the Architects' Emergency Committee, which published *Great Georgian Houses in America* in the 1930s to provide work for unemployed draftsmen during the Great Depression. He was known principally as the creator of large, low-key country houses. His avocation was painting in watercolor.[1]

Archibald Manning Brown, FAIA, was also born in New York, attended Groton School, and graduated from Harvard in 1903. That same year Brown married Caroline Helen Parrish, a Parrish of the Southampton resort colony where his parents had always summered. In the spring of 1905 Peabody and Brown were both admitted to the Ecole des Beaux-Arts and joined the Atelier Deglane. Among his earlier works upon his return to New York, before he joined Peabody and Wilson, were the Brooklyn Children's Museum building and the President's House at Dartmouth College. While the Browns lived in New York during the winter, and spent part of each summer in Southampton, their main residence was on Stony Brook Harbor in St. James, Long Island. It is not known whether Archibald or his brother Lathrop (1883–1959) was the first family member to build in St. James. Lathrop Brown's mansion on Stony Brook Harbor was one of the firm's early commissions. Nor is it known how the Browns happened to find St. James in the first place, as most of the estates around the harbor were owned by descendants of Richard "Bull" Smith, the original settler, and both Archibald and Lathrop had spent the summers from 1886 to 1903 in Southampton.[2]

After the death of Julian Peabody and the breakup of the firm, Brown practiced alone until 1946, and then with the firm of Brown, Lawford & Forbes until 1956, the year of his death. In 1937 and 1938, Brown's Harlem River Housing Project, one of the first of New York's federal housing projects, was singled out in architectural journals. In 1944 Brown was made a fellow of the American Institute of Architects. The announcement of that event praised the "simplicity and dignity" of his work. Brown's second wife, who survives, was Eleanor Stockstrom, president of McMillen, Inc., the interior decorators.

Albert E. Wilson was born in New York City and graduated from Columbia University in 1904. He was a member of Peabody, Wilson & Brown for 25 years and, after Peabody's death, was a partner in the Mamaroneck firm of Wilson & Rahm. He belonged to the American Institute of Architects and served at one time as president of the National Council of Business and Professional Men.

Norman W. McBurney (1889–1958), also known to have been a member of the practice, graduated from the University of the State of New York in 1916 when he joined the firm. He lived in Smithtown and was responsible for supervising most of the firm's work on Long Island. McBurney wrote specifications and made periodic trips to supervise the actual building. After the dissolution of the firm, McBurney worked on his own, except for a short period when he was associated with August Viemeister, and designed a considerable number of buildings in the Smithtown area. A map in the possession of McBurney's son shows the locations of the commissions that Peabody, Wilson & Brown executed in the New York City vicinity between 1911 and 1921. There were 11 in Westchester, 16 in Manhattan, 32 in Nassau County, 11 in western Suffolk, and 7 in the Southampton area, totaling 50 commissions on Long Island in a ten-year period. As far as can be ascertained, there has been no repository for the Peabody, Wilson & Brown papers.[3]

Peabody, Wilson & Brown was considered to be one of the leading architectural firms of New York. Its members were known primarily as prolific designers of large country residences from the years before World War I until Julian Peabody's untimely death. Although the firm's work was wide-ranging geographically, including New Jersey, Connecticut, Westchester and upstate New York, Aiken in South Carolina, Virginia, Ohio, and even Tahiti, many of its commissions were on Long Island, where both Julian Peabody and Archibald Brown lived. The majority of these architects' buildings in Nassau County were clustered in Old Westbury and nearby Brookville, Glen Cove, Matinecock, Mill Neck, Oyster Bay, Jericho, and Roslyn. In Suffolk County, the firm's houses were mainly in the Town of Smithtown and in Southampton. It is interesting to note that Peabody and members of both his and his wife's families lived in Old Westbury, and that the Browns lived in St. James, and had been childhood summer residents of Southampton. Thus, the major part of the firm's Long Island work appears to have been for friends, relatives, and neighbors.[4]

Research inquiring about the clients and their business interests is hampered by the fact

that although the majority were listed in the *New York Social Register,* very few of the clients could be found in *Who's Who,* suggesting that while they were often socially prominent, they usually were not tycoons or leaders of industry to any degree. However, James Norman Hall, for whom the firm did a house in Tahiti, was a very different type of client. Hall—with Charles Nordoff—had written the trilogy about the mutiny on board *HMS Bounty.* This very popular novel had been published in three volumes in 1932, 1933, and 1934.

The firm started designing in the fully developed Colonial Revival style, and then continued in the eclectic styles of the era, even experimenting with a so-called "Bermuda style."[5] However, when not embracing the Georgian, Southern, English, Brittany, Normandy, Provençal, or later stripped styles, and after a brief excursion into the Spanish tile-roof mode, Peabody, Wilson & Brown usually worked in the Long Island farmhouse idiom or some variation of it; a few of their commissions involved the remodeling of old farmhouses.

Today, in researching the estate areas of Long Island's North Shore, it becomes apparent that the so-called Long Island farmhouse mode was very popular in the first quarter of this century. This style was not so much a re-creation of the local vernacular as a low-profile amalgam of scale, mood, texture, *parti,* and general ambience. Architectural features were kept few in number, and the detail portrayed the Colonial spirit, though in every case reduced to the simplest terms, depending upon mass and outline for its effect. According to a contemporary account, the objective was to create "the peaceful atmosphere of Colonial days." Although they were mansions, the Long Island farmhouse–style residences lacked the ornateness of the Colonial Revival and the formality of the Georgian and were usually clad in white shingles. Small-paned sashes were used and the entrance surrounds were often inspired by Long Island or New England prototypes. The interiors were notable for graceful, delicate stairways and reused old mantlepieces with modern paneling designed to match.[6]

While the firm of Peabody, Wilson & Brown was highly regarded for its work in the Long Island farmhouse idiom, its architects were not alone in working in that mode. Others designing country houses in the Long Island farmhouse style during this era included Aymar Embury II; Polhemus & Coffin; J. W. O'Connor; Foster, Gade & Graham; W. L. Bottomley; and Lawrence Butler of Ford, Butler & Oliver, to name only a few. However, the precursor of this mode on Long Island was McKim, Mead & White's mansion built near Westbury for E. D. Morgan (1890–1900).

Although this was an exceptionally large establishment, the general scheme was to make it appear like a Long Island farm complex. Arranged in a quadrangle, the huge main residence with its simple gable roof had small-paned, double-hung windows with louvered shutters, a modest pedimented entrance porch, and was obviously modeled on the typical Long Island farmhouse. Various attached wings, some at right angles, continued the farmhouse vocabulary, and flared overhanging eaves on some of the units recalled the Dutch/Flemish influence often found in western and middle Long Island.

The Long Island farmhouse style was considered to be an outstanding characteristic of the firm's work. As early as 1914, when *Architecture* devoted most of an issue to "The Country Work of Peabody, Wilson & Brown," the editors commented on the firm's successful effort to reflect the spirit of the old Long Island farmhouse idiom, and noted that Peabody and Brown had designed their own homes in that vernacular in 1910 and 1912, respectively. In 1919 work in that mode for Huntington Norton at Oyster Bay and for John S. Phipps at Westbury was discussed in the *Architectural Forum* in an article entitled "A Group of Long Island Country Houses from the Designs of Peabody, Wilson and Brown, Architects." A later house, built in 1924 for William P. T. Preston at Jericho, was selected by Harold Donaldson Eberlein as the subject of a lengthy article entitled "Individuality in Architectural Vernacular, A Study in Materials and Detail as Revealed in the Interesting Home of W. P. T. Preston, Esq., Long Island."[7]

Not in the Long Island farmhouse style, but certainly closely related to it, were Peabody, Wilson & Brown's two commissions in the 1920s and 1930s to remodel ancient mills. The moving of the old windmill from Wainscott to Montauk for Lathrop Brown was well executed with interesting results, and the conversion of the T. J. White water-powered grist mill in Smithtown for use as a guest house was equally successful. Both commissions showed sensitivity, originality, and respect for the integrity of the old structures.[8]

Regardless of which idiom Peabody, Wilson & Brown employed, the firm always paid the same careful attention to the quality of the details. A contemporary reporter made special mention of this from the standpoint of architectural precedent, commenting that the work of the firm was unusual in that both interior and exterior details were carefully designed and conformed to the style of the house, yet exhibited a spirit of freedom and originality that made the architect's handling of the various styles distinctive. A good example was a carved molding resembling a rope that was used in the Fincke

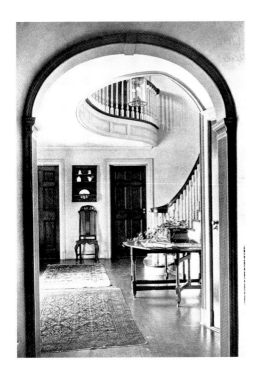

Peabody, Wilson & Brown: Elliptical Stairway, "High Elms," Richard Emmet Residence, Glen Cove, c. 1929 (ARAT, 1929)

house at Southampton, in "Deepwells" at St. James, and in Brown's own home in St. James. Another outstanding example was the Playhouse, built at Southampton for the Tyngs. Taylor Scott Hardin wrote in 1931 that the aesthetic originality and technical skills manifested in solving this unique commission were instrumental in the firm's winning the 1931 Silver Medal awarded by the Architectural League.[9]

Upon a number of occasions, the firm featured graceful, elliptical, freestanding stairways. These were of considerable interest as no two were exactly alike. For instance, the Alonzo Potter staircase had a round mahogany rail with thin, round balusters in the Greek Revival manner, and the Richard Emmet stairway had an 18th-century-style molded rail of mahogany and turned balusters painted white. Both rails terminated in a whorl instead of a newel post. Peabody, Wilson & Brown were also recognized for the thoughtful treatment of the settings of their houses. They tried to keep the exterior lines of the houses as simple as possible so as to stress the relationship of the garden, the lawns, and the vistas to the interior of the house.

Even though the firm was deeply involved with the settings for the houses it designed, the landscape architect Ellen Shipman was identified with four of the estates: William P. T. Preston's and A. Ludlow Kramer's estates in Jericho; J. Averell Clark's in Old Westbury; and Richard S. Emmet's in Glen Cove. Olmsted Brothers landscaped Hiram Dewing's estate in Oyster Bay and Gerald Dahl's in Smithtown (Dahl being a subsequent owner of the Alonzo Potter estate). Of particular interest in reference to this was the work the firm did in St. James for four waterfront properties on Stony Brook Harbor. This historic, shallow-draft harbor was surrounded by rolling uplands that were either

wooded or, often, cultivated fields and pasture. Brown's own home, known as "East Farm," was located there, its setting described by Elizabeth Blair Jones in her historic structure report as "particularly well sited with a magnificent view across pasture and wetlands to the harbor." Another of the waterfront properties was the large new house designed for Brown's brother, Lathrop. The two other waterfront properties were remodeled for George Bacon and William Dixon, both from ancient Smith family homesteads. The sites of all four of these houses were treated with sympathy and care in order to preserve their giant trees and scenic vistas. Today, the picturesque settings of the four houses survive undisturbed, including their views over the tranquil harbor.[10]

In summation, it becomes obvious that Peabody, Wilson & Brown designed in many different modes, although, like Delano & Aldrich, the firm usually eschewed the Tudor or Gothic mode. Some of the contemporary architects had much narrower stylistic interests, like Lindeberg's concentration on the Cotswolds. The firm's position within the framework of contemporaneous architecture was mainstream, neither *retardataire* nor avant-garde, but nevertheless consistently progressive, innovative, even pioneering, as evidenced by the introduction of what is believed to be the first International Style house in Southampton, designed for Lucien H. Tyng. The following commissions are discussed chronologically, but divided into two groups. The first covers large country houses, the second deals with rehabilitations, remodelings, and alterations.

Julian L. Peabody Residence, "Pond Hollow Farm," Old Westbury, c. 1910 (Extant)

Julian Peabody's own home in Old Westbury, now a private residence, was apparently the firm's earliest commission and probably the work of Peabody himself. "Pond Hollow Farm" was designed in the Long Island farmhouse mode and built on the site of an earlier house. Typical of the estate era, "Pond Hollow Farm" had an entrance front and a garden front. The garden front featured a two-story, five-bay portico, probably inspired by Mt. Vernon. The exposed-beam ceiling of the living room was a standard contemporary interpretation of a Long Island farmhouse as the turn-of-the-century architects thought it might have looked. Actually, the main rooms of an 18th-century Long Island farmhouse would have had plastered ceilings, but exposing the joists in the recycling of old houses was the vogue at the time.

Peabody, Wilson & Brown: Entrance Facade, "Pond Hollow Farm," Julian L. Peabody Residence, Old Westbury, c. 1910 (ARTR, 1914)

Peabody, Wilson & Brown: First and Second Floor Plans, "Pond Hollow Farm," Julian L. Peabody Residence, Old Westbury, c. 1910 (ARTR, 1914)

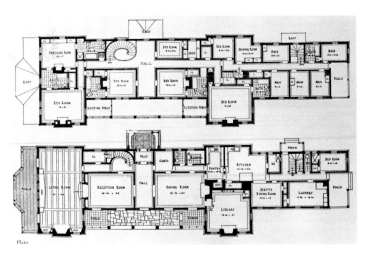

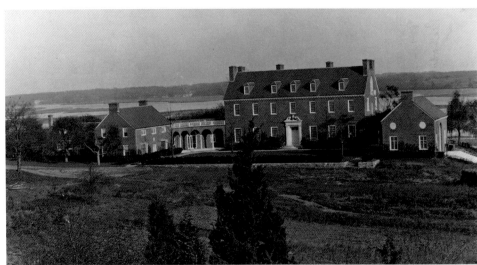

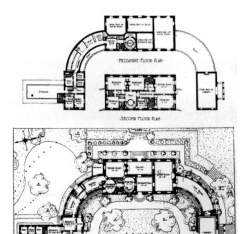

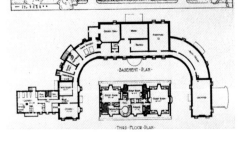

Peabody, Wilson & Brown: Entrance Facade, "Land of Clover," Lathrop Brown Residence, St. James, 1912–17 (MCBU, n.d.)

Peabody, Wilson & Brown: Floor Plans, "Land of Clover," Lathrop Brown Residence, St. James, 1912–17 (ARRC, 1921)

Peabody, Wilson & Brown: Photograph and Plans, Oval Stables, "Land of Clover," Lathrop Brown Residence, St. James, 1912–17 (ARRC, 1921)

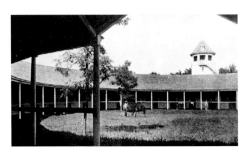

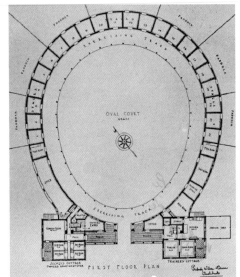

A feature of some of the firm's houses that distinguished them from other Long Island estates was the omission of a formal forecourt. While a large, well-screened service court was always included, there was often no nearby parking court for the front entrance, or at best a circle with a lawn in the center. In the case of "Pond Hollow Farm," the driveway proceeded across the front of the house with no parking area except a circle at some distance to the east of the front door.[11]

Lathrop Brown Residence, "Land of Clover," St. James, 1912–17 (Extant)

The Lathrop Brown residence in St. James, in the Town of Smithtown, was believed to have been Archibald Brown's first commission. It was designed for the architect's brother, who

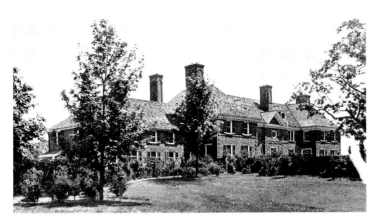

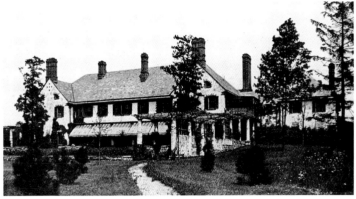

Peabody, Wilson & Brown: "Harbor House," Alonzo Potter Residence, Smithtown, c. 1914 (ARFO, 1924)

Peabody, Wilson & Brown: Rear Facade, "Sunridge Hall," Devereux Milburn Residence, Westbury, 1916 (PATT, 1924)

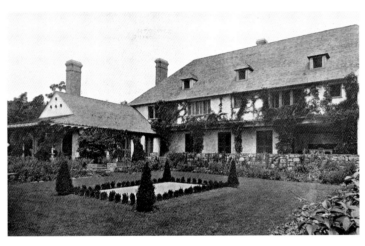

Peabody, Wilson & Brown: Garden Facade, "Darragh Hall," Darragh Park Residence, Old Brookville, 1917 (ARFO, 1921)

inherited his father's New York real estate firm, became a member of Congress, and subsequently was special assistant to the Secretary of the Interior. Although located on scenic Stony Brook Harbor across from "East Farm," the Archibald Brown residence, the Lathrop Brown house, instead of being in the Long Island farmhouse tradition, was an enlarged version of a southern mansion, with certain details derived from "Westover" in Virginia. This magnificent property included, in addition to the main house, an interesting shingled water tower and a remarkable oval stable, all buildings being respectfully maintained by its current owner, the Knox School. Above all, "Land of Clover" was a fine example of the firm's sensitivity in siting.

The balanced Beaux-Arts floor plan featured a large central mass of two stories and a high roof, with two lower wings connected by curved arcades forming a porch on one side and a pantry on the other. Like its Virginia prototype, this house had two facades, an entrance front planned around a garden and a second facade facing the harbor. The walls of the house were composed of Virginia brick delivered directly to the property via Stony Brook Harbor at high tide by a shallow-draft schooner. The Brown house had limestone trim and a slate roof, the slates also coming from Virginia. A good-sized dock with narrow-gauge railroad tracks was built to facilitate the unloading and transporting of the brick. This house is true to the Peabody, Wilson & Brown tradition of

simplicity of detail. To quote a contemporary account, the "house differs from recent examples of the so-called Georgian types in that it has been kept as simple as the models from which the architects were inspired."[12]

Alonzo Potter Residence (later Gerald Dahl), "Harbor House," Smithtown, c. 1914

This brick house was designed in the Georgian manner, with hip roofs, high-paneled brick chimneys, white dentiled/modillioned cornice, and pedimented entrance bay on the garden facade. Particularly notable in this classic country house was the fine elliptical stairway in the large entrance hall. Also noteworthy was the antique Italian marble mantelpiece in the library. The cottage added for the estate superintendent was in the Long Island farmhouse style, with small, floor-level windows under the eaves, and a typical Adamesque Federal entrance. The residence was demolished around 1979.

Devereux Milburn Residence, "Sunridge Hall," Old Westbury, 1916 (Extant)

The house on Store Hill Road in Old Westbury that the firm designed for Devereux Milburn is today part of the State University Empire State College, Old Westbury Campus. The client, a graduate of Harvard and Oxford, was an outstanding polo player and one of the great figures of American sport. Describing the house in 1924, Augusta Owen Patterson referred to it as "The Modern Picturesque." Built of brick, the two-and-a-half-story main mass is flanked by gable-roof, two-bay wings at right angles. Pergolas shade the terraces on the garden fronts.

Darragh Park Residence, "Darragh Hall," Old Brookville, 1917 (Extant)

While the house for banker Darragh A. Park in Old Brookville is still standing, it is so overgrown with trees and shrubbery as to be almost

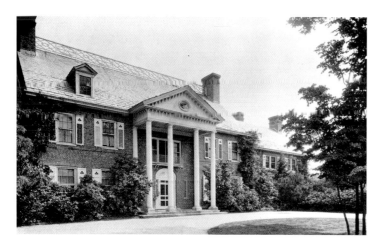
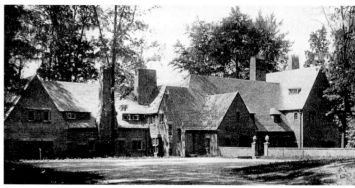

Peabody, Wilson & Brown: Front Facade, "Pickett Farm," A. Ludlow Kramer Residence, Jericho, c. 1918 (HEWI, n.d.)

Peabody, Wilson & Brown: Front Facade, "Nonesuch House," Courtlandt D. Barnes Residence, Manhasset, c. 1918 (PATT, 1924)

hidden. Typical of the firm's eclectic approach, this large stucco house was in the English mode reminiscent of Voysey, with an enveloping roof, casement windows, high brick chimneys, and entrance porch of framing timbers. True to its prototype, the floor plan was irregular and the large living room was open to the rafters, recalling an English great hall. The dining room, however, was in the Colonial style of a handsome Long Island farmhouse. Usually, Peabody, Wilson & Brown's clients wintered in New York, but the Parks were among the few who resided at their country house the whole year, using a Roslyn post office address.[13]

A. Ludlow Kramer Residence, "Picket Farm," Jericho, c. 1918

The general mass of this house and the use of a two-storied entrance portico suggested southern mansions. Its detail was developed in a restrained manner that was exceedingly light and graceful. A good balance of color was maintained between the red-brick walls and the white trim. The garden front was given an intimate relation to the setting by a semicircular porch and open loggia above. This again recalled features of some early southern houses. As mentioned earlier, the house was planned with special reference to the site. The land sloped gradually from front to back, so that the view of greatest interest was to the north. The main rooms were disposed at that side of the house, and the living room, 25 by 42 feet, occupied the whole right wing. A glazed porch at the end of this wing linked the house with the walled-in flower garden. The walks of this garden were paved with broken flagstones, while interesting arched openings in the wall gave on vistas to a wooded knoll opposite the porch and, on the other axis, to the rose garden and pool at a higher level. A charming one-story octagonal brick tool-house with small belvedere and weather vane stood beside the garden. Its entrance was embellished with a pediment above a

round-topped door and a large round window pierced its flank.

The client, A. Ludlow Kramer (1878–1948), married to the former Anna Bement, practiced law in Philadelphia until he was appointed vice president of the Equitable Trust Co. of New York in 1912, and president of the holding company for Westinghouse Electric Co. in 1914. He retired in 1916 and apparently built this house shortly thereafter. "Picket Farm" was destroyed by fire in 1977.[14]

Courtlandt D. Barnes Residence, "Nonesuch House," Manhasset, c. 1918

The firm designed a picturesque English-style house for stockbroker Courtlandt D. Barnes in Manhasset. Barnes was a member of the A. S. Barnes & Co. publishing family. Described as "Very Modern Picturesque," the Barnes residence was modeled on the sturdy lines of early English houses, with steeply sloping roofs broken by many gables. The eaves projected but slightly beyond the walls, and were, for the most part, brought close to the ground. The roofs were covered with heavy slate graduated in size and thickness and varying in shades of brown and black. The walls were a mixture of common red brick and dark headers laid at random and slightly out of plumb to create an appearance of age. The exterior woodwork was of oak, a large part of which had been obtained from old barns in the vicinity. This was apparently a common practice of the firm. The interiors generally followed the English theme. The living room was designed to reflect the character of English rooms of the 16th century. The walls were of rough plaster, hand-patted and tinted buff. The woodwork of old oak was dark brown. The windows at the end of the room were leaded casements with some panes of stained glass. No longer standing, this house was a good example of the firm's versatility.[15]

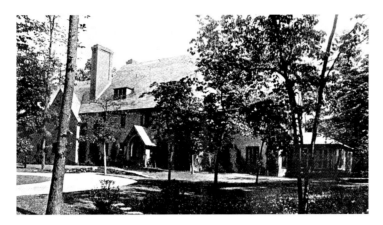

Peabody, Wilson & Brown: Front Entrance, Mrs. J.E.S. Hadden Residence, Jericho, 1918 (PBWB, 1922)

Peabody, Wilson & Brown: Entrance Facade, J. Averell Clark Residence, Westbury, c. 1920 (HOWE, 1933)

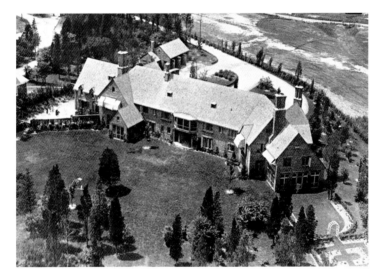

Peabody, Wilson & Brown: Aerial View of Rear Facade, William F. Ladd Residence, Lawrence, c. 1920 (VIEW, 1930)

Mrs. J. E. S. Hadden Residence, Jericho, c. 1918

Another early work of the firm was the handsome residence for Mrs. J. E. S. Hadden in nearby Jericho. The Haddens' son, Hamilton Hadden, was married to Julian Peabody's sister, Anita Peabody. As the years passed, the house became the home of the Hamilton Haddens.

The Hadden house followed English precedent more closely than did any other of the

Peabody, Wilson & Brown's country houses in which the setting played an important part. Completely surrounded by trees, the house was situated on a knoll and designed to blend naturally with its environment. The latticed windows, porches with copper roofs, and French windows on the terrace suggested an English house built in the later years of the Georgian period. The walls were constructed of common bond red brick. The steeply sloping roof was covered with slate in varying shades of brown, green, and black. The exterior woodwork of oak was left in its natural state. Most of the woodwork was obtained from old buildings and barns in the neighborhood and its aged color and adzed surfaces were left intact. The intimacy of the house and grounds was best shown by the views from the terrace. Here the trees were thinned out to provide a sunny spot just outside the windows of the principal rooms. A brick wall with an arched doorway screened the terrace from east winds and the service portion beyond. Old broken flagstones with wide grass joints formed the pavement of the terrace, greatly adding to the appearance of the informality and making a harmonious link between the house and its surroundings.[16]

J. Averell Clark Residence, Westbury, c. 1920 (Extant)

This residence in the picturesque English manner was one of Peabody, Wilson & Brown's smaller houses, but has considerable distinction. Irregular in form, with steeply gabled roofs and matching wall-faced dormers, it has a casement-windowed facade dominated by a magnificent, very high, corbelled brick chimney, the huge mass of which is articulated by receding planes. The simplicity of the exterior surface treatment was typical of the firm's work. The interior, finished in the Long Island farmhouse style, included pine paneling and a corner cupboard. It is now a private residence.

Mrs. Clark had been Helen Hitchcock, and was the sister of Celestin Hitchcock Peabody. Her husband, Averell Clark, a stockbroker, was a partner in Clark, Dodge & Co., a brokerage firm, founded by his father, George C. Clark.[17]

William F. Ladd Residence, Lawrence, c. 1920

Built in Lawrence near the Rockaway Hunting Club, the Ladd house was another example of the rambling "picturesque" English style. Peabody, Wilson & Brown was associated in the design of this house with Carroll Ladd, probably a relative of the owners. Subsequently, in

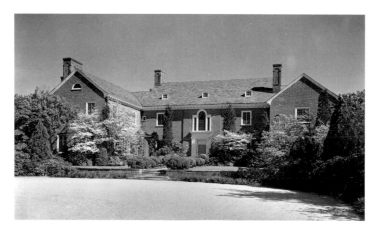

Peabody, Wilson & Brown: Entrance Facade, "Boxwood Farm," Hugh Murray Residence, Old Westbury, c. 1922 (GOTT, 1936)

Peabody, Wilson & Brown: "Longfields," William P. T. Preston Residence, Jericho, 1924 (MCBU, n.d.)

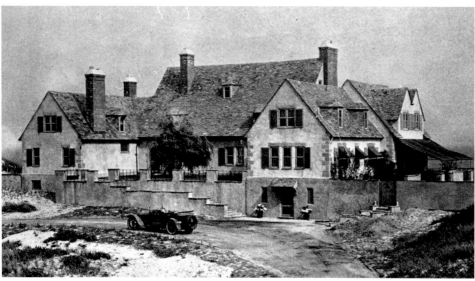

Peabody, Wilson & Brown: Reginald Finke Residence, Southampton, c. 1925 (ARRC, 1926)

William P. T. Preston Residence, "Longfields," Jericho, 1924

Situated on Jericho Turnpike at Jericho, this was another example of the Long Island farmhouse style. The two-and-a-half-story, gable-roofed house was clad in white shingles, while its large double-hung windows had small panes in the Colonial manner. The segmental arch pediment over the classic six-panel front door was borrowed from New England prototypes. The interior, although handsomely designed for country living and entertaining, was simple in treatment, with plaster walls and pine paneling. The grounds were designed by Ellen Shipman to "create a peaceful atmosphere reflecting Colonial days."[20]

1929, the firm built another house for the Ladds on the barrier beach west of Southampton (see below). Only outbuildings of the Cedarhurst residence remain standing today.[18]

Hugh Murray Residence, "Boxwood Farm," Old Westbury, c. 1922 (Extant)

This house, built for the Hugh Murrays, was acquired in 1936 by Charles V. Hickox, an insurance broker, and his wife, the former Catherine Barker Spaulding, both known for their philanthropies. A preliminary sketch, dated 1922, published in *Peabody, Wilson and Brown, Architects, New York City,* shows an earlier version, rather than the house built soon thereafter. While both versions were Georgian in style with a main unit flanked by balanced projecting wings, the houses were otherwise quite dissimilar. Celestin Hitchcock Peabody considered the built house "one of her husband's finest designs and most attractive country houses."[19]

Reginald Fincke Residence, Southampton, c. 1925 (Extant)

For this house located on the dunes at Southampton, Brown provided an open court on the north facing away from the sea with one entrance at the roadside level, and an upper entrance at the dune-top level on the ocean side. This English-style stucco house is a generally balanced composition, with a high gable roof flanked by lower wings projecting at right angles on either side of the entrance court. A matching garage/cottage auxiliary building was erected opposite the main house on the north side of Meadow Lane. A carved molding resembling twisted rope was used in this house, as it was in "East Farm," Brown's own residence on Stony Brook Harbor.

Charles M. Pratt, Jr., Residence, Glen Cove, c. 1926

The Georgian-style house designed for Pratt was of brick with gabled roofs of slate. The unusual off-center floor plan, atypical for a Georgian-style house, placed the front entrance on a side facade in a forecourt formed by the arcaded service wing. The expansive first floor included a

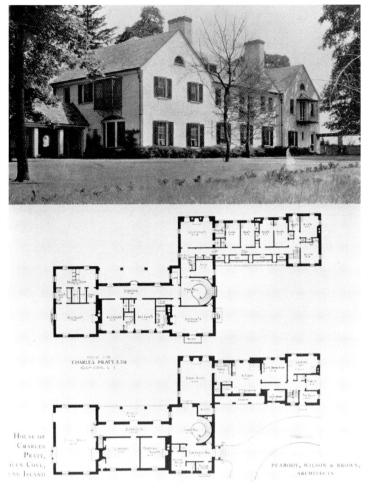

HOUSE FOR
CHARLES PRATT, ESQ.
GLEN COVE, L. I.

HOUSE OF
CHARLES
PRATT,
GLEN COVE,
LONG ISLAND

PEABODY, WILSON & BROWN,
ARCHITECTS

Peabody, Wilson & Brown: Charles Pratt, Jr., Residence, Glen Cove, 1926 (ARTR, 1927)

Peabody, Wilson & Brown: Front Facade, "Rhonda," Gordon Auchincloss Residence, Matinecock, 1927–29 (INVE, 1978)

Peabody, Wilson & Brown: Rear Facade, "High Elms," Richard S. Emmet Residence, Glen Cove, 1928–29 (ARAT, 1929)

large living room, library, morning room, reception room, and flower room, as well as the usual dining room, pantry, kitchen, servants' dining room, and laundry, plus a cold room and a toy room, over 21 main rooms in all. The elliptical freestanding stairway was embellished with a delicate curvilinear railing with S-shaped iron balusters on each step. This house, which was demolished in 1969, replaced the early Kirk homestead that had occupied the site. Charles Pratt was a grandson of the founder of Standard Oil Company and the son of Frederick B. Pratt, whose Glen Cove mansion, "Poplar Hill," had been designed by Charles A. Platt, around 1917–24.

Gordon Auchincloss Residence, "Rhonda," Matinecock, 1927–29 (Extant)

This five-bay, two-and-a-half-story, hip-roof house was designed in the formal French Provincial style. However, its simplicity of detailing, especially the entrance, presaged Art Deco and the so-called "stripped" styles of the 1930s. The handsome formal planting was also in the French manner. This house is a good example of the firm's varied idiom. The client, an attorney and graduate of Yale and Harvard, was a grandson of Samuel Sloan, who had been president of the Delaware, Lackawanna and

Western Railroad and of the Hudson River Railroad, predecessor of the New York Central System. Mrs. Auchincloss was the former Janet House, daughter of Colonel Edward M. House, advisor to President Woodrow Wilson.[21]

Richard S. Emmet Residence, "High Elms," Glen Cove, c. 1928–29

The client, a graduate of Harvard and a lawyer, was married to the former Helen L. Pratt, sister of Charles Pratt, whose nearby house also had been designed by Peabody, Wilson & Brown.[22] A simple, perfectly balanced, 21-room, white frame house, "High Elms" had green shutters and a plain shingle roof. The outer walls were made of flush boarding with wood quoins at the corners. The entrance facade was characterized by a classic pedimented doorway with fanlight, while the garden front was distinguished by five French doors opening onto a flag-paved terrace. One of the many fine interior details was the stairway that circled delicately around an oval well, centered by a pendant lamp. "Quiet, modest, unobtrusive, the house stands alone. Its beauty is that species which defies analysis," wrote Taylor Scott Hardin in 1930 in the magazine *Home and Field.* The landscape architect was Ellen Shipman.

Peabody, Wilson & Brown:
Rear Facade, "Appledore,"
Hiram Dewing Residence,
Locust Valley, c. 1928
(Courtesy of Mrs. Henry
P. Davison.)

Peabody, Wilson & Brown:
Design Rendering, "Ocean
Castle," William F. Ladd
Residence, Southampton,
c. 1929 (ARLG, 1929)

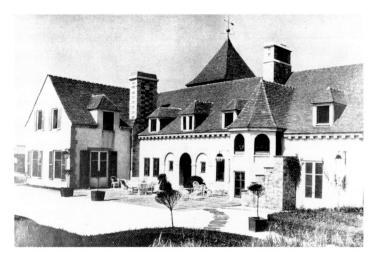

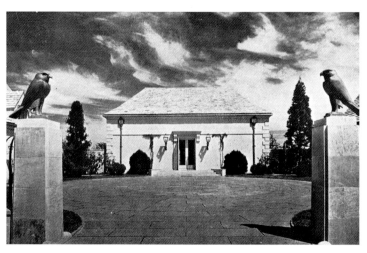

Peabody, Wilson & Brown:
Rear Facade, "Cobble
Court," J. W. Funk
Residence, Southampton,
1929 (COUN, 1936)

Peabody, Wilson & Brown:
Playhouse, Front Facade,
"Four Fountains," Lucien
H. Tyng Playhouse,
Southampton, c. 1930
(ARAT, 1931)

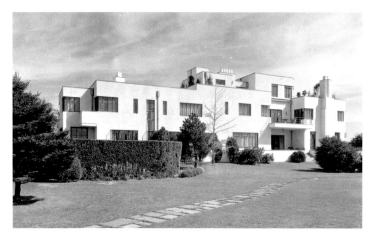

Peabody, Wilson & Brown:
Rear Facade, "The
Shallows," Lucien H. Tyng
Residence, Southampton,
1930–31 (GOTT, 1931)

oceanfront dunes for 300 feet, offering a view of both the ocean and Shinnecock Bay to the north. "Ocean Castle" was designed in response to the Ladds' requirements. Constructed of concrete blocks textured to resemble stone, and roofed with specially prepared rust-red tiles, it was built on stilts, with sand pumped in around it. The irregularity of the structure evoked the feeling of a Brittany fishing village as each unit of the house appeared to be a separate cottage. The landscape gardener was John Raum of East Hampton.[23]

Hiram Dewing Residence, "Appledore," Locust Valley, c. 1928 (Extant)

Located on Crab Apple Lane in Locust Valley, "Appledore" is a high-roofed house of brick in the French Manorial mode with high roof peaks and casement windows topped by semi-elliptical arches.

William F. Ladd Residence, "Ocean Castle," Southampton, c. 1929 (Extant)

This summer home followed an earlier one built for the Ladds at Cedarhurst in 1921. Inspired by the studio on the barrier beach that Brown had built for his wife, the Ladds asked the architect to design a dune house for them. The long, irregular, one-story house, with a facade punctuated by three squat towers, sprawled over the

J. W. Funk Residence, "Cobble Court," Southampton, 1929

Displaying French Provincial inspiration, "Cobble Court" was built of concrete blocks and stucco. Red bricks were used in the chimneys and flat brown tiles on the roof. The outstanding feature of this handsome house was the large square "watch tower" at the corner of the entrance court. The building was severely damaged by an ocean storm but part of the wing is still standing and a new house has been built on the old foundation.[24]

Lucien H. Tyng Playhouse, "Four Fountains," Southampton, c. 1930 (Extant)

Unique was the remarkable playhouse, called "Four Fountains," built for public utility executive and philanthropist Lucien Hamilton Tyng

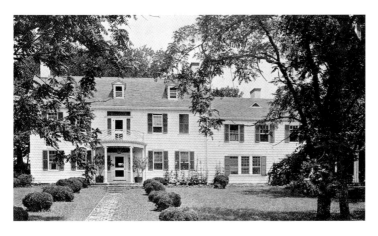

Peabody, Wilson & Brown:
Rear Facade (Alterations),
"East Farm," Archibald M.
Brown Residence, St. James,
c. 1914 (ARTR, 1914)

Peabody, Wilson & Brown:
Front Facade (Alterations),
"Thatch Meadow Farm,"
George W. Bacon Residence,
St. James, c. 1914 (MCBU,
n.d.)

Peabody, Wilson & Brown:
Alterations, William Dixon
Residence, St. James, c. 1927
(MCBU, n.d.)

and his wife on the east side of Halsey Neck Lane in Southampton.[25] Designed by Brown with many suggestions from Mrs. Tyng, the building was considered to be in the "Provençal style," although executed with an Art Deco simplicity. This hip-roofed stucco building with flanking one-and-a-half-story detached wings, followed the pattern of restraint typical of the work of Peabody, Wilson & Brown. The details were truly remarkable, from the carefully designed bronze grilles and doors, to the ceiling mural by Ernest Peixotto. This building was widely admired for its successful solution to a most unusual commission. Today the playhouse is a private residence.

Lucien H. Tyng Residence, "The Shallows," Southampton, 1930–31 (Extant)

The Tyng residence, situated on the west side of Halsey Neck Lane, was built shortly after the completion of the playhouse. With this house the firm ventured into a new field. It is believed that this was the first appearance of the International Style in Southampton. The first exhibition of "Modern" Architecture at the Museum of Modern Art was not held until 1932, and the first book on the subject was Hitchcock and Johnson's *International Style,* published in 1933, which indeed suggests that this house introduced the astringent purity of the Bauhaus to eastern Long Island. The interior, however, did not venture into the Bauhaus "open" floor plan, but was composed of individual rooms arranged in the traditional manner. The Tyngs' earlier house on this site had burned around 1930. While this new house was being designed and built, the Tyngs lived in one of the detached wings of the playhouse that had just been completed across the road.[26]

Commissions for which Peabody, Wilson & Brown remodeled, enlarged, and recycled old houses are of particular interest. As Long Islanders, Julian Peabody and Archibald W. Brown would have been familiar with the many ancient structures which abounded on Long Island in the early years of the 20th century.

A. M. Brown Residence, "East Farm," St. James, Alterations c. 1914 (Extant)

Brown himself bought an old farm in St. James (c. 1911–12) and remodeled and enlarged the 18th-century house for his family, calling it "East Farm." In doing so he emphasized its magnificent setting on Stony Brook Harbor. One of the most interesting details he designed for this house was the carved molding resembling twisted rope, using it in the new dining room and, on a smaller scale, repeating it throughout the house. This detail occurs in a number of other houses designed by the firm. However, the only known Long Island examples are the Fincke house at Southampton and the Winthrop Taylor house, "Deepwells," at nearby St. James. The large dining room (22 by 32 feet) added on the north side of the house was unique in that the north wall was of glass, consisting of three high, round-topped windows which could be lowered into pockets below the floor to afford the total enjoyment of the rose garden, lawn, and vista beyond to Stony Brook Harbor.[27] This delightful and exquisite estate with the original barns still standing, survives relatively unaltered.

George W. Bacon Residence, "Thatch Meadow Farm," St. James, Alterations, Barn, c. 1914 (Extant)

The George W. Bacon place, "Thatch Meadow Farm," is also on Stony Brook Harbor in St. James. Here an 18th-century house was enlarged by adding two consecutive lateral wings on the west of the main structure which was left unaltered. A handsome new barn and clock tower

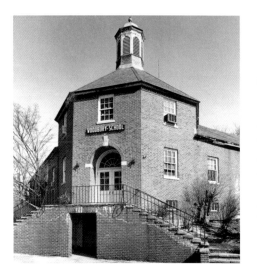

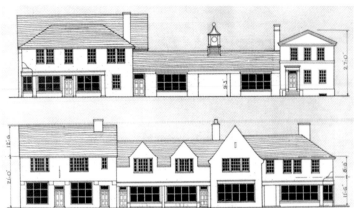

Peabody, Wilson & Brown:
Walt Whitman School,
Woodbury, c. 1923 (Harvey
Weber photo, 1983)

Peabody, Wilson & Brown:
The Heelbarp Corporation
Building, Westhampton,
c. 1930 (AMAR, 1933)

complex was built for Bacon's herd of Guernsey cows. George W. Bacon, a Cornell graduate of 1892, was the principal partner in Ford, Bacon and Davis, a world-renowned engineering firm.[28]

William H. Dixon Residence, St. James, c. 1927 (Extant)

The William H. Dixon house in St. James, another early Smith family home located on Stony Brook Harbor, reportedly had been built partly in the last years of the 17th century. Aside from adding a new kitchen, installing bathrooms, and building a service wing, the architects altered the house very little in this remodeling. The only change was the removal of a wall between the front parlor and two first-floor bedrooms, thus creating a larger living room. The new entrance porch was copied from an old house in Wading River.[29]

Other remodeling commissions by the firm include the Carl J. Schmidlapp residence, Mill Neck (c. 1920); alterations for Mrs. Montgomery Hare in Smithtown (c. 1922); the Winthrop Taylor residence, "Deepwells," in St. James (c. 1923); the C. C. Auchincloss residence, Wheatley Hills (c. 1925); the Fulton Cutting house (originally the C. C. Rumsey house), also in Wheatley Hills (c. 1930); and alterations to the F. S. Von Stade residence in Westbury (c. 1930).

The following sampling of the firm's nonresidential commissions shows the architects' sensitivity and versatility. Many of the nonresidential projects were directly related to their country-house work, either through their social connections, such as the Library and Carnegie Institute in Cold Spring Harbor, or through previous estate commissions.

Cold Spring Harbor Library, 1913 (Extant)

The Cold Spring Harbor Library was one of the firm's early commissions, probably for their friend Robert W. de Forest. This small, one-story, five-bay, hip-roofed structure with a columned, pedimented entrance portico and octagonal cupola cost $11,743 to build. The entrance porch with its four columns, railing, and side benches is reminiscent of the typical Long Island entrance stoop.[30] The building now functions as The Gallery for the Society for the Preservation of Long Island Antiquities.

Walt Whitman School, Woodbury, c. 1923 (Extant)

Executed ten years later and quite different in appearance was the Walt Whitman School in Woodbury. This has always been one of the most admired buildings on Jericho Turnpike. Its unusual design and purity of line were especially noteworthy, and remain so today. It has been reported that Julian Peabody was considerably challenged by the odd shape of the site and this angled building was the result of that restriction. The main body of the building is a simplified brick octagon with wings extending to the south and east. This is a typical example of the taste and restraint of this firm's response to a challenging commission.[31]

The Heelbarp Corporation Building, Westhampton, c. 1930 (Extant)

Planned to serve the many interests of the average suburban downtown, this group of one- and two-story shops has an English feeling, created by the building's irregular composition and variety of roof lines. It is interesting that at this time, when the firm was already exploring both the "stripped" styles and the International Style, the architects decided to design in an eclectic "Modern Picturesque" idiom for this commission that both contributed to and conformed to

344

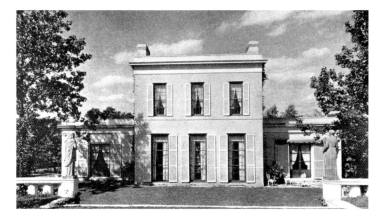

Pennington, Lewis & Lewis: Rear Facade, H. Pleasants Pennington Residence, Locust Valley, c. 1938 (COUN, 1931)

the ambience of the streetscape.[32] Here Peabody, Wilson & Brown succeeded in uniting all the components in a harmonious manner.

Other nonresidential commissions of the firm include the Huntington Town Hall (1911); the Eugenics Record Office and the Experimental Research Building at the Carnegie Institution for Biological Research in Cold Spring Harbor (1913); the Children's Library in Westbury (1924); the North Country Community Hospital in Glen Cove (c. 1927); the Southampton Bathing Corporation Pavilion (1928); the Union Free School at Cold Spring Harbor (c. 1928); the Freeport Municipal Building (c. 1929); the Wheatley Hills National Bank (c. 1930); and the Glamor Ford Showroom in Smithtown (c. 1930s).

Barbara Ferris Van Liew

∎

Hall Pleasants Pennington, 1889–1942

Hall Pleasants Pennington, a principal of Pennington, Lewis & Mills, a Manhattan architectural firm specializing in apartment buildings, was a native of Baltimore where his father Josias was a well-known architect. Pennington graduated from Princeton in 1910 and studied architecture at the Ecole des Beaux-Arts in Paris. He designed at least three Long Island country houses. Pennington's own house, built c. 1929 in

Locust Valley near the Piping Rock Club, of which he was a member, was unusual in the Long Island context for both its modest scale and its neoclassic design. Published in *Country Life in America* in 1931, the house survives today. Pennington's other Long Island commissions included "Dolonar," a Georgian-style residence for Philip J. Roosevelt in Oyster Bay built in 1928 on land given to Roosevelt by his father, W. Emlen Roosevelt, and a 1927 whitewashed-brick Federal house for prominent Manhattan pediatrician Dr. Harold Mixsell.

Robert B. MacKay

∎

John H. Phillips, 1876–1921

John Phillips was born and raised in Sun Prairie, Wisconsin, but practiced in Manhattan as an architect, etcher, and teacher. The firm he founded continued under his name at least until 1940. Active as a member of the Salmagundi Club, he made his home in Babylon, Long Island. His most notable work is the Elizabethan Theatre in Upper Montclair, New Jersey. His firm's first Long Island commission was a two-and-a-half-story, Federal-inspired brick residence designed in the 1928 on Cleft Road in Mill Neck for James T. Bryan. This was followed in 1929 with a 28-room Cotswold-inspired design for George Anderson in Brookville that was enlarged in 1938.

James Ward

∎

Charles A. Platt, 1861–1933

A man of varied and accomplished artistic production, Charles Platt deserves to be remembered as the penultimate American country-house architect. He designed 12 of his 82 major suburban or country residences for Long Island clients, primarily between 1904 and World War I. This regional microcosm both reflects the

John H. Phillips: Front Facade, James T. Bryan Residence, Mill Neck, 1928 (SPLI, 1980)

John H. Phillips: Front Facade, George A. Anderson Residence, Brookville, 1929 (INVE, 1979)

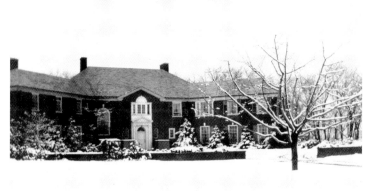

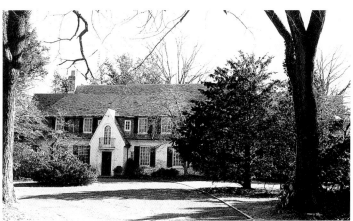

Charles A. Platt, 1861–1933
(COUN, 1927)

general development of Platt's ideas on domestic architecture and permits a closer focus on his handling of site, planning, and style—issues on which he evolved firm responses. His dozen Long Island country houses, and a small number of related commissions, also reveal significant trends for the American country house, clearly one of the most important building types of the early 20th century. In addition, these projects permit characterizations both of Platt's patronage network and of the nature of the Long Island country-house environment.

Platt's personal and artistic background equipped him ideally to provide the complete country-living ambience for wealthy and sophisticated New Yorkers of the early 20th century. He was born in Manhattan in 1861, the son of John Platt, a successful corporate lawyer, and Mary Cheney Platt, a descendant of the Cheney family, owners of a silk mill in Manchester, Connecticut.[1] Reared in a home where literature and the arts were encouraged, Charles Platt decided to become an artist before he entered his teens. While showing little interest in his general education, he enrolled in classes at the National Academy of Design and the Art Students League, supplementing them with summer sketching trips. On one such outing in 1879, he met the artist Stephen Parrish, who introduced him to the art of etching, then experiencing a revival in America. As he would later with other new media, Charles quickly mastered the etching process and established a professional reputation before his twentieth year. By this time, however, he had decided upon a career as a landscape painter, and in 1882 he sailed for Paris to begin five years of training, first on his own and later in the Académie Julian. He returned to New York at the end of the decade intending to pursue a landscape painter's career.

The transition from etching and painting to architecture occurred for Platt in the 1890s and proceeded "through the garden gate." In 1892, being dissatisfied with the training in landscape architecture that William, his younger brother, was receiving in the Frederick Law Olmsted office, Charles proposed that he and William spend several months sketching, measuring, and photographing the Renaissance and Baroque gardens of Italy. The results of their expedition included two articles for *Harper's Magazine* in 1893 which were reissued as a book, *Italian Gardens,* the following year.[2] The popularity of this publication, the first illustrated monograph in English on Italian gardens—and Charles's eagerness to apply the principles that he had learned—led to several major commissions for American gardens beginning in 1896.

The second element that encouraged Platt to desert his proposed career as a painter was the success of his projects as the designer of summer houses for artist friends. From 1889 until his death in 1933, Platt summered in the artist colony at Cornish, New Hampshire, designing houses and gardens for fellow painters, sculptors, writers, and others from 1890 onward.[3] By the turn of the century, marriage and the financial needs of an expanding family, reinforced by a growing list of architectural clients, convinced Platt that architecture, especially the design of houses and gardens, would provide the most fulfilling and remunerative expression of his diverse talents.[4] His lack of formal training in either architecture or landscape architecture did not stand in the way; once again he achieved quick and easy mastery of his choice of media.

Platt's projects on Long Island clearly reveal the rapid maturing of the young architect's genius. In the first year of the new century, Platt still vacillated between thinking of himself as a landscape designer or an architect. His most important projects of the late 1890s were definitely the landscape plans he devised for country houses designed by other architects, and his first Long Island commissions were most likely secured because of his recent work as a landscape architect. In 1900, both Herbert L. Pratt and Frederic B. Pratt commissioned Platt to prepare designs for entrance gates to their nearby estates at Glen Cove.[5] The resulting ball-mounted limestone piers with wrought-iron gates give little indication of Platt's later Long Island work, except in the obvious classicism and attention to all details of design that these simple drawings suggest. Much more important than the designs were the patrons, sons of Charles Pratt, a founder of the Standard Oil Company, and the creator of an immense family estate complex on Dosoris Pond in Glen Cove, where Platt would later build two of his most impressive houses. The Frederic Pratt house at Glen Cove had been designed in 1898 by the New York firm of Babb, Cook & Willard.[6] George Fletcher Babb had been a frequent visitor to the sculptor Augustus Saint-Gaudens, Platt's neighbor at Cornish, New Hampshire, and he would most certainly have seen Platt projects there during his visits. Babb may have been responsible for directing the incidental garden-related projects at Glen Cove to Platt to help the younger man establish himself. There is no record, however, in the Platt or Pratt archives suggesting that the commissions included a landscape plan, only posts, gates, and walls.

One reason for Platt's quick success as a country-house architect was his personal relationship with two of the leading architectural critics of the period. Both Royal Cortissoz, art

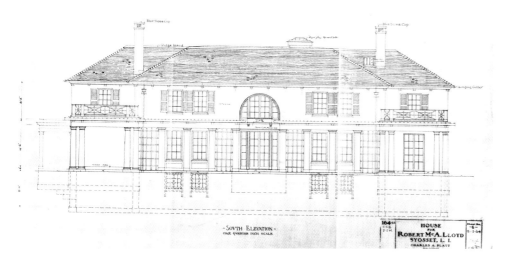

Charles A. Platt: South
Elevation, "Tapis Vert,"
Robert M. Lloyd Residence,
Syosset, c. 1904 (AVER,
Charles A. Platt Collection,
n.d.)

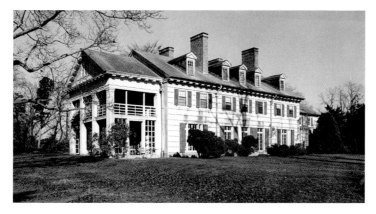

Charles A. Platt: South
(Rear) Facade, "The
Mallows," C. Temple
Emmet Residence, Stony
Brook, 1905 (SPLI, Joseph
Adams photo, n.d.)

inheritance of American students at the Ecole. But the static, empty effect of this space, contained by dense woodlands on three sides and focused on an underscaled loggia at the far end, is one of the rare instances in which Platt's innate sense of proportion and effect in landscape seems to have failed him.

Although the house has been altered by the addition of a third floor under a gabled roof with dormers and the reworking of the main staircase and interior paneling, the original plan demonstrated Platt's skillful, direct organization of exterior and interior space. A central, wide stair hall divided the house from front to back, flanked by the drawing and dining rooms overlooking the garden vista. The hall was designed so that upon entrance to the house, the immediate, dramatic view presented was the two-story rear archway and axial greensward.[8]

C. Temple Emmet Residence, "The Mallows," Stony Brook, 1905 (Extant)

If the Lloyd house reveals a lingering ghost of Platt's first projects in New Hampshire, "The Mallows" is more representative of his mature work of the first decade of this century. In 1904 Platt had designed "Sylvania," a country retreat for John Jay Chapman, the literary critic, at Barrytown on the Hudson River. Elizabeth Chanler Chapman, who carefully supervised the construction of the house, must have recommended Platt to her sister Alida Chanler Emmet as architect for "The Mallows." The Emmet house is also located near "Box Hill," the summer house of architect Stanford White, who designed the barns for the Emmet complex. White had also designed an earlier house, "Sherrewogue," for Devereux Emmet, Temple's brother, which somewhat influenced Platt's designs for "The Mallows,"[9] as did "Wyck," a house begun in 1690 in Germantown, Pennsylvania.[10]

For the high site overlooking the Head of the Harbor inlet, Platt created a two-and-a-half-story, gabled, rectangular block with the entrance centered on the north, the water side of the house. At the west end, Platt extended a slightly lower gable into a monumental Doric portico, creating a loggia at the first level and a sleeping porch above, both of which provided views to Long Island Sound. This porch arrangement was probably inspired by "Sherrewogue," which otherwise had a more rambling and informal feeling than the Platt design. Stanford White had used large-scale, white-painted shingles and a characteristic shed-roofed entrance porch to suggest a vernacular

critic for the New York *Sun*, and Herbert Croly, an editor of *Architectural Record* and a client for a Platt-designed house in Cornish, supported and encouraged Platt's work as an architect. In 1904 Croly wrote a lengthy review for the *Architectural Record* surveying his neighbor's work to date.[7] This may have resulted in Platt's first Long Island commission for a country residence and its grounds, which shared certain characteristics with Cornish projects illustrated by Croly in his *Architectural Record* article.

Robert MacAlister Lloyd Residence, "Tapis Vert," Syosset, c. 1904 (Extant)

"Tapis Vert" reveals the dual influences of Platt's close study of the villas of Renaissance Italy and his contact with American architectural students at the Ecole des Beaux-Arts during his own student years in Paris. The stuccoed exterior, the original low-hipped roof, the paired projecting rear loggias, and the wisteria-entwined lattice surrounding the monumental central arch of the garden elevation all speak of the warm textures and interpenetration of interior and exterior space that Platt found so appealing in Italian models. The garden plan emphasized a rectangular greensward on axis with the central archway of the rear facade. This obviously French device was undoubtedly the source for the name of the house and characteristic of the landscape

Charles A. Platt: Front
Facade, James A. McCrea
Residence, Woodmere,
1909 (HICK, 1911)

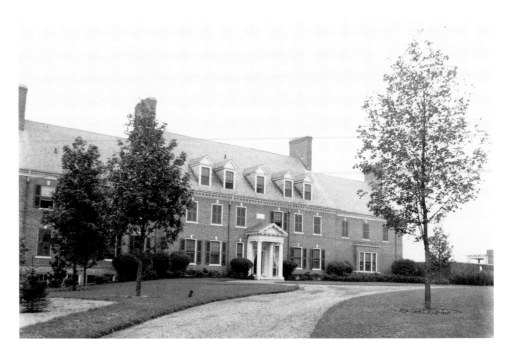

Charles A. Platt: First and
Second Floor Plans, James
A. McCrea Residence,
Woodmere, 1909 (AVER,
n.d.)

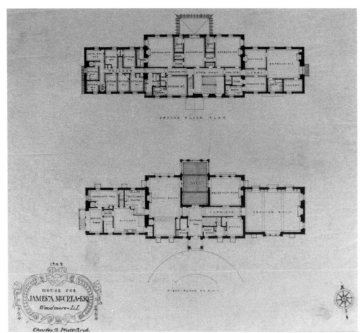

end, "The Mallows" has little resemblance to either of the houses from which Platt drew ideas, but represents his practice of adapting design ideas from other buildings to the needs of a new commission.

James Alexander McCrea Residence, Woodmere, 1909 (Demolished)

Although the number and scale of Platt's country-house commissions continued to grow after 1905, he did not undertake another Long Island project until the end of the decade. In 1909, however, he worked on three major country estates on both the North and South shores. For the railroad capitalist James Alexander McCrea, Platt designed his only South Shore house at Woodmere. This commission marked his first statement of a theme or formula that would characterize several of his later Long Island commissions. A seven-bay, two-and-a-half-story central section was flanked by two-story wings of three or four bays in width, one devoted to service, the other designed for a drawing room with bedrooms above. The interior plan, here and in later commissions, emphasized a dominant short axis from entrance hall to rear loggia, crossed by perpendicular corridors to connect major rooms on the first and second floors. The relation of the house to its surroundings was zoned with an entrance on the north, a vista across open lawns to the water on the south, a formal flower garden to the west, and a service court to the east.

Long Island Colonial farmhouse. Platt was not interested in the picturesque quaintness of White's design, but did respond here to other American Colonial forms. In the numerous albums of reference photographs Platt assembled in his office library were a series of "Wyck" views which document the relationship of that model to both "The Mallows" and to a somewhat similar house that Platt designed in 1904 for Marshall Slade at Mount Kisco, New York.[11] "Wyck" provided inspiration for a web of lattice to cover the stuccoed rear elevations of both houses and a series of glass double doors opening from the major rooms onto a brick terrace across the garden elevation. Platt coordinated the scale of the door muntins, the applied lattice, and the lattice infill of the west portico to create a system of continuous geometry. In the

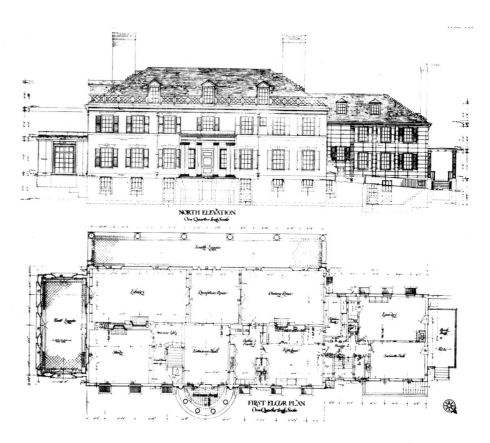

Charles A. Platt: North Elevation and Floor Plan, "The Orchards," George R. Dyer Residence, Brookville, 1910–10 (ARRV, 1912)

NORTH ELEVATION
One Quarter Inch Scale

FIRST FLOOR PLAN
One Quarter Inch Scale

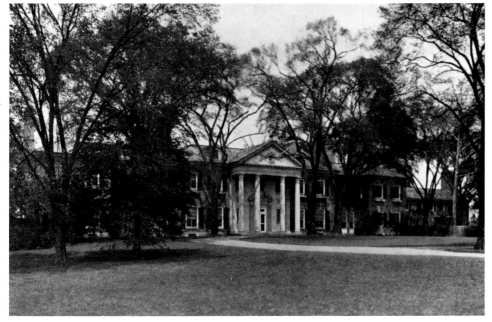

Charles A. Platt: Entrance (South) Front, "Manor House," John T. Pratt Residence, Glen Cove, 1909–15 (PLAS, 1913)

Mt. Vernon's piers to composite columns and liberally opened the rear elevation through five bays of glass double doors.

John Teele Pratt Residence, "Manor House," Glen Cove, 1909–15 (Extant)

The third project of this period was the largest and most interesting of Platt's Long Island commissions. John Teele Pratt, a brother of the men who had been Platt's earliest clients on the Island, requested designs for a new residence in the Pratt family complex at Glen Cove. Included were Platt schemes for the main house, formal gardens, grounds, garden pavilion, garage and stable, laundry building, children's playhouse, a camp on Long Island Sound, and the alteration of an existing farmhouse for guest quarters. The majority of the work was completed by 1911, but Platt was still working on alterations as late as 1915. The cost of construction was close to $300,000.[12] By 1915 Platt was also at work on plans for a New York City townhouse for the same client. Taken together, the two houses give a full picture of the aspirations of wealthy New Yorkers in the years before World War I.

In the "Manor House" designs Platt reveals his occasional excursion into restrained Georgian elegance. Despite its exceptional height of two-and-a-half stories, the building reads as a horizontal composition because of the extraordinary extent of its rectilinear plan. The horizontality was offset by the graceful verticals of the ancient elms among which the house was

George R. Dyer Residence, "The Orchards," Brookville, 1909–10 (Extant)

A contemporary project that was typical neither of Platt's work in general nor of his Long Island commissions was "The Orchards." This broadly spaced seven bays of stuccoed entrance facade below a dominating hipped roof gave no indication of the Mt. Vernon-derived monumental colonnade across the rear elevation. Platt admired specific American Colonial buildings but he rarely betrayed his inspiration as clearly as in this rear colonnade. However, he changed

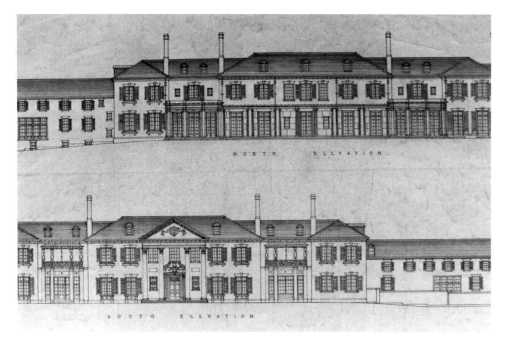

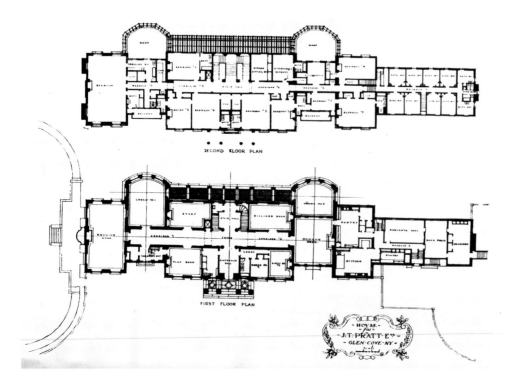

from view by high brick walls, projected from the west end of the building.

The main axis from the entrance portico on the south passed through the wide stair hall with its paired staircases climbing the outside walls and turning to meet over an uninterrupted vista to Long Island Sound. A broad cross-axial corridor was the circulation route for the relatively few but large public rooms on the first level. The drawing room, the largest and most prominent room in the house, whose 15-foot, 6-inch ceiling was the highest Platt ever designed, was placed at the western end and was connected by an ample hallway to the dining room at the opposite, eastern, end of the house, with a massive service wing extending beyond it.

Both Mr. and Mrs. Pratt had large studies on the first floor. (Mrs. Pratt's office is incorrectly labeled as a billiard room on the plan.) These rooms also served as informal sitting areas before and after dinner on evenings when the immense scale of the drawing room was inappropriate. All the public rooms were arranged along the north side of the house with views through sheltering elms and across rolling lawns to Long Island Sound. The rooms were also connected on the north through two projecting loggias and an interconnecting pergola. The western loggia was the larger of the two and provided more informal expansion for the adjacent drawing room. The eastern loggia was located north of the dining room and was used as the breakfast room.

The sense of clear axial organization and obvious progression through the house was extended out into the landscape. The location of the house with its main view of Long Island Sound to the north meant that the southern exposure could only be partially utilized by Platt. He ensured, however, that the most important rooms—the drawing room, dining room, and master bedroom—all enjoyed both the water view and a southern exposure. Atypical for a Platt house was his placement of the children's playroom and the bachelors' bedrooms on either side of the entrance hall, segregating these units from the major public rooms yet providing southern sunlight and easy means of exit.

Extending from the house in the four cardinal directions were distinct areas of function with differing landscape treatments, each screened from the other. The southern lawn contained a densely planted grove of elms, partially screening the house from view and suggesting centuries of domesticity. The northern lawn was more open to allow the widest possible

Charles A. Platt: North/South Elevations, "Manor House," John T. Pratt Residence, Glen Cove, c. 1909–15 (AVER, n.d.)

Charles A. Platt: Floor Plans, "Manor House," John T. Pratt Residence, Glen Cove, c. 1909–15 (PLAS, 1913)

set and the frequent projections or recessions of its components. Built of dark-red brick, the house was fronted on the south by a projecting, monumental limestone portico of the composite order. This frontispiece may have been inspired by two of Platt's favorite Colonial houses, "Homewood," near Baltimore, and "Whitehall," near Annapolis.[13] From this central focus, the building spread laterally in a five-part, Palladian plan. The seven-bay, hipped-roof, central section was flanked by recessed, gabled hyphens with elaborate wrought-iron balconies, which connected to cross-axial, hipped roof-end pavilions. A recessed, two-story service wing extended on axis from the eastern end of the house, and the formal flower garden, concealed

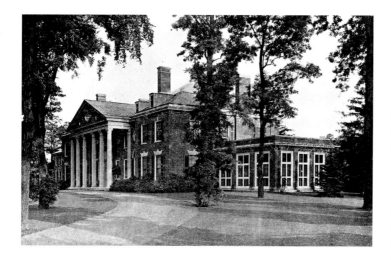

Charles A. Platt: Entrance Front, "The Elms," Clifford J. Brokaw Residence, Glen Cove, 1912–14 (BRIC, 1916)

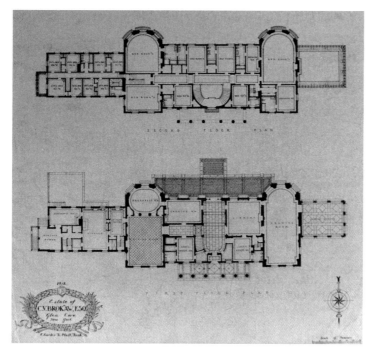

Charles A. Platt: First and Second Floor Plans, "The Elms," Clifford J. Brokaw Residence, Glen Cove, 1912–14 (AVER, n.d.)

with southern exposure and separate entrance ensured the children of maximum enjoyment of their retreat without danger of their interfering with the activities of their parents and weekend guests. The ten bedrooms for servants within the house were supplemented by additional housing for servants throughout the estate. Recreational facilities included a bowling alley in the basement.

In 1915, just as the final adjustments on the "Manor House" were completed, John Pratt commissioned Platt to design a townhouse on East 61st Street in Manhattan. The five-story house, faced in limestone, was the grandest city residence Platt designed in Manhattan. Until their owners' death in 1927, the two residences Platt had designed for the Pratts admirably fulfilled that family's needs. At the time of his death, John Pratt had just completed his morning's commute by yacht from Glen Cove, suggesting a possible preference for the more expansive lifestyle of his country home.

Clifford J. Brokaw Residence, "The Elms," Glen Cove, 1912–14 (Demolished)

In this house for a client who was a successful broker, Platt reworked certain ideas from the Pratt house on a slightly reduced scale. For Brokaw, Platt increased the size of the portico to six monumental Ionic columns but removed the hyphen sections of the Pratt five-part plan. He retained a clear vista through the building, with the stairway curving over the entrance vestibule. A less dominant cross-axis hallway again connected the drawing and dining rooms at the east and west ends of the house with bowed projections on the north front and a brick terrace between. The service wing extending on axis beyond the dining room was partially balanced by a loggia attached to the drawing room. The Brokaws would certainly have known the recently completed Pratt house and may have asked Platt to produce something similar for them. Unfortunately, the house was demolished in 1946.

Francis M. Weld, Jr., Residence, "Lulworth," Lloyd Harbor, 1912–14 (Extant)

A second Long Island commission more characteristic of Platt's country-house work in general and of domestic architecture on Long Island in the years before World War I, was the residence for a New York lawyer and a descendant of the Weld family of Boston for whose relatives Platt had designed two important gardens at the turn of the century.[14] On a site high above Long Island Sound at Lloyd Harbor, Platt placed a two-story, nine-bay, gabled brick box across the

panorama of the Sound. The architectonic formal garden was placed at the west end of the house, aligned with the axis of the drawing room and contained by walls and planting so as not to compete with the natural landscape vista. A service court, approached by a separate road, was concealed at the southeast corner of the building. And to the north and east, again separated from all other landscape features, Platt placed a large, circular pool hidden by encircling banks of rhododendrons. The other service and pleasure facilities were removed from the immediate environs of the house. The stable-garage complex and farmhouse for guests were removed to the south, and the camp was located on the shore of the Sound.

Platt skillfully integrated the needs of family life and entertaining into the plan for the "Manor House." There were 11 bedrooms for the family and guests, including the separate suite for bachelors on the first floor. A playroom

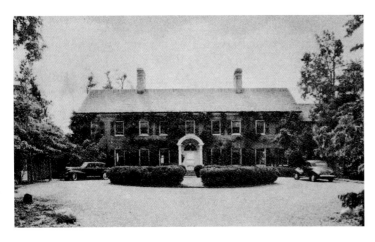

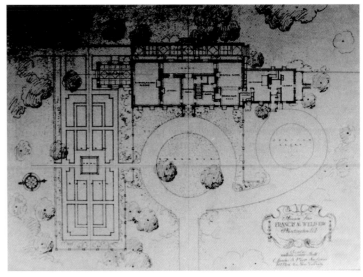

Charles A. Platt: Entrance
Facade, "Lulworth," Francis
M. Weld, Jr., Residence,
Lloyd Harbor, 1912–14
(PREV, n.d.)

Charles A. Platt: Plot Plan,
"Lulworth," Francis M.
Weld, Jr., Residence, Lloyd
Harbor, 1912–14 (AVER, n.d.)

Charles A. Platt: Swimming
Pool and Bathhouse,
"Kiluna Farm," Ralph
Pulitzer Additions,
Manhasset, 1913 (PREV,
c. 1937)

Charles A. Platt: North and
South Elevations, L.C.
Ledyard, Jr., Residence,
Syosset, 1914 (AVER, n.d.)

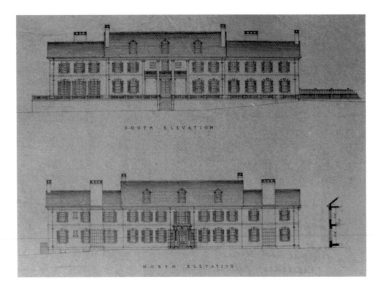

were again segregated at opposite ends of the
house. The center entrance hallway connected
to a transverse hall across the rear, forming a T-
shaped circulation pattern. Otherwise, the finely
scaled red-brick exterior resembled the con-
trolled elegance of earlier commissions, such as
the McCrea project.

Ralph Pulitzer Additions, "Kiluna Farm," Manhasset, 1913 (Partially Demolished)

The importance of recreation and gardening to
the American country house of the time is
emphasized by the projects Platt undertook for
the publisher Ralph Pulitzer. For a site distant
from Pulitzer's Manhasset country place, Platt
designed a swimming pool and bathhouse set
off in the woods. South of the main house, he
added a formal garden, a large rectangle cen-
tered on a circular lily pond with a rustic pergo-
la across the short end furthest from the house.
The pool and pool house were conspicuously
Roman, with a thermal design for the contain-
ing balustrade, stop-fluted columns set into an
exedra at one end of the pool, and changing
rooms ranged on either side of this semicircle.

Lewis Cass Ledyard, Jr., Residence, Syosset, 1914

For this client, Platt built a house and, three
years later, designed a garden and pavilion.
Once more, using stucco over hollow tile
blocks, Platt planned a two-and-a-half-story,
seven-bay, central gabled section with two-story
gabled wings attached to the short ends, one
containing the library and bedrooms, the other
comprising the service areas for the house. The
pattern of pulling out the plan along the trans-
verse axis was one that Platt explored in several
commissions during these years, including his
next Long Island commission. A second plan-

axis of the approach drive and view to the har-
bor. The entrance drive from the east culminat-
ed in a circular court in front of the house and
continued on to a concealed service yard on the
north; a one-story loggia connected a walled
flower garden on the south to the drawing
room; and a brick terrace across the west front
provided the water views for which the site had
been chosen. Only the lower two-story service
wing on the north broke the simplicity of the
main mass of the house. The more condensed
massing of the exterior is reflected in the clearer
interior plan. The drawing and dining rooms

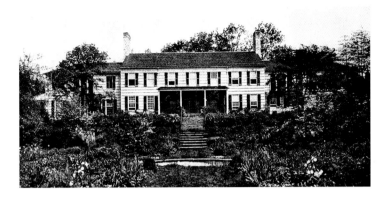

Charles A. Platt: Rear Facade, "Pidgeon Hill," Meredith Hare Residence, Huntington, 1916–17 (ARRC, 1920)

ning concern he investigated here was the creation of transitional spaces between the inside and outside areas. The inset two-story loggia on the center of the rear elevation provided a casual living area at the first level for summer and warm weekends throughout the year and a sleeping porch at the second level. Both provided a view down the central allée stretching on axis behind the house.

Meredith Hare Residence, "Pidgeon Hill," Huntington, 1916–17 (Extant)

This commission bears a revealing similarity to Platt's Ledyard scheme. Again, a seven-bay, two-and-a-half-story core is extended laterally by two-story Ls to the left and right, which contain the library and service areas, respectively. Within the central block, Platt included a loggia at the middle of the rear elevation. This time, however, more than half of the loggia extends beyond the rear wall of the house, pushed out to accommodate a large stair hall, a feature absent from the Ledyard commission. Despite the relationships in planning, however, Platt produced two houses of strikingly different character. For the Hares, Platt used a large, rough, white-painted shingle, the vernacular material of Colonial Long Island architecture. The attenuated colonnettes of the rear projecting loggia and the gabled entry porch with its built-in benches suggested the welcoming and informal lifestyle of an ample farmhouse. The view from the Hare loggia overlooked two terraces moving down to a circular flower garden and on to a small lake. This circular garden represented a collaboration of Platt and a friend from Cornish, Ellen Shipman, who provided the planting schemes for several gardens at Platt houses.[15]

World War I marked a turning point in Platt's career. The number of country-house projects that he executed in the 1920s, both nationally and on Long Island, declined radically, in the main for socioeconomic reasons. Instead, institutional, commercial, and urban projects claimed his attention. Even earlier, however, Platt had already noted a shift in the tastes of his clients and the work of his colleagues. In 1927, in a rare interview published in *Country Life in America,* he offered some observations on recent American domestic design. After praising the developments beginning in the 1880s based on precedents from the Italian Renaissance through the 18th century, Platt noted a change around 1917, "when somewhere and for reasons difficult to ascribe the progress was halted and a tendency to picturesqueness became the order of the day. . . . 'Interest' in a house," he continued, "should derive from the planning and handsome facade rather than from the curious texture of its surface or the trick in its interior arrangements."[16] Some historians have suggested that young architects returned from the war in Europe with their heads and scrapbooks full of sketches of farmhouses, manors, and quaint village streets they had seen from Normandy to the Rhine.[17]

At the same time the more casual lifestyle of the well-to-do during the postwar years—one less dependent on servants, among other things—may also have influenced the trend to less formal country houses. In any case, the identification of Platt's work with classical elegance and balanced, axial plans appears to have diminished the number of country-house commissions he received during the last decade of his professional career. His two postwar commissions on Long Island represented a continuation of the patronage network that had nurtured his earlier work.

Frederic B. Pratt Residence, "Poplar Hill," Glen Cove, 1917–24 (Extant)

The first of these was a new country house for a client for whom he had designed gates and walls as early as 1900. Frederic Pratt, brother of John Teele Pratt, may well have been encouraged to demolish his earlier summer residence in order to replace it with a more comfortable one by the giant scale of Platt's design for "Manor House." Frederic Pratt's new house was set on Poplar Hill and originally enjoyed a commanding view of Long Island Sound. The entrance on the north was from a circular drive set in a square courtyard. Built of a warm tan St. Quentin stone, the entrance elevation consisted of a two-and-a-half-story, seven-bay central section flanked by two-bay, gable-end pavilions. Tall stone chimneys topped by terra-cotta pots emphasized the divisions between the main and side sections. Both the choice of material and the oak entrance doors surmounted by segmental transoms suggested the forms of 18th-century France.

The interiors of "Poplar Hill" include a combination of paneling designed by Platt and

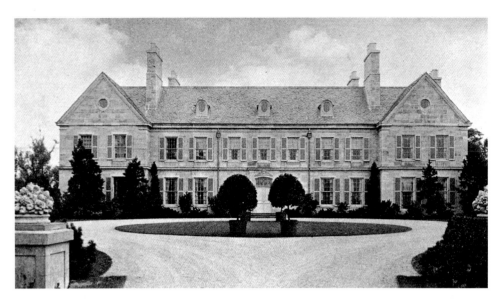

Charles A. Platt: Entrance
Facade, "Poplar Hill,"
Frederic Platt Residence,
Glen Cove, 1917–24 (ARAT,
1927)

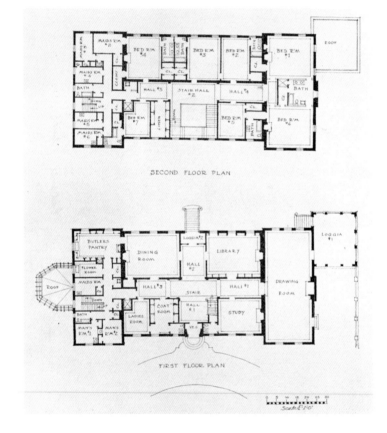

SECOND FLOOR PLAN

FIRST FLOOR PLAN

Charles A. Platt: Floor
Plans, "Poplar Hill,"
Frederic Platt Residence,
Glen Cove, 1917–24 (ARAT,
1927)

Lansing P. Reed Residence, "Windy Hill," Lloyd Harbor, 1926–27

A successful attorney who had numbered J. P. Morgan among his clients, Lansing Reed may have met Platt through their membership in the Century Club, of which Platt was president at the time of the commission. Reed was also a trustee of Phillips Academy, Andover, Massachusetts, for which Platt was executing multiple projects at the time. The Reed house, the last domestic project Platt completed on Long Island, was set at the edge of a hilltop with a commanding view over Lloyd Harbor to the west. The entrance drive took an L-shaped route, with the final leg ending in a circle in front of the house. Built of white-painted shingles, the house had a five-bay, two-and-a-half-story central section flanked by two-bay projecting, hipped-roof end pavilions. A one-story loggia extended to the south and a two-story service wing stretched to the north. Gardens designed by Platt and Ellen Shipman were placed on terraces adjoining the house on the west and the south. Within the house a wide hallway facilitated the characteristic vista from the entrance to the distant harbor. The library and dining room flanked this hall on the west side of the house, while the drawing room, the largest space in the house, consumed the entire depth of the two-bay southern section of the building. The choice of large white shingles, similar to those used for the Hare project, ironically provided the same interest in texture that Platt had criticized in the *Country Life* article written while the Reed house was under construction.

A number of characteristics distinguish Platt's Long Island commissions from his country-house work in general and, perhaps, from country houses designed by his contemporaries. First, his projects represent an extraordinarily tight community of patrons, the clients for more than half of the commissions being connected through family or business associations. Secondly, when compared with Platt country houses overall, recreation facilities seem to have been emphasized in these commissions and formal gardens de-emphasized. Thirdly, there are clearly similarities in the planning of the interior spaces, although the variety within these patterns shows Platt's persistent inventiveness and response to the changing needs of each client and site. And finally, the stylistic intentions of Platt's designs show his unfailing devotion to post-Renaissance classicism, while all his designs escape from the restraint of proper precedents to reveal new forms appropriate to the conditions, uses, and expectations of specific patrons.

In the patronage for these dozen Long Island projects, one obvious commonality among clients was membership in the Century Club, a

antique woodwork—from Gothic linenfold paneling to a gilt Venetian ceiling—acquired by Platt for the house from 1920 onward. This practice of installing antique woodwork became increasingly popular during the 1920s, but "Poplar Hill" is the only house in which Platt used old materials at the owner's request. The result was an interior environment that was eclectic rather than—as was usual with Platt's work—one of uniform architectural character, for although Platt had often selected furnishings for his country-house commissions without a purist concern for a simple style or period, he sought a more uniform classicism in the interior architecture he designed.

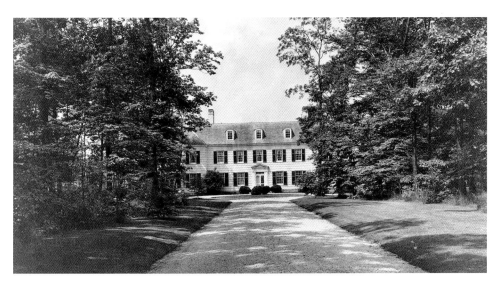

Charles A. Platt: Entrance
Front, "Windy Hill,"
Lansing P. Reed Residence,
Lloyd Harbor, 1926–27
(CORN, n.d.)

prominent New York men's association for those interested in arts and letters. Platt was a member from 1889 until 1933, and served as president from 1927 until 1929. His Long Island clients who were fellow Centurions included Frederic B. Pratt, Robert MacAlister Lloyd, Lewis Cass Ledyard, Lansing P. Reed, and Francis M. Weld.[18]

Even more significant was the interrelationship among Platt's Long Island patrons and their connection with earlier Platt clients. The latter included the direct relationship, for example, of the John Jay Chapman residence at Barrytown, New York, with C. Temple Emmet's at Stony Brook. Or the connection between Francis M. Weld and two other descendants of the Weld dynasty of 19th-century Boston—Anna Pratt Sprague and Isabel Weld Perkins Anderson—who, with their husbands, were clients for important Platt gardens in Brookline, Massachusetts, built between 1897 and 1901. And the network of the Pratt family on Long Island was, of course, far-reaching.

Family and business relationships aside, Platt's clients shared many characteristics. Nearly all inherited substantial wealth, much of it in the family for more than one previous generation.[19] They all went on to expand their inheritances as successful lawyers, brokers, railroad executives, and publishers, as well as through skillful investment in an age of economic growth. Their country houses provided release from competition in the marketplace on the one hand and an environment for transaction of political, financial, and other negotiations on the other.

These men and their families pursued leisure with the same vigor that they devoted to their professional lives. A number of them were avid sailors—including Francis M. Weld, John T. Pratt, and James A. McCrea—and the majority of Platt's Long Island houses had direct access to

the water. The pleasure that tennis provided for Ralph Pulitzer was shared by nearly all of the other clients, and swimming pools were constructed at 7 of the 12 houses Platt designed. The bowling alleys at the "Manor House" or the squash building at the Emmet estate suggest the range of other recreation interests. And, of course, all of these estates provided easy access to private country clubs, where golf, tennis, or polo could be the focus of activity. Certainly, health consciousness was a major factor in the popularity of country living.[20]

Another national characteristic of the time was an enthusiasm for nature and gardening. Platt demonstrated clear and uniform planning principles for both houses and gardens in his Long Island commissions. And just as he established planning rules for axial alignment, bilateral balance, and a clear relationship of interior spaces to the site, Platt evolved a strict philosophy for the architectural character of his houses. He firmly believed that American domestic architecture would develop its finest expressions by basing designs on appropriate historical models. For Platt, these included the buildings of Renaissance Italy and subsequent architecture in France, England, and America that displayed the same knowledge of classical forms. Although the Italian Renaissance was his first love, Platt did not design any Long Island country houses of Italian inspiration, with the possible exception of the Ledyard house at Syosset. Only the Frederic B. Pratt house displayed the Renaissance-based forms of 18th-century France in the use of St. Quentin stone, the oval dormers, and the oak double doors with segmental transom. The remaining Long Island commissions were designs derived from 18th-century England or Colonial America. These ranged from the Long Island regional vernacular form of large, white-painted shingles for the Meredith Hare house to the English-inspired finely scaled brickwork, limestone trim, and delicate wrought-iron work for John Pratt's "Manor House." Although most Platt houses projected a certain national or stylistic identity, he was not a purely revivalist architect. He fully absorbed and reworked his sources so that the new building had a fresh sense of design coherence and suitability to the needs of the client and of the time. To Platt, his buildings were thoroughly modern and totally appropriate to the demands of elegant country living on Long Island in the early 20th century.

Keith N. Morgan

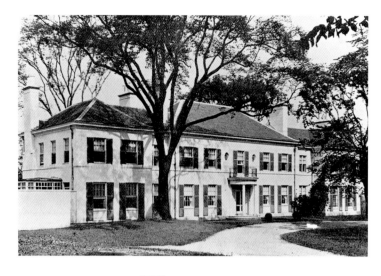

William Platt: Front Facade, "Beachwood," John T. Pratt, Jr., Residence, Glen Cove, 1930 (HOWE, 1933)

William Platt, b. 1897

Son of famed architect Charles Adam Platt, William Platt was born in New York and educated at Harvard and Columbia. Completing his studies in 1923, the young Platt assisted his father before forming a partnership with his brother, Geoffrey, in 1934. "Beachwood," built in 1930 for John T. Pratt, Jr., at Glen Cove, represented a collaboration of two generations. John Pratt's grandfather, Charles Pratt, was a co-founder of the Standard Oil Company and founder of the Pratt Institute. His sons built some of the most significant residential architecture of their era in Brooklyn and at Glen Cove. In 1909 John Teele Pratt, Sr., had commissioned Charles Platt to design his "Manor House," which, like William Platt's house for John Teele Pratt, Jr., was in the Neo-Georgian style. More specifically, the formally balanced design of "Beachwood" is in the Federal mode. The long, hipped-roofed central block is linked to end pavilions by recessed single-bay wings. The horizontal lines of the whitewashed brick facade are relieved by a semi-elliptical entrance porch flanked by oculi. On the garden elevation, shallow bow windows on either side of the central French door provide similar variety of form.

Michael Adams

John Russell Pope, 1874–1937

In the course of his distinguished career, John Russell Pope's achievements as an architect were recognized and honored both at home and abroad. Upon his death in 1937, the *New York Times* summed them up in highly adulatory terms:

John Russell Pope's contribution, keyed to so lavish a scale of endeavor furnished with so deep a knowledge of the elements involved, must be submitted to the tribunal of time. We may, however, applaud with a sincere and reasoned enthusiasm the consistency of purpose that animated him throughout his career as an architect. A disciple of the Neoclassical belief in both the rightness and practicability of perpetuating in America the ideals of an ancient world Mr. Pope was equipped with brilliant success to translate his dreams into a speech of marble. Those dreams—those temples that sit serene in the moil and toil of modern commerce—belong to a specific period in our development as a nation; help express and interpret what has been called the "sweeping orgy of architectural 'embellishment and aggrandizement'" of the era through which we have just lived and in which we still strive to come to grips with our national soul.[1]

Born in an age of nascent academic classicism, Pope received the perfect training to pursue a successful career in architecture before World War II. After three years at the City College of New York, he entered the Department of Architecture in the School of Mines at Columbia University. Under the tutelage of William Robert Ware, the founder of American architectural education, Pope was imbued with principles that affirmed the inherent importance of historical precedent and encouraged strict adherence to the classical principles of design.

In 1895, the year following his graduation from Columbia, Pope won the first McKim Rome Scholarship to the American Academy in Rome, and the following year the Schermerhorn Traveling Scholarship. These awards provided him with 18 months of close contact with the great architectural monuments of the Mediterranean basin. In 1897 Pope entered the Atelier Deglane at the Ecole des Beaux-Arts, where he studied for three years, completing his exposure to the principles and paradigms of a classical academic education. In 1900 he returned to New York and entered the office of Bruce Price. By 1903 he was practicing on his own and running the Atelier McKim at Columbia's School of Architecture.

Today Pope is recognized, above all, for his successes as the designer of an impressive list of

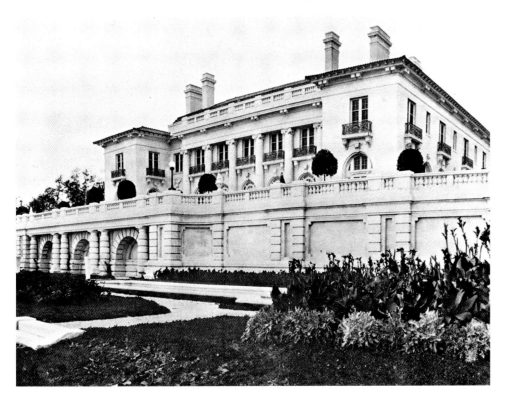

John Russell Pope: Terrace and South Facade, William L. Stow Residence, Roslyn, 1900–1903 (FERR, 1904)

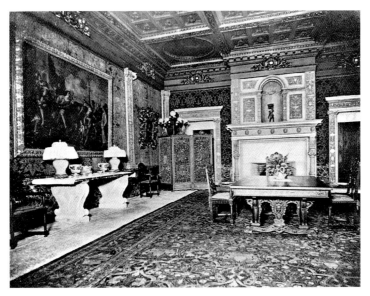

John Russell Pope: Dining Room, William L. Stow Residence, Roslyn, 1900–1903 (FERR, 1904)

public buildings, churches, museums, and monuments, including the National Archives Building in Washington, D.C. (1929–35), the American Museum of Natural History in New York (1925), the National Gallery and Jefferson Memorial in Washington, D.C. (completed by Eggers and Higgins after his death), and galleries at the British Museum and the Tate Gallery in London (1937–39), among others. In 1921, however, Pope was recognized as a consummate designer of both country houses and public buildings. His Hitt House in Washington, D.C. (1907–09) and his Temple of the Scottish Rite in Washington, D.C. (1910–17) were both considered the *dernier cri* of their respective building types.[2]

Just as Freedman's Hospital and the John McLean House (commissions shared with Price) won Pope acclaim in Washington, so his involvement on Long Island stemmed from his work in Price's office, for it was there that he probably met the people who would, in a few years, become his clients, including William K. Vanderbilt, Jr., and William L. Stow. As one would expect, his early involvement on Long Island was limited to smaller outbuildings, gate houses, and stables. It was one of these smaller projects, the Vanderbilt gate house (1905), that apparently attracted the attention of the press and helped Pope gain subsequent commissions from Vanderbilt and his circle.

The success of several more outbuildings and the accompanying attention in the press afforded Pope a greater clientele. Subsequent stylistic development of his work followed the vogue of the then nationally popular styles. However, Pope was characteristically able to go beyond merely copying various styles to absorbing their underlying principles, with the result that his works ended up as perfect restatements of particular modes. This skill gave his designs a credibility and solidity lacking in the work of many of his contemporaries. At the same time, his avoidance of superfluous ornamentation gave his houses a casual dignity that was especially appealing to the country-house owner who preferred to reserve his yearnings for ostentation for his city residence.

William L. Stow Residence, Roslyn, 1900–1903

Pope's early work can be classed as decidedly French-inspired, although he never resorted to the Beaux-Arts excesses of such contemporaries as Jules de Sibour and Joseph Freedlander. The Stow House, designed in the manner of an Italian Renaissance villa with the eclectic addition of French-influenced details, was one of Pope's most important early commissions, probably conceived while he was still in Price's office. Critic Herbert Croly described the appearance of the house as "smart and gay; but . . . also careful . . . sober. . . ."[3] The structure itself also seems to have expressed Price's conservative strain of design. The apparent success of this building set the stage for other works designed in a consistently restrained manner that created a unified effect out of seemingly disparate forms. This house is no longer standing.

John Russell Pope: South Gate Lodge, "Deepdale," W. K. Vanderbilt, Jr., Residence, Great Neck, 1906 (ARRC, 1921)

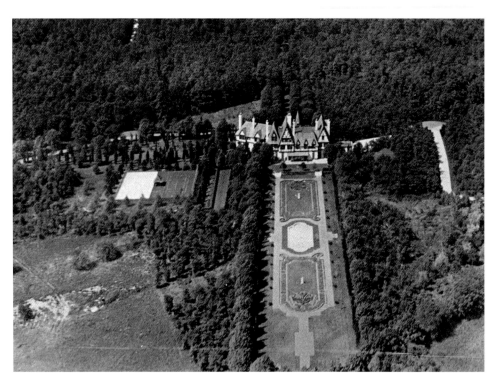

John Russell Pope: Aerial View of House and Formal Gardens, Mrs. W. K. Vanderbilt, Jr., Residence, Jericho, c. 1911 (AVER, c. 1930)

John Russell Pope: Artist's Rendering, Michael Gavin Residence, Brookville, 1928 (Smithsonian Institution, n.d.)

William K. Vanderbilt, Jr., Gate Lodge, Great Neck, 1906; Mrs. William K. Vanderbilt, Jr., Residence, Jericho, c. 1911

After the Stow commission, Pope's work showed two divergent strains. The first manifested itself in a rather short-lived move to an early Northern Renaissance mode, best characterized by his work for the Vanderbilt family. In his gate lodge for William K. Vanderbilt, Jr., Pope's incessant attention to historic methods of construction and picturesque massing, coupled with a Ruskinian interest in detail, combined to create one of the few American outbuildings for which several reviews were written. In

Mrs. Vanderbilt's house, similar attention to detail and massing were lavished on the building that was designed in what was for Pope an uncharacteristically Norman half-timber mode. This choice of style probably reflected the client's Francophile tastes, reinforced by her frequent motor tours across France before her estrangement from her husband. The house is no longer standing.

Michael Gavin Residence, Brookville, 1928

The house Pope designed for lawyer and banker Michael Gavin, also in the Norman mode, was similarly massed, but built of stone. (It was destroyed by fire in 1928.)

The Gavin house also seems to stand as further confirmation that Pope's work of the late 1920s was often nothing more than a rote continuation of the work of the previous five years. Designed, as requested by the client, in the mode of a French château, the exterior decoration of the house, with its elaborate dormers and arcaded wings, seems to owe much to Chambord, while the U-shaped mass would seem to derive from Pope's designs for the Gould house. Since few illustrations of this house seem to have survived, any detailed analysis of the house's function is impossible. However, based on the existing information one must reiterate that this house seems to be a more extensively decorated restatement of Pope's previous designs in this mode.

The dog-leg plans of the building are characteristically American, evoking a romantic image that is found as well in Pope's works in Rhode Island—"Bonniecrest" for Stuart Duncan in Newport, Rhode Island (1912), and the Myers residence in Watch Hill, Rhode Island (1915). This picturesque note continued to surface in Pope's work from time to time, most notably in his work in the South, finding expression in a variety of modes. In Long Island it marked his design of a house on the South Shore.

Joseph P. Knapp Residence, "Tenacre," Southampton, c. 1920 (Extant)

For publisher Knapp, the architect designed a house in the Shingle Style. Although this was a relatively small commission, the romantically sloping gable and relatively loose massing, skillful handling of the shingles as a membrane, and effectively sympathetic plantings demonstrate Pope's skill in this mode. A contemporary critic, commenting on the reserved interior, noted that

John Russell Pope: Entrance Front, "Tenacre," Joseph P. Knapp Residence, Southampton, c. 1920 (AMAR, 1922)

John Russell Pope: Cottage, "Brookholt," O. H. P. Belmont Residence, Hempstead, c. 1906 (ARRC, 1921)

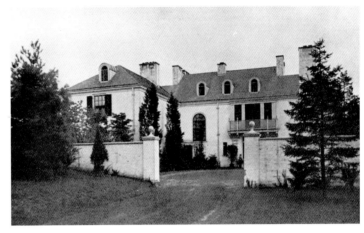

John Russell Pope: Front Facade and Entrance Court, "Old Acres," Robert L. Bacon, Sr., Residence, Westbury, 1907 (ARRC, 1911)

John Russell Pope: "Arlough," Robert L. Bacon, Jr., Residence, Westbury 1915 (PATT, 1924)

"those elements of refined gentility that have become the outstanding feature of our domestic architecture"[4] were present in Pope's design. The house survives today as a private residence.

Pope received greater acclaim for the second strain that characterized his domestic work, a restrained, severe approach reminiscent of several architectural styles ranging from vaguely Tuscan through severe Georgian and Adamesque to stripped Norman. Generally speaking the plans of all his houses were derived from the same principles, so that the layouts became somewhat formulaic. The formula, which he probably learned in Price's office, called for a separation of entry spaces from living areas by means of a large entry hall. This created a buffer, a transitional space that prepared guests coming in from the outside for the more private living areas.

O. H. P. Belmont Cottage, Hempstead, c. 1906

Pope's move toward severity and refinement of detail, with a corresponding emphasis on proportion and massing, produced a conservative architecture that matched perfectly the tastes of his wealthy and powerful clients. The cottage he designed for banker O. H. P. Belmont was described as having a "peaceful rural atmosphere, while at the same time it indicates to the passer-by that it is the farmhouse of a gentlemen farmer."[5]

Robert L. Bacon, Sr., Residence, "Old Acres," Westbury, 1907

Robert L. Bacon, Jr., Residence, "Arlough," Westbury, 1915 (Extant)

Both these houses were designed in a mode whose type escaped characterization by contemporary critics. In these houses all superfluous detail was avoided, the result being stark buildings that recalled small Italian farmhouses, or *casa colonica*. The power of the somber image thus created derived from the buildings' proportions and stark murality. In the house for the son, Pope relieved the severity by employing an L-shaped plan and finishing the exterior with distressed whitewash. These two elements combined to create a surprisingly picturesque image from initially austere elements.

J. Randolph Robinson Residence, Wheatley Hills, c. 1917 (Extant)

J. Seward Pulitzer Residence, Wheatley Hills, c. 1925

Pope approached the Colonial Revival mode in the same severe and analytical manner that he confronted the problem of the Italian *casa colonica*. Deriving his *partis* from familiar sources, most notably Mount Vernon and the typical five-part Maryland house, Pope endowed the Robinson and Pulitzer houses with aloof

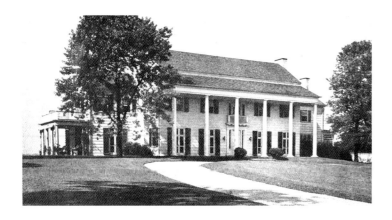

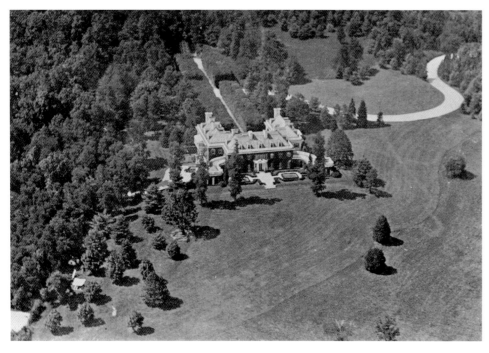

John Russell Pope: Entrance
Front, J. Randolph
Robinson Residence,
Wheatley Hills, c. 1917
(COUN, 1919)

John Russell Pope: Artist's
Rendering, J. Seward
Pulitzer Residence,
Wheatley Hills, c. 1925
(Smithsonian Institution)

John Russell Pope: Aerial
View of Entrance Front,
"Jericho Farm," Middleton
S. Burrill Residence, Jericho,
c. 1906 (ELWO, 1924)

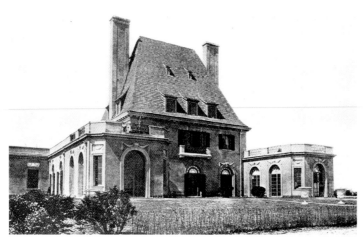

John Russell Pope: Garden
Facade, "Châteauiver,"
Charles A. Gould Residence,
Greenlawn, 1908 (ARRC,
1911)

and austere main facades that contrasted with
picturesque rear elevations.

The Robinson house now serves as the Fine
Arts Center of C. W. Post College, Long Island
University.

The Seward Pulitzer house's aloof and ex-
cessively austere facade is a clear demonstration
of the occasionally banal outcome of Pope's
efforts in this style. The main facade is a scaled
and watered-down version of the Carstairs
house (near Philadelphia). Its picturesque rear
elevation probably reflects the use patterns of
the house.

Middleton S. Burrill Residence, "Jericho Farm," Jericho, c. 1906 (Extant)

Charles A. Gould Residence, "Châteauiver," Greenlawn, 1908

The largest and most ambitious of Pope's early
commissions, his houses for Middleton Burrill
and Charles A. Gould demonstrate his further
experimentation with reducing different modes
to their stylistic essentials.

The Burrill house, the more ambitious pro-
ject of the two, is a highly eclectic mix of styles
united only by the uniformly austere interpreta-
tion they receive. Despite the attenuation of
decorative elements, the elaborate Palladian
plan negates any real sense of simplified form.
At the same time, the imposition of various clas-
sical elements introduces a dissonant note. The
most successful element is the entry facade, with
its two large wings enclosing a courtyard. Since
1953 the Burrill estate has housed the Meadow
Brook Club.

An exuberant slanted roof of handsome tile
and engaged pilaster chimneys, characteristic
of a style of French hunting box popular as a
model for country estates, capped the Gould
house. The roof accentuated the location of the
building, on one of the highest points on Long
Island. The H-shaped symmetry of the plan,

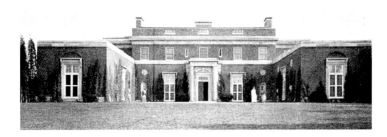

John Russell Pope: Entrance Front, Odgen L. Mills Residence, Woodbury, c. 1915 (PATT, 1924)

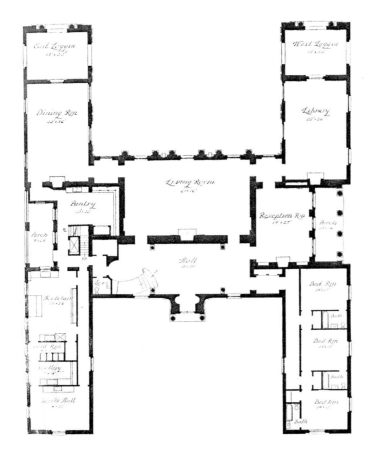

John Russell Pope: Floor Plans, Ogden L. Mills Residence, Woodbury, c. 1915 (PREV, n.d.)

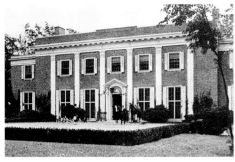

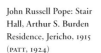

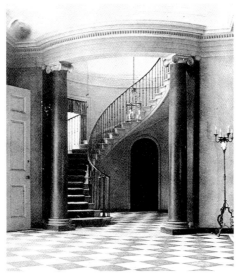

John Russell Pope: Front Facade, Arthur S. Burden Residence, Jericho, 1915 (PATT, 1924)

John Russell Pope: Stair Hall, Arthur S. Burden Residence, Jericho, 1915 (PATT, 1924)

however, ran counter to the effect created by the flamboyant roof, as did the extreme economy of detail, which created an almost scaleless, impersonal exterior. The southern wing of the house contained bedrooms; the central portion housed the formal public rooms; and the northern wing accommodated the owner's office and the service facilities. The house was demolished in 1954.

Ogden L. Mills Residence, Woodbury, c. 1915 (Extant)

Pope's most famous early houses on Long Island resulted from his masterful manipulation of the Adamesque style—the Mills house and the Burden/Cary house of 1915. In planning a house for Secretary of the Treasury Ogden Mills, Pope selected an H-shaped plan, spreading the house over a low plateau to provide views in all directions. This ensured that the house would be flooded with light and avoided giving it a rambling appearance.

Unique among Pope's work, the building was massed as a two-story central block flanked by one-story wings. Such decorative elements as Adamesque niches with urns and low-relief plaques were used to supplement a large attached order in the two courtyards. Entry to the house was from the north side. The monumentality of the structure was softened by a large opening and open loggias on the southern legs of the building. To further soften the effect of severe angularity and murality, heavy vines were planted against the walls.

Pope's emphasis on mass proportion and understated detail provided his clients with a solid conservative architectural vocabulary that perfectly met their needs. The buildings were neither extravagant nor ostentatious in their detail or material, achieving their monumentality through massing and refined detail. This former country house is now the Woodbury Country Club.

Arthur S. Burden Residence, Jericho, 1915

Contemporary critics called the house built for iron baron A. S. Burden, and later owned by Burden's widow, Mrs. G. F. Cary, "as nearly perfect for purposes which the modern American Country house is planned to serve as anything can be . . . cool and sure and skillful."[6] This coolness is especially conveyed by severely understated exteriors that emphasize the classical volumetric proportions of the building.

U-shaped in plan, with wings flanking the garden facade, this house projected a serene and strong outward presence through its main facade. The arched open-bed pediment and

John Russell Pope: Rear Facade, "Caumsett," Marshall Field III Residence, Lloyd Harbor, 1921–25 (COUN, 1927)

John Russell Pope: Stable Group, "Caumsett," Marshall Field III Residence, Lloyd Harbor, 1921–25 (COUN, 1927)

blind fan of the entry provided a strong caesura in the rhythm of the giant Adamesque pilasters that marched across the main facade. In the intervening bays, double-height windows created a strong connection between the interior and exterior.

The interior's most striking feature was an elliptical stair hall off the entry hall. Pope's facility with form was demonstrated by his handling of the juncture of the stair and entry halls. At this point a semicircular entablature jutted out into the ceiling of the entry hall, without disrupting the symmetry and proportion of the hall itself. Living room, library, and dining room occupied two-thirds of the U, while a service wing extended to the east. This service area was balanced by a loggia and plantings to the west. The house was demolished in the 1950s.

Marshall Field III Residence, "Caumsett," Lloyd Harbor, Huntington, 1921–25 (Extant)

Pope's most ambitious work on Long Island was carried out in the Georgian style, popular in the 1920s for its air of solid comfort and reserved dignity. His earliest work in that style, as well as the best known because of its scope and scale,

was the estate for Marshall Field III. "Caumsett" was begun in 1921, when Field bought 1,750 acres at Lloyd Harbor to be developed as a completely self-contained rural estate with 25 miles of roads, facilities for generating electricity, a dairy farm, greenhouses, and a stable complex. Also disposed around the estate were various athletic facilities, including riding stables, tennis courts, ponds, wharves, and beach cabanas. The main house itself was organized according to the usual Pope formula, with a central great hall and adjoining stair hall providing a mediating space between public intrusions and private rooms.

Although referred to as early Georgian during the period of its construction, the house borrows more heavily from late Stuart sources; clearly the formal severity of such houses must have appealed to Pope. In fact, the spatial planning of the Field house resembled the plan of "Eltham Lodge" in London, whose entrance served as one of the precedents for the north facade of the Field house. For the southern facade, Field appears to have borrowed heavily from slightly later houses such as "Hanbury Hall" (Worcestershire), "Coles Hill" (Berkshire), and "Belton House" (Lincolnshire). The polo stable complex is clearly based on that of "Arbury Hall" (Warwickshire). For the remaining outbuildings, Pope used a variety of sympa-

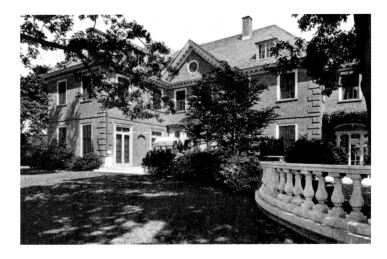

John Russell Pope: Rear Facade, Joseph J. Kerrigan Residence, Oyster Bay, 1929 (COUN, 1933)

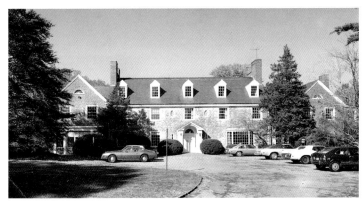

John Russell Pope: Front Facade, "Mariemont," H. W. Lowe Residence, Wheatley Hills, 1927 (Richard Cheek photo, 1981)

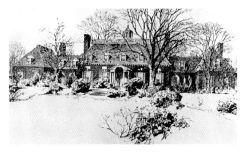

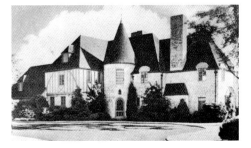

John Russell Pope: Sketch, Wayne Johnson Residence, Southampton, c. 1925 (COUN, 1925)

John Russell Pope: Front Facade and Entrance Court, "Les Bouleaux," Louis F. Bertschmann Residence, Syosset, 1937 (PREV, n.d.)

result, did not display to the full the severity characteristic of Pope's own work. Several eclectic elements in the interior, including a Louis XVI sun room and a Regency reception room, create a somewhat jarring eclectic interior. The house survives today as a private residence.

The H. W. Lowe Residence, "Mariemont," Wheatley Hills, 1927 (Extant)

The H. W. Lowe house seems to be another composite of New England and Mid-Atlantic Federal forms. Pope, at this point, seems to be composing a new mode based on the vast precedent of American vernacular. The ground plan is a variant on the five-part plan, while its interior articulation, including the semicircular thrust of the main staircase, follows the expected pattern. The interior decoration, with its chaste Adamesque detailing, maintains a tone in consonance with the sparse exterior design. Not surprisingly, this house also seems to be based on Pope's Wilkins house in Maryland and could be considered its northern counterpart if one ignores the change in material from stone to stucco and whitewashed brick. However, the addition of a large porch and the use of more refined details make this residence more exciting than the Wilkins house.

Wayne Johnson Residence, Southampton, c. 1925

The house for attorney Wayne Johnson in Southampton is a composite of the typical Tidewater five-part house and more direct borrowings from James River plantations such as "Westover" and "Shirley," with further additions of other Colonial details including the balustraded roof, cupola, and entry porch. With its Flemish-bond brickwork, the result is an excessively busy pastiche whose forms fail to gel into an integrated image.

Louis F. Bertschmann Residence, "Les Bouleaux," Syosset, 1937

During the Great Depression, Pope's architectural focus turned from residential to more monumental works, such as the National Archives building in Washington, D.C. As a result, he left most of his later domestic commissions to his younger draftsmen, who lacked his sense of refined severity. This is demonstrated most clearly in "Les Bouleaux," built in 1937. Compared with the strength of Pope's earlier Norman designs, this is clearly a tentative effort. It is the combination of that tentativeness on the one hand, and a strict adherence to classicism on the other, that led to Pope's work being

thetic styles, including Dutch Colonial for the beach and winter houses. The gate house was the original Henry Lloyd house of 1711, and the dairy barns, taking their inspiration from it, were shingled, painted white, and adorned with a Tuscan order. Today "Caumsett" is owned and operated by the New York State Parks Department.

Joseph J. Kerrigan Residence, Oyster Bay, 1929 (Extant)

In the five years following his work on the Field house, Pope designed two major houses in the same mode. The Kerrigan house, however, was decidedly more antiquarian than the Field house because its decorative elements were taken from or patterned exactly after English precedent. The entry was removed from a house in Portland Square in London and the front balusters were also taken from a site in Britain. The interiors were decorated in paneling also brought from various English sites and, as a

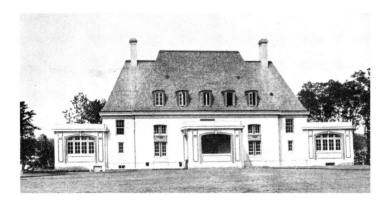

John Russell Pope: Petit Trianon Restaurant, Lake Ronkonkoma, 1907 (TOWN, 1911)

overlooked by architectural historians. However, an examination of his residential work on Long Island prior to 1930 suggests that its cool refinement and academic severity reflected the personal styles and preferences of his clients.

Long Island Motor Parkway Buildings, 1907

While Pope, for the most part, disdained commercial commissions, the Long Island Motor Parkway was difficult to refuse for two reasons. First, it was commissioned by one of his most important clients, William K. Vanderbilt, Jr. Second, it was perceived as a recreational extension of country-estate life, rather than as a

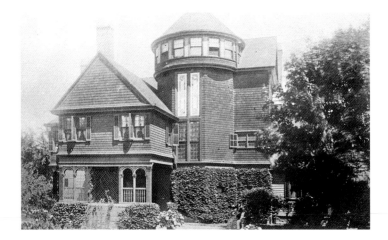

George B. Post: Alterations c. 1888, Francis T. Underhill Residence, Oyster Bay, 1885 (Oyster Bay Historical Society, n.d.)

George B. Post: Alterations c. 1890, "Strandhome," Charles A. Post Residence, Bayport (Bayport Heritage Association, n.d.)

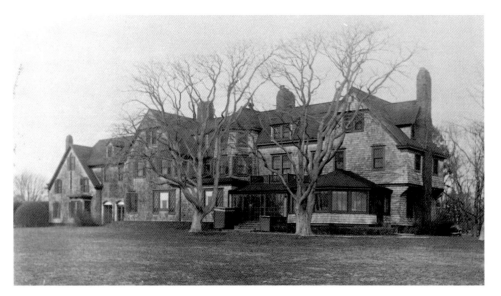

commercial venture. Vanderbilt and his circle were avid motorists and, in the first decade of this century, sponsored a road race around Long Island that, due to poor roads and reckless spectators, always caused a number of deaths. To counter this unsatisfactory situation, Vanderbilt arranged for the construction of America's first limited-access highway. It eventually ran from Queens to Lake Ronkonkoma. Pope was commissioned to design the toll houses and a hotel at its eastern terminus. Completed in 1911, the toll houses were subdued variants on the gate houses designed for Vanderbilt's own estate, while the hotel, loosely based on the Petit Trianon, was similar in massing to the Gould residence.

Steven Bedford

George B. Post, 1837–1913

Although known primarily as a great commercial architect famous for his design of the Equitable Life Assurance Building in New York City (1868–70) and whose career was synonymous with the rise of the skyscraper, George Browne Post (1837–1913) designed more than 30 country houses. Surprisingly, only one was on Long Island, his ancestral home where so many of his clients and relatives summered and where Post was a member of a yacht club (the Seawanhaka Corinthian at Oyster Bay). Perhaps his domestic work beyond Manhattan was primarily done as a favor. His country-house commissions were largely for neighbors at Bernardsville, New Jersey, while on Long Island a series of alterations appear to have been done for the benefit of relatives and a friend, Francis T. Underhill, who held memberships in four of the same clubs as the architect. Of the four house alterations credited to the firm,[1] the Shingle Style Underhill residence at Oyster Bay, originally built in 1885, was the most interesting; but what Post was responsible for in the c. 1888 remodeling three years later is not exactly known. Sadly, the same is true for his 1874 alteration to the H. A. V. Post house in Babylon for which no illustration survives. At "The Locusts," the Bellport residence of Frank Alleyne Otis, for whom Post's son John Otis Post may have been named, a surviving illustration indicates that the 1880 and subsequent 1888 alterations must have been minor in nature. At Bayport, however, the Charles A. Post and Regis H. Post houses bore a slight resemblance, possibly representing the architect's influence. William S. Post, George's son and a junior partner in the firm at the time, signed the drawing of the Regis Post house for the firm and it is possible that "Strandhome,"

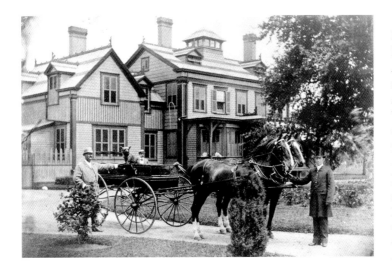

George B. Post: Alterations 1880 and 1888, "The Locusts," Frank Alleyne Otis Residence, Bellport (Bellport– Brookhaven Historical Society, n.d.)

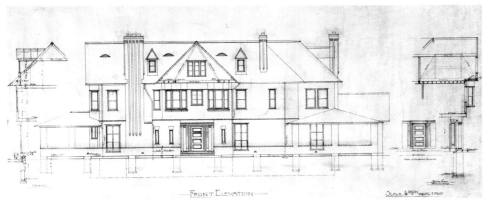

George B. Post: Front Elevation, "Littlewood," Regis H. Post Residence, Bayport, c. 1895 (NYHS, n.d.)

William Appleton Potter, 1842–1909 (Courtesy of Mrs. J. H. N. Potter)

the country seat of George's brother Charles, may have also been originally designed by the firm, which oversaw the alterations c. 1890. Today only the Regis H. Post house, a simple Shingle Style residence with a transverse gable, survives of the five Long Island efforts of the distinguished architect George B. Post, who was to receive the American Institute of Architects' highest award, its gold medal, two years before his death.

Robert B. MacKay

■

Potter & Robertson, 1875–1880
William Appleton Potter, 1842–1909
Robert Henderson Robertson, 1849–1919

The Potter & Robertson partnership existed from 1875 through 1880—a time when the English-imported Queen Anne mode was being assimilated and Americanized as the rambling, informal shingled house. Each of the New York City firm's six documented Shingle Style houses exemplifies a stage in that style's evolution, but one is more significant than the rest because it is a rare and remarkably intact survivor. It is the firm's only known Long Island house, the Mrs. S.S. Adam house (1878) in Oyster Bay.

Despite their important jointly designed houses, neither Potter nor Robertson is particularly remembered as a house architect. William Appleton Potter is noted for his college, church, and government buildings, and Robert Henderson Robertson is known primarily for his New York skyscrapers. Potter's octagonal Chancellor Green Library (1871–73) at Princeton, his strikingly massed South Congregational Church (1872–73) in Springfield, Massachusetts, and his distinctive Evansville, Indiana, Customhouse and Post Office building (1875–79) established his reputation as a leading High Victorian Gothic practitioner. Less well known, though very productive, Robertson designed the picturesquely roofed American Tract Society (1894–95) and twin-towered Park Row (1896–99) skyscrapers. Built by financier August Belmont, Jr., the Park Row, at 30 stories, was the city's tallest building at the turn of the century.

After their partnership was dissolved, both architects continued to design houses but only Robertson for Long Island. He was responsible for two Southampton cottages, that of his brother-in-law Dr. Frances H. Markoe (1886–87), and his own (1887–88). Years later, in 1902, Robertson took in Robert Burnside Potter (1869–1934), William Potter's nephew, as his partner; the firm, now Robertson & Potter, produced at least one and likely several cottages for Regis H. Post in Bayport. None of these Long Island houses qualify as mansions by North Shore standards, but all are capacious, well-designed summer residences.

Potter & Robertson's first summer house was the Bryce Gray house (c. 1877), built in Long Branch, New Jersey. Its informal massing, abundance of shingled and half-timbered gables, center-hall plan, and all-embracing veranda were, fortunately, further developed in the Mrs. S. S. Adam house, for the Gray house is long gone.

It is impossible to say for sure whether one or the other partner was responsible for the firm's houses. Robertson was clearly the junior partner; but, as he already had to his credit one of the earliest American houses to manifest "Queen Anne" features—the Theodore Timpson cottage (1875) in Seabright, New Jersey—and as he rendered the published perspectives of many of the firm's houses including the Adam house, he may have been the firm's house designer.

The firm's next cottage, which immediately preceded the Oyster Bay house, was the Commodore C. H. Baldwin house (1877–78) in Newport. It was directly inspired by H. H. Richardson's famous Newport house for William Watts Sherman (1874–76).

Potter & Robertson: Christ
Episcopal Church, Oyster
Bay, 1878 (AMAR, 1878)

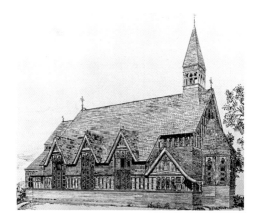

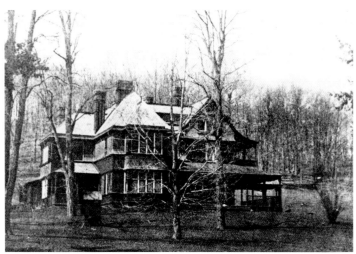

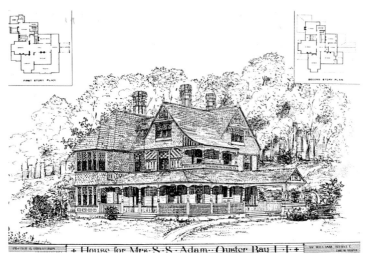

+ House for Mrs. S. S. Adam. Oyster Bay. L. I. +

Potter & Robertson: Facade,
"Hillside," Mrs. S. S. Adam
Residence, Oyster Bay, 1878
(SPLI, c. 1900)

Potter & Robertson: Design
Rendering, First and Second
Floor Plans, "Hillside,"
Mrs. S. S. Adam Residence,
Oyster Bay, 1878 (AABN,
1878)

Potter & Robertson:
Entrance Hall, "Hillside,"
Mrs. S. S. Adam Residence,
Oyster Bay, 1878 (S. B.
Landau photo, c. 1974)

Christ Episcopal Church, Oyster Bay, 1878 (Extant)

Potter & Robertson also designed Christ
Episcopal Church (1878) in Oyster Bay. Orig-
inally partially shingled with Queen Anne
gables over its leaded glass windows, this very
domestic-looking building was enlarged and
completely encased in stone walls by Delano
& Aldrich in 1925. Listed among the parish-
ioners in the vestry minutes of 1878 are four
members of the Adam family—doubtless the
link to Sarah Sampson Adam whose Oyster
Bay house, known as "Hillside," was designed
by Potter & Robertson that same year.

Mrs. S. S. Adam Residence, "Hillside," Oyster Bay, 1878 (Extant)

Mrs. S. S. Adam lived in New York City and
was the widow of John H. Adam, who had been
president of the New York Gas Light Company.
About 1913 she rented her Oyster Bay house
to Dr. Richard H. Derby and his wife Ethel
Roosevelt Derby. In 1917 the Derbys bought
the house, and Mrs. Derby, who was President
Theodore Roosevelt's youngest daughter, lived
there until she died in 1977.[1]

As a result of having been so long occupied
by the same family, the house has been very
little altered and may even have retained its
original paint colors until it was bought by the
Derbys. It was then yellow with red trim, a
combination in vogue in Newport during the
early 1870s. According to Vincent Scully's
definition of the Shingle Style, the house is
almost as advanced as William Ralph Emerson's
C. J. Morrill House (1879) in Bar Harbor,
Maine; and its combination of clapboards and
imbricated shingles is actually more character-
istic of the type than the entirely shingled
Morrill house. Especially appealing are its cor-
ner balconies subsumed by the swooping eaves
and the snug union of veranda and library wall.
Along with the sunflowers, half-timbering,
and leaded-glass windows commonly associated
with the Queen Anne style, classical moldings
and pilaster motifs suggestive of the nascent
Colonial Revival also decorate the exterior.

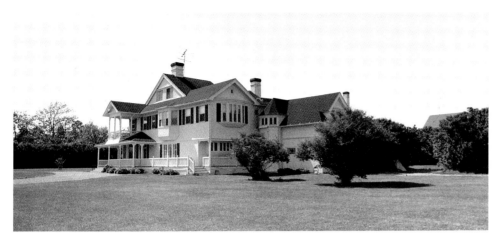

Potter & Robertson:
"Sunnymede," Dr. Francis
H. Markoe Residence,
Southampton, 1886–87
(INVE, 1979)

R. H. Robertson:
"Wyndecote," Robert H.
Robertson Residence,
Southampton, 1887–88
(INVE, 1979)

R. H. Robertson: Rogers
Memorial Library,
Southampton, 1895 (INVE,
1979)

Inside, the principal rooms open off either side of an entrance hall that might be considered a living hall by virtue of its fireplace. In general the medium-sized rooms and traditional layout seem cozily Colonial, but the extruded service wing and projecting library and dining room walls reflect the period's ideals of free planning. Throughout the house a variety of carved floral motifs—sunflowers, rosettes, and dogwood blossoms—decorate window and door surrounds.

Dr. Francis Markoe Residence, "Sunnymede," Southampton, 1886–87 (Extant)

By 1886, the year Robertson designed "Sunnymede" for Dr. Markoe, the fashion for picturesque summer cottages had altered markedly. Largely due to the influence of H. H. Richardson and McKim, Mead & White, simpler massing and more casual designs with fewer decorative details had become the style. In its discussion of a contemporary house by Robertson, the *Art Age* observed, "Within the past few years the Queen Anne craze has sobered down a little, and exterior effect and ginger-bread embellishment have given place to interior comfort. . . ."[2] And, as explained by Mosette Broderick, "Houses at Southampton, like those of this period [1880s] at Newport, were designed to fit in with the Colonial character of the towns."[3] "Sunnymede," now re-sided with clapboards, combines the simplicity of a Colonial farmhouse with effects such as the double-tiered entrance porch, bay window, and towerlike section that recall the complexities of the Adam house. Considerations of comfort, openness to the view towards the ocean, and a leisurely lifestyle seem to have determined the design. The wing at the east end of the house appears to be a 19th-century addition. About the time the house was finished, Robertson designed "Hammersmith Farm" (1887–89) in Newport for John W. Auchincloss. Sited high on a bluff overlooking Narragansett Bay, that large, shingled house is in many respects a grander "Sunnymede."

Robert H. Robertson Residence, "Wyndecote," Southampton, 1887–88 (Extant)

In 1887 Robertson also began building his own house, "Wyndecote," just behind and to the north of the Markoe cottage. Known today as the T. Markoe Robertson house, after Robertson's only son whose family occupied it until recently, the Robertson house was inspired by Charles F. McKim's Moses Taylor house (1877) in Elberon, New Jersey. The main front, with its two-tiered veranda, broad flat-tened arches at the upper level, and band of four windows flanked by ornamental panels under the gable peak, is the section that imitates the Taylor house. Interestingly, the galleries of the Moses Taylor house seem to echo those of a chalet-like cottage just up the road in Elberon built for the New York banker James M. Brown ten years earlier (1867–68). The architect was William Potter's half-brother Edward T. Potter in whose office both William Potter and Robertson had worked during the early 1870s. Perhaps Robertson was also thinking of the Potter cottage. As the Taylor house has been

demolished, it is especially fortunate that "Wyndecote" survives.

The Robertsons left their mark on Southampton with other buildings too. R. H. Robertson's Rogers Memorial Library and Hall (1895), a discreetly picturesque brick building with some half-timbering, still functions as the town library. Robertson also designed a charming, one-story wing (1909) of the Southampton Fresh Air Home that was recently refurbished. Robertson's son T. Markoe Robertson (1878–1962), with whom he practiced after R. B. Potter left the firm—from about 1908 until his death in 1919—designed the Southampton Hospital (1911–13).

Regis H. Post, who had served as State Assemblyman from 1899 to 1900 and was to be Governor General of Puerto Rico under Theodore Roosevelt from 1907 to 1909, built six rental cottages near his own residence in Bayport in about 1902. Although only one of these can be securely documented as the work of Robertson & Potter, the others are so similar that they too may be the firm's work. The rental cottages are compactly planned, two-and-a-half-story houses that have the classical porch columns and gambrel or hip roofs associated with the Colonial Revival. Throughout his career Robertson had kept abreast of the latest developments in domestic style.[4] Post himself had a much larger shingled house (c. 1896) just up the road, which seems to have been designed by the son, William S. Post, of his distant cousin, the architect George B. Post.[5]

Sarah Bradford Landau

Bruce Price, 1845–1903
(*King's Notable New Yorkers*, 1899)

Bruce Price, 1845–1903

Born in Cumberland, Maryland, Bruce Price studied at Princeton (then called the College of New Jersey), but the death of his father, a distinguished lawyer and judge, forced him to quit his studies in order to help support the family. He took a job as a shipping clerk but studied architecture at night with the prestigious Baltimore firm of Niernsee & Neilson. In 1864 Price was hired as a draftsman, and four years later he left for a year-long stay in Europe to finish his architectural studies.

In 1877, after practicing briefly in Baltimore and Wilkes Barre, Pennsylvania, Price moved to New York. His career took off with a series of resort and residential commissions, beginning with the Long Beach Hotel at Long Beach, Long Island (demolished), which was a quarter mile in length. In the early 1880s, Price designed several summer houses and hotels in the Shingle Style at Bar Harbor, Maine, as well as on Long Island, taking his cue from early American architecture. In 1885 Pierre Lorillard of the tobacco family commissioned Price to design a resort development at Tuxedo Park, New York. Price designed the rustic gate, laid out the development, and was responsible for several important Shingle Style houses there. Lorillard also asked the architect to design a summer home in Newport, Rhode Island, ensuring Price's popularity among America's super rich.

By the turn of the century, Price was a well-known and popular public figure. During the 1890s he received more and more commercial commissions, including ones for several hotels and railroad stations in Canada; a classically ornamented 20-story office building in New York (for the American Surety Company); and a proposal for a skyscraper tower for the New York *Sun* that was never built but generated much discussion. His later work became much more classically oriented in plan and detailing, as can be seen in "Georgian Court" (1898), an elaborate estate with fountain and peristyle that Price designed for George Jay Gould at Lakewood, New Jersey, and "Williston House" (1898) in Southampton, Long Island. He also designed the memorial to Richard Morris Hunt in the Central Park wall at 71st Street and Fifth Avenue. After a global hunt for an appropriate architect, the Japanese selected Price to design a new Imperial Palace for the Crown Prince of Japan. It was his last work; he finished the plans just before his death in Paris in 1903 from a stomach disorder. His daughter, Emily Price Post, was well known for her books on etiquette and her own interest in American Colonial architecture.

Two of Price's Long Island works—"Yellowbanks" for the Roosevelt family in Oyster Bay (1881) and the Rockaway Hunting Club in Lawrence (1884, destroyed by fire in 1893)—were done in the Shingle Style. According to historians Vincent Scully and Antoinette Downing in *The Architectural Heritage of Newport, Rhode Island, 1640–1915,* Price's Shingle Style houses, particularly their massing, axial plans, and manipulation of space, were an important influence on Frank Lloyd Wright.[1] Price explained his own feelings about these houses in his book *Homes in City and Country: Our wants call for new form in plans and masses; our materials for new lines and textures in elevations; and with our national inventiveness fostered by the problem, our work becomes more and more national.*[2]

The Rockaway Hunting Club, Lawrence, 1884

The oldest surviving club on Long Island, the Rockaway Hunting Club was founded as a fox hunting and polo club in 1878 and became a center for the social life of the wealthy in an area

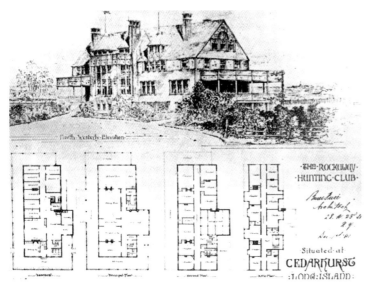

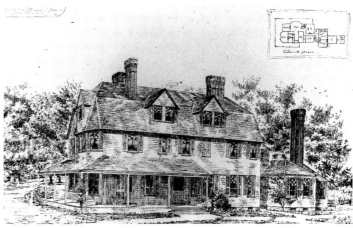

house than was typical for the time. The Shingle Style house has a wide entrance hall with fireplace, a light-filled stairwell, and other features that came to be hallmarks of the then-emerging Shingle Style. In *Homes in City and Country,* Price wrote that the house should be a "barrier between the turmoil of the world and the peace and privacy within and beyond its portals."[3] Named for the forsythia that lines the banks to Oyster Bay, the house was carefully sited to take advantage of the summer breezes and the view; it was clad in shingles and clapboards that were typical of earlier indigenous Long Island houses. Like other Shingle Style practitioners of his era, Price believed this style was the only true American architecture:

It is molded to the need of its users, and the result is a genuine American art creation, as good in itself and as honest in its purpose as any of its forerunners upon the borders of the Loire or among the hills of England.[4]

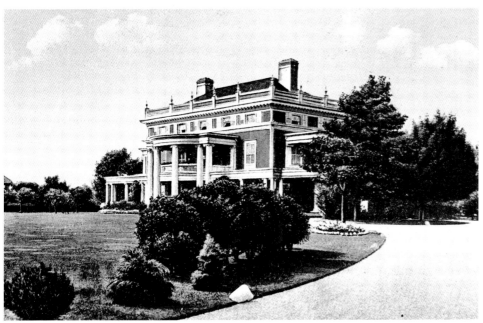

Bruce Price: Drawing and Floor Plans, The Rockaway Hunting Club, Lawrence, 1884 (*The Rockaway Hunting Club* by Benjamin R. Allison, 1952)

Bruce Price: "Yellowbanks," James Alfred Roosevelt Residence, Oyster Bay, 1881 (AVER, n.d.)

Bruce Price: "Williston House," Judge Horace Russell Residence, Southampton, 1898 (VAND, n.d.)

that had been an exclusive resort since the 1830s. The club initially used several existing buildings on an old estate, but as it grew, fueled by the popularity of polo, members decided to build a more impressive structure and add new kennels, stables, and a steeplechase course. Price designed a large, shingled clubhouse with wide porches and verandas adjacent to the steeplechase course, where members and guests gathered to watch the races. When it was completed, the clubhouse was described as the most luxurious country club on Long Island and the largest in the United States.

James Alfred Roosevelt Residence, "Yellowbanks," Oyster Bay, 1881 (Extant)

Situated on Cove Neck Road, this is one of the finest examples of Price's earlier work. Built for Theodore Roosevelt's uncle as a summer house, "Yellowbanks" is a less formally structured

Judge Horace Russell Residence, "Williston House," Southampton, 1898 (Extant)

Price's "Williston House" is more eclectic than "Yellowbanks," and with its classical detailing and a formal Beaux-Arts plan, is more typical of this architect's later work. For it, he used classical proportions, massive pillars and porticoes, and classical ornament in an eclectic and grandiose mix that was typical of many of the great estates built along Long Island's Gold Coast during this period.

Kevin Wolfe

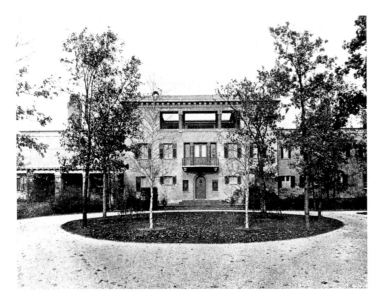

J. W. von Rehling Quistgaard: Front Facade, "Villa Gerdrup," J. W. von Rehling Quistgaard Residence, Oyster Bay, 1920 (SPUR, 1922)

J. W. von Rehling Quistgaard, practiced 1920s

J. W. von Rehling Quistgaard, the Danish artist, designed and drew the plans for his own country residence in Oyster Bay in 1920, utilizing the staff of the well-known architectural firm of Kirby & Petit for the final drawings. Italian Renaissance in tone, "Villa Gerdrup" was an original composition reflecting the owner-designer's Danish background and artistic sensibilities. The symmetrical three-story main section with flanking wings of two stories featured an unusual roof garden and was built of stucco painted a soft rose. Exterior ornamentation included wrought-iron grilles and balconies designed by Danish artist Peer Smed, and terra-cotta decoration designed by another Dane, architect Viehelm Kiorboe. On the water side, the solarium opened on a brick terrace that overlooked Long Island Sound.

Carol A. Traynor

T. Henry Randall, 1862–1905

T. Henry Randall took his B.A. in architecture at M.I.T. He completed his architectural training at the Ecoles des Beaux-Arts, and began work in the Brookline office of H. H. Richardson. After Richardson's death, Randall worked as a chief clerk for McKim, Mead & White. He opened a New York office in 1890, and afterwards became known for his residential work. The William Poor residence, Tuxedo Park, New York,[1] and the W. B. Boulton residence, Lawrence, Long Island, were widely publicized and received critical acclaim. His work is very consistent—usually simple brick structures that recall late-medieval manor houses and at the same time bear witness to Randall's familiarity with H. H. Richardson. The latter's influence is especially clear in Randall's skillful use of simple brick construction to produce austere, massive structures.

William B. Boulton Residence, "Avila," Lawrence, 1898

Both the north and garden facades of this house were organized around three projecting wings terminating in a Jacobean (also referred to as Anglo-Saxon by contemporary critics)[2] gable. The formal entrance was marked by the most elaborate decoration on the house, a shallow Corinthian porch supporting a frieze surmounted by a broken, segmental pediment. Above, an ornate window marked the second-story stair hall. This window, like the entry below, made extensive use of mannered Dutch or German classical ornamentation. The house was planned with a polygonal parlor to the west and an open porch above.[3] Randall eliminated this feature by extending the family living quarters in a large three-story wing. The garden facade, in keeping with the informal character of this side of the house, was unornamented.

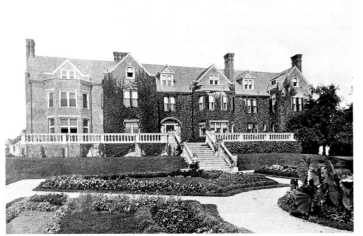

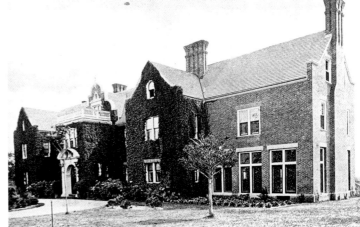

T. Henry Randall: Rear (Garden) Facade, "Avila," William B. Boulton Residence, Lawrence, 1898 (BRIC, 1902)

T. Henry Randall: Front Facade, "Avila," William B. Boulton Residence, Lawrence, 1898 (BRIC, 1902)

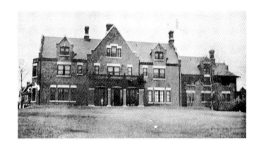

T. Henry Randall: "Orchard Hall," Winthrop Burr Residence, Lawrence, c. 1900 (Family Album of Robert Page Burr, n.d.)

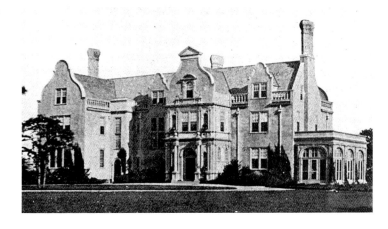

T. Henry Randall: Entrance Facade, Frederick Phillips Residence, Lawrence, c. 1900 (ARBJ, 1903)

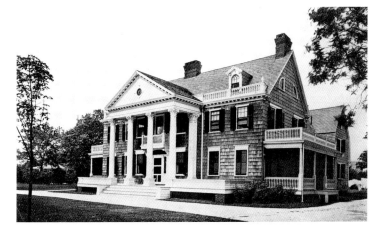

T. Henry Randall: Entrance Facade, E. S. Rogers Residence, Lawrence, c. 1900 (LIHS, n.d.)

The chief architectural interest here was found in the pleasing contrapuntal rhythm produced by the four simple gables.

Winthrop Burr Residence, "Orchard Hall," Lawrence, c. 1900

Winthrop Burr (1861–1929) was the founder of a very successful brokerage firm with offices in New York and Boston. He was a member of the governing committee of the New York Stock Exchange from 1909 to 1919, and served as that body's director from 1912 to 1915. Like many of his wealthy contemporaries, he was involved with sponsorship of the fine arts. His other interests included riding, and he was a member of the nearby Rockaway Hunt Club. "Orchard Hall" was similar to the Boulton residence in its material and overall massiveness. As in the Boulton residence, the composition relied on the prominence of the gables; yet here the gables' size and complexity varied greatly. The

garden front had an enclosed glass porch which resembles the one originally designed for the Boulton residence. The service wing was located in a smaller arrangement of buildings to the east.

Frederick Phillips Residence, Lawrence, c. 1900

This residence is in the Rockaway Hunt Club section of Lawrence. This development was laid out from 1873 to 1884 and followed the tradition of the Olmsteds in its naturalistic landscaping derived from the principles of the English picturesque. In the Phillips house Randall retained the stylistic type discussed above. The overall appearance, however, was more refined than either the Boulton or Burr residences, which relied on the strength of their simple massing for architectural effect. The Phillips residence was stucco over wood. Decoration was not, as it was in the above houses, restricted to the main entrance pavilion. An elaborate balustrade marked the roof line, there were a variety of gable shapes, and the window moldings were elaborately carved. The main entry was in a double false arcade of Ionic pilasters, and a pair of freestanding Ionic columns surrounded the door supporting a single block of correct Ionic frieze. Above them were globe-like finials which correspond to the flambeaux supported by the second-story arcade.

Edward S. Rogers Residence, Lawrence, c. 1900

The Rogers residence is very unusual in Randall's oeuvre, different from the type of work which led J. W. Dow, a contemporary critic, to declare Randall's Poor and Boulton residences examples "of a beautiful type of simple and consistent domestic work," which "might withstand the odious ordeal of international comparison."[4] The Rogers residence, built for the chairman of the Sterling Drug Company and a leading expert on patent law, is Randall's attempt at the Colonial Revival. A colossal portico of Corinthian columns dominated the north facade. The dormers and the balustrade, as well as the use of shingles, refer to the vernacular sources which served as the inspiration for the revival. Because of its homey associations, Randall used a gambrel roof to distinguish the less important service wing from the house itself. This approach was in contrast with his other Long Island commissions in which the service wings were incorporated into the main block of the house.

Christopher E. Miele

Renwick, Aspinwall & Owen, 1883–1940s

James Renwick, 1818–1895

J. Lawrence Aspinwall, 1854–1936

William H. Russell, 1856–1907

William Whetton Renwick, 1864–1933

Walter T. Owen, d. 1902

Success came early to James Renwick and continued throughout his career. After his death, his reputation survived not only through his work but also through his firm which continued to bear his name into the 1940s.[1] Other members of the firm included J. Lawrence Aspinwall, a distant cousin of Renwick's wife, who was employed as a draftsman in 1875 and promoted to partnership in 1883. After Renwick's death, Aspinwall became the senior partner and continued in that capacity until his death in 1936. William Russell is first listed as working in the firm in 1881 and by 1883 was made a partner. A nephew of the founder, William Renwick began working for the firm around 1885 and became a partner in 1892. He left the firm after his uncle's death to work on church design and decoration. Following his departure, Walter Owen became a partner.

In 1843 twenty-four-year-old James Renwick captured the commission for the now-treasured Manhattan landmark Grace Church, located on Broadway at 10th Street. Because it was built for one of the country's most prominent congregations at a time when a large new church attracted as much attention as a corporate skyscraper would today, the sparkling white miniature cathedral won Renwick a national reputation. Commissions for other large churches followed, culminating in the one for St. Patrick's Cathedral. When the cornerstone of that monumental Gothic Revival structure was laid on August 15, 1858, it represented a milestone in the development of American architecture. Renwick's original design—abandoned for lack of funds—included the first giant masonry vault supporting a stone tower over the crossing to be proposed for a building in the United States.

Although Renwick is known primarily as a church architect, he also designed major museums, schools, hotels, hospitals, theaters, and commercial buildings. Among those still standing are: the Smithsonian's Castle (1847–55) in Washington, D.C.; the Corcoran Gallery (1859–61, resumed 1870–71), later renamed the Renwick Gallery, also in Washington, D.C.; the original main building of Vassar College in Poughkeepsie, New York (1863–c. 1864); the addition to the old Cathedral of St. Augustine in St. Augustine, Florida (1887–88); the warehouse (1887–88), now an apartment house called "The Renwick," north of Grace Church in New York; the former St. Denis Hotel (1851?–52) in New York; and the Smallpox Hospital (1853–56?) and Island Hospital (1858; addition 1879) on Roosevelt Island in New York City's East River.

Like a number of his colleagues, Renwick came from a privileged background. He was born in his paternal grandmother's country house in upper Manhattan. His mother, the former Margaret Brevoort, was the daughter of a large landowner. His father, also named James Renwick, was a successful merchant and engineer. Young James was the seventh generation of Dutch Brevoorts in the United States and the fourth of his father's Scottish-English line. Renwick's marriage in 1851 to Anna Lloyd Aspinwall, the daughter of one of the richest men in the United States, was an added advantage.

At the customary age of 12 he was enrolled in Columbia College, from which he was graduated in 1836, and received his M.A. degree in 1839. By then, Renwick's father was a professor of chemistry and physics at Columbia, a position he accepted in 1820 after the family business went bankrupt. The professor quickly became a famous engineer, as well as an expert astronomer, surveyor, mineralogist, early art collector and patron, prolific author, and talented artist. He was also an accomplished amateur architect, building projects for friends.

With his father's help, young James got his first job in 1836 as an engineer on the Erie Railroad. A year later he became second assistant engineer for the Croton Aqueduct Commission, for which he supervised construction of the mammoth Distributing Reservoir that supplied New York City with water. He also received a license to work as a city surveyor. The following year, with hardly more design experience than a wildly picturesque fountain in Bowling Green in lower Manhattan, young Renwick was selected as architect of Grace Church. He soon earned a reputation as an architect capable of producing (when funds permitted) solid, well-planned, technically advanced, original work.

The 1870s were a confusing period in architecture. While it was generally accepted that a country house should fit comfortably into its rural surroundings and, ideally, be expressive of the client's background and personality, there was no consensus on how this was to be achieved. Members of the Arts and Crafts

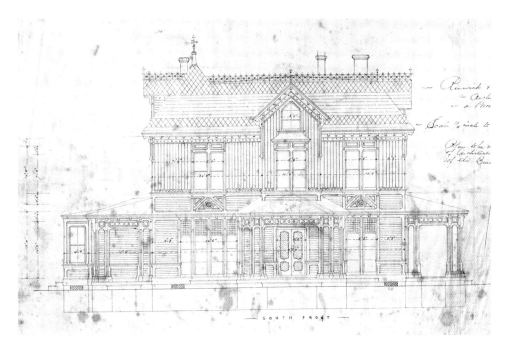

James Renwick: Drawing of South Facade, "Breezy Lawn," Frederic Gallatin Residence, East Hampton, 1877–78 (East Hampton Free Library, n.d.)

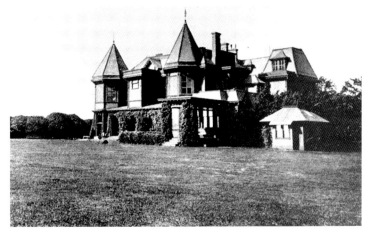

James Renwick: Postcard Showing Later Additions and Alterations, "Breezy Lawn," Frederic Gallatin Residence, East Hampton (Courtesy of Carlton Kelsey)

movement in England advocated returning to preindustrial design and craftsmanship. Others responded to the French architect Viollet-le-Duc's (1814–79) plea for a "rational" approach that paid special attention and gave logical expression to function, material, and building methods using improved technology.[2] However, both schools agreed that "sincerity" or "honesty" along with "appropriateness" (to use some of their favorite catchwords) were essential to good design. This led architects to plan buildings from the inside out, avoiding, except in special circumstances, the wholesale copying of historic forms, and using the structural system as a design element. Traditionalists and rationalists found a mutual source of inspiration in the exposed network of columns, vaults, walls, and buttresses of medieval cathedrals, as well as in the structural and functional clarity of alpine chalets, Japanese tea houses, and half-timbered cottages. Renwick responded to both points of view. With the possible exception of a home planned for himself, the house most representative of his taste is one designed in 1877 for Almy (1840–1917) and Frederic (1841–1927) Gallatin in East Hampton.[3]

Frederic Gallatin Residence, "Breezy Lawn," East Hampton, 1877–78

The Gallatins and Elbridge T. Gerry, Mrs. Gallatin's brother, were James Renwick's closest friends, and their East Hampton retreat, "Breezy Lawn," became Renwick's second home. The architect thoroughly understood his clients' needs, and they, in turn, had complete confidence in their architect, as well as the money to build exactly what they wanted.

Born to old wealth, the Gallatins created their own high society. East Hampton at the time was unpretentious, a place were pedestrians would readily give way to herds of cows led home by barefoot boys. The small colony of summer people, which included a few other socially prominent families, distinguished artists, and a number of clergymen, did not participate in customary social rituals. Instead, the highlight of their day was assembling on the beach between 11:00 a.m. and 1:00 p.m. For the Gallatins and Renwick, there was the added attraction of excellent sailing and fishing, two favorite activities.

By Newport standards, "Breezy Lawn" was a relatively small house, approximately 46 feet square and two stories high plus an attic.[4] It was built of wood—East Hampton's chief export— and painted gray, the predominant color of the village buildings.[5] The rooms were grouped around a central staircase, linked to one another by connecting doorways. This provided both free circulation and maximum proximity between family and guests. It also resulted in a house that was almost square in its proportions. Renwick gave it the preferred irregular appearance by adding piazzas on three sides, bay windows, and a patterned slate roof with dormers,

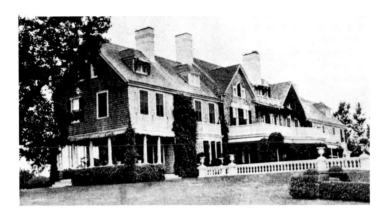

gables, chimneys, a handsome tower, and, to
break the skyline, a bristly iron crest rail. The
lively interplay of pattern against pattern and
the contrast between light and shadow were also
present in the rustic exterior boarding, horizon-
tal on the first story and vertical on the second;
in the decorative brackets that supported the
projecting eaves on both stories; and in the
angles formed by the gables and roof—features
reminiscent of alpine chalets and possibly a
symbolic reference to the Gallatins' Swiss her-
itage. As modest as the Gallatin residence was
compared to those in Newport, the hardwood
floors, plastered walls, decorative tiles on the
fireplaces, stained glass—frequently depicting
the Gallatin coat of arms—and other "artistic"
furnishings made it the showplace of East
Hampton.

Vaguely medieval by virtue of its pointed
dormer windows, Eastlake decoration, and myr-
iad gables, "Breezy Lawn" was distinguished on
the exterior by the articulation of its framing
system. This frank expression of structure had
been used by the French-trained Richard Morris
Hunt in the "Griswold House" in Newport as
early as 1862, and probably reached its zenith in
the numerous examples evident at the Philadel-
phia Centennial Exposition of 1876. The noted
19th-century architectural critic Montgomery
Schuyler described this system as "expositions
of the mechanical facts of the case in wood,"[6]
and according to the official guide to the 1876
Centennial Exposition in Philadelphia, it repre-
sented "modern" wood architecture.[7]

Two other highly influential buildings at the
Centennial Exposition were the half-timbered
and stucco, multigabled structures with tile
roofs and stacks of red-brick chimneys, built by
the English government. One represented the
16th-century residence of an English squire and
contained stained and varnished paneled dados,
English wallpaper, and furnishings of that peri-
od.[8] As contemporary historians noted, the
Elizabethan, exposed half-timbered construc-
tion was fundamentally a rational form despite
its historic garb.[9] It was with the features of that
appealing English domestic setting that the next
generation of Renwick clients preferred to sur-
round themselves.

It was also admiration for the sporty, yet
elegant, English country life that transformed
obscure Long Island villages into towns of great
wealth and social fame. Americans mimicked
the British by establishing country clubs, and,
instead of modest villas, they built impressive
houses surrounded by expensive landscaping,
stables, conservatories, boathouses, and servants'
quarters.[10]

For Renwick's firm, this development
brought commissions for three country estates
on the narrow peninsula of Centre Island and
another on the grounds of the Rockaway
Hunting Club in Lawrence. All were in the
16th-century Elizabethan style of the British
buildings at the Centennial Exposition, a mode
the Renwick firm used as early as 1880.[11] The
Centre Island designs coincided with the con-
struction in 1891 of the Seawanhaka Corinthian
Yacht Club, of which both the clients and, with
one exception, the Renwick partners were
members.

Colgate Hoyt Residence, "Eastover," Centre Island, 1891

The 173-acre estate of Colgate Hoyt (1849–
1922), a leading Wall Street broker and rail-
road and steel tycoon, covered more than one-
quarter of Centre Island, the largest single hold-
ing. Russell, by then a partner in the firm, is
believed to have been the architect for the entire
complex.[12] Since the boathouse—the only sur-
viving building—retains traces of its original
Elizabethan appearance despite attempts to
remodel it in the Colonial style, it is likely that
the main house was also Elizabethan, similarly
remodeled or replaced by a shingled Colonial-
style dwelling.[13]

Charles W. Wetmore Residence, "Applegarth," Centre Island, 1892

The story of "Applegarth"—named after the old
apple orchard in which it was built—is more
amply recorded. It was designed in 1892 for the
recently married Elizabeth Bisland (1861–1929)
and Charles Whitman Wetmore (1854–1919),
and occupied by the summer of 1893.[14] When
they married, Charles was retiring as a partner
in a leading New York law firm to concentrate
on several lucrative business enterprises and fur-
ther his reputation as a yachtsman. Elizabeth
was a prominent journalist whose work was
published in *Puck, Harper's Bazaar, Cosmopoli-
tan,* and other leading magazines.[15] On the day
Nellie Bly left New York for her famous trip
around the world, the editor of *Cosmopolitan*
asked Elizabeth if she could leave that evening
and try to beat Bly's time.

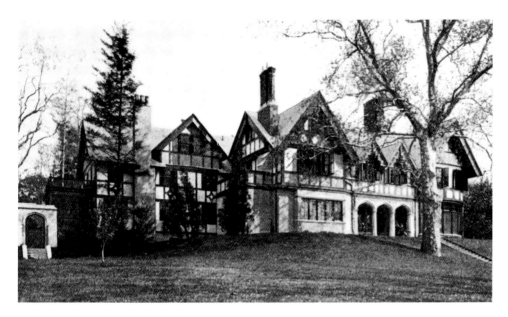

Renwick, Aspinwall & Owen: Rear Facade, "Applegarth," Charles W. Wetmore Residence, Centre Island, 1892 (ARRC, 1903)

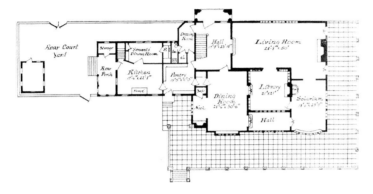

Renwick, Aspinwall & Owen: First Floor Plan, "Applegarth," Charles W. Wetmore Residence, Centre Island, 1892 (PREV, n.d.)

The site was unusual. Virtually all the estates on Centre Island were split by a main road, which ran from one end to the other. Although most of the Wetmores' 63 acres were east of the road, the couple wanted their house to be close to the protected boat basin on the narrow western strip. This meant that the house would be within sight of the road, a situation that, in Elizabeth Wetmore's opinion, called for the comparatively modest early Elizabethan style because it did not "jump to the eye" as other more "salient" types would.

Stately yet picturesque, the Elizabethan style also enabled the owners to preserve an apple orchard and many other fine, old trees. Elizabeth Wetmore noted that, unlike a symmetrical classical form, the design could be "wound and looped between these irreplaceable treasures, pushing out a porch here, or a window there . . . and stepping up and down to rooms of different levels as the grade of the land required, so that roots need not be cut nor branches lopped."

Both the interior and the exterior of the house took account of the Elizabethan prototypes favored by the client. The interior conformed to the needs of its occupants, providing "Applegarth" with appealing nooks and crannies. The multigabled exterior of the house, designed for use in winter as well as summer, was built of brick, half-timbering, and stucco. All the familiar details were included: carved barge boards, multiple chimney flues, leaded windows, even Elizabethan finials on the gateposts. But not one "anachronistic" shingle marred the purity of design.

Purity did not mean that "Applegarth" was inspired by a single model: it drew on a number of historic examples. The entrance porch was adapted from the Baptistry of Canterbury Cathedral and the balustrade surrounding the terrace from St. Fagin's Castle in Wales. Each of the important rooms combined motifs from a variety of sources. In the dining room, the design of the rich oak paneling came from the carved stone walls of the robing room of Chartres Cathedral (admittedly Gothic but acceptable since it was a source of Tudor ornament), the decorated ceiling from Queen Elizabeth's bedroom at Knole, and the fireplace from the Château at Blois. The furniture was copied from pieces in the Cluny Museum in Paris and the Victoria and Albert Museum in London.

Owen, the architect in charge, had been working in Renwick's office since 1888, but did not become a partner until four years after the project began. He died in 1902, just one year after marrying Elizabeth's sister, Melanie.[21]

Elizabeth accepted the assignment, but lost by about four days due to the cancellation of the steamer she was scheduled to take from England to New York.[16] Otherwise, "Bisland" rather than "Bly" might have became the synonym for a female star reporter. However, the trip made a deep impression on Elizabeth. Her book recounting the trip extols the "magnificent possessions" and "unrivalled physical beauty" of England.[17]

But what she admired most about England was that early feminist, Queen Bess.[18] For her wedding, Elizabeth Bisland Wetmore wore an Elizabethan gown[19] and, shortly after, chose the architectural style of that period for the couple's country house. Dominating the interior of "Applegarth" was a great carved stone fireplace in the drawing room, modeled on one belonging to Queen Elizabeth, richly decorated with Tudor heraldry. The scroll beneath the central panel read: "May the Lion of Judah, and the Flower of Jesse protect thy Lions and thy Roses, O Elizabeth."[20]

Rather than following a predetermined plan and adapting the site to the house, the design for "Applegarth" was based on the integration of existing physical conditions and the needs of its occupants. In both respects, Elizabeth Bisland said, the Elizabethan style was the ideal model.

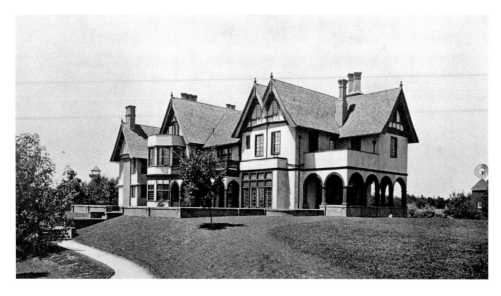

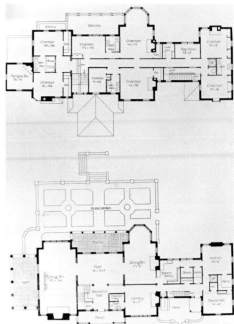

Renwick, Aspinwall &
Owen: Garden Facade, "The
Folly," George Bullock
Residence, Centre Island,
1899 (ARTR, 1900)

Renwick, Aspinwall &
Owen: First and Second
Floor Plans, "The Folly,"
George Bullock Residence,
Centre Island, 1899 (ARTR,
1900)

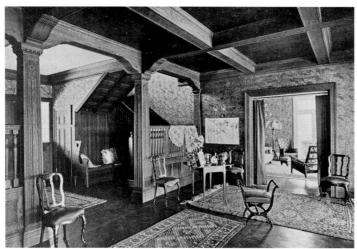

Renwick, Aspinwall &
Owen: Hall, "The Folly,"
George Bullock Residence,
Centre Island, 1899 (ARTR,
1900)

main living areas and the more intimate rela-
tionship between interior and exterior. Al-
though identical in length to "Applegarth," the
Bullock house was much narrower, with large
expanses of glass providing optimum views of
the gardens, rolling lawns, and Cold Spring
Harbor. From the entrance hall a view through
an open screen partition gave onto a larger hall
that ran along the rear of the house (rather than
into the dining room as in "Applegarth"), con-
necting the living and dining rooms. All three
rooms opened onto the piazza and its glorious
view. In addition, the living room opened onto
another loggia and had exposures on the other
two sides. The house was demolished in the
1960s.

George Bullock Residence, "The Folly,"
Centre Island, 1899

"Applegarth" was so successful that George
Bullock (c. 1860–1932), a close friend of both
the Hoyts and the Wetmores, engaged the firm
to design an Elizabethan house for him about
half a mile south of the Wetmore residence.
Bullock's original Long Island residence, a
Queen Anne design by Stickney & Austin
known as "The Folly," burned down on Jan-
uary 7, 1899. Exactly three weeks later, the
Renwick firm unveiled its plans for a replace-
ment. The designs by the younger Renwick,
Aspinwall, and Owen were exhibited and pub-
lished the following year.[22]

"Applegarth" and Bullock's new house, also
known as "The Folly," were similar on the out-
side and in the design of the richly paneled inte-
riors. Both had central entrances with a service
wing on one side and the main rooms on the
other. But the significant developments in the
Bullock house were the greater flow between the

R. A. Peabody Residence, "Terrace Hall,"
Cedarhurst, c. 1900 (Extant)

The only survivor of the Renwick's firm Long
Island houses is "Terrace Hall," adjacent to
the Rockaway Hunt Club in Lawrence. This
Elizabethan structure was designed for Richard
A. Peabody (c. 1860–1937), a New York stock-
broker, shortly after "The Folly." Peabody was
a club member since 1891, and had resided in
the clubhouse for about a year before his mar-
riage in 1895, commuting to his office in the
city. He continued living near the club after his
marriage, first in rented houses and, by 1901, in
"Terrace Hall."[23]

Although it was situated on a suburban site
of slightly more than three acres, the architect
oriented the house so that the main rooms faced
in a southerly direction, overlooking the club's
extensive grounds. Like "Applegarth" and "The
Folly," the house was divided into a main and

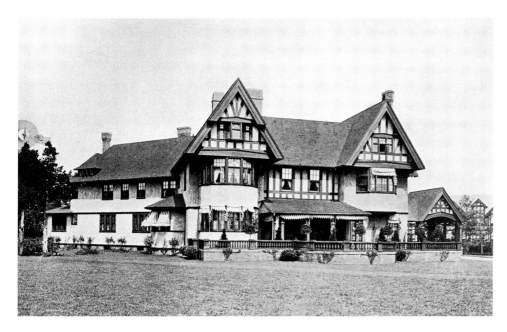

Renwick, Aspinwall &
Owen: "Terrace Hall,"
R. A. Peabody Residence,
Cedarhurst, 1900 (ARTR,
1901)

Greville Rickard: Front
Facade, "Topping," John H.
Eden Residence, Kings
Point, c. 1927 (COUN, 1927)

Greville Rickard: East
Facade, "Elm Point,"
William Slocum Barstow
Residence, Kings Point,
1930–31 (Bob Zucker photo,
n.d.)

Style is conspicuous. So, too, is the increasingly flowing circulation both within the interiors and between them and the outdoors, clearly leading toward what is known today as "organic design." And finally, the soaring gables and bands of windows of the Elizabethan houses bring to mind similar features that became hallmarks of the Prairie Style made famous by Frank Lloyd Wright.

<div style="text-align: right">Selma Rattner</div>

Greville Rickard, 1890–1956

Little information is recorded about Greville Rickard. In addition to his Long Island commissions only two works can be attributed to him based on published references: a house for a Dr. Milton Barkann in Jersey City, New Jersey (1933), and a shop at 9 East 56th Street in New York City (1925). He received a Gold Medal Award from the Fifth Avenue Association for the best alteration of the year in 1926 and an award for the best residence of the year from the Greenwich, Connecticut, Real Estate Board in 1931. Rickard's Long Island commissions, both located in Kings Point, reveal a tendency toward severity in the massing and a dearth of decorative embellishment. In c. 1927 he designed a brick Georgian house for John H. Eden which appeared in the April issue of *Country Life in America,* and he is credited with the 1930–31 Mediterranean Modern style house for William Slocum Barstow, the mayor of Kings Point from 1924 to 1940 and a noted inventor, which is today the U.S. Merchant Marine Museum.

<div style="text-align: right">Peter Kaufman</div>

service wing (in this case set at an angle off the main block because of the limitations of the site) but with the entrance at the side farthest from the club. One entrance was a narrow stair hall with a small, 18-foot-square parlor on the south, leading into what was called the "Main Hall," which was more than three times the size of the parlor. It contained a huge fireplace and side alcove. Like the Bullock's living room, it, too, covered the full width of the house, with glazed French doors opening onto the covered piazza and adjoining terrace. Sliding doors to the parlor and, on the opposite side, to the dining room with its two spacious bay windows, gave the Peabodys easy movement between the major living areas but total privacy when desired.

There are certainly connections between the designs of these Long Island houses and future architectural developments in the United States. The similarity between the "mechanical expositions" of the Gallatin house and the exposed modular system of the International

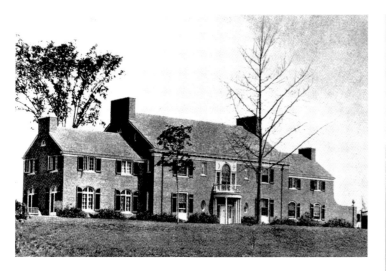

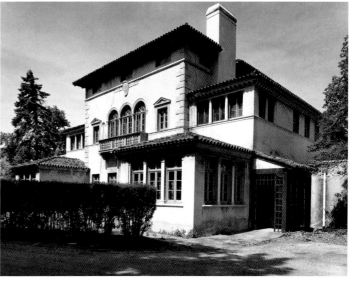

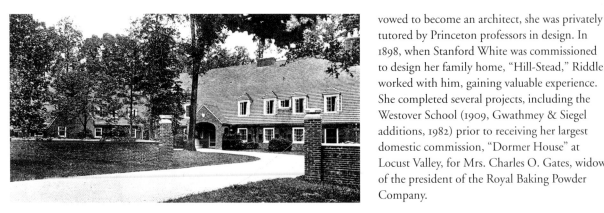

Theodate Pope Riddle: "Dormer House," Mrs. Charles O. Gates Residence, Lattingtown, 1916–17 (COUN, 1919)

vowed to become an architect, she was privately tutored by Princeton professors in design. In 1898, when Stanford White was commissioned to design her family home, "Hill-Stead," Riddle worked with him, gaining valuable experience. She completed several projects, including the Westover School (1909, Gwathmey & Siegel additions, 1982) prior to receiving her largest domestic commission, "Dormer House" at Locust Valley, for Mrs. Charles O. Gates, widow of the president of the Royal Baking Powder Company.

Theodate Pope Riddle, 1868–1946

Theodate Pope Riddle was one of America's earliest and most distinguished women architects. At a time when women rarely acquired any architectural training, Riddle became a registered architect, a member, and subsequently a fellow, of the American Institute of Architects. For over 30 years she maintained offices in New York and/or Farmington, Connecticut, as she undertook a variety of projects: workers' housing, the reconstruction and addition to Theodore Roosevelt's birthplace in Manhattan, educational complexes, and country estates. To this work she brought a conscious sense of the past, a sensitivity to natural materials and settings, and a passion for the process of construction.

Riddle grew up in a wealthy family whose social circle included some of the leading cultural and political figures of the day. After graduating from Miss Porter's School in 1888, where she

Mrs. Charles O. Gates Residence, "Dormer House," Lattingtown, 1916–17 (Extant)

"Dormer House," situated on a hilltop, consists of two main wings spread at a wide angle amid a lovely setting Riddle deliberately left undisturbed. Riddle's ability to let the nature and texture of the materials themselves become the decorative elements is seen here. The angle of the roof is as steep as any medieval prototype; the shingles seem to cascade down the slope. Only the dormers interrupt the flow, protruding slightly from the roof itself. Despite the steep roof line, the effect is of a rambling English house, somehow cozy, but dignified at the same time. The result is a strong composition, harmonious in its proportions and relationship to the site. The house was remodeled for a subsequent owner in the 1930s by James W. O'Connor and William Bottomley and is still standing today.

Judith Paine

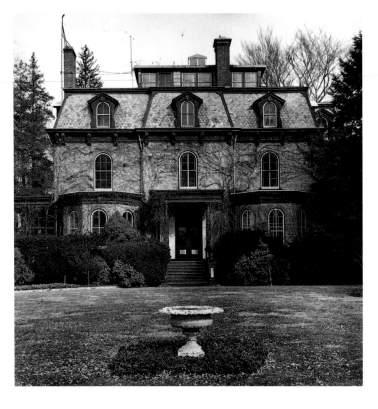

John W. Ritch: South Facade, "Evergreens," Edward H. Swan Residence, Oyster Bay, 1859 (SPLI, Michael Mathers photo, 1980)

John W. Ritch, b. 1822

John W. Ritch, a 19th-century New York architect who trained in the offices of William Hurry between 1836 and 1846 and was still active in the 1890s, owes his appearance in this book to a fire. A versatile practitioner, whose qualifications included the title of engineer, Ritch designed banks, hospitals, and houses. In the 1850s he had supplied plans for Edward H. Swan's country house on Cove Neck near Oyster Bay as well as for barns and other outbuildings. Little is known about the appearance of this timber-frame house, although it is thought to have been similar to his brother Benjamin L. Swan's adjacent Italianate villa, which may also have been designed by Ritch and which was destroyed in 1909. What is known from family papers is that Edward's house was destroyed in a conflagration in 1858 soon after its completion, an event which so disturbed his father, a prominent Manhattan merchant and landowner, that

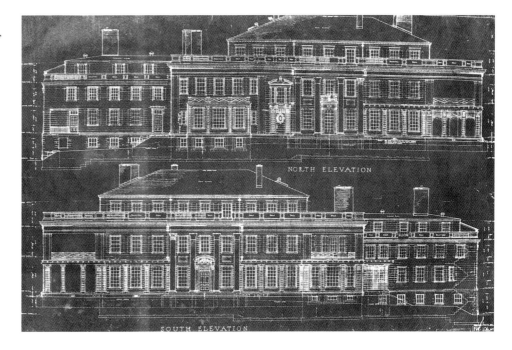

James Gamble Rogers: North and South Elevations, William L. Harkness Residence, Glen Cove, 1913 (Courtesy of John Samuels)

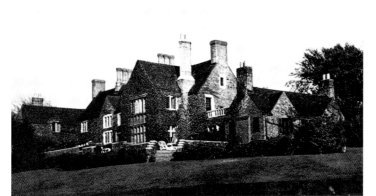

John Gamble Rogers: Rear (Garden) Facade, "Buckmeadow," Robert Huntington Residence, Mill Neck, 1926–27 (Courtesy of Robert D. Huntington)

John Gamble Rogers: Front Facade, George Ide Residence, Lattingtown, c. 1917 (INVE, 1978)

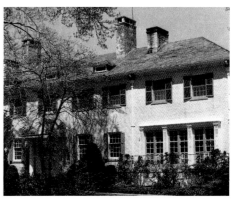

James Gamble Rogers: Le Clanche Moën Residence, Oyster Bay, alterations 1924 (PREV, n.d.)

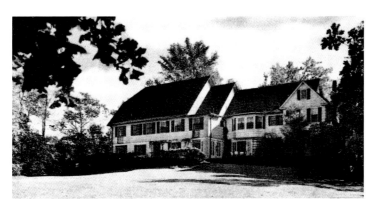

he financed the construction of a new and much grander edifice. "The Evergreens," designed by Ritch in 1859 in the then-fashionable French Second Empire mode, was built in masonry with a slate roof and cast-iron porches. With its tripartite facade with a projecting central pavilion, round-headed windows, and mansard roof, Edward's residence quickly became one of the early showplaces of Oyster Bay's summer colony. Ritch's specifications survive in the collection of the Society for the Preservation of Long Island Antiquities, as does the house which remains in private ownership.

Robert B. MacKay

James Gamble Rogers, 1867–1947

Designer of much of Yale's colleges and the Columbia Presbyterian Medical Center, James Gamble Rogers was Kentucky bred, Yale educated, and Ecole des Beaux-Arts trained. Starting his professional career in Chicago in the 1890s, Rogers moved his office to New York in 1906 where he was to practice for over 40 years. His four Long Island commissions occurred during the most productive period of his career, when he was completing Columbia Presbyterian (1923–28) and designing a 12-story School of Education for New York University (1928).

Rogers' first and most impressive Long Island commission was in 1913 for William Lamon Harkness, financier, philanthropist, and prominent Yale alumnus, a commission which undoubtedly led to his position as designer of the Harkness Memorial Quadrangle (1916–19) at Yale and architectural adviser to the university for ten years. For Harkness, Rogers enlarged a mid-19th-century structure that was originally part of the Charles Dana estate, incorporating this earlier structure as the servants' wing of the

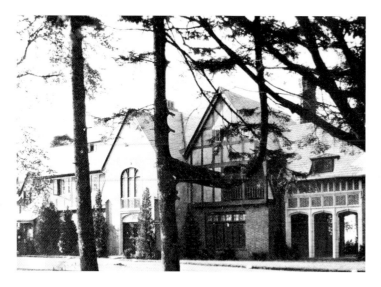
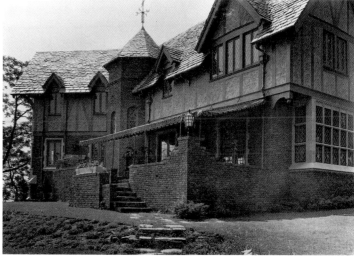

Thomas C. Rogers: Front Facade, Bernard C. Black Residence, Great Neck, c. 1928 (SPUR, 1928)

Thomas C. Rogers: Rear Facade, Kenneth F. Cooper Residence, Kings Point, c. 1930 (HEWI, 1930)

new house. Located on West Island in Glen Cove, this large (40-room) and impressive stucco Neoclassic structure, a three-story hip-roofed main block with a second-story roof balustrade and an open loggia projecting off the west facade, stood for only 20 years before a later owner, Junius Morgan, demolished all but the servants' wing.

Rogers' other Long Island commissions, the 1926–27 Tudor manor for Robert D. Huntington at Mill Neck, his c. 1917 Georgian house for Yale-educated insurance broker George Ide, and the 1924 Colonial Revival remodeling of an earlier house for Le Clanche Moën, were unpre-

tentious, comfortable, and picturesque houses that might well have been built around Sorority Quadrangle at Northwestern, another of Rogers's innumerable collegiate commissions. Over the door of one of his buildings at Yale is a quote from Sabatini that bespoke Rogers' low-key approach to estate architecture on Long Island: "He was born with a gift of laughter and a sense that the world was mad."

Robert B. MacKay

Thomas C. Rogers, practiced 1920s

While no biographical information has come to light on the architect Thomas C. Rogers, there are two extant examples of his work on Long Island, both in the Neo-Tudor Style. One is the c. 1928 Bernard C. Black residence at Great Neck; the other is the Kenneth F. Cooper residence at Kings Point built two years later. The brick-and-stone Black residence incorporates areas of half-timbering with casement windows and an arcade of Tudor-headed arches. Cross gables and dormers pierce its steep slate roof. The L-shaped brick-and-fieldstone residence for Cooper, a one-time director of the American Cyanamid Company, has a prominent battlemented fieldstone turret over the entrance, a polygonal brick stair tower, and mullioned casement windows.

Wendy Joy Darby

Romeyn & Stever: Rear Facade, "Villa Louedo," Edward R. Ladew Residence, Glen Cove, 1894 (AABN, 1894)

Romeyn & Stever: Front Facade, "Villa Louedo," Edward R. Ladew Residence, Glen Cove, 1894 (Hester/Gibb Family Album, c. 1912)

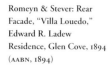
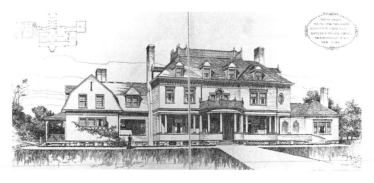

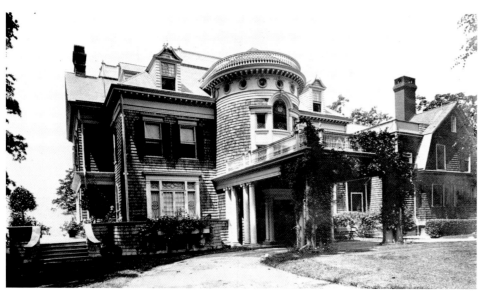

Romeyn & Stever, practiced 1890s

Little is known of A. J. Stever; however, Charles W. Romeyn (1854–1942), a native of Kingston, New York, was trained as an architect in the offices of Calvert Vaux and Frederick Law Olmsted. Romeyn & Stever developed a reputa-

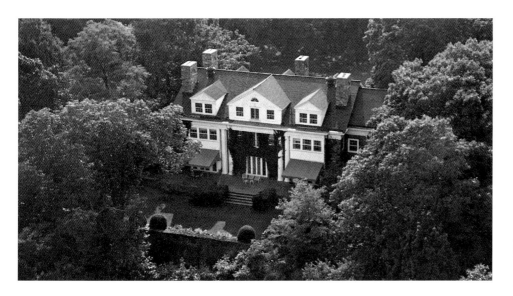

Erick K. Rossiter: Garden
Facade, "Three Harbors
Hill," William H. Peters
Residence, Mill Neck,
c. 1904 (Courtesy of
Anthony K. Baker, 1986)

tion designing apartment buildings and town-houses on Manhattan's West Side. Their only known Long Island commission, "Villa Louedo," was built at Glen Cove in 1894 for Edward R. Ladew, a vice president of the U.S. Leather Co., whose family was prominent in the tanning industry. An exuberant Colonial Revival creation with some lingering Queen Anne features, including a large tower from which the porte cochere sprang, "Villa Louedo" lasted only 21 years before subsequent owner William Hester employed Howard Major to strip away the superfluous features in favor of a more academic Colonial Revival treatment. The house was demolished in 1985.

Robert B. MacKay

Erick K. Rossiter, 1854–1941

Erick Kensett Rossiter, born in Paris of American parents, was educated at Cornell University. Married in 1877 to Mary Heath, he worked as a draftsman in several New York architectural firms before engaging in private practice in 1900. After 1910 he formed the partnership of Rossiter & Muller, designing several institutional structures, such as the Church of St. Michael at Litchfield, Connecticut, and several school buildings at Scarsdale, New York. The country residence of William H. Peters,

built at Mill Neck c. 1904, was an early commission of the Rossiter office. Approached along an embanked drive, the stone dwelling was set on a low grass terrace commanding vistas of the Sound, suggesting the name "Three Harbors Hill." As originally erected, the house presented a free interpretation of the Colonial Revival, with a three-bay garden facade containing a colossal galleried portico. In the 1940s the structure was remodeled to the designs of Bradley Delehanty, who gave the house a more academic appearance.

Michael Adams

Rouse & Goldstone, 1909–1926

William Lawrence Rouse, 1874–1963

Lafayette Anthony Goldstone, 1876–1956

Rouse & Goldstone were in partnership from 1909 through 1926. They specialized in luxury apartment houses, hotels, and office buildings in New York City. Their apartments at 1107 Fifth Avenue (at 92nd Street) are crowned by an immense 54-room triplex once owned by Marjorie Merriwether Post.

Two large Georgian Revival houses represent the firm's Long Island domestic work. "Maple Knoll" on Overlook Road in Lattingtown was built in 1917 for Isaac Cozzens, and it is still standing. The garden facade of the two-and-a-half-story main block is centered by a monumental Corinthian portico, while the more restrained driveway front has an elliptical-pedimented doorway framed by full-height engaged pilasters. (The two lateral wings were added in 1929 by Roger Bullard.)

The Huntington house of Augusta Hays (Heckscher) Lyon (1917) no longer survives. It, too, was a broad, two-and-a-half story brick house, but less formal than "Maple Knoll." Windows were its dominant feature; set into the brick facade plane, no two were alike. There were loggias, French doors, triple windows, and an oriel, and on one side of the entry a trio of narrow openings rose in steps to light the stair.

Ellen Fletcher

Rouse & Goldstone: Rear
Facade, "Maple Knoll,"
Isaac Cozzens Residence,
Lattingtown, 1917 (HEWI,
n.d.)

Rouse & Goldstone:
Entrance Facade, Augusta
Hays Lyon Residence,
Huntington, 1917 (ARTR,
1920)

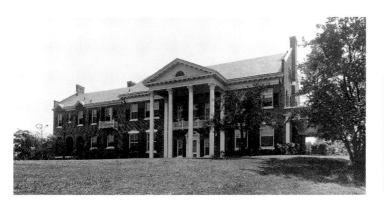

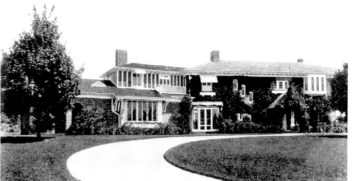

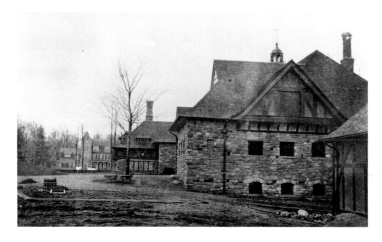

Rowe & Smith: Stable
Group, J. E. Aldred
Residence, Lattingtown,
c. 1913 (FLON, c. 1915)

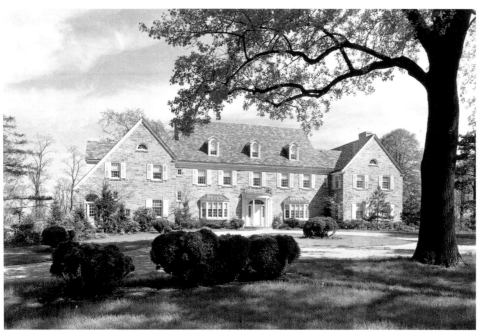

Leon H. Smith: Front
Facade, Hannibal Choate
Ford Residence, Kings
Point, 1930 (GOTT, n.d.)

Rowe & Smith, practiced 1910s–1920s

Henry W. Rowe, 1880–1927

Leon H. Smith

Working both independently and together, Henry W. Rowe and Leon H. Smith were responsible for a number of country-house projects on Long Island. Henry W. Rowe was born in Lawrence, Massachusetts, earned his undergraduate and graduate degrees from M.I.T., and subsequently maintained an architectural office in New York City and Boston. Beginning in 1913, when he was associated with Leon H. Smith as Rowe & Smith, he was the principal designer for the estate service buildings for "Ormston," the Lattingtown country house of utility magnate J. E. Aldred, who was also born in Lawrence. Working in the Tudor style, Rowe designed two gate houses, several cottages for estate workers, the stables and farm group, and a stone bath house and pier. Rowe

discussed the importance of site development in the overall design of "Ormston" in a 1914 article he wrote for *The American Architect* in which he states that the main house, designed by Bertram G. Goodhue, was erected only after all the service buildings had been plotted and built on the 117-acre site.

Working independently, Rowe's former partner, Leon H. Smith, designed a country residence at Kings Point in 1930 for Hannibal Choate Ford, inventor, manufacturer, and founder of the Ford Instrument Co. The two-and-a-half-story stone Colonial Revival residence commands a view overlooking Long Island Sound.

Carol A. Traynor

Mott B. Schmidt, 1889–1977

Mott Schmidt was an erudite and careful designer of elegant houses in town and country settings for clients who wanted luxury handled with classical restraint. He is best known for the ballroom at Gracie Mansion, installed at the end of his career in 1966, which he modeled after a room in "The Vale" (Waltham, Massachusetts), an elegant Federal style house designed in 1793 by Samuel McIntyre.

Born in 1889 in Middletown, New York, Schmidt earned a degree in 1906 from Pratt Institute in Brooklyn. His career commenced in 1916, spanned more than 50 years, and resulted in more than 600 designs. Schmidt's legacy includes houses in such affluent communities as Grosse Point, Michigan, and Coral Gables, Florida, as well as in New York City, Westchester County, and Long Island's North Shore. His clients included Mrs. Vincent Astor, Mrs. William K. Vanderbilt II, Anne Morgan, and members of the Rockefeller and Ford families. Houses he built for some of them still stand on Manhattan's Sutton Place and Upper East Side.

Mott Schmidt's records list 20 Long Island commissions, including a tombstone and service buildings, as well as reconstructions of entire estates. His first commission was a residence on the North Shore designed in 1917; his last, a house in Southampton, was erected in 1964. Three of his Long Island houses, all extant, were designed in collaboration with the Danish architect Mogens Tvede.

Schmidt's first Long Island client was stockbroker Clarkson Runyon, a partner in the firm of Carlisle, Mellick & Co. "The Farm House," in Glen Cove, commissioned by Runyon in 1917, seems atypical of Mott Schmidt's later work. Although built of brick and restrained in design, the asymmetrical facade gable, the oriel

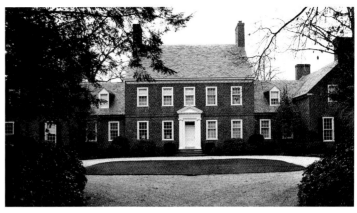

Mott B. Schmidt: Front
Facade, "The Farm House,"
Clarkson Runyon
Residence, Glen Cove, 1917
(INVE, 1983)

Mott B. Schmidt: Entrance
Court and Front Facade,
Charles A. Bateson
Residence, Huntington,
1933 (INVE, 1983)

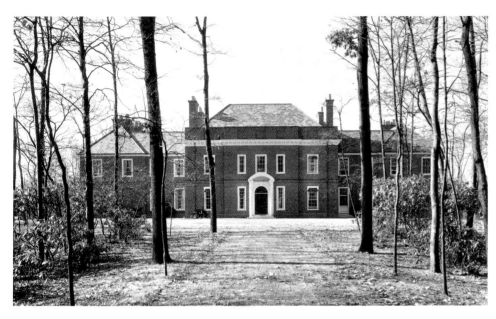

Mott B. Schmidt & Mogens
Tvede: Front Facade,
"Elyston," Albert H. Ely, Jr.,
Residence, Cold Spring
Harbor, 1929 (GOTT, 1931)

Mott B. Schmidt & Mogens
Tvede: Rear Facade, "Dark
Hollow," Oliver Jennings
Residence, Lloyd Harbor,
1930–31 (SPLI, n.d.)

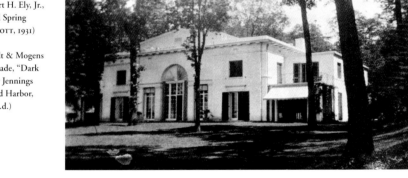

Mott B. Schmidt & Mogens
Tvede: Entrance Front,
Jeremiah Clark Residence,
Brookville, 1933 (INVE, 1983)

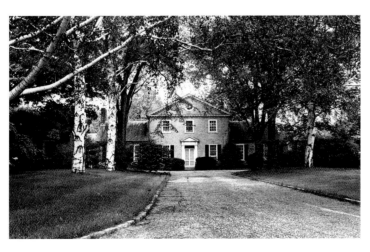

window, and the jerkin-headed side gable
impart a Jacobean character to the house.
However, its slate roof, consistent eave line,
and double-hung windows are incongruous
in this picturesque design.

In 1933, Schmidt designed a Georgian
Revival house for Charles A. Bateson on Wood-
bury Road in Huntington. Its quality lies in its
careful proportioning and in the restrained rich-
ness of its trim. The simple front doorway is
balanced by a subtly detailed cornice. The
molded brick belt course and narrow chim-
neys emphasize the fine proportion and detail
that give the house its distinction.

In nearby Lloyd Harbor is the Charles
Robertson house, which Schmidt designed
between 1937 and 1940. This two-story, five-
bay brick house has as its focus a Georgian-style
broken-scroll pedimented doorway. The modil-
lioned cornice and raised brick belt course add
texture to the house's restrained elegance. The
evenly spaced, double-hung windows and the
lateral wings enhance the classical regularity of
the design. Inside, antique mantelpieces add to
the "period" feeling. Like many of Schmidt's
designs, especially after 1930, the Robertson
house is smaller in scale than many of its Gold
Coast neighbors.

Schmidt collaborated with Mogens Tvede
on three Long Island mansions. These houses
reveal a vision of Neoclassicism somewhat more
cosmopolitan and mannered than Schmidt's
own. The first, "Elyston," was built in 1929 for
the corporate and real-estate lawyer Albert H.
Ely, Jr., in Cold Spring Harbor. Like Schmidt's
solo designs, "Elyston" is perfectly symmetrical,
its center-entry main block balanced by wings
that terminate in hipped-roof pavilions. Other
features of the design, however, disturb the har-
mony of this quiet composition. Architraves
squeeze the windows into narrow verticals, and
the three central bays cluster tightly around the
curved-pediment entry door. An exaggerated
expanse of brick separates the end bays from
their neighbors, giving the facade a Mannerist
rhythm unlike the regularity of the Bateson and
Robertson houses. A brick parapet above the

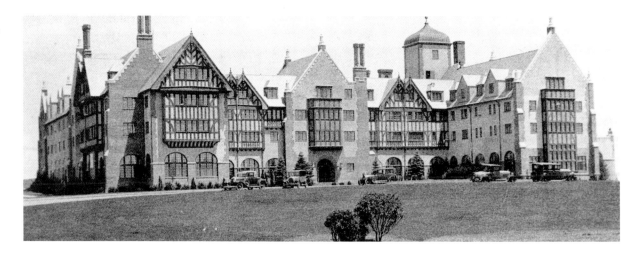

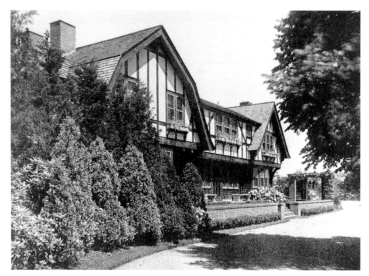

modillioned cornice screens a hipped roof, setting off the unusual configuration of the facade elements.

"Dark Hollow," built in 1930–31 in Lloyd Harbor for Oliver Burt Jennings, is a stunning Neo-Palladian house. The assemblage of blocky forms centers on an immense Palladian tripartite doorway, while a deep, overhanging cornice with shallow modillions draws attention to the perimeter of the building. The continental quality of this villa suggests that Mogens Tvede, who had met the clients in Paris, was perhaps the dominant designer here. The original blue-and-white Art Deco interiors survive intact at "Dark Hollow."

The last of the Schmidt-Tvede collaborations is the Jeremiah Clark house of 1933 on McCoun's Lane in Brookville. With its main block symmetrically placed beneath a broad pedimented gable, this house is a more typical Georgian Revival effort than its immediate predecessors. Inside its pedimented front door, the entry hall features the dramatic circular staircase often found in Schmidt's New York townhouses. Built near the end of the Gold Coast era, the Clark house is compact, modest, and restrained when judged by the standards of 20 years earlier.

Ellen Fletcher

Schultz & Weaver, practiced 1920s
Leonard Schultz
Spencer F. Weaver, 1879–1939

This New York City firm, formed in 1921, was best known for its hotel designs. The Waldorf-Astoria, the Sherry-Netherland, the Pierre, the Park Lane, and the Lexington hotels were among the firm's New York commissions. In Florida, Schultz & Weaver designed the Breakers Hotel, Palm Beach, and the Nautilus Hotel, Miami.

"Montauk Manor," the large resort hotel Schultz & Weaver designed in Montauk, Long Island, dominated the high ground of Signal Hill north of the business district. From its porches one can see Fort Pond, the Atlantic Ocean, and Gardiners Bay. As much a local landmark as the Montauk Point lighthouse, this enormous Tudor-style structure symbolizes Montauk's somewhat eccentric past.

Following his successful transformation of Miami Beach from a mangrove swamp into a resort, developer Carl Fisher advanced on eastern Long Island. As part of his ambitious scheme to turn Montauk into the "Miami Beach of the North," Fisher hired Schultz & Weaver to design the Manor, a 200-room hotel. It was built in 1926–27 at a cost of $1.5 million. A seven-story office tower, a yacht club, beach club, golf course, polo field, private residences, and many other buildings were constructed as well. Like most of the other Fisher buildings in Montauk, the Manor was designed in keeping with the Tudor look popular at the time. Half-timbering distinguishes many of the large gabled bays. Double chimney stacks rise high above the roof line and a large Elizabethan tower with a curvilinear roof stands on the eastern side. The Manor has recently been renovated for condominium use.

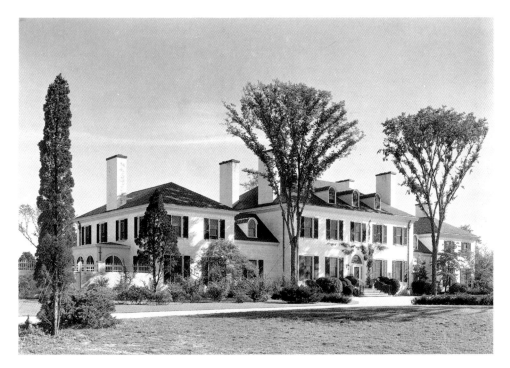

Henry R. Sedgwick:
"The Ranch," Robert M.
Winthrop Residence, Old
Westbury, 1932 (AVER,
Samuel Gottscho photo,
n.d.)

In 1925, Weaver purchased and remodeled the Preston B. Spring residence on Apaquogue Road in East Hampton for his own use. Originally built in 1895, this Tudoresque house was designed by Joseph Greenleaf Thorp. With half-timbering, bay windows, and projecting gables, the design was similar to that of Thorp's own East Hampton house on Woods Lane (1893), the first such Elizabethan vernacular house in East Hampton.[1] The Weaver house was demolished c. 1970.

Alastair Gordon

■ Henry R. Sedgwick, 1881–1946

Henry Renwick Sedgwick's 1932 Palladian house for Robert Winthrop in Old Westbury is a fine example of Georgian design on Long Island. The building's lack of ornamentation, crisp lines, and pleasing scale were noticed by Fraser Nairn, who published the house in the February 1934 issue of *Country Life in America,* praising its "dignified maturity." Sedgwick may have known his Long Island country-house client quite well as they were both Harvard graduates and fellow members of three Manhattan clubs. After receiving his architectural education at Columbia, Sedgwick first worked as a draftsman in a number of New York offices, and then entered a partnership with Frederick A. Godley before establishing his own practice. A member of the New York Chapter of the American Institute of Architects, Sedgwick served as corresponding secretary of the Society of Beaux-Arts Architects. His only other known country-house commission was the 1934 addition of a third story to the Effingham Lawrence house in Cold Spring Harbor.

Robert B. MacKay

Severance & Schumm:
South Facade,
"Summerhill," John
Anderson Residence,
Lattingtown, 1909 (MLAE,
n.d.)

Severance & Schumm:
Remodeling, "Munnysunk,"
Frank Bailey Residence,
Lattingtown, 1912 (INVE,
1978)

Severance & Van Alen: C. A.
O'Donahue Residence,
Huntington, 1917
(ARRC, 1918)

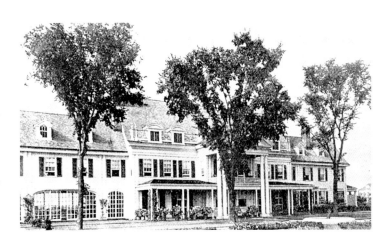

■ H. Craig Severance, 1879–1971

H. Craig Severance worked in several New York architectural offices, including that of Carrère & Hastings. In addition to partnerships with Walter Schumm and William H. Van Alen, Severance practiced alone. In 1909 John Anderson commissioned Severance & Schumm to design his Lattingtown residence. End chimneys frame the central block of his three-part, clapboarded Federal-style mansion. The gable roof is pierced by segmental dormers, with pedimented dormers on the wings. The entry facade carries a two-story, gabled portico, the pediment supported by paired columns. Similarly, the garden facade has a two-story, semicircular porch. A strong cornice line emphasizes the overall horizontal massing of the building.

In 1917, while still in partnership with Schumm, Severance designed the C. A. O'Donahue residence in Huntington, incorporating Colonial and Georgian Revival elements. This white-shingled, gable-roofed mansion consists of a central block with flanking wings. A porte cochere supported on massive fluted columns and carrying a full entablature spans the three-bay-wide central block. A balustrade with vase-shaped finials and the use of segmental dormers on the roof were design solutions employed earlier on the Anderson house.

Wendy Joy Darby

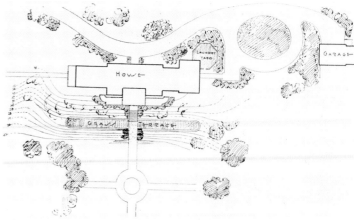

Ellen Shipman, Landscape Design: Garden Facade and Landscape Plan, "Pidgeon Hill," Meredith Hare Estate, Huntington, 1916–17 (ARRC, 1920)

Ellen B. Shipman, 1870–1950

Though frequently overlooked, the emergence of women in the field of American landscape architecture had a significant effect on the development of the profession in the early 20th century. Beatrix Jones Farrand is best known in this regard. The phenomenon was a collective one, and many women made important contributions. One early practitioner was Ellen Biddle Shipman of Cornish, New Hampshire.

Ellen Shipman was born in Philadelphia, Pennsylvania, to "well-connected" parents. Gifted in design and an avid plantswoman, she attended Radcliffe College and then studied landscape architecture under the noted architect Charles Platt who encouraged her to enter independent practice. She opened an office in New York City; by 1933, she had been elected to the *House and Garden* Hall of Fame for being the "dean of women landscape architects, . . . and [an] understanding leader in her profession."[1]

During her illustrious 40-year career, Ellen Shipman designed estate gardens as well as large municipal works like the six-mile Lake Shore Boulevard in Grosse Pointe, Michigan, and developed master plans for the Bronx Botanical Gardens (New York), Duke University (Durham, North Carolina), and Longue Vue Gardens (New Orleans, Louisiana).

She is best remembered, however, for her estate gardens.[2] Several important examples are located on Long Island, in the fashionable part of Nassau County between Huntington and Westbury. Viewed chronologically, these commissions offer a representative picture of the design characteristics that made Ellen Shipman so successful at her art.

Shipman's earliest known Long Island commission was for the William P. T. Preston estate "Longfields," in Jericho. The Colonial Revival house, built in 1924 to the designs of Peabody, Wilson & Brown, is basically rectangular in plan with an L-shaped service wing. Shipman's garden plan was quite simple but it contained

all the elements that reach maturity in her later, more elaborate works. The treatment of the entrance front is restricted to some simple planting near the house to relieve the starkness of the elevation and accentuate the principal entrance; a rolling expanse of lawn, interrupted only by a circular driveway and randomly placed trees, reveals her sensitivity to the site.

On the garden front, the landscape scheme is much more formal, in the style that dominated most of her estate work. Based on a series of axes, terraces, and enclosed spaces that provide a transition from the house to the surrounding landscapes, Shipman's plan reflects the principles of Italian villa design promoted by her teacher Charles Platt. In the case of the Preston estate, the principles are seen in schematic form. The scheme includes a flagstone terrace, axially related to the main block of the house, which opens onto a lower, grassed terrace enclosed by a low wall. A fenced rectangular garden placed perpendicular to the terrace at an angle between the main building and the service court is the other principal element of this design.

These design principles appear with increasing surety in subsequent estates. The plan of the Meredith Hare residence "Pidgeon Hill" (1916–17) in Huntington is a distinct link in the progression. Here, Shipman worked with her mentor, Charles Platt. His design for the house was loosely based on American colonial prototypes with some references to the shingled Long Island farmhouse.[3] The plan is basically rectangular with a projecting library wing on the west and a service wing on the east. Shipman's landscape plan shows immediate similarities with her Preston design but in a bolder form. Again, a curving drive and scattered trees accent the approach, and a series of terraces bisected by a grassy walkway embellish the garden elevation. On the garden side, a rectangular, paved patio opens off the stair hall, and two smaller porch areas, irregularly paved, flank the terrace. As at the Preston estate, steps provide a transition

Ellen Shipman, Landscape Design: Rose Garden, "Windy Hill," Lansing P. Reed Estate, Lloyd Harbor, 1926–27 (CORN, n.d.)

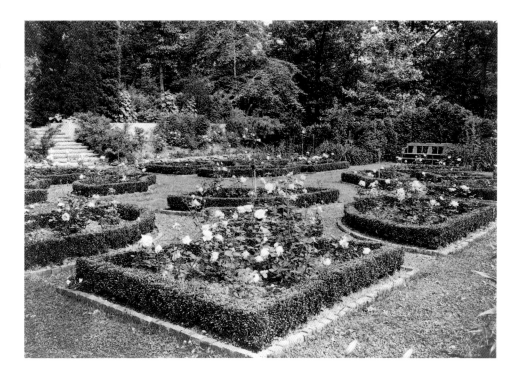

Ellen Shipman, Landscape Design: Sketch Plan of Garden, "Windy Hill," Lansing P. Reed Estate, Lloyd Harbor, 1926–27 (CORN, n.d.)

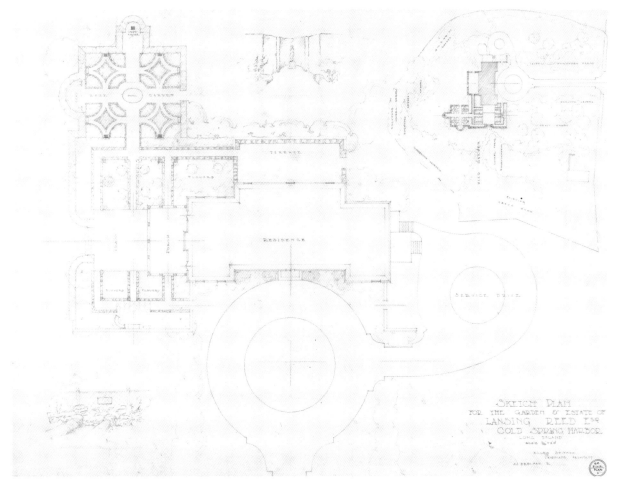

from the patio to a lower, grassed terrace. In the Hare plan, however, the main axial walkway is boldly continued to form the spine of the principal garden which leads to the open space beyond. Informal planting relieves the geometry and eases the transition from the house to the surrounding landscape.

In following years, Ellen Shipman worked on several other large estate gardens on Long Island. These include the residence of J. Averell Clark (c. 1920) in Old Westbury and the Lansing P. Reed estate "Windy Hill" (1926–27, with Charles Platt) in Lloyd Harbor. Both are well-considered designs. Yet the full development of Shipman's art is better seen in two other examples from 1926–27: the J. Randolph

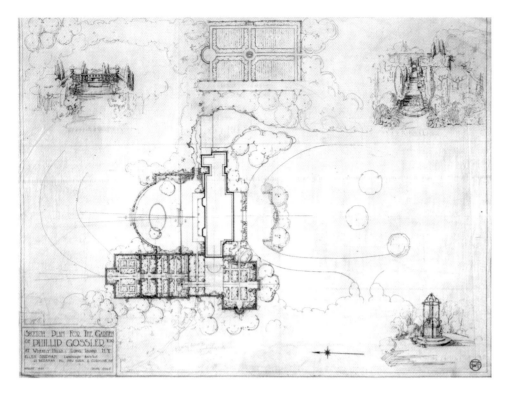

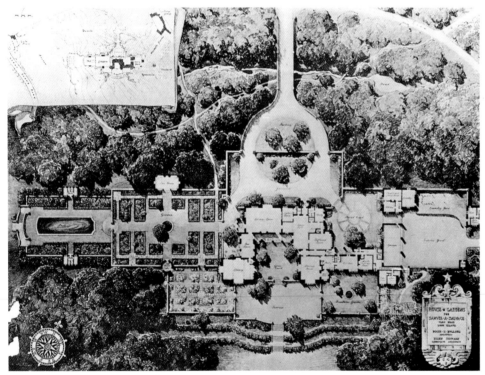

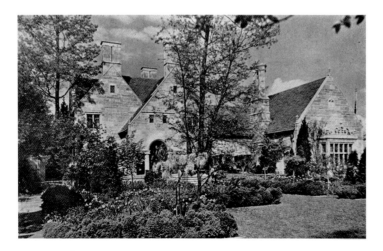

Ellen Shipman, Landscape
Design: Sketch Plan of
Garden, Philip Gossler
Estate, Wheatley Hills, 1926
(CORN, n.d.)

Ellen Shipman, Landscape
Design: Plot Plan,
"Rynwood," Sir Samuel A.
Salvage Estate, Glen Head,
1927 (ARLG, 1929)

Ellen Shipman, Landscape
Design: Garden View,
"Rynwood," Sir Samuel A.
Salvage Estate, Glen Head,
1927 (ARLG, 1929)

Robinson estate in Westbury and the Samuel A.
Salvage design in Glen Head.

The J. Randolph Robinson (1879–1933) resi-
dence was originally designed for the wealthy
businessman and manufacturing representative
in 1917 by John Russell Pope. Pope's Georgian
Revival design was symmetrically organized
around the centered stair hall. In the mid-1920s,
the property was purchased by Philip Gossler
(1870–1945), then president of Columbia Gas
and Electricity Company and a director of the
Guaranty Trust Company of New York. Gossler
commissioned Pope to add a semicircular porch
off the living room and to make some additions
to the eastern end of the house. Gossler also
requested that Ellen Shipman develop a more
extensive landscape plan. Here again, the gar-
dens are clearly related to the house, but they
also assume greater independence in the design.

The entrance court on the north side of the
house consists of a rectangular paved terrace
that descends to an enclosed lawn terrace. A
central opening in this enclosure reinforces the
north-south axis of the plan and provides a con-
nection between the architecture and the open
space beyond. The principal gardens take their
inspiration from the semicircular porch off the
west wing. Using the porch as a pivot, Shipman
designed a series of rectangular terraces that
descend to the north. Planting is symmetrically
organized around a central axis, accentuated by
staircases at each level change. A secondary axis
placed somewhat further west integrates the
garden to the south into the design. While the
gardens still function as a transitional element
between house and landscape, the complex geo-
metric relationships and greater boldness in
their design show the hand of a more mature
artist.

The same can be said of Shipman's design
for the Samuel A. Salvage residence,"Rynwood,"
in Glen Head, which was completed one year
later (1927). This estate received great acclaim in
the architectural press[4] both for the design of its
"Elizabethan Revival" manor house by Roger H.
Bullard and for the sensitivity of its landscape
plan. In the words of one critic:

*There is no evidence of a forced arrangement or an
attempt for effect, but rather a feeling of repose and
inviting simplicity. . . . It has been accomplished
here by a logical irregularity of plan which allows
for a low-lying rambling structure with various
courts and terrace gardens adjoining, each designed
so that it is an integral part of the whole.*[5]

Shipman's landscape plan is, in fact, a master-
piece of independently articulated spaces deli-
cately interwoven by a subtle geometry. The
northern entrance court opens on the east to a

Snelling & Potter: Front
Facade, C. Raoul Duval
Residence, Roslyn, c. 1900
(ARTR, 1902)

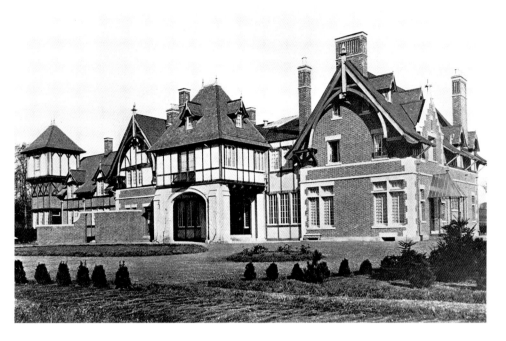

paved court (designed around an existing oak tree) that separates the house from the service wing. This paved court is balanced by a fountain garden on the south side of the kitchen.

The western opening leads to the main walled flower garden, which is aligned with the principal axis of the house. Further west, an apron of semicircular steps lead down to the swimming pool and, finally, via a curved staircase, to the tennis courts beyond.

On the south side of the house, Shipman again uses a progression of enclosed spaces to create a transition from architecture to nature. A grass court leads to a walled terrace, which in turn descends to a lilac walk and wooded ravine. This area is related to the main walled garden on the west by a formal, enclosed rose garden just west of the lower terrace. A dovecote at the northwest corner of this rose garden is aligned with the short axis of the main garden. This axis, in turn, terminates on the north with a small rustic tea house, open on the front but shut in by high stone walls on the garden side. The result is a series of uniquely defined spaces, gently interwoven, which respect the natural site while giving it coherence and definition. The Salvage design represents Shipman in masterful control of her art.

Three other Long Island commissions date from the last years of the 1920s. These are the Richard S. Emmet residence in Glen Cove, another Colonial Revival house designed in collaboration with the firm of Peabody, Wilson & Brown; the Franklin P. Lord estate, "Cottsleigh," in Syosset; and the nearby George de Forest Lord residence, "Overfields." Though none of these landscape plans duplicates the mastery of the Salvage estate, each shows the hand of a mature artist.

After 1930, Ellen Shipman turned to commissions outside the residential sphere, yet her contribution to the renaissance in landscape art was considerable and her influence continued to be felt on Long Island. In 1938, she told an interviewer:

Until women took up landscaping, gardening in this country was at its lowest ebb. The renaissance of the art was due largely to the fact that women, instead of working over their boards, used plants as if they were painting pictures, and as an artist would.[6]

Shipman's Long Island commissions are a testament to this assertion.

Jeanne Marie Teutonico

Snelling & Potter, practiced 1900s

Grenville T. Snelling and Howard Nott Potter (d. 1937) entered architectural partnership in 1895, and together they designed residences, hotels, and churches. The great-grandson of Union College founder Eliphalet Nott, Potter graduated from Union College in 1881. He then studied architecture at Columbia. Grenville Snelling taught architecture at Columbia during the early 1890s. The firm's Long Island work is represented by the c. 1900 (now-demolished) house of C. Raoul Duval in Roslyn. This picturesque, two-story house sported gable ends and a textural wall treatment that combined brick with limestone frame and half-timbering.

Ellen Fletcher

Chandler Stearns: Garden
Facade, John Carlos Ryan
Residence, Roslyn, 1926
(SPUR, 1928)

Robert S. Stephenson, 1858–1929

Educated at Amherst College and Cornell
University, Robert Storer Stephenson worked in
the offices of McKim, Mead & White before
going into private practice in New York about
1890. Although he designed several churches,
the major portion of his work was domestic.
His only known Long Island commission was
the Oyster Bay residence of lawyer John A.
Garver, now the Harmony Heights Residence
for Girls. Built in 1913, the yellow-stucco half-
timbered Tudor-style house presents a pic-
turesque arrangement of sweeping gables and
oriel and casement windows. A passageway with
an open-timbered roof connects a porte
cochere.

Wendy Joy Darby

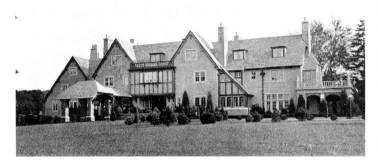

Robert S. Stephenson:
John A. Garver Residence,
Oyster Bay, 1913 (AMCO,
1915)

Chandler Stearns, practiced 1920–30s

The John Carlos Ryan house built at Roslyn in
1926 was the only Long Island product of
Chandler Stearns, son of the noted Boston
architect John Goddard Stearns. This Tudor-
style structure, originally of whitewashed brick,
incorporates two steep-roofed gables on the gar-
den side, which flank an open loggia. Masonry
lintels, a slate roof, half-timbering, and clay
chimney pots provide a variety of color, tex-
ture, and materials. Landscape architect Noel
Chamberlain integrated the house into a setting
of changing levels and vistas. Industrialist John
Dennis Ryan had this house built for his son
John adjoining his own estate. Since 1955 the
Ryan house and grounds have served as the
Renaissance Country Club.

Michael Adams

Frederick J. Sterner, 1862–1931

Frederick Junius Sterner was an English artist
who immigrated to the United States in 1882, at
age 16. After studying architecture in New York,
he moved to Denver, where he practiced with
Varian until 1910. Among the firm's work were
the Colorado Springs' Antlers Hotel (c. 1910),
the castle-like William J. Palmer estate, "Glen
Eyrie" (c. 1910), and a number of other public
buildings and residences. Around 1909–10,
while still living in Colorado, Sterner designed a
number of summer houses, most of them in the
Tudor Revival style, in the "Belle Terre" devel-
opment at Port Jefferson, Long Island. From
1915 through the early 1920s, Sterner practiced
independently in New York, earning a reputa-
tion as a specialist in the conversion of 19th-
century brownstone row houses into homes of
artistic individuality, often featuring gardens.

Frederick J. Sterner, in asso-
ciation with Polhemus &
Coffin: "Falaise," Harry F.
Guggenheim Residence,
Sands Point, 1923 (HOWE,
1933)

Frederick J. Sterner, in associ-
ation with Polhemus &
Coffin: Floor Plan, "Falaise,"
Harry F. Guggenheim
Residence, Sands Point, 1923
(ARAT, 1925)

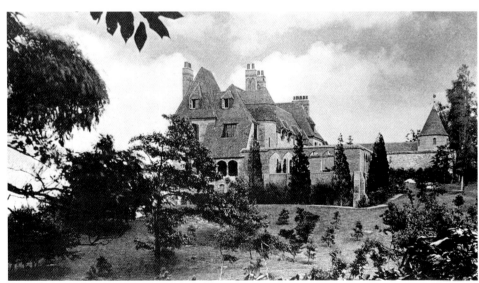

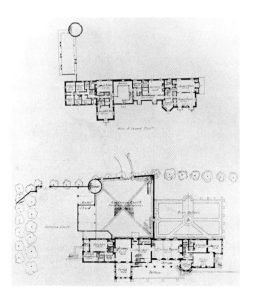

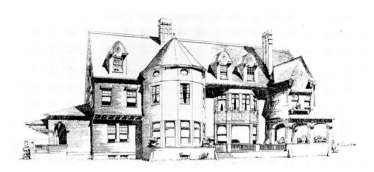

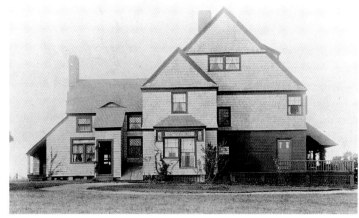

Stickney & Austin: "The Folly," George Bullock Residence, Centre Island, 1894 (AABN, 1894)

Stickney & Austin: Rev. H. T. Rose Residence, Water Mill, 1884 (Courtesy of Cordinley/King)

After 1920 he retired from active practice to spend most of his time traveling in Europe, where he died in 1931.

In 1923, Harry F. Guggenheim hired Sterner as consulting architect (with Polhemus & Coffin) to design a house on 90 acres of Sands Point waterfront land, which had been a wedding present from Guggenheim's father. "Falaise" is a Norman-style, tile-roofed mansion of tapestry brick, stretching northward along a bluff above the ocean. A series of walled courts were designed along the southern front. The tall, pitched roof, hipped dormers and projecting round and polygonal towers, coupled with the pointed-arch arcades give the house its French Provincial character, while the warm-colored walls and roof tiles create a look of mellow antiquity. "Falaise," together with the furnishings acquired in the 1920s, is now a museum operated by Nassau County in association with the Sands Point Park and Preserve.

Ellen Fletcher

on his own, Stickney later formed a partnership with William D. Austin of Boston in 1892. The partners operated from separate offices, with Stickney at Lowell and Austin at Boston. Although by 1900 the architects maintained independent practices, they retained their old firm name out of sentiment. Stickney, who specialized in school buildings, designed two Long Island houses. The 1894 George Bullock residence in Oyster Bay (destroyed by fire in 1899) was a large Shingle Style structure. Bell-shaped dormers and bay and oriel windows formed a lively exterior design. Ten years earlier, Stickney had designed a Shingle Style summer cottage in Water Mill for the Rev. H. T. Rose, a descendant of early settlers of Southampton. The abstract geometry of the exterior relied on the juxtaposition of simple forms for decorative effect, while the interior was resplendent with Arts and Crafts-inspired furniture and decoration designed by the Rev. Rose. Both the house and the interior remain intact today.

Michael Adams

■

Stickney & Austin, 1892–1900
Frederick W. Stickney, 1853–1918
William D. Austin, 1856–1944

Frederick Stickney was born in Lowell, Massachusetts, and studied architecture at M.I.T., graduating at the top of his class in 1872. Working briefly for a local architect and then

■

Charles A. Stone, 1867–1941

A noted engineer and co-founder of Stone & Webster, Inc., one of the largest engineering organizations in the world, Charles A. Stone entered the architectural arena in 1928 when he designed a country house for his own use in Matinecock. Originally intended as a large guest house adjoining Stone's residence (1927, William W. Bosworth), this impressive and creatively landscaped house stands as a well-appointed small estate, a function it continues to fulfill today. Reminiscent of a Tuscan villa, the stucco, two-story structure features a three-story tower and a glazed loggia which faces the courtyard, flanked on one side by a long pergola with decorative iron trellis.

Carol A. Traynor

Charles A. Stone: Rear Facade, Charles A. Stone Residence, Matinecock, 1928 (PREV, n.d.)

Penrose V. Stout: Entrance Gates and Front Facade, Carroll Wainwright Residence, Southampton, c. 1928 (HEWI, 1928)

Joseph H. Taft: Front Facade, "Albro House," R. L. Burton Residence, Cedarhurst, c. 1900 (Courtesy of Mrs. Betty Kuss)

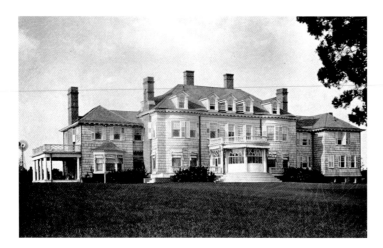

Joseph H. Taft: Rear Facade, "Albro House," R. L. Burton Residence, Cedarhurst, c. 1900 (Courtesy of Mrs. Betty Kuss)

Penrose V. Stout, 1887–1934

Born and educated in Alabama, Penrose Stout began to practice architecture in New York in the early 1920s, after his return from service during World War I. During his brief career, Stout designed several estate buildings on Long Island. Around 1928 he planned the Carroll Wainwright residence on Apaquogue Road in Southampton. This shingled, hipped-roof house still stands on a bluff overlooking the ocean, its symmetrical main block and lateral wings centered by a stylized portico-like entrance bay. Stout also designed a garage and cottage for the Nelson Doubleday estate in Mill Neck.

Ellen Fletcher

Joseph H. Taft, practiced 1900s

The only known Long Island commission executed by Joseph H. Taft was "Albro House," the Cedarhurst residence of Robert Lewis Burton, located directly east of the Rockaway Hunting Club. Built c. 1900 and demolished shortly after World War II, the shingled mansion, consisting of a central block and flanking wings, incorporated Colonial and Georgian Revival elements. The front elevation had a two-story-high portico, the columns having Ionic capitals and carrying a full entablature which extended across the width of the central block. The encasing framework of the main doorway echoed the form of the portico. Fenestration formed the chief source of embellishment, with combinations of tripartite, circular, round-headed, bow, and blind windows being used. A glass-enclosed piazza was set at the rear of the main block overlooking a lawn which extended down almost to the water's edge.

Wendy Joy Darby

Robert Tappan, 1884–1961

Robert Tappan studied architecture at M.I.T. and worked for Ralph Adams Cram in his early years. He was responsible for inventing a system of coordinated unit planning and construction for small homes. Tappan's Long Island work includes two East Hampton houses. Just to the south of picturesque Lily Pond, "Cima Del Mundo" sprawls like an ancient Spanish hacienda, low and horizontal in profile, amid the beach grass of East Hampton's ocean dunes. Designed by Tappan in 1926 for Eltinge F.

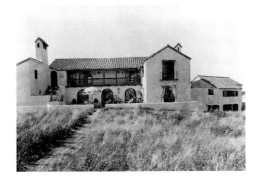

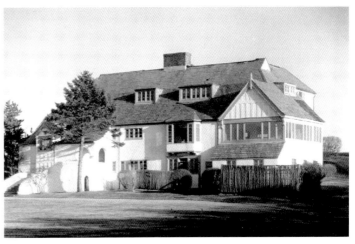

Robert Tappan: "Cima Del Mundo," Eltinge F. Warner Residence, East Hampton, 1926 (HEWI, 1927)

Robert Tappan: "Camelot," Nathaniel A. Campbell Residence, East Hampton, 1928 (INVE, 1978)

Warner, the publisher of *Arts & Decoration* magazine, the house suggests in spirit a movie set for *Zorro* just as much as it does an authentic Spanish farmhouse. The rustic-surfaced stucco walls were originally pink in color. The sloping roof of Spanish tile creates an overhang to the south above a loggia suitable for serenading and looking down to the open patio area below. Three arched doorways lead from the patio into the interior of the house. Inside, the living room ceiling is supported by large wooden beams that are decorated with multicolored peasant patterns. To the west of the main house lies a walled garden and a guest cottage. A lower lying structure, which originally housed servants' quarters and ground-floor bathhouses, is connected to the eastern end of the house.

At the foot of an expansive front lawn, the 1928 Nathaniel A. Campbell house, also in East Hampton, stands prominently on its site near the ocean. The green slate of its roof and the light color of its stucco walls are complementary with the natural surroundings. The Tudor-style half-timbering on the house's projecting gabled bays, its single, central chimney, and the house's name, "Camelot," all suggest an interest in Arthurian romance on the part of the original owner. The house was built on the former site of the Everett E. McCall (originally C. C. Rice) house which burned down in 1927.

Alastair Gordon

■

Charles C. Thain, practiced 1890s–1900s

Charles C. Thain, an architect who maintained an office in New York City beginning in 1896, designed a Tudor-style residence at Great River for Raymond S. White in 1899. No longer standing, the estate was located on River Road south of Montauk Highway and featured a castellated masonry tower.

Carol A. Traynor

■

Joseph Greenleaf Thorp, 1862–1934

A sensitive and perceptive architect, Joseph Greenleaf Thorp developed his architectural career designing residences in East Hampton, establishing the present-day architectural character of this 17th-century English settlement. His career is comparable to many of his contemporaries who designed "summer cottages" along the New England coast, such as Maine's John Calvin Stevens (1855–1940). In contrast to Stevens, however, Thorp made no effort to publish his designs in the architectural press. Thorp's work is almost wholly within the Shingle Style idiom, using a sophisticated interpretation of elements developed by the architects of the English Arts and Crafts movement.

Slightly built, with reddish hair and a slender face, Thorp had great personal charm. One can easily picture the conversations over tea at the home of a fashionable city client, with Thorp earnestly describing and drawing details of a planned summer cottage in East Hampton.[1]

Not much is known about Thorp's architectural education, but it appears to have been typical of the time—some formal schooling, work in architects' offices, and travel-study abroad. He set up his own office in 1886 at Temple Court, a building at 5 Beekman Street

Charles C. Thain: Raymond S. White Residence, Great River, 1899 (VAND, n.d.)

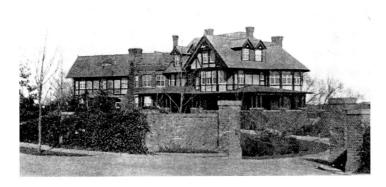

Joseph Greenleaf Thorp, 1862–1934, photo by Kasebier [*sic*], Frederick Keppel & Co., N.Y., 1912 (Courtesy of Sherrill Foster)

in Manhattan before moving in 1893 to No. 26, The Metropolitan, at 1 Madison Avenue. Two years later, in 1895 he moved again to the Constable Building at 111 Fifth Avenue.[2] By this time his pattern of living in the city winters and in East Hampton summers was well established.

Thorp developed a marvelous facility for sketching and drawing, and his one published drawing is a view of a Renaissance building.[3] Thorp is known to have subscribed to the leading architectural magazines of the period which published the work of such English Arts and Crafts architects as Richard Norman Shaw, C. F. A. Voysey, Charles Rennie Mackintosh, and Baillie Scott.[4]

Thorp's connections with East Hampton began early in his career. There, in September 1888, Thorp's stockbroker brother William (1865–1921) married Eleanor Papendiek, daughter of George Papendiek of Boston.[5] The minister for this socially prominent event was the Rev. J. Nevett Steele, who in 1891 would engage Thorp to design his East Hampton summer residence.

Other men of the cloth, such as the Rev. T. DeWitt Talmage, were attracted to Thorp and his architectural ideas. Thorp supervised the remodeling of Talmage's Oak Bluffs-style cottage. Talmage had frequently visited Martha's Vineyard, at the behest of his friend and church trustee, Dr. Harrison A. Tucker of Brooklyn, developer of Oak Bluffs.[6] A man with his hand on America's pulse (and pocketbook), Talmage soon recognized that East Hampton's cottages would be of a different caliber and in 1893 hired the man with the most sensitivity to redesign his own.

The remodeling of the Talmage cottage included oversailing gables and a steep, dominant roof, a primary characteristic of the Arts and Crafts house and of the work of C. F. A. Voysey (1857–1941), the British architect whose work seems to have inspired Thorp. The local newspaper editor, who followed building activity closely, noted that nothing old was recognizable in the new work, but "a sloping main roof gives that gracious style so common among our seaside cottages. . . ."[7]

J. Greenleaf Thorp Residence, East Hampton, 1893–94 (Extant)

About the same time as the Talmage commission, Thorp began building a cottage for his widowed mother, sister, and brother, on Woods Lane. This would be his only essay in the Richard Norman Shaw Old English manner, with its mixed fenestration, varied roof massing, and steep Gothic angle to the gables, a facade of voids and solids, a subsumed porch, and brick first level with half-timbering above. From the porch one enters a hallway, with stairs going up the north wall with its wide stained-glass window. It is possible that Anna Thorp wanted this Shavian-style house to recall days abroad, as this style was already *retardataire* and is an anomaly in Thorp's oeuvre, however well done.

Thorp and his family would live in this house every summer until 1912 when he moved to Florence, Italy, with his mother and sister Emmeline.[8] The reasons for this move are unclear. (Thorp's youngest brother, Edward, had died from the effects of the Cuban campaign in the Spanish-American War.)[9] Thorp, however, soon returned to the States and continued his practice.

In his designs Thorp was able to keep the Queen Anne-stylistic details separated from those of the Shavian Old English style, reinterpreting these themes within the newfound vocabulary of the American Shingle Style. As Shaw left those styles behind, so did Thorp, who picked up on the ideas of Voysey and Edwin Landseer Lutyens. Thorp's work is less personal than that of his English mentors and exhibits a charm based on the subtle use of details. His best work is from this period, 1893 to 1914, when he adapted Arts and Crafts-movement concepts to the needs of an American summer resort. After World War I, Thorp became involved in restoriong, renovating, and remodeling many of the 18th-century homes of the area.[10]

Thorp's clients appear to have been very faithful. Many built several Thorp-designed houses, such as the Potters, a family of Manhattan realtors, and the Rev. Dr. Paxton and his daughter, Mrs. Harry Hamlin.[11]

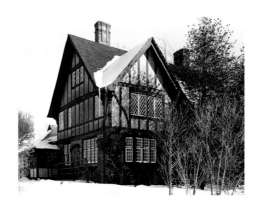

J. Greenleaf Thorp: J. Greenleaf Thorp Residence, East Hampton, 1893–94 (INVE, 1980)

Mrs. S. Fisher Johnson Residences, East Hampton, 1895–97 (Extant)

In 1895 Mrs. S. Fisher Johnson, wife of a Wall Street broker,[12] had Thorp design a typical Shingle Style "cottage" on Dunemere Lane. Two years later, further down the street, Mrs. Johnson had Thorp design two smaller cottages, one behind the other. These cottages were among the most charming Thorp

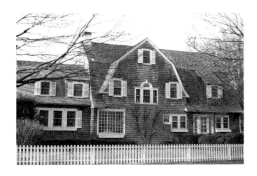

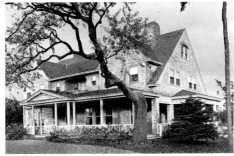

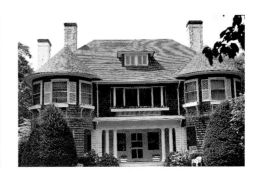

J. Greenleaf Thorp: Mrs. S. F. Johnson Residence, East Hampton, 1895–97 (Woodward Rowland Simes photo, 1976)

J. Greenleaf Thorp: Mrs. F. Stanhope Phillips Residence, East Hampton, 1897 (Harvey A. Weber photo, n.d.)

J. Greenleaf Thorp: F. H. Davies Residence, East Hampton, 1899 (Woodward Rowland Simes photo, 1976)

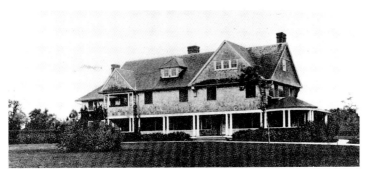

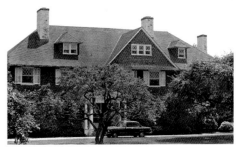

J. Greenleaf Thorp: Mrs. Charles L. Hackstaff Residence, East Hampton, 1899 (ARRC, 1903)

J. Greenleaf Thorp: Front Facade, Frederick G. Potter Residence, East Hampton, 1899 (Woodward Rowland Simes photo, 1976)

designed, with wide gambrel roofs, gambrel cross-gables, gently undulating eaves, and asymmetrically placed windows.

Mrs. F. Stanhope Phillips Residence, East Hampton, 1897 (Extant)

Thorp designed a much larger house in 1897 on the corner of West End Road for Mrs. F. Stanhope Phillips (1854–1943) of New York, daughter of the first editor of the *Detroit Free Press*.[13] In later years under different owners this house became famous as "Grey Gardens," home of Edith Bouvier Beale. Thorp's design, as usual, shows a light touch with decorative elements, but with just the right angle to the gable roof, and a most pleasing spacing between the two, large, wall-face gable dormers.

Seven houses from Thorp's hand were constructed in 1899, the most of any year of his documented work in East Hampton.

F. H. Davies Residence, East Hampton, 1899 (Extant)

Thorp's F. H. Davies house on Ocean Avenue was the most sophisticated design of this group.[14] Here Thorp placed round towers at each corner of the facade, incorporating them into the design of the porch and the second-floor balcony. The house is topped with a hip roof, a Thorp characteristic, with bell-cast eaves. Even the fat towers have a slight bell-cast to the edge of their roofs. The entry is formal, a recessed porch with paired Tuscan columns *distyle in antis*.

Mrs. Charles L. Hackstaff Residence, East Hampton, 1899 (Extant)

The 1899 Lee Avenue house for Mrs. Charles L. Hackstaff of Manhattan is very reminiscent of contemporary work by C. F. A. Voysey: the dominant roof with its large gables, almost oversailing the body of the house, as well as the rectilinearity and the slightly protruding two-story square bay which balances the heaviness of the large cross gable at the other end of the facade.[15] The house is particularly reminiscent of Voysey's "Perrycroft," published in 1894.

Frederick G. Potter Residence, East Hampton, 1899 (Extant)

Across Lee Avenue, Frederick G. Potter (1860–1926) had Thorp design another Voysey-inspired house the same year, this time with a dominant hip roof. Thorp used the published designs of both Lutyens' "Munstead Wood" and Voysey's "Broadleys" as a basis for a sophisticated American Shingle Style "cottage." The gentle slope of the roof, the great triangular gable, the flared string course, and the very wide windows are synthesized into a lovely and enduring design.

E. Clifford Potter Residence, East Hampton, 1899 (Extant)

Simultaneously, E. Clifford Potter (1863–1937), Frederick's brother and partner in their Manhattan real estate organization, commissioned Thorp to design a house on Ocean Avenue which resembles Voysey's 1890 A. J. Ward house, "Dovercourt," in Essex, England. This too has a wide, flaring, hip roof, and a subsumed porch—

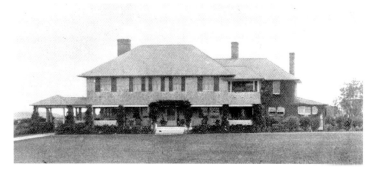

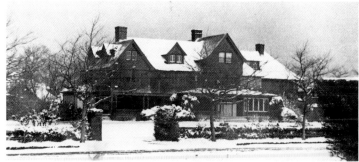

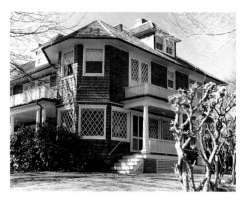

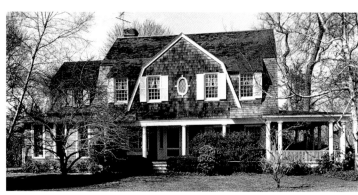

J. Greenleaf Thorp: E. C. Potter Residence, East Hampton, 1899 (ARRC, 1903)

J. Greenleaf Thorp: Entrance Front, "Windward," Rev. John R. Paxton Residence, East Hampton, 1900 (East Hampton Free Library, n.d.)

J. Greenleaf Thorp: Second Frederick G. Potter Residence, East Hampton, 1905 (Woodward Rowland Simes photo, 1976)

J. Greenleaf Thorp: Front Facade, Andrew C. Bradley Residence, East Hampton, 1900 (Harvey A. Weber photo, n.d.)

the whole almost devoid of decoration yet with graceful lines that make it the ageless summer cottage. The discreet Voyseyesque themes are typical of Thorp, who may have employed these Lake Country designs because of the similarity of climate and use.

Rev. John R. Paxton Residence, "Windward," East Hampton, 1900 (Extant)

The Rev. Paxton was one of the first to rent a "Talmage Cottage," soon purchasing it and adding amenities. Retiring in 1898 at the age of 55 because of ill health (he would live to be 80), Paxton soon realized his need for a proper summer cottage. He engaged Thorp in 1900 to build, at a cost of $15,000, an asymmetrical facade incorporating varied roof massing, half-timbered cross gables in the West of England style, and a piazza across the facade with a small, second-floor roofed porch above (possibly a reinterpretation of Eidlitz's loggia effect on his sister's Lee Avenue house of 1899). George Eldredge, the builder, could handle these complicated facades with facility and built a number of these asymmetrical solid and void houses at that time in East Hampton.

Second Frederick G. Potter Residence, East Hampton, 1905 (Extant)

In 1905 Frederick Potter had Thorp design a new house on Ocean Avenue. Although many elements are similar to the one on Lee Avenue, the site is much more commanding, with views of the Atlantic Ocean to the east over Hook Pond and the sand dunes along the shoreline.

There are the sheltering hip roof, wide overhangs, solids and voids across the facade, and just a hint of asymmetricality in the placement of the two-story octagonal bay. This later house shows Thorp's consciousness of the elements of the newly popular Colonial Revival style which are interpreted in the restrained manner so typical of Thorp.

Andrew C. Bradley Residence, East Hampton, 1900 (Extant)

The turn of the century brought a gambrel-roof Shingle Style house for Associate Supreme Court Justice Andrew C. Bradley (1844–1902) on Woods Lane, a larger version of the cottages Thorp had designed for Mrs. S. Fisher Johnson on Dunemere Lane.[16] A graciously designed gable facade contains a subsumed porch supported by slender posts. Wings to each side carry shed dormers.

Although Thorp's work is restrained, it is not pinched. His facades are pleasingly full and coordinated, seemingly inspired by the work of his English contemporaries. Such unassuming, quiet designs, carefully balanced and presented, are typical of his work.[17] This restraint is as appreciated today as it was in period, and not surprisingly adds to the charm of East Hampton's leafy streets. All the houses discussed in this essay survive today and continue to be used as private residences.

Sherrill Foster

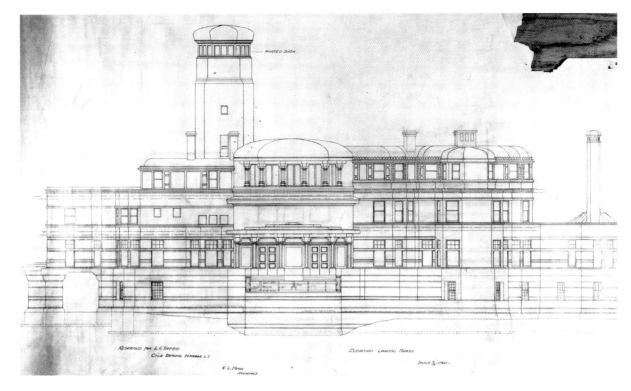

Louis C. Tiffany: North
Elevation, "Laurelton Hall,"
Louis C. Tiffany Residence,
Laurel Hollow, 1902–05
(From the collection of the
Charles Hosmer Morse
Museum of American Art,
through the courtesy of the
Charles Hosmer Morse
Foundation. Theodore
Flagg photography, 1905)

Louis Comfort Tiffany, 1848–1933

Sited on a rise overlooking Cold Spring Harbor, with its gray walls and blue-green roofs and floating in a sea of green tint, "Laurelton Hall" hovered like a mirage, as if it were the legendary palace of Kublai Khan. To one observer it seemed as if it embodied a combination of "the perfume of the Orient and the horse sense of America."[1] Its strange, haunting beauty attracted sightseers, critics, and writers, and inspired them to sing its beauty and pleasures. One journalist wrote that "stars of wonder" danced in the eyes of Long Island natives brought up on traditional prim buildings, while another writer claimed that Tiffany had refused "to be controlled by the harsh rule and iron despotism of classic precedent."[2] An "experiment" in direct conflict with the usual American tendency to "follow the history and spirit of other nations" was the verdict of still another writer; the house and its interior betrayed the hand of an "alchemist," "an intensely original mind" in sympathy "with American ideals of beauty."[3]

The house Louis Comfort Tiffany created for himself between 1902 and 1905 is one of the few in America that might be called Art Nouveau. A striking and original break with architectural precedents, "Laurelton Hall" ranks with some of Frank Lloyd Wright's houses in the Midwest, Charles Sumner and Henry Mather Greene's in Southern California, and the masterpieces of European architects and designers in Brussels, Paris, and Vienna. Its owner and designer, Louis Comfort Tiffany, is not normally known as an architect but as an artisan in glass, an inventor and manufacturer of Favrile, iridescent stained glass and glassware, and other decorative objects, and as a decorator and designer.[4]

Born in New York, the son of Charles Lewis Tiffany, the founder of Tiffany & Company, and Harriet Oliva (Young) Tiffany, Louis studied painting in America with George Inness—whose Swedenborgian mysticism greatly influenced him—and Samuel Colman, and then in Paris with Leon Bailly. He also traveled extensively in Spain and North Africa, and the ornament, color, decorative arts, and patterns of both would later reappear in his work.

In the 1870s Tiffany, working as a painter in collaboration with John La Farge, began to experiment with stained glass. By the later 1870s he had set up the firm of Associated American Artists in conjunction with Lockwood de Forest, Candace Wheeler, and Samuel Colman, and decorated many interiors, including the White House in Washington and Mark Twain's house in Hartford.[5] In 1883 he set up the first of several companies under his own name and began the production and marketing of his own products: glassware, stained glass, lamps, metalwork, pottery, mosaics, furniture, and other items. At the same time he operated a decorating firm. By the early 1890s Tiffany had gained an international reputation and his work was regularly shown at exhibitions. In Paris, Siegfried Bing, the founder of the gallery *L'Art Nouveau,* showed Tiffany's work and commissioned special windows from him.[6]

Louis C. Tiffany: North (Sound) Side, "Laurelton Hall," Louis C. Tiffany Residence, Laurel Hollow, 1902–05 (Courtesy of Mrs. Collier Pratt)

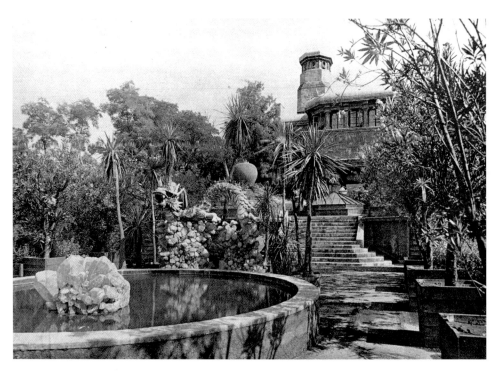

Identified with Art Nouveau because of his association with Bing and the frequent use of blossoms, vines, and curves in his work, Tiffany was actually more in tune with the English and American Aesthetic and Arts and Crafts movements, dedicated to introducing beauty into everyday life. Stylistically, he was a true eclectic with an exotic bent; he drew upon the Near East, Europe, and Asia—especially Japan and China—as well as nature. As he did not confine himself to any one art form, Tiffany was free to express himself as he chose. His endeavors were immensely profitable, and the proceeds, coupled with the money he inherited at the death of his father in 1902, made him a rich man able to indulge his tastes. "Laurelton Hall" was his supreme creation, the product of an obsession with the totality of art, craft, and nature in the service of beauty.

Although Tiffany never worked as an architect professionally, he was constantly involved in architectural projects because his firm designed interiors. In the early 1880s he had worked with Stanford White of McKim, Mead & White on the design of the Tiffany family mansion at Madison Avenue and 72nd Street in New York. Around 1890 Tiffany acquired a house at Oyster Bay, "The Briars," which he remodeled extensively in the prevailing modernized Colonial or Shingle Style mode, also redoing the interiors. Surviving photographs reveal interiors that emphasized flat planes, color, texture, and simple furniture, all very much in the international Arts and Crafts mode.[7]

In 1902, following the death of his father, Tiffany began to acquire land adjacent to "The Briars," which opened on Cold Spring Harbor, accumulating nearly 600 acres in time. The site closest to the harbor contained an old resort hotel, "Laurelton Hall," dating from the 1860s, which he razed. So that he could treat the site as a totality, he commissioned a clay model of the topography and vegetation and, using modeling wax, formed his structures in three dimensions. Although he was the designer, Tiffany asked Robert L. Pryor, a young architect who worked for him, to produce the working drawings.

Instead of presenting itself as a plastic mass of external form, the main house consisted of a series of spaces, including a central court, dining room, and terraces, each with the most advantageous views. The whole long line of the house fit snugly into the hillside with the road passing around it. As one commentator observed, "there was not cutting and filling on a wholesale plan, . . . Nature has been met half-way, not antagonized and bullied."[8] Also laid out were the stables and model farm, a huge Moorish complex designed by Alfred Hopkins, and tennis courts, ponds, gardens, and roads. A long road past the gate house—formerly the mid-19th-century Wood family summer house remodeled by Tiffany and, after 1919, an art gallery—led the visitor through groves of vegetation, some exotic and imported, and some native such as laurels, oak, hickory, and rhododendrons. Gardens and terraces abounded, some in native plants, others with foreign plants and motifs reminiscent of oriental sunken gardens. The water system serving the house emerged as a cascade, ponds, a hanging garden, and seven fountains. Work by American artists, as well as a sculpted Japanese dragon, were part of the exterior display, and on a lower terrace overlooking the harbor a giant rock crystal stood in the middle of a pool. Entrances, like the porte cochere on a lower

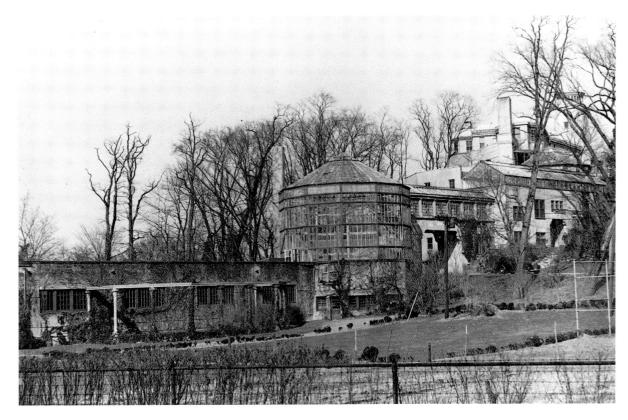

Louis C. Tiffany: Main House, "Palm Garden" and Greenhouse before the 1957 fire, "Laurelton Hall," Louis C. Tiffany Residence, Laurel Hollow, 1902–05 (SPLI photo, n.d.)

level than the main floor, testified to the fit of the house into the natural slope, as did the various gardens and terraces that spun down the hillside. The interior encompassed eight levels, among them conservatories on the lowest, a squash court—marked by a skylight—underneath the north terrace, and the main living floor whose major rooms enjoyed double exposures to both the south and north.

The exterior form of "Laurelton Hall," a long rambling affair of over 280 feet, exhibited none of the usual Beaux-Arts symmetry and separation from the landscape. Instead, it opened on all sides to gardens, terraces, and pergolas (each treated as an extension of the interior space), or onto separate rooms like the "Daffodil Terrace" off the dining room on the south side. Here marble columns topped with capitals set with glass daffodils supported a wooden ceiling open in the center to preserve an old pear tree. This opening was surrounded by an attic of iridescent blue glass in the form of five-and-a-half-inch squares which created a pattern of branches, leaves, and fruit in bloom. "Laurelton Hall" was a plastic mass of horizontal striations—belt courses and moldings—in shades of gray stucco topped by a rounded roof of acid-tinted blue-green copper that rolled back from the deep overhanging eaves. The juxtaposition of sharp planes crisply delineated and molded with the rounded forms provided a striking contrast. As a counterpoint to the horizontality of the building, a faceted tower rose next to the garden entrance, offering a single

vertical accent. A loggia adjacent to the tower evoked Middle Eastern forms, the columns covered with bright, wine-red ceramic poppies in various stages of bloom.[9] Two turquoise-colored 17th-century Chinese Kang-hsi dogs stood guard in front of the entrance to the house. Highlighting the horizontality of the architecture, all fenestration was placed between the horizontal bands with the windows (grouped in ribbons) and open loggias forming rectangular voids.

"Laurelton Hall's" long horizontal layers were further emphasized by a concrete ledge on top of the foundation which rose to the sills of the main floor. Set back above the concrete base stood the superstructure of iron, wood, and stucco on lath. The ledge between the two sections formed a continuous base for the house, linking together all the terraces and long rambling appendages. A copper trough set into the ledge served as an extended planter, so that the entire house seemed alive with growth. After a few years one observer noted, "Time has softened the daring masses . . . Nature has filled the chinks with growing things, little and large."[10] The concrete foundation of "Laurelton Hall" was roughly textured with large surface stones, while the stucco above had a less coarse pebble-dash. This treatment of layers and vegetation was Tiffany's attempt to "symbolize Americanism" and create an "indigenous" American architecture. He claimed that it had been inspired by the stratified cliffs in Yellowstone and the Grand Canyon, which he saw on his travels in the West.[11]

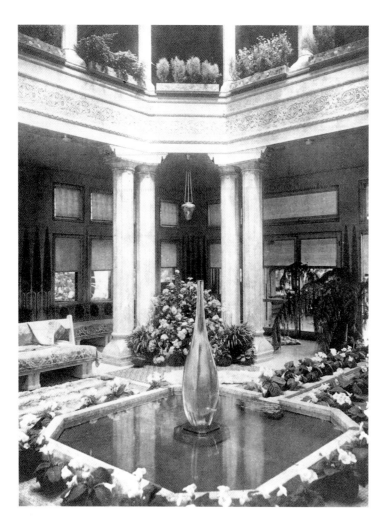

Louis C. Tiffany: Entrance Hall or Court, "Laurelton Hall," Louis C. Tiffany Residence, Laurel Hollow, 1902–05 (ARLG, 1907)

Tiffany's catholic taste also manifested itself in the interior of "Laurelton Hall." Color prevailed throughout, from the choice windows installed in many of the rooms, to the deep purple and blue mosaic columns recalling the interiors of renowned basilicas in Ravenna and Constantinople.[12] An octagon-shaped room displayed Tiffany's Far Eastern antiques, while other rooms showed his collections of Native American and American Colonial art. The living room was a vast, dim space, warmed by walls covered in a vine-patterned wallpaper and a huge inglenook and fireplace. In many rooms Tiffany dispensed with traditional wood or plaster moldings for door and window surrounds or cornices. The dining room stretched 38 feet through the house; over the center of the room hung an inverted dome made of thousands of pieces of Favrile glass in green, yellow, gold, and orange arranged in a pattern echoed by the rugs below. In 1910 climbing wisteria vines over the window bays in the southwest part of the room inspired Tiffany to create stained-glass panels which would remain in constant bloom. From all accounts, the most memorable space was the three-story-tall, octagonal-shaped hall or court at the center of the house, where visitors first entered. Covered by a translucent blue-glass dome from which hung a spherical glass lamp, the hall conveyed a sense of a quietude and reverence for

beauty. White marble columns ringed the space and supported the balcony, while the outer walls were covered in stenciled canvas with a pine tree pattern taken from a mural in the Topkapi Palace in Constantinople. Lit from below, a pool occupied the middle of the hall, which was filled with plants and objects. In the center of the pool stood perhaps the most serene shape that ever emerged from Tiffany's highly charged imagination—a simple pear-shaped vase in the form of a Greek amphora. Emerging almost imperceptibly from its mouth, water flowed down the sides of the vase. So subtly did its colors change, depending not only on the time of day but also on reflections and the water itself, that the vase seemed to be alive. Tiffany himself commented, "The Vase, it seems, has a term of life So ethereal, so exquisite is it that one seeks in vain for a smile."[13]

The house and grounds were largely completed in 1905, although Tiffany continued to make changes and additions. While initially "Laurelton Hall" had been intended for summer living only, Tiffany decided to keep it open year-round and installed a power plant by the shore with a smokestack recalling an Islamic minaret. He added studios on the grounds and, in time, homes for his daughters. In 1916 he acquired the glass chapel he had created for the 1893 World's Columbian Exposition in Chicago and installed it on the property.

Always a supreme egotist, Tiffany loved to host parties at "Laurelton Hall" and organized many costume festivals there. In 1919 he established the Louis Comfort Tiffany Foundation with the house and grounds as its major assets. The purpose of the foundation was to encourage young artists to develop their talents by spending summers at "Laurelton Hall" studying nature. The site and grounds certainly provided ideal opportunities to appreciate nature firsthand, while the collection of fine art and artifacts within the house offered further inspiration.

The Great Depression led to the collapse of Tiffany's business and personal fortune and sent him into bankruptcy.[14] He died in January 1933. The Tiffany Foundation continued to manage "Laurelton Hall," but the upkeep of the house and the expense of maintaining the art school exhausted its resources. From 1942 to the end of World War II, "Laurelton Hall" served as the headquarters of the Marine Research Organization and the National Defense Research Committee. In 1946 most of the contents of the house were auctioned, and three years later the remaining property, house, and other buildings were sold. In 1957 a fire destroyed the house, but some of the important decorative elements were salvaged and eventually acquired by several museums.[15]

Richard Guy Wilson

Tooker & Marsh: Front Facade, "Ryefield Manor," Amos D. Carver Residence, Lattingtown, 1910 (Courtesy of Anthony K. Baker)

Tooker & Marsh, practiced 1910s

Designed for Amos Dow Carver, one-time owner and operator of coastal trading schooners and head of the marine supply firm of Baker, Carver & Morrell, established in 1827, "Ryefield Manor" in Lattingtown is typical of the early 20th-century Georgian Revival mansions built in this area. The central-hall plan structure, designed in 1910 by the architectural firm of Tooker & Marsh, is laid up in Flemish bond with brick quoining. The entry portico, with its four massive Ionic columns, marks the three-story-high galleried central hall. The hall terminates in a glass-enclosed sun room which had its own fountain. Beyond was a formal garden centering on a large lily pond. The house is extant and continues today as a private residence.

Wendy Joy Darby

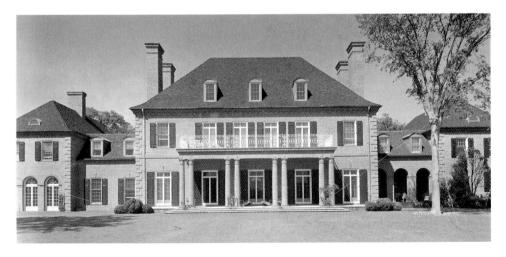

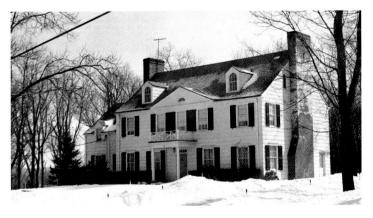

Treanor & Fatio: Rear Facade, "Oldfields," George Backer Residence, Oyster Bay, 1934 (GOTT, 1934)

Treanor & Fatio: "Hawk Hill," Emil J. Stehli Residence, Lattingtown, 1925, alterations, 1929 (INVE, 1978)

Treanor & Fatio, 1921–1930s
Maurice Fatio, 1897–1943
William A. Treanor, 1878–1946

Maurice Fatio was born in Geneva, Switzerland, into a banking family of Italian, Swiss, and French ancestry. Fatio studied at the Ecole des Beaux-Arts and the Zurich Polytechnic where he graduated in 1920. Coming to New York, he formed a partnership in 1921 with a native of Yonkers, New York, William A. Treanor. Treanor was a product of Pratt and Columbia University. In only a short time, Treanor and Fatio were acknowledged designers of distinctive houses; the partners' clientele included Edward Stotesbury, Mortimer Schiff, Harold S. Vanderbilt, Joseph E. Widener, and Consuelo Vanderbilt, the former Duchess of Marlborough. They maintained offices in New York and Palm Beach, and for a time, during the Florida land boom, Treanor and Fatio had an office in Miami. In terms of talents, social and aesthetic, the handsome and well-to-do Maurice Fatio was the unchallenged heir to Addison Mizner.

In 1934 Treanor & Fatio designed two houses destined for a linked history. One was built just outside of Palm Beach for Col. and Mrs. Louis Jacques Balsan (Mrs. Balsan was the former Consuelo Vanderbilt and later Duchess of Marlborough). The other, called "Oldfields"— an adaptation of "Carter's Grove," the mid-18th-century Tidewater plantation house—was designed for George Backer at Oyster Bay. Not long after its completion, Mr. Backer sold his house to Dorothy Schiff, daughter of the prominent financier, Mortimer Schiff, and owner of the *New York Post*. She, in turn, around 1939, sold "Oldfields" and its 135 acres to the Balsans. Today the house is maintained as the clubhouse for the Pine Hollow Country Club.

The firm's other Long Island commissions include "Hawk Hill," a Neo-Colonial house at Lattingtown built in 1925 for Emil J. Stehli. In 1929 Treanor & Fatio enlarged the house to include a Tudor Revival great room replete with oak wainscoting and several other rooms built around a paved courtyard. This spatial arrangement gives an intimate scale to the mammoth structure that, put on axis, would have resembled a resort hotel. In fact, the house was cut in half in 1969 to form two separate dwellings.

In 1931 Treanor & Fatio designed a pool house at Southampton for Woolworth heiress Mrs. James P. Donahue, who had acquired the former Wyckoff estate in the 1920s. A picturesque pastiche of half-timbering with fancy brick nogging and elaborate chimneys, the pool house was completely demolished in the 1938 hurricane.

Michael Adams

Trowbridge & Ackerman:
Front Facade,
"Killenworth," George D.
Pratt Residence, Glen Cove,
c. 1913 (Courtesy of
Sherman Pratt)

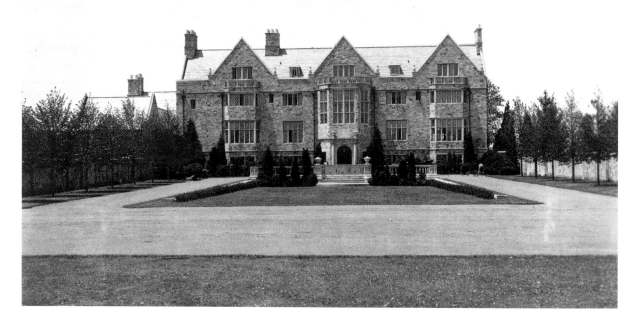

Trowbridge & Ackerman:
Rear Facade, "Killenworth,"
George D. Pratt Residence,
Glen Cove, c. 1913 (PATT,
1924)

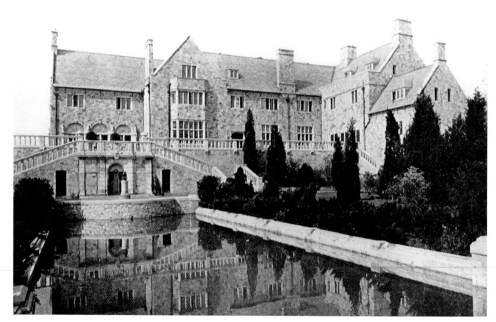

Trowbridge & Ackerman, 1906–1921
Frederick Lee Ackerman, 1878–1950
Alexander B. Trowbridge, 1872–1940

Frederick Lee Ackerman and Alexander B. Trowbridge practiced architecture together in New York City from 1906 until 1921. Both had graduated from Cornell (Trowbridge in 1890, Ackerman in 1901), and both had gone on to study at the Ecole des Beaux-Arts in Paris. Trowbridge went back to Cornell, where he was director and dean of the College of Fine Arts during Ackerman's undergraduate years.

In addition to the interest in country-house architecture which the partners shared, Frederick Ackerman was involved in public housing and urban planning, and contributed to a number of significant urban and suburban projects. Sunnyside Gardens, the model medium-income project built by New York City's Housing Corporation in Long Island City, Queens, was Ackerman's plan. He was also a consultant for "The Town for the Motor Age" in Radburn, New Jersey, a large mixed-unit housing development with playgrounds, gardens, and a community center.

Trowbridge & Ackerman:
Floor Plans, "Killenworth,"
George D. Pratt Residence,
Glen Cove, c. 1913 (PREV,
n.d.)

Trowbridge & Ackerman:
The Gallery, "Killenworth,"
George D. Pratt Residence,
Glen Cove, c. 1913 (PREV,
n.d.)

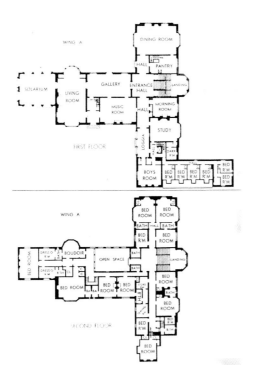

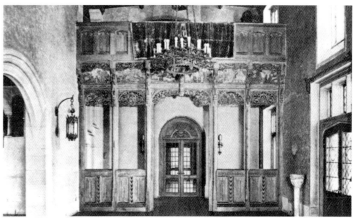

Ackerman developed a reputation as a writer and speaker on housing and city planning, often acting as a consultant for public agencies in New York, Providence, Rhode Island, and other cities. Lewis Mumford called Ackerman "the first important architect after Louis Sullivan to be fully alive to the social responsibilities—and economic conditioning—of architecture."

Alexander Trowbridge, a native of Detroit, brought a different asset to the partnership. He was the brother-in-law of George D. Pratt, third son of the Standard Oil magnate. Through this connection the firm became involved in the Pratt family complex at Glen Cove, Long Island.

Dosoris Park, the 1,100-acre estate George Pratt's father had begun building in 1890, was the summer retreat for three generations of Pratts, whose year-round home was in Brooklyn. Before Trowbridge & Ackerman began their work, the compound already represented the work of several architects of national reputation. Charles Pratt's mansion, the first to be built, was designed by Lamb & Rich, and other houses were by Charles A. Platt and Delano & Aldrich. At its peak, the Dosoris complex comprised 21 houses, 61 outbuildings, and a mausoleum, built between 1850 and 1968.

George Pratt, who commissioned Trowbridge & Ackerman to design his Glen Cove mansion, was known chiefly as a patron of the arts. Commissioner of Conservation for the State of New York, Pratt was also a trustee of the Metropolitan Museum of Art, the American Museum of Natural History, and president of the American Forestry Association.

His home, "Killenworth," a two-and-a-half-story Tudor Revival mansion, was named "Best House of the Year" by the magazine *Country*

Life in America in 1914, and received an AIA prize for country houses the same year. It replaced a smaller, wooden Queen Anne-style summer house on the same site, designed in 1897 by William B. Tubby.

The 39-room building of gray Weymouth granite is limestone-trimmed, with a slate roof. It is a sophisticated, symmetrical example of its style, with two-story bay windows centering three facade gables on the front (east) facade. The west wing, which opens onto terraces above a swimming pool, contains the principal public rooms, a two-story gallery, living room, music room, and solarium. The 39½-acre grounds, laid out by James L. Greenleaf and Beatrix Farrand, allow the T-shaped house with its formal terracing to emerge from a dense wooded setting. The grounds originally included greenhouses, tennis courts, and a garage in addition to gardens, woodland, and lawn. Today, "Killenworth" is owned by the U.S.S.R. (now the Confederation of Independent States), and is used as a recreational retreat for employees based in the United States.

Trowbridge & Ackerman designed another house in the Pratt complex, "Whispering Pines," the home of Charles Pratt's grandson Theodore Pratt. This Pratt, the third generation to live in the Glen Cove compound, was a financier, a director of Socony, the Chase Manhattan Bank, and the Germanic Safe Deposit Company. He had the house built in 1923, and lived in it until he retired to an early-18th-century house in Virginia.

"Whispering Pines" was built two years after Trowbridge retired from the partnership and, as the drawings are stamped "Trowbridge & Ackerman, Frederick L. Ackerman," it is likely that he did not participate in the design.

Trowbridge & Ackerman:
South Facade, "Whispering
Pines," Theodore Pratt
Residence, Glen Cove, 1923
(PREV, n.d.)

Trowbridge & Ackerman:
Garden Facade,
"Whispering Pines,"
Theodore Pratt Residence,
Glen Cove, 1923 (PREV, n.d.)

Trowbridge & Ackerman:
Rear Facade, Jay F. Carlisle
Residence, East Islip, 1917
(HOWE, 1933)

The house is a substantial two-and-a-half-story Federal Revival structure of whitewashed brick with a red-slate roof. The five-bay, center-entry main block is flanked by lateral wings, with a later extension added to the east. Exterior detail is simple: six-over-six windows have black shutters, and the fascia below the main cornice is trimmed with a Greek key motif. The main entrance on the south facade is sheltered by a one-story pagoda-roofed portico with wrought-iron colonettes and side panels. The garden facade of the main block has a two-story veranda under its eaves. The interior is simpler than "Killenworth," featuring a paneled library setting off simpler plastered rooms, most with delicate Federal Revival mantels. A detached studio/bathhouse stands near the swimming pool. "Whispering Pines" is still a residence today.

In addition to the two estate houses, Trowbridge & Ackerman were also responsible for the Dosoris Park beach house, which is no longer standing.

In 1917 Trowbridge & Ackerman designed a large Mediterranean villa-style estate in East Islip on the south shore for Jay F. Carlisle, one of the leading industrialists of his day and former Secretary of the Treasury under Grover Cleveland. No longer standing, the slate-roofed tile-and-stucco house surrounded three sides of a court, with a formal, architectural garden terrace at one side and lake frontage at the other. The extensive grounds were landscaped by Vitale, Brinkerhoff & Geiffert.

Ellen Fletcher

Trowbridge & Livingston, 1899–1946
Goodhue Livingston, 1867–1951
S. B. Parkman Trowbridge, 1862–1925

The firm of Trowbridge & Livingston was among the best-known firms of the day. Begun as Trowbridge, Colt, and Livingston in 1894, it was renamed in 1899 following the withdrawal of Colt, and it lasted until the retirement of Livingston in 1946. All three founders graduated from the Columbia School of Architecture and apprenticed with George B. Post in the 1880s and 1890s. The solidity in the massing of their buildings and their careful detailing reflect the well-schooled academic spirit of Post's work. They executed many important civic, business, and residential buildings throughout the country including the Palace Hotel in San Francisco (1909–10), Hogan Hall at Columbia University, the Saint Regis Hotel in New York City (1902–03), the Mellon National Bank building in Pittsburgh (1925–26), and residences for Henry Phipps in New York City, Amory Carhart in Tuxedo Park, New Jersey, and Frederick W. Sharon in Menlo Park, California, to mention only a few. Their most notable commissions included the New Brunswick, New Jersey, industrial housing project No. 271 for the U.S. Industrial Housing Corporation during World War I and the commission for the new state capitol in Oregon, which Livingston won in 1936 in competition with 136 other entries. Both men were active professionally and suitably honored. Trowbridge served as president of the Architectural League of New York in 1913, trustee of the American Academy in Rome, president of the Society of Beaux-Arts Architects, and commissioner of the first National Council of Fine Arts under President Theodore Roosevelt. Livingston won the medal of honor from both the Architectural League of New York and the American Institute of Architects of New York City.

Trowbridge & Livingston:
Front Facade, "Fairlegh,"
George S. Brewster
Residence, Brookville, 1914
(ARRV, 1919)

Trowbridge & Livingston:
Entrance Facade, "Broad-
view," Dennistoun M. Bell
Residence, Amagansett, 1916
(SPLI, photo by Harvey
Weber, 1980)

Trowbridge & Livingston:
Rear (Garden) Facade,
Goodhue Livingston
Residence, Southampton,
c. 1911 (HEWI, n.d.)

The firm of Trowbridge & Livingston executed three country estates on Long Island. "Fairlegh," the 1914 George S. Brewster residence in Brookville, was by far the most imposing. It presents a full two stories to the south, with outer bays pavilioned out from the main block, a studied example of the Georgian Revival manner resting securely under a huge hipped slate roof of one-and-a-half stories topped by a decorative balustrade and two sets of paired chimneys. The careful detailing, including apt proportions and delicate dentilled cornice, mark this house as a full-grown version of the 18th-century southern plantation house—"Westover" writ large within the full panoply of Beaux-Arts detailing. The 1916 Dennistoun Bell residence in Amagansett, called "Broadview," presents a starker facade of Neoclassical character with white corner pilasters rising the full height of the house somewhat in the manner of Bullfinch's University Hall at Harvard, a popular reference point for much Beaux-Arts architecture in the Neoclassical mold. Finally, the private residence of Goodhue Livingston himself, built c. 1911 in Southampton, is a satisfying eclectic effort mixing Colonial Revival porches under a broad, hipped roof extended over the body of the house on exposed rafter ends, considered an Italianate feature at the time. The tight, shingled massing of the house recalls the best examples of H. H. Richardson's architecture of the 1880s, while the high, hipped roof, punctuated by assertive chimneys, evokes the spirit of the British architect Sir Edwin Landseer Lutyens. Both the Bell and the Livingston houses survive today as private residences while the Brewster residence is now the Fox Run Golf and Country Club.

Peter Kaufman

Horace Trumbauer, 1868–1938

By the time he began creating Long Island mansions at the age of 33, Horace Trumbauer was already a noted architect. No impediments could divert the lifelong Philadelphian. Foregoing high school, he entered the architectural firm of G. W. & W. D. Hewitt, where he rose rapidly. Trumbauer opened his own firm as soon as he turned 21. From the start he attracted prosperous clients and within two years embarked on the first of the many palaces he designed for tycoons of the era.[1] In short order his buildings reached beyond Philadelphia to include townhouses along Fifth Avenue in New York City and "cottages" in Newport, Rhode Island, eventually extending west to Colorado

Horace Trumbauer, 1868–1938 (The Free Library of Philadelphia, n.d.)

and east to England.[2] Little time was left for a personal life outside his office, which produced an average of one work every two weeks for the near half-century until his death. Despite their abundance, he expended meticulous care on every commission. Although he employed capable designers and draftsmen, they gave final credit to the "Old Man."

William K. Vanderbilt, Jr., Residence, "Deepdale," Lake Success, Great Neck, 1902 (Extant)

Trumbauer's introduction to Long Island came through one of the Vanderbilts. Both his client's mother, the tyrannical Alva, and his father, grandson of the "Commodore," would scatter residences along the Island, but William Kissam Vanderbilt, Jr. (1878–1944), looked to his uncle for inspiration. George W. Vanderbilt had, during 1895, completed the biggest of all the family mansions, "Biltmore," a 250-room French Renaissance château set amid 125,000 acres in Asheville, North Carolina. Willie K., as he was nicknamed, aimed to assemble a similar barony ruled from a manor designed by Hunt & Hunt (the sons of Richard Morris Hunt [1828–1895], designer of "Biltmore"). In fact the result was among the most modest of Vanderbilt homesteads.

Vanderbilt and his bride, née Virginia Graham Fair, needed a home while he bought up land on either side of the Queens-Nassau border. Satisfied with Trumbauer's 1901 alterations to their Manhattan residence, the couple asked the architect to erect a simple house—which is where the matter grows complex. Listed in the architect's ledgers is a "cottage for Sydney J. Smith," a cotton broker, but more importantly a sportsman. Once the Vanderbilt castle was ready, Smith (1868–1949) was scheduled to occupy the cottage so that Vanderbilt could have his jovial companion nearby.[3] Vanderbilt paid for the 1902 house, and his is the name that appears in connection with the additional work carried out from 1902–03 on the estate he called "Deepdale."[4] Modeled after

the austere Federal Long Island abodes of earlier times, the central block beneath the gable roof held the family lodgings. Low passageways join both ends to facing L's that housed servants and their workplaces.

Lake Success, which lent its name to the surrounding village in Great Neck, measures 80 feet deep in places but less than a quarter-mile across. Still, a lake was mandatory, so that Vanderbilt found himself upping his offer to $50,000 for the largest body of fresh water on Long Island. In the new climate of reform, the millionaire wresting a public preserve from the stubborn citizenry became national news.[5] Realizing he was licked, Vanderbilt summoned Carrère & Hastings to turn his Trumbauer-designed house into the main residence. In addition to adding two enormous L's on the garden side of the house, the architects brought along trellises and antique fireplaces and other paraphernalia thought necessary for a rich man's house. Trumbauer had converted the plainness of the original house into its strength, emphasized by such solid features as the brick chimneys that rose from both ends of the three gables. Now the dolled-up farmhouse recalled a character familiar to that era: the sturdy bumpkin uncertain what to make of sudden wealth. Cut down to size in 1931, the house was stripped of all its wings, although parts of them were used to construct a separate garage. A development of large homes from the 1950s surrounds the wooden house now to be found on Westcliff Drive east of Lakeview Drive.[6]

Joseph P. Grace Residence, Alterations to "Tullaroan," North Hills, 1917 (Extant)

Golf formed a continuous link in Trumbauer's efforts on Long Island. Vanderbilt originally laid out a course on his estate where he could play with his friends, but the economies made necessary by the Great Depression led him to organize the select Deepdale Golf Club. When the 1950s brought the Long Island Expressway, the land not usurped became the public Lake Success Park Golf Club. Its 1926 clubhouse, designed by Warren & Wetmore, doubles as the village's administrative office. Meanwhile, in 1954 the Deepdale Golf Club purchased an estate of 176 acres on the northeast corner of the raucous Expressway and Community Road. "Tullaroan" had been the home of Joseph Peter Grace (1872–1950) and the mansion-turned-clubhouse had been altered by Horace Trumbauer. Around 1910 James W. O'Connor (1886–1953) had designed a Georgian residence of brownish-red brick for the son of steamship operator W. R. Grace.[7] While the servants' wing

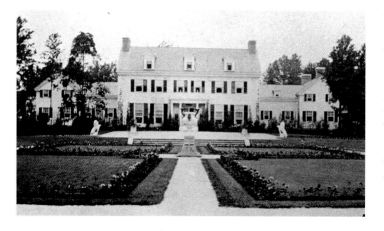

Horace Trumbauer: Garden Front Before Alterations by Carrère & Hastings, "Deepdale," W. K. Vanderbilt, Jr., Residence, Great Neck, 1902 (VANB, 1903)

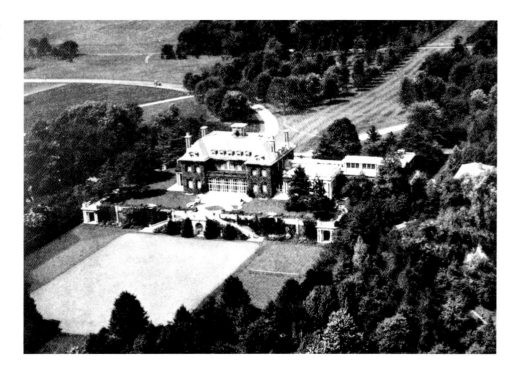

was extended and heightened, Trumbauer stretched a pair of L's back from the sides of the house. Tentative drawings were prepared for these 1917 alterations, then the architect's fabled salesmanship must have helped Grace decide to overhaul the house completely and to eventually spend one-quarter of a million dollars.

John S. Phipps Residence, Addition of Service Wing to "Westbury House," Old Westbury, 1910–11 (Extant)

One architect's revision of another's efforts occurred throughout the age, usually at the owner's whim but sometimes with reason. English architect George Crawley (1864–1926), designer of the original house, may even have recommended that Trumbauer alter "Westbury House" since living in London he was too far away to be concerned about changes that did not affect the nature of the mansion, and Trumbauer had earlier collaborated with a foreign architect on another project. Margarita Cecile Grace Phipps was from Sussex, England, which may explain why Phipps (1874–1958) had commissioned Crawley to design their 1906 mansion. (Crawley would add the dining room in 1915 and the west porch in 1924.) Hidden among the trees, the servants' wing that Trumbauer attached to the east end in 1910–11 is brick Georgian to match the house, yet its facade and other elevations are thoroughly Trumbauer, and not imitation Crawley.[8] On the east side of Old Westbury Road between the Long Island Expressway and the Jericho

Turnpike, the house and gardens are open to the public and are the setting for innumerable advertisements.[9]

Henry Phipps Residence, "Bonnie Blink," Great Neck, 1916–18 (Extant)

It was John Phipps's father Henry Phipps (1839–1930) who ordered the architect's most prominent work for the family. Pittsburgh might seem a more likely setting for the principal partner of Andrew Carnegie, but in 1901 both men had left that city for New York to devote themselves to philanthropy. At 345 Lakeville Road between the Long Island Expressway and the Northern State Parkway, "Bonnie Blink" lies directly across the street from Lake Success and the former "Deepdale" estate. The residence and garage belong to a spurt of Long Island activity from 1916 to 1918 during which Trumbauer was working on six properties simultaneously, including alterations. All three houses built from scratch share the Georgian style, brick construction, slate roofs, and an H-plan, along with landscaping by the Olmsted Brothers. Rather than being repetitive, however, each mansion is a variation on a theme.

"Bonnie Blink" is based upon "Whitehill," built during 1764–65 for Gov. Horatio Sharpe in Anne Arundel County, Maryland.[10] Here, however, all grows less strict, the order intensifying from Doric to Corinthian and the window sizes increasing to admit the light that Trumbauer required for his airy rooms. Four colossal columns, evenly spaced, uphold a blank pediment to form a portico that shields a Palladian window above the front door (an institutional replacement) flanked by profusely carved stone

407

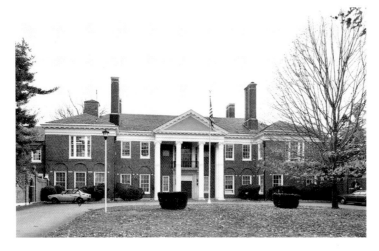

Horace Trumbauer: Front Facade, "Bonnie Blink," Henry Phipps Residence, Great Neck, 1916–18 (Richard Cheek photo, 1981)

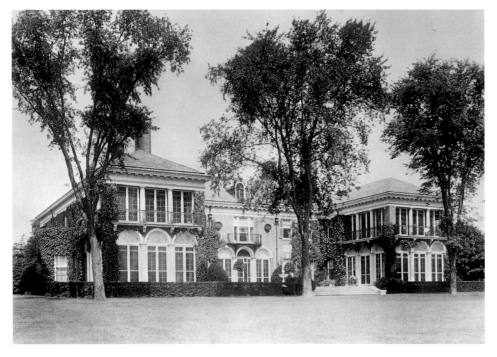

Horace Trumbauer: Rear Facade, "Bonnie Blink," Henry Phipps Residence, Great Neck, 1916–18 (Lewis & Valentine, n.d.)

the diversity of elegant moldings; the wrought-iron railings that guard the Palladian window; the upper porches; and the great staircase.

Wrapped up in the staircase that rises around three walls to carry the upstairs hallway across the fourth, the entrance hall is floored in oblique slabs of white marble with corners clipped diagonally by tiny squares of black marble. Amid white-marble treads of intricately varied widths and angles, the central landing of the stairway divides the front door from the Palladian window, which is fitted with four Corinthian pilasters on the interior. So exquisite was the interior finish throughout the more than 30 rooms that the architect tallied its cost separately. Anne Shaffer Phipps predeceased her husband, after whose death "Bonnie Blink" stood empty for nearly two decades—except for three years during World War II when 30 children evacuated from London lived there under the care of Lady Margaret Barry.[12] In 1949 the Phipps family gave the structure and nine acres to the Great Neck School District for use as its administration building. The board's adaptation has been thoughtful.

David Dows Residence, "Charlton Hall," Brookville, 1916–17 (Extant)

For an unusual, indeed unique client, Trumbauer designed a unique mansion. David Dows (1885–1966) pursued his business interests, which ranged from iron mining[13] to cattle, with no less passion than polo. (His adventurous nature further led six-foot-six "Big Dave" to get himself elected sheriff of Nassau County.) Even the size of Dow's residence made it rare: it was larger than the residences Trumbauer built for the mildly wealthy, yet smaller than the palaces he designed for the super rich. Stripped of nonessential ornament and bulk, "Charlton Hall" is a squarish box of compact elegance.

"Groomsbridge Place," a stately home near Tunbridge Wells on the Kent side of the Sussex border, served as the model. This kind of "swiping" was common practice among architects, but Trumbauer had an unusual feel for what to copy, and then what to save and what to Americanize. At Tunbridge Wells, Philip Packer had erected in the late 17th century what his friend John Evelyn termed "a modern Italian villa,"[14] partly because of its Ionic porch. Trumbauer discarded this feature from between the L's on what is now the garden front. First-floor windows became French and shutters appeared, but otherwise this facade is virtually identical to that of "Groomsbridge Place." Quoins and lintels were kept in brick, and the flat course between the stories was simplified from stone to brick.

panels. Directing attention to the facade are low gateways stretching forward from either end so that the service wing at the left is less evident.[11] A single-story bay protrudes from the opposite side in a semicircle. Circles form a motif around the exterior. Within the round recesses above the first-floor windows across the entrance front are herringbone circles in brick. Astride the middle window upstairs on the garden front are a pair of bull's-eye windows. From the hip roofs spring round-top dormers at the rear. Separating the round arches that appear in threes are limestone panels, with circles at center and half-circles at top and bottom. On three sides of the deeper L's behind the house these arches open on the lower porches, while the upper ones directly overhead sport Tuscan columns supported by rich brackets. In every way this is a house of details, expressed in the big marble florette beneath the vault of the portico; the stone bands around the tall chimneys;

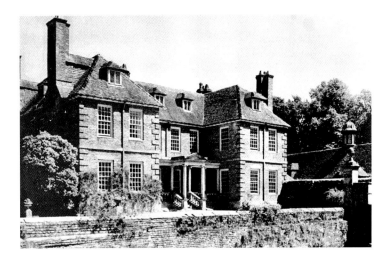

"Groomsbridge Place," Kent, England, 1660, which served as a model for the David Dows Residence (Nigel Nicolson, *Great Houses of Britain*, New York: Putnam, 1965)

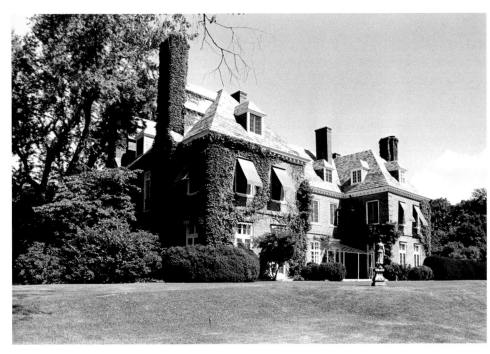

Horace Trumbauer: Garden Facade, "Charlton Hall," David Dows Residence, Brookville, 1916–17 (Michael Fairchild photo, courtesy of Watson Blair, n.d.)

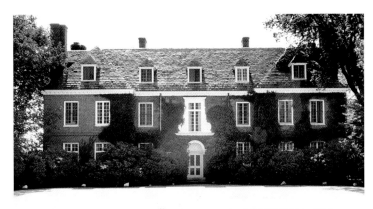

Horace Trumbauer: Front Facade, "Charlton Hall," David Dows Residence, Brookville, 1916–17 (Michael Fairchild photo, courtesy of Watson Blair, n.d.)

On the entrance front the windows downstairs were shortened to their former length and the side projections were much shallower, but basically the same arrangement was retained. At center, the front door of unexceptional size was shielded beneath a round hood supported by ancons. Flanking the large window above, these brackets were turned sideways for gigantic scrolls carved elaborately, as if all the decoration eliminated elsewhere were concentrated here. Rectangular chimneys were added toward the middle but the original T-shaped ones remained in pairs at either end, those at left running down from the slate roof to the service area in the basement, reached through a cutaway in the house's hill restrained by walls of round, brown local stones.

If the resulting house is a box, the architectural detail of the interior proves it a jewel box. Its floor of black-and-white Belgian marble in the entrance hall is like those of other residences Trumbauer was constructing on Long Island at the time. Rooms are fewer but grandly proportioned, including the drawing room of 35 by 65 feet. Fronting on Brookville Road southeast of the North Hempstead Turnpike, 97 landscaped acres include several Trumbauer outbuildings executed in 1916. They are prevailingly clapboard painted white, and line up on a flat area not far from the mansion.[15] Wolcott Blair, who in 1936 began renting the residence from Dows, bought the estate soon afterward;[16] today, it is home to his son Watson Blair.

Howard C. Brokaw Residence, "The Chimneys," Brookville, 1916–17 (Extant)

Yet another of the architect's Georgian residences sprawls atop the hill adjacent to the one occupied by the Dows house. Brokaw (1875–1960) had in 1914 purchased 86 acres across the North Hempstead Turnpike, northeast of its intersection with Ripley Lane. A football star at Princeton, he had become president of Brokaw Brothers, the clothing establishment founded by his father. "Long, low and not formal"[17] were his instructions to the architect, who during 1916–17 erected "The Chimneys," named for the abundance of this feature. In truth the house has plenty of everything, so that Trumbauer deserves credit for keeping it all under control.

"Long" is represented by no fewer than seven curve-roof dormers across the midsection of the entrance front. Twelve pairs of upper and lower windows flank a wide window behind a wrought-iron railing supported by a massive doorway with Tuscan columns in front of matching pilasters. Limestone composes the

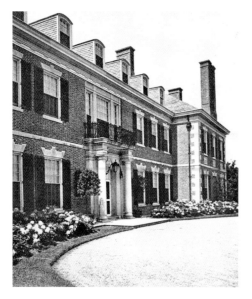

Horace Trumbauer:
Entrance Front, "The
Chimneys," Howard C.
Brokaw Residence,
Brookville, 1916–17
(ARRV, 1920)

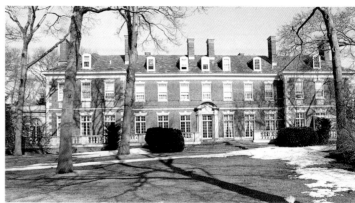

Horace Trumbauer: Rear
Facade, "The Chimneys,"
Howard C. Brokaw
Residence, Brookville,
1916–17 (Joseph Adams
photo, SPLI, 1977)

Horace Trumbauer: First
Floor Plan, "The
Chimneys," Howard C.
Brokaw Residence,
Brookville, 1916–17
(ARRV, 1920)

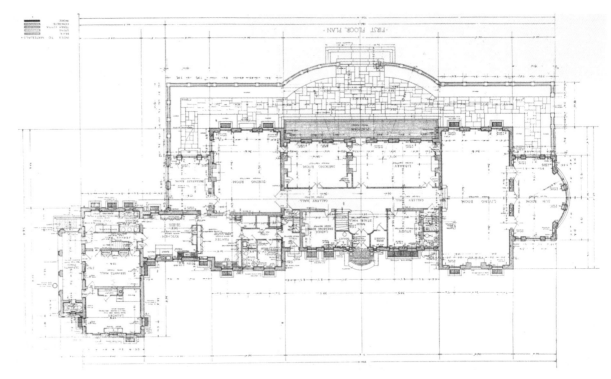

doorway, the lintels upstairs and down, the
string course dividing the stories, and the
quoins that set off the projecting sides, where
beneath the upper set of three windows are
carved plaques of the same material.

"Low" is aided by the narrow cornice that
surrounds the house with endless clusters of
guttae. Cornice and course are nearly reached
by the windows, those at bottom raising their
farthest voussoirs as well as their keystones.
Curving outward at center, the balustraded ter-
race is lifted only a little.

"Not formal" is achieved through lapping
rhythms, pink-red brick, and the subliminal
presence of the service wing stretching forward
at left. Similar fenestration is kept at the rear,
even more relaxed since the seven dormers
spread themselves to the side roof hips and the

lower windows extend to the floor. Between
two pilasters, the door is crested by a curved
broken pediment containing a shield. Instead of
toying with folksy styles, the architect took for-
mal elements befitting so expansive a house and
arranged them with an easygoing amiability,
much as starched linen can make for a casual
luncheon.

Single-story conservatories in wood and
stone were a frequent means by which Trum-
bauer offset the brick of his Georgian mansions,
so this one naturally has two, both of limestone.
A breakfast room is tucked between the left side
and the service wing, while a sun room closes
the right side. Behind the sun room the Eliza-
bethan living room fills the width of the house

Horace Trumbauer: Living
Room Fireplace Detail,
"The Chimneys," Howard
C. Brokaw Residence,
Brookville, 1916–17 (Joseph
Adams photo, SPLI, 1977)

Horace Trumbauer:
Entrance Hall, "The
Chimneys," Howard C.
Brokaw Residence,
Brookville, 1916–17 (ARRV,
1920)

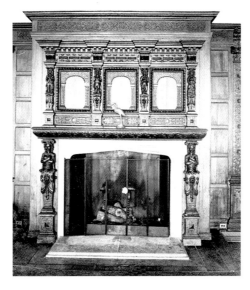

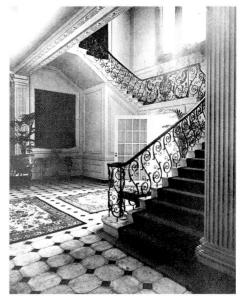

Horace Trumbauer:
Administration Building,
Belmont Park, Elmont,
1924–25 (New York Racing
Association, 1925)

with oak paneling and plaster strapwork ceiling. Abetting the residence's desired length is a gallery hall whose marble floor—not unexpectedly, black and white—adjoins the wood-tread staircase lit from the big middle window. Bedrooms on the second floor total ten, although there are many more for the servants both on that level and inside the roof. Considerable clearing was specified in the landscape plans, by chance creating an ideal setting for the Muttontown Golf and Country Club, which bought the estate in 1960. The residence became the clubhouse, with suitable additions behind the service wing, and the garage[18] was converted to a pool and tennis house set amid new courts, the pool, and the pump house.

Belmont Park, Elmont, 1922–29

When not at their Long Island mansions, Trumbauer's patrons were very likely at Belmont Park. Founded by a wealthy cadre headed by August Belmont II (1853–1924), who named it for his father, the racetrack had remained society-minded since its opening in 1905.

Trumbauer was first summoned to design improvements to the grandstand, most probably spiffing up the private clubhouse attached to its west end. Along with a restaurant and kitchens, he also provided in 1922 a judges' stand, a judges' straightaway stand, a timers' stand, and a telegraph stand, each occupying but a single blueprint. Further employment at Belmont became certain when the presidency of its parent organization, the Westchester Racing Association, passed upon August Belmont's death to Joseph E. Widener (1872–1943), whose family were Trumbauer's best customers. Resembling a French orangerie, an administration building was constructed during 1924–25 (only to be Anglicized by another hand in the mid-1940s with bricks and cupola). Trumbauer altered the racetrack itself in 1924 by laying out what would be known as the "Widener Course," a straightaway of six furlongs, 165 yards that sliced across the grounds from right to left as seen from the grandstand in front of which it halted.

With one of the properties bought to make up the Park's 560 acres at Elmont (plus a corner in Queens) came "Oatlands," a Gothic-Tudor mansion De Forest Manice had erected around 1840. Louis Philippe of France had spent part of his exile here, but since the track's inception the mansion had housed the exclusive Turf and Field Club. In 1926 Trumbauer updated this castle, added a new balcony in 1928, and finally in 1929 appended a living-room building, an octagon where he did what he could with the archaic style by putting Tudor tops above the three French windows on each side. The mansion was torn down in 1956 together with the grandstand clubhouse, which had been demoted to a storehouse, holding also the print shop which produced racing programs. (Not for his usual

Horace Trumbauer: Turf and Field Club, Belmont Park, Elmont, Remodeling 1926–29 (NASS)

Horace Trumbauer: Entrance Facade and Court Yard, "La Lanterne," James B. Clews Residence, Brookville, 1929–30 (Library of Congress)

customers, Trumbauer had around 1902 designed yet another recreational building on Long Island: the wooden shelter for a carousel at North Beach, a working-class resort whose site is today occupied by La Guardia Airport.)

Widener Course vanished during 1958; the administration building came tumbling down soon after. Declared structurally unsafe, the grandstand was demolished in 1963. A new Belmont Park on the old site was inaugurated in 1968, but of Trumbauer's contribution not one jot remains.

James B. Clews Residence, "La Lanterne," Brookville, 1929–30

Even to its name, "La Lanterne" derives from a château that Louis Le Vau (1612–1670) designed at the command of Louis XIV.[19] In 1929–30 Trumbauer's patron was James Clews (1869–

1934), a banker whose Fifth Avenue mansion in Manhattan Trumbauer had fashioned in 1908–10. Front and rear facades, identical on the Versailles original, are carried over identically to the Brookville copy, except for the addition of shutters and the removal of one chimney to leave two that balance neatly from either end of the slate roof. On its L's, however, this limestone adaptation was enriched. French windows remain on the first floor but are divided into pairs by three niches containing elaborate urns. Replacing the dormers of the *pavillion* on the Route de Saint Cyr is a second story of eight windows.[20] Downstairs, at center, the architect placed the living and dining rooms, with a ballroom, reading room, and library in the right wing. Upstairs the combined sections held seven bedrooms. Service facilities including a chauffeur's apartment fill the left wing above a four-

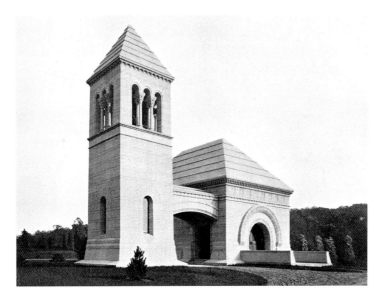

William B. Tubby: Pratt
Mausoleum, Glen Cove,
1892–96 (ARCH, 1900)

car garage in the basement. Jutting from four
pillars along the courtyard fence, defenseless
stags relate the peril of swiping, since these later
additions to the French version were reproduced
before their antlers had been restored.

After the death of Clews, the estate on the
west side of Wolver Hollow Road between
Chicken Valley and Pine Valley roads served as
the Sisters of Saint Joseph Convent from 1934
to 1952. Next, the central block of the mansion
was torn down, and its wings became separate
houses, sold off like the gardener's cottage and
gate lodge.[21] In 1950 material from the demoli-
tion was used by architect Alfred Shaknis (born
1908) for the nearby residence of Charles Paul.
Considering the vulnerability of big houses,
however, the wings at Brookville are better than
nothing. Neither Le Vau nor Trumbauer long
survived the construction of the Long Island
rendition of "La Lanterne." Each of Trum-
bauer's residences on Long Island survive in at
least some form because they focused on com-
fort rather than flash. In their dominant brick
Georgian style, these mansions reflect the
atmosphere that bred them. It is as if a corner
of Philadelphia had moved to Long Island.

Frederick Platt

William B. Tubby, 1858–1944

William Bunker Tubby was one of a number of
architects active in Brooklyn during the last two
decades of the 19th century. While most of them
worked primarily in this affluent community,
designing both residential and institutional
buildings there, they occasionally designed
country houses in places like Glen Cove and
Shelter Island, which were popular vacation
spots for Brooklynites. As a group, these
Brooklyn architects were not great innovators
within the larger spectrum of American design.

Rather, their work showed the influence of the
Romanesque Revival style originated by H. H.
Richardson and the Queen Anne style of
English architecture made popular by Richard
Norman Shaw and his followers. Tubby was
among the most talented of the Brooklyn
architects, the finest of whom were particularly
skillful at adapting the popular styles to the
needs of affluent middle-class homeowners.
While he lived first in Brooklyn Heights and
then in Greenwich, Connecticut, Tubby main-
tained his office in lower Manhattan, which
was convenient for his clients, most of whom
commuted to jobs nearby.

Tubby was born in Des Moines, Iowa, and
grew up in Brooklyn, attending the Friends
School and Polytechnic Institute, both of which
would become major clients. His architectural
training was in the office of Ebenezer L. Roberts
(1825–1890), a conservative architect who de-
signed many important buildings in Brooklyn
and was closely associated with the Standard
Oil Company. Roberts designed Standard Oil's
headquarters in Manhattan, as well as houses
for several of the company's executives, includ-
ing the Brooklyn mansion of Charles Pratt
(1839–1891), a prominent builder and philan-
thropist. It was through his connection with
Roberts that Tubby became acquainted with the
Pratt family, several members of which became
the young architect's major patrons, commis-
sioning many buildings in Brooklyn as well
as structures for the Pratts' "Dosoris" estate
complex in Glen Cove.

Tubby began his independent career in 1881
and in his early years designed modest row
houses, as well as undertaking stylish alterations
to older buildings in Brooklyn's prestigious
residential neighborhoods. By 1887 he had per-
fected a personal style that was a distillation of
Romanesque Revival forms. His major works
are simple, often austere structures with bold
planar surfaces that are frequently softened by
curving bays, towers, or gables, and by small
areas of extremely fine carving. The majority of
Tubby's works were residences, some commis-
sioned by wealthy Brooklynites, and others built
as speculative ventures. A large number of his
most important commissions came from the
Pratts, including the library at Pratt Institute
(1894), speculative row houses, and, most
importantly, the mansion of 1890 on Clinton
Avenue in Brooklyn for Charles Millard Pratt
(Charles Pratt's eldest son), and the Charles
Pratt Mausoleum (1892–96) at "Dosoris."

Pratt Family Mausoleum, Glen Cove,
1892–96 (Extant)

A small but monumentally scaled pink-granite
structure in the Romanesque Revival style, the
mausoleum is Tubby's major surviving building

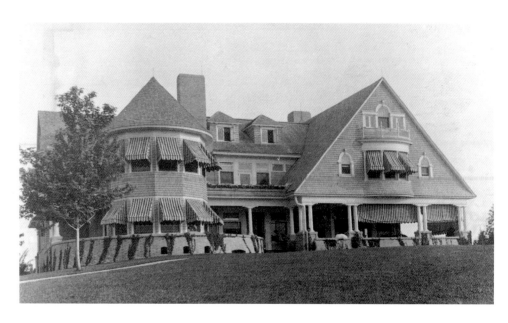

William B. Tubby: George D. Pratt Residence, Glen Cove, 1897 (Courtesy of Mr. Sherman Pratt)

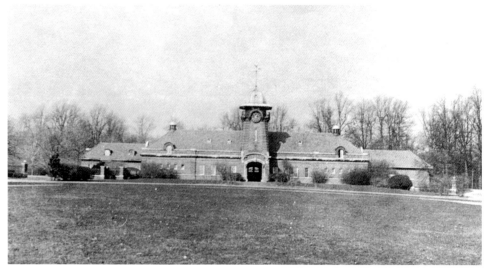

William B. Tubby: Pratt Oval Administration Building, Glen Cove, c. 1905 (Courtesy of Mrs. Richardson Pratt)

on Long Island and is one of his great masterpieces. With its separate crypt and tower connected by a bridge of sighs, it resembles a miniature version of H. H. Richardson's great Alleghany County Courthouse and Jail (1884–86) in Pittsburgh. The interior of the mausoleum was decorated by the Tiffany Glass and Decorating Company with multicolored mosaics and rich marbles. It contains the Sienna marble sarcophagus of Charles Pratt as well as the tombs of seven of his eight children.

George D. Pratt Residence, "Killenworth," Glen Cove, 1897

In 1897 Tubby designed a country house for Charles Pratt's son, George Dupont Pratt (1869–1935), who was involved with many of his family's business enterprises. He was a renowned collector whose art works and ethnographic collections were donated to the Metropolitan

Museum of Art and the American Museum of Natural History. For several years George Pratt served as an assistant to the president of the Long Island Railroad (Charles Millard Pratt was the head of a syndicate that ran the railroad during the late 19th century) "and in that position [he] played an important part in the early control of the company."[1] His house was erected at "Dosoris," one of a number of comfortable wooden homes built by Charles Pratt's children late in the 19th century, when each was restricted in the amount of money he could spend on a country home.

Tubby designed a handsome asymmetrical shingled house set on a high brick base. In its massing it was not unlike the Shingle Style homes designed by McKim, Mead & White, William Randolph Emerson, and other architects at popular seaside resorts over 15 years earlier. Tubby's building differed from these houses, being more representative of its own time in its more emphatic use of Colonial Revival details such as Palladian windows, round-arched and

William B. Tubby: Front Facade, "Maxwellton," John Rogers Maxwell Residence, Glen Cove, 1898 (ARBD, 1899)

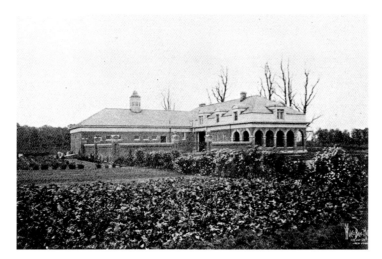

William B. Tubby: Stables, "Maxwellton," John Rogers Maxwell Residence, Glen Cove, 1898 (ARBD, 1899)

dormer windows with Gothic sash, columnar porches, and brick laid in Flemish bond with burned headers. As on Tubby's masonry buildings, this house was composed of several volumetric masses that flowed into one another, its elevations arranged with broad unornamented planes relieved by window openings and subtle bowed oriels. The house stood for only a few years; it was replaced c. 1912 by a far grander, but less interesting, mansion named "Killenworth," designed by Trowbridge & Ackerman.

Pratt Oval Administration and Farm Buildings, Glen Cove, c. 1905 (Extant)

Several smaller estate structures at "Dosoris" also are known to have been the work of Tubby or are attributed to him. These include a dairy (1899), a greenhouse (1900), a cow barn (c. 1908), and the farm and administration buildings on the Pratt Oval, which was part of the service compound for the Pratt family's complex of estates in Glen Cove. The Administration Building formerly housed the offices from which the many employees at "Dosoris Park" were administered. In 1942 the Pratt family sold the Oval, and today this building is used as a warehouse.

John Rogers Maxwell Residence, "Maxwellton," Glen Cove, 1898

Tubby's other major residential work on Long Island was a country house for Brooklyn businessman John Rogers Maxwell (1846–1910), a banker and broker who was actively involved in several railroads and industrial firms. He was president of the Central Railroad of New Jersey, served as vice president of the Long Island Railroad during the 1880s, and was president of the Atlas Portland Cement Company which provided the cement used in the construction of the Panama Canal. In 1896 Tubby was responsible for an addition to Maxwell's city house in the Park Slope section of Brooklyn and in the same year designed "Maxwellton" in Glen Cove. This large residence, a Colonial Revival-style structure, was not one of Tubby's most inventive works. The symmetrical clapboard house, demolished in the 1920s, was extremely awkward in its design, sporting two overscaled Ionic porticos and an incongruous cupola which crowned its roof. Several outbuildings by Tubby still survive on the estate's grounds.

"Maxwellton" was designed at a time when the general quality of Tubby's work was beginning to decline as he tried, generally unsuccessfully, to meld his love for massive planar forms with the more refined and ornamental styles then gaining in popularity. While the Maxwell residence exhibited the broad unornamented planes Tubby favored, this did not work as well on a symmetrical Colonial Revival structure as it did on Romanesque Revival and Shingle Style buildings.

Tubby's practice continued well into the 20th century. He designed public libraries in Brooklyn, large estate houses in Connecticut, the Nassau County Court House and Jail in Mineola (1899), and several buildings in Roslyn, including the Roslyn High School (1926), the Roslyn Presbyterian Church (1928), and the Roslyn National Bank and Trust Company (1931). In these and other later works Tubby was rarely able to rekindle the creativity that enlivened his earliest buildings and left Brooklyn and Glen Cove with some of their most outstanding structures.

Andrew S. Dolkart

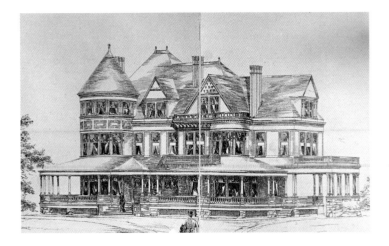

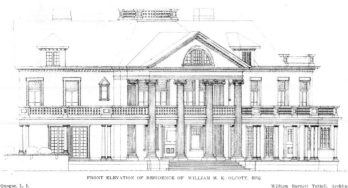

Quogue, L. I.

FRONT ELEVATION OF RESIDENCE OF WILLIAM M. K. OLCOTT, ESQ.

William Burnett Tuthill, Architect.

William B. Tuthill: Design Rendering, Charles H. Adams Residence, East Hampton, 1889–91 (ARBD, 1890)

William B. Tuthill: Front Elevation, William M. K. Olcott Residence, Quogue, c. 1900 (AABM, 1905)

William B. Tuthill, 1855–1929

Still regarded as one of New York's most acoustically perfect auditoriums, Carnegie Hall (1891, in association with Adler and Sullivan) is William Burnet Tuthill's best-known work. It is a fitting monument in that he delighted in music and was a member of the Oratorio Society as well as a cellist. Born in Manhattan, Tuthill had ancestors who had settled at Southold as early as 1644. Graduating from City College in 1875, he worked for two years in the office of Richard Morris Hunt before opening his own office in the city. Tuthill's other noteworthy commissions include the Harlem Young Women's Christian Association (1888), the Carnegie Library, Pittsburgh (1894), and the Columbia Yacht Club in New York (1900). In 1889–91 Tuthill designed the summer residence of former State Senator and U.S. Congressman Charles H. Adams. Located on Lee Avenue in East Hampton, the Adams house, still extant, is a classic example of the Queen Anne Shingle Style. Low verandas shade the first story, ending on the right as a porte cochere. A round corner tower, tall ribbed

chimney stacks, and gabled dormers enliven the massive roof. The windows, with single-sheet plate glass below multipaned upper sashes, represented a typically Victorian compromise between charm and utility. Around 1900 Tuthill designed a residence in Quogue for William M. K. Olcott.

Michael Adams

Charles A. Valentine, practiced 1895–1930s

Charles A. Valentine began his architectural practice about 1895 and was associated with William Orr Ludlow and James Albro, eventually maintaining offices in New York City and Chappaqua, New York. Their commissions included the East Orange National Bank in New Jersey and the residence of A. G. Hyde in Larchmont, New York (1899). "Wildwood," the country residence Valentine designed for Eustis L. Hopkins in Matinecock, is in an excellent state of preservation today. Cotswold-inspired, the whitewashed brick, hip-roofed house with eyebrow dormers and cross gables has an outstanding Tudor stairwell window with heavy wooden mullions.

Carol A. Traynor

Charles A. Valentine: Front Facade, "Wildwood," Eustis L. Hopkins Residence, Matinecock, 1927 (INVE, 1979)

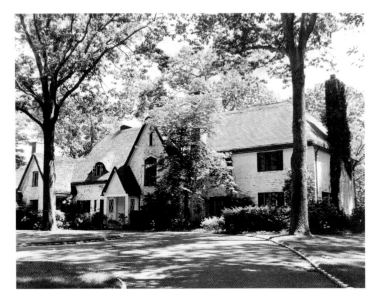

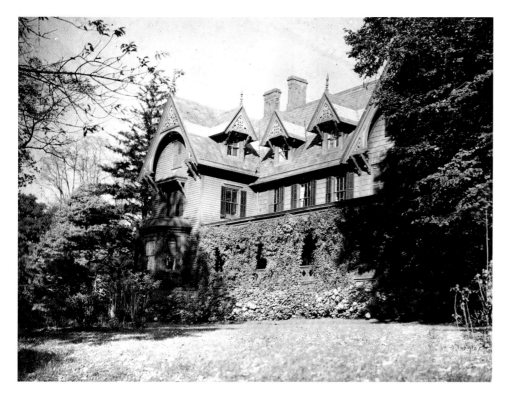

Vaux & Withers:
Alterations, "Clovercroft,"
Fanny and Parke Godwin
Residence, Roslyn Harbor,
1869 (BRYA, n.d.)

Vaux & Withers: North
Elevation, "Clovercroft,"
Fanny and Parke Godwin
Residence, Roslyn Harbor,
1869 (BRYA, n.d.)

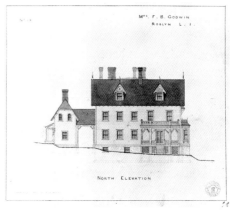

Calvert Vaux, 1824–1895

Vaux, Withers & Company, 1863–1872

Olmsted, Vaux & Company, 1865–1872

One of several highly respected English-born and -trained architects who practiced in New York in the 19th century, Calvert Vaux has often been overshadowed by his two more prominent partners, Andrew Jackson Downing and Frederick Law Olmsted. In 1850 Vaux arrived in Newburgh, New York, to assist Downing, the influential landscape gardener, in the design of residential architecture in the English picturesque tradition. Following Downing's death two years later, Vaux worked briefly with fellow Englishman and Downing assistant, Frederick Clarke Withers, while also practicing landscape architecture with Olmsted. The two had already received national renown for their collaborative design for Central Park. In his later years, Vaux served as the landscape architect to the New York City Department of Parks while continuing to maintain a small private office. He was also associated with the British émigré architect Jacob Wrey Mould in the design of various Central Park structures, as well as in the initial plans for the Metropolitan Museum of Art and the Museum of Natural History. A founding member of the American Institute of Architects, in which he was active during its early years, Vaux made significant contributions to the development of landscape architecture, as well as to architecture in the United States.

Vaux's Long Island commissions demonstrate a longstanding involvement with suburban and rural architecture. Predating the Civil War, his first known project on the Island was an independent commission in c. 1853–54 in Ravenswood, a residential section of Long Island City in Queens. It was for an unpretentious clapboarded Italian villa for wealthy New York businessman Charles H. Rogers and featured a three-story tower topped by an octagonal belvedere which provided extensive views of the East River. Rogers's residence was described and illustrated in Vaux's popular *Villas and Cottages* of 1857 (2nd edition, in 1864), a publication in the Downing tradition which summarized his early domestic work and espoused country living.

Fanny and Parke Godwin Residence, Alterations, "Clovercroft," later "Montrose," Roslyn Harbor, 1869 (Extant)

Drawings preserved in the Bryant Library in Roslyn credit Vaux's firm with the redesigning in 1869 of the Fanny and Parke Godwin residence in Roslyn Harbor. Now known as "Montrose," the house is still standing near "Cedarmere," the country place of Mrs. Godwin's father, William Cullen Bryant, the renowned poet and editor of the New York *Evening Post,* who had purchased the late Federal farmhouse 17 years earlier for his daughter and son-in-law. Preserving many of the architectural details and much of the original fabric of the Federal house, Vaux, Withers &

Calvert Vaux and Jacob Weidenmann, Landscape Design: Artificial Lake on Property, "Masquetux," Henry Baldwin Hyde Residence, Bay Shore, 1874–76 (HICK, n.d.)

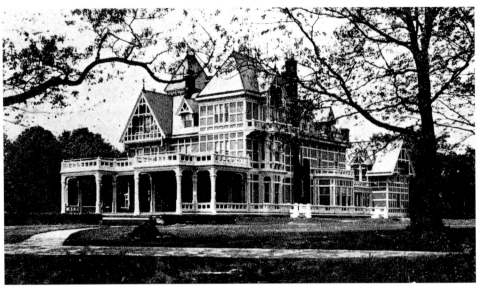

Calvert Vaux: "Masquetux," Henry Baldwin Hyde Residence, Bay Shore, 1874–76 (COUN, 1903)

Henry Baldwin Hyde Residence, "Masquetux," later "The Oaks," Bay Shore, 1874–76 (Extant)

This large summer house was built soon after the termination of Vaux's partnerships with Olmsted and Withers. One of his largest residential commissions, it is one of the least known of his major domestic works, for it postdated his *Villas and Cottages* and was not written up in contemporary architectural journals during Vaux's lifetime. This commission's only public notice was in 1880, when the architect exhibited a perspective rendering at the National Academy of Design. The client, founder of the Equitable Life Assurance Co. and the chief spirit behind its rise to preeminence among insurance companies, received one of the largest salaries ever paid to a businessman in his day. He spared no expense in building his large country seat near the Great South Bay on the country road between Babylon and Bay Shore.

Jacob Weidenmann, a landscape architect associated with Olmsted, planned the improvements of the picturesquely landscaped estate. His plans for "Masquetux," which were awarded special honors at the 1876 Centennial Exhibition in Philadelphia, included a large pleasure ground of meadows, ponds, and curving drives and paths. Some of the numerous outbuildings which formerly graced the Hyde property were designed by Vaux, others by Weidenmann.

Vaux's palatial villa, the centerpiece of the estate, was characteristic of the developed Stick Style of the 1870s, which was especially in vogue for seaside residences and which Vaux had used for several large park structures. The exterior surface was treated with prominent "stickwork" of a contrasting color which, along with the window frames, created a dominating rectilinear pattern. Such features as the wide veranda, terraces, and balconies, and the irregular massing of the steeply pitched roofs with overhanging gables, pointed braced dormers, and a wedge-shaped tower, demonstrate Vaux's use of elements from his earlier domestic designs, updated to suit the latest architectural fashion.

In the early 1900s James Hazen Hyde, son of the original owner, added a squash court and "bachelor's annex," altered the exterior color scheme, and, in keeping with contemporary taste, eliminated some of the High Victorian ornamentation. After financial reverses in 1905, the estate, by this time known as "The Oaks," was sold once again, first to Louis Bossert; later much of the property was purchased by the Southward Ho Country Club. The residence was drastically altered to serve as a clubhouse and the grounds adapted for golf.

Joy Kestenbaum

Co. sensitively remodeled and enlarged the structure, transforming it into a Victorian Gothic villa. Some of the Gothic detailing was removed in the 20th century: the front porch originally had a pierced quatrefoil railing, and the dormer windows and third-story gable ends, although still retaining their bracing, are missing their pierced decorative screens. The Godwin house is an excellent example of the kind of remodeling of older structures that Vaux had recommended in *Villas and Cottages.* He is said also to have designed the Gothic Mill at "Cedarmere," and both he and Olmsted have been connected with landscaping improvements to the Bryant and Godwin property.

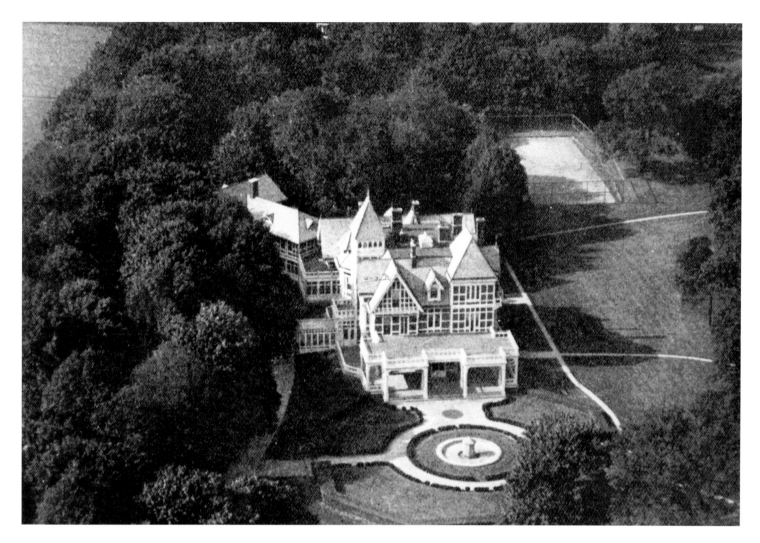

Calvert Vaux: "Masquetux,"
Henry Baldwin Hyde
Residence, Bay Shore,
1874–76 (TOWN, 1923)

Vitale & Geiffert Associated, 1908–1933

Vitale, Brinkerhoff & Geiffert, 1917–c. 1924

Vitale & Geiffert, 1932–1933

Ferruccio Vitale, 1875–1933

Alfred Geiffert, Jr., 1890–1975

Norman T. Newton, in his book *Design on the Land*,[1] sees the shift in American architecture in the last decades of the 19th century—from fanciful eclecticism to academic revivalism—as having its counterpart in landscape design. Country houses designed upon historical precedent called for a similarly historically accurate setting, generally of a formal nature. As a consequence, the more pastoral treatment of land was relegated to areas beyond the immediate architectural influence of the house. Newton sees this means of solving the dichotomy of formal versus pastoral landscape aesthetics as a particularly American contribution to landscape design. The works of Vitale & Geiffert under review can

be placed readily in this context. An example of historical precedent in the house that was not at all matched in the landscaping is provided in the entry on the work of Edgar L. Williams.

Born in Florence, Italy, Ferruccio Vitale first worked in America c. 1904 with the landscape architects Parsons & Pentecost. He practiced alone from 1908 to 1917 before forming the partnership of Vitale, Brinkerhoff & Geiffert, which lasted until 1924. From 1924 to 1932 he practiced under his own name before becoming the senior partner in Vitale & Geiffert.

A trustee of the American Academy in Rome, he was instrumental, together with Frederick Law Olmsted, Jr., in founding its department of landscape architecture in 1915. In 1925 he established the Foundation for Architecture and Landscape Architecture at Lake Forest, Illinois. Appointed by President Calvin Coolidge to the Commission of Fine Arts in 1927, he helped formulate the landscape program carried out in Washington over the next four years.[2]

Alfred Geiffert, Jr., born in Cincinnati, Ohio, began his career in 1908 as assistant to

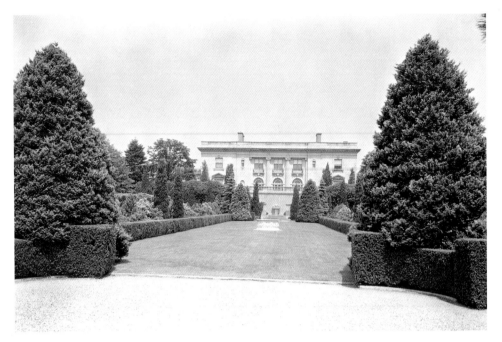

Vitale & Geiffert, Land-
scape Design: "Knollwood,"
Charles I. Hudson Estate,
East Norwich, c. 1906
(Courtesy of Anthony
Baker)

Vitale & Geiffert, Land-
scape Design: "Knollwood,"
Charles I. Hudson Estate,
East Norwich, c. 1906
(Courtesy of Anthony
Baker)

Ferruccio Vitale, and became his partner in
1917.[3] Vitale's Italianate classicism was reinforc-
ed by Geiffert's use of the Beaux-Arts idiom.
Geiffert was a member of the Beaux-Arts
Institute of Design. The period in which the
two men worked together was marked by a sec-
ond wave of newly made fortunes often used by
their owners to provide settings expressive of
their recently acquired status. Instant wealth
called for instant estates, and so blossomed the
practice of planting mature trees to create the
illusion of age and personal rootedness. Tree
nurseries developed appropriate techniques to
create "landscapes to order."[4] In Geiffert's
design plan for the Myron C. Taylor estate at
Lattingtown, even the orchard was an instant
creation of mature trees.[5]

Representative of their most formal Italianate
design plans was "Knollwood," the East Nor-
wich residence of Charles I. Hudson. The man-
sion, built c. 1906 of Indiana limestone, was
designed by Hiss & Weekes in the Louis XVI
style. The northern entry facade was dominated
by a massive porte cochere whose outermost set
of Ionic columns were entwined with vines
trained on ropes. The southern garden facade
gave onto a spacious brick terrace with views
extending over a series of descending gardens.
Wide stone steps led down to the formal Italian-
ate garden and on either side of a central stretch
of turf were located a series of rectangular ever-
green gardens; the ensemble was bordered to the
west and east by *allées couvertes* terminating on
stone pavilions. Below this garden was a linden
tree garden at the end of which was a stone log-
gia on axis with the house. Beyond this, running
on an east-west axis, was a wisteria pergola.
Elsewhere in the grounds was a small enclosed
garden set off from a catalpa walk, and another
walk of several hundred yard's length hedged by
clipped and shaped hemlock. Naturalistic alter-
natives were provided by woodland footpaths
and bridle trails.

Other Long Island commissions of a similar
nature were G. Beekman Hoppin's residence
"Four Winds" at Oyster Bay, and the Arthur
Vining Davis estate at Mill Neck.

By contrast, the landscaping for the Tudor-
style residence of Landon K. Thorne at Bay
Shore was of an overall informal and pictur-
esque character. Water was the dominant design
element: the curved entry drive crossed over one
end of a large lake while a separate good-sized
pond and an extremely lengthy canal let out
into the bay. The house, designed by architect
William F. Dominick around 1928, was framed
by large trees. The garden facade's broad grass
terrace gave onto a lawn via wide grass steps.
Flanking the lawn were raised, brick-walled,
perennial flower beds interspersed with brick
walks. The nearby lake, with waterside plant-
ings of willow, silver birch, and iris, acted as a
reflecting pool for the house. A moment of
quadrilateral symmetry was created by the
almost theatrical placement of canoes on either
side of the sweep of landing steps. There were
numerous, carefully contrived vistas across the
lake to the naturalistically planted surrounding
areas. One formal feature was a silver birch allée
terminating in a columnar cedar.

The landscaping of the Condé Nast resi-
dence at Sands Point was similarly much less
formal, the symmetry of design being softened
by the ways in which plant materials were used
and man-made features built.

Also at Sands Point was Isaac Guggenheim's
"Villa Carola," designed in 1916 by architect H.
Van Buren Magonigle. The house stood at the

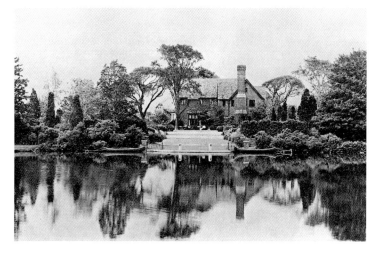

Vitale & Geiffert,
Landscape Design: Boat
Landing, Landon K. Thorne
Estate, Bay Shore, c. 1928
(ARLG, 1929)

Vitale & Geiffert,
Landscape Design: Bird
Allée, Landon K. Thorne
Estate, Bay Shore,
c. 1928 (ARLG, 1929)

Vitale & Geiffert,
Landscape Design: "Villa
Carola," Isaac Guggenheim
Estate, Sands Point, c. 1916
(AVER, c. 1930)

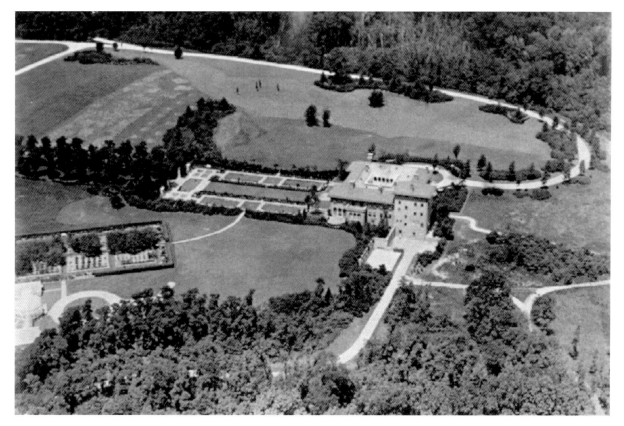

highest point on the rather long and narrow property. This commission is of interest because it shows how a pre-existing dominant garden feature became the lynchpin of the whole design plan. The feature was a 1,400-foot-long, straight entry drive bordered by locusts and maples. Guggenheim had the previous house demolished and the entry drive grassed over, but the shaded allée determined the setting of the new Italianate house—a reversal of the classic situation in which the axiality of the house is imposed upon the landscape. Magonigle's design reversed the orientation of the earlier house, so that the southwest entry facade became the garden facade and a new curved drive replaced it

as the main entry. A lawn below the garden terrace was set on axis with, and the same width as, the allée. Flanking the lawn were perennial flower gardens walled by a double hedge of box and hemlock. The lawn led down to a brick pool terrace, flanked by rose gardens. Broad low steps joined terrace and allée, the juncture being marked by a pair of double-columned pylons surmounted by winged griffins. A circular temple was to have been built as the allée's terminal feature.

Other Long Island commissions of Vitale & Geiffert included the Edwin Fish estate at Locust Valley, where much use was made of mature tree plantings; the residence of Mrs. I. D. Sloan at Lattingtown; the swimming pool complex at Carl J. Schmidlapp's estate at Mill

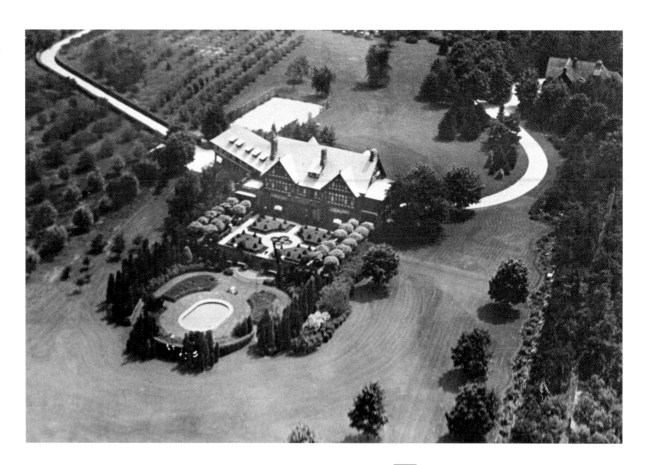

Vitale & Geiffert,
Landscape Design: Donald
Geddes Estate, Glen Cove
(AVER, C. 1930)

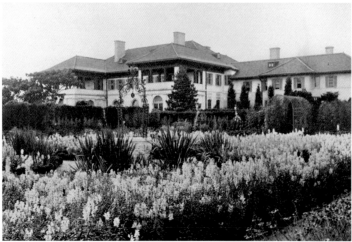

Vitale & Geiffert,
Landscape Design: Mrs.
Alfred H. Hoyt Estate,
Southampton (ARTR, 1918)

Neck; and the East Islip residence of Jay F. Carlisle. The Donald Geddes estate at Glen Cove featured a sunken garden enclosed by mature evergreens, while the use of specimen trees and plants at the Mrs. Alfred M. Hoyt residence at Southampton earned fellow landscape architect Ruth Dean's warm approval.[6]

Wendy Joy Darby

Walker & Gillette, 1906–1945
Alexander Stewart Walker, 1876–1952
Leon Gillette, 1878–1945

As practiced by the firm of Walker & Gillette, architecture was the science of the program clad in the appropriate aesthetic. The Long Island legacy of the firm illustrates the partners' consistent ability to produce smoothly functioning buildings that provided harmonious, correctly proportioned, and accurately detailed environments. Also amply illustrated—by houses at Kings Point, Lattingtown, Oyster Bay, Manhasset, and elsewhere on Long Island—was the ability of the principals to choose selectively and learnedly[1] from the rich profusion of motifs provided by a broad range of American, English, and European architectural traditions.

Walker & Gillette's Long Island residences were a small, but award-winning,[2] portion of the total output of the firm. In joint practice for nearly 40 years, Walker and Gillette produced an impressive array of building types, including commercial structures, churches, individual residences, apartment houses, institutional buildings, industrial airfields, yacht and railroad car interiors, an amusement park complex, and an entire small Florida community.[3] Utilizing a

Walker & Gillette: Rear
Facade, "Kiluna Farm,"
Ralph Pulitzer Residence,
Manhasset, c. 1910 (HICK,
1911)

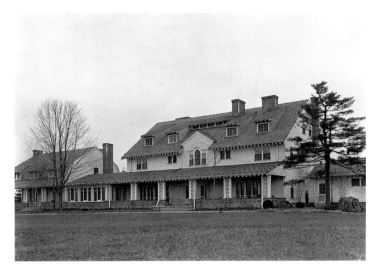

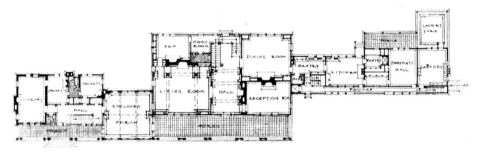

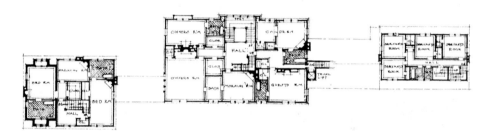

Walker & Gillette: Floor
Plans, "Kiluna Farm,"
Ralph Pulitzer Residence,
Manhasset, c. 1910 (ARRC,
1912)

The two men brought complementary skills and assets to the partnership. Walker, the salesman, with his Harvard education and family connections to the banking community,[7] moved easily in the social milieu of the Union, Harvard, and Knickerbocker clubs, making and renewing the contacts necessary to expand and strengthen a growing practice. Gillette contributed his strong Beaux-Arts training and administrative abilities. Their skilled staff included such people as delineator Earl Purdy, who was responsible for many of the firm's romantic renderings. Evocative works of art, the renderings stand apart from their original function, combining structure, setting, lighting, and decoration in such a way that every project is shown to best advantage.

Prominent landscape architects were frequently members of the design team. On Long Island, the firm most often worked with the Olmsted Brothers of Brookline, Massachusetts, successors to the firm of Frederick Law Olmsted. The care taken to integrate the natural and built environments, characteristic of all Walker & Gillette's efforts, is particularly evident in the firm's suburban residential work.

Walker & Gillette's Long Island residences—the first designed in 1910, the last in 1940—essentially span the firm's entire career, mirroring the development of the partners' design and planning skills and providing quintessential illustrations of several of the firm's preferred stylistic modes. Designed to meet a variety of siting considerations and programmatic needs, the large residences and accompanying outbuildings are representative of Long Island estate architecture generally, as well as of the specific orientation and talents of these two skilled practitioners.

variety of styles, appropriate to the program at hand, the designers exhibited in all phases of their work a versatile vocabulary and a highly visible attention to detail.

The backgrounds of the partners who created this large body of work were different in ways that would prove critical to the development of a successful architectural practice. Alexander Walker was born in Jersey City, New Jersey, and received his early education at St. Paul's School, Concord, New Hampshire. He graduated from Harvard in 1898. In 1901 he joined the New York firm of Warren & Wetmore as a draftsman,[4] leaving in 1906 to begin private practice.[5]

Leon Gillette, born in Malden, Massachusetts, attended the University of Minnesota. He received his architectural degree from the University of Pennsylvania in 1899, the same year he came to New York and worked first for Howell & Stokes and then for Babb, Cook & Willard. Following attendance at the Ecole des Beaux-Arts in Paris, Gillette went into practice with Walker, an association that lasted for the remainder of his life.[6]

Ralph Pulitzer Residence, "Kiluna Farm," Manhasset, c. 1910 (Extant)

"Kiluna Farm" is the earliest of the group. The client, son of Joseph Pulitzer (owner and publisher of the *New York World*), graduated from Harvard two years after Walker. Drawing selectively on Colonial, Craftsman, and indigenous traditions, Walker & Gillette produced a large, deceptively simple farmhouse, sited on the third highest natural point on Long Island, with views of Manhasset Bay and the Sound. The only extant example of Walker & Gillette's use of shingle cladding,[8] set apart from its true Colonial antecedents by scale, syncopated fenestration, and unique plan, the tripartite main structure incorporates an office dependency and

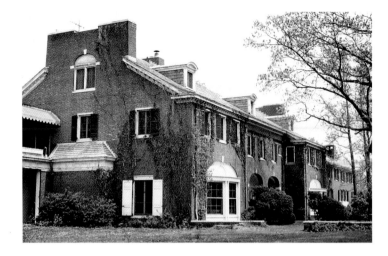

Walker & Gillette: Rear Facade, "Vikings Cove," George F. Baker, Jr., Residence, Lattingtown, 1913 (INVE, n.d.)

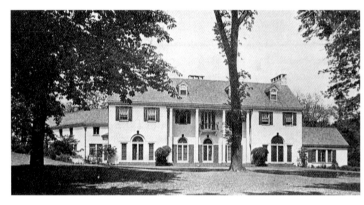

Walker & Gillette: Rear (Garden) Facade, "Snug Harbor," Sherwood Aldrich Residence, Kings Point, c. 1916 (PATT, 1924)

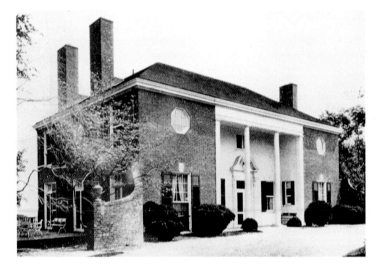

Walker & Gillette: The Creek Club, Lattingtown, 1923 (SPUR, 1924)

a service wing, both semidetached from the central block. Part of a complex including numerous farm and utility buildings, the residence is reached via a curving entrance road, an integral component of the property's romantic landscaping designed by Charles A. Platt.

The firm's Long Island commissions in the Georgian Revival style are more numerous than those in any other mode. Included in this group are the 1913 Baker house, the 1916 Aldrich house, the 1923 Creek Club, and the Gibson house, remodeled in 1926.

George F. Baker, Jr., Residence, "Vikings Cove," Lattingtown, 1913 (Extant)

A Harvard graduate related to Walker by marriage, George Baker was associated with the First National Bank from 1900 until his death in 1937, becoming chairman of the board of directors in 1931.

"Vikings Cove" is a substantial, expansive, two-story brick structure overlooking the Sound. Quietly reflecting the taste and worldly assets of its owner, it is perhaps the most traditional in plan and scale of all the firm's Georgian Revival designs. The central block features symmetrical facades with modillion-enriched cornices; round and segmentally arched window surrounds; and recessed entrances, flanked by projecting bays.

Sherwood Aldrich Residence, "Snug Harbor," Kings Point, c. 1916 (Extant)

At "Snug Harbor," built for a lawyer whose fortune was made through mining interests in Colorado,[9] round-arched openings appear again, this time as central elements in full-length Palladian-style windows. The building's height is emphasized by light brick, a steep gable roof, and two-story square Doric columns fronting the main, recessed entrance. With interior decoration by Karl Freund, the Aldrich residence is the centerpiece of a landscape designed over a ten-year period (1916–26) by Olmsted Brothers.

The Creek Club, Lattingtown, 1923 (Extant)

The club was commissioned by a board of directors that included George F. Baker, Jr., and Harvey D. Gibson, themselves clients of the firm. The main clubhouse is a two-and-a-half-story, hip-roofed brick structure with a recessed, two-story portico that was enlarged in 1928 with flanking gable roof wings. "Dormey House," the current golf clubhouse, was converted from a barn, and lends itself admirably to the vernacular detail chosen by the architects, including the charming Palladian-style gable window, wide frieze, broad multilight bay window, and understated entrance canopy.

Harvey D. Gibson Residence, Alterations to "Land's End," Lattingtown, 1926 (Extant)

Gibson, one of the founders of the Creek Club, commissioned Walker & Gillette to remodel "Land's End," a mid-19th-century house. The existing, five-bay-wide, brick residence of c. 1850 was altered on the interior, preserving the cen-

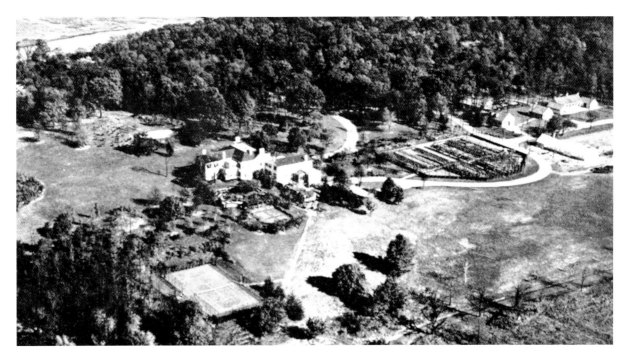

Walker & Gillette: Aerial View, Harvey D. Gibson Residence, "Land's End,"Lattingtown, 1926 (COUN, 1930)

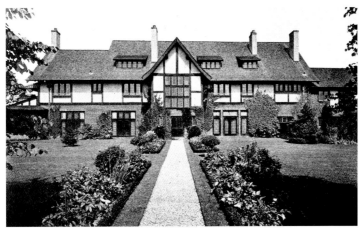

Walker & Gillette: Rear Facade, Henry F. Godfrey Residence, Westbury, c. 1910 (ARRC, 1912)

Medieval in plan as well as in detail, the building had a long, seven-bay-wide central block with side extensions, and combined the half-timbering of the early Middle Ages with brick, a material much favored for country houses in 15th- and 16th-century England. The large size of the Godfrey residence was both emphasized and balanced in a skillful composition that incorporated sweeping, flared-eaved, shingled-roof surfaces, multilight casement windows, and a projecting two-story central entrance bay. In a 1912 photograph, the landscape appears to have been characterized by a definite formality, with axial paths and flanking rectangular planting beds.[10]

William R. Coe Residence, "Coe Hall" at "Planting Fields," Oyster Bay, 1919–26 (Extant)

"Coe Hall," constructed on an existing estate, "Planting Fields," was the grandest of the Medieval Revival constructions designed by Walker & Gillette on Long Island. More information is available on this client and commission than on any of the firm's other designs on the Island.

William Coe was an Englishman with extensive investments in American insurance, mining, utilities, and railroads, married to the former Mai Rogers, daughter of Henry Huddleston Rogers, a founder of Standard Oil. In 1913 the Coes purchased the Byrne estate of 350 acres of farmland, to which they quickly added 59 more acres. The estate included a large residence and several outbuildings designed by Grosvenor Atterbury in 1906. The Coes commissioned Walker & Gillette to design additional outbuildings and, after the Atterbury

tral-hall plan, but reorganizing much of the surrounding space. The existing stairs, for example, were replaced by an elegant, elliptically curved flight. With a two-story, clapboard, servants' wing added to the south facade, the building presented an L-shaped configuration to the sweeping entrance drive incorporated in the Olmsted Brothers' landscape plans.

More rural and overtly English in their antecedents than those in the Georgian Revival style, the firm's three Medieval Revival estates share a character that can be traced to clients who were Anglophiles, or, in the case of the Coe property, to a client who was born in England.

Henry F. Godfrey Residence, Westbury, c. 1910

Godfrey, who graduated from Harvard a year earlier than Walker, had a love of things English, reflected in his role as Master of the Hounds for the Meadowbrook Hunt Club. This predilection was undoubtedly a factor in the choice of style for his residence.

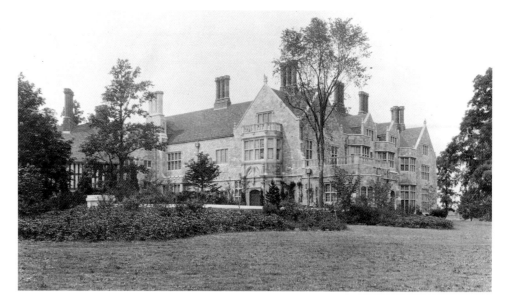

Walker & Gillette: Entrance Facade, "Coe Hall," William R. Coe Residence, Oyster Bay, 1919–26 (HEWI, 1921)

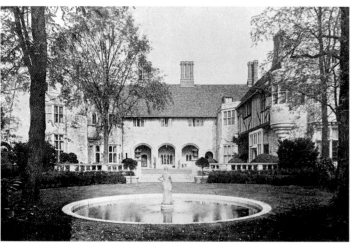

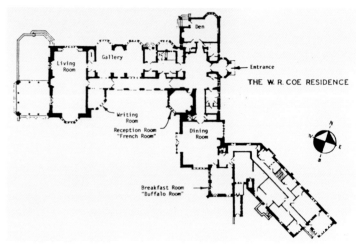

THE W. R. COE RESIDENCE

Walker & Gillette: Rear Facade, "Coe Hall," William R. Coe Residence, Oyster Bay, 1919–26 (PATT, 1924)

Walker & Gillette: Floor Plans, "Coe Hall," William R. Coe Residence, Oyster Bay, 1919–26 (Courtesy of Coe Hall, Planting Fields Arboretum)

Walker & Gillette: Interior Detail, "Coe Hall," William R. Coe Residence, Oyster Bay, 1919–26 (OLMC, 1921)

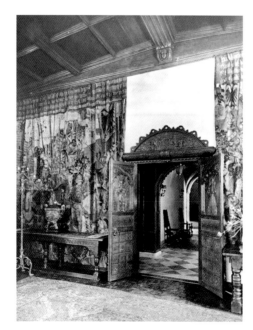

mansion was destroyed by fire, asked the firm to design a new main residence.[11]

Located on the site of the earlier structure, "Coe Hall" utilized half-timbering and a pale Indiana limestone. It followed the Medieval central-hall plan, with cross blocks at either end and a diagonally placed service wing, and incorporated Medieval and Elizabethan antecedents, including oriels, gabled wall dormers, arched openings of segmental and Gothic configurations, casement windows containing square or diamond-shaped lights, and clusters of tall, highly decorative chimneys with pots atop the tiled roof.

The effect achieved on the interior of "Coe Hall" by the variety and placement of rooms was that of "historic English houses built gradually over a space of centuries. The entrance hall is Norman, as if it were the remains of an old feudal keep; the bulk of the house is Elizabethan."[12] Charles Duveen, known professionally as "Charles of London," was responsible for the interior decoration.[13]

Soon after the Coes' acquisition of the property, landscaping was begun by the firm of Guy Lowell and A. R. Sargent of New York and

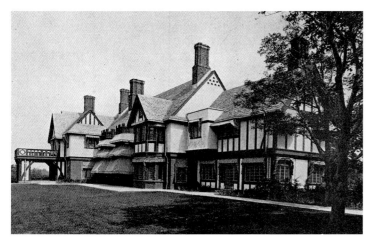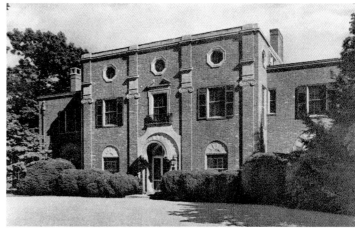

Walker & Gillette: South Facade, "Hamptworth House," Jacob Aron Residence, Kings Point, 1926 (ARBD, 1927)

Walker & Gillette: Front Facade, "Frost Mill Lodge," Irving Brokaw Residence, Mill Neck, 1926 (PREV, n.d.)

Boston, and completed, in conjunction with the erection of the new mansion, by Olmsted Brothers. The talents of Walker, Gillette, and the Olmsted firm blended successfully with those of Lowell and Sargent. In a March 1921 *Architectural Record* article, John Taylor Boyd, Jr., commented about the house that "Its long mass lies beautifully amid the slopes of the landscape, enframed by tree tops, and in the foreground, by sunken terraces and lawns."[14]

The site, which evolved into a horticultural showplace because of William Coe's interest in rare species and plant collecting,[15] is enhanced by entry through the famed Carshalton Gates. Wrought in Sussex, England, in the 18th century, the gates stood near Wimbledon until 1910, when they were offered for sale. Eventually, in spite of public protest in England, they were purchased by Coe, and erected at "Planting Fields."

Jacob Aron Residence, "Hamptworth House," Kings Point, 1926

This Tudor Revival residence was the third and last of the firm's Long Island designs in this mode. No longer standing, the residence was less grand and more additive in character than either the Godfrey house or "Coe Hall." To the designers' credit, a resolution of scale laid a quiet hand on the pastiche of half-timber and brick, angular oriels and polygonal bays, corbelled chimneys, and crenellation rising whimsically above levels of striped awnings resembling nothing so much as layered crinoline skirts. The structure's considerable charm was enhanced by the Olmsted Brothers' landscaping, including a distinctly English country garden.

Irving Brokaw Residence, "Frost Mill Lodge," Mill Neck, 1926 (Extant)

The first of the firm's three Neo-Palladian residences on Long Island, "Frost Mill Lodge" is also the most Mannerist. Brokaw, a Princeton

graduate who was admitted to the New York bar but who never practiced law, gained world renown as a figure skater but was also an artist and author. The slightly antic character of "Frost Mill Lodge" must be attributed to Brokaw's involvement, since it does not appear in anything else produced by the firm.

The advancing central block of the brick and limestone main facade is full of restless energy generated by the tightly squeezed curvilinear entrance surround, suddenly transformed at the second level into an earred window enframement with broken pediment and by the astonishing stylized Ionic capitals, seemingly arrested in mid-flight as they slide up the bay-flanking pilasters. The pilasters, thus freed visually to shoot up and off the facade plane, are decisively prevented from doing so by the presence of a short but solid limestone parapet above the slightly projecting cornice. Attic-level octagonal oculi, somewhat Directoire in derivation, also attract the eye.

After the excitement of the facade, the interior spaces are remarkable only for the configurations of the bowed library and octagonal dining and breakfast areas, and for the quantity of first-floor coatrooms: three in number.

Much more traditional in appearance and plan was the estate's U-shaped outbuilding complex, incorporating a small residence connected by a covered passageway to a stable with stalls for cows and horses, a dairy, a garage, and a wagon shed.

Henry P. Davison Residence, "Peacock Point," Locust Valley, 1914–16

Brick and limestone were combined again in the much grander, now demolished, "Peacock Point," constructed for Davison, a financier and head of the American Red Cross during World War I. The large Beaux-Arts residence presented

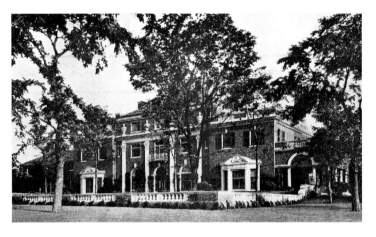

Walker & Gillette: Garden Facade, "Peacock Point," Henry P. Davison Residence, Locust Valley, 1914–16 (ARRC, 1917)

Walker & Gillette: Entrance Detail, "Peacock Point," Henry P. Davison Residence, Locust Valley, 1914–16 (PATT, 1924)

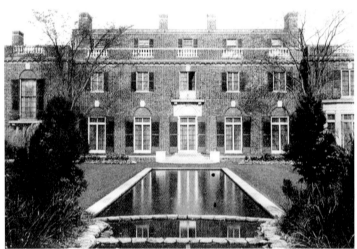

Walker & Gillette: Rear (Garden) Facade, "Big Tree Farm," James N. Hill Residence, Brookville, 1917 (PATT, 1924)

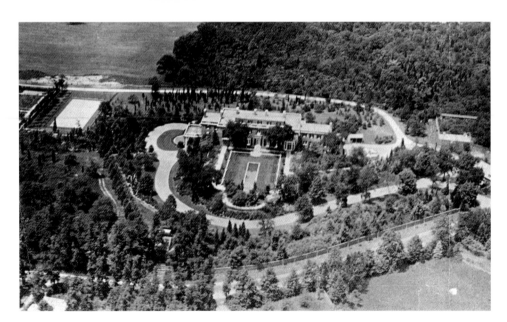

Walker & Gillette: Aerial View, "Big Tree Farm," James N. Hill Residence, Brookville, 1917 (VIEW, c. 1930)

not have such strong contrasts of color, would appear at a distance as a flat dark mass without any architectural character whatsoever.[16]

The character to which Boyd referred lay in the contrast—against the dark brick—of the colossal Corinthian limestone pilasters flanking the limestone-trimmed bays of the slightly recessed central block, and of the side pavilions' first-level bay windows, constructed entirely of limestone and crowned by proud, tail-fanned peacocks.

Peacocks appeared as well on the main, or garden, facade, settled regally at the balustrade angles of the south terrace. Other detail was primarily concentrated in the exuberant, exquisitely carved limestone entrance surround, incorporating many elements of Jacopo Sansovino's Venetian Library (begun 1536), even to the small representations of roaring lions.[17]

Traditional in plan, the "Peacock Point" interior included an entrance hall floor of old English Portland stone, an elliptical breakfast room, and classically detailed woodwork. The Olmsted Brothers' landscape included broad expanses of lawn, a circular drive, a reflecting pool, and a casino with pergola and balustraded terrace.

James N. Hill Residence, "Big Tree Farm," Brookville, 1917 (Extant)

Born in Minnesota, James Hill was an 1893 Yale graduate, vice president and director of the Northern Pacific Railway, president of the United Securities Corporation of St. Paul, and trustee of Great Northern Iron Ore.[18]

"Big Tree Farm," the name Hill and his wife, Marguerite Sawyer Fahnestock, gave to the estate, contrasted strongly with the classical character of the main residence. A large brick

two distinct faces to the world. In a 1917 issue of the *Architectural Record,* John Taylor Boyd, Jr., described the dramatic north facade on the Sound side as providing:

A motive powerful enough to carry across the waters of Long Island Sound. The house stands only some 250 feet from the shore line, and did it

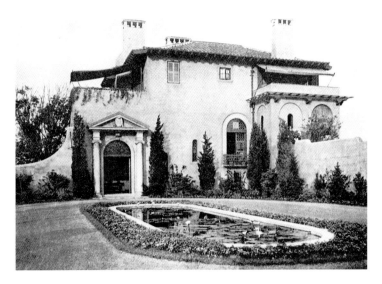

Walker & Gillette: Front Facade, "Black Point," Henry H. Rogers Residence, Southampton, 1914–16 (PATT, 1924)

mansion, the house is a quieter, less dramatic, variation of the planning and design themes found in the Brokaw and Davison houses. Horizontality is the dominant theme, with no strong vertical elements to arrest the eye. Limestone detail includes the entrance surround with engaged Doric columns beneath a corbelled shelf lintel, and the classically turned balusters, alternating with sections of brick, on the roofline balustrade. The estate survives today as the A. H. R. C. School.

Representing styles each of which appear only once in the Walker & Gillette Long Island lexicon are the Mediterranean Rogers residence in Southampton and the French-chateau inspired Tailer house in Lattingtown. Brought to the firm through personal connections—Rogers was the father-in-law of William Coe and Tailer the son-in-law of George Baker, Jr.—the two commissions provided the firm with opportunities to work out solutions to the unusual problems of siting, context, or design.

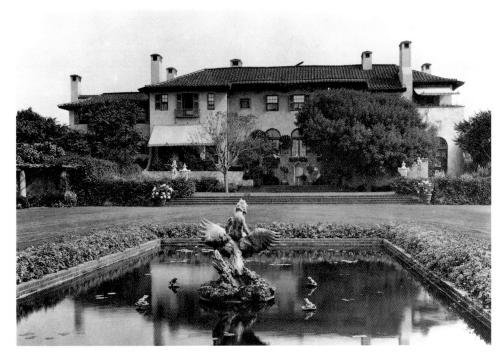

Henry H. Rogers Residence, "Black Point," Southampton, 1914–16

At Southampton, where the proposed isolated dune site fronted directly on the ocean, the firm combined stuccoed walls of ocher-gray and louvered shutters of blue-gray with a hipped roof of deep-red tiles for Rogers's now-demolished "Black Point." "Disposition of the grounds"[19] necessitating access from the end of the house, the architects resolved the informality of the entrance location by emphasizing the formality of the entrance itself in sober and impeccably classical terms, setting this element apart from the rest of the facade by placing it in a balconied projection and flanking the round-arched, molding-enriched opening with engaged Ionic columns that supported entablature blocks beneath a strongly crafted triangular pediment with central cartouche. On the long elevation, the house, with its broad-eaved hipped roof, became a recessed central block with pavilions, wings, and loggias, a composition of skillfully integrated curved and angular forms, of recesses and projections, and of light and shadow.

The interior of "Black Point" showed the same intense, all-encompassing design concern, evidenced by the spatial proportions and thoughtful detailing, from the groin-vaulted entrance hall with textured-plaster walls and graceful wrought-iron stair railing, to the coffered wood ceiling, hooded imported Italian stone fireplace, and oak floor of the reception room, and the practical expansiveness of the bedroom floor, divided into six self-contained suites.[20]

Walker & Gillette: Rear (Garden) Facade, "Black Point," Henry H. Rogers Residence, Southampton, 1914–16 (HEWI, 1923)

Walker & Gillette: Floor Plans, "Black Point," Henry H. Rogers Residence, Southampton, 1914–16 (ARRC, 1916)

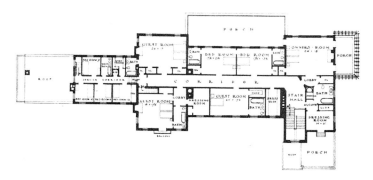

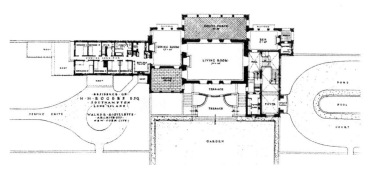

Walker & Gillette. Garden Facade, "Mayhasit," Francis L. Hine Residence, Glen Cove, 1915 (ARRC, 1918)

Walker & Gillette: Front Facade and Entrance Court, "Beaupré," T. Suffern Tailer Residence, Lattingtown, 1932 (INVE, 1978)

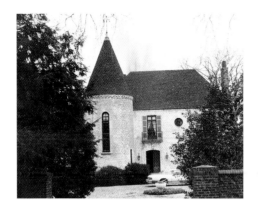
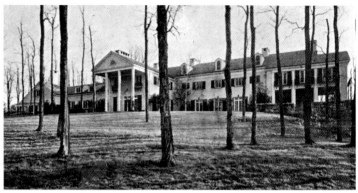

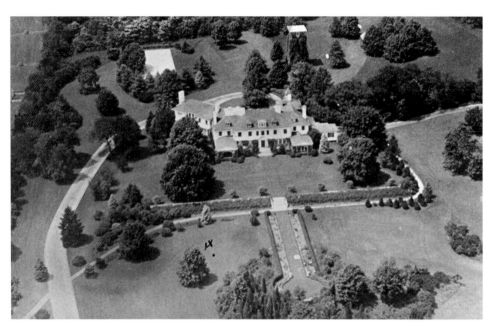

Walker & Gillette: Aerial View, Alterations, "Loewmoor," William G. Loew Residence, Wheatley Hills, 1934 (VIEW, c. 1930)

High stucco and terra-cotta walls fronted the property on the ocean side, surrounding and traversing extensive Olmsted-designed gardens. Providing a background for plantings and a sense of intimate enclosure that was eminently practical on this windswept site, the walls also defined the terraced expanse of lawn on the sheltered facade of the residence and protected a children's garden with brick paths, low flower beds, and a delightful trellised playhouse.[21]

Undoubtedly one of the firm's most successfully executed commissions, the Rogers estate was documented extensively in contemporary publications and contributed to the decisions of the Architectural League and the American Institute of Architects to award the firm gold medals for Excellence in Residential Design. John Taylor Boyd, Jr., describing the estate for *Architectural Record* in 1917, concluded:

All this work, house and gardens, is conceived in the spirit of true architecture. The practical needs are completely fulfilled, and are expressed in terms of mass, shapes, colors, and textures, in the most perfect way. Fortunately, the day of architecture copied from books . . . is passing, and we are glad to have a work so free, so sure, and so splendidly dramatic.[22]

Francis L. Hine Residence, "Mayhasit," Glen Cove, c. 1915 (Extant)

Designed and built between 1914 and 1916, while the firm was also working on the Davison and Rogers houses, this residence is sited on a knoll near the water. Of white-painted, wood-trimmed brick, it is a flattened Z in plan, drawn out on the east-west axis. Charles Cornelius viewed it with favor, noting.

The long low mass of the exterior simulated that of an ancient house remodelled through a century or two and binds convincingly into the contour of the land, while the many chimneys bespeak as many cheerful blazing hearths.[23]

Entrance appears to be gained directly through the end arcade that completes the circular forecourt enclosure, as in the Rogers house. In contrast to the latter, however, the opening—fronted by a simple but elegant square-columned portico with a gracefully curved, urn-decorated broken pediment—is a visual solution only; the entrance door is actually located at the end of the structure's long garden elevation.

On the interior, the entrance hall's wood-paneled walls are, according to Cornelius, "detailed with a naive freedom and a beautiful disregard of T-square regularity." Primary spaces are conventionally configured, "low ceiled and full of repose," with a "consistent formality and a judiciously restrained elaboration."[24]

Hine, chairman of the executive committee of the First National Bank of New York, also commissioned Walker & Gillette to design the estate's outbuildings: three cottages, a garage, and a stable complex.

Thomas Suffern Tailer Residence, "Beaupré," Lattingtown, 1932 (Extant)

"Beaupre" is one of the firm's last Long Island designs. Commanding wide vistas from its elevated site, the main facade, with its round conical-roofed tower keep, resembles a Loire château. Other details of note include the main entrance and the second-level oculus, both with subtle brick surrounds, and the balconied, full-length upper-story window.

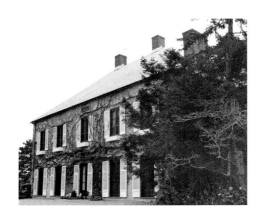

William G. Loew Residence, "Loewmoor,"
Alterations, Wheatley Hills, 1934

Alterations to existing houses complete the
firm's Long Island work. In 1932 Walker &
Gillette remodeled "Loewmoor," the now-
demolished Wheatley Hills home of William
G. Loew.[25] Working yet another time with the
Olmsted Brothers of Brookline, the architects
greatly enlarged and expanded Loew's 1896 resi-
dence, placing a new service wing diagonally to
partially enclose a circular entrance court and
adding square-columned porticos and loggias.

Walker & Gillette:
Alterations, "Oliver's
Point," Mrs, George F.
Baker III Residence, Centre
Island, 1940 (INVE, 1979)

Mrs. George F. Baker III Residence, "Oliver's
Point," Alterations, Centre Island, 1940

For the daughter-in-law of the firm's first Long
Island client, Walker & Gillette undertook an
unusual commission, namely, to reduce the size
of her residence. The result of the firm's labors
was the reduction of the original stone and shin-
gle residence, designed around 1910 by Herbert
Brewster with two broadly bowed main facade
windows, by half.[26]

In their work on Long Island, the firm of
Walker & Gillette achieved a distinctive record
of estate residences and outbuildings in a variety
of styles; many of these structures continue
today to contribute significantly to the stylistic
character of their surroundings. The number of
interconnected commissions bears testimony to
the fact that Walker & Gillette possessed con-
siderable facility for creating pleasing and
appropriate architectural backgrounds—formal
or informal, quiet or startling, evocative of local
or European traditions—that succeeded in satis-
fying each of the firm's client.

In the words of a contemporary critic:
*Perhaps the most noteworthy point in the varied
works of Walker & Gillette is the fact that they*
*have not attempted to impose a previous set of con-
ditions upon a problem governed by a different set
of conditions.*

*In each case they have allowed the problem in
hand to dictate certain important points in its
solution, and have expressed in a number of differ-
ent kinds of buildings a quality of selective archi-
tectural judgment which is at once a cause and
a result of our very diverse architecture in this
country.*[27]

<div align="right">Karen Morey Kennedy</div>

Hobart A. Walker, b. 1869

Brooklyn-born Hobart Alexander Walker stud-
ied architecture at Pratt Institute, subsequently
working in the offices of several well-known
architects, including Ernest Flagg, and Renwick,
Aspinwall & Owen. In 1907 he was working
under the firm name of Walker & Hazzard, and
following World War I resumed his architectural
practice in Orange, New Jersey. His commercial
designs include bank and office buildings in
New York City and Orange, New Jersey, as well
as numerous residential commissions, mostly
in New Jersey. A professed student of the
Colonial idiom, Walker, working independent-
ly, designed a large Colonial Revival-style coun-
try house for William Burger in Lattingtown
around 1900, apparently his only Long Island
commission. No longer extant, the shingled,
hip-roofed residence was characterized by its
balustraded port cochere and widow's walk.

<div align="right">Carol A. Traynor</div>

Hobart A. Walker: Front
Facade, William Burger
Residence, Lattingtown,
c. 1900 (SAAB, 1902)

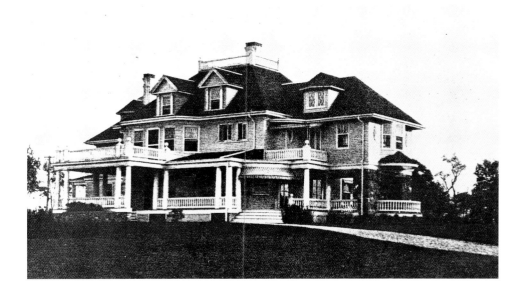

Leroy P. Ward: Entrance Facade, Stephen L. Vandeveer Residence, Great Neck, 1926 (ARRC, 1926)

Leroy P. Ward: Entrance and Front Facade, A. C. Schermerhorn Residence, Matinecock, 1929 (INVE, 1979)

Leroy P. Ward: "The Bouwerie," Dr. Wesley C. Bowers Residence, Southampton, 1930 (AVER, n.d.)

Leroy P. Ward, b. 1889

Leroy Ward's houses are always arresting to see: No matter what style, they are dramatically organized to highlight surface planes and textures, and elements are picturesquely massed and placed to catch light and cast shadows.

Born in Burlington, Vermont, in 1889, Ward studied architecture at Cornell. After working in other architectural offices, he established his own practice in New York in 1928. He worked alone until 1945, when he formed a partnership with Harry J. Kerrigan.

Four—possibly five—houses represent Ward's residential work on Long Island. Many are in Great Neck and Kings Point, and all were built between 1926 and 1930.

For banker Stephen L. Vanderveer, Ward designed a striking, multigabled house in Great Neck. Rough-faced brick dramatizes the receding planes of the main facade, the walls, gable fields, and chimney stacks, which are otherwise plain. Openings are few, and fenestration is irregular, with no two windows alike. It is impossible to miss Ward's distinctive hand in this house, featured on the cover of *Portfolio* in September 1926.

In 1929 Ward built a large, formal Federal Revival house in Matinecock for A. C. Schermerhorn. Although the center-entry main block and lateral wings seem unlike the picturesque Vanderveer house, the textured brick and the unusual arrangement of windows in the central pavilion suggest Ward's eccentric way with surface and fenestration.

"Porto Bello," a Norman Revival house in Great Neck, was built for Fenley Hunter around 1929. The irregular, multigabled mass pivots on an octagonal center tower; and the walls are a rich mixture of half-timbered brick, fieldstone, stucco, and hand-hewn boards. Ragged-ended slates in muted colors roof the gables, peaks, and sweeping eaves. Antique elements—a Spanish door, a French weather vane, and a flower-shaped tower finial—add still more richness and texture to the house.

The Mediterranean-style "The Bouwerie" was built in Southampton in 1930 for Dr. Wesley Bowers. The largest of the Ward houses, it is a three-and-a-half-story, irregularly massed villa set on a sand dune overlooking Shinnecock Bay and the ocean. Ward's characteristic freedom with wall planes and window placement give "The Bouwerie" the look of an Italian palazzo amid the fortunate accretions of centuries.

A design for a large Norman-style stable for lawyer Thompson Ross in Great Neck was published in 1930, but it is not known whether stable or residence was actually built.

Ellen Fletcher

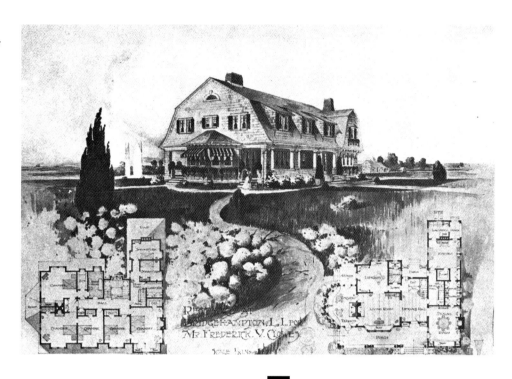

James E. Ware & Sons: Design Rendering and Floor Plans, F. V. Clowes Residence, Bridgehampton, c. 1906 (ARTR, 1906)

James E. Ware, 1846–1918

A pioneer in the design of fireproof warehouses at the turn of the century, James Edward Ware opened his first New York City architectural office in 1869. In addition to his Manhattan Storage & Warehouse Co. (1899), he also designed the 19th Regiment Armory and the Madison Avenue Presbyterian Church, both in New York City. In later years, beginning in 1897, his two sons, Arthur and Franklin B., were associated with him as James E. Ware & Sons. Around 1906 he was commissioned by F. V. Clowes to design a summer residence in Bridgehampton. Employing characteristic details of the Neo-Dutch Colonial style—gambrel roofs, deep eaves, wide columned porches—Ware's plan also featured an open spatial arrangement on the interior consistent with an informal summer residence near the water.

Carol A. Traynor

Warren & Clark: Front Facade, P. F. Collier Residence, Southampton, 1915 (ARRC, 1916)

Warren & Clark: Front Facade, A. Perry Osborn Residence, Glen Head, 1919 (ARTR, 1919)

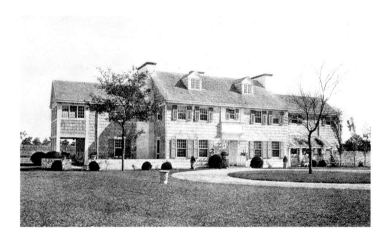

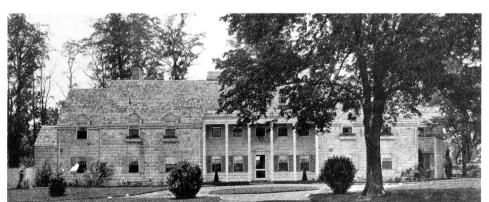

Warren & Clark, practiced 1910s

Warren & Clark designed at least three country houses on Long Island before their association with Christopher Grant LaFarge in the 1920s as LaFarge, Warren & Clark. For Irish-born publisher Peter Fenelon Collier, editor of *Collier's Weekly,* and his wife, the partners designed a large, Federal Style, shingled residence in Southampton in 1915 to replace an earlier country residence for the Colliers destroyed by fire in 1914. In 1919, lawyer, banker, and broker A. Perry Osborn had the firm remodel an 18th-century

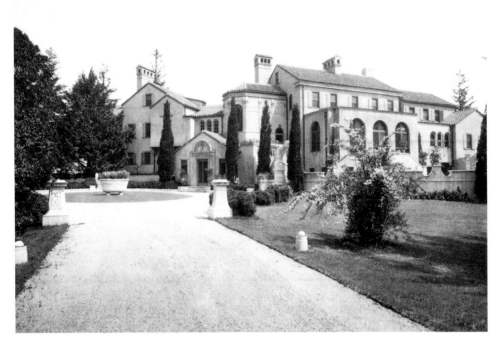

Warren & Clark: Entrance
Front, "Villa Maria," Frank
C. Henderson Residence,
Roslyn, 1920 (HEWI, c. 1930)

farmhouse in Glen Head into a long, sprawling
summer residence while retaining its colonial
feeling through the use of shingles, sash win-
dows, and shutters, the whole composition
being dominated by a Mount Vernon-inspired
entrance portico. The partners' most impressive
foray into the country-house idiom on Long
Island was "Villa Maria" in Roslyn, designed in
1920 for Frank C. Henderson, who had amassed
a fortune in the oil business in Oklahoma before
moving to Long Island. The house is Neo-
Italian Renaissance in style with a soft, Italian-
inspired polychromatic color scheme of red-tile
roofs, pink-stucco walls, and dull-blue shutters.
The irregular floor plan allows for an interesting
juxtaposition of roof lines and projecting wings.
The extensive grounds were designed by land-
scape architects Hattan & DeSuarez, and a pri-
vate golf course on the property was laid out by
noted golf course designer Devereux Emmet.
All three of the firm's Long Island commissions
are extant today.

Carol A. Traynor

Warren & Wetmore, 1898–1928
Whitney Warren, 1864–1943
Charles D. Wetmore, 1866–1941

The firm of Warren & Wetmore is best known
for its work for commercial clients. Whitney
Warren studied at Columbia University and at
the Ecole des Beaux-Arts. Returning to New
York in 1894, he joined the firm of McKim,
Mead & White. Charles D. Wetmore, a gradu-

ate of Harvard Law School and a practicing
lawyer, met Warren when he consulted him on
the design of his own house. Shortly after the
firm was established in 1898, it won the compe-
tition for the New York Yacht Club building, an
expressive and personal rendering in the Beaux-
Arts style. Grand Central Terminal, built in
1903–13, in conjunction with Reed & Stern,
fully established the firm's reputation. The firm
also designed five hotels in the vicinity of Grand
Central, all under the auspices of the Vander-
bilts and the New York Central Railroad, as well
as other railroad stations and hotels throughout
the United States. The New York Central
Building (1926–28), north of Grand Central,
illustrates the firm's mastery of office tower
design. While private residences were a lesser,
and earlier, part of the firm's work, Warren's
social connections—he was a cousin of the
Vanderbilts—brought a roster of socially prom-
inent clients, including James A. Burden,
R. Livingston Beekman, and Marshall Orme
Wilson.

The firm's Long Island work, which spanned
some 30 years, was predominantly domestic in
nature but included few private houses. Its com-
missions were located on the North Shore as
well as in the western section of Suffolk County.
At least three of these projects were generated
through the firm's Vanderbilt connections.

Clarence H. Mackay Residence, Roslyn, Estate
Outbuildings, 1900–1902

The firm's first Long Island commission was for
the design of the outbuildings (1900–02) of the
Clarence H. Mackay estate, "Harbor Hill," at
Roslyn. Mackay (1874–1938), capitalist, philan-
thropist, and head of the Postal Telegraph–
Commercial Cable empire, had commissioned
the house and lodge from McKim, Mead &
White and the landscape architecture from Guy
Lowell. Strained architect-client relationships
have been conjectured as the cause for a change
in architect.[1] The two-story carriage house and
stable, designed in the form of a fanciful French
château, was situated at the top of a hill, fairly
close to the main house. The farm buildings,
superintendent's house, polo pony stables, and
kennels were picturesque designs, recalling the
forms of Swiss chalets. The court tennis build-
ing was a French Norman-inspired half-timber
design. Most of these buildings were situated
near the northern edge of the property, in accor-
dance with Lowell's overall landscape plan.

The attention given to these outbuildings
attests to their importance in the scheme of a
country estate. Not only was the design of the
stable particularly grand, its plan reflected pro-
gressive thinking of the period about this build-
ing type. Situated facing a courtyard, the main
block of the building incorporated the carriage

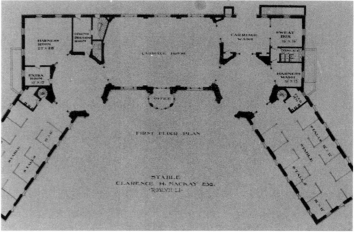

Warren & Wetmore: Stable/Carriage House, "Harbor Hill," Clarence H. Mackay Residence, Roslyn, 1900–1902 (AVER, n.d.)

Warren & Wetmore: Floor Plan, Stables, "Harbor Hill," Clarence H. Mackay Residence, Roslyn, 1900–1902 (AVER, n.d.)

Warren & Wetmore: Tennis Building, "Harbor Hill," Clarence H. Mackay Residence, Roslyn, 1900–1902 (AVER, n.d.)

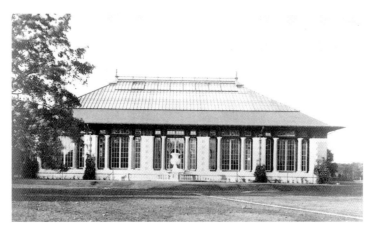

Warren & Wetmore: Court Tennis Building, "Idle Hour," W. K. Vanderbilt, Sr., Residence, Oakdale, c. 1902–04 (AVER, n.d.)

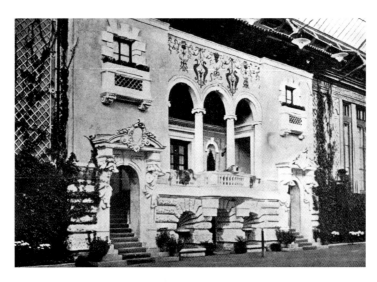

Warren & Wetmore: Indoor Tennis Court, "Idle Hour," W. K. Vanderbilt, Sr., Residence, Oakdale, c. 1902–04 (VAND, n.d.)

house flanked by towers which served as entrance (with adjacent carriage wash and harness wash) and exit (with adjacent harness room). Extending diagonally from the main block were the stable wings with ample box stalls, each with its own outside doorway (so horses could be led directly in from the courtyard) and double casement window. Some 35 years later this stable would still be described as "superb."[2]

The court tennis building, which appears to be the first structure of this type designed by the firm,[3] was equally interesting. T-shaped in plan, the portion of the structure containing the squash court, pool, and "dedans" salon (for viewing the tennis matches) was set perpendicular to the double-height tennis court, designed in such a way that the framing of the windows echoed the half-timbering of the exterior walls. The buildings of the Mackay estate do not survive.

William K. Vanderbilt, Sr., Guest Wing at "Idle Hour," Oakdale, c. 1902–04 (Extant)

The firm's next Long Island work (c. 1902–04) was in Oakdale at "Idle Hour," the estate of William K. Vanderbilt, Sr. (1849–1920), head of the Vanderbilt railroad and financial empire and avid yachtsman.[4] The main house, designed by Richard Howland Hunt in 1900,[5] is linked by a covered cloister to a palm garden. Extending diagonally from the palm garden is Warren & Wetmore's two-story guest wing, or "bachelors' quarters," joined to a large indoor tennis court. This glass-roofed Beaux-Arts pavilion, designed to blend with the main house, is dominated on its interior by an open loggia, almost Baroque in conception, with heavily rusticated base and supporting herms. The buildings of "Idle Hour" are now part of Dowling College.

Warren & Wetmore: Garden Facade, "Ivy Hall," Ralph J. Preston Residence, Jericho, c. 1904 (AVER, n.d.)

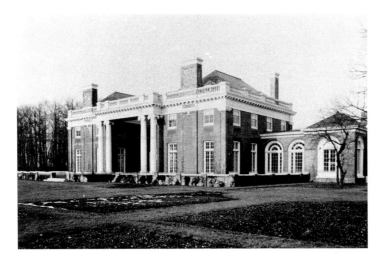

Warren & Wetmore: Garden Facade, "Ivy Hall," Ralph J. Preston Residence, Jericho, c. 1904 (AVER, n.d.)

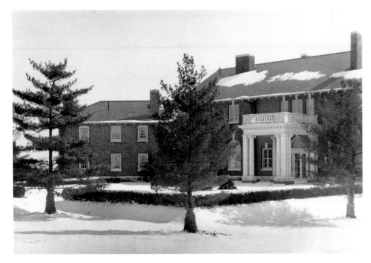

Warren & Wetmore: Entrance Front, "Kirby Hall," Joseph S. Stevens Residence, Jericho, c. 1904 (HICK, n.d.)

Ralph J. Preston Residence, "Ivy Hall," Jericho, c. 1904

Houses and outbuildings for two major estates date from about 1904[6] (the firm was most active in the design of private residences in the early years of the century). Ralph J. Preston (1864–1919), a lawyer and,39
from 1914, deputy Red Cross Commissioner for Europe during World War I, commissioned a house in Jericho, al-though he appears not ever to have lived there.[7] The property was owned by James B. Taylor
c. 1906 to 1920; Elbert N. Gary in the 1920s. Designed in the manner of an 18th-century French château, the three-story brick house had two pavilions, containing a living room and a dining room—which flanked an open portico with paired double-height Ionic columns opening onto a walled terrace—that extended across the western front of the house. This portico was on axis with the large central entrance hall which was lit by a multipaned tripartite window. The entrance hall was approached by an open vestibule framed by rusticated brick piers and a three-centered arch with a slightly recessed entry. A balustraded parapet, tall paneled chimneys, and hipped roofs accentuated the roof line. A conservatory and study, both of

brick with arched openings, was linked to the house on the south. This was balanced by a side terrace at the north. Other buildings on the estate were an entrance lodge, stable and carriage house, garage, and farm buildings. The buildings of the estate do not survive.

Joseph Sampson Stevens Residence, "Kirby Hall," Jericho, c. 1904 (Extant)

The two-and-a-half-story, red-brick house for Joseph Sampson Stevens (1867–1935), sportsman and member of the Rough Riders regiment, was located just to the east of the Preston house, across Kirby Lane, north of the Jericho Turnpike.[8] The house owes its design more to 18th-century Georgian than to French prototypes. A projecting, low hipped-roof portico with Ionic columns and roof balustrade leads to the central entrance hall and connecting stair hall with sweeping staircase. A "petit salon" is on axis with the entrance hall and to either side are the salon and dining room. The paneling, chimney pieces, and interior detail reflect the Georgian style of the exterior. The facades are enlivened by round-arched openings with decorative transoms at the first story. The gabled roof has prominent rafters under the eaves. A hipped-roof servants' wing extends at an angle from the main block of the house. A partially walled terrace extends across the rear facade of the house and is accessible through French doors from the major rooms.

Warren & Wetmore also designed the stable. While more modest in scale than the Mackay stable, it has a similar plan, with the main stable block containing the carriage and harness rooms and stall wings opening onto a roofed court. The buildings of the Stevens estate survive and are still owned by the family.

William K. Vanderbilt, Jr., Residence, "Eagle's Nest," Centerport, 1910–30 (Extant)

The Vanderbilt connection brought the firm work at "Eagle's Nest," the Centerport estate of William K. Vanderbilt, Jr. (1878–1944), president of the New York Central Railroad, sportsman, and collector of marine specimens. The location was particularly advantageous for Vanderbilt's yachting interests. The buildings on the estate went through several phases of construction, beginning in 1910–12. By this time the firm was moving out of the sphere of private residential architecture, which gives this work for Vanderbilt special interest; the commission is undoubtedly an outgrowth of the Grand Central Terminal project. Early buildings

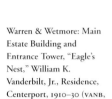

Warren & Wetmore: Bungalow, "Eagle's Nest," William K. Vanderbilt, Jr., Residence, Centerport, 1910–30 (VANB, n.d.)

Warren & Wetmore: Boathouse, "Eagle's Nest," William K. Vanderbilt, Jr., Residence, Centerport, 1910–30 (VANB, n.d.)

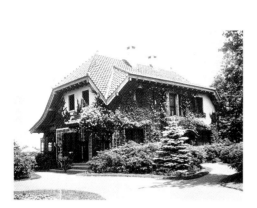
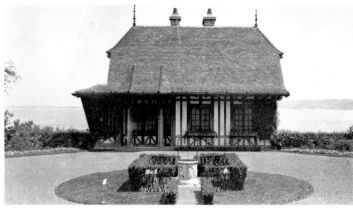

Warren & Wetmore: Main Estate Building and Entrance Tower, "Eagle's Nest," William K. Vanderbilt, Jr., Residence, Centerport, 1910–30 (VANB, n.d.)

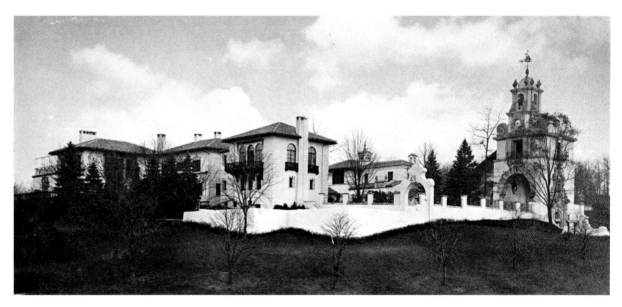

Warren & Wetmore: Entrance Tower, "Eagle's Nest," William K. Vanderbilt, Jr., Residence, Centerport, 1910–30 (VANB, n.d.)

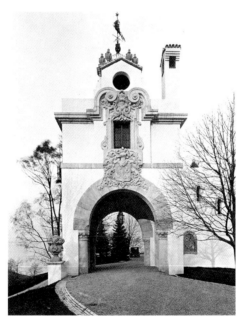

included an "English" bungalow (1911), a picturesque boathouse of stone and half-timber work with steep, exotically pitched roofs (1914), a similarly styled superintendent's cottage (1917), and the one-story, stucco-faced Vanderbilt Marine Museum with Spanish Baroque detail (1922). Based on stylistic evidence and the firm's later work at "Eagle's Nest," these early buildings are attributed to Warren & Wetmore.[9]

In 1924 Vanderbilt undertook a major building campaign to enlarge the bungalow. Completed by 1928, the work coincided with Vanderbilt's second marriage, to Rosamund Lancaster Warburton. Warren & Wetmore created a multistoried, multilevel, and multiwinged house in a "Spanish" style, with stucco walls, red-tile roofs, fanciful balconies, recessed windows with grillework, cast-stone enframements, and polychromed cast-stone ornament. The complex nature of the plan allows for a series of relatively small-scale, interlocking spaces, in contrast to much grander country-house architecture of the preceding period. Dominating the composition is an entrance tower, crowned by a domed bell tower.

There was little precedent for the use of a Spanish style in Warren & Wetmore's work, with the exception of the stuccoed, tile-roofed Shelburne Hotel (1922) in Atlantic City. Consequently, the house is seen to be a very personal expression of Vanderbilt's taste for the fantastic and the exotic.[10] Architectural features incorporated into the design can be traced to specific

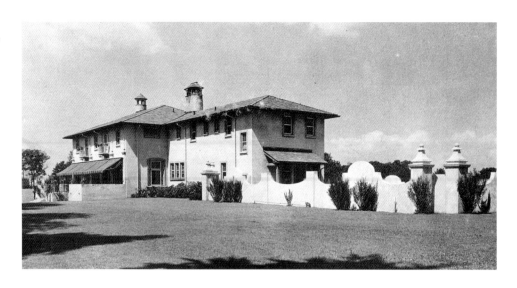

Warren & Wetmore: Deepdale Golf and Country Club, Great Neck, 1925–26 (VANB, n.d.)

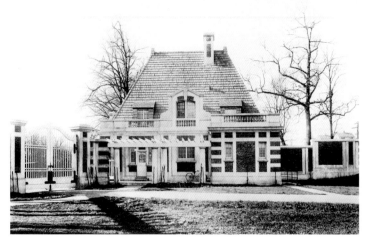

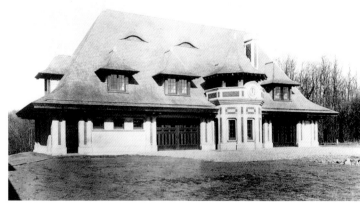

Warren & Wetmore: Gate Lodge, "Villa Carola," Isaac Guggenheim Residence, Sands Point, c. 1907 (AVER, n.d.)

Warren & Wetmore: Garage, "Villa Carola," Isaac Guggenheim Residence, Sands Point, c. 1907 (AVER, n.d.)

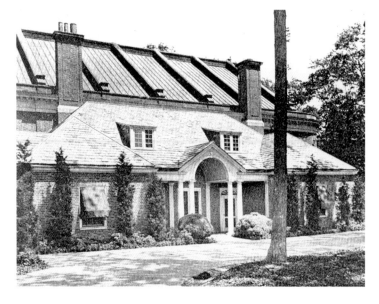

Warren & Wetmore: Indoor Tennis Court, "Caumsett," Marshall Field III Residence, Lloyd Harbor, 1924 (COUN, 1927)

stylistic precedents,[11] but the house has been described as "evocative of an architectural mode rather than being academically historical . . . it says more about the personality of its owner than it does about architectural and cultural precedents. In short, Eagle's Nest is history filtered through the powerful sensibility of its creator. . . ."[12]

In 1929–30, the firm enlarged the Marine Museum for Vanderbilt. Renamed the "Hall of Fishes," the building gained a second story and suitable Spanish-style ornament. The buildings of the estate survive as the Vanderbilt Museum, now under the jurisdiction of Suffolk County.

Deepdale Golf and Country Club, Great Neck, 1925–26 (Extant)

Vanderbilt was also responsible for bringing Warren & Wetmore the commission for the Deepdale Golf and Country Club in Great Neck, built in 1925–26. The firm's other major Spanish-style commission, the design recalls certain features of the Vanderbilt house with its stuccoed walls, low hipped roofs, major exterior staircases, and stylized buttresses flanking the main entrance. The intent of the design was to create "a building more like a private country house in which the members could feel at ease to do as they wished."[13] The west wing, set at right angles to the main block of the clubhouse, is a later addition. Deepdale Golf Club is still in use today, although largely altered.

Several years earlier, about 1917, the firm had proposed major alterations for the Great Neck

Golf and Country Club (also known as Sound View), designing a new clubhouse and a new beach house. Both took the form of large arcaded pavilions with sprawling wings. The club is no longer in existence. Given the proposed scale of alterations in the year when the United States entered World War I, it is unlikely the plan was carried out.

Isaac Guggenheim Estate Buildings, Sands Point, c. 1907 (Extant)

Three additional projects are more akin to the firm's work at "Idle Hour" and "Harbor Hill." In about 1907,[14] a gate lodge, farmhouse, barn, garage, and conservatory were designed for the Sands Point estate of Isaac Guggenheim (1854–1922), a director of the American Smelting and Refining Company and a member of Guggenheim Brothers. These predated the present main house "Villa Carola" (1916) by H. Van Buren Magonigle. The three masonry buildings are of Norman-inspired design with very steeply pitched, slate-covered roofs. The garage took the place of a stable on the estate and assumed many of the same functions, with a large space to house vehicles, a washroom, repair room, and estate office on the first floor, and servants' rooms on the second floor. The office is located in a five-sided tower with clock and cupola roof. The glass conservatory has a central octagonal structure with a dome flanked by wings with gabled roofs. The Guggenheim estate is now an IBM management training center.

Marshall Field III Tennis Building, Lloyd Harbor, 1924 (Extant)

Marshall Field III (1893–1956), publisher, president of Field Enterprises, and yachtsman, began work on his Lloyd Harbor estate "Caumsett" in 1924. The major buildings were designed by John Russell Pope and Alfred Hopkins; however, Warren & Wetmore created the large indoor tennis structure. Such structures enjoyed a flurry of popularity in the 1920s, and the firm

designed several.[15] Situated somewhat to the south of the main house, it is a gable-roofed, shingled building with flanking wings. The buildings of "Caumsett" are vacant but survive on the grounds of what is now Caumsett State Park.

C. Oliver Iselin Residence, Brookville, Additions to Main House

A final project (date undetermined) was the addition of a wing to the house of C. Oliver Iselin (1854–1932), avid yachtsman and defender of the America's Cup in 1893, 1895, 1899, and 1903. The original, shingled, Colonial Revival house of 1914 was designed by Hoppin & Koen. The new wing continues the form of the original design.

Marjorie Pearson

■

Louis S. Weeks, 1881–1970

Louis S. Weeks was born in Grand View-on-Hudson. He received a B.A. from Columbia University before moving to Paris, where he studied architecture at the Ecole des Beaux-Arts. He worked for three New York firms—Kenneth Murchison, Benjamin W. Morris, and, finally, Erving & Allen. He began to receive important commissions by the late 1920s; among these were the W. E. Kluge residence in Montclair, New Jersey (1929), and the International Telephone and Telegraph office building at 67 Broad Street in Manhattan (1930). He also built telephone buildings in Madrid and Bucharest. One of his best-known works was the Dry Dock Savings Institution on the corner of 59th Street and Lexington Avenue. While there is little biographical information available on him, it is clear that he lived on Long Island, as he was the municipal architect for the Village of Lawrence. In addition, he was a member, and later a member emeritus, of the New York chapter of the American Institute of Architects.

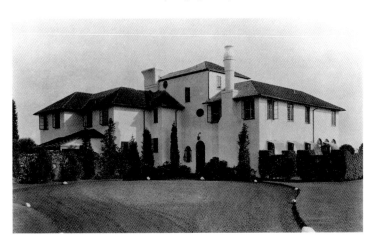

Louis S. Weeks: Entrance Facade, Mrs. Clarkson Potter Residence, Southampton, c. 1927 (HEWI, 1927)

Mrs. Clarkson Potter Residence, Great Plains Road, Southampton, c. 1927 (Extant)

This rambling stuccoed house draws on elements from the contemporary Spanish Colonial Revival. Weeks interjected picturesque elements into the composition. The plantings are in close proximity to the house and serve as architectural screens to ensure privacy. An arcuated open porch overlooks the water. Of special interest are the two chimneys whose sinuous and abstracted geometric shapes play off

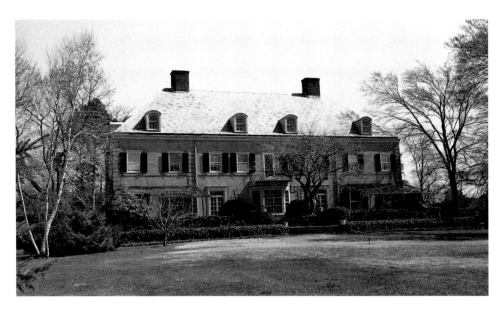

Louis S. Weeks: Garden (Rear) Facade, "The Causeway," Courtland Dixon Residence, Lawrence, 1930 (INVE, 1980)

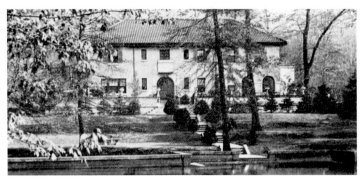

Louis S. Weeks: Garden (Rear) Facade, "The Terraces," Hugo Branca Residence, Manhasset, 1928 (TOWN, 1928)

against an otherwise rectilinear composition. Curved, decorative ironwork also accents the planarity of the exterior walls.

Courtland Dixon Residence, "The Causeway," Lawrence, 1930 (Extant)

This house is situated in the Rockaway Hunt Section of Lawrence, and is the second house on the Dixon estate. The first was built in 1906 by an unnamed architect. It is described as having "large porches and stained glass windows."[1] It was gutted by fire in 1930. The current Dixon residence was built to the north of the former house, and represents a later development in the Colonial Revival. The surfacing material is rough-finish stucco. Mock quoining marks the interior division of the main public spaces and the master bedrooms from the children's rooms and informal family spaces. Flattened arch dormers accent the high, single-hipped, slate roof. Trellises attached to the garden facade link the house with the garden.

Hugo Branca Residence, "The Terraces," Manhasset, 1928 (Extant)

The Spanish Colonial Revival style became popular in the northeast and in southern California in the second and third decades of this century.

"The Terraces" is an excellent illustration of its features: high hipped roof covered with Spanish terra-cotta tiles, symmetrical composition, and round-arched openings. The most noteworthy feature about the house are the three earth terraces which connect the house with the man-made reflecting pool. Urns placed on the garden terrace mitigate the transition from house to garden. As we have little documentation regarding this commission, we are unable to say whether Weeks landscaped the grounds himself.

Christopher E. Miele

Werner & Windolph, practiced 1890s–1900s

Harold Werner, 1871–1955
August P. Windolph

Brooklyn and Manhattan's huge German-American population led such a separate existence in the late 19th century that they had their own banks, schools, hospitals, newspapers, and even National Guard regiments. At the shore their cottages were designed and built by fellow émigrés from the Fatherland, and in the exclusive enclaves of Far Rockaway that firm was likely to be Werner & Windolph. Little is known of August P. Windolph but Harold Werner, AIA (1871–1955), studied abroad after graduating from the Columbia School of Mines in 1892. The partnership the two formed c. 1894 was responsible for buildings connected with Croton Aqueduct, schools in Mount Vernon, New York, and private residences in New York, Connecticut, and New Jersey. Between 1895 and 1900 the firm received commissions for five country houses at Far Rockaway. The houses were to be thoroughly American; only in the German Renaissance dormer windows for the Gustave Salomon house at Bayswater was there even a reference to the Fatherland. Working in the Queen Anne and Colonial Revival modes, their work was characterized by an affinity for double and tripartite windows, radiating shingle patterns, and colossal porticos. Two residences in the Wave Crest section of Far Rockaway, for Mrs. Eva M. Foster and Messrs. Kraus and Stern, and the one at Bayswater for Gustave Salomon, were all of the type in which projecting pavilions or turrets flanked a recessed loggia above an encompassing veranda. For R. J. Gerstle at Arverne and Louis Auerbach at Wave Crest, colossal porticos and flanking porches adorned three-story, hipped-roofed houses. Werner & Windolph may also have been responsible for other houses at Far Rockaway whose architects remain unknown.

Robert B. MacKay

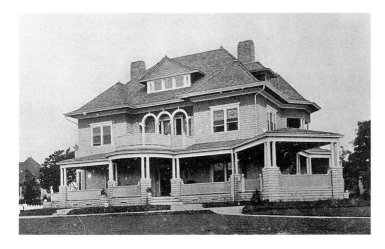

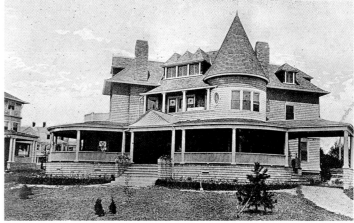

Werner & Windolph: Front Facade, Mrs. Eva M. Foster Residence, Far Rockaway, c. 1895 (ROCK, 1901)

Werner & Windolph: Front Facade, Messrs. Kraus and Stern Residence, Far Rockaway, c. 1895 (ROCK, 1901)

Werner & Windolph: Gustave Salomon Residence, Far Rockaway, c. 1895 (ROCK, 1901)

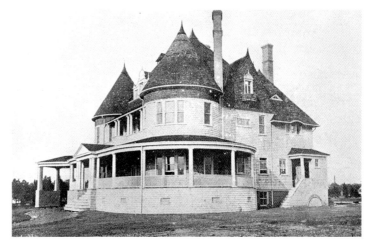

Werner & Windolph: Front Facade, R. J. Gerstle Residence, Far Rockaway, c. 1895 (ROCK, 1901)

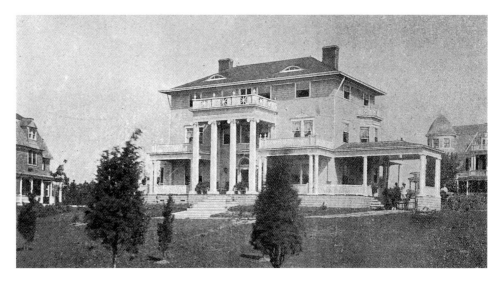

Werner & Windolph: Front Facade, Louis Auerbach Residence, Far Rockaway, c. 1895 (ROCK, 1901)

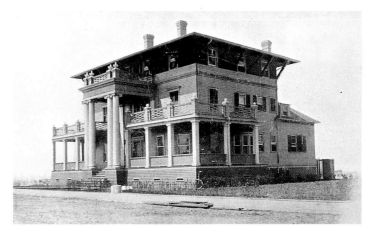

A. Dunham Wheeler:
Entrance Drive and Front
Facade, "The Boulders," H.
B. Anderson Residence,
Great Neck, c. 1895 (ARLG,
1898)

A. Dunham Wheeler:
Entrance Front,
"Fleetwood," Robert V. V.
Sewell Residence, Oyster
Bay, c. 1907 (AMHO, 1909)

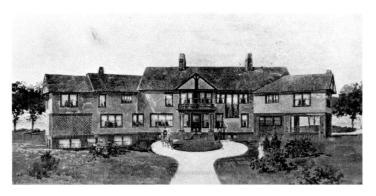

A. Dunham Wheeler, 1862–1938

A. Dunham Wheeler was the son of pioneer
American textile designer and interior decorator
Candace Thurber Wheeler, who founded the
short-lived but influential decorating firm of
the Associated American Artists with Louis
Comfort Tiffany and others. Dunham, no
doubt influenced by his mother's line of work,
chose a career in architecture. He assisted his
mother with her own decorating business, the
Associated Artists, which she organized after the
dissolution of the original partnership in 1883,
and he managed it until its termination in
1907. Primarily a designer of domestic architec-
ture, he continued to practice in New York until
1912. Dunham Wheeler's first architectural work
comprised the "rustic" inn and cottages at
Onteora Park, a summer colony begun by his
parents and uncle in the Catskills. Other clients
included fellow artists and wealthy business-
men. Wheeler remodeled the country home of
John D. Rockefeller, Sr., in Lakewood, New
Jersey, and planned other residences there.

In the late 1890s he designed "The Boulders"
for Henry Burrall Anderson, a prominent New
York lawyer. No longer extant, this large, eclec-
tic house was designed to take advantage of its
site at Great Neck, overlooking the Sound. The
central rectangular block, and flanking, angled
wings had intersecting slate roofs with over-
hanging eaves and half-timbered gabled ends.
The irregular plan and asymmetrically placed
windows of various sizes reflecting the interior
arrangement suggest that the house may have
been the result of a remodeling.

Still standing, better documented, and of
greater aesthetic interest is "Fleetwood," former-
ly the house and studio of the artist Robert Van

Vorst Sewell, which was erected about 1907 on a
60-acre site at Oyster Bay. Sewell is best known
for his mural of the Canterbury Pilgrims, exe-
cuted for the rear hall of "Georgian Court,"
the residence of George Gould in Lakewood.
Wheeler was responsible for the plan, construc-
tion, and general form of the house, and the
client for the decorative features. Painter turned
sculptor, Sewell designed and carved the unusu-
al brackets supporting the overhanging second
story, the barge boards and doors, and the great
hall chimney piece, which give the house its
special character. Described as "a modern house,
designed and decorated in the spirit of the
medieval craftsman," it reflects the ideas of the
Arts and Crafts movement and exemplified the
owner's preference for the Late Gothic period of
design. Symmetrical yet informal in character,
the house was sited so that the longer garden
facade with its projecting gabled bays is turned
perpendicular to the street; the main entrance
front with its gabled porch is at the narrow end
of the house. The first story is brick and the
upper portions stucco and half-timbered, with a
slate roof.

Joy Kestenbaum

Willauer, Sharpe & Bready

The firm of Willauer, Sharpe & Bready de-
signed a country residence for J. Herbert
Johnston in Lloyd Harbor, the only known
commission of the firm on Long Island. Arthur
E. Willauer (1876–1912), the senior partner in
the firm, was born in Pennsylvania, studied
architecture there, and in 1897 started his archi-
tectural career in the office of George B. Post,
later forming an association with Sharpe and
Bready. Built c. 1910, "Boatcroft" is a striking
example of Neo-Georgian architecture.
Originally on 120 acres and commanding a
prominent site facing Lloyd Harbor, the 42-
room house was owned briefly by the Orza fam-
ily and since 1961 had been readapted as the
official residence of the Ivory Coast Mission to
the United Nations.

Carol A. Traynor

Willauer, Sharpe & Bready:
Rear Facade, "Boatcroft," J.
Herbert Johnston
Residence, Lloyd Harbor,
c. 1910 (ARTR, 1915)

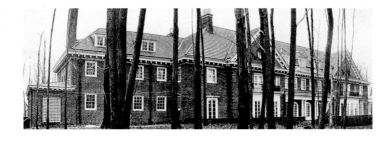

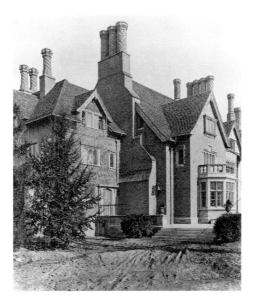

Edgar I. Williams: Rear Facade Detail, "The Chimneys," Mrs. Christian R. Holmes Residence, Sands Point, 1929 (HEWI, 1931)

Edgar I. Williams, 1884–1974

Upon graduating from the Massachusetts Institute of Technology's School of Architecture, Edgar Irving Williams won the Prix de Rome, and studied at the American Academy there from 1902 to 1912. He later combined private practice with teaching, serving on the faculty of M.I.T., New York University and, for 25 years, Columbia University. In 1929 he designed "The Chimneys" for the Sands Point estate of Mrs. Christian Holmes. The exterior of this vast Neo-Tudor mansion was a veritable dictionary of Tudor forms and included some authentic architectural elements imported from England. The house took its name from the extraordinary array of chimneys, made of imported brick, which stood singly or in groups—every shaft being laid up in individual spiral or diaper patterns. In plan, a particularly Tudor feature was the great hall, extending the full depth of the house. It is interesting to note that the period style of the house is not matched by the grounds, which were landscaped in the picturesque manner. Today the house serves as the Sands Point Community Synagogue.

Wendy Joy Darby

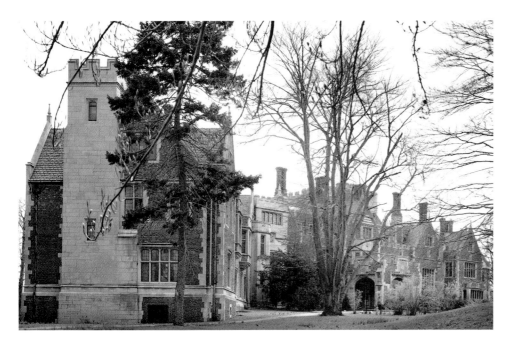

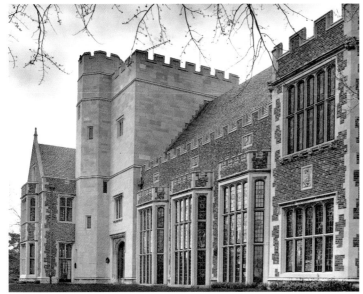

John T. Windrim: North Facade, "Inisfada," Nicholas Brady Residence, Manhasset, 1916–20 (SPUR, 1929)

John T. Windrim: South Facade, "Inisfada," Nicholas Brady Residence, Manhasset, 1916–20 (Bob Zucker photo, 1978)

John Torrey Windrim, 1866–1934

John Torrey Windrim was the son of Philadelphia architect James H. Windrim (1840–1919), under whom he presumably trained. He has been credited with many prominent Philadelphia buildings, including the Franklin Institute, Jefferson Hospital, the Lincoln Liberty Building, and dormitories at Girard College. His sole Long Island commission, "Inisfada," is his only recorded work outside Pennsylvania. Built between 1916 and 1920 in Manhasset, "Inisfada" is a discriminating example of the Tudor Revival style, offering dramatic contrast between its big southern facade and the more delicate northern one. From the south, the building crowns the summit of a huge expanse of lawn which slopes up from the entrance gateway; from the north, the building declares the zeal with which it was ornamented in innumerable limestone copings, dripstones, quoinings, and crenellations. The great hall is the centerpiece of the interior, which originally contained ten paintings by Angelica Kauffman and two great Tournai Gothic tapestries among many other notable artworks which were sold at auction in 1937. The house was the country residence of Nicholas F. Brady and Genevieve (Garvan) Brady, one of the foremost Catholic lay couples

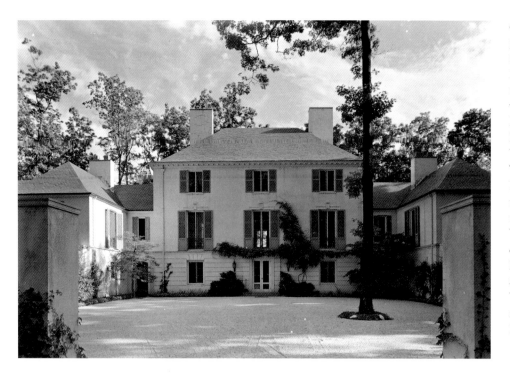

Wyeth & King: Front Facade, Linzee Blagden Residence, Cold Spring Harbor, 1930 (GOTT, 1935)

of Carrère & Hastings before going into private practice in Florida. He returned to New York in 1932, forming a partnership with Frederick Rhinelander King. Among Wyeth's works are the Church of the Epiphany, New York (1940, with Eugene W. Mason) and the Governor's Mansion, Tallahassee, Florida (1947). Of the large number of private homes designed by Wyeth, only two are known of on Long Island. The Linzee Bladgen house at Cold Spring Harbor was built in 1930. The central block of this five-part Palladian-style house is set up on a rusticated base. Somewhat similar in plan is Wyeth's 1925 two-and-a-half-story shingled residence for Anson Hard in Brookhaven. The house was built on the site of the original Suffolk Club organized c. 1827 by Daniel Webster, Martin Van Buren, and others, and is now a public park owned by the Suffolk County Parks Department.

Wendy Joy Darby

of their generation. The most notable event in the life of the building was its service in 1936 as the American headquarters for the Papal Secretary of State, Cardinal Eugenio Pacelli, soon to be the next pope, Pope Pius XII. In 1937, Mrs. Brady donated the estate and approximately 122 acres of surrounding land to the New York Province of the Society of Jesus, and it now serves as one of approximately 30 Jesuit retreat houses in the United States.

Peter Kaufman

■

Wyeth & King, practiced 1930s–1940s

Marion Sims Wyeth, 1889–1982

Frederick R. King

Educated at Princeton and the Ecole des Beaux-Arts, Marion Sims Wyeth worked in the offices

York & Sawyer: Rear (Garden) Facade, D.W. Smith Residence, Oyster Bay, 1910 (PREV, 1948)

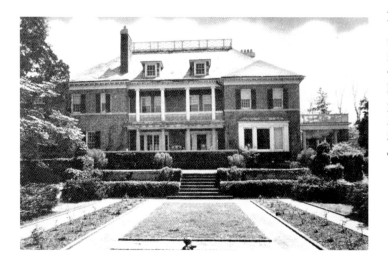

■

York & Sawyer, practiced 1898–1930s

Edward Palmer York, 1865–1927

Philip Sawyer, 1868–1949

Edward Palmer York, born at Wellsville, New York, and Philip Sawyer, a native of New London, Connecticut, forming the partnership of York & Sawyer in 1898, were noted for their bank designs, including the Byzantine-style Bowery Savings Bank (1923) and the robustly rusticated Federal Reserve Bank (1925), both in New York City. Sawyer, descended from a Colonial New England family, trained at Columbia University and the Ecole des Beaux-Arts. Both he and York worked for McKim, Mead & White, where Sawyer assisted Stanford White with residential commissions. York & Sawyer made their reputation with public and institutional buildings such as the New York Historical Society (1903), the United States Assay Office, New York (1920), and the New York Athletic Club (1929). Not surprisingly, their Oyster Bay house for D. W. Smith (1910) is strongly reminiscent of the Colonial Revival work of McKim, Mead & White. Intricately leaded sidelights at the entrance and the fretted parapet surmounting the hipped roof recall McKim, Mead & White's Breese house at Southampton, as does the restrained simplicity of the interior.

Michael Adams

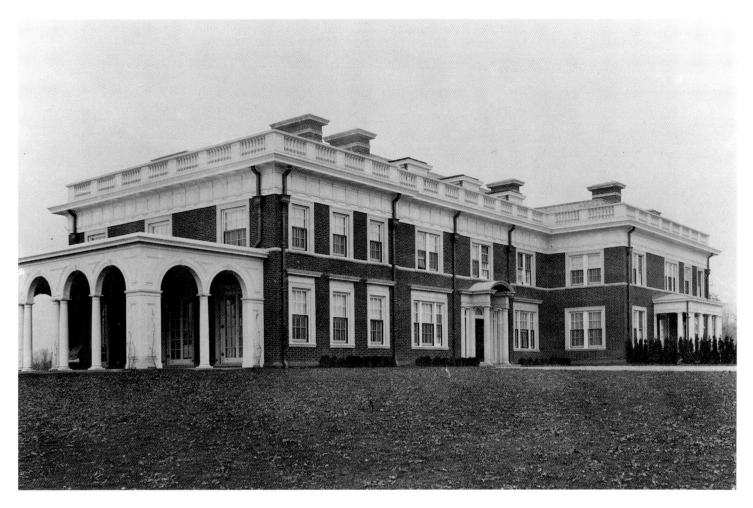

Harry St. Clair Zogbaum:
"Broad Hollow," F. Ambrose
Clark Residence, Westbury,
c. 1912 (HEWI, n.d.)

■

Harry St. Clair Zogbaum, 1885–1954

Educated at Columbia University, Harry St. Clair Zogbaum, whose best-known commission was the Baseball Hall of Fame at Cooperstown, worked in the office of McKim, Mead & White from 1906 to 1909, before going into private practice. His c. 1912 design for F. Ambrose Clark's "Broad Hollow" at Westbury was Georgian Revival in style, with a strong Palladian cast. The geometric quality of the cubist design, which was laid up in brick, was accentuated by stone loggias and a massive, two-story portico. The use of stone for the string course, entablature, and roof balustrade emphasized the horizontality of the design. Both Clark, a thread manufacturer, and his wife, Florence L. Stokes Clark, bred and trained racehorses. The Dutch Colonial-style stable complex, still extant, was symmetrically organized around a courtyard. The estate was purchased in 1968 by the State University of New York. Shortly afterwards the main house was destroyed by fire.

Wendy Joy Darby

Notes

Introduction, page 19

1. Edward Windsor, *A King's Story, The Memoirs of The Duke of Windsor* (New York: G. P. Putnam's Sons, 1947), p. 203.

2. *New York Herald,* July 6, 1902.

3. *Brooklyn Daily Eagle,* Oct. 12, 1902.

4. "The North Shore," *Life* (July 22, 1946), pp. 73–83, and Morris Markey, "Luxury Land," *Holiday* (Oct., 1948), pp. 107–26.

5. David McCullogh, *Mornings on Horseback* (New York: Simon and Schuster, 1981), p. 142.

6. See Mildred H. Smith, "The Tile Club," *Long Island Courant* (March, 1967) 1, pp. 7–17, and Robert W. Gibson, "Annals of North Point," diary excerpt in the archives of the Society for the Preservation of Long Island Antiquities (SPLIA), Setauket, NY.

7. See Robert B. MacKay, "Of Grand Hotels and Great Estates," in Robert B. MacKay et al., *Between Ocean and Empire: An Illustrated History of Long Island* (Northridge, CA: Windsor Publications, Inc., 1985), pp. 112–31.

8. Caleb Swan to Edward Swan, July 5, 1855, SPLIA.

9. A. R. Pardington, "The Modern Appian Way for the Motorist," *Harper's Weekly* (March 16, 1907), p. 390.

10. *New York Herald,* Nov. 16, 1902.

11. "Residence of Mr. and Mrs. Wilton Lloyd-Smith, Lloyd's Neck, Long Island, Construction Accounts, Barrow, Wade, Godroe & Company, Accountants and Auditors," in files of SPLIA.

12. Mosette Glaser Broderick, "A Place Where Nobody Goes: The Early Work of McKim, Mead & White and the Development of the South Shore of Long Island," in Helen Searling, ed., *In Search of Modern Architecture: A Tribute to Henry Russell Hitchcock* (Boston: MIT Press, 1982), pp. 185–205.

13. William H. P. Robertson, *The History of Thoroughbred Racing.* "Toward the middle of Long Island lieth a plain sixteen miles long and four broad, upon which grows very fine grass that makes exceeding good hay; where you shall find neither stick nor stone to hinder the horseheels or endanger them in their races, and once a year the best horses in the Island are brought hither to try their swiftness, and the swiftest rewarded with a silver cup, two being annually provided for the purpose." Daniel Denton, "A Brief Description of New-York: Formerly Called New Netherlands" in Cornell Jaray, ed., *Historical Chronicles of New Amsterdam, Colonial New York and Early Long Island,* 1965 reprint (Port Washington, NY: Ira J. Friedman, 1968), p. 16.

14. Stephanie S. Bigelow, *Bellport and Brookhaven* (Bellport-Brookhaven Historical Society, 1968), p. 27.

15. J. P. Giraud, *Birds of Long Island* (New York: Wiley & Putnam, 1844) pp. iii–iv.

16. There were earlier rod and reel clubs such as Riverhead's Hunters' Garden which dates from at least the 1830s (and is still extant), but these organizations had resident memberships.

17. David Black, *Thinking of Fifth Avenue: The Fortunes of August Belmont* (New York: The Dial Press, 1981), p. 284 as quoted from Bowmar, *Grants of The Turk* (Lexington, KY. The Bloodhorse, 1960), p. 53.

18. W. P. Stephens, *The Seawanhaka Corinthian Yacht Club: Origins and Early History, 1871–1896* (New York: privately printed, 1963), p. 15.

19. *Brooklyn Daily Eagle,* clipping c. 1899, SPLIA.

20. Robert F. Kelley, "Meadow Brook, The Heart of American Polo," *Country Life in America* (June 1927), p. 11.

21. Paul D. Cravath, "Preserving the Country Lanes," *Country Life in America* (Jan. 1913), p. 27.

22. Benjamin R. Allison, *The Rockaway Hunting Club* (Brattleboro, VT: privately printed by the club, 1952), p. 31.

23. *Brooklyn Daily Eagle,* clipping c. 1899, SPLIA.

24. Cromwell Child, "Beautiful Country Homes," *Brooklyn Daily Eagle,* Nov. 2, 1902.

25. *Harper's New Monthly Magazine,* clipping c. 1881, SPLIA.

26. *Prominent Residents of Long Island and Their Pleasure Clubs* (New York: Thompson & Watson, 1916), p. 7.

27. Charles A. Dana, of the *New York Sun,* was one of Glen Cove's earliest summer residents, while his contemporary William Cullen Bryant, of the *New York Evening Post,* resided in Roslyn. Col. William V. Hester, of the *Brooklyn Daily Eagle,* and Herbert Bayard Swope, of the *New York World,* were later arrivals summering at Glen Cove and Sands Point, respectively. Also at Sands Point was Condé Nast, publisher of *Vogue, House and Garden, Glamour,* and other magazines. Nelson Doubleday's Country Life Press at Garden City, which published *Country Life in America,* was not far from his Mill Neck estate. Ormond G. Smith, of the huge "dime novel" house of Smith and Street, resided at Centre Island, while Ralph Pulitzer and William Randolph Hearst also summered on Long Island, not to mention members of the Guggenheim, Lamont, Whitney, and Schiff families, all of whom owned major papers at one time or another. Writers and entertainers were also important boosters. F. Scott Fitzgerald wrote much of *The Great Gatsby* in a room over the garage of the Spanish Colonial house he and Zelda rented in Great Neck in 1922. Ring Lardner had a house nearby, as did Francis Burnett and such Broadway luminaries as Basil Rathbone, Eddie Cantor, W. C. Fields, and George M. Cohan. Frequent visitors to Long Island included Will Rogers, who hit his head on a rock while diving into the Great South Bay, Annie Oakley, P. G. Wodehouse, and Sinclair Lewis.

28. *Prominent Residents* (note 26), p. 2.

29. "Piping Rock Club," *Country Life in America* (Feb. 1920), p. 50.

30. "Noted Men in New Club," *The Long Islander* (Feb. 21, 1919).

31. Mrs. Bradford G. Weekes, Oyster Bay, to Louis De B. Moore, Oyster Bay, May 31, 1925, SPLIA.

32. W. Emelen Roosevelt to Mrs. Percy S. Weeks, May 29, 1925, SPLIA.

33. A new wave of club formation on Long Island would occur after World War I, following a dramatic growth in population.

34. *Brooklyn Daily Eagle,* Oct. 5, 1902, p. 1.

35. Thomas Hastings, "A Decade in Domestic Architecture," *Country Life in America* (Apr. 15, 1912), p. 27.

36. Walter Manning, Cambridge, to Wilton Lloyd-Smith, New York City, July 25, 1924, SPLIA.

37. "The Best House of the Year," *Country Life in America* (Oct. 1914), p. 35.

38. *New York World Telegram,* Oct. 20, 1942, p. 17.

39. Joseph Purtell, *The Tiffany Touch* (New York: Random House, 1972), p. 153.

40. Alfred P. Hopkins to Wilton Lloyd-Smith, Dec. 1, 1924, SPLIA.

41. *New York Tribune, Illustrated Supplement* (Sunday, Sept. 21, 1902), p. 8.

42. Ibid.

43. *A King's Story* (note 1), p. 200.

44. *The Rockaway Hunting Club,* p. 93.

45. Isaac Hicks to Mary E. Thompson, Ogontz, PA, March 7, 1900. Hicks Nursery archives, Jericho, NY.

46. *New York Herald,* Jan. 25, 1903.

47. Malcolm MacKay and Charles G. Meyer, Jr., *A History of Centre Island* (The Centre Island Association, 1976), p. 15.

48. *The Long Islander,* August 17, 1906, p. 2.

49. Ibid.

50. *New York Herald,* Jan. 25, 1903.

51. *The Long Islander,* Oct. 7, 1904.

52. Monica Randall, *The Mansions of Long Island's Gold Coast* (New York: Hastings House, 1979).

53. *The Long Islander,* Feb. 9, 1923.

54. James McCullagh, Inc., New York, to Cauldwell Wingate Company, New York, April 29, 1925, SPLIA.

55. Lewis Valentine Company, New York, to Mrs. Wilton Lloyd-Smith, Oyster Bay, Sept. 16, 1924, SPLIA.

56. Edward J. Smits, *Nassau Suburbia, U.S.A.: The First Seventy-five Years of Nassau County, New York (1899 to 1974)* (Garden City: New York Friends of the Nassau County Museum, 1974).

57. Richard Guy Wilson, "Picturesque Ambiguities: The Country House Tradition in America," in *The Long Island Country House 1870–1930* (Southampton, NY: The Parrish Art Museum, 1988), pp. 13–14.

58. F. Scott Fitzgerald, *The Great Gatsby* (New York: Charles Scribner's Sons, 1925), p. 5.

59. Clive Aslet, *The Last Country Houses* (New Haven: Yale University Press, 1982), p. 3.

Adams & Prentice, page 36
SELECTED SOURCES

Sources for Lewis Greenley Adams: Yale alumni records; *American Architects Dictionary*, 1956 and 1962 editions; student record, Ecole des Beaux-Arts (in vol. XCVII, 1921–30, at the Ecole); obituary in the *New York Times*, Dec. 1, 1977, section 2, p. 27.

Sources for Thurlow Merrill Prentice: Yale alumni records; Columbia alumni records; student record, Ecole des Beaux-Arts (in vol. CXVIII, 1921–30, at the Ecole), American Institute of Architects application (RG 803, Box 20, Folder P in the Institute's archives); *Journal of the Society of Architectural Historians*, vol. XLIV, Dec. 1985, pp. 384–87.

Adams & Warren, page 36
SELECTED SOURCES

Francis, Dennis Steadman, *Architects in Practice, New York City 1840–1900* (New York: Committee for the Preservation of Architectural Records, Inc., 1979), p. 11.

Warren, Charles P., Obituary, *New York Times*, Oct. 18, 1918, p. 53.

Warren, Charles P., "Examples of the Country House Work of William Adams," *Architectural Record* 44 (Oct. 1918), pp. 505–25.

Withey, Henry F., and Elsie Rathburn Withey, *Biographical Dictionary of American Architects (Deceased)* (Los Angeles: Hennessey and Ingalls, Inc., 1970).

Albro & Lindeberg, page 39

1. Lewis Colt Albro and Harrie T. Lindeberg, *Domestic Architecture* (New York: privately published, 1912), n.p.

2. John E. Burchard and Albert Bush-Brown, *The Architecture of America, A Social and Cultural History* (Boston: Atlantic-Little, Brown), 1961.

3. Harrie T. Lindeberg, "A Return of Reason In Architecture," *Architectural Record* 74 (Oct. 1933), pp. 252–313.

4. Biographical information on Albro and Lindeberg from Henry F. Withey and Elsie Rathburn Withey, *Biographical Dictionary of American Architects (Deceased)* (Los Angeles: Hennessey and Ingalls, Inc., 1970), pp. 12–13; *National Cyclopedia of American Biography*.

5. Albro and Lindeberg (note 1).

6. Ibid.

7. Ibid.

8. "Thatched Roof Effects with Shingles," *The Brickbuilder* 18 (July 1909), pp. 133–40.

9. "The Work of Albro & Lindeberg," *Architecture* 26 (Nov. 15, 1912), pp. 206–40.

10. C. Matlack Price, "The Recent Work of Albro & Lindeberg," *Architecture* 31 (Jan. 1915), pp. 1–10.

11. Ibid.

12. See: Building-Structure Inventory Form, Lattingtown (#La47, Ball-Scherin House), Division for Historic Preservation, Albany, NY; Olmsted Brothers, Collection of Plans and Drawings (C. O. Iselin), National Park Service, Brookline, MA.

13. C. Matlack Price, *Country Life in America* 71 (Nov. 1936), pp. 48–51.

14. Russell J. Whitehead, "Harrie T. Lindeberg's Contribution to American Domestic Architecture," *Architectural Record* 55 (Apr. 1924), pp. 309–65.

15. Harrie T. Lindeberg, "A Return of Reason In Architecture," *Architectural Record* 74 (Oct. 1933), pp. 252–313.

16. C. Matlack Price, "A Cellular Steel-Unit House," *Architectural Record* 74 (Oct. 1933), pp. 249–51.

Babb, Cook & Willard, page 58

1. That Babb was primarily an interiors specialist by the mid-1870s was first suggested by Sarah Bradford Landau and ardently resisted for two years until reason won out.

2. Letter, American Academy and Institute of Arts and Letters, New York. Babb was elected a member of the Academy, and this letter is in reply to a dues request made after Babb's death

3. Ibid. Surely one of the letters from former students comes from W. R. Mead. In fact, Babb probably brought the young Charles McKim to the Sturgis office, as Babb and James Miller McKim, father of the architect, were well acquainted and had designed houses together in the Orange County area of New Jersey.

4. White wrote to Augustus St. Gaudens on September 14, 1879, concerning the base White was laboring on for St. Gaudens's statue of Farragut, which was in the final stage. White was going to show his work for review to John LaFarge and to Babb, "on whose judgement I most rely." Charles C. Baldwin, *Stanford White* (New York: Dodd, Mead, and Co., 1931, reprint 1976), p. 129.

5. Sarah Bradford Landau, "The Tall Office Building Artistically Reconsidered: Arcaded Buildings of the New York School, c. 1870–1890," in Helen Searling, ed., *In Search of Modern Architecture: A Tribute to Henry-Russell Hitchcock* (Cambridge, MA, and London: MIT Press, 1982), pp. 148–54.

6. A photograph of a picnic in Sneden's Landing in 1893 shows St. Gaudens, McKim, Babb, and Platt had dived under a blanket to avoid being photographed. (In fact, no picture of Babb exists.) In 1894–97, Babb, White, and St. Gaudens collaborated on a granite memorial tablet for Frederick L. Ames in the village cemetery at North Easton, Massachusetts. But, by 1905, Babb, still close to St. Gaudens, was avoided socially. He neglected himself so that, according to a letter from White to St. Gaudens, any room he entered had to be fumigated after he left. Baldwin (note 4), p. 291.

7. It is unclear how Carnegie came to choose Babb, Cook & Willard. Perhaps the firm's fine manufacturing and office blocks for New York Life appealed to the sensible mind of the Scotsman. The enormous home the firm built on a cleared hill at 91st Street was notable for its practicality and now serves as the Cooper-Hewitt Museum. The interiors, rather old-fashioned for the early 1900s, are probably the work of Babb.

8. The Dutch elements may have another family reference as Pierce's mother, Jane Hendricks, may have had Dutch ancestry. Certainly, the style bears no relationship to the decorous scrolled gable revival used on Manhattan's west side in the 1880s and 1890s. The influence of the late Renaissance in Holland and the transferral of the gable motif from Holland to England coincides in date to the time when Pierce's ancestors left Britain for Massachusetts in 1633. Perhaps Pierce wanted to reinforce his family's early arrival on these shores by associating his new house with the early 17th century.

Barney & Chapman, page 62

1. Barney's obituary appeared in the *New York Times* on Nov. 23, 1925; his age was given as 57. He was a member of the Union, New York Yacht, and Tuxedo clubs.

2. Obituary, *New York Times*, July 28, 1929.

3. Details of the Porter house are published in *The Brickbuilder* (Jan. 1902).

4. Although Barney is recorded in his obituary (note 1) as having left his architectural practice in 1915, the Emanuel house cannot be dated earlier than c. 1920.

Beers & Farley, page 68

1. See, for example, A. Downing and V. Scully, *The Architectural Heritage of Newport, Rhode Island 1640–1915* (Cambridge, 1982), pls. 191 and 214; compare also with McKim's contemporary Rudley Newton, ibid,, pl. 215.

2. See correspondence in SPLIA files.

3. *Noted Long Island Homes* (Babylon, NY: E. W. Howell Co., 1933).

Alfred C. Bossom, page 73

1. *Architecture* 38 no. 3 (Sept. 1918), p. 255.

2. *Architectural Record* 43 no. 1 (Jan. 1918), p. 3.

William Bottomley, page 75

1. The foregoing information is taken from *Who Was Who in America, 1951–1960*, Vol 3; *Dictionary of National Biography*, Supplement, January 1910–December 1911; the *National Cyclopedia of American Biography*; and family records kindly furnished by Susan Bottomley Chambers, as well as the files of the American Academy in Rome.

2. The remodeling of c. 1915 at Mill Neck for James Mulford Townsend, Sr., Bottomley's father-in-law, seems to have been the earliest remodeling done by Bottomley, or more properly, Hewitt and Bottomley, on Long Island. It was used in the central illustrations for "Reclaiming the Old House," *American Architect and Building News* (May 24, 1916). The house was later sold to the Winmills and enlarged, once more by Bottomley. Also at Mill Neck, Bottomley remodeled another house for his brother-in-law, James Mulford Townsend, Jr., c. 1920. The work here was attributed to Bottomley alone in an article, "The Residence of J. M. Townsend, Jr., Esq., Mill Neck, L.I.," in *House and Garden's Book of Houses* (New York: Condé-Nast Publishing Co., 1920). This house, sold later to Faris Russell, was also enlarged by Bottomley and again published by Augusta Owen Patterson, "The Residence of Mr. Faris Russell," *Town and Country* 85 (June 1, 1930), pp. 46–51. In addition to these two double commissions, Bottomley also remodeled the Phantom House at Old Brookville in the 1920s, his own house there about the same time, a house for Mrs. Cameron Tiffany at Upper Brookville, also in the 1920s, and made alterations for the Burchard/Carlisle House in Lattingtown in the 1930s.

3. William L. Bottomley to Arthur A. Shurcliff, June 5, 1940.

4. John Taylor Boyd, Jr., "The Country House and the Developed Landscape," *Arts and Decoration* 32 (Nov. 1929), pp. 98, 100.

5. Ibid.

6. Richardson Wright, "Which Way Gardening?" *House and Garden* (Jan. 1947), pp. 26–27, 94.

7. Wheeler Williams, "To An Architect," *New York Herald-Tribune*, Feb. 9, 1951.

8. *National Cyclopedia of American Biography* (note 1).

9. "Recalling the Georges," *Country Life in America* 65 (Mar. 1934), pp. 46–48.

10. Liisa and Donald Sclare, *Beaux-Arts Estates: A Guide to the Architecture of Long Island* (New York: Viking Press, 1980), pp. 135–37.

11. Augusta Owen Patterson. "A Muted Exterior Based on Subtle Detail," *Town and Country* 85 (Sept. 15, 1930), pp. 45–46.

12. "North Country Colony at Glen Cove," *Country Life in America* 71 (Feb. 1937), pp. 65–66.

13. Obituary, *New York Times*, Oct. 29, 1940.

14. "Overlooking Hempstead Harbor, at Roslyn," *The Spur* 51 (Mar. 1933), pp. 36–37.

15. "Pelican Farm," *Country Life in America* 78 (June 1940), pp. 15–18.

Brite & Bacon, page 82

1. Henry F. and Elsie Rathburn Withey, *Biographical Dictionary of American Architects (Deceased)* (Los Angeles: New Age Publishing Co., 1956), p. 77. C. H. Whitaker, "Bacon, Henry," *Dictionary of American Biography* (1928), p. 477; and Withey, pp. 28–29.

Although the entries cited above state that Brite and Bacon formed their partnership in 1897, according to the *Real Estate Record and Builders' Guide*, their partnership was formed in 1896, when they successfully won a competition for a $6,000 prize for the design of a museum in Philadelphia's Fairmount Park, which was never constructed. The issue is further confused by the fact that Charles Moore stated that Henry Bacon did not leave the employ of the McKim, Mead & White firm until May 28, 1897, substantially after he and James Brite had won the competition in Philadelphia. See "Personal," *Real Estate Record and Builders' Guide* 57, 1452 (1896), p. 41, and Charles Moore, *The Life and Times of Charles Follen McKim* (Boston: Houghton Mifflin Co., 1929), pp. 328–29.

According to Moore, Brite joined the firm in June 1886 and left on March 12, 1892, whereas Bacon started in May 1888. Bacon won a Rotch Traveling Scholarship in 1889, which enabled him to travel abroad extensively for two years; thus his tenure at the McKim, Mead & White firm was interrupted at that time. See Bacon obituary, *New York Times*, Feb. 17, 1924.

2. The Architectural League of New York, *Catalogue of The Fourth Annual Exhibition of The Architectural League of New York* (1888), p. 50.

3. Letter from John E. Wells, June 21, 1986. Brite last appeared in a New York City directory in 1920. See R. L. Polk & Co., *Trow General Directory of New York City and the Boroughs of Manhattan and the Bronx* (1920), p. 377.

4. "Harding Lauds Work of Lincoln Architect," *New York Times*, May 19, 1923.

5. "Lafayette Memorial, Prospect Park, Brooklyn, NY," *The American Architect* 61, 2163 (1917), pp. 348–49.

6. Henry Bacon's association with Charles Follen McKim during his apprenticeship with the McKim, Mead & White firm may have contributed to this tendency. See Whitaker (note 1).

7. Edmund W. Miller, *Fifty Years of Service, 1891–1941* (Jersey City, NJ: Free Public Library, 1941), p. 10.

8. Workers of the Writers' Program of the Works Projects Administration in the State of South Carolina, *South Carolina, A Guide to the Palmetto State* (New York: Oxford University Press, 1941), p. 235. This may well have been the work of Brite, as he designed four other structures for the same client, Edwin Wales Robertson, in Columbia, South Carolina. Letter from Wells (note 3).

9. *Country Life in America* 5 (Dec. 1903), p. 196.

10. Like four of his five older siblings (a sister moved to Brookline, Massachusetts), Herbert L. Pratt built his city house in Brooklyn near Pratt Institute; his two younger siblings chose to build in Manhattan, seemingly a reflection of Brooklyn's waning social cachet at the time. See National Register of Historic Places—Nomination Form, "Dosoris" and "Dosoris Park," Erin Drake, 1980, SPLIA archives.

11. See "Residence for H. L. Pratt, Brooklyn, NY," *Architectural Review* 16, 5 (1909), pp. 66–67, pls. 37–54; "Country House, H. L. Pratt, Glen Cove, Long Island," *Architecture* 29, 11 (1914), pp. 257–59, pls. 130–33.

12. "Study and Executed Plan for House for H. L. Pratt, Esq., Glen Cove, Long Island, NY, " *American Architect and Building News* 70 (1900), p. 31, pl. 1296.

13. "Residence, Mrs. Sara E. K. Hudson, 1 E. 76th Street, New York," *Architecture* 6, 31 (1902), pp. 214, 218–23. "Scranton Memorial Library, Madison, Conn.," *American Architect and Building News* 69, 1283 (1900), p. 31; and L. R. McCabe, "Darlington, A Jacobean Manor in New Jersey," *Architectural Record* 32, 10 (1912), pp. 496–509.

14. After Pratt's death, the mantle was removed to Amherst College; it is now installed in the Mead Art Gallery. C. J. Charles or "Charles of London," pseudonym for Charles Joel Duveen, brother of Joseph Duveen, the famous turn-of-the-century art dealer, was an importer of period English interior decor, and may have been instrumental in this acquisition, as he included three renderings of interiors from "The Braes" in his *Elizabethan Interiors*. See letter from Frank Trapp, June 5, 1978, and C. J. Duveen, *Elizabethan Interiors*, 2nd edition (New York: Greenfield, 1917), n.p.

15. "Country House, H. L. Pratt," *Architecture* (see note 11); "Home of Mr. H. L. Pratt, Glen Cove, L. I." in *American Country Houses of Today* (New York: The Architectural Book Publishing Co., 1915), p. 219.

16. "Study and Executed Plan for House for H. L. Pratt," *American Architect and Building News* (see note 12).

17. Long pergolas flanking the main block and a handsomely planted, terraced landscaping scheme, complete with a reflecting pool, were design elements employed at Brite's "Darlington," as well. The landscape architect used there is unknown, however. See McCabe (note 13).

18. Webb Institute of Naval Architecture, *Catalog, Webb Institute of Naval Architecture: Academic Years 1977–78 and 1978–79*.

Katherine Budd, page 86

SELECTED SOURCES

Collier's, The National Weekly 77 (Jan. 2, 1926), p. 16.

Francis, Dennis Steadman, *Architecture in Practice, New York City 1840–1900* (New York: Committee for the Preservation of Architectural Records, Inc., 1979).

The Journal of the American Institute of Architects, XII (1924), p. 453.

Petteys, Chris, *Dictionary of Women Artists* (Boston: G. K. Hall & Co., 1985).

The Students of William Merritt Chase (Huntington, NY: Heckscher Museum, 1973).

Woman's Home Companion 46 (1919), p. 44.

Roger H. Bullard, p. 87

1. I want to thank Mr. Henry Bullard for providing me with information and anecdotes about the life of his father, Roger Harrington Bullard.

2. *The American Architect* 135 (May 1929), p. 593.

3. I want to thank Edward Scott, currently archivist at St. Anthony's Fraternity, for his help in determining the membership of the fraternity between 1903 and 1907. Henry Bullard relates that three of his father's associates at St. Anthony's later became his clients. He designed the home of Seth Low Pierrepont at Ridgefield, Connecticut, that of Perry Bogue at Greenwich, Connecticut, and a house in Flushing for Arthur L. Willes.

4. W. Knight Sturges, "The Long Shadow of Norman Shaw," *Journal of the Society of Architectural Historians* 9 (Dec. 1950), pp. 16, 29 n. 2.

5. Philip Goodwin received his A.B. from Yale University in 1908. He then studied architecture at Columbia.

6. Philip L. Goodwin, *Rooftrees* (Philadelphia: J.B. Lippincott Co., 1932), p. 58.

7. Henry Bullard relates that Philip Goodwin's father and John Pierpont Morgan, Jr., were first cousins. He also dates the commissions to the pre–World War I period.

8. In 1924, Bullard added wings to a house then owned by Henry Sturgis Morgan, "Maple Knoll" in Lattingtown, Oyster Bay. The design for the original house, which is Colonial in style, had been commissioned by Isaac Cozzens from Rouse and Goldstone, c. 1917.

9. Nonetheless, Bullard and Goodwin continued to collaborate on projects.

10. Roger H. Bullard, "Three Different Types of Clubs," *The American Architect* 130 (July 20, 1926), p. 54.

11. Ibid., p. 47.

12. Clay Lancaster, Robert A. M. Stern, and Robert J. Hefner, *East Hampton's Heritage* (New York: W. W. Norton & Company, 1982), pp. 106–7.

13. Bullard, "Three Different Types of Clubs," *The American Architect* 130 (July 20, 1926), p. 47.

14. Lancaster, et al., p. 111.

15. "The House of Ellery S. James, East Hampton, Long Island, N.Y.," *The American Architect* 35 (June 5, 1929), pp. 711–20.

16. Henry Bullard provided much information concerning the professions and relationships among his father's clients, and descriptions of this house.

17. See the pamphlet *America's Little House* (New York: McGraw-Hill, 1934) from Better Homes in America, Inc.

18. Henry Bullard's response to question about Bullard's philosophy of architecture.

Carrère & Hastings, page 98

1. "John Merven Carrère," *The New York Architect* 5 (May 1911), p. 65.

2. Flagler apparently continued his interest in the careers of Carrère and Hastings, for he is credited with compiling the list of the firm's commissions that appeared at the end of "The Work of Messrs. Carrère & Hastings," *Architectural Record* 27 (Jan. 1910), pp. 1–120.

3. "A Letter from Thomas Hastings, F.A.I.A., Reminiscent of the Early Work of Messrs. Carrère & Hastings, Architects," *The American Architect* 96 (July 7, 1909), p. 3.

4. "John Merven Carrère," *The New York Architect* (note. 1), p. 66.

5. "The Late John M. Carrère," *Being the Journal of the Royal Institute of British Architects*, 18, 3d ser. (Mar. 18, 1911), p. 353.

6. "John M. Carrère, Architect," *The American Society Legion of Honor Magazine* 16 (Spring 1946), p. 325.

7. "Thomas Hastings, 1860–1929," *Architectural Record* 66 (Dec. 1929), p. 596.

8. "John Merven Carrère," *The New York Architect* (note 1), p. 65.

9. "A Visit with Bernard Maybeck," *Journal of the Society of Architectural Historians* 11 (Aug. 1952), pp. 30–31.

10. "John Merven Carrère," *The American Architect* 99 (Apr. 5, 1911), p. 131.

11. John M. Carrère, "Making a Choice of a Profession, IX.—Architecture," *Cosmopolitan* 35 (Sept. 1903), p. 498.

12. "John Merven Carrère," *The New York Architect* (note 1), p. 67.

13. Charles Wharton Stork, "Thomas Hastings, Architect and Prophet," *The Landmark* 4 (Aug. 1922), p. 587.

14. Thomas Hastings, "Simplicity of Form Is Beauty's Blood-Brother," *Arts and Decoration* 19 (Aug. 1923), p. 12.

15. Thomas Hastings, "The Relations of Life to Style in Architecture," *Harper's New Monthly Magazine* 88 (May 1894), p. 961.

16. Thomas Hastings, "Architecture and Modern Life, " *Harper's New Monthly Magazine* 94 (Feb. 1897), p. 403.

17. Ibid., p. 402.

18. Thomas Hastings, "A Decade in Domestic Architecture," *Country Life in America* 21 (Apr. 15, 1912), pt. 2, pp. 27–28.

19. Clipping, undated, from *Architecture*, in scrapbook of the work of Carrère & Hastings at the New York Public Library.

20. *Brooklyn Daily Eagle*, July 17, 1899.

21. Kate Greenleaf Locke, "Mr. Bradley Martin, Jr.'s House at Westbury," *Town and Country* 67 (Sept. 21, 1912), p. 37.

22. Barr Ferree, "Notable American Houses, The House of Herman B. Duryea, Esq., Old Westbury, N.Y.," *Scientific American Building Monthly* (Nov. 1904), p. 93.

23. Locke, pp. 36–37.

24. Bart Ferree, *American Estates and Gardens* (New York: Munn and Co., 1904), p. 53.

25. Ralph Adams Cram, Thomas Hastings, and Claude Bragdon, *Six Lectures on Architecture, The Scammon Lectures for 1915* (Chicago: published for the Art Institute of Chicago by the University of Chicago Press, 1917), p. 81.

26. John M. Carrère, "Better Taste in Small Houses," *Country Life in America* 20 (May 15, 1911), p. 19.

27. Barr Ferree, "Notable American Homes, 'Deepdale,' the Estate of W. K. Vanderbilt, Jr., Great Neck, Long Island," *American Homes and Gardens* 2 (Apr. 1906), pp. 229–30. The *New York Herald* reported on January 25, 1903, that Horace Trumbauer, a Philadelphia architect, was drawing plans for a "club house" on the site.

28. "The William K. Vanderbilt, Jr. Place at Deepdale, Long Island," *The Spur* 13 (Jan. 15, 1914), p. 27.

29. David Gray, *Thomas Hastings, Architect* (Boston: Houghton Mifflin Co., 1933), p. 72.

30. Ibid., p. 73.

31. Ibid., p. 71.

32. "Mr. Thomas Hastings' Home at Roslyn, L. I.," *American Country Homes of Today* 1 (1912), pp. 203–4.

33. "The Country Home of Mr. James A. Blair," *Town and Country* 65 (Nov. 5, 1910), p. 34.

34. Liisa and Donald Sclare, *Beaux-Arts Estates, A Guide to the Architecture of Long Island* (New York: The Viking Press, 1980), p. 103.

35. Cram et al., *Six Lectures*, p. 80.

36. "Homewood in Locust Valley," *The Spur* 40 (Oct. 15, 1927), p. 69.

SELECTED SOURCES

"A Beautifier of Cities," *Harper's Weekly* (Mar. 11, 1911). Another obituary of Carrère.

Blake, Channing, "The Early Interiors of Carrère and Hastings," *Antiques* 110 (Aug. 1976), pp. 344–51.

Howe, Samuel, "Mr. Hastings' House at Roslyn Reveals a Sincere Reverence for Italy's Renaissance," *Town and Country* 69 (Aug. 22, 1914), pp. 18–19.

Isbouts, Jean-Pierre, "Carrère and Hastings, Architects to an Era," Doctorial thesis, Kunsthistorisch Institute, Rijksuniversiteit Leiden. 1980.

Clinton & Russell, Wells, Holton & George, page 110

1. *The American Architect* 98 (Dec. 7, 1910), p. 3; Russell Sturgis, (catalogue of Clinton & Russell), *Architectural Record* 7 (Dec. 31, 1897), pp. 1–61.

2. *Architects and Builders Magazine* 39 (Sept. 1907), p. 614; *American Architect and Builders News* 92 (Aug. 3, 1907), pp. 33–34; Russell Sturgis (note 1).

3. Harry W. Desmond and Herbert Croly, *Stately Homes in America* (New York: D. Appleton & Co., 1903).

4. Russell Sturgis (note 1). Additional research has not revealed the names of the original owners or exact locations of these commissions.

5. Henry F. and Elsie Rathburn Withey, *Biographical Dictionary of American Architects (Deceased)* (Los Angeles: Hennessey and Ingalls, Inc., 1970).

6. Nassau County Liber 590 of Deeds, p. 204.

7. Stamped working drawings dated August 1923 survive bearing the firm name of Clinton & Russell, Wells, Holton & George. In addition, Mrs. Dodge's daughter, Mary S. Thomas, recalls her mother speaking of Colonel Wells.

8. Russell Sturgis (note 1).

Ogden Codman, Jr., page 112

1. References to other Long Island commissions by Ogden Codman are: Mrs. M. M. Ludlow, Oakdale, 1911; A. Cass Canfield, "Cassleigh," Roslyn, prior to 1906; W. Bourke Cockran, "The Cedars," Port Washington, extent and date of work unspecified.

2. Letters to Sarah Bradlee Codman from Ogden Codman, Jr., Codman Family Manuscripts Collection, property of Society for the Preservation of New England Antiquities.

3. Barr Ferree, *American Estates and Gardens* (New York: Munn and Company, 1906).

Marian C. Coffin, page 116

1. Coffin described this choice in a letter of 1932:
. . . I secretly cherished the idea of being a great artist in the future, but that dream seemed in no way possible of realization, and though my desire to create beauty was strong, I did not seem to possess talent for music, writing, painting or sculpture, at that time the only outlet a woman had to express any artistic ability she might have. So my artistic yearnings lay fallow until I realized it was necessary to earn my living, when talking over the problem with some friends one of them, an architect, said he thought that some courses in 'Landscape Gardening' for women were to be started in this country and that it would be an interesting thing for a woman to go in for. At the same time, I had been hearing of Beatrix Jones Farrand's novel profession and the success she was making of it, so on further investigation I found by far the most worthwhile course being offered was at the M.I.T. and off I went gaily expecting to be welcomed with open arms.
Cited in Clarence Fowler, "Three Women in Landscape Architecture," Cambridge School of Architecture and Landscape Architecture, *Alumnae Bulletin* 4 (1932), p. 11.

2. M.I.T. class lists provided by Deborah A. Cozort, Assistant Archivist, M.I.T. Museum and Historical Collections, M.I.T., Cambridge, Massachusetts.

3. See "Women in Architecture and Landscape Architecture," a 1928 publication of the Institute for the Coordination of Women's Interests, Smith College, Northampton, Massachusetts.

4. By the early 1920s, Coffin had executed or was engaged in at least 30 major commissions.

5. She wrote on the very first page:
Too much emphasis has been laid by gardening books on the ephemeral value of color and color schemes, and too little on the enduring importance of sculptural form, which is given by trees and trees alone.
In any landscape scheme the designer should think as the architect does, not only of his plan but also of the elevation which expresses this plan and the interrelation of the two.
See Marian Coffin, *Trees and Shrubs for Landscape Effects* (New York: Charles Scribner's Sons, 1940), p. 1.

6. Ibid., p. 38.

7. Coffin (note 5), p. 39.

8. Coffin also worked with du Pont on the gardens at Winterthur, his elaborate estate museum in Delaware.

9. Nancy Cooke Dillard, "Pioneering Women in Landscape Architecture 1875–1930," unpublished, May 1980, p. 13.

10. Coffin (note 5), p. 38.

11. Inspired by such designs as the Dutch garden at Levens Hall in Westmoreland, the architects of the English Arts and Crafts movement had seized upon the enclosed topiary garden as a particularly honest expression of man's tampering with nature. In a series of essays in the *Studio* (1901), for example, E. S. Prior, a student of L. Norman Shaw, attacked the so called natural garden, writing:
Such should go by the name of the unnatural garden—for, since man is a part of Nature, his natural garden will be that which shows itself his, not by its wildness, but by the marks of order and design which are inseparable from his work.
Cited in Peter Davy, *Architecture of the Arts and Crafts Movement* (New York: Rizzoli, 1980), p. 74. Thus, the ideal Arts and Crafts design featured a deliberately organic, vernacular house in a rather formal landscape, clearly divided by walls and full of clipped topiary forms. With the dawn of the "Country Place Era" in the United States, the topiary garden came to be considered correct for houses in the Tudor or Elizabethan styles (i.e., those designs most similar to the work of the English Arts and Crafts architects).

12. Coffin (note 5), p. 30.

George Abraham Crawley, page 119

1. This parcel had originally been assembled by wealthy Chicagoan General Joseph T. Torrence, father of the system of belt-line railroads around Chicago. Following the death of Torrence's daughter, her husband, Kinsley McGowan, abandoned his partially built summer home (several hundred yards north of the present Westbury House and no longer extant) and sold the land to Jay Phipps.

2. The chief source of information on Crawley is *George Abraham Crawley: A Short Memoir by Cuthbert Headlam* (London: The Chiswick Press, 1929). Headlam was his brother-in-law. See also Clive Aslet, *The Last Country Houses* (New Haven: Yale University Press, 1982), pp. 161–64.

3. In 1906, Crawley exhibited two drawings in the 21st annual exhibition of the Architectural League of New York entitled "Country House for John S. Phipps, Esq., Style of Charles II." Within Westbury House, there are many deferential quotations from Restoration or Charles II buildings such as Hampton Court Palace, St. Paul's Cathedral, Wren's city churches, Ham House, and others. A small wooden model in the Old Westbury Gardens archives shows an earlier version in the English Restoration idiom of what would become "Westbury House."

4. In the summer of 1902, Atterbury was engaged in the execution of an "automobile house" adjoining apartments Henry Phipps owned at 6 East 87th Street, on the north side of the block where his townhouse was being built. On June 6, 1902, Atterbury's office issued blueprints for a townhouse for John S. Phipps, on East 87th Street as well. Crawley's young assistant, Alfred C. Bossom, would also develop into a prominent member of the New York architectural establishment, a specialist in the design of bank buildings and a champion of the vertical integration that skyscrapers could provide society. Following official rejection of his elaborate proposal for a bridge to span the Hudson River at midtown Manhattan, he returned to England in 1926.

5. Crawley was later to import stone carvers from England for "Westbury House," feeling that the "American carvers at that time showed a strong French feeling in their work..." Headlam (note 2), p. 24.

6. From a survey of the office stamps and imprimaturs on the plans, it can be determined that all of the technical specifications for the house were issued from Atterbury's office and all specifications for interior decorating from Crawley's.

7. In 1905, Henry Phipps announced his proposal to organize a society for the purpose of building housing for the working class to provide buildings with ample light and air, fireproofing, sanitary conditions, and space for children to play. The first model tenement, containing 142 units, was designed by Atterbury in New York. Atterbury was commissioned to design model tenements for Pittsburgh as well.

8. The third line of this ancient Cistercian saying, "BENEDICTO HABITANTIBUS" or "blessing on those who dwell herein," was not included in the design.

9. Jay Phipps can be described as a financier-sportsman. His great passion was for polo and later, for thoroughbred racing. In 1906, he placed an order with Crichton Bros., London, for a two-handed trophy cup in Britannia Standard. The "Westbury House Cup" and the slightly later "Westbury House Challenge Cup" reside today within "Westbury House."

10. It may have been through Trumbauer that Jay Phipps was introduced to the French landscape architect Jacques Auguste Henri Gréber, Trumbauer's collaborator on "Whitemarsh Hall" in Pennsylvania. There are a number of colored-pencil renderings for suggested replantings of the lawn and allée south of "Westbury House," suggestions that were not followed. It is generally conceded that, following their original layout by Crawley, the gardens soon became the personal demesne of Mrs. Phipps, and by the time of her death, had become totally identified with her.

11. White/Allom & Co. superintended the installation. In addition to silver locks and a silver chandelier designed by Crawley, the dining room contains silver sconces and an elaborate mantelpiece by Derwent Wood.

12. A contemporary appreciation of Crawley's career remains to be written. Headlam's *Memoir* is altogether too indulgent and Aslet's discussion of his later English projects ignores completely his American contributions.

13. Since 1977, Old Westbury Gardens has produced a quarterly newsletter in which articles of interest regarding the displays, programs, collections, and history of the property are published. In 1984, *Old Westbury Gardens: A History and a Guide* was published. This was followed, in 1985, by a 64-page, all-color picture book entitled *Old Westbury Gardens.* Peggie Phipps Boegner's reminiscences, *Halcyon Days,* written with historian Richard Gachot, appeared in 1986. Mrs. Boegner is the daughter of Jay and "Dita" Phipps.

Cross & Cross, page 122

1. This house is beautifully maintained today by New York University.

2. The younger of John's two sons, H. Page Cross, became his father's partner on his uncle's death. After his father died, he practiced independently. Working exclusively for Paul Mellon, Page Cross was a rare and accomplished revivalist during the height of the International Style era.

3. Augusta Owens Patterson, *American Homes of Today* (New York: Macmillan, 1924).

Delano & Aldrich, page 127

1. "Arts," *Time* (Nov. 12, 1928), p. 32.

2. "Arts," *Time* (June 2, 1930), p. 28. *Time* has done 13 cover stories devoted to architects.

3. A. Lawrence Kocher, "The Country House," *Architectural Record* 62 (Nov. 1927), p. 341.

4. "The Talk of the Town, Architect," *The New Yorker* (Apr. 5, 1959), pp. 23–24. No recent study of either Delano or Aldrich has been done except for Richard Guy Wilson's *The AIA Gold Medal* (New York: McGraw-Hill, 1983), which contains some discussion and a bibliography by Frederick D. Nichols. The firm is also briefly mentioned in the National Academy of Design, *Between Traditions and Modernism* (New York: The National Academy of Design, c. 1980); however, this contains some factual inaccuracies. In addition to the above citations, the biography of Delano is based on résumés located in the AIA Archives, Washington, D.C. (the assistance of Tony Wren is greatly acknowledged); *The National Cyclopedia of American Biography,* vol. f (New York: J. T. White, 1942), pp. 383–84; and materials deposited by Delano in the Avery Architectural Library at Columbia University (the assistance of Janet Parks is gratefully acknowledged). The Avery material contains some drawings by the firm for Long Island buildings.

5. "The Talk of the Town, Architect" (note 4), p. 23.

6. Personal communication to author from Richard Chafee, Providence, Rhode Island.

7. Some of Delano's student drawings at the Beaux-Arts are deposited in the Avery Library. Some of his student work is illustrated in: Richard Guy Wilson, Dianne Pilgrim, and Richard Murray, *The American Renaissance, 1876–1917* (Brooklyn and New York: Brooklyn Museum and Pantheon, 1979), p. 77; "Une Rampe" entry for the Concours Godeboeuf, 1901; and "Le Titre d'une livre d'architecture" entry for Concours sur Esquisse, 1902, in Ecole Nationale des Bêaux-Arts, *Les Médailles de Concours d'Architecture de l'Ecole Nationale des Bêaux-Arts à Paris* (Paris: A. Guerinet), vol. 4 (1901–1902), p. 75, and vol. 5 (1902–1903), p. 112.

8. "The Talk of the Town, Architect" (note 4), p. 24.

9. Information derived from American Institute of Architects Archives and *Cyclopedia of Biography* 33 (1974), pp. 237–38.

10. Cited in "The Talk of the Town, Architect" (note 4), p. 24.

11. The list is in the archives of the National Commission of Fine Arts, submitted in connection with competition for the Federal Reserve Building. It is interesting that the list specifically identifies by "L.I." all the New York State works located on Long Island.

12. "Arts" (note 2), p. 26.

13. "Arts" (note 1), p. 32. From 1903 to 1935, the average was about eight buildings per year.

14. "Arts" (note 2), p. 28.

15. William Adams Delano, "Memoirs of Centurian Architects," *Journal of the AIA* 10 (July 1948), p. 10.

16. Richard Guy Wilson, *McKim, Mead & White, Architects* (New York: Rizzoli, 1983).

17. "The Talk of the Town, Architect" (note 4), p. 24.

18. Ibid., pp. 23–24.

19. So listed on the letterhead (note 11).

20. From an examination of materials in the Avery Library.

21. Royal Cortissoz, "Introduction," *Portraits of Ten Country Houses, Designed by Delano and Aldrich, Drawn by Chester B. Price* (New York: William Helburn, Inc., 1924) pp. xiii–xv.

22. John Taylor Boyd, Jr., "The Classic Spirit in Our Country Homes," *Arts & Decoration* 31 (Oct. 1929), p. 62; for English models, see Roderick Gradidge, *Dream Houses, The Edwardian Ideal* (New York: George Braziller, 1980).

23. Richard Guy Wilson, "Scientific Eclecticism," *American Renaissance* (note 7).

24. Cortissoz (note 21), p. xiii.

25. Quoted in Kocher (note 3), p. 342.

26. Ibid.

27. Cortissoz (note 21), p. xiii.

28. Quoted in Kocher (note 3), p. 342.

29. Ibid., p. 343.

30. From 1899 onward, Lutyens and Jekyll published extensively in the British magazine *Country Life*; many of these articles were collected and rewritten in Lawrence Weaver, *Houses and Gardens by E. L. Lutyens* (London: Country Life, 1913); and Weaver's *Lutyens Houses and Gardens* (London: Country Life, 1921).

31. Lewis Mumford, *American Taste* (San Francisco: Watergate Press, 1929), p. 21.

32. "Arts" (note 2), p. 26.

33. William Adams Delano, "Mass versus Mass," *Shelter* 2 (May 1932), p. 12; reprinted in *The Octagon* 4 (July 1932), pp. 10–11; William Adams Delano, "My Architectural Creed," *Pencil Point* 13 (Mar. 1932), p. 145; and Delano, "Architecture in Art," *Architectural Forum* 72 (Apr. 1940), pp. 17–18.

34. William Lawrence Bottomley, "A Selection from the Works of Delano and Aldrich," *Architectural Record* 54 (July 1923), p. 3. For the background on this quest for a national style, see Wilson, Pilgrim, and Murray, *American Renaissance*; and Wilson, "American Architecture and the Search for a National Style in the 1870s," *Nineteenth Century* 3 (Autumn 1970), pp. 74–80; and idem., "Architecture and the Reinterpretation of the Past in the American Renaissance," *Winterthur Portfolio* 18 (Spring 1983), pp. 69–87.

35. A. Lawrence Kocher, "The Country House: Are We Developing An American Style," *Architectural Record* 60 (Nov. 1926), p. 389.

36. Ibid., p. 393; some other writings expressing similar ideas about the uniqueness of the American country house are: John Cordis Baker, *American Country Homes and Their Gardens* (Philadelphia: House and Garden, 1906); Montgomery Schuyler, "Recent American Country Houses," *Architectural Record* 32 (Oct. 1912), pp. 271–74; Harold D. Eberlein, "Five Phases of the American Country House," *Architectural Record* 36 (Oct. 1914), pp. 273–341;

Fiske Kimball, "The American Country House," *Architectural Record* 46 (Oct. 1919), pp. 291–400; and Russell F. Whitehead, "The American Country House," *Architectural Record* 54 (Nov. 1923): entire issue.

37. Kocher (note 3), p. 338.

38. Ibid., p. 337.

39. Edward, Duke of Windsor, *A King's Story* (New York: G. P. Putnam's Sons, 1951), pp. 199–200.

40. See "From Informality to Pomposity: The Resort Casino in the Late Nineteenth Century," *Victorian Resorts and Hotels,* edited by Richard Guy Wilson (Philadelphia: The Victorian Society, 1982), pp. 109–16.

41. *The American Architect* 41 (May 4, 1907), p. 188; see also *Architectural Record* 21 (May 1907), pp. 154–55, 392–93.

42. Ibid.

43. Illustrated in Arthur Drexler, *The Architecture of the Ecole des Beaux-Arts* (New York: MIT Press, 1977), pp. 312–14, 316–19.

44. Aldrich quoted in Boyd (note 22), p. 62.

45. Ibid.

46. It is interesting that McKim, Mead & White used essentially the same form for two similar buildings: the Walker Art Gallery, Bowdoin College, Minneapolis; and the Morgan Library, New York.

47. B. C. Forbes, *Men Who Are Making America* (New York: B. C. Forbes Publishing Company, 1921), pp. 214–23.

48. Cortissoz, p. xiv.

49. Burden house drawings in the Avery Library.

Bradley Delehanty, page 144

1. Obituary, *New York Times,* June 9, 1965.

2. The other three structures in the development were the Otley residence, also designed by Delehanty, and the c. 1917 Pennoyer and Morgan houses designed by Goodwin, Bullard & Woolsey.

3. The Warren S. Crane, Sr., residence (c. 1925) was designed by August Noel.

4. The house was illustrated in 1933 in *House and Garden Magazine.* By 1939, it was owned by Arthur K. Peck, who had married Warren Crane's sister; the Pecks later sold the house and moved into the Noel-designed residence next door.

5. Cravath had built three earlier country houses; the first two were built c. 1900 and c. 1911 to the designs of Babb, Cook & Willard. These structures were destroyed by fire in 1908 and 1914, respectively. The third house, later altered but still standing, was built c. 1914 to the designs of Guy Lowell.

6. The real-estate brochure also states that the house "crowns the Highest Point of an eight acre Estate in Syosset" and that it is located "in a district of large estates, on Oyster Bay Road a short distance from the newly concreted Hempstead Turnpike." SPLIA archives, n.d.

7. See Pierre de la Ruffinière du Prey, *John Soane, The Making of an Architect* (Chicago: University of Chicago Press, 1982).

8. Compare, for example, Bulfinch's design for the Governor Gore house in Waltham, Massachusetts.

9. O. S. Fowler, *A home for all or the gravel wall and octagon mode of building new, cheap, convenient, superior and adapted to the rich and poor* (New York: 1854). The Livingston plan bears some resemblance to Fowler's fig. 30 ("the best plan yet") but relates more closely to that of the Solon Van Burkirk house (c. 1860) in Canandaigua, New York, which employs a similar central staircase with principal rooms arranged in a cross and intermediate, triangular closets and entryways. The Van Burkirk house appears in Carl F. Schmidt, *The Octagon Fad* (privately printed, 1958), pp. 56 and 185.

10. Another example is the wood frame Wetherill house (c. 1894–96) by McKim, Mead & White in Head-of-the-Harbor.

Frederic Diaper, page 151

SELECTED SOURCES

Dwight, Benjamin W., *The History of the Descendants of Elder John Strong of Northampton, Mass.* (Baltimore: Gateway Press, 1975).

C. L. W. Eidlitz, page 153

1. *East Hampton Star*, May 1891. "Mr. and Mrs. Schuyler Quackenbush have rented the Satterthwaite Cottage for another season." Built in 1874 for Dr. and Mrs. James S. Satterthwaite of Belleville, New Jersey, the house was rented by the family after the doctor died in 1884. It was a large Stick Style house with encircling two-story porches. Purchased by Charles G. Thompson of New York, it was remodeled in the Georgian Colonial Revival style in 1895. Thompson paid the firm of McKim, Mead & White $500 for the plans, with the work done by George A. Eldredge.

2. *East Hampton Star*, Aug. 28, 1891.

3. *East Hampton Star*, May 31, 1899. "G. A. Eldredge has summer residences for S. Quackenbush, Theron Strong and E. C. Potter about completed."

Ewing & Chappell, page 156

SELECTED SOURCES

On Charles Ewing: AIA application (RG 803, Box 5, Book 4, p. 163 in the Institute's archives); M.I.T. annual catalogues; student record, Ecole des Beaux-Arts (in vol. AJ-52–404 at the French *Archives Nationales*); *It's Me O Lord: The Autobiography of Rockwell Kent* (New York: 1955), and letters from Mr. Robert M. Ewing, whom I thank for his help.

On George Shephard Chappell: Yale alumni records; student record, Ecole des Beaux-Arts (in vol. AJ-52–402, *Archives Nationales*); obituary in *Architectural Record*, vol. 101, Jan. 1947, p. 122; Brendan Gill, "The Sky Line: Prospectus," *The New Yorker*, February 23, 1987, p. 106.

Wilson Eyre, page 157

1. In addition to numerous, smaller articles, several extended considerations of Eyre and his work appeared during his lifetime. The best are: Alfred Morton Githens, "Wilson Eyre, Jr., and His Work" in Albert Kelsey, ed., *The Architectural Annual 1900* (Philadelphia: Architectural League of America, pp. [121–184]); Julian Millard, "Wilson Eyre, His Work," *Architectural Record* 14, no. 4 (Oct. 1903), pp. 279–325; and Roger Caye, "The Offices and Apartments of a Philadelphia Architect, Mr. Wilson Eyre, at 1003 Spruce Street," *Architectural Record* 34, no. 178 (July 1913), pp. 78–88. Also see C. Matlack Price, "The Development of a National Architecture, The Work of Wilson Eyre—Fifth Article," *Arts & Decoration* 3, no. 1 (Nov. 1912), pp. 16–19.

Recent studies include: Edward Teitelman, "Wilson Eyre in Camden, The H. G. Taylor House and Office," *Winterthur Portfolio* 15, no. 3 (Autumn 1980), pp. 229–55; Betsy Fahlman, "Wilson Eyre in Detroit, The Charles Lang Freer House," *Winterthur Portfolio* 15, no. 3 (Autumn 1980), 257–70; Edward Teitelman and Betsy Fahlman, "The Furniture and Furnishings of Wilson Eyre," in Kenneth Ames, ed., *Victorian Furniture* (Philadelphia: Victorian Society, 1982), pp. 214–29; and Edward Teitelman and Betsy Fahlman, "Wilson Eyre and the Colonial Revival in Philadelphia," in Alan Axelrod, ed., *The Colonial Revival in America* (New York: W. W. Norton & Company, 1985).

For his work and the Philadelphia tradition, see Edward Teitelman, "Philadelphia Residential Regionalism," *Journal of Regional Cultures* 2, no. 2 (Fall/Winter 1982), pp. 23–36.

2. Eyre's office was first located at 35 West 21st Street. Sometime after 1912, he moved to 40 East 30th Street. Design work was done in Philadelphia with Eyre traveling weekly to New York City to supervise a small resident staff.

3. Several non–country-house commissions on Long Island include a set of quadruple houses built for the Russell Sage Foundation at Forest Hills, Queens, about 1911. There was also a c. 1895 unbuilt design for a townhouse for Frederick B. Pratt in Brooklyn and a possible alteration to another Brooklyn house for William O. Miles in 1907.

A much abbreviated and error-filled office list in the Architectural Archives at the Avery Architectural and Fine Arts Library,

Columbia University, New York (hereafter cited as "Avery"), indicates an "alteration to a residence" for a John N. Castles at Oyster Bay (1908), for which there is no confirming evidence.

4. Although our knowledge of the history of its ownership is incomplete, the house apparently survived into the 1930s. The Fuller name never appears on survey maps, and, in 1913, the property is shown under either Lucille Alger or Lulu Grace on different maps. We know nothing currently about either Alger or Fuller. Louise Grace was the daughter of New York Mayor William R. Grace, who also founded the Grace Shipping Lines. The Graces were prominent in the Great Neck area. Louise appears to have been an artist.

The commission, in both original and enlarged versions, was published in "Elements of the Picturesque—A Country House at Great Neck," *Architectural Record* 34, no. 4 (Oct. 1913), pp. 302–5; *American Architect and Building News* 53, no. 1951 (May 14, 1913), p. 227; and *House Beautiful* 20, no. 6 (Nov. 1906), pp. 12–13. The designs were shown by Eyre in the Philadelphia T-Square Club Annual Architectural Exhibitions in 1903, 1912, and 1913; and are well represented by sketches and photographs in Eyre's scrapbooks at Avery.

In Wilson Eyre, "Planning of Country Houses," *American Architect and Building News* 93, no. 1684 (Apr. 1, 1908), pp. 107–8, he discusses his approach to the "house of moderate size" which seems to have been followed in this case.

5. Apparently first used as a summer house, it was published in *American Architect and Building News* 43, no. 1685 (Apr. 4, 1908), unnumbered plates, and in *House Beautiful* 24, no. 6 (Nov. 1908), p. 140. There are drawings and photographs in the Avery papers.

Conklin, of New Rochelle, New York, was the founder of the T. E. Conklin Brass and Copper Company of New York City. His daughter-in-law, Louise, indicates that Mrs. Conklin directed the commission toward Eyre because of dissatisfaction with what McKim, Mead & White had done for her father, William Brigham, in 1887 in Connecticut (letter, Carol A. Traynor to Edward Teitelman, Dec. 14, 1983).

6. Now on the grounds of the Seminary of the Immaculate Conception, Diocese of Rockville Center. The commission was widely published, including in: "'Rosemary Farm'—The Residence of Roland R. Conklin, Esq., Wilson Eyre, Architect," *Architectural Record* 28, no. 4 (Oct. 1910), pp. 236–54; *Brickbuilder* 20, no. 10 (Oct. 1911), pls. 130–33; *Country Life in America* 44, no. 2 (June 1923), p. 13; "'Rosemary—That's for Remembrance'"; and "Rosemary Farm—That's for Love and Memory Too," *Touchstone* 2, no. 4 (Feb. 1918), pp. 484–90. Also see Zachary Studentroth, Nomination Form, National Register of Historic Places (undated).

For Eyre's brief description of his philosophy of the design of large country houses, see Wilson Eyre, "The Planning of Country Houses," *American Architect and Building News* 93, no. 1685 (Apr. 8, 1908), pp. 115–16.

7. The furnishing of the interior of the house is discussed in Teitelman and Fahlman, "The Furniture and Furnishings of Wilson Eyre," pp. 226–30 (note 1). The house was altered before 1918 by Hoggson Brothers who also appear to have done some refurnishing. An Italian entrance doorway was added to the outside, and the library was changed considerably. See "'Rosemary—That's for Remembrance'. . .," (note 6).

8. "'Rosemary—That's for Remembrance'. . .," p. 289 (note 6). The bricks were made locally in West Neck.

9. Versions are at Avery and in the Architectural Archives, University of Pennsylvania. The design probably dates from 1903.

10. Commission No. 5526. Twenty-four plans and photographs survive in the Olmsted collection, Brookline, Massachusetts, dating from 1912 and 1913.

11. Compare this with the contemporary early scheme for Roland Conklin which is of about the same size but clearly developed for a different set of client expectations and a different type of site.

Copies of the sketch plan are in the Eyre collections at the Avery, the Architectural Archives of the University of Pennsylvania, and in the Detroit Institute of Art. There is a citation to the house as built being designed by A. Van Antwerp of New York (see *The Long Islander*, Feb. 16, 1906). It was demolished about 1960.

12. Eyre's plan exists in the Architectural Archives, University of Pennsylvania. Mrs. Lillian Kent was a sister of Louise Grace. The house, as constructed, was illustrated in Augusta Patterson, *American Homes of Today* (New York: Macmillan, 1924), p. 14, and in records at the Olmsted collection, Brookline, Massa-chusetts. It was a symmetrical, French Provincial design.

13. A sketch plan and sketch are in the Architectural Archives, University of Pennsylvania. Roswell Eldridge, a close neighbor of the Misses Alger, Fuller, and Grace, was an owner of smaller parcels of land near his extensive estate, and this commission may have been for a tenant or rental house.

Eldridge apparently commissioned plans for a house in 1899 from Eyre's close colleagues in Philadelphia, Cope and Stewardson. See: "Architect Notes," *Philadelphia Real Estate Record and Builders' Guide* 14, no. 50 (Dec. 13, 1899), p. 805.

14. The sketch is in the possession of Edward Teitelman. No evidence of Wadsworth at Belle Terre, beyond his obituary, has yet emerged, nor is anything else known about the design.

Beatrix Farrand, page 163

SELECTED SOURCES

Balmori, Diana, "Beatrix Farrand: Pioneer Landscape Architect," Newsletter of the Preservation League of New York State (Nov./Dec., 1985), pp. 4–5.

Beatrix Farrand Collection, College of Environmental Design, University of California, Berkeley.

Ernest Flagg, page 167

1. For a contextual discussion of the Bourne House, on which this essay is based, see Mardges Bacon, *Ernest Flagg: Beaux-Arts Architect and Urban Reformer* (New York: The Architectural History Foundation; Cambridge, MA: MIT Press, 1986), pp. 158–61; and "A Fine Residence," *Suffolk County News*, June 18, 1897, sec. 3, p. 2. Photographs of "Indian Neck Hall" appear in H. W. Desmond, "The Works of Ernest Flagg," *Architectural Record* 11 (Apr. 1902), pp. 67–75, figs. 64–72.

2. I. N. Phelps Stokes, "Appendix: Historical Summary," in James P. Ford, *Slums and Housing* (Cambridge, MA: Harvard University Press, 1936), vol. 2, p. 871; and Bacon (note 1), pp. 234–66.

3. This argument is advanced in Bacon, "Toward a National Style of Architecture: The Beaux-Arts Interpretation of the Colonial Revival," in Alan Axelrod, ed., *The Colonial Revival in America* (New York: W. W. Norton & Company, 1985), pp. 91–121.

4. "Indian Neck Hall," *New York Herald*, Sept. 9, 1900, sec. 5, p. 11.

5. Letter, Brother Roger Chingas, FSG, Archivist, La Salle Military Academy, to Barbara Ferris Van Liew (SPLIA), Oct. 7, 1980. A photograph of the Bourne garage, which originally appeared in the November 1915 issue of *Town and Country*, is reproduced in *Preservation Notes* (SPLIA), Fall/Winter 1980, p. 5.

6. See Bacon (note 1), pp. 160, 364, n. 55.

SELECTED SOURCES

Bacon, Mardges, *Ernest Flagg: Beaux-Arts Architect and Urban Reformer* (New York: The Architectural History Foundation; Cambridge, MA: MIT Press, 1986).

Bacon, Mardges, "Toward a National Style of Architecture: The Beaux-Arts Interpretation of the Colonial Revival," in Alan Axelrod, ed., *The Colonial Revival in America* (New York: W. W. Norton & Company, 1985), pp. 91–121.

"Bourne Garage," *Preservation Notes* (SPLIA), Fall/Winter 1980, p. 5.

Desmond, H. W., "The Works of Ernest Flagg," *Architectural Record* 11 (April 1902), pp. 1–104.

"A Fine Residence," *Suffolk County News*, June 18, 1897, sec. 3, p. 2.

Flagg, Ernest, "American Architecture as Opposed to Architecture in America," *Architectural Record* 10 (Oct. 1900), pp. 178–90.

Flagg, Ernest, "Influence of the French School on Architecture in the United States," *Architectural Record* 4 (Oct./Dec. 1894), pp. 210–28.

Ford, James P., *Slums and Housing*, 2 vols. (Cambridge, MA: Harvard University Press, 1936).

"Indian Neck Hall," *New York Herald*, Sept. 9, 1900, v, p. 11.

Sclare, Liisa and Donald, *Beaux-Arts Estates* (New York: Viking Press, 1980).

Wittlock, Lavern A., "Pepperidge Hall, The Robert 'Castle' at Oakdale," *Long Island Forum*, Dec. 1978, pp. 268–78.

Robert W. Gibson, page 177

1. *The Century Yearbook 1928* (New York: The Century Association, 1929), p. 32.

2. This and the words of Gibson cited here are taken from Robert W. Gibson, *The Annals of North Point* (unpublished diary owned by Mrs. Joseph Wilmerding, Katonah, New York). Gibson called his house "North Point" and described its site in his diary: "It was just beyond the limit of civilization of Oyster Bay Village. The Roosevelts were then the advance guard—they had acquired land and built houses on Cove Neck on the side toward the village, the west side, and Theodore Roosevelt, the popular 'Teddy' then and now President, was in possession of the crest and top of the hill, but our north shore was a beautiful solitude of sweeping meadow, grassy knolls, cedar clad hills and then steep woods. . . ."

3. *American Architect and Building News* 20 (Oct./Dec. 1886). This commission may never have been executed. There is no reference to Harriman owning a house at Far Rockaway in George Kennan's two-volume biography of Harriman (1922).

4. W. P. Stephens, *The Seawanhaka Corinthian Yacht Club: Origins and Early History 1871–1896* (New York: Seawanhaka Corinthian Yacht Club, 1963), p. 197.

C. P. H. Gilbert, page 180

1. Nassau County Liber 371 of Deeds, p. 444.

2. *American Architect* 26 (Sept. 21, 1899), p. 135.

3. *Architectural League of New York, Catalog* 11 (1896), p. 35a. Although not officially attributed to Gilbert, Harvey Murdock's residence in the North Country Colony may have been a Gilbert design. This house was remodeled by Howard Major for the Samuel Brewsters around 1915.

4. *Architecture* (May 15, 1901), p. 122.

5. *Architecture* (Jan. 1901), pp. 47 and 14, respectively.

6. *Architectural League of New York: Catalogue* 17 (1902).

7. *Architectural League of New York: Catalogue* 21 (1906).

8. Jeffrey Potter, *Men, Money and Magic: The Story of Dorothy Schiff* (New York: Coward, McCann & Geoghegan, 1976).

9. *Architecture* 3 (June 1, 1900), p. 227.

10. Frederick Ruther, *Long Island Today* (New York: Essex Press, 1909).

11. Harry W. Desmond and Herbert Croly, *Stately Homes in America* (New York: D. Appleton & Co., 1903).

12. *Architecture* 22 (July 1910).

13. *Architectural League of New York: Catalog* 16 (1900).

14. Helen Worden, "Aldred Lost $3,000,000 L.I. Estate," *New York World Telegram*, Oct. 20, 1942, p. 17.

15. *Architectural Record* 12 (July 1905), p. 155.

16. Glen Cove *Record-Pilot* (Aug. 1, 1968).

17. Nassau County Liber 371 of Deeds, p. 492.

18. *Architectural Record* 11 (Oct. 1901), p. 694.

19. Nassau County Surrogate's Court, Probate Department, F. W. Woolworth, #7966 and Box 22. Contains a schedule of the construction costs and payment dates for the bills for "Winfield Hall."

20. John K. Winkler, *Five and Ten: The Fabulous Life of F.W. Woolworth* (New York: R.M. McBride & Co., 1940), p. 225.

21. Ibid.

22. Herbert Croly, "Residence of the late F. W. Woolworth," *Architectural Record* 47 (Mar. 1920), p. 194.

Bertram G. Goodhue, page 193

1. For a list of Goodhue's projects and completed works, see R. Oliver, *Bertram Grosvenor Goodhue* (New York, Cambridge, MA, and London: 1983), pp. 285–88, hereafter referred to as "Oliver (note 1)." All dates given in this essay are those provided by Oliver. For some reason, Oliver omitted mention of the Lloyd-Smith house from his otherwise excellent study of Goodhue.

2. On Aldred, see Helen Worden, "Aldred Lost $3,000,000 L.I. Estate," in the *New York World Telegram*, Oct. 20, 1942, p. 17, hereafter referred to as "*World Telegram* (note 2)."

3. Aldred obituary in the *New York Times*, Nov. 22, 1945, p. 35, and *World Telegram* (note 2), p. 17.

4. *World Telegram* (note 2), p. 17.

5. Ibid.

6. Ibid.

7. Oliver (note 1), p. 103.

8. *World Telegram* (note 2), p. 17.

9. Oliver (note 1), p. 103.

10. The information on "Ormston's" use today is from Terry Winters, "National Register of Historic Places Inventory-Nomination Form," Mar. 11, 1977, p. 7, which also contains a lengthy description of the house. SPLIA archives.

11. The details of Wilton Lloyd-Smith's life come from the *National Cyclopedia of American Biography* 30 (New York: 1943), pp. 401–2.

SELECTED SOURCES

Aldred Obituary, *New York Times*, Nov. 22, 1945, p. 35.

Oliver, Richard, *Bertram Grosvenor Goodhue* (New York, Cambridge, MA, and London: 1983).

———, "Goodhue, Bertram Grosvenor," in the *Macmillan Encyclopedia of Architects*, ed. A. Placzek (New York, 1982).

"Wilton Lloyd-Smith, " in the *National Cyclopedia of American Biography* 30 (New York: 1943), pp. 401–2.

Winters, Terry, "National Register of Historic Places—Nomination Form," Mar. 11, 1977 (unpublished).

Worden, Helen, "Aldred Lost $3,000,000 L.I. Estate," *New York World Telegram*, Oct. 20, 1942, p. 17.

Isaac Henry Green, page 197

1. Green's career has never been formally studied. What follows has been culled from newspaper accounts, records at SPLIA, and Robert A. M. Stern's essay, "One Hundred Years of Resort Architecture in East Hampton" in *East Hampton's Heritage* (New York: W. W. Norton & Company, 1982). This last essay contains the first scholarly consideration Green has ever received in print.

2. Green's name does not appear in David de Penanrun's comprehensive *Les Architectes élèves de l École des Beaux-Arts*, 2nd ed. (Paris: Librarie de la Construction Moderne, 1907).

3. A social anthropological study of this settlement has recently been published: Lawrence J. Taylor, *Dutchmen on the Bay* (Philadelphia: University of Pennsylvania Press, 1983).

4. See Vincent Scully, *The Shingle Style*, rev. ed. (New Haven and London: Yale University Press, 1971), pp. 152–53; and, also by idem., *The Shingle Style Today, or, The Historian's Revenge* (New York: George Braziller, 1974), passim.

James L. Greenleaf, page 201

1. Liisa and Donald Sclare, *Beaux-Arts Estates: A Guide to the Architecture of Long Island* (New York: Viking Press, 1980), p. 95.

2. Ibid., p. 95.

3. Several nurseries, like that of Lewis & Valentine, developed complex tree-moving machines which made possible the transplanting of large trees; a landscape scheme could, thus, seem "mature" immediately upon completion.

4. All biographical information is derived from Greenleaf's obituary in the *New York Times*, Apr. 16, 1933, p. 28.

Henry G. Harrison, page 207
SELECTED SOURCES
PUBLISHED SOURCES:

"Death of Henry G. Harrison, Architect," *American Architect and Building News* 49 (Sept. 1895), pp. 97–98.

Murphy, J. Arthur, & Co., *Confidential Reference Book and Directory* (New York: 1873).

White, James F., *The Cambridge Movement: The Ecclesiologists and the Gothic Revival* (Cambridge, England: University Press, 1962).

UNPUBLISHED SOURCES:

Garden City, New York, The Archives of the Episcopal Diocese of Long Island, New York, New York. New-York Historical Society, Print Collection, Photography Collection, and Museum Catalogue.

Hiss & Weekes, page 210
SELECTED SOURCES

Brown, Elizabeth Mills, *New Haven: A Guide to Architecture and Urban Design* (New Haven: Yale University Press, 1978).

Hoffstot, Barbara D., *Landmark Architecture of Palm Beach* (Pittsburgh: Ober Park Associates, 1974).

White, Norval, and Elliot Willensky, *AIA Guide to New York City* (New York: Macmillan, 1978).

Wilson, Richard Guy, "Architecture, Landscape, and City Planning," in *The American Renaissance: 1876–1917* (Brooklyn, NY: Brooklyn Museum, 1979).

F. Burrall Hoffman, page 212

1. Augusta O. Patterson, *American Homes of Today* (New York: The Macmillan Company Publishers, 1924), pp. 264–67.

2. *Architectural Record* 41 (June 1917), pp. 560–61.

Alfred Hopkins, page 215

1. Letter, Alfred Hopkins to Wilton Lloyd-Smith, July 12, 1924.

2. Alfred Hopkins, *Modern Farm Buildings* (New York: Robert M. McBride & Co., 1920), p. 18.

3. Ibid., p. 16.

4. Letter, Alfred Hopkins to Wilton Lloyd-Smith (note 1).

5. *Modern Farm Buildings* (note 2), p. 17

6. "Random Thoughts on Farm Buildings," *Country Life In America* (July 1924), p. 67.

7. Ibid.

8. *Modern Farm Buildings* (note 2), p. 16.

Hunt & Hunt, page 223

1. I wish to thank Ms. Carol A. Traynor of the Society for the Preservation of Long Island Antiquities for assistance in the research for this paper and for arranging a visit to the buildings for me. I also would like to thank the following people for their help: at Dowling College, to which "Idlehour" now belongs, Mrs. Betty Kuss of the Vanderbilt Historical Society, Ms. Jeanne Straub, and Mrs. Betty Remmer; at "La Selva," which now belongs to the Saint Francis Religious Order, Brother Roman; and at what was "Castlegould" and is now "Hempstead House" of the Sands Point Preserve, the director, Mr. Ron Wyatt. Finally, I wish to express

my gratitude to Dr. Robert B. MacKay, Director of the Society for the Preservation of Long Island Antiquities, for giving me an opportunity to write about the Hunts' Long Island houses.

2. For a recent study of his work, see *The Architecture of Richard Morris Hunt*, Susan R. Stein, ed. (Chicago and London: The University of Chicago Press, 1986). For a biography, see *Richard Morris Hunt* by Paul R. Baker (Cambridge, MA, and London: MIT Press, 1980).

3. On W. K. Vanderbilt, see the *Dictionary of American Biography*, vol. XIX, pp. 176–77. On Alva Smith Vanderbilt Belmont, see the *Dictionary of American Biography*, Supplement One (New York; 1944), pp. 68–69. On the whole family, see *The Vanderbilt Legend*, by Wayne Andrews (New York: Harcourt, Brace & Co., 1941), and *Fortune's Children*, by Arthur T. Vanderbilt II (New York: William Morris & Co., 1989).

4. On the importance of the South Side Sportsmen's Club, see *The Old Oakdale History*, Vol. I (Oakdale, NY: The William K. Vanderbilt Historical Society of Dowling College, 1983). What was the club's land is now the Connequot River State Park Preserve.

5. On Hunt's relation to this revival, see Sarah Bradford Landau's "Richard Morris Hunt, the Continental Picturesque, and the 'Stick Style,'" *Journal of the Society of Architectural Historians* 42 (Oct. 1983), pp. 272–89.

6. *The South Side Signal*, Babylon, Long Island, April 23, 1880, quoted in *The Old Oakdale History* (note 4), p. 57.

7. On Château-sur-Mer, see John A. Cherol's and Christopher P. Monkhouse's entry in the catalogue, *Buildings on Paper: Rhode Island Architectural Drawings, 1825–1945*, by William H. Jordy and Christopher P. Monkhouse, with contributors (Providence, RI: Brown University, the Rhode Island Historical Society and Rhode Island School of Design, 1982), pp. 92–93. For colored photos of the house, see *Newport Mansions: The Gilded Age*, photography by Richard Cheek, text by Thomas Gannon, and introduction by David Chase (Dublin, NH: Foremost Publishers, 1982), pp. 46–57.

8. *The Old Oakdale History* (note 4), pp. 45–46.

9. On the 1867 visit to Europe, see Baker (note 2), pp. 156–61. On the significance of his seeing Norwegian church architecture, see Landau (note 5), p. 283.

10. The *Annual Catalogues* of M.I.T. for the two school years 1880–81 and 1881–82 show Richard Howland Hunt to have been enrolled. His Ecole record is to be found at the French Archives Nationales, in vol. AJ-52–369.

11. Little has been written on Richard Howland Hunt. Baker (note 2) gives him some attention; see pp. 127, 166, etc. In *Who Was Who in America*, vol. I, 1897–1942 (Chicago: The A. N. Marquis Co., 1942) is an entry that may be autobiographical, it having been reprinted from *Who's Who in America*. Obituaries are in *Architectural Forum* 55 (Aug. 1931), supplementary p. 19; *The Technology Review* [of M.I.T.], 34 no. 3, Dec. 1931, p. vii; and *The New International Year Book . . . for the Year 1931*, ed. by Herbert Treadwell Wade (New York: 1932), p. 564.

12. On O. H. P. Belmont, a son of the banker August Belmont, see *Who Was Who in America*, vol. I, 1897–1942 (note 11).

13. *The South Side Signal*, Babylon, Long Island, of August 4, 1883, quoted in *The Old Oakdale History* (note 4), p. 81.

14. The woodwork of the living room and the main staircase was lost, sad to say, in yet another fire, in 1974.

15. Joseph Howland Hunt's Ecole record is in vol. AJ-52–394 at the Archives Nationales. For biographical material, see the *Reports* of the class of 1892 of Harvard College (especially nos. II, V, and *Necrology 1922–1927*). See also the following obituaries: *Pencil Points* 5 no. 11 (Nov. 1924), p. 86; *Architectural Record* 56, no. 6 (Dec. 1924), p. 578; and *The Journal of the American Institute of Architects* 12 no. 12 (Dec. 1924), p. 542.

16. For its elevations, see *Architecture* 9 (1904), p. 68.

17. So say the obituaries cited above (note 11).

18. Liisa and Donald Sclare in their *Beaux-Arts Estates: A Guide to the Architecture of Long Island* (New York: Viking Press, 1980), pp. 58–66, are most perceptive as to the planning of this house. They are also illuminating on the second "Idlehour."

19. Three drawings at the American Institute of Architects in Washington are dated December 3, 1915. My thanks to Ms. Sherry C. Birk of the AIA Foundation for information about drawings in its collection.

20. Obituary of Joseph Howland Hunt in *Pencil Points* (note 15).

21. "The house, as its name would intimate, is pure Italian in character." *Country Life in America* 42 (Oct. 1922), pp. 53–57.

22. Richard Howland Hunt's obituaries call it his. There are many drawings of it at the AIA in Washington: elevations and plans dated May and June 1917 and numerous interior studies in 1919. There was one other Hunt & Hunt house on Long Island: for S. L. Schoonmacker, completed in 1918, in Lattingtown. Which Hunt designed it is unknown. Brick, with four pairs of engaged Ionic columns in a giant order creating a frontispiece, the Schoonmacker house could have been in an English park. It was demolished in 1954.

Innocenti & Webel, page 233

1. Biographical information from the *National Cyclopedia of American Biography*, vol. 54, p. 202; and obituary, *New York Times*, Oct. 11, 1968.

2. Biographical information supplied by Innocenti & Webel, Landscape Architects–Planning Consultants, Greenvale, Long Island; see also "Innocenti & Webel: Classical Proportion in Landscape Architecture," *Building Stone Magazine* (July 8, 1984), pp. 24–27.

Kirby, Petit & Green, page 237

1. The Biological Laboratory was refitted in 1953 to serve as the main library for the Carnegie Institute. See *American Architect* 88 (July 8, 1905), p. 76, and plates.

2. For the Bush Terminal Building on 100 Broad Street (now destroyed) see *Architectural Record* 19 (June 1906), p. 472–73. Some working drawings were published in *The American Architect* 87 (Jan. 7, 1905).

3. Shiras Campbell, "An Excellent Gothic Residence," *Architectural Record* 29 (Apr. 1911), p. 289–99.

4. Michael R. Corbett, *Splendid Survivors, San Francisco's Downtown Architectural Heritage* (San Francisco: 1979), p. 85. The Hearst Building is the only work of Kirby, Petit & Green located outside the Northeast (at least to my knowledge). It was built for William Randolph Hearst to replace the old Hearst Building, destroyed in the 1906 earthquake. As pointed out by Charles Nicholas, the structural engineer for the project, the new building was specially constructed to resist future earthquakes; see "Engineering Features of the New Hearst Building," *The American Architect* 93 (Jan. 18, 1908), p. 21–23. Unfortunately, most of the "mission style" ornamentation on the structure was confined to the massive, never-built clock tower that was to be placed on top. Drawings of the building with the intended tower are in the *San Francisco Architectural Yearbook, 1909*. Even without the tower, though, the Hearst Building remained the tallest building in the West for several years; see the *San Francisco Examiner*, June 1, 1920, 12, p. 1.

5. Withey, Henry F., and Elsie Rathburn Withey, *Biographical Dictionary of American Architects (Deceased)* (Los Angeles; Hennessey and Ingalls, 1970), 348.

6. Henry P. Kirby, *Architectural Compositions . . . comprising a series of fifty sketches, parts of which have been made in connection with actual projects, but many being the result of study during leisure moments* (Boston: 1892). Drawings dated 1882 include pls. 9, 10, and 41. Two drawings are dated 1887—pl. 13, "Bayeaux," and pl. 28, "St. Lizier, Ariege": this suggests that Kirby returned to Normandy five years after his first trip.

7. Winston Wiseman, "Post, George Browne," in Adolf Placzek, ed., *MacMillan Encyclopedia of Architects* (New York, NY: MacMillan), vol. III, pp. 460–62.

8. It is pure conjecture, but it may be that Post's two sons, William and James, caused Kirby to leave his position with Post. Even after over twenty years' service in the Post firm, Kirby was never made a partner; however, the year after he left, in 1905, Post took on his sons as full partners.

Again it is conjecture, but it seems likely that Petit and Green were fellow draftsmen in Post's office. To my knowledge, though, there are no extant records from that office where this could be verified.

One thing we do know about Green in particular: he had exotic taste. In 1907 *The American Architect* 91 (June 22, 1907) published the house he built for himself in Greenwich, Connecticut—a wild Lombardo-Germanic pile roofed with Spanish tiles, and on the interior, decorated with brightly colored oriental wallpapers.

9. For the shingled Belle Terre Clubhouse, which "suggests the charm of an old English inn," see *Country Life* 12 (June 1907), p. 124, and 14 (Oct. 1908), p. 515. Kirby, Petit & Green have also been credited with a third shingled house on Long Island, the William Talmadge House in Bellport; the house was never published, though, so its date and authorship are questionable (SPLIA has photographs).

10. *Country Homes* 7 (July, Aug., Sept., 1928), pp. 32–37.

11. On Doubleday and his wife see *Who Was Who*, vol. I, p. 334. Doubleday's memoirs indicate that Petit was his most trusted architect: "I was in such a hurry to put the plan [for the Country Life Press plant] before my partners that I cabled them to get the help of J. J. Petit, the architect who had built our house at Locust Valley [Mill Neck] . . ." See F. N. Doubleday, *He's Done It Again, More Indiscreet Recollections* (privately printed manuscript limited to 99 copies, 1933), p. 3.

12. Mt. Vernon no longer has this balustrade. For the way it looked to Kirby, Petit & Green, see William Rotch Ware, *The Georgian Period* (New York: 1923), vol. I, p. 81.

13. For the porch as originally built, see *The American Architect* 90 (Oct. 1906). The second porch appears in *Country Life* 21 (Mar. 1912), p. 3. A similar entrance arrangement—a two-story porch over a fanlit Federalist entrance and tripartite window above—can be found in the George Taylor House, "Horn Quarter," in King William County, Virginia (early 19th century): see William B. O'Neal, *Architecture in Virginia: An Official Guide to Four Centuries of Buildings in the Old Dominion* (Richmond, VA: published for the Virginia Museum of Fine Arts, 1968), p. 106.

14. Doubleday, Page and Co., *The Country Life Press* (Garden City, NY: 1919), p. 15.

15. Petit's interest in Westover may have been inspired by Charles Platt's design for "Eastover," the George T. Palmer House in New London, Connecticut (1909–10). For the Palmer house, see "A Contemporary Westover," *Architectural Record* 25 (Apr. 1909), pp. 249–58; and Royal Cortissoz, *Monograph on the Work of Charles Platt* (New York: 1913), p. 53.

A July 1948 real estate guide (Previews, Inc.) indicates that Harrie Lindeberg had prepared drawings for alterations to the plan of Effendi Hill, presumably sometime after Doubleday's death in 1934. It is doubtful if these plans were carried out before the house was so radically altered in the 1950s.

Lamb & Rich, page 242

1. Traditionally, 1882 is listed as the first year of the partnership, as is cited in *Who Was Who in America* (Chicago, 1950), vol. II, p. 447. However, the firm had to have been formed no later than June 1881. Plans for the William I. Russell house in Short Hills, a structure firmly documented as designed by Lamb & Rich (*American Architect and Building News* 12 (Sept. 2, 1882), were approved by the owner before construction began on July 2, 1881: see William Ingraham Russell, *The Romance and Tragedy of a Widely Known Business Man of New York* (New York: 1905), 97.

2. Montgomery Schuyler offers very positive comments on the firm's urban work in "The Romanesque Revival in New York," *Architectural Record* 1 (July 1891), pp. 26, 36. See also Sarah Bradford Landau, "The Row Houses of New York's West Side," *Journal of the Society of Architectural Historians* 34 (1975), pp. 19–36; and Paul Goldberger, *The City Observed: A Guide to the*

Architecture of Manhattan (New York: Random House, 1979), pp. 221, 270. Most of Lamb & Rich's Upper West Side apartment houses were built between the years 1886 and 1891, and were located between 72nd and 82nd Streets along West End Avenue. For some of these, check the *American Architect and Building News* 22 (Nov. 5, 1887); 34 (Oct. 17, 1891); 37 (Aug. 20, 1892); and *Building* 6 (Apr. 30, 1887).

3. *American Architect and Building News* 20 (Nov. 13, 1886), pp. 230–31.

4. Rich designed most of the buildings that were constructed at Dartmouth between 1890 and 1920; see Montgomery Schuyler, "Architecture of American Colleges, Part 6," *Architectural Record* 28 (Dec. 1910), pp. 424–42; "Dartmouth College Buildings," *Architecture* 18 (Nov. 15, 1908), pp. 176–79, 185; Leon V. Solon, "The Spaulding Swimming Pool at Dartmouth," *Architectural Record* 50 (Sept. 1921), pp. 183–92.

The Berkeley School is illustrated in *American Architect and Building News* 30 (Nov. 1, 1890); Barnard College in the same volume (Dec. 3, 1890) and in *Architecture* 10 (Nov. 15, 1904), pp. 172–75.

5. Vincent J. Scully, Jr., *The Shingle Style and the Stick Style*, rev. ed. (New Haven, CT, and London: Yale University Press, 1971), pp. 101–3.

6. *New York Times*, April 4, 1903, p. 9, col. 6. Lamb's obituary also notes that he was "one of the most prominent temperance workers in Essex County as a member of the Advisory Board of the Women's Christian Temperance Union."

7. Rich wrote in *American Architect and Building News* 26 (Dec. 7, 1889), p. 269, that he had worked for "one of New England's most famous architects." That this figure was Emerson is proven by the April 1876 issue of the *New York Architectural Sketchbook*, where there is a fine perspective of Emerson's house for Margaret and Frances Forbes in Milton, Massachusetts. The drawing is signed by Rich. See Cynthia Zaitzevsky, *The Architecture of William Ralph Emerson, 1833–1917*, art exhibition catalogue (Cambridge, MA: Fogg Art Museum in collaboration with the Carpenter Center for the Visual Arts, Harvard University Press, 1969), pl. 3.

8. Rich published many travel sketches from his tour of Europe in three of his anonymous articles for the *American Architect and Building News*: "Sketching in Nuremberg," 11 (Jan. 14, 1882), pp. 15–16; "Sketches on the Wing," 11 (March 25, 1882), pp. 135–37; and "A Splendid Trip," 11 (April 22, 1882), pp. 183–85. His sketches of the Château at Amboise and the Palace at Evreux, France, both dated 1880, are illustrated in *Building* 7 (Sept. 24, 1887).

Rich traveled extensively during his career to acquire furnishings for his clients and stories for his publishers: see his "A Visit to Luxor and Karnak," *Architecture and Building* 30 (May 6, 1889), pp. 139–42, and (June 3, 1889), pp. 175–77; "Ancient Thebes," *Architecture and Building* 31 (July 1, 1899), pp. 3–6, and (Aug. 5, 1899), pp. 43–46; "Architecture in Spain," *Architectural Record* 4 (July–Sept. 1894), pp. 14–35, and 5 (July–Sept. 1895), pp. 47–64, and 5 (Jan.-Mar. 1896), pp. 227–43; and "Monastic Architecture in Russia," *Architectural Record* 9 (July–Sept. 1899), pp. 21–49.

9. *New York Times*, Dec. 5, 1943, p. 66, col. 5; *Who Was Who In America* (Chicago: A. N. Marquis, 1950), vol. II, p. 447.

10. See the following plates within vol. 11 (1882): 315, 320, 333, and 340; and, in vol. 12 (1882), pl. 349.

11. *Building* 9 (Sept. 29, 1888), p. 101 and plates.

12. The Hinckley house was first described in *Artistic Houses* (New York: 1883) (reprinted by B. Blom, 1971), vol. II, part I, pp. 91–93. An expanded description appears in George Sheldon, *Artistic Country Seats* (New York: 1886), vol. II, pp. 139–42. Scully discusses the plan in *The Shingle Style* (note 5), p. 192. For the Cochrane House, see Zaitzevsky, *Emerson* (note 7), pl. 11.

13. Sheldon, *Artistic Country Seats*, vol. II (note 12), p. 133. Sheldon notes that the Rich House was "one of the first houses in this country where the weather-boards or shingles have been stained in gradations so as to give the appearance of age. The tint at the top of the exterior walls is a yellow gray, which deepens as it descends into a dark Indian red." Of the Hinckley house Sheldon writes (vol. II, p. 139), "the second story is colored an old gold, with here and there a shingle picked out in the same tint, while the base courses are an Indian red." While not precisely mentioning "gra-

dations" of color in the Hinckley house, Sheldon nevertheless describes two very similar color schemes. The two houses had many other similarities as well, including the use of "sea-pebbles," sun dials, and Latin phrases for exterior detailing.

14. The interiors of all five Hinckley houses were described as such in *Building* 9 (Sept. 29, 1888) p. 101.

15. Sheldon, *Artistic Country Seats*, vol. II (note 12), pp. 140–41.

16. Herman Hagedorn, *The Roosevelt Family of Sagamore Hill* (New York: Macmillan, 1954), pp. 5–9. Theodore's grandfather, Cornelius Van Schaack Roosevelt, built a summer house on his estate in Oyster Bay in the early 19th century (Karl Schriftgiesser, *The Amazing Roosevelt Family, 1613–1942* [New York: 1942], p. 170). As a teenager Theodore had spent the summers of 1874–76 with his family in Oyster Bay.

Interestingly, just two years before construction started on "Sagamore Hill," John Aspinwall Roosevelt, Theodore's cousin, hired architect Bruce Price to design a house in North Oyster Bay; see *American Architect and Building News* 11 (Jan. 28, 1882), p. 43 and plate.

17. According to Corinne Roosevelt Robinson in *My Brother Theodore Roosevelt* (New York: Charles Scribner's Sons, 1921), p. 365, "Sagamore" was an old Indian word meaning "chief or chieftain." Roosevelt himself claimed that the name was taken from a specific Indian, Sagamore Mohannis, "who, as chief of his little tribe, signed away his rights to the land [around Oyster Bay] two centuries and a half ago." See *Theodore Roosevelt, An Autobiography* (New York: Macmillan, 1913), p. 342.

18. In about 1915 Roosevelt wrote to the editor of *Country Life in America*, "I did not know enough to be sure what I wished in outside matters. . . . Rich put on the outside cover with but little help from me." Quoted in Hagedorn, *The Roosevelt Family* (note 16), p. 7.

19. *American Architect and Building News* 39 (Feb. 18, 1893).

20. Hagedorn, *The Roosevelt Family* (note 16), p. 7.

21. This huge reception room, 30 by 40 feet, paneled in mahogany, black walnut, cypress, and hazel, and decorated with T.R.'s game trophies, was designed by C. Grant La Farge, son of celebrated artist John La Farge. Care was taken to align the room on axis with the central hall.

22. *New York Times*, Dec. 5, 1943, p. 66, col. 5.

23. Rich's description of both his house and "The Hulk" is in the *American Architect and Building News* 26 (Dec. 7, 1889), pp. 268–69. Rich does not mention by name Emerson, Hunt, or "The Hulk," but his description of the 1877 studio is so precise that there is no doubt as to its reference. So far overlooked, it is a most valuable source for one of Emerson's more unusual works. Scully, in *The Shingle Style* (note 5), pp. 82–83, puts Hunt's studio in perspective.

24. The rear court of the Rich house is remarkably similar to that of the medieval manor of Tourpe, near Neufchatel-en-Bray, in Normandy. Rich's sketch of this "Old French Farm House" is illustrated in *Building* 8 (Apr. 21, 1888).

25. At about the same time Lamb & Rich designed the Charles M. Pratt house (1890), they also enlarged and altered the existing Charles Pratt, Sr., house (Frederick B. Pratt, *The Pratt Family at Dosoris, 1889–1939, A Camera Chronicle of the Early Days at Glen Cove*, n.d.).

26. *Who Was Who in America* (Chicago: A.N. Marquis, 1942), pp. I, 40, and 991. After graduating from Amherst, Pratt became director of the Chelsea Fibre Mills, while Babbott assumed a similar position at the Chelsea Jute Mills.

27. *American Architect and Building News* 22 (July 9, 1887).

28. Taylor's obituary (*New York Times*, April 3, 1938, II, p. 6, col. 8) notes, "On May 15, 1892, Mr. Taylor married . . . Jessica Harwar Keene, and established a home at Cedarhurst, L.I., which he made one of the finest Long Island estates of the period." Presentation drawings for the house are in *Architecture and Building* 22 (June 22, 1895). The decision to give "Talbot House" a Tudor guise may have been inspired by another Tudor Revival house in Cedarhurst, designed by H. Howard; see *Architecture and Building* 19 (Nov. 11, 1893).

29. Barr Ferree, *American Estates and Gardens* (New York: Munn and Co., 1904), pp. 260–69.

30. Ferree, *American Estates* (note 29), p. 261.

31. Rich's design for this ceiling was probably inspired by a print of the drawing room at Broughton Castle in Joseph Nash, *The Mansions of England in the Olden Time*, 2nd series (London: Bounty Books, 1970), pl. XXXIV. A photo of the same appears in J. Alfred Gotch, *Early Renaissance Architecture in England* (London: 1901), pl. LI.

32. The *Brooklyn Daily Eagle*, April 5, 1902: "Plans are also being prepared by Mr. Rich for an attractive residence to be built not far from the . . . house of Mr. Gates [i.e. in Glen Cove]. It will be of the Spanish style of architecture, the outside to be plastered." This reference must be to the Jennings house, the only residence, besides the Gates house, known to have been designed by Rich in Glen Cove; it is certainly the only house by Rich that could conceivably be classified as "Spanish."

33. The *Brooklyn Daily Eagle*, April 5, 1902.

34. It would appear from their obituaries (*New York Times*, May 9, 1906, p. 9, col. 5; Dec. 7, 1919, p. 22, col. 3) that both Gates and Tangeman were married to daughters of Cornelius Hoagland, founder of the Cleveland (later Royal) Baking Powder Company. Both men also had townhouses in Brooklyn and summer houses in Glen Cove. The Tangeman house in Brooklyn appears in *American Architect and Building News* 35 (Feb. 27, 1892).

35. The *Brooklyn Daily Eagle*, April 5, 1902.

36. The Jacobean style, characterized by brick construction and curved Flemish-style gables, was thought by some architectural critics of the era to be the best possible style for a large country residence. And the Poor house was usually considered the premier example, as is the case in Harry W. Desmond and Herbert Croly, *Stately Homes in America* (New York: D. Appleton & Co., 1903), p. 412. For illustrations of the Poor house, see *Brickbuilder* 8 (June 1899), p. 122; and *Architectural Record* 12 (May 1902), pp. 156–73.

J. Custis Lawrence, page 250

1. *East Hampton Star*, obituary J. Custis Lawrence, August 26, 1944, p. 1, col. 1.

2. East Hampton Historical Society. Information with high chest of drawers. Gift of Frank A. Eldredge, Mary Eldredge and Edith Eldredge Weed, c. 1960.

3. William H. Jordy, *American Buildings and Their Architects: Progressive and Academic Ideals at the Turn of the Twentieth Century* (Garden City, NY: Doubleday, 1976), pp. 79–80.

4. This information on Lawrence's work for Babcock and Gay is ascertained from a perusal of lists of the blueprints at the East Hampton Free Library. The information on Lawrence's registration is in the collection of the Suffolk County Historical Society. I am indebted to the late Mrs. Hanna for alerting me to this register.

5. Frank B. Smith became a leading builder and dealer in building supplies in East Hampton. Nothing is known of E. W. Davis.

Charles W. Leavitt, Jr., page 252

1. *Country Life* (America) 38 (June 1920); *National Cyclopedia of American Biography*, vol. 24, p. 37; obituary, *New York Times*, Apr. 24, 1928.

2. Barr Ferree, *American Estates and Gardens* (New York: Munn and Co., 1904), pp. 155–58.

Little & Browne, page 256

1. See "Arthur Little and the Colonial Revival," *Journal of the Society of Architectural Historians* 32 (May 1973), pp. 147–63; Sturgis describes in excellent detail Little's early professional career. Another important source of commentary on Little's early work is Vincent J. Scully, Jr., *The Shingle Style and the Stick Style*, rev. ed. (New Haven, CT, and London: Yale University Press, 1971), pp. 104–8. For biographical information on Arthur Little, see Hubert G. Ripley, Arthur Little obituary, *American Institute of Architect's Journal* 13 (1925), p. 191.

2. Arthur Little, *Early New England Interiors* (1878), preface.

James Brown Lord, page 261
SELECTED SOURCES

This essay is factually dependent upon Robin Elfenbein, *James Brown Lord, Architect: A Social History*, an unpublished typescript with extensive bibliography prepared for the Society of the New York Hospital, New York City.

Guy Lowell, page 262

1. "Lowell, Guy," *Dictionary of American Biography*, vol. 6 (New York: Charles Scribner's Sons, 1961), p. 457.

2. Benjamin F. W. Russell, "The Works of Guy Lowell," *Architectural Review* (Boston), 13 (Feb. 1906), pp. 13–40.

3. Herbert Croly, "The Lay-out of a Large Estate," *Architectural Record* 16 (Dec. 1904), p. 540.

4. Croly (note 3), pp. 554–55.

5. *Country Life in America* 26 (Aug. 1914), p. 42.

6. A photo of the house taken c. 1910 is in the Nassau County Museum Collection (#5365.177).

7. Mrs. Barclay, the former Bertha Fahys, was Harry Payne Whitney's cousin.

8. "Piping Rock Club," *Country Life in America* 37 (Feb. 1920), p. 50.

9. Henrietta Sargent, who married Guy Lowell in 1898, and A. Roland Sargent were the children of Charles Sprague Sargent, professor of arboriculture at Harvard and director of the Arnold Arboretum, who had spent part of his career working with Frederick Law Olmsted.

10. John Taylor Boyd, Jr., "Residence of William R. Coe, Esq.," *Architectural Record* 49 (Mar. 1921), pp. 194–224. Sargent had died three weeks before the fire. Memo from Thomas R. Hauck to Planting Fields Files, March 13, 1979, on the Early Landscape Work on W. R. Coe's Estate, Planting Fields, Oyster Bay.

11. Farnsworth was the maiden name of Billing's mother.

12. While the earliest published references to the house are in 1920, A. Roland Sargent is credited with the landscaping, and he died in 1918.

13. Certainly one of the most unusual features of the estate was a five-furlong race track, an indication of the client's enthusiasm for horse racing.

14. *American Landscape Architect* (Dec. 1931).

McKim, Mead & White, page 273

1. Among the vast literature on the firm see:

Richard Guy Wilson, *McKim, Mead & White, Architects* (New York: Rizzoli, 1983); Richard Guy Wilson, "The Early Work of Charles F. McKim: Country House Commissions," *Winterthur Portfolio* 14 (Autumn, 1979), pp. 235–67; Leland Roth, *McKim, Mead & White, Architects* (New York: Harper & Row, 1983); Leland Roth, *The Architecture of McKim, Mead & White, 1870–1920: A Building List* (New York: Garland Press, 1978); and *A Monograph of the Works of McKim, Mead & White, 1879–1915*, 4 vols. (New York: The Architectural Book Publishing Company, 1915–1920; reprinted in one volume, New York: Benjamin Bloom, 1973).

2. Lawrence Kocher, "The American Country House," *Architectural Record* 62 (Nov., 1927), p. 337.

3. Charles McKim, quoted in Charles Moore, *The Life and Times of Charles Follen McKim* (Boston and New York: Houghton Mifflin Company, 1929), p. 40.

4. William R. Mead, quoted in Lawrence Grant White, *Sketches and Designs by Stanford White* (New York: The Architectural Book Publishing Company, 1920), p. 17.

5. The standard source on McKim is Moore, *McKim* (note 3); in addition, see Richard Guy Wilson, "Charles F. McKim and the Development of the American Renaissance: A Study in Architecture and Culture" (Ph.D. dissertation, University of Michigan, 1972).

6. A series of letters in the offices of Walker O. Cain and Associates, the successor firm to McKim, Mead & White, dating from 1902 and 1903 from Edith K. Roosevelt and Isabella L. Harper (Mrs. Roosevelt's secretary) to McKim deal with both McKim's work at the White House in Washington, D.C., and also remodeling of the Oyster Bay property's pantry, dining room, and purchase of new furniture. How much of this was carried out is unknown; the commission does not appear in the *McKim, Mead & White Bill Books* at the New-York Historical Society. In 1906 Sagamore Hill was extended by the architect C. Grant La Farge.

7. Charles McKim, letter to "Judge" Samuel A. B. Abbott, Dec. 1, 1893; McKim Collection, Library of Congress.

8. Among the various accounts are: Gerald Langford, *The Murder of Stanford White* (Indianapolis: Bobbs Merrill, 1962); Michael Mooney, *Evelyn Nesbit and Stanford White: Their Love and Death in the Gilded Age* (New York: William Morrow, 1976); E. L. Doctorow, *Ragtime* (New York: Random House, 1975); and two movies, *The Girl in the Red Velvet Swing* (1958) and *Ragtime* (1986).

9. On Bigelow, see Richard Guy Wilson, "McKim's Country House Commissions" (note 1), p. 259 and ff. 52. Also, see Lewis Mumford, *The Brown Decades (1931)* (New York: Dover Publications, 1955), p. 249.

10. On Wells, see the discussion in Wilson, *McKim, Mead & White, Architects* (note 1), pp. 16–17.

11. Notations regarding Stratton's rental of office space, usage of draftsmen, and his commissions appear in *McKim, Mead & White Bill Books*, vols. 1–3 (note 6). In addition to the works noted below, charges appear in Stratton's name for alterations and additions to the Louis V. Bell house, Oyster Bay, and a proposed house for Thomas S. Young at Oyster Bay.

12. "More Fine Houses," *The Sun* (New York), Jan. 14, 1883, p. 3.

13. "A Country House at Cooperstown, New York—Babb, Cook & Willard, Architects," *The Sanitary Engineer* 14 (July 1, 1886), p. 104. See also Robert Guy Wilson, "The Big Gable," *Architectural Review*, London (Aug., 1984), for a discussion of this theme.

14. Moore, *McKim*, Appendix II (note 3).

15. H. Van Buren Magonigle, "A Half Century of Architecture: 3," *Pencil Points* 15 (Mar. 1934), p. 117.

16. Letter quoted in Aline Saarinen, unpublished manuscript on Stanford White, ch. 9, Aline Saarinen Collection, Archives of American Art.

17. Philip Sawyer, *Edward Palmer York: Personal Reminiscences* (Stonington, CT: privately printed, 1951), p. 17.

18. Wilson, *McKim, Mead & White* (note 1), pp. 14–15.

19. Charles H. Reilly, "The Modern Renaissance in American Architecture," *Journal of the Royal Institute of British Architects* 17 (June 25, 1910), pp. 632–34.

20. Richard Guy Wilson, Dianne Pilgrim, and Richard Murray, *The American Renaissance, 1876–1917* (Brooklyn: The Brooklyn Museum, and New York: Pantheon Press, 1979); and Wilson, "Architecture and the Reinterpretation of the Past in the American Renaissance," *Winterthur Portfolio* 18 (Spring 1983), pp. 69–87.

21. Vincent J. Scully, Jr., *The Shingle Style* (New Haven: Yale University Press, 1955).

22. See Wilson, "McKim's Country House Commissions" (note 1); Richard Guy Wilson, "American Architecture and the Search for a National Style in the 1870s," *Nineteenth Century* 3 (Autumn, 1977), pp. 74–80; and accounts in contemporary sources such as George W. Sheldon, *Artistic Country Seats* (New York: D. Appleton & Co., 1886), passim.

23. John A. Gade, "Long Island Country Places Designed by McKim, Mead & White, I. Sherrewogue, St. James," *House and Garden* 3 (Feb. 1903), p. 51.

24. See Wilson, "Scientific Eclecticism," in *The American Renaissance* (note 20), ch. 4.

25. McKim, Mead & White, *Photographs of Renderings*, Album 13, pp. 15–19. McKim, Mead & White Collection, Avery Architectural Library, Columbia University.

26. Lawrence Grant White, *"Box Hill" St. James, Long Island*, private ms. in possession of the White family. See also Trudy Baltz, "Pageantry and Mural Painting," *Winterthur Portfolio* 15 (Autumn 1980), pp. 211–28.

27. Wilhelm Miller, "Successful American Gardens II. The Breese Estate . . ." *Country Life in America* 18 (May 1910), pp. 45–56.

28. Clipping, Aug. 10, 1902, in Mackay Scrapbooks, vol. 1, Mackay Collection, Bryant Public Library, Roslyn, L.I., New York. See also (note 76).

29. Herbert Croly, "The Lay-out of a Large Estate. 'Harbor Hill,' The Country Seat of Mr. Clarence Mackay at Roslyn, L. I.," *Architectural Record* 16 (Dec., 1904), p. 535.

30. Edwin D. Morgan, *Recollections for My Family* (New York: Charles Scribner's Sons, 1938), pp. 174–75.

31. See Robert A. Caro, *The Power Broker: Robert Moses and the Fall of New York* (New York: Vintage Books, 1975), pp. 148–52, 163, and 184–85.

32. Edward, The Duke of Windsor, *A King's Story* (New York: G. P. Putnam's Sons, 1951), p. 200.

33. The Butler house commission is not listed in the *McKim, Mead & White Bill Books* at the New-York Historical Society (note 6). The earliest entry is for July 22, 1878. Moore, *McKim* (note 3), pp. 38–39 and 318, indicates the date as 1871. A letter from Bert Fenner (a McKim, Mead & White partner) to Lawrence S. Butler, son of Prescott Hall Butler, Dec. 10, 1912 (at the New-York Historical Society), gives the date as 1872.

In this letter, a number of plans are mentioned with seemingly accurate dates next to them. More recently Zach Studenroth of the SPLIA has noted (letter from Carol A. Traynor to Robert Guy Wilson, Jan. 31, 1984) that Butler purchased some land in April 1878 and made another purchase in October 1879. In the possession of the present owners of the Butler house is a *Ledger of Accounts by the Harbor: Smithtown, L. I.* with an entry: p. 1, April 3, 1878, for adding some land; p. 2, Building of Cottage and Out-Buildings; 1879, January 16, Mead & Taft on A/C contrast $2,000.00 and McKim, Mead & Bigelow, Architects Commission, $100.00. This account lists no more payments to McKim, Mead & Bigelow but others to Mead & Taft and to building materials suppliers for a total, January 1, 1880, of $5,182.34. On p. 3 the building of the stable is listed as 1878, April 17 through September 31, 1878, and the cost of $873.58. It is doubtful that the Butler house could have been built for such a small sum; the accounts probably are for additions and outbuildings. It is entirely likely that Butler built the house—as was common—before actually owning the land. There is one further piece of evidence to support the date of prior to 1878, in addition to certain primitive features of the house, such as the staircase, which is that McKim designed a bookcase for Butler that was published in *The New York Sketch Book of Architecture* 3 (Sept. 1876), pl. 35.

34. John W. Matheson, *An Historic Sketch of Fort Hill, Lloyd Harbor, Long Island* (n.p., privately printed, [1917]); *The Brickbuilder* (1903); Moore, *McKim* (note 3), pp. 47, 166.

35. Scully, *The Shingle Style* (note 21), p. 82, and Henry-Russell Hitchcock, *The Architecture of H. H. Richardson and His Times* (Cambridge, MA: MIT Press, 1966, rev. ed.), p. 316, have speculated that the excellence of the Alden house was due to Stanford White. This appears to have been impossible. The commission entered the McKim, Mead & Bigelow offices in March or April 1879, the preliminary drawings were ready on May 10, 1879; *McKim, Mead & Bigelow/White Bill Books*, (note 6), vol. I, 45. The house was published in the *American Architect and Building News* 6 (August 30, 1879), p. 69, under the name McKim, Mead & Bigelow. Stanford White had been out of the country since July 1878, and he did not return until September 6, 1879. Additionally, Lawrence G. White, *Sketches and Designs by Stanford White* (New York: 1920), pl. 29, assigned the design of the house to McKim. This sketch had earlier appeared in Mariana G. Van Rensselaer, "American Country Dwellings, III," *The Century* 32 (July 1886), p. 433.

36. Frederick Law Olmsted, Jr., and Theodora Kimball, eds., *Frederick Law Olmsted Landscape Architect, 1882–1903* (New York and London: G. P. Putnam's Sons, 1922, 1928) vol. I; p. 25; the *New York Herald Tribune*, Sept. 1, 1963, sec. II, p. 2. Mosette Glaser Broderick, "A Place Where Nobody Goes: The Early Work of McKim, Mead & White and the Development of the South Shore of Long Island," in *In Search of Modern Architecture: A Tribute to*

Henry-Russell Hitchcock, ed. by Helen Searing (New York: The Architectural History Foundation, and Cambridge, MA: MIT Press, 1982), pp. 199–200, has a brief consideration.

37. White, "*Box Hill*" (note 26).

38. Peter White to Robert Guy Wilson, June 22, 1973.

39. Moore, *McKim* (note 3), p. 305. Guest books of "Box Hill" in the possession of Laura White, Saint James, L.I., New York.

40. John A. Gade, "Long Island Country Places Designed by McKim, Mead & White, III. Mrs. Stanford White's Home at St. James," *House and Garden* 3 (Apr., 1903), pp. 198–207; see also Barr Ferree, *American Estates and Gardens* (New York: Munn and Co., 1904), pp. 138–46; Guy Lowell, ed., *American Gardens* (Boston: Bates & Guild, 1902), pls. XII-XIV, and passim; and John Cordis Baker, ed., *American Country Homes and Their Gardens* (Philadelphia: House and Garden, 1906), pp. 204–19.

41. Illustrated in Mark Girouard, *The Victorian Country House* (Oxford: Oxford University Press, 1971), figs. 367 and 370.

42. White, "*Box Hill*" (note 26); also, a drawing dated January 1899 at the Avery Library shows this scheme.

43. *McKim, Mead & White Bill Books*, II (note 6), pp. 157, 217; the house is treated briefly in Broderick, "A Place Where Nobody Goes" (note 36), pp. 188–89; and Scully, *Shingle Style* (note 21), p. 145.

44. Sheldon, *Artistic Country Seats* (note 22), p. 165.

45. *McKim, Mead & White Bill Books*, III (note 6), pp. 157, 217; the casino is briefly treated in Broderick, "A Place Where Nobody Goes" (note 36), pp. 185–87. Letter from Carl A. Starace, editor of the *Long Island Forum* to Robert Guy Wilson, Feb. 6, 1974.

46. See Richard Guy Wilson, "From Informality to Pomposity: The Resort Casino in the Later 19th Century," in *Victorian Resorts and Hotels*, ed., Richard Guy Wilson (Philadelphia: The Victorian Society, 1982), pp. 111–16.

47. Sheldon, *Artistic Country Seats* (note 22), pp. 101–4.

48. James & Chabot, *The Argyle Hotel* (n.p.: James & Chabot, c. 1902). See also, *Picturesque Babylon, Bay Shore and Islip* (New York: Mercantile Illustrating Co., 1894), p. 19; and *Brooklyn Life* (June 15, 1895), p. 41.

49. John Gilmer Speed, "An Artist's Summer Vacation," *Harper's New Monthly Magazine* 87 (June 1893), p. 4.

50. Charles Baldwin, *Stanford White* (New York: Dodd, Mead & Co., 1931), p. 271; Broderick, "A Place Where Nobody Goes" (note 36), pp. 197–98. See also, letters, Charles Atterbury to Stanford White, Sept. 6, 1889, Mar. 11, 1891, and Jan. 8, 1892; Manuscript Room, The New-York Historical Society.

51. McKim, Mead & White, *Photographs of Renderings*, Album 8 (note 25), p. 69, Avery Architectural Library, Columbia University. Baldwin, *White* (note 4), p. 317, claims the Atterberry [sic] house became Chases's house and studio. Material in the Archives of American Art, Roll N/69–115, frames 005–007, has information on Chases's houses; as does also Katherine Metcalf Roof, *The Life and Times of William Merritt Chase* (New York: Charles Scribner's Sons, 1917) pp. 162–65, 175–85.

52. Speed, "An Artist's Summer Vacation" (note 49), p. 5.

53. Morgan, *Recollections* (note 30), passim, and p. 276.

54. John A. Gade, "An Ideal American Country Place," *Architectural Review* 14 (Sept. 1907), p. 201.

55. Russell Sturgis, "The Work of McKim, Mead & White," *Architectural Record*, Great American Architect Series (May 1895), p. 59.

56. Gade, "An Ideal American Country Place" (note 54), p. 201.

57. Morgan, *Recollections* (note 30), p. 171.

58. Certainly McKim did not do all of the designing; for instance, a letter from Charles McKim to Edwin D. Morgan, Apr. 21, 1899, Library of Congress, indicates that Henry Bacon (then in the office) did some of the work, and Stanford White did the wainscot in the chapel.

59. Morgan, *Recollections* (note 30), p. 174, and also p. 49.

60. Letter from Elizabeth Jay Hollins to Julia Freeman Fairchild, reprinted in: Julia Freeman Fairchild, *A Fifty Year History of the North Country Garden Club, 1913–1963*, p. 29; reference courtesy of Barbara Ferris Van Liew.

61. Morgan, *Recollections* (note 30), p. 162.

62. The commission was originally billed to Samuel L. Parrish, *McKim, Mead & White Bill Books* (note 6), vol. 4, p. 214. On the club's history, see Ross Goodner, *The 75 Year History of Shinnecock Hills Golf Club* (Southampton: Shinnecock Hills Golf Club, 1966); and Samuel L. Parrish, *Some Facts, Recollections and Personal Reminiscences Connected with the Introduction of the Game of Golf into the United States—More Especially as Associated with the Formation of the Shinnecock Hills Golf Club* (New York: privately printed, 1923). Broderick, "A Place Where Nobody Goes" (note 36), pp. 187, 197–98, briefly covers the club. H. B. Martin, *Fifty Years of American Golf* (New York: Dodd, Mead & Co., 1936), op. p. 22, claims it to be the first clubhouse.

63. Quoted in M. H. Smith, *History of Garden City* (Manhasset, NY: Channel Press, Inc., 1963), p. 20; my thanks to Mrs. Smith for her help on the history of the hotel and Garden City.

64. *McKim, Mead & White Bill Books* (note 6), vol. 5, p. 1, Oct. 12, 1893, lists a commission on "Houses at Garden City." At the bottom it is noted payment was received from David W. King and S. Edson Gage.

65. John Maass, "Architecture and Americanism or Pastiches of Independence Hall," *Historic Preservation* 22 (Second Quarter, 1970), pp. 17–25.

66. Roy R. Silver, "Famed Garden City Hotel Is Closing," *New York Times*, July 16, 1971, p. 33.

67. "New Chapter Begins in Garden City Hotel History," *Garden City News*, November 11, 1965, pp. 17–18; and Smith, *History of Garden City* (note 63), passim.

68. Related to the author by different family members during the summer of 1973.

69. *McKim, Mead & White Bill Books* (note 6), vol. 5, pp. 91 and 245, notes charges for "draughtsmen time." At the Avery Library, *McKim, Mead & White, Photographs of Renderings* (note 25), Album 8, p. 73, there is a photograph labeled "Wetherill" that is different from the house as built.

70. Gade, "Sherrewogue" (note 23), p. 51.

71. Baldwin, *White* (note 4), p. 326, assigns the house to White; a letter from Frances Breese Miller (Breese's daughter) to Wilson, Oct. 5, 1973, remembers McKim being largely in charge. Materials at the New-York Historical Society and the Library of Congress indicate both partners had a hand.

72. Janet Scudder, *Modeling My Life*, reprinted in Baldwin, *White* (note 4), p. 283.

73. Letter from Charles McKim to James L. Breese, Jan. 7, 1903, Library of Congress; and drawings for studio addition in possession of Robert White.

74. John A. Gade, "Long Island Country Places, Designed by McKim, Mead & White II—'The Orchard' at Southampton," *House and Garden* 3 (Mar. 1903), pp. 117, 126; see also Henry H. Saylor, "The Best Twelve Country Houses in America, I, The Home of James L. Breese, Esq., at Southampton, L. I.," *Country Life in America* 27 (Mar. 1915), pp. 46–50; Miller, "Successful American Gardens" (note 27); Barr Ferree, *American Estates and Gardens* (note 40), pp. 172–81; and Liisa and Donald Sclare, *Beaux-Arts Estates on Long Island* (New York: Viking Press, 1979), pp. 228–35.

75. Letter from Stanford White to Clarence Mackay, Apr. 18, 1900, the New-York Historical Society.

76. This material is based upon Ellin Berlin, *Silver Platter* (New York: Doubleday, 1957); Mrs. Berlin was the daughter of Clarence Mackay and married the composer Irving Berlin; John William Mackay, *National Cyclopedia of American Biography* (New York: James T. White, 1897), vol. 4, p. 487; Clarence Hungerford Mackay, *National Cyclopedia of American Biography*, vol. 21, pp. 24–25; and 46 family scrapbooks and eight other files in the Bryant Library, Roslyn, L.I., New York, which contain newspaper clippings, magazine articles, and other information. Lawrence Wodehouse, "Stanford White and the Mackays," *Winterthur Portfolio* 11 (1976), pp. 213–33, covers some of the same material but with a different emphasis. When I began my research on the Mackay's in the summer of 1971 and 1973, I did not know of Professor Wodehouse's work.

77. Katherine Mackay to Stanford White, July 24 [1899], The New-York Historical Society. All further references to correspondence between the Mackays and White and the firm, unless noted, will be from this collection.

78. K. Mackay to S. White, July 27, [1899].

79. C. Mackay to S. White, Feb. 24, 1903.

80. Barr Feree, "On Architecture," *Scientific American Building Monthly* (Sept. 1903), p. 60, clipping from the Bryant Library. This was largely reprinted in Ferre, *American Estates and Gardens* (note 40), pp. 26–35.

81. "Journey started February 21, 1903 from Florence to note objects . . ." Document in McKim, Mead & White collection, the New-York Historical Society.

82. K. Mackay to S. White, May 23, 1901.

83. C. Mackay to S. White, Feb. 24, 1903.

84. C. Mackay to S. White, Nov. 2, 1902.

85. S. White to C. Mackay, Apr. 18, 1900.

86. C. Mackay to S. White, Apr. 15, 1901.

87. S. White to C. Mackay, Oct. 27, 1904.

88. S. White to C. Mackay, Jan. 24, 1903.

89. Guy Lowell, ed., "Introduction," *American Gardens* (Boston: Bates & Guild Company, 1902), n.d.

90. Herbert Croly, "The Lay-out of a Large Estate" (note 29), p. 549. Peter Ross, *A History of Long Island* (New York: Lewis Publishing Company, 1902), vol. 3, p. 914.

91. While Lowell was apparently responsible for the formal garden to the west of the house, drawings apparently by McKim, Mead & White exist in a McKim, Mead & White *Album* 13, pp. 42–44, Avery Architectural Library, Columbia University. Photographs of these drawings exist at the Museum of the City of New York, McKim, Mead & White Collection. Later, Jacques Greber replanned the garden; see his *L'Architecture aux États-Unis* (Paris: Payot, 1920) vol. 1, pp. 74, and pl. VIII.

92. Croly, "The Lay-out of a Large Estate" (note 29), p. 554.

93. Ferree, "On Architecture" (note 80), p. 47.

94. Clipping, August 10, 1902, Mackay scrapbooks (note 76), vol. II.

95. Quoted in Wodehouse, "Stanford White and the Mackays" (note 76), p. 230.

96. Information from the *Dictionary of American Biography* (New York: Charles Scribner's Sons, 1946), vol. 20, pp. 165–66; and *National Cyclopedia of American Biography*, vol. 2, pp. 407–8.

97. Given the usual character of the design and the later work of Harrie T. Lindeberg, one would be tempted to assign it to him; however, the roster in Moore, *McKim* (note 3), p. 334, indicates Lindeberg did not enter the office until February 1901. *The McKim, Mead & White Bill Books* (note 6), vol. 7, pp. 108, 124, 169, 358, and 413, indicate design work began in April 1900; however, some of the earlier work was on farm buildings. The house *could* have been designed in early 1901; however, to assign it to Lindeberg is *pure speculation*.

98. Lutyens began to be published in *Country Life* in 1899. A tantalizing parallel is Frank Lloyd Wright's Nathan G. Moore house, Oak Park, 1895 (reconstructed in 1923) which has similar tall gables. On the Whitney house, see "A Notable Country Seat," *New-York Tribune Illustrated Supplement*, Sept. 14, 1902, pp. 8–9. For interiors, see, Harry Desmond and Herbert Croly, *Stately Homes in America* (New York: D. Palleton & Co., 1903), pp. 475, 479, and 481. See also *Town & Country* (Nov. 16, 1901), pp. 25–28.

99. The Coolidge house is illustrated in *Monograph of the Works of McKim, Mead & White* (note 1), (vol. 2, 1915–1920, pl. 222–24).

100. Letter from Charles McKim to William R. Mead, Apr. 2, 1902, Library of Congress; and *McKim, Mead & White Bill Books* (note 6), vol. 8, p. 165.

101. Ferree, *American Estates* (note 40), p. 147.

102. Ibid., p. 153.

Addison Mizner, page 300
SELECTED SOURCES

NEWSPAPERS

Plain Talk (Port Washington, NY), 1911–1914.

Port Washington (NY) *News*, 1907–1917.

PUBLISHED BOOKS

Andrews, Wayne *The Vanderbilt Legend: The Story of the Vanderbilt Family, 1794–1940* (New York: Harcourt, Brace and Co., 1941).

Curl, Donald W., *Mizner's Florida: American Resort Architecture* (New York: Architectural History Foundation and MIT Press, 1984).

Florida Architecture of Addison Mizner (New York: William Helburn, 1928).

Johnson, Alva, *The Legendary Mizners* (New York: Farrar, Straus and Young, 1953).

Marshall, Virginia D., *Port Washington Recalled* (Port Washington, NY: Port Printing Service, 1967).

Mizner, Addison, *The Many Mizners* (New York: Sears Publishing Co., 1932).

Orr, Christina, *Addison Mizner: Architect of Dreams and Realities (1872–1933)* (West Palm Beach, FL: Norton Gallery and School of Art, 1977).

PERIODICAL ARTICLES

Kent, Joan, "The Baxter Homestead: Busy Past, Busy Present," *Cow Neck Historical Journal* (Oct. 1970), pp. 12–14.

"The Old Cow Bay Manor House," *Architectural Record* 56 (Mar. 1917), pp. 259–66.

Jacob Wrey Mould, page 304
SELECTED SOURCES

Bicknell, Amos Jackson, *Wooden and Brick Building, with details, containing one hundred and sixty plates, plans, elevations, views, sections and details of villas, cottages, farm houses, country seats, street fronts for dwellings, published under the direction of A. J. Bicknell,* (New York: A. J. Bicknell & Co., 1875). Reprinted in 1977 by DeCapo Press.

Landau, Sarah Bradford, "Richard Morris Hunt, the Continental Picturesque, and the 'Stick Style,'" *Journal of the Society for Architectural Historians* 42 (1983), pp. 281–82.

"A Princely Home in the Suburbs of New York—How Railroad Princes Live," *The Horticulturist and Journal of Rural Art and Rural Taste* 28 (1873) 268–69.

James W. O'Connor, page 309

1. *New York Times*, November 18, 1952, 31.

2. *Architectural Record* 113 (Jan. 1953), p. 280.

3. O'Connor met Dorothy Ladew Williams as a young girl through his friendship with J. P. Grace and W. R. Grace, Jr.

4. W. R. Grace had been Mayor of New York City for two nonconsecutive terms in 1880 and 1884. See J. P. Grace, "W. R. Grace (1832–1904) and the Empires He Created," American Newcomer Society, Collection New-York Historical Society.

5. The interrelationship of the Ladew and Grace families is further evident in the 1914 marriage of Elise Ladew to W. R. Grace, Jr.

6. For many years O'Connor had a prominent part in staging the well-known annual Beaux-Arts Balls. See *New York Times*, November 18, 1952. His name is also listed in Beaux-Arts Society Bulletins, Avery Architectural Library, Columbia University.

7. Ada Louise Huxtable, "What's Best for Business Can Ravage Cities," *New York Times*, Apr. 6, 1975, 1, 31.

8. Although the New Buildings Application of 1912 (see N. B. 437–12, Municipal Archives, New York City) lists O'Dench, Yost, and James O'Connor as architects, O'Connor seems to be credited with the design of this building. A picture of the building appears in the 1922 catalog of his work for which he received a prize from The Architectural League "for the best designed building in downtown New York, that of the Grace Steamship Lines." A picture of this building appears in a 1922 catalogue of his work, *Work Designed by James W. O'Connor, Architect* (Architectural Catalog Company, New York, 1922).

9. James W. O'Connor is listed as the sole architect for the design and a 1920s addition; see New Buildings Application 437–12, Municipal Archives, New York City.

10. *Covered Tennis Courts, James W. O'Connor, Architect* (Architectural Catalog Company, New York, 1932).

11. Although The Morrisania Project was built, it was the last time O'Connor ever attempted a city project. Given his background, it makes sense that he would have trouble with city housing. He actually designed statues for the grounds which were repeatedly vandalized. Finally, he removed the statues at his own expense.

12. This facility was never built. Though credited for the plan, O'Connor basically gave the design of this facility over to a younger architect, William N. Breger.

13. *The American Architect* (Feb. 24, 1909), 951, no. 1731, p. 67.

14. "English Manor House," *New York Times*, Feb. 3, 1911, 2:7.

15. See *Covered Tennis Courts, James W. O'Connor Architect* (New York: Architectural Catalogue Co., Inc., 1932).

16. *Architectural Record* 59 (Feb. 1926), p. 110–21.

17. Preview Brochure Listing 40831, "Midland Farm," East Norwich, L.I, New York. SPLIA archives.

Olmsted Brothers, page 315

I am very grateful to Lucinda Whitehill Brockway for her initial research into the FLON plan file in 1981, which has made a complicated task much easier.

APPENDIX A

MR. H. H. ROGERS
SOUTHAMPTON, NEW YORK
PLANTING LIST
TO ACCOMPANY NO. 68
FILE NO. 6042
OLMSTED BROTHERS
BROOKLINE, MASS.
LANDSCAPE ARCHITECTS
MARCH 13, 1915
TYPED JULY 29, 1931

1. Catalpa, 8 plants

2. Wisteria multijuga, 2 plants
 Longoluster Wisteria

3. Clematis paniculata, 3 plants
 Sweet Autumn Clematis

4. Ailanthus glandulosa, 56 plants
 Ailanthus

5. Fagus americana, 12 plants
 American Beech

6. Juniperus virginiana, 13 plants
 Redcedar

7. Acer dasycarpus, 33 plants
 Silver Maple

8. Catalpaspeciosa, 100 plants
 Western Catalpa

9. Salix pentandra, 12 plants
 Laurel Willow

10. Morus alba, 1 plant
 White Mulberry

11. Koelreuteria paniculata, 19 plants
 Goldenrain Tree

12. 9 Beds, 173 Plants, 8' apart
 Salix pentandra, 100 plants
 Laurel Willow
 Salix alba, 73 plants
 White Willow

13. Syringa vulgaris, 66 plants, 3½' apart
 Common Lilac

14. 12 Beds, 66 Plants, 10' apart
 Philadelphus coronarius aurea, 20 plants
 Golden Mockorange
 Viburnum sieboldi, 15 plants
 Siebold Viburnum
 Ligustrum ibota, 16 plants
 Ibota Privet
 Aralia pentaphylla, 15 plants
 Five-Leaf Aralia

15. Robinia pseudacia, 3 plants
 Common Locust

16. Gleditsia triacanthos, 8 plants
 Common Honeylocust

17. Prunus serotina, 36 plants
 Wild Black Cherry

18. Ligustrum ovalifolium, 38 plants, 10' apart
 California Privet

19. Rhus cotinus, 9 plants
 Common Smoketree

20. Aesculus parviflora, 4 plants
 Bottlebrush Buckeye,
 or Japanese Maple, 4 plants

21. 15 Beds, 354 Plants, 3' apart
 Rhus copallina, 70 plants
 Shining Sumac
 Myrica cerifera, 107 plants
 Southern Waxmyrtle

22. Ampelopsis quinquefolia, 220 plants, 12' apart
 Virginia Creeper

23. Ilex crenata, 3 plants
 Japanese Holly

24. 4 Beds, 170 Plants, 3' apart
 Mahonia aquifolia, 40 plants
 Oregon Hollygrape
 Ilex glabra, 30 plants
 Inkberry
 Leucothoe catesbaei, 40 plants
 Drooping Leucothoe
 Euonymus radicans carrierei, 40 plants
 Glossy Wintercreeper
 Euonymus radicans reticulata, 20 plants
 Whitevein Wintercreeper

25. 5 Beds, 89 Plants, 2½' apart
 Rose Mme. Georges Bruant, 39 plants
 Hybrid Rugosa Rose–white
 Rose Blanche Double de Coubert, 50 plants
 Hybrid Rugosa Rose–white

26. Rhododendron maximum, hybrids, 82 plants, 6' apart
 Hybrid Rhododendrons

27. Kalmia latifolia, 14 plants, 5' apart
 Mountain Laurel

28. 9 Beds, 133 Plants, 5' apart
 Viburnum sieboldi, 20 plants
 Siebold Viburnum
 Tamarix africana, 17 plants
 African Tamarix
 Philadelphus in varieties, 30 plants
 Mockorange
 Weigela Eva Rathke, 20 plants
 Pink Weigela
 Ligustrum ibota, 15 plants
 Ibota Privet
 Ligustrum regelianum, 15 plants
 Regel Privet
 Amorpha fruticosa, 16 plants (omitted)
 Indigobush

29. Aesculus hippocastanum rubrum, 2 plants,
 Red Horsechestnut

30. Aralia spinosa, 17 plants, 5' apart
 Devils Walkingstick

31. Rhus typhina, 12 plants, 5' apart
 Staghorn Sumac

32. 5 Beds, 82 Plants, 3' apart
 Rosa lucida, 42 plants
 Virginia Rose
 Rosa blanda, 40 plants
 Meadow Rose

33. Berberis thunbergi, 10 plants, 4' apart
 Japanese Barberry

34. Ligustrum regelianum, 25 plants, 3' apart
 Regel Privet

35. Philadelphus coronarius aurea, 9 plants, 5' apart
 Golden Mockorange

36. 1 Bed, 10 Plants, 6' apart
 Philadelphus in variety,
 Mockorange
 Deutzia crenata Pride of Rochester, 5 plants
 Fuzzy Deutzia
 Exochorda grandiflora, 5 plants
 Pearlbush

37. 17 Beds, 120 Plants
 Lilium croceum
 Orange Lily
 Lilium martagon
 Martagon Lily
 Lilium martagon album
 White Martagon Lily
 Lilium japonicum
 Japanese Lily
 Lilium chalcedonicum
 Chalcedonian Lily

38. 7 Beds, 48 Plants
 Lilium auratum
 Goldband Lily
 Lilium krameri (japonicum)
 Japanese Lily
 Lilium speciosum roseum
 Pink Speciosum Lily
 Lilium henryi
 Henry Lily
 Lilium batemanni
 Bateman Lily

39. Not used.

40. Hibiscus moscheutos, pink and white, 100 plants
 Common Rosemallow

41. Crataegus oxyacantha, 6 plants
 English Hawthorn

42. Platanus occidentalis, 18 plants
 European Planetree

43. 6 Beds, 158 Plants, 3' apart
 Rosa rugosa
 Rugosa Rose
 Rosa rugosa alba
 White Rugosa Rose

44. Lycium chinensis, 15 plants
 Chinese Matrimony-vine

45. Tecoma radicans, 7 plants
 Trumpet-creeper

46. Ipomea Heavenly Blue
 Heavenly Blue Morning Glories

47. 2 Beds, 40 Plants, 2' apart
 Hemerocallis thunbergi, 10 plants
 Japanese Daylily
 Hemerocallis flava, 10 plants
 Lemon Daylily
 Funkia sieboldiana, 10 plants
 Cushion Plantainlily
 Funkia subcordata grandiflora, 10 plants
 Large White Plantainlily

48. Vitis labrusca varieties, 38 plants
 Foxgrape

49. Apple, Porter, 2 plants

50. Apple Red Astrachan, 3 plants

51. Apple, Early Harvest, 3 plants

52. Ilex opaca, 3 plants
 American Holly

53. Buxus suffruticosa, 100 plants
 Boxwood

54. Prunus serotina, 4 plants, hedge
 Wild Black Cherry

55. Carpinus betulus, 17 plants
 European Hornbeam

56. Syringa japonica, 2 plants
 Japanese Tree Lilac

57. Apple, Yellow Transparent, 2 plants

58. Buddleia varabilis magnifica, 6 plants
 Oxeye Butterflybush

59. Amorpha canescens, 5 plants
 Leadplant

60. Hypericum calycinum, 400 plants, 1' apart
 St. Johnswort

61. Pachysandra terminalis, 1,000 plants, 9" apart
 Japanese Pachysandra

62. Hedera helix, 584 plants, 2½' apart
 English Ivy

63. 19 Beds, 245 Plants, 5' apart
 Lonicera fragrantissima, 10 plants
 Winter Honeysuckle
 Lonicera tatarica alba, 15 plants
 White Tatarian Honeysuckle
 Lonicera bella albida, 10 plants
 White Belle Honeysuckle
 Lonicera chrysanthia, 10 plants
 Coralline Honeysuckle
 Ligustrum vulgaris, 30 plants
 European Privet
 Philadelphus grandiflorus, 20 plants
 Big Scentless Mockorange
 Philadelphus zeyheri speciossissimus, 10 plants
 Roundleaf Mockorange
 Hamamelis virginiana, 20 plants
 Common Witch-hazel
 Azalea nudiflora, 50 plants
 Pinxterbloom
 Azalea arborescens, 50 plants
 Sweet Azalea
 Viburnum dentatum, 10 plants
 Arrowwood
 Viburnum dilatatum, 10 plants
 Linden Viburnum

64. 9 Beds, 267 Plants, 4' apart
 Viburnum opulus, 10 plants
 European Cranberrybush
 Viburnum dentatum, 15 plants
 Arrowwood
 Rhamnus cathartica, 15 plants
 Common Buckthorn
 Rhodotypos kerrioides, 30 plants
 Jetbead
 Ligustrum ibota, 25 plants
 Ibota Privet
 Ligustrum vulgaris, 25 plants
 European Privet
 Azalea calendulacea, 50 plants
 Flame Azalea
 Azalea viscosa, 50 plants
 Swamp Azalea
 Diervilla florida candida, 10 plants
 Drimson Weigela
 Eleagnus longipes, 20 plants
 Cherry Eleagnus
 Philadelphus grandiflorus, 10 plants
 Big Scentless Mockorange
 Philadelphus coronarius, 7 plants
 Sweet Mockorange

65. Plumbago larpente
 Larpente Plumbago

66. Annual vines on walls under grape arbor, from seed
 Tropaeolum canariensis
 Canary Nasturtium
 Dolichos Daylight
 Hyacinth-Bean–white
 Dolichos Darkness
 Hyacinth-Bean-purple
 Momordica balsamina
 Balsam-apple
 Thunbergia grandiflora
 Bengal Clockvine

67. Under Grape Arbor, next to walls
 Funkia coerulea, 50 plants
 Blue Plantainlily
 Funkia fortunei gigantea, 50 plants
 Great Plantainlily
 Funkia subcordata grandiflora, 50 plants
 Great White Plantainlily
 Funkia sieboldiana, 50 plants
 Cushion Plantainlily
 Tradescantia virginica, 50 plants
 Virginia Spiderwort
 Tradescantis virginia alba, 50 plants
 White Virginia Spiderwort
 Osmunda claytoniana, 50 plants
 Interrupted Fern
 Dicksonia punctilobula, 50 plants
 Hay-scented Fern
 Aspidium marginale, 50 plants
 Leather Woodfern

68. Under Grape Arbors
 Anemone japonica Queen Charlotte, 50 plants
 Japanese Anemone-pink
 Campanula pyramidalis, 60 plants
 Chimney Bellflower
 Oenothera missouriensis, 30 plants
 Ozark Sundrops
 Ageratum, from seed
 Tradescantia virginica, 30 plants
 Virginia Spiderwort
 Tradescantia virginica alba, 30 plants
 White Virginia Spiderwort
 Onoclea struthiopteris, 12 plants
 Ostrich Fern
 Osmunda claytoniana, 12 plants
 Interrupted Fern
 Dicksonia punctilobula, 12 plants
 Hay-scented Fern
 Asplenium felix-foemina, 12 plants
 Lady Fern
 Hemerocallis citrina, 30 plants
 Citron Daylily
 Hemerocallis minor, 60 plants
 Dwarf Daylily
 Hypericum calycinum, 60 plants
 St. Johnswort
 Calceolaria, dwarf yellow form, 150 plants
 Calceolaria

69. 1 Bed, 1,000 Plants
 Aspidium marginale, 200 plants
 Leather Woodfern
 Aspidium acrostichoides, 200 plants
 Christmas Fern
 Dicksonia punctilobula, 200 plants
 Hay-scented Fern
 Camunda claytoniana, 100 plants
 Interrupted Fern
 Asplenium felx-foemina, 100 plants
 Lady Fern
 Asplenium angustifolium, 100 plants
 Silvery Spleenwort
 Galax aphylla, 100 plants
 Galax

70. 1 Bed, 180 Plants
 Aconitum wilsoni, 10 plants
 Violet Monkshood
 Aconitum napellus, 10 plants
 Aconite
 Senecio clivorum, 12 plants
 Gromwell
 Viola cornuta varieties, 50 plants
 Tufted Pansy - blue, white and yellow
 Lysimachia clothriodes, 20 plants
 Clethra loosestrife
 Cimicifuga simplex, 20 plants
 Kamchatka Bugbane
 Thalictrum adiantifolium, 20 plants
 Maidenhair Meadowrue
 Gentiana andrewsi, 20 plants
 Closed Gentian
 Lythrum roseum superbum, 15 plants
 Rose Campion
 Campanula persicifolia, 20 plants
 Peachleaf Bellflower
 Thalictrum flavum, 12 plants
 Yellow Meadowrue
 Anemone pennsylvanica, 25 plants
 Meadow Anemone

71. 2 Beds, 38 Plants
 Bambusa aurea, 4 plants
 Golden Japanese Bamboo
 Bambusa Viminalis, 10 plants
 Dwarf Cane
 Pennisetum japonicum, 6 plants
 Crimson Fountain Grass
 Arundo donax, 2 plants
 Giant Reed
 Bambusa metake, 6 plants
 Arrow Bamboo
 Kerria japonica, 10 plants
 Kerria

72. Ampelopsis lowi (small-leaved), 44 plants
 Geranium Creeper

73. 2 Beds, 970 Plants, 2' apart
 Myrica cerifera, 160 plants
 Southern Waxmyrtle
 Ampelopsis quinquefolia, 165 plants
 Virginia Creeper
 Rosa lucida, 165 plants
 Virginia Rose
 Prunus maritima, 160 plants
 Beach Plum
 Cytisus scoparius, 160 plants
 Scotch Broom

74. 2 Beds, 300 Plants, 2' apart
 Lathyrus maritima, 100 plants
 Sea-side Pea
 Veronica martima, 100 plants
 Beach Speedwell
 Solidago odora, 100 plants
 Fragrant Goldenrod
 Portulaca, from seed

75. Hedera helix, 9 plants
 English Ivy

76. Euonymus radicans, 8 plants
 Wintercreeper

77. Bambusa aurea, 3 plants
 Golden Japanese Bamboo

78. Lilium auratum, 10 bulbs, 2' apart
 Goldband Lily

79. Hemerocallis flava, 20 plants, 1½' apart
 Lemon Daylily

80. 4 Beds, 60 Plants, 1½' apart
 Tradescantia virginica, 40 plants
 Virginia Spiderwort
 Tradescantia virginica alba, 20 plants
 White Virginia Spiderwort

81. 2 Beds, 10 Plants, 2' apart
 Astilbe Salmon Queen, 5 plants
 Astilbe
 Astilbe White Pearl, 5 plants
 Astilbe

82. 2 Beds, 12 Plants, 2' apart
 Bambusa henonis, 6 plants
 Blackjoint Bamboo
 Bambusa simoni, 6 plants
 Simmond's Bamboo

83. Myosotis palustris, 80 plants, 9" apart
 True Forget-Me-Not

84. Hollyhock Newport Pink, 12 plants

85. Delphinium formosum, 9 plants, 2' apart
 Hardy Larkspur

86. Digitalis purpurea, 50 plants, 1½' apart
 Common Foxglove

87. Anemone pennsylvanicum, 100 plants, 1½' apart
 Meadow Anemone

88. Trollius europeus, 30 plants, 2' apart
 Common Globeflower

89. Iris kaempferi, 22 plants
 Japanese Iris

APPENDIX B

MR. MARSHALL FIELD
LLOYD'S NECK, LONG ISLAND
PLANTING WEST OF HOUSE
LIST TO ACCOMPANY PLAN NO. 26
FILE NO. 7359
OLMSTED BROTHERS
LANDSCAPE ARCHITECTS
BROOKLINE, MASS.
FEBRUARY 15, 1926.

1. Forsythia suspensa or intermedia, 4 plants, large
 Weeping or Border Forsythia

2. Fagus sylvatica, 2 plants, planted
 European Beech

3. Hornbeam, 7 plants, planted

4. Hybrid Rhododendrons, 3' apart, 175 plants, 18"–3'

5. Rhododendron maximum, 3' apart, 1000 plants, 2–4'
 Rosebay Rhododendron

6. 2 beds, 1150 plants, 2½' apart
 Kalmia latifolia, 550 plants, 18"–2 ½'
 Mountain-laurel
 Azalea nudiflora, 150 plants, 18" – 3'
 Pinxterbloom
 Azalea canescens, 150 plants, 18"–3'
 Piedmont Azalea
 Azalea vaseyi, 150 plants, 18"–2 ½'
 Pinkshell Azalea
 Azalea arborescens, 150 plants, 2–3'
 Sweet Azalea

7. Kalmia latifolia, 2½' apart, 290 plants, 18"–2½'
 Mountain-laurel

8. 1 bed, 110 plants, 2½' apart
 Rhus canadensis, 50 plants, 2–3'
 Fragrant Sumac
 Symphoricarpos vulgaris, 60 plants, 2–3'
 Coralberry

9. 3 beds, 152 plants, 3' apart,
 Aronia arbutifolia, 75 plants, 3–4'
 Red Chokeberry
 Aronia melanocarpa, 77 plants, 3–4'
 Black Chokeberry

10. 1 bed, 65 plants, 4' apart
 Cornus alternifolia, 20 plants, 5–6'
 Pagoda Dogwood
 Forsythia viridissima, 25 plants, 4–5'
 Greenstem Forsythia
 Ligustrum vulgare, 20 plants, 4–5'
 European Privet

11. 1 bed, 85 plants, 4' apart
 Viburnum cassinoides, 30 plants, 4–5'
 Withe-rod
 Lonicera morrowi, 30 plants, 4–5'
 Morrow Honeysuckle
 Rhamnus caroliniana, 25 plants, 5–6'
 Carolina Buckthorn

1. For a listing of the entire output of the firm up to 1950, by state and design type, see Charles E. Beveridge and Carolyn F. Hoffman, *The Master List of Design Projects by the Olmsted Firm, 1857–1950* (Washington, D.C.: National Association for Olmsted Parks, 1987). Residential commissions account for more than one-third of this listing (pages 75–134). It should be stressed that this listing is preliminary in that it does not distinguish between projects that involved a complete design and those that may have progressed no further than an initial consultation or preliminary drawings, or those that may have involved additions to or a re-design of an existing site. There is also no way of determining from the list alone whether the landscapes designed by the Olmsted firm still remain on the ground or whether they have been obliterated or altered by later events.

2. There is currently a large body of scholarly research on Frederick Law Olmsted, Sr. The best sources for an overview of his life and work are: Albert Fein, *Frederick Law Olmsted and the American Environmental Tradition* (New York: George Braziller, 1972); Laura Wood Roper, *FLO: A Biography of Frederick Law Olmsted* (Baltimore: Johns Hopkins University Press, 1973); Elizabeth Stevenson, *Park Maker: A Life of Frederick Law Olmsted* (New York: Macmillan, 1977); and Julius G. Fabos, Gordon T. Milde, and V. Michael Weinmayr, *Frederick Law Olmsted, Sr., Founder of Landscape Architecture in America* (Amherst, MA: University of Massachusetts Press, 1968). See also Charles Capen McLaughlin and Charles E. Beveridge, eds., *The Papers of Frederick Olmsted* (Baltimore: Johns Hopkins University Press), a twelve-volume series, of which the first six volumes have been issued to date.

The career of Calvert Vaux is also being reevaluated. For the most recent and complete information, see William Alex and George B. Tatum, *Calvert Vaux, Architect & Planner* (New York: Ink, Inc., 1994); Dennis Steadman Francis and Joy M. Kestenbaum, "Calvert Vaux," *MacMillan Encyclopedia of Architects* (New York: The Free Press, 1982), vol. IV, pp. 303–04; and John David Sigle, comp., "Bibliography of the Life and Work of Calvert Vaux," *Papers of the American Association of Architectural Bibliographers* (Charlottesville, VA: University Press of Virginia, 1968), vol. V, pp. 69–93.

3. For Jacob Weidenmann, see Norman T. Newton, *Design on the Land: The Development of Landscape Architecture* (Cambridge, MA: Harvard University Press, 1971), pp. 307–08. For John Charles Olmsted, see "John Charles Olmsted: A Minute on His Life and Service," *Transactions of the American Society of Landscape Architects*, vol. II (1909–1921), 104–07. For Charles Eliot (Charles W. Eliot), see *Charles Eliot, Landscape Architect* (Boston: Houghton Mifflin, 1902). For Henry Sargent Codman, see his obituary in *Garden and Forest* 6, no. 256 (January 18, 1893), p. 36, and the *Boston Evening Transcript*, January 14, 1893. For the Montauk Summer Colony, see F. L. Olmsted, Jr., and Theodora Kimball, eds., *Frederick Law Olmsted, Landscape Architect, 1822–1903* (New York: Benjamin Blom, 1970, reprint ed.), p. 25; Leland M. Roth, *McKim, Mead & White* (New York: Harper and Row, 1983), p. 71; and the National Register nomination for the Montauk Association Historic District (copy on file at SPLIA). Montauk is not discussed in detail in this article, since it was a subdivision rather than a residential plan.

4. For Frederick Law Olmsted, Jr., see Newton, *Design on the Land* (note 3), pp. 389–90, and Edward Clark Whiting and William Lyman Phillips, "Frederick Law Olmsted, 1870–1957, An Appreciation of the Man and His Achievements," *Landscape Architecture* 48, no. 3 (Apr. 1958), pp. 144–57.

5. For Edward Clark Whiting, see American Society of Landscape Architects, *Bulletin* 105 (Aug. 1962), p. 10.

6. For Percival Gallagher, see *Landscape Architecture* 24, no. 3 (Apr. 1934), pp. 166–68.

7. For James Frederick Dawson, see Frederick Law Olmsted, Jr., "James Frederick Dawson, A Biographical Minute on His Professional Life and Work," *Landscape Architecture*, 32, no. 1 (Oct. 1941), pp. 1–2. For a fascinating study of Dawson's father Jackson and the remarkable Dawson family, see Sheila Connor Geary and B. June Hutchinson, "Mr. Dawson, Plantsman," *Arnoldia*, 40, no. 2 (Mar./Apr. 1980), pp. 50–75.

8. Frederick Law Olmsted, "Plan for a Small Homestead," *Garden and Forest* 1 (May 2, 1888), pp. 111–13, and Frederick Law Olmsted, "Terrace and Verandah—Back and Front," *Garden and Forest* 1 (June 6, 1888), pp. 170–77. The Phillips estate, "Moraine Farm," in North Beverly, Massachusetts (1883), which still exists in excellent condition, was published in *Garden and Forest* 5 (Mar. 3, 1892), pp. 145–46, 149. Another important early residential commission by F. L. Olmsted, Sr., the Barthold Schlesinger Estate in Brook-line, Massachusetts (begun 1879), also extant, was published in John Nolen, "Frederick Law Olmsted and His Work," Part III *House and Garden* 9, no. 5 (May 1906), pp. 216–22.

9. "Biltmore" is discussed in most general studies of Olmsted's work. See especially Fein, *Frederick Law Olmsted* (note 2), pp. 55–57, and Newton, *Design on the Land* (note 3), pp. 346–51.

10. For a discussion of what Newton calls the "Country Place Era," see *Design on the Land* (note 3), pp. 427–46.

11. George Roussos, *A History and Description of William Bayard Cutting and His Country House, Westbrook, Great River, Long Island* (Long Island State Park and Recreation Commission, 1984), pp. 7–8. Cutting's first contact for this commission was with Olmsted, but we do not yet know whether Olmsted followed the project through personally or whether it was delegated to another member of the firm. See W. Bayard Cutting to Frederick Law Olmsted, June 18, 1886, Olmsted Associates Papers (B-files), Manuscript Division, Library of Congress.

12. *Landscape Architecture* 28, no. 1 (Oct. 1937), pp. 1–12. Quotation on p. 2.

13. I have written elsewhere about Frederick Law Olmsted, Sr.'s choice and use of plant materials in the Boston parks. However, Olmsted frequently used more exotic and ornamental plants in private gardens than he felt appropriate for a park setting. See Cynthia Zaitzevsky, *Frederick Law Olmsted and the Boston Park System* (Cambridge, MA: Harvard University Press, 1982), pp. 184–201.

14. *Landscape Architecture* (Oct. 1937) (note 12), pp. 8–11. Quotation on p. 9. There are 28 drawings for "Westbrook" at FLON. All are for that part of the property most directly associated with the house: the entrance and entrance lodge, the approach road, the oak park, house turnaround, house lawn, and carriage house. There is only one planting plan and plant list for the Cutting estate at FLON, and this is limited to shrub plantings near the house (FLON plan no. 1047–9, Mar. 21, 1887). No plans exist or appear ever to have existed for the pinetum, farm group, river walk, or locust bridge. Some of these may have been designed after 1894, except for the pinetum. The article in *Landscape Architecture* in 1937 and the size of the trees illustrated in the article indicate that this area must have been planted at approximately the same time the Olmsted firm's drawings were executed, with the exception of the Chinese specimens. Ernest H. Wilson did not begin his plant-hunting expeditions to the Orient for the Arnold Arboretum until 1906. Unfortunately, the original pinetum was almost entirely destroyed in 1985 by Hurricane Gloria.

15. Julia B. de Forest, *A Short History of Art* (New York: Dodd, Mead and Co., 1881). See *Dictionary of American Biography*, p. 217 (Henry); Harris E. Starr, *Dictionary of American Biography*, vol. XXI, Supplement One (New York: Charles Scribner's Sons, 1944), pp. 236–37 (Robert); Eva Ingersoll Gatling and Anne Suydam Lewis, *Lockwood DeForest: Painter, Importer, Decorator* (Huntington, NY: Heckscher Museum, 1976), p. 4 (Julia). The Henry G. de Forest House at Montauk is illustrated in Roth, *McKim, Mead & White*, (note 3), p. 71. Robert W. de Forest is also listed as a member of the Montauk Association but does not seem to have had his own house.

16. Whiting and Phillips, "Olmsted" (note 4), p. 147. A notation in the "Nethermuir" photograph album at FLON indicates that F. L. Olmsted, Jr., sent photograph no. 3175–134 (no longer in the book) to the National Academy of Design as an example of his work in January 1930. Olmsted was elected an Associate of the National Academy of Design in 1914 and a full member in 1929. See Eliot Clark, *History of the National Academy of Design, 1825–1953* (New York: Columbia University Press, 1954), p. 266. Edward Clark Whiting worked on this project along with Olmsted. "Nethermuir" was also published in *Garden Magazine*, 35, no. 2

(Apr. 1922), pp. 108–9; *House Beautiful*, LII, no. 3 (Sept. 1922), p. 206, and in John Taylor Boyd, Jr., "The Work of Olmsted Brothers," *Architectural Record* 44, no. 6 (Dec. 1918), pp. 502–21 (photographs only in all cases).

17. Roland Ray Conklin was involved in the early stages of the development of the community of Roland Park in Baltimore, the planning of which was done by George E. Kessler and Olmsted Brothers (Robert A. M. Stern, ed., *The Anglo-American Suburb*, (London: Architectural Design Profile, 1981), p. 39.

Roland Park included an outdoor theater. The Conklin, Roland Park, and Bryn Mawr Amphitheaters (also by Olmsted Brothers) are all illustrated, but not discussed, in Frank A. Waugh, "Some Garden Theaters," *Architectural Review* 4, no. 9 (Sept. 1916), pp. 161–67. The same author wrote a book: *Outdoor Theaters* (Boston: Richard G. Badger, 1917), in which the Conklin Amphitheater was illustrated, again without text (p. 117). All of the final drawings for the amphitheater were approved by Dawson, strongly indicating that he played an important role as F. L. Olmsted, Jr.'s second-in-command on the project. In his initial letter to F. L. Olmsted, Jr., Conklin noted that the amphitheater would be used as such only once or twice a year and the "effect to be produced should be justified from the standpoint of a garden aside from its use as a theater." See Roland R. Conklin to Frederick L. Olmsted, June 7, 1912, Olmsted Associates Papers (B-files). Conklin proved to be a difficult client, often disputing charges and balking at having the firm supervise construction.

18. For the Vassar College Amphitheater, see Phillip H. Elwood, Jr., ed., *American Landscape Architecture* (New York: The Architectural Book Publishing Co., Inc., 1924), p. 162, as well as the publications by Waugh (note 17). For the Camden, Maine, Garden Theater, see *Country Life in America* 64, no. 5 (Sept. 1933), pp. 54–55.

The interest in outdoor theaters in the early twentieth century seems to have stemmed from the discussion of Italian prototypes by Edith Wharton in her *Italian Villas and Their Gardens* (New York: The Century Co., 1903). In this country, most open-air theaters were designed for colleges or municipalities, and privately owned examples were rare.

19. Edward Clark Whiting, "The Gardens at Ormston, an American Country Seat in the English Manner," *Landscape Architecture* 28, no. 4 (July 1938), pp. 193–94. "Ormston" is also discussed in Newton, *Design on the Land* (note 3), pp. 429–31.

The landscape architects, Goodhue, and Henry W. Rowe, architect of the farm group and other outbuildings, all seem to have worked together very smoothly. The first building to be constructed was the bath and tea house (no longer extant) at the edge of the water. The Aldreds took up residence here and, from this vantage point, participated actively in decisions for siting the other buildings and the roads. See Henry W. Rowe, "An Estate in the Making," *The American Architect* 106, no. 2033 (Dec. 9, 1914), pp. 349–54. The first contact was a brief note from Aldred to Olmsted Brothers dated July 19, 1912 (Olmsted Associates Papers, B-files). Later correspondence indicates that the Aldreds developed a close personal relationship with Gallagher and suggested the article that Whiting finally wrote.

20. Quotation from Whiting (note 19), p. 195. Newton describes the Elizabethan garden as the "blue" garden. Early plans for "Ormston" show only one main garden on axis with the house—a larger version of the perennial garden or bowling green. To the east, where the rose garden is now, was another elongated formal garden within a curved enclosure (FLON plan no. 5578–183). The plans for the three allées discussed below also underwent modifications: the central (lilac) allée appears on early plans as a much broader vista with a more formal treatment. Although only about 200 of the 732 plans for "Ormston" remain at FLON, they shed considerable light on the evolution of the plan. Included is a subdivision plan for land south of Lattingtown Road (FLON plan no. 5578–729, April 8, 1937). FLON also has more than 30 plant lists for "Ormston."

21. Except for changes in plant materials and paving, the forecourt and formal gardens are intact. At some time in the past, the privet allée was changed to an informal, winding path. The temple with its transparent dome still stands but seems in shaky condition. There are no longer any lilacs along the lilac allée, but its outlines remain, along with the sundial and bench that mark its termini. The cedar allée is impassable. The Greenway still exists, as do the lawn, meadow, beach, tennis courts, vegetable garden, and most

outbuildings. A new building has been put up on the eastern edge of the meadow.

22. The Rogers estate was photographed exhaustively by John Wallace Gillies, Mattie E. Hewitt, and Samuel H. Gottscho for numerous publications: John Taylor Boyd, Jr., "The Country House of H. H. Rogers, Esq., Walker and Gillette, Architects, *Architectural Record* 39, no. 1 (Jan. 1916, photographs by Gillies); "Where House and Gardens are One," unidentified periodical, n.d., offprint at FLON, pp. 47–49 (photographs by Gillies); "Midsummer in the Flower Garden," *House Beautiful* 55, no. 9 (June 1924), p. 665; "The Garden in Good Taste," *House Beautiful* 56, no. 1 (July 1924), pp. 33–36 (photographs by Hewitt); Boston Society of Landscape Architects, *Yearbook for 1929* (Boston: Office of the Publication Committee, 1929), n.p. (photograph by Gottscho).

Walker & Gillette's contribution to the garden plan may have been considerable. The statement by Boyd that the architects "supervised" the garden design seems to be borne out by the fact that the drawings at FLON include several plans received from Walker & Gillette, showing both layout and construction details. The earlier plans do not show the allée and indicate a tennis court where the rose garden was eventually located. See FLON plans no. 6024–1 and 6024–17. A good deal of the plant material at "Black Point"—more than 600 shrubs and three dozen trees—may have been moved by Lewis & Valentine from the H. H. Rogers, Sr., place in Fairhaven, Massachusetts, to Southampton. See Olmsted Brothers to H. H. Rogers, September 22, 1914, Olmsted Associates Papers (B-files). In the same collection is an interesting analysis of the landscape design and particularly of the vistas at "Black Point" (Olmsted Brothers, "Notes on the Pictures of the H. H. Rogers Estate, Southampton, L.I., Appearing in the *House Beautiful* Magazine," April 28, 1924).

At the Southampton site, one may still see the boundary wall, outbuildings, and some of the original trees, but the main house and gardens, as well as the inner walls that defined the gardens, are gone.

23. I am grateful to Brother Roman of the St. Francis Center for information about the history of the estate. The center also has numerous drawings, watercolors, and photographs of the house and garden.

24. *Brooklyn Daily Eagle*, July 17, 1899; a subdivision plan from Weekes and Weekes, Relators, n.d., shows the Olmsted plan.

25. In his obituary of James Frederick Dawson, Frederick Law Olmsted, Jr., attributes the Jennings estate primarily to him. However, the drawings at FLON indicate clearly that both Whiting and Gallagher were involved in the early stages of design. In particular, Whiting designed two alternative studies for the ravine garden (FLON plan nos. 6287–8, February 1916 and 6287–10, March 1916) as well as the Revised Sketch illustrated on page 326. The alternative plans show a much more elaborate arrangement than that finally adopted. A lower and an upper pool were shown connected by canals or cascades following the natural descent of the land. Presumably, this idea was abandoned because of expense or difficulty of execution. Photographs of models of the adopted version of the Jennings ravine garden are illustrated in Boyd, "The Work of Olmsted Brothers" (note 16), p. 519.

26. Mack Griswold and Eleanor Weller, *The Golden Age of American Gardens: Proud Owners, Private Estates, 1890–1940* (New York: Harry N. Abrams, Inc., 1991), pp. 95–96; Carol K. Johnston, Fred E. Knapp, and Joann S. Knapp, *Planting Fields, Past and Present* (Oyster Bay, NY: Planting Fields Arboretum, 1976), pp. 10–13; Thomas Hauck, "The Planting Fields," unpub. ms., Planting Fields, 1979, pp. 1–5. For Andrew Robeson Sargent, see *Harvard Graduates' Magazine* (Dec. 1918) and S. B. Sutton, *Charles Sprague Sargent and the Arnold Arboretum* (Cambridge, MA.: Harvard University Press, 1970), pp. 225–29, 318–19, 321. The landscaping done for the Byrnes has been attributed to James Greenleaf.

27. Johnston, Knapp, and Knapp, *Planting Fields* (note 26), p. 14; Hauck, "The Planting Fields" (note 26), pp. 7–9. Taped interviews with William Robertson Coe (1954), Everett Miller (August 22, 1978), and Michael D. Coe (December 20, 1978) are reproduced in Maximilian I. Ferro, "Coe Hall: The House at Planting Fields," Historic Structure Report, May 1981.

28. Hauck, "The Planting Fields" (note 26), p. 6; Oliver E. Allen, "Mr. Coe's Camellia House," *Horticulture* (Jan. 1984), pp. 21–25. FLON has photographs of the Camellia House received from W. H. Lutton Co.

29. Johnston, Knapp, and Knapp, *Planting Fields* (note 26), p. 11; Boston Society of Landscape Architects, *Yearbook for 1929* (Boston: Office of the Publications Committee, 1929), n.p. The latter publication includes three photographs of the Coe estate. Two showing the garden and "cottage" (tea house) are credited to Olmsted Brothers, landscape architects, and Guy Lowell, architect. Everett Shinn (1876–1953) was a realist painter, a member of the "Ash Can School," who also had many friends in the theater and in society. He was the model for the hero of Theodore Dreiser's 1915 novel, *The Genius*. See Milton W. Brown, et al., *American Art* (New York: Harry N. Abrams, Inc., 1979), pp. 353–55.

30. *Country Life in America* 50, no. 6 (Oct. 1926), pp. 446–47. The Mitchell garden was also published in the Architectural League of New York, *Year Book and Catalogue of the Forty-Second Annual Exhibition* (New York: 1927), n.p.; *American Architect* 131, no. 2515 (Feb. 20, 1927), p. 247; and *Country Life in America* 64, no. 4 (Aug. 1933), p. 38. The Olmsted firm also designed the grounds of the S. Z. Mitchell house in Brookville in 1925. The drawings for this project are included in the S. Z. Mitchell job number and are labeled "Son's place."

31. Daniel P. Higgins, "Business and Management in the Practice of Architecture: Their Application in Coordinating Office and Field Forces in the Development of the Estate of Mrs. Marshall Field," *The American Architect* 133, no. 2543 (Apr. 20, 1928), p. 502. This entire issue is devoted to the Field estate. Although there is considerable information about engineering and site construction, little mention is made of landscaping and the Olmsted firm is not identified. Of particular interest in the same issue is Adolph C. Frank, "Constructing a Residential Estate," pp. 553–64. The initial contact with the Olmsted firm was made by John Russell Pope in the fall of 1924. Most of the correspondence is between Gallagher and Pope (Olmsted Associates Papers, B-files).

See also Stephen Becker, *Marshall Field III, A Biography* (New York: Simon and Schuster, 1964), p. 105, and *The Long Islander*, June 17 and 24, 1921; Feb. 9 and Mar. 16, 1923.

32. In order to create this pristine and seemingly natural view, a bluff north of the house had to be cut down and graded, a massive construction job; see *Country Life in America* 52, no. 4 (Aug. 1927) p. 52.

33. Quoted in Becker (note 31), p. 130. Gillies was head horticulturalist and then superintendent of the Field estate from 1923 to 1966 (*The Long Islander*, May 19, 1977, p. 8). The plant lists referred to in this paragraph are set out in Appendix B, and include "List to Accompany Plan 7359–3 (Revised Planting Plan), February 18, 1925." FLON also has several photographs of trees being planted, including a huge linden being moved by barge. The latter operation is also described in *The Long Islander*, Dec. 11, 1925.

See also Mark Alan Hewitt, *The Architect and the American Country House, 1890–1940* (New Haven and London: Yale University Press, 1990), pp. 188–93. Hewitt discusses the landscaping of "Caumsett" and mentions Marian Coffin but not Olmsted Brothers. He also attributes the planning of the whole estate to Warren & Wetmore. "Caumsett" is also discussed in Clive Aslet, *The American Country House* (New Haven and London: Yale University Press, 1990), pp. 71–77, and in Griswold and Weller, *The Golden Age of American Gardens* (note 26), pp. 99–101, where there is considerable information.

Peabody, Wilson & Brown, page 332

1. *New York Times*, Jan. 26, 1935; Jan. 29, 1935; Feb. 7, 1935; May 7, 1935; H. F. Withey & E. R. Withey, *Biographical Dictionary of American Architects (Deceased)* (Los Angeles: Hennessey & Ingalls, Inc., 1970). The date given by Withey for the establishment of the firm is not correct. It would appear that the fact that the firm was 24 years old was confused with the date of founding; interview with Mrs. Edward E. Murray, daughter of Julian Peabody, Feb. 21, 1983; *American Architect and Architecture* (Feb. 1935), p. 105; *Architectural Record* (Mar. 1935), p. 219; *The American Architect* 100, no. 1862 (Aug. 30, 1911); letter from Norman McBurney, Jr., to author, Dec. 26, 1977; *Great Georgian Houses of America*, published for the Architects Emergency Committee (New York: Dover Publications, Inc., 1970).

2. *New York Times*, Nov. 30, 1956; *Harvard Decennial Report—1913*. Class of 1903, Third Report, p. 62; Harvard University; *Who's Who In America* (27), A. N. Marquis, Chicago, IL. 1952–53, p. 309; Michael Winkelman, "Visible City," *Metropolis* (September 1983), p. 29; National Register Nomination Form, "Dosoris Park," Erin Drake, August 1980 (SPLIA Archives)

3. *New York Times*, June 18, 1955. Wilson obituary; Letter from Norman McBurney, Jr., to author, December 26, 1977; Interview with Mrs. Edward E. Murray, February 21, 1983; Note from Mrs. Archibald Brown, September 1983. The material that McBurney's son had saved for his personal collection has been given to SPLIA, and Mrs. Edward E. Murray, Peabody's daughter, has recently given any material she had to the Rhode Island School of Design.

4. *Architecture* 30 (Oct. 1914), p. 214; *Architectural Forum* 30 (Feb. 1919), p. 47; *Peabody, Wilson & Brown, Architects, New York City, 1911–1921*, Architectural Catalog Co., March 1922.

5. The "Bermuda style" was described in an undated tear sheet from *American Home* in the McBurney collection, SPLIA.

6. Wayne Andrews, *Architecture, Ambition and Americans: A Social History of American Architecture* (New York: The Free Press, 1964), p. 193; John A. Gade, "Successful Country Houses," *Country Life in America* 4 (Oct. 1903), pp. 397–405.

7. "The Country Work of Peabody, Wilson & Brown," *Architecture* 30 (Oct. 1914), p. 214. Harold Donaldson Eberlein, *Architectural Forum* 30 (Feb. 1919), p. 47.

8. *Country Life*, August 1924. Tear sheet, McBurney Collection, SPLIA. This Lathrop Brown residence was near the lighthouse at the tip of Montauk Point. During World War II the U.S. government had it removed from that sensitive area. The ancient windmill was returned to Wainscott, where it remains today: *Home and Field*. August 1932, Tear sheet, McBurney Collection, SPLIA; Letter from Norman McBurney, Jr., December 26, 1977.

9. *Architectural Forum* 30 (Feb. 1919), p. 47; Taylor Scott Hardin, "A Pleasure Dome at Southampton," *Town and Country* 86 (July 1, 1931), p. 32.

10. "East Farm, Stony Brook, Long Island, An Historic Structure Report," Elizabeth Blair Jones, June 1982. Unpublished document, SPLIA archives; *Architecture* 30 (Oct. 1914), p. 214.

11. Electus D. Litchfield, "Country House Architecture in the East," *Architectural Record* 38 (Oct. 1915), pp. 452–488. *Architecture* 30 (Oct. 1914), p. 228.

12. *Architecture* 30 (Oct. 1914), pp. 243–45 for cottage, stable, and water tower. Brad Harris, "News of Long Ago," *Smithtown News*, June 24, 1982.

13. William J. Lamb, "The Garden of the Country House," *Architectural Record* 50 (Oct. 1921), p. 336. *Architectural Forum* (Nov. 1921). *New York Times*, Feb. 10, 1953.

14. *Architectural Forum* 30 (Feb. 1919). *New York Times*, Aug. 9, 1948.

15. Augusta Owen Patterson, *American Homes of To-day* (New York: The MacMillan Company, 1924), p. 233. *New York Times*, Feb. 25, 1952.

16. *Peabody, Wilson & Brown, Architects, New York City, 1911–1921* (New York: Architectural Catalog Co., 1922), pp. 31 and 47.

17. *Architectural Forum* (Dec. 1923). *New York Times*, Mar. 12, 1960.

18. *The American Architect* 120, nos. 1–2 (Oct. 1921).

19. Letter from Julian L. Peabody, Jr., Mar. 20, 1978. Interview with Mrs. Frederick Courdert (Paula Murray), Feb. 20, 1983. *New York Times*, Jan. 26, 1979.

20. *The Architect* 10 (April 1928).

In late 1923, Percy K. Hudson sold 32 acres on the north side of Jericho Turnpike in Jericho to William P. T. Preston who immediately built the house under discussion in back of an old house that was on the property. The old house was bought by one Hoffman and moved across the turnpike. Interview with Mrs. Myron Mitchell, Dec. 16, 1985. See also *The Long Islander*, Jan. 19, 1924.

21. *New York Times*, Apr. 17, 1943.

22. *Home and Field* 40 (May 1930). *New York Times*, Oct. 7, 1969.

23. *Home and Field* 40 (July 1930), pl. 38.

24. Interview with Mrs. J. W. Funk, Oct. 4, 1983.

25. *Town & Country* 86 (July 1, 1931), p. 32. *New York Times*, Mar. 7, 1948.

26. *Arts & Decoration* 39 (Oct. 1933). *Architectural Record* 70 (Nov. 1931).

27. *Architecture* 30 (Oct. 1914), p. 238. *Construction Details* 7 (Jan. 1915). *Architectural Record* 38 (Oct. 1915). Elizabeth Blair Jones, "East Farm, Stony Brook, Long Island, An Historic Structure Report" (privately distributed: June 1982).

28. *Architecture* 30 (Oct. 1914), p. 232. *Architectural Record* 38 (Oct. 1915), p. 452.

29. *Garden Home Builder* (May 1927). Tear sheet, McBurney Collection, SPLIA.

30. *Architecture* 30 (Oct. 1914), p. 219.

31. *Preservation Notes* (Feb. 1967), SPLIA Interview with Superintendent, Central School District No. 2, Syosset, L.I., 1967. Interview with Mrs. Edward E. Murray (daughter of Julian Peabody), Feb. 21, 1983.

32. *The American Architect* 143 (Sept. 1933), p. 81.

Charles A. Platt, page 345

1. For further information on Platt's background and his work in general, see Keith N. Morgan, *Charles A. Platt, The Artist as Architect* (New York: The Architectural History Foundation, Inc., and Cambridge, MA: MIT Press, 1986); and *Shaping an American Landscape: The Art and Architecture of Charles A. Platt* (Hanover, NH: The University Press of New England, 1995).

2. Charles A. Platt, "Italian Gardens," *Harper's Magazine* 87 (July 1893), pp. 165–80, and (Aug. 1893) pp. 393–406. Charles A. Platt, *Italian Gardens* (New York: Harper & Brothers, 1894).

3. Additional information on Platt's project for his fellow Cornish colonists can be found in Keith N. Morgan, "Charles A. Platt's Houses and Gardens for the Cornish Colony," in *Antiques* 123 (July 1982), pp. 117–29.

4. Charles Platt married Annie C. Hoe on April 10, 1886, but she died in childbirth, losing twins, on March 18, 1887. He married again on July 13, 1893, to Eleanor Hardy Bunker. They had five children: Sylvia (1895–1912), William (1897–1984), Roger (1898–1948), Geoffrey (1905–1985), and Charles (1913–).

5. The designs for the Herbert L. Pratt gates and walls are in the Charles A. Platt Collection, Avery Architectural Library, Columbia University, New York City. See also letters, Frederic B. Pratt to Charles A. Pratt, Mar. 27, 1900 (Letterbook 18, p. 241), and June 1, 1900 (Letterbook 18, p. 463), Pratt Archives, Pratt Institute, Brooklyn, New York.

6. For illustrations of the first Frederic B. Pratt house at Glen Cove, designed by Babb, Cook & Willard in 1898, see Frederic B. Pratt, "The Pratt Family at Dosoris 1889–1939. A Camera Chronicle of the Early Days at Glen Cove," unpublished photograph album with text, Pratt Collection, Pratt Institute.

7. Herbert Croly, "The Architectural Work of Charles A. Platt," *Architectural Record* 25 (Mar. 1904), pp. 181–244.

8. The first "High Court" was built of stucco over wood frame. After the house burned in 1895, Annie Lazarus, the owner, asked Stanford White's advice on replacing the monumental arch in the center of the courtyard loggia with a second-story balcony above the loggia. Platt resented White's support for this change when the house was rebuilt in brick.

9. For an illustration of "Sherrewogue," see John Cordis Baker, ed., *American Country Homes and Their Gardens* (Philadelphia: House and Garden, 1906), pp. 42–50.

10. The extensive photograph collection that Platt maintained in his office library contained an album on American colonial architecture. The photographs of "Wyck" that Platt had purchased and mounted included one that was later published in Frank Cousins and Phil M. Riley, *The Colonial Architecture of Philadelphia*

(Boston: Little, Brown & Company, 1920), pl. XIII. The photograph album, along with the majority of Platt's office library, are now held by The Century Association in a special Platt Room at their New York City clubhouse. In a 1914 lecture to architecture students at Harvard, Platt showed a slide of "Wyck" and stated: "That to me suggests every kind of beauty in the country house," lecture, Harvard University, Feb. 1914; Papers of the Platt Office, private collection.

11. "Woodston" is illustrated in *The Works of Charles A. Platt* (New York: The Architectural Book Publishing Company, 1913), pp. 84–89; and "The House of Mr. Marshall Slade at Mount Kisco, New York," *Architectural Record* 22 (Sept. 1907), pp. 260–71.

12. John T. Pratt file, Platt Office Papers (note 10).

13. As in the case of "Wyck's" relationship to "The Mallows," photographs in albums that Platt assembled for office reference document his interest in both "Homewood" and "Whitehall."

14. The Weld family commissions included the gardens of "Faulkner Farm," the Charles F. Sprague estate (1897–98), and the formal gardens of "Weld," the Larz Anderson estate (1901). Anna Pratt Sprague and Isabel Weld Perkins Anderson were cousins who had both inherited substantial wealth from the Weld family. For illustrations of these important gardens, see *The Works of Charles A. Platt* (note 11), pp. 18–22 and 112–15.

15. Plans and photographs for these commissions can be found in the Ellen Shipman Papers, Special Collections, Olin Library, Cornell University, Ithaca, New York.

16. For a general discussion of the economic considerations of the period, see "The Performance of the American Economy Since 1860," in *The Growth of The American Economy*, ed. Harold F. Williamson (New York: Prentice Hall, 1944), pp. 751–80.

17. "The Architecture of Houses, Discussed by Charles A. Platt," *Country Life in America* 52 (May 1927), p. 48.

18. For example, see Walter C. Kidney, *The Architecture of Choice: Eclecticism in America 1880–1930* (New York: George Braziller, 1974), passim.

19. *The Century Association Year-Book* (New York: The Century Association, 1975), pp. 358, 360, 376, 377, 379, and 400.

20. For basic biographical information on Platt's Long Island clients, consult the following *New York Times* obituaries: Clifford V. Brokaw, July 14, 1956, p. 15; George R. Dyer, Sept. 1, 1934, p. 13; C. Temple Emmet, July 25, 1957, p. 23; Mrs. Meredith Hare, Aug. 23, 1948, p. 17; Lewis Cass Ledyard, Jan. 28, 1932, p. 23; Robert McAlister Lloyd, Dec. 16, 1927, p. 25; James A. McCrea, Oct. 18, 1923, p. 19; Herbert Lee Pratt, Feb. 4, 1945, p. 37; Frederic B. Pratt, May 4, 1945, p. 19; John T. Pratt, June 18, 1923, p. 17; Ralph Pulitzer, June 15, 1939, p. 23; Lansing P. Reed, Dec. 3, 1937, p. 23; Francis M. Weld, Nov. 2, 1942, p. 12.

John Russell Pope, page 356

1. *New York Times*, Aug. 29, 1937, sec. 4, p. 8.

2. Aymar Embury, "Architectural Impressions," *Arts & Decoration* 14 (Feb. 1921), p. 284.

3. Herbert Croly, "A New Use of Old Forms," *Architectural Record* 17 (Apr. 1905), p. 273.

4. "House of Joseph P. Knapp," *The American Architect* 122 (Sept. 1922), p. 241.

5. Herbert Croly, "Recent Works of John Russell Pope," *Architectural Record* 29 (June 1911), p. 468.

6. Augusta Owen Patterson, *American Country Houses of Today* (New York: Macmillan, 1924), p. 87.

George B. Post, page 364

1. The commissions of the firm discussed in this essay appear in either the Archives of George B. Post & Sons in the New York Historical Society, including Job Records, Office Ledgers, and correspondence, or in a letter and building list dated April 22, 1980, from Edmund Everett Post (SPLIA). Additional information was provided by the Bellport–Brookhaven Historical Society and the Bayport Heritage Association.

Potter & Robertson, page 365

1. A Potter & Robertson design for an unidentified Oyster Bay house is illustrated in *The American Architect* (Dec. 21, 1878). It may be an alternate design for the Adam-Derby house.

2. *Art Age* 3 (Feb. 1886), p. 125.

3. Mosette Glaser Broderick, "A Place Where Nobody Goes: The Early Work of McKim, Mead & White and the Development of the South Shore of Long Island," in *In Search of Modern Architecture: A Tribute to Henry-Russell Hitchcock*, ed. Helen Searing (New York: The Architectural History Foundation, and Cambridge, MA: MIT Press, 1982), p. 192.

4. On Robertson and the Potters, see Sarah Bradford Landau, *Edward T. and William A. Potter, American Victorian Architects* (New York/London: Garland, 1979). Building-structure inventories compiled by SPLIA have provided information about the Long Island houses discussed in this chapter; and my own interview with Ethel Roosevelt Derby on Aug. 22, 1974, so kindly arranged by Ethel Glaser, provided information about the Adam-Derby house as well as the opportunity to visit it while it was still occupied by a Derby.

5. According to Lisa B. Mausolf, "A Catalog of the Work of George B. Post Architect," Columbia University M.S. thesis, 1983, p. 39.

Bruce Price, page 368

1. Antoinette Downing and Vincent Scully, *The Architectural Heritage of Newport, Rhode Island, 1640–1915* (New York: Clarkson N. Potter, Inc., 1967), p. 161.

2. Bruce Price, *Homes in City and Country* (New York: Charles Scribner & Sons, 1893), p. 97.

3. Ibid., pp. 70–91.

4. Vincent J. Scully, Jr., *The Shingle Style and the Stick Style* (New Haven, CT, and London: Yale University Press, 1971), p. 24.

T. Henry Randall, page 370

1. *Architecture and Building News* 5 (1903), p. 20.

2. *Architectural Review* 12 (Aug. 1904), p. 20.

3. *The Brickbuilder* 7 (Apr. 1898), pls. 31, 32.

4. *Architecture and Building News* 5 (1903), p. 20.

Renwick, Aspinwall & Owen, page 372

1. Information about Renwick's life and professional career is from Selma Rattner, "James Renwick," *Macmillan Encyclopedia of Architects* (New York: Free Press of Macmillan Publishing Co., 1982), vol. 4, pp. 541–48. Following Renwick's death in 1895, the firm name was Renwick, Aspinwall and Owen. Despite subsequent changes in the partnership, Renwick's name continued to be used.

2. The most comprehensive publication on Viollet-le-Duc is: *Eugene Emmanuel Viollet le Duc, 1814–1879,* Architectural Design Profile Series (London: Rizzoli Academy Editions, 1980). Scant attention has been paid to Viollet's great influence on American architects; Scully, for example, barely mentions him in his treatise on what he named the Stick Style.

3. Except as otherwise noted, information about the Gallatin house is from: Sherrill Foster, "Four Early Summer Cottages in East Hampton Built Before 1880," Part 4, 1976, Aug. 1, unpublished manuscript; and Selma Rattner, "Renwick's Gallatin Cottage in East Hampton, N.Y.," unpublished manuscript, May 1977. The Gallatin house was demolished in the 1930s.

4. In the 1880s, the house was enlarged and altered twice, giving it a more Queen Anne appearance.

5. Charles deKay, "Summer Homes at East Hampton," *Architectural Record* 13 (Jan. 1903), p. 32.

6. Quoted by Marcus Whiffen, *American Architecture Since 1780* (Cambridge, MA: MIT Press, 1969), p. 112.

7. *Magee's Illustrated Guide of Philadelphia and the Centennial Exhibition*, reprint of 1876 edition (New York: Nathan Cohen Books, 1975), p. 135.

8. *Magee's Illustrated Guide* (note 7), p. 142.

9. John Calvin Stevens and Albert Winslow Cobb, *Examples of American Domestic Architecture* (New York: William T. Comstock, 1889), p. 21.

10. May King Van Rensselaer, *The Social Ladder* (New York: Henry Holt & Co., 1924), pp. 288–89.

11. Renwick and William H. Russell, a member of the firm and later a partner, used that style in 1880 for a small country house in Morrisania, now part of the Bronx; illustrated in *American Architect and Building News* (Mar. 18, 1881), pl. 273.

12. Hoyt is reported to have bought 200 acres in 1890 (Henry Isham Hazelton, *The Boroughs of Brooklyn and Queens, Counties of Nassau and Suffolk* (New York and Chicago: Lewis Historical Publishing Co. 1925), p. 132, but according to information on page 3 of "The Story of Eastover," an undated real estate brochure published after Hoyt's death in 1922, Hoyt is said to have initially bought only a small parcel, later increasing his holdings to 173 acres, probably the correct amount. A memoir, written by Hoyt's son, "indicates that the house was finished the same day as the club" (Mosette Glaser Broderick to "Bob and Valerie," Nov. 27, 1978 SPLIA), which I believe was in May 1892. This would indicate that the house was designed by William H. Russell, credited as the architect by Hazelton, sometime after he bought the first parcel and no later than 1891, during which time he was still a partner in Renwick's firm.

13. There is also documentary evidence to support that theory. Surviving views all date from after Hoyt's death in 1922 and show a Colonial Revival building. However, the ground plan of that house does not conform to the ground plan on the 1908 (or 1909?) map of the property. There is also an interior view of the oak-paneled living room which closely resembles the 1892–94 "Applegarth" living room. It is possible and plausible that after widower Hoyt's remarriage in 1912, he and his new wife wanted "a new look."

14. *The Social Register* (Aug. 1893), p. 268, lists "Applegarth" as their summer residence.

15. "The Southern Woman in New York," *Bookman* 18 (Feb. 1904), p. 633.

16. *New York Times*, Jan. 10, 1890, p. 1.

17. Elizabeth Bisland, *A Flying Trip Around the World* (New York: Harper & Bros., 1891), p. 193.

18. Elizabeth Bisland Wetmore, "The Abdication of Man," *North American Review* 167 (Aug. 1898), pp. 191–99.

19. "Her Lifetime Journey," unidentified newspaper clipping describing the wedding, Oct. 7, 1891.

20. All of the information about "Applegarth" is from the article published under Elizabeth Bisland Wetmore's maiden name: Elizabeth Bisland, "The Building of Applegarth," *Country Life in America* (Oct. 1910), pp. 657–60.

21. The earliest reference to Owen's working for the firm is in *Building* 8, no. 5 (Feb. 1888), "List of Illustrations"; no plate or page numbers. The date Owen became a partner is taken from Dennis Steadman Francis, "Renwick, Aspinwall, and Owen," *Architects in Practice in New York City 1840–1900* (New York: Committee for the Preservation of Architectural Records, Inc., 1980), p. 64. Information about Owen's marriage is from the *Social Register, New York, 1902* (New York: New York Social Register Association, 1901), p. 499, and his death from the Architectural League *Year Book* (1903), not paged.

22. In addition to their memberships in the Seawanhaka–Corinthian Yacht Club, Wetmore and Bullock, for example, were joint owners of another piece of property on Centre Island, and Bullock was an honorary pallbearer at Hoyt's funeral. The first Bullock house was designed by the Boston firm of Stickney and Austin, c. 1892. Announcements of the fire and the new house appeared in *The Long Islander*, on Jan. 7 and Jan. 28, 1899, respectively. Architectural League, *15th Annual Exhibition Catalog, 1900*, no. 632, not paged; *Architectural Review* 8 (July/Dec. 1900), p. 277; *Architecture* 2 (Oct. 1900), pp. 367, 370, 372, 379, and 381. A stable, considerably altered, and another secondary building survive.

23. Biographical information about Peabody is from the wedding announcement, "Peabody-Miller," *New York Times*, June 23, 1895, p. 8; and his obituary, "Richard Peabody," *New York Times*, Dec. 27, 1937, p. 16. The house was illustrated in *Architectural League 15th Annual Exhibition Catalog, 1900*, no. 1122, not paged. I am indebted to Johanna and Jeff Reckseit for the opportunity of exploring from cellar to attic this single surviving example of the firm's Long Island Elizabethan mansions.

Schultz & Weaver, page 384

1. Clay Lancaster, Robert A. M. Stern, Robert J. Hefner, *East Hampton's Heritage* (New York: W. W. Norton & Company, 1982), p. 98.

Ellen B. Shipman, page 386

1. Nancy Cooke Dillard, *Pioneering Women in Landscape Architecture 1875–1930*, unpublished paper, May 1980, p. 30.

2. These are located principally on the east coast in the vicinity of New York City and Cornish, New Hampshire, and in the South.

3. *Architectural Record* 48 (Sept. 1920), p. 180.

4. Among the periodicals which published Shipman's design for the Samuel Salvage estate were: *American Architect and Building News* 36 (Oct. 1929), pp. 52–54; *Architectural Forum* 53 (July 1930), pp. 51–85; *Country Life in America* 65 (April 1934), p. 59; *Architectural League of New York Catalog* 44, 1929.

5. *Architectural Forum* 53 (July 1930), p. 51.

6. Quoted in her obituary, *New York Times*, Mar. 29, 1950.

Joseph Greenleaf Thorp, page 393

1. Thorp's parents were George Washington Thorp, who died on a transatlantic crossing in 1872, and Anna Greenleaf Thorp (1828–1922), who lived abroad for extended periods. George Washington Thorp's occupation is unknown. There were four children. Thorp never married, although he was romantically involved with one of the daughters of essayist Charles De Kay of New York City.

2. Information from Earle E. Coleman, University Archivist, Seeley G. Mudd Manuscript Library, Princeton University; and Dennis Stedman Francis, *Architects in Practice in New York City 1840–1900* (New York: Committee for the Preservation of Architectural Records, Inc., 1979).

3. "Sketch from 'Croquis d' Architecture,' J. G. Thorp," *Architecture and Building* 5 (Nov. 20, 1886), p. 21.

4. Norman Barns conversation with Sherrill Foster, East Hampton, fall 1976. On the importance of magazines to architects in this period, see Roderick Gradidge, *Dream Houses—The Edwardian Ideal* (New York: George Braziller, 1980), pp. 23–29. For an overview of this period, see Peter Davey, *Architecture of the Arts & Crafts Movement* (New York: Rizzoli, 1980).

5. *New York Times*, September 7, 1888, p. 5. The Papendieks were living in the 18th-century house at 181 Main Street, East Hampton (before its remodeling). The wedding took place across the Green in the wooden St. Luke's Chapel with its new James Renwick, Jr.,–designed addition. A red carpet was laid from door to door. For other activities of Renwick in East Hampton, see Sherrill Foster, "Boarders to Builders, The Beginnings of Resort Architecture in East Hampton, L. I.: 1870–1894," unpublished master's thesis, SUNY Binghamton, 1977.

6. Henry B. Hough, *Martha's Vineyard: Summer Resort After 100 Years* (Rutland, VT, 1966), pp. 189 ff. Dr. Tucker invited Talmage to speak at the July 4th events at Oak Bluffs in 1887. In 1893 Talmage officiated at Tucker's daughter's wedding on Oak Bluffs.

7. *East Hampton Star*, Mar. 10, 1893.

8. *East Hampton Star*, Nov. 1912. Emmeline and her mother remained in Florence as expatriates. Thorp had given up his New York office by late summer of 1906. *East Hampton Star*, Sept. 21, 1906.

9. *East Hampton Star*, May 13, 1921, p. 7, col. 1.

10. Mrs. Lorenzo E. Woodhouse financed the restoration of the 1784 Clinton Academy, using J. G. Thorp as the supervising architect. Thorp also "restored," among others, "The Old Fithian House," "Aunt Phoebe's," for Percy Hammond, the New York drama critic, and the Gardiner "Brown House," all moved to new sites in the 1920s. Obituary for Lorenzo E. Woodhouse (1862–1935), *New York Times*, Jan. 24 1935. See also Sherrill Foster, "Mary Kennedy Woodhouse," in *Life Styles: East Hampton: 1630–1976*, exhibition catalogue, Guild Hall Museum, 1976.

11. Obituary for E. Clifford Potter (1863–1937), *New York Times*, Dec. 12, 1937, sec. 2, p. 9, col. 1. Obituary for Frederick G. Potter (1860?–1926), *East Hampton Star*, Oct. 1, 1926, p. 1. . The Potters were principals in Potter & Bros., a real estate firm building apartment houses on Park Avenue, such as the Montana. Thorp designed three houses for the two brothers. *Who Was Who In America*, vol. 1, s.v. The Rev. Dr. John R. Paxton (1843–1923) was a Presbyterian minister with the West Church in New York City and then with the New York Church. His daughter Mary, Mrs. Harry Hamlin, engaged Thorp to design her "Stony Hill Farm" on Town Lane in Amagansett, a large Neoclassical or Colonial Revival complex in 1907. She later had Thorp "restore" several older houses for rental, which she dubbed "Rowdy Hall" and "Gansett House." One of these was rented by the Bouviers when Jacqueline was a toddler.

12. Obituary for S. Fisher Johnson (1831–1904), *New York Times*, June 2, 1904, p. 9. Johnson was a member of the New York Stock Exchange and several brokerage firms. Johnsons' son, Seymour Johnson, was at Harvard in 1904.

13. Obituary for Mrs. Martha Bagg Phillips (1854–1943), daughter of John Sherman Bagg, pioneer editor of the *Detroit Free Press*, *New York Times*, Aug. 28, 1943, p. 11. Mr. Phillips died c. 1923.

14. Information about F. H. Davies has eluded research.

15. Marriage of Carol Hackstaff, daughter of Charles L. Hackstaff of 45 East 62nd Street, New York City, *East Hampton Star*, May 10, 1918. Information on her parents has proved elusive.

16. *Who Was Who In America*, vol. 1, s.v. Andrew Coyle Bradley (1844–1902), Harvard L.L.B. 1867, residence in Washington, D.C.

17. Thorp's commercial structures reflect this same care. They include the Odd Fellows Hall (1896), Newtown Lane, the 5th Post Office (1907), Main Street, Vetault Nursery Sales Office (1921), and Newtown Lane, among others.

Louis Comfort Tiffany, page 397

1. Samuel Howe, "The Dwelling Place as an Expression of Individuality," *Appleton's Magazine* 9 (Feb. 1907), p. 156.

2. J. K. Mumford, "A Year at the Tiffany Foundation," *Arts & Decoration* 14 (Feb. 1921), p. 273; and Samuel Howe, "An American Country House," *International Studio* 33, no. 132 (Feb. 1908), p. 294.

3. Edward Harold Conway, "Mr. Louis C. Tiffany's Laurelton at Cold Spring, Long Island," *The Spur* 14 (Aug. 15, 1914), pp. 25–29.

4. Background on Tiffany (and "Laurelton Hall") can be found in: [Charles De Kay], *The Art Work of Louis C. Tiffany* (New York: Doubleday, Page & Co., 1914), which while apparently written by De Kay, is largely Tiffany's own account; Robert Koch, *Louis C. Tiffany, Rebel in Glass*, 2nd ed. (New York: Crown, 1966); Hugh McKean, *The "Lost" Treasures of Louis Comfort Tiffany* (Garden City, NY: Doubleday, 1980); and Donald Stover, *The Art of Louis Comfort Tiffany*, (San Francisco: M. H. de Young Memorial Museum, 1981), exhibition catalogue.

5. Wilson H. Faude, "Associated Artists and the American Renaissance in the Decorative Arts," *Winterthur Portfolio* 10 (1975), pp. 101–30.

6. Samuel [Siegfried] Bing, *Artistic America, Tiffany Glass and Art Nouveau*, ed. R. Koch (Cambridge, MA: MIT Press, 1970), reprints Bing's articles; see also, Gabriel P. Weisberg, *Art Nouveau Bing: Paris Style 1900* (New York: Harry N. Abrams, 1986).

7. "The Briars" is shown in A. W. Fred, "Interieurs van L. C. Tiffany," *Dekorative Kunst* 9 (1901), pp. 110–16; and his later work on its garden in Samuel Howe, "One Source of Color Values," *House and Garden* 10 (Sept. 1906), pp. 104–13.

8. Henry H. Saylor, "The Country Home of Mr. Louis C. Tiffany," *Country Life in America* 15 (Dec. 1908), p. 158.

9. The loggia is now installed in the American Wing Garden Court at the Metropolitan Museum in New York.

10. Mumford, *Arts & Decoration* (note 2), p. 273.

11. Saylor, "The Country Home of Mr. Louis C. Tiffany," *Country Life in America*, 15 (Dec. 1908), 160; Saylor claims Yellowstone on p. 159; while Conway, *The Spur* (note 3), p. 27, claims the Grand Canyon.

12. Tiffany's infatuation with Early Christian mosaics can be found in his *Tiffany Glass Mosaics* (New York: Tiffany Glass and Decorating Co., 1896).

13. [De Kay], *The Art Work* (note 4), p. 62.

14. See Charles De Kay, "Laurelton Studios: A New Idea," *The International Studio* 71, no. 283 (Oct. 1920), lxxviii-lxxxi; Mumford, *Arts & Decoration* (note 2); Stanley Lothrop, "The Louis Comfort Tiffany Foundation," *The American Magazine of Art* 11 (Dec. 1919), pp. 49–52; and Hobart Nichols, *Louis Comfort Tiffany Foundation* (Oyster Bay, NY: privately printed n.d. [ca. 1934]).

15. The most important salvage was by Hugh and Jeanette McKean; see McKean, *The "Lost" Treasures* (note 4). In addition to sources noted above, other contemporary articles of value on the house and grounds are: Samuel Howe, "The Garden of Mr. Louis C. Tiffany," *House Beautiful* 35 (Jan. 1914), pp. 40–42; Donn Barber, ed., *Catalogue of the 22nd Annual Exhibition of the Architectural League of New York* (New York: Architectural League, 1907), n.p., five photographs; Charles De Kay, "A Western Setting for the Beauty of the Orient," *Arts & Decoration* (Oct. 1911), pp. 468–71; Samuel Howe, "The Long Island Home of Mr. Louis C. Tiffany," *Town and Country* (Sept. 6, 1913), pp. 24–26, 42; Samuel Howe, "The Silent Fountains of Laurelton Hall," *Arts & Decoration* (Sept. 1913), pp. 377–79. In addition, I would like to acknowledge the help of Frank Brown III, who assisted on research and is preparing a thesis on Laurelton Hall.

Horace Trumbauer, page 405

1. "Gray Towers," residence for W. W. Harrison (now Beaver College), Glenside, Pennsylvania, 1893, was followed by "Lynnewood Hall" for P. A. B. Widener (now Faith Theological Seminary), Elkins Park, Pennsylvania, 1898–1900; "Elstowe Manor" for William L. Elkins (now the Dominican Retreat House), Elkins Park, Pennsylvania, 1898–1900; "The Elms" for Edward J. Berwind (now open to the public), Newport, Rhode Island, 1899–1902; "Ardrossan" for Robert L. Montgomery (still in the family), Villanova, Pennsylvania, 1911–13; and "Rose Terrace" for Mrs. Horace Dodge (demolished), Grosse Pointe Farms, Michigan, 1931–32.

2. Nonresidential works include the Philadelphia Museum of Art (in collaboration with Charles L. Borie, Jr., and Clarence C. Zantzinger), 1919–31; the central building of the Free Library of Philadelphia, 1917–27; the Harry Elkins Widener Memorial Library, Harvard University, 1912–14; and virtually the whole of Duke University, Durham, North Carolina, east campus 1925–27, west campus 1926–33.

3. Another conjecture is that Smith put the place in his name to keep the locals from seeking Vanderbilt prices for land. Held at the Atheneum of Philadelphia, the architect's records prove this the same house when compared with a list of rooms in "The Baronial Parks of Long Island," *New York Herald*, Jan. 25, 1903, sec. 5, p. 7, which speaks of plans "drawn by Horace Trumbar [sic] of Philadelphia."

4. Other ancient structures got demolished as Vanderbilt added real estate, but the one house and stable that Trumbauer altered can be seen in a photograph album at the W. K. Vanderbilt Historical Society of Dowling College, Oakdale, Long Island. The architect also planned "Deepdale's" formal gardens. From the remodeled form of a cart shed extended a mile-long fence, a stretch of which remains along Lakeville Road south of Lake Road. Possibly the pair of brick piers on that side of Lake Road were part of this fence. A log of employee hours mentions a gate lodge and fence, while the considerable bill for road building resulted from "drives enough on the premises, seemingly, for one to spend a day in going over them without retracing his route," according to the *Brooklyn Daily Eagle*, July 20, 1907, following p. 16.

5. Robert Moses met no more success in his 1935 attempt to establish a park around the lake. Kate Van Bloem, *History of the Village of Lake Success* (published there by the Incorporated Village of Lake Success, 1968), p. 27.

6. From an illustrated description of the expanded house, see *American Homes and Gardens* 2, no. 4 (April 1906), pp. 229–35. The present version appears in a 1949 sale brochure held at the Long Island Division, Queens Borough Public Library, Jamaica, New York. From 1913, the office records speak of another residence for William K. Vanderbilt on Long Island but no more precise location is given nor whether the patron was Sr. or Jr., who may have sought new digs following his divorce. Blueprints for this house that never materialized totaled only eleven.

7. *The American Architect* 103, no. 1036 (Jan. 29, 1913), manages to get wrong the name of the town, but the house is unmistakable. Trumbauer's account books also err by designating the earliest plans for Brookville, where he was simultaneously working, instead of Lakeville, an alternate name for the residence's location. As their lone alteration, the golf club enclosed O'Connor's porch at the right for the men's locker room.

8. From 1919 a lesser alteration involving the likes of the smoking room fireplace was recorded, but in 1924 the replacement of a support wall in the ballroom by means of a cantilever seemed not worthy of entering the ledgers. Correspondence and specification sheets are owned privately. A guide to the house is published by Old Westbury Gardens, as the estate is now called.

9. Also in Old Westbury lived John's brother Henry Casvigil Phipps, who had called on Trumbauer in 1918 for alterations to the former W. L. Stow Residence. Designed by John Russell Pope (1874–1937), the 1902 residence northwest of Red Ground Road and the Long Island Expressway is shown in Barr Ferree, *American Estates and Gardens* (New York: Munn & Co., 1904), p. 12 ff. In 1907 Phipps purchased the palace which, c. 1971, would be demolished after the death of his widow Gladys, daughter of Ogden Mills.

10. Most likely Trumbauer discovered Whitehall from plates 17, 19, and 24 of Joseph Everett Chandler, *The Colonial Architecture of Maryland, Pennsylvania, and Virginia* (Boston: Bates, Kimball, and Guild, 1892), a battered copy appearing as lot 494 in the auction catalogue *The Architectural Library of the Late Horace Trumbauer* (Philadelphia: Samuel T. Freeman, 1939).

11. Miniaturized from the residence whose service wing it faces, the four-bay garage is also brick with a hip roof of slate. Likewise carried over are the pair of chimneys and the eight round-top dormers that surround the apartment upstairs with its long rear window.

12. Van Bloem (note 5), p. 28.

13. His mining studies were conducted for W. R. Grace & Co., suggesting that Dows led J. P. Grace to Trumbauer for the alterations already described. The architect would have come to Dows via his wife, née Mary Gwendolyn Burden, for whose family Trumbauer had already done residential work in Manhattan.

14. Quoted on p. 32 of an illustrated chapter on this residence in Charles Latham, *In English Homes* (London: Country Life, 1904), v. 1, pp. 31–35, which book belonged to the architect, as proven by the catalogue from the sale of his library, lot 332. Possibly another source was lot 188, John Belcher and Mervyn E. Macartney, *Later Renaissance Architecture in England* (London: Batsford, 1901), p. 41, plates 51–54. A plan of the house and its surroundings is given on p. 52 of A. E. Richardson and H. D. Eberlein, *The Smaller English House of the Later Renaissance, 1660–1830* (New York: William Helburn, 1925) which made up lot 308, but had appeared too late to contribute to "Charlton Hall."

15. Joined to one side of a five-car garage, a cottage has its gable balanced by one slightly smaller at the other side. Around 1930 the farmer's cottage was enlarged to a family member's residence by William Adams Delano (1874–1960). Drawn by William H. Seaman, C. E., Glen Cove, a 1922 map of the property includes the bungalow, now vanished. Five doors with double-X braces stretch beneath the cupola on either wing of the two-and-a-half-story farm barn, which with its own cupola resembles a country church. Besides the Olmsted Brothers' efforts, ongoing until at least 1928, additional landscaping was executed by Martha Brooks-Hutcheson, Consulting Landscape Gardener, New York, 1918, and Wallace H. Halsey, C. E., Southampton, 1925.

16. For the house during the Blair occupancy, see Augusta Owen Patterson, "Charlton Hall," *Town and Country* (Feb. 1948), pp. 76–79 and 118.

17. Thorough plans and pictures are given in the *Architectural Review* 9 (old v. 27) no. 2 (Aug. 1920), pp. 33–40, pls. 17–24.

18. Adopting the shape of the mansion, the three-bay garage has at either end a portico where a pointed pediment with a semicircular cutout straddles columns between piers. Alfred Hopkins (1870–1941) was the architect for a farm group that revives Greek Revival.

19. Praised on p. 12 and illustrated on pp. 20–38, this model is the first edifice thoroughly treated in Leigh French, Jr., and Harold Donaldson Eberlein, *The Smaller Houses and Gardens of Versailles from 1680–1815* (New York: Pencil Points Press, 1926) from which Trumbauer assuredly drew his inspiration, since the book is part of Lot 463 in the executors' sale of his library. For photographs of the antlers restored, see Cyril Connolly and Jerome Zerbe, *Les Pavilions* (New York: Macmillan, 1962), pp. 76–81.

20. Soon after this house was started, Trumbauer changed the coating to brick Georgian, lowered the Ls to their original height, and began "Briar Hill," a residence for William M. Elkins (now Eugenia Hospital), Lafayette Hill, Pennsylvania, 1929–30.

21. Clad in the big shingles favored hereabout, an existing house part way down the hill had been converted to the gardener's cottage presumably by the barn-like extension with hayloft and octagonal cupola. At the foot of the slope sits the gate lodge, a stucco bungalow whose mansard roof of slate matches a dormer to each window or door below. Linked to the mid-rear wing by a little gateway, the garage has its back embedded half in the earth to resemble a springhouse. Stone baskets of carved fruit top each pillar of the estate gateway, the lower pairs on both sides supporting the iron fence that curves inward at center to meet the higher two from which the gates are suspended.

William B. Tubby, page 413

1. George DuPont Pratt obituary, *New York Times*, Jan. 21, 1935, p. 15.

Vitale & Geiffert, page 419

1. Norman T. Newton, *Design on the Land: The Development of Landscape Architecture* (Cambridge, MA: Harvard University Press, Belknap Press, 1971).

2. Biographical information from: *National Cyclopedia of American Biography*, Vol. 31, p. 106; obituary, *New York Times*, Feb. 27, 1933; Newton, *Design on the Land* (note 1), p. 396.

3. Biographical information from: *National Cyclopedia of American Biography*, Vol. 44, p. 83; obituary, *New York Times*, Aug. 27, 1957.

4. George H. Dacy, "Landscapes to Order," *Country Life in America* 65 (Nov. 1933) p. 56.

5. Alfred Geiffert, Jr., "Landscape Design for the Modern Country House," *Architectural Forum* 38 (Mar. 1923).

6. Ruth Dean, *The Liveable House: Its Garden* (New York: Moffat Yard and Co., 1917) p. 71.

Walker & Gillette, page 422

The editors would like to acknowledge the research assistance of John Winslow in assembling information concerning the firm's Long Island commissions.

1. Walter C. Kidney, *The Architecture of Choice: Eclecticism in America, 1880–1930* (New York: George Braziller, 1974), p. viii.

2. The firm was awarded two gold medals for excellence in residential work: 1922, Architectural League of New York; and 1925, American Institute of Architects. Other awards received by Walker & Gillette included a medal for excellence in the exterior design of apartment houses, 1910, New York City Chapter of the American Institute of Architects; and a silver medal for the best building in downtown Manhattan (the National City Bank Building at Canal and Broadway), 1927, American Institute of Architects. *The National Cyclopedia of American Biography*, s.v. Walker, A(lexander) Stewart.

3. Ibid.

4. Walker was in the Warren & Wetmore office during the design and early construction period of Grand Central Terminal (1903–19).

5. Following Gillette's death in 1945, Walker joined Alfred Easton Poor and practiced until his death in 1952 as the senior partner in Walker and Poor. *National Cyclopedia* (note 2), p. 63.

6. Henry F. Withey and Elsie Rathburn Withey, *Biographical Dictionary of American Architects (Deceased)* (Los Angeles: Hennessey & Ingalls, Inc., 1970), pp. 235–36.

7. In 1906, the same year he and Gillette established their practice, Walker married Sybil Kane, daughter of Grenville Kane. Sybil's sister, Edith Brevoort Kane, married a Harvard classmate of Walker's, George F. Baker, Jr., son of the president of the First National Bank of New York. Source: SPLIA files.

8. Perhaps as a result of the influence of McKim, Mead & White, who designed the 1903 Manhattan townhouse for Joseph Pulitzer. Leland Roth, *McKim, Mead & White, Architects* (New York: Harper & Row, 1983), pp. 259–60.

9. From 1927 to 1950, Snug Harbor was owned by Alfred P. Sloane, Jr., founder of General Motors. See the Fact Sheet on the Sherwood Aldrich House, archives of SPLIA, Setauket, Long Island, New York.

10. No landscape architect of record has been discovered.

11. William and Mai Coe also commissioned Walker & Gillette to design the main residence and outbuildings at their 200,000 acre Cody, Wyoming, ranch. Called "Shoeshone Lodge," the ranch had once belonged to William "Buffalo Bill" Cody. Liisa and Donald Sclare, "William R. Coe Estate, Planting Fields, Upper Brookville," *Beaux-Arts Estates: A Guide to the Architecture of Long Island* (New York: Viking Press, 1979), pp. 155–62.

12. John Taylor Boyd, Jr., "The Residence of William R. Coe, Esq., Oyster Bay, Long Island: Walker and Gillette, Architects," *Architectural Record* (Mar. 1921), p. 195.

13. Duveen was a specialist in carved oak furniture and had published a book titled *Elizabethan Interiors*. Material prepared for public distribution by the Planting Fields Foundation, Oyster Bay, Long Island; archives of SPLIA.

14. Boyd, "The Residence of William R. Coe," (note 12).

15. The property, now owned by the state of New York, is open to the public and administered by the Long Island State Park Commission. Sclare, *Beaux-Arts Estates* (note 11), p. 155.

16. John Taylor Boyd, Jr., "Peacock Point—The Residence of Henry P. Davison, Esq." *Architectural Record* (July 1917), pp. 249–51.

17. Bates Lowry, *Renaissance Architecture* (New York: George Braziller, 1971), illustration 109. See also Henry A. Milon, ed., *Key Monuments in the History of Architecture* (New York: Harry N. Abrams), p. 337.

18. Biographical information from the archives of the SPLIA.

19. Alwyn T. Covell, "Variety in Architectural Practice: Some Works of Walker & Gillette," *Architectural Record* (Apr. 1914), p. 297.

20. John Taylor Boyd, Jr., "The Country House of H. H. Rogers, Esq., Walker & Gillette, Architects," *Architectural Record* (Jan. 1916), p. 7.

21. Walker & Gillette were to repeat the playhouse motif and form in a more public setting, as part of the Kiddyland section of the Art Deco 1928–29 Playland Amusement Park, Rye, New York.

22. Boyd, "The Country House of H. H. Rogers," (note 20), p. 23.

23. Charles Over Cornelius, "The Country House of Francis L. Hine, Esq.," *Architectural Record* (July 1918), p. 20. The house has been converted to condominiums. Nancy Ruhling, "Manors for the Masses," *Historic Preservation* (Feb. 1986), p. 55.

24. Ibid., pp. 12, 20.

25. Walker & Gillette also designed a 1932 Manhattan townhouse for Loew, described in the *AIA Guide* as "the last great mansion." Norval White and Elliot Willensky, *AIA Guide to New York* (New York: Macmillan, 1967; rev. ed. 1978), p. 240.

26. Material in the archives of SPLIA.

27. Covell, "Variety in Architectural Practice," (note 19), p. 355.

Walker & Gillette, page 422
SELECTED SOURCES

Cook, Olive, *The English Country House* (London: Thames and Hudson, 1974).

O'Brien, Austin, "Planting Fields Arboretum." National Register of Historic Places. Inventory-Nomination Form. New York State Department of Parks, Recreation and Historic Preservation, Albany, NY, 1978.

"Planting Fields: The Residence of William R. Coe, Esq., at Oyster Bay, Long Island," *Country Life in America* 53 (Feb. 1928), pp. 49–53.

Warren & Wetmore, page 434

1. Lawrence Wodehouse, "Stanford White and the Mackays: A Case Study in Architect-Client Relationships," *Winterthur Portfolio* 11 (1976), p. 229. It must also be remembered that Warren began his career with McKim, Mead & White.

2. Richard V. N. Gambrill and James C. Mackenzie, *Sporting Stables and Kennels* (New York: The Derrydale Press, 1935), plate opposite p. 29.

3. It is assumed that the firm did all its work for Mackay at one time. This tennis court structure at "Idle Hour" was built at about the same time.

4. The original "Idle Hour," built in 1878–80 and designed by Richard Morris Hunt, was destroyed by fire in 1899.

5. "Idle hour, the Estate of W. K. Vanderbilt," *Architectural Record* 13 (May 1903), pp. 455–92.

6. Joseph Sampson Stevens first appears listed at "Kirby Hill" (later called "Kerby Hill") in Jericho in the 1905 *Social Register* (published Nov. 1904); Preston's property is shown by name in *Map of Nassau County, Long Island* (Brooklyn: E. Belcher Hyde, 1906). Similarities in plan and detail suggest a closeness of date for the two houses.

7. A systematic review of the *Social Register* does not show Preston ever living in Jericho. The house was occupied in the summer by Mrs. William Thorne and her daughter and son-in-law, Lilla and James Blackstone Taylor, between 1909 and 1913, went up for sale in 1914, then was acquired by Elbert H. Gary, a former judge and founder of U.S. Steel.

8. While the records of the Warren & Wetmore firm list the location as Westbury, the *Social Register* and the records of Hicks Nurseries cite the location as Jericho.

9. "Eagle's Nest, the William K. Vanderbilt Jr. Estate: An Historic Structure Report," Zachary N. Studenroth, unpublished report in the SPLIA archives, 1982, pp. 78–80.

10. Ibid., p. 53.

11. Ibid., p. 54.

12. Ibid., pp. 54, 55.

13. Ronald H. Pearce, "The Deepdale Golf and Country Club, Great Neck, Long Island," *Architectural Record* 60 (Dec. 1926), p. 524.

14. The date is based on a notation on a photograph in the Warren & Wetmore Collection in the Avery Architectural Library, Columbia University.

15. The Field structure and an indoor tennis court for Harry Payne Whitney, also by Warren & Wetmore, were published in *Architectural Forum* 49 (Aug. 1928), pp. 270–74. Of course, the firm had designed the two tennis structures discussed above some 20 years earlier.

Louis S. Weeks, page 439

1. E. Belcher-Hyde, *Atlas of Nassau County* (1914), p. 44.

A. Dunham Wheeler, page 442
SELECTED SOURCES

Francis, Dennis Steadman, *Architects in Practice in New York City, 1840–1900* (New York: Committee for the Preservation of Architectural Records, Inc., 1979).

Obituary, *New York Times*, Mar. 4, 1938, 23:3.

Stern, Madeleine B., *We the Women: Career Firsts of Nineteenth Century America* (New York: Schulte Publishing Company, 1963).

Wheeler, Candace T., *Yesterdays in a Busy Life* (New York and London: Harper Brothers, 1918).

Appendices

List of Architects and Commissions

Adams & Prentice
Howard Phipps, Sr., Residence, Old Westbury

Adams & Warren
Mrs. S. P. Sampson Residence, Lawrence

William Adams
Howard S. Kniffen Residence, Cedarhurst
J. Edward Meyer Residence, Great Neck
Arthur N. Peck Residence, Woodmere
Norton Perkins Residence, Lawrence
Frederick L. Richards Residence, Kings Point
John F. Scott Residence, Hewlett
Edmund S. Twining Residence, Southampton

David Adler
Mrs. Diego Suarez Residence, Syosset

Albro & Lindeberg
Clarence F. Alcott Residence, East Hampton
Henry L. Batterman Residence, Mill Neck
Russell S. Carter Residence, Hewlett
Edward T. Cockcroft Residence, East Hampton
John E. Erdman Residence, East Hampton
Frederick K. Hollister Residence, East Hampton
Carleton Macy Residence, Hewlett
V. Everitt Macy Residence, Hewlett
Arthur W. Rossiter Residence, Glen Cove

William T. Aldrich
Winthrop Aldrich Residence, Brookville
George Mixter Residence, Manhasset

Augustus N. Allen
Julius Fleischmann Residence, Sands Point
Howard Gould Stables, Sands Point

Grosvenor Atterbury
Grosvenor Atterbury Residence, Southampton
James Byrne Residence, Oyster Bay
Arthur B. Clafin Residence, Southampton
Dr. Albert H. Ely Residence, Southampton
Robert W. de Forest Residence,
 Cold Spring Harbor
Henry O. Havemeyer Residence, Islip
Albert Herter Residence, East Hampton
Dr. Walter B. James Residence,
 Cold Spring Harbor
Walter G. Oakman Residence, Roslyn
Lucien Oudin Residence, Water Mill
Rufus L. Patterson Residence, Southampton
Charles A. Peabody, Jr., Residence,
 Cold Spring Harbor
Dr. C. C. Rice Residence, East Hampton
W. A. W. Stewart Residence,
 Cold Spring Harbor
H. G. Trevor Residence, Southampton
Robert Waller Residence, Southampton
Harold H. Weeks Residence, Islip
William H. Woodin Residence, East Hampton

Babb, Cook & Willard
Paul D. Cravath Residence, Lattingtown
Winslow S. Pierce Residence, Bayville
Frederic B. Pratt Residence, Glen Cove
Harold I. Pratt Residence, Glen Cove

Donn Barber
Horatio S. Shonnard Residence, Oyster Bay

Barney & Chapman
Henry Otis Chapman Residence, Woodmere
E. L. Maxwell Residence, Glen Cove
Henry H. Porter Residence, Lawrence
Dr. Peter B. Wyckoff Residence, Southampton

J. Stewart Barney
Victor Emanuel Residence, Manhasset

Thorbjorn Bassoe
Lamotte T. Cohu Residence, Southampton

Dwight James Baum
Arthur Hammerstein Residence, Whitestone
John F. Murray Residence, Old Westbury
Timothy J. Shea Residence, Bayshore

Beers & Farley
John P. Kane Residence, Matinecock
Franklin B. Lord Residence, Syosset
George deForest Lord Residence, Syosset
George deForest Lord Residence, Woodmere
Cornelius V. Whitney Residence, Wheatley Hills

Algernon S. Bell
R. P. R. Nielson Residence, Westbury

John P. Benson
William F. Ashley Residence, Shoreham

Charles I. Berg
John Chandler Moore Residence, Oyster Bay

Wesley Sherwood Bessell
Leroy Latham Residence, Plandome

Clarence K. Birdsall
Richard Hyde Residence, Bay Shore
Nathaniel Myers Residence, Bay Shore

Boring & Tilton
William J. Matheson Residence, Lloyd Harbor

Sir Alfred C. Bossom
Joseph Harriman Residence, Brookville
Henry D. Whiton Residence, Hewlett

William Welles Bosworth
Cornelius N. Bliss, Jr., Residence, Wheatley Hills
William Welles Bosworth Residence, Matinecock
Walter Farwell Residence, Syosset
Charles A. Stone Residence, Matinecock

Bottomley, Wagner & White
Mrs. Herbert Shipman Residence, Roslyn

William T. Bottomley
George E. Fahys Residence, Matinecock
Graham B. Grosvenor Residence, Westbury
Lewis V. Luckenbach Residence, Glen Cove
J. Cornelius Rathborne Residence,
 Old Westbury
J. Randolph Robinson Residence, Brookville
James M. Townsend, Jr., Residence, St. James
Norman DeR. Whitehouse Residence,
 Brookville

F. Nelson Breed
J. Herbert Ballantine Residence, Kings Point
Kingsland Macy Residence, Islip

Herbert R. Brewster
Henry L. Batterman Residence, Glen Cove
Howard Maxwell Residence, Glen Cove
Herbert Smith Residence, Centre Island

Briggs & Corman
James S. Satterwaite Residence, Southampton

Brite & Bacon
William H. Arnold Residence, Great Neck
Herbert L. Pratt Residence, Glen Cove (c. 1902)
Herbert L. Pratt Residence, Glen Cove (c. 1912)
W. de Forest Wright Residence, Sands Point

Buchman & Fox
Isaac D. Levy Residence, Cedarhurst

Katherine Budd
Howland Residence, Southampton
Frank Melville, Jr., Residence, Old Field

Roger Bullard
Roger H. Bullard Residence, Manhasset
Henry E. Coe, Jr., Residence, Syosset
E. J. Dimock Residence, Manhasset
William Everdell, Jr., Residence, Manhasset
Henry Upham Harris Residence, Brookville
Ellery S. James Residence, East Hampton
Junius Spencer Morgan Residence, Glen Cove
Martin Richmond Residence, Glen Head
Paul Salembier Residence, East Hampton
Sir Samuel A. Salvage Residence, Glen Head
Malcolm Stevenson Residence, Westbury
Maidstone Club, East Hampton
Oakland Golf Club, Bayside

James L. Burley
Edward Cahoon Residence, Southold
Alfred H. Cosden Residence, Southold

Butler & Corse
Mrs. Bradley Watson Dickerson Residence,
 Mill Neck
Francis L. Steeken Residence, Old Field
H. C. Taylor Residence, Cold Spring Harbor

Lawrence S. Butler
Francis C. Huntington Residence, St. James
Mrs. Alice T. McLean Residence, St. James

J. E. R. Carpenter
J. E. R. Carpenter Residence, Sands Point

Carrère & Hastings
James A. Blair, Jr., Residence, Oyster Bay
William Butler Duncan Residence,
 Port Washington
Alfred I. du Pont Residence, Wheatley Hills
Herman B. Duryea Residence, Old Westbury
Thomas Hastings Residence, Old Westbury
W. Deering Howe Residence, Brookville
Walter Jennings Residence, Cold Spring Harbor
Robert S. Lovett Residence, Lattingtown
Edith Pratt McLane Residence, Glen Cove
Elihu Root Residence, Southampton
William P. Thompson Residence, Westbury
William K. Vanderbilt, Jr., Residence,
 Great Neck
Harriet Pratt Van Ingen Residence, Glen Cove
Salem H. Wales Residence, Southampton
Julius A. White Residence, Mill Neck

Walter B. Chambers
Brewster Jennings Residence, Brookville

Henry Otis Chapman
Henri Bendel Reisdence, Kings Point
Cornelius Provost Residence, East Norwich
George Smith Residence, Muttontown

Clinton & Russell, Wells, Holton & George
Lillian S. T. Dodge Residence, Mill Neck
Harry K. Knapp, Jr., Residence, East Islip

Ogden Codman, Jr..
Lloyd Stevens Bryce Residence, Roslyn
Walter E. Maynard Residence, Jericho

Marian C. Coffin (Landscape Design)
W. W. Benjamin Estate, East Hampton
Harry Benkard Estate, Oyster Bay
Albert B. Boardman Estate, Southampton
Irving Brokaw Estate, Mill Neck
Henry F. du Pont Estate, Southampton
Marshall Field III Estate, Lloyd Harbor
Childs Frick Estate (formerly Lloyd
 Bryce), Roslyn
Edward F. Hutton/Marjorie M. Post
 Estate, Wheatley Hills
Charles H. Sabin Estate, Southampton

Fredrick S. Copley
Anna Eliza Cairs Residence, Roslyn Harbor

Henry Corse
Edwin Gould Residence, Oyster Bay

George Abraham Crawley
John S. Phipps Residence, Old Westbury

Cross & Cross
Eliot Cross Residence, Westbury
Henry F. du Pont Residence, Southampton
Mrs. Herbert M. Harriman Residence, Jericho
Harry B. Hollins, Jr., Residence, Islip
Edward S. Moore Residence, Old Westbury
Percy R. Pyne II Residence, Roslyn
Charles H. Sabin Residence, Southampton
F. S. von Stade, Sr., Residence, Westbury
J. Watson Webb Residence, Syosset

Robert Crowie
Henry P. Davison, Jr., Residence, Upper
Brookville

George B. de Gersdorff
Fay Ingalls Residence, Oyster Bay

d'Hauteville & Cooper
William P. Whitney Residence, Manhasset
Henry Rogers Winthrop Residence, Woodbury

Delano & Aldrich
Vincent Astor Residence, Port Washington
Mrs. Richard F. Babcock Residence, Woodbury
James A. Burden Residence, Syosset
Clinton H. Crane Residence, Glen Cove
William A. Delano Residence, Syosset
Beverly Duer Residence, Syosset
Mrs. Lewis Eldridge Residence, Great Neck
Edwin A. Fish Residence, Matinecock
Olga Flinsch Residence, Lloyd Harbor
Lloyd P. Griscom Residence, East Norwich
Paul Hammond Residence, East Norwich
G. Beekman Hoppin Residence, Oyster Bay
Otto H. Kahn Residence, Cold Spring Harbor
Malcolm McBurney Residence, East Islip
Benjamin Moore Residence, Syosset
Victor Morawetz Residence, Woodbury
Charles S. Payson Residence, Manhasset
Harold I. Pratt Residence, Glen Cove
Helen Porter Prybil Residence, Glen Cove
Willard D. Straight Residence, Old Westbury
Roderick Tower Residence, Brookville
Frederic Watriss Residence, Greenvale
George Whitney Residence, Westbury
Mrs. Harry P. Whitney Studio, Roslyn
Harrison Williams Residence, Bayville
Bronson Winthrop Residence, Syosset
E. L. Winthrop, Jr., Residence, Syosset
Chalmers Wood Residence, Syosset
Bertram G. Work Residence, Mill Neck
Chateau des Beaux-Arts, Huntington

Bradley Delehanty
Carroll B. Alker Residence, Brookville
F. Gordon Brown Residence, Glen Head
John K. Colgate Residence, Oyster Bay
Warren S. Crane, Jr., Residence, Cedarhurst
Paul D. Cravath Residence, Locust Valley
Col. Franklin W. M. Cutcheon Residence,
 Matinecock
Dr. Walter Damrosch Residence, Brookville
William N. Davey Residence, West Hills
Hunt T. Dickinson Residence, Brookville
George R. Dyer, Jr., Residence, Brookville
Frank Finlayson Residence, Locust Valley
Phillip A. S. Franklin Residence, Matinecock
Eugene M. Geddes Residence, Matinecock
Clarence E. Groesbech Residence, Matinecock
Sam H. Harris Residence, Kings Point
Robert Hattersley Residence, Glen Head
Frederick T. Hepburn Residence, Lattingtown
George W. Hepburn Residence, Lattingtown
George Ide/Thomas Dickson Residence,
 Lattingtown
Robert B. Law Residence, Syosset
Alida Livingston Residence, Brookville
Edgar Marston Residence, Syosset
Otley Residence, Matinecock
Renard Residence, Lattingtown
Julien A. Ripley Residence, Brookville
William J. Ryan Residence, St. James
Kenneth Sheldon Residence, Glen Head
Daniel P. Woolley Residence, Lattingtown

J. Henri de Sibour
Dewees W. Dilworth Residence, Roslyn

Frederic Diaper
Selah B. Strong, Jr., Residence, Setauket

Albert F. D'Oench
Albert F. D'Oench Residence, Manhasset

William F. Dominick
Landon K. Thorne Residence, Bay Shore

Gordon Dudley
Mrs. Eunice D. Culver Residence, Remsenberg

C. L. W. Eidlitz
C. L. W. Eidlitz Residence, East Hampton
Mrs. Schuyler Quackenbush Residence, East
 Hampton

Thomas H. Ellett
Carroll B. Alker Residence, Brookville
E. Mortimer Barnes Residence, Glen Head
Donald H. Cowl Residence, Sands Point
Henry M. Minton Residence, Manhasset
Mrs. Helen Peters Residence, Brookville

Aymar Embury
Wallace Chauncey Residence, East Hampton
Marshall Fry Residence, Southampton
Ralph Peters Residence, Garden City
George Roberts Residence, East Hampton
G. A. Schieren Residence, Great Neck
East Hampton Public Library
Guild Hall, East Hampton
Playhouse, Hofstra University, Hempstead

Harold Perry Erskine
G. W. White Residence, Mill Neck

Ewing & Chapell
Richard E. Forrest Residence, Cedarhurst
S. B. Lord Residence, Cedarhurst

Wilson Eyre
Miss Lucille Alger Residence, Great Neck
Roland R. Conklin Residence, Lloyd Harbor
Stanley L. Conklin Residence, Lloyd Harbor
Theodore E. Conklin Residence, Quoque

Beatrix Farrand (Landscape Design)
Dr. J. C. Ayer Estate, Glen Cove
Percy Chubb Estate
 (formerly Elizabeth Coles), Glen Cove
William Bayard Cutting Estate, Great River
William A. Delano Estate, Syosset
Mrs. Richard Derby Estate (formerly Mrs.
 Adam), Oyster Bay
Sherman Flint Estate, Islip
Edward S. Harkness Estate, Manhasset
Thomas Hastings Estate, Westbury
Charles O. Iselin Estate, Brookville
Otto H. Kahn Estate, Cold Spring Harbor
P. L. Livermore Estate, Brookville
Mrs. A. T. Mahan Estate, Quoque
S. Vernon Mann Estate, Great Neck
D. H. Morris Estate, Glen Head
Mrs. Douglas W. Paige Estate, Bellport
George D. Pratt Estate, Glen Cove
Percy R. Pyne II Estate, Roslyn
Willard D. Straight Estate, Old Westbury
Josiah C. Thaw Estate, Southampton
Edward Whitney Estate, Oyster Bay
Harrison Williams Estate, Bayville

H. Edwards Ficken
Christopher R. Robert II Residence, Oakdale

Ernest Flagg
Frederick G. Bourne Residence, Oakdale

Montague Flagg
Montague Flagg Residence, Brookville

Annette Hoyt Flanders (Landscape Design)
Vincent Astor Estate, Port Washington
E. Mortimer Barnes Estate, Glen Head
Benson Flagg Estate, Brookville
Charles B. MacDonald Estate, Southampton
Charles McCann Estate, Oyster Bay
William R. Simonds Estate, Southampton

Ford, Butler, & Oliver
George C. Case Residence, Nissequoque

Frank J. Foster
Sherman M. Fairchild Residence, Lloyd Harbor
John R. Hoyt Residence, Great Neck
Raymond F. Kilthau Residence, Great Neck

Mortimer Foster
Frank N. Hoffstot Residence, Sands Point

Freeman & Hasselman
William H. Erhart Residence, Cedarhurst
Foxhall P. Keene Residence, Old Westbury
William C. Whitney Stables, Old Westbury

Frank Freeman
Edward Phinley Morse Residence, Water Mill

William E. Frenaye, Jr.
Francis T. Nichols Residence, Brookville

Fuller & Dick
Adolph G. Dick Residence, Islip
William K. Dick Residence, Islip
R. K. White Residence, Mill Neck

John A. Gade
Effingham Lawrence Residence, Cold Spring
 Harbor
George W. Wickersham, Cedarhurst

Gage & Wallace
Mrs. William Arnold Residence, Islip
Perry Tiffany Residence, Westbury

Gambrill & Richardson
Samuel Wilkeson Residence, Bridgehampton

Robert W. Gibson
George Bullock Residence, Centre Island
Robert W. Gibson Residence, Oyster Bay
E. H. Harriman Residence, Far Rockaway
George Thayer Residence, Port Washington
Seawanhaka Corinthian Yacht Club,
 Centre Island

Archibald F. Gilbert
Eddie Cantor Residence, Great Neck

Bradford Lee Gilbert
William H. Baldwin Residence, Lattingtown
South Side Sportsmen's Club, Oakdale

C. P. H. Gilbert
Dr. J. C. Ayer Residence, Glen Cove
Leonard J. Busby Residence, Glen Cove
Joseph R. DeLamar Residence, Glen Cove
George E. Fahys Residence, Glen Cove
William D. Guthrie Residence, Lattingtown
Parker D. Handy Residence, Glen Cove
C. N. Hoagland Residence, Glen Cove
Alexander C. Humphreys Residence, Glen Cove
Harvey Murdock Residence, Glen Cove
E. J. Rickert Residence, Great Neck
Mortimer Schiff Residence, Oyster Bay
Robert A. Shaw Residence, Glen Cove
F. W. Woolworth Residence, Glen Cove

John I. Glover
John I. Glover Residence, Baldwin

Frederick A. Godley
Jesse Ricks Residence, Plandome

William H. Gompert
Mrs. Eugene S. Kienle Residence, Kings Point

Bertram G. Goodhue
John E. Aldred Residence, Lattingtown
Wilton Lloyd-Smith Residence, Lloyd Harbor

Goodwillie & Moran
Mrs. Norma T. Johnson Residence, Water Mill

Goodwin, Bullard & Woolsey
Philip L. Goodwin Residence, Woodbury
Junius Spencer Morgan Residence, Matinecock
P. G. Pennoyer Residence, Matinecock

Isaac Henry Green
Arthur K. Bourne Residence, Oakdale
Boathouse, Frederick Bourne Residence, Oakdale
Eversley Child Residence, Sayville
Anson Hard Residence, West Sayville
W. T. Hayward Residence, Sayville
Dr. Everett Herrick Residence, East Hampton
Gerald Hollins Residence, Islip
Bradish Johnson, Jr., Residence, East Islip
Frank S. Jones Residence, Sayville
Dr. George Munroe, Jr., Residence, East
 Hampton
Mrs. James W. Phyfe Residence, St. James
Homer W. Reboul Residence, St. James
John E. Roosevelt Residence, Sayville
Robert B. Roosevelt, Jr., Residence, Sayville
Charles A. Schieren Residence, Islip
Mrs. W. M. Simonds Residence, Sayville
John D. Skidmore Residence, Sayville
S. T. Skidmore Residence, East Hampton

Mrs. E. J. Stoppani Residence, Bayport
Gate Lodge, William K. Vanderbilt Residence,
 Oakdale
William E. Wheelock Residence, East Hampton
Lorenzo G. Woodhouse Residence,
 East Hampton
Maidstone Club, East Hampton
Maidstone Inn, East Hampton
Methodist Episcopal Church, Sayville
Oystermen's Bay Bank, Sayville
St. Anne's Episcopal Church, Sayville
Sayville Opera House
Annex, South Side Sportsmen's Club, Oakdale
Suffolk County News Building, Sayville

James L. Greenleaf (Landscape Design)
George S. Brewster Estate, Brookville
George D. Pratt Estate, Glen Cove
Harold I. Pratt Estate, Glen Cove
Herbert L. Pratt Estate, Glen Cove
Percy R. Pyne II Estate, Roslyn
Mortimer Schiff Estate, Oyster Bay

Howard Greenley
Anson W. Burchard Residence, Lattingtown
Charles A. Coffin Residence, Locust Valley

Julius Gregory
Thomas O'Hara Residence, Kings Point

Rafael Guastavino
Rafael Guastavino Residence, Bay Shore

John A. Gurd
Milton L'Ecluse Residence, Huntington

Charles C. Haight
William Bayard Cutting Residence, Great River

Henry J. Hardenbergh
F. Thurber Residence, Babylon

A. J. Harris
Frank Tilford Residence, Cedarhurst

Henry G. Harrison
James W. Beekman Residence, Oyster Bay

Hart & Shape
Charles Hart Residence, Pelham Manor
Edward F. Hutton (Marjorie M. Post)
 Residence, Brookville
Alfred Mudge Residence, Northport
Richard Remsen Residence, Garden City
William H. Robbins Residence, Bay Shore
Mrs. C. Porter Wilson Residence, Mill Neck
Otto Young Residence, Great Neck
Timber Point Clubhouse, Great River

Hewlitt & Bottomley
Edward E. Bartlett, Jr., Residence, Amagansett

Hill & Stout
Albert B. Boardman Residence, Southampton

Frederick R. Hirsh
Samuel T. Shaw Residence, Centre Island

Hiss & Weekes
Mrs. Frederick Baker Residence, Southampton
Mrs. Alfred M. Hoyt Residence, Southampton
Charles I. Hudson Residence, East Norwich

F. Burrall Hoffman
C. H. Lee Residence, Southampton
Charles B. MacDonald Residence, Southampton
Charles Cary Rumsey Residence, Wheatley Hills
Thomas Hunt Talmadge Residence, Hauppauge
Playhouse, Lorenzo E. Woodhouse Residence,
 East Hampton
Post Office and Town Hall, Southampton

Hood & Fouilhoux
Joseph W. Brooks Residence, Sands Point

Alfred Hopkins (Farm Buildings)
Frederick G. Bourne Residence, Oakdale
George Brewster Residence, Brookville
C. V. Brokaw Residence, Glen Cove
Howard Brokaw Residence, Brookville
A. W. Burchard Residence, Locust Valley
Joseph E. Davis Residence, Brookville
Marshall Field III Residence, Lloyd Harbor
Adolph Mollenhauer Residence, Bay Shore
Samuel T. Peters Residence, Islip
Mortimer Schiff Residence, Oyster Bay
Glenn Stewart Residence, Locust Valley
Conde R. Thorn Residence, Massapequa
Louis C. Tiffany Residence, Laurel Hollow

Hoppen & Koen
J. Stewart Blackton Residence, Oyster Bay
C. Oliver Iselin Residence, Brookville
Phillip W. Livermore Residence, Brookville
Sterling Postley Residence, Oyster Bay
George Rose Residence, Westbury
William F. Sheehan Residence, Roslyn
Ormond G. Smith Residence, Centre Island

Howells & Stokes
H. B. Hess Residence, Huntington
Albert Milbank Residence, Lloyd Harbor

Richard Howland Hunt
O. H. P. Belmont Residence, Hempstead
William K. Vanderbilt Residence, Oakdale
(1899)

Richard Morris Hunt
Mrs. Elizabeth Coles Residence, Glen Cove
Thomas Hitchcock Residence, Westbury
William K. Vanderbilt Residence,
 Oakdale (c. 1878)
St. Marks Church and Rectory, Islip

Hunt & Hunt
Mrs. O. H. P. Belmont Residence, Sands Point
Howard Gould Residence, Sands Point
Louis Horowitz Residence, Lattingtown
Henry Sanderson Residence, Brookville

Hunt & Kline
Oscar Hammerstein II Residence, Kings Point

Innocenti & Webel (Landscape Design)
Mrs. Richard Babcock Estate, Woodbury
Frank Finlayson Estate, Locust Valley
Eugene M. Geddes Estate, Locust Valley
Edwin Gould Estate, Oyster Bay
Charles McCann Estate, Oyster Bay
Martin Richmond Estate, Glen Head
Mrs. Diego Suarez Estate, Syosset

Chauncey Ives
Warren Curtis Residence, Southampton

Allen W. Jackson
Dr. Farquahar Ferguson Residence, Huntington

J. Sarsfield Kennedy
Foster Crampton Residence, Westhampton

Kern & Lippert
William Kennedy Residence, Syosset

Kimball & Husted
Alexander M. White, Jr., Residence, Oyster Bay

R. Barfoot King
Rufus Scott Residence, Lattingtown

Kirby, Petit & Green
Robert B. Dodson Residence, West Islip
Frank N. Doubleday Residence, Mill Neck
 (c. 1904)
Frank N. Doubleday Residence, Mill Neck
 (c. 1914)
William Talmadge Residence, Bellport
Belle Terre Clubhouse, Port Jefferson
Country Life Press Building, Garden City

Christopher Grant La Farge
John Pierpont Morgan, Jr., Residence,
 Glen Cove
Addition, Theodore Roosevelt Residence,
 Oyster Bay
John Hay Whitney Boathouse, Manhasset

Lamb & Rich
Frank Lusk Babbott Residence, Glen Cove
Charles Benner Residence, Setauket
Charles O. Gates Residence, Locust Valley
S. P. Hinckley Residence, Lawrence, 1883
S. P. Hinckley Residence, Lawrence, 1883–88
S. P. Hinckley Residence, Lawrence, 1883–88
S. P. Hinckley Residence, Lawrence, 1883–88
S. P. Hinckley Residence, Lawrence, 1883–88
S. A. Jennings Residence, Glen Cove
Charles M. Pratt Residence, Glen Cove
Charles A. Rich Residence, Bellport
Theodore Roosevelt Residence, Oyster Bay
Talbot J. Taylor Residence, Cedarhurst
Henry C. Tinkler Residence, Setauket

William A. Lambert
John W. Masury Residence, Center Moriches

J. Custis Lawrence
John T. Baker Residence, East Hampton
Benjamin Franklin Evans Residence,
 East Hampton
Mrs. S. Fisher Johnson Residence,
 East Hampton
Ring Lardner Residence, East Hampton
Grantland Rice Residence, East Hampton
Arthur Van Brunt Residence, East Hampton
Dr. James D. Voorhees Residence, East
 Hampton

Charles W. Leavitt, Jr. (Landscape Design)
Henri Bendel Estate, Kings Point
Isaac Cozzens Estate, Lattingtown
Lillian S. T. Dodge Estate, Mill Neck
Anson W. Hard Estate, Sayville
Foxhall Keene Estate, Old Westbury
Harry K. Knapp Estate, East Islip
Carleton Macy Estate, Hewlett
George C. Smith Estate, Muttontown

Thomas L. Leeming
Abram S. Post Residence, Quoque

Woodruff Leeming
Nassau Country Club

Adolph F. Leicht
Frank C. Havens Residence, Sag Harbor

J. J. Levison (Landscape Design)
Francis Bailey Estate, Lattingtown
Walter P. Chrysler (originally H. Bendel) Estate,
 Kings Point
Marshall Field III Estate, Lloyd Harbor
Nathan S. Jonas Estate, Great Neck
Otto Kahn Estate, Cold Spring Harbor
A. J. Milbank Estate, Lloyd Harbor

James H. L'Hommedieu
Edward Bell Residence, Southampton

Detlef Lienau
August P. Belmont Residence, Babylon

Harrie T. Lindeberg
Wilbur Ball Residence, Lattingtown
George Bourne Residence, Mill Neck
Irving Brokaw Residence, Mill Neck
Charles T. Church Residence, Mill Neck
Nelson Doubleday Residence, Mill Neck
Richard E. Dwight Residence, Locust Valley
W. N. Dykman Residence, Glen Cove
George Gales Residence, Lattingtown
H. O. Havemeyer, Jr., Residence, Islip
C. Oliver Iselin Residence, Brookville
J. J. Levison Residence, Glen Head
Harrie T. Lindeberg Residence, Matinecock
Frederick L. Lutz Residence, Oyster Bay
Henry C. Martin Residence, Glen Cove
Dale Parker Residence, Sands Point
Jackson E. Reynolds Residence, Lattingtown
Bertrand L. Taylor Residence, Locust Valley
James B. Taylor, Jr., Residence, Glen Cove
Myron C. Taylor Residence, Lattingtown

Edward D. Lindsey
James H. Aldrich Residence, Sag Harbor

Little & Browne
Horatio Adams Residence, Glen Cove
George Fowler Residence, Glen Cove
James W. Lane Residence, Smithtown
Tyler Morse Residence, Westbury
Frank C. B. Page Residence, Brookville
Charles E. Proctor Residence, Great Neck

Little & O'Connor
William Gould Brokaw Residence, Great Neck
Harry S. Gilbert Residence, Great Neck
James E. Martin Residence, Great Neck

Grover Loening
Grover Loening Residence, Mill Neck

Lord & Hewlett
James M. Hewlett Residence, Lawrence
Marshall C. Lefferts Residence, Lawrence
Rockaway Hunting Club, Lawrence

James Brown Lord
John Drew Residence, East Hampton
James F. D. Lanier Residence, Westbury
Stanley Mortimer Residence, Roslyn

Guy Lowell
Reginald Barclay Residence, Sag Harbor
C. K. G. Billings Residence, Matinecock
Paul D. Cravath Residence, Locust Valley
Guernsey Curran Residence, Oyster Bay
Arthur Vining Davis Residence, Mill Neck
Julien A. Ripley Residence, Brookville
Piping Rock Club House, Locust Valley
(Landscape Design)
William R. Coe Estate, Oyster Bay
Clarence Mackay Estate, Roslyn
William P. Whitney Estate, Manhasset

Clarence Luce
George McKesson Brown Residence,
 Lloyd Harbor

J. Clinton Mackenzie
Farm Complex, James A. Blair Residence,
 Oyster Bay
B. H. Inness Brown Residence,
 Plandome Manor
Farm Complex, Robert W. de Forest Residence,
 Cold Spring Harbor
Farm Complex, Walter Jennings Residence,
 Cold Spring Harbor
J. Clinton Mackenzie Residence, Centre Island
Garden, Garage & Gate House, William
 Matheson Residence, Lloyd Harbor
Henry A. Rusch Residence, Centre Island

Alexander Mackintosh
John Slade Residence, Oyster Bay

H. van Buren Magonigle
Isaac Guggenheim Residence, Sands Point

Howard Major
Mrs. William Beard Residence, Glen Cove
Mrs. Samuel D. Brewster Residence, Glen Cove
Harold Carhart Residence, Lattingtown
E. L. Eldridge Residence, Locust Valley
William Hester Residence, Glen Cove
James H. Ottley Residence, Glen Cove
Norman Toerge Residence, Matinecock
Mrs. Howard Whitney Residence, Glen Cove

Mann & MacNeille
Nathan S. Jonas Residence, Great Neck

Matthews & Short
Orson D. Munn Residence, Southampton

McKim, Mead & White
Mrs. A. C. Alden Residence, Lloyd Harbor
Charles L. Atterbury Residence,
 Shinnecock
James L. Breese Residence, Southampton
Prescott Hall Butler Residence, St. James
A. Cass Canfield Residence, Roslyn
William Merritt Chase Residence and Studio,
 Shinnecock

John H. Cheever Residence, Far Rockaway
Robert Colgate, Jr., Residence, Quoque
Devereux Emmet Residence, St. James
James K. Gracie Residence, Oyster Bay
Charles R. Henderson Residence, Southampton
Clarence H. Mackay Residence, Roslyn
Edward Spencer Mead Residence, Southampton
Roland G. Mitchell Residence, Wading River
Edwin D. Morgan Residence, Wheatley Hills
Samuel L. Parrish Residence, Southampton
John F. Pupke Residence, Southampton
James H. Robb Residence, Southampton
Mrs. C. C. Rumsey Residence, Sands Point
Walter C. Tuckerman Residence, Oyster Bay
Mrs. Joseph B. Wetherill Residence, St. James
Stanford White Residence, St. James
William C. Whitney Residence, Westbury
Edward Winslow Residence, Great Neck
Robert D. Winthrop Residence, Westbury
Babylon–Argyle Casino, Babylon
Garden City Hotel, Garden City
Montauk Point Association Residence and
 Club House, Montauk
Shinnecock Hills Golf Club, Shinnecock
Trinity Episcopal Church and Parrish
 House, Roslyn
Wardenclyffe Tower, Shoreham

Mrs. John E. McLeran
Charles E. Pettinos Residence, Centre Island

McIlvane & Tucker
T. F. White Residence, Cedarhurst

Edward P. Mellon
Duncan S. Ellsworth Residence, Southampton
Edward P. Mellon Residence, Southampton

William H. Miller
Timothy S. Williams Residence, Lloyd Harbor

Addison Mizner
Beach House, Mrs. O. H. P. Belmont Residence,
 Sands Point
Stephen H. Brown Residence, Matinecock
I. Townsend Burden, Jr., Residence, Greenvale
Garden/Amphitheater, W. Bourke Cockran
 Residence, Port Washington
Garden, Raymond Hitchcock Residence,
 Kings Point
Addison Mizner Residence, Port Washington
Sarah Cowen Monson Residence,
 Huntington
John A. Parker Residence, Sands Point
William A. Prime Residence, Wheatley Hills
Tennis House, Ralph Thomas Residence,
 Sands Point

Benjamin W. Morris
Mrs. Fremont Peck Residence, Brookville

Montrose W. Morris
Harry F. Cook Residence, Sag Harbor
Joseph Fahys Residence, Sag Harbor
Montrose W. Morris Residence, Glen Cove

Lionel Moses
Mrs. Robert Stafford Residence, Lloyd Harbor

Jacob Wrey Mould
Thomas Clapham Residence, Roslyn Harbor
Thomas W. Kennard Residence, Glen Cove

Kenneth M. Murchinson
William J. Tully Residence, Mill Neck

Daniel Murdock
Henry Alker Residence, Sands Point

Francis A. Nelson
John B. Niven Residence, Mill Neck

Frank Eaton Newman
Robert Appleton Residence, East Hampton

Minerva Nichols
J. W. T. Nichols Residence, Oyster Bay

Noel & Miller
W. S. Crane Residence, Lawrence
Frank M. Gould Residence, Cold Spring Harbor
William Greer Residence, Matinecock
Barklie McKee Henry Residence, Old Westbury
Louis Milhau Residence, Glen Head
Douglas M. Moffat Residence, Huntington
D. Chester Noyes Residence, Huntington

James W. O'Connor
John F. Bermingham Residence, East Norwich
A. C. Bostwick Residence, Old Westbury
George E. Fahys Residence, Locust Valley
Joseph P. Grace Residence, North Hills
Mrs. W. R. Grace Residence, Kings Point
William Russell Grace, Jr., Residence, Westbury
F. H. Haggerson Residence, Port Washington
Artemas Holmes Residence, Brookville
Tennis Court & Playhouse, Charles McCann
 Residence, Oyster Bay
Sidney A. Mitchell Residence, Brookville
Sidney Z. Mitchell Residence, Brookville
Geraldyn Redmond Residence, Brookville
L. H. Sherman Residence, North Hills
John N. Stearns, Jr., Residence, Brookville
Charles H. Thierot Residence, Oyster Bay
Church of St. William the Abbot, Seaford
Garden Apartments, Great Neck
St. Boniface Church, Sea Cliff
Split Rock School, Syosset
Thomaston Building, Great Neck

Olmsted Brothers (Landscape Design)
John E. Aldred Estate, Lattingtown
George F. Baker Estate, Lattingtown
William R. Coe Estate, Oyster Bay
Roland Ray Conklin Estate, Lloyd Harbor
William Bayard Cutting Estate, Great River
Gerald Dahl Estate, Smithtown
Henry W. de Forest Estate, Cold Spring Harbor
Hiram Dewing Estate, Oyster Bay
Marshall Field III Estate, Lloyd Harbor
Walter Jennings Estate, Cold Spring Harbor
Otto H. Kahn Estate, Cold Spring Harbor
Sydney Z. Mitchell Estate, Brookville
Henry Huddleston Rogers, Jr., Estate,
 Southampton
Henry Sanderson Estate, Oyster Bay
Creek Club, Locust Valley
Montauk Point Association, Montauk

Palmer & Hornbostel
Arthur S. Dwight Residence, Great Neck
J. G. Robin Residence, Riverhead

Chester A. Patterson
H. L. Batterman Residence, Matinecock
W. Rossiter Betts Residence, Syosset
Mrs. Prescott Slade Residence, Mill Neck
Walter Wyckoff Residence, Kings Point

Peabody, Wilson & Brown
C. C. Auchincloss Residence, Wheatley Hills
Gordon Auchincloss Residence, Matinecock
George W. Bacon Residence, St. James
Courtlandt D. Barnes Residence, Manhasset
Archibald M. Brown Residence, St. James
Lathrop Brown Residence, St. James
Cates Residence, Southampton
J. Averell Clark Residence, Westbury
Fulton Cutting (originally C. C. Rumsey)
 Residence, Wheatley Hills
Hiram Dewing Residence, Locust Valley
William H. Dixon Residence, St. James
Richard S. Emmet Residence, Glen Cove
Reginald Fincke Residence, Southampton
J. W. Funk Residence, Southampton
Mrs. J. E. S. Hadden Residence, Jericho
Mrs. Montgomery Hare Residence, Smithtown
A. Ludlow Kramer Residence, Jericho
William F. Ladd Residence, Lawrence
William F. Ladd Residence, Southampton
Devereux Milburn Residence, Old Westbury
Hugh Murray Residence, Old Westbury
Darragh Park Residence, Old Brookville
Julian L. Peabody Residence, Old Westbury
Alonzo Potter Residence, Smithtown
Charles M. Pratt, Jr., Residence, Glen Cove
William P. T. Preston Residence, Jericho
Carl J. Schmidlapp Residence, Mill Neck
Lucien H. Tyng Residence and Playhouse,
 Southampton
F. S. Von Stade Residence, Westbury

Children's Library, Westbury
Library and Carnegie Institute, Cold Spring
 Harbor Laboratory, Cold Spring Harbor
Cold Spring Harbor Library,
 Cold Spring Harbor
Freeport Municipal Building, Freeport
Glamor Ford Showroom, Smithtown
Heelbarp Corporation Building, Westhampton
Huntington Town Hall, Huntington
North Country Community Hospital,
 Glen Cove
Southampton Bathing Corporation Pavilion,
 Southampton
Union Free School, Cold Spring Harbor
Walt Whitman School, Woodbury
Wheatley Hills National Bank, Wheatley Hills

Hall Pleasants Pennington
Dr. Harold Mixsell Residence, Matinecock
H. Pleasants Pennington Residence,
 Locust Valley
Philip J. Roosevelt Residence, Oyster Bay

John H. Phillips
George A. Anderson Residence, Brookville
James T. Bryan Residence, Mill Neck

Charles A. Platt
Clifford J. Brokaw Residence, Glen Cove
George R. Dyer Residence, Brookville
C. Temple Emmet Residence, Stony Brook
Meredith Hare Residence, Huntington
L. C. Ledyard, Jr., Residence, Syosset
Robert M. Lloyd Residence, Syosset
James A. McCrea Residence, Woodmere
Frederic B. Pratt Residence, Glen Cove
John T. Pratt Residence, Glen Cove
Ralph Pulitzer Residence, Manhasset
Lansing P. Reed Residence, Lloyd Harbor
Francis M. Weld, Jr., Residence, Lloyd Harbor

William Platt
John T. Pratt, Jr., Residence, Glen Cove

Polhemus & Coffin
Mrs. Allen Bakewell Residence, Southampton
Charles A. Blackwell Residence, Brookville
Albert Boardman Residence, Southampton
Countess Di Zippola Residence, Mill Neck
Nevil Ford Residence, Lloyd Harbor
Mrs. Daniel Guggenheim Residence,
 Sands Point
William S. Jenney Residence, East Hampton
Alexander Zabriskie Residence, Smithtown

John Russell Pope
Robert L. Bacon, Sr., Residence, Westbury
Robert L. Bacon, Jr., Residence, Westbury
Cottage, O. H. P. Belmont Residence,
 Hempstead
Louis F. Bertschmann Residence, Syosset

Arthur S. Bruden Residence, Jericho
Middleton S. Burrill Residence, Jericho
Marshall Field III Residence, Lloyd Harbor
Michael Gavin Residence, Brookville
Charles A. Gould Residence, Greenlawn
Wayne Johnson Residence, Southampton
Joseph J. Kerrigan Residence, Oyster Bay
Joseph P. Knapp Residence, Southampton
H. W. Lowe Residence, Wheatley Hills
Ogden L. Mills Residence, Woodbury
J. Seward Pulitzer Residence, Wheatley Hills
J. Randolph Robinson Residence,
 Wheatley Hills
William L. Stow Residence, Roslyn
Mrs. W. K. Vanderbilt, Jr., Residence, Jericho
Gate House, William K. Vanderbilt, Jr.,
 Residence, Great Neck
Toll Houses & Hotel, Vanderbilt Motor
 Parkway

George B. Post
Frank Alleyne Otis Residence, Bellport
Charles A. Post Residence, Bayport
Col. H. A. V. Post Residence, Babylon
Regis H. Post Residence, Bayport
Francis T. Underhill Residence, Oyster Bay

Potter & Robertson
Mrs. S. S. Adam Residence, Oyster Bay
Dr. Francis Markoe Residence, Southampton
Robert H. Robertson Residence, Southampton
Christ Episcopal Church, Oyster Bay
Rogers Memorial Library, Southampton
Wing, Southampton Fresh Air Home,
 Southampton

Bruce Price
James Alfred Roosevelt Residence, Oyster Bay
Judge Horace Russell Residence, Southampton
Rockaway Hunting Club, Lawrence

J. W. von Rehling Quistgaard
J. W. von Rehling Quistgaard Residence,
 Oyster Bay

T. Henry Randall
William B. Boulton Residence, Lawrence
Winthrop Burr Residence, Lawrence
Frederick Phillips Residence, Lawrence
Edward S. Rogers Residence, Lawrence

Renwick, Aspinwall & Owen
George Bullock Residence, Centre island
Colgate Hoyt Residence, Centre Island
R. A. Peabody Residence, Cedarhurst
Charles W. Wetmore Residence, Centre Island

James Renwick
Frederic Gallatin Residence, East Hampton

Greville Richard
William S. Barstow Residence, Kings Point
John H. Eden Residence, Kings Point

Theodate Pope Riddle
Mrs. Charles O. Gates Residence, Lattingtown

John W. Ritch
Edward H. Swan Residence, Oyster Bay

James Gamble Rogers
W. L. Harkness Residence, Glen Cove
Robert D. Huntington Residence, Mill Neck
George E. Ide Residence, Lattingtown
Le Clanche Moën Residence, Oyster Bay

Thomas C. Rogers
Bernard C. Black Residence, Great Neck
Kenneth F. Cooper Residence, Kings Point

Romeyn & Stever
Edward R. Ladew Residence, Glen Cove

Eric K. Rossiter
William H. Peters Residence, Mill Neck
Charles Lane Poor Residence, Shelter Island

Rouse & Goldstone
Isaac Cozzens Residence, Lattingtown
Augusta Hays Lyon Residence, Huntington

Rowe & Smith
Estate Outbuildings, John E. Aldred Residence,
 Lattingtown

William Schickel
A. Kuttroff Residence, Shelter Island
W. Paul Pickhardt Residence, Shelter Island
William Schickel Residence, Shelter Island

Mott B. Schmidt
Charles A. Bateson Residence, Huntington
Charles Robertson Residence, Lloyd Harbor
Clarkson Runyon Residence, Glen Cove

Mott B. Schmidt & Mogens Tvede
Jeremiah Clarke Residence, Brookville
Albert H. Ely, Jr., Residence,
 Cold Spring Harbor
Oliver Burr Jennings Residence, Lloyd Harbor

Schultz & Weaver
Spencer F. Weaver Residence, East Hampton
Montauk Manor, Montauk

Henry R. Sedgwick
Robert M. Winthrop Residence, Westbury

H. Craig Severance (Severance & Schrumm)
John Anderson Residence, Lattingtown
Frank Bailey Residence, Lattingtown
C. A. O'Donahue Residence, Huntington

Ellen Shipman (Landscape Design)
J. Averell Clark Estate, Westbury
George deForest Lord Estate, Syosset
Richard S. Emmet Estate, Glen Cove
Miss Julia Fish Estate, Greenport
Phillip Gossler Estate, Wheatley Hills
Mrs. Edwin Gould Estate, Oyster Bay
Meredith Hare Estate, Huntington
Edward F. Hutton (M.M. Post) Estate,
 Wheatley Hills
Franklin P. Lord Estate, Syosset
Julian Peabody Estate, Old Westbury
Harry T. Peters Estate, Islip
Mrs. E. J. Plumb Estate, Shelter Island
William P. T. Preston Estate, Jericho
Misses Pryne Estate, East Hampton
Lansing P. Reed Estate, Lloyd Harbor
Samuel A. Salvage Estate, Glen Head
Miss Eleanor Swayne Estate, Southampton
Mrs. Eugene Taliaferro Estate, Oyster Bay
F. M. Towle Estate, Shelter Island

George Skidmore
Frank M. Lupton Residence, Mattituck

Leon H. Smith
Hannibal C. Ford Residence, Kings Point

Richard H. Smythe
Ward Melville Residence, Old Field

Snelling & Potter
C. Raoul Duval Residence, Roslyn

Chandler Stearns
John C. Ryan Residence, Roslyn

Robert S. Stephenson
John A. Garven Residence, Oyster Bay

Frederick J. Sterner
Harry F. Guggenheim Residence, Sands Point

Harvey Stevenson
Paul Leonard Residence, Huntington

Stickney & Austin
George Bullock Residence, Centre Island
Rev. H. T. Rose Residence, Water Mill

Charles A. Stone
Charles A. Stone Residence, Matinecock

Penrose V. Stout
Carroll Wainwright Residence, Southampton

Joseph H. Taft
Robert Lewis Burton Residence, Cedarhurst

Robert Tappan
Nathaniel A. Campbell Residence,
 East Hampton
Eltinge F. Warner Residence, East Hampton

Charles C. Thain
Raymond S. White Residence, Great River

Joseph Greenleaf Thorp
Andrew C. Bradley Residence, East Hampton
F. H. Davies Residence, East Hampton
Rev. T. DeWitt Talmage Residence,
 East Hampton
Mrs. Charles Hackstaff Residence,
 East Hampton
Mrs. S. Fisher Johnson Residence,
 East Hampton
Rev. John R. Paxton Residence, East Hampton
Mrs. F. Stanhope Phillips Residence,
 East Hampton
E. Clifford Potter Residence, East Hampton
Frederick G. Potter Residence, East Hampton
 (1899)
Frederick G. Potter Residence, East Hampton
 (1905)
Laura Sedgwick Residence, East Hampton
Rev. J. Nevett Steele Residence, East Hampton
J. Greenleaf Thorp Residence, East Hampton
Lorenzo E. Woodhouse Residence,
 East Hampton

Louis Comfort Tiffany
Louis Comfort Tiffany Residence,
 Laurel Hollow

Tooker & Marsh
Amos D. Carver Residence, Lattingtown

Treanor & Fatio
George Backer Residence, Oyster Bay
Poolhouse, Mrs. James P. Donahue Residence,
 Southampton
Emil J. Stehli Residence, Lattingtown

Trowbridge & Ackerman
Jay F. Carlisle Residence, East Islip
George D. Pratt Residence, Glen Cove
Theodore Pratt Residence, Glen Cove

Trowbridge & Livingston
Dennistoun M. Bell Residence, Amagansett
George S. Brewster Residence, Brookville
Goodhue Livingston Residence, Southampton

Horace Trumbauer
Howard C. Brokaw Residence, Brookville
James B. Clews Residence, Brookville
David Dows Residence, Brookville
Joseph P. Grace Residence, North Hills
Henry Phipps Residence, Great Neck
Service Wing, John S. Phipps Residence,
 Old Westbury
William K. Vanderbilt, Jr., Residence,
 Great Neck
Belmont Park, Elmont

William B. Tubby
John Rogers Maxwell Residence, Glen Cove
George D. Pratt Residence, Glen Cove
Pratt Mausoleum, Glen Cove
Pratt Administration Buildings, Glen Cove
Oyster Bay Town Hall

William B. Tuthill
Charles H. Adams Residence, East Hampton
William M. K. Olcott Residence, Quoque

Charles A. Valentine
Eustis L. Hopkins Residence, Matinecock

Calvert Vaux (Vaux, Withers & Company)
Fanny and Parke Godwin Residence,
 Roslyn Harbor
Henry B. Hyde Residence, Bay Shore

Vitale & Geiffert (Landscape Design)
Jay F. Carlisle Estate, East Islip
Arthur V. Davis Estate, Mill Neck
Edwin Fish Estate, Locust Valley
Donald Geddes Estate, Glen Cove
Isaac Guggenheim Estate, Sands Point
G. Beekman Hoppin Estate, Oyster Bay
Mrs. Alfred M. Hoyt Estate, Southampton
Charles I. Hudson Estate, East Norwich
Condé Nast Estate, Sands Point
Carl J. Schmidlapp Estate, Mill Neck
Mrs. I. D. Sloan Estate, Lattingtown
Myron C. Taylor Estate, Lattingtown
Landon K. Thorne Estate, Bay Shore

Wait & Cutter
A. Schwarzmann Residence, Shelter Island

Walker & Gillette
Sherwood Aldrich Residence, Kings Point
Jacob Aron Residence, Kings Point
George F. Baker, Jr., Residence, Lattingtown
Mrs. George F. Baker III Residence, Lattingtown
Irving Brokaw Residence, Mill Neck
William R. Coe Residence, Oyster Bay
Henry P. Davison Residence, Locust Valley
Harvey D. Gibson Residence, Lattingtown
Henry F. Godfrey Residence, Westbury
James N. Hill Residence, Brookville
Francis L. Hine Residence, Glen Cove
William G. Loew Residence, Wheatley Hills
Charles Lane Poor Residence, Shelter Island
Ralph Pulitzer Residence, Manhasset
Henry H. Rogers Residence, Southampton
Thomas S. Tailer Residence, Lattingtown
The Creek Club, Lattingtown

Hobart A. Walker
William Burger Residence, Lattingtown

Leroy P. Ward
Dr. Wesley C. Bowers Residence, Southampton
Fenley Hunter Residence, Great Neck
A. C. Schermerhorn Residence, Matinecock
Stephen L. Vandeveer Residence, Great Neck

James E. Ware
F. V. Clowes Residence, Bridgehampton

Warren & Clark
P. F. Collier Residence, Southampton
Frank C. Henderson Residence, Roslyn
A. Perry Osborn Residence, Glen Head

Warren & Wetmore
Tennis Court Building, Marshall Field III
 Residence, Lloyd Harbor
Gate Lodge & Garage, Isaac Guggenheim
 Residence, Sands Point
C. Oliver Iselin Residence, Brookville
Estate Outbuildings, Clarence H. Mackay
 Residence, Roslyn
Ralph J. Preston Residence, Jericho
Joseph S. Stevens Residence, Jericho
Tennis Court Wing, William K. Vanderbilt, Sr.,
 Residence, Oakdale
William K. Vanderbilt, Jr., Residence,
 Centerport
Deepdale Golf and Country Club, Great Neck

Louis S. Weeks
Hugo Branca Residence, Manhasset
Courtland Dixon Residence, Lawrence
Mrs. Clarkson Potter Residence, Southampton

Werner & Windolph
Louis Auerbach Residence, Far Rockaway
Mrs. Eva M. Foster Residence, Far Rockaway
R. J. Gerstle Residence, Far Rockaway
Messrs. Kraus and Stern Residence,
 Far Rockaway
Gustave Salomon Residence, Far Rockaway

A. Dunham Wheeler
H. B. Anderson Residence, Great Neck
Robert V. V. Sewell Residence, Oyster Bay

Willauer, Sharpe & Bready
J. Herbert Johnston Residence, Lloyd Harbor

Edgar I. Williams
Mrs. Christian R. Holmes Residence,
 Sands Point

John Torrey Windrim
Nicholas Brady Residence, Manhasset

Wyeth & King
Linzee Blagden Residence, Cold Spring Harbor
Anson Hard Residence, Brookhaven

York & Sawyer
D. W. Smith Residence, Oyster Bay

Harry St. Clair Zogbaum
F. Ambrose Clark Residence, Westbury

Key to Bibliographic Abbreviations

Special Collections

AVER	Avery Architectural Library
BAYV	Bayville Historical Museum
BROK	Brooklyn Public Library
BRYA	Bryant Library
BYRO	Byron Photograph Collection, Museum of the City of New York
CORN	Ellen Shipman Collection
FAML	Family Records, photographs, interviews
FAND	Beatrix J. Farrand Collection
FLON	Frederick Law Olmsted National Historic Site, National Park Service
FULL	Fullerton Photograph Collection, Suffolk County Historical Society
GLEN	Glen Cove Public Library
GOTT	Samuel H. Gottscho Photograph Collection, Avery Architectural Library
HEWI	Mattie Edwards Hewitt Photograph Collection
HICK	The Hicks Nursery Collection
HUNT	Huntington Historical Society
INVE	Building-Structure Inventory, NYSOPRH
LIHS	The Brooklyn Historical Society
MCBU	Norman McBurney Photograph & Clipping Collection
MEAD	Meadow Brook Club
NASS	Nassau County Museum
NASU	Nassau County Planning Dept., Surrey, 1976
NRNF	National Register Nomination Form, SPLIA archives
NYHS	Collection of the New-York Historical Society
PENN	University of Pennsylvania
PRES	Preservation Notes, SPLIA Library
PREV	Previews, Inc.
QUES	Queens Borough Public Library
ROSL	Roslyn Landmark Society
SPLI	Society for the Preservation of Long Island Antiquities
SPNE	Society for the Preservation of New England Antiquities
VANB	The Suffolk County Vanderbilt Museum
VAND	The William K. Vanderbilt Historical Society
VANO	Van Orden Photograph Collection
VIEW	View of Various Estates on Long Island, Aerial Photograph Collection, c. 1930, Avery Library
WURT	Wurts Photograph Collection, Museum of the City of New York

Periodicals

AAAA	*The American Architect*
AABN	*American Architect and Building News*
AMAR	*American Architect and Builders Monthly*
AMCO	*American Country Houses of Today*
AMHO	*American Homes and Gardens*
ARAT	*The Architect*
ARBD	*Architecture and Building*
ARBJ	*Architect and Builders Journal*
ARBW	*Architecture, Builder & Woodworker*
ARDI	*Architectural Digest*
ARFO	*Architectural Forum*
ARLG	*Architectural League of New York*
ARRC	*Architectural Record*
ARRV	*Architectural Review*
ARTR	*Architecture*
ARTS	*Arts & Decoration*
ARYB	*The Architectural Year Book*
BRIC	*The Brickbuilder*
COHO	*Country Homes*
COUN	*Country Life in America*
FORT	*Fortune Magazine*
GARD	*The Garden Magazine*
HOUG	*House and Garden*
HOUS	*The House Beautiful*
INDO	*Indoors and Out*
LAND	*Landscape Architecture*
LIFO	*Long Island Forum*
NYAR	*The New York Architect*
POLO	*Polo Monthly*
REAL	*Real Estate Record and Guide*
SAAB	*Scientific American*
SPUR	*The Spur*
TOWN	*Town and Country*

Newspapers

BKLY	*Brooklyn Daily Eagle*
HERL	*Herald Tribune*
LOIS	*The Long Islander*
NYTI	*New York Times*
NYTO	*New York Times Obituary*
OBGU	*Oyster Bay Guardian*

Books

AJRP *Architecture of John Russell Pope*, Royal Cortissoz (1925)

AMER *America's Gilded Cage*, F. Pratt (1976)

AMGS *Amagansett, A Pictorial History* (1986)

AMRE *American Renaissance*, Joy W. Dow (1904)

ARCS *Artistic Country Seats*, George Sheldon (1979)

ATLA *Concrete Country Residences* (1907)

BABY *Picturesque Babylon, Bay Shore and Islip* (1902)

BARD *A Monograph of the Work of Donn Barber*, John Cordis Baker (1924)

BEAU *Beaux-Arts Estates*, Liisa & Donald Sclare (1979)

BROD "A Place Where Nobody Goes," Mosette Glaser Broderick (1982)

COUE *Country Estates* (1914)

COUH *Country Houses* (1928)

DEBE *Long Island*, C. Manley de Bevoise (1963)

DELA *Residences Designed by Bradley Delehanty* (1934)

DELE *Residences Designed by Bradley Delehanty* (1939)

DESM *Stately Homes in America*, Croly and Desmond (1903)

EHHE *East Hampton's Heritage*, Clay Lancaster et al. (1982)

ELWO *American Landscape Architecture*, P. H. Elwood, Jr. (1924)

EMBU *100 Country Houses*, Aymar Embury II (1909)

FERR *American Estates and Gardens*, Barr Ferree (1904)

FOST *Boarders to Builders*, Sherrill Foster (1977)

FYMC *Fifty Years of the Maidstone Club* (1941)

GREA *This Is Great Neck*, Roberta Pincus (1975)

HELB *The Work of D. J. Baum*, C. Matlack Price (1927)

HIST *The Smallest Village* (1976)

HOUH *House and Garden Book of Houses* (1920)

HOWE *Noted Long Island Homes* (1933)

LAPE *Landscape Planting and Engineering* (1922)

LEVA *Lewis & Valentine Co.* (1916)

LHDG *The Livable House, Its Garden*, Ruth Dean (1917)

LINB *Domestic Architecture of H. T. Lindeberg* (1940)

LINT *Domestic Architecture*, Albo and Lindeberg (1912)

MASS *Manhasset: The First 300 Years* (1980)

MCKI *The Architecture of McKim, Mead & White (1870–1920), A Building List*, Leland Roth (1978)

MIZN *Addison Mizner*, Christina Orr (1977)

MLAE *Modern Landscape Engineering* (n.d.)

MOFB *Modern Farm Building*, Alfred P. Hopkins (1920)

NCAB *National Cyclopedia of American Biography*

OAKD *The Old Oakdale History* (1983)

OCOR *Selections from the Work of James W. O'Connor*, James Delaney (1930)

OCOU *Work Designed by James W. O'Connor* (1922)

PATT *American Homes of Today*, Augusta Owen Patterson (1924)

PELL *American Families of Historic Lineage*, William S. Pelletreau (1912)

PHDA *Portrait of 10 Country Houses* (1922)

PLAS *Monograph of the Work of Charles A. Platt* (1913)

POLC *The Work of Polhemus & Coffin* (1932)

PROM *Prominent Residents on Long Island and Their Pleasure Clubs* (1916)

RAND *The Mansions of Long Island's Gold Coast*, Monica Randall (1979)

ROCK *History and View of the Rockaways*, William S. Pettit (1901)

RUTH *Long Island Today*, Frederick Ruther (1909)

SAVG *Saving Large Estates* (1977)

SORG *New York Social Register*

VANL *Fifty Years Head-of-the-Harbor*, Barbara Van Liew (1978)

VIEM *An Architectural Journey Through Long Island*, August Viemeister (1974)

WHIT *Bertram Grosvenor Goodhue*, C. H. Whitaker (1925)

WWIA *Who Was Who in America*

Key to Architectural Styles

Style Codes

CLCO	Classic Colonial
CLOL	Neo Colonial
CLRV	Colonial Revival
COTM	Modified Cotswold
COTS	Cotswold
DCMD	Modified Neo Dutch Colonial
DCRV	Neo Dutch Colonial
EGMV	English Medieval
FBAT	French Beaux-Arts
FRNC	French Neoclassic
FRPM	François Premier
FSCE	French Second Empire
GRRM	Modified Neo Georgian
GRRV	Neo Georgian
HTRV	Neo Tudor/Half-Timbered
HVGO	High Victorian Gothic
INTL	International Style
ITAM	Modified Italianate
ITAN	Italianate
JACB	Neo Jacobean
JACM	Modified Neo Jacobean
LNCL	Late Neoclassic
MEVI	Mediterrean Villa Style
NECL	Neoclassic
NEFD	Neo Federal
NEFL	Neo Flemish
NEFM	Modified Neo Federal
NEGT	Neo Gothic
NEIR	Neo Italian Renaissance
NFRI	Modified Neo French Renaissance
NFRM	Neo French Manorial
NFRR	Neo French Renaissance
NIRM	Modified Neo Italian Renaissance
NSPR	Neo Spanish Renaissance
QUAN	Queen Anne
ROMA	"Romanesque" Revival
SCAN	Scandinavian
SHIM	Modified Shingle Style
SHIN	Shingle Style
SPCM	Neo Spanish Colonial/Mission
STIK	"Stick Style"
TUDM	Modified Neo Tudor
TUDR	Neo Tudor
TWEC	20th Century Eclectic
TWPC	20th Century Picturesque
WRIN	Wrightian Influence

Adaptive Reuse Codes

C	Club
D	Condo
E	Private Estate
G	County/State Community Owned
L	Church/Religious Use
M	Museum
N	Navy/Military
O	Other
R	Corporate HQ
S	School

Estate Owner Index

original owner

date of birth; date of death; maiden name; estate name; adaptive reuse; street address; town or village; construction date; architectural firm; landscape architect; style; year of demolition or NA (not applicable); subsequent owner 1; subsequent owner 2; extant (Y, N)

BIBLIOGRAPHY: publication (volume), issue, year, page

Abbott, Phillip
unknown; unknown; unknown; unknown; E; West Shore Road; Mill Neck; 1895; unknown; NA; DCMD; NA; Nickerson, Hoffman; Hollander, Mrs.; Y

BIBLIOGRAPHY: INVE

Adam, Mrs. S. S.
unknown; unknown; unknown; Hillside; E; Lexington Avenue; Oyster Bay; 1878; Potter & Robertson; Farrand, Beatrix (1921); QUAN; NA; Derby, Ethel Roosevelt; Dieffenbach, William; Y

BIBLIOGRAPHY: AABN (4), Dec. 1878; PRLN, 1985

Adams, Charles H.
1825; 1902; Coleman, Judith; Mount Wollaston; E; Lee Avenue; East Hampton; c. 1889; Tuthill, William B.; unknown; QUAN; NA; Hodson, Dr. J. M. & Mrs.; Mairs, Olney B., Mr. & Mrs.; Y

BIBLIOGRAPHY: FOST, 1977; ARBD, Dec. 1890; SORG; FYMC, 1941: 21; EHHE, 1982: 167

Adams, Horatio
unknown; unknown; unknown; unknown; E; Middle Cross Lane; Glen Cove; c. 1895; Little & Browne; unknown; SHIN; NA; unknown; unknown; Y

BIBLIOGRAPHY: ARBD, Jan. 12, 1895; INVE

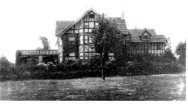

Adams, John Dunbar
unknown; 1934; Burchell, Susan; Woodlea; unknown; S. Country Road; Bay Shore; c. 1902; unknown; unknown; TUDR; c. 1950; unknown; unknown; N

BIBLIOGRAPHY: LIFO, Feb. 1990; VAND; SPUR (14), Oct. 1914: 22

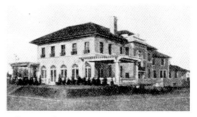

Adams, Thomas C.
1846; 1926; Mills, Emma; Admore; C; S. Country Road; Bay Shore; c. 1905; unknown; unknown; MEVI; NA; Ellis, Mrs. George; Southward Ho Country Club; Y

BIBLIOGRAPHY: BKLY, Aug. 3, 1907; INVE; RUTH, 1909

Alcott, Clarence F.
unknown; unknown; Burke, Lucie; unknown; E; unknown; East Hampton; 1915; Albro & Lindeberg; unknown; COTS; NA; unknown; unknown; Y

BIBLIOGRAPHY: INVE; ARRC (55), APR. 1924: 342; LINB: 204; ARTS (26), MAR. 1927: 54; EHHE: 192

Alden, Mrs. A. C.
unknown; 1896; unknown; Fort Hill; E; unknown; Lloyd Harbor; c. 1879; McKim, Mead & White; Mackenzie, J. Clinton; QUAN; NA; Matheson, William; Wood, Mrs. Willis D.; Y

BIBLIOGRAPHY: AAAA (99), Feb. 1911; MCKI, 1978: 13; INVE; AAAA, 1879; HICK; WURT; TOWN, May 1917: 28; ARLG (26), 1911

Aldred, John E.
unknown; 1945; Ormston; Ormston; L; Lattingtown Road; Lattingtown; 1916; Goodhue, Bertram Grosvenor; Olmsted Brothers (1919); TUDR; NA; St. Josephat's Monastery; NA; Y

BIBLIOGRAPHY: WWIA (11), 950: 20; ARTS (39), May, 1933: 8; LEVA; LAND (28), July 1938: 191; ELWO, 1924; FLON; INVE; SPUR (40), Aug. 927: 53; WHIT, 1925: 39; ARBD (47), Aug. 1916: 311

Aldrich, James H.
unknown; unknown; Edson, Mary G.; Maycroft; S; Ferry Road; Sag Harbor; 1886; Lindsey, Edward; unknown; SHIN; NA; Episcopal Church; Tuller Episcopal School; Y

BIBLIOGRAPHY: *Sag Harbor Express*, May 13, 1886; VAND

Aldrich, Sherwood
1868; 1927; unknown; Snug Harbor; F; West Shore Road; Kings Point; c. 1920; Walker & Gillette; Olmsted Brothers; NFRR; NA; Slone, Alfred P., Jr.; unknown; Y

BIBLIOGRAPHY: PATT, 1924: 65; SPUR (26), Sept. 1920: 36; WWIA (1): 13; FLON; INVE

Aldrich, Winthrop W.
c. 1885; unknown; Alexander, Harriet; Broad-hollow; E; Cedar Swamp Road; Brookville; c. 1926; Aldrich, William T.; unknown; GRRV; NA; Uris, Percy; unknown; Y

BIBLIOGRAPHY: PREV, 1945; NCAB: 74; INVE

Alger, Miss Lucille
unknown; unknown; unknown; unknown; unknown; unknown; Great Neck; c. 1902; Eyre, Wilson; unknown; TWEC; unknown; unknown; unknown; N

BIBLIOGRAPHY: ARRC (34), Oct. 1913: 302; HOUS, Nov. 1906: 10

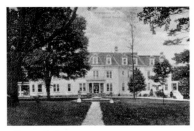

Alker, Alphonse H.
1851; 1913; Ward, Florence; Idlewilde; unknown; East Shore Road; Kings Point; c. 1896; unknown; unknown; FSCE; c. 1950; unknown; unknown; N

BIBLIOGRAPHY: SORG; NCAB

Alker, Carroll B.
1893; 1946; Ingalls; unknown; R; Cedar Swamp Road; Brookville; c. 1924; Ellett, Thomas Harlan; unknown; NEFM; NA; Dillon, Herbert L.; Sunninghill Corp.; Y

BIBLIOGRAPHY: INVE; NCAB; ARAT (4), June 1925

Alker, Carroll B.
1893; 1946; Kohler, Vera; Ca Va; E; Wheatley Hills Road; Brookville; c. 1934; Delehanty, Bradley; unknown; NFRM; NA; unknown; unknown; Y

BIBLIOGRAPHY: DELA; GOTT, 1934

Alker, Henry
unknown; unknown; unknown; unknown; E; Middle Neck Road; Sands Point; c. 1927; Murdock, Daniel; unknown; MEVI; NA; Mohibu, A.; unknown; Y

BIBLIOGRAPHY: INVE

Altha, Benjamin
1843; 1925; unknown; unknown; unknown; Shore Road; Shelter Island; 1907; unknown; unknown; unknown; unknown; unknown; unknown; N

BIBLIOGRAPHY: INVE

Anderson, George A.
unknown; unknown; unknown; unknown; E; Hegeman Lane; Brookville; c. 1929; Phillips, J. H.; unknown; COTM; NA; unknown; unknown; Y

BIBLIOGRAPHY: INVE

Anderson, H. B.
1863; 1938; Larocque, Marie; The Boulders; unknown; unknown; Great Neck; c. 1895; Wheeler, A. Dunham; unknown; TWEC; unknown; unknown; unknown; N

BIBLIOGRAPHY: ARLG (13), 1898; NCAB

Anderson, John
unknown; unknown; unknown; unknown; E; Skunks Misery Road; Lattingtown; c. 1909; Severance & Schumm; unknown; NEFD; NA; Shea, Edward; unknown; Y

BIBLIOGRAPHY: VIEW; ARRC (42), Oct. 1917: 328; INVE; LAPE

Appleton, Robert
unknown; unknown; unknown; Nid de Pappillon; E; unknown; East Hampton; c. 1918; Newman, Frank Eaton; unknown; COTS; NA; unknown; unknown; Y

BIBLIOGRAPHY: PATT, 1924: 232; ARRC (46), Oct. 1919: 380; COUN, Oct. 1926: 37; TOWN, May 1921: 32; INVE

Arnold, Mrs. William
unknown; unknown; Frothingham, D.; Maple Lodge; E; The Crescent; Babylon; c. 1906; Gage, S. Edson; Sanger, Prentice; CLRV; NA; Kulak, Mr. and Mrs. Marion; unknown; Y

BIBLIOGRAPHY: LEVA, 1916; BKLY, Aug. 9, 1906; INVE

Arnold, William H.
unknown; unknown; unknown; unknown; unknown; unknown; Great Neck; c. 1900; Brite & Bacon; unknown; SHIM; c. 1950; unknown; unknown; N

BIBLIOGRAPHY: INVE; FAML

Aron, Jacob
unknown; unknown; unknown; Hamptworth House; unknown; unknown; Kings Point; 1926; Walker & Gillette; unknown; HTRV; c. 1950; unknown; unknown; N

BIBLIOGRAPHY: ARBD, Sept. 1927: 304; FLON; INVE; WURT, 1929

Ashley, William F.
unknown; unknown; unknown; unknown; E; unknown; Shoreham; c. 1910; Benson, John P.; unknown; TWEC; NA; unknown; unknown; Y

BIBLIOGRAPHY: TOWN, Mar. 1912: 38; INVE

Astor, Vincent
1891; 1959; Dinsmore; Cloverley Manor; E; W. Shore Road; Port Washington; 1922; Delano & Aldrich; Flanders, Annette Hoyt; TUDR; NA; Schenck, Nicholas; unknown; Y

BIBLIOGRAPHY: AVER; ARLG, 1926; ARRC (60), Nov. 1926: 422; HEWI, 1925; ARTS (31), Oct. 1929: 59; INVE, 1990; NCAB: 56

Atterbury, Grosvenor
1869; 1956; Johnestone, D.; The Lodge; E; unknown; Southampton; c. 1900; Atterbury, Grosvenor; unknown; shin; na; unknown; unknown; Y

BIBLIOGRAPHY: ARAT (9), Jan. 1928: 475; ARTS (24), Mar. 1926: 35; SORG

Atwater, William
unknown; unknown; Hay, Ida; Brightwaters; E; Seafield Lane; Westhampton; c. 1904; Brite & Bacon; unknown; GRRM; NA; O'Brien, Henry; unknown; Y

BIBLIOGRAPHY: NYTI, June 22, 1989

Auchincloss, C. C.
1881; 1961; Saltonstall, R; Builtover; E; unknown; Wheatley Hills; c. 1916; Peabody, Wilson & Brown; unknown; GRRV; NA; unknown; unknown; Y

BIBLIOGRAPHY: LAPE; NCAB; FLON; SORG, 1929

Auchincloss, Gordon
1886; 1943; House, Janet; Ronda; E; unknown; Matinecock; c. 1927; Peabody, Wilson & Brown; unknown; GRRV; NA; Theriot; unknown; Y

BIBLIOGRAPHY: INVE; SORG

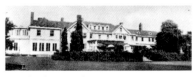

Auerbach, Joseph
unknown; unknown; unknown; unknown; C; Club Drive; Hewlett; c. 1914; unknown; unknown; GRRM; NA; Seawane Golf Club; unknown; Y

BIBLIOGRAPHY: LIHS

Auerbach, Louis
unknown; unknown; unknown; unknown; unknown; unknown; Far Rockaway; c. 1895; Werner & Windolph; unknown; MEVI; c. 1950; unknown; unknown; N

BIBLIOGRAPHY: ROCK

Ayer, Dr. J. C.
unknown; unknown; Hancock, May. C.; Shadowland; unknown; Sunview Drive; Glen Cove; c. 1910; Gilbert, C. P. H.; Farrand, Beatrix; MEVI; c. 1960; Appleby, J. S.; unknown; N

BIBLIOGRAPHY: ARRC (36), Oct. 1914: 287; ARTR (22), July 1910: 104; SORG; PRLN, 1985

Babbott, Frank Lusk
1854; 1933; Pratt, Lydia; Dosoris; E; Dosoris Lane; Glen Cove; c. 1890; Lamb & Rich; unknown; TWEC; NA; Macdonald, Helen; unknown; Y

BIBLIOGRAPHY: NRNF, 1980; SORG; WWIA (I): 40

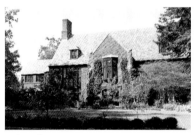

Babcock, F. Huntington
1886; 1973; Doubleday, Dorothy; Pepperidge Point; E; Cleft Road; Mill Neck; c. 1915; unknown; unknown; TUDR; NA; Lutheran School Deaf; Quales, Mr.; Y

BIBLIOGRAPHY: SORG; INVE, 1978

Babcock, Mrs. Richard F.
unknown; unknown; Thompson, E. S.; Hark Away; E; unknown; Woodbury; c. 1923; Delano & Aldrich; Innocenti & Webel; NEFD; unknown; unknown; unknown; Y

BIBLIOGRAPHY: FAML; SORG, 1929

Backer, George
unknown; unknown; unknown; Oldfields; C; unknown; E. Norwich; c. 1934; Treanor & Fatio; Treanor & Fatio; GRRV; NA; Schiff, Dorothy; Balson, Consuelo Vanderbilt; Y

BIBLIOGRAPHY: COUN (67), Jan. 1935: 71; GOTT, 1934

Bacon, George W.
1869; 1953; unknown; Thatch Meadow Farm; E; Harbor Road; St. James; c. 1912; Peabody, Wilson & Brown; unknown; CLOL; NA; Billings, Viola; unknown; Y

BIBLIOGRAPHY: ARRC (38), 1915; NRNF, 1992; ARTR (30), Oct. 1914

Bacon, Robert L., Jr.
1884; 1938; Murray, Virginia; Arlough; E; Willets Road; Westbury; c. 1915; Pope, John Russell; unknown; NFRM; NA; unknown; unknown; Y

BIBLIOGRAPHY: PATT, 1924: 246; AJRP (I), 1925: 14; ARTS (14), Apr. 1919: 13; HOUS (48), July 1920: 9; COUN (65), Apr. 1934: 68; ARTS (14), Apr. 1921: 436; HICK; WWIA (I): 12; SORG, 1929

Bacon, Robert L., Sr.
unknown; unknown; Cowdin, Martha; Old Acres; unknown; Willets Road; Westbury; c. 1907; Pope, John Russell; Hutcheson, Mrs. M. B.; GRRM; c. 1960; unknown; unknown; N

BIBLIOGRAPHY: ARTS (14), Apr. 1921: 440; ARRC (29), June 1911: 471; SORG, 1929

Bailey, Frank
unknown; c. 1955; unknown; Munnysunk; G; Feeks Lane at Bayville Rd; Lattingtown; c. 1912; Severance & Shumm; unknown; CLOL; NA; unknown; Nassau County Arboretum; Y

BIBLIOGRAPHY: INVE

Baker, Mrs. Frederick
1841; 1919; unknown; unknown; unknown; unknown; Southampton; c. 1915; Hiss & Weekes; unknown; NEIR; c. 1950; unknown; unknown; N

BIBLIOGRAPHY: LEVA, 1916; ARRC (40), Dec. 1916: 569

Baker, Mrs. George F. III
1878; 1937; Kane, Edith B.; Vikings Cove; E; Peacock Lane; Lattingtown; 1913; Walker & Gillette; Olmsted Brothers; NEFD; NA; unknown; unknown; Y

BIBLIOGRAPHY: INVE; NCAB: 487

Baker, John T.
unknown; unknown; unknown; unknown; E; Lily Pond Lane; East Hampton; 1907; Lawrence, John C.; unknown; SHIM; NA; unknown; unknown; Y

BIBLIOGRAPHY: EHHE; INVE

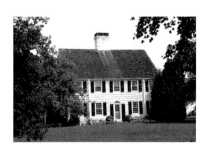

Bakewell, Mrs. Allen
unknown; unknown; Avery, Elizabeth; The Orchard; E; Foster Crossing; Southampton; c. 1929; Polhemus & Coffin; unknown; SHIN; NA; unknown; unknown; Y

BIBLIOGRAPHY: INVE

Baldwin, William H.
1863; 1905; Bowles, Ruth; unknown; unknown; Overlook Drive; Lattingtown; c. 1900; Gilbert, B. L.; unknown; CLRV; c. 1937; Smithers, C. D.; unknown; N

BIBLIOGRAPHY: ARBD (36), June 1904: 390; FULL; INVE; HICK

Ball, Wilbur
c. 1874; c. 1941; Kouwenhoven, J; unknown; E; Skunks Misery Road; Lattingtown; c. 1928; Lindeberg, Harrie T.; unknown; CLOL; NA; unknown; unknown; Y

BIBLIOGRAPHY: ARBD (36), June 1904: 390; FULL; INVE; HICK

Ballantine, J. Herbert
1867; 1946; Drake, Gertrude; Holmdene; unknown; Kings Point Road; Kings Point; c. 1929; Breed, F. Nelson; unknown; NEFD; unknown; unknown; unknown; N

BIBLIOGRAPHY: HOUS (66), Aug. 1929: 162; SORG, 1929; NYTI, June 8, 1946

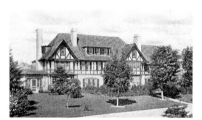

Ballantine, J. H.
unknown; unknown; unknown; unknown; E; Albro Lane; Lawrence; c. 1915; unknown; unknown; HTRV; NA; Gray, Joel; unknown; Y

BIBLIOGRAPHY: INVE, 1981

Barber, Thomas H.
unknown; unknown; Townsend, Harriet; Claverack; E; Halsey Neck Lane; Southampton; c. 1892; unknown; Olmsted Brothers; GRRV; NA; unknown; unknown; Y

BIBLIOGRAPHY: PREV; INVE, 1979

Barclay, Reginald
unknown; unknown; Fahys; West Banks; L; unknown; Sag Harbor; c. 1910; Lowell, Guy; unknown; NEFM; NA; Barclay, George; Pallotine Fathers; Y

BIBLIOGRAPHY: PREV; SORG

Barnes, Courtlandt D.
1882; 1952; Barney, K. L.; Nonesuch House; unknown; Valley Road; Manhasset; c. 1918; Peabody, Wilson & Brown; unknown; COTM; unknown; unknown; unknown; N

BIBLIOGRAPHY: PATT, 1924: 233; ARFO (30), Feb. 1919; SORG, 1929; NYTO; ARRC (50), Oct. 1921: 321

Barnes, E. Mortimer
unknown; 1955; Chalmers, Theresa; Manana; E; Cedar Swamp Road; Glen Head; 1914; Ellett, Thomas Harlan; Flanders, Annette Hoyt; NFRM; NA; Breed, William; unknown; Y

BIBLIOGRAPHY: COUN (59), Mar. 1931: 45; ARAT (4), June 1925: 254; AABN (135), Mar. 1929: 291; SORG; ARAT (9), Nov. 1927: 166; HEWI, 1929; LEVA, 1916

Barnes, Henry B.
unknown; unknown; unknown; Edgecombe; unknown; Gin Lane; Southampton; c. 1895; unknown; unknown; SHIN; unknown; Watson, George E.; unknown; N

BIBLIOGRAPHY: INVE, 1982

Barney, C. T.
unknown; unknown; unknown; unknown; unknown; First Neck Road; Southampton; c. 1890; unknown; unknown; CLRV; unknown; unknown; unknown; N

BIBLIOGRAPHY: INVE, 1982

Barstow, Wm. Slocum
1866; 1942; Duclos, F. M.; Elm Point; N; Steamboat Road; Kings Point; c. 1930; Rickard, Greville; unknown; NEIR; NA; Lundy, William I., U. S. Merchant Marine; Y

BIBLIOGRAPHY: WWIA (11), 1950: 47; GOTT, 1931; BEAU: 55; NRNF

Bartlett, Edward E., Jr.
unknown; unknown; unknown; unknown; unknown; unknown; Amagansett; c. 1915; Hewitt & Bottomley; unknown; NFRM; unknown; unknown; unknown; unknown

BIBLIOGRAPHY: COUN (52), May 1927: 50; ARRC (38), Oct. 1915: 467; NCAB

Bateson, Charles A.
unknown; unknown; unknown; unknown; E; Woodbury Road; Huntington; 1933; Schmidt, Mott B.; unknown; GRRV; NA; unknown; unknown; Y

BIBLIOGRAPHY: INVE; Ledger in Possession of Mrs. B. Schmidt

Batterman, Henry L.
unknown; c. 1961; Whitney, Edith; Beaverbrook Farm; unknown; unknown; Mill Neck; 1914; Albro & Lindeberg; unknown; NFRM; c. 1950; unknown; unknown; N

BIBLIOGRAPHY: INVE; ARTS (23), July 1925: 24; ARTR (31), Jan. 1915: 4ff; HOUS (47), June 1920: 537; LINB; ARRC (55), Apr. 1924: 343; TOWN, June 1921: 26; FORT (4), Sept. 1931: 132; LEVA, 1916; NCAB; SORG, 1929

Batterman, Henry L.
1841; 1904; unknown; unknown; L; Crescent Beach Road; Glen Cove; c. 1900; Brewster, Herbert R.; unknown; DCMD; NA; unknown; No. Shore Reform Temple; Y

BIBLIOGRAPHY: ARBJ (49), July 1917; FORT (4), Sept. 1931: 132; INVE; NCAB

Batterman, Henry L.
1841; 1904; unknown; unknown; E; unknown; Matinecock; c. 1927; Patterson, Chester A.; unknown; GRRV; NA; remained empty; Turner; Y

BIBLIOGRAPHY: FORT (4), Sept. 1931: 132; PREV; INVE

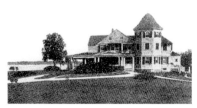

Baylis, Willard N.
unknown; unknown; unknown; unknown; E; unknown; Huntington; c. 1890; unknown; unknown; SHIN; NA; unknown; unknown; Y

BIBLIOGRAPHY: LOIS, Mar. 19, 1909; LOIS, Apr. 26, 1907; *Huntington, Cold Spring Harbor Booklet:* 1909, 43; LOIS, May 29, 1914

Beard, Mrs. William
unknown; unknown; unknown; unknown; E; unknown; Glen Cove; c. 1910; Major, Howard; unknown; GRRM; NA; unknown; unknown; Y

BIBLIOGRAPHY: ARRC (44), Oct. 1918: 362; LEVA

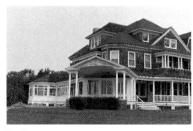

Becker
unknown; unknown; unknown; unknown; E; unknown; Shelter Island; c. 1908; unknown; unknown; CLRV; NA; unknown; unknown; Y

BIBLIOGRAPHY: INVE

Bedford, Alfred C.
1864; 1925; Clarke, Edith; unknown; E; Overlook Road; Lattingtown; c. 1906; unknown; unknown; SHIN; NA; Davis, John W.; unknown; Y

BIBLIOGRAPHY: LOIS, Feb. 2, 1923; WWIA (1): 77; INVE

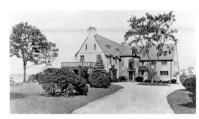

Beech, William
unknown; unknown; unknown; unknown; E; Kings Point Road; Kings Point; c. 1920; unknown; unknown; NFRM; NA; Krim, Arthur B.; unknown; Y

BIBLIOGRAPHY: INVE; MLAE

Beekman, James W.
1815; 1877; Milledoller; The Cliffs; E; West Shore Road; Mill Neck; c. 1863; Harrison, Henry G.; unknown; HVGO; NA; Fritz, Dr. Albert; unknown; Y

BIBLIOGRAPHY: VIEW; SORG; NYHS

Behman, Louis C.
1855; 1902; unknown; Lindenwaldt; E; Seamans Avenue; Bayport; c. 1900; unknown; unknown; SHIN; NA; Osk-Poli; Owens, James; Y

BIBLIOGRAPHY: LIFO, Feb. 1989: 6.2

Bell, Dennistoun M.
1879; 1954; Dolan, Francis; Broadview; E; unknown; Amagansett; c. 1916; Trowbridge & Livingston; unknown; CLCO; NA; unknown; unknown; Y

BIBLIOGRAPHY: PRES (19), 1981: 1

Bell, Edward
unknown; unknown; Wilmerding, Helen; The Crossways; E; S. Main Street & Foster Cross; Southampton; c. 1890; L'Hommedieu, J. H.; unknown; CLRV; NA; unknown; unknown; Y

BIBLIOGRAPHY: INVE; SORG; SAAB, Apr. 1986

Belmont, August P.
1816; 1890; Perry; unknown; G; unknown; Babylon; c. 1867; Lienau, Detlef; unknown; FSCE; c. 1960; Belmont, August, Jr.; Belmont State Park; N

BIBLIOGRAPHY: OAKD

Belmont, August P.
1816; 1890; Perry; Blemton Manor; unknown;
Fulton Avenue; Hempstead; c. 1865; unknown;
unknown; CLCO; unknown; unknown; un-
known; N

BIBLIOGRAPHY: NCAB; NASS

Belmont, Oliver H. P.
1858; 1908; Vanderbilt, Alva; Brookholt; un-
known; unknown; Hempstead; c. 1897; Hunt,
Richard Howland; unknown; CLCO; c. 1950;
unknown; unknown; N

BIBLIOGRAPHY: TOWN, Apr. 1903: 12; HICK; ARRC
(12), May 1902: 100; WWIA (1): 81; SORG

Belmont, Mrs. O. H. P.
unknown; c. 1933; Vanderbilt, Alva; Beacon
Towers; unknown; unknown; Sands Point;
c. 1917; Hunt & Hunt; unknown; NFRR;
c. 1943; Hearst, William R.; unknown; N

BIBLIOGRAPHY: SPUR (26), Sept. 1920: 48; PATT,
1924: 15; VIEW; ARBD (52), Sept. 1920; WWIA (1):
81; TOWN, Dec. 1921: 36

Bendel, Henri
1867; 1936; unknown; Forker House; M; Kings
Point Road; Kings Point; c. 1916; Chapman,
Henry Otis; Leavitt, Charles W.; NECL; NA;
Chrysler, Walter; U. S. Merch. Marine Acad.; Y

BIBLIOGRAPHY: NASU, 1976; WWIA (1): 219; ARLG
(44), 1929; BEAU: 51; SORG

Benner, Charles
unknown; unknown; unknown; unknown; E;
Van Brunt Manor Road; Setauket; c. 1892;
Lamb & Rich; unknown; SHIN; NA; Vaus; Foos,
Ferguson; Y

BIBLIOGRAPHY: HICK; AABN (39), 1893; INVE, 1983

Bermingham, John F.
1878; 1942; Moore, Agnes; Midland Farm; E;
Route 25A, South; East Norwich; c. 1923;
O'Connor, James W.; Olmsted Brothers; NEFM;
NA; unknown; unknown; Y

BIBLIOGRAPHY: ARRC (59), Feb. 1926: 110; WURT,
1930; NYTI, Aug. 26, 1942; FLON

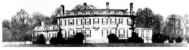

Berquist, John G.
unknown; unknown; unknown; Brympton-
wood; unknown; Linden Lane; Brookville;
c. 1915; unknown; Platt, Charles A.; GRRV;
unknown; Halloway, W. G.; unknown; N

BIBLIOGRAPHY: INVE; LEVA, 1916; COUN (58),
May 1930: 18

Bertschmann, Louis F.
unknown; unknown; Smith, Maude M.; Les
Bouleaux; unknown; Muttontown Road;
Syosset; c. 1937; Pope, John Russell; unknown;
NFRM; unknown; unknown; unknown; un-
known

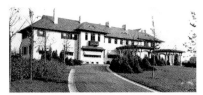

Berwind, John
unknown; unknown; Owood, Katherine;
Minden; E; Ocean Road; Bridgehampton; 1912;
unknown; unknown; MEVI; NA; Presbyterian
Church; Luckey, Dr. E. Hugh; Y

BIBLIOGRAPHY: COUN (60), May 1931: 20; COUN
(33), Nov. 1917: 42; SORG; TOWN, Mar. 1929: 8;
HEWI

Betts, W. Rossiter
unknown; unknown; Pope, Ruby R.; The
Pebbles; E; Route 25A; Syosset; c. 1930;
Patterson, Chester A.; unknown; COTM; NA;
unknown; unknown; Y

BIBLIOGRAPHY: GOTT; SORG; HOWE, 1933; HEWI,
1931; COUN (60), Oct. 1931

Betts, Wyllis
unknown; unknown; unknown; Nightbrink; E;
Dune Road; Southampton; c. 1885; unknown;
unknown; DCMD; NA; unknown; unknown; Y

BIBLIOGRAPHY: PREV; INVE

Billings, C. K. G.
1862; 1937; Macleish, Blanch; Farnsworth;
unknown; Planting Field Rd; Matinecock; c.
1914; Lowell, Guy; Sargent. A. R.; NEFD; c. 1966;
Bird, W.; R. C. Diocese Rock. Cen.; N

BIBLIOGRAPHY: AAAA (108), Sept. 1915: 2072;
BRIC (25), June 1916: 146; INVE; SORG; COUN
(34), May 1918: 42; HICK; LEVA; ARLG (33), 1918;
WWIA (1), Oct. 1943: 95

Black, Bernard C.
unknown; unknown; unknown; unknown; E;
unknown; Great Neck; c. 1928; Rogers, Thomas
C.; unknown; HRTV; NA; unknown; unknown; Y

BIBLIOGRAPHY: SPUR (41), June 1928: 74

Blackton, J. Stuart
1875; 1941; Mac Arthur; Harbourwood; E; un-
known; Oyster Bay; c. 1914; Hoppin and Koen;
Weinrichter, Ralph; FBAT; NA; Leeds, William
B.; unknown; Y

BIBLIOGRAPHY: COUE, 1914; SPUR (21), May 1918:
3; NCAB; AVER

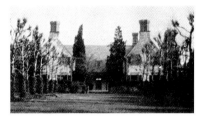

Blackwell, Charles A.
unknown; unknown; Rhodes, Karyn; The
Cedars; E; Piping Rock Road; Brookville;
c. 1926; Polhemus and Coffin; unknown; TUDM;
NA; Thomas, Joseph A.; unknown; Y

BIBLIOGRAPHY: INVE; POLC, 1932; WURT, 1926;
SORG; PREV

Blagden, Linzee
unknown; unknown; Draper, Dorothy; un-
known; E; Woodbury Avenue; Cold Spring
Harbor; c. 1930; Wyeth & King; unknown;
NFRR; NA; Mrs. Richter; unknown; Y

BIBLIOGRAPHY: SORG; INVE

Blair, James A., Jr.
unknown; unknown; Meyers, Isabel; Ontare;
unknown; Blair Road.; Oyster Bay; c. 1910;
Carrère & Hastings; unknown; NFRM; un-
known; unknown; unknown; N

BIBLIOGRAPHY: AMCO, 1915: 370; ARLG (26), 1911;
TOWN, Nov. 1910: 34; BRIC (19), Sept. 1910; FORT
(6), 1932: 118; WURT; WWWA; SORG; ARTR (23),
Jan. 1911

Bliss, Cornelius N., Jr.
1874; 1949; Cobb, Zaidee C.; Oak Hill;
unknown; Wheatley Road; Wheatley Hills;
c. 1916; Bosworth, W. Welles; unknown; GRRM;
1929; Kohler, Calvin; unknown; N

BIBLIOGRAPHY: HOWE, 1933; SORG, 1929

Blum, Edwin E.
unknown; c. 1946; Abraham, Florence; Shore
Acres; unknown; Penataquit Avenue; Bay Shore;
c. 1902; unknown; unknown; QUAN; unknown;
unknown; unknown; N

BIBLIOGRAPHY: LIFO, Feb. 1990; SORG; BKLY,
Aug. 1907; HICK

Boardman, Albert B.
1853; 1933; Oakley, Louise; Villa Mille Fiori;
unknown; Great Plains Road; Southampton; c.
1910; Hill & Stout; unknown; NEIR; c. 1930;
O'Brien, Judge Morgan; unknown; N

BIBLIOGRAPHY: SPUR (24), Mar. 1919: 38; HICK;
SORG; WWIA; ARRC (40), Sept. 1916: 267; REAL
(85), June 1910: 1299; ARTR (28), Oct. 1913

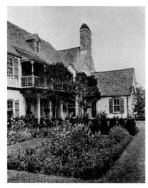

Boardman, Albert B.

1853; 1933; Oakley, Louise; Wind Swept; unknown; unknown; Southampton; c. 1930; Polhemus & Coffin; Coffin, Marian C.; NFRM; unknown; unknown; unknown; unknown

BIBLIOGRAPHY: POLC, 1932; SORG; WWIA

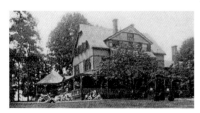

Booth, Mrs. H. P.

unknown; unknown; unknown; unknown; unknown; unknown; Kings Point; c. 1896; unknown; unknown; QUAN; c. 1920; unknown; unknown; N

BIBLIOGRAPHY: COUN (44), May 1923: 16; VIEW; TOWN, Apr. 1923: 11; SPUR (31), Sept. 1923: 10; INVE

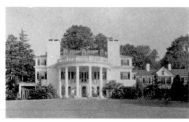

Booth, Mrs. H. P.

unknown; unknown; unknown; Broadlawns; E; Broadlawns Avenue; Kings Point; c. 1923; unknown; unknown; CLRV; NA; unknown; unknown; Y

BIBLIOGRAPHY: RUTH, 1909

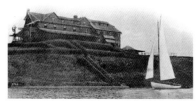

Borrowe, H. A.

unknown; unknown; unknown; unknown; unknown; unknown; Southampton; c. 1900; unknown; unknown; SHIN; unknown; unknown; unknown; N

BIBLIOGRAPHY: SPLI, postcard collection

Bostwick, A. C.

unknown; unknown; unknown; unknown; E; Jericho Turnpike; Old Westbury; c. 1930; O'Connor, James W.; unknown; NEFD; NA; unknown; unknown; Y

BIBLIOGRAPHY: PRES, 1980

Boulton, William B.

unknown; unknown; Kelly, Louisa; Avila; unknown; unknown; Lawrence; c. 1898; Randall, T. Henry; unknown; TUDR; c. 1950; unknown; unknown; N

BIBLIOGRAPHY: AABN (88), July 1905; BRIC (7), Apr. 1898; BRIC (11), July 1902; ARRV (12), Aug. 1904: 166; SORG

Bourne, Arthur K.

unknown; unknown; Hollins, Ethel; Fernwood; S; Montauk Highway; Oakdale; 1904; Green, Isaac Henry; unknown; SHIN; NA; unknown; La Salle Military Academy; Y

BIBLIOGRAPHY: INVE

Bourne, Frederick G.

1851; 1919; Keeler, Emma S.; Indian Neck Hall; S; Montauk Highway; Oakdale; c. 1890; Flagg, Ernest; Olmsted Brothers; NEFM; NA; unknown; Lasalle Military Academy; Y

BIBLIOGRAPHY: AMCO, 1915: 236; ARRC (1), Apr. 1902: 67ff; INVE; ARFO (6), May 1897; WWIA (1): 120; TOWN, Mar. 1915: 24; SORG; HICK; VAND; BYRO; FLON; DESM, 1903

Bourne, George

unknown; unknown; unknown; unknown; E; unknown; Mill Neck; c. 1920; Lindeberg, Harrie T.; unknown; COTS; NA; unknown; unknown; Y

BIBLIOGRAPHY: HOUH, 1920; HOUS (49), Feb. 1921: 90

Bowers, Dr. Wesley C.

unknown; unknown; Seward, Gladys; The Bouwerie; E; Meadow Lane; Southampton; c. 1930; Ward, Leroy P.; unknown; NIRM; NA; Lawrence, Martha; unknown; Y

BIBLIOGRAPHY: GOTT; ARTS (38), Mar. 1933: 28; SORG; COUN (54), Aug. 1928: 54

Bradley, Andrew C.

1844; 1902; unknown; unknown; E; Woods Lane; East Hampton; 1900; Thorp, Joseph Greenleaf; unknown; SHIN; NA; Lachman, Judith; unknown; Y

BIBLIOGRAPHY: SORG; FOST, 1977

Brady, Nicholas F.

1878; 1930; Garvan, G.; Inisfada; L; Searingtown Road; Manhasset; 1916; Windrim, John T.; Parsons, Samuel; TUDR; NA; unknown; NY Prov. Soc. of Jesus, Y

BIBLIOGRAPHY: TOWN, Nov. 1926: 64; FLON; LEVA, 1916; SORG; HEWI; SPUR (44), July 1929: 57; AABN (120); HICK, 1927; WWIA (1): 129; PATT, 1924; ARLG, 1927; AAAA (120), Dec. 1921: 2383; AAAA (121), Feb. 1922: 2386

Branca, Hugo

unknown; unknown; unknown; The Terraces; E; unknown; Manhasset; c. 1928; Weeks, Louis S.; unknown; SPCM; NA; unknown; unknown; Y

BIBLIOGRAPHY: COUN (48), July 1925: 40

Breese, James L.

1854; 1934; Potter, Frances; The Orchard; D; Hill Street; Southampton; 1897; McKim, Mead & White; White, Stanford; NEFD; NA; Merrill, Charles E.; Nyack Boys School; Y

BIBLIOGRAPHY: ARTR (25), Jan. 1912; SORG; LHDG, 1917; TOWN, Oct. 1919: 37; COUN (18), May 1910: 45; COUN (27), Mar. 1915: 46; HOUG (17), Jan. 1910: 15; ARFO (49), Aug. 1928: 306; MCKI, 1978: 33; BEAU; HEWI; COUN (10), Oct. 1906: 620

Breeze, William L.

unknown; unknown; unknown; Timber Point; C; unknown; Great River; 1882; unknown; Hutcheson, Martha Brooks; SHIN; 1970; Davies, Julian T.; Timber Point Club; N

BIBLIOGRAPHY: HOWE, 1933

Brewster, George S.

1869; 1936; Parks, Isabel; Fairlegh; C; Route 25A; Brookville; 1914; Trowbridge & Livingston; Greenleaf, James L.; GRRV; NA; unknown; Fox Run Golf & Country Club; Y

BIBLIOGRAPHY: ARRV (25), Jan. 1919; COUN (46), July 1924: 67; SORG; 1929; TOWN, Nov. 1918: 31; VIEM, 1974: 80; LEVA, 1916.

Brokaw, Clifford J.

unknown; unknown; Joel, Audrey S.; The Elms; unknown; Lattingtown Road; Glen Cove; 1912; Platt, Charles A.; Morris & Rotch; GRRV; c. 1946; unknown; unknown; N

BIBLIOGRAPHY: SPUR, Aug. 1917: 24; COUN (34), Oct. 1918: 42; SORG; ARRC (40), Oct. 1916: 383; BRIC (25), June 1916; PLAS; SORG, 1929; LEVA; AVER

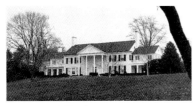

Brokaw, Clifford J.
unknown; unknown; Joel, Audrey; unknown; E; Centre Island Road; Centre Island; c. 1920; unknown; unknown; NEFD; NA; De La Begassierre; Von Bothmer; Y

BIBLIOGRAPHY: INVE, 1979; PREV

Brokaw, Howard C.
1875; 1960; Loew, Edna G.; The Chimneys; C; unknown; Brookville; c. 1916; Trumbauer, Horace; Olmsted Brothers; GRRV; NA; unknown; Muttontown Golf Club; Y

BIBLIOGRAPHY: ARRV (27), July, 1920; SORG, 1929; NRNF, 1976; SORG; FLON

Brokaw, Irving
unknown; unknown; Nave, Lucille; Goose Point; E; Frost Mill Road; Mill Neck; c. 1914; Lindeberg, Harrie T.; unknown; COTS; NA; Smithers, R. B.; unknown; Y

BIBLIOGRAPHY: AAAA (111), Feb. 1917; INVE

Brokaw, Irving
unknown; unknown; Nave, Lucille; Frost Mill Lodge; E; Oyster Bay–Glen Cove Road; Mill Neck; c. 1926; Walker & Gillette; Olmsted Brothers; NFRR; NA; Smithers, Brinkley; unknown; Y

BIBLIOGRAPHY: ARAT (15), Apr. 1931: 447; INVE; FLON; SORG, 1929; NCAB

Brokaw, William Gould
1863; 1941; unknown; Nirvana; unknown; Beach Road; Great Neck; c. 1900; Little & O'Connor; unknown; SPCM; c. 1950; unknown; unknown; N

BIBLIOGRAPHY: GREA; NYTI, 1941

Brooks, Joseph W.
unknown; unknown; unknown; unknown; E; unknown; Sands Point; c. 1927; Hood & Fouilhoux; unknown; INTL; NA; unknown; unknown; Y

BIBLIOGRAPHY: GOTT, 1934

Brooks, Reginald
unknown; unknown; unknown; unknown; unknown; unknown; Westbury; c. 1900; unknown; unknown; SHIN; unknown; unknown; unknown; N

BIBLIOGRAPHY: SPLI, postcard collection, 1910

Brown, Archibald M.
1881; 1956; Parrish, Caroline; East Farm; E; Harbor Road; St. James; c. 1914; Peabody, Wilson & Brown; unknown; CLOL; NA; Coleman, Leighton H.; unknown; Y

BIBLIOGRAPHY: NRNF, 1992; ARTR (30), Oct. 1914: 239; ARRC (38), 1915

Brown, B. H. Inness
unknown; unknown; unknown; The Point; E; unknown; Plandome Manor; c. 1910; Mackenzie, J. Clinton; unknown; NEFM; NA; unknown; unknown; Y

BIBLIOGRAPHY: GOTT, 1935; MASS, 1980; SORG

Brown, F. Gordon
unknown; unknown; Ponvert, Natalie; Willow Bank; E; unknown; Glen Head; c. 1920; Delehanty, Bradley; unknown; TWEC; NA; unknown; unknown; Y

BIBLIOGRAPHY: SORG; DELA, 1934

Brown, George McKesson
unknown; unknown; unknown; West Neck Farm; M; Brown's Road; Huntington; c. 1911; Luce, Clarence; unknown; NFRR; NA; unknown; Suffolk County; Y

BIBLIOGRAPHY: INVE; HICK; LOIS, Mar. 13, 1914; ARRC (42), Oct. 1917: 72; BEAU: 177

Brown, Lathrop
1883; 1959; Hooper, Helen; Land of Clover; s; Long Beach Road; Stony Brook; 1912; Peabody, Wilson & Brown; unknown; GRRM; NA; Larosa, V.; Knox School; Y

BIBLIOGRAPHY: INVE; ARFO (33), Sept. 1920: 89ff; ARRC (50), Oct. 1921: 243; SORG; PATT, 1924; MCBU; NRNF, 1992

Brown, Stephen
unknown; unknown; Leonard, Mary; Solana; E; Duck Pond Road; Matinecock; c. 1917; Mizner, Addison; Tibbetts, Armand J.; NSPR; NA; Stone, Charles; Foy, Thelma Chrysler; Y

BIBLIOGRAPHY: PREV; HOUG (40), Oct. 1921; ARLG (36), 1921; SORG

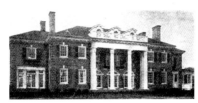

Brownlie, George
unknown; unknown; unknown; Willow Close; C; Little East Neck Road; Babylon; c. 1913; unknown; unknown; GRRV; NA; unknown; Long Island Yacht Club; Y

BIBLIOGRAPHY: PREV; COUN (24), Oct. 1913: 2

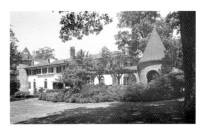

Brownsard, Mrs. D.
unknown; unknown; unknown; Bagatelle; s; Burrs Lane; Huntington; c. 1910; unknown; unknown; NFRM; NA; Baruch, Herman B.; Modonna Heights School; Y

BIBLIOGRAPHY: SORG; INVE

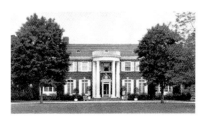

Bruce-Brown, Mrs. George
unknown; unknown; Loney, Ruth A.; Bronhurst; E; Islip Avenue; Islip; c. 1915; unknown; unknown; NEFD; NA; Nancy, W. K.; unknown; Y

BIBLIOGRAPHY: INVE; SORG

Bryan, James T.
unknown; unknown; unknown; unknown; E; Cleft Road, Mill Neck, 1928; Phillips, John H.; unknown; NEFD; NA; unknown; unknown; Y;

BIBLIOGRAPHY: INVE

Bryce, Lloyd Stevens
1851; 1917; Cooper; Bryce House; M; Northern Boulevard; Roslyn; c. 1901; Codman, Ogden, Jr.; Coffin, Marian C.; GRRV; NA; Frick, Childs; Nassau County Museum; Y

BIBLIOGRAPHY: BEAU: 83; TOWN, Dec. 1904: 20; VIEM, 1974, 70; COUN (60), June 1931: 68; FERR, 1904; ROSL; AMER, 1976: 68; NCAB

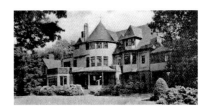

Bucknall, G. Stafford
unknown; unknown; Powers, Margaret; The 19th Hole; E; St. Andrews Lane; Glen Cove; c. 1891; unknown; unknown; TWEC; NA; Wilde, Mr. and Mrs. J.; unknown; Y

BIBLIOGRAPHY: HEWI, 1946; SORG, 1929; INVE

Bullock, George
unknown; unknown; Eckstein, Jane; Yeadon;
E; unknown; Centre Island; c. 1913; Gibson,
Robert W.; Steele, Fletcher; TUDR; c. 1990;
Deans, Mrs. Robert; Palmer, Carlton; N

BIBLIOGRAPHY: PREV; INVE; SORG, 1929; COUH,
1928

Bullock, George
unknown; unknown; Eckstein, Jane; The Folly;
unknown; Centre Island Road; Centre Island; c.
1899; Renwick, Aspinwall & Owen; unknown;
TUDR; c. 1960; Smith, Albert E.; Mahanna,
George S.; N

BIBLIOGRAPHY: ARTR (2), Oct. 1900: 367f; WURT;
LOIS, Jan. 28, 1899; BAYV; ARRV, (9), Sept. 1902: 9

Bullock, George
unknown; unknown; Eckstein, Jane; The Folly;
unknown; unknown; Centre Island; c. 1892;
Stickney & Austin; unknown; QUAN; 1899; un-
known; unknown; N

BIBLIOGRAPHY: AABN (43), 1894: 949; LOIS,
Jan. 7, 1899

Burchard, Anson W.
unknown; unknown; Tew, Allenen; Birchwood;
E; Feeks Lane; Lattingtown; c. 1906; Greenley,
Howard; Hopkins, Alfred; CLOL; NA; Carlisle,
Mrs. Floyd; Hall, Leonard; Y

BIBLIOGRAPHY: INVE; PREV; LEVA, 1916; SORG

Burden, Arthur Scott
unknown; unknown; Roche, Cynthia; un-
known; E; Cedar Swamp Road; Jericho; 1915;
Pope, John Russell; Lewis & Valentine; NEFD;
c. 1960; Cary, Mrs. Guy F.; unknown; N

BIBLIOGRAPHY: ELWO, 1924; AAAA (113), 1918:
2206; BRIC (25), Aug. 1916: 193; COUN (33), Feb.
1918: 47; COUN (34), Oct. 1918:42; PATT, 1924;
PREV; LEVA; TOWN, Sept. 1916: 17

Burden, I. Townsend, Jr.
unknown; unknown; unknown; unknown; S;
Northern Boulevard; Greenvale; 1916; Mizner,
Addison; unknown; NSPR; NA; Kountz, Delaney;
NYI of Technology; Y

BIBLIOGRAPHY: ADDM, 1977

Burden, James A.
1871; 1932; Sloane, F. Adele; Woodside; C;
Muttontown Road; Syosset; 1916; Delano &
Aldrich; Olmsted Brothers 1922–24; NEFD;
NA; Tobin, F.; Woodcrest Country Club; Y

BIBLIOGRAPHY: HEWI; ARTR (41), Mar. 1920;
PATT, 1924; ARFO (34), June 1921; ARFO (36), June
1922: 248; ARFO (37), Oct. 1922: 201; ARRC (50),
Oct. 1921; ARRC (54), July 1923; COUN (38), May
1920: 58; COUN (46), Sept. 1924: 39; COUN (51),
Mar. 1927: 59; PHDA, 1922; ARLG (43), 1928;
HICK; TOWN, May 1933: 43; ARTS (23), July 1925:
42; AVER; FLON

Burger, William H.
unknown; unknown; unknown; unknown;
unknown; Overlook Road; Lattingtown; c.
1900; Walker, Hobart A.; unknown; CLRV; c.
1910; unknown; unknown; N

BIBLIOGRAPHY: SAAB (33), Mar. 1902; 50

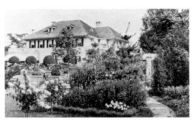

Burnett, Mrs. Frances H.
1849; 1924; unknown; Fairseat; unknown;
unknown; Plandome; c. 1908; unknown;
unknown; GRRV; c. 1950; Fahnestock, Archer;
unknown; N

BIBLIOGRAPHY: LIFO, July 1981; MASS, 1980; NCAB

Burr, Winthrop
unknown; unknown; Page, Frances; Orchard
Hall; E; The Causeway; Lawrence; c. 1900;
Randall, T. Henry; unknown; JACB; 1968;
Greenberg, Henry; unknown; N

BIBLIOGRAPHY: HICK; SORG, 1900; FAML

Burrill, Middleton S.
unknown; unknown; Neilson, Emily; Jericho
Farms; C; Cedar Swamp Road; Jericho; c. 1906;
Pope, John Russell; unknown; GRRV; NA;
unknown; Meadow Brook Club; Y

BIBLIOGRAPHY: ELWO, 1924; ARRC (29), June 1911:
482; HICK; SORG; AAAA (113), 1918: 397

Burton, Robert Lewis
1861; unknown; Southwick, F.; Albro House; E;
unknown; Lawrence; 1898; Taft, J. H.; unknown;
CLRV; c. 1945; Burton, John H.; unknown; N

BIBLIOGRAPHY: AMHO (4), Mar. 1907: 85; HICK

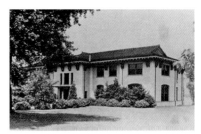

Burton, William L.
unknown; unknown; unknown; Bodlaw;
unknown; Willets Point Road; Bayside; 1918;
unknown; unknown; MEVI; unknown; GTE-
Sylvania; unknown; unknown

BIBLIOGRAPHY: PREV

Busby, Leonard J.
unknown; unknown; unknown; unknown; S;
Crescent Beach Road; Glen Cove; 1896; Gilbert,
C. P. H.; unknown; CLRV; NA; Leeming; North-
shore Day School; Y

BIBLIOGRAPHY: ARTR (3), May 1901: 120f; INVE;
TOWN, May 1910; 40; WURT; LOIS, Apr. 25, 1896

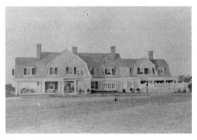

Bush, D. Fairfay
unknown; unknown; unknown; unknown;
E; Lattingtown Road; Glen Cove; c. 1906;
unknown; unknown; DCMD; c. 1930; Porter,
W. H.; unknown; N

BIBLIOGRAPHY: HICK; LIFO, Feb. 1900

Butler, Prescott Hall
1848; 1901; Smith; Bytharbor; E; Moriches Road;
St. James; 1879; McKim, Mead & White;
unknown; NEFM; NA; unknown; unknown; Y

BIBLIOGRAPHY: NRNF, 1992; MCKI, 1788: 38

Butler, William Allen
unknown; unknown; unknown; To Windward;
unknown; Gin Lane; Southampton; 1897;
unknown; unknown; SHIN; unknown; Stafford,
John W.; unknown; N

BIBLIOGRAPHY: INVE, 1982

Byrne, James
1857; 1942; Hay, Adele; unknown; E; unknown;
Oyster Bay; 1906; Atterbury, Grosvenor;
Greenleaf, James L.; COTM; c. 1918; Coe, William
Robertson; unknown; N

BIBLIOGRAPHY: BRIC (17), Jan. 1908: 34; EMBU,
1909: 147; SORG; *Inland Architect*, 1907; LEVA;
WWIA (11), 1950: 96

Cahoon, Edward
1859; 1920; Rockwell, Georgia; unknown; unknown; unknown; Southold; c. 1900; Burley, James L.; unknown; MEVI; unknown; unknown; unknown; N

BIBLIOGRAPHY: PELL; WURT

Cairns, Anna Eliza
unknown; unknown; unknown; Clifton; E; Bryant Avenue; Roslyn; 1862; Copley, Frederick S.; unknown; NEFL; NA; Emory, William H.; Demerast, John; Y

BIBLIOGRAPHY: ROSL; Woodward S., *Country Homes*, 1865; *The Horticulturist*, 1865

Campbell, Nathaniel A.
unknown; unknown; Detwiller, Elizabeth; Camelot; E; West End Avenue; East Hampton; c. 1928; Tappan, Robert; unknown; TWEC; unknown ; Stokes, Lydia S.; unknown; N

BIBLIOGRAPHY: EHHE: 200; INVE

Canfield, A. Cass
unknown; unknown; White, Jane S.; Cassleigh; E; Searington Road; Roslyn; c. 1902; McKim, Mead & White; Olmsted Brothers; NEFM; c. 1940; Griswold, Frank; Ryan, John D.; N

BIBLIOGRAPHY: AMER, 1976: 82; MCKI, 1978: 39; FLON; FERR, 1904: 147F; SORG

Cantor, Eddie
unknown; unknown; unknown; unknown; E; Lakeville Road; Great Neck; c. 1929; Gilbert, A. F.; unknown; TUDR; c. 1949; unknown; unknown; N

BIBLIOGRAPHY: WURT; NCAB

Carhart, Harold
unknown; c. 1960; Gibb, Ruth; unknown; E; Lattingtown Road; Lattingtown; c. 1923; Major, Howard; unknown; NEFD; NA; unknown; unknown; Y

BIBLIOGRAPHY: INVE; ARFO, Oct. 1923: 168; SORG

Carlisle, Jay F.
unknown; unknown; Pinkerston, Mary; Rosemary; E; Merrick Road; East Islip; 1916; Trowbridge & Ackerman; Vitale & Geiffert; MEVI; c. 1960; unknown; unknown; N

BIBLIOGRAPHY: HOWE, 1933; ELWO, 1924: 166; SORG, 1929; ARLG (36), 1921

Carpenter, H. I.
unknown; unknown; unknown; unknown; unknown; Feekes Lane; Lattingtown; c. 1906; unknown; unknown; QUAN; c. 1930; Woodward, O. P.; unknown; N

BIBLIOGRAPHY: HICK, 1911

Carpenter, J. E. R.
1867; 1932; Stires; unknown; E; unknown; Sands Point; c. 1931; Carpenter, J. E. R.; unknown; GREV; NA; Lavilla, Adolph; unknown; Y

BIBLIOGRAPHY: *Newsday*, 1973

Carter, Russell S.
1880; 1944; Bates, Florence; unknown; unknown; Cedar Avenue; Hewlett; c. 1910; Albro & Lindeberg; unknown; TWEC; unknown; unknown; unknown; unknown

BIBLIOGRAPHY: VIEW; AAAA (98), 1910: 1824; AMHD (11), Jan. 1914: 18

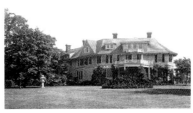

Cartledge, John
unknown; unknown; unknown; unknown; E; unknown; Huntington Bay; c. 1890; unknown; unknown; CLRV; unknown; unknown; unknown; N

BIBLIOGRAPHY: *Huntington, Cold Spring Harbor Booklet:* 1909: 46

Carver, Amos D.
unknown; unknown; Nickels, Inez; Ryefield Manor; E; Ryefield Road; Lattingtown; c. 1912; Tooker & Marsh; unknown; NEFD; NA; Carver, Clifford N.; Korboth, Roland S.; Y

BIBLIOGRAPHY: AAAA (120), Aug. 1921; 2374; INVE; WURT

Case, George C.
unknown; unknown; unknown; Harbour House; E; Spring Hollow Road.; Nissequoque; c. 1910; Ford, Butler and Oliver; unknown; DCMD; NA; Whittemore, Laurence W.; Windels, Mrs. Paul; Y

BIBLIOGRAPHY: INVE, 1980; NRNF, 1990

Cates
unknown; unknown; unknown; Robins Nest; E; Meadow Lane; Southampton; c. 1937; Peabody, Wilson & Brown; unknown; INTL; NA; unknown; unknown; Y

BIBLIOGRAPHY: INVE

Chapman, Henry Otis
1862; 1929; unknown; unknown; unknown; unknown; Woodmere; c. 1900; Barney & Chapman; unknown; TUDR; unknown; unknown; unknown; N

BIBLIOGRAPHY: ARRC (16), Dec. 1904

Chapman, Mrs. M. W.
unknown; unknown; unknown; Blue Top; E; Sands Point Road; Sands Point; c. 1896; unknown; unknown; CLOL; NA; Burns, Mrs. Mary; unknown; Y

BIBLIOGRAPHY: HICK

Chauncey, Wallace A.
c. 1891; unknown; Ruxton, Louise; Our Place; E; unknown; East Hampton; c. 1936; Embury, Aymar II; unknown; TWEC; NA; unknown; unknown; Y

BIBLIOGRAPHY: ARTS (49), Mar. 1939: 31; FYMC, 1941: 75

Cheever, John H.
1824; 1901; Dow, Anna; The Barracks; unknown; unknown; Far Rockaway; c. 1885; McKim, Mead & White; unknown; SHIN; c. 1940; unknown; unknown; N

BIBLIOGRAPHY: COUN (21), Apr. 1912: 6; MCKI, 1978: 41

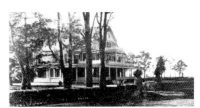

Chesebrough, Elizabeth
1840; 1924; Gordon; unknown; unknown; unknown; Northport; c. 1890; unknown; unknown; SHIM; c. 1940; unknown; unknown; N

BIBLIOGRAPHY: *Huntington, Cold Spring Harbor Booklet:* 1909: 53

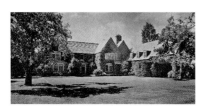

Chew, J.
unknown; unknown; Todd; Phoenix House;
E; Eastwoods Road; Muttontown; c. 1936; un-
known; unknown; TUDR; NA; unknown; un-
known; Y

BIBLIOGRAPHY: INVE; PREV

Childs, Eversley
unknown; unknown; unknown; unknown;
Edwards Avenue; Sayville; c. 1894; Green, Isaac
Henry; unknown; CLRV; NA; unknown;
unknown; Y

BIBLIOGRAPHY: INVE

Church, Charles T.
unknown; unknown; Nichols, Charlotte; Three
Brooks; E; unknown; Mill Neck; c. 1930; Linde-
berg, Harrie T.; unknown; TUDM; NA; unknown;
unknown; Y

BIBLIOGRAPHY: LINB: 78; COUN (65), Nov. 1933:
55; SORG; NCAB

Clafin, Arthur B.
1859; c. 1939; Anderson, Minnie; unknown; S;
unknown; Southampton; c. 1896; Atterbury,
Grosvenor; unknown; MEVI; NA; Tucker Mill
Inn; Southampton College; Y

BIBLIOGRAPHY: AAAA (94), Aug. 1908; SORG;
NYTI, 1939; BEAU: 223

Clapham, Thomas
c. 1838; unknown; Durand, Georgia; Stone
House; E; Glenwood Road; Roslyn Harbor;
c. 1868; Mould, Jacob Wrey; Du Chene, M.;
HVGO; NA; Stern, Benjamin; Hughes, Dr.
Wendell; Y

BIBLIOGRAPHY: ROSL; Bicknell, Amos J., *Wooden
& Brick Buildings*, I, 1875; HICK; PREV., 1942;
VIEW

Clark, F. Ambrose
1881; 1964; Stokes, Florence; Broad Hollow; S;
Store Hill Road; Westbury; c. 1912; Zogbaum,
Harry St. C.; unknown; GRRV; 1968; unknown;
St. Univ. of New York; N

BIBLIOGRAPHY: COUN (66), June 1934: 48; HEWI;
SORG; BEAU: 131; ARTR (37), Apr. 1918: 106F

Clark, J. Averell
unknown; unknown; Hitchcock, Helen; un-
known; E; Powell Lane; Westbury; c. 1920;
Peabody, Wilson & Brown; Shipman, Ellen;
TUDM; NA; unknown; unknown; Y

BIBLIOGRAPHY: HOWE, 1933; TOWN, Jan. 1929:
42; ARLG (45), 1930; SPUR (44), Aug. 1929: 51;
ARRC (64), Nov. 1928: 393; ARFO, Dec. 1923;
SORG

Clarke, Jeremiah
unknown; unknown; unknown; unknown; E;
McConn's Lane; Brookville; c. 1933; Schmidt,
Mott & Mogens Tvede; unknown; NEFD; NA;
McClure, Francis; Appleby, Francis S.; Y

BIBLIOGRAPHY: INVE; Ledger in Possession of
Mrs. Matt B. Schmidt; AVER

Clews, James B.
1869; 1934; Payne, Mary A.; La Lanterne; L;
Wolver Hollow Road; Brookville; c. 1920;
Trumbauer, Horace; unknown; FSCE; unknown;
NA; Sisters of St. Joseph; Y (partial house)

BIBLIOGRAPHY: SORG; INVE; WWIA (I): 231; FAML

Clowes, F. V.
unknown; unknown; unknown; unknown;
unknown; unknown; Bridgehampton; c. 1906;
Ware, James E.; unknown; DCMD; unknown;
unknown; unknown; N

BIBLIOGRAPHY: ARTR (13), Apr. 1906

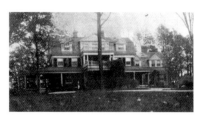

Cochran, W. Bourke
unknown; c. 1923; unknown; The Cedars;
unknown; Middle Neck Road; Sands Point;
c. 1895; unknown; unknown; SHIN; c. 1972;
Cosden, J. S.; Astor, Vincent; N

BIBLIOGRAPHY: MEAD, 1900; SORG; MIZN, 1977;
HICK

Cockcroft, Edward T.
unknown; unknown; Baker, Viola A.; Little
Burlees; E; Lily Pond Lane; East Hampton;
c. 1905; Albro & Lindeberg; unknown; NIRM;
NA; unknown; unknown; Y

BIBLIOGRAPHY: COUN (20), June 1911: 61; ARYB
(I), 1912: 125; ARTR (25), Jan. 1912: 125; AABN
(92), 1907: 1659; SORG; LINB: 1940: 207; EHHE

Coe, Henry E., Jr.
unknown; unknown; unknown; unknown; E;
unknown; Syosset; c. 1930; Bullard, Roger H.;
unknown; TUDM; NA; unknown; unknown; Y

BIBLIOGRAPHY: ARFO (55), Aug. 1931: 153

Coe, Williams Robertson
1869; 1955; Rogers, Mai; Coe Hall; M; Planting
Fields Road; Oyster Bay; c. 1919; Walker &
Gillette; Olmsted Brothers; TUDR; NA;
unknown; State of New York; Y

BIBLIOGRAPHY: COUN (53), Mar. 1928: 51; COUN
(53), Feb. 1928: 49; SPUR (28), Aug. 1921: 352;
ARRC (49), Mar. 1921: 195; COUN (57), Jan. 1930:
76; HEWI; ARRC (54), Aug. 1923: 131; *Life
Magazine*, July 1946: 73; LAPE; TOWN, July 1946:
73; FLON; WURT; ARTS (14), Mar. 1921: 352; COUN
(73), Feb. 1938: 72; BEAU: 155

Coffin, Charles A.
1844; 1926; Russel, Carol; Portledge; S; Duck
Pond Road; Locust Valley; c. 1910; Greenley,
Howard; unknown; TUDM; NA; unknown;
Portledge School; Y

BIBLIOGRAPHY: LEVA; TOWN, July 1914; ARLG
(28), 1913; HICK; INVE; ARTR (26), Dec. 1912:
251F; WWIA (I): 237; AMCO, 1915: 108; ARTR (39),
June 1919: 155; SORG

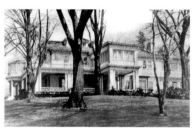

Cohan, George M.
1878; unknown; Levy, Ethel; unknown; E; Kings
Point Road; Kings Point; c. 1905; unknown;
unknown; MEVI; NA; Annenburg, M. I.; Gross,
John; Y

BIBLIOGRAPHY: GREA; NCAB: 285; INVE; PREV

Cohu, Lamotte T.
1895; 1968; Muus, Didi H.; Gissa Bu; unknown;
unknown; Southampton; c. 1930; Bassoe,
Thorbjorn; unknown; SCAN; unknown;
unknown; unknown; unknown

BIBLIOGRAPHY: SPUR (48) Aug. 1931: 32; WWIA;
SORG; HEWI, 1930

Coles, Mrs. Elizabeth
unknown; unknown; unknown; Rolling
Spring; unknown; Lattingtown Road; Glen
Cove; c. 1887; Hunt, Richard Morris; Farrand,
Beatrix (1900); GRRM; c. 1948; Chubb, Percy;
unknown; N

BIBLIOGRAPHY: SORG, 1929; VIEW

Colgate, John K.

unknown; unknown; Manuel, Florence; Oaklea; E; Laurelton Beach Road; Oyster Bay; c. 1935; Delehanty, Bradley; unknown; NEFD; NA; unknown; unknown; Y

BIBLIOGRAPHY: DELE, 1939; SORG

Colgate, Robert, Jr.

unknown; unknown; unknown; Sandacres; E; unknown; Quoque; c. 1885; McKim, Mead & White; unknown; SHIN; NA; Eggert, Herman F.; unknown; Y

BIBLIOGRAPHY: BROD; MCKI

Collier, P. F.

c. 1849; unknown; Dunn, Katherine; unknown; E; unknown; Southampton; c. 1915; Warren & Clark; unknown; NFRR; NA; unknown; unknown; Y

BIBLIOGRAPHY: AMCO, 1915: 246; ARRC (39), June 1916: 554; NCAB

Conklin, Roland Ray

1858; 1938; MacFadden, M.; Rosemary Farm; unknown; West Neck Road; Lloyd Harbor; 1903; Eyre, Wilson; Olmsted Brothers (1912–13); TWPC; 1991; unknown; Diocese of Rockville Center; N

BIBLIOGRAPHY: FLON; WWIA (I): 250; INVE; ARRC (18), Oct. 1905: 314; ARYB (I), 1912: 47; AVER; BRIC (20), Oct. 1911; REAL (86), Oct. 1910: 568; COUN (44), June 1923: 13; ARRC (28), Oct. 1910: 236f; SORG; TOWN, July 1912; *Touchstone* 2 (no. 4), Feb. 1918: 484–90

Conklin, Stanley l.

unknown; unknown; unknown; unknown; unknown; unknown; Lloyd Harbor; c. 1902; Eyre, Wilson; unknown; TWEC; unknown; unknown; unknown; N

BIBLIOGRAPHY: AVER

Conklin, Theodore E.

unknown; unknown; Cox, Louise; Meadowcraft; E; unknown; Quoque; c. 1900; Eyre, Wilson; unknown; TWEC; NA; unknown; unknown; Y

BIBLIOGRAPHY: AABN (93), Apr. 1908; HOUS (24), June 1908: 140; AVER; SORG, 1929

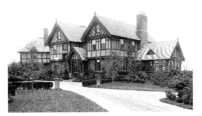

Connable, A. W.

unknown; unknown; unknown; unknown; unknown; East Rockaway Road; Hewlett; c. 1910; unknown; unknown; HTRV; unknown; unknown; unknown; unknown

BIBLIOGRAPHY: HICK; COUN (24), Oct. 1913: 2

Connover, Augustus

unknown; unknown; unknown; unknown; unknown; Saxon Avenue; Bay Shore; c. 1896; unknown; unknown; HVGO; unknown; Rothschild, Simon; Hutton, Franklyn; N

BIBLIOGRAPHY: LIFO, Feb. 1990

Cook, Henry F.

1855; 1932; Fahys, Lena; Clench-Warton; unknown; Ferry Road; Sag Harbor; c. 1891; Morris, Montrose W.; unknown; SHIN; unknown; unknown; unknown; N

BIBLIOGRAPHY: REAL (47), Apr. 4, 1891: 519; PELL

Cooper, Kenneth F

unknown; unknown; unknown; unknown; E; Grenwolde Drive; Great Neck; c. 1930; Rogers, Thomas C.; unknown; HTRV; NA; Opperman, Joseph; unknown; Y

BIBLIOGRAPHY: HEWI, 1930; INVE

Corbin, Austin

1827; 1896; Wheeler, Hanna; Deerpark; unknown; unknown; Babylon; c. 1875; unknown; unknown; unknown; unknown; unknown; unknown; N

BIBLIOGRAPHY: NCAB

Corbin, Austin

1827; 1896; Wheeler, Hanna; unknown; unknown; Mariners Court; Centerport; c. 1890; unknown; unknown; QUAN; 1958; Stewart, J. K.; Honeyman; N

BIBLIOGRAPHY: NCAB; HICK

Cosden, Alfred H.

unknown; unknown; unknown; Eastward; unknown; unknown; Southold; c. 1900; Burley, James L.; unknown; GRRM; unknown; unknown; unknown; N

BIBLIOGRAPHY: INVE; TOWN, Oct. 20, 1920

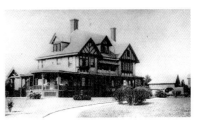

Covell, C. H.

unknown; unknown; unknown; unknown; E; Clinton Avenue; Bay Shore; c. 1902; unknown; unknown; TUDR; NA; unknown; unknown; Y

BIBLIOGRAPHY: FAML; VANO

Cowl, Donald H.

unknown; unknown; unknown; unknown; unknown; Cedar Lane; Sands Point; 1924; Ellett, Thomas Harlan; unknown; NFRM; unknown; Neelands, T. D.; Lenyt, Babette; N

BIBLIOGRAPHY: ARAT (3), Mar. 1925; ARLG, 1925; SPUR (42), Feb. 1928: 64; COUH

Cozzens, Isaac

unknown; unknown; unknown; Maple Knoll; E; Overlook Road; Lattingtown; 1917; Rouse & Goldstone; Leavitt, Charles W.; NEFD; NA; Morgan, Henry S.; Oberlin, Abe; Y

BIBLIOGRAPHY: HEWI, 1920; ARTR (42), Dec. 1920; INVE; PREV; HOUS (49), Feb. 1921; 65

Cram, J. S.

unknown; unknown; Bryce, Edith; unknown; E; Wheatley Road; Old Westbury; c. 1900; unknown; unknown; HTRV; NA; unknown; unknown; Y

BIBLIOGRAPHY: HICK

Crampton, Foster

unknown; unknown; unknown; Aratapa; unknown; unknown; Westhampton; c. 1909; Kennedy, J. Sarsfield; unknown; MEVI; unknown; unknown; unknown; unknown

BIBLIOGRAPHY: REAL (84), Oct. 1909: 640

Crane, Clinton H.

unknown; unknown; unknown; unknown; E; Crane Road; Glen Cove; c. 1934; Delano & Aldrich; unknown; GRRM; NA; unknown; unknown; Y

BIBLIOGRAPHY: NCAB; INVE; PREV

Crane, W. S.

unknown; unknown; Wallace, Violet; East View; E; Polo Lane; Lawrence; c. 1925; Noel, Auguste; unknown; GRRM; NA; Peck, A. K; unknown; Y

BIBLIOGRAPHY: HEWI, 1927; INVE; SORG

Crane, Warren S., Jr.

unknown; unknown; Crane, Christine; East View; E; Polo Lane; Cedarhurst; c. 1932; Delehanty, Bradley; unknown; TWEC; NA; Peck, Arthur; Botur, Freddy; Y

BIBLIOGRAPHY: DELE, 1939; SORG; INVE

Cravath, Paul D.

1861; 1940; Huntington, A.; Veraton (III); E; unknown; Locust Valley; c. 1914; Lowell, Guy; Olmsted Brothers; NEFD; NA; Rentschler, Gordon; unknown; Y

BIBLIOGRAPHY: VIEW; PREV; INVE

Cravath, Paul D.

1861; 1940; Huntington, A.; Still House; E; Duck Pond Road; Locust Valley; c. 1920; Delehanty, Bradley; Pendelton, Isabella; NEFM; NA; Porter, Seton; Rothschild, Barone; Y

BIBLIOGRAPHY: SPUR (54), Feb. 1934: 33; INVE (78), Oct. 1940: 15; DELA, 1934; FLON; ARTR (69), Apr. 1934: 195; VIEW; COUN (60), May 1931: 47

Cravath, Paul D.

1861; 1940; Huntington, A.; Veraton (I); unknown; unknown; Lattingtown; c. 1905; Babb, Cook & Willard; Lowell, Guy; GRRM; c. 1908; unknown; unknown; N

BIBLIOGRAPHY: ARTR (17), Feb. 1908; HICK; TOWN, Nov. 1907: 12; LOIS, Feb. 16, 1900; WWIA (I): 273; TOWN (17), Nov. 1907: 12

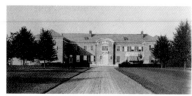

Cravath, Paul D.

1861; 1940; Huntington, A.; Veraton (II); unknown; unknown; Lattingtown; c. 1911; unknown; unknown; NEFD; c. 1914; unknown; unknown; N

BIBLIOGRAPHY: INVE, 1978; WWIA (I): 273; NASS

Crossman, W. H.

unknown; unknown; unknown; unknown; E; Kings Point Road; Kings Point; c. 1880; unknown; unknown; NEFM; NA; Wilson, G. B.; Muncie, C. H.; Y

BIBLIOGRAPHY: INVE, 1979

Cruger, Col. S. V. R.

c. 1844; c. 1898; unknown; Italian Gardens; unknown; unknown; Bayville; c. 1894; unknown; unknown; GRRV; c. 1899; unknown; unknown; N

BIBLIOGRAPHY: BAYV

Culver, Mrs. Eunice D.

unknown; unknown; unknown; unknown; unknown; unknown; Remsenberg; c. 1933; Dudley, Gordon; unknown; unknown; unknown; unknown; unknown; unknown

BIBLIOGRAPHY: PREV

Curran, Guernsey

unknown; unknown; Postley, Elise; Farlands; unknown; Mill River Road; Oyster Bay; c. 1917; Lowell, Guy; Sargent, A. R.; NEFD; unknown; Douglas, Josephine H.; unknown; unknown

BIBLIOGRAPHY: ARRC (48), Oct. 1920: 324; PATT, 1924: 42; ARRV (27), Aug. 1920: 324; VIEW; TOWN, Dec. 1920: 45; INVE; SORG; LAPE

Curtis, George Warren

unknown; c. 1932; unknown; unknown; unknown; unknown; Southampton; c. 1905; unknown; unknown; CLOL; unknown; unknown; unknown; P

BIBLIOGRAPHY: INVE; HICKS, 1912

Curtis, Warren

unknown; unknown; unknown; unknown; E; Captains Neck Lane; Southampton; c. 1914; Ives, Chauncy; unknown; DCMD; NA; unknown; unknown; Y

BIBLIOGRAPHY: INVE

Cutcheon, Franklin W.

1864; 1936; Flandrau, S. G.; unknown; E; Piping Rock Road; Matinecock, c. 1920, Delehanty, Bradley; unknown; CLOL; NA; unknown; unknown; Y

BIBLIOGRAPHY: WWIA (I): 288; DELA, 1934; INVE

Cutting, Wm. Bayard

1850; 1912; Murray, Olivia; Westbrook; M; Route 27; Great River; 1886; Haight, Charles C.; Olmsted Brothers (1887-94); TUDM; NA; Cutting heirs; N. Y. C., Parks and Rec.; Y

BIBLIOGRAPHY: PRLN; FLON; LAND (28), Oct. 1937: 36; LIFO (18), June 1955: 107; SORG; TOWN (16), Apr. 1907: 24; HICK; WWIA (I): 290; BEAU: 191

Dale, Mrs. Chester

unknown; unknown; unknown; unknown; E; First Neck Lane; Southampton; c. 1925; unknown; unknown; NFRM; NA; Fuller, Andrew; unknown; Y

BIBLIOGRAPHY: INVE, 1982

Damrosch, Dr. Walter

unknown; unknown; Blaine, M.; Monday House; E; Mill River Road; Brookville; 1930; Delehanty, Bradley; unknown; NEFD; NA; Sperry, E.; Collado, Emilio; Y

BIBLIOGRAPHY: DELA, 1934; INVE; SORG; GOTT, 1934

Dana, Charles Anderson

unknown; c. 1897; Macdaniel, Eunice; Westmere; unknown; Olmsted Lane; Glen Cove; c. 1874; unknown; unknown; STIK; c. 1930; Underhill, Mrs. M. B.; Harkness, Wm. L.; N

BIBLIOGRAPHY: NYTI, Sept. 1902; HICKS

Dana, Paul

unknown; unknown; Duncan, Mary B.; Dosoris Island; unknown; unknown; Glen Cove; c. 1893; unknown; unknown; GRRM; c. 1925; unknown; unknown; N

BIBLIOGRAPHY: FAML

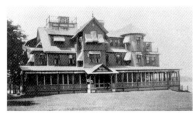

Dana, William B.
1829; 1910; Floyd, K. Mosslots; unknown; Riverside Avenue; Mastic; c. 1883; unknown; unknown; SHIN; c. 1969; unknown; unknown; N

BIBLIOGRAPHY: Moriches Bay Historical Society

Davey, William N.
unknown; unknown; unknown; Pidgeon Hill; E; unknown; West Hills; c. 1939; Delehanty, Bradley; unknown; NEFD; NA; unknown; unknown; Y

BIBLIOGRAPHY: DELE

Davies, F. H.
unknown; unknown; unknown; unknown; E; Coopers Neck Lane; East Hampton; 1899; Thorp, Joseph Greenleaf; unknown; SHIN; NA; Thorpe, H. C.; Heyman, Stephen J.; Y

BIBLIOGRAPHY: FOST, 1977; ARRC (13), Jan. 1903: 19FF; INVE; EHHE

Davies, Mrs. F. M.
unknown; unknown; O'Neill, Emily; unknown; E; Cooper's Neck Lane; Southampton; c. 1916; unknown; unknown; TWEC; NA; Thorpe, H. C.; unknown; Y

BIBLIOGRAPHY: SORG; INVE

Davis, Arthur Vining
unknown; unknown; unknown; unknown; E; Cleft Road at Horseshoe Drive; Mill Neck; 1922; Lowell, Guy; Vitale, Ferruccio; NEIR; NA; Nicastro, Louis; unknown; Y

BIBLIOGRAPHY: GOTT, 1931; COUN (52), Oct. 1927: 57; INVE; COUN (64), Aug. 1933: 60

Davison, Henry P.
unknown; unknown; Sparks; Appledore; C; Mill River Road; Upper Brookville; c. 1926; Crowie, Robert; Olmsted Brothers; TUDM; NA; unknown; Mill River Club; unknown; Y

BIBLIOGRAPHY: INVE; FAML; FLON

Davison, Henry P.
1867; 1922; Trubee, Kate; Peacock Point; unknown; Peacock Lane; Lattingtown; c. 1914; Walker & Gillette; Olmsted Brothers; GRRM; c. 1962; Davison, Mrs. Henry P.; unknown; N

BIBLIOGRAPHY: COUN (34), Aug. 1918: 40; COUN (34), June 1918: 46; PATT; ARRC (42), July 1917: 2FF; WWIA (I): 304; COUN (36), Aug. 1919: 40; SPUR, June 1917: 22; SORG

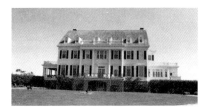

Day, Henry
1820; 1893; Lord, Phoebe; Meadow Beach; E; Gin Lane; Southampton; c. 1890; unknown; unknown; NEFD; NA; Stevenson, Charles P.; unknown; Y

BIBLIOGRAPHY: NCAB; INVE, 1977

Debost, Depevre
unknown; unknown; Ludlam, Louise; unknown; E; South Main Street; Southamp-ton; 1872; unknown; unknown; ITAN; NA; Kilbreth; Bronson, Dr.; Y

BIBLIOGRAPHY: INVE, 1982

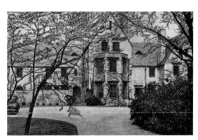

De Brabant, Marius
unknown; c. 1937; unknown; Plaisance; unknown; Little Neck Road; Centerport; c. 1910; unknown; unknown; TUDM; c. 1978; Vanderbilt Estate; Roth, Axe; N

BIBLIOGRAPHY: PREV; HUNT

de Forest, Henry W.
c. 1855; c. 1938; Noyes, Julia G; Nethermuir; E; unknown; Laurel Hollow; c. 1900; unknown; Olmsted Brothers; CLRV; c. 1960; unknown; unknown; N

BIBLIOGRAPHY: WWIA (I): 310; FLON; SORG; HICK; GARD (35), Apr. 1922: 108

de Forest, Robert W.
1848; 1931; Johnson, Emily; Wawapek Farm; E; Shore Road; Cold Spring Harbor; 1898; Atterbury, Grosvenor; Olmsted Brothers 1910–12; TWEC; NA; De Forest, Johnston; Williams, Priscilla D.; Y

BIBLIOGRAPHY: HEWI; WWIA (I): 310; LOIS, May 6, 1899; WURT; HICK; INVE; FLON; SORG

Delamar, Joseph R.
1843; 1918; Sands; Pembroke; E; Red Springs Road; Glen Cove; c. 1916; Gilbert, C. P. H.; unknown; FRNC; c. 1968; Loew, Marcus (MGM Studios); unknown; N

BIBLIOGRAPHY: RAND; ARTS (16), Apr. 1922: 430; HICK; WWIA (I): 311; TOWN, Dec. 1921: 37; LEVA; SPUR (31), Apr. 1916: 22; TOWN, Nov. 1925: 64; TOWN, Dec. 1921: 37; AAAA (116), 1919: 367

Delano, William A.
1874; 1960; Potter, Louisa; Muttontown Corners; E; unknown; Syosset; 1914; Delano & Aldrich; Farrand, Beatrix/Delano; NFRM; NA; unknown; unknown; Y

BIBLIOGRAPHY: AMCO, 1915: 14; ARRC (54), July 1923: 63; COUN (34), May 1918: 68; PHDA, 1922: 55; PRLN, 1985; ARTS (23), July 1925: 42

Deselding, Herman
c. 1856; unknown; Clark, Anna J.; unknown; unknown; West Shore Road; Mill Neck; c. 1906; unknown; unknown; SHIN; c. 1964; Martin, Mrs. William; Sterling, G.; N

BIBLIOGRAPHY: INVE; COUN (42), July 1922: 9; COUN., Apr. 1910: 650

Dewing, Hiram
unknown; unknown; Franklin, Susan; Appledore; E; Crabapple Lane; Locust Valley; c. 1928; Peabody, Wilson & Brown; Olmsted Brothers; NEFD; NA; unknown; unknown; Y

BIBLIOGRAPHY: SORG; FAML

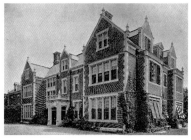

Dexter, Stanley W.
unknown; unknown; McAllister, G.; Sunny-meade; unknown; East Main Street; Oyster Bay; c. 1896; unknown; unknown; TUDR; unknown; unknown; unknown; N

BIBLIOGRAPHY: HEWI

Dick, Adolph G.

1883; 1948; unknown; Allen Winden Farm; E; unknown; Islip; c. 1930; Fuller & Dick; unknown; GRRM; c. 1960; unknown; unknown; N

BIBLIOGRAPHY: COUN (66), July 1934: 68

Dick, William K.

1888; unknown; Force, Madeleine; Allen Winden Farm; unknown; Ocean Avenue; Islip; c. 1890; Fuller & Dick; unknown; NFRM; c. 1960; unknown; unknown; N

BIBLIOGRAPHY: HOWE, 1933; NCAB; SORG

Dickerman, Mrs. Watson

unknown; unknown; Calkin, Florence; Hillandale; E; Mill Hill Road; Mill Neck; c. 1936; Butler & Corse; unknown; TUDR; NA; Vanderbilt, Alfred G.; Whitney, Cornelius V.; Y

BIBLIOGRAPHY: SORG; INVE

Dickinson, Hunt T.

unknown; unknown; Gilbert, Eliza; Hearthstone; E; Ponk Woods Lane; Brookville; c. 1936; Delehanty, Bradley; Olmsted Brothers 1933-37; NEFD; NA; unknown; unknown; Y

BIBLIOGRAPHY: INVE; SORG; DELE, 1939; FLON; PREV

Dilworth, Dewees W.

unknown; unknown; Logan, Edith; Gloan House; unknown; unknown; Roslyn; c. 1930; de Sibour, J. Henri; unknown; NFRM; c. 1970; Manville, Lorraine; unknown; N

BIBLIOGRAPHY: NASS; PREV; TOWN, Aug. 1932; HICK

Dimock, E. J.

unknown; unknown; Bullard, Constance; unknown; unknown; Shelter Rock Road; Manhasset; c. 1928; Bullard, Roger H.; unknown; unknown; unknown; unknown; unknown; unknown

BIBLIOGRAPHY: SORG; PREV

Dixon, Courtland

unknown; unknown; unknown; unknown; E; The Causeway; Lawrence; c. 1930; Weeks, Louis S.; unknown; GRRM; NA; unknown; unknown; Y

BIBLIOGRAPHY: INVE

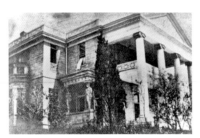

Dixon, Dr. George A.

unknown; unknown; Dunton, Sarah P.; By the Way; E; Gin Lane; Southampton; c. 1890; unknown; unknown; unknown; NA; Benjamin, Henry R.; Cromwell, Hon. J. H.; Y

BIBLIOGRAPHY: TOWN, July 1931; INVE

Dixon, William H.

unknown; unknown; unknown; unknown; E; Smith Lane; St. James; c. 1924; Peabody, Wilson & Brown; unknown; CLOL; NA; unknown; unknown; Y

BIBLIOGRAPHY: *Garden Home Builder,* May 1927; NRNF, 1992; ARFO, Oct. 1927; EHHE: 167; FOST, 1977; FYMC 1941: 25; SORG

Di Zippola, Countess

unknown; unknown; unknown; unknown; E; Mill Hill Road; Mill Neck; c. 1927; Polhemus & Coffin; NFRM; NA; unknown; unknown; Y

BIBLIOGRAPHY: PREV; INVE

Dodge, Lillian S. T.

1879; unknown; Sefton; Sefton Manor; L; Frost Mill Road; Mill Neck; 1923; Clinton, Russell, Wells, Holton & George; Leavitt, Charles W.; TUDR; NA; unknown; Luth Friends of Deaf; Y

BIBLIOGRAPHY: HEWI, 1928; INVE; SPUR (53), Mar. 1934: 39

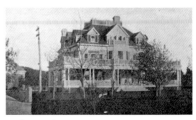

Dodge, William L.

c. 1867; unknown; Pryor; Villa Francesca; unknown; unknown; Setauket; c. 1906; unknown; unknown; CLRV; unknown; unknown; unknown; N

BIBLIOGRAPHY: INVE

Dodson, Robert B.

unknown; unknown; Wells, Mary; Kanonsioni; unknown; South Country Road; West Islip; c. 1905; Kirby, Petit & Green; unknown; QUAN; c. 1950; unknown; unknown; unknown

BIBLIOGRAPHY: AABN (90), Oct. 1906; COHO (7), July 1928: 32; SORG; HICK

D'Oench, Alfred F.

c. 1852; 1918; Grace, Alice; Sunset Hill; unknown; Plandome Road; Manhasset; c. 1905; D'Oench, A. F.; unknown; HTRV; c. 1937; unknown; unknown; N

BIBLIOGRAPHY: SORG; MASS, 35; COHO (5), 8, 1925: 40

Dohse, John

1857; 1902; Quinn, Alice; unknown; unknown; unknown; Far Rockaway; c. 1895; unknown; unknown; CLRV; c. 1960; unknown; unknown; N

BIBLIOGRAPHY: ROCK, 1901

Donnell, Harry E.

unknown; unknown; unknown; unknown; E; Kings Point Road; Kings Point; c. 1902; Donnell, Harry E.; unknown; NEFM; NA; Wilson, G. B.; Muncie, C. H.; Y

BIBLIOGRAPHY: INVE

Doubleday, Frank N.

unknown; unknown; Van Wyck, Flora; New House; unknown; Feeks Lane; Mill Neck; c. 1904; Kirby, Petit & Green; unknown; CLRV; c. 1914; unknown; unknown; N

BIBLIOGRAPHY: SORG; AABN (90), Oct. 1906; INVE; WWIA; LOIS, May 8, 1903; HICK

Doubleday, Frank N.

unknown; unknown; Van Wick, Flora; Effendi Hill; E; Cleft Road; Mill Neck; c. 1914; Kirby, Petit & Green; unknown; NFRR; NA; Keating, Cletus; unknown; Y

BIBLIOGRAPHY: INVE; PREV, 1948; LOIS, Jan. 30, 1914; SORG; ARRC (27), Jan. 1910: 88

Doubleday, Nelson

unknown; 1949; McCarter, Elle; Barberrys; E; Cleft Road; Mill Neck; c. 1916; Lindeberg, Harrie T.; Olmsted Brothers; MEVI; NA; unknown; unknown; Y

BIBLIOGRAPHY: COUN (46), Oct., 1924: 63; ARRC (55), Apr. 1924: 317; INVE; HOUH, 1920; LINB, 193; WWIA (11), 1950: 160; FLON; SORG

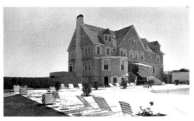

Douglas, Mrs. W. P.

unknown; unknown; unknown; unknown; c; Gin Lane; Southampton; c. 1895; unknown; unknown; SHIN; NA; Mitchell, Charles E.; Overdune Tennis Club; Y

BIBLIOGRAPHY: INVE

Dows, David

unknown; c. 1966; Burden, Mary G.; Charlton Hall; E; Brookville Road; Brookville; c. 1916; Trumbauer, Horace; Olmsted Brothers; GRRV; NA; Wolcott, Blair; Watson, Blair; Y

BIBLIOGRAPHY: TOWN, Feb. 1948; FAML; SORG

Drew, John

1853; 1927; Baker, Josephine; unknown; unknown; Lily Pond Lane; East Hampton; c. 1900; Lord, James Brown; unknown; TWEC; unknown; unknown; unknown; N

BIBLIOGRAPHY: ARTR (2), Dec. 1900: 450; WWIA (1): 340; FYMC, 1941: 161

Duer, Beverly

unknown; unknown; de Forest, J.M; White Eagle; E; Ridge Road; Syosset; c. 1929; Delano & Aldrich; Olmsted Brothers; TWEC; NA; Dering, William; Smith, Owen; Y

BIBLIOGRAPHY: PREV; FLON; SORG, 1929

Duncan, Wm. Butler

1830; 1912; unknown; Park Hill; unknown; Astor Lane; Port Washington; c. 1903; Carrère & Hastings; unknown; unknown; c. 1920; unknown; unknown; N

BIBLIOGRAPHY: SORG; WWIA (1): 346

du Pont, Alfred I.

1864; 1935; Ball, Jessie D.; White Eagle; S; Route 25A; Wheatley Hills; c. 1916; Carrére & Hastings; unknown; NEFD; NA; Guest, Mrs. Frederick E.; N.Y. I. of Technology; Y

BIBLIOGRAPHY: ARTS (19), May 1923: 24; VIEW; AAAA (112), Sept. 1917: 2176; SPUR (25), Apr. 1920: 47; RAND: 21; TOWN, June 1913; AVER; BEAUX: 101; WWIA (1): 249; ARLG (44), 1929: 333; LOIS, Apr. 29, 1921

du Pont, Henry F.

1880; 1969; Wales, Ruth; Chestertown House; E; Meadow Lane; Southampton; c. 1925; Cross & Cross; Coffin, Marian C.; TWEC; NA; Holzer, Leonard; unknown; Y

BIBLIOGRAPHY: NCAB; INVE; SORG

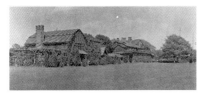

Durkee, Eugene W.

1850; 1926; Bingham, Emma; Nahmke; unknown; Durkee Lane; Patchogue; c. 1890; unknown; unknown; SHIN; c. 1949; Humphrey, Col. C. B.; unknown; N

BIBLIOGRAPHY: INVE; NCAB; SORG

Duryea, Herman B.

1865; 1916; Winchester, Eleanor; Knole; E; Wheatley Road; Old Westbury; c. 1903; Carrère & Hastings; Lewis & Valentine; NECL; NA; Martin, Bradley; Martin, Esmond; Y

BIBLIOGRAPHY: VIEW; FERR, 1904: 43ff; COUN (21), Apr. 1912: 28; ARRC (27), Jan. 1910: 85; COUN (21), Apr. 1912: 28; SORG; TOWN, Sept. 1912: 35; LAPE; AVER; FERR, 1906: 21; LOIS, Oct. 7, 1910

Duval, Charles Raoul

unknown; unknown; unknown; unknown; unknown; unknown; Roslyn; c. 1900; Snelling & Pottter; unknown; FBAT; c. 1950; unknown; unknown; N

BIBLIOGRAPHY: ARTR (5), Mar. 1902: 79; ARRV (9), Sept. 1902

Dwight, Arthur S.

unknown; unknown; unknown; unknown; E; unknown; Great Neck; c. 1915; Palmer & Hornbostal; unknown; TWEC; NA; unknown; unknown; Y

BIBLIOGRAPHY: ARTR (110), July 1916; INVE

Dwight, Richard E.

unknown; unknown; Grace, Gertrude; unknown; E; unknown; Locust Valley; c. 1920; Lindeberg, Harrie T.; unknown; COTM; NA; unknown; unknown; Y

BIBLIOGRAPHY: NCAB; HOUS (49), Feb. 1921: 90; SORG

Dyer, George R.

unknown; unknown; Scott, Grace E.; The Orchard; E; Brookville Road; Brookville; 1909; Platt, Charles A.; unknown; NEFM; NA; Dyer, Elisha; unknown; Y

BIBLIOGRAPHY: PLAS; PREV; ARRV (1), Aug. 1912; AVER; INVE; NCAB; SORG

Dyer, George R., Jr.

unknown; unknown; unknown; unknown; E; Wheatley Road; Brookville; 1934; Delehanty, Bradley; unknown; INTL; NA; Choate, Thos. H.; unknown; Y

BIBLIOGRAPHY: DELE, 1939; HERL, Mar. 1940; SORG

Dykman, W. N.

unknown; unknown; Merrick, Susan; White Acre; E; unknown; Glen Cove; c. 1920; Lindeberg, Harrie T.; unknown; COTM; NA; unknown; unknown; Y

BIBLIOGRAPHY: COUN (48), June 1925: 46; SORG

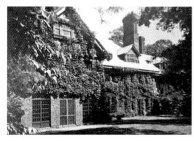

Earle, H. M.

unknown; unknown; unknown; Dorset Lodge; E; Route 25D; Westbury; c. 1900; unknown; unknown; TUDM; NA; unknown; unknown; Y

BIBLIOGRAPHY: PREV; SORG

Eddy, Spencer

1874; 1939; Spreckels, L. E.; Holiday House; unknown; unknown; Manhasset; c. 1928; unknown; unknown; unknown; unknown; unknown; unknown; unknown

BIBLIOGRAPHY: VIEW, 1930; WWIA (1): 357

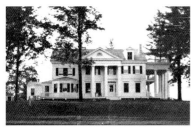

Eden, Dr. John

unknown; unknown; Chidsey, Mary; Edenhall; unknown; Steamboat Road; Great Neck; c. 1910; unknown; unknown; CLRV; unknown; unknown; unknown; N

BIBLIOGRAPHY: HICK

Eden, John H.

unknown; unknown; Tuttle, Muriel; Topping; E; unknown; Great Neck; c. 1927; Rickard, Greville; unknown; NFRR; NA; unknown; unknown; Y

BIBLIOGRAPHY: COUN (51), Apr. 1927: 53; SPUR (48), July 1931: 35; ARAT (7), Feb. 1927: 575; SORG; SPUR (40), June 1927: 65

Eidlitz, C. L. W.
1853; 1921; Dudley, Jennie; Overlea; E; Ocean
Avenue; East Hampton; 1896; Eidlitz, C. L. W.;
unknown; SHIN; NA; unknown; unknown; N

BIBLIOGRAPHY: FOST, 1977; FYMC, 1941: 22; INVE;
SORG, 1929

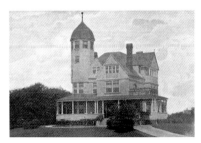

Einstein, B. J.
unknown; unknown; unknown; unknown;
unknown; unknown; Far Rockaway; c. 1895;
unknown; unknown; QUAN; c. 1950; unknown;
unknown; N

BIBLIOGRAPHY: ROCK, 1901

Eldridge, E. L.
unknown; unknown; unknown; unknown; R;
unknown; Locust Valley; c. 1920; Major,
Howard; unknown; CLRV; NA; Guinzberg,
Harold; Geo Corporation; Y

BIBLIOGRAPHY: COUN (42), July 1922: 63

Eldridge, Mrs. Lewis
unknown; unknown; Huyck, Eliz.; Redcote;
unknown; Bayview Avenue; Great Neck; c.
1930; Delano & Aldrich; unknown; NEFM; un-
known; unknown; unknown; N

BIBLIOGRAPHY: HOWE, 1933; GREA: 37

Ellsworth, Duncan S.
unknown; unknown; Hutchinson, Jane;
unknown; E; Dune Road; Southampton; c.
1925; Mellon, E. P.; unknown; TWPC; NA;
Meyers, Bradley E.; unknown; Y

BIBLIOGRAPHY: SORG; INVE; PREV; COUN (48),
Dec. 1925: 80

Ely, Dr. Albert H., Jr.
1894; 1964; Jennings, Constance; Elyria; E; Ox
Pasture Road; Southampton; c. 1900; Atterbury,
Grosvenor; unknown; TWEC; NA; Donahue,
Mrs. Woolwort; unknown; Y

BIBLIOGRAPHY: SORG, 1929; HOUS (24), June
1908: 140; WWIA (1): 370

Ely, Dr. Albert H., Jr.
1894; 1964; Jennings, Constance; Elyston; E;
unknown; Cold Spring Harbor; c. 1929;
Schmidt, Mott, and Mogens Tvede; unknown;
GRRV; NA; unknown; unknown; Y

BIBLIOGRAPHY: NCAB; SORG; GOTT, 1931

Emanuel, Victor
unknown; unknown; unknown; Dorwood; L;
unknown; Manhasset; c. 1927; Barney, J.
Stewart; Brickerhoff, A. F.; NFRR; NA; unknown;
Lady of Grace Convent; Y

BIBLIOGRAPHY: SPUR (39), Apr. 1927: 95

Emmet, C. Temple
unknown; unknown; Chanler, Alida; The
Mallows; E; Emmet Drive; Stony Brook; 1905;
Platt, Charles A.; Platt, Charles A.; CLOL; NA;
unknown; unknown; Y

BIBLIOGRAPHY: PREV; AVER; NRNF, 1992; SORG;
PLAS; INVE

Emmet, Devereux
unknown; unknown; Smith, Ella; Sherrewogue;
E; Harbor Road; St. James; c. 1895; McKim,
Mead & White; unknown; CLOL; NA; Bacon,
Frances MacNeil; unknown; Y

BIBLIOGRAPHY: NRNF, 1992; MCKI, 1978: 56; INVE

Emmet, Richard S.
unknown; unknown; Pratt, Helen I.; High
Elms; unknown; Old Tappen Road; Glen Cove;
c. 1929; Peabody, Wilson & Brown; Shipman,
Ellen; GRRM; c. 1960; unknown; unknown; N

BIBLIOGRAPHY: *Home & Field* (40), May 1930:
IIFF; ARAT (12), July 1929: 425; SORG; ARLG (45),
1930

Erdman, John F.
unknown; unknown; Wright, Georgia;
Coxwould; E; Lily Pond Lane; East Hampton;
1912; Albro & Lindeberg; unknown; COTS; NA;
Weinstein, Joseph; unknown; Y

BIBLIOGRAPHY: LINB: 206; ARTR (31), Jan. 1915:
22; INVE; EHHE, 1941: 189; SORG

Erhart, William H.
unknown; unknown; Graves, E. Henriette; Five
Oaks; unknown; Ocean Avenue; Lawrence;
c. 1906; Freeman & Hesselman; unknown;
HTRV; c. 1950; unknown; unknown; N

BIBLIOGRAPHY: ARTR (14), Aug. 1906: 140; SORG

Evans, Benjamin Franklin
unknown; unknown; unknown; unknown; E;
Gracie Lane; East Hampton; c. 1913; Lawrence,
J. C.; unknown; TWEC; NA; unknown;
unknown; Y

BIBLIOGRAPHY: INVE; EHHE: 190

Everdell, William., Jr.
unknown; unknown; Romeyre, Rosalie; un-
known; unknown; unknown; Manhasset;
c. 1928; Bullard, Roger; unknown; COTS;
unknown; unknown; unknown; unknown

BIBLIOGRAPHY: ARTS (31), May 1929: 73; SORG

Fahys, George E.
unknown; unknown; unknown; Hilaire; un-
known; Red Springs Lane; Glen Cove; c. 1900;
Gilbert, C. P. H.; unknown; NEGT; c. 1960;
unknown; unknown; N

BIBLIOGRAPHY: PREV; ARTR (3), Jan. 1901: 47;
VIEW

Fahys, George E.
unknown; unknown; Hodenpyl, A.; Hilaire;
unknown; unknown; Locust Valley;
c. 1910; O'Connor, James W.; Olmsted
Brothers; NEFD; c. 1980; Vietor, J.; Lynch, E.; N

BIBLIOGRAPHY: LEVA; INVE; VIEW, 1930

Fahys, George
unknown; unknown; Hodenpyl, A; unknown;
E; Piping Rock Road; Oyster Bay; c. 1928;
Bottomley, William; unknown; NIRM; NA;
unknown; unknown; Y

BIBLIOGRAPHY: INVE

Fahys, Joseph
c. 1832; unknown; Payne, M.; Andelmans; un-
known; Ferry Road; Sag Harbor; c. 1889;
Morris, Montrose W.; unknown; QUAN;
unknown; unknown; unknown; N

BIBLIOGRAPHY: Pell; REAL (44), Oct. 1889: 1409

Fairchild, Julian
unknown; unknown; Simonton, Clova; Mea-
dow Springs; E; Meadow Spring Road; Glen
Cove; c. 1916; unknown; unknown; GRRV; NA;
Coe, W. R., Jr.; Stralem, Mrs. Donald; Y

BIBLIOGRAPHY: INVE; PREV; SORG

Fairchild, Sherman M.
1896; 1971; unknown; Eastfair; E; unknown;
Lloyds Neck; c. 1931; Forster & Gallimore;
unknown; NFRM; NA; unknown; unknown; Y

BIBLIOGRAPHY: NCAB; HOWE, 1933; RAND

Farwell, Walter
1863; 1943; Williams, Mildred; Mallow; S; Yellow
Cote Road; Syosset; 1918; Bosworth, W. Welles;
unknown; NEFD; NA; Hedges, Benjamin; East
Woods Schools; Y

BIBLIOGRAPHY: AAAA, 122, 1922: 239; SORG;
HEWI, 1929

Ferguson, Dr. Farquar

unknown; unknown; Amour, Juliana; The Monastery; unknown; East Shore Road; Halesite; c. 1908; Jackson, Allen W.; unknown; NEIR; c. 1970; unknown; unknown; N

BIBLIOGRAPHY: LOIS, Jan. 1926; SORG; *Ferguson's Castle,* 1978; COUN (47), Apr. 1925: 12; COUN (41), Apr. 1922: 12; TOWN, June 1925: 43; HUNT

Field, Marshall III

1893; 1956; Pruyn, Ruth; Caumsett; G; West Neck Road; Lloyd Harbor; 1921; Pope, John Russell; Olmsted Brothers; GRRV; NA; unknown; N.Y.S. Parks Dept.; Y

BIBLIOGRAPHY: COUN (48), Oct. 1925: 36; ARLG, 1925; PATT, 1924; AAAA (133), 1928: 491; COUN (52), Aug. 1927: 30; COUN (65), Apr. 1934: 44; AJRP (3), 1930: 51; NCAB; *Holiday Magazine* (4), Oct. 1948; TOWN, July 1925: 4; HICK; FLON; BEAU: 170; SORG; AVER

Fincke, Reginald

unknown; unknown; Clarke, Edith; unknown; E; Meadow Lane; Southampton; c. 1924; Peabody, Wilson & Brown; unknown; NFRM; NA; Hannan, Joseph A.; unknown; Y

BIBLIOGRAPHY: ARRC (60), Nov. 1926: 434; HOUS (62), July 1927: 35; INVE; SORG

Finlayson, Frank

unknown; unknown; unknown; unknown; E; Underhill Road; Locust Valley; c. 1936; Delehanty, Bradley; Innocenti & Webel; CLOL; NA; unknown; unknown; Y

BIBLIOGRAPHY: ARTS (47), Jan. 1937: 8; DELE, 1939

Fish, Edwin

c. 1887; c. 1968; unmarried; Airdrie House; E; Chicken Valley Road; Locust Valley; c. 1926; Delano & Aldrich; Vitale, Ferruccio; NEFM; NA; unknown; unknown; Y

BIBLIOGRAPHY: MLAE: 7; WURT; *Life Magazine* (21), July 1946: 73

Fisher, Carl

unknown; unknown; unknown; unknown; E; North Farragut Road; Montauk; 1927; unknown; unknown; CLRV; NA; Akin, Robert; unknown; Y

BIBLIOGRAPHY: *Newsday,* Sept. 21, 1990

Flagg, Montague

1883; 1924; unknown; Applewood; E; Wolver Hollow Road; Upper Brookville; c. 1915; Flagg, Montague; Flanders, Annette Hoyt; TUDR; NA; Kellogg, Morris; McClintock H. C.; Y

BIBLIOGRAPHY: INVE; WWIA (11), 1950: 189; SORG

Fleischmann, Julius

unknown; 1925; unknown; The Lindens; E; Middle Neck Road; Sands Point; c. 1910; Allen, Augustus N.; unknown; GRRV; NA; Schwartz, Charles; Vanderbilt, A. J., Jr.; Y

BIBLIOGRAPHY: BEAU

Flinsch, Olga

unknown; unknown; Von Neufville; Target Rock Farm; unknown; unknown; Lloyd Harbor; c. 1937; Delano & Aldrich; unknown; GRRV; 1995; Eberstadt, Mr. and Mrs.; T. Rock Natl Ref; N

BIBLIOGRAPHY: SORG; INVE

Folger, Henry Clay

1857; 1930; Jordan, Emily; unknown; E; St. Andrews Lane; Glen Cove; c. 1910; unknown; unknown; NEIR; NA; unknown; unknown; Y

BIBLIOGRAPHY: NCAB; INVE, 1983; PREV, 1938

Ford, Hannibal C.

1877; 1955; Eldredge, Katherine; unknown; E; Kings Point Road; Kings Point; c. 1930; Smith, Leon H.; unknown; TWEC; NA; Seeger, Hal; unknown; Y

BIBLIOGRAPHY: NCAB; GOTT, 1933

Ford, Nevil

unknown; unknown; unknown; Woodford; E; unknown; Lloyd Harbor; c. 1930; Polhemus & Coffin; unknown; NFRM; NA; unknown; unknown; Y

BIBLIOGRAPHY: POLC; SORG

Forrest, Richard E.

unknown; unknown; unknown; unknown; unknown; Longwood Crossing; Lawrence; c. 1905; Ewing & Chappell; unknown; unknown; unknown; unknown; unknown; N

BIBLIOGRAPHY: ARLG (23), 1908; AMCO (1), 1912: 76; WURT

Foster, Mrs. Eva M.

unknown; unknown; unknown; unknown; unknown; unknown; Far Rockaway; c. 1899; Werner & Windolph; unknown; QUAN; c. 1950; unknown; unknown; N

BIBLIOGRAPHY: ROCK, 1901

Foster, J. Stanley

unknown; unknown; Knowles, E.; unknown; unknown; Little East Neck Road; Babylon; c. 1902; unknown; unknown; MEVI; unknown; Bromell, A. H.; Sumpawams Club House; N

BIBLIOGRAPHY: Babylon Historical Society; AARC (28), Aug. 1910: 137; HICK

Fowler, George

unknown; unknown; unknown; unknown; E; Crescent Beach Road; Glen Cove; c. 1894; Little & Browne; unknown; DCMD; NA; Loening, Rudolph; Shepard, R. M.; Y

BIBLIOGRAPHY: INVE, 1978

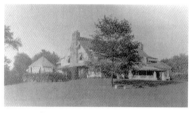

Fox, William

c. 1879; c. 1952; unknown; Fox Hall; unknown; unknown; Woodmere; c. 1920; unknown; unknown; CLOL; c. 1960; unknown; unknown; N

BIBLIOGRAPHY: NASS

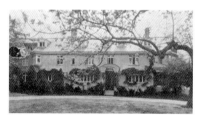

Francke, Louis J.

unknown; unknown; unknown; Ferncote; E; Brookville Road; Brookville; c. 1910; unknown; unknown; GRRM; NA; Vitrol, H. A.; unknown; Y

BIBLIOGRAPHY: INVE, 1983; PREV

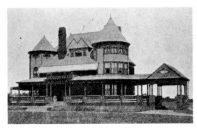

Frank, Emil H.
1843; 1919; unknown; unknown; unknown; Awixa Avenue; Bay Shore; 1894; unknown; unknown; QUAN; unknown; Fairchild, Julian D.; unknown; N

BIBLIOGRAPHY: BABY, 1902; BKLY, Aug. 3, 1907

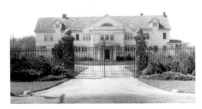

Franke, C.A.
unknown; unknown; unknown; unknown; E; Crescent Beach Road; Glen Cove; c. 1904; unknown; unknown; CLRV; NA; Knott, D. H.; unknown; Y

BIBLIOGRAPHY: LOIS, Dec. 2, 1904; INVE, 1978; HICK

Franklin, Phillip A. S.
1871; 1939; Merryman, L. F.; Hayfields House; E; Glen Cove–Oyster Bay Road; Matinecock; 1926; Delehanty, Bradley; unknown; DCMD; NA; Pickett, John O.; unknown; Y

BIBLIOGRAPHY: INVE; SORG; WWIA (1): 422; DELA, 1934

Fraser, Robert
unknown; unknown; unknown; Ashcombe; unknown; Middle Neck Road; Sands Point; c. 1900; unknown; unknown; unknown; unknown; Fraser, A. V.; unknown; N

BIBLIOGRAPHY: INVE

Fry, Marshall
unknown; unknown; unknown; Wayside; E; Hill Street; Southampton; c. 1911; Embury, Aymar II; unknown; CLOL; NA; unknown; unknown; Y

BIBLIOGRAPHY: HOUS (32), Dec. 1912: 134; COUN (28), May 1915: 42; LHDG (2), 1917: 101; INVE; LHDG (2), 1917: 19

Funk, J. W.
unknown; unknown; unknown; unknown; E; unknown; Southampton; c. 1929; Peabody, Wilson & Brown; unknown; NEFM; c. 1938; unknown; unknown; N

BIBLIOGRAPHY: COUN (69), Apr. 1936: 12

Gales, George
unknown; unknown; Houghton, Helen; Eckingston; E; Overlook Road; Lattingtown; c. 1927; Lindeberg, Harrie T.; unknown; NFRM; NA; unknown; unknown; Y

BIBLIOGRAPHY: LINB: 96; INVE; SORG

Gallatin, Frederic
1841; 1927; Gerry, Almy; Breezy Lawn; unknown; Ocean Avenue; East Hampton; 1877; Renwick, James; unknown; STIK; c. 1930; Leonard, Stephen J.; unknown; N

BIBLIOGRAPHY: EHHE

Garver, John A.
1854; 1936; Fair, Virginia; Wrexleigh; S; unknown; Oyster Bay; c. 1913; Stephenson & Wheeler; Olmsted Brothers; HTRV; NA; unknown; Harmony Heights; Y

BIBLIOGRAPHY: AMCO, 1915: 74ff; ARRC (35), Mar. 1914: 182; HOUS (37), Nov. 1913: 106; ARTS (4), Aug. 1914: 363; NASU, 1976; TOWN, May 1914: 29; WWIA (11), 1950: 545; SORG

Gates, Charles O.
unknown; unknown; Hoagland, Ida; Peacock Point; unknown; Peacock Lane; Lattingtown; c. 1902; Platt, Charles A.; unknown; JACM; c. 1914; unknown; unknown; N

BIBLIOGRAPHY: ARTR (5), Mar. 1902: 59; ARTR (8), Aug. 1903; ARRV (10), Sept. 1903: 139; WURT

Gates, Mrs. Charles O.
unknown; unknown; unknown; Dormer House; E; unknown; Lattingtown; c. 1917; Riddle, Theodate, Pope; Vitale, Ferruccio; COTM; NA; Sloane, Mrs. I. Dodge; unknown; Y

BIBLIOGRAPHY: ARTR (37), Apr. 1918; COUN (35), Feb. 1919: 56; INVE; COUN (34), Oct. 1918: 40; *Theodate Pope: Her Life & Work*. 1979

Gavin, Michael
1873; 1960; Hill, Gertrude; unknown; unknown; unknown; Wheatley Hills; c. 1928; Pope, John Russell; Olmsted Brothers; NFRM; c. 1962; unknown; unknown; N

BIBLIOGRAPHY: FLON; SORG

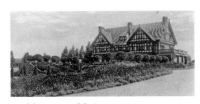

Geddes, Donald G.
unknown; unknown; Maxwell, Grace; unknown; unknown; Lattingtown Road; Glen Cove; c. 1906; unknown; Vitale, Ferruccio; HTRV; c. 1964; unknown; unknown; N

BIBLIOGRAPHY: SORG; NASS; LEVA; VIEW; GOTT, 1931

Geddes, Eugene M.
unknown; unknown; Ahles, Ludia L.; Punkin Hill; E; Piping Rock Road; Matinecock; c. 1934; Delehanty, Bradley; unknown; NEFM; NA; Geddes; unknown; Y

BIBLIOGRAPHY: GOTT; INVE; SORG; HERL, Mar. 1940; DELA, 1934

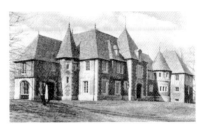

Gelder, I. L.
unknown; unknown; unknown; The Terraces; E; Pond Road; Kings Point; c. 1927; unknown; unknown; FRNC; NA; Leigh, Samuel; unknown; Y

BIBLIOGRAPHY: INVE; SPUR (41), May 1928: 17; TOWN, May 1928: 4

Gerstle, R. J.
unknown; unknown; unknown; unknown; unknown; unknown; Far Rockaway; c. 1895; Werner & Windolph; unknown; CLCO; c. 1950; unknown; unknown; N

BIBLIOGRAPHY: ROCK, 1901

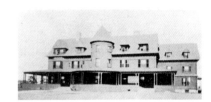

Gibb, John
1829; unknown; Baison, Harriet; Afterglow; unknown; Ocean Avenue; Islip; c. 1890; unknown; unknown; SHIN; c. 1950; Stanchfield, J. B.; Wright, Dr. Arthur M.; N

BIBLIOGRAPHY: BKLY, Aug. 18, 1907; PREV

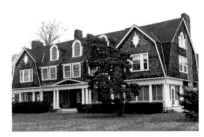

Gibb, Lewis M.
unknown; unknown; Pinkerton, Mary; unknown; E; Saxon Avenue; Bay Shore; 1903; unknown; SHIN; NA; Tenney, Charles H.; unknown; Y

BIBLIOGRAPHY: INVE; LIFO, Feb. 1990

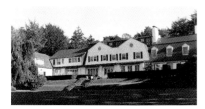

Gibb, Walter

unknown; unknown; unknown; Iron Acton; E; Middle Cross Lane; Glen Cove; c. 1906; unknown; unknown; DCMD; NA; unknown; unknown; Y

BIBLIOGRAPHY: INVE, 1978

Gibson, Harvey D.

unknown; unknown; Whitney, Helen; Lands End; E; Sheep Lane; Lattingtown; c. 1926; Walker & Gillette; Olmsted Brothers; GRRM; NA; Astin, Dr. Sherrill; unknown; Y

BIBLIOGRAPHY: COUN (58), July 1930: 38; INVE; SORG; FLON

Gibson, Robert W.

1854; 1927; unknown; North Point; unknown; unknown; Oyster Bay; 1899; Gibson, Robert W.; unknown; CLRV; c. 1950; Smith, Howard; unknown; N

BIBLIOGRAPHY: FAML

Gilbert, H. S.

unknown; unknown; unknown; Sunshine; unknown; West Shore Road; Great Neck; c. 1900; Little & O'Connor; unknown; MEVI; unknown; Sinclair, Harry; unknown; N

BIBLIOGRAPHY: AMHO (8), Nov. 1911; FORT, June 1932: 57; RUTH; VIEW; SORG

Glover, John I.

unknown; unknown; unknown; unknown; unknown; unknown; Baldwin; c. 1890; Glover, John I.; unknown; CLCO; unknown; unknown; unknown; N

BIBLIOGRAPHY: Baldwin Historical Society; AABN (44), 1894

Godfrey, Henry F.

unknown; unknown; Havemeyer, Mary; unknown; unknown; unknown; Westbury; c. 1911; Walker & Gillette; unknown; HTRV; unknown; Manice, Wm. Def.; unknown; unknown

BIBLIOGRAPHY: ARLG (27), 1912; FERR (8), June 1912: 199; ARRC (32), Nov. 1912: 472; ARRC (35), Apr. 1914: 304; SORG; TOWN, Apr. 1911: 54; LOIS, Apr. 1911

Godwin, Parke

unknown; unknown; Bryant, Fanny; Clovercroft; E; unknown; Roslyn; 1869; Vaux & Withers; unknown; HVGO; NA; unknown; unknown; Y

BIBLIOGRAPHY: BRYA; ROSL, June 7, 1975: 52-62

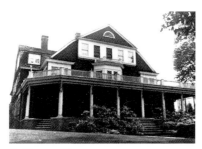

Goldman, Herman

1881; 1967; unknown; unknown; M; unknown; Plandome; c. 1927; unknown; unknown; DCMD; NA; unknown; North Shore Museum; Y

BIBLIOGRAPHY: MASS

Goodwin, Philip L.

1885; 1958; unknown; Goodwin Place; E; unknown; Woodbury; 1917; Goodwin, Bullard & Woolsey; Goodwin, James; NFRR; c. 1975; Jennings, Oliver; unknown; N

BIBLIOGRAPHY: PREV; ARRC (48), Oct. 1920: 274; FAML; Hamlin, Talbot, *The American Spirit in Architecture,* 1926: 268

Gould, Charles A.

unknown; c. 1926; Stocking, Adele; Chateauiver; E; Caladonia Road; Greenlawn; 1908; Pope, John Russell; unknown; NFRR; c. 1954; Amari, Philippo; unknown; N

BIBLIOGRAPHY: ARTS (6), Jan. 1916: 125; ARRC (29), June 1911: 492; ARTS (6), Jan. 1916: 125; PATT, 1924: 181; PREV; NCAB; LOIS, 1909; LOIS, 1909; FAML; SORG; TOWN, Jan. 1916: 20

Gould, Edwin

1866; 1933; Shrady, Sarah; Highwood; E; unknown; Oyster Bay; 1931; Corse, Henry; Innocenti & Webel; NEFD; NA; Montana, Dr. Christopher; Minicozzi, Alexander; Y

BIBLIOGRAPHY: GOTT, 1934; COUN (67), Apr. 1935: 16; WWIA (1): 473; SORG

Gould, Frank Miller

1899; 1945; Bacon, Florence; Cedar Knolls; E; unknown; Cold Spring Harbor; c. 1929; Noel & Miller; unknown; NEFR; NA; Gubelman, Walter; Miller, Andrew Ott; Y

BIBLIOGRAPHY: WWIA (11), 1950: 216; SORG; COUN (57), Nov. 1929: 55

Gould, Howard

1871; 1959; Clemmons, Katherine; Hempstead House; M; Middle Neck Road; Sands Point; c. 1900; Hunt & Hunt; unknown; TUDR; NA; Guggenheim, Daniel; U.S. Navy; Y

BIBLIOGRAPHY: NASS; NYAR (1), 1907; ARTR (26), Sept. 1912: 166; BEAU: 58; RAND: 16; ARTR (9), May 1904: 68; REAL (85), Jan. 1910: 107; HICK; AMCO, 1915: 312; AABN (102): 1912

Grace, J. P.

c. 1872; unknown; Macdonald, Janet; Tullaroan; C; L.U. Willets Road; North Hills; c. 1910; O'Connor, James W.; Olmsted Brothers; NEFM; NA; unknown; Deepdale Golf Club; unknown; Y

BIBLIOGRAPHY: AAAA (103), Jan. 1913; OCOU; COUN (38), June 1920: 45; LEVA; FLON

Grace, W. Russell, Jr.

1879; 1943; Ladew, Elsie W.; The Crossroads; E; Wheatley Road; Westbury; c. 1919; O'Connor, James W.; unknown; NEFD; NA; unknown; unknown; Y

BIBLIOGRAPHY: ARAT (7), Nov. 1926; NYTI, 1943; HICK; SPUR (24), July 1919: 35; TOWN, May 1927: 71; HOUS (50), Sept. 1921: 173; SORG, 1929

Grace, Mrs. W. R.

unknown; unknown; unknown; Gracefield; E; Waterview Lane; Kings Point; c. 1909; O'Connor, James W.; unknown; NEFM; NA; Zilinsky; unknown; Y

BIBLIOGRAPHY: AAAA (95), Feb. 1909: 1731; GREA; INVE; TOWN, Apr. 1924: 7

Gracie, James

unknown; unknown; Bulloch, Anna; Gracewood; E; Cove Neck Road; Oyster Bay; 1884; McKim, Mead & White; unknown; SHIN; NA; unknown; Roosevelt, Geo. Emelyn; Y

BIBLIOGRAPHY: MCKI, 1978: 67; SORG

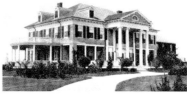

Greeff, Dr. Ernest F.

unknown; unknown; unknown; Rose Manor; E; Shinnecock Road; Quoque; c. 1906; unknown; unknown; GRRV; NA; Cushing, Dr. Robert; unknown; Y

BIBLIOGRAPHY: FAML; COUN (43), Jan. 1922: 9

Greer, William

unknown; unknown; Noel, Louise; Flower de Hundred; E; Chicken Valley Road; Matinecock; c. 1928; Noel & Miller; unknown; TUDM; NA; unknown; unknown; Y

BIBLIOGRAPHY: SORG; AABN (134), Aug. 1928: 167; INVE; *Home & Field,* Mar. 1931

Griscom, Lloyd P.

unknown; unknown; unknown; unknown; unknown; unknown; East Norwich; c. 1920; Delano & Aldrich; unknown; GRRM; 1931; unknown; unknown; N

BIBLIOGRAPHY: PHDA

Groesbech, Clarence E.

unknown; unknown; unknown; Roads End; E; Piping Rock Road; Matinecock; c. 1918; Delehanty, Bradley; Olmsted Brothers; NEFD; NA; unknown; unknown; Y

BIBLIOGRAPHY: INVE; FLON

Grosvenor, Graham B.

c. 1884; c. 1943; Ritchie, Mary; Graymar; E; unknown; Westbury; c. 1930; Bottomley, William; unknown; GRRV; NA; unknown; unknown; Y

BIBLIOGRAPHY: SORG; WWIA (11), 1950: 224; PREV

Grumman, Leroy P.

unknown; unknown; unknown; unknown; E; Bayview Road; Plandome; c. 1940; Franklin, Paul A.; unknown; unknown; NA; unknown; unknown; Y

BIBLIOGRAPHY: FAML; LIFO, July 1981; MASS

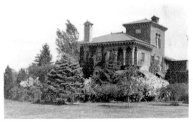

Guastavino, Rafael

1872; 1950; unknown; unknown; E; Awixa Avenue; Bayshore; c. 1912; Guastavino, R.; unknown; TWEC; NA; Gulden, Mrs. Frank; unknown; Y

BIBLIOGRAPHY: INVE

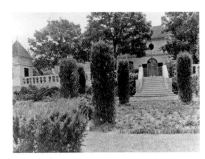

Guggenheim, Mrs. D.

unknown; unknown; unknown; Mille Fleurs; M; Middle Neck Road; Sands Point; c. 1931; Polhemus & Coffin; unknown; NFRM; NA; U.S. Navy Testing Center; Nassau City Museum; Y

BIBLIOGRAPHY: POLC, 1932; BEAU: 73; NASS

Guggenheim, Harry F.

1890; 1971; Rosenberg, H.; Falaise; M; Middle-neck Road; Sands Point; 1923; Sterner, Frederick James; Polhemus & Coffin; NFRR; NA; unknown; Nassau County; Y

BIBLIOGRAPHY: NASS; HOWE, 1933; TOWN, Sept. 1925: 45; ARTS (24), Mar. 1926: 38; BEAU: 67; ARAT (5), Oct. 1925; ARLG, 1926; RAND, 1924: 155

Guggenheim, Isaac

1854; 1922; Sonneborn, C.; Villa Carola; R; Middle Neck Road.; Sands Point; c. 1916; Magonigle, H. V. P.; Vitale & Geiffert; NEIR; NA; Guggenheim, Solomon R.; IBM Mgmt. Training Center; Y

BIBLIOGRAPHY: ARTS (12), Feb. 1920: 244; VIEW; ARLG (35), 1920; ARFO (32), Apr. 1920: 143; HOUS (50), Nov. 1921: 371; WWIA (1): 193; AVER

Guggenheim, William

unknown; unknown; unknown; Fountainhill; E; Harriman Lane; Sands Point; c. 1900; unknown; unknown; NFRR; NA; Harriman, W. Averell; Berritt, Harold; Y

BIBLIOGRAPHY: INVE, 1990

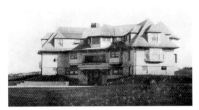

Gulliver, William C.

1847; 1919; Green, Louisa; The Box; unknown; Squabble Lane; Southampton; c. 1900; unknown; unknown; SHIN; c. 1962; McDonnell; unknown; N

BIBLIOGRAPHY: INVE, 1979; NCAB; FAML

Guthrie, William D.

1859; 1935; Fuller, Ella E.; Meudon; unknown; Frost Creek Road; Lattingtown; c. 1900; Gilbert, C. P. H.; Olmsted Brothers; FRNC; 1955; unknown; unknown; N

BIBLIOGRAPHY: ARRC (12), Nov. 1902: 662; ARLG (15), 1900; ARTR (8), Aug. 1903: 109; VIEW; ARTR (1), Apr. 1900: 148; INVE: 41; ARTS (16), Apr. 1922: 431; SORG; HOUG (17), May 1910: 173; TOWN, Sept. 1911: 18; TOWN, Sept. 1920: 31; ARTR (5), June 1902: 183; HICK; FLON; WURT; LOIS, Feb. 16, 1900; WWIA

Hackstaff, Mrs. Charles

unknown; unknown; unknown; unknown; E; Lee Avenue; East Hampton; 1899; Thorp, Joseph Greenleaf; unknown; SHIN; NA; Gebauer, Fernanda; unknown; Y

BIBLIOGRAPHY: ARRC (13), Jan. 1903; INVE, 1979

Hadden, Mrs. J. E. S.

unknown; unknown; unknown; unknown; unknown; unknown; Jericho; c. 1918; Peabody, Wilson & Brown; unknown; COTM; unknown; unknown; unknown

BIBLIOGRAPHY: PATT, 1924; *The Work of Peabody, Wilson & Brown,* Architectural Catalog, Mar. 1922

Haggerson, F. H.

unknown; 1952; unknown; unknown; unknown; unknown; Port Washington; c. 1920; O'Connor, James W.; unknown; NFRM; unknown; unknown; unknown; unknown

BIBLIOGRAPHY: NYTI; OCOR, 1930

Halsey, R. T. Haynes

unknown; unknown; Tower, Elizabeth; Tallwood; unknown; unknown; Cold Spring Harbor; c. 1924; unknown; unknown; unknown; unknown; unknown; unknown; unknown

BIBLIOGRAPHY: SPUR (43), Mar. 1929: 11; LOIS, Mar. 16. 1923

Hammerstein, Arthur

unknown; unknown; unknown; Wildflower; E; unknown; Whitestone; 1925; Baum, Dwight James; unknown; TUDR; NA; Morrow, George K.; unknown; Y

BIBLIOGRAPHY: ARAT (5), Feb. 1926; COUN (51), Dec. 1926: 71; ARTS (25), Oct. 1926: 32; HELB, 1927

Hammerstein, Oscar

unknown; 1960; unknown; Sunny Knoll; unknown; unknown; Kings Point; c. 1930; Hunt & Kline; unknown; unknown; unknown; unknown; unknown; unknown

BIBLIOGRAPHY: NCAB; ARTS (30), Feb. 1929: 50

Hammond, Paul
unknown; unknown; Sedgewick, S. R.; Mutton-
town Lodge; E; unknown; East Norwich;
c. 1930; Delano & Aldrich; unknown; NEFM;
NA; unknown; unknown; Y

BIBLIOGRAPHY: NASS; SORG; HOUS (67), May
1930: 594

Handy, Parker Douglas
1858; 1929; Warner, A. K.; Groendak; unknown;
unknown; Glen Cove; c. 1900; Gilbert, C. P.
H.; unknown; NEFL; unknown; unknown;
unknown; N

BIBLIOGRAPHY: WWIA (I): 515; ARTR (3), Jan. 1901:
14; SORG

Hard, Anson
unknown; unknown; unknown; Meadow Edge;
G; unknown; Sayville; 1905; Green, Isaac Henry;
Leavitt, Charles; CLRV; NA; unknown; Suffolk
County; Y

BIBLIOGRAPHY: INVE; ARLG

Hard, Anson W.
unknown; unknown; unknown; Fireplace; G;
unknown; Brookhaven; 1925; Wyeth & King;
unknown; unknown; NA; unknown; Suffolk
County Parks Dept; unknown; Y

BIBLIOGRAPHY: INVE, 1982; QUES

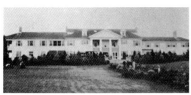

Hardjes, Herman H.
unknown; unknown; unknown; unknown;
unknown; unknown; Syosset; c. 1900;
unknown; unknown; GRRV; c. 1968; Kahn,
Otto; Sparks, Sir Ashley; N

BIBLIOGRAPHY: RAND: 199; FAML

Hare, Meredith
unknown; unknown; unknown; Pidgeon Hill;
unknown; unknown; Huntington; 1916; Platt,
Charles A.; Shipman, Ellen; NEFM; c. 1950;
unknown; unknown; N

BIBLIOGRAPHY: ARRC (48), Sept. 1920: 179

Hare, Mrs. Montgomery
unknown; unknown; unknown; unknown;
unknown; Long Beach Road; St. James; c. 1920;
Peabody, Wilson & Brown; unknown; NEFM; c.
1980; unknown; unknown; N

BIBLIOGRAPHY: INVE; PREV

Harkness, W. L.
1859; 1919; unknown; unknown; unknown;
unknown; Glen Cove; c. 1913; Rogers, James
Gamble; unknown; NECL; c. 1950; unknown;
unknown; N

BIBLIOGRAPHY: NCAB; ARAT (6), Sept. 1926

Harper, J. Henry
unknown; unknown; unknown; unknown; E;
The Breezy Way; Lawrence; c. 1896; Carrère &
Hastings; unknown; GRRV; NA; Throop, E. T.;
unknown; Y

BIBLIOGRAPHY: INVE

Harriman, Edward H.
c. 1848; c. 1909; Averall, Mary; unknown; un-
known; unknown; Far Rockaway; c. 1885;
Gibson, Robert W.; unknown; QUAN; unknown;
unknown; unknown; N

BIBLIOGRAPHY: AABN (20), 1886; WWIA (I): 523

Harriman, Mrs. Herbert M.
unknown; unknown; Hunnewell, Isa; un-
known; unknown; unknown; Jericho; c. 1915;
Cross & Cross; unknown; NEFD; c. 1950;
unknown; unknown; N

BIBLIOGRAPHY: LEVA, 1916; HEWI; TOWN, Sept.
1918: 25; SORG

Harriman, Joseph Wright
1867; 1949; Barney, Augusta; Avondale Farms;
unknown; unknown; Brookville; c. 1918;
Bossom, Alfred C.; Olmsted Brothers; NEFD;
c. 1950; Smith, Albert L.; unknown; N

BIBLIOGRAPHY: COUN (53), Mar. 1928: 42; ARLG
(43), 1928; PREV; SPUR, Apr. 1918: 23; SORG;
WWIA (II), 1950: 236; FLON; ARRC (43), Jan. 1918:
2FF

Harris, Henry Upham
unknown; unknown; Webster, Mary; unknown;
E; Brookville Road; Westbury; c. 1929; Bullard,
Roger; Payson, Louise; TUDR; NA; unknown;
unknown; Y

BIBLIOGRAPHY: AAAA (142), July 1932: 49; INVE;
SORG

Harris, Sam H.
1872; 1941; Watson, Brenda; unknown; E; Sunset
Drive; Geat Neck; c. 1920; Delehanty, Bradley;
unknown; NEIR; NA; Cohn, Milton; unknown; Y

BIBLIOGRAPHY: WWIA (I): 525; INVE; HEWI, 1922

Hastings, Thomas
1860; 1929; Benedict, Helen; Bagatelle; E; Stone
Arch Road; Old Westbury; c. 1910; Carrère &
Hastings; Farrand, Beatrix, 1915; NEFM; NA; Mr.
Osted; unknown; Y

BIBLIOGRAPHY: AMCO (I), 1912: 36; AMCO, 1915:
198F; PATT, 1924; LEVA, 1916; ARTR (24), Sept.
1911; TOWN, Aug. 1914: 18; ELWO, 1924: 91; WWIA
(I): 533; SORG; ARRC (27), Jan. 1910: 61; PRLN,
1985

Hattersley, Robert
unknown; unknown; unknown; unknown; E;
Cedar Swamp Road; Glen Head; c. 1929;
Delehanty, Bradley; unknown; NFRM; NA;
unknown; unknown; Y

BIBLIOGRAPHY: DELE, 1939

Havemeyer, Henry O., Jr.
unknown; unknown; Dick, Doris; Modern
Venice; E; unknown; Islip; c. 1897; Atterbury,
Grosvenor; unknown; NEIR; NA; unknown;
unknown; Y

BIBLIOGRAPHY: AAAA (96), 1909: 94; ARRC (28),
Aug. 1910: 79FF; EMBU, 1909: 95; LOIS, Jan. 30,
1903; LOIS, Oct. 7, 1893; SORG

Havemeyer, Henry O., Jr.
unknown; unknown; Dick, Doris; Olympic
Point; E; Saxon Avenue; Islip; c. 1918;
Lindeberg, Harrie T.; unknown; COTM; c. 1940;
unknown; unknown; N

BIBLIOGRAPHY: HOUS (57), Feb. 1925: 130; ARRC
(55), Apr. 1924: 357; COUN (61), Jan. 1932: 3;
COUN (50), Oct. 1926: 38; SORG; COUN (48), June
1925: 45; LINB; ARTS (12), Jan. 1920: 158; FLON

Havens, Frank Colton
1848; 1918; Bell, Sadie; unknown; L; Bay Street;
Sag Harbor; c. 1905; Leicht, Adolph; unknown;
SHIN; NA; unknown; Roman Catholic Retreat; Y

BIBLIOGRAPHY: COUN (40), June 1921: 21; COUN
(35), Apr. 1919: 12; WWIA (I): 535

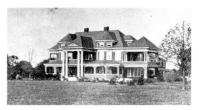

Hawkins, William
unknown; unknown; unknown; unknown; O;
Montauk Hwy & Great Neck; Copiague;
c. 1918; unknown; unknown; CLRV; NA; Nassau
Suffolk Hospital; Lakeside Hospital; Y

BIBLIOGRAPHY: A. *Backward Glance*, Amityville
H. S.

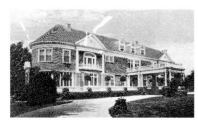

Hawley, Edwin
1850; 1912; Shaw, Katharine; unknown; E; unknown; Babylon; c. 1900; unknown; unknown; CLRV; unknown; unknown; unknown; N

BIBLIOGRAPHY: INVE

Hayward, W. T.
unknown; unknown; unknown; unknown; E; Greene Avenue; Sayville; c. 1893; Green, Isaac Henry; unknown; SHIN; NA; unknown; unknown; Y

BIBLIOGRAPHY: ARBD, 1893; INVE

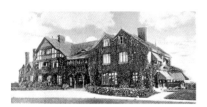

Hazard, W. A.
unknown; unknown; Pelton, Laura; Meadow Hall; unknown; The Mall; Cedarhurst; c. 1910; unknown; unknown; HTRV; c. 1950; unknown; unknown; N

BIBLIOGRAPHY: SPLI, Postcard Collection

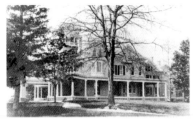

Heckscher, August
unknown; unknown; unknown; Wincoma; unknown; unknown; Huntington; c. 1898; unknown; unknown; ITAM; unknown; Frost, Henry S.; unknown; N

BIBLIOGRAPHY: LOIS, Aug. 27, 1898; PREV, 1939

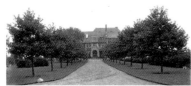

Heinsheimer, A. M.
unknown; 1910; unknown; Breezy Point; unknown; Mott Avenue; Far Rockaway; c. 1907; Daus, Rodolphe; unknown; HTRV; 1987; Heinsheimer, Alfred; Maimonides Institute; N

BIBLIOGRAPHY: HICK, 1911

Henderson, C. S.
unknown; unknown; unknown; White Caps; unknown; unknown; Southampton; c. 1886; McKim, Mead & White; unknown; SHIN; c. 1938; unknown; unknown; N

BIBLIOGRAPHY: BROD

Henderson, Frank C.
unknown; unknown; unknown; Villa Marina; E; unknown; Roslyn; c. 1920; Warren & Clark; Hatton & De Suarez; NIRM; NA; unknown; unknown; Y

BIBLIOGRAPHY: COUN (41), Dec. 1921: 51; SPUR (27), 11, 1921: 36; LAPE; COUN (45), Apr. 1924: 7; HEWI, 1920

Henry, Barklie McKee
1902; 1966; Whitney, Barbara; unknown; unknown; unknown; Old Westbury; c. 1930; Noel & Miller; unknown; NEFM; c. 1975; unknown; unknown; N

BIBLIOGRAPHY: COUN (63), Apr. 1933: 60; NCAB; GOTT, 1934

Hepburn, Frederick T.
unknown; unknown; unknown; Long Field; E; Lattingtown Road; Lattingtown; c. 1929; Delehanty, Bradley; unknown; NEFD; NA; Herzog, Edwin; unknown; Y

BIBLIOGRAPHY: DELA, 1934; INVE; GOTT

Hepburn, George
unknown; unknown; Kelley, Cornelia; unknown; E; Skunks Misery Road; Lattingtown; 1927; Delehanty, Bradley; unknown; NEFD; NA; Romeo; unknown; Y

BIBLIOGRAPHY: INVE; SORG; GOTT, 1934; DELA, 1934

Hepburn, L. F.
unknown; unknown; unknown; unknown; E; West Shore Road; Mill Neck; c. 1906; unknown; unknown; TWEC; NA; unknown; unknown; Y

BIBLIOGRAPHY: INVE

Herrick, Dr. Everett
1840; 1914; Ford, Harriet; Puddynge Hill; E; Ocean Avenue at Woods Lane; East Hampton; c. 1887; Green, Isaac Henry; unknown; SHIN; NA; Ford, James B.; Bishop, Bennett; Y

BIBLIOGRAPHY: FOST, 1977; FYMC, 1941: 24; INVE; EHHE, 1982: 68; SORG

Herter, Albert
unknown; unknown; Mcginnnis, Adele; The Creeks; E; unknown; East Hampton; 1898; Atterbury, Grosvenor; unknown; MEVI; NA; Ossorio, Alfonso; unknown; Y

BIBLIOGRAPHY: NCAB; SORG; ARTR (69), Mar. 1934: 182; EHHE, ARTR (40), Sept. 1919; HEWI; COUN (31), May 1917: 36; AABN (94), 1908; COUN (33), Feb. 1918: 47; ARTS (23), July 1925: 35; SPUR, July 1914: 27; ARRC (17), Feb. 1905: 86; COUN (29), Feb. 1919: 19

Hess, H. Bellas
unknown; unknown; unknown; The Cedars; unknown; unknown; Huntington; c. 1914; Howells & Stokes; unknown; NEIR; c. 1958; unknown; unknown; N

BIBLIOGRAPHY: AAAA (120), 1921; ARRC (46), Oct. 1919: 332; LEVA, 1916; LOIS, Oct. 23, 1914

Hewlett, James M.
unknown; unknown; unknown; unknown; E; Briarwood Crossing; Lawrence; c. 1927; Lord & Hewlett; unknown; NEFD; NA; Bierworth, John E.; Marmo, Anthony; Y

BIBLIOGRAPHY: INVE

Hill, James Norman
1870; 1932; Fahnestock, M.; Big Tree Farm; S; Wheatley Road; Brookville; c. 1917; Walker & Gillette; Olmsted Brothers; NEFD; NA; unknown; A. H. R. C. School; Y

BIBLIOGRAPHY: PATT, 1924; INVE; SORG, 1929; FLON; WWIA (1): 564; WURT

Hinckley, S. P.
unknown; unknown; unknown; Sunset Hall; unknown; unknown; Lawrence; c. 1883; Lamb & Rich; unknown; SHIN; unknown; unknown; unknown; N

BIBLIOGRAPHY: ARBW (9), Sept. 1888; AABN (15), Feb. 1884

Hinckley, S. P.
unknown; unknown; unknown; Briar Hall; E; Ocean Avenue; Lawrence; c. 1888; Lamb & Rich; unknown; SHIN; NA; unknown; unknown; Y

BIBLIOGRAPHY: INVE; ARBW (9), Sept. 1888

Hinckley, S. P.
unknown; unknown; unknown; Elm Hall; E; Ocean Avenue; Lawrence; c. 1888; Lamb & Rich; unknown; SHIN; NA; unknown; unknown; Y

BIBLIOGRAPHY: INVE; ARBW (9), Sept. 1888

Hinckley, S. P.
unknown; unknown; unknown; Meadow Bank; E; Ocean Avenue; Lawrence; c. 1888; Lamb & Rich; unknown; SHIN; NA; unknown; unknown; Y

BIBLIOGRAPHY: ARBW (9), Sept. 1888; INVE

Hinckley, S. P.
unknown; unknown; unknown; Sunnyside; E; Ocean Avenue; Lawrence; c. 1888; Lamb & Rich; unknown; CLRV; NA; unknown; unknown; Y

BIBLIOGRAPHY: ARBW (9), Sept. 1888; INVE

Hine, Francis Lyman
unknown; 1927; Ide, Mary L.; Mayhasit; E; Lattingtown Road; Glen Cove; c. 1916; Walker & Gillette; Olmsted Brothers; NEFD; 1986; Bartow, Francis D.; Le Roux, Edward; N

BIBLIOGRAPHY: COUN (34), Oct. 1918: 43; PATT, 1924: 50; ARRC (44), July 1918: 2FF; HEWI, 1925; FLON; WWIA (1): 567; TOWN, Dec. 1918: 41; SPUR (36), 1925: 49

Hitchcock, Thomas
1831; 1910; unknown; Center Maria; O; Hollow Farm; Westbury; 1892; Hunt, Richard Morris; unknown; CLRV; NA; Cerebral Palsy Assn.; Old Westbury Farms; Y

BIBLIOGRAPHY: NCAB: 548; RUTH, 1909; COUN (58), July 1930: 39; AAAA (135), Jan. 1929: 63

Hoagland, C. N.
unknown; unknown; unknown; unknown; E; Crescent Beach Road; Glen Cove; c. 1896; Gilbert, C. P. H.; unknown; SHIN; NA; Tangeman, G. P.; O'Keefe; Y

BIBLIOGRAPHY: INVE; WURT

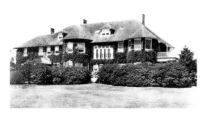

Hobart, Mrs. Garret
unknown; unknown; Briggs, Caroline; T' Other House; E; Lee Avenue; East Hampton; c. 1900; unknown; unknown; SHIN; NA; unknown; unknown; Y

BIBLIOGRAPHY: HEWI, 1927; SORG

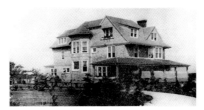

Hobbs, C. B.
unknown; unknown; unknown; unknown; unknown; Great River Road; Great River; c. 1902; unknown; unknown; SHIN; 1960; unknown; unknown; N

BIBLIOGRAPHY: VANO; INVE

Hodenpyl, Anton G.
unknown; unknown; Pruesser, Annie; Hill House; unknown; Duck Pond Road; Matinecock; c. 1900; unknown; Simmonds, Ossian C.; TUDR; c. 1940; unknown; unknown; N

BIBLIOGRAPHY: INVE

Hoffstot, Frank N.
unknown; c. 1938; Willard, Annie; Belcaro; unknown; Hoffstots Lane; Sands Point; c. 1910; Foster, Mortimer; unknown; NEIR; unknown; unknown; unknown; N

BIBLIOGRAPHY: HICK; SORG; WWIA (1): 575; TOWN, Apr. 1914: 32; VIEW

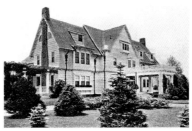

Hofstra, William S.
unknown; c. 1932; Mason, Katherine; Netherlands; S; Fulton Avenue; Hempstead; c. 1904; unknown; unknown; SHIM; NA; unknown; Hofstra College; Y

BIBLIOGRAPHY: HICK; SORG; TOWN, Oct. 1912: 28

Hollins, Gerald
unknown; unknown; Kobbe, V.; unknown; E; Bay View Avenue; Islip; c. 1912; Green, Isaac Henry; unknown; SHIM; NA; unknown; unknown; Y

BIBLIOGRAPHY: INVE; Sayville Historical Society

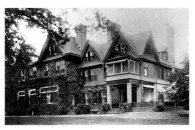

Hollins, H. B.
1854; 1938; Knapp, Evelina; Meadow Farm; unknown; unknown; Islip; c. 1880; unknown; Olmsted Brothers; QUAN; unknown; unknown; unknown; N

BIBLIOGRAPHY: INVE; FLON; VAND; SORG, 1929

Hollins, H. B., Jr.
1882; 1956; Livingston, Lila; Crickholly; E; Bay View Avenue; Islip; c. 1907; Cross & Cross; unknown; GRRV; NA; De Cort; unknown; Y

BIBLIOGRAPHY: SORG; INVE; VAND; NYTO

Hollister, Dr. F. K.
unknown; unknown; Shelton, Harriet; unknown; E; Lily Pond Lane; East Hampton; c. 1908; Albro & Lindeberg; unknown; ITAM; NA; unknown; unknown; Y

BIBLIOGRAPHY: EHHE; SORG; NCAB; LINB: 203

Holmes, Artemas
unknown; 1944; Smith, Dorothy; Holmstead Farms; E; Chicken Valley Road; Brookville; c. 1925; O'Connor, James W.; unknown; CLOL; NA; unknown; unknown; Y

BIBLIOGRAPHY: HEWI, 1925; NYTI, Apr. 4, 1944; SORG

Holmes, Mrs. Christian
unknown; 1941; Fleischmann, B.; The Chimneys; L; Middle Neck Road; Sands Point; c. 1930; Williams, Edgar Irving; unknown; TUDR; NA; U.S. Naval Devices; Sands Pt. Synagogue; Y

BIBLIOGRAPHY: HEWI, 1931; SORG; BEAU: 79; RAND: 73

Hopkins, Eustis
unknown; unknown; unknown; Wildewood; E; unknown; Matinecock; c. 1927; Valentine, Charles A.; unknown; COTS; NA; unknown; unknown; Y

BIBLIOGRAPHY: PREV; INVE

Hoppin, G. Beekman
1870; 1957; Hout, Rosina; Four Winds; L; unknown; Oyster Bay; c. 1930; Delano & Aldrich; Vitale, Ferruccio; GRRV; NA; unknown; Mount Saint Ursula Retreat; Y

BIBLIOGRAPHY: COUN (65), Mar. 1934: 44; GOTT, 1931; SORG; HOWE, 1933

Horowitz, Louis
unknown; unknown; unknown; unknown; unknown; Skunks Misery Road; Lattingtown; c. 1918; Hunt & Hunt; unknown; GRRV; c. 1954; unknown; unknown; N

BIBLIOGRAPHY: INVE; ARLG, 1918

Houston, William
unknown; unknown; unknown; unknown; unknown; Kings Point Road; Kings Point; c. 1923; unknown; unknown; TUDM; c. 1940; unknown; unknown; N

BIBLIOGRAPHY: SPLI, 1935

Howe, Richard Flint
1863; 1941; Deering, Abby; Linden Hill Road; unknown; Wheatley Hills Road; Brookville; c. 1920; Carrère & Hastings; unknown; NFRM; unknown; unknown; unknown; N

BIBLIOGRAPHY: SORG; WWIA (11), 1950: 226; VIEW

Howe, W. Deering
unknown; unknown; Brooks, Polly; Highpool; S; Brookville Road; Brookville; c. 1926; Carrère & Hastings; unknown; NFRM; NA; unknown; Lutheran High School; Y

BIBLIOGRAPHY: INVE; SORG; AVER

Howland, Georgina and Abby
unknown; unknown; unknown; unknown; E; unknown; Southampton; 1896; Budd, Katherine; unknown; SHIM; NA; Wurlitzer; Scavullo, Francesco; Y

BIBLIOGRAPHY: COUN (4), Oct. 1903: 411.

Hoyt, Mrs. Alfred M.
unknown; unknown; Nicholson, Mary; Red Maples; unknown; Ox Pasture Road; Southampton; c. 1900; Hiss & Weekes; Vitale, Ferruccio; NEIR; unknown; unknown; unknown; N

BIBLIOGRAPHY: ARTR (37), Apr. 1918; HOUS (34), June 1913: 116; COUN (43), Mar. 1923: 15; TOWN, May 1914: 33; LHDG (2), 1917: 71; INVE; HICK; SPUR, Sept. 1915: 14; SORG

Hoyt, Colgate
unknown; unknown; Williams, Muriel; Meadow Spring; unknown; unknown; Centre Island; c. 1892; Clinton & Russell; unknown; SHIN; c. 1930; unknown; unknown; N

BIBLIOGRAPHY: SORG; TOWN, Apr. 1923: 7; LOIS, May 3, 1901

Hoyt, John R.
unknown; unknown; unknown; unknown; E; Kings Point Road; Great Neck; c. 1920; Caretto & Foster; unknown; COTS; NA; unknown; unknown; Y

BIBLIOGRAPHY: ARRC (49), Jan. 1921: 84

Hudson, Charles I.
1850; 1921; Kierstede, Sara; Knollwood; unknown; unknown; East Norwich; c. 1906; Hiss & Weekes; Vitale & Geiffert; unknown; c. 1962; Senff, Mrs. Charles H.; Macveigh, C. S.; N

BIBLIOGRAPHY: HOUS (55), Apr. 1924: 32; COUN (37), Apr. 1920: 19; VIEW; ELWO, 1924: 166; GOTT, 1928; ARTR (24), Dec. 1911; LOIS, Nov. 18, 1921; TOWN, Sept. 1911: 16; SORG; SPUR (29), Apr. 1922: 64; HICK; NYTI, Nov. 16, 1921

Humphrey, A. C.
unknown; unknown; unknown; unknown; unknown; unknown; Glen Cove; c. 1899; Gilbert, C. P. H.; unknown; MEVI; c. 1916; Queen, Ernest; unknown; N

BIBLIOGRAPHY: ARRC (12), Nov. 1902: 668; ATLA; ARTR (3), Jan. 1901: 90FF; ARTR (1), June 1900: 227; LOIS, Feb. 2, 1906; TOWN, July 1906: 10; WURT

Hunter, Fenley
unknown; unknown; unknown; Porto Bello; unknown; unknown; Great Neck; c. 1929; Ward, Leroy P.; unknown; NFRM; unknown; unknown; unknown; unknown

BIBLIOGRAPHY: HOUG, Mar. 1929: 117; GOTT

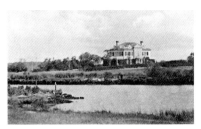

Huntington, Dr.
unknown; unknown; unknown; unknown; E; unknown; Bay Shore; c. 1900; unknown; unknown; GRRV; NA; unknown; unknown; Y

BIBLIOGRAPHY: COUN (11), Mar. 1907: 470; Babylon Historical Society; INVE

Huntington, F. C.
1865; 1916; Butler, Susan; Rassapeague; E; Long Beach Road; Smithtown; c. 1908; Butler, Lawrence; unknown; CLRV; NA; unknown; unknown; Y

BIBLIOGRAPHY: PREV; NRNF, 1992; INVE

Huntington, Robert D.
c. 1900; unknown; Taylor, Edith; Buckmeadow; unknown; Horseshoe Road; Mill Neck; c. 1926; Rogers, James Gamble; unknown; TUDR; c. 1973; Lehman, Ellen; unknown; N

BIBLIOGRAPHY: INVE; FAML; HOWE, 1933; SORG; COUN (63), Dec. 1932: 54

Hutton, Edward F.
unknown; unknown; Post, Marjorie; Hillwood; S; Northern Boulevard; Brookville; 1921; Hart & Shape; Coffin, Marian C.; TUDR; NA; unknown; C.W. Post College; Y

BIBLIOGRAPHY: COUN (53), Mar. 1928: 45; COUN (60), Oct. 1931: 40; ARRC (52), Oct. 1922: 492; HOWE, 1933; SORG; AAAA (123), 1923: 241I; COUN (58), July 1930: 39; HEWI, 1924; ARAT (1), Jan. 1924; AAAA (133), 1928: 297; BEAU: 138; SPUR (31), Apr. 1923: 54; ARLG, 1924; ARTS (21), Oct. 1924: 27

Hyde, Henry B.
c. 1834; 1899; Fitch, Annie; The Oaks; unknown; South Country Road; Bay Shore; c. 1874; Vaux, Calvert; Olmsted Brothers; STIK; c. 1973; Hazen, James Hyde; Bossert, Louis; N

BIBLIOGRAPHY: TOWN, Oct. 1903: 10; COUN (4), July 1903: 201; BKLY, Aug. 1907: 3; OAKD (1); SORG; HICK; TOWN, May 1923: 9

Hyde, Richard
1856; 1912; unknown; unknown; unknown; South Country Road; Bay Shore; 1895; Birdsall, Clarence K.; unknown; SHIN; unknown; Rising, Mrs. Neil; unknown; N

BIBLIOGRAPHY: LIFO, Feb. 1989: 6; *New York Herald,* June 23, 1895

Ide, George E.
unknown; unknown; Carne, Hester; unknown; E; unknown; Lattingtown; c. 1917; Rogers, James Gamble; unknown; NEFM; NA; Dickson, Thomas; unknown; Y

BIBLIOGRAPHY: ARRC (41), May 1917: 458; INVE; SORG

Ingalls, Fay
1882; 1957; Holmes, Rachel; Sunken Orchard E; unknown; Oyster Bay; c. 1916; de Gersdorff, George B.; Flanders, Annette Hoyt; GRRV; NA; McCann, Charles E. F.; Douglas, Barry; Y

BIBLIOGRAPHY: GOTT, 1936; SORG; LOIS, Jan. 1926; NYTI, Nov. 25, 1957; PREV; *The Magazine Antiques,* Apr. 1985; SPUR (49), Apr. 1932: 36; COUH

Iselin, Charles Oliver
unknown; c. 1932; Goddard, Hope; Wolver Hollow; C; Chicken Valley Road; Brookville; c. 1914; Hoppin & Koen; Olmsted Brothers/ Beatrix Farrand; NEFM; NA; unknown; Franconia Associates; Y

BIBLIOGRAPHY: SORG; FLON; HICK; INVE; WWIA (1): 621; NASU; LOIS, July 15, 1910

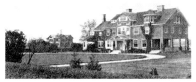

Jackson, Theodore F.
unknown; unknown; Burr, Cornelia; Fairlawn; unknown; Seafield Lane; Westhampton; c. 1902; unknown; unknown; SHIN; unknown; unknown; unknown; N

BIBLIOGRAPHY: RUTH, 1909

James, Ellery S.
unknown; unknown; Headley, Louise; Heatherdune; E; West End Avenue; East Hampton; c. 1926; Bullard, Roger H.; unknown; COTM; NA; unknown; unknown; Y

BIBLIOGRAPHY: AAAA (135), June 1929: 711; EHHE: 198; INVE; SORG

James, Dr. Walter B.
1858; 1927; Jennings, Helen; Eagles Beak; unknown; unknown; Cold Spring Harbor; 1899; Atterbury, Grosvenor; unknown; TWEC; c. 1960; unknown; unknown; N

BIBLIOGRAPHY: INVE

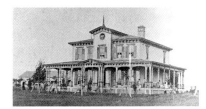

Jeffreys, C. P. B.
unknown; unknown; unknown; Sommariva; unknown; James Lane; East Hampton; c. 1872; unknown; unknown; STIK; unknown; Mills, Abraham; Craig, Dr. Stuart; unknown

BIBLIOGRAPHY: FOST, 1977; EHHE: 63; FYMC, 1941: 24

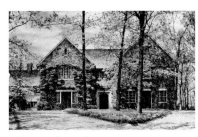

Jelke, Ferdinand
unknown; unknown; unknown; Laurelcroft; unknown; Bayville Avenue; Bayville; c. 1923; unknown; TUDM; c. 1950; unknown; unknown; N

BIBLIOGRAPHY: PREV

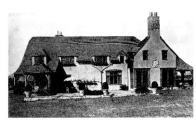

Jenney, William S.
unknown; unknown; Bevan, Nina; Settle Close; E; unknown; East Hampton; c. 1917; Polhemus & Coffin; unknown; COTM; NA; unknown; unknown; Y

BIBLIOGRAPHY: ARRC (54), Nov. 1923: 417; ARLG, 1923; EHHS: 197

Jennings, Brewster
unknown; unknown; Prentice, Kate; Windward; E; Pound Hollow Road; Brookville; c. 1924; Chambers, Walter; unknown; GRRV; NA; unknown; unknown; Y

BIBLIOGRAPHY: INVE; NCAB; SORG

Jennings, Oliver Burr
unknown; unknown; Goodsell, Esther; Dark Hollow; E; Dock Hollow Road; Lloyd Harbor; c. 1930; Schmidt, Mott B. & Mogens Tvede; unknown; NECL; NA; unknown; Freidus, Jacob & Ella; Y

BIBLIOGRAPHY: SORG; INVE; ARTR (2), July 1900: 256

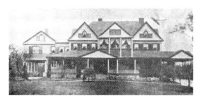

Jennings, P. R.
unknown; c. 1914; Asman, Louise; Edgehurst; unknown; Merrick Road at Lindenmere; Merrick; unknown; unknown; unknown; SHIN; c. 1933; unknown; unknown; N

BIBLIOGRAPHY: *Memories of Merrick,* 1977; SORG

Jennings, S. A.
unknown; unknown; unknown; unknown; O; Red Spring Lane; Glen Cove; c. 1900; Lamb & Rich; unknown; TWEC; NA; Livermore; Glen Cove BPOE; Y

BIBLIOGRAPHY: WURT; INVE

Jennings, Walter
1858; 1932; Brown, Jean P.; Burrwood; O; Jennings Road; Cold Spring Harbor; 1898; Carrère & Hastings; Olmsted Brothers, 1916–38; NFRR; 1995; Jennings, Oliver Burr; Indus. Home for Blind; N

BIBLIOGRAPHY: SORG; INVE; HICK; ARRC (27), Jan. 1910: 45; HEWI; FLON; AABN (70), Dec. 1, 1900: 71; BRIC (9), Aug. 1900; WWIA (1): 634; TOWN, Aug. 1917: 22; WURT

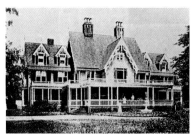

Johnson, Bradish, Sr.
unknown; unknown; Johnson, Louisa; Sans Souci; unknown; South Country Road; West Islip; c. 1860; unknown; unknown; HVGO; unknown; unknown; unknown; N

BIBLIOGRAPHY: BABY, 1902

Johnson, Bradish, Jr.
unknown; c. 1944; Gillard; Woodland; S; Suffolk Lane; East Islip; c. 1909; Green, Isaac Henry; unknown; NEFM; NA; Johnson, Mrs. Aymar; Hewlett School; Y

BIBLIOGRAPHY: SORG; TOWN, May 1915

Johnson, F. Coit
unknown; unknown; Dickinson, Florence; Kaintuck Farm; E; Feeks Lane; Mill Neck; unknown; unknown; unknown; TWEC; NA; unknown; unknown; Y

BIBLIOGRAPHY: INVE; COUN (23), Apr. 1913: 104; SORG

Johnson, Mrs. Norma T.

unknown; unknown; unknown; unknown; unknown; unknown; Water Mill; c. 1930; Goodwillie & Moran; unknown; GRRV; unknown; unknown; unknown; unknown

BIBLIOGRAPHY: ARRC (72), Aug. 1932: 105

Johnson, Mrs. S. Fisher

1850; 1924; unknown; unknown; E; Dunemere Lane; East Hampton; 1895; Thorp, Joseph Greenleaf; unknown; SHIN; NA; unknown; unknown; Y

BIBLIOGRAPHY: INVE, 1979; EHHE

Johnson, Mrs. S. Fisher

unknown; unknown; unknown; Onadune; E; Georgica Road; East Hampton; 1903; Lawrence, John C.; unknown; SHIM; NA; unknown; unknown; Y

BIBLIOGRAPHY: EHHE

Johnson, Wayne

1892; 1947; Royer, Gladys; unknown; unknown; unknown; Great Neck; c. 1925; Pope, John Russell; unknown; GRRM; unknown; unknown; unknown; N

BIBLIOGRAPHY: COUN (48), Oct. 1925: 37; SORG; WWIA (11), 1950: 285

Johnston, J. Herbert

unknown; unknown; Noel, Teenie; Boatcroft; O; Harbor Hill Drive; Lloyd Harbor; c. 1915; Willaver, Shape & Bread; unknown; GRRV; NA; unknown; Rep Ivory Coast; Y

BIBLIOGRAPHY: ARTR (6), Jan. 1915; INVE

Jonas, Nathan S.

unknown; unknown; unknown; unknown; unknown; unknown; Great Neck; c. 1924; Mann & MacNeille; Levinson, J. J.; TUDM; c. 1960; Devendorf, George; unknown; N

BIBLIOGRAPHY: COUN (52), May 1927; ARTS, Jan. 1829; PREV

Jones, Frank

unknown; unknown; unknown; unknown; unknown; Benson Avenue; Sayville; c. 1902; Green, Isaac Henry; unknown; SHIN; c. 1960; Perrine, Russel J.; unknown; N

BIBLIOGRAPHY: SPUR (38), Oct. 1926: 17; INVE

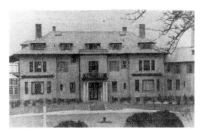

Jones, Mary Elizabeth

unknown; c. 1918; unknown; unknown; E; Cold Spring Harbor Road; Laurel Hollow; c. 1918; unknown; unknown; GRRM; NA; Deesposito, Frank; unknown; Y

BIBLIOGRAPHY: QUES

Kahn, Otto H.

1867; 1934; Wolff, Addie; Oheka; E; Cold Spring Hills; Cold Spring Harbor; 1914; Delano & Aldrich; Olmsted Brothers, 1916–17; NFRR; NA; Oheka Corp.; N.Y. Sanitation Dept.; Y

BIBLIOGRAPHY: WWIA (1): 655; COUN (46), Sept. 1924: 37; COUN (39), Dec. 1920: 50; COUN (64), Aug. 1933: 50; HEWI, 1920; PHDA, 1922: 18; ARLG, 1923; PATT, 1920; ARRC (54), July 1923: 22FF; ELWO, 1924; FLON; ARTS (23), July 1925: 42; SORG; TOWN, Sept. 1920: 30; SPUR (42), Sept. 1928: 59; LEVA; LOIS, May 20, 1921; LOIS, Mar. 13, 1914

Kailly, Hester

unknown; unknown; unknown; Lindenmere; E; Sedgemere Road; Center Moriches; 1908; unknown; unknown; SHIN; NA; Leslie, Warren; Lindenmere Hotel; Y

BIBLIOGRAPHY: INVE, 1982; *Newsday*, Sept. 23, 1982

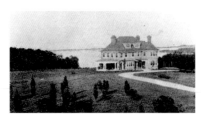

Kane, Frederick L.

unknown; unknown; unknown; unknown; unknown; unknown; Huntington; c. 1890; unknown; unknown; SHIN; c. 1950; unknown; unknown; N

BIBLIOGRAPHY: *Huntington, Cold Spring Harbor Booklet:* 1909: 67

Kane, John P.

unknown; unknown; Yauch, Margaret A; unknown; E; Wellington Road; Matinecock; c. 1920; Beers & Farley; Payson, Louise; NFRR; NA; Wellington, Herbert G.; Lundy; Y

BIBLIOGRAPHY: SORG; INVE; SPUR (50), Oct. 1932: 38

Keene, Foxhall

1870; 1959; Lawrence, Mary; Rosemary Hall; E; Wheatley Road; Old Westbury; c. 1902; Freeman & Hesselman; Leavitt, Charles W.; GRRV; NA; Holloway, W. M; unknown; Y

BIBLIOGRAPHY: NYAR (2), Apr. 1908; VIEW; ARTR (6), May 1902; RAND: 97; FERR, 1904; SORG; BEAU: 118

Kelley, Cornelius E.

unknown; unknown; unknown; Sunny Skies; unknown; Shelter Rock Road; North Hills; c. 1930; unknown; unknown; NFRM; unknown; unknown; unknown; unknown

BIBLIOGRAPHY: PREV

Kennard, Thomas W.

unknown; unknown; unknown; Glen Chalet; unknown; unknown; Glen Cove; c. 1865; Mould, Jacob Wrey; unknown; unknown; unknown; Barlow, Samuel; Ladew, Edward; N

BIBLIOGRAPHY: GLEN; INVE; NCAB; *The Horticultural Journal* (28), 1873: 268–9

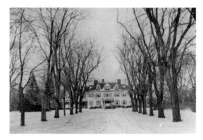

Kennedy, Henry Van R.

1863; 1912; Robbins, Maria; Three Oaks; unknown; unknown; Hempstead; c. 1895; unknown; unknown; GRRV; 1965; Village of Hempstead; unknown; N

BIBLIOGRAPHY: NASS; NCAB

Kennedy, William

unknown; unknown; unknown; Bayberry Hill; E; Split Rock Road; Syosset; c. 1922; Kern & Lippert; unknown; GRRV; NA; unknown; unknown; Y

BIBLIOGRAPHY: LOIS, Apr. 1, 1921; HICK; PREV, 1936

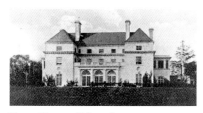

Kent, George Edward
unknown; unknown; Grace, Lilias; Jericho House; unknown; Jericho Turnpike; Jericho; c. 1906; unknown; Olmsted Brothers/Arthur Shurcliff; NECL; unknown; unknown; unknown; N

BIBLIOGRAPHY: FLON; AVER; SORG; PATT, 1924: 14

Kerrigan, Joseph H.
unknown; unknown; Slates, Esther; unknown; E; Cove Neck Road; Oyster Bay; c. 1929; Pope, John Russell; unknown; GRRV; NA; unknown; unknown; Y

BIBLIOGRAPHY: SORG; COUN (64), Aug. 1933: 40; FLON

Keyes, Dr. E. L.
unknown; unknown; unknown; Grass Land; unknown; unknown; Water Mill; c. 1895; unknown; unknown; QUAN; unknown; unknown; unknown; N

BIBLIOGRAPHY: PELL; *Newsday*, Dec. 5, 1976

Kienle, Mrs. Eugene S.
unknown; unknown; unknown; Many Gables; E; East Shore Road; Kings Point; c. 1920; Grompert, William; unknown; TWEC; NA; Ades, Robert; unknown; Y

BIBLIOGRAPHY: MLAE; INVE; AAAA (121), 1922; PREV

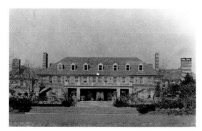

Kiser, John W.
unknown; unknown; Pierce, Mary B.; unknown; E; Ox Pasture Road; Southampton; c. 1927; unknown; unknown; CLOL; NA; Leas, Fernanda; unknown; Y

BIBLIOGRAPHY: HEWI, 1930; INVE; SORG

Knapp, Edward Spring
1852; 1895; Lawrence, Marg; Awixa Lawn; unknown; Saxon Avenue; Bay Shore; c. 1879; unknown; unknown; CLRV; 1982; Belmont, August, Jr.; Hawkins; N

BIBLIOGRAPHY: LIFO, Feb. 1990

Knapp, Edward Spring
1852; 1895; Lawrence, Marg; unknown; E; Saxon Avenue; Bay Shore; c. 1896; unknown; unknown; CLRV; NA; Belmont, August, Jr.; unknown; Y

BIBLIOGRAPHY: LIFO, Feb. 1990

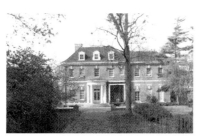

Knapp, Harry K.
unknown; unknown; Mann, Elza M.; Brookwood Hall; G; Montauk Highway; Islip; 1910; unknown; unknown; GRRV; NA; Thorne, Francis B.; Islip Art Center; Y

BIBLIOGRAPHY: SORG; INVE

Knapp, Harry K., Jr.
unknown; unknown; unknown; Creekside; E; unknown; East Islip; c. 1930; Clinton & Russell; Leavitt, C. W., Jr.; NEFD; NA; unknown; unknown; Y

BIBLIOGRAPHY: INVE; HOWE

Knapp, Joseph P.
unknown; unknown; Laing, Elizabeth H.; Tenacre; E; Ox Pasture Road; Southampton; c. 1920; Pope, John Russell; unknown; SHIN; NA; unknown; unknown; Y

BIBLIOGRAPHY: AAAA (122), Sept. 1922; NCAB; SORG; INVE

Kniffin, Howard S.
unknown; unknown; Aldirch, Florence; unknown; E; Ocean Avenue; Cedarhurst; 1911; Adams, William; unknown; GRRV; NA; Morrow, Robert; unknown; Y

BIBLIOGRAPHY: INVE; ARRC (43), June 1918: 507; AABN (101), 1912; SORG; HEWI

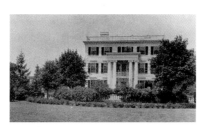

Knopf, Samuel
unknown; unknown; unknown; unknown; unknown; Lord Avenue; Lawrence; c. 1900; unknown; unknown; NEFM; c. 1950; unknown; unknown; N

BIBLIOGRAPHY: HEWI; ARRC (39), Mar. 1916: 197

Kramer, A. Ludlow
1878; 1948; Bement, Anna; Picket Farm; unknown; unknown; Jericho; c. 1918; Peabody, Wilson & Brown; unknown; NEFD; c. 1977; Lehman, Allan; unknown; N

BIBLIOGRAPHY: HEWI; COUN (49), Feb. 1926: 45; COUN (30), Feb. 1919: 45; TOWN, May 1920: 53; WWIA (11), 1950: 206; SORG

Kraus/Stern
unknown; unknown; unknown; unknown; unknown; unknown; Far Rockaway; c. 1895; Werner & Windolph; unknown; QUAN; unknown; unknown; unknown; N

BIBLIOGRAPHY: ROCK

Kuttroff, A.
unknown; unknown; unknown; unknown; E; Sylvester Road; Shelter Island; c. 1890; Schickel, William; unknown; SHIN; NA; Hench; McCormick, Florence; Y

BIBLIOGRAPHY: INVE, 1982; HIST

Ladd, William F.
unknown; unknown; Lee, Cornelia; unknown; unknown; unknown; Lawrence; c. 1920; Peabody, Wilson & Brown; unknown; TUDR; unknown; unknown; unknown; N

BIBLIOGRAPHY: AAAA (120), Oct. 1921: 2378; INVE; VIEW

Ladd, William F.
unknown; unknown; Lee, Cornelia; Ocean Castle; E; Meadow Lane; Southampton; c. 1929; Peabody, Wilson & Brown; unknown; NEFM; NA; Raydin, Roy; unknown; Y

BIBLIOGRAPHY: SORG; PREV; ARLG (44), 1929; INVE

Ladew, Edward R.
1855; 1905; Wall; Villa Louedo; E; Red Springs Lane; Glen Cove; c. 1894; Romeyn & Stever; unknown; QUAN; c. 1985; Hester, William; M.T. Ward; N

BIBLIOGRAPHY: WWIA (1): 697; INVE; AABN (43), 1894

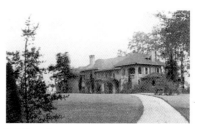

Laidlaw, James
1868; 1932; unknown; Hazeldean Manor; E; Middle Neck Road; Sands Point; c. 1905; unknown; unknown; MEVI; NA; Dana C. Backus; unknown; Y

BIBLIOGRAPHY: NCAB; NASS

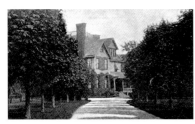

La Montagne, Mrs. R.
unknown; unknown; unknown; unknown; unknown; Nameoke Lane; Far Rockaway; c. 1895; unknown; unknown; QUAN; unknown; unknown; unknown; N

BIBLIOGRAPHY: ROCK

Lane, James W.
1864; 1927; Bliss, Eva; Suffolk House; E; Boney Lane; Smithtown; c. 1916; Little, Arthur; unknown; GRRV; NA; Purisic, Elena; unknown; Y

BIBLIOGRAPHY: INVE; NCAB

Lanier, J. F. D.
1858; 1928; Bishop, Harriet; unknown; unknown; unknown; Westbury; c. 1891; Lord, James Brown; unknown; NECL; c. 1950; Steele, Charles; unknown; N

BIBLIOGRAPHY: ARRC (1), Dec. 1891: 142; NCAB

Lardner, Ring
unknown; unknown; unknown; unknown; E; West End Lane; East Hampton; 1927; Lawrence, John C.; unknown; SHIM; NA; unknown; unknown; Y

BIBLIOGRAPHY: EHHE

Latham, Leroy
unknown; unknown; unknown; Hemlock Hollow; E; Brookside Drive; Plandome; unknown; Bessell, Wesley Sherwood; unknown; TUDR; NA; unknown; unknown; Y

BIBLIOGRAPHY: MASS: 32; PREV; LAPE

Law, Robert B.
unknown; unknown; unknown; unknown; E; unknown; Syosset; c. 1930; Delehanty, Bradley; unknown; COTM; NA; Mr. Veinstock; unknown; Y

BIBLIOGRAPHY: GOTT, 1931

Lawrence, Effingham
unknown; unknown; unknown; unknown; E; unknown; Cold Spring Harbor; 1909; Foster, Gade & Graham; unknown; GRRV; NA; unknown; unknown; Y

BIBLIOGRAPHY: INVE

Ledyard, L. C., Jr.
unknown; unknown; unknown; unknown; E; unknown; Syosset; 1914; Platt, Charles A.; Flanders, Annette Hoyt; GRRM; NA; unknown; unknown; Y

BIBLIOGRAPHY: ARLG (48), 1933; AVER; NCAB

L'Ecluse, Milton
unknown; unknown; unknown; unknown; unknown; unknown; Huntington; c. 1920; Gurd, John; unknown; NIRM; c. 1960; unknown; unknown; N

BIBLIOGRAPHY: LOIS, Apr. 1919

Lee, C. H.
unknown; unknown; unknown; Westlawn; E; Great Plains Road; Southampton; c. 1910; Hoffman, F. Burrall; unknown; GRRV; NA; Dyer, Mrs. Tiffany L.; Johnson, Harold; Y

BIBLIOGRAPHY: INVE

Lefferts, Marshall C.
1848; 1928; Baker, Carrie; Hedgewood; unknown; Ocean Avenue; Lawrence; c. 1905; Lord & Hewlett; unknown; SHIN; c. 1960; unknown; unknown; N

BIBLIOGRAPHY: SORG; INVE; HICK; AABN (88), July 1905: 1543; NCAB

Leonard, Paul
unknown; unknown; unknown; unknown; E; White Hill Road; Huntington; c. 1931; Stevenson, H.; unknown; NFRM; NA; unknown; unknown; Y

BIBLIOGRAPHY: INVE

Levering, Mrs. Mortimer
unknown; unknown; unknown; unknown; unknown; unknown; Amagansett; 1910; unknown; unknown; MEVI; unknown; unknown; unknown; unknown

BIBLIOGRAPHY: AMGS

Levering, Richmond
1881; 1920; unknown; unknown; E; Cranberry Hill Road; Amagansett; 1908; unknown; unknown; MEVI; NA; Chatfield, Henry; unknown; Y

BIBLIOGRAPHY: AMGS

Levison, J. J.
1873; 1961; unknown; unknown; E; unknown; Glen Head; 1924; Lindeberg, Harrie T.; unknown; TUDM; NA; unknown; unknown; Y

BIBLIOGRAPHY: ARRC (74), Oct. 1933: 302; ARRC (55), Apr. 1924: 363; LINB: 1940: 43

Levy, I. D.
unknown; unknown; unknown; Roselle Manor; unknown; unknown; Cedarhurst; c. 1900; Buchman & Fox; unknown; JACO; c. 1960; Wardwell; unknown; N

BIBLIOGRAPHY: ARTR (33), June 1916: 33

Lindeberg, Harrie T.
1880; 1959; Krech, Angelina; unknown; E; unknown; Matinecock; 1926; Lindeberg, Harrie T.; unknown; NFRM; NA; unknown; unknown; Y

BIBLIOGRAPHY: GOTT; ARRC (74), Oct. 1933: 312; COUN (71), Nov. 1936: 48; INVE; LINB: 3; SORG

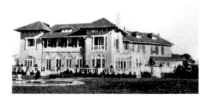

Litt, Mrs. Ruth
unknown; unknown; unknown; Jackwell Farm; unknown; S. Ocean Avenue; Patchogue; c. 1910; unknown; unknown; MEVI; c. 1950; unknown; unknown; N

BIBLIOGRAPHY: COUN (41), Apr. 1922: 1; COUN (24), May 1913: 3

Livermore, Phillip W.
unknown; unknown; Iselin, Fannie; Bois Joli; unknown; unknown; Brookville; unknown; Hoppin & Koen; Farrand, Beatrix; NFRR; c. 1950; Harriman, J. W.; unknown; N

BIBLIOGRAPHY: PREV: 1953; PRLN, 1985; SORG; REAL (86), Aug. 1910: 338

Livingston, Alida
unknown; unknown; unknown; unknown; E; Remsen Lane; Brookville; c. 1939; Delehanty, Bradley; unknown; TWEC; NA; Delano, Michael; unknown; Y

BIBLIOGRAPHY: DELE, 1939; INVE

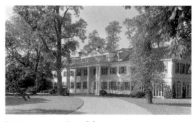

Livingston, Gerald M.
unknown; unknown; Rodewald, Eleanor; Kilsyth; O; School and Plover Lanes; Lloyd Harbor; c. 1930; unknown; unknown; NEFM; NA; unknown; Friends World College; Y

BIBLIOGRAPHY: GOTT, 1934; COUN (67), Feb. 1935: 53; SORG; INVE

Livingston, Goodhue

unknown; 1951; Allen, Joan L.; The Mill; E; First Neck Lane; Southampton; 1911; Trowbridge & Livingston; unknown; TWEC; NA; Fosdick, P.; unknown; Y

BIBLIOGRAPHY: INVE; SORG; NCAB

Lloyd, Robert McAllister

unknown; unknown; unknown; Tapis Vert; E; unknown; Syosset; c. 1904; Platt, Charles A.; Platt, Charles A.; GRRM; NA; unknown; unknown; Y

BIBLIOGRAPHY: HICKS; NCAB; AVER

Lloyd, Smith Wilton

unknown; c. 1940; Flemming, Marjori; unknown; E; Mallard Drive; Lloyd Harbor; c. 1924; Goodhue, Bertram Grosvenor; Manning, Warren H.; TUDM; NA; Cournand, Mrs. Edouard; Rice, Paula; Y

BIBLIOGRAPHY: COUN (52), Oct. 1927: 48; SORG; ARLG (39), 1924; INVE; ARTR (56), July 1927: 31; NCAB; WHIT, 1925

Loening, Grover

unknown; unknown; unknown; Margrove; E; Horseshoe Road; Mill Neck; 1930; Loening, Grover; unknown; INTL; NA; unknown; unknown; Y

BIBLIOGRAPHY: PREV; INVE; COUN (61), Apr. 1932: 57; HOWE, 1933

Lord, Franklin B.

unknown; unknown; Barker, Lilian; Cottsleigh; L; Split Rock Road; Syosset; 1927; Beers & Farley; Shipman, Ellen; TUDM; NA; unknown; Religious Center; Y

BIBLIOGRAPHY: SORG; HEWI, 1930

Lord, George deForest

1891; 1950; Symington, Hazel; unknown; E; Ocean Avenue; Woodmere; 1924; Beers & Farley; unknown; GRRV; NA; Lord, Edward C. III; unknown; Y

BIBLIOGRAPHY: HOWE, 1933; TOWN, Apr. 1924: 55; PATT, 1924

Lord, George deForest

1891; 1950; Symington, Hazel; Overfields; E; Split Rock Road; Syosset; 1924; Beers & Farley; Shipman, Ellen; GRRV; NA; unknown; unknown; Y

BIBLIOGRAPHY: WWIA (II), 1950: 329; SORG; HEWI, 1937

Lord, S. B.

unknown; unknown; unknown; unknown; unknown; unknown; Cedarhurst; c. 1910; Ewing & Chappell; unknown; GRRM; unknown; unknown; unknown; N

BIBLIOGRAPHY: ARRC (28), Oct. 1910: 306

Lovett, Robert Scott

unknown; unknown; Abercrombie, L.; Woodfield; unknown; unknown; Lattingtown; c. 1910; Carrère & Hastings; unknown; GRRV; c. 1938; Diebold, Trevor; unknown; N

BIBLIOGRAPHY: BRIC (22), Jan. 1913; INVE; WWIA; VIEW

Low, C. E.

unknown; unknown; unknown; Seaward; E; Penataquit Avenue; Bay Shore; c. 1880; unknown; unknown; QUAN; NA; Quinn, Mike; unknown; Y

BIBLIOGRAPHY: INVE, 1989; BABY, 1902

Lowe, H. W.

unknown; unknown; unknown; Mariemont; S; unknown; Wheatley Hills; c. 1927; Pope, John Russell; unknown; NEFD; unknown; Hutton, W. E.; Roth Business School; Y

BIBLIOGRAPHY: FAML; BEAU (1979)

Luckenbach, Edgar F.

c. 1868; c. 1943; Fenwick, A. M.; Elm Court; S; Middle Neck Road; Sands Point; c. 1921; unknown; Greber, Jacques; NEIR; NA; Sands Pt. Day School; Maimonidis School; Y

BIBLIOGRAPHY: WWIA (II), 1950: 332; LAPE; NASU, 1976; VIEW; SPUR (33), Feb. 1924: 63; PREV; MLAE

Luckenbach, Lewis

unknown; unknown; unknown; unknown; E; Crescent Beach Road; Glen Cove; c. 1928; Bottomley, William; unknown; NFRR; NA; Powell, John; unknown; Y

BIBLIOGRAPHY: COUN (71), Feb. 1937: 65; INVE

Luning, John N.

unknown; unknown; unknown; unknown; E; Shore Road; Shelter Island; 1900; unknown; unknown; unknown; NA; Heatherton, James W.; unknown; Y

BIBLIOGRAPHY: HIST; INVE, 1982

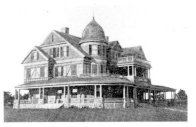

Lupton, Frank M.

unknown; unknown; unknown; Mo-mo-weta; E; New Suffolk Avenue; Mattituck; c. 1886; Skidmore, George; unknown; QUAN; NA; Norris, Bruce; unknown; Y

BIBLIOGRAPHY: INVE, 1982

Lutz, Frederick

unknown; unknown; unknown; Laurel Acres; E; unknown; Oyster Bay; 1920; Lindeberg, Harrie T.; unknown; TUDM; NA; unknown; unknown; Y

BIBLIOGRAPHY: HOUS (49), Feb. 1921: 90; LINB: 167; NASU; SORG

Lyon, Augusta Hays

unknown; unknown; Heckscher, Emily; unknown; unknown; unknown; Huntington; c. 1917; Rouse & Goldstone; unknown; GRRV; unknown; unknown; unknown; unknown

BIBLIOGRAPHY: ARTR (41), Dec. 1920: 240F; LHDG, 1917: 9; TOWN, 1921: 30; SORG

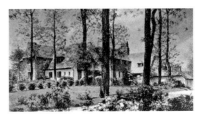

Lyon, Frank T.

unknown; unknown; unknown; unknown; unknown; unknown; Port Washington; c. 1920; unknown; unknown; TWEC; unknown; unknown; unknown; N

BIBLIOGRAPHY: ARAT (9), Dec. 1927: 349

Lyon, J. D.

unknown; unknown; unknown; unknown; E; Dock Pond Road; Matinecock; c. 1925; unknown; unknown; NFRM; NA; Bast, W. C.; unknown; Y

BIBLIOGRAPHY: INVE, 1978

Lytton

unknown; unknown; unknown; unknown; unknown; Mineola Avenue; Roslyn; c. 1920; unknown; unknown; GRRM; unknown; unknown; unknown; unknown

BIBLIOGRAPHY: PREV

MacDonald, Charles B.

unknown; unknown; unknown; Ballyshear; E; Shinnecock Hills; Southampton; c. 1913; Hoffman, F. Burrall; Nichol, Rose Standish; GRRV; NA; Chisholm, Hugh J.; unknown; Y

BIBLIOGRAPHY: HEWI; TOWN, Dec. 1913: 14; AMCO (39), Mar. 1915: 184

Mackay, Clarence H.

1874; 1938; Duer, Katherine; Harbor Hill; unknown; Harbor Hill Road; Roslyn; c. 1900; McKim, Mead & White; Lowell, Guy; NFRR; c. 1949; unknown; unknown; N

BIBLIOGRAPHY: FERR, 1904: 26ff; AMER, 1976: 84; PATT, 1924: 16; VIEW; DESM, 1903: 459ff; TOWN, June 1923: 7; PATT, 1924: 16; BRYA; SORG; TOWN, Sept. 1920: 30; HICK; ARRC (16), Dec. 1904: 272; COUN (35), Apr. 1919: 27; AVER; WWIA (1): 762; COUN (58), July 1930: 38

MacKelvie, N. Bruce

unknown; unknown; unknown; Cedar Knoll; unknown; unknown; Sands Point; c. 1906; unknown; unknown; NEFM; c. 1940; Fisher, Carl; Emerson, Mrs. Margaret; N

BIBLIOGRAPHY: PREV

Mackenzie, J. Clinton

1872; 1940; Schantz, Cornelia; unknown; E; Centre Island Road; Centre Island; c. 1900; Mackenzie, J. Clinton; unknown; NSPR; NA; Count de Dampierre; unknown; Y

BIBLIOGRAPHY: ARTR (8), Aug. 1903; EMBU, 1909: 97; HOUS (23), Feb. 1908: 17; AAAA (108), 1915: 2045; INVE; ATLA: 47; ARLG (20), 1905; ARRV (10), Sept. 1903: 139; WURT; SORG

Macy, Carleton

unknown; 1949; Lefferts, Helen; Wonder Why; unknown; Meadow View Avenue; Hewlett; c. 1908; Albro & Lindenberg; unknown; COTM; unknown; unknown; unknown; N

BIBLIOGRAPHY: ARRC (28), Oct. 1910: 264; EMBU, 1909: 203; AAAA (98), 1910: 1821; ARTR (26), Nov. 1912: 238; AABN (94), 1908: 1712; NCAB; SORG; ARLG (24), 1909; COUN (15), Nov. 1908: 59

Macy, George H.

1858; 1918; Carter, Kate L.; The Bungalow; unknown; unknown; Lawrence; c. 1910; unknown; unknown; SHIM; c. 1950; unknown; unknown; N

BIBLIOGRAPHY: FAML; SORG

Macy, Kingsland

1889; 1961; Dick, Julia A.; unknown; E; unknown; Islip; c. 1929; Breed, F. Nelson; unknown; GRRM; NA; Kulak, Marian, Jr.; unknown; Y

BIBLIOGRAPHY: SORG; HOUS (66), Aug. 1929: 160

Macy, V. Everitt

1871; 1930; Carpenter, E. O.; unknown; E; unknown; Hewlett; c. 1910; Albro & Lindeberg; unknown; TUDR; NA; unknown; unknown; Y

BIBLIOGRAPHY: ARTR (26), Nov. 1912: 283; ARLG (27), 1912; HICK; NCAB; AABN (100), Nov. 1911

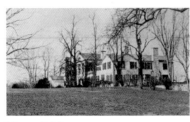

Mann, S. Vernon

unknown; unknown; Colgate, Helen; Grove Point; E; Harbor Road; Lawrence; c. 1905; unknown; Farrand, Beatrix, 1918-1930; NEFD; NA; unknown; unknown; Y

BIBLIOGRAPHY: SORG; HICK; PREV; PRLN, 1985

March, S. H.

unknown; unknown; unknown; unknown; unknown; unknown; Great Neck; c. 1928; unknown; unknown; unknown; unknown; unknown; unknown; unknown

BIBLIOGRAPHY: VIEW

Markoe, Dr. Francis

unknown; unknown; unknown; Sunnymede; E; Gin Lane; Southampton; c. 1886; Potter & Robertston; unknown; STIK; NA; Barbey, Henry I.; unknown; Y

BIBLIOGRAPHY: INVE

Marston, Edgar

unknown; unknown; Carr, Florence; Carston Hill; E; unknown; Syosset; c. 1939; Delehanty, Bradley; unknown; NEFM; NA; unknown; unknown; Y

BIBLIOGRAPHY: SORG; DELE, 1939

Martin, H. C.

unknown; unknown; Weber, Elfrieda; unknown; E; Valley Road; Glen Cove; 1924; Lindeberg, Harrie T.; unknown; TUDR; NA; Fromm, Robert M.; unknown; Y

BIBLIOGRAPHY: ARRC (55), Apr. 1924: 365; INVE; HOUS (56), Sept. 1924: 221; SORG; ARTS (12), Jan. 1920: 168

Martin, James E.

unknown; unknown; Brokaw, F. C.; Martin Hall; unknown; West Shore Road; Great Neck; c. 1900; Little & O'Connor; Olmsted Brothers/ Bev. M. Britting; NEFM; c. 1932; Satterwaite, Dr. P.; unknown; N

BIBLIOGRAPHY: FLON; ARRV (9), Sept. 1902: 211; SORG; FERR, 1904: 204f; ARLG (15), 1900; GREA; LEVA; TOWN, Aug. 1903: 10; TOWN, Dec. 1912: 25; ARTR (2), Sept. 1900: 332; VIEW; ARTR (1), Feb. 1900: 65

Masury, Mrs. John

unknown; unknown; unknown; Beaurivage; unknown; unknown; Center Moriches; c. 1898; Lambert, William A.; unknown; CLRV; c. 1963; Holiday Beach Assoc.; unknown; N

BIBLIOGRAPHY: PREV; ARBD (32), Mar. 1900: 205

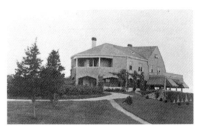

Matheson, William

1857; 1930; Torrey, Harriet; unknown; unknown; Boney Lane; Nissequoque; c. 1880; unknown; unknown; SHIN; NA; Stewart, Alexander; Lane, James W.; Y

BIBLIOGRAPHY: INVE

Maxwell, E. L.

unknown; unknown; Carlton, Mary; Maxwell Hall; unknown; Lattingtown Road; Glen Cove; c. 1900; Barney & Chapman; unknown; SHIM; c. 1930; unknown; unknown; N

BIBLIOGRAPHY: HICK; SORG; VIEW; ARTR (17), Jan. 1908: 111

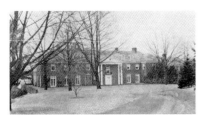

Maxwell, George T.

unknown; unknown; Raymond, Marie; Sunset House; E; Cove Neck Road; Oyster Bay; c. 1906; unknown; unknown; NEFD; NA; Taylor, J. B.; unknown; Y

BIBLIOGRAPHY: SORG; PREV

Maxwell, Howard

unknown; c. 1947; Young, Helen S.; unknown; unknown; unknown; Glen Cove; c. 1905; Brewster, Herbert R.; unknown; MEVI; c. 1950; unknown; unknown; N

BIBLIOGRAPHY: SORG; ARBD (49), July 1917

Maxwell, J. Rogers

unknown; unknown; Washburn, Maria; Maxwelton; unknown; Seaward Avenue; Glen Cove; c. 1898; Tubby, William B.; unknown; unknown; unknown; unknown; unknown; N

BIBLIOGRAPHY: HICK; ARBD (32), Oct. 1899: 20; ARRV (9), Sept. 1902: 2; SORG

Maynard, Walter E.

1871; 1925; Ives, Eunice; Haut Bois; E; Cedar Swamp Road; Jericho; 1916; Codman, Ogden, Jr.; Greber, Jacques; NFRR; NA; Munsell, Patrice; Maddocks, John L., Jr.; Y

BIBLIOGRAPHY: HEWI, 1930; PRES, June 1975: 5; INVE; WWIA (1): 793; SORG

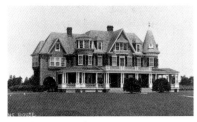

McAleenan, Arthur

unknown; unknown; unknown; unknown; L; Union Avenue; Center Moriches; c. 1900; unknown; unknown; QUAN; NA; unknown; St. Angelas Convent; Y

BIBLIOGRAPHY: INVE; Moriches Bay Historical Society

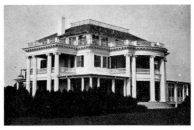

McAleenan, Joseph A.

unknown; unknown; unknown; unknown; unknown; Union Avenue; Center Moriches; c. 1920; unknown; unknown; CLCO; c. 1970; unknown; unknown; N

BIBLIOGRAPHY: INVE

McBurney, Malcolm

unknown; unknown; Moran, Dorothy; unknown; E; unknown; East Islip; c. 1915; Delano & Aldrich; unknown; NFRM; NA; unknown; unknown; Y

BIBLIOGRAPHY: ARFO (29), July 1918: ARRC (52), Oct. 1922: 269; SORG; INVE

McCall, Edward E.

1863; 1924; Gaynor, Ella; Evesdune; unknown; West End Road; East Hampton; c. 1916; unknown; unknown; SHIN; c. 1925; unknown; unknown; N

BIBLIOGRAPHY: HEWI; EHHE; WWIA (1): 797

McCrea, James A.

1875; 1923; Clarke, Mabel; unknown; unknown; South End Drive; Woodsmere; c. 1909; Platt, Charles A.; unknown; GRRV; c. 1960; unknown; unknown; N

BIBLIOGRAPHY: SPUR (33), Apr. 1924; WWIA (1): 806; SORG; HICK; AVER

McLane, Edith Pratt

unknown; unknown; Pratt, Edith G.; Friend Field; E; Overlook Road; Glen Cove; c. 1924; Carrère & Hastings; unknown; GRRV; NA; Pratt, Frederick R.; Bogart, A.; Y

BIBLIOGRAPHY: SORG; SPUR (40), Oct. 1927: 70; AVER, 1980; INVE

McLean, Mrs. James

unknown; unknown; unknown; Tulip Knoll; S; Three Sisters Road; St. James; c. 1912; Butler, Lawrence; unknown; GRRV; NA; unknown; Harbor City Day School; unknown; Y

BIBLIOGRAPHY: PREV; INVE; VANL: 55

Mead, Edward Spencer

unknown; unknown; unknown; unknown; unknown; Halsey Neck Lane; Southampton; c. 1886; McKim, Mead & White; unknown; SHIN; NA; unknown; unknown; Y

BIBLIOGRAPHY: BROD

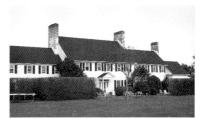

Mellon, Mrs. C. H.

unknown; unknown; Manice, Sarah; The Shutters; E; Little Plains Road; Southampton; c. 1920; unknown; unknown; CLOL; NA; unknown; unknown; Y

BIBLIOGRAPHY: INVE

Mellon, E. P.

unknown; unknown; Humphrey, Ethel; Villa Maria; E; Meadow Lane; Southampton; unknown; Mellon, E. P.; unknown; NEIR; NA; Carr, F. William; unknown; Y

BIBLIOGRAPHY: SORG; INVE; ARTR (40), Nov. 1919; COUN (50), Aug. 1926: 57

Melville, Frank, Jr.

1860; 1935; McConnell, J.; Sunwood; unknown; unknown; Old Field; 1919; Budd, Katherine; unknown; HTRV; c. 1986; Melville, Ward; SUNY at Stony Brook; N

BIBLIOGRAPHY: COUN (64), Aug. 1933: 66; HEWI, 1932; WWIA (1): 829

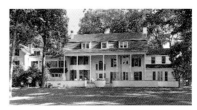

Melville, Ward

unknown; unknown; Bigelow, Dorothy; Wide Water; E; Old Field Road; Old Field; 1924; Smythe, Richard H.; unknown; NEFM; NA; unknown; unknown; Y

BIBLIOGRAPHY: HEWI, 1932; SPUR (55), Mar. 1935: 56; INVE; SORG

Merritt, Reeve

unknown; unknown; Roosevelt, Lelia; Elfland; unknown; unknown; Oyster Bay; c. 1900; unknown; unknown; unknown; unknown; unknown; unknown; N

BIBLIOGRAPHY: FAML

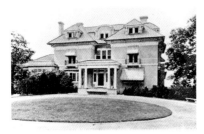

Meurer, Jacob
unknown; unknown; unknown; Treetop; unknown; unknown; Port Jefferson; c. 1912; unknown; unknown; NSPR; unknown; unknown; unknown; N

BIBLIOGRAPHY: COHO (5), Nov. 1924: 26

Meyer, Cord
unknown; c. 1910; Thaw, Katherine B.; The Cove; unknown; West Shore Road; Great Neck; c. 1900; unknown; unknown; CLRV; c. 1950; unknown; unknown; N

BIBLIOGRAPHY: PRES, June 1974: 4; INVE; SORG; HAZE

Meyer, J. Edward
1881; unknown; Alker, Florence; Rhoda; E; West Shore Road; Great Neck; c. 1909; Adams, William; unknown; HTRV; NA; unknown; unknown; Y

BIBLIOGRAPHY: HEWI; INVE; SORG

Milburn, Devereux
unknown; unknown; Steele, Nancy; Sunridge Hall; S; unknown; Westbury; 1916; Peabody, Wilson & Brown; unknown; TWEC; NA; unknown; SUNY–Old Westbury College; Y

BIBLIOGRAPHY: PATT, 1924: 47; SORG; TOWN, Mar. 1922

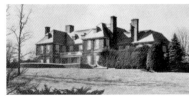

Milburn, John G.
unknown; unknown; unknown; Groombridge; L; Route 25D; North Hills; c. 1924; unknown; unknown; GRRV; NA; unknown; Seventh Day Adventists; Y

BIBLIOGRAPHY: PREV

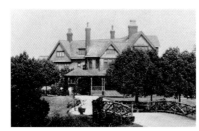

Milderberger, E. E.
unknown; unknown; Drumm, Mollie; Okelwood; E; Awixa Avenue; Bay Shore; c. 1900; unknown; unknown; QUAN; NA; unknown; unknown; Y

BIBLIOGRAPHY: PREV; INVE

Millbank, Albert Goods
1873; 1949; Robbins, Majorie; Panfield; E; Quail Hill Road; Lloyd Harbor; c. 1915; Howells & Stokes; Levison, J. J.; TUDR; NA; unknown; Castro, Bernardette; Y

BIBLIOGRAPHY: VIEM, 1977: 73; WWIA (II), 1950: 372; COUN (59), Mar. 1931: 66; LAPE; AABN (378), Apr. 1918; SORG; HEWI

Mills, Ogden Livingston
1884; 1937; Fell, Dorothy; unknown; unknown; Jericho Turnpike; Woodbury; c. 1915; Pope, John Russell; unknown; NEFD; unknown; Spiegel, Jerry; Woodbury Country Club; N

BIBLIOGRAPHY: ARRC (41), Oct. 1, 1916: 357; PATT, 1924: 92; GOTT; SORG; LEVA; WWIA (1): 846; BRIC (25), Aug. 1916: 197

Minton, Henry M.
unknown; unknown; Church, Helen; Brookwood; unknown; unknown; Manhasset; c. 1930; Ellett, Thomas Harlan; unknown; TWEC; unknown; unknown; unknown; N

BIBLIOGRAPHY: HOWE, 1933; SORG; ARLG (45), 1930; HOUS (68), Dec. 1930: 623

Mitchell, Edward
unknown; unknown; unknown; unknown; E; Gin Lane; Southampton; c. 1890; unknown; unknown; QUAN; NA; Ferriday, H. M.; unknown; Y

BIBLIOGRAPHY: INVE, 1982

Mitchell, Roland
unknown; c. 1906; unknown; unknown; P; unknown; Wading River; c. 1905; McKim, Mead & White; Olmsted Brothers; GRRV; c. 1934; Wildwood State Park; unknown; N

BIBLIOGRAPHY: FLON; MCKI, 1978: 96; INVE

Mitchell, S. A.
unknown; unknown; unknown; Marney; E; unknown; Brookville; c. 1924; O'Connor, James W.; Olmsted Brothers; NFRM; NA; unknown; unknown; Y

BIBLIOGRAPHY: SORG; FLON; OCOR, 1930; INVE

Mitchell, Sidney Zoll
unknown; 1949; unknown; unknown; unknown; Chicken Valley Road; Brookville; 1924; O'Connor, James W.; Olmsted Brothers; 1921–39; NFRI; c. 1950; unknown; unknown; N

BIBLIOGRAPHY: COUN (64), Aug. 1933; INVE; OCOR, 1930; COUN (50), Oct. 1926: 46; ARRC (60), Nov. 1926: 498; FLON; AAAA (131), 1927: 247; HICK; WWIA (II), 1950: 377; ARLG (61), 1927: 243

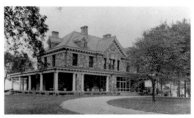

Mitchell, Willard H.
1848; 1941; Atkins, Anna; unknown; E; Pond Road; Kings Point; c. 1900; unknown; unknown; GRRV; NA; Heckscher, August; Haar, Herbert; Y

BIBLIOGRAPHY: WWIA; HEWI; INVE

Mixsell, Dr. Harold
unknown; unknown; unknown; unknown; E; Valley Road; Matinecock; 1927; Pennington, Hall P.; unknown; NEFD; NA; Mixsell, Mrs. Harold; unknown; Y

BIBLIOGRAPHY: INVE

Mixter, George
unknown; unknown; unknown; unknown; unknown; unknown; Manhasset; c. 1930; Aldrich, William T.; unknown; EGMV; unknown; unknown; unknown; unknown

BIBLIOGRAPHY: HOUS (71), Apr. 1932: 261

Moen, LeClanche
1881; 1957; Jones, Margaret; unknown; E; unknown; Oyster Bay; c. 1924; Rogers, James Gamble; unknown; CLRV; NA; Martin, G.; Lindsey, Chris; Y

BIBLIOGRAPHY: PREV; SORG, 1935

Moeran
unknown; unknown; unknown; Gostmere; unknown; First Neck Lane; Southampton; c. 1880; unknown; unknown; SHIN; unknown; unknown; unknown; N

BIBLIOGRAPHY: INVE, 1982; LIFO, Apr. 1943: 71

Moffat, Douglas M.
unknown; unknown; unknown; unknown;
E; Woodbury Road; Huntington; c. 1931; Noel
& Miller; unknown; FSCE; NA; unknown; un-
known; Y

BIBLIOGRAPHY: INVE

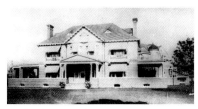

Mollenhauer, John A.
unknown; unknown; Seims, Doris; Homeport;
E; Awixa Avenue; Bay Shore; c. 1900; unknown;
unknown; QUAN; NA; unknown; unknown; Y

BIBLIOGRAPHY: INVE; BABY, 1902

Moore, Benjamin
unknown; unknown; Emery, Alexandra;
Chelsea; G; Route 25A; Syosset; 1924; Delano
& Aldrich; Vitale with Delano & Aldrich;
NFRM; NA; unknown; Nassau County; Y

BIBLIOGRAPHY: NLRF, 1977; SORG; HOWE, 1933

Moore, Edward S.
1881; 1948; Nickels, Evelyn; unknown; un-
known; Club Drive; Old Westbury; 1922; Cross
& Cross; unknown; CLOL; NA; Draper, Mrs.
Charles D; unknown; Y

BIBLIOGRAPHY: NYTI, 1948; SORG; HEWI

Moore, John Chandler
unknown; c. 1946; Debebian, C.; Moorelands;
E; unknown; Oyster Bay; unknown; unknown;
unknown; NIRM; NA; unknown; unknown; Y

BIBLIOGRAPHY: ARTR (38), Nov. 1919; SORG;
WWIA (11), 1950: 380

Morawetz, Victor
1859; 1938; Nott, Marjorie; unknown; P; un-
known; Woodbury; c. 1912; Delano & Aldrich;
unknown; NEFD; NA; Brucc, Mrs. Alissa Mel;
Town of Oyster Bay; Y

BIBLIOGRAPHY: ARFO (29), July 1918; PATT, 1924:
147; ARTR (37), Apr. 1918; COUN (46), Sept. 1924:
34; SORG; PHDA, 1922: 29; ARLG (33), 1918; LAPE

Morgan, Edwin D.
1854; unknown; Emmet, Elizabeth W.; Wheat-
ley; unknown; Wheatley Road; Wheatley Hills;
c. 1890; McKim, Mead & White; unknown;
GRRV; c. 1950; unknown; unknown; N

BIBLIOGRAPHY: REAL (78), Sept. 1906: 490;
MCKI, 1978; TOWN, July 1908: 12; COUN (24),
May 1913: 40; SORG; HICK; TOWN, Dec. 1904: 34;
ARRC (20), Sept. 1906: 230

Morgan, John Pierpont, Jr.
1867; 1943; Grew, Jane N.; Matinecock;
unknown; unknown; Glen Cove; c. 1913; La
Farge & Morris; unknown; GRRV; 1980;
unknown; Russian UN Delegation; N

BIBLIOGRAPHY: COUN (64), Aug. 1933: 51; ARTR
(27), Apr. 1913; PATT, 1924: 13; HEWI; TOWN,
Sept. 1920: 31; SORG; WWIA (1): 865

Morgan, Junius Spencer
unknown; c. 1960; Converse, Louise; Apple-
trees; E; Piping Rock Road; Matinecock; c. 1917;
Goodwin, Bullard & Woolsey; unknown;
COTM; NA; unknown; unknown; Y

BIBLIOGRAPHY: PREV, 1935; ARFO, May 1923: 19;
SORG; INVE; ARLG, 1923

Morgan, Junius Spencer
unknown; c. 1960; Converse, Louise; The
Salutation; E; unknown; Glen Cove; c. 1930;
Bullard, Roger H.; unknown; TUDR; NA;
Samuels, John; unknown; Y

BIBLIOGRAPHY: RAND; INVE

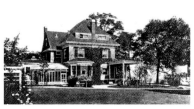

Morrell, Joseph B.
unknown; unknown; unknown; unknown; E;
unknown; Northport; c. 1890; unknown; un-
known; SHIM; NA; unknown; unknown; Y

BIBLIOGRAPHY: *Huntington, Cold Spring Harbor
Booklet*. 1909: 92

Morris, Montrose W.
1861; 1916; unknown; unknown; E; Crescent
Beach Road; Glen Cove; 1894; Morris,
Montrose W.; unknown; SHIM; NA; Hadley;
unknown; Y

BIBLIOGRAPHY: INVE

Morse, Edward Phinley
unknown; c. 1930; unknown; Villa Maria; L;
unknown; Water Mill; 1919; Freeman, Frank;
unknown; TWEC; NA; unknown; Sisters of Saint
Dominic; Y

BIBLIOGRAPHY: FAML

Morse, Tyler
unknown; unknown; unknown; Morse Lodge;
E; unknown; Westbury; 1909; Little & Browne;
unknown; TWEC; NA; unknown; unknown; Y

BIBLIOGRAPHY: HEWI; PRES, 1975

Mortimer, Stanley
unknown; unknown; Hall, Elizabeth; Roslyn
Hall; unknown; unknown; Roslyn; c. 1891;
Lord, James Brown; Olmsted Brothers; HTRV;
c. 1974; Garvan, Frances P.; unknown; N

BIBLIOGRAPHY: RAND; FLON; AABN (42), Oct.
1893: 929; ARRC (3), Mar. 1894: 242; HICK

Munn, Orson D.
unknown; unknown; Lawrence, M.; Arches;
E; unknown; Southampton; c. 1930; Matthews
& Short; unknown; NFRM; NA; unknown; un-
known; Y

BIBLIOGRAPHY: ARTS (36), Jan. 1932: 20; WWIA
(1): 879

Munroe, Dr. George, Jr.
1851; 1901; Reynolds, Jessie; Wayside; E; Ocean
Avenue; East Hampton; c. 1888; Green, Isaac
Henry; unknown; DCMD; NA; Munroe, Marjory;
unknown; Y

BIBLIOGRAPHY: AABN (92), 1907: 1667; FOST,
1977; EHHE; INVE; FYMC, 1941: 24

Murdock, Harvey
unknown; unknown; unknown; The Birches;
E; Crescent Beach Road; Glen Cove; c. 1895;
Gilbert, C. P. H.; unknown; CLOL; NA; Brewster,
Mrs. Sam; unknown; Y

BIBLIOGRAPHY: HEWI, 1929; INVE

Murdock, U. A.
unknown; unknown; unknown; unknown; un-
known; First Neck Lane; Southampton; c. 1890;
unknown; unknown; SHIN; unknown;
unknown; unknown; N

BIBLIOGRAPHY: INVE, 1982

Murray, Hugh
unknown; unknown; Barker, Catherine;
Boxwood Farm; E; unknown; Old Westbury;
c. 1922; Peabody, Wilson & Brown; unknown;
GRRV; NA; Hickox, Charles V.; unknown; Y

BIBLIOGRAPHY: GOTT, 1936; SORG

Murray, John F.
unknown; unknown; unknown; unknown;
E; unknown; Old Westbury; c. 1930; Baum,
Dwight James; unknown; TUDR; NA; unknown;
unknown; Y

BIBLIOGRAPHY: GOTT, 1931; HOWE, 1933

Murray, Thomas E.
unknown; unknown; unknown; Wickapogue;
E; Wickapoque Road; Southampton; c. 1920;
unknown; unknown; unknown; unknown; un-
known; unknown; N

BIBLIOGRAPHY: INVE, 1982

Myers, Nathaniel

unknown; unknown; unknown; unknown; unknown; Montgomery Avenue; Bay Shore; 1899; Birdsall, Clarence K., unknown; DCRV; unknown; Eastwood, John H.; unknown; N

BIBLIOGRAPHY: COUN (61), Apr. 1932: 6; *South Side Signal*, Feb. 4, 1899

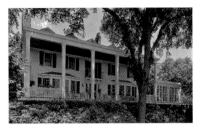

Nast, Conde

1874; 1942; Coudert, Clarice; unknown; unknown; Sands Point Road; Sands Point; c. 1930; unknown; unknown; NEFD; unknown; unknown; unknown; N

BIBLIOGRAPHY: GOTT, 1932; WWIA (II), 1950: 393

Neilson, R. P. R.

unknown; unknown; Park; unknown; unknown; unknown; Westbury; unknown; Bell, Algernon S.; unknown; TWEC; unknown; unknown; unknown; unknown

BIBLIOGRAPHY: WURT

Nichols, Francis T.

unknown; unknown; unknown; unknown; E; Brookville Road; Brookville; c. 1930; Howard & Frenaye; unknown; NFRM; NA; Martin, Esmond; unknown; Y

BIBLIOGRAPHY: GOTT, 1931; COUN (65), Nov. 1933: 40

Nichols, J. W.

unknown; unknown; Slocum, Mary B.; The Kettles; E; unknown; Oyster Bay; c. 1903; Nichols, Minerva; unknown; DCMV; NA; unknown; unknown; Y

BIBLIOGRAPHY: FAML

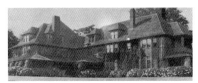

Nicoll, Mrs. Delancy

unknown; c. 1924; Churchill, Maura; Windymere; E; First Neck Lane; Southampton; c. 1900; unknown; unknown; SHIN; NA; Bixby, B. K.; Andrews, Beatrice Bixby; Y

BIBLIOGRAPHY: PREV; INVE; WWIA (I): 898

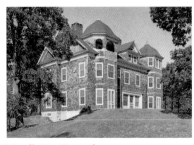

Nicoll, Dr. Samuel

unknown; unknown; unknown; unknown; P; unknown; Shelter Island; c. 1890; unknown; unknown; SHIN; NA; Kahn, Otto; Mashomack Preserve; Y

BIBLIOGRAPHY: INVE

Niven, John B.

unknown; unknown; unknown; Rhunacraig; E; Mill Hill Road; Mill Neck; c. 1923; Nelson, Francis B.; unknown; TUDR; NA; Close, Leroi; unknown; Y

BIBLIOGRAPHY: INVE

Noyes, Chester D.

1883; 1954; unknown; unknown; E; Saw Mill Road; Huntington; 1928; Noel & Miller; unknown; NFRM; NA; unknown; unknown; Y

BIBLIOGRAPHY: INVE; NCAB

Oakman, Walter G.

unknown; c. 1922; Conkling, Elizabeth; Oakdene; unknown; Mineola Avenue; Roslyn; c. 1900; Atterbury, Grosvenor; unknown; CLRV; c. 1946; Walbridge, Henry D.; Ruebel, Samuel; N

BIBLIOGRAPHY: SPUR (36), Sept. 1925; TOWN, June 1908; WWIA (I): 909; HICK

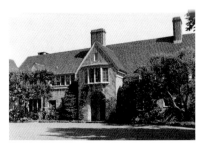

O'Brien, Henry

unknown; unknown; unknown; Laurel Hill; E; Cleft Road; Mill Neck; c. 1906; unknown; unknown; TUDM; NA; Pratt, H. I., Jr.; Catacosinos, W.; Y

BIBLIOGRAPHY: INVE

O'Brien, Kenneth

unknown; c. 1954; Mackay, Katherine; Chateau O'Brien; unknown; unknown; Southampton; c. 1925; Polhemus & Coffin; unknown; unknown; unknown; unknown; unknown; unknown; unknown

BIBLIOGRAPHY: POLC, 1932; NYTI, 1954; SPUR (44), Sept. 1929: 64

O'Donahue, C. A.

unknown; unknown; unknown; unknown; E; unknown; Huntington; c. 1910; Severance & Van Alen; unknown; GRRV; NA; unknown; unknown; Y

BIBLIOGRAPHY: ARRC (44), Oct. 1918: 358

O'Hara, Thomas

unknown; unknown; unknown; unknown; E; unknown; Kings Point; c. 1920; Gregory, Julius; unknown; TUDR; NA; unknown; unknown; Y

BIBLIOGRAPHY: ARTS (30), Apr. 1929: 46

Olcott, William M. K.

unknown; unknown; unknown; unknown; unknown; unknown; Quoque; c. 1900; Tuthill, William Burnet; unknown; CLRV; unknown; unknown; unknown; N

BIBLIOGRAPHY: VAND, Postcard, c. 1908; ARBJ, June 1904

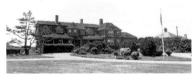

Olyphant, Robert

unknown; unknown; unknown; Dune Eden; unknown; Gin Lane; Southampton; c. 1887; unknown; unknown; SHIN; NA; Patterson, Geo. S.; unknown; Y

BIBLIOGRAPHY: INVE, 1979

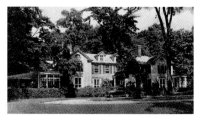

O'Rourke, John F.
unknown; unknown; unknown; unknown; E; Kings Point Road; Kings Point; c. 1900; unknown; unknown; CLOL; NA; Hill, Grace; unknown; Y

BIBLIOGRAPHY: INVE, 1979; PREV, 1951

Osborn, Capt. A. P.
unknown; unknown; unknown; unknown; E; Valentine Lane; Glen Head; unknown; Warren & Clark; unknown; CLOL; NA; unknown; unknown; Y

BIBLIOGRAPHY: ARTR (40), Oct. 1919

Otis, Frank Alleyne
1842; 1903; unknown; The Locusts; unknown; unknown; Bellport; 1880; Post, George B.; unknown; CLOL; 1955; Bellport Country Club; unknown; N

BIBLIOGRAPHY: NYHS; Bellport-Brookhaven Historical Society

Otley
unknown; unknown; unknown; Wuff Woods; E; Eyre Lane; Matinecock; c. 1920; Delehanty, Bradley; unknown; NEFD; NA; unknown; unknown; Y

BIBLIOGRAPHY: INVE

Ottley, James H.
1851; 1922; Gilbert, Lucet; Oakleigh; unknown; Crescent Beach Road; Glen Cove; c. 1915; Major, Howard; unknown; GRRV; c. 1950; unknown; unknown; N

BIBLIOGRAPHY: FAML; HICK; INVE; NCAB

Oudin, Lucien
unknown; unknown; unknown; unknown; unknown; unknown; Water Mill; c. 1905; Atterbury, Grosvenor; unknown; SHIN; unknown; unknown; unknown; unknown

BIBLIOGRAPHY: AMHO (5), Apr. 1908; ARLG (22), 1907; AAAA (94), Sept. 1908

Page, F. C.
1870; 1938; Jackson, Henriet; unknown; G; Remsen Lane and Mill River; Brookville; c. 1917; Little & Browne; Manning, A. Chandler; NEFM; NA; Miller, Nathan; Russian Mission to UN; Y

BIBLIOGRAPHY: VIEW; NYTI, 1938; PREV; LAPE; INVE

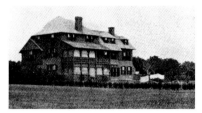

Palmer, F. T.
1816; 1906; Slocum, Margaret; Cedarcroft; unknown; Ocean Avenue; Lawrence; c. 1892; unknown; unknown; QUAN; c. 1950; Sage, Mrs. Russell; unknown; N

BIBLIOGRAPHY: COUN (37), Apr. 1920: 18; INVE; WWIA (1): 1073; SORG

Park, Darrah
unknown; unknown; unknown; Darragh Hall; E; Simonson Road; Brookville; c. 1920; Peabody, Wilson & Brown; unknown; NFRM; NA; unknown; unknown; Y

BIBLIOGRAPHY: ARFO (35), Nov. 1921; ARTS (13), May 1920: 16; INVE

Parker, Dale
1892; 1959; unknown; unknown; E; Middle Neck Road; Sands Point; c. 1921; Lindeberg, Harrie T.; unknown; TUDR; NA; vacant; Ohl, John; Y

BIBLIOGRAPHY: ARRC (74), Oct. 1933: 307; LINB: 73

Parker, Mrs. John A.
unknown; unknown; unknown; Driftwood; E; Sands Pt. Road; Sands Point; c. 1912; Mizner, Addison; unknown; NSPR; NA; Johnson, S.; Deleslie, Countess; Y

BIBLIOGRAPHY: PREV; MIZN, 1977: 15

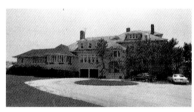

Parrish, James C.
1840; 1926; unknown; Heathermere; E; First Neck Lane; Southampton; c. 1895; unknown; unknown; TWPC; NA; unknown; unknown; Y

BIBLIOGRAPHY: INVE

Parrish, Samuel L.
unknown; unknown; unknown; White Fence; E; First Neck Lane; Southampton; c. 1889; McKim, Mead & White; unknown; SHIN; NA; Fruman, Grace; unknown; Y

BIBLIOGRAPHY: MCKI: 118; NCAB; INVE

Pasternack, Dr.
unknown; unknown; unknown; unknown; E; St. Mark's Lane; Islip; c. 1920; unknown; unknown; NFRM; NA; unknown; unknown; Y

BIBLIOGRAPHY: INVE

Patterson, Rufus l.
1872; 1943; Morehead, Marie; Lenoir; E; Ox Pasture Road; Southampton; c. 1900; Atterbury, Grosvenor; Olmsted Brothers; COTM; NA; Smith, Lloyd H.; unknown; Y

BIBLIOGRAPHY: HEWI, 1923; ARRC (44), Oct. 1918: 372; FLON; WWIA (11), 1950: 416; INVE

Paxton, Rev. John R.
unknown; 1923; unknown; Windward; E; Lily Pond Lane; East Hampton; c. 1900; Thorp, Joseph Greenleaf; unknown; SHIN; NA; Hamlin, Mrs. Harry; Gordon, Nancy Fox; Y

BIBLIOGRAPHY: WWIA; ARRC (13), Jan. 1903; EHHE; PREV; INVE

Payson, Charles S.
unknown; unknown; Whitney, Joan; unknown; L; Shelter Rock Road; Manhasset; 1924; Delano & Aldrich; unknown; NEFD; NA; Payson, Joan; NS Unitarian Univer. Soc.; Y

BIBLIOGRAPHY: HOWE, 1933; NCAB

Peabody, Charles A., Jr.
1849; 1931; unknown; unknown; E; Lawrence Hill Road; Cold Spring Harbor; c. 1910; Atterbury, Grosvenor; unknown; TUDM; 1978; unknown; unknown; N

BIBLIOGRAPHY: INVE; BRIC (22), May 1913; WWIA (1): 947; HICK

Peabody, Julian
1881; 1935; Hitchcock, Celia; Pond Hollow Farm; E; Powells Lane; Westbury; c. 1911; Peabody, Wilson & Brown; unknown; CLOL; NA; unknown; unknown; Y

BIBLIOGRAPHY: SORG; ARRC (38), Oct. 1915: 483; HOUG, 1917

Peabody, R. A.
c. 1860; 1937; Miller, Mary; Terrace Hall; E; Ocean Avenue; Cedarhurst; c. 1900; Renwick, Aspinwall & Owen; unknown; TUDM; NA; Raymond, William; Gamel, Isaac; Y

BIBLIOGRAPHY: ARTR (4), Nov. 1901: 315; INVE; WURT; SORG

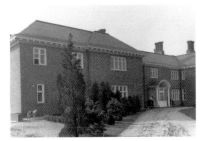

Pearse, Arthur
unknown; unknown; unknown; unknown;
unknown; Schencks Lane; Hewlett; c. 1911;
unknown; unknown; GRRM; unknown;
unknown; unknown; unknown

BIBLIOGRAPHY: HICK; COUN (24), Oct. 1913: 2

Peck, Arthur N.
unknown; unknown; Knowlton, Ella; Eastview;
unknown; unknown; Woodmere; c. 1910;
Adams, William; unknown; NEFD; unknown;
unknown; unknown; unknown

BIBLIOGRAPHY: HOUS (31), Feb. 1912: 183

Peck, Mrs. Fremont
unknown; unknown; unknown; unknown; E;
Piping Rock Road; Brookville; c. 1929; Morris,
Benjamin W.; Fitzhugh, Armistead; NEFM; NA;
Burden, J. A.; unknown; Y

BIBLIOGRAPHY: INVE; ARRC (68), Nov. 1930: 417;
ARAT (14), July 1930: 397; ARLG (44), 1929: 221

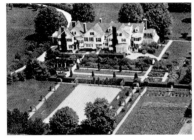

Pell, Haggerty
unknown; unknown; unknown; unknown; E;
Jericho Turnpike; Westbury; c. 1920; unknown;
unknown; CLRV; NA; unknown; unknown; Y

BIBLIOGRAPHY: HOUS (55), Apr. 1924: 375; HICK

Pennington, Pleasants
1889; 1942; Montauzan, De; unknown; E; un-
known; Locust Valley; c. 1938; Pennington &
Lewis; unknown; NECL; NA; Merrill; unknown;
Y

BIBLIOGRAPHY: COUN (59), Apr. 1931: 46; SORG;
NYTI, Apr. 3, 1942; INVE

Pennoyer, P. G.
unknown; unknown; Morgan, Frances; Round
Bush; E; unknown; Locust Valley; c. 1917;
Goodwin, Bullard, & Woosley; unknown;
HTRV; unknown; unknown; unknown; N

BIBLIOGRAPHY: ARFO (38), May 1923; INVE;
COUN (61), Jan. 1932: 67; ARLG (38), 1923; NASU,
1976; FLON; SORG

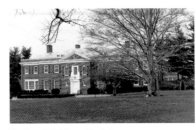

Perine, William D. N.
unknown; unknown; unknown; Braewood; E;
Horse Shoe Road; Mill Neck; c. 1930;
unknown; unknown; NEFD; NA; unknown;
unknown; Y

BIBLIOGRAPHY: INVE, 1978

Perkins, Norton
unknown; unknown; Holbrooke, Ethel; un-
known; E; 350 Ocean Lane Avenue; Lawrence;
c. 1914; Adams, William; unknown; NEFD; NA;
unknown; unknown; Y

BIBLIOGRAPHY: ARRC (43), June 1918: 516; INVE

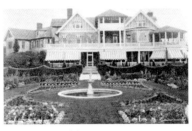

Peters, Harry T.
unknown; unknown; Wells, Nathalie; Near-
holme; unknown; St. Marks Lane; Islip; c. 1900;
unknown; unknown; SHIM; c. 1950; unknown;
unknown; N

BIBLIOGRAPHY: SORG; INVE; FAML

Peters, Mrs. Helen
unknown; unknown; Frew, Helen; Braestead; E;
Cedar Swamp Road; Brookville; c. 1929; Ellett,
Thomas Hartlan; unknown; GRRV; NA; Kahn,
Elliott; unknown; Y

BIBLIOGRAPHY: SORG; INVE; PENN

Peters, Ralph
unknown; unknown; unknown; unknown;
unknown; Carteret Place & Eleventh Street;
Garden City; c. 1904; Embury, Aymar, II;
unknown; DCMD; unknown; unknown; un-
known; N

BIBLIOGRAPHY: NCAB; HOUG (23), June 1913: 495

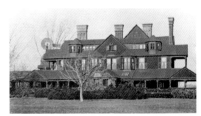

Peters, Samuel Twyford
unknown; unknown; Elder, Adelaid; Wind-
holme; unknown; St. Marks Lane; Islip; c. 1880;
unknown; unknown; QUAN; c. 1950; unknown;
unknown; N

BIBLIOGRAPHY: SORG; INVE; AABN (109), 1916;
FAML

Peters, William H.
unknown; unknown; unknown; Harbor Hills;
E; Rogers Canoe Hollow Road; Mill Neck;
c. 1904; Rossiter, Erick; unknown; NEFM; NA;
Marsh, Mrs. John; Vanderbilt, A. G.; Y

BIBLIOGRAPHY: INVE; PREV, 1952

Pettinos, Charles E.
unknown; unknown; Chapman, Joy; Thatch
Cottage; E; unknown; Centre Island; c. 1920;
McLeran, Mrs. John C.; unknown; unknown;
NA; Fairchild; Weiss, William E.; Y

BIBLIOGRAPHY: SPUR (33), Apr. 1924: 73; ARTS
(26), Mar. 1927: 61; SORG

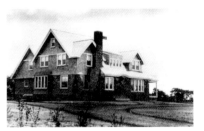

Phelps, Charles E.
unknown; unknown; unknown; unknown; un-
known; Windsor Avenue; Brightwaters; c. 1915;
unknown; unknown; SHIN; unknown; un-
known; unknown; unknown

BIBLIOGRAPHY: FAML; VANO

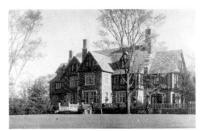

Phillips, Ellis L., Sr.
unknown; unknown; unknown; Laurimore; E;
Bayview Road; Plandome; c. 1926; unknown;
Dean, Ruth; HTRV; NA; unknown; unknown; Y

BIBLIOGRAPHY: FAML; MASS; LIFO, July 1981

Phillips, Mrs. F. Stanhope

1854; 1943; Bagg, Martha; unknown; E; West End Road; East Hampton; 1897; Thorp, Joseph Greenleaf; unknown; SHIN; NA; Hill, Robert Carmen; Beale, Edith Bouvier; Y

BIBLIOGRAPHY: NYTI, Aug. 1943: II; EHHE; INVE, 1979

Phillips, Fredrick

unknown; unknown; unknown; unknown; E; Ocean Avenue; Lawrence; c. 1900; Randall, T. Henry; unknown; JACO; NA; unknown; unknown; Y

BIBLIOGRAPHY: AMRE, 1904: 169; INVE; ARBD (36), Oct. 1903: 23

Phipps, Henry

1839; 1930; Shaffer, Anne; Bonnie Blink; S; Lakeville Road; Great Neck; c. 1916; Trumbauer, Horace; Olmsted Brothers, 1915–16; NEFD; NA; unknown; Great Neck School; Y

BIBLIOGRAPHY: WWIA (I): 970; SORG; FORT (2), Nov. 1930: 131; FLON; LAPE; FAML; INVE

Phipps, Howard

unknown; unknown; unknown; unknown; E; unknown; Old Westbury; c. 1935; Adams & Prentice; unknown; GRRV; NA; unknown; unknown; Y

BIBLIOGRAPHY: FAML

Phipps, John S.

1874; 1958; Grace, Margarite; Westbury House; M; I. U. Willets Road; Old Westbury; c. 1906; Crawley, George A.; Crawley, G. A.; GRRV; NA; Phipps; Old Westbury Gardens; Y

BIBLIOGRAPHY: PATT, 1924; BEAU: 123; SORG; HICK; HOUS (57), Mar. 1925: 229; TOWN, Dec. 1921: 36

Phyfe, James

1844; 1914; Smith, Anne; unknown; E; Stillwater Road; St. James; c. 1906; Green, Isaac Henry; unknown; CLOL; NA; Camp Nissequoque; Hamilton, William H.; Y

BIBLIOGRAPHY: NRNF, 1992; PREV

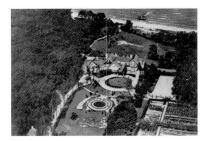

Physioc, Joseph

unknown; unknown; unknown; Cedar Cliff; unknown; Bayville Avenue; Bayville; c. 1895; unknown; unknown; SHIM; c. 1950; unknown; unknown; N

BIBLIOGRAPHY: LIHS

Pickhardt, W. Paul

unknown; unknown; unknown; unknown; unknown; Sylvester Road; Shelter Island; c. 1890; Schickel, William; unknown; SHIN; unknown; unknown; unknown; N

BIBLIOGRAPHY: INVE, 1982; HIST

Pierce, Winslow Shelby

1857; 1938; Williams, G. D.; unknown; unknown; Bayville Avenue; Bayville; c. 1901; Babb, Cook & Willard; unknown; JACO; c. 1960; Williams, Harrison; unknown; N

BIBLIOGRAPHY: BAYV; ARBJ (6), Apr. 1905: 57; ARTR (8), July 1903; LOIS, Feb. 15, 1901; WWIA (I): 972; WURT

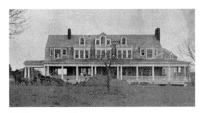

Pinkerton, Allan

1876; 1930; unknown; unknown; unknown; Saxon Avenue; Bay Shore; c. 1903; unknown; unknown; CLRV; c. 1950; unknown; unknown; N

BIBLIOGRAPHY: HICK; LIFO, Feb. 1990

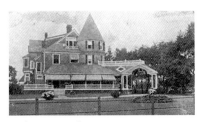

Pinkerton, Robert A.

unknown; unknown; unknown; Dearwood; unknown; Pentaquot Avenue; Bay Shore; c. 1902; unknown; unknown; SHIN; unknown; Vanderbilt, H. S.; unknown; N

BIBLIOGRAPHY: VAND

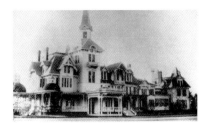

Plumb, James Neale

unknown; unknown; Ives, Anna B.; unknown; unknown; unknown; Great River; c. 1872; unknown; unknown; STIK; unknown; unknown; unknown; N

BIBLIOGRAPHY: VAND; SORG; INVE

Poor, Charles Lane

1866; 1951; Easton, Anna L.; Laneholm; unknown; Shore Road; Shelter Island; 1898; Rossiter & Wright; unknown; CLOL; 1911; unknown; unknown; N

BIBLIOGRAPHY: HIST

Poor, Charles Lane

1866; 1951; Easton, Anna L.; Eastward; E; Shore Road; Shelter Island; 1914; Walker & Gillette; unknown; CLOL; NA; Brownlie, Jan; unknown; Y

BIBLIOGRAPHY: HIST; INVE, 1982

Porter, Henry Hobart

1865; 1947; Porter, Katherine D.; Lauderdale; E; Ocean Avenue; Lawrence; c. 1900; Barney & Chapman; unknown; HTRV; NA; Ijams, Margaret Porte; Dachowitz, Rabbi; Y

BIBLIOGRAPHY: INVE; SORG; WWIA (II), 1950: 428; ARRV (12), Aug. 1905: 167; BRIC (2), Jan. 1902: 261; FAML

Post, Abram S.

unknown; unknown; unknown; Winnecomac; unknown; Quogue Street; Quogue; c. 1908; Leeming, Woodruff; unknown; GRRV; NA; Post, George B. (son); Baird, Richard; Y

BIBLIOGRAPHY: PREV; FAML, June 15, 1988

Post, Carroll L.

1860; 1948; unknown; unknown; unknown; unknown; Roslyn; c. 1910; unknown; unknown; unknown; unknown; unknown; unknown; unknown; unknown; unknown

BIBLIOGRAPHY: MLAE; NYTI, 1948

Post, Charles A.

unknown; unknown; unknown; Standhome; unknown; Salt Meadow Lane; Bayport; c. 1890; Post, George B.; unknown; SHIN; c. 1953; Elrich; unknown; N

BIBLIOGRAPHY: Bayport Heritage Association; INVE

Post, Col. H. A. V.
unknown; unknown; McLean, Caroline; Postholme; unknown; unknown; Babylon; 1874; Post, George B.; unknown; unknown; unknown; Post, Mrs. C. E.; unknown; N

BIBLIOGRAPHY: NYHS

Post, Regis H.
unknown; unknown; Post, Beatrice; Littlewood; E, Gillette Avenue; Bayport; c. 1895; Post, George B.; unknown; SHIN; NA; unknown; unknown; Y

BIBLIOGRAPHY: INVE

Postley, Sterling
unknown; unknown; unknown; Framewood; E; Mill River Road; Oyster Bay; c. 1918; Hoppin & Koen; unknown; TUDN; NA; Bonney, Mrs. L.W.; unknown; Y

BIBLIOGRAPHY: COUN (48), Oct. 1925: 47; INVE; SORG; ARTR (37), Apr. 1918; HICK

Potter, Alonzo
unknown; unknown; Nicholas, Elsie; Harbor House; unknown; unknown; Smithtown; c. 1914; Peabody, Wilson & Brown; Olmsted Brothers, 1925-26; GRRV; c. 1979; Dahl, Gerhard M.; unknown; N

BIBLIOGRAPHY: FLON; ARFO (41), Oct. 1924; INVE; ARFO (47), Oct. 1927: 386; SORG

Potter, Mrs. Clarkson
unknown; unknown; Holland, Amy; unknown; unknown; Great Plains Road; Southampton; c. 1927; Weeks, Louis S.; unknown; SPCM; NA; unknown; unknown; Y

BIBLIOGRAPHY: SORG; HEWI, 1927

Potter, E. Clifford
1863; 1937; unknown; unknown; E; Lily Pond Lane; East Hampton; c. 1899; Thorp, Joseph Greenleaf; unknown; SHIM; NA; unknown; O'Connell, J. J.; Y

BIBLIOGRAPHY: ARRC (13), Jan. 1903; INVE; EHHE

Potter, Frederick G.
c. 1860; 1926; unknown; unknown; E; Lee Avenue; East Hampton; c. 1899; Thorp, Joseph Greenleaf; unknown; SHIN; NA; Harkness, L. V.; Briggs, James; Y

BIBLIOGRAPHY: INVE; EHHE

Potter, Frederick G.
unknown; unknown; unknown; unknown; E; Lily Pond Lane; East Hampton; 1905; Thorp, Joseph Greenleaf; unknown; CLOL; NA; Rose, Joanna S.; unknown; Y

BIBLIOGRAPHY: FYMC, 1941; INVE, 1979; FOST, 1977; EHHE; ARTS (31), Aug. 1929

Pratt, Charles M.
1855; 1935; Morris, Mary S.; Seamoor; unknown; unknown; Glen Cove; c. 1890; Lamb & Rich; unknown; SHIN; unknown; unknown; unknown; N

BIBLIOGRAPHY: SORG; NRNF, 1980

Pratt, Charles M., Jr.
unknown; unknown; Moms, Mary S.; unknown; unknown; unknown; Glen Cove; 1926; Peabody, Wilson & Brown; unknown; TWEC; 1969; unknown; unknown; N

BIBLIOGRAPHY: ARAT (8), July 1927: 493F; HOWE, 1933; ARTR (55), June 1927: 337F; AABN (131), 1927; SORG

Pratt, Frederic B.
1865; 1945; Ladd, Caroline; Friend Field; unknown; unknown; Glen Cove; c. 1898; Babb, Cook & Willard; unknown; TWPC; c. 1927; unknown; unknown; N

BIBLIOGRAPHY: PLAS; ARAT (7), Jan. 1927; COUN (52), May 1927: 48; FAML; INVE; SORG; AVER; SPUR (40), July 1927; NRNF 1980

Pratt, Frederic B.
1865; 1945; Dodge, Pauline; Poplar Hill; O; Dosoris Lane; Glen Cove; 1917; Platt, Charles A.; Pendleton; GRRV; NA; Glengariff Home; unknown; Y

BIBLIOGRAPHY: WWIA; NRNF, 1980; SORG

Pratt, George Dupont
1869; 1935; Sherman, Helen; Killenworth I; unknown; unknown; Glen Cove; c. 1899; Tubby, William B.; Olmsted Brothers, 1907–09; SHIN; c. 1912; unknown; unknown; N

BIBLIOGRAPHY: FAML; ARBD (32), Nov. 1899: 45; NRNF, 1980; FLON; WWIA (1): 991

Pratt, George Dupont
1869; 1935; Sherman, Helen; Killenworth II; O; Dosoris Lane; Glen Cove; c. 1913; Trowbridge & Ackerman; Greenleaf, James L.; JACO; NA; Miller, Thomas; USSR Delegation; Y

BIBLIOGRAPHY: NRNF, 1980; WWIA (1): 991; FLON; FAML; ARBD (32), Nov. 1899: 45; SORG; PATT, 1924; COUN (33), Feb. 1918: 46; HEWI; ELWO, 1924: 43; COUN (26), Oct. 1914: 35; LEVA; FAML; PRLN, 1985; ARLG (29), 1914; LAPE (12), Nov. 1919: 26; SORG; TOWN, Dec. 1916: 30; COUN (34), Oct. 1923; ARRC (35), June 1914: 558; COUN (29), Jan. 1916: 21

Pratt, Harold I.
1877; 1939; Barnes, Harriett; Welwyn; G; Crescent Beach Road; Glen Cove; 1904; Babb, Cook & Willard; Olmsted Brothers, NFRI; NA; Pratt; Nassau County; Y

BIBLIOGRAPHY: PATT, 1924; FAML; ARTS (23), ⅛ULY 1925: 28; NRNF, 1980; LAPE, 1922; LEVA, 1916; FLON; HICK; WWIA (1): 991

Pratt, Herbert L.
1871; 1945; Winchester, H.; The Braes I; unknown; unknown; Glen Cove; c. 1902; Brite & Bacon; unknown; GRRM; 1910; unknown; unknown; N

BIBLIOGRAPHY: LOIS, Mar. 3, 1900; SORG; NRNF, 1980; ARTR (5), Jan. 1902: 10

Pratt, Herbert L.
1871; 1945; Winchester, H.; The Braes; N; Crescent Beach Road; Glen Cove; c. 1912; Brite & Bacon; Greenleaf, James L.; JACO; NA; Pratt; Webb Inst. Naval Arch; Y

BIBLIOGRAPHY: HEWI; COUN (29), Jan. 1916: 19; ELWO, 1924: 44; AMCO, 1915: 218; COUN (34), Oct. 1918: 43; FAML; COUN (34), May 1918: 43; COUN (36), Aug. 1919: 41; SPUR, Nov. 1914: 21; TOWN, May 1915: 33; SORG; WURT; WWIA (11), 1950: 431; BEAU: 95; LEVA

Pratt, John
unknown; unknown; unknown; The Farm House; E; Old Tappan Road; Glen Cove; c. 1913; Platt, Charles A.; unknown; CLOL; NA; unknown; unknown; Y

BIBLIOGRAPHY: NRNF, 1980

Pratt, John T., Jr.
1904; 1969; Woodward, Eliza; Beechwood; L; Old Tappen Road; Glen Cove; c. 1930; Platt, William; unknown; NEFM; NA; unknown; Russian Orthodox Church; Y

BIBLIOGRAPHY: INVE; NRNF, 1980; HOWE, 1933

Pratt, John Teele, Sr.
1873; 1927; Baker, Ruth S.; Manor House; R; Dosoris Lane; Glen Cove; c. 1909; Platt, Charles A.; Platt, Charles A.; GRRV; NA; unknown; Harrison House Conference; Y

BIBLIOGRAPHY: AABN (101), 1912; ARTR (26), Aug. 1912; PLAS, 1913; COUN (27), Apr. 1915: 41; VIEW; COUN (29), Jan. 1916: 20; ARTS (22), Apr. 1925: 23; NRNF, 1980; AMCO (1), 1912: 139; TOWN, Dec. 1912: 43; SPUR, Dec. 1913: 27; AVER; WWIA (1): 991

Pratt, Theodore

1897; 1977; Maynard, Pauline; Whispering Pines; E; Old Tappan Road; Glen Cove; c. 1923; Trowbridge & Ackerman; unknown; NEFD; NA; Cook, Walter; unknown; Y

BIBLIOGRAPHY: NRNF, 1980; INVE; SORG

Preston, Ralph J.

unknown; c. 1919; Graves, Julia; Ivy Hall; unknown; Kirbys Lane; Jericho; c. 1904; Warren & Wetmore; unknown; NEFD; c. 1950; Taylor, James B.; Gary, Judge Elbert H.; N

BIBLIOGRAPHY: SORG; COUN (25), Mar. 1914: 2; COUN (58), Aug. 1930: 15; AVER; WWIA (1): 443

Preston, William P.T.

unknown; unknown; Alford, Doris; Longfields; unknown; unknown; Jericho; c. 1913; Peabody, Wilson & Brown; Shipman, Ellen; CLOL; unknown; Straus, J. L.; unknown; N

BIBLIOGRAPHY: ARAT (10), Apr. 1928: 105; ARRC (58), Nov. 1925: 509; HICK; SORG

Prime, William A.

1863; 1936; unknown; unknown; unknown; unknown; Wheatley Hills; c. 1912; Mizner, Addison; unknown; unknown; c. 1924; unknown; unknown; N

BIBLIOGRAPHY: NCAB; MIZN, 1977

Proctor, Charles E.

unknown; c. 1950; Jones, Nina G.; Shadowlane; unknown; Shadow Lane; Kings Point; c. 1914; Little & Browne; unknown; TWEC; c. 1960; unknown; unknown; N

BIBLIOGRAPHY: AMCO, 1915: 84FF; TOWN, Nov. 1914: 18; SPUR, Aug. 1916: 18; ARRC (36), Oct. 1914: 278; VIEW, 1930; SORG

Proctor, William C.

unknown; unknown; unknown; unknown; E; unknown; Amagansett; 1908; unknown; unknown; MEVI; NA; unknown; unknown; Y

BIBLIOGRAPHY: AMGS

Provost, Cornelius

unknown; unknown; Smith, Alice; Woodstock Manor; E; Mill River Road; East Norwich; c. 1912; Chapman, Henry Otis; unknown; NEFM; NA; Vanderpoel, W. H.; Amato, Camille; Y

BIBLIOGRAPHY: SORG; VIEW

Prybil, Helen Porter

unknown; unknown; Porter; Bogheid; E; Lattingtown Road; Glen Cove; c. 1937; Delano & Aldrich; unknown; NFRM; NA; Carey, Martin; unknown; Y

BIBLIOGRAPHY: INVE

Pulitzer, Ralph

1879; 1939; unknown; Kiluna Farm; E; unknown; Manhasset; 1913; Walker & Gillette; Platt, Charles A.; GRRM; NA; Paley, William; unknown; Y

BIBLIOGRAPHY: PREV; SORG; HICK; ARRC (35), Apr. 1914: 310; AMHO (10), Jan. 1913: 20; WWIA; ARFO (29), Aug. 1918; ARRC (32), Nov. 1912: 471

Pupke, John F.

unknown; unknown; unknown; unknown; unknown; Coopers Neck Road; Southampton; c. 1892; McKim, Mead & White; unknown; SHIN; unknown; Davis, Emily M.; unknown; N

BIBLIOGRAPHY: BROD

Pyne, Percy R., II

1882; 1929; unknown; Rivington House; E; unknown; Roslyn; c. 1925; Cross & Cross; Farrand, Beatrix; NFRM; NA; unknown; unknown; Y

BIBLIOGRAPHY: PRLN, 1985; SORG; WWIA (1): 1003; TOWN, Oct. 1929: 54; COUN (52), Sept. 1927: 66

Quackenbush, Schuyler

unknown; unknown; Eidlitz; unknown; E; Lee Avenue; East Hampton; c. 1899; Eidlitz, C. L.W.; unknown; SHIN; NA; Edwards, Dr. O. M.; Nichols, H. Willis; Y

BIBLIOGRAPHY: EHHE; INVE

Quistgaard, J.W. Von R.

unknown; unknown; unknown; Villa Gerdrup; unknown; unknown; Oyster Bay; c. 1920; Kirby, Petit & Green; unknown; NEIR; unknown; unknown; unknown; unknown

BIBLIOGRAPHY: SPUR (30), July 1922: 45

Rathborne, J. Cornelius

unknown; unknown; Helen Idekoper; Pelican Farm; unknown; unknown; Old Westbury; c. 1937; Bottomley, William; unknown; GRRV; unknown; unknown; unknown; N

BIBLIOGRAPHY: COUN (78), June 1940: 16; SORG

Rawson, John

unknown; unknown; unknown; unknown; unknown; unknown; Amagansett; c. 1910; unknown; unknown; MEVI; unknown; unknown; unknown; unknown

BIBLIOGRAPHY: AMGS

Reboul, Homer W.

unknown; unknown; unknown; Foxfields; E; unknown; St. James; 1896; Green, Isaac Henry; unknown; SHIN; NA; Rockwell, Embry; unknown; Y

BIBLIOGRAPHY: NRNF, 1992; PREV

Redmond, Gerald L.

unknown; unknown; Register, Katherine; Gray Horse farm; E; Piping Rock Road; Brookville; c. 1924; O'Connor, James W.; Fowler, Robert, Jr.; NEFM; NA; Patterson, Dorothy F.; Sandford, Mr. and Mrs. S.; Y

BIBLIOGRAPHY: COUN (55), Feb. 1929: 55; AAAA (135), 1929: 292; GOTT, 1928; ARLG (44), 1929; ARAT (11), Feb. 1929: 533; INVE; SORG; OCOR, 1930; TOWN, June 1929; FORT (7), 1933: 96

Reed, Lansing P.

1882; 1937; Lawrence, Ruth; Windy Hill; E; Snake Hill Road; Lloyd Harbor; 1926; Platt, Charles A.; Shipman, Ellen; GRRM; NA; unknown; unknown; Y

BIBLIOGRAPHY: CORN; INVE; SORG

Remington, Franklin

unknown; unknown; Howard, Maude; Driftwood; E; unknown; Centre Island; 1911; Ewing & Chappell; unknown; GRRM; NA; unknown; unknown; Y

BIBLIOGRAPHY: SORG; WWIA; INVE

Renard

unknown; unknown; unknown; unknown; E; Ryefield Road; Lattingtown; unknown; Delehanty, Bradley; unknown; unknown; NA; unknown; unknown; Y

BIBLIOGRAPHY: INVE; HEWI, 1927

Reynolds, Jackson E.

unknown; unknown; Taylor, Marion; unknown; E; unknown; Locust Valley; c. 1919; Lindeberg, Harrie T.; unknown; unknown; NA; unknown; unknown; Y

BIBLIOGRAPHY: ARRC (55), Apr. 1924: 359; COUN (46), Oct. 1924: 63; SORG; TOWN, Oct. 1924: 36

Rice, Dr. C. C.

unknown; unknown; unknown; unknown; unknown; unknown; East Hampton; c. 1905; Atterbury, Grosvenor; unknown; COTS; unknown; McCord, D.W.; unknown; N

BIBLIOGRAPHY: FYMC, 1941: 144; ARTR (24), Oct. 1911; ARYB (1), 1912; ARRC (17), Feb. 1905: 87; AAAA (94), Aug. 1908; HEWI

Rice, Grantland

unknown; unknown; unknown; unknown; E; West End Lane; East Hampton; 1927; Lawrence, John C.; unknown; SHIM; NA; unknown; unknown; Y

BIBLIOGRAPHY: EHHE

Rich, Charles Alonzo
1855; 1943; Bradbury; Old Rider Farm; E; Thornhedge Road; Bellport; c. 1889; Rich, Charles A.; unknown; SHIN; NA; unknown; unknown; Y

BIBLIOGRAPHY: WWIA (11), 1950: 446; INVE

Richards, Frederick L.
unknown; unknown; Bache, Hazel J.; Hazelmere; F; unknown; Kings Point; c. 1910; Adams, William; Adams, William; GRRV; NA; unknown; unknown; Y

BIBLIOGRAPHY: INVE; SORG; LEVA, 1916; ARRC (43), June 1918: 522

Richmond, Martin L.
unknown; unknown; Thacker, Sarah; Sunninghill; E; unknown; Glen Head; c. 1928; Bullard, Roger H.; Innocenti & Webel; EGMV; NA; unknown; unknown; Y

BIBLIOGRAPHY: SORG; INVE; AMCO, 1930: 20; ARRC (70), Nov. 1931: 330; ARTS (36), Feb. 1932: 24; ARAT (12), July 1929: 439

Rickert, E. J.
unknown; unknown; unknown; unknown; unknown; unknown; Great Neck; c. 1908; Gilbert, C. P. H.; unknown; TWEC; c. 1960; unknown; unknown; N

BIBLIOGRAPHY: TOWN, Mar. 1911; RUTH; ARBD (46), May 1914: 184

Ricks, Jesse Jay
1879; 1944; Hayward, Sybil; unknown; unknown; Stonytown Road; Plandome; c. 1927; Godley, Frederick A.; Marsh, J. R.; TUDR; c. 1964; unknown; unknown; N

BIBLIOGRAPHY: WWIA (11), 1950: 448; LAPE; ARLG, 1929: 291

Ripley, Julien A.
unknown; unknown; Ball, Helen A.; unknown; unknown; Ripley Lane; Brookville; c. 1910; Lowell, Guy; Lewis & Valentine; GRRV; NA; Hecht, George; Coleman, Gregory & Marianne; Y

BIBLIOGRAPHY: LEVA; NASS, Korten Photo, 1910

Ripley, Julien A.
unknown; unknown; Bell, Helen A.; unknown; E; Brookville Road; Brookville; c. 1924; Delehanty, Bradley; unknown; NEFD; NA; unknown; unknown; Y

BIBLIOGRAPHY: SORG; DELA, 1934

Robb, James H.
unknown; unknown; unknown; The Dolphins; E; unknown; Southampton; c. 1885; McKim, Mead & White; unknown; unknown; NA; unknown; unknown; Y

BIBLIOGRAPHY: BROD

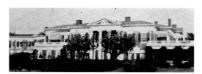

Robbins, H. P.
unknown; unknown; Welles, Emily; Pelham Farm; unknown; South Main Street; Southampton; c. 1901; unknown; unknown; GRRV; unknown; unknown; unknown; N

BIBLIOGRAPHY: BYRO, 1937; SORG; HICK; RUTH, 1909; INVE

Robbins, William H.
unknown; unknown; unknown; unknown; E; unknown; Bay Shore; c. 1928; Hart & Shape; unknown; TUDR; NA; unknown; unknown; Y

BIBLIOGRAPHY: INVE, 1930

Robert, Christopher R.
1830; 1898; Remington; Pepperidge Farm; unknown; unknown; Oakdale; c. 1896; Ficken, H. Edward; unknown; JACO; c. 1940; Aston, W. R.; Wiedenbach, Mrs. Regin; N

BIBLIOGRAPHY: LIFO, Dec. 1978; VAND; AABN, Nov. 1887; INVE; SORG

Roberts, George
unknown; unknown; Middleton, B; Furtherfield; E; unknown; East Hampton; c. 1930; Embury, Aymar, II; unknown; NEFD; NA; unknown; unknown; Y

BIBLIOGRAPHY: EHHE: 200; ARTS (36), Apr. 1932: 46; SORG

Robertson, Markoe T.
unknown; unknown; unknown; Wyndecote; unknown; South Main Street; Southampton; c. 1887; Potter & Robertson; unknown; unknown; NA; unknown; unknown; Y

BIBLIOGRAPHY: INVE

Robertson, Mrs. Charles
unknown; unknown; unknown; unknown; E; Banbury Lane; Lloyd Harbor; c. 1932; Schmidt, Mott B.; unknown; GRRV; NA; unknown; unknown; Y

BIBLIOGRAPHY: INVE

Robin, J. G.
unknown; unknown; unknown; Driftwood Manor; unknown; Sound Avenue; Riverhead; c. 1906; Palmer & Hornbosteal; unknown; MEVI; c. 1978; Wagg, Alfred; Meyer, Arthur G.; N

BIBLIOGRAPHY: BEAU: 216; INVE

Robinson, J. Randolph
c. 1879; c. 1973; unknown; unknown; S; Northern Boulevard; Westbury; c. 1917; Pope, John Russell; Shipman, Ellen; CLRV; NA; Grossler, Philip; Hutton, Edward F.; Y

BIBLIOGRAPHY: COUN (35), Mar. 1919: 60; AAAA (117), Jan. 1920: 2298; ARFO (28), Jan. 1917; TOWN, Feb. 1918: 19; BEAU

Robinson, J. Randolph
1879; 1933; Metcalf, Mary; unknown; S; unknown; Brookville; c. 1930; Bottomley, William; unknown; GRRV; NA; Tenney, Daniel G.; L.I.U.-Administration Center; Y

BIBLIOGRAPHY: COUN (65), Mar. 1934: 47; BEAU: 135; SORG

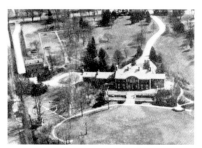

Roessler, August
unknown; unknown; unknown; Silvermore; unknown; Kings Point Road; Kings Point; c. 1910; unknown; unknown; NEFD; c. 1950; Livermore; unknown; N

BIBLIOGRAPHY: PREV

Rogers, E. S.
unknown; unknown; unknown; unknown; unknown; Broadway Avenue; Lawrence; c. 1900; Randall, T. Henry; unknown; CLRV; unknown; unknown; unknown; N

BIBLIOGRAPHY: LIHS

Rogers, Henry Huddleson
c. 1879; unknown; Mary, Benjamin; Black Point; unknown; Gin Lane; Southampton; 1914; Walker & Gillette; Olmsted Brothers, 1914–1915; NEIR; c. 1930; unknown; unknown; N

BIBLIOGRAPHY: ARAT (2), Aug. 1924; HOUS (56), July 1924: 33; HEWI, 1923; PATT, 1924; ARAT (3), Nov. 1924; ARAT (14), Aug. 1930: 461; COUN (34), May 1918: 41; COUN (33), Feb. 1918: 46; ARRC (39), Jan. 1916: 1; WWIA (1): 1051; LHDG; ARLG (31), 1916; SPUR (46), July 1930: 54; LEVA; COUN (50), Oct. 1926: 37; ARTS (6), Feb. 1916: 167; FLON; TOWN, Mar. 1916: 30; SORG

Roig, Harold

unknown; unknown; unknown; unknown; E; Kings Point Road; Kings Point; c. 1920; unknown; unknown; NFRM; NA; unknown; unknown; Y

BIBLIOGRAPHY: INVE, 1978

Roosevelt, James Alfred

unknown; unknown; Emlen; Yellowbanks; E; Cove Neck Road; Oyster Bay; c. 1881; Price, Bruce; unknown; SHIN; NA; Roosevelt, William Emlen; Roosevelt, John Kean; Y

BIBLIOGRAPHY: SORG; INVE

Roosevelt, John E.

unknown; 1939; Hamersly, Edith; Meadow Croft; M; Middle Road; Sayville; c. 1890; Green, Isaac Henry; unknown; CLRV; NA; unknown; Suffolk County; Y

BIBLIOGRAPHY: INVE; SORG

Roosevelt, Kermit

1889; 1943; Willard, Betty; Mohannes; unknown; Cove Neck Road; Oyster Bay; c. 1927; unknown; unknown; CLRV; c. 1950; unknown; unknown; N

BIBLIOGRAPHY: WWIA (II), 1950: 457; COUN (584), July 1930: 39; LOIS, Jan. 10, 1914; SORG

Roosevelt, Philip James

unknown; unknown; unknown; Dolonor; E; unknown; Oyster Bay; 1928; Pennington, Hall P.; unknown; GRRV; NA; unknown; Wang, Charles; Y

BIBLIOGRAPHY: FAML

Roosevelt, Robert B., Jr.

unknown; unknown; Hamersley, Lilie; The Lilacs; unknown; unknown; Sayville; c. 1899; Green, Isaac Henry; unknown; SHIM; unknown; unknown; unknown; N

BIBLIOGRAPHY: Sayville Historical Society Collection

Roosevelt, Theodore

1858; 1919; Hathaway, Alice; Sagamore Hills; M; Cove Neck Road; Oyster Bay; c. 1884; Lamb & Rich; unknown; QUAN; NA; Mrs. Roosevelt, heirs; National Park Site; Y

BIBLIOGRAPHY: WWIA (I): 1055; SORG; COUN (28), Oct. 1915: 33; AABN (39), 1893: 895; BEAU: 163

Roosevelt, Theodore, Jr.

1887; 1944; Alexander, E.B.; Old Orchard; M; Cove Neck Road; Oyster Bay; c. 1937; unknown; unknown; GRRV; NA; Roosevelt, Mrs. Theodore; National Park Site; Y

BIBLIOGRAPHY: WWIA (II), 1950: 457; SORG; *Sagamore Hill, An Historical Guide*, ROTH, 1977

Root, Elihu

1845; 1937; Wales, Clara; unknown; E; Pond Lane; Southampton; c. 1896; Carrère & Hastings; unknown; GRRV; NA; Sherrill, Mrs. Virgil; unknown; Y

BIBLIOGRAPHY: ARRC (27), Jan. 1910: 62; INVE; SORG; WWIA (I): 11056

Rose, George

unknown; unknown; Ross, Jeanette; Bennett Cottage; unknown; unknown; Westbury; unknown; Hoppin & Koen; unknown; unknown; c. 1950; unknown; unknown; N

BIBLIOGRAPHY: ARYB (I), 1912: 147; SORG; TOWN, May 1924: 6; HICK

Rose, Rev. H. T.

unknown; unknown; unknown; Rosemary Lodge; E; Rosehill Road; Water Mill; 1884; Stickney & Austin; unknown; SHIN; NA; unknown; Cordingley, A.; Y

BIBLIOGRAPHY: INVE

Rossiter, Arthur W.

unknown; unknown; Guthrie, Ella; Cedarcroft; E; Ridge Road; Glen Cove; c. 1906; Albro & Lindeberg; unknown; NEIR; NA; Beale, Bouvier; unknown; Y

BIBLIOGRAPHY: AMCO, 1915: 60FF; TOWN, Dec. 1914: 22; INVE; COUN (23), Nov. 1912: 22; WWIA (I): 1065; ARTR (26), Nov. 1912: 232F; TOWN, May 1917: 29; SORG; ARRC (32), Oct. 1912: 301

Rothschild, Simon F.

1861; 1936; Abrahma, Lillian; San Souci; unknown; Saxon Avenue; Bay Shore; c. 1905; unknown; unknown; unknown; unknown; unknown; unknown; N

BIBLIOGRAPHY: BKLY, Aug. 3, 1907

Rouss, Peter Winchester

unknown; 1909; unknown; Callender House; O; Bayville Avenue; Bayville; c. 1903; unknown; unknown; NECL; NA; Clarkson, Robert; Oyster Bay Hospital; Y

BIBLIOGRAPHY: HICK; BAYV

Rowe, William S.

1857; 1941; unknown; unknown; E; unknown; Amagansett; 1909; unknown; unknown; MEVI; NA; unknown; unknown; Y

BIBLIOGRAPHY: AMGS

Rumsey, Mrs. C. C.

unknown; unknown; Hammer, Mary; Keewayden; E; Middle Neck Road; Sands Point; unknown; unknown; unknown; unknown; NA; Rumsey, Charles C.; unknown; Y

BIBLIOGRAPHY: SORG

Rumsey, Charles Cary

1879; 1922; Harriman, Mary; unknown; E; Wheatley Road; Wheatley Hills; c. 1910; Hoffman, F. Burrall; Morris & Rotch; DCMD; NA; Cutting, Fulton; unknown; Y

BIBLIOGRAPHY: PATT, 1924: 251; HICK; LEVA; ARRC (41), June 1917: 554; ARTR (22), July 1910: 105; BRIC (25), June 1916: 152

Runyon, Clarkson

1874; 1945; Allen, Jane P.; The Farm House; unknown; unknown; Glen Cove; c. 1917; Schmidt, Mott B.; unknown; unknown; NA; unknown; unknown; Y

BIBLIOGRAPHY: SORG; FLON; COUN (31), Mar. 1917: 69; INVE; NYTO, Feb. 8, 1945

Rusch, Henry A.

unknown; c. 1938; Dolliver, Florence; June Acres; E; Centre Island Road; Centre Island; c. 1908; Mackenzie, J. Clinton; unknown; NSPR; NA; unknown; unknown; Y

BIBLIOGRAPHY: INVE; SORG

Russell, Judge Horace
unknown; unknown; Hilton, Josephine; Williston House; E; Ox Pasture Road; Southampton; 1898; Price, Bruce; Flanders, Annette Hoyt; CLCO; NA; Simonds, Wm. R.; unknown; Y

BIBLIOGRAPHY: GOTT; COUN (72), June 1937: 9; HEWI, 1930; NCAB; COUN (66), Aug. 1934: 59; INVE; SORG

Ryan, John C.
unknown; unknown; unknown; unknown; C; unknown; Roslyn; c. 1926; Stearns, Chandler; Chamberlain, Noel; TUDM; NA; Whelan, Grover; Renaissance Country Club; Y

BIBLIOGRAPHY: SPUR (41), Apr. 1928: 74

Ryan, William J.
1874; 1966; Cuddihy, Helen; Narrow; C; Moriches Road; St. James; c. 1930; Delehanty, Bradley; unknown; NEFM; NA; unknown; Nissequoque Golf Club; Y

BIBLIOGRAPHY: DELA, 1934; HERL, Mar. 1940; NRNF, 1992; GOTT, 1932; INVE; SORG

Sabin, Charles Hamilton
1869; 1933; Whitney, Maybel; Bayberryland; R; unknown; Southampton; c. 1919; Cross & Cross; Coffin, Marian C.; NFRM; NA; unknown; Int. Industry Brd. Electrica; Y

BIBLIOGRAPHY: HEWI; ELWO, 1924: 26; PATT, 1924; ARTS (13), Jan. 1923; ARRV (24), Sept. 1919: 133; ARFO (36), Feb. 1922: 78; ARRC (54), Aug. 1923: 135; LAPE; TOWN, Sept. 1919: 32; LAND (13), Jan. 1923; SORG; WWIA (I): 1072; COUN (51), Apr. 1927: 43

Salembier, Paul
unknown; unknown; unknown; unknown; E; Lily Pond Lane; East Hampton; c. 1924; Bullard, Roger H.; unknown; TWEC; NA; unknown; unknown; Y

BIBLIOGRAPHY: INVE

Salomon, Gustave
unknown; unknown; unknown; unknown; unknown; unknown; Far Rockaway; c. 1895; Werner & Windolph; unknown; QUAN; unknown; unknown; unknown; N

BIBLIOGRAPHY: ROCK

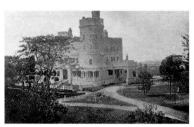

Salomon, Louis
unknown; unknown; unknown; Castle-las; unknown, unknown, Far Rockaway, c. 1900; unknown; unknown; TUDM; c. 1950; unknown; unknown; N

BIBLIOGRAPHY: ROCK

Salvage, Sir Samuel A.
1876; 1946; Richmond, Kathy; Rynwood; R; Cedar Swamp Road; Brookville; 1927; Bullard, Roger H.; Shipman, Ellen; TUDR; NA; Vanderbilt, Alfred G.; Lundy, F. W. I.; Y

BIBLIOGRAPHY: HEWI, 1934; COUN (73), Mar. 1938: 41; AABN (133), 1928; ARLG, 1927; COUN (65), Apr. 1934: 59; AABN (136), 1929; AABN (135), May 1929: 593; ARFO (53), July 1930: 51; SORG; TOWN, May 1929: 59; INVE; ARLG, 1927; *Life Magazine*, July 1946: 73; WWIA (II), 1950: 466; COHO (8), May 1930: 4

Sampson, Mrs. S. P.
unknown; unknown; unknown; unknown; unknown; unknown; Lawrence; c. 1900; Adams & Warren; unknown; unknown; unknown; unknown; unknown; N

BIBLIOGRAPHY: INDO (2), May 1906: 49; INVE

Sanderson, Henry
1868; 1934; Walter, Beatrice; La Selva; L; Planting Field Road; Brookville; c. 1916; Hunt & Hunt; Olmsted Brothers, 1915–35; NEIR; NA; Wheeler, Frederich C.; St. Francis Religious Order; Y

BIBLIOGRAPHY: COUN (42), Oct. 1922: 53; HEWI, 1921; INVE; LEVA; FLON; WWIA (I): 1077

Satterwaite, James
unknown; c. 1884; unknown; unknown; E; Ocean Avenue; East Hampton; c. 1873; Briggs & Corman; unknown; STIK; NA; Thompson, Charles G.; unknown; Y

BIBLIOGRAPHY: INVE; FOST, 1977; EHHE

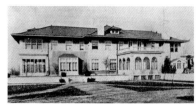

Schenck, Nicholas
unknown; unknown; unknown; unknown; N; Kings Point Road; Kings Point; c. 1920; unknown; unknown; NIRM; NA; unknown; U.S. Merchant Marine Academy; Y

BIBLIOGRAPHY: TOWN, Apr. 1929: 7

Schermerhorn, A. C.
unknown; unknown; Fahnestock; unknown; E; Piping Rock Road; Matinecock; c. 1929; Ward, Leroy P.; unknown; NFRR; NA; unknown; unknown; Y

BIBLIOGRAPHY: INVE

Schermerhorn, A. J.
unknown; unknown; unknown; unknown; E; South Main Street; Southampton; c. 1887; unknown; unknown; SHIN; NA; Murray, Allan; unknown; Y

BIBLIOGRAPHY: INVE, 1982

Schickel, William
1850; 1907; unknown; Mostly Hall; E; Sylvester Road; Shelter Island; c. 1890; Schickel, William; unknown; SHIN; NA; Carpenter, Rachel; unknown; Y

BIBLIOGRAPHY: HIST; INVE, 1982

Schieren, Charles A.
c. 1842; unknown; unknown; Mapleton; E; Ocean Avenue; Islip; c. 1890; Green, Isaac Henry; unknown; CLRV; NA; Atwood, Frederick; unknown; Y

BIBLIOGRAPHY: Sayville Historical Society; INVE

Schieren, G. A.
unknown; unknown; unknown; Beachleigh; E; unknown; Great Neck; c. 1915; Embury, Aymar II; Dean, Ruth; NFRR; NA; Kaliman, A.; unknown; Y

BIBLIOGRAPHY: COUN (46), July 1924: 62; ARTR (37), Apr. 1918: 101F; COUN (33), Dec. 1917: 62; GARD (35), Apr. 1922: 120; INVE

Schiff, Mortimer
unknown; unknown; Neustadt, Adele; Northwood; unknown; Berry Hill Road; Oyster Bay; c. 1905; Gilbert, C. P. H.; Greenleaf, James L.; HTRV; c. 1948; unknown; unknown; N

BIBLIOGRAPHY: SORG; SPUR, Sept. 1918: 28; HOWE (32), Aug. 1915; LHDG (2), 1917: 164; ARLG (21), 1906; REAL (88), Nov. 1911: 784

Schmidlapp, Carl J.
unknown; unknown; Cooper, Frances; Rumpus House; E; unknown; Mill Neck; unknown; Peabody, Wilson & Brown; Vitale, Ferruccio; CLOL; NA; unknown; unknown; Y

BIBLIOGRAPHY: HOWE, 1933; SORG; INVE; SPUR (46), Sept. 1930: 52

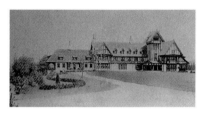

Schultze, Max
unknown; unknown; unknown; The Gables; unknown; Horse Hollow Road; Lattingtown; c. 1910; unknown; unknown; HTRV; unknown; Dugmore; unknown; N

BIBLIOGRAPHY: PREV; INVE, 1978; NASS

Schwarzmann, A.
unknown; unknown; unknown; unknown; unknown; unknown; Shelter Island; 1893; Wait & Cutter; unknown; CLRV; unknown; unknown; unknown; N

BIBLIOGRAPHY: INVE

Scott, Rufus W.
unknown; unknown; Burt, Daisy F.; Scottage; E; Feeks Lane; Lattingtown; unknown; King, R. Barefoot; Chamberlin, Noel; CLRV; NA; Lynch, Edmund, Jr.; unknown; Y

BIBLIOGRAPHY: GOTT, 1934; HEWI, 1923; SORG; INVE; COUN (69), Nov. 1935: 44

Sedgwick, Laura
unknown; unknown; unknown; unknown; E; West End Avenue; East Hampton; c. 1891; Thorp, Joseph Greenleaf; unknown; SHIN; NA; Trippe, Juan; unknown; Y

BIBLIOGRAPHY: INVE; EHHE

Senff, Charles H.
unknown; unknown; unknown; unknown; unknown; unknown; Whitestone; unknown; unknown; Parsons, Samuel; unknown; unknown; unknown; unknown; unknown

BIBLIOGRAPHY: ELWO, 1924: 123

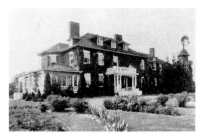

Senior, J. H.
unknown; unknown; unknown; Shadow Lane; unknown; unknown; Quoque; c. 1927; unknown; unknown; CLRV; unknown; unknown; unknown; unknown

BIBLIOGRAPHY: COHO (7), Mar. 1927: 36

Sewell, Robert Van Vors
1860; 1924; Brewster, L. A.; Fleetwood; E; unknown; Oyster Bay; c. 1907; Wheeler, Dunham; unknown; HTRV; NA; unknown; unknown; Y

BIBLIOGRAPHY: AMHO (6), Dec. 1909; SORG; WWIA (1): 1106

Shaw, Robert A.
unknown; unknown; unknown; unknown; unknown; unknown; Glen Cove; c. 1900; Gilbert, C. P. H.; unknown; HTRV; unknown; unknown; unknown; N

BIBLIOGRAPHY: WWIA; REAL (85), June 1910

Shaw, Samuel T.
unknown; unknown; unknown; The Sunnyside; E; unknown; Centre Island; c. 1906; Hirsch, F. R.; unknown; NSPR; NA; Oelsner, Warren; unknown; Y

BIBLIOGRAPHY: NYHS; ARTR (13), Apr. 1906: 64; INVE

Shea, Timothy, J.
unknown; unknown; unknown; O'Conee; unknown; Garner Avenue; Bay Shore; c. 1930; Baum, Dwight James; unknown; TUDR; NA; unknown; unknown; Y

BIBLIOGRAPHY: GOTT, 1931; INVE

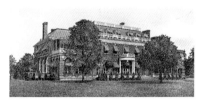

Sheehan, William Francis
1859; 1917; Nellany, Blanche; The Height; E; Shelter Rock Road; North Hills; 1916; Hoppin & Koen; unknown; NEFD; NA; Elborne, Roger G. Elbert; Grace, J. Peter; Y

BIBLIOGRAPHY: NCAB; VIEW

Sheldon, Kenneth
unknown; unknown; unknown; unknown; E; North McCown Lane; Glen Head; c. 1929; Delehanty, Bradley; unknown; clapboard; NA; unknown; unknown; Y

BIBLIOGRAPHY: DELE, 1939

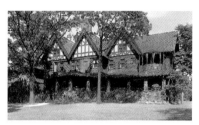

Sherman, Charles Austin
unknown; unknown; unknown; unknown; E; Centre Island Road; Centre Island; c. 1900; unknown; unknown; SHIM; NA; Mooney; unknown; Y

BIBLIOGRAPHY: INVE; WURT

Sherman, L. H.
unknown; unknown; unknown; unknown; S; unknown; North Hills; c. 1918; O'Connor, James W.; Smith, Paul; TUDM; NA; Lunning, Frederick; Buckley Country School; Y

BIBLIOGRAPHY: HOUS (50), Dec. 1921: 455; PATT, 1924: 51; HOUS (55), Apr. 1924: 375; OCOR, 1922; COUN (50), Oct. 1926: 55; TOWN, Oct. 1921

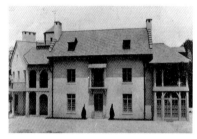

Sherry, Louis
unknown; unknown; unknown; Sherryland; E; unknown; Manhasset; c. 1915; unknown; Olmsted Brothers; NFRI; NA; Munsey, Frank; Metropolitan Museum; Y

BIBLIOGRAPHY: ARTS (39), June 1933: 24; SPUR (26), Aug. 1920: 36

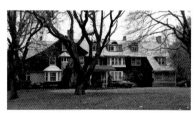

Sherwood, J. K.
unknown; unknown; unknown; unknown; E; Cedar Lane; Glen Cove; c. 1895; unknown; unknown; SHIN; NA; Rothberg, L.; unknown; Y

BIBLIOGRAPHY: INVE, 1978

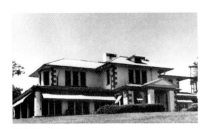

Shields, John
1857; 1921; unknown; Daybreak; unknown; Sunken Meadow Road; Fort Salonga; c. 1917; unknown; unknown; WRIN; c. 1950; unknown; unknown; N

BIBLIOGRAPHY: INVE; LOIS Feb. 11, 1921

Shipman, Mrs. Herbert
unknown; unknown; Bradley, Julie; Lynrose; unknown; Glenwood Road; Roslyn; c. 1931; Bottomley, Warner & White; unknown; unknown; unknown; Fremont, Mrs. Julia; unknown; unknown; N

BIBLIOGRAPHY: PREV; SPUR (51), Mar. 1933: 36; SORG

Simonds, Mrs. W. M.
unknown; unknown; unknown; unknown; unknown; Benson Avenue; Sayville; unknown; Green, Isaac Henry; unknown; MEVI; NA; Mason, William; unknown; Y

BIBLIOGRAPHY: INVE

Simpson, R. H.
unknown; unknown; Wood, Alice; Allways; unknown; unknown; Oyster Bay; c. 1920; unknown; Lay, Charles Downing; unknown; unknown; unknown; unknown; unknown

BIBLIOGRAPHY: ELWO, 1924: 70; HOUS (50), July 1921: 38; SORG

Skidmore, S. T.
unknown; unknown; unknown; Idlerest; E; Georgia Road; East Hampton; c. 1894; Green, Isaac Henry; unknown; SHIN; NA; unknown; unknown; Y

BIBLIOGRAPHY: FOST, 1977; INVE, 1977; EHHE: 170

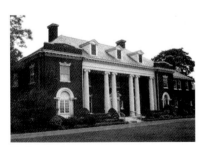

Skylar, Dr. Leo
unknown; unknown; unknown; Byrnewood; E; Central Avenue; Lawrence; c. 1918; unknown; unknown; NEFM; NA; unknown; unknown; Y

BIBLIOGRAPHY: INVE

Slade, John
unknown; unknown; Weekes, Edith.; Underhill House; E; unknown; Oyster Bay; c. 1918; MacIntosh, Alexander; unknown; NEFM; NA; Uzielli; Baehr, I. E.; Y

BIBLIOGRAPHY: ARLG (39), 1924; SORG

Slade, Mrs. Prescott
unknown; unknown; unknown; unknown; E; Horseshoe Road; Mill Neck; c. 1929; Patterson, Chester A.; unknown; DCMD; NA; Babcock, H. D.; unknown; Y

BIBLIOGRAPHY: COUN (60), Oct. 1931: 36; INVE

Sloane, M. D.
unknown; unknown; unknown; Kidd's Rocks; E; Middle Neck Road; Sands Point; c. 1900; unknown; unknown; CLRV; NA; Swope, Herbert Bayard; Richter, Horace; Y

BIBLIOGRAPHY: VIEW, 1930; TOWN, Mar. 1921

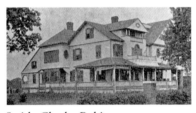

Smith, Charles Robinson
1855; 1930; Steele, Jeannie; unknown; E; Montgomery Avenue; Bay Shore; c. 1890; unknown; unknown; SHIM; NA; Gordon, Edward; unknown; Y

BIBLIOGRAPHY: BABY, 1902; INVE

Smith, D. W.
1857; 1930; unknown; unknown; E; Cove Neck Road; Oyster Bay; c. 1910; York & Sawyer; unknown; unknown; NA; Anderson, H. J.; unknown; Y

BIBLIOGRAPHY: SORG; PREV

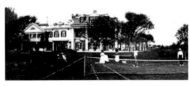

Smith, Frank M.
unknown; c. 1929; unknown; Presdeleau; unknown; unknown; Shelter Island; c. 1896; unknown; unknown; CLRV; c. 1939; unknown; unknown, N

BIBLIOGRAPHY: INVE

Smith, George
unknown; unknown; unknown; Blythewood; E; Route 25A; Muttontown; c. 1913; Chapman, Henry Otis; Leavitt, Charles W.; NEFR; NA; Bedford, Alfred C.; Hoffman, E. S.; Y

BIBLIOGRAPHY: SORG; LEVA; PREV; HICK

Smith, Herbert
unknown; unknown; unknown; Oliver's Point; unknown; Centre Island Road; Centre Island; c. 1912; Brewster, Herbert R.; unknown; SHIM; c. 1970; Baker, Mrs. George; unknown; N

BIBLIOGRAPHY: INVE; PREV; ARBD (49), July 1917; TOWN, Oct. 1922

Smith, Howard C.
unknown; unknown; Moen, Katherine; Merry Manor; unknown; Cove Neck Road; Oyster Bay; c. 1906; unknown; unknown; TUDM; c. 1960; unknown; unknown; N

BIBLIOGRAPHY: FAML

Smith, Ormond Gerald
1860; 1933; Pellett, Grace; Shoremonde; unknown; Centre Island Road; Centre Island; c. 1910; Hoppen & Koen; Weinrichter, Ralph; NEFD; c. 1940; Willys, John N.; Le Roux, E.; N

BIBLIOGRAPHY: SPUR (26), Aug. 1920: 24; ARRC (40), Aug. 1916: 114; WWIA (1): 1147; COUH, 1924; COUN (32) Sept. 1917: 56; LEVA; TOWN, June 1917: 29; COUN; SORG

Sparrow, Edward W.
unknown; c. 1913; Beattie, Margaret P.; Killibeg; E; Duck Pond Road; Matinecock; 1912; Greenley, Howard; unknown; HTRV; NA; unknown; unknown; Y

BIBLIOGRAPHY: SORG; NCAB; INVE

Stafford, Mrs. Robert
unknown; unknown; Schall, Margaret T.; Broadwaters; E; Lloyd Lane; Lloyd Harbor; c. 1902; Moses, Lionel; unknown; NSPR; NA; Mulferrig, John B.; unknown; Y

BIBLIOGRAPHY: ARTR (21), Feb. 1910: 26; INVE; AAAA (97), Apr. 1910: 1790; LOIS, Apr. 1924; *Concrete & Stucco Houses*, 1922; SORG

Stearns, John N.
unknown; unknown; Kepper, Helen; The Cedars; unknown; Wheatley Road; Brookville; c. 1939; O'Connor, James W.; Innocenti & Webel; unknown; NA; unknown; unknown; Y

BIBLIOGRAPHY: COUN (76), May 1939: 6820; INVE; SORG

Steeken, Francis L.

unknown; unknown; unknown; unknown; L; unknown; Old Field; c. 1920; Butler & Corse; unknown; NIRM; NA; unknown; Maryville Convent; Y

BIBLIOGRAPHY: HOUG (43), Jan. 1923: 64

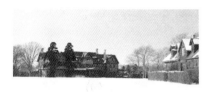

Steele, Charles

unknown; c. 1939; French, Nannie; unknown; unknown; South Main Street; Southampton; c. 1895; unknown; unknown; HTRV; c. 1984; unknown; unknown; N

BIBLIOGRAPHY: SORG; INVE; WWIA (I), 1943: 1174

Stehli, Emil. J.

unknown; unknown; Zweifel, Margo; Hawk Hill; E; Wildwood Court; Lattingtown; 1927; Treanor & Fatio; unknown; unknown; c. 1960; Bonner, Paul H.; Hagen, W.; N

BIBLIOGRAPHY: SPUR (46), Aug. 1930: 38

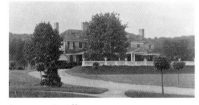

Stevens, C. Albert

unknown; unknown; Brady, May; Annandale; unknown; Wheatley Road; Westbury; c. 1896; unknown; Olmsted Brothers; SHIN; c. 1940; Barney, Charles T; Loew, William G.; N

BIBLIOGRAPHY: HICK; FLON

Stevens, Joseph S.

unknown; unknown; Sherwood, Clara; Kirby Hall; E; Kirby's Lane; Jericho; c. 1904; Warren & Wetmore; unknown; NEFD; NA; Stevens, Byam K.; unknown; Y

BIBLIOGRAPHY: HICK, 1912; AVER

Stevenson, Malcolm

unknown; unknown; unknown; unknown; unknown; unknown; Westbury; c. 1925; Bullard, Roger G.; unknown; NEFD; unknown; unknown; unknown; unknown

BIBLIOGRAPHY: ARTS (31), May 1929: 73

Stewart, Glenn

unknown; unknown; unknown; unknown; unknown; unknown; Locust Valley; unknown; Hopkins, Alfred; unknown; TWEC; NA; unknown; unknown; Y

BIBLIOGRAPHY: ARTR (33), Feb. 1916: 38; INVE, 1928

Stewart, H. J.

unknown; unknown; unknown; Canon Hill; E; Ridge Road; Laurel Hollow; c. 1911; unknown; unknown; SHIN; NA; James, O. B.; Dwyer, Martin, Jr.; Y

BIBLIOGRAPHY: NASU, 1976; SAVG

Stewart, W. A. W.

unknown; unknown; de Forest, Frances; Edgeover; E; unknown; Cold Spring Harbor; unknown; Atterbury, Grosvenor; Olmsted Brothers; unknown; NA; unknown; unknown; Y

BIBLIOGRAPHY: LOIS, June 10, 1910; COUN (34), Oct. 1918: 43; SORG; FLON

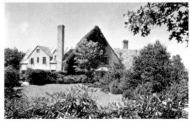

Stimson, Henry L.

unknown; c. 1950; White, Mabel; Highhold; unknown; unknown; Huntington; c. 1903; unknown; unknown; SHIM; c. 1960; Council of Boy Scouts; unknown; N

BIBLIOGRAPHY: *Our Town Huntington*, Apr. 1936

Stone, Charles A.

unknown; unknown; unknown; unknown; E; Duck Pond Road; Matinecock; c. 1927; Bosworth, W. Welles; Tibbets, Armand J.; GRRM; NA; Gilmour, L.; unknown; Y

BIBLIOGRAPHY: INVE

Stone, Charles A.

unknown; unknown; unknown; unknown; E; Duck Pond Road; Matinecock; c. 1927; Stone, Charles A.; unknown; GRRM; NA; Foy, Thelma Chrysler; Doubleday, Nelson; Y

BIBLIOGRAPHY: INVE; ARLG, 1927

Stoppani, J. H.

unknown; unknown; unknown; Liberty Hall; E; Ocean Avenue; Bayport; c. 1897; Green, Isaac Henry; unknown; CLRV; NA; Cox, Stephen P.; unknown; Y

BIBLIOGRAPHY: INVE

Stow, W. L.

unknown; unknown; unknown; unknown; unknown; Phipps Road; Roslyn; 1902; Pope, John Russell; unknown; unknown; c. 1960; Crocker, George; Phillips, Henry C.; N

BIBLIOGRAPHY: ARRC (17), Apr. 1905: 271; ATLA, 1907: 158; TOWN, May 1908: 28; ARRV (10), Dec. 1903: 178; REAL (81), Apr. 1908: 704; WURT; ARTS (2), Dec. 1911: 53; FERR, 1904: 12FF

Straight, Willard D.

1880; 1918; Whitney, D. P.; Applegreen; unknown; unknown; Old Westbury; c. 1913; Delano & Aldrich; Farrand, Beatrix; SHIN; c. 1970; Elmhurst, Mrs. Leonard; unknown; N

BIBLIOGRAPHY: ELWO, 1924: 37; WWIA (I): 1196; BRIC (25), Apr. 1916; TOWN, Feb. 1915: 23; SORG; NASS; LHGD (2), 1917

Strong, Selah

unknown; unknown; unknown; The Cedars; E; Strongs Neck Lane; Setauket; c. 1879; Diaper, Frederick; unknown; HVGO; NA; Strong, Ms. Kate; unknown; Y

BIBLIOGRAPHY: FAML

Strong, Theron G.

1846; 1924; Prentice, Martha; unknown; unknown; Pentaquit Avenue; Bay Shore; 1890; Romeyn & Stever; unknown; unknown; unknown; Healey, John; unknown; N

BIBLIOGRAPHY: AABN (28), Apr.–June 1890: 123; WWIA: 1245

Suarez, Mrs. Diego

unknown; unknown; Marshall, Evelyn; Easton; E; Muttontown Road; Syosset; c. 1931; Adler, David; Innocenti & Webel; GRRV; c. 1953; unknown; unknown; N

BIBLIOGRAPHY: SORG; LAPE (27), Oct. 1936: 195; PREV; INVE

Sutton, Frank

unknown; unknown; Bauman, Jane; The Farm House; unknown; Deer Park Road; Babylon; c. 1916; unknown; unknown; TWEC; unknown; unknown; unknown; N

BIBLIOGRAPHY: GOTT, 1932; SORG

Swan, Edward H.

unknown; unknown; Paris, Katherine; Ever-greens; E; Cove Neck Road; Oyster Bay; c. 1859; Ritch, John W.; unknown; FSCE; NA; Mather, William; unknown; Y

BIBLIOGRAPHY: NLRF; SORG; NASU

Tailer, Thomas S.

unknown; unknown; Baker, Florence; Beaupre; E; Horse Hollow Road; Lattingtown; 1932; Walker & Gillette; unknown; NFRM; NA; Howe, Polly Brooks; Tower, Roderick; Y

BIBLIOGRAPHY: INVE

Talmadge, Thomas Hunt

unknown; unknown; Ketcham, Mary; Sweet-water Farm; unknown; unknown; Hauppauge; c. 1920; Hoffman, F. Burrall; unknown; CLOL; unknown; unknown; unknown; N

BIBLIOGRAPHY: HEWI, 1925; SORG; COUN (49), Apr. 1926: 57

Talmadge, William

unknown; unknown; unknown; unknown; E; Brewster Lane; Bellport; 1904; Kirby, Petit & Green; unknown; SHIN; NA; French, Dr. William; Damask, Arthur P.; Y

BIBLIOGRAPHY: FAML

Taylor, Bertrand L.

unknown; unknown; unknown; unknown; E; Chicken Valley Road; Locust Valley; c. 1920; Lindeberg, Harrie T.; unknown; NFRR; NA; unknown; unknown; Y

BIBLIOGRAPHY: ARRC (55), Apr. 1924: 339; LINB

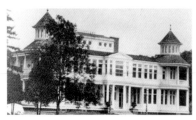

Taylor, George C.

unknown; unknown; unknown; unknown; unknown; unknown; Moriches; c. 1884; unknown; unknown; unknown; unknown; Heckscher State Park; unknown; N

BIBLIOGRAPHY: MCKI, 1978: 147; BROD; INVE; VAND

Taylor, H. C.

unknown; unknown; Jennings; Cherridore; E; Snake Hill Road; Cold Spring Harbor; c. 1923; Butler & Corse; unknown; NFRR; NA; unknown; unknown; Y

BIBLIOGRAPHY: INVE; ARRC (59), June 1926: 555

Taylor, James B., Jr.

unknown; unknown; unknown; Little Waddingfield; E; unknown; Glen Cove; c. 1922; Lindeberg, Harrie T.; unknown; COTS; NA; Horvath; unknown; Y

BIBLIOGRAPHY: COUN (43), Nov. 1922: 57; NCAB

Taylor, Myron C.

unknown; 1957; unknown; Underhill Farm; L; Factory Pond Road; Lattingtown; c. 1924; Lindeberg, Harrie T.; Vitale & Geiffert; TWEC; NA; unknown; Protestant Episcopal Diocese; Y

BIBLIOGRAPHY: INVE; ARFO (38), Mar. 1923: 141; SORG; INVE (41), Oct. 1924: 164; HEWI; ARFO (41), Oct. 1924: 164; NCAB

Taylor, Talbot J.

unknown; unknown; Keene, Jessie; Talbot House; unknown; Longwood Crossing; Cedarhurst; c. 1895; Lamb & Rich; unknown; HTRV; c. 1914; unknown; unknown; N

BIBLIOGRAPHY: NYTI, 1938; FERR, 1904: 260F; OBGU, Dec. 25, 1914; SORG; INVE; SAAB (39), June 1905: 113

Terbell, Henry S.

1820; 1900; unknown; Maidstone Hall; E; Ocean Avenue; East Hampton; c. 1870; unknown; unknown; CLRV; NA; Kennedy, Arthur; Gardiner, Robert; Y

BIBLIOGRAPHY: INVE; TOWN, June 1926: 12

Thaw, Josiah Copley

1875; 1944; Thompson, M.; Windbreak; unknown; Gin Lane; Southampton; c. 1911; unknown; Farrand, Beatrix; MEVI; c. 1938; unknown; unknown; N

BIBLIOGRAPHY: INVE, 1979; HICK; PRLN, 1985

Thayer, Kendall

unknown; unknown; unknown; unknown; E; Forest Drive; Sands Point; c. 1900; Gibson, Robert W.; unknown; CLRV; NA; Thayer, Francis; Siegel, Edward; Y

BIBLIOGRAPHY: INVE

Thierot, Charles H.

unknown; unknown; Thornton, Frances; Cedar Hill; E; unknown; Oyster Bay; c. 1919; O'Connor, James W.; unknown; NEFD; NA; unknown; unknown; Y

BIBLIOGRAPHY: OCOR; SORG; INVE

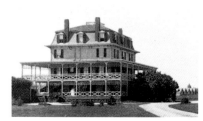

Thomas, Dr. T. Gaillard

unknown; unknown; unknown; unknown; unknown; Gin Lane; Southampton; c. 1877; unknown; unknown; FSCE; c. 1910; unknown; unknown; N

BIBLIOGRAPHY: PELL

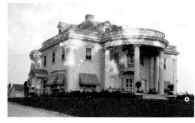

Thompson, L. A.

1848; 1919; Nixon, Ada; Marcada; unknown; Duke Place; Glen Cove; c. 1905; unknown; unknown; CLCO; c. 1950; Appleby, E. S.; unknown; N

BIBLIOGRAPHY: COUN (16), June 1909: 140; NCAB; HICK; INVE

Thompson, William P.

unknown; unknown; Blight, Edith; Longfields; unknown; Route 25; Westbury; c. 1910; Carrère & Hastings; unknown; NEFM; unknown; Preston, William P. T.; unknown; N

BIBLIOGRAPHY: VIEW; HICK; ARRC (27), Jan. 1910; HOUS (55), Apr. 1925: 375; SORG

Thorn, Conde

unknown; unknown; Floyd-Jones; Little Unqua; unknown; Merrick Road; Massapequa; unknown; unknown; Patterson, Harold T.; unknown; unknown; unknown; unknown; N

BIBLIOGRAPHY: HICK; COUN (50), June 1926: 40

Thorne, Landon K.

unknown; 1964; Loomis, Julia; Thorneham; unknown; Montauk Highway; Bay Shore; c. 1928; Dominick, William F.; Vitale, Ferruccio; TUDR; 1976; unknown; unknown; N

BIBLIOGRAPHY: SORG; ARLG (44), 1929; ARTS (38), Mar. 1933: 27; COUN (56), May 1929: 57; HOWE, 1933; ARAT (15), Apr. 1931: 441F; ARTS (32), Feb. 1930: 48; GOTT; INVE; SPUR (42), Sept. 1928: 83

Thornhill

unknown; unknown; unknown; unknown; E; Overlook Road; Lattingtown; unknown; unknown; unknown; NEFD; NA; unknown; unknown; Y

BIBLIOGRAPHY: INVE

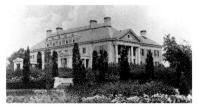

Thornton, William D.

unknown; unknown; unknown; Villa Me Mo; unknown; Gate Road; St. James; unknown; unknown; unknown; GRRM; c. 1950; unknown; unknown; N

BIBLIOGRAPHY: INVE; NCAB; SORG

Thorp, Joseph Greenleaf

1862; 1934; unmarried; unknown; E; Woods Lane; East Hampton; c. 1893; Thorp, Joseph Greenleaf; unknown; HTRV; NA; Bock, Mr. and Mrs. Louis; unknown; Y

BIBLIOGRAPHY: FYMC, 1941; FOST, 1977; EHHE; INVE

Thurber, F.

unknown; unknown; unknown; unknown; unknown; Pentaquit Avenue; Bay Shore; c. 1881; Hardenburg, Henry G.; unknown; QUAN; unknown; Hubbard, H. B.; unknown; N

BIBLIOGRAPHY: BABY, 1902; ARRC, 1897

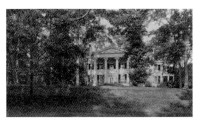

Tiffany, Mrs. Charles L.

unknown; c. 1898; Young, Harriet; Elmwood; E; Oyster Bay Cove Road; Oyster Bay; c. 1863; unknown; unknown; CLRV; NA; unknown; unknown; Y

BIBLIOGRAPHY: HEWI, 1927; LOIS, Apr. 21, 1902; WWIA (1): 1239

Tiffany, Louis Comfort

1848; 1933; Knox, Louise W.; Laurelton Hall; unknown; Laurel Hollow Road; Laurel Hollow; 1904; Tiffany, Louis C.; unknown; TWEC; 1957; Tiffany Foundation; unknown; N

BIBLIOGRAPHY: TOWN, Sept. 1913: 24; LOIS, May 13, 1904; SORG; WWIA: 1239; ARTS (14), Feb. 1921: 273; COUN (15), Dec. 1908: 157; SPUR, Aug. 1914: 25 ARLG (22), 1907

Tiffany, Perry

unknown; unknown; unknown; unknown; E; Jericho Turnpike; Westbury; c. 1891; Gage & Wallace; unknown; GRRM; NA; Park, William; Bingham, H. P.; Y

BIBLIOGRAPHY: TOWN, July 1925: 4; ARTR (3), Jan. 1901: 17

Tilford, Frank

1852; c. 1924; unknown; unknown; unknown; unknown; Cedarhurst; unknown; Harris, A. J.; unknown; SHIN; unknown; unknown; unknown; N

BIBLIOGRAPHY: *Architectural Era* (4), Mar. 1890: 58

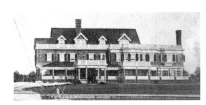

Timmermann, H. G.

unknown; unknown; Fry, Kate; Breeze Lawn; unknown; Ocean Avenue; Islip; c. 1900; unknown; unknown; CLRV; unknown; unknown; unknown; N

BIBLIOGRAPHY: VAND

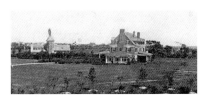

Timpson, James L.

unknown; unknown; unknown; unknown; unknown; Willow Road; Woodmere; c. 1909; unknown; unknown; CLRV; unknown; unknown; unknown; unknown

BIBLIOGRAPHY: HICK; RUTH

Tinker, Edward L.

unknown; unknown; McKee, Frances; unknown; E; Birchwood Drive; Setauket; c. 1923; Goodwin, Philip; unknown; CLRV; NA; unknown; unknown; Y

BIBLIOGRAPHY: Three Village Historical Society

Tinker, Henry C.

1849; unknown; Laroque, Louise; Briarcroft; unknown; Van Brunt Manor Road; Setauket; c. 1890; Lamb & Rich; unknown; SHIM; 1923; unknown; unknown; N

BIBLIOGRAPHY: Three Village Historical Society; WWIA: 1276

Toerge, Norman

unknown; unknown; Register, Katherine; The Hitching Post; E; Piping Rock Road; Matinecock; c. 1920; Major, Howard; unknown; TWEC; NA; unknown; unknown; Y

BIBLIOGRAPHY: ARTS (21), May 1924: 12; INVE; ARFO (38), Mar. 1, 1923: 115; SORG

Tower, Roderick

unknown; unknown; Whitney, Flora; unknown; S; Route 25A; Brookville; c. 1924; Delano & Aldrich; unknown; NFRM; NA; Miller, George MacCulloch; N.Y.I. of Technology; Y

BIBLIOGRAPHY: BEAU: 114; INVE

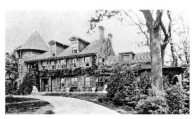

Townsend, Edward N.

unknown; unknown; Greenough, Alice; Townsend Place; E; East Main Street; Oyster Bay; c. 1906; unknown; unknown; SHIM; NA; Bowen, David; unknown; Y

BIBLIOGRAPHY: PREV

Townsend, J. Allen

unknown; unknown; Hawkins, Viola; Forest Edge; E; unknown; Locust Valley; c. 1914; unknown; unknown; unknown; NA; unknown; unknown; Y

BIBLIOGRAPHY: VIEW; SORG; TOWN, May 1915: 12

Townsend, James

unknown; unknown; Sherwood, Cynthia; Brookshot; E; unknown; St. James; c. 1931; Bottomley, William; unknown; GRRV; NA; unknown; unknown; Y

BIBLIOGRAPHY: SORG; PREV; INVE

Trevor, H. G.

unknown; unknown; Schiejjelin, M.; Meadowmere; E; Coopers Neck Lane; Southampton; c. 1910; Atterbury, Grosvenor; unknown; COTS; NA; unknown; unknown; Y

BIBLIOGRAPHY: INVE; BRIC (22), Nov. 1913; SORG

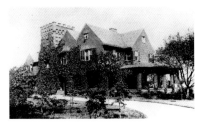

Truslow, F. C.
unknown; unknown; unknown; unknown; unknown; Great River Road; Great River; unknown; unknown; unknown; SHIN; unknown; Stewart, James; unknown; N

BIBLIOGRAPHY: VAND, 1912

Tuckerman, Walter
unknown; unknown; unknown; unknown; unknown; unknown; Oyster Bay; c. 1882; McKim, Mead & White; unknown; unknown; unknown; unknown; unknown; N

BIBLIOGRAPHY: MCKI, 1978: 151

Tully, William John
c. 1870; unknown; Houghton, Clara; unknown; E; Feeks Lane; Mill Neck; c. 1916; Murchinson, Kenneth; Capan, Harold A.; TUDR; NA; Winter, Albert C.; unknown; Y

BIBLIOGRAPHY: ARLG, 1927; SPUR, 1916; WWIA; INVE; ARFO, Mar. 1916: 25

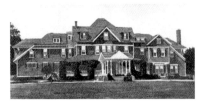

Turnbull, G.T.
unknown; unknown; unknown; The Pines; unknown; South Country Road; Bay Shore; c. 1900; unknown; unknown; SHIN; unknown; unknown; unknown; N

BIBLIOGRAPHY: VAND

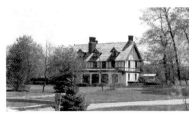

Turner, Thomas M.
unknown; unknown; Winthrop, Mary; Never Never Land; E; Westmoreland Drive; Shelter Island; c. 1900; unknown; unknown; HTRV; NA; Brander, Louis; Roe, John; Y

BIBLIOGRAPHY: INVE, 1978

Twining, Edmund S.
unknown; unknown; Brown, Ursula; Near By; E; Great Plains Road; Southampton; c. 1910; Adams, William; unknown; GRRV; NA; Hearst, Mrs. Millicent; unknown; Y

BIBLIOGRAPHY: INVE; ARRC (44), Oct. 1918: 355; SORG

Tyng, Lucien N.
unknown; unknown; Hunt, Ethel; The Shallows; E; Halsey Neck Lane; Southampton; c. 1930; Peabody, Wilson & Brown; unknown; INTL; NA; McDonnell, Mrs. James; Greve, William; Y

BIBLIOGRAPHY: GOTT, 1931; INVE; ARRC (70), Nov. 1931: 365; ARTS (39), Oct. 1933: 20; SORG

Underhill, Francis T.
1863; 1929; unknown; unknown; unknown; East Main Street; Oyster Bay; c. 1885; Post, George B.; unknown; SHIN; c. 1950; Weidenfeld, Camille; Shonnard, Horatio S.; N

BIBLIOGRAPHY: ARRV (24), 1918; AAAA (122), 1922: 2400; ARAT (1), Jan. 1924; ARLG (37), 1922; BARD, 1924

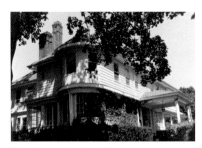

Van Brunt, Arthur H.
1866; 1951; unknown; unknown; E; Ocean Avenue; East Hampton; 1907; Lawrence, John C.; unknown; SHIM; NA; unknown; unknown; Y

BIBLIOGRAPHY: EHHE

Van Cott
unknown; unknown; unknown; unknown; E; West Shore Road; Mill Neck; unknown; unknown; unknown; CLOL; NA; unknown; unknown; Y

BIBLIOGRAPHY: INVE

Vanderbilt, William K., Sr.
unknown; unknown; Smith, Alva; Idle Hour I; unknown; Idle Hour Boulevard; Oakdale; c. 1878; Hunt, Richard Morris; unknown; STIK; c. 1899; unknown; unknown; N

BIBLIOGRAPHY: LOIS, Apr. 15, 1899; INVE; VAND

Vanderbilt, William K., Sr.
1849; 1920; Smith, Alva; Idle Hour; S; unknown; Oakdale; c. 1900; Hunt, Richard Howland; unknown; FBAT; NA; Oakdale Club; Dowling College; Y

BIBLIOGRAPHY: ARRC (10), July 1900: 1; HEWI; VIEM, 1974: 115; ARRC (13), May 1903: 455F

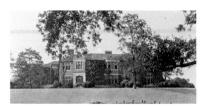

Vanderbilt, William K., Sr.
unknown; unknown; unknown; Stepping Stones; unknown; Cedar Swamp Road; Jericho; c. 1915; unknown; Patterson, Harold T.; TUDR; unknown; Smith, Ormond, G.; unknown; N

BIBLIOGRAPHY: HEWI; LOIS, Mar. 1921; LEVA, 1916

Vanderbilt, Mrs. W. K., Jr.
unknown; unknown; Fair, Virginia; unknown; unknown; unknown; Jericho; c. 1911; Pope, John Russell; Du Chene, M.; TUDM; unknown; Sage, Henry; unknown; N

BIBLIOGRAPHY: VIEW; AAAA (131), 2520, 1927: 565

Vanderbilt, William K., Jr.
1878; 1944; Fiar, Virginia; Eagle's Nest; M; Little Neck Road; Centerport; c. 1912; Warren & Wetmore; unknown; NSPR; NA; Vanderbilt; Vanderbilt Museum; Y

BIBLIOGRAPHY: VIEM, 1974: 117; TOWN, Oct. 1928: 45

Vanderbilt, William K., Jr.
unknown; unknown; Fair, Virginia; Deepdale; unknown; unknown; Great Neck; unknown; Carrère & Hastings; unknown; GRRV; c. 1970; unknown; unknown; N

BIBLIOGRAPHY: ARRC (27), Jan. 1910: 83; AMHO (2), Feb. 1906: 227; GREA; COUN (20), May 1911: 19; ARTS (3), Nov. 1912: 1; AJRP (1), 1924: 100; SPUR, Jan. 1914: 27

Vandeveer, S. L.
unknown; unknown; unknown; unknown; unknown; unknown; Great Neck; c. 1926; Ward, Leroy P.; unknown; NFRM; NA; unknown; unknown; Y

BIBLIOGRAPHY: ARRC (60), Sept. 1926: 225

Van Ingen, Mrs. Lawrence B.
unknown; 1978; Pratt, Harriet; Preference; E; Old Tappan Road; Glen Cove; 1925; Carrère & Hastings; unknown; GRRM; NA; Van Ingen, Lawrence; Woods, Ward; Y

BIBLIOGRAPHY: HEWI, 1925; INVE; SORG; NRNF, 1980

Von Stade, F. S.
1884; 1967; Steele, Kathryne; unknown; E; Powell's Lane; Westbury; c. 1914; Cross & Cross; Lewis & Valentine; NEFM; NA; unknown; unknown; Y

BIBLIOGRAPHY: WURT; ARTR (31), Mar. 1915; SORG; LEVA, 1916

Voorhees, J. D.
unknown; unknown; unknown; unknown; E; Dunmere Lane; East Hampton; c. 1913; Lawrence, J. C.; unknown; LTAM; NA; Taylor, Irene; unknown; Y

BIBLIOGRAPHY: EHHE: 190; INVE

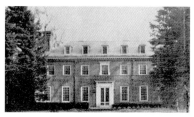

Wagner, Edward H.
unknown; unknown; unknown; Eventide; E; Cedar Swamp Road; Brookville; c. 1937; unknown; unknown; GRRM; NA; unknown; unknown; Y

BIBLIOGRAPHY: PREV; INVE, 1981

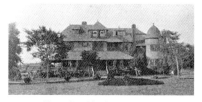

Wagstaff, Col. Alfred
1844; 1921; Barnard, Mary; Apokeepsing; unknown; South Country Road; West Islip; c. 1870; unknown; unknown; QUAN; unknown; unknown; unknown; N

BIBLIOGRAPHY: BKLY, Aug. 1907: 3; VAND

Wainwright, Carroll
unknown; unknown; Gould, Edith C.; Gullcrest; E; Apaquoque Road; Southampton; c. 1920; Stout, Penrose V.; unknown; NEFM; NA; unknown; unknown; Y

BIBLIOGRAPHY: SORG; HEWI, 1928

Wales, Salem H.
unknown; unknown; unknown; Ox Pasture; unknown; unknown; Southampton; c. 1880; Carrère & Hastings; unknown; unknown; unknown; unknown; unknown; N

BIBLIOGRAPHY: PELL; ARRC (27), Jan. 1910: 120

Waller, Robert
1850; 1915; Stewart, Emily; Vyne Croft; E; First Neck Lane; Southampton; c. 1900; Atterbury, Grosvenor; unknown; CLCO; NA; unknown; unknown; Y

BIBLIOGRAPHY: INVE; SORG; PREV; NYTI, Feb. 22, 1915

Ward, Artemus
unknown; unknown; Robinson, Rebeca; Wautauchit; E; Shorewood Drive; Shelter Island; 1892; unknown; unknown; SHIN; NA; Gangle, Jean Garr; unknown; Y

BIBLIOGRAPHY: INVF, 1978

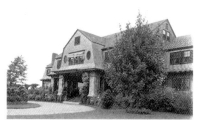

Ward, Mortimer
unknown; unknown; Post, Mary K.; Elkhurst; E; Feeks Lane; Lattingtown; unknown; unknown; unknown; SHIN; NA; unknown; unknown; Y

BIBLIOGRAPHY: INVE; HICK; SORG

Warner, Eltinge
unknown; unknown; Eaton, Ruth; Cima Del Mundo; E; Lily Pond Lane; East Hampton; c. 1926; Tappan, Robert; unknown; SPCM; NA; Olin, John M.; unknown; Y

BIBLIOGRAPHY: HEWI, 1927; INVE; EHHE: 199; ARTS (28), Feb. 1928: 52

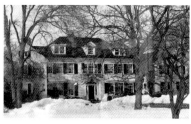

Warner, H. W.
unknown; unknown; unknown; Northway; E; Feeks Lane; Lattingtown; c. 1906; unknown; unknown; NEFD; NA; McNair, Wm. B.; unknown; Y

BIBLIOGRAPHY: INVE

Watriss, Frederick
unknown; unknown; unknown; unknown; S; unknown; Greenvale; unknown; Delano & Aldrich; unknown; NFRR; NA; Preston, L. H.; N.Y.I. of Technology; Y

BIBLIOGRAPHY: INVE; PREV; PHDA, 1922: 34; ARLG, 1923; COUN (46), Sept. 1924: 38

Watson, Walter
unknown; unknown; Burrill, Beatrice; unknown; unknown; unknown; unknown; Roslyn; unknown; unknown; unknown; unknown; unknown; unknown; unknown; unknown

BIBLIOGRAPHY: ELWO, 1924: 145; SORG

Webb, James Watson
1884; 1960; Havemeyer, Eleanor; Woodbury House; G; Jericho Turnpike; Syosset; c. 1915; Cross & Cross; unknown; TUDR; NA; Tinker, Edward, R; Syosset Community Center; Y

BIBLIOGRAPHY: SPUR (23), Apr. 1919: 2; TOWN, Jan. 1919: 26; COUN (37), Apr. 1920: 17; COHO (3), Oct. 1921: 73; ARRC (46), Oct. 1919: 312; HICK; TOWN, Jan. 1919: 26; SORG; *Life Magazine*, July 1946: 73; NCAB

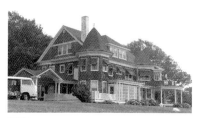

Webber
unknown; unknown; unknown; Alturas; unknown; unknown; Shelter Island; unknown; unknown; unknown; CLRV; NA; unknown; unknown; Y

BIBLIOGRAPHY: INVE

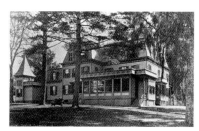

Weekes, John A.
unknown; unknown; unknown; The Other House; unknown; Main Street; Oyster Bay; unknown; unknown; unknown; FSCE; NA; Weekes, Mrs. Arthur D., Jr.; unknown; Y

BIBLIOGRAPHY: FAML

Weeks, Harold H.
unknown; unknown; Peters, Louise; Wereholme; E; South Bay Avenue; Islip; c. 1917; Atterbury, Grosvenor; unknown; NFRM; NA; unknown; unknown; Y

BIBLIOGRAPHY: SORG; AABN (121), 1922; INVE; FAML

Weicker, Theodore
1861; 1940; Palmer, Florence; unknown; s; Frost
Mill Road; Mill Neck; unknown; unknown;
unknown; NEIR; NA; Mill Neck Manor School
for Deaf; unknown; Y

BIBLIOGRAPHY: INVE, 1978; NCAB

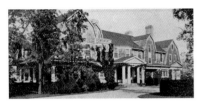

Weir, L. C.
unknown; c. 1910; Weibel, Mary; The Hedges;
unknown; Shelter Lane; Lattingtown; c. 1905;
unknown; unknown; SHIN; unknown; Stettin-
ius, Edward; unknown; N

BIBLIOGRAPHY: WWIA (1): 1317; INVE, 1978; PREV;
TOWN, Sept. 1905: 153

Weld, Francis Minot
1875; 1949; White, Margaret Low; Lulworth; E;
Westview Drive; Lloyd Harbor; 1912; Platt,
Charles A.; Platt, Charles A.; NEFD; NA; Peters;
unknown; Y

BIBLIOGRAPHY: ARRC (50), Oct. 1921: 255; AAAA
(108), July 1915; INVE; LOIS, Mar. 29, 1921; PLAS;
AVER; SORG

Wellis, W. Bosworth
unknown; unknown; unknown; Old Trees;
E; Duck Pond Road; Matinecock; c. 1921;
Bosworth, W. Welles; unknown; NECL; NA;
Franklin, P. A. S., Jr.; unknown; Y

BIBLIOGRAPHY: INVE

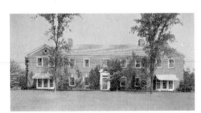

Wellman, R.
unknown; unknown; Smith, Evelyn; Penderell;
E; Mill River Hollow Road; Oyster Bay; c. 1933;
unknown; unknown; GRRV; NA; unknown;
unknown; Y

BIBLIOGRAPHY: GOTT

Wetherill, Mrs. Joseph
1852; 1908; Smith, Kate; unknown; E; Harbor
Hill Road; St. James; c. 1894; McKim, Mead &
White; White, Stanford; CLOL; NA; Wetherill,
Isabella; unknown; Y

BIBLIOGRAPHY: NRNF, 1992; MCKI

Wetmore, Charles W.
1854; 1919; Bisland, Eliza; Applegarth; unknown;
Centre Island Road; Centre Island; c. 1892;
Renwick, Aspinwall & Owen; unknown; HTRV;
c. 1940; Nichols, Wm. T.; unknown; N

BIBLIOGRAPHY: ARTR (2), Oct. 1900: 366; ARTR
(5), May 1902: 131F; ARRC (13), Mar. 1903: 279F;
PREV; COUN (18), Oct. 1910: 657; WURT; ARTR (1),
1900: 334; NCAB

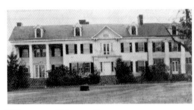

Wetmore, Edmund
unknown; c. 1918; unknown; unknown; E;
Cedar Lane; Glen Cove; c. 1900; unknown; un-
known; CLRV; NA; Stearns, J. N.; Sobelman; Y

BIBLIOGRAPHY: HICK; PREV, 1937; INVE, 1978

Wheelock, William Almy
1825; 1905; Efner, Harriet; unknown; E; Apaquo-
gue Road; East Hampton; c. 1891; Green, Isaac
Henry; unknown; GRRV; NA; unknown;
unknown; Y

BIBLIOGRAPHY: EHHE

Wheelock, Dr. William E.
1852; 1926; Hall, Emily; Wutherie; E; Georgia
Rd.; East Hampton; 1890; Green, Isaac Henry;
unknown; DCMD; NA; Wheelock, John H.;
unknown; Y

BIBLIOGRAPHY: FOST, 1977; FYMC, 1941: 25; EHHE

White, A. M., Jr.
unknown; unknown; Linmar, Evelyn; Hickory
Hills; E; unknown; Oyster Bay; c. 1915; Kimball
& Husted; unknown; NEFM; NA; unknown; un-
known; Y

BIBLIOGRAPHY: ARRC (84), Nov. 1938: 113; SORG

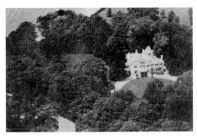

White, Alfred W.
unknown; unknown; unknown; The Lindens;
unknown; West Shore Road; Kings Point;
c. 1900; unknown; unknown; FSCE; c. 1950; un-
known; unknown; N

BIBLIOGRAPHY: PREV

White, G. W.
unknown; unknown; Curtis, Sylvia; White-
lodge; E; Rogers Canoe Hollow Road; Mill
Neck; unknown; Epskine, Harold; unknown;
NFRR; NA; unknown; unknown; Y

BIBLIOGRAPHY: SORG; INVE

White, Julius A.
unknown; unknown; unknown; unknown; un-
known; unknown; Mill Neck; c. 1928; Carrère
& Hastings; unknown; NEFD; unknown; un-
known; unknown; unknown

BIBLIOGRAPHY: AVER

White, R. K.
unknown; unknown; unknown; unknown; E;
Cleft Road; Mill Neck; unknown; Fuller &
Dick; unknown; unknown; NA; unknown; un-
known; Y

BIBLIOGRAPHY: INVE

White, Raymond S.
unknown; unknown; unknown; unknown;
unknown; Cutting Avenue; Great River; c. 1899;
Thain, Charles C.; unknown; unknown; un-
known; unknown; Dr. Stewart; N

BIBLIOGRAPHY: LIFO (55), May 1982: 94; VAND

White, Stanford
1853; 1906; Smith, Bessie; Boxhill; E; Moriches
Road; St. James; 1884; McKim, Mead & White;
unknown; CLRV; NA; unknown; White family; Y

BIBLIOGRAPHY: AMER, 1976: 72; HICK; FERR,
1906: 204; MCKI, 1978: 163; ELWO, 1924: 171;
SORG; WWIA (1): 1336; FERR, 1904: 138F

White, T. F.
unknown; unknown; unknown; unknown;
unknown; White Drive; Cedarhurst; c. 1901;
McIlvane & Tucker; unknown; TUDR; un-
known; unknown; unknown; N

BIBLIOGRAPHY: AABN (71), Jan.–Mar. 1901: 1318R

Whitehouse, Norman De R.
unknown; unknown; unknown; Green
Court; E; Wheatley Road; Brookville; c. 1920;
Bottomley, William L.; unknown; GRRM; NA;
Robertson, Julian H.; unknown; Y

BIBLIOGRAPHY: ARTR, Apr. 1931; INVE

Whitney, Cornelius V.
unknown; unknown; unknown; unknown; s;
unknown; Wheatley Hills; c. 1942; Beers &
Farley; unknown; unknown; NA; unknown;
N. Y. Institute Technology; Y

BIBLIOGRAPHY: FAML

Whitney, George
1885; 1963; Bacon; unknown; E; unknown;
Westbury; 1915; Delano & Aldrich; unknown;
TWEC; NA; Glass, Harry; unknown; Y

BIBLIOGRAPHY: NCAB; ARFO (29), July 1918;
HOWE, 1933; ARRC (52), Oct. 1922: 276; AVER;
ARRC, July 1923: 49

Whitney, Mrs. Harry P.
1875; 1942; Vanderbilt, G.; Studio; E; Wheatley
Road; Roslyn; c. 1918; Delano & Aldrich;
Leavitt & Aldrich; FRNC; NA; Leboutillier, Mrs.
Thomas E.; unknown; Y

BIBLIOGRAPHY: ARRC (54), July 1923: 47; COUN
(37), Feb. 1920: 25; ARLG (28), 1913; LHDG (2),
1917: 103; LHDG (2), 1917: 162; MCKI, 1978: 164;
COUN (46), Sept. 1924: 40; TOWN, Mar. 1914: 31;
ARRV (25), Jan. 1919; SORG; ELWO, 1924: 32; WWIA
(11), 1950: 574; PATT, 1924: 9; AAOT: 134

Whitney, Mrs. Howard
unknown; unknown; unknown; unknown;
unknown; unknown; Glen Cove; c. 1916; Major,
Howard; Pendelton, Isabella; unknown; c. 1962;
unknown; unknown; N

BIBLIOGRAPHY: ARLG, 1925; PROM, 1916

Whitney, John Hay
unknown; unknown; unknown; Greentree; E;
Lake Road; Manhasset; c. 1928; La Farge,
Warren & Clark; Brickerhoff, A. F.; SHIN; NA;
Kelly, John; unknown; Y

BIBLIOGRAPHY: SPUR (43), June 1929: 74; PREV;
SORG; LIFO, July 1981: 140; OBIT, Feb. 9, 1982;
AAAA (135), Apr. 1929: 511

Whitney, William Collins
1841; 1904; Payne, Flora; The Manse; unknown;
unknown; Westbury; c. 1900; McKim, Mead &
White; Olmsted Brothers; TWEC; c. 1942;
Whitney, Harry Payne; unknown; N

BIBLIOGRAPHY: TOWN, Nov. 1901: 28; *Gertrude
Vanderbilt Whitney*, B. F. Friedman, 1978; HICK;
DESM, 1903; NYTI, Nov. 30, 1959; *New York
Tribune*, Sept. 14, 1902: 8

Whitney, William Payne
1876; 1927; Hay, Helen; Greentree; E; unknown;
Manhasset; c. 1903; D'Hauteville & Cooper;
Lowell, Guy; DCMD; NA; Whitney, John Hay;
Whitney; Y

BIBLIOGRAPHY: RAND; HEWI; COUN (26), Aug.
1914: 42; ARBD (36), June 1904: 394; ARBJ (6),
Apr. 1905: 62; SORG; HICK; MASS: 79; ARRV (13),
Feb. 1906: 30-8

Whiton, Henry D.
1871; 1930; Frasch, Frieda; unknown; s; un-
known; Hewlett; c. 1916; Bossom, Alfred C.;
unknown; unknown; NA; unknown; Lawrence
Country School; Y

BIBLIOGRAPHY: ARLG, 1923; NCAB

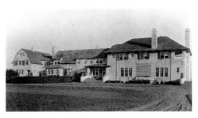

Wiborg, Frank Bestow
1855; 1930; Sherman, Adelia; Dunes; unknown;
unknown; East Hampton; c. 1915; unknown;
unknown; TWPC; unknown; unknown; un-
known; N

BIBLIOGRAPHY: HEWI; SORG; WWIA (1): 1342

Wilkeson, Samuel
unknown; unknown; unknown; unknown;
unknown; unknown; Bridgehampton; 1875;
Gambrill & Richardson; unknown; QUAN;
unknown; unknown; unknown; N

BIBLIOGRAPHY: *The New York Sketch Book of
Architecture* (2), 1875

Willets, I. U.
unknown; unknown; unknown; Whispering
Wishes; E; Powerhouse Road; East Hills;
c. 1900; unknown; Parsons, Samuel; unknown;
NA; Auchincloss, Hugh; Twohig, Dr. Daniel; Y

BIBLIOGRAPHY: HICK

Williams, Arthur
1868; 1937; unknown; Greenridge; E; Bryant
Avenue; Roslyn; 1916; Hartman, Harold Victor;
unknown; TUDR; NA; Seligman, Josephine;
Briggs, Mead L.; Y

BIBLIOGRAPHY: ROSL

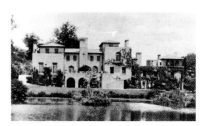

Williams, Arthur
unknown; unknown; unknown; Brook Corners;
C; Glenwood Road; Roslyn; c. 1920; unknown;
unknown; NSPR; NA; Swann Club; unknown; Y

BIBLIOGRAPHY: PREV

Williams, Harrison
1874; 1946; Strader, Mora; Oakpoint; unknown;
Bayville Avenue; Bayville; 1927; Delano &
Aldrich; Farrand, Beatrix, 1928–29; JACO; 1968;
Northland Corp.; unknown; N

BIBLIOGRAPHY: PRLN, 1985; SORG; SPUR (60),
Nov. 1937: 70; PREV; HOWE, 1933; FLON; AABN
(135), May 1929, 9: 567; NYTI, 1946

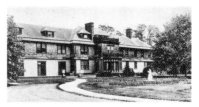

Williams, Percy G.
unknown; unknown; unknown; Pineacres; un-
known; unknown; East Islip; c. 1900; unknown;
unknown; SHIM; c. 1975; unknown; unknown; N

BIBLIOGRAPHY: VAND

Williams, Col. Timothy
unknown; unknown; Williams, Alice; Shore-
lands; E; Camel Hollow Road; Lloyd Harbor;
c. 1903; Miller, W. H.; unknown; TUDR; NA;
unknown; unknown; Y

BIBLIOGRAPHY: SORG; INVE; COHO, Aug. 1930: 5;
LOIS, May 19, 1905

Wilson, Mrs. C. Porter
unknown; unknown; unknown; unknown; E;
Horse Shoe Road; Mill Neck; c. 1928; Hart &
Shape; unknown; TUDR; NA; Wanner, Ernest P.;
Dane, Mrs. Chester; Y

BIBLIOGRAPHY: ARAT (10), May 1928: 186; HEWI,
1930; COUN (60), Oct. 1931: 35; ARAT (10), June
1927: 300; CLA (58), May 1930; INVE; PREV;
HOWE, 1933

Winslow, Edward
unknown; unknown; unknown; unknown; E;
unknown; Great Neck; c. 1887; McKim, Mead
& White; unknown; unknown; unknown;
unknown; unknown; N

BIBLIOGRAPHY: MCKI, 1978

Winthrop, Bronson
1863; 1944; unknown; unknown; unknown; unknown; Syosset; c. 1909; Delano & Aldrich; unknown; TWEC; c. 1980; Grisom, Lloyd P.; unknown; N

BIBLIOGRAPHY: AMCO, 1915: 4FF; TOWN, Dec. 1914: 24; *Antiques Magazine*, Aug. 1987; WWIA (II), 1950: 587; PHDA; LHDG.

Winthrop, E. L., Jr.
1361; 1926; unknown; Muttontown Meadow; M; Muttontown Road; Syosset; 1903; Delano & Aldrich; unknown; GRRV; unknown; Walker, Elisha; Nassau County; Y

BIBLIOGRAPHY: AABN (107), 1915; ARTR (41), Apr. 1920; HEWI; AABN (108), 1915; PHDA, 1922: 50; ARRC (54), July 1923: 59; TOWN, Feb. 1925: 85; AMCO: 240; PATT, 1924; TOWN, Nov. 1914: 16; LEVA; ARTS (23), July 1925: 42; BEAU, 1979: 149; TOWN, May 1921; WWIA

Winthrop, Henry Rogers
unknown; unknown; unknown; East Woods; unknown; unknown; Woodbury; c. 1910; D'Hauteville & Cooper; Lowell, Guy; GRRM; unknown; unknown; unknown; N

BIBLIOGRAPHY: HICK; COUN (43), Feb. 1923: 60; AIA correspondence/files; SORG

Winthrop, Robert
unknown; unknown; unknown; unknown; unknown; unknown; Old Westbury; c. 1897; McKim, Mead & White; unknown; CLRV; unknown; Winthrop, Beckman; unknown; N

BIBLIOGRAPHY: TOWN, May 1902; HICK; AVER

Winthrop, Robert M.
c. 1904; unknown; Ayer, Theodora; unknown; unknown; unknown; Westbury; c. 1932; Sedgewick, Henry R.; unknown; GRRV; unknown; unknown; unknown; N

BIBLIOGRAPHY: GOTT, 1933; COUN (66), July 1934: 74; COUN (65), Feb. 1934: 35; SORG

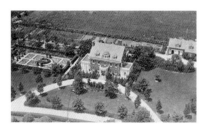

Wolf, J. S.
unknown; unknown; unknown; unknown; unknown; unknown; Woodmere; unknown; unknown; unknown; GRRM; unknown; unknown; unknown; unknown

BIBLIOGRAPHY: VIEW

Wood, Chalmers
1883; 1952; Pope, Ruby; Little Ipswich; E; Woodbury Road; Syosset; c. 1927; Delano & Aldrich; unknown; NECL; NA; unknown; unknown; Y

BIBLIOGRAPHY: COUN (65), Nov. 1933: 39; PREV; HOWE, 1933; NCAB; HEWI, 1931

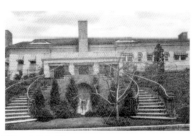

Wood, H. Hayes
unknown; unknown; unknown; Sterling; unknown; Horse Shoe Road; Mill Neck; c. 1906; unknown; unknown; CLRV; unknown; Hudson, H. K.; unknown; N

BIBLIOGRAPHY: INVE; PREV

Wood, James R.
unknown; unknown; unknown; Oak Openings; unknown; Laurel Hollow Road; Laurel Hollow; c. 1860; unknown; unknown; unknown; unknown; Tiffany, L. C.; Randall, Bruce; N

BIBLIOGRAPHY: INVE

Woodhouse, Lorenzo E.
unknown; unknown; Kennedy; Greycroft; E; Huntting Lane; East Hampton; c. 1894; Green, Isaac Henry; unknown; DCRV; NA; Rollins, Leighton; unknown; Y

BIBLIOGRAPHY: INVE; EHHE: 169

Woodhouse, Lorenzo E.
unknown; unknown; Kennedy; The Fens; unknown; Huntting Lane; East Hampton; c. 1904; Thorp, Joseph Greenleaf; unknown; SHIM; c. 1949; unknown; unknown; N

BIBLIOGRAPHY: INVE; EHHE: 91

Woodin, William H.
1868; 1934; Jessup, Annie; Dune House; E; Lily Pond Drive; East Hampton; c. 1916; Atterbury, Grosvenor; unknown; COTS; NA; Bruckman, D. J.; unknown; Y

BIBLIOGRAPHY: INVE: 192; INVE; NCAB, 1941: 70

Woolley, Daniel P.
unknown; unknown; Starr, Miriam; Wooldon; E; Sunks Misery; Lattingtown; c. 1925; Delehanty, Bradley; unknown; GRRV; NA; unknown; unknown; Y

BIBLIOGRAPHY: PREV; DELE, 1939; SORG; INVE; LOIS, Mar. 16, 1923; SPUR (43), 3, 1929: 11

Woolworth, Franklin W.
1852; 1919; Creighton, Jennie; Winfield Hall; R; Crescent Beach Road; Glen Cove; 1916; Gilbert, C. P. H.; Brinley & Holbrook; FRNC; NA; Woolworth, Jennie; Paul Corp.; Y

BIBLIOGRAPHY: LAPE; VIEW; INVE; INVE; WWIA (1): 1381; LAPE; SPUR (24), Oct. 1919; BEAU (1): 91; ARRC (47), Mar. 1920: 194; COUN (53), Nov. 1927: 17

Work, Bertham G.
unknown; unknown; unknown; Oak Knoll; E; Cleft Road; Mill Neck; c. 1916; Delano & Aldrich; unknown; NECL; NA; Trevor; unknown; Y

BIBLIOGRAPHY: PATT, 1924; ARRC (54), July 1923: 51; HEWI, 1920; INVE; COUN (37), Nov. 1919: 26; ARFO (41), Sept. 1924: 36; ARTS (31), Oct. 1929: 59; COUN (46), Sept. 1924: 36; PHDA: 8

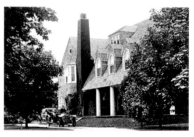

Wray, William H.
unknown; unknown; unknown; unknown; E; Awixa Avenue; Bay Shore; c. 1890; Wray, William H.; unknown; SHIN; NA; Lemmerman, Fred; Clarkson, William; Y

BIBLIOGRAPHY: BABY, 1902; INVE; VAND

Wright, W. de Forest
unknown; unknown; Higenham, Deephaven; E; Cedar Lane; Sands Point; c. 1900; Brite & Bacon; unknown; SHIN; NA; Alcott; Goldman, K. M.; Y

BIBLIOGRAPHY: COUN (5), Dec. 1903: 196; AMHO (2), Feb. 1906: 88; SORG

Wyckoff, Dr. Peter B.
unknown; unknown; Pillon, Cora; unknown; unknown; Gin Lane; Southampton; c. 1900; Barney & Chapman; unknown; HTRV; c. 1928; Donohue, Mrs. James P.; unknown; N

BIBLIOGRAPHY: COUN (72), May 1937: 8; SORG; HICK; *Treavor & Fatio*, Architectural Catalog Co. N.Y., 1932; FAML; ARRC (16), Sept. 1904: 252

Wyckoff, Walter

unknown; unknown; unknown; Twin Lindens; E; West Shore Road; Kings Point; c. 1920; Patterson, Chester A.; Fowler, Clarence; NEIR; NA; Wyckoff, Richard D.; unknown; Y

BIBLIOGRAPHY: ARAT (3), Oct. 1924; VIEW; COUN (52), June 1927: 66; HOUS (75), Jan. 1934: 47; INVE; GARD (39), June 1924: 288; COUN (50), May 1926: 76

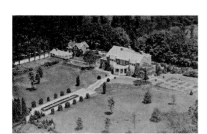

Wylie, H. G.

unknown; unknown; unknown; unknown; unknown; Kings Point Road; Kings Point; c. 1920; unknown; unknown; NEFD; unknown; Syosset Corp.; Hudson, Percy K.; N

BIBLIOGRAPHY: VIEW

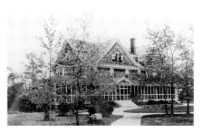

Yoakum, Benjamin F.

unknown; 1929; Bennett, Eliza; Meadow Farm; unknown; Round Swamp Road; Farmingdale; 1906; unknown; unknown; SHIM; unknown; Bethpage State Park; unknown; N

BIBLIOGRAPHY: INVE; WWIA (1): 1390; WWIA (1): 1390; LOIS, May 8, 1914; LOIS, Jan. 19, 1906

Young, Albert

unknown; unknown; unknown; Awixaway; unknown; Awixa Avenue; Bay Shore; c. 1880; unknown; unknown; QUAN; unknown; Coddinham, C. E.; Oelsner, Rudolph; N

BIBLIOGRAPHY: BABY, 1902; COUN (60), May 1931: 20

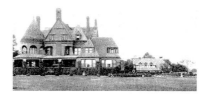

Young, Edward L.

unknown; unknown; Eager, Sybil; Meadow Farm; E; Duck Pond Road; Glen Cove; c. 1920; unknown; Vitale, Ferruccio; CLOL; NA; unknown; unknown; Y

BIBLIOGRAPHY: SORG; INVE

Zabriskie, Alexander

unknown; unknown; Gray, Sarah; Nissequogue; E; Boney Lane; Smithtown; c. 1915; Polhemus & Coffin; unknown; SHIN; NA; Blodgett, Alden; Weld, David; Y

BIBLIOGRAPHY: POLC, 1932; INVE

General Bibliography

General References

Dictionary of American Biography. New York: Charles Scribner's Sons, 1943, Vol. 1–22.

National Cyclopedia of American Biography. New York: J. T. White Co., 1898–1984, Vol. 1–63.

Placzek, Adolf K. (ed.), *Macmillan Encyclopedia of Architects,* Vol. 1–4. New York: The Free Press, Macmillan, 1982.

Henry Withey and Elsie Rathburn Withey, *Biographical Dictionary of American Architects (Deceased).* Los Angeles, California: New Age Publishing Company, 1956.

Wodehouse, Lawrence, *American Architects from the First World War to the Present,* Vol. 1–2. Detroit, Michigan: Gale Research Co., 1977.

Periodicals

The American Architect (1908–1940)

American Architect and Building News, Vol. 1–93 (1876–1908)

American Architect and Builders Monthly (1870–1871)

American Builder and Journal of Art (1868–1874)

The American Home, Vol. 1–23 (1928–1940)

American Homes and Gardens, Vol. 1–12 (1900–1915)

The Architect, Vol. 1–15 (1923–1931)

Architect, Builder and Woodworker (1868–1892)

The Architectural Annual, Vol. 1–7 (1900–1907)

The Architectural Association Sketchbook, Vol. 1–4 (1873–1876)

The Architectural Digest, Vol. 1–12 (1926–1947)

Architectural Era, Vol. 1–4 (1887–1890)

Architectural Forum (absorbed *The Brickbuilder*), Vol. 1–72 (1892–1940)

Architectural League of New York, Catalog of Annual Exhibitions, Vol. 9–52 (1893–1937)

Architectural Record, Vol. 1–83 (1891–1945)

The Architectural Reprint, Vol. 1–7 (1900–1907)

Architectural Review (merged with *The American Architect* in 1921), Vol. 1–88 (1912–1940)

Architectural Studies, Vol. 1–2

Architectural Year Book, Vol. 1 (1912)

Architects and Builders Journal, Vol. 1–9 (1899–1908)

Architecture, Vol. 1–73 (1900–1936)

Architecture and Building, Vol. 1–63 (1882–1932)

Architecture and Design, Vol. 1–15 (1937–1939)

Arts & Decoration, Vol. 1–49 (1910–1938)

The Brickbuilder (1892–1916)

The Builders' Journal, Vol. 1–3 (1920–1921)

Brochure Series of Architectural Illustrations (1895–1903)

Carpentry and Building, Vol. 1–44 (1879–1922)

The Century Magazine, Vol. 28–32 (1884–1886)

Country Homes, Vol. 1–8 (1921–1929)

Country Life in America, Vol. 1–42 (1901–1942)

Countryside Magazine and Suburban Life (1907–1917)

Fortune, Vol. 1–21 (1930–1940)

The Garden Magazine (1905–1928)

Golf, Vol. 1–40 (1897–1917)

Home and Field, Vol. 1–43 (1902–1933)

House and Garden, Vol. 1–40 (1901–1940)

The House Beautiful, Vol. 1–82 (1896–1940)

Indoors and Out, Vol. 1–5 (1905–1907)

Landscape Architecture: A Quarterly Magazine, Vol. 1–30 (1910–1940)

Long Island Forum (1965–1994)

Modern Architectural Designs and Details, Vol. 1–4 (1881–1890)

The New York Architect, Vol. 1–6 (1907–1912)

Polo Monthly (1927–1940)

Real Estate Record & Guide (1891–1913)

Scientific American: Architect and Builders Edition, Vol. 2–39 (1886–1905)

The Spur, Vol. 1–65 (1905–1940)

Technology Architectural Record, Vol. 1–8 (1907–1915)

Technology Architectural Review, Vol. 1–3 (1887–1890)

Touchstone, Vol. 1–8 (1917–1921)

Town and Country (1901–1921)

Special Collections

Avery Architectural and Fine Arts Library, Columbia University in the City of New York

Bayville Historical Museum, Bayville, NY

Brooklyn Historical Society, Brooklyn, NY

Brooklyn Public Library, Brooklyn, NY

Bryant Library, Local History Collection, Roslyn, NY

Building-Structure Inventory, Division for Historic Preservation, New York State Office of Parks, Recreation, and Historic Preservation, Albany, NY

East Hampton Free Library, Pennypacker Collection, East Hampton, NY

Beatrix J. Farrand Collection, University of California, Berkeley

Glen Cove Public Library, Local History Collection, Glen Cove, NY

Mattie Edwards Hewitt Photograph Collection, Nassau County Museum, Long Island Studies Institute, Hempstead, NY

The Hicks Nursery Collection, Jericho, NY

Huntington Historical Society, Photograph Collection, Huntington, NY

Long Island Studies Institute, Hofstra University, Hempstead, NY

Norman McBurney Photograph and Clipping Collection, SPLIA Archives, Setauket, NY

Meadow Brook Club, Photograph Collection, Brookville, NY

Museum of the City of New York, New York, NY (Byron Photograph Collection, Wurts Brothers Photograph Collection, McKim, Mead & White Collection)

Nassau County Museum, Long Island Studies Institute, Hempstead, NY

The New-York Historical Society, New York, NY

Frederick Law Olmsted National Historic Site, National Parks Service, Brookline, MA

Architecture Archives, University of Pennsylvania, Philadephia, PA.

Previews Incorporated, The National Real Estate Clearing House, New York, NY

Queens Borough Public Library, Long Island Division, Jamaica, NY

Roslyn Landmark Society, Roslyn, NY

Ellen Shipman Collection, Dept. of Manuscripts, Cornell University, Ithaca, NY

Suffolk County Historical Society, Riverhead, NY

Suffolk County Vanderbilt Museum, Vanderbilt Family Albums, Centerport, NY

The William K. Vanderbilt Historical Society, Oakdale, NY

Van Orden Photograph Collection, Carl Starace, Islip, NY

General Bibliography

Albro, Lewis Colt, and Harry T. Lindeberg, *Domestic Architecture*. New York: privately published, 1912.

Andrews, Wayne, *Architecture, Ambition and Americans: A Social History of American Architecture*. New York: The Free Press, 1947, 1964.

Andrews, Wayne, *Architecture in New York*. Kingsport, TN: Kingsport Press, Inc., 1969.

The Architecture of the American Summer: The Flowering of the Shingle Style, The Temple Hayne Buell Center for the Study of American Architecture, Columbia University. New York: Rizzoli International Publications, Inc., 1989.

Bailey, Paul, *Long Island —A History of Two Great Counties*. New York: Lewis Historical Publishing Co., 1949.

Baker, John Cordis, *American Country Homes and Their Gardens*. Philadelphia: John C. Winston Co., 1906.

Baker, John Cordis, *Monograph of the Work of Donn Barber*. Philadelphia: John Cordis Baker, 1924.

Baldwin, Charles, *Stanford White*. New York: Da Capo Press, 1971.

Bayles, Richard M. *Bayles' Long Island Handbook*. Babylon, NY: privately printed, 1885.

Broderick, Mosette Glaser, "A Place Where Nobody Goes: The Early Work of McKim, Mead & White and the Development of the South Shore of Long Island," in *In Search of Modern Architecture: A Tribute to Henry Russell Hitchcock,* Helen Searing, ed. New York: The Architectural History Foundation, and Cambridge, MA: MIT Press, 1982.

Brooks, John, *Once in Galconda: A True Drama of Wall Street*, 1920–1938. New York: Harper & Row, 1969.

Burchard, John, and Albert Bush-Brown, *The Architecture of America: A Social and Cultural History*. Boston: Little, Brown, 1961.

Burnham, Alan, ed., *New York Landmarks*. New York NY: Wesleyan University Press, 1964.

Cavalier, Julian, *American Castles*. South Brunswick, NJ, and New York: A. S. Barnes & Co., 1973.

Clowes, Ernest S., *The Hurricane of 1938 on Eastern Long Island*. New York: Bridgehampton, NY: Hampton Press, 1939.

Coles, Robert Reed, and Peter Luyster Van Santvoord, *A History of Glen Cove 1668–1968*. Glen Cove, NY: privately published, 1967.

Concrete Country Residences. New York: Atlas Portland Cement Co., 1907.

Cortissoz, Royal. *Architecture of John Russell Pope*. New York: William Helburn, Inc., 1922.

Country Estates. New York: Elliot C. Brown Co., 1914.

Country Homes. New York: Elliot C. Brown Co., 1928.

Cran, Marion, *Gardens in America*. London: Herbert Jerkins Limited, 1931.

Davidson, Marshall B., *The American Heritage History of Notable American Houses*. New York: American Heritage Publishing Co., 1971.

Davis, John H., *The Guggenheims: An American Epic*. New York: William Morrow & Co., 1978.

Dean, Ruth, *The Livable House: Its Garden*. New York: Moffat Yard & Co., 1917.

DeBevoise, C. Manley, Richard N. Powdrell, ed., *Long Island*. Port Washington, NY: Kennikat Press, 1963.

Delany, James F., and Peter Schulz, *Selections from the Work of James W. O'Connor Associates*. New York: Architectural Catalogue Co., Inc., 1930.

Desmond, Harry W., and Herbert Croly, *Stately Homes in America*. New York: D. Appleton & Co., 1903.

Dibbins, Elodie, Seth Purdey, Jr., and Cecil H. Ruggles, eds., *A Backward Glance*. Amityville, NY: The Amityville Historical Society, 1980.

Domestic Architecture of H. T. Lindeberg. New York: William Helburn, Inc., 1940.

Dow, Joy Wheeler, *American Renaissance—A Review of Domestic Architecture*. New York: W. T. Comstock, 1904.

Downing, A. J., *The Architecture of Country Houses*. New York: Dover Publications, 1969.

Dyson, Verne, *The Human Story of Long Island*. Port Washington, NY: Kennikat Press, 1969.

Edgell, G.H., *The American Architecture of Today*. New York: Charles Scribners & Sons, 1928.

Elwood, P. H., Jr., ed., *American Landscape Architecture*. New York: The Architectural Book Publishing Co., 1924.

Embury, Aymar II, *Architecture in American Country Homes*. New York: Mentor Associates, 1915.

Embury, Aymar II, *Country Houses by Aymar Embury II*. Garden City, NY: Doubleday, 1914.

Embury, Aymar II, *One Hundred Country Houses: Modern American Examples*. New York: The Century Co., 1909.

Englehardt, George W., *New York, The Metropolis*. 1902.

Ferree, Barr, *American Estates and Gardens*. New York: Munn & Co., 1904.

Fifty Years of the Maidstone Club, 1891–1941. East Hampton, NY: Privately printed by the Maidstone Club, 1941.

Flint, Martha B., *Early Long Island*. New York: Putnam and Sons, 1896.

Folsom, Merrill, *Great American Mansions*. New York: Hastings House, 1968.

Foster, Neston Sherrill, *Boarders to Builders: The Beginnings of Resort Architecture in East Hampton, Long Island 1870–1894*. Unpublished M.A. thesis, State University of New York at Binghamton, 1977.

French, Lillie Hamilton, *The House Dignified: Its Design, Its Arrangement, and Its Decoration*. New York: The Knickerbocker Press, 1908.

Friedman, B. H., *Gertrude Vanderbilt Whitney*. Garden City, NY: Doubleday, 1978.

Fuller, Albert W., *Artistic Homes in City and Country*. Boston: James R. Osgood & Co., 1884.

Furness, Frank, *Architecture of H. H. Richardson*.

Gebhard, David, and Deborah Nivens, *200 Years of American Architectural Drawings*. New York: Whitney Library of Design, 1977.

Gillon, Edmund V., Sr., *Early Illustrations and Views of American Architecture*. New York: Dover Publications, 1971.

Girouard, Mark, *Life in the English Country House*. New Haven, CT, and London: Yale University Press, 1978.

Girouard, Mark, *The Victorian Country House*. Oxford: Clarendon Press, 1971.

Goddard, Conrad Godwin, *The Early History of Roslyn Harbor*. Roslyn, NY: Privately published, 1972.

Greiff, Constance M., *Lost America*. Princeton: The Pyne Press, 1971.

Hamlin, Talbot, *The American Spirit in Architecture*. New Haven, CT: Yale University Press, 1926.

Hawers, M. E., *Beautiful Houses*. London: Sampson Low, Marston, Searte & Rivington, 1882.

Hazelton, Henry Isham, *Boroughs of Brooklyn and Queens, Counties of Nassau and Suffolk 1609–1924*. New York and Chicago: Lewis Historical Publishing Co., Inc., 1925.

Hering, Oswald C., *Concrete and Stucco Houses*. New York: Robert M. McBridge & Co., 1922.

Herman, Stewart H., *The Smallest Village: The Story of Dering Harbor*. Shelter Island, NY: The Shelter Island Historical Society, 1976.

Hewitt, Mark Alan, *The Architect and the American Country House*. New Haven, CT, and London: Yale University Press, 1994.

Hitchcock, Henry-Russell, *American Architectural Books*. New York: Da Capo Press, 1976.

Hitchcock, Henry-Russell, *Architecture: 19th and 20th Centuries*. Baltimore, MD: Penguin Books (1958), 1968.

Hitchcock, Henry-Russell, *Architecture of H. H. Richardson*. New York (1936, rev. ed., 1961; paper-back ed., Cambridge, MA, 1966).

Hooper, Charles Edward, *The Country House*. Garden City, NY: Doubleday & Page Co., 1913.

Hopkins, Alfred, *Modern Farm Buildings*. New York: Robert M. McBride & Co., 1920.

Howe, Samuel, *American Country Houses of Today*. New York: The Architectural Book Publishing Co., 1915.

E. W. Howell Co., Builders, *Noted Long Island Homes*. Babylon, NY: Privately printed, 1933.

Huntington, Northport, Centerport, Cold Spring Harbor. New York, NY: American Photograph Co., 1897.

Johnson, William Martin, *Inside of One Hundred Homes*. New York: Doubleday & McClure Co., 1897.

Kaufmann, Edgar, Jr., ed., *The Rise of An American Architecture*. New York: Metropolitan Museum of Art, and Frederick A. Praeger, Publishers, 1970.

Keefe, Charles S., *The American House*. New York: U.P.C. Book Company, Inc., 1922.

Kelsey, Carleton, *Amagansett, A Pictorial History 1680–1940*. Amagansett, NY: The Amagansett Historical Society, 1986.

Kidney, Walter C. *The Architecture of Choice: Eclecticism in America, 1880–1930*. New York: G. Braziller, 1974.

Kimball, S. Fiske, *American Architecture*. New York: The Bobbs-Merrill Co., 1928.

Kimbrough, Sara Dodge, *Drawn from Life*. Jackson, MS: University Press of Mississippi, 1976.

King, Robert B., *Ferguson's Castle: A Dream Remembered*. Hicksville, NY: Exposition Press, 1978.

Lancaster, Clay, Robert A. M. Stern, and Robert J. Hefner, *East Hampton's Heritage*. New York, NY: W. W. Norton & Company, 1982.

Landscape Planting and Engineering. New York: Lewis & Valentine Company, 1922.

Lewis & Valentine Nursery. New York: Lewis & Valentine Company, 1916.

Lundberg, Ferdinand, *America's 60 Families*. New York: The Citadel Press, 1937.

Manhasset, The First 300 Years. Manhasset, NY: Privately printed by the Manhasset Chamber of Commerce, 1980.

McGrath, Raymond, *Twentieth Century Houses*. London: Faber and Faber, 1934.

Miller, Frances (daughter of James Breese), *"Tanty" Encounters with the Past*. Sag Harbor, NY: Sandbox Press, 1979.

Modern Landscape Engineering. New York: Lewis & Valentine Company, n.d.

Monograph of the Work of Charles A. Platt. New York: The Architectural Book Publishing Co., 1913.

Myers, Denys Peter, and Eva Ingersoll Gatling, *The Architecture of Suffolk County*. Huntington, NY: Heckscher Museum, 1971.

Myers, Gustavus, *History of the Great American Fortunes*. New York: The Modern Library (1936), 1937.

New York Social Register. New York: Social Register Association (Summer issues: 1895, 1900, 1910, 1915, 1920, 1925, 1930, 1935, 1940).

The Old Oakdale History, Volume 1. Oakdale, NY: The William K. Vanderbilt Historical Society, privately printed, 1983.

Orr, Christina, *Addison Mizner: Architect of Dreams and Realities (1872–1933)*. Palm Beach, FL: Norton School of Art, 1977.

Paine, Judith, *Theodate Pope Riddle; Architect: Her Life and Work*. New York: The National Park Service, 1979.

Parsons, Samuel, Jr., *The Art of Landscape Architecture*. New York and London: G. P. Putnam's Sons, 1915.

Parish Art Museum, *The Long Island Country House, 1870–1930*. Southampton, NY: The Parish Art Museum, 1988.

Parish Art Museum, *Landscape Gardening*. New York: G. P. Putnam's Sons (1891), 1908.

Patterson, Augusta Owen, *American Homes of Today*. New York: Macmillan, 1924.

Pelletreau, William S., *American Families of Historic Lineage*, Vol. 1–2. New York: National American Society, 1912.

Pettit, William S., *History and Views of the Rockaways*. New York: William T. Comstock, 1889.

Picturesque Babylon, Bay Shore and Islip. New York: Mercantile Illustrating Co., 1894.

Pincus, Roberta, ed., *This Is Great Neck*. Great Neck, NY: A publication of the League of Women Voters of Great Neck, 1975.

Pine, Robert H., *Sag Harbor Past, Present and Future*. New York: Sag Harbor Historical Preservation Commission, 1973.

Platt, Frederick, *America's Gilded Age: Its Architecture and Decoration*. South Brunswick, NJ, and New York: A. S. Barnes, 1976.

Portraits of Ten Country Houses Designed by Delano & Aldrich. Garden City, NY: Doubleday, Page & Co., 1922.

Price, C. Matlack. *The Work of Dwight James Baum*. New York: William Helburn, Inc., 1927.

Prominent Residents of Long Island and Their Pleasure Clubs. New York: Thompson & Watson, 1916.

Purtell, Joseph, *The Tiffany Touch*. New York: Pocket Books (1972), 1973.

Rains, Albert, *With Heritage So Rich*. New York: Random House, 1966.

Randall, Monica, *The Mansion of Long Island's Gold Coast*. New York: Hastings House, 1979.

Residences Designed by Bradley Delehanty, New York: Architectural Catalogue Co., Inc., 1939.

Reynolds, Quentin, *The Fiction Factory: The Story of 100 Years of Publishing at Street & Smith*. New York: Random House, 1955.

Rifkind, Carole, and Carol Levine, *Mansions, Mills and Main Streets*. New York: Schocken Books, 1975

Rile, Louvett, Associate, *Selections from Work Designed and Erected During the Last Ten Years by Lewis Colt Albro*. New York: Architectural Catalogue Company, March 1924.

Roth, Leland M., *The Architecture of McKim, Mead & White 1870–1920, A Building List*. New York and London: Garland Publishing Co., Inc., 1978.

Ruther, Frederick, *Long Island Today*. Hicksville, NY: Privately printed, 1909.

Saylor, Henry H., *Architectural Styles for Country Houses*. New York: Robert M. McBride & Co., 1919.

Saylor, Henry H., ed., *Distinctive Homes of Moderate Cost*. New York: McBride, Winston & Co., 1910.

Sclare, Liisa, and Donald, *Beaux-Arts Estates, A Guide to the Architecture of Long Island*. New York: The Viking Press, 1980.

Scully, Vincent J., Jr., *The Shingle Style: Architectural Theory and Design from Richardson to the Origins of Wright*. New Haven, CT: Yale University Press, 1955.

Seale, William, *The Tasteful Interlude: American Interiors Through the Camera's Eye, 1860–1917*. New York: Praeger, 1975.

Sheldon, George, ed., *Artistic Country Seats: Types of Recent American Villa and Cottage Architecture*. New York: Da Capo Press, 1979 (first edition 1886).

Shelton, Louise, *Beautiful Gardens in America*. New York: Charles Scribner's Sons, 1928 (first edition, 1915).

Shopsin, William C., and Grania Bolton Marcus, *Saving Large Estates: Conservation, Historic Preservation, Adaptive Re-Use*, Setauket, NY: Society for the Preservation of Long Island Antiquities, privately printed, 1977.

Smith, G. E. Kidder, *A Pictorial History of Architecture in America*. Vol. 1. New York: American Heritage Publishing Co., 1976.

Sobin, Dennis P., *Dynamics of Community Change: The Case of Long Island's Declining Gold Coast*. Port Washington, NY: Ira J. Friedman, Inc., 1968.

Stevens, J. C., and A.W. Cobb, *Examples of American Domestic Architecture*. New York: William T. Comstock, 1889.

Swaine, Robert T., *The Cravath Firm and Its Predecessors*. Vols. 1, 2. New York: Ad Press, Ltd., 1946, 1948.

Swanbery, W. A., *Whitney Father, Whitney Heiress*. New York: Charles Scribner's Sons, 1980.

Tallmadge, Thomas E., *The Story of Architecture in America*. New York: W. W. Norton & Company, 1927.

Thorndike, Joseph J., Sr., *The Magnificent Builders and Their Dream Houses*. New York: American Heritage Publishing Co., 1978.

Townsend, Reginald T., *The Country Life Book of Building and Decorating*. Garden City, NY: Doubleday, Page & Co., 1922.

Townsend, Reginald T., *House and Garden Book of Houses*. Garden City, NY: Doubleday, Page & Co., 1940.

Tredwell, Daniel M., *Personal Reminiscences of Men and Things on Long Island*. Brooklyn, NY: 1912.

Updike, D. P., *Hunt Clubs and Country Clubs in America*. Cambridge, MA: The Merrymount Press (private printing), 1928.

Van Bloem, Kate, *History of the Village of Lake Success*. Incorporated Village of Lake Success, NY, 1968.

Vanderbilt, Consuelo, *The Glitter and the Gold*. New York: Balsan, Harper & Brothers, 1952.

Van Liew, Barbara, *50 Years, 1928–1979, Head-of-the-Harbor*. St. James, NY: Incorporated Village of Head-of-the-Harbor, privately printed, 1978.

Viemeister, August, edited and introduction by Marian Leifsen, *An Architectural Journey Through Long Island*. Port Washington, NY: Kennikat Press, 1974.

Wallick, Frederick, "*'Fairacres' and Some Other Recent Country Houses by Wilson Eyre*," *The International Studio*. 40 no. 15: (Apr. 1910) pp. 29–36.

Wecter, Dixton, *The Saga of American Society: A Record of Social Aspiration, 1607–1937*. New York: Charles Scribner's Sons, 1937.

Weigold, Marilyn, *The American Mediterranean: An Environmental, Economic and Social History of Long Island Sound*. Port Washington, NY: Kennikat Press, 1974.

Whiffen, Marcus, *American Architecture Since 1780*. Cambridge, MA: MIT Press, 1969.

Whitaker, Charles Harris, *Bertram Grosvenor Goodhue: Architect and Master of Many Arts*. New York: Press of the American Institute of Architects, Inc., 1925.

Whitney, Caspar, *Evolution of the Country Club*. New York: Harper's New Monthly Magazine, 1894.

Williams, H. L., and O. K. Williams, *A Treasury of Great American Houses*. New York: G. P. Putnam's Sons, 1970.

Work Designed by James W. O'Connor. New York: Architectural Catalogue Co., Inc., 1922.

The Work of Polhemus & Coffin. New York: Architectural Catalogue Co., Inc., 1937.

W. P. A. Project, *The Story of the Five Towns*. Nassau County, NY: The Nassau Daily Review Star, 1941.

Index

List of Contributors

Michael Henry Adams
Architectural historian
Upper Manhattan Society for Progress
through Preservation,
New York, NY

Mardges Bacon
Professor of art and architecture,
Northwestern University,
Boston, MA

Diana Balmori
Balmori Associates, Inc.,
New Haven, CT

Steven Bedford
Rensselaer Polytechnic Institute,
Troy, NY

Mosette Glaser Broderick
Acting chair, Urban Design Department,
Department of Fine Arts,
New York University, NY

Dr. Albert Bush-Brown
New York, NY

Richard Chafee
Architectural historian,
Providence, RI

Freya Carlbom
Artist and granddaughter of
James W. O'Connor,
New York, NY

Leslie Rose Close
New York, NY

John Coolidge
William Dorr Professor of Fine Arts, Emeritus,
Harvard University (deceased)

Donald W. Curl
Professor and chair, Department of History,
Florida Atlantic University,
Boca Raton, FL

Wendy Joy Darby
Consultant on gardens and cultural landscape,
New York, NY

Andrew S. Dolkart
Adjunct associate professor, Columbia
University, School of Architecture,
New York, NY

Donald Dwyer
Architectural historian, Huntington, NY

Dr. Mary D. Edwards
Pratt Institute and School of Visual Arts,
New York, NY

Betsy Fahlman
Associate professor of art history,
School of Art, Arizona State University,
Tempe, AZ

Ellen Fletcher
Writer and interpretive planner
Frenchtown, NJ

Sherrill Foster
Architectural historian and writer,
East Hampton, NY

Cornelia B. Gilder
Architectural historian,
Tyringham, MA

Alastair Gordon
School of Architecture, Princeton University,
Princeton, NJ

Erin Drake Gray
New York, NY

Thomas R. Hauck (deceased)

Jethro M. Hurt III
West Palm Beach, FL

Peter Kaufman
School of Architecture,
Florida A & M University,
Tallahassee, FL

Joy Kestenbaum
Preservation consultant and teacher,
New York Institute of Technology,
Old Westbury, NY

Karen Morey Kennedy
Historic Preservation Planner,
County of Westchester, NY

Sarah Bradford Landau
Professor of art history,
New York University,
New York, NY,
and vice chairman of the New York City
Landmarks Preservation Commission

Robert B. MacKay
Director, Society for the Preservation of Long
Island Antiquities,
Setauket, NY

Pauline C. Metcalf
New York, NY

Christopher E. Miele
New York, NY

Keith N. Morgan
Director, American and New England
Studies Program, Boston University,
Boston, MA

William B. O'Neal, F.A.I.A.
Professor Emeritus, University of Virginia,
Charlottesville, VA

Judith Paine
Westport, CT

Marjorie Pearson
Landmarks Preservation Commission,
New York, NY

Frederick Platt
Forest Hills, NY

Selma Rattner
New York, NY

Joel Snodgrass
Integrated Conservation Resources, Inc.,
Brooklyn, NY

Anna Lee Spiro
New York, NY

Gwen W. Steege
Williamstown, MA

Zachary Studenroth
President, Lockwood-Mathers Mansion,
Norwalk, CT

Dr. Edward Teitelman
Camden, NJ

Jeanne Marie Teutonico
Rome, Italy

Dr. Gavin Townsend
Associate professor of art history and
assistant director of the honors program,
University of Tennessee at Chattanooga, TN

Carol A. Traynor
Public Affairs Officer, Society for the
Preservation of Long Island Antiquities,
Setauket, NY

Barbara Ferris Van Liew
Editor, Preservation Notes, Society for the
Preservation of Long Island Antiquities,
Setauket, NY

Anne H. Van Ingen
New York, NY

Diana S. Waite
Mount Ida Press,
Albany, NY

James A. Ward
New York, NY

Elizabeth L. Watson
Architectural Historian,
Cold Spring Harbor, NY

Richard Guy Wilson
Commonwealth Professor and Chair,
Department of Architectural History,
University of Virginia,
Charlottesville, VA

Kevin Wolfe
New York, NY

Dr. Cynthia Zaitzevsky
Consultant on the history and preservation of
architecture and landscape architecture,
Teacher, Radcliffe Seminars,
Cambridge, MA